McGRAW-HILL DICTIONARY OF ART

McGRAW-HILL

McGRAW-HILL BOOK COMPANY NEW YORK

DICTIONARY OF ART

Edited by
BERNARD S. MYERS
Consulting Editor, *Encyclopedia of World Art*
Editor, *Encyclopedia of Painting*
Formerly New York University, Rutgers University,
University of Texas, The City University of New York

Assistant Editor
SHIRLEY D. MYERS
Assistant Editor, *Encyclopedia of Painting*

Volume 5 ROUAULT – ZYL

TORONTO LONDON SYDNEY JOHANNESBURG

Library of Congress Catalog Card Number: 68-26314
Printed in Italy by Arnoldo Mondadori, Officine Grafiche - Verona
Illustration credits are listed in Volume 5.

McGRAW-HILL STAFF

Executive Editor: David I. Eggenberger
Director of Design and Production: Gerard G. Mayer
Associate Editor: Beatrice Carson
Editing Managers: Tobia L. Worth; Margaret Lamb
Research Editor: Donald Goddard
Proof Editor: Gordon L. Gidley
Administrative Editor: M. Barat Kerr Sparks
Bibliographers: Sally Evans; Donald Goddard; Marian Williams
Editorial Assistant: Ethel M. Jacobson
Copy Editors and Proofreaders: Monica Bayley; Olive Collen; Beatrice Eckes
Art and Design: David Ross-Robertson; Edward Fox; Ann Bonardi

ART AND DESIGN STAFF

Picture Editor: Giorgio Marcolungo

Art Director: Fiorenzo Giorgi

Assistants: Massimo Bucchi
Raffaele Curiel
Isabella Piombo
Adolfo Segattini
Maurizio Turazzi

Line Drawings Prepared by: 5 Lines Studio - Rome
Design Italiana - Milan

R

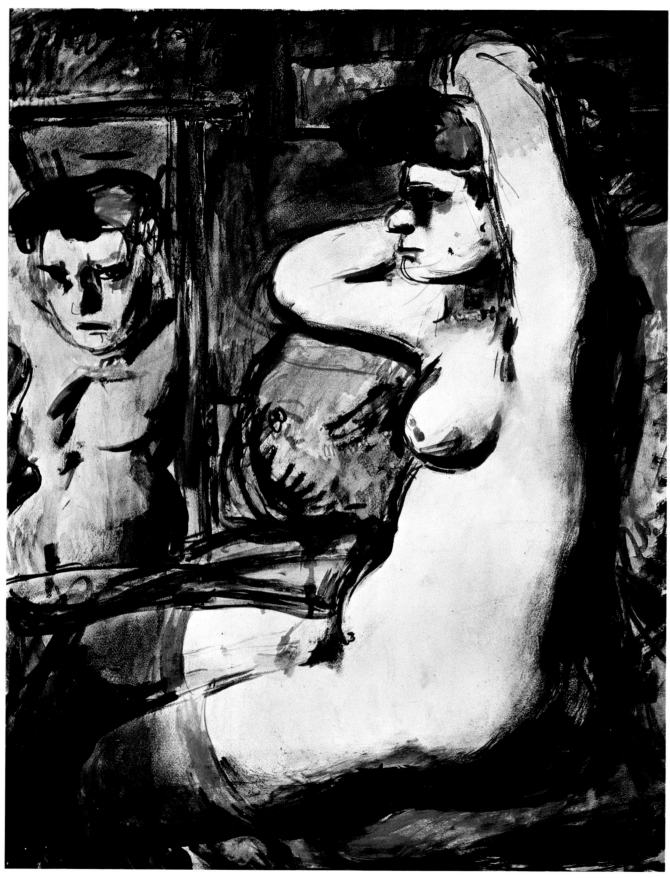

Georges Rouault, *The Mirror*, 1906. Aquarelle on cardboard. National Museum of Modern Art, Paris.

ROUAULT, GEORGES. French painter and printmaker (b. Paris, 1871; d. there, 1958). He received some drawing lessons from his grandfather, an amateur painter who admired Rembrandt, Courbet, and Manet. From 1885 to 1890 Rouault worked as an apprentice to a stained-glass repairer and designer, collaborating on new windows for St-Severin in Paris. He took evening courses at the Ecole Nationale des Arts Décoratifs, and in 1891 entered the Ecole des Beaux-Arts with Elie Delaunay as his teacher. He then studied with Gustave Moreau and came to know Matisse, Manguin, Marquet, Camoin, and others who were to become Fauves soon after 1900. He took prizes for pictures on religious themes in 1892 and 1894. His religious and mythological canvases were exhibited at the official salons between 1895 and 1901. Rouault also worked at landscape during that period.

Moreau died in 1898, and Rouault, as one of his leading pupils, was named director of the museum founded in Moreau's honor. At that time, however, Rouault underwent a severe psychological strain and reacted aesthetically against his academic manner. Convalescing in 1902 and 1903, he developed the blunt, forceful style that connected him with the Fauvist circle, and he helped to found the first Salon d'Automne in 1903, becoming a target for the invective of the academicians of whom he had only recently been a colleague. Rouault's personality was increasingly shaped by religious and sociological considerations, and his subjects, interpreted in bold washes of darkish reds and blues with powerful linear definitions, became correspondingly somber—images of corrupt jurists, prostitutes, and disenchanted clowns and acrobats. Rouault was represented in the renowned and controversial 1905 Salon d'Automne, although his canvases were not placed with the Fauvist collection.

His first one-man show was held at the Galerie Druet in 1910. He continued his religious and morally conscious paintings until 1916, when his dealer, Ambroise Vollard, persuaded him to turn to printmaking and illustration. The French government in 1919 purchased his painting *The Child Jesus* (1893). The Galerie Druet held a retrospective of his works in 1924. He worked chiefly in graphic media until about 1927, occasionally producing paintings of a somewhat more varied and richer coloration.

Turning to painting again after 1927, Rouault developed the thickly crusted, richly toned style with thickly outlined images for which he is best known. His themes repeated the clowns and religious figures he had done earlier, but he seldom painted his aggressive indictments of judges and prostitutes of about 1903-16. Rouault's manner, especially his persistent use of heavy black outlines as well as his sometimes luminous encrustations of grainy blues, reds, greens, and yellows, has frequently been related to the effect of medieval stained-glass technique. While he may have retained some affinity for that medium, this analogy is only superficially pertinent. Rouault's outlines are specifically applied to definitions of silhouette and main bodily divisions, whereas Gothic tracery joins together the irregular pieces of glass irrespective of whether or not the line marks off a particular sector of form. Nonetheless, the general effect of Rouault's color and line are not without a certain medieval flavor, the more so because of the gravity of his subjects.

Rouault's art after 1930 became internationally famous through showings in Munich, London, Chicago, New York, and elsewhere; and his style also won recognition through tapestry designs. His pictures following the early 1930s are difficult to date precisely because he seldom designated the year of completion with his signature. Moreover, he often reworked or finished canvases he had started from about 1910 through the 1920s. His works increased in richness of color and texture, however, from about 1932 on.

A retrospective of his work was held in 1945 at the Museum of Modern Art in New York. In 1947 Rouault won a lawsuit against the heirs of his dealer, Vollard, for the right to reclaim some 800 unsold and unsigned works, which he regarded as unfinished. Rouault burned more than 300 of these before witnesses. Universally acclaimed as one of the major French artists of the 20th century, he was made a Commander of the Legion of Honor in 1951. In 1952-53 major retrospectives of his paintings and graphic art were held in Brussels, Amsterdam, Paris, Cleveland, New York, and Los Angeles. He is represented in

leading museums and private collections throughout Europe and America.

Rouault's important paintings include *The Child Jesus among the Doctors* (1893; Colmar, Unterlinden Museum), *Le Chahut* (1905; Paris, private collection), *The Mirror* (1906; Paris, National Museum of Modern Art), *Head of a Clown* (1908; Washington, D.C., Dumbarton Oaks Collection), *Mr. X* (1911; Buffalo, Albright-Knox Art Gallery), *Three Judges* (1913; New York, Museum of Modern Art), *Small Family of Clowns* (1933; Paris, private collection), *The Old King* (1936; Pittsburgh, Carnegie Institute), *Head of a Clown* (1948; Boston, Museum of Fine Arts), and *Twilight* (1952; Paris, private collection).

Rouault is one of the most distinguished modern printmakers; he worked in various media including wood engraving, color lithography, and etching. His first important series was the famous *Miserere*, some sixty etchings and aquatints finished in 1927 but not actually published until 1948. His *Fleurs du mal*, based upon Baudelaire's poems, were partly done in 1926–27 and were completed in the 1930s. Another significant group is *Les Réincarnations du Père Ubu* (1928), consisting of eighty-two wood engravings and seven color etchings.

A close associate of the Fauvist group between 1903 and 1907, Rouault may only inexactly be classified as an exponent of the Fauve style. He somewhat better fits the designation of expressionist; but, despite his sharing of religious themes with Nolde and certain other members of Die Brücke, Rouault's expressionism is only generally related to that of the Germans. He is a major early modern artist whose contribution is distinguished for its great independence.

BIBLIOGRAPHY. M. Puy, *Georges Rouault*, Paris, 1921; J. T. Soby, *Georges Rouault: Paintings and Prints*, 3d ed., New York, 1947; Musée National d'Art Moderne, *Georges Rouault* (exhibition catalog), Paris, 1952; Cleveland Museum of Art and Museum of Modern Art, New York, *Rouault: Retrospective Exhibition, 1953*, New York? 1953; L. Venturi, *Rouault*, Paris, 1959; P. Courthion, *Georges Rouault*, Paris, 1962.

JOHN C. GALLOWAY

ROUBILIAC, LOUIS FRANCOIS. French sculptor (b. Lyons, 1702/05; d. London, 1762). He went to England about 1732 and was an assistant to Cheere. His statue of Handel, executed in 1738 for Vauxhall Gardens (now London, Messrs. Novello), brought him fame. He was undoubtedly the most outstanding sculptor in 18th-century England. He was not only a great artist but also a superb craftsman, as the overall quality of his monuments prove. His portrait busts are powerful likenesses (for example, the *Ninth Earl of Pembroke*, 1750; Birmingham, City Museum and Art Gallery); and his monuments are baroque in conception (for example, those of the Duke of Argyll, 1745–49, and Elizabeth Nightingale, 1761; both Westminster Abbey). He was also influenced by current French works, as may be seen in his monuments of the Duke and Duchess of Montagu (1752–53) at Warkton, Northhamptonshire.

BIBLIOGRAPHY. K. A. Esdaile, *The Life and Works of Louis François Roubiliac*, London, 1928.

ROUBLEW, ANDREI, see RUBLEV, ANDREI.

ROUEIHA (Rouweha), CHURCH OF. One of a group of north Syrian churches of the 5th century. Roueiha is a three-aisled East Christian basilica. It has a semicircular apse flanked by rectangular chambers. Low, massive T-shaped piers support diaphragm arches which separate the three bays of the nave. The church is vaulted by an open-trusswork timber roof.

BIBLIOGRAPHY. H. C. Butler, *Early Christian Churches in Syria...*, ed. and completed by E. B. Smith, Princeton, 1929.

ROUEN. City in northern France near the mouth of the Seine. Until World War II Rouen was richer in superb examples of medieval architecture than any other city of France. Most of the medieval half-timbered houses and the fine early Renaissance mansions, such as the Hôtel du Bourgtheroulde and the so-called House of Diane de Poitiers, were severely damaged or totally destroyed, but the Cathedral, St-Maclou, and St-Ouen still stand despite some damage. *See* SAINT-MACLOU; SAINT-OUEN.

In 260 Rouen was established as a bishopric. In 912 it was made the capital city of the dukes of Normandy, and after the Conquest remained intermittently in English hands until 1449. Rouen was the scene of the trial and burning of Joan of Arc in 1419; she had been imprisoned in the ancient castle of the dukes of Normandy, most of which was demolished in 1809. However, one tower, called the Tower of Joan of Arc, still stands, though it is not certain that this was the actual place of her imprisonment.

Among the most famous monuments is the Palace of Justice, begun in 1499 by Roger Ango and Roland Le Roux. Its lavish Flamboyant Gothic architecture bespeaks the wealth of 16th-century Rouen. Though the exterior is being restored to its original appearance, the famous interiors were irrevocably ruined in World War II.

The Cathedral of Notre-Dame is one of the most richly decorated in France. The façade presents a fascinating assemblage of every medieval style from 12th-century Romanesque through late Gothic, including the superbly elegant Tour de Beurre (Butter Tower) of the 14th century and the great florid Flamboyant Gothic screen across the central section dating from 1509–30. Crowning the tower over the crossing is the handsome cast-iron spire (486 ft.) erected by Alavoine in 1825. Though the south aisle of the Cathedral was demolished in World War II, the rest of the church remains intact.

The lovely little 16th-century Church of St. Vincent was totally destroyed, though its fine 16th-century glass had been removed and remains intact. Before World War II ancient houses stood against the walls of the Cathedral and picturesque streets wound between the Cathedral and the Seine, but this area was totally obliterated.

See also ROUEN: FINE ARTS MUSEUM.

BIBLIOGRAPHY. H. La Farge, *Lost Treasures of Europe*, New York, 1946; M. Aubert and S. Goubet, *Gothic Cathedrals of France and Their Treasures*, London, 1959.

ALDEN F. MEGREW

ROUEN: FINE ARTS MUSEUM. French collection. The foreign paintings include works by Gerard David (*Virgin and Child with Angels and Saints*), Rubens (*Adoration of the Shepherds*), Herrera the Elder (*Temptation of St. Jerome*), Velázquez (*Portrait*), and Botticelli (*Madonna*). Despite the presence of an important Poussin (*Venus Arming Aeneas*, 1639), the French paintings are mainly from the 18th and 19th centuries. Noteworthy are Fragonard's *Washerwomen*, Delacroix's *Justice of Trajan*, Ingres's *Belle Zélie*, and Monet's *Portal of Rouen Cathedral*. The mu-

Henri Rousseau, *The Snake Charmer*, 1907. Musée du Jeu de Paume, Paris.

seum also displays sculptures by Pajou, Caffieri, Lemoine, Canova, David d'Angers, and others.

BIBLIOGRAPHY. M. Nicolle, *Le Musée de Rouen, peintures*, Paris, 1920.

ROUEN CATHEDRAL. Oil painting by Monet; versions in the Louvre Museum, Paris, the Metropolitan Museum of Art, New York, and elsewhere. *See* MONET, CLAUDE-OSCAR.

ROUGH-IN. First step in carving in stone. The large areas of stone which protrude beyond the general outline of the figure are roughly cut away by chisel and hammer, and sometimes by saw.

ROULETTE. In the intaglio field, a hand tool whose base contains a narrow to wide disk of steel that rolls on its own axis, similar to the working of a spur, with many regular or irregular teeth. Roulettes are used in the making of mezzotints and also on grounded etching plates to produce prints in the "crayon manner."

ROUNDEL. Small circular panel, window, or niche. Roundels as circular niches containing freestanding busts were particularly favored in 18th-century neoclassic architecture.

ROUSSEAU, HENRI. French primitive painter (b. Laval, Mayenne, 1844; d. Paris, 1910). From 1864 to 1868, according to Rousseau himself, he went as a regimental musician in the French army to Mexico in the campaign of Napoleon III to aid Maximilian. In 1869 he went to Paris, first to work as a lawyer's clerk, then as a *douanier*, a minor customs official. He was to bear the name "Le Douanier" thereafter. He often went to the Louvre to copy; such study was the only form of instruction he received. In 1886 he exhibited at the Salon des Indépendants. That year he left his work in customs and lived on a small pension and income from music lessons.

In 1889 he wrote a play called *A Visit to the Exhibition of 1889*. In 1890 he met Gauguin, Seurat, Pissarro, Re-

don, and the critic Gustave Coquiot. The following year Rousseau began to paint the first of many pictures with tropical themes. He was inspired by a visit to the Paris Botanical Gardens, which presumably evoked memories of Mexico. In 1895 he painted the large canvas *War* (Paris, Louvre). He also painted a portrait of Alfred Jarry, author of *Ubu Roi*. In 1898 Rousseau offered his celebrated *The Sleeping Gypsy* (New York, Museum of Modern Art) to Laval, his home town, for a small amount, but the offer was refused. The next year he wrote another play, *A Russian Orphan's Vengeance*. In 1905 he exhibited three paintings, among them *The Hungry Lion*, at the Salon d'Automne.

He became acquainted with Picasso, Delaunay, Vlaminck, Max Jacob, Apollinaire, Raynal, and Salmon in 1906 and, the next year, with the American Max Weber and the critic Wilhelm Uhde, who was to write the first monograph on Rousseau. Uhde also acquired a number of his paintings. Mme. Delaunay commissioned Rousseau to paint his *Snake-Charmer* (Paris, Musée du Jeu de Paume), and the dealer Joseph Brummer sold a number of Rousseau's works. In 1908 Picasso gave a banquet in Rousseau's honor at the Bateau-Lavoir studio on rue Ravignan. In 1910 he was given his first American showing, arranged by Max Weber at the "291" Gallery in New York.

Rousseau's lack of a formal art education, although evident in his drawing of ambitious subjects, freed him from all academic convention and permitted instinct to have full reign. His unerring sense of pattern, his imaginative use of color, and his taste for lyrical and exotic themes give credence to his painting because he had, as a primitive, unquestioning conviction in his vision of nature and in the efficacy of his art.

BIBLIOGRAPHY. D. C. Rich, *Henri Rousseau*, 2d ed., New York, 1946; J. Bouret, *Henri Rousseau: Le Douanier*, New York, 1961.
ROBERT REIFF

ROUSSEAU, PIERRE-ETIENNE-THEODORE. French painter of the Barbizon school (b. Paris, 1812; d. Barbizon, 1867). Rousseau's cousin Alexandre Pau de Saint-Martin, a landscape painter, encouraged him to begin painting, and they went on excursions together. By the time Rousseau was fourteen he was studying seriously with Charles Remond. He was set to making copies of old masters, notably the 17th-century Dutch landscapists and Claude Lorraine. Rousseau, however, preferred to work out of doors, and as early as 1826 began to visit the forest park in Fontainebleau. He went to the Auvergne Mountains to paint wild mountainsides, gorges, and gushing streams in a free manner suggesting the spirit and influence of Delacroix and Victor Hugo. He showed these pictures to the painter Ary Scheffer when he returned to Paris in 1830. Scheffer, struck by their expressive power, exhibited them in his studio. These Byronic works so impressed adventurous collectors and young artists that by the age of eighteen Rousseau had a reputation.

Rousseau exhibited at the Salon regularly from 1831 to 1836, and became known to a larger public as a controversial figure. His works were purchased by the champion of the romantic artists, the Duc d'Orléans. In 1833 the critic Thoré-Bürger became a close friend and praised his art. When Rousseau's *Descent of the Cattle* (Amiens,

Museum of Picardy) was rejected for the 1836 Salon, even Delacroix came to his defense.

Rousseau had undoubtedly seen the landscapes of Constable at the Salon of 1832. Although, at the time, Rousseau's work had more in common with Claude Lorraine, the impression Constable obviously made on him was not only strong but lasting. Rousseau's debt to the painting of the Dutch, particularly Jacob van Ruisdael and Salomon van Ruysdael, is unmistakable. These influences merged by 1836 to create an original stylistic statement, which was more compelling to Rousseau's contemporaries than it appears today, because he took to using bitumin, a substance that is rich in quality when fresh but clouds with age. Rousseau's great friend at this time was Dupré. The two men, with Corot, Diaz, and Troyon, and then Daubigny and Millet, came to be known as the Barbizon school because they worked throughout the 1830s near the town of Barbizon and because of a similarity of intent. They were all landscapists and plein-airists.

Rousseau had no success with the Salons of the 1840s. Even so, his reputation continued to grow. He went to the plains of Berry in 1842, isolated himself completely, and adopted an approach to composition in which a single tree or a clump dominates the middle distance of a plain. He began to give more attention to the sky. The Revolution of 1848 led to a liberalization of the Salon and a first-class medal for Rousseau the following year.

BIBLIOGRAPHY. A. Sensier, *Souvenirs sur Th. Rousseau*, Paris, 1872; P. Dorbec, *Théodore Rousseau*, Paris, 1911; R. L. Herbert, *Barbizon Revisited . . .*, New York, 1962.
ROBERT REIFF

ROUSSEAU, VICTOR. Belgian sculptor (b. Feluy-Ardennes, 1865; d. Brussels, 1954). As a boy he worked in marble quarries and as a laborer on the construction of the Palace of Justice in Brussels. He later studied with Van der Stappen and Houstont at the Brussels Academy of Fine Arts and traveled throughout Europe. In Rousseau's portraits, monuments, and many works with literary or classical themes, he was primarily interested in the expressive possibilities of the body through mass and line and its full realization in finished marble rather than in academic classicism.

BIBLIOGRAPHY. R. Dupierreux, *Victor Rousseau*, Antwerp, 1949.

ROUSSEL, KER-XAVIER. French painter and decorator (b. Lorry-les-Metz, 1867; d. L'Etang-la-Ville, 1944). He studied with Maillart, Fleury, and Bouguereau and was a member of the Nabis group. Many of Roussel's early works are fluid, skillful still lifes. Under the influence of the Nabis, he turned to figure painting, at first with closed silhouettes and linear emphasis and later in a broader style. He eventually concentrated on decorative paintings and murals of figures in landscape, often based on mythological subjects. With Vuillard, Roussel executed the large decorative panels of the Palais des Nations, Geneva, in 1938.

BIBLIOGRAPHY. L. Cousturier, *K.-X. Roussel*, Paris, 1927; Galerie Charpentier, *K.-X. Roussel*, Paris, 1947.

ROUSSILLON. District of France just north of the Pyrenees, bordering on the Spanish region of Catalonia. It is particularly noted for the richness of its Romanesque frescoes and sculpture. The work in Roussillon, stylistically, is a synthesis of Mozarabic art and the early Romanesque style of Languedoc.

The 11th-century Chapel of St-Martin-de-Fenouillar, with 12th-century frescoes depicting scenes from the life of Mary, the childhood of Christ, and the Apocalypse, is typical of this stylistic mixture. Flat, bold colors are combined with a strongly emphasized, highly expressive linear quality, suggestive of the style of the Spanish Beatus manuscript illuminations.

The sculptured reliefs on the capitals and arcade of the nave (probably the earlier porch) of the former Augustinian church in Serrabone are typical of the style of this area. The capitals are formed of fabulous beasts and human elements combined in a highly stylized, decorative manner. The stylization of the sculptural masses results in good part from making the sculpture conform to the functional structural shape of the capitals.

BIBLIOGRAPHY. H. Focillon, *The Art of the West in the Middle Ages*, vol. 1: *Romanesque Art*, New York, 1963.

STANLEY FERBER

ROUWEHA, CHURCH OF, *see* ROUEIHA, CHURCH OF.

ROUX-SPITZ, MICHEL. French architect (1888-1957). He was born in Lyons. A follower of Tony Garnier and Auguste Perret and a leading practitioner in France during the 1930s, Roux-Spitz worked largely in the ferroconcrete classicism of Perret.

ROVERE, GIOVANNI MAURO DELLA (Il Fiammenghino). Italian history painter and engraver (b. Milan, ca. 1575; d. there, 1640). He came from a family of painters of Flemish origin and was the brother of Giovanni Battista Rovere. A follower of the Procaccinis, especially Giulio Cesare, Rovere favored battlepieces and landscapes as well as religious subjects.

ROVEZZANO, DA, *see* BENEDETTO DI BARTOLOMMEO DEI GRAZZINI.

ROWLANDSON, THOMAS. English draftsman and caricaturist (b. London, 1757 or 1756; d. there, 1827). The facts concerning Rowlandson's life and artistic training are tantalizingly few, although he was by no means an obscure artist in his day. He was admitted to the Royal Academy schools in 1772. During the 1770s he also spent some time studying in Paris; he may have been there for as long as two years. He began exhibiting at the Royal Academy in 1777, and during the next few years sent in a series of portrait drawings. This material has now largely disappeared, and it is not until the early 1780s that we encounter any substantial quantity of work from Rowlandson's hand. By that time he was a fully developed artist, at the height of his powers; his subsequent drawings seldom attained again the level of artistic excellence and vigor of these early productions.

Rowlandson has been considered primarily a caricaturist. Caricature does occupy an important place in his work, especially during the later part of his career, but his best work is much broader in artistic intention than this term would imply. Another circumstance affecting his reputation has been the fact that, in order to meet the popular demand for his work, he turned out almost endless repetitions of indifferent quality. Many of these were probably done by other artists who were either working for him or capitalizing on his reputation, but a great quantity are undoubtedly by Rowlandson himself. Nevertheless, when judged by his best work, which is usually from the 1780s, Rowlandson emerges as one of the most lively and powerful draftsmen England has produced.

The quantity of drawings by and attributed to Rowlandson is astounding, and examples are to be found in nearly all public art galleries. In England there is a fine collection in the British Museum. In America there are particularly large and distinguished collections in the Boston Public Library and in the Henry E. Huntington Library and Art Gallery, San Marino, Calif.

BIBLIOGRAPHY. A. P. Oppé, *Thomas Rowlandson: His Drawings and Water-colours*, London, 1923; B. Falk, *Thomas Rowlandson: His Life and Art*, London, 1949; R. R. Wark, ed., *Drawings for a Tour in a Post Chaise*, San Marino, Calif., 1963; R. R. Wark, ed., *Drawings for the English Dance of Death*, San Marino, Calif., 1966.

ROBERT R. WARK

ROY, PIERRE. French painter and graphic artist (b. Nantes, 1880; d. Milan, 1950). He studied with his father, Donatien Roy, and with Jean-Paul Laurens at the Académie Julian. Although he was often associated with the surrealists, the air of mystery which Roy's meticulously realistic works, mostly still lifes, evoke is produced more by a free association of objects than by a strict use of the principle of incongruous juxtaposition. His often reproduced painting of the snake on the landing, *Danger on the Stairs* (1927–28; New York, Museum of Modern Art), is simply and immediately frightening. In his compositions of the 1930s, often with visual plays on the real, involving painted shadows cast on painted frames, the combination of objects, rarely strange in themselves, seems to hint at a perpetually inaccessible deeper meaning, as in the interior with calibrated instruments and a deep landscape view called *Metric System* (ca. 1933; Philadelphia Museum of Art).

BIBLIOGRAPHY. A. H. Barr, Jr., ed., *Fantastic Art, Dada, Surrealism*, New York, 1936.

ROYAL ACADEMY OF ARTS, ENGLAND. Honorary society of painters, architects, and sculptors. It was founded in 1768 through the efforts of Sir William Chambers, Benjamin West, and Sir Joshua Reynolds. Established under the patronage of King George III in London, the Academy has been located in Burlington House since 1868. Its ac-

Thomas Rowlandson, illustration for 1791 edition of *Tom Jones*.

tivities include schools, art scholarships, and separate annual exhibitions of old masters and of contemporary works by its members.

ROYAL ACADEMY OF PAINTING AND SCULPTURE, FRANCE. Founded in 1648 and strengthened under the protection of Colbert (1661–83) and the directorship of Charles Le Brun (1683–90). The establishment of the Academy was an event of great significance to art in France and elsewhere. Under Louis XIV it assumed a virtual dictatorship over artists, requiring membership and attendance and forbidding life drawing outside its confines. Its express purpose was to train students in the prevailing court style, Poussinesque classicism. Following the tradition set by the Academy of St. Luke in Rome, it held discourses during which paintings were analyzed according to various categories, such as drawing and expression. Toward the end of the 17th century a change of taste, expressed in the famous quarrel between the Rubenists and the Poussinists, decreased its authority considerably. In 1666 the Academy established the Prix de Rome, which awards an artist four years of study at the French Academy in Rome, founded the same year. *See* LE BRUN, CHARLES; RUBENISTS.

See also BEAUX-ARTS, ECOLE DES, PARIS.

BIBLIOGRAPHY. N. Pevsner, *Academies of Art, Past and Present*, Cambridge, Eng., 1940.

ROYAL BAZAAR (Qaysariya), ISFAHAN. Building of 1619–20 entered from the north side of the Maidan-i-Shah through a monumental portal. The domed inner court has two stories. *See* MAIDAN-I-SHAH, ISFAHAN.

ROYALL, ISAAC, HOUSE, MEDFORD, MASS. Built in 1631 and remodeled in 1733–37 and 1747–50, the façades and interior of this American Georgian house reveal the desire for academic correctness and exhibit the architectural embellishments of the period. The brick exterior is overlaid with wood. The highly finished interiors are no longer frankly structural as before.

BIBLIOGRAPHY. H. R. Morrison, *Early American Architecture*, New York, 1952.

ROYAT, CHURCH OF. French Romanesque church a little less than 2 miles from Clermont-Ferrand. It is of the Auvergnat school and dates from the 12th century. A rather small, unusual building without aisles, it resembles a Germanic hall church, a type uncommon in France. In addition, it is fortified, giving it a bulky, massive appearance.

ROYMERSWAELEN, MARINUS CLAESZ., *see* REYMERSWAELE, MARINUS VAN.

RUBBING. Misleading term for an impression obtained by placing paper over a raised or indented surface (incised, carved, molded, or chiseled) and patting or stroking it with heelball, graphite, or the like, using pressure. Sometimes, as in Chinese stone rubbings, the paper may be moistened and powdered ink used. Rubbings of memorial brasses in English churches are often made on sheets of tracing paper.

See also RUBBINGS, CHINESE.

RUBBINGS, CHINESE. Method of reproduction practiced by the Chinese probably since the Han dynasty. The *Hou*

Chinese rubbings. Example of a rubbing made from a stone engraving. Provincial Museum, Chengtu, Szechwan.

Han-shu (History of the Later Han Dynasty) mentions an imperial decree to have the Confucian classics standardized and engraved on stone tablets that were to be set before the Imperial Academy. The engravings became famous in the empire, and scholars from all corners came to make accurate copies of the classics. It is presumed that rubbings were the chief means of making these copies, as was the case in all subsequent periods of Chinese civilization. The earliest extant rubbing, however, dates from the T'ang dynasty. Among the finds at Tun-huang made by Pelliot was a 7th-century rubbing on paper of a Buddhist text, and more recently numerous stone tablets bearing inscriptions after Buddhist sūtras, ranging in time from the early T'ang dynasty to the Ming period, were discovered near Peking. Evidently, the Buddhists used rubbings taken from stone-engraved sūtras as one method of distributing the sūtras on a wide basis. Even after the invention of printing by wood block, stone engravings and rubbings remained popular and continued to be the orthodox method of reproducing the Confucian classics.

Most Chinese rubbings were probably made by the "wet" technique, whereby a piece of tough, resilient paper was dampened slightly and squeezed into the engraved portions of the stone (or wood). After the paper had dried, the surface was rubbed with a waxy substance to ensure sharpness and clarity, and the whole paper was then inked so that the portions of the paper squeezed into the engraving remained clear and would show as white against the black ink parts. The ink was applied with a variety of tools that could dab or swab it evenly over the surface.

In addition to reproducing texts, rubbings were also used in the Sung dynasty for taking inscriptions from ancient bronzes and pictures that had been engraved on stele (*pei-lin*) or tomb interiors. The general interest in archaeology, or antiquarian-type research, in the Sung dynasty probably helped to foster the art of stone rubbing significantly. Furthermore, in the Sung period rubbings became identified with the art of calligraphy, and orders to copy the work of master calligraphers of ancient times, such as Wang Hsi-chih, were issued so that rubbings might be made and dispersed to students. By the time of the Ming dynasty copies of paintings that had been engraved on stone became increasingly popular, judging from the number of examples preserved. Whether engraved paintings were made specifically for the purpose of having rubbings executed, however, is questionable. There is little evidence that rubbings were particularly prized as a special form of art by the Chinese, but there seems no doubt that they served as a major means of reproduction and large-scale dissemination of information directly related to other major art forms.

BIBLIOGRAPHY. Zurich, Kunstgewerbemuseum, *Ausstellung chinesischer Steinabklatsche aus den Sammlungen Prof. Otto Fischer*, Zurich, 1944; E. Burckhardt, *Chinesische Steinabreibungen*, Munich, 1961; G. Pommeranz-Liedtke, *Die Weisheit der Kunst, chinesische Steinabreibungen*, Leipzig, 1963; W. Speiser, R. Goepper, and J. Fribourg, *Chinese Art: Painting, Calligraphy, Stone Rubbing, Wood Engraving*, New York, 1964. MARTIE W. YOUNG

RUBBLE. Coarse building material that may consist of irregular stones, crushed rock, old concrete, or even broken bricks. It has been employed from the earliest periods of architecture as fill between walls or in foundations. With the addition of cement, it can form a rough type of masonry. In medieval England, small churches were often built with very thick walls of flint rubble masonry which was plastered for surface smoothness.

BIBLIOGRAPHY. R. H. G. Thomson, "The Medieval Artisan," in C. Singer, ed., *A History of Technology*, vol. 2, Oxford, 1956.

RUBENISTS. One of two factions in the artistic phase of the celebrated *Querelle des anciens et des modernes*. This ideological polemic in French intellectual circles of the late 17th century had its inception in Charles Perrault's ironical poem, *Le Siècle de Louis-le-Grand*. The poem was covert criticism of the current overadulation by many Frenchmen, known as "Ancients," of antique and High Renaissance Italian art. The "Moderns" insisted that the merit of native French creativity be recognized.

The artistic phase of this dispute had as its arena the Royal Academy of Painting and Sculpture. Here the Ancients were synonymous with the "Poussinists," who favored the preeminence of drawing (that is, draftsmanship and design), as exemplified in the artistic practice of Raphael, the Carraccis, and Poussin. The Moderns, or "Rubenists," preferred the expressive potential of freely applied, highly pigmented oil paint; their standard was epitomized in the art of Peter Paul Rubens. The dictum of Charles Le Brun, arch-Ancient in theory and head of the Royal Academy, that "the function of color is to satisfy the eyes, whereas drawing satisfies the mind" was the current French understanding of the Italian term *disegno*, as practiced by the French classical painter Poussin. Color, to the Poussinists, was a sensuously distracting appurtenance. To the Rubenists it was the means of vitalizing visual reality into expressive naturalism. The origin of this colorist concept is in the Venetian High Renaissance art of Titian, whose color techniques Rubens had absorbed and incomparably demonstrated in his *Life of Marie de Médicis* series for the Luxembourg Palace (Paris, Louvre). This series served as a ready example to incite praise or opprobrium, depending on the faction.

After the acceptance of Roger de Piles, who wrote the *Life of Rubens* (1677), as an honorary member of the Academy (1699) and the authorized republication of his *Dialogue sur le coloris* (1st ed., 1673), Le Brun's dogmatic *Table de préceptes* for great art was definitively superseded. The more liberal (Rubenist) tendencies of De Piles led the way to the *style moderne* of Watteau, which was the criterion for 18th-century artistic practice until the resuscitation late in the century of the severe principles of the Ancients, inherent in the neoclassical art of Jacques-Louis David. Later, the terms loosely connoted any academic (Poussinist) and independent (Rubenist) tendencies.

BIBLIOGRAPHY. A. Fontaine, *Les Doctrines d'art en France...*, Paris, 1909; A. Fontaine, *Académiciens d'autrefois...*, Paris, 1914. GEORGE V. GALLENKAMP

RUBENS, PETER PAUL. Flemish painter and engraver (b. Siegen, Germany, 1577; d. Antwerp, 1640). He painted religious, mythological, historical, and genre scenes as well as portraits and landscapes.

This most illustrious of Flemish painters was born outside the borders of the Netherlands. His father, Jan Rubens, a lawyer and magistrate, was a Calvinist who because of his religion was forced to flee from Flanders. He died in Germany, and his widow returned to Antwerp in 1587. By the age of thirteen Peter Paul was thoroughly grounded

in the German, Latin, French, and Flemish languages and literatures. After a short term as page to the Countess of Lalaing, he studied painting with Tobias van Haecht, then with Adam van Noort, and finally with Otto van Veen.

Early work: Italian period. In 1598 Rubens became a master, opened a studio, and from the very beginning had a few apprentices. Little is known of his artistic production during his early years except for a small portrait of a man (1597; New York, Mr. and Mrs. Jack Linsky Collection). A letter by a contemporary states that Rubens's pre-Italian works "bore a certain resemblance to Octavius van Veen's, his master."

In 1600 the young artist set out for Italy. In Venice he copied Titian, Tintoretto, and Veronese. Owing to a chance acquaintance with a nobleman in the service of Vincenzo I Gonzaga, duke of Mantua, Rubens was taken into the service of the Duke. The celebrated court, the extensive collections, and the whole atmosphere, permeated with the culture of antiquity, exercised a decisive influence upon Rubens. He also visited many other Italian cities.

Our knowledge of Rubens's *oeuvre* from the Italian period is based solely on some groups of works authenticated by documents from the archives; signed and/or dated canvases are nonexistent, and most of these works are attributions. Further difficulties arise because the artist, seeking his way, refused to be restricted by a formula. The material is even now in a state of flux. Although many authentic canvases were formerly concealed by mistaken labels, critics currently tend to attribute to Rubens many others as well, perhaps overgenerously. Among the authentic works are three paintings done in Rome in 1601–02 for Archduke Albert, originally for the Chapel of St. Helena at Sta Croce di Gerusalemme (Grasse, Grasse Hospital). In its mannerist qualities *St. Helena* recalls Van Veen. The Carraccis and Caravaggio left their imprint on *Christ Crowned with Thorns*. The *Elevation of the Cross* (a copy after the lost original?) owes much to Michelangelo and Tintoretto.

In 1603–04 Rubens set out for Spain on a diplomatic mission for his patron. From this Hispanic period stem a series of *Twelve Apostles* (Madrid, Prado) and the *Portrait of the Duke of Lerma* (Madrid, Capuchin Fathers of Castilla). When Rubens returned to Mantua, Duke Vincenzo commissioned a series of three altarpieces for the Jesuit church there (SS. Trinità), which were done in 1604–05: *The Holy Trinity Adored by Vincenzo Gonzaga and His Family* (formerly in the center; Mantua, Ducal Palace), the *Baptism of Christ* (formerly to the right; Antwerp, Fine Arts Museum), and *The Transfiguration* (formerly to the left; Nancy, Museum of Fine Arts). The central picture, although badly cut up, shows Rubens's preoccupation with the richness of fabrics and gold, his powerful modeling of faces, and his seemingly Venetian expression. In Genoa, Rubens painted a series of decorative and meticulous official portraits of the local aristocracy. His *Marchesa Brigida Spinola Doria* (Washington, D.C., National Gallery), though cut down in length and width, and bereft of its original inscription, sets the pattern.

From 1606–08 date the *Adoration of the Shepherds* (Fermo, Municipal Picture Gallery), which leans heavily

Rubens, *The Arrival of Marie de Médicis at Marseille*. Louvre, Paris.

on the famous *Notte* of Correggio, and the two versions of the high altar for the Chiesa Nuova (S. Maria in Vallicella) in Rome (one version is in Grenoble, Museum of Painting and Sculpture; the other *in situ*). The Grenoble painting, which was rejected by the Oratorian Fathers, shows great development in the sensibility of Rubens's Italian style; the Chiesa Nuova version, which was eagerly accepted, echoes Zuccaro's classical mannerism.

Early Antwerp style. In 1608, on receiving news of his mother's ill-health, the artist hurried home to Antwerp but arrived after her death. He remained in Flanders, and the archdukes appointed him "Painter to their Serene Highnesses." In Italy Rubens had constantly copied Renaissance painters as well as his contemporaries. In the course of his stay he had gathered a store of forms, compositional ideas, and types that he drew on for the rest of his life, adapting them to his individual style.

In 1609 he married Isabella Brant, painted state portraits of the archdukes, became a member of the Guild of Romanists, and bought property on the Wapper. He designed and built his Italian-style house, finished in 1618, in which his magnificent career was to unfold.

The years up to 1612 may well be called Rubens's *Sturm und Drang* period. During this time an ill-disguised exaggeration revealed itself in the forms and size was magnified. *The Adoration of the Magi* (Prado), painted in 1609–10 for the city of Antwerp, was enlarged and retouched by the master fifteen years later. Correggio's and Michelangelo's influences are dominant, though the canvas acknowledges Tintoretto in the execution. Only with the altarpiece *The Elevation of the Cross* (Antwerp Cathedral) did Rubens decisively confirm his mastership. It was the first baroque altarpiece in the Low Countries and the last work, stylistically speaking, of Rubens's transition period. Between about 1611 and 1614 he reverted to the Romanist conception, adopting an extremely personal and complicated mode of expression in response to apparent pressure from patrons. This retrogressive formula was also more easily translated by his numerous students and disciples. *The Descent from the Cross* (Antwerp Cathedral) exemplifies Rubens's return to classicism. Not until 1614–15 did he venture to take up again the color contrasts of Caravaggio—though at the same time rejecting Caravaggio's generally somber tones (for example, *Tribute Money*, San Francisco, M. H. de Young Memorial Museum).

The Rubens studio. Rubens was highly successful. Commissions abounded, and he enjoyed the highest esteem of his contemporaries and maintained a voluminous correspondence with foreign dignitaries and scholars, who treated him as one of their own. The profusion of work flowing out of the Rubens studio is generally explained by a system under which the artist himself generally did the preliminary sketches, *modelli*, and drawings, while fellow artists under contract and pupils were responsible for the large-scale output. Rubens then retouched the work of his helpers. The degree of authenticity varies according to the extent of the master's intervention. Rubens was a great entrepreneur not only in painting; more than 700 engravings after his compositions are known to have been done in the 17th century, and his inventive mind assured him many orders for illustrations of title pages. *See* RUBENS SCHOOL.

"Great series." Baroque maturity. The years from 1620 to about 1630 were the years of the "great series." Rubens's style passed from clear composition, carefully balanced and dominated by the memory of the Romanists, to conceptions more clearly baroque. His palette changed accordingly: from great splashes of well-defined color to blending. For the earlier appearance of hard smoothness Rubens substituted a more unctuous and elaborate pigment, reminiscent of the Venetian school. In 1622 he began the famous series of twenty-one paintings of *The Life of Marie de Médicis* (Paris, Louvre) for the first gallery of the Luxembourg Palace. Rubens did the sketches in Paris and had the canvases executed in his studio in Antwerp. For a long time they were considered the essence of the master's style and were highly admired as one of his greatest achievements. Rubens accepted a commission for the second gallery, this time dealing with the life of Henry IV. Owing to the political vicissitudes that befell the Queen Mother, this series was never finished, and only a few sketches and large canvases survive. *See also* OIL PAINTING.

In 1625 Rubens met the Duke of Buckingham in Paris and painted his portrait (destroyed in World War II). As one consequence of the encounter, Rubens sold Buckingham his collection of classical statues as well as a number of his own paintings in 1626. The two men may also have engaged in political conversations with respect to an armistice between Spain and England.

In fact, Rubens had previously served the Infanta Isabella on political missions. A widower after 1626, he was sent to Spain in 1628, where he painted the King and the royal family and executed a number of copies after Titian. He met Velázquez, and the two great artists held each other in mutual esteem. Philip IV was henceforth among Rubens's most faithful admirers. In April, 1629, Rubens was nominated "Secretary to the Secrete Council" and entrusted with the conduct of peace negotiations at the Court of St. James. He was received in England with great honor and stayed there nine months, during which he successfully concluded his mission and also did some paintings—among others, of the King and the Queen with their four children (Windsor Castle) and the ceiling paintings for the Banqueting Hall in Whitehall, London. At the conclusion of his sojourn Charles I knighted the artist; this honor was later to be repeated by the Spanish sovereign.

Late mature period. In December, 1630, the aging artist married Helena Fourment, who was henceforth the inspiration of his artistic vision. The period 1630–40 represents Rubens's full maturity, during which the artist reached unsuspected heights. His colors softened and became tempered; instead of the fire and dash of youth, we now find mellowness served by a complete mastery of technique. The *Ildefonso Altarpiece* (Vienna, Museum of Art History) shows rare perfection and gentleness, and its sparkling coloration approaches the impressionist techniques dear to Titian in his old age. From 1635 stem the projects for the decorations on the occasion of the entry of the new governor, Cardinal Infante Ferdinand, into Antwerp; many of Rubens's *modelli* for the designs still exist (Antwerp, Fine Arts Museum; Leningrad, Hermitage; and elsewhere). That same year the artist bought a new estate, Steen, located between Mechlin and Vil-

vorde. There he retired for months at a time, and joyous and vibrant compositions flowed from his brush. Landscape painting, formerly an occasional preoccupation, evolved out of direct contact with nature; and in this genre, too, he attained a freedom in rendering, a dynamism of movement, and a full immediacy that go far beyond baroque conceptions to attain universality.

Despite the gout that crippled his hands, Rubens accepted a new commission in 1636 from the King of Spain for decorations for the royal lodge of the Torre de la Parada near Madrid. The master reserved to himself only the sketches and some few large paintings (Prado), for the first time permitting his chief assistants to sign the canvases in which they had materially collaborated. The sketches from this series, executed with a light touch and the greatest fluidity, appropriately reveal Rubens's last style. When Rubens died in 1640, all Europe mourned him.

Rubens was the outstanding artistic personality of Flanders's second "golden century." His style, conceptions, and inventions were echoed by a school that flourished during his lifetime but rapidly decayed after his death. One of the greatest European masters of the 17th century, diplomat, and humanist, Rubens may be considered the embodiment of the Flemish baroque and a genius of universal scope.

BIBLIOGRAPHY. M. Rooses, *L'Oeuvre de P. P. Rubens*, 5 vols., Antwerp, 1886–92; J. Burckhardt, *Erinnerungen aus Rubens*, Basle, 1898; E. Michel, *Rubens: Sa vie, son oeuvre et son temps*, Paris, 1900; R. Oldenbourg, *Rubens, Des Meisters Gemälde*, Berlin, Leipzig, 1921; G. Glück and F. Haberditzl, *Die Handzeichnungen von Peter Paul Rubens*, Berlin, 1928; P. Arents, *Geschriften van en over Rubens*, Antwerp, 1940; H. Evers, *Peter Paul Rubens*, Munich, 1942; L. van Puyvelde, *Rubens*, Brussels, 1952; E. Larsen, *P. P. Rubens*, Antwerp, 1952; R. S. Magurn, *The Letters of P. P. Rubens*, Cambridge, Mass., 1955; J. Held, *Rubens. Selected Drawings*, 2 vols., London, 1959. ERIK LARSEN

Andrei Rublev, *Icon of the Trinity.* **Tretyakov Gallery, Moscow.**

RUBENS SCHOOL. Artistic workshop operated by Rubens, one of the largest of such enterprises in the history of art. It has been estimated that nearly 600 paintings bear Rubens's signature and are at least in part executed by him; countless additional works stem directly from his school. His most important students were Van Dyck, Snyders, De Vos, Van Uden, and Wildens. De Vos specialized in animal representations, Van Uden and Wildens in landscape. In addition to these painters, Rubens was in close contact with many graphic artists who copied or adapted his compositions. Soutman, Vorsterman, and above all Schelte van Bolswert were among this group. *See* DYCK, ANTHONY VAN; SNYDERS, FRANS; UDEN, LUCAS VAN; VOS, PAUL DE; WILDENS, JAN.

BIBLIOGRAPHY. G. Glück, *Rubens, Van Dyck und ihr Kreis*, Vienna, 1933.

RUBEUS, *see* BERMEJO, BARTOLOME.

RUBINI, LORENZO. Italian sculptor (fl. Vicenza, ca. 1543–69). Rubini was a follower of Alessandro Vittoria and was associated with the architect Andrea Palladio, who admired his sculptured figures, probably for their decorative qualities and their graceful classical poses. Two statues of Rubini's stand on a staircase parapet of Palladio's Villa Rotonda; others on the Palazzo della Ragione in Vicenza are attributed to him.

RUBLEV (Roublew), ANDREI. Russian fresco and icon painter (b. ca. 1350–75; d. Moscow, ca. 1430). Rublev's life is scantily documented. We know that he was a monk at the Trinity-Sergius Monastery near Moscow and that he transferred to the Andronikov Monastery there shortly before 1425. His paintings betray an intimate knowledge of the work of contemporary Greek masters, and he seems to have spent some time in Constantinople and in other centers of production.

In 1405 he collaborated with Theophanes the Greek and Prochor of Gorodets on a great fresco cycle for the Cathedral of the Annunciation, Moscow. Rublev's share in this work constitutes his earliest documented paintings. However, since the paintings were destroyed in 1482 when the building was damaged, the question of their quality and influence remains unresolved. According to a 16th-century chronicle, the iconostasis of the Cathedral includes the earliest icons of Rublev. Theophanes and his apprentices apparently did the icons for the *deësis* tier of the iconostasis, and Prochor of Gorodets and Rublev were responsible for the icons in the festival tier.

With Daniel Chorny, Rublev painted the frescoes and iconostasis in the Cathedral of the Dormition, Vladimir, in 1408 and 1409. Although it is all but impossible to differentiate the hands of the two artists, no fewer than fourteen sections have been attributed to Rublev, as well as the *St. Paul*, the *Ascension*, and the *Descent into Hell* from the iconostasis. To this period also belongs Rublev's copy of the older icon, the *Virgin of Vladimir*.

Sometime between 1408 and 1425 (perhaps 1422–23) Rublev painted what today may be considered his most celebrated work, *The Old Testament Trinity* (Moscow, Tretyakov Gallery). Unfortunately, repeated cleanings in the first two decades of the 20th century have dimmed it to only a faint reflection of its former brilliance. The

Rucellai Palace, Florence. Early Renaissance structure, designed by Leon Battista Alberti.

great masterpieces of Rublev's old age were presumably the frescoes for Trinity Cathedral of the Trinity-Sergius Monastery near Moscow, which he executed between 1425 and 1427, again in collaboration with Daniel Chorny. No trace of these works has been found; however, Rublev is represented by a number of icons from the iconostasis. He may also have done the frescoes and iconostasis of the Andronikov Monastery (1427–29).

Rublev realized the purest form of Byzantine art on Russian soil and represents the high-water mark of religious painting in the Eastern Church. His particular contributions to this style were a dynamic rhythm of line and a rare brilliance of color.

BIBLIOGRAPHY. M. Alpatov, *Andrej Rublev*, Milan, 1962; J. A. Lebedeva, *Andrei Rubljow und seine Zeitgenossen*, Dresden, 1962.

FRANKLIN R. DIDLAKE

RUCELLAI MADONNA. Tempera panel by Duccio, in the Uffizi Gallery, Florence. *See* DUCCIO DI BUONINSEGNA.

RUCELLAI PALACE, FLORENCE. Early Renaissance palace in Italy. This influential monument was designed by Leon Battista Alberti and executed between 1445 and 1454. For the façade Alberti went beyond the type of severe scheme pioneered by Brunelleschi in Florence to a subtle and elegant design based on a proportional system of interlocking rectangles. The façade is in three stories, with round-headed windows containing two lights on the upper two stories. It is thought that the building was originally intended to be longer, with three doorways opening onto the street instead of two. Nearby is the Rucellai Chapel, which contains Alberti's curious Shrine of the

François Rude, *Joan of Arc.* Louvre, Paris.

the overwhelming motion, intensity of feeling, and compositional complexities of the figures. Classical dignity is discarded in favor of an emotional naturalism more akin to the baroque. In a quieter way, the same is true of the sweeping gesture of the bronze *Monument to Marshal Ney* (1852–53), in the Place de l'Observatoire, Paris.

Rude's other great political work, the bronze *Napoleon Awakening to Immortality* (1845–47), at Fixin-les-Dijon, is his strangest. It shows Napoleon rising out of the sleep of death and struggling to throw off the heavy shroud wrapped around him. This consummation of Bonapartist grandeur exerts a powerful, if unstable, fascination through the romanticism of its conception and the sculptural subtlety of its execution. The strength of the Napoleon monument is paralleled in the same period by the tomb of Godefroy Cavaignac (1845–47), in Montmartre Cemetery, Paris. The stark realism of the sepulchral effigy goes back to the late medieval *gisants* (recumbent effigies) which Rude in his youth must have seen in Dijon. Rude's other sculptures, such as the marble *Love Triumphant*, posthumously shown in the Salon of 1857, or the marble *Joan of Arc* (1845–52; Louvre), do not rise above the pretty or charming. They lack the tense fusion of realism and romanticism found in the great works on patriotic themes.

BIBLIOGRAPHY. A. Bertrand, *François Rude*, Paris, 1888; L. de Fourcaud, *François Rude, sculpteur*, Paris, 1904; J. Calmette, *François Rude*, Paris, 1920; H. Drouot, *Une Carrière: François Rude*, Dijon, 1958.

JEROME VIOLA

RUDELSBURG AN DER SAALE: CASTLE. Large German fortified castle first mentioned in 1171. Although it has been a ruin since 1641, many parts are in relatively good condition, particularly the *Bergfried* (main tower). The castle gives a good idea of late Romanesque fortification.

BIBLIOGRAPHY. H. J. Mrusek, *Burgen in Sachsen und Thüringen*, Munich, 1966.

RUDOFSKY, BERNARD. American architect and designer (1905–). Rudofsky has designed posters, billboards, textiles, furniture, rugs, china, glass, and wallpaper, among other things. His work usually stresses comfort and simplicity, avoiding the stamp of high fashion; hence he prefers to design sandals rather than dress shoes. An outdoor house on Long Island, N.Y., features a breakdown of the barrier between indoor and outdoor space. The hub of the plan consists of an exposed cooking terrace.

RUDOLPH, PAUL MARVIN. American architect and educator (1918–). Born in Elkton, Ky., he studied architecture at the Alabama Polytechnic Institute (1935–40) and at Harvard in the 1940s. He was associated with Ralph S. Twitchell at Sarasota, Fla., before establishing practice in New Haven, Conn., where until 1965 he was chairman of the Department of Architecture at Yale. His Jewett Art Center in Wellesley, Mass. (1959), is an imaginative contemporary work that harmonizes well with an existing collegiate Gothic environment. The bold forms of his Art and Architecture Building at Yale (1963) have influenced many younger men. In 1966 he received a first honor award from the U.S. Department of Housing and Urban Development for the design excellence of his ele-

Holy Sepulchre, a kind of toy building with fine incrustation work on the exterior. *See* ALBERTI, LEON BATTISTA.

RUDDER, ISIDORE DE. Belgian sculptor (1855–1943). A student of Simonis, Portaels, and Stallaert at the Royal Academy in his native Brussels, De Rudder was also a painter, ceramist, and engraver. Active in the industrial arts movement of the 1890s, he created medals, vases, goldwork, and plaques in an elegant Art Nouveau style.

RUDE, FRANCOIS. French sculptor (b. Dijon, 1784; d. Paris, 1855). He studied in Dijon with Devosge and in 1807 went to Paris, where he worked under Cartellier. Rude grew up during the French Revolution, and much of his life was colored by his political ideas. As a Bonapartist, he left France for Belgium in 1814 and worked on sculptural decorations in Brussels. He returned to Paris in 1827. The sense of movement, heroic grandeur, and realism of his best works belie the academic classicism of his training. His marble *Neapolitan Fisher Boy* (1833; Paris, Louvre), is a surprising combination of ideal beauty and charming genre detail.

Rude's most famous work is the bas-relief *La Marseillaise*, or *The Departure of the Volunteers in 1792* (1835–36), on the Arc de Triomphe de l'Etoile in Paris. In this sculpture the traditional academic accessories, heroic nudity and antique costume, are completely subordinate to

gantly conceived Crawford Manor, a housing development for the elderly in New Haven, Conn.

BIBLIOGRAPHY. I. R. M. McCallum, *Architecture USA*, New York, 1959.

RUE, LISINKA, *see* MIRBEL, LISINKA AIMEE ZOE DE.

RUELAS, JUAN DE, *see* ROELAS, JUAN DE.

RUE TRANSNONAIN. Lithograph by Daumier. *See* DAUMIER, HONORE.

RUGENDAS, GEORG PHILIPP. German painter and engraver (b. Augsburg, 1666; d. there, 1742). The son of Georg Philipp Rugendas II, he was in the third generation of a well-known artistic family and its most important member. Rugendas is perhaps justly known as a war painter, for most of his works, both painted and etched, are scenes from the life of a soldier. After training in his father's workshop, he spent five years with the Augsburg painter Isaac Fisches; he formed his style under Fisches' influence and in the manner of Jacques Courtois and Philips Wouwerman. Between 1690 and 1692 his studies took him to Vienna and Venice. In 1693 he arrived in Rome, where he studied ruins and antique sculpture. Two years later he returned for good to Augsburg, where he founded his own publishing house and became director of the Augsburg Academy of Art. Between 1695 and 1735 Rugendas turned almost exclusively to engraving and toward 1700 took up the illustration of contemporary scenes, such as the siege of Augsburg of 1703. Toward 1735 he once again turned to painting.

BIBLIOGRAPHY. A. Feulner, *Skulptur und Malerei des 18. Jahrhunderts in Deutschland*, Potsdam, 1929.

JULIA M. EHRESMANN

RUGENDAS, JOHANN MORITZ. German painter active in Latin America (b. Augsburg, 1802; d. Weilheim, 1858). Rugendas spent most of his creative life, from 1820 to 1848, in Latin America, where he drew and painted every aspect of life. *Plaza de Armas, Lima* (ca. 1842; Lima, Taurino Museum) is characteristically observant and freely romantic in style.

BIBLIOGRAPHY. T. Lago, *Rugendas, pintor romántico de Chile*, Santiago, 1960.

RUGERUS, *see* ROGER VON HELMARSHAUSEN; THEOPHILUS PRESBYTER.

RUGS, NEAR AND MIDDLE EASTERN. The use of rugs as floor coverings or wall hangings can be traced back to the ancient Near East; there are indications that rugs were made in Assyria and Babylonia. Some of the stone slabs from the palace of Sennacherib (r. 705–681 B.C.) and Assurbanipal (r. 668–627 B.C.) at Nineveh suggest rugs. Russian excavations in the Pazyryk Valley of the Altai Mountains have brought to light a burial ground consisting of forty mounds and containing a veritable treasure of Scythian art of the 5th century B.C., including appliqué felt, woven textiles, and a well-preserved rug measuring 6 feet 3 inches by 6 feet 4½ inches. Its red central field has a decoration of six rows of rosettes in squares derived from the Assyrian design of pine cones and lotus. The double border has a decoration of "Persian" horsemen and a frieze of elks or stags on a yellow ground. The style clearly shows a mixture of Assyrian, Achaemenian, and Scythian motifs. This rug shows the true Ghiordes knot; another rug fragment found at Bashadar, near Pazyryk, has the Persian or Senna knot.

Important fragments of woolen pile rugs dating from the beginning of the 1st millennium of the Christian era were found in Chinese Turkestan, Egypt, and Syria. Literary sources indicate that Persians of the Sassanian period (3d–7th cent.) manufactured two types of rugs: knotted pile rugs and smooth-faced rugs. Arab sources mention a famous garden rug, known as the *Spring of Chosroes*, which was kept in the palace of Sassanian kings at Ctesiphon. The Byzantines also manufactured rugs; in the 6th century rugs covered the floors of Hagia Sophia and the palace of Justinian in Constantinople.

Pile rugs were manufactured in Egypt by the Christian Copts. An important fragment (New York, Metropolitan Museum) found in Antinoë, in Upper Egypt, can be dated to about 400. It originally had a field of four or six rectangles with a geometric design inspired by early Christian mosaic pavements. The technique is not a true knotting but a development of the Coptic process of loop weaving and was produced by the cutting of woolen loops.

With the rise of Islam a new era in the history of Near Eastern art began in 622. Fragments of rugs found in the ruins of Al-Fustat (Old Cairo) indicate that rug knotting was practiced in Egypt and Syria in the 9th, 10th, and 11th centuries. In Arabic literary sources of the 10th and 11th centuries we also find frequent reference to the rug industry in Iraq and Persia, where several types of rugs were made for export.

SALJUK PERIOD

The Turkish Saljuks, who came from Central Asia in the 11th century, created a true Islamic style of decoration. In Konia, their capital in Asia Minor, the Saljuk rulers of the 13th century erected many fine palaces and mosques, which are still standing. From the Allauddin Mosque, built in 1219/20, came a group of Saljuk rugs (Istanbul, Museum of Turkish and Islamic Art). The decoration of these rugs is geometric, consisting of allover patterns of octagons, lozenge diapers, oval medallions, star motifs, and interlacings combined with hooked motifs and often bordered by Kufic writing. The color scheme is limited to two tones of red, blue, or yellow on a red or blue ground. Marco Polo, who visited Asia Minor in 1270, reported that the finest and most beautiful rugs in the world were made in the Saljuk empire.

Related to the Konia group are fragments of 14th-century rugs found in 1929 in the Mosque of Beyşehir (Konia Museums). They show two types of decoration: either purely geometric or with an allover design of arabesques and palmettes, treated in an angular fashion. Both groups must be regarded as prototypes and predecessors of later Anatolian rugs from the 15th to the 19th century.

ANATOLIAN AND CAUCASIAN RUGS (14th–17th cent.)

The appreciation of Oriental rugs in Europe is well known to us from Italian, Flemish, Dutch, and German paintings from the 14th century on. Anatolian rugs, imported in great quantity through Venice, were used on the altar steps in churches and as festive decorations to be hung from windows and balconies. In Italian paintings of

the 14th and 15th centuries we often find representations of geometric rugs, some with angularly stylized birds or animals, singly or in pairs, within octagonal compartments. Only three fragments of such animal rugs are in existence. The first (Metropolitan Museum) has a single bird; the second (Berlin, former State Museums) represents a fight between a dragon and a phoenix; and the third (Stockholm, National Museum) has two confronted birds.

A well-known group of Turkish geometric rugs is known as "Holbeins" because they are frequently represented in paintings by Hans Holbein the Younger and also in Italian and Flemish paintings from the 15th to the end of the 16th century. The repeat pattern, usually on a small scale, shows geometric devices of octagons and star and cross motifs combined with arabesque scrolls and interlacings. These rugs are usually attributed to the town of Ushak in Asia Minor.

A second group of geometric rugs, also known as "Holbeins," shows a division of the field into squares that are filled with octagons containing star-shaped motifs or polygonal devices. The border has simulated Kufic inscriptions, a feature that survived in many later Anatolian and Caucasian rugs. They were very popular with the Flemish painter Hans Memling, who used them quite frequently in his pictures of the Virgin (for example, a painting in Vienna, Austrian Museum of Applied Art).

An interesting variety of Anatolian rugs consists of the arabesque rugs, attributed to the looms of Ushak, where the manufacture of rugs began in the 15th century. Rugs of this type are known in the United States as "Lottos" because they were depicted in paintings by Lorenzo Lotto, as well as by other Italian and Dutch painters of the 16th and 17th centuries. These rugs have an allover pattern of angular arabesques in yellow on a vivid red background. Like the "Holbeins," they have common borders of interlaced simulated Kufic writing or a series of medallions. A 17th-century rug of this type is depicted as a table cover in a painting by Vermeer (Metropolitan Museum).

The popularity of Anatolian rugs in Europe increased considerably in the 16th century. In Ushak several types of rugs with star-shaped compartments or medallions, with an intricate pattern of stylized floral scrolls and arabesques, were made. Some of these rugs reached England before the middle of the 16th century and were made to order for English and other European families. Two such Ushaks with the coat of arms of Sir Edward Montagu, dated 1584 and 1585, are in the Duke of Buccleuch Collection in England.

MONGOL AND TIMURID PERIODS

In Persia the development of rug design was closely associated with the art of illumination. Our knowledge of Persian rugs of the 14th and 15th centuries is based on miniature paintings. In the 14th century under the Mongols and in the 15th century under the rule of the Timurids, the rugs represented in Persian miniature paintings show geometric patterns not unlike those of Turkish rugs from Asia Minor.

At the close of the 15th century a change of rug design took place in Persia. In miniatures of the celebrated Persian painter Bihzad we find, besides the traditional rugs with geometric design, new types of rugs decorated with arabesque and floral scrolls forming an allover design or placed in medallions and compartments. These changes of style may be attributed to the royal patronage of Sultan Husain Mirza (r. 1468–1506), whose court at Herat, in eastern Persia (now Afghanistan), was a brilliant gathering place of poets and artists. Rugs depicted in the miniatures of his period are prototypes of late-16th-century Persian rugs. In 1510 Bihzad and other painters, including illuminators, moved to Tabriz, the capital and residence of the new Persian dynasty of the Safavids.

SAFAVID PERIOD

The finest Persian carpets were made during the 16th and 17th centuries in the court looms established by the Safavid rulers in Tabriz, Kashan, Herat, Isfahan, and other centers. The rug was elevated to a work of art produced by master craftsmen, often from cartoons designed by famous illuminators and court painters such as Mirak and Sultan Muhammad. Many types of Persian rugs, showing a great variety of patterns, are known. The greatest achievement of the Persian rug designers was the development of an ornament consisting of floral scrolls with blossoms and palmettes, frequently intertwined with arabesques. Every Persian rug shows a well-balanced composition of arabesques and floral scrolls that forms a background for various other decorative elements, such as Chinese cloud bands, animals of Persian and Chinese origin, and figure subjects. Persian poets were frequently inspired by the beauty of the royal carpets and compared them to "a garden full of tulips and roses" or to a "wild white rose." Many famous Persian carpets are in museums of Europe and the United States, particularly the Metropolitan Museum of Art.

During the reign of Shah Isma'il (1502–24) the medallion rug with hunting scenes in Milan (Poldi-Pezzoli) was made, inscribed with the date A.H. 929 (A.D. 1522/23) and the name of the maker, Ghiyath ad-Din Jami. The cartouche rug in the Metropolitan Museum also belongs to this period. It is decorated with arabesques, palmette scrolls, flying geese, and Chinese animals such as lion-*kilins* and dragons in combat with the phoenix, placed in small medallions and cartouches. Both rugs are masterpieces of the royal looms of Tabriz.

The style developed under Shah Tahmasp (r. 1524–76) is best known from a famous medallion rug from the tomb-mosque of Shaikh Safi in Ardabil (London, Victoria and Albert). According to the inscription, it was made to the order of Maksud of Kashan in A.H. 946 (A.D. 1539–40) as an offering to the shrine. Its deep-blue ground has an intricate pattern of the floral scrolls bearing a great variety of elaborate palmettes. Other important 16th-century rugs are two medallion rugs in the Metropolitan Museum, one from the Dukes of Anhalt Collection, the other from the Blumenthal Collection; and the splendid medallion rug with Chinese vases in the Victoria and Albert Museum.

Rugs with animal decoration were very popular in Persia during the 16th and 17th centuries. A masterpiece of balance and rhythm is the well-known animal rug in the Metropolitan Museum, which came from the tomb-mosque of Shaikh Safi in Ardabil and was made in Tabriz. The design of this rug consists of a repeat pattern of a lion and tiger attacking a Chinese *kilin* and other animals disposed symmetrically on a background of floral scrolls.

A famous center of rug weaving during the 16th and 17th centuries was Herat, where some of the great animal and floral rugs were made for Shah Tahmasp and his court. The best known are a pair of rugs, one in the Austrian Museum of Applied Art, the other in the Metropolitan Museum. The Herat rugs have many characteristic features, such as fan-shaped composite palmettes, serrated leaves, and lanceolate leaves that form part of a dense floral pattern, upon which groups of animals are placed. Floral rugs continued to be made in Herat during the 17th century, when the palmettes and curved lanceolate leaves became larger and bolder. Such rugs are depicted frequently in paintings of 17th-century Dutch and Spanish masters.

Luxurious products of the royal looms of Kashan were rugs made of silk. The most famous of these rugs is the hunting carpet in the Austrian Museum of Applied Art depicting huntsmen, mounted and armed with spears, swords, and bows, attacking lions, leopards, wolves, and other wild animals. The border of this great carpet shows representations of the Muslim paradise with angels (houris) serving the deceased. It was made in the time of Shah Tahmasp and must have been designed by his favorite painter, Sultan Muhammad. A number of small silk rugs, either medallion or animal rugs, are extant. Three important pieces are in the Altman Collection of the Metropolitan Museum.

Fine rugs continued to be made during the reign of Shah Abbas the Great (1587–1628), who established new looms for weaving silk fabrics and rugs in Isfahan. Luxurious silk rugs, enriched with gold and silver threads, were made in the 17th century, both in Kashan and in Isfahan. Many of these rugs were ordered by European rulers and nobles. The Polish kings were especially fond of these rugs and ordered tapestries and knotted rugs to be made in Kashan. A fine group of these silk rugs, a gift of John D. Rockefeller, Jr., is in the Metropolitan Museum; others are in the Bavarian National Museum, Munich.

In Isfahan some of the famous Persian garden carpets and vase rugs were manufactured. Landscapes and gardens played an important role in the daily life of Persia. Persian painters from the 14th century on took delight in depicting in their miniatures beautiful landscapes with orchards. Garden and tree designs became part of the early Safavid rug decoration, exemplified by a splendid early-16th-century rug decorated with large cypress trees, shrubs, and flowering trees on a red background (Philadelphia Museum of Art, Williams Collection). A more formal representation of flowering plants is known from a group of rugs made in Isfahan or Jushagan and called vase rugs, named for the vases introduced into the floral decoration. The bold design has either a lozenge diaper or a trellis with large composite palmettes, floral sprays, and vases. In another variety of floral rugs, also attributed to Isfahan, the pattern consists of flowering shrubs and sprays of various flowers such as irises, carnations, asters, lilies, tulips, and peach blossoms. Garden rugs showing schematic representations of gardens seen from above and divided into rectangular plots with trees and shrubs, separated by canals, are attributed to the Isfahan looms. One of the most magnificent and largest garden rugs made in the time of Shah Abbas is in the Central Museum, Jaipur.

After the gradual decline of royal patronage, animal, floral, and garden rugs made in Isfahan, neighboring Jushagan, and Herat were copied in various regions of Persia. Some of the finest rugs were made in Kurdistan in northwest Persia, where the rug industry, organized in villages, flourished until the 19th century.

MUGHAL PERIOD

Like the Mughal school of painting in India, Mughal rug weaving was of Persian origin. According to the historian Abu'l-Fazl, the emperor Akbar (r. 1556–1605) "caused carpets to be made of wonderful variety and charming textures." The rugs woven in Lahore, to judge from representations of rugs in miniature paintings, were much influenced by Persian models. Hindu weavers, working in the state manufactories of Akbar and Jahangir (r. 1605–28), under the guidance of Persians, copied the floral rugs of Persia. A number of such Mughal rugs exist in museums and private collections, particularly in the Maharajah of Jaipur Collection, and are known as Indian Isfahans.

Gradually the Hindu weavers introduced into rug design naturalistic plants, flowers, animals, and figure subjects. The design of these Mughal rugs shows considerably more freedom of composition than is evidenced in the Persian rugs that served as their models. This may be seen in two pictorial rugs (Washington, D.C., National Gallery, Widener Collection; Boston, Museum of Fine Arts).

The native Hindu style was fully developed in the time of Shah Jahan (r. 1628–58), and in technical skill the Indian weavers often surpassed their Persian masters. Most of the rugs made under this ruler are decorated with realistic plants in rows or in a trellis framework. In the Altman Collection of the Metropolitan Museum are several magnificent floral rugs of the period of Shah Jahan. In the Maharajah of Jaipur Collection are a number of rugs in the Hindu style, originally made for the palace in Amber, built about 1630. The pile of some of the woolen rugs is of such fine quality that they are often mistaken for silk rugs. A fragment of a silk rug in the Altman Collection has the incredible number of 2,552 knots to the square inch.

TURKISH RUGS

Turkish court rugs of the 16th and 17th centuries were first made in Brussa in Asia Minor and then in Istanbul from the time of Sulaiman the Magnificent (r. 1520–66). Brussa, the early capital of the Ottoman emperors, was famed from the 15th century for its brocades and velvets. Here a national Turkish style, which also influenced the design of Turkish rugs, was born. A special group of Turkish rugs with geometric design in imitation of Mamluk tile or mosaic patterns has been attributed to the looms of Cairo, which was ruled by the Ottomans from 1517 to 1805. The finest collection of these 16th-century geometric rugs, one of them in silk, is in the Austrian Museum of Applied Art.

The 16th- and 17th-century Turkish court rugs made in Brussa and Istanbul have allover floral patterns bearing palmettes, curving lanceolate leaves, and naturalistic Turkish flowers such as hyacinths, tulips, roses, carnations, sprays of plum blossoms, and pomegranates. These rugs frequently have a central medallion or several medallions. An example is the *Blumenthal Rug* in the Metropolitan

Jacob Isaacksz. van Ruisdael, *The Cottage*, 1646. Art Gallery, Hamburg. One of the artist's early works.

Museum. Some of the finest of these rugs are of the 16th century, the coarser ones of the 17th century. To this group of court rugs, well represented in the Austrian Museum of Applied Art and the Textile Museum, Washington, D.C., belong several fine prayer rugs that have mosque columns in the field and in the floral border. The design of the Turkish court rugs influenced Anatolian peasant rugs of the 18th and 19th centuries.

ANATOLIAN AND CAUCASIAN RUGS (18th–19th cent.)

The most popular and best-known Anatolian rugs are the prayer rugs of Ghiordes, Kula, and Ladik. All of them have a central prayer niche, or mihrab, which indicates in the mosque the direction of Mecca, toward which the Muslim faces at the time of prayer. The decoration of the Ghiordes and the related Kulas is usually floral. The colors of the Ghiordes rugs are vivid, red and blue predominating. In the Kula variety the borders are usually divided into a number of narrow stripes, and the niche sometimes has an allover pattern of small floral motifs or star rosettes.

A fine group of Anatolian prayer rugs was made in Ladik and its neighborhood. Their characteristic features make it easy to distinguish them from other Anatolian rugs. The early examples, of the first half or middle of the 18th century, are known as column Ladiks. The later Ladiks, some of which are dated 1794, 1795, and 1799, have a panel above or below the niche, decorated with pointed arches that look like arrowheads, from which issue stalks of stylized tulips.

The best-known peasant and nomad rugs of the Near East are those of the Caucasus area, which is situated between the Black Sea and the Caspian. It is populated by Armenians, Georgians, and many tribes of Persian and Turanian origin, including the nomad Tatars. The animal style developed by the much earlier Scythians influenced the art of the Caucasus and survived in metalwork, sculpture, rugs, and textiles of the Muslim era. In 1049 the Turkish Saljuks invaded the Caucasus, and their influence was soon apparent in the arts and crafts of various provinces. From the 15th century on close relations existed between Persia and the Caucasus, and many parts of the Caucasus were under the rule of the Persian Safavids well into the 18th and 19th centuries.

The earliest Caucasian rugs, the so-called dragon rugs, which have been frequently called Armenian, can be assigned to the region of Kuba. They show a lozenge-diaper pattern, formed by serrated leaves, enclosing stylized dragons, sometimes in combat with a phoenix; deer or gazelles, singly or in pairs; birds; and large palmettes. The pattern is bold and is rendered in vivid contrasting colors, mostly on a red or blue ground. These rugs began to be produced in the Shah Abbas period at the end of the 16th century and production continued through the 17th and 18th centuries. At the end of the 17th century we find a gradual degeneration of the animal forms; these are finally transformed into unrecognizable geometric forms. Related to the dragon carpets are rugs with a palmette decoration in vivid colors but without animals. One of the finest examples of this group is the magnificent 17th-century rug

from the mosque of Niğde in Anatolia (Metropolitan Museum).

Many of the Caucasian rugs, known in the trade as Kabistans, were made in the southeastern district of Shirvan. Quite a variety of types with stylized floral design or geometric patterns are attributed to this district. The characteristic feature of many Shirvans is the border of simulated Kufic writing, derived from Turkish rugs of Anatolia. Small figures of geometrically stylized animals and human figures are often added to the decoration of the Shirvans. A number of 19th-century prayer rugs, some dated (1862, 1867), have a small allover floral pattern in rich colors. A group of prayer rugs assigned to Baku is decorated with a repeat pattern of cone-shaped palmettes, derived from Persian rugs, mostly of the Senna variety.

Other popular varieties of Caucasian peasant and nomad rugs are the Lezghians, Chichis, Karabaghs, and Kazaks. The Kazaks, made by Tatar tribes of the southern Caucasus, usually have a high lustrous pile and a bold design in vivid colors.

Besides knotted rugs, the various tribes of the Caucasus manufactured smooth-faced rugs without a pile. These are either woven or show the so-called Sumak technique, after the town of Shemakha in the Shirvan district.

TURKOMAN RUGS

The wandering Turkoman tribes of Transcaspia and Western Turkestan have long been skilled weavers of rugs, which serve a variety of purposes in the life of these tent-dwelling people. Turkoman rugs thus include not only floor coverings but also rugs for the tent entrance, tent bags, and saddlebags. The Turkoman rugs were made by various tribes, whose names usually designate the different types of rugs, such as Tekkes, Salors, Saryks, Yomuds, Ersaris, and Afghans. These tribes occupy the regions from the Caspian Sea eastward to Bukhara, northward to the Aral Sea, and southward to the boundary of Persia, including Afghanistan and parts of Baluchistan. Although all the Turkoman rugs have common characteristics, each tribe developed its own peculiar features of decoration with its own peculiar "gul," or flower. The pattern of the Turkoman rugs is entirely geometric and goes back to old Turkish and Central Asian traditions. The predominant color of the Turkoman rugs, none of which are earlier than the 19th century, ranges from a reddish brown to a dark brown, with the addition of a few colors such as blues, greens, oranges, and yellows.

BIBLIOGRAPHY. A. F. Kendrick and C. E. C. Tattersall, *Fine Carpets in the Victoria and Albert Museum*, London, 1924; F. Sarre and H. Trenkwald, *Old Oriental Carpets*, 2 vols., Vienna, 1926–29; W. von Bode and E. Kühnel, *Vorderasiatische Knüpfteppiche aus alte Zeit*, 4th ed., Brunswick, 1955; K. Erdmann, *Der orientalische Knüpfteppich*, Tübingen, 1955; M. S. Dimand, *A Handbook of Muhammadan Art*, 3d ed., New York, 1958; A. U. Dilley, *Oriental Rugs and Carpets*, rev. by M. S. Dimand, New York, 1959.

MAURICE S. DIMAND

RUHMESHALLE, MUNICH, *see* KLENZE, LEO VON.

RUIJSCH (Ruysch), RACHEL. Dutch still-life painter (b. Amsterdam, 1664; d. there, 1750). Ruijsch was a pupil of Willem van Aelst. In 1701 she and her husband, the portrait painter Jurriaan Pool, were recorded as members of the painters' confraternity in The Hague. In 1708 she went to Düsseldorf as court painter to the Elector of the Palat-

inate. She painted mostly flower pieces, for which she was very well paid.

BIBLIOGRAPHY. M. H. Grant, *Rachel Ruysch*, Leigh-on-Sea, 1956.

RUISDAEL (Ruysdael; Ruijsdael), JACOB ISAACKSZ. VAN. Dutch landscape painter (b. Haarlem, 1628/29? d. Amsterdam? 1682). Jacob was a pupil of his father, Isaack van Ruisdael, a Haarlem painter and framemaker. Since there are no certain works by the father, it is difficult to establish exactly what influence he had upon the young Ruisdael's style. Jacob Ruisdael seems to have been somewhat precocious in his development, and was apparently an independent artist at about the age of eighteen. There are dated works by him from 1645 or 1646, but he did not become a member of the Haarlem painters' guild until 1648.

It has been suggested that Ruisdael may also have studied with his uncle Salomon van Ruysdael, but this contact does not seem to be documented. The influence of such Haarlem painters as Cornelis Vroom, on the other hand, can be found in several of Ruisdael's earliest works (*Forest Entrance*, Vienna, Academy of Fine Arts). About 1650 Ruisdael visited Bentheim, just over the German border, possibly in the company of Claes Berchem, who, according to Dutch sources, was his good friend. Berchem is known to have collaborated with Ruisdael on occasion. By 1657 Ruisdael was living in Amsterdam.

According to Arnold Houbraken, Ruisdael took a degree as a doctor of medicine in Caen, France. Houbraken further states that Ruisdael performed successful surgical operations in Amsterdam. Recent scholarship, however, has rejected the statement that the Jacobus Ruysdael who was a doctor is identical with the artist. In 1661 Ruisdael seems to have been seriously ill; this probably accounts for the absence of works that can be placed in the early 1660s.

Ruisdael's artistic beginnings are unusual in that even his earliest works show him to be in complete control of all the elements of landscape painting. In many ways such works as the *Dunes* (1646; Leningrad, Hermitage) and *The Cottage* (1646; Hamburg, Art Gallery) surpass those of his models.

During the first half of the 1650s Ruisdael's landscapes develop toward the heroic, with larger and more massive forms. It is possible that this development was encouraged by his travels near the German border and through his association with Berchem and perhaps with other Dutch landscape painters, such as Jan Both and Jan Asselijn, who had been to Italy. Into this period falls the romantic *Bentheim Castle* (1653; Blessington, Ireland, Sir Alfred Beit Collection) and the *Forest Entrance* (1653; Amsterdam, Rijksmuseum).

Once Ruisdael had settled in Amsterdam, probably by 1656, he seems to have been influenced by the panoramic landscapes of Philips Koninck. The panoramic approach can be seen in such works as the *Rabbit Hunt* (Haarlem, Frans Hals Museum) and eventually develops, about 1670, into one of Ruisdael's most beautiful works, the *View of Haarlem* (Rijksmuseum). Other influences seem to have played upon Ruisdael's work at this time. The most apparent is the impact of the waterfall landscapes executed by Allart van Everdingen about 1650. From this motif Ruisdael developed a series of landscapes with related

themes, for example, the *Waterfall with Castle* (Cambridge, Mass., Fogg Art Museum), which served as models for much later painters.

In the 1660s Ruisdael produced what is without doubt his best-known landscape, *The Jewish Cemetery*. This poetic landscape, with its symbolic view of life's transience, exists in two versions: the earlier is in the Detroit Institute of Art and the later (ca. 1660) in the Dresden State Art Collections. Ruisdael also painted several seascapes, such as the *View of Het IJ* (Worcester, Mass., Art Museum), as well as a few winter landscapes (ca. 1670; Rijksmuseum). Ruisdael's most famous pupil was Meindert Hobbema, but he had numerous other pupils and followers.

BIBLIOGRAPHY. K. E. Simon, *Jacob van Ruisdael, eine Darstellung seiner Entwicklung,...*, Berlin, 1927; J. Rosenberg, *Jacob van Ruisdael*, Berlin, 1928; J. Rosenberg, S. Slive, and E. H. ter Kuile, *Dutch Art and Architecture, 1600–1800*, Baltimore, 1966; W. Stechow, *Dutch Landscape Painting of the Seventeenth Century*, London, 1966. LEONARD J. SLATKES

RUISDAEL, JACOB SALOMONSZ. VAN, *see* RUYSDAEL, JACOB SALOMONSZ. VAN.

RUISDAEL (Ruijsdael), SALOMON VAN, *see* RUYSDAEL, SALOMON VAN.

RUIZ, FERNAN I AND II. Spanish architects (fl. 16th cent.). Fernán (Hernán) Ruiz I (fl. after 1520; d. 1556/58) began the Capilla Mayor (1523; vaulted in 1560), transept, and choir in the middle of the Great Mosque in Cordova, transforming it into a Cathedral. His son Fernán II (ca. 1515–1606) completed the transept and choir and designed the altar (1567) of the Capilla de la Natividad de la Virgen there. He also built the Puerta del Puente and the tower (1593–99). In 1558 he was named *maestro mayor* of the Cathedral of Seville, where he erected the Giralda (1568). His most important Sevillian work is the Hospital de la Sangre. *See* SEVILLE.

BIBLIOGRAPHY. F. Chueca Goitia, *Ars Hispaniae*, vol. 11: *Arquitectura del siglo XVI*, Madrid, 1953.

RULER CULT. Cult that probably originated in Pharaonic Egypt. Following the example of Alexander, who had himself declared a god in 324 B.C., the Hellenistic monarchs, and subsequently the Roman emperors, were deified and worshiped after their death by their successors. An elaborate iconography, revolving around the ruler's life and apotheosis, was developed in Hellenistic and Roman art.

RUNDBOGENSTIL. Round-arched style, derived ultimately from the utilitarian models of Jean Nicholas Louis Durand. Though it spread to most northern European countries and even to the United States, it is connected with the style of the 1830s and 1840s in most German states and is comparable to the English Neo-Gothic style of the same decades.

BIBLIOGRAPHY. K. Möllinger, *Elemente des Rundbogenstiles*, Munich, 1845–47.

RUNEBERG, WALTER. Finnish sculptor (b. Bargå, 1838; d. Helsinki, 1920). The son of the Finnish national poet Johan Ludvig Runeberg, he studied in Helsinki with Sjöstrand, as well as in Copenhagen, Paris, and Rome. Runeberg was the most active sculptor in Helsinki, where he carried out many public commissions. He was a classicist with a preference for Hellenistic realism, particularly in working with mythological themes.

RUNE STONES, *see* RUNIC STONES.

RUNGE, PHILIPP OTTO. German painter (b. Wolgast, 1777; d. Hamburg, 1810). After studying in Copenhagen (1799–1801) and Dresden (1801–04), Runge developed in Hamburg an art of esoteric nature symbolism, influenced by the mysticism of Jakob Böhme and the writings of Tieck. Starting with traditional allegorical devices, he sought to transform them into a pictorial language that would express his religious insights into nature, partly through symbolical allusions, partly through the suggestive power of arabesque and color. *Flight into Egypt* (1805) concentrates in one image the ideas of awakening nature and renewal through Christ. The *Hülsenbeck Children* (1806) and *Parents of the Artist* (1807) are portraits charged with symbolical meaning.

The allegorical cycle the *Times of Day*, Runge's most ambitious work, was conceived as a series of monumental decorations. Except for *Morning* (1810), of which two painted versions survive, these compositions were realized only in drawings and etchings. Highly gifted for expressive linear design, Runge resembles Blake in intention and sometimes in style. His work remained a fragment but deeply influenced later German romantics. Runge is rightly considered a key figure of the romantic movement. Most of his works, including those mentioned above, are at the Hamburg Art Gallery.

BIBLIOGRAPHY. P. O. Runge, *Hinterlassene Schriften*, 2 vols., Hamburg, 1840; O. Böttcher, *Philipp Otto Runge*, Hamburg, 1937; C. A. Isermeyer, *Philipp Otto Runge*, Berlin, 1940. LORENZ EITNER

RUNIC (Rune) STONES. Stones or monuments (chiefly grave markers) with inscriptions in runic characters, the alphabet developed by the Germanic peoples about A.D. 200–250. The earliest runic alphabet consisted of twenty-four characters, or runes, but later versions had only sixteen. Though the origin of this alphabet is still highly controversial, one probable explanation holds that it was a form of the Greco-Roman system transmitted to the Germanic peoples by the Goths of southern Russia. Runic inscriptions have been found on stones and on weapons, jewelry, and statuettes, primarily in the Scandinavian countries but also in Poland, Romania, Germany, and Russia. The Anglo-Saxons introduced runes to the British Isles, where many examples have also been found.

The Scandinavian inscriptions on stone are the most noteworthy. Many of these runic stones are simple memorials, containing only a few words, a magic formula, or sometimes a single name. A few have carved scenes as well, perhaps in imitation of Roman grave memorials.

BIBLIOGRAPHY. H. Shetelig and H. Falk, *Scandinavian Archaeology*, Oxford, 1937.

RUNKELSTEIN BEI BOZEN (Castel Roncolo): VINTLERBURG. Famous large South Tyrolean fortress near Bolzano, Italy. Built about 1385 by Nicolaus and Franz Vintler, it is noted for the important series of wall paintings dating from the same period. They depict scenes of courtly life in the International Gothic Style.

BIBLIOGRAPHY. W. Frodl, *Kunst in Südtirol*, Munich, 1960.

RUOPPOLO, GIOVANNI BATTISTA. Italian painter (b. Naples, 1629; d. there, 1693). He was a student of Paolo

Runic stones. Example from Rök, Sweden, 9th century.

Porpora (1616–73), a Caravaggesque still-life painter. Ruoppolo is justly esteemed for his sumptuous flower pieces composed on a grand scale, which contrast so sharply with the Flemish still lifes he must have known.

BIBLIOGRAPHY. R. Wittkower, *Art and Architecture in Italy, 1600–1750*, Baltimore, 1958.

RUPERT (Ruprecht von der Pfalz), PRINCE. German-English amateur engraver (b. Prague, 1619; d. Spring Gardens, Westminster, 1682). Prince Rupert, Duke of Cumberland, was the son of "Winter King" Frederick V and Elizabeth Stuart. He was educated in Holland, where his family was in exile. He learned mezzotint from its inventor, Ludwig von Siegen, at a meeting which probably took place in Brussels in 1654. Rupert passed the new technique on to Waillerant Vaillant in Frankfurt am Main and thus for a long time was credited with its invention. His earliest plates are dated 1636 and 1637; perhaps his most important is *Executioner with the Head of John the Baptist*, after Ribera. Although definitely an amateur, Prince Rupert nonetheless did develop certain technical possibilities of mezzotint and encouraged more gifted artists, such as Vaillant, in its use.

BIBLIOGRAPHY. E. Scott, *Rupert, Prince Palatine*, New York, 1899.

RUSCONI, BENEDETTO, *see* DIANA, BARTOLOMMEO.

RUSH, WILLIAM. American sculptor (1756–1833). Rush was born in Philadelphia and is sometimes called the first native sculptor of the United States. His reputation is based primarily upon his wood carvings of ship figureheads and upon the allegorical figure *The Nymph of the Schuylkill* (Philadelphia Museum of Art). Despite Rush's active part in founding the Pennsylvania Academy and his role as early artist of the Republic, his sculpture falls within the category of visual Americana, rather than art.

BIBLIOGRAPHY. H. Marceau, *William Rush, 1756–1833, the First Native American Sculptor*, Philadelphia, 1937.

RUSHANA, *see* VAIROCANA.

RUSINOL Y PRATS, SANTIAGO. Spanish painter (b. Barcelona, 1861; d. Aranjuez, 1931). Rusiñol studied with Tomás Moragas. His art was developed in Paris, where he became a prominent figure in the group of expatriate Spanish artists. Also a poet and playwright, he published a book about the experiences of the group illustrated by his friend Ramón Casas. His art at the end of the 19th century combined elements of realism, romanticism, and symbolism. Later he devoted himself to landscape, working in mainland Spain and the Balearic Islands, although his art retained its *fin de siècle* exoticism in paintings of the richly patterned gardens of the Generalife or Aranjuez.

BIBLIOGRAPHY. J. Plá, *Rusiñol y su tiempo*, Barcelona, 1942; J. Francés, *Santiago Rusiñol y su obra*, Gerona, 1945.

RUSKIN, JOHN. English artist, writer, and social reformer (b. London, 1819; d. Coniston, 1900). For fifty years he was the most powerful influence on the English public in matters of art, and it is doubtful whether any other English critic ever had so wide a following. He was born to wealth and was dedicated from childhood to the pursuit of culture. He was educated by his parents in the classics and the Bible, and in their company he traveled widely in Great Britain and on the Continent.

Ruskin went up to Oxford in 1836 and that year published his first article, which was in defense of Turner. He first met Turner in 1840, and he first visited Venice, which was to become as significant to him as it had been to Turner, in 1841. The first volume of *Modern Painters*, "by a Graduate of Oxford," (essentially a eulogy of Turner) appeared in 1843, and from that time Ruskin was recognized and his authority grew. *The Seven Lamps of Architecture* appeared in 1849 and *The Stones of Venice* in 1851–53. From the 1860s he wrote less to inspire an understanding of the arts than to present a wider social message. His efforts resulted in the foundation in 1871 of the Guild of St. George, a social experiment whose aim was to expunge the evils of the Industrial Revolution. His most important social writings were *Unto This Last* (1860) and *Fors Clavigera* (1871).

In the late 1840s Ruskin championed the cause of the Pre-Raphaelite Brotherhood. He admired all forms of truth to nature in the art of painting, but he was unable to accept the nocturnes of Whistler, who sued him for libel in 1878. His own painting, almost entirely in water color, was the result of intense observation and scientific understanding of natural phenomena. His subjects were mostly architectural or landscapes. Many of his studies are of an exquisite delicacy. In England there is a good collection

at the Ashmolean Museum, Oxford, and in the United States, at the Fogg Art Museum of Harvard University, where Charles Eliot Norton was his friend.

Ruskin was largely responsible for the growth of an appreciation of art of the early Italian Renaissance both in England and in the United States. He aroused enthusiasm in particular for Fra Angelico and Botticelli. His lectures at Oxford, where he was elected Slade Professor in 1869, drew large audiences. He retired to Coniston in the Lake District in 1871.

BIBLIOGRAPHY. E. T. Cook and A. Wedderburn, *The Works of John Ruskin*, 39 vols., London, 1903–12; J. Evans, *John Ruskin*, London, 1954; J. Evans and J. H. Whitehouse, eds., *Diaries of John Ruskin*, 3 vols., Oxford, 1956–59.

KENNETH J. GARLICK

RUSSELL, ALFRED. American painter and graphic artist (1920–). Born in Chicago, he studied painting in Detroit and with William C. McNulty at the Art Students League in New York City. Russell's first artistic interests were such modern figure painters within the classical tradition as André Derain and Felice Casorati. From 1945, however, under the influence of Hayter's Atelier 17, he began painting in a linear abstract style, for example, *La Rue de Nevers* (1949; New York, Whitney Museum). Since the early 1950s Russell has returned to the classical figure derived from antique art, Poussin, and Renaissance theories of construction and perspective.

BIBLIOGRAPHY. New York, Whitney Museum of American Art, *The New Decade*, ed. J. I. H. Baur, New York, 1955.

RUSSELL, SIR (Sydney) GORDON. English furniture designer (1892–). Born in London and educated at Campden Grammar School, Russell became a partner in Russell and Sons in 1919 and managing director of Gordon Russell Ltd. in 1926. He was elected Royal Designer for Industry in 1940 and director of the Council of Industrial Design in 1947. He was knighted in 1955. His furniture is simple and structural.

BIBLIOGRAPHY. "Mr. Gordon Russell's Furniture," *The Studio*, LXXXVII, March, 1924.

RUSSELL, JOHN. English pastelist (1745–1806). He was a pupil of Francis Cotes and also studied the works of Rosalba Carriera. Russell is probably the best known of the English pastelists, but there are others, particularly Daniel Gardner and Ozias Humphrey, who are equally, if not more, accomplished. His portraits have a superficial brilliance that only lightly conceals insipid characterization and weak draftsmanship.

BIBLIOGRAPHY. G. C. Williamson, *John Russell*, London, 1894.

RUSSELL, JOHN. Australian painter (1858–1931). Russell painted with the French impressionist group and was a friend of Monet, Van Gogh, and Rodin. He married Rodin's model. Russell's most famous work is his portrait of Van Gogh, painted when they were fellow students. His landscapes closely resemble those of Monet.

RUSSELL, MORGAN. American painter (b. New York City, 1886; d. Broomall, Pa., 1953). He studied with Robert Henri and in 1906 went to Paris, where he met Matisse. There, in 1912, Russell and Stanton Macdonald-Wright founded synchromism, a movement similar in theory and

Luigi Russolo, *Synthesis of the Actions of a Woman.* **Museum of Painting and Sculpture, Grenoble.**

result to its rival, orphism. In his paintings in this style, Russell aimed at the creation of form and space by means of rhythmic, nonobjective arrangements of arcs and segments of contrasted colors. After 1920 Russell returned to figurative painting.

BIBLIOGRAPHY. W. H. Wright, *Modern Painting*, New York, 1915; A. C. Ritchie, *Abstract Painting and Sculpture in America*, New York, 1951.

RUSSICO MONASTERY, MOUNT ATHOS. Modern complex of many buildings constructed beginning in 1814. Early in the 20th century it held some 1500 monks. The monastery contains a small treasure of Byzantine art from the 11th to the 13th century.

BIBLIOGRAPHY. J. A. Hamilton, *Byzantine Architecture and Decoration*, 2d ed., London, 1956.

RUSSOLO, LUIGI. Italian painter and musician (b. Portogruaro, near Venice, 1885; d. Cerro di Laveno, 1947). A self-taught artist, he was one of the founders of futurism in 1910. Russolo's personal mysticism of universal forces, expressed in paintings such as *Synthesis of the Actions of a Woman* (1912; Grenoble, Museum of Painting and Sculpture) or *Interpenetration of Houses + Light + Sky* (1912; Basel, Art Museum) fitted well with the movement's emphasis on the depiction of motion. He experimented with the incorporation of noise into traditional music and published a manifesto, "The Art of Noises," in 1913. In his later paintings, Russolo worked in a more representational style.

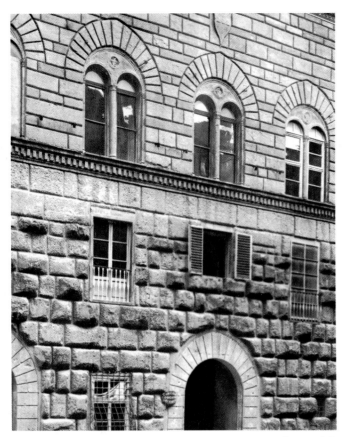
Rustication. The rusticated stone masonry façade of a Renaissance palace in the Piazza Strozzi, Florence.

RUSTICATION. Type of stone masonry in which the joints are beveled or otherwise recessed and the surface is often chipped or roughened. Perhaps inspired by Roman grottoes, rusticated masonry was used extensively during the Renaissance, particularly in Italy. The masonry of the Medici-Riccardi Palace, Florence, has a chipped stone face and recessed joints; that of the Strozzi Palace in Florence is roughened to give it a fortress look. Rusticated masonry was imitated in wood in the American colonies. In Georgian New England planks were grooved in the "rustick" manner seen in the Redwood Library, Newport, of the mid-18th century. Washington called the beveled planks in Mount Vernon, Va., "rusticated boards."

RUSTIC CAPITALS, see CAPITALS, RUSTIC.

RUSTICI, GIOVANNI FRANCESCO. Italian-French sculptor (b. Florence, 1474; d. Tours, 1554). Rustici's style is derived from that of his friend Leonardo, but modified by that of Donatello and Verrocchio, and influenced by antique medallions. His masterpieces include figures for the Baptistery in Florence depicting John the Baptist (1506–11); a *Noli me tangere* (Florence, National Museum) glazed by Giovanni della Robbia; and a series of terra-cotta *tondos* from antique medallions for the Villa Salviati in Florence. Rustici collaborated on the 1515 entry of Leo X into Florence. In 1528 he went to France to do an equestrian statue of Francis I (not executed), and attributions for his French period are uncertain. He was especially noted for his bas-reliefs of horse combats and for his portraits.

BIBLIOGRAPHY. A. Venturi, *Storia dell'arte italiana*, vol. 10, pt. 1, Milan, 1935; W. R. Valentiner, "Rustici in France," *Studies in the History of Art Dedicated to William E. Suida...*, London, 1959; M. Dupré, "Giovan Francesco Rustici," *Paragone*, CLVII, 1963.

RUSTIC MASONRY, see MASONRY.

RUSUTI, FILIPPO. Italian mosaicist and painter (fl. early 14th cent.). He was a follower of Jacopo Torriti. Although frescoes depicting the four Doctors of the Church in the upper church of S. Francesco, Assisi, have been attributed to him, Rusuti's only signed work is the series of mosaics on the façade of S. Maria Maggiore in Rome. These mosaics show the enthroned Lord in benediction with scenes from the legend of the building of the church below. The linear and figural stylizations are those of Torriti and Byzantine tradition, but the massive, almost obese figures seem to show the influence of Giotto's monumental art. The lower scenes were probably completed by assistants after Rusuti had left to work at the palace of King Philip the Fair in Poitiers (1308–ca. 1317).

BIBLIOGRAPHY. R. van Marle, *The Development of the Italian Schools of Painting*, vol. 1. The Hague, 1923.

RUTAN, CHARLES HERCULES, see SHEPLEY, RUTAN, AND COOLIDGE.

RUTHWELL CROSS. Large carved and inscribed cross (17 ft. high) of the late 7th century. It is a product of Early Christian art in Northumbria. The arms of the cross, now missing, presumably depicted two of the Evangelists, while figures of the other two were placed above and below the crossing. Runic inscriptions contain the earliest extant fragments of the "Dream of the Holy Rood." *See* CROSS; NORTHUMBRIAN ART.

BIBLIOGRAPHY. G. B. Brown, *The Arts in Early England* [vol. 5]: *The Ruthwell and Bewcastle Crosses...*, 2d ed., London, 1921.

RUYESDAEL, SALOMON VAN, see RUYSDAEL, SALOMON VAN.

RUYSBROECK, JAN VAN. Flemish architect (d. 1485). In 1448 Van Ruysbroeck was named architect in charge of the tower of the Hôtel de Ville in Brussels (completed 1455). In 1470 he was architect of St. Gudule and in 1477, municipal architect of Brussels.

RUYSCH, RACHEL, see RUIJSCH, RACHEL.

RUYSDAEL, JACOB ISAACKSZ. VAN, see RUISDAEL, JACOB ISAACKSZ. VAN.

RUYSDAEL (Ruisdael), JACOB SALOMONSZ. VAN. Dutch landscape painter (b. Haarlem, 1629/30? d. there, 1681). Jacob Salomonsz. was the son of the painter Salomon van Ruysdael and a cousin of the most famous painter in the family, Jacob Isaacksz. van Ruisdael. He seems to have received his training from his father. Ruysdael entered the Haarlem painters' guild in 1664; in 1666 he was living in Amsterdam. He does not seem to have devoted all his efforts to painting, since at one time he owned a hosiery shop. Ruysdael continued to live in Am-

sterdam until 1681, when, having been declared insane, he was returned to his native Haarlem, just before his death.

The *Waterfall by a Cottage in a Hilly Landscape* (London, National Gallery), signed "Ruysdael," is generally accepted to be a work of this artist and part of a group of similar works which date from 1650 to 1668. They are dependent upon the manner of Salomon van Ruysdael. Some of these works also show a relationship to the style of Jacob Isaacz. van Ruisdael.

BIBLIOGRAPHY. H. F. Wijnman, "Het Leven der Ruysdaels," *Oud-Holland*, XLIX, 1932; N. Maclaren, *National Gallery Catalogues: The Dutch School*, London, 1960.
LEONARD J. SLATKES

RUYSDAEL (Ruijsdael; Ruisdael; Ruyesdael), SALOMON VAN. Dutch painter of landscape, genre, and some still life (b. Naarden, 1600/03? d. Haarlem, 1670). Ruysdael was the son of Jacob de Gooyer, and he occasionally used his original family name. He entered the Haarlem painters' guild in 1623 under the name of Salomon de Gooyer. He was the uncle of Jacob van Ruisdael and the father of Jacob Salomonsz. van Ruysdael.

Ruysdael is one of the important early-17th-century Dutch landscape painters. His earliest development, in works such as *On the Ice* (ca. 1627; location unknown), shows the influence of Esaias van de Velde, who was active in Haarlem from 1610 to 1618. His earliest landscape paintings also show the impact of the work of Jan van Goijen. *Dune Landscape* (1628; location unknown) can be related as well to an important contemporary, Pieter de Molijn, who was active in Haarlem.

In *A View of Amersfoort* (1634; location unknown) Ruysdael also came under an influence from Hercules Seghers, the unusual Dutch landscape painter and etching innovator. However, from about 1631 he followed the general lead established by Van Goijen. This compositional type can be seen in the *River Bank* (1632; Hamburg, Art Gallery). After about 1642 Ruysdael experimented with new compositional formats, away from the earlier strong diagonals into space (*Ferry*, 1647; Brussels, Fine Arts Museum). Toward the end of his life Ruysdael also painted several still-life subjects, mostly of game (*Still Life with Dead Hare*, 1662; Copenhagen, State Museum of Fine Arts).

BIBLIOGRAPHY. H. F. Wijnman, "Het leven der Ruysdaels," *Oud-Holland*, XLIX, 1932; W. Stechow, ... *Salomon van Ruysdael, eine Einführung in seine Kunst*, Berlin, 1938; W. Stechow, *Dutch Landscape Painting of the Seventeenth Century*, London, 1966.
LEONARD J. SLATKES

RYCK, CORNELIA DE, *see* RIJCK, CORNELIA DE.

RYCK, PIETER CORNELISZ. VAN, *see* RIJCK, PIETER CORNELISZ. VAN.

RYCKAERT (Rijckaert), DAVID, III. Flemish painter of interiors, kermisses, and occasional still lifes (1612–61). Ryckaert was a native of Amsterdam. He worked first in the manner of Adriaen Brouwer. During the later part of his career he pictured the middle class, adapting types borrowed from David Teniers the Younger and Jacob Jordaens.

Jacob van Ruysdael, *Waterfall by a Cottage*. National Gallery, London.

RYCKAERT (Rijckaert), MARTEN. Flemish painter (1587–1631). Born in Antwerp, he was a pupil of his father, David Ryckaert II, and of Tobias Verhaecht. He mostly painted mountainous landscapes in the style of Verhaecht and in the manner of Paul Bril's middle period.

RYCKHALS, FRANCOIS. Dutch still-life painter (b. Middelburg, ca. 1600; d. there, 1647). In 1633 Ryckhals joined the Dordrecht guild; in 1644, the Middelburg guild. He specialized in cottage interiors and *pronk* still lifes, featuring pell-mell many objects in precious metals, books, fruits, and glasses. His works, painted in low color harmonies and precisely drawn, may have influenced Willem Kalf.

BIBLIOGRAPHY. I. Bergström, *Dutch Still-Life Painting in the Seventeenth Century*, New York, 1956.

RYDER, ALBERT PINKHAM. American painter (b. New Bedford, Mass., 1847; d. Elmhurst, N.Y., 1917). Ryder best exemplifies what is loosely termed the visionary strain in American painting. Instantly identifiable, his imagery nonetheless denotes an outlook that remarkably transforms the configurations of the environment. Ryder, as a visionary painter, is broadly related to some aspects of Washington Allston and forecasts much of the work of Arthur Garfield Dove and others in the 20th century, but the spell exerted through his dream world is uniquely potent.

About 1870 Ryder settled in New York City, which remained his home for the rest of his life. He did make several trips abroad: to London for a month in 1877; to England, France, Holland, Italy, Spain, and Tangier on a hurried trip in 1882; and again to London for a couple of months in 1887 and 1896. Neither these trips nor some brief instruction at the National Academy of Design and a friendship with the portraitist William E. Marshall had any bearing on his style. Ryder cared nothing for money. Though his paintings did find buyers, he lived, especially toward the end of his career, as a shabby eccentric.

Ryder's paintings do not feature intimate detail; much of his work is distinguished by an extraordinarily sensitive balance of large masses. The color is prevailingly dark, but of great richness. Since Ryder worked over his paintings for years, constantly refining, dating is usually difficult. Unfortunately, he used unsound methods, such as painting over pictures when they were still wet and using alcohol and candle grease as media, and as a result his work has largely deteriorated.

Ryder's themes are often based on Biblical and other literary sources. The *Jonah* of the 1890s (Washington, D.C., National Collection of Fine Arts) shows a terror-stricken prophet floundering in a churning ocean. From Shakespeare came *Macbeth and the Witches* (Washington, D.C., Phillips Collection) and *The Forest of Arden* (Stephen C. Clark Collection), a curious metamorphosis of Bronx Park in New York; and from Chaucer came *Constance* (Boston, Museum of Fine Arts). In these, the state of nature becomes not merely a background, but an embodiment of the condition of the human actors. A rare example of a work based on a contemporary event is *The Race Track*, or *Death on a Pale Horse* (Cleveland Museum of Art), with its mounted figure of death holding a scythe: the inspiration came from the story of a waiter who committed suicide

Albert Pinkham Ryder, *Autumn Meadows*. Metropolitan Museum of Art, New York.

because of his losses at betting. Among the best known of the marines is the *Toilers of the Sea* (New York, Metropolitan Museum). In *The Race Track, Jonah,* and many other paintings, one is aware of Ryder's concern over the minuteness and helplessness of man.

BIBLIOGRAPHY. F. F. Sherman, *Albert Pinkham Ryder,* New York, 1920; L. Goodrich, *Albert P. Ryder,* New York, 1959.

ABRAHAM A. DAVIDSON

RYN, REMBRANDT VAN, see REMBRANDT HARMENSZ. VAN RIJN.

RYOANJI GARDEN, KYOTO. Japanese garden at a Zen temple of the Ryōanji in Kyoto. The temple was built sometime between 1469 and 1486 on the site of the 12th-century villa of a Fujiwara courtier. The garden, usually dated to the 16th century, is small (about 77 by 30 ft.) and consists only of white sand and five groups of rocks; it contains no plants. It is meant to be seen from a fixed point of view and not to be walked on. The abstract beauty of its rock arrangement sharply contrasted with the silver-white ground has been admired by many visitors from different parts of the world.

See also JAPAN: ARCHITECTURE.

BIBLIOGRAPHY. Tokyo National Museum, *Pageant of Japanese Art,* vol. 6: *Architecture and Gardens,* Tokyo, 1952; Kokusai Bunka Shinkōkai, *Tradition of Japanese Garden,* Tokyo, 1962.

RYOZEN. Japanese painter (fl. mid-14th cent.). Ryōzen did both ink paintings and color paintings of Buddhist subjects. His life is not known, and he had long been identified with Kaō. His ink paintings are thoroughly Zen in spirit, executed with economy and swiftness of brushstroke and a deep appreciation of unfilled space. *See* KAO; ZEN.

BIBLIOGRAPHY. R. T. Paine and A. Soper, *The Art and Architecture of Japan,* Baltimore, 1955.

RYSBRACK, JOHN MICHAEL. Flemish-English sculptor (b. Antwerp, 1694; d. London, 1770). Son of the landscape painter Peter Rysbrack, he was probably a pupil of Michael Vervoort in Antwerp. About 1720 he went to England, where he was the leading sculptor until rivaled by Peter Scheemakers in the 1740s. Extremely prolific, he specialized in busts and monuments, and his works are always of high quality. His statue of Hercules at Stourhead, Wiltshire (ca. 1743), is one of his greatest works.

BIBLIOGRAPHY. M. I. Webb, *Michael Rysbrack, Sculptor,* London, 1954.

RYSBRAECK, PIETER. Flemish painter (b. Antwerp, 1655; d. Brussels, 1729). He is said to have studied in France under Jean-François Millet. His landscapes bear, in fact, the stamp of the Frenchman's Italianizing concepts. Rysbraeck became the foremost exponent of this style in Antwerp after he returned there in 1692.

BIBLIOGRAPHY. R. Oldenbourg, *Die flämische Malerei des XVII. Jahrhunderts,* 2d ed., Berlin, 1922.

RYSSELBERGHE, THEO VAN. Belgian painter and graphic artist (b. Ghent, 1862; d. Saint-Clair, France, 1926). He studied at the academies of Ghent and Brussels. In 1882 he accompanied Constantin Meunier to Spain on an official commission to copy paintings, afterward traveling in and painting scenes of North Africa, for example, the vivid *Arab Fantasy* (1884; Brussels, Fine Arts Museum).

Van Rysselberghe's early paintings were generally academic, for example, the Whistler-influenced, full length *Portrait of Octave Maus* (1885; Brussels, Fine Arts Museum). However, in 1884, he was a founding member of the Belgian avant-garde art group called The Twenty (Les Vingt), and when on a visit to Paris in 1886 he saw Seurat's *La Grande Jatte* at the impressionists' exhibition, he became instrumental in obtaining for Seurat an invitation to show with Les Vingt in 1887. Van Rysselberghe himself soon became a convert, although not a slavish one, to Seurat's divisionism. He was one of the few neoimpressionists to attempt the serious application of that technique to portraiture which retained the traditional virtues of accurate depiction and psychological penetration. However, in the portraits he used a composition that was closer to Whistler or Manet than to the theories of Seurat: the full length *Mme Théo van Rysselberghe* (1890; Otterlo, Kröller-Müller Museum); the seated half figure against the composed rectangles of the interior in *Mme Charles Maus* (1890; Brussels, Fine Arts Museum); or the cross section of Belgian and French literary and artistic society, *La Lecture* (1903; Ghent, Fine Arts Museum).

Van Rysselberghe's painting style gradually loosened shortly after 1900, becoming more simply broad brush painting rather than true divisionism, for example, *Jeune fille en rouge* (1910; Brussels, Fine Arts Museum). Apart from his role in the introduction of neoimpressionism to Belgium, he is also important as an Art Nouveau decorator and designer.

BIBLIOGRAPHY. P. Fierens, *Théo van Rysselberghe,* Brussels, 1937; F. Maret, *Théo van Rysselberghe,* Antwerp, 1948.

JEROME VIOLA

S

Eero Saarinen, General Motors Technical Center, 1948–56. Warren, Michigan.

SAARINEN, EERO. Finnish-American architect (b. Kirkkonummi, Finland, 1910; d. Ann Arbor, Mich., 1961). The son of Eliel Saarinen, Eero studied sculpture in Paris (1930–31) and architecture at Yale (until 1934). He worked in his father's office in Bloomfield Hills, Mich., from 1936 to 1950, when he formed Eero Saarinen and Associates, which still carries on his work.

Saarinen's first recognition came when he won the competition for the Jefferson National Expansion Memorial (1948–65) in St. Louis, Mo. After that he designed such large-scale works as the General Motors Technical Center in Warren, Mich. (1948–56), and the Auditorium and Chapel at the Massachusetts Institute of Technology, Cambridge, Mass. (1953–56), the first major shell construction in the United States. He gained world attention with the United States Chancellery buildings in Oslo (1955–59) and London (1955–60) and with his soaring shapes in reinforced concrete in the Ingalls Hockey Rink, Yale University (1956–59), and the TWA Flight Center, Kennedy Airport, N.Y. (1956–62).

One of Saarinen's last, and probably most mature, works is the Dulles International Airport Terminal Building in Chantilly, Va. (1958–62), a vast complex designed specifically for jet travel, where everything from the magnitude of the planning to the minutiae of the details seems appropriate to the task.

BIBLIOGRAPHY. E. Saarinen, *Eero Saarinen on His Work*, ed. by A. B. Saarinen, New Haven, Conn., 1962; A. Temko, *Eero Saarinen*, New York, 1962.

THEODORE M. BROWN

SAARINEN, ELIEL. Finnish-American architect and planner (b. Rantasalmi, Finland, 1873; d. Bloomfield Hills, Mich., 1950). He studied painting and architecture simultaneously in Helsinki (1893–97) and started architectural practice in 1896 with H. Gesellius and A. E. Lindgren.

His European reputation was established by his designs for the Finnish Pavilion at the Paris Exposition (1899–1900), the National Museum (Helsinki, 1902), and the Helsinki Central Station (1904; constructed 1910–14). In 1922 Saarinen became known in the United States with his design for the Chicago Tribune competition, which took second prize. A *succès d'estime*, it influenced skyscrapers

in the United States for years to come. *See* CHICAGO TRIBUNE BUILDING, CHICAGO; HELSINKI CENTRAL STATION.

After immigrating to the United States about 1922 he undertook many large-scale works, such as the Cranbrook School for Boys (1926–30) and the Cranbrook Academy of Art (1926–41), both in Bloomfield Hills, Mich.

His more structurally expressive, later works include the Kleinhans Music Hall (1938) in Buffalo, done in collaboration with his son Eero, and the Tabernacle Church of Christ (1940) in Columbus, Ind., a large complex of blocks interlocking around a tower and water pools. *See* SAARINEN, EERO. (See illustration.)

BIBLIOGRAPHY. A. Christ-Janer, *Eliel Saarinen*, Chicago, 1948.

THEODORE M. BROWN

SABATINI (Sabbatini), ANDREA (Andrea da Salerno). Italian religious painter (b. Salerno, ca. 1484; d. Gaeta, 1530). His father, a wealthy merchant, took him to Naples, where he studied with Raimo Epifanio. Earlier sources held that Sabatini was a pupil and collaborator of Raphael, whose style his resembles, but more recent biographies state that Sabatini never left Naples. In that city he was regarded as a most able artist.

SABINE WOMEN. Oil painting by David, in the Louvre Museum, Paris. *See* DAVID, JACQUES-LOUIS.

SABOGAL, JOSE. Peruvian painter (b. Cajabamba, 1888; d. Lima, 1956). José Sabogal was trained in Europe (1909–12) and in Buenos Aires (1912–18). He taught at the School of Fine Arts, Lima, starting in 1920, and was its director from 1933 to 1943. He visited Mexico in 1922 and absorbed the art of Orozco and Rivera. Sabogal became the leader of the indigenist school, stressing native Peruvian subjects. Simple color masses and experimental techniques characterize his work.

BIBLIOGRAPHY. G. L. M. Morley, *An Introduction to Contemporary Peruvian Painting*, San Francisco, 1942.

SACCA FAMILY. Italian wood carvers, intarsia craftsmen, and architects (fl. Cremona, Parma, and Prato in the late 15th and early 16th cent.). They are best known for church furniture. Reading stands at several churches in Cre-

Eliel Saarinen (with Herman Gesellius, Armas Lindgren), National Museum, Helsinki, built 1905–11.

mona are by them, as are the choir stalls at S. Francesco del Prato. The *Anonimo Morrelliano* credits Filippo da Sacca with the building of the cloister court of the Monastery of S. Pietro, Cremona. Other important members of the family are Tommaso Sacca (d. 1517) and his son Paolo (d. Cremona, 1537).

SACCHI, ANDREA. Italian painter (1599–1661). He was the unquestioned leader of the movement in Rome known as "high baroque classicism." His early style is strongly dependent on the works of the Bolognese Carraccis, but his classical compositions, such as *St. Gregory and the Miracle of the Corporal* (ca. 1625–27; Vatican Museums, Pinacoteca), are enlivened by a new attention to warm Venetian color and extremely loose handling of the paint surface. By 1630 Sacchi had completely dissociated himself from the prevailing expressionistic style of his contemporary rival Pietro da Cortona. Hence, his ceiling decorations in the Barberini Palace, Rome (1629–33), are executed without any attempt at illusionism, with few figures, and with extremely quiet poses. His mature style is best represented by the *Vision of St. Romuald* (ca. 1638; Vatican Museums, Pinacoteca), which emphasizes clarity of compositional organization and has few monumental figures, strictly defined forms, and a quiet, introspective atmosphere evocative of a deeply felt mood.

BIBLIOGRAPHY. G. Incisa della Rocchetta, "Notizie inedite su Andrea Sacchi," *L'Arte*, XXVII, 1924; H. Posse, *Der römische Maler Andrea Sacchi*, Leipzig, 1925; E. K. Waterhouse, *Baroque Painting in Rome*, London, 1937; R. Lee, "Ut pictura poesis: The Humanistic Theory of Painting," *Art Bulletin*, XXII, December, 1940; R. Wittkower, *Art and Architecture in Italy, 1600–1750*, Baltimore, 1958.

SACCHI, GIOVANNI ANTONIO DE', *see* PORDENONE.

SACCHI, PIER FRANCESCO. Italian painter (1485–1528). The leading Genoese painter of his time, he did a number of signed altarpieces (1514, Berlin, former State Museums; 1516, Paris, Louvre, and Genoa, Palazzo Bianco; 1526, Genoa, S. Maria del Castello; 1527, Multedo). His shadowy High Renaissance forms are in the general line of descent from Leonardo and are parallel to those of Francia; some influence of Giulio Romano can also be observed. But different from these and typical of Genoa is the adoption of Flemish motifs, not only in the richly detailed landscapes, but also in the angular poses and the particularized surfaces of skin and garments.

BIBLIOGRAPHY. A. Morassi, *Capolavori della pittura a Genova*, Milan, 1951.

SACHAROV, ADRIAN DMITRIEVICH, *see* ZAKHAROV, ADRIAN DMITRIEVICH.

SACK OF TROY, *see* ILIUPERSIS.

SACRA CONVERSAZIONE. Italian for "holy conversation," a type of the Madonna and Child popular in 15th- and 16th-century Italian painting. The Madonna, enthroned, is surrounded by saints whose awareness of one another implies that they are conversing among themselves, perhaps over the significance of the Madonna in their midst. An example of the *Sacra Conversazione* is Domenico Veneziano's *St. Lucy Altarpiece* (ca. 1445; Florence, Uffizi).

SACRAE URBIS, TEMPLUM, ROME. Temple erected by Vespasian as a repository for municipal archives (A.D. ca. 73–75). The north wall of the building was covered with marble blocks on which was engraved a map of the city of Rome. The temple was later incorporated in the Church of SS. Cosmas and Damian.

SACRAMENTARY. Early Christian liturgical book containing the Canon, Proper, Collects, and other prayers used by the celebrant of the Mass, as well as the rites for other sacraments. The Sacramentary, used from the 4th to the 13th century, was replaced by the Missal.

SACRAMENT HOUSE. Type of tabernacle, popular in medieval Germany, used to contain the Eucharist pyx, or box. German sacrament houses were often intricately carved with architectural forms and sculpture, their spire-like structures sometimes reaching great heights.

SACRAMENTO, CALIF.: E. B. CROCKER ART GALLERY. Collection established in 1885. It comprises examples of painting, particularly German painting, from the 15th to the 20th century. There are also 1,000 master drawings, rare Korean ceramics, 12th- and 13th-century Chinese and Japanese objects, American glass, and a display of California pioneer material. Exhibitions of contemporary art are held frequently.

SACRE COEUR, PARIS. Pilgrimage church at the summit of Montmartre, erected from 1876 to 1910. Realized from a vow made by the Archbishop of Paris, the structure was declared a public utility and erected from public funds. Abadie was chosen as architect in 1874 in competition with seventy-eight architects. The church was finished by Lucien Magne.

Sacré Coeur is centralized and cruciform and combines elements of St-Germigny-des-Prés, St. Mark's in Venice, and St-Front-de-Périgueux. In spite of its central planning, however, a distinct direction is given to the church by the large portico and the ambulatory and radiating chapels surrounding the choir. An outstanding monument of the Romanesque-Byzantine style, this building marks a trend toward the simplification and monumentalization of eclectic historical vocabulary.

SACRED AND PROFANE LOVE. Oil painting by Titian, in the Borghese Gallery, Rome. *See* TITIAN.

SACRED PALACE, ISTANBUL (Great Palace of Constantinople). Palace in Turkey, dating from the time of Constantine. It was sumptuously restored by Theophilus in the 9th century and further embellished by Basil I. It contained many halls and galleries, gardens and terraces, chapels, pavilions, and art treasures. All that remain of this once great complex of buildings that housed the Byzantine emperors are the 6th-century floor mosaics. These excellent works show the emergence of a new Byzantine style. The many scenes (including hunting, architecture, and animals) with rich foliate borders, all executed in a naturalistic manner, manifest their departure from the antique in their neglect of background (all white) and their cast shadows.

BIBLIOGRAPHY. J. A. Hamilton, *Byzantine Architecture and Decoration*, London, 1933.

SACRED WOOD, THE (Le Bois sacre). Oil painting by Puvis de Chavannes, in the Sorbonne, Paris. *See* PUVIS DE CHAVANNES, PIERRE.

Sacré Coeur, Paris. Pilgrimage church on Montmartre, 1876–1910.

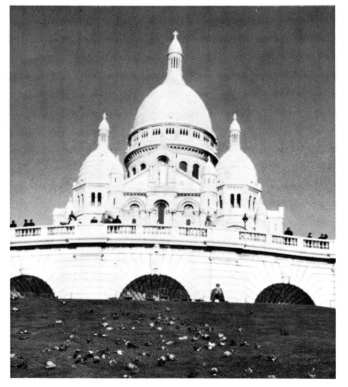

SACRISTY. Small chamber in, or attached to, a church, where vestments, books, and chalices and other sacred vessels are kept. It is sometimes called a vestry.

SACRISTY, NEW, OF SAN LORENZO (Medici Chapel), FLORENCE. The New Sacristy of S. Lorenzo was built by Michelangelo between 1520 and 1533. (Certain additions to complete the building, including the mosaic floor, were undertaken by Vasari in 1557.) The three-story scheme of the interior, with its detailing in dark *pietra serena*, follows the prototype of the Old Sacristy, except that the proportions have been altered to give the effect of ascent.

The sacristy contains two stupendous tomb groups created by Michelangelo for two Medici princes. The figure of Lorenzo, duke of Urbino, traditionally known as *Il Pensieroso*, forms the apex of a pyramidal group whose base is the sarcophagus with the allegorical pair *Dawn* and *Evening*. The corresponding sepulchral group on the other wall is dominated by the energetic figure of Giuliano, duke of Nemours; his sarcophagus supports the figures *Night* and *Day*. On the third wall, facing the altar of the sacristy, is Michelangelo's *Madonna and Child*, flanked by *St. Cosmas* and *St. Damian*, carved by G. A. Montorsoli and Raffaello di Montelupo respectively. *See* MICHELANGELO BUONARROTI.

BIBLIOGRAPHY. C. de Tolnay, *The Medici Chapel*, Princeton, 1948.
WAYNE DYNES

SACRISTY, OLD, OF SAN LORENZO, FLORENCE. This small building, a gem of early Italian Renaissance architecture, was erected by Brunelleschi between 1420 and 1429 adjacent to the Medici Church of S. Lorenzo, which the architect rebuilt later. The interior consists of a square room supplemented by a small apsidal choir. The careful proportioning is emphasized by the crisp detailing in dark *pietra serena* contrasting with the white walls. The colored stucco medallions in the pendentives of the dome (scenes from the life of St. John) and in the lunettes (Evangelists) and the frieze of cherubim are by Donatello, who also created the bronze doors at the entrance to the chapel. Among several works of art displayed within is the sarcophagus of Giovanni and Piero de' Medici by Verrocchio (1472).

BIBLIOGRAPHY. P. Sanpaolesi, *Brunellesco e Donatello nella Sacristia Vecchia*, Pisa, 1950.

SADANGA. Six principles of Indian painting according to Yaṣoḍhara in a 12th-century commentary on the *Vātsāyana Kāmasūtra*. The ṣaḍaṅga are (1) differentiation of forms or types; (2) measure, or canons of proportion; (3) embodiment of sentiment or feeling; (4) infusion of grace or charm; (5) similitude or correspondence of formal and pictorial elements; and (6) preparation of materials (literally, "breaking of pigments").

SADDHARMAPUNDARIKA, see LOTUS SUTRA.

SADELER, AEGIDIUS, II. Flemish engraver, print dealer, and painter (b. Antwerp, 1575; d. Prague, 1629). A skillful engraver from a large family of proficient printmakers, Sadeler traveled to Munich, Venice, and Rome, and finally settled in Prague. There he was employed by the emperor Rudolph II and his successors. Almost all his

prints were reproductions of the work of other artists, particularly the mannerists in favor at the court of Prague, including Spranger, Von Aachen, Candid, Heintz, and the landscapist Savery. He also engraved a splendid view of the hall of the Castle of Prague (1607) and a view of that city in nine plates. From his Italian trip there are prints after such major artists as Tintoretto, Titian, Raphael, Ligozzi, and Agostino Carracci.

SAEDELEER, VALERIUS DE. Belgian painter, graphic artist, and designer (b. Alost, 1867; d. Leupegem, 1941). He studied in Brussels and was associated with the artists of the village of Laethem-Saint-Martin, where he lived from 1904 to 1907. De Saedeleer's prime subject was sky-filled, low landscapes of simplified forms, restricted color range, and a firm drawing style whose linearity often transformed branches into tracery patterns. The synthetic tendency of his work later became more obviously decorative.

BIBLIOGRAPHY. J. Walravens, *Valérius de Saedeleer*, Antwerp, 1949

SAENREDAM, JAN PIETERSZ. Dutch engraver and print publisher (b. Saerdam, 1565; d. Assendelft, 1607). A pupil of Jacob de Gheyn II and of Hendrik Goltzius, he was particularly drawn to the drawing and engraving style of the latter. The most adept of Goltzius's pupils, he frequently equals his master in elegance of line and engraving skill. His control of the burin enabled him to create shimmering blacks and gleaming whites. Half of his entire *oeuvre* is after the designs of his former master. Other artists after whom he made the most numerous prints are Abraham Bloemaert, Polidoro da Caravaggio, Veronese, Lucas van Leyden, and Karel van Mander. Events in the Lowlands and historical allegories are the main subjects of engravings after his own designs.

SAENREDAM, PIETER JANSZ. Dutch painter of architectural subjects (b. Assendelft, 1597; d. Haarlem, 1665). He was the son of the engraver Jan Pietersz. Saenredam. As a child he was taken to Haarlem, where in 1612 he entered the studio of Frans Pieter de Grebber. He remained with De Grebber until about 1623, when he entered the Haarlem Guild of St. Luke. He traveled widely in the Netherlands and was active in The Hague (1625), 's Hertogenbosch (1632), Assendelft (1633), Alkmaar (1634/35), Utrecht (1636), and Amsterdam (1641). He seems to have known the best architects of his day, and had contact with Jacob van Campen, Salomon de Braij, and Bartholomeus van Bassen.

Saenredam is one of the first painters to faithfully record buildings in works of art. This is especially true of his drawings. His first dated work (1617) is a sheet of drawings with four sketches (Berlin, former State Museums, Print Gallery). His earliest known painting is much later (*Interior of St. Bavo, Haarlem, from the Northern Transept*, 1628; Oosterbeek, J. C. H. Heldring Collection). Among his best-known paintings are *The Old Town Hall of Amsterdam* (1657) and the *Interior of the Church of St. Bavo at Haarlem* (1636; both Amsterdam, Rijksmuseum).

BIBLIOGRAPHY. P. T. A. Swillens, *Pieter Janszoon Saenredam*, Amsterdam, 1935; N. Maclaren, *National Gallery Catalogues: The Dutch School*, London, 1960; Centraal Museum, *Pieter Jansz. Saenredam*, Utrecht, 1961.

LEONARD J. SLATKES

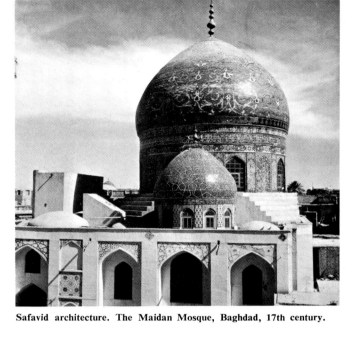

Safavid architecture. The Maidan Mosque, Baghdad, 17th century.

SAFAVID ARCHITECTURE. The Safavid dynasty ruled Iran from 1502 until well into the 18th century. During the 17th century, particularly in the reign of Shah Abbas (1587–1628), the country was a major military power, enjoyed economic prosperity, and devoted important sums to public works and monumental structures. From the preceding Timurid period the Safavid architects took over monumental plan types, continued to use baked brick as the major construction material, and refined the technique of faïence mosaic decoration. Safavid style featured surpassing elegance rather than technical innovation.

The capital of the dynasty after 1514 was Qazvin, but, as the result of later earthquakes, little remains of a mosque and palace built there by Shah Tahmasp (r. 1524–76). It was not until Shah Abbas transferred the capital to Isfahan in 1598 that the high period of Safavid architecture began. Shah Abbas ordered the construction of an imperial city in the area between the old town and the Zayandeh River. Between the spacious Chahar Bagh avenue, which led north from the river, and the Maidan-i-Shah, some hundreds of yards east, lay a vast wooded area in which royal living quarters, garden pavilions, and administrative structures were erected. Access to this area from the Maidan-i-Shah was through the 'Ali Qapu, a lofty multistoried building used for royal audiences. At the southern end of the square rose the Masjid-i-Shah, on its eastern side the Lutfullah Mosque was constructed, and on the north a monumental entrance to the covered bazaars appeared. Two magnificent bridges spanned the river. *See* ISFAHAN, ARCHITECTURE OF.

These structures and others, painstakingly repaired in recent years, survive in excellent condition and offer a comprehensive picture of Safavid architecture at its finest. Shah Abbas ordered the embellishment of the shrine of Imam Riza in Meshed, and his successors were responsible for notable buildings in Isfahan and other important towns. *See* IMAM RIZA, MESHED.

Great domes on high drums characterized the major religious structures, and domes and all other exterior and interior surfaces were coated with faïence in which a general blue tonality was livened by green, white, brown, and black. The technique of faïence mosaic, in which thousands of small pieces were fitted together to make a single panel, was so time-consuming and costly that in later Safavid monuments it gave way to that of *haft rangi*, or seven colors, in which the multicolored patterns were fired on square tiles. Religious inscriptions were an important feature of design and decoration, and the leading calligraphers of the period wrote these inscriptions.

BIBLIOGRAPHY. A. Godard, "Isfahan," *Athār-é Irān*, II, 1937; A. U. Pope, ed., *A Survey of Persian Art*, vol. 2, London, 1939.

DONALD N. WILBER

SAFAVID METALWORK, PAINTING, POTTERY AND TILES, RUGS, TEXTILES, *see* Safavid period under ISLAMIC METALWORK; ISLAMIC PAINTING; ISLAMIC POTTERY AND TILES; ISLAMIC TEXTILES; RUGS, NEAR AND MIDDLE EASTERN.

SAFDAR JANG, MAUSOLEUM OF, DELHI. Indian tomb located about 5 miles south of Delhi. Erected in 1753 by Ahmad Shah after the death of his prime minister, Safdar Jang, it is the last great monument of the Mughal period. Traditional in form, the square mass features four corner minarets and a huge bulbous dome. In comparison with earlier Mughal tombs, the proportions are attenuated and the ornamentation is more varied in scale and in the use of contrasting materials.

BIBLIOGRAPHY. R. C. Arora, *Delhi: The Imperial City*, New Delhi, 1953.

SAFTLEVEN, CORNELIS. Dutch painter of genre and history (b. Gorinchem, 1607/08; d. Rotterdam, 1681). He must have been brought to Rotterdam as a child, for his brother was born in that city in 1609. Cornelis received his earliest training from his father, Herman Hermansz. Saftleven the Elder. Cornelis was in Antwerp for a short time, probably between 1627 and 1632. In 1667 he was dean of the Guild of St. Luke in Rotterdam.

While in Antwerp he seems to have had close contact with the circle of Peter Paul Rubens. Eight of Saftleven's pictures were listed in the inventory of Rubens's effects, and in four of these Rubens himself had painted the figures. Saftleven's portrait was painted by Anthony van Dyck. In Antwerp he was also influenced by the works of Adriaen Brouwer and David Teniers (*Satire*, 1629; Rotterdam, Boymans-Van Beuningen Museum). He was influenced occasionally by the works of Aelbert Cuijp and Egbert van der Poel. His brothers Herman Hermansz. Saftleven the Younger and Abraham were also painters, and Herman may have studied with Cornelis.

BIBLIOGRAPHY. W. Martin, *De Hollandsche schilderkunst in de zeventiende eeuw*, vol. 2, Amsterdam, 1936.

LEONARD J. SLATKES

SAFTLEVEN, HERMAN HERMANSZ., THE YOUNGER. Dutch painter of landscapes, cityscapes, and history; also graphic artist (b. Rotterdam, 1609; d. Utrecht, 1658). He was a pupil of his father, Herman Hermansz. Saftleven the Elder, and possibly of his brother Cornelis. By 1633 Herman settled in Utrecht where he remained, except for a journey through the Rhineland, for the rest of his life.

In 1635 he painted one of four scenes based on Guarini's *Pastor Fido* for the palace at Honselaersdijk (Berlin, former State Museums). The series was probably commissioned by the stadtholder Frederik Hendrik.

In his early landscapes Saftleven shows the influence of the works of Jan van Goijen and Pieter Molijn. However, in the 1640s this is replaced by influences from Flanders. He was also influenced by the work of Cornelis van Poelenburgh. Among Saftleven's late landscapes are a number that show the impact of the Rhineland landscape upon his style (*Landscape near Boppard*, 1663; Amsterdam, Rijksmuseum). Willem Bemmel was his pupil.

BIBLIOGRAPHY. N. Maclaren, *National Gallery Catalogues: The Dutch School*, London, 1960; W. Stechow, *Dutch Landscape Painting of the Seventeenth Century*, London, 1966.

SAGRARIO METROPOLITANO, MEXICO CITY. Building located at the southeast corner of the Cathedral of Mexico in Mexico City, serving in various ecclesiastical capacities, but essentially as a center of parish activities of the Cathedral area and as the repository of the consecrated Host. The building was begun in 1749–50, with Lorenzo Rodríguez (1704–74) as architect. The façades were largely finished by 1759, and the building was dedicated in 1768. A fire in 1776 and a more serious one in 1796 damaged the interior. The surviving interior work was redone in the neoclassic style. The Sagrario (145 by 156 ft.; 132 ft. high) is the most characteristic example of Rodríguez's mature style: Mexican materials (reddish volcanic stone and grey-white limestone), the Mexican enthusiasm for richly decorated wall façades, and a mixed ornamental vocabulary of southern Spanish origins but with Mexican interpretation. Extremely influential in its period, it created a vogue for *estípites* (mannerist columns or pilasters) and a complex Renaissance, mannerist, baroque, and Mudéjar ornamental language for Mexican façades and retables. *See* RODRIGUEZ, LORENZO.

BIBLIOGRAPHY. M. Alvárez Cortona and A. le Duc, "Sagrario de México," *Archivo Español de Arte y Arqueología*, XI, January, 1935; J. A. Baird, Jr., *The Churches of Mexico, 1530–1810*, Berkeley, 1962.

JOSEPH A. BAIRD, JR.

SAGRERA, GUILLEM (Guillen; Guillermo). Spanish architect and sculptor (d. 1456). Born in Palma de Mallorca of a family of stone cutters, Sagrera is documented as directing the work at Perpignan Cathedral, as intervening in 1416 at Gerona Cathedral, and as being in charge in 1420 of Palma Cathedral. Six years later he contracted to design and build La Lonja in Palma. Called to Naples by Alfonso VI in 1446, he built the main hall of the Castel Nuovo and designed an entire village, Cordídola. *See* PALMA DE MALLORCA: LA LONJA.

As a sculptor he executed works for La Lonja and the Cathedral of Palma, including *St. Peter* and *St. Paul* (1422) for the Puerta del Mirador of the Cathedral. These large, standing jamb figures, which show a relationship to the art of Claus Sluter, are the first works of sculpture to introduce the Burgundian style into the Levant. Sagrera accomplished this with originality, lightening and refining the models with a more simplified plasticity that is appropriate within the framework of his sober architecture.

BIBLIOGRAPHY. E. Bertaux, "La Peinture et la sculpture espagnoles au XIVe et au XVe siècles jusqu'au temps des Rois Catholiques," in A. Michel, *Histoire de l'art*, vol. 3, pt. 2, Paris, 1908; F. Jiménez-Placer, *Historia del arte español*, vol. 1, Barcelona, 1955.

SAHN. In Muslim architecture, the courtyard of a mosque.

SAHURE, PYRAMID AND TEMPLE OF, *see* ABUSIR.

SAIHOJI GARDEN, KYOTO. Japanese garden, more popularly known as the Kokedera Garden (Garden of the Moss Temple), as the grounds are almost completely covered by a variety of mosses. The Saihōji was founded in the Nara period (710–784) and was converted into a Zen monastery by Musō Soseki (1275–1351). A large pond, in the shape of the Chinese character for "heart," serves as the garden's focal point. Originally, four buildings stood in the garden, but now only one small tea ceremony house, the Shōnantei, remains.

BIBLIOGRAPHY. Tokyo National Museum, *Pageant of Japanese Art*, vol. 6: *Architecture and Gardens*, Tokyo, 1952; S. Horiguchi and Y. Kojiro, *Architectural Beauty in Japan*, 2d ed., Tokyo, 1957.

SAILLY, JACQUES-FRANCOIS-JOSEPH, *see* SALY, JACQUES-FRANCOIS-JOSEPH.

ST. ALBAN, LIFE OF. Thirteenth-century Gothic illuminated manuscript, in Trinity College Library, Dublin. *See* MATTHEW PARIS.

ST. ALBANS. City in Hertfordshire, southern England. It stands on the site of Verulamium, the only Romano-British city to become a municipium. Excavations have revealed remains of the forum, basilica, and theater, as well as two monumental gateways. The Verulamium Museum handsomely displays the finds. The abbey, established in the 8th century, ranked as an important center of intellectual life throughout the Middle Ages. Under Paul of Caen the severe Norman portions of the abbey (now cathedral) church were erected (1077–88). In the Gothic period the nave was enlarged and the west front was finished. The monastic scriptorium flourished especially in the 12th century, when the great St. Albans Psalter (Hildesheim, St. Godehard) was produced. *See* ST. ALBANS CATHEDRAL.

BIBLIOGRAPHY. O. Pächt et al., *The St. Albans Psalter*, London, 1960; N. Pevsner, *The Buildings of England*, vol. 7, Harmondsworth, 1953.

ST. ALBANS CATHEDRAL. English church with an architectural history of unbalanced building periods. The Romanesque structure (1077–88) was exceptionally grand for its period. The crossing produces a mighty effect, peculiarized by the use of Roman bricks and tiles. The nave was lengthened and the west front completed by about 1230. In 1323 half of one side of the Norman nave was rebuilt in Early English style. Parts east of the crossing were rebuilt about 1257, and the Lady Chapel was completed by 1320. The rood screen, or pulpitum, is of the 14th century. The Cathedral is unique in possessing an almost entirely Victorian west front, the result of rebuilding by Lord Grimsthorpe in 1879.

BIBLIOGRAPHY. N. Pevsner, *The Buildings of England*, vol. 7, Harmondsworth, 1953.

SAINT-AMAND-LES-EAUX: ABBEY CHURCH. Church in northern France. The monastery and church were established in the 7th century but achieved their final form in the 17th century, with the vast building program of the abbot Nicolas Du Bois. Little remains but the west façade, which rises to 269 feet, including its two towers and dome. There is an anomaly in the close relationship the heavily encrusted surface and profusion of classical elements seem to have with Spanish baroque architecture. The willful Du Bois may have been responsible for the fancifulness of the design and decoration.

BIBLIOGRAPHY. B. Bevan, "Spanish Baroque in Northern France," *Apollo*, V, Feb., 1927.

ST. ANNE PORTAL. Gothic stone sculpture, in the Cathedral of Notre-Dame, Paris.

SAINT-AUBIN, AUGUSTIN DE. French engraver (b. Paris, 1736; d. there, 1807). He was a pupil of Etienne Fessard and Laurent Cars. A prolific and accomplished engraver (he produced more than 1,300 prints), Saint-Aubin is best known for his portraits after Cochin and others. The portraits of a pair of lovers entitled *Au Moins soyez discret* and *Comptez sur mes serments*, after Gabriel de Saint-Aubin, are especially noteworthy. His two brothers were also artists: Charles Germain de Saint-Aubin (1721–86), an engraver whose best-known work is a surrealistic series entitled *Curieux essais de papillonneries humaines*; and Gabriel de Saint-Aubin (1724–80), a prolific draftsman who produced, however, only a few painterly etchings, such as *L'Académie particulière*, which are much prized.

BIBLIOGRAPHY. E. Bocher, *Les Gravures françaises du XVIIIᵉ siècle*, vol. 1, Paris, 1875; E. Dacier, *L'Oeuvre gravé de Gabriel de Saint-Aubin*, Paris, 1914.

SAINT-AUBIN, ABBEY OF, ANGERS. Former Benedictine abbey in France, two important parts of which are still in existence: the cloister and the bell tower. The prefecture of the city contains several parts of the former cloister, the most important being an arcade whose arches originally opened into the chapter house and sacristy. These exceptionally wide arcades, built in 1122–24 when Robert de la Tour-Landrie was abbot, contain important fragments of Angevin Romanesque sculpture (mid-12th cent.) in voussoirs, tympanums, and capitals, as well as an extraordinary example of a painted double arcade (early 13th cent.). Of special interest are the tympanum with David and Goliath and one with the Madonna and Child in a mandorla upheld by angels. The painted double arcade contains the Adoration of the Magi and Massacre of the Innocents. The bell tower, at a slight distance from the cloister arcades, is a massive square tower (ca. 120 ft. high) with a solid, heavily buttressed lower half. The upper half consists of a lower portion with two windows on each side and an upper portion with one window on each side and octagonal towers at the four corners.

The abbey was an extremely important center of manuscript illumination in the late 11th and the 12th century. Some of the most important manuscripts, executed by a certain Fulque between 1082 and 1108, are now in the Municipal Library at Angers.

BIBLIOGRAPHY. E. W. Anthony, *Romanesque Frescoes*, Princeton, 1951; *Anjou Roman*, text by P. d'Herbecourt and J. Porcher [La-Pierre-qui-Vire (Yonne)], 1959; P. Deschamps and M. Thibout, *La Peinture murale en France au début de l'époque gothique, de Philippe Auguste à la fin du règne de Charles V (1180–1380)*, Paris, 1963.

EDWARD P. LAWSON

ST. BARLAAM MONASTERY, METEORA. One of the monasteries built on high, pillar-like rocks in the region of

St. Basil's Cathedral, Moscow. A 16th-century central-plan church.

the Meteora in Greece. Founded in the 14th century, it has a chapel in the rock containing paintings with episodes from the legend of St. Ephraim.

BIBLIOGRAPHY. J. A. Hamilton, *Byzantine Architecture and Decoration*, 2d ed., London, 1956.

ST. BASIL'S CATHEDRAL, MOSCOW.

Russian Cathedral dominating the narrow southern side of Red Square. Commissioned by Ivan IV as a national votive church commemorating his conquests of the Khanates of Kazan and Astrakhan, it was originally dedicated to the protection and intercession of the Virgin. Built by the Russian architects Postnik and Barma between 1555 and 1560, the Cathedral is centrally planned around a high octagonal tower, which stands on a platform concealed externally by the forest of towers over the four large octagonal chapels on the main axes and the four smaller polygonal ones between them. The central tower, the onion-shaped cupolas of the smaller towers, and the polychromatic decoration of the exterior were completed in the 17th century. St. Basil's is important in two respects: it is the culmination of the Russian tradition of 16th-century centralized churches and, in its richness and variety of plastic expression, it is the most sculptural work of Russian architecture.

BIBLIOGRAPHY. G. H. Hamilton, *The Art and Architecture of Russia*, Baltimore, 1954.

ST. BAVO, HAARLEM.

Excellent example of the Dutch late Gothic style, similar to, yet less extravagant than, the churches of Belgium. The spacious three-aisled basilica was constructed mostly in brick. The nave was begun about 1400 and finished in 1445 by Godevaert de Boscher and Steven van Afflighem. The choir was completed in 1483. Supported on twenty-eight heavy columns of brick and flooded with light, the long nave and choir are covered with intricate lierne vaults in cedar. The handsome lantern tower with openwork top was finished in 1519.

BIBLIOGRAPHY. A. Melchior, *De Haarlemsche Sint Bavo of Groote Kerk*, Haarlem, 1946.

ST. BAVON, GHENT.

Cathedral in East Flanders, Belgium. The present structure was superposed on an earlier one, whose 11th-century crypt, embellished with mural paintings in the 15th century, is now the Cathedral Treasury. The Gothic choir was built in the 13th century and the nave, transept, and tower in the late 15th and the early 16th century. The vaulting of the nave dates from the 16th and 17th centuries.

St. Bavon houses the great *Ghent Altarpiece*, whose frame is inscribed with the names of Hubert and Jan van Eyck and dated 1432. After many vicissitudes the panels were reassembled in 1920. One of the panels, *The Just Judges*, stolen in 1934, has never been recovered. Other paintings of note in St. Bavon include *The Crucifixion* by Justus of Ghent; *Christ among the Doctors* by Pourbus; and Rubens's *Conversion of St. Bavon*.

BIBLIOGRAPHY. P. Bergmans, *Les Ruines de l'abbaye Saint-Bavon à Gand*, Ghent, 1913; M. Laurent, *L'Architecture et la sculpture en Belgique*, Paris, 1928; L. van Puyvelde, *Van Eyck, the Holy Lamb*, Paris, 1947.

SAINT-BENIGNE, DIJON.

French abbey church founded in pre-Carolingian times. Under William of Volpiano and the Cluny reform movement an impressive new church was built (1001–18). An entirely vaulted five-aisled basilica, it had an east end in rotunda form, so that the whole (with the exception of the nine towers) was reminiscent of the Constantinian Church of the Holy Sepulchre, Jerusalem. Of this church only the crypt remains (rebuilt 19th cent.); the rest was rebuilt in the Burgundian Gothic style (1281–1325).

SAINT-BENOIT-SUR-LOIRE (Abbey of Fleury).

Benedictine Abbey in France, founded about 620. Relics thought to be those of St. Benedict (St-Benoît) were transferred to Fleury from Montecassino in the late 7th century. Soon pilgrimages to the shrine of St. Benedict began, and despite the ravaging of the monastery by the Huguenots under Condé in 1562, the relics are still venerated there. In 1004 Gauzelin, illegitimate son of Hugh Capet, became abbot, and a long history of growth and prosperity began. Between about 1071 and 1130 the present magnificent church, still almost intact in its original state, was erected. There is particularly interesting sculpture on the blind triforium arcade, as well as on the capitals of the engaged columns of the clerestory. There is also especially fine 12th-century carving on the tower porch. Nothing remains of the early monastic buildings.

BIBLIOGRAPHY. K. J. Conant, *Carolingian and Romanesque Architecture, 800–1200*, Baltimore, 1959.

ST. BRIDE'S FLEET STREET, LONDON.

One of Sir Christopher Wren's major city churches (1670–84). The interior is of a fine basilical plan with a nave divided into five bays by giant Tuscan columns and two lower aisles. The nave has circular windows and the clerestory has oval ones. The steeple was added in 1702–03, and is famed as the highest of Wren's spires. Its four diminishing octagonal *tempietti* crowned by an obelisk are related to similar schemes proposed by Wren for St. Paul's and St. Magnus's, and are probably derived from early reconstructions of

the Tower of the Winds as described by Vitruvius. Beneath the church, toward the altar, is a 15th-century bone hole, which is entered from the outside.

BIBLIOGRAPHY. N. Pevsner, *London*, vol. 1: *The Cities of London and Westminster*, Harmondsworth, 1957; J. N. Summerson, *Architecture in Britain, 1530–1830*, 4th rev. ed., Baltimore, 1963.

SAINT-BRIEUC CATHEDRAL. French church, constructed initially from about 1170 to 1248. It has been restored numerous times, especially in the 14th and 15th centuries after a fire and several sieges had ravaged the early building and in the 18th century when the nave was completely rebuilt. In the present building only parts of the northwest tower and south transept are of the earlier date. The exterior today has a fortresslike aspect with its heavy unornamented west towers and immense, typically Breton roof over the transept. The most interesting parts of the interior are the choir and polygonal *chevet* (late 14th cent.) and the Chapel of the Annunciation (late 15th cent.), which has vaulting ribs that merge with wall and column without the employment of capitals.

BIBLIOGRAPHY. R. Couffon, "Cathédrale de Saint-Brieuc," *Congrès Archéologique de France, CVIIᵉ Session, Saint-Brieuc*, Paris, 1950.

ST. CECILIA MASTER, *see* MASTER OF THE ST. CECILIA ALTARPIECE.

SAINT-CLOUD PORCELAIN. Products of a French ceramic factory of importance from before 1678 until 1766. Pierre Chicaneau is credited with introducing a porcelain body there, and this was improved by his successors. Characteristically a warm, yellowish body with a soft glassy look, the typical forms follow Rouen faïence models, silver, or more delicate small Oriental shapes.

BIBLIOGRAPHY. W. B. Honey, *French Porcelain of the Eighteenth Century*, London, 1950.

ST. DAVIDS CATHEDRAL. Welsh church, whose transitional Norman nave was built from 1180. The presbytery is also of this date. The Lady Chapel to the east was added early in the 13th century. The late-15th-century nave roof is a remarkable example of timber construction.

BIBLIOGRAPHY. G. H. Cook, *The English Cathedral through the Centuries*, London, 1957.

ST. DEMETRIUS, THESSALONIKA, *see* HAGIOS DIMITRIOS, THESSALONIKA.

SAINT-DENIS, ABBEY OF. Formerly a royal abbey, 7 miles from Paris. About 630 the Merovingian king Dagobert I founded an abbey and built a church on the site of an earlier sanctuary (ca. 475). Dagobert's church was of considerable magnificence, enriched by the hand of the King's sculptor and goldsmith St. Eloy. This church was replaced by a new one, begun about 754 and consecrated in 775. About 1091 the young Suger entered the abbey. Years later, when he had become abbot, statesman, and historian as well as friend and adviser to both Louis VI and VII, he began planning a new church. Between 1137 and 1144 workmen from all over France created Suger's new "ideal," executing the west façade and narthex and the east end with its double ambulatory. It is said that Suger himself superintended everything, even to the quarrying of the stone and the selection of wood beams. In the east end particularly, with its light, slender forms and

extensive use of stained glass, the transcendental quality of Gothic architecture is first expressed.

In the full glory of the Gothic ideal, the Carolingian nave that had been retained by Suger was completely rebuilt (1231–39) during the reign of Louis IX by Pierre de Montreuil. He introduced the open nave arcades, the glazed triforium, and the vast expanse of clerestory windows and also reconstructed the upper portions of Suger's east end to make it conform with the nave.

Despite restorations, the beauty of much of the 12th-century sculpture of the west doors is still apparent. Characteristically, the central door deals with the Last Judgment and the south door relates the story of the martyrdom of St. Denis and his two companions. The archivolts are unusually fine. Most of the stained-glass windows were destroyed during the French Revolution, but the Chapel of the Virgin windows (ca. 1150) were spared.

Aside from its significance as a great abbey, St-Denis is a repository of royal tombs. During the Revolution all the tombs and royal crypts were opened; in the 1860s Viollet-le-Duc rearranged the tombs according to their original plan. Many tombs from various destroyed churches and abbeys were assembled at St-Denis at that time.

The plaque of Frédégonde, originally from St-Germain-des-Prés, dates from the 11th or 12th century. It is a handsome marble mosaic outlined by strips of gilded copper, and suggests Oriental influences. The 12th-century tomb of Clovis was brought to St-Denis from the destroyed Abbey of Ste-Geneviève. Childebert's tomb, from St-Germain-des-Prés, shows a masterly precision both in the modeling of the figure and in the beauty of the treatment of the drapery. Nearby is an unusually fine 12th-century polychrome wood sculpture of the Madonna and Child, brought from St-Martin-des-Champs.

Dating from the 13th century is the beautiful tomb of Dagobert. The recumbent figure of Dagobert lies beneath an arched and peaked canopy. The scenes behind the figure relate the vision of John the Hermit that occurred to Dagobert on the day of his death. Also from the 13th century are the lovely embossed and enameled copper tomb slabs of Blanche and Jean, children of St. Louis.

Among the most interesting 14th-century tombs are the one with the recumbent figures of Louis, count of Evreux, and Marguerite d'Artois and that of France's great champion against the English, Bertrand du Guesclin.

The tomb of the dukes of Orléans was executed (1502–15) in Genoa by Italian sculptors. The portrait statues of Charles, his brother Philippe, and his grandparents Louis and Valentine de Milan are of especial elegance. The porcupine at the feet of Charles recalls the order that he founded; the porcupine was adopted as a symbol by his son Louis.

The magnificent tomb of Louis XII and Anne de Bretagne (1516–31) was executed at Tours by Antonio and Giovanni Giusti. It is built in the form of an open temple. The King and Queen are represented twice: above, as kneeling figures on the roof; below, as nude figures in all the tragic realism of death. Rich ornamentation and scenes from Louis' Italian campaigns further enhance the architectural setting.

The tomb of Francis I and Claude de France was designed by the architect Philibert de L'Orme and begun in

Ste-Chapelle, Paris. A jewel of French Gothic architecture, famous for its 13th-century stained glass.

1547, with sculptures by Pierre Bontemps and others. This tomb is very similar to that of Louis XII, but it is even more sumptuous. The nude figures are depicted with greater nobility and tenderness than in the earlier work. Nearby is the remarkable Renaissance urn for the heart of Francis I by Bontemps (1550).

The richest of all the tombs is that of Henry II and Catherine de Médicis (1563–70), designed by Primaticcio and with sculpture by Germain Pilon. Here the same general plan, on an even grander scale, is used. The nude figures are treated as if asleep rather than as in death. Originally intended for the Chapel of the Valois, it was placed in the north transept in 1719 when the chapel was destroyed.

See also SAINT-DENIS STYLE.

BIBLIOGRAPHY. S. Crosby, *L'Abbaye royale de Saint-Denis*, Paris, 1953. ALDEN F. MEGREW

SAINT-DENIS STYLE. Style used in a group of illuminated manuscripts of the latter half of the 9th century, associated with the emperor Charles the Bald. Since he was lay abbot of St-Denis, it is thought that this monastic scriptorium produced the lavishly illuminated manuscripts associated with his name.

The characteristics of this style, as seen in such manuscripts as the Psalter of Charles the Bald, the Coronation Sacramentary (both Paris, National Library), and the Codex Aureus of St. Emmeram (Munich, Bavarian State Library), are an almost excessive use of gold, acanthus leaf, and simulated jeweled borders; a florid, abundant use of foliate forms; and a linear outlining of figural representations. The St-Denis style has many features in common with that of the Reims school, especially in initials and figures.

See also CORBIE SCHOOL.

ST. DMITRI, VLADIMIR, *see* VLADIMIR: CATHEDRAL OF ST. DMITRI.

SAINTE-CHAPELLE, PARIS. Medieval French chapel. A jewel of French Gothic architecture (1246–48), Ste-Chapelle was constructed in the courtyard of the royal palace (now the Palace of Justice) by St. Louis to provide a worthy setting for the Sacred Crown of Thorns and a piece of the True Cross. Defaced in the 17th and 18th centuries, it was restored in the 19th century to an approximation of its original state.

Small and handsomely proportioned, the building comprises two stories. The lower floor, originally the chapel of the palace servants, which was dedicated to the Virgin, has two narrow side aisles with flying buttresses to support the pillars of the low-sprung central vault. The windows are modern. Winding staircases in the two turrets lead to the upper story.

The single-naved royal chapel on the upper floor was dedicated to the Holy Crown and Holy Cross. Only the slender columns that support the ribs of the vault interrupt the expanse of the famous 13th-century stained-glass windows that flood the interior with light and color. More subdued in color is the 15th-century rose window that pierces the square of wall above the two-story porch of the façade.

Along the walls under the windows is a blind arcade, enriched by pillars with varied foliate capitals and quatrefoils of colored glass. Against the major pillars, in elaborate Gothic tabernacles, stand statues of the apostles (mostly restored), each bearing a cross of consecration. The sculptures, like the walls, glow with the colors of glass incrustations, gold, and painted patterns. Behind the altar rises the tribune designed to display the shrine of the holy relics, now lost.

From the outside, too, Ste-Chapelle is distinguished by its look of exquisite lightness. Only slender buttresses separate the soaring windows above the sturdy foundation provided by the lower chapel. All the sculptures of the great porch are modern. The spire and crest of the roof, the only parts visible from any distance above the surrounding walls, are modern reconstructions in 15th-century style.

BIBLIOGRAPHY. F. Gebelin, *La Sainte-Chapelle et la Conciergerie*, Paris, 1931; J. D. Spencer, "Les Vitraux de la Sainte-Chapelle de Paris," *Bulletin Monumental*, XCI, 1932.
 MADLYN KAHR

SAINTE-CLOTILDE, PARIS. Church in Paris begun by Gau in 1846 and completed by Ballu in 1856. It is modeled on the 14th-century Church of St-Ouen in Rouen.

STE. FOY, RELIQUARY OF. Gold and jeweled Romanesque sculpture (late 10th cent.), in the Treasury of Ste-Foy in Conques, France.

SAINTE-MARIE-DES-DAMES, SAINTES. French Romanesque abbey church, consecrated in 1047. The façade (ca. 1150) is extraordinarily rich in sculptural ornamentation. The west front is divided into three sections vertically as well as horizontally, with clustered piers at the corners, and is reminiscent of Poitou. The two lower stories consist of three arcades each, in which the center arches are widest. As is characteristic of the Saintonge area, the voussoirs of the main door are superbly carved, not only on the faces of each stone but equally splendidly on the undersides. The nave is vaulted by a series of domes on pendentives in the manner of the Aquitainian churches. The tower over the crossing closely imitates that of Notre-Dame-la-Grande at Poitiers.

BIBLIOGRAPHY. M. Aubert et al., *L'Art monumental roman en France*, Paris, 1955.

SAINTE-RADEGONDE, POITIERS. French church originally founded in the 6th century. It was first known as St. Mary outside the Walls. Later it was renamed Ste-Radegonde in honor of the illustrious Thuringian princess who founded an abbey there. Her tomb in the crypt is venerated today. The church was burned in 1083 but reconsecrated in 1099. Most of the present structure dates from the 12th century; the upper levels of the octagonal bell tower are particularly handsome. The main entrance beneath the bell tower dates from the 15th century. The nave is covered by Gothic vaulting of the 13th century. There are especially fine sculptured Romanesque capitals around the ambulatory, which have been rather unfortunately repainted. The sacristy is noteworthy for its peculiar Angevin Gothic vault system supporting a cupolalike structure.

BIBLIOGRAPHY. R. Crozet, *Poitiers* (La France illustrée), Paris, 1948.

SAINTES, FRANCE, *see* SAINTE-MARIE-DES-DAMES, SAINTES; SAINT-EUTROPE, SAINTES.

SAINT-ETIENNE, CHURCH OF, *see* ABBAYE-AUX-HOMMES, CAEN; BEAUVAIS; NEVERS: SAINT-ETIENNE; PERIGUEUX.

SAINT-ETIENNE-DU-MONT, PARIS, *see* BIARD, PIERRE, THE ELDER.

SAINT-EUSTACHE, PARIS. French church built between 1532 and 1637, principally to the designs of Pierre Lemercier. St-Eustache shows in its ornamentation the influence of the northern Italian Renaissance, but the plan and structure adhere to the Gothic tradition. The façade was completed in the 18th century and is classical. During the French Revolution St-Eustache had a brief career as the Temple of Agriculture.

SAINT-EUTROPE, SAINTES. French Romanesque church of a Cluniac priory, originally built between 1081 and 1096. It has been much renovated, but the unusual crypt beneath the sanctuary is preserved in its original form. The crypt consists of a nave, aisles, an apse, an ambulatory, and radiating chapels, covered by groined vaulting with massive transverse ribs dividing the bays. Fine figure sculptures decorate many of the capitals.

ST. FIRMIN, FIGURE OF. Gothic stone sculpture, in the Cathedral of Amiens, France.

ST. FRANCIS OF ASSISI, CHURCH OF, ASSISI. Italian church; the first Franciscan church. It was built (1228–53), as a shrine for the body of St. Francis (d. 1226). Its hill site divides it into an upper and a lower church; because it was built on the southwestern slope, it has a reversed orientation—its façade is at the east end. A vast monastery adjoins the church on the west and south.

The lower church has two transepts connected by a nave and by aisles that are divided into rectangular chapels. Each transept has three bays and is terminated by a polygonal chapel. The eastern transept is actually a narthex, and its south end contains the main portal. The nave has three square bays: The nave arcade consists of very low, round arches borne by huge, round piers. Similar arches separate the bays of the nave. The nave bays and the crossing are roofed by slightly domed cross vaults hung upon square ribs. The transept ends are roofed by barrel vaults, the eastern transept bays by sexpartite vaulting, and the round apse by a half dome. Though the lower church is dark, it is impressive because of the frescoes by Cimabue, Pietro Lorenzetti, and Simone Martini that completely cover the walls and vaults. *See* CIMABUE; LORENZETTI, PIETRO; SIMONE MARTINI.

The upper church is much lighter and airier, and shows strong Gothic influence. It is a Latin cross in plan and has a three-bay transept. The nave is without aisles and contains four square bays. Its walls are supported by the massive nave arcade beneath. All arches and vaults are highly pointed. A tall, narrow window of stained glass, divided by a mullion, is centered in each of the nave arches, as well as in each of the three faces of the apse. These windows are doubled in the transept. A very narrow gallery lies directly under the windows and cuts through the deep wall arches to run uninterruptedly around the church. A polygonal apse stands over the round apse of the lower church. Though structurally plain, the upper church interior is made sumptuous by the wall paintings of Giotto and Cimabue. *See* GIOTTO DI BONDONE.

The façade is unrelated to the interior. It features a gable far higher than the roof, a double pointed and cusped doorway under an enclosing pointed arch, a rose window above it, and a smaller circle in the gable. The sides exhibit half-round wall buttresses and flying buttresses from these to the outer wall of the lower church. Also, half-round buttresses flank the apse. A broad, square, typically Lombard campanile fills the corner between the nave and the south transept.

BIBLIOGRAPHY. I. B. Supino, *La Basilica di S. Francesco d'Assisi*, Bologna, 1924; C. A. Cummings, *A History of Architecture in Italy . . .*, rev. ed., vol. 2, Boston, New York, 1927; B. Kleinschmidt, *Die Basilika S. Francesco in Assisi*, vol. 3, Berlin, 1928.
LEON JACOBSON

ST. FRANCIS PREACHING TO THE BIRDS. Fresco painting by Giotto, in the Church of St. Francis, Assisi. *See* GIOTTO DI BONDONE.

SAINT-FRONT CATHEDRAL, PERIGUEUX, *see* PERIGUEUX.

SAINT-GABRIEL, CHURCH OF. Tiny French Romanesque church of the mid-12th century, located about 8 miles north of Arles, near the Rhone River. Built as a chapel for the masons' guild, St-Gabriel exemplifies the many stylistic motifs available to Romanesque masons. Each portal is designed differently, combinations and variations of columnar supports are seen, and there are adaptations of classical motifs, all incorporated in a single building.

ST. GALL (Sankt Gallen): ART MUSEUM. Swiss museum housed with the Natural History Collection in the Altes Museum, a building of 1877. It consists of the Sturzenegger painting collection, given to the museum in 1925, and collections of the municipality and the Kunstverein St. Gallen.

Most of the paintings date from the 19th and 20th centuries. These include works from the Appenzell region and other parts of Switzerland as well as from France and Germany. Some of the artists represented are Courbet, Corot, Monet, Pissarro, Sisley, Graff, Waldmüller, Spitzweg, Feuerbach, Liebermann, Corinth, Kirchner, Böcklin, Hodler and Klee.

BIBLIOGRAPHY. U. Diem, *Kunstmuseum St. Gallen, Verzeichnis der Gemälde und Bildwerke*, St. Gall, 1935; W. Hugelshofer, *Katalog der Sturzeneggerschen Gemäldesammlung der Stadt St. Gallen*, St. Gall, 1937.

ST. GALL (Sankt Gallen): COLLEGIATE CHURCH. Rococo Swiss cathedral. The plans of G. G. Bagnato (1750) for the elevation of the new collegiate church were changed by Peter Thumb in 1755 to eliminate galleries in favor of a monumental clerestory. The church was begun in 1756, the nave was consecrated in 1760, and the double tower façade was completed by J. M. and F. Beer in 1796. The wide nave and the unification of space achieved by the use of an oval transept makes this cathedral the most elegant rococo structure in Switzerland. J. A. Feuchtmayr's sculptures on the east façade (1763–64; now replaced by copies), his grandiose confessionals (1762–63), and C. Wenzinger's stucco work add to the distinction of the building. The magnificent library, which contains important medieval manuscripts, was built in 1758–67 by Peter Thumb and his son. *See* ST. GALL: MONASTERY.

BIBLIOGRAPHY. J. Gantner, *Kunstgeschichte der Schweiz...*, 2 vols., Leipzig, 1936–1947; E. Poeschel, *Die Kunstdenkmäler des Kantons St. Gallen*, vol. 3, Basel, 1961.

ST. GALL (Sankt Gallen): MONASTERY. Former Benedictine monastery in Switzerland, founded in 612 by the Irish hermit St. Gall. Nothing remains of the buildings of the Carolingian and Ottonian periods, when the monastery was one of the leading centers of art and learning and had a famed scriptorium. The present abbey church and library are rococo. *See* ST. GALL: COLLEGIATE CHURCH.

St. Gall is noted for its library. Perhaps the most famous item is the drawing (ca. 820) showing the "ideal" monastic plan. St. Gall itself was not laid out entirely according to this plan, which is thought to be the work of Benedict of Aniane or of Einhard, both major figures in the court of Charlemagne. The plan shows a typical large Carolingian monastery. Such monastic establishments were meant to be generally self-sufficient, and they provided space and buildings for livestock, gardens, shops, bakeries, breweries, and guesthouses. The church in the plan is a three-aisled columnar basilica, with an east transept and east and west apses. The west apse is surrounded by an unusual curved portico flanked by two round staircase towers. The double apse and tower arrangement was a feature of Carolingian building (as in Fulda, St-Riquier, and Aachen) that persisted and became a stylistic feature of German Ottonian and Romanesque churches. *See* CAROLINGIAN ART AND ARCHITECTURE.

Many of the 8th- and 9th-century manuscripts produced by the St. Gall scriptorium are still in the library. The earlier manuscripts are generally of the Franco-Saxon style and are illuminated primarily with full-page initial letters. In the later manuscripts full-page pictures are used, as in the Psalterium Aureum, with a fully illustrated David cycle, one of the finest St. Gall manuscripts.

Ivories were also produced in St. Gall. The most important work is the diptych made by the monk Tuotilo (fl. 895–912), one of the rare examples of a Carolingian ivory whose carver is known. Christ in Majesty is flanked by cherubim, the Evangelists and their symbols, and personifications of Ocean and Earth. The ivory shows the florid, overly elaborate style of Franco-Saxon work of the late 9th and the early 10th century.

BIBLIOGRAPHY. A. Merton, *Die Buchmalerei in St. Gallen...*, 2d ed., Leipzig, 1923; K. J. Conant, *Carolingian and Romanesque Architecture, 800–1200*, Baltimore, 1959.

STANLEY FERBER

SAINT-GAUDENS, AUGUSTUS. American sculptor (1848–1907). Saint-Gaudens was born in Dublin; he was brought to the United States as an infant by his French father and Irish mother. After being apprenticed to a cameo maker, he studied at Cooper Union in New York and at the National Academy of Design. He lived in Paris in the late 1860s and attended the Ecole des Beaux-Arts; from there he went to Italy, where he was influenced by the highly popular neoclassical mode. After returning to the United States, he became affiliated with the architectural firm of McKim, Mead and White and received numerous commissions for decorative and monumental sculptures. By the late 1880s Saint-Gaudens was one of the best-known and most influential American neoclassicist sculptors.

Admiral Farragut (1881; New York, Madison Square), the standing *Lincoln* (1887; Chicago, Lincoln Park), and *Amor Caritas* (1887; Paris, Luxembourg), a bronze relief, show Saint-Gaudens's attempt to reconcile his European training with his American affiliations. *Puritan*, a posthumous, imagined portrait of the deacon Samuel Chapin, like so many sculptures by European-trained American artists of the late 19th century, is "American" largely because of its subject. Its style, like that of a second version some years later, remains substantially academic.

A distinctive mastery of material and anatomy is reflected in the following works, the culminating development of Saint-Gaudens's aesthetic: *Diana*, a huge copper statue showing Diana drawing the bow (1892; Philadelphia Museum of Art); *General Sherman* (ca. 1900), by which he was represented at the Exposition in Paris in 1900; the delicate bas-relief of Robert Louis Stevenson, dating from 1882 to 1902; and the seated *Lincoln* (1907; Chicago,

Grant Park). His most distinguished work is *Grief* in Rock Creek Cemetery in Washington, D.C. This seated, draped, and brooding image achieves an expressive quality that approaches the Gothic—though its details of interpretation of drapery and features combine other medieval and neoclassical statements. Additional sculptures by Saint-Gaudens are located at the memorial gallery in his name in Cornish, N.H., where he spent the last years of his life.

Saint-Gaudens escaped the most detrimental influences of the neoclassical style so popular in Europe and America in the middle and late 19th century. Nonetheless, his contribution lies as much within the precincts of European stylistic development as it anticipates any significant American trends that shortly followed his death. He may be regarded, however, as one of the most gifted sculptors who practiced the neoclassical style in the United States in his time.

BIBLIOGRAPHY. B. Hollingsworth, *Augustus Saint-Gaudens*, New York, 1948.

<div style="text-align: right">JOHN C. GALLOWAY</div>

SAINT-GENEROUX, CHURCH OF. Late Carolingian French church in Aquitaine, built before 950. Its patterned, decorative stonework exhibits features of the *premier roman* (earliest Romanesque). Originally a wide-naved church, it had a columnar screen separating the nave from the dwarf transepts. Its three apses are in echelon.

ST. GENEVIEVE WATCHING OVER PARIS. Oil on canvas murals by Puvis de Chavannes, in the Panthéon, Paris. *See* PUVIS DE CHAVANNES, PIERRE.

SAINT-GENIS-DES-FONTAINES, CHURCH OF. Small Romanesque church in French Catalonia. It is noted for its early use of figural sculpture. The lintel of the main portal, dated 1020–21, presents the apocalyptic scene of Christ in Glory. The figural style and ornamentation suggest Mozarabic influence; the iconographic prototype might have been the famed Beatus manuscripts.

BIBLIOGRAPHY. G. Gaillard, *Premiers essais de sculpture monumentale en Catalogne aux X^e et XI^e siècles*, Paris, 1938.

SAINT GEORGE, CHURCH OF, *see* EZRA: ST. GEORGE; THESSALONIKA.

ST. GEORGE, JAMES OF, *see* JAMES OF ST. GEORGE.

ST. GEORGE'S CHAPEL, WINDSOR CASTLE. A great achievement of the last phase of the English Perpendicular style, it was built in two stages and occupies the lower ward of the castle. The initial works were designed for Edward IV in the second half of the 15th century by Master Henry Janyns, who completed the choir, except for the vault, and began the nave and transepts. Under Henry VII the vaulting was put up by William Vertue (1500–11). He may also have designed the crossing vault, which was not erected until 1528 by the mason Henry Redman. The lierne vaults are handled with unsurpassed mastery.

The west window was filled with stained glass between 1503 and 1509. The various side chapels around the nave contain tombs, effigies, and paintings ranging from the

St. George's Chapel, Windsor Castle. A work in the English Perpendicular style, begun in the last half of the 15th century.

15th to the 20th century. The great screen across the nave supports the organ and broadens out on each side into two transeptal chapels. East of the screen is the choir with notable carved wood stalls by John Squyer, set up in 1482–83. They carry the incised armorials of the Order of the Garter. The lectern is late 15th century, as is the ironwork of the high altar. One of the finest examples of English medieval ironwork (ca. 1482), by John Tresilian, encloses the tomb of Edward IV.

Beyond the ambulatory in the east wall are the remains of the west front of Henry III's chapel (1240) with its doorway and unique 13th-century scrolled ironwork, probably by Gilbert the Carpenter II.

BIBLIOGRAPHY. W. H. St. J. Hope, *Windsor Castle*, 2 vols., London, 1913; G. F. Webb, *Architecture in Britain: The Middle Ages*, Baltimore, 1956.

<div style="text-align: right">JOHN HARRIS</div>

SAINT-GEORGES-DE-BOSCHERVILLE, *see* BOSCHERVILLE, SAINT-GEORGES-DE.

ST. GEORGE'S HALL, LIVERPOOL. With the Palace of Westminster and the Crystal Palace, one of the three great English early Victorian monuments. In July, 1839, Harvey Lonsdale Elmes won the first premium for the competition for St. George's Hall, and in 1840 he won the further competition for the Assize Courts. Both projects were united, and work was begun in 1842. At that time Elmes was only twenty-eight years old; by 1847 he was dead. Work was completed by Robert Rawlinson according to Elmes's designs (1847–51), and C. R. Cockerell did the interior. It is the last of the great buildings in a classical tradition to follow an elaborate spatial formula and a theme of fusing refined Greek detail with Roman monumentality.

BIBLIOGRAPHY. H.-R. Hitchcock, *Early Victorian Architecture in Britain*, 2 vols., New Haven, 1954.

ST. GEREON, COLOGNE. German church, largely built from the 11th through the 13th century. It rests on Early Christian foundations, probably of the last part of the 4th century. At that time St. Gereon was a central-plan martyrium type of church, with eight side niches, the eastern one enlarged (apse) and the western one in the form of a vestibule. Under Archbishop Anno (1056–75) a long

choir resting on a raised crypt was added in the east and was flanked by two stair towers. The central-plan nave area was rebuilt from 1219 to 1227 into a larger, central-plan decagon, which fit more readily to previous enlargements (of the sanctuary, 1151–56, and of the western end, 1191). Standing at the transition point of German late Romanesque and early Gothic, St. Gereon is one of the most impressive central-plan buildings in Germany.

SAINT-GERMAIN-DES-PRES, PARIS. French church, originally founded about 543 by Childebert I. It served as the repository for the tunic of St. Vincent. The burial place of the Merovingian kings, it also contained the tomb of St. Germain of Autun, bishop of Paris, who died in 576 and for whom the church was named. The original entrance tower (990–1014) still stands; the nave and aisles, despite much Gothic rebuilding, date mostly from 1005–21 and later. The two towers flanking the apse were removed in 1821; they recalled German tradition and were similar to those still standing at Morienval. There is a fine Romanesque relief of the Last Supper over the main door. The interior of St-Germain-des-Prés was most unfortunately restored in the 19th century. There are a number of good 17th-century tombs.

SAINT-GERMAIN-EN-LAYE: MUSEUM OF NATIONAL ANTIQUITIES. French collection housed in a former royal château near Paris, which serves as the central museum of deposit for prehistoric, Gallo-Roman, and early medieval antiquities recovered in excavations made throughout France. The Gallo-Roman sculptures, which have a rude vigor recalling some Etruscan works, thoroughly document the religious life of pre-Christian Gaul. Perhaps the most outstanding of these is the metal image of a stag

Abbey Church of Saint-Germer-de-Fly. A 12th-century structure.

god. The early medieval section is noteworthy for its extensive collection of fibulas (brooches), which show a masterful use of such techniques as damascening, enamel, and filigree.

BIBLIOGRAPHY. S. Reinach, *Catalogue illustré du Musée des Antiquités Nationales au château de Saint-Germain-en-Laye*, 2 vols., Paris, 1921–26; R. Lantier, *Guide illustré du Musée des Antiquités Nationales au château de Saint-Germain-en-Laye*, Paris, 1948.

SAINT-GERMER-DE-FLY, ABBEY CHURCH OF. Gothic church near Beauvais, France, built entirely during the 12th century. Here we find further advances in the evolution of the Gothic ribbed-vault system over the crude beginnings displayed in the ambulatory vaults of Morienval. The broken diagonal ribs in the ambulatory are of great aesthetic beauty and are an indication of the development of the polygonal choir scheme. The scale and artistic handling of St-Germer, with its fine comprehension of the possibilities of the ribbed vault as a new mode of expression, attest to the creative imagination of the builders. The stately apse with its richly ornamented arcades is especially noteworthy. The triforium, with its groined vaulting, still remains completely Romanesque, reflecting both Lombard and Norman Romanesque influences.

SAINT-GERVAIS, PARIS. French Flamboyant Gothic church begun in 1494. It was given a classical west front by Salomon de Brosse between 1616 and 1621. Based on the entrance to Philibert de l'Orme's Château of Anet, this façade consisted of three stories of superimposed columns with a triangular pediment over the doorway and a segmental pediment at the top. It became an influential prototype in French church design.

BIBLIOGRAPHY. Abbé L. Brochard, *Saint-Gervais; histoire du monument d'après de nombreux documents inédits*, Paris, 1938.

SAINT-GILLES, ABBEY CHURCH OF. French church situated in the Department of the Gard. Of the original work, begun in 1116, only a ruined choir, the lower section of the façade, and the west part of the crypt remain. The greatest glory of St-Gilles is its façade, whose three portals form a unified sculptural masterpiece covering the entire width of the church. The carvings, in high and low relief, are the product of at least three different workshops. The central portal, begun perhaps as early as 1140 by artists of the school of Toulouse, is the oldest part and is inferior in quality to the others, which were the work of sculptors from the Ile-de-France.

The sculptures show evidence of Gallo-Roman influences, as well as debts to the earlier Romanesque achievements of the schools of Burgundy and Languedoc and to Lombard sculpture, from which the lion pedestals are derived. The overall composition and the architectural forms are Roman; columns with correct Corinthian capitals support classic entablatures and moldings. In the manner of a Roman frieze, the Life of Christ spans the entablature of the central portal and the lintels of the lateral doors. In niches formed by engaged columns flanking the principal doorway stand large figures of the apostles in which stylistic traits from varied sources are successfully assimilated, resulting in a style that may be called Provençal Romanesque. The central tympanum is modern. The tympanums of the subordinate portals depict an Adoration of the Magi and a Crucifixion.

Abbey Church of St-Gilles, Department of the Gard. The façade with its three portals, begun ca. 1140.

The crypt is a complete subterranean 12th-century church. Here pilgrims on the way to Compostela came to venerate the relics of St. Gilles, which were kept in a magnificent golden casket. Part of the crypt is still covered by the original herringbone vaults. The rest has ogive vaults from the middle of the 12th century that are among the oldest extant in France. The crypt houses a small lapidary museum.

The old choir of the church, now in ruins, was flanked by two belfries with spiral staircases. That of the north, called the "Vis de St. Gilles," has been preserved and is famous for the quality of its stonework. Only vestiges remain of the ambulatory with five radiating chapels.

BIBLIOGRAPHY. M. Gouron, "Saint-Gilles-du-Gard," *Congrès Archéologique de France, CVIIIe Session, Montpellier*, Paris, 1951; R. Hamann, *Die Abteikirche von St. Gilles und ihre künstlerische Nachfolge*, Berlin, 1955; A. Villard, *Art de Provence*, Grenoble, 1958.

MADLYN KAHR

ST. GODEHARD, HILDESHEIM. German High Romanesque basilica built between 1133 and 1172. Following the typical Lower Saxon plan, it has a flat wooden-beamed ceiling, a nave arcade resting alternately on two columns and a pier, and richly painted triforium and clerestory walls. The façade sculpture is in the famous Hildesheim-workshop style.

SAINT-GUDULE, BRUSSELS. Belgian church, the full name of which is the Collegiate Church of SS. Michel et Gudule. Construction of the Gothic basilica was begun about 1226 on the ruins of an 11th-century church. The choir dates from the 13th century, the nave and aisles from the 14th and 15th centuries, the towers from the 15th century, and the chapels from the 16th and 17th centuries. There are interesting 16th-century windows after cartoons by Bernard van Orley. The two graceful towers of the façade were built by Van Ruysbroeck.

BIBLIOGRAPHY. P. F. Lefèvre, *La Collégiale des Saints-Michel-et-Gudule à Bruxelles*, 2d ed., Brussels, 1948.

SAINT-GUILHEM-LE-DESERT, ABBEY OF. Famous abbey near Montpellier, France. William, the childhood friend and valiant lieutenant of Charlemagne, came to the abbey in 804 to finish his days in religious devotion. Here he deposited the relic of the True Cross given to him by Charlemagne, which made this monastery a place of pilgrimage. Of the abbey there remain today the church, built in the 10th and 11th centuries and largely restored, in which Gallo-Roman, Merovingian, and Romanesque sculptures are displayed; and two restored galleries of the cloister, most of whose original columns are in New York's Cloisters.

BIBLIOGRAPHY. J. Vallery-Radot, "L'Eglise de Saint-Guilhem-le-Désert," *Congrès Archéologique de France, CVIIIe Session, Montpellier*, Paris, 1951.

SAINT-HILAIRE-LE-GRAND, POITIERS. French church, begun about 1025 as a result of a pilgrimage in France to the tomb of St. Hilaire, teacher of St. Martin. Queen Emma of England, the Norman architect Walter Coorland, and perhaps Bishop Fulbert of Chartres were involved in the pilgrimage. Though St-Hilaire was dedicated in 1049, much rebuilding continued until 1068. The sense of vastness of the interior is heightened by the way in which the nave piers are strengthened by bridgelike interior buttresses. The choir, raised high above the nave, is enhanced by the apse with its ambulatory and radiating chapels, all dating from the 12th century. There are a number of fine narrative capitals and several 12th-century frescoes. Though the façade was destroyed, the exterior of the apse is superbly preserved.

BIBLIOGRAPHY. K. J. Conant, *Carolingian and Romanesque Architecture, 800-1200*, Harmondsworth, 1959.

ST. IRENE, CONSTANTINOPLE, *see* HAGIA IRENE, CONSTANTINOPLE.

ST. ISAAC'S CATHEDRAL, LENINGRAD. The first designs for the new Cathedral of St. Isaac of Dalmatia were made at the end of the 18th century by Antonio Rinaldi, one of the architects of Catherine the Great. His project was abandoned but then hastily finished in 1801 by Vincenzo Brenna. In 1817 the commission for a new design was awarded to the obscure French architect August Ricard de Montferrand, who built the present structure, a centrally planned Greek cross with a central dome resembling the dome of the Panthéon in Paris and four subsidiary domes. Each of the four sides of the square block is preceded by a classical portico with pedimental sculpture. As a whole, it shows the confusion of scale and weakness in proportion that were to become typical of Russian neoclassical architecture. Its effect is made chiefly through size and richness of materials.

BIBLIOGRAPHY. G. H. Hamilton, *The Art and Architecture of Russia*, Baltimore, 1954.

SAINT-JACQUES, TOULOUSE, *see* JACOBINS, CHURCH OF THE, TOULOUSE.

ST. JAMES'S PALACE, LONDON. Palace built for Henry VIII soon after 1532. The gatehouse and outlines of the Friary, Color, and Ambassadors' courts remain. Christopher Wren added new state rooms, mostly on the embattled south side of the Engine Court; and John Vanbrugh perhaps added the great kitchen (1717–18). The great staircase is probably by William Kent, who redecorated Queen Anne's room. The Chapel Royal is part of the work of the 1530s but was redone in the 1830s. Notable are the armory and tapestry rooms, both redecorated by William Morris in 1866–67—a recognition of an avant-garde moment where it was not expected. The state rooms are linked to Clarence House, built by John Nash in 1825. The stable yard included Warwick House with a range by Nicholas Hawksmoor dated 1716.

BIBLIOGRAPHY. N. Pevsner, *London*, vol. 1: *The Cities of London and Westminster*, Harmondsworth, 1957.

SAINT-JEAN, BAPTISTERY OF, POITIERS. French Merovingian Baptistery of the 7th or 8th century. It is

St. Isaac's Cathedral, Leningrad.

one of the earliest buildings of this type that has been preserved in France.

In the absence of any large Merovingian architectural monuments, the structure assumes great importance for our knowledge of this early period of Western Christian architecture. The Baptistery is a square triapsidal building of largely unadorned brick construction, basically of a cross plan. The plan is similar to that of the crypt of St-Laurent, Grenoble, of about the same period, and seems ultimately to have been derived from North African and

Baptistery of St-Jean, Poitiers. A 7th- or 8th-century French Merovingian monument.

Egyptian prototypes. This architectural relationship is consistent with our knowledge of the large influx of Eastern, especially Syrian, churchmen into France at this time.

After a fire in 1018 the structure was considerably enlarged and enriched with sculptural ornamentation. Between the 12th and 14th centuries frescoes were painted on the walls; the most famous of them is *Constantine on Horseback*, as the inscription testifies. There are also fine paintings of the apostles and a *Christ in Majesty*. Today the Baptistery houses a most interesting collection of local examples of Merovingian art.

BIBLIOGRAPHY. G. G. Dehio and G. von Bezold, *Die kirchliche Baukunst des Abendlandes...*, 7 vols., Stuttgart, 1887–1901.

ALDEN F. MEGREW

ST. JOHN CHRYSOSTOM, HOMILIES OF, *see* BYZANTINE ART AND ARCHITECTURE (MACEDONIAN RENAISSANCE).

ST. JOHN LATERAN, ROME, *see* LATERAN, THE, ROME (SAN GIOVANNI IN LATERANO).

ST. JOHN OF STUDION, CONSTANTINOPLE. One of the oldest extant Byzantine church ruins in Constantinople. Probably of Constantinian foundation, it was a famous monastic church dedicated in 463. The extant ruins indicate a basilican-plan church constructed of hewn stone alternating with courses of brick—a type of masonry construction common in Constantinople during the 5th century. It was a three-aisled church without a nave clerestory. The remains also show the nave to have been lined with columns of verd-antique marble.

Stylistically, St. John of Studion indicates that Constantinian architecture still followed the Roman style of building, with no evidence to indicate the beginnings of a purely Byzantine style.

ST. JOHN OF THE HERMITS, PALERMO, *see* SAN GIOVANNI DEGLI EREMITI, PALERMO.

ST. JOHN'S CHAPEL, TOWER OF LONDON. The White Tower, one of the most impressive of early Norman hall keeps, was completed by 1097. Gundulf, bishop of Rochester, has been associated in an administrative or architectural way with its design. The chapel, situated on the second floor with the banqueting hall, is one of the most poignant and evocative, historically as well as architecturally, of any early Norman building in England. It possesses a rare tunnel-vaulted nave with severe unornamented piers and arcades, a gallery, aisles, and an ambulatory. The aisles are groin-vaulted, and the gallery has a tunnel vault. The chapel is 60 by 35 feet, with the living space opening off north and west.

See also TOWER OF LONDON.

BIBLIOGRAPHY. N. Pevsner, *London*, vol. 1: *The Cities of London and Westminster*, Harmondsworth, 1957.

ST. JOHN'S COLLEGE, CAMBRIDGE, ENGLAND. College of Cambridge University founded in 1511, with buildings dating from every century from the 16th through the 20th. The First Court was built in 1511–20 by Master William Swayn. The Second Court dates from 1598–1602 and was done by Ralph Symons and Gilbert Wigge. The Third Court was formed in 1669. The New Court is a Picturesque essay done by Richman and Hutchinson in 1825–31.

BIBLIOGRAPHY. N. Pevsner, *Cambridgeshire*, Harmondsworth, 1954.

ST. JOHN THE DIVINE CATHEDRAL, NEW YORK. Episcopal cathedral in New York City, begun in 1891. The area of this still unfinished cathedral, 121,000 square feet, exceeds that of any other in the world, except St. Peter's in Rome. The architects of the Cathedral have been George L. Heins and C. Grant La Farge, from 1891 until Heins's death in 1907; La Farge from 1907 until April, 1911; and Cram and Ferguson from April, 1911, to 1942. It was left unfinished early in World War II. A new design by Adams and Woodbridge was approved in 1966, which provides for the building's completion with a large cylindrical dome of stained glass panels set between concrete piers. This dome is to replace the Gothic tower planned earlier. Other changes involve shorter towers for the west end and less pronounced transepts. In 1967, however, it was decided to leave the Cathedral in an unfinished state as a symbol of the "anguish" of the nearby slum areas.

The foundation stone of the nave was laid on Nov. 9, 1925. From the narthex there is a clear vista eastward to the Transfiguration Window in the Chapel of St. Savior—a distance of 601 feet from the bronze doors. A feeling of spaciousness is produced by the relatively small number of columns and piers. An alternating system of supports produces four square bays. At the east end are seven apsidal chapels, above which rises the clerestory of the choir. The choir has half-round arches of a late Romanesque style, as opposed to the Gothic character of most of the rest of the Cathedral. An ambulatory, leading around the choir, gives access to the seven chapels and the baptistery.

The great bronze doors in the central portal, cast and fabricated in Paris, consist of four valves, two on each side of the *trumeau*, showing subjects from the Old and New Testaments. The other doors of the west portals are made of teakwood from Burma. Facing the north tower entrance is the Martyrs' Portal, where eight figures stand, each eight feet high and carved in Indiana limestone. The high altar, completely freestanding and made of white Vermont marble, is one of the few liturgically correct high altars in the country, recalling those of such cathedrals as Amiens and Canterbury. The great rose window in the west front is dominated by the figure of Christ in Glory.

BIBLIOGRAPHY. E. H. Hall, *A Guide to the Cathedral Church of St. John the Divine, in the City of New York*, rev. 12th ed., New York, 1942.

EMMA N. PAPERT

SAINT-JOUIN-DE-MARNES, CHURCH OF. French church, once belonging to a Benedictine abbey of the same name. St-Jouin is of provincial Romanesque Poitevin style. Dating from the first half of the 12th century, it is most attractive because of its sculptures, which are beautifully integrated into the façade. The east end of the choir is also rich in sculptural decoration.

BIBLIOGRAPHY. P. Deschamps, *French Sculpture of the Romanesque Period...*, Florence [1930?].

SAINT-LAURENT, GRENOBLE. Eleventh-century church in southeastern France. The oldest church in Grenoble,

St-Laurent was built over a Carolingian chapel. The crypt, restored in 1851, was long thought to date from the end of the 6th century, but recent scholarship places it approximately at the end of the 8th century, on the basis of the decoration of the capitals and certain details of construction. It is in the form of a cross with rounded ends. The columns supporting the barrel vault have capitals of Gallo-Roman origin and imposts bearing interlaces and symbols found on sarcophagi of the Early Christian period.

BIBLIOGRAPHY. R. Lantier and J. Hubert, *Les Origines de l'art français*, Paris, 1947.

SAINT-LEU-D'ESSERENT, CHURCH OF. Church of the former Benedictine priory in France, of the Cluniac order. The three-aisled basilican church has an unusual western porch of three bays (ca. 1150), with a room above, and a tower to the south with a stone flèche. Begun about 1160, the nave and aisles, with both quadripartite and sexpartite vaults, a developed tribune, and simple flying buttresses, are fine examples of the early Gothic style in France.

BIBLIOGRAPHY. A. Fossard, *Le Prieuré de Saint-Leu d'Esserent*, Paris, 1934.

ST. LOUIS, MO.: CITY ART MUSEUM. The building in Forest Park, designed by Cass Gilbert, was erected in 1904 to serve as the Palace of Art. Its entrance is flanked by limestone figures, representing Painting and Sculpture, by Louis and Annetta St. Gaudens and Daniel Chester French, respectively. It is city-owned; it also benefits from several local funds and donors. There is a wealth of material relating to this strategic area in America's history as well as a fine collection of world art.

George Caleb Bingham's painting *Raftsmen Playing Cards* and paintings and sculptures by Catlin, Bodmer, and Remington graphically tell the story of the winning of the West. Here, in oil, water color, and bronze, are the wagon trains, Indians, cowboys, and buffalo of the American saga. The museum also has a four-story Gothic building from Brittany with a narrow stairway; a miniature Chinese village from the Han dynasty (206 B.C.–A.D. 221) with spirited clay animals and playful children; and a room from Spain, superbly furnished and designed in the style of Castile.

The vaulted central hall of the building lends itself to the display of heroic sculpture. Jacques Lipchitz's contemporary abstraction *The Bathers* and a *Reclining Figure* by Henry Moore are shown with a sculpture once attributed to Michelangelo and a *Satyr* from Rome's Barberini Palace (sold to St. Louis in 1937).

The paintings in St. Louis are outstanding in variety and quality. Among the European and American masters represented are Bellini, Chardin, Claude Lorraine, Corot, Courbet, Cranach (*The Judgment of Paris*), Daumier, Van Dyck, Eakins, Gainsborough, Goya, El Greco, Greenwood (*Sea Captains Carousing at Surinam*), Guardi, Hals (*Portrait of a Lady*), Holbein (*Portrait of Lady Guildford*), Homer, De Hoogh (*A Game of Skittles*), Matisse (*Bathers with Turtle*), Murillo, Poussin, Raeburn, Rembrandt, Rubens, Tiepolo, Tintoretto, Titian (*Ecce Homo*), Velázquez, Veronese, Wyeth (*A Day at the Fair*), and Zurbarán.

BIBLIOGRAPHY. J. D. Morse, *Old Masters in America*, Chicago, 1955; E. Spaeth, *American Art Museums and Galleries*, New York, 1960; *Museums Directory of the United States and Canada*, American Association of Museums, 2d ed., Washington, D.C., 1965.

JOHN D. MORSE

SAINT-LOUP-DE-NAUD, CHURCH OF. French church, constructed in two different periods. St-Loup is unusual for its variety of vaulting types—barrel, groin, rib, dome on squinches—which show in a striking way the progress from the Romanesque to the Gothic in the Ile-de-France. The three-apse *chevet*, transept, and first two bays of the nave date from the end of the 11th century; the two western bays of the nave and the porch with its sculptured portal, from about 1170. The western portal displays St. Loup on the *trumeau*, scenes from his life and angels in the voussoirs, Christ in Glory with the symbols of the Evangelists and the Apostles with the Virgin in the tympanum and lintel, and Old and New Testament figures in the jambs. Of the same series as the Royal Portal at Chartres, the portal of St-Loup is the last and one of the finest sculptural ensembles of the early Gothic style.

BIBLIOGRAPHY. F. Salet, "Saint-Loup-de-Naud," *Bulletin Monumental*, XCII, 1933.

ST. LUKE, ACADEMY OF, see ACADEMY OF ST. LUKE.

SAINT-MACLOU, ROUEN. French church begun from plans by the architect Pierre Robin in 1437. The handsome openwork spire over the crossing was restored in 1869 but seems a close copy of the original. Another unusual feature is the pentagonal porch surmounted by open gables, which reflects the characteristic nature of the French type of apse. Throughout, the church is extremely rich in lacework designs that accentuate the highly ornamented yet beautifully controlled qualities of the best examples of the Flamboyant Gothic style. The sculptures of the wood main doors are usually ascribed to Jean Goujon. Above them is a tympanum of the Last Judgment, which Ruskin describes as of a "fearful grotesqueness." A fine Gothic staircase leads to the organ loft. St-Maclou contains excellent examples of carved ornamentation.

SAINT-MARCEAUX, CHARLES-RENE DE. French sculptor (b. Reims, 1845; d. Paris, 1915). A student of Jouffroy, he received many honors during his career, including the medal of honor at the Salon of 1879 and a gold medal at the Universal Exposition in Paris in 1889. A combination of virtuoso naturalism and classicism characterizes his many portraits, tomb sculptures, and public and religious works. In impressionistic technique, romantic pathos, and allegorical pretension they parallel, in a more bombastic vein, the works of Rodin.

BIBLIOGRAPHY. A. Beaunier, *Saint-Marceaux*, Reims, 1922.

ST. MARK'S (San Marco), VENICE. Northern Italian church. The architecture, decoration, and furnishings of the Basilica of St. Mark (since 1807 the Cathedral) constitute an ensemble of Veneto-Byzantine art that is of unique importance. Although the first church was built in the 9th century, the core of the present building dates from the second half of the 11th century (apparently begun in 1063). Following the example of the 6th-century Church of the Holy Apostles in Constantinople, St. Mark's was

erected in brick on a Greek-cross plan with five domes. After the conquest of Constantinople in 1204 many sculptures in marble and bronze brought back as booty were used to decorate the church. The influx of this material stimulated a veritable passion for decorative embellishment and enlargement that was to last for some four centuries. In this way the original Byzantine core of the building became incased in a splendid Venetian covering with successive Romanesque, Gothic, and Renaissance accents. The numerous sculptures visible on the exterior include earlier pieces accumulated after 1204 as well as new works commissioned for the church. Notable in the former group are the four horses in gilded bronze on the terrace (Greek; 4th–3d cent. B.C.) and the two pairs of tetrarchs in porphyry produced by the imperial workshops in the 4th century of the Christian era.

The cycle of mosaics in the domes and vaults of the *atrio* (actually a kind of narthex) represents a remarkable synthesis of Byzantine and Romanesque pictorial art. These mosaics (12th–14th cent.) depict scenes from the Old Testament and the life of Christ. The mosaics of the interior are less unified in style and include some panels made after cartoons by such artists as Tintoretto and Veronese. In the presbytery the *Pala d'oro*, an altarpiece assembled between 1105 and 1345 from hundreds of panels in enamel and gold- and silverwork, achieves an almost overwhelming concentration of richness. The ciborium is supported by four sculptured columns, of which two are thought to be Early Christian and two Romanesque. The Cathedral Treasury displays Byzantine manuscripts, reliquaries in gold- and silverwork, and objects of rock crystal (7th–12th cent.).

BIBLIOGRAPHY. P. Toesca, *The Mosaics in the Church of St. Mark's in Venice*, London, 1958; O. Demus, *The Church of San Marco in Venice*, Washington, D.C., 1960; H. R. Hahnloser, ed., *Il Tesoro di San Marco*, Florence, 1965.

WAYNE DYNES

ST. MARTIN, BASILICA OF, TOURS. Early Romanesque church, built about 1014 to replace the church of 997, which had been destroyed by fire. St. Martin was an important pilgrimage church and followed, or possibly initiated, the pilgrimage-church plan: a wide nave with four aisles, long transepts with aisles around them, and an apse with an ambulatory and radiating chapels. The church of 1014 had groin-vaulted aisles and gallery and an open-timber roof. By 1050, probably under the influence of Cluny II and the Gulf of Lions school, the nave was barrel-vaulted. The highly articulated wall surface, gallery treatment, and ambulatory seem to indicate strong pilgrimage-school connections with the north of France (Reims and Normandy). The well-preserved fresco cycles here are among the more notable examples of Romanesque wall painting.

ST. MARTIN-IN-THE-FIELDS, LONDON. Built between 1721 and 1726 by James Gibbs, this building had enormous influence and became the prototype for many churches. It is rectangular in shape and fronted by a giant Corinthian portico. A steeple rises through the roof inside the church proper, going beyond Wren's method in which the steeple is an adjunct to the building.

The interior is aisled and galleried. Gibbs emphasized the columns that support the barrel-vaulted roof by giving each column an individual entablature and placing the gallery behind them. This arrangement also marks a step in the further articulation of parts.

BIBLIOGRAPHY. N. Pevsner, *London*, vol. 1: *The Cities of London and Westminster*, Harmondsworth, 1957.

ST. MARY, DEERHURST. Early 10th-century English church. Enough of the original structure remains to make this church an important English example of the influence of Carolingian architecture, especially of the scheme of the French monastery church of St-Riquier. A strong western tower, with triangular-headed windows opening on the nave, precedes the nave, and interesting rooms off the nave to the north and south form a rudimentary transept. From the unusual seven-sided apse is preserved a fine sculptured angel similar to those at Bradford-on-Avon.

BIBLIOGRAPHY. G. F. Webb, *Architecture in Britain: The Middle Ages*, Baltimore, 1956.

ST. MARY, LUBECK. Beautiful example of Low German brick architecture of the Gothic period. It was built from 1251 to 1310 by the burghers of Lübeck to compete with the bishop's cathedral. The Church of St. Mary differs from the majority of German brick churches in having its side aisles lower than the nave, one of the many features taken over from French High Gothic cathedral design.

BIBLIOGRAPHY. D. Ellger, *St. Marien zu Lübeck und seine Wandmalereien*, Neumünster, 1951.

ST. MARY-LE-BOW, LONDON. Church built by Sir Christopher Wren between 1670 and 1683 in accordance with a plan based on the Templum Pacis given by Serlio. Its magnificent steeple is composed of circular and Greek-cross *tempietti* crowned by an obelisk. This was Wren's first classical steeple, and it is unrivaled among his city churches.

BIBLIOGRAPHY. N. Pevsner, *London*, vol. 1: *The Cities of London and Westminster*, Harmondsworth, 1957.

ST. MARY-LE-STRAND, LONDON. Built in 1714–17, this is the first of the fifty new churches provided for under the Act of 1711 and James Gibbs's first important commission following his return from Rome. The motifs used here have been associated with 16th-century Roman mannerist sources. The small scale of the church distinguishes it from its contemporaries.

BIBLIOGRAPHY. N. Pevsner, *London*, vol. 1: *The Cities of London and Westminster*, Harmondsworth, 1957.

ST. MARY PAMMAKARISTOS (Fetiye Cami), CONSTANTINOPLE. Thirteenth-century Byzantine church. It rests on the site of an earlier monastic church. The original structure, probably of the 10th century, enlarged later by the addition of aisles and an outer narthex, was a three-aisled, three-apsed central-domed building. The exterior, of later date, is of unusual elaboration with niches and blind arcades. There are numerous notable 13th-century mosaics on the interior.

SAINT-MAURICE, CATHEDRAL OF, ANGERS. Best example of the aisleless church covered with Angevin rib

St. Mark's (San Marco), Venice. The richly decorated interior of the basilica.

vaults in the Anjou region of France. The first building, begun shortly after 1010 and consecrated in 1025, was a basilica composed of nave and side aisles, an apse with an ambulatory, and a transept with an apsidal chapel on each wing. The nave walls of the present building have been retained from the 11th-century Cathedral, but between 1125 and 1148 the aisles of the old Cathedral were abolished and the wooden roof of the nave was replaced by three remarkable domed-up, square-shaped vaults, which, with their thin cells, represent an ingenious early solution of the problem of rib vaulting. To these great Angevin vaults, each one spanning the entire almost 50-foot width of the aisleless nave, the Cathedral owes its magnificent interior space.

The transept, similarly vaulted, also consists of three square bays, but the vaults (1177–97) are octopartite whereas those of the nave are quadripartite. The choir, with one similar bay, and the semicircular apse, with eight triangular cells, bring the overall length of the interior to 295 feet.

Less successful is the blocklike west front. Its finest feature is the central portal (ca. 1155–65), similar in many ways to the Royal Portal at Chartres. The tympanum, like that of Chartres, contains a *Majestas Domini*; in the jambs are figures from the Old Testament. The bell towers above and the crossing tower are from the first decade of the 16th century.

Also important is the series of early stained-glass windows (1160–77) in the left side of the nave, executed in a style similar to that of St-Denis and Chartres. The choir has a great deal of 13th-century stained glass.

BIBLIOGRAPHY. R. de Lasteyrie, *L'Architecture religieuse en France à l'époque gothique*, vol. 1, Paris, 1926; *Anjou roman*, text by P. d'Herbecourt and J. Porcher [La-Pierre-qui-Vire (Yonne)], 1959; M. Aubert and S. Goubet, *Gothic Cathedrals of France and Their Treasures*, London, 1959; K. J. Conant, *Carolingian and Romanesque Architecture, 800–1200*, Baltimore, 1959; P. Frankl, *Gothic Architecture*, Baltimore, 1962.

EDWARD P. LAWSON

ST. MAXIMIN'S, TRIER: CAROLINGIAN FRESCOES.
Frescoes in Germany dating from the end of the 9th century, probably shortly after 882. They are among the few Carolingian frescoes extant. Iconographically and stylistically they come closest to contemporary illumination. The marked linear quality and the expressive hand gestures of the figures show them to be stylistically derivative from Reims.

ST. MICHAEL'S, HILDESHEIM. German church (1001–15), one of the first late Ottonian buildings to show a consistent development of Romanesque characteristics. Founded by the famous Bishop Bernward, St. Michael's is basilican in plan, with three aisles, a long nave, transept arms, and apses in the east and west. The nave is supported by alternating groups of two columns and one pier, a style reminiscent of Byzantine buildings such as Hagios Dimitrios, Thessalonika, as is the use of alternating white and colored masonry.

The distinctly Western and proto-Romanesque qualities of St. Michael's are a careful articulation of interior and exterior walls, a visually exciting exterior silhouette, and a logical grouping of separate units. For example, the crossing bays are demarcated from the nave by huge arches that emphasize the square character of the crossing bay. In turn, this square becomes the module unit in determining the proportions of all the other elements in the ground plan of the church.

The cubelike quality of the crossing bay and its related elements is reinforced by the use of cubic capitals, clearly geometric in mass, and by surfaces so delineated as to strengthen the directional movement. The exterior groupings are three in number, each a complete unit (compartmented) but also related to the others. The east end, with its apse, transept, and two staircase towers that abut the ends of the transept arms, composes one clear unit of varying heights and blocklike relationships. The long nave (high) with its side aisles (quite low, allowing for large clerestory windows) comprises a second unit. The west end, with its apse, transept, stair towers similar to those on the east end, and apsidioles on the west side of the transept arms, forms a third unit. Because of the apsidioles on the west end, the exterior is not symmetrical. But the added weight of the western apsidioles is offset by the added length of a chancel before the eastern apse. Hence a rational asymmetrical balance is achieved.

Not only does St. Michael's hold an important place in the development of Romanesque architecture, but it is also noteworthy for its famous bronze doors (1007–15). Their format may have been influenced by the wooden doors of S. Sabina, Rome. Executed by the Hildesheim bronze workshop under the aegis of Bishop Bernward, they set a pattern for many subsequent church doors as far away as the Cathedral of Gnesen, Poland. The Hildesheim doors have rectangular panels illustrating scenes from the Book of Genesis and the life of Christ and seem to be iconographically related to earlier cycles found in illuminated manuscripts and mosaics. *See* BERNWARD, BISHOP.

BIBLIOGRAPHY. F. Tschan, *Saint Bernward of Hildesheim*, 3 vols., Notre Dame, Ind., 1942–52.

STANLEY FERBER

ST. MICHAEL'S, MUNICH. Bavarian church, first great postmedieval church in Germany. Built by the Jesuits between 1583 and 1597, it represents a fusion of local traditions with new conceptions of ecclesiastical design brought from Rome by the order. Perhaps because of this, the church influenced south German design considerably.

St. Michael's, Hildesheim. The nave of this late Ottonian church.

SAINT-MICHEL, DIJON. French church built between 1537 and 1540. Its tripartite façade surmounted by two octagonal, domed towers is typical, in its reversion to the Romanesque, of the beginnings of French Renaissance architecture.

BIBLIOGRAPHY. A. Blunt, *Art and Architecture in France, 1500–1700*, Baltimore, 1954.

SAINT-MICHEL-DE-CUXA, ABBEY CHURCH OF. Important Spanish Romanesque church near Prades, France. St-Michel represents a later phase of *le premier roman* (earliest Romanesque). The abbey was founded in 878. Its church (955–974) was influenced by French and Italian architecture. Parts of this building are extant: the long nave, two side aisles, a transept with four apsidioles on its east wall, and an oblong sanctuary. St-Michel was rebuilt and enlarged (1009–40) by Abbot Oliva. The cloister (2d half of 12th cent.) has been reconstructed at The Cloisters, New York City.

SAINT-MORITZ: SEGANTINI MUSEUM. Swiss collection housed in a domed rotunda built in 1909 to the plans of Nicolaus Hartmann. It consists of the paintings, drawings, and etchings of the Swiss artist Giovanni Segantini, including his symbolic *Triptych*. A bust of the artist by Paul Trubetskoi and a statue by Bistolfi stand outside the building.

SAINT-NAZAIRE, BASILICA OF, CARCASSONNE. Church in southern France, built into the famous ramparts of Carcassonne. The sturdy nave and crypt are Romanesque (late 11th–early 12th cent.); the spacious transept and *chevet* are Gothic (2d half 13th–early 14th cent.). Stained-glass windows (13th–14th cent.) lend a glory of color to the interior, which also houses noteworthy sculptures.

BIBLIOGRAPHY. R. de Lasteyrie, *L'architecture religieuse en France à l'époque gothique*, 2 vols., Paris, 1926–27.

SAINT-NECTAIRE, CHURCH OF. French Romanesque church of the school of Auvergne, completed about 1080. It is apparently the oldest of a group of stylistically related churches of the region, which include that of Orcival, St-Julien in Brioude, and St-Saturnin. The church is characterized by a barrel-vaulted nave without ribs and half-barrel-vault abutments over the aisles; there is no gallery or clerestory. The capitals (early 12th cent.) in the nave and choir are richly carved in a compact, highly plastic ordering of figures and beasts, lending an energetic forcefulness to the sculptured groups.

BIBLIOGRAPHY. P. Frankl, *Baukunst des Mittelalters ...*, Wildpark-Potsdam, 1926; H. Focillon, *The Art of the West in the Middle Ages*, vol. 1: *Romanesque Art*, New York, 1963.

ST. NICODEMUS, ATHENS. Byzantine church founded in the first quarter of the 11th century on the site of Roman baths and cisterns of the time of Hadrian. St. Nicodemus was largely demolished in 1780 by the Turkish governor. It was restored in Byzantine style in 1847, with interior decorations by the Bavarian painter Thiersch.

BIBLIOGRAPHY. E. Boissonnas, *Athènes moderne*, Geneva, 1920.

SAINT-NON, JEAN CLAUDE RICHARD, ABBE DE. French amateur etcher and aquatinter (b. Paris, 1730; d. there, 1797). He resigned from the Legislative Assembly to devote himself to art. In Rome he became associated with Hubert Robert and Honoré Fragonard, and later published a lavishly illustrated but financially ruinous *Voyage pittoresque* of Naples and Sicily.

BIBLIOGRAPHY. L. Guimbaud, *Saint-Non et Fragonard*, Paris, 1928.

ST. ODILIA, see HERRADE OF LANDESBERG.

SAINT-OMER. French town, site of the Abbey of St-Bertin. It was an important center of learning and manuscript production in Carolingian and Romanesque times. The Carolingian importance of the abbey is evidenced by Alfred the Great's importation of the monk Grimbald from St-Bertin to organize schools in England. Grimbald became the first abbot of the New Minster in Winchester. St-Bertin reached its height in the late 11th and the 12th century with the production of medieval "schoolbooks" (redactions of earlier encyclopedia material). The most important of its productions was the Liber Floridus, by the canon Lambert of St-Omer, which was completed before 1120 (Ghent, University Library). This work, also an "encyclopedia," is most interesting for the type of schematic, moralizing illustrations accompanying the text. Such didactic imagery is a hallmark of St-Omer as well as of the Romanesque period.

See also WINCHESTER SCHOOL.

ST. OMER PSALTER. Thirteenth-century Gothic illuminated manuscript, in the British Museum, London.

SAINTONGE, CHURCHES OF. The region just south and west of Poitou (and Poitiers) in France is the area in which we find a style of Romanesque architecture related to that of Poitou, yet with very special distinctions, notably in the matter of sculptural ornamentation. Fanning out from the churches of Saintes as far north as Aulnay, one finds magnificent and fantastic undercutting of the archivolts of both doorways and adjacent recesses. The peculiarly beautiful treatment of angels and of the Vices and Virtues and the curious beasts and monsters all attest to the influence of Moorish objects and embroideries. The apses of these churches are especially rich in sculptural décor, and here again Moorish treatment is prevalent, undoubtedly owing to the assistance of the regional leaders in the reconquest of Spain, who brought back precious Moorish materials. *See* AULNAY: ABBEY CHURCH OF SAINT-PIERRE; SAINTE-MARIE-DES-DAMES, SAINTES; SAINT-EUTROPE, SAINTES.

BIBLIOGRAPHY. E. Mâle, *L'Art religieux du XIIe siècle en France*, Paris, 1922.

SAINT-OUEN, ROUEN. French church whose choir and transepts were completed during the 14th century. The remainder of the building, however, though it belongs to the 15th century, still adheres to the finest traditions of the Rayonnant Gothic period. The tower over the crossing is especially beautiful. The doorway of the Marmosets and the rose window of the south transept are noteworthy.

ST. PARASKEVI CHURCH (Eski Djuma; Achiropiitos; Church of the Virgin), SALONIKA. Early Byzantine building of the 5th century. It has three aisles, an east apse, and

a gallery and is timber-roofed. The aisles are separated from the nave by a columnar arcade. Great emphasis on the ground level windows give the arcade a light-screen effect. This basilican type is probably similar to the pre-Justinian second church of Hagia Sophia, Constantinople.

ST. PATRICK'S CATHEDRAL, NEW YORK. Cathedral built by James Renwick between 1858 and 1888, it was the first major American cathedral in French Gothic style. Its interior length is 306 feet, the height of its nave is 108 feet, and its tower is 330 feet high. A Lady chapel was added between 1901 and 1906.

BIBLIOGRAPHY. M. Schuyler, *American Architecture and Other Writings*, ed. W. H. Jody and R. Coe, 2 vols., Cambridge, Mass., 1961.

ST. PATRICK'S SHRINE. Celtic metalwork, in the National Museum, Dublin.

ST. PAUL'S CATHEDRAL, LIEGE. Former abbey church in Belgium. Although it was designated a cathedral in 1802, St. Paul's has a Gothic *chevet* that dates from 1280. Most of the decoration, however, is later. The nave was completed in 1528, but was restored in the Renaissance style. The western tower dates from 1812.

ST. PAUL'S CATHEDRAL, LONDON. Great church in the English Renaissance style. The masterpiece of Sir Christopher Wren, it was built between 1675 and 1710. After the Great Fire of 1666 the burned-out medieval Church of St. Paul's, which had been worked on early in the century by the architect Inigo Jones, was dismantled. Wren presented a series of designs and models to King Charles II and his advisers, and in 1675 a project was approved that called for a cross plan 500 feet in length. Modifications were introduced as the building was erected; the result is a majestic edifice with a two-story exterior façade, twin towers at the west end, and a dome over the crossing that rises 350 feet above the pavement. Wren also planned the surroundings of the church, but these designs were never executed.

Under the building are massive masonry vaults that house the tombs of Wellington, Nelson, Wren, and other eminent figures. Behind the monumental west façade with its twin towers is a domical vestibule flanked by large vaulted chapels. The nave, aisles, transept, and choir are marked off by piers carrying huge Corinthian pilasters, and all these spaces are covered by domical vaults. Wren's knowledge of engineering and mathematics is demonstrated by his structural method, especially in the ingenious solution of the problem of the main dome. A cone of brick, unseen by the visitor, supports the stone lantern at the very top of the building. Above and below this cone are two domes, the inner one decorated with paintings by Sir James Thornhill, the outer one forming the most famous silhouette of London. Throughout the building the woodwork and ironwork, by Gibbons and Tijou, are of very high quality.

The building has been criticized chiefly on two counts: the handling of the forms of the piers and arches below the central dome; and the false walls of the exterior upper stories, which mask a buttress system almost Gothic in its dispositions. But it would be difficult to underestimate St. Paul's importance in the history of art. Here Wren

St. Patrick's Shrine. National Museum, Dublin.

trained junior designers and employed craftsmen and artists of the first rank, and the finished building deeply influenced the art and architecture of England, its colonies and Commonwealth, and the United States. St. Paul's was struck during the air raids of World War II but was saved by heroic efforts. A chapel has since been dedicated to Americans who died in that war.

BIBLIOGRAPHY. *Publications of the Wren Society*, vols. 13–16, Oxford, 1936–39; E. Sekler, *Wren and His Place in European Architecture*, New York, 1956; J. N. Summerson, *Architecture in Britain, 1530–1830*, 4th rev. ed., Baltimore, 1963.
WILLIAM L. MAC DONALD

ST. PAUL'S CHAPEL, NEW YORK. Erected in 1764–66, Thomas McBean's building is the only pre-Revolutionary religious structure surviving in New York. Based on James Gibbs's prototypes, it was designed to have a portico and a large steeple rising above its two tiers of windows. The portico and steeple were not added until 1794–96. The Chapel's rich ornament and sense of scale create a handsome interior space.

BIBLIOGRAPHY. H. S. Morrison, *Early American Architecture*, New York, 1952.

ST. PAUL'S OUTSIDE THE WALLS (Basilica Ostiense), ROME. Early Christian church, one of the four major basilicas of Rome. St. Paul's was built late in the 4th century and richly decorated with mosaics a few decades later. The greater part of the building burned down in 1823; rebuilt, the church was reconsecrated in 1854. In form a five-aisled basilica 400 feet long, St. Paul's has a deep transept and a large semicircular apse at its east end. During the 19th-century reconstruction a spacious atrium was added to the west in imitation of the presumed original plan; this work has a rather harsh quality. Inside, the two files of twenty columns each that flank the nave form

St. Paul's outside the Walls, Rome. Columned side aisle of this early Christian basilica, built in the 4th century and largely reconstructed in the 19th century.

a splendid perspective vista toward the distant triumphal arch (separating the nave from the transept) and the apse. The double side aisles are covered by roofs lower than the high upper walls of the nave, so that the latter space is generously lit by clerestory windows.

Only the mosaics upon the triumphal arch are Early Christian; they depict the Savior, adoring angels, the symbols of the Evangelists, saints, and elders. Over the main altar is a magnificent tabernacle by Arnolfo di Cambio (1285), and in the apse is a mosaic (early 13th cent.) depicting Christ, saints, a jeweled cross, and the symbols of the Passion. Throughout the church there are a number of works of art donated by various heads of state, for example, two transeptal altars from Nicholas I of Russia. Among the treasures of the church are the remains of magnificent bronze doors made in Constantinople in 1070 and donated by a merchant family of Amalfi. They were badly damaged in the fire of 1823, but something of their engraving and silver inlay can still be seen: the Byzantine artist executed twelve Gospel scenes and explained them in his native Greek. *See* AMALFI DOORS.

The cloister (early 13th cent.) is remarkable for its pavements, columns, fantastic carvings, and collection of sculpture. Some of the columns are fluted and inlaid with sparkling mosaic, some are of spiral shapes, and others appear to have been twisted from baker's dough. Although largely rebuilt, St. Paul's preserves the effect of noble spaciousness that was common to all the large Early Christian basilicas, and it is important for that reason as well as for its historic monuments.

BIBLIOGRAPHY. I. Schuster, *La basilica e il monastero di S. Paolo*, Turin, 1934; M. Armellini, *Le chiese di Roma...*, 2d ed., 2 vols., Rome, 1942; E. Mâle, *The Early Churches of Rome*, London, 1960.

WILLIAM L. MAC DONALD

ST. PETER IN CHAINS, ROME, *see* SAN PIETRO IN VINCOLI, ROME.

ST. PETER'S (New), ROME. By the 15th century Old St. Peter's was threatening to collapse. A new building was started in 1452 under Pope Nicholas V with the larger choir, which is usually attributed to Bernardo Rossellino, then engineer of the Vatican palace. At the same time the south (left) transept was begun, also on a larger scale; the choir was continued in 1471–72 by Giuliano da Sangallo. *See* ST. PETER'S (OLD).

The real history of the modern church begins under Pope Julius II (1503–13). At first Julius planned to continue the work begun by Nicholas V; in March, 1505, a special chapel was planned for Michelangelo's tomb of Julius, but by the next month the Pope had changed his mind, perhaps transferring the idea of a domed chapel to the more grandiose memorial of a new domed church. Projects were begun by Fra Giocondo, Giuliano da Sangallo, and Bramante.

Bramante, who dominated the first stage of planning, was architect of St. Peter's between 1506 and his death in 1514. In April, 1506, the first stone was laid under one of the crossing piers; the other three piers were begun a year later. By the time of the death of Julius II in February, 1513, all four piers were vaulted with arches and the tribunes were begun. Apart from this beginning, the record of Bramante's project is conflicting. A medal of 1506 shows a large domed structure with corner towers. A similar, but not identical, scheme is seen in the parchment plan (Florence, Uffizi; no. 1) that shows half of what may be a centralized building. These are the only two completely acceptable records of Bramante's project, and both are equivocal. Neither necessarily represents a cen-

tralized structure, although both may be so interpreted. The confusion over Bramante's intentions is heightened by the fact that he vaulted the "Rossellino" choir as if to incorporate it into his own design. There are also indications that a nave was seriously considered in the same years; there was constant pressure to cover the entire area of Old St. Peter's, and Bramante may have kept his centralizing projects ambiguous for fear of interference. The central plan, with the dome design published by Serlio, can be reconstructed with some clarity. It was essentially a Greek cross superimposed on a square; the dome diameter is wider than the arms of the crossing, and between these arms lie subordinate areas that connect with the corner towers. The large hemispheric dome, above a drum buttressed by a ring of freestanding columns, is the central feature and inaugurates a new era in church design. Based on Bramante's reconstruction of antique *tholoi* (circular domed buildings) and prefigured by his tiny Tempietto of S. Pietro in Montorio, Rome, the dome itself is modeled on the Pantheon, Rome, and is of the same diameter. Vasari said that Bramante envisioned the dome of the Pantheon above the Basilica of Maxentius. Such a single-shell dome would have been possible only in concrete, a medium that Bramante rediscovered from his study of antique examples. The arches below the dome were cast in this material beginning in 1610. Whether central or longitudinal, Bramante's scheme was centered on the domed unit on pendentives supported by piers faced with a paired pilaster motif. While everything else has changed around this domed unit, Bramante's crossing piers set the super-human scale that is still the basic quality of the church.

Raphael took over the duties of architect in 1514 on the recommendation of Bramante. To this period belong an assortment of projects; the confusion is perhaps reflected in Uffizi no. 20, a plan that shows the Rossellino choir and the Constantinian basilica with variants on Bramante's piers, plus ambulatories, and the beginning of a nave. Date and author are uncertain, but 1514 may be close. Raphael's new plan, mentioned in the bill of appointment, seems to have incorporated a nave; the plan printed by Serlio probably dates from the later years of Leo X; it has a nave attached to the "Bramante" plan of Uffizi 20; the façade was based on a portico of freestanding columns, and the rest of the exterior employed a colossal order corresponding to the one inside. This stage of planning may be reflected in the elevations of S. Biagio, Montepulciano (1518; Antonio da Sangallo the Elder).

In the years following Raphael's death (1520) little progress was made. The sack of Rome (1527) interrupted all building; the new architect, Antonio da Sangallo the Younger, spent most of the available money on a huge wooden model (1539; Museo Petriano, St. Peter's). This combined the central plan of Bramante with a forechurch with two towers; the dome, now double shelled, was circled by tiers of ornament.

This scheme incurred the ridicule of Michelangelo, who was appointed architect on Jan. 1, 1547, after the death of Sangallo. Sangallo had raised the pavement height and had strengthened the crossing piers to support a traditional masonry dome. Michelangelo turned back to Bramante's central scheme ("He who departs from Bramante departs from the truth") but simplified the elements, eliminated the corner towers, and greatly increased the mass of the walls in relation to the space. He gave the exterior a colossal paired pilaster order and an active plan that achieves a uniquely dynamic power and movement. His studies for the dome were first based on Brunelleschi's Florence Cathedral cupola, but later resolved on a compromise: hemispheric in profile, but unified by ribs running from the drum to the lantern. This project was commemorated by a wooden model whose inner shell survives. After Michelangelo's death in 1564 the project (with later additions) was preserved in engravings by Du Pérac, which combine features of Michelangelo's early model (lost) with his later dome ideas.

The church was continued on this scheme: the Rossellino choir was destroyed, an attic of ambiguous character was built above Michelangelo's colossal exterior order, the drum was erected. The Cappella Gregoriana (begun by Vignola) and the Cappella Clementina (by Giacomo della Porta) were built and given exterior domes by Della Porta. The main dome was finally built by Della Porta between 1588 and 1590 under Sixtus V. Della Porta's new design, based on Michelangelo's, has a pointed profile and increased vertical movement. In the same pontificate the Neronian obelisk was moved to its present site, where it became the center of Bernini's piazza. The church, without façade, but with the great dome and the two smaller eastern domes, was finished and partially decorated under Clement VIII (1592–1605). *See also* DOME.

Under Paul V (1605–21) it was finally determined to complete the building with a nave; after a competition the commission went to Carlo Maderno, who finished the façade in 1612. Only in this period was the nave of Old St. Peter's finally pulled down. In 1612, with the new nave under construction, it was decided to add towers at either side of the façade. These were carried only as high as the attic and give the composition unusually long proportions. The façade proper is based on Michelangelo's exterior: engaged colossal columns support the entablature and a central pediment that stands before the attic. Within, a narthex is surmounted by the Papal Benediction Loggia. Towers were begun by Bernini in 1637 but had to be abandoned. The interior was given its baroque character by Bernini for the 1650 Jubilee, and the great oval piazza (1656–67) is also his.

St. Peter's is as notable for its decorations, statues, and tombs as for its architecture. Among these may be mentioned Bernini's equestrian *Constantine*, the altar in the Cappella del Sacramento, the baldacchino, and the cathedra; his tombs of Urban VIII and Alexander VII; and the statues in the crossing piers by Bernini, Mochi, Duquesnoy, and Bolgi. Earlier monuments placed in the church include the medieval bronze statue of St. Peter, Michelangelo's *Pietà*, and Guglielmo della Porta's tomb of Paul III. The great series of baroque paintings executed for the altars have been replaced by mosaic copies.

BIBLIOGRAPHY. D. Frey, *Bramantes St. Peter-Entwurf und seine Apokryphen*, Vienna, 1915; R. Wittkower, "Zur Peterskuppel Michelangelos," *Zeitschrift für Kunstgeschichte*, II, 1933; N. Caflisch, *Carlo Maderno*, Munich, 1934; G. Giovannoni, *Saggi sulla architettura del rinascimento*, Milan, 1935; R. Wittkower, *Art and Architecture in Italy, 1600–1750*, Baltimore, 1958; J. Ackerman, *The Architecture of Michelangelo*, 12 vols., London, 1961.

HOWARD HIBBARD

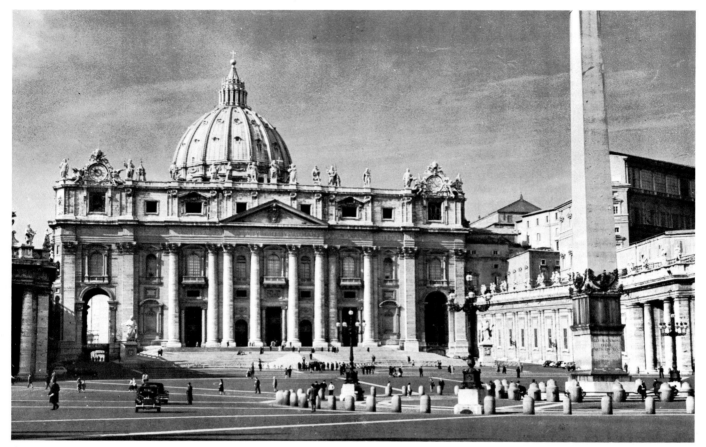

New St. Peter's, Rome. The façade, based on plans by Maderno, seen from Bernini's great oval piazza.

ST. PETER'S (Old), ROME. Original, Early Christian basilica as distinguished from the Renaissance church of St. Peter's on the same site. *See* ST. PETER'S (NEW).

Old St. Peter's was of Constantinian foundation, and was completed about 333. The church was built on the site of an old necropolis (135–180) that contained tombs of wealthy adherents to the various Oriental mystery cults flourishing in Rome at the time. Some of these tombs, found recently, were richly decorated in stucco and paint. One tomb within this complex, the so-called "red room," which contained a niche (ca. 180), began to be venerated as the burial place of St. Peter. This area became the focal point for the building of Old St. Peter's, with the "red room" serving as the point of orientation for the altar.

Nothing remains of the Constantinian building, but archaeological investigations have shown that the church was a five-aisled, columnar basilica, with a long, rectangular transept. The transept and a semicircular, vaulted apse were at the west end of the building, and the east end opened onto an atrium. (This was quite common in the Early Christian period, when churches had not yet been oriented.) The ends of the transept, north and south, had small rectangular alcoves, separated from the transept proper by a columnar screen. In all probability, there were upper rooms over the alcoves. The aisles terminated in a columnar screen that separated them from the transept. The east end of the atrium was entered through a gatehouse. It is still not known if Old St. Peter's had a gallery,

or if the aisles were single story, with large clerestory windows in the nave. The building was roofed with open timber trusswork, and the vaulted apse (as we learn from the *Liber Pontificalis*) was covered with gold.

The continuous, undivided transept gave Old St. Peter's the form of a "T" basilica, one of only two of this type constructed by Constantine (the other is St. Paul's outside the Walls). Along with the Lateran, S. Lorenzo, and S. Agnese (all 4th cent.), Old St. Peter's is one of the Constantinian basilicas dedicated to martyrs. Each church shows a different approach to the problem of building a basilica associated with the veneration of a martyr. One can only assume that, in this early period of Christian architecture, Constantine and his builders were experimenting with various building types that would fit the liturgical needs of the Church and the community. Old St. Peter's represents one of their solutions—imaginative and unusual, but not necessarily the most successful (judging by the lack of repetition of this type).

BIBLIOGRAPHY. R. Krautheimer, "The Carolingian Revival of Early Christian Architecture," *Art Bulletin*, XXIV, 1942; J. G. Davies, *The Origin and Development of Early Christian Church Architecture*, London, 1952.

STANLEY FERBER

ST. PETERSBURG, *see* LENINGRAD.

SAINT-PHILIPPE-DU-ROULE, PARIS. Church designed by Chalgrin before 1765 to replace a church demolished

in 1750. The work was begun in 1772, and the high altar was consecrated in 1784. The project and original state of the church is known through engravings in Legrand-Landon. *See* CHALGRIN, JEAN-FRANCOIS-THERESE.

Setting the pattern for churches inspired by the Early Christian basilica, the church contains a peristyle, nave, and two aisles separated from the nave by columns and entablature. Both nave and aisles are barrel-vaulted; the nave vault is coffered. A crossing area is defined by a clerestory window and two chapels that occupy the transept wing section. The exterior is extremely simple, the only accent being the four columns of the portico, in the Roman Doric order. The interior was modified by Godde in 1846 and again by Ballard in 1853.

SAINT-PIERRE, CATHEDRAL OF, BEAUVAIS. The ultimate attainment of verticalism in French Gothic architecture. The choir vaults are 157 feet 6 inches from the pavement of the church; those of the aisles are 69 feet 8 inches. The high vaults are upheld by a series of massive double flying buttresses built in two stages. Stone gives way almost completely to great surfaces of stained glass, the triforium and clerestory seeming almost one continuous glazed surface. Although St-Pierre is unfinished, it remains one of the great triumphs of the High Gothic style. The present Cathedral consists of a choir with three double bays and flanking double aisles, a broad ambulatory with seven polygonal radiating chapels, the grand transept extending three bays on either side of the crossing, and one nave bay with double aisles on either side.

The Cathedral was designed between 1230 and 1240 after a fire of 1225 had destroyed the old Carolingian choir. It was planned to be the replacement for the double Church of Notre-Dame, called the "Basse Oeuvre," and St-Pierre, sometimes called the "Haut Oeuvre." The architect for the new Cathedral may have been one employed in the masons' lodge at Amiens, for he used a similar plan for the choir, although Amiens had not been begun at this time. His work also shows some relationship to the Cathedral of Le Mans and the Abbey Church of St-Denis. *See* NOTRE-DAME-DE-LA-BASSE-OEUVRE.

In 1272 the apse and a part of the choir were nearly finished, but before the church was completed, in 1284, some of the exterior buttresses gave way, causing a number of the choir vaults to collapse. As a result, the pillars of the choir were doubled, so that in the three bays of the choir the original quadripartite vaults were replaced with sexpartite vaults. At the end of the 14th century, when the choir was finished, work was interrupted by the Hundred Years' War and civil disturbances.

In 1494 Jean Vast and Martin Chambiges were asked to construct a transept and accompanying portals. In 1500 new foundations were begun for the crossing. The two portals are magnificent examples of the Flamboyant Gothic style. The south portal was begun by Chambiges in 1500 and was finished in 1548 by Michel de la Lalict. It is the richer of the two in its ornamentation and resembles the south transept portal at Senlis, for which it served as the prototype. The façade itself, flanked by two small, elaborately decorated towers, gives way almost entirely to stained glass above the portal. The twin doors have elaborate carved panels on the top part, the work of Jean Le Pot. The north portal was begun by Chambiges in 1510 and was completed in 1537 by Lalict. Its ornamentation is similar to, if not as rich as, that of the south portal.

In 1544 the bishop and chapter met to discuss the possibility of adding a tower and flèche, or spire. In 1558 the necessary stone for the building of the tower was obtained, and in 1561, under François Mareschal, Master of the Works since 1555, the project was authorized. This work was accomplished at great expense: a major part of the Cathedral treasury was sold to provide the funds. In 1564 Jean Vast, the son of the builder of the transept, was charged with the construction of the flèche, which was completed by 1567.

The crossing tower consisted of four stages. The lower square stage of 48 feet, the second octagonal one of 68 feet, and the third of 50 feet, all in stone, were surmounted by a wooden flèche of 96 feet, crowned by a huge iron cross. Thus above the loftiest crossing that had yet been achieved was added a 262-foot tower. The total height from ground level to the top of the cross was more than 502 feet. The Cathedral had been built with inadequate foundations, and in 1573 the tower and spire fell, bringing down a great part of the Cathedral in the vicinity of the crossing. By 1575 all vaults that had fallen were repaired, but the Cathedral treasury was exhausted and the Wars of Religion had taken such a turn that neither a rebuilding of the church tower nor the construction of a nave was ever attempted.

After the fall of the crossing tower, all the main crossing supports, with the exception of those to the southeast, were completely reconstructed. The transept vaulting itself is of wood, including the vault over the crossing.

BIBLIOGRAPHY. R. de Lasteyrie, *L'Architecture religieuse en France à l'époque gothique*, vol. 1, Paris, 1926; V. Leblond, *La Cathédrale de Beauvais*, Paris, 1926; M. Aubert and S. Goubet, *Gothic Cathedrals of France and Their Treasures*, London, 1959; P. Frankl, *Gothic Architecture*, Baltimore, 1962.

EDWARD P. LAWSON

SAINT-PORCHAIRE. Site near Bressuire, Deux-Sèvres, France, of a 16th-century French pottery. An unusual fine white earthenware with inlaid decoration was produced there. French Renaissance metalwork and architectural forms provided the main inspiration for shapes colorfully inlaid in blue, green, ocher, and black. This earthenware was once called "Henri Deux."

BIBLIOGRAPHY. W. B. Honey, *European Ceramic Art from the End of the Middle Ages to About 1815*, 2d ed., London, 1963.

SAINT-REMI, REIMS. French abbey church. Built over the traditional tomb of St. Remi, one of the greatest of the early apostles of Gaul, and dedicated to the saint prior to the year 1000, it was the most celebrated abbey church in Champagne. Of the Carolingian choir, consecrated in 852 by Archbishop Hincmar, nothing remains today. The present church, in its essential elements, dates from two periods: the nave, aisles, and west front, with the exception of the vaulting, from the middle of the 11th century; and the choir and the vaulting of the nave, from the late 12th century.

About 1005 Abbot Arard began to replace the Carolingian building with a most ambitious structure. This was never completed and was extensively modified under his successor, Thierry, from 1039 to 1045. The 11th-cen-

tury church was finished in 1049 by Thierry's successor, Herimar, and dedicated that same year by Pope Leo IX.

In 1170 Abbot Pierre de Celles vaulted the nave and entirely rebuilt the choir, a masterpiece of the early Gothic and related to the choir of Notre-Dame in Paris. The aspect of the nave vaulting was in large part ruined by the complete fall of the nave in 1918 under German bombardment. Today the church is a three-aisled basilica with an open west façade with 11th-century towers and a harmoniously disposed gable filled with windows. The arcades of the nave preserve their 11th-century aspect with tribunes over the aisles, but extra ribs were added to support the 12th-century quadripartite vaults.

The abbey itself was suppressed as a religious establishment at the time of the Revolution, and now houses the Historical and Lapidary Museum. A few fragments of the 12th century still exist in other abbey buildings. Especially notable is a series of 12th-century arcades, discovered in 1953 in the thickness of a wall of the chapter house, with historiated and grotesqued capitals.

BIBLIOGRAPHY. L. Demaison, "Eglise Saint-Remi," *Congrès Archéologique de France, LXXVIIIe Session tenue à Reims en 1911,* vol. 1, Paris, 1912; R. de Lasteyrie, *L'Architecture religieuse en France à l'époque romane,* 2d ed., Paris, 1929; G. Crouvezier, *Saint-Rémi de Reims,* Reims, 1957.

EDWARD P. LAWSON

SAINT-REMY, MONUMENT OF (Mausoleum of the Julii). Roman mausoleum of the late 1st century B.C., situated in Provence, France. Built of local stone, it consists of three parts. The lowest part is a square pedestal decorated with pilasters on the corners, which frame four relief panels, one on each side. Above the pedestal rises a square structure in the form of an *arcus quadrifons* with an archway on each face and engaged Corinthian columns at the angles, supporting an entablature decorated with a floral frieze. This, in turn, is surmounted by a circular structure consisting of ten freestanding Corinthian columns carrying an entablature and a conical stone roof. The plan of the mausoleum shows Eastern origin, and the treatment of the floral ornamentation derives from the Hellenistic tradition. The four relief panels on the pedestal are decorated with battle scenes (battles between Romans and Gauls) on three sides and a hunting scene on the fourth side. The relief carving is a provincial work. The scenes are crowded, and their composition lacks clarity.

BIBLIOGRAPHY. W. J. Anderson, R. P. Spiers, and T. Ashby, *The Architecture of Greece and Rome,* vol. 2: *The Architecture of Ancient Rome,* London, 1927; H. Rolland, *Saint-Rémy de Provence,* Bergerac, 1934.

SAINT-RIQUIER, ABBEY OF. French abbey founded at ancient Centula about 645. The design of the Carolingian church, of which nothing remains, was very influential in Germany. The church was executed under the aegis of the abbot Angilbert sometime after 790 and was dedicated in 799. A three-aisled basilica with transepts and a semicircular apse, St-Riquier achieved its dynamic quality from its multitude of towers. Two flanked the apse, one rose above the crossing, one above the westwork, and one above the axial entrance of the atrium. The towers terminated in gracefully proportioned, stepped circular spires, giving an exciting silhouette to the whole. Most significant at St-Riquier was the westwork, the earliest known example of this feature. This massive structural unit, which encom-

passed the entranceway and contained the Chapel of the Savior, foreshadowed the strongly articulated, highly plastic west façades so characteristic of Romanesque and Gothic churches.

The plan and the transept of the present church are of the 13th century, but the choir, ambulatory, nave, and aisles were rebuilt in the Flamboyant Gothic style in the 15th–16th century. The abbey buildings date mainly from the 17th century.

STANLEY FERBER

SAINT-ROCH, PARIS, *see* DE COTTE, ROBERT.

SAINTS, BIOGRAPHIES OF, *see* names of individual saints. *See also* SAINTS IN ART.

SAINT-SATURNIN, CHURCH OF. Church near Riom-ès-Montagne in south central France. While less well known than Notre-Dame-du-Port at Clermont-Ferrand or St-Austremoine at Issoire, St-Saturnin is a characteristic example of the early 12th-century French Auvergne style, with its curious raised box beneath the crossing tower and exterior polychrome decorations. Here, however, the usual radiating chapels are lacking.

SAINT-SAUVEUR, AIX-EN-PROVENCE. Cathedral in southeastern France. Its principal nave, a Gothic structure of the 13th century that was built on the remains of 11th-century walls, was modified repeatedly between the 14th and the 18th century by the addition of chapels.

On the right side of the west façade is a Provençal Romanesque portal belonging to the original parish church that was incorporated in the Cathedral. This portal is strikingly incompatible with the Flamboyant Gothic style of the central façade (early 16th cent.). The exterior sculptures were almost all destroyed in the Wars of Religion and the Revolution; only the Virgin and Child of the trumeau (ca. 1505) and the St. Michael above the central window are old. At the north corner is a Gothic bell tower (14th–15th cent.). A small, elegant, timber-roofed 12th-century Romanesque cloister adjoins the Cathedral.

The interior of the Cathedral contains elements from the 5th to the 16th century, the oldest remnants being the 5th-century Baptistery, which was largely rebuilt in the 16th century, and the sarcophagus of St-Mitre. The octagonal font of the baptistery is surrounded by eight Roman columns surmounted by a Renaissance dome.

The triptych of the *Burning Bush* by Nicolas Froment is among the outstanding works of art in St-Sauveur. The 15th-century retable of the *Legend of St-Mitre* is attributed to Froment. The collection of twenty-six 16th-century Brussels tapestries is noteworthy.

BIBLIOGRAPHY. F. Benoit, "Cathédrale Saint-Sauveur," *Congrès Archéologique de France, 1932,* Paris, 1933.

MADLYN KAHR

SAINT-SAVIN-SUR-GARTEMPE: ABBEY CHURCH. French church founded by Charlemagne as part of an abbey and fortress in 800, on the spot where St. Savin had been martyred in the 5th century. Later Louis the Pious took the body of St. Cyprien of Poitiers there to be interred. Destroyed in 876 by vandals, the church was completely rebuilt in its present state between about 1060

and 1115. The superbly graceful Gothic spire was added in the 14th century. The church was damaged by the Huguenots between 1562 and 1568 and neglected during the 17th century. It was excellently restored by the Benedictines after the French Revolution.

Aside from the handsome quality of its architecture, St-Savin is most famous for its 11th- and 12th-century frescoes. Near the entrance through the porch beneath the western tower is a series of scenes derived from the Apocalypse of St. John. The style of the paintings, which is tremendously dynamic, was undoubtedly inspired by manuscripts of the school of Limoges. A close relationship may be found between these paintings and the famous tapestries of the *Apocalypse of Angers*. Among the paintings are Christ in the setting of the Heavenly Jerusalem, angels and apostles, archangels, and beasts, all powerfully and colorfully delineated. Many paintings of the tribune gallery suffered during the Wars of Religion, but there is still a fine painting of the Descent from the Cross. Here the style is as restrained as it was animated in the frescoes of the entrance porch. The colors of the Romanesque paintings in the vaults of the nave are somewhat faded, but the power of the drawing is superbly clear. The frescoes depicting the creation of the world, Adam and Eve, the Temptation, Moses and Noah, Abraham and Isaac, and Jacob and Joseph run the length of the nave in parallel bands. There is grace, strength, and elegance in the work, and a wonderful rapidity of style that is at once controlled and vividly expressive. In the crypt is a series of frescoes dealing with the lives of St. Savin and St. Cyprian. Here the painting is much tighter, the mood is more somber, and the colors are darker and richer. It is thought that the paintings were executed by four artists over a considerable period of time.

BIBLIOGRAPHY. M. Aubert, "St. Savin," *Congrès Archéologique de France*, CX, 1952; P. Deschamps, "Les Peintures de L'Église de St. Savin," *Congrès Archéologique de France*, CX, 1952.
ALDEN F. MEGREW

ST. SAVIOR PANTEPOPTES, CONSTANTINOPLE. Byzantine church of the 11th century, now a mosque. It is in plan a cross inscribed in a rectangle, with a central dome, an elongated sanctuary, and a narthex. Remains of excellent architectural carvings are still to be seen.

BIBLIOGRAPHY. A. van Millingen, *Byzantine Churches in Constantinople*, London, 1912.

SS. COSMAS AND DAMIAN, ROME. Early Christian church beside the Roman Forum. It was fashioned from a pagan building in the early 6th century by Pope Felix IV. The building is of interest chiefly because of its mosaics, which, though damaged during the 16th century and shortly thereafter restored in part, preserve the grandeur of their original composition and colors. On the triumphal arch appear the Lamb of God, seven-branched candelabra, angels, and symbols of the Evangelists. In the quarter sphere of the apse is a majestic Christ in Glory, flanked by SS. Peter and Paul, the titular saints, and Pope Felix offering a model of the church (the latter figure is entirely restored). This composition greatly influenced medieval Roman artists, particularly those of the 9th century.

BIBLIOGRAPHY. J. Wilpert, *Die römischen Mosaiken und Malereien der kirchlichen Bauten vom IV. bis XIII. Jahrhunderts*, 2d ed., 4 vols., Freiburg im Breisgau, 1917; E. Mâle, *The Early Churches of Rome*, London, 1960.

ST. SEBALD, NURNBERG. Double-choir parish church in Germany. It combines contrasting Romanesque and Gothic elements. The earlier style is still evident in the square double towers of the west façade, the square piers, the squat proportions, the large areas of blank wall in the nave (1225), and the round arches on the exterior of the west choir (consecrated 1273). The original east choir, consecrated in 1255, also belonged to this transitional period, but it was replaced in 1361–79. Octagonal piers soar straight up to the star vaults, raising them above those of the nave and opening the interior to light which floods in through the large stained-glass windows (14th–16th cent.).

A wealth of sculptures adorns the exterior, including the Schreyer Monument by Adam Kraft on the exterior of the east choir. Late Gothic and Renaissance sculptures of the Nürnberg school are found throughout the interior, including Peter Vischer the Elder's tomb of St. Sebald in the east choir, Veit Stoss's *Crucifixion* over the high altar, and many other works by these artists. *See* ST. SEBALD, TOMB OF, NURNBERG.

BIBLIOGRAPHY. F. W. Hoffmann, *Die Sebalduskirche*, Vienna, 1912.
EDWARD P. LAWSON

ST. SEBALD, TOMB OF, NURNBERG. The major work of Peter Vischer the Elder, located in the east choir of the parish church of St. Sebald, Nürnberg. It was executed between 1508 and 1519 with the collaboration of Vischer's sons, Hermann and Peter the Younger, and presents a compendium of Gothic and Renaissance forms. The earlier silver sarcophagus (1397), which holds the relics of St. Sebald, is sheltered under a Gothic canopy surmounted by three domes. Prophets, apostles, and reliefs of the miracles of St. Sebald adorn the base; Renaissance ornament and figures from classical mythology adorn the canopy. *See* VISCHER, PETER, AND SONS.

St-Sernin, Toulouse. The largest Romanesque church in southern France.

SAINT-SERNIN, TOULOUSE. Romanesque basilica famed as the largest and most beautiful in southern France, as well as the richest in relics. The present church replaced earlier sanctuaries established at the burial place of St. Saturnin, first bishop and martyr of Toulouse, popularly called St. Sernin. Its relics, which included the bodies of six of the apostles, the gift of Charlemagne, made it a favored stopping place for pilgrims on their way to Santiago de Compostela. Like the church at Compostela, the Benedictine abbey church of St-Sernin, begun in 1060 and completed in the middle of the 12th century, was laid out according to a new plan designed for the movement of large crowds. It comprises double aisles, multiple naves, transepts, ambulatories, radiating chapels, and galleries. Exceptionally large for a Romanesque structure, the church is 377 feet long, with a transept 210 feet wide; the roof is 69 feet high.

The interior is tall and dark. Above the arcade is a gallery, and above that is the tunnel vault; thus there are no clerestory windows to pierce the gloom. The view of the chancel is obstructed by the massive piers, which are needed to support the tower that rises at the crossing. Choir, transept, and triforium are enriched by finely carved capitals. The transept is bordered by aisles surmounted by galleries.

At the crossing stands the original Romanesque marble altar consecrated in 1096. Of the same period and material are seven bas-reliefs now embedded in the wall of the ambulatory, depicting Christ in Majesty with angels and apostles. An extraordinarily moving 12th-century Christ on the Cross in copper-sheathed wood hangs at the end of the north transept. There are two crypts, for under the 11th-century one a second was dug in the 13th century. Reliquaries and liturgical objects of the 12th and 13th centuries are exhibited in the crypts.

As to the exterior, the oldest part of the building, that dedicated in 1096, is seen from the east: the apse with five radiating chapels and the transepts with four. The *chevet* is largely of stone; in the nave, transepts, and tower brick predominates. The octagonal tower over the crossing has three lower stories, built in the early 12th century, with typical Romanesque arcades, and two upper stories, added 150 years later, with miter-shaped arches. The spire was built in the 14th century. The style of this belfry is reflected in many others in Languedoc and Gascony.

The south doorway, called the Porte Miègeville, a Romanesque structure of the early 12th century, established a style for the whole south of France. In its tympanum is depicted the Ascension, with the apostles gazing at the miracle from the lintel below. Before this portal stands a Renaissance gateway, all that remains of the wall that once enclosed the abbey.

Restorations by Viollet-le-Duc have marred the exterior of the basilica. The west front was completed only in 1929.

BIBLIOGRAPHY. A. Auriol and R. Rey, *La Basilique Saint-Sernin de Toulouse*, Toulouse, 1930; K. J. Conant, *Carolingian and Romanesque Architecture, 800–1200*, Baltimore, 1959.

MADLYN KAHR

SAINT-SEVER BEATUS, *see* BEATUS OF SAINT-SEVER.

SS. FELICE E FORTUNATO, VICENZA. Italian Romanesque church built in the 10th and 12th centuries on the site of an Early Christian building. Adjacent to the church is the Chapel of S. Maria Mater Domini, a domed cross-plan building of about 500.

SS. GIOVANNI E PAOLO, ROME. Church founded about 410 on the west slope of the Caelian hill, near the site where SS. John and Paul were said to have been martyred. The three-aisled basilica incorporates the walls of 2d- and 3d-century houses, parts of which are visible in the foundations and south flank of the church. The front portico and the campanile date from the 12th century. The interior was remodeled in 1715–18. The two-storied Roman house beneath the church is decorated with pagan and Christian frescoes (2d–3d cent.).

BIBLIOGRAPHY. A. Prandi, *Il complesso monumentale della basilica celimontana dei SS. Giovanni e Paolo*, Vatican City, 1953.

SS. GIOVANNI E PAOLO, VENICE. Large Italian church erected by the Dominicans between 1246 and 1430 in the sober form favored by the mendicant orders. Of the monuments to the twenty-five doges buried in the building perhaps the finest is the tomb of Pietro Mocenigo by Pietro Lombardo (completed 1481). The paintings include altarpieces by Giovanni Bellini and Lotto, as well as frescoes by Piazzetta, A. Vivarini, and Veronese.

BIBLIOGRAPHY. A. M. Caccin, ed., *La Basilica dei SS. Giovanni e Paolo in Venezia*, 3d ed., Venice, 1961.

ST. SIMEON STYLITES, *see* KALAT SEMAN: CONVENT OF ST. SIMEON STYLITES.

SAINTS IN ART. In the early centuries of the Church during the Roman Empire, the term saint was applied to any Christian; but a century or two later, it became limited to one whose exceptional holiness qualified him to be canonized and entitled to the veneration of the faithful. The cult of the early saints, the martyrs, was established by the community and by the local bishops, who canonized the community's saints. The Church honored them by an annual funeral commemoration sometimes held in the catacombs, using the tomb containing the saint's relics for the altar. Their names were inscribed in the local calendars on their feast days (date of death) and many subsequently became part of more universal calendars. Christianity spread over the Continent, Britain, and Ireland, reaching the Scandinavian countries last, in the 10th and 11th centuries. Names of "confessors," non-martyrs, were added to the calendars and the cult spread. With the increase in papal power, canonization became a papal prerogative in the 13th century.

Sources for the lives of the saints include the New Testament, especially the Acts of the Apostles; The Acts and Passions of the Martyrs, witnesses' accounts of their trials and executions (many were lost); Martyrologies, official registers of the martyrs, and "historical" martyrologies by Bede, Maurus, Ado, and Usuard; uncritical works such as Pope Gregory the Great's Dialogues; Jacobus de Voragine's edifying Golden Legend; and the 16th-century Roman Martyrology. Many such texts seem to have been written by conscientious religious clerks to lend support to canonization processes and to glorify the Church. Not

always having access to the facts, they improvised, then repeated incidents from one legend in another; if they added new material, they made no critical analysis or selection.

The saints wielded an enormous influence socially, economically, and artistically. When a child was baptized with the name of a saint, he was given a protector whom he was expected to venerate. Every guild had its patron saint. In addition, hosts of others were invoked for a variety of utilitarian causes: victory in battle; protection from disease; watching over the vineyards, crops, and livestock; and so forth. Prodigious wealth accrued from pilgrims' offerings to the church or abbey possessing the relics of a popular saint. Pilgrimage churches had to be enlarged to accommodate the crowds, and ambulatories were introduced behind the choir to make chapels with relics of individual saints accessible to pilgrims while Mass was being celebrated at the main altar. Sculptured and painted images and narrative scenes depicting the saints encouraged veneration; handsomely crafted reliquaries of dazzling gold, silver, and crystal protected and enhanced their relics and made them easily portable, and thus available for exposition. See PILGRIMAGE.

The Byzantine East loaded its mosaics, frescoes, and icons with inscriptions identifying the saints, whereas in the West the clergy and artists worked out an iconography, a system of characteristics and attributes, by which the illiterates of the congregation could identify the saints in sculpture, painting, or the minor arts. The first Christian art had shown a typically medieval lack of interest in the individual. The apostles, for example, with the exception of Peter and Paul, looked alike. Information about a saint's appearance was occasionally provided, as in the case of Pope Gregory the Great who admitted in writing to being obese, but the iconographers, like the saints' legend makers, chose to ignore or possibly to censure the facts and create their own forms. When the cult of saints became popular in the late Gothic period, the greater interest in the individual saint was apparent in art, for example, Dirk Bouts's *Last Supper* in the Church of St-Pierre, Louvain, Belgium.

The major categories of saints after the martyrs and confessors are the archangels, apostles, and Evangelists; the clergy; abbots, monks, and nuns; ascetics and hermits; laymen, from the ruler to his lowest subject, including pilgrims, penitents, and warriors; and scholars, doctors, and lawyers.

Costume can indicate whether a saint is Western or Byzantine and to what category he belongs: bishop, monk, or warrior. Until the realistic art of the 17th century, in which the penchant for contemporary costume became even stronger than in the late Middle Ages, the apostles and Evangelists commonly wore what Christ did, the classical tunic, mantle, and sandals (unless they were barefoot). The original Doctors of the Latin Church—Jerome, Ambrose, Augustine, and Gregory the Great—are attired as cardinal, bishops, and pope, respectively, with their heads covered; usually they have individual attributes. In Western art, the original Greek Church Doctors—Athanasius, Gregory of Nazianzus, Basil the Great, and John Chrysostom—all bishops, dress similarly in chasuble or cope, with pallium or an omophorion, usually without

miter; they often carry a book or scroll rather than a specific attribute. A pope, such as Gregory the Great, may wear the chasuble or cope worn by bishops and the tiara; he may carry a cross staff, Peter's key or keys, or a bishop's crozier. Jerome may appear in the scarlet robes and broadbrimmed hat of the cardinal, as an old desert hermit, as a scholar in his study, or in a combination of these roles.

Abbots wear their order's habit, often with the cope or a hooded cloak (scapular) and the miter, and carry the crozier. The outstanding monastic orders most frequently represented in art wore the following habits: Benedictine, black (Benedict may wear white to indicate a reformed order); Cluniac, Camaldolese, Carthusian, Cistercian, all reformed Benedictines, ordinarily wear white, Cistercians sometimes with a black scapular; Hospitalers of St. Antony, black; Augustinian Hermits, black with leather girdle, Augustine's usual garment; Friars Minor (Franciscans) and Poor Clares, coarse gray or brown with tri-knotted cord; Dominicans, white with black scapular; Carmelites, brown or black with white or striped cloak (Theresa wears a black veil, white coif, brown habit); Jesuits are dressed like 16th-century priests.

Desert ascetics and hermits, like Jerome, are often bald, long-bearded old men clad in tunics, tree bark, or leaves; they may carry a staff or crutch, and sometimes hold beads. Rulers wear crowns, royal regalia, and may have scepters. Professionals tend to wear contemporary costume, for example, in Fra Filippo Lippi's *St. Lawrence Enthroned with Saints and Donors* (New York, Metropolitan Museum) Cosmas and Damian are represented in the red cloak and biretta of the apothecary or physician.

What a saint wears may document changes in liturgy, arms and armor, or even fashions. Thus, 15th-century Flemish Annunciations were endowed with new liturgical meaning when the archangel Gabriel appeared as a deacon in a cope over an alb or dalmatic. It seemed natural to the late medieval or Renaissance artist, now on more familiar terms with his saints, to clothe the secular ones according to what the well-accoutered knight or fashionable lady was wearing, as Raphael does in *St. George and the Dragon* (Washington, D.C., National Gallery) or Lucas Cranach, in the *Martyrdom of St. Barbara* (New York, Metropolitan Museum).

The primary generic symbol of the saints is the halo, a disk of light associated with the sun-god, Apollo, and the pagan emperors as a symbol of power. The halo, with its suggestion of divine light, was first set apart for Christ and the Lamb, but was soon appropriated for the saints; to prevent confusion, Christ was given the cruciform halo (with cross inscribed). The rectangular halo, relatively rare, designated a "beatus," still living and uncanonized.

The almost ubiquitous book can be either a symbol or an attribute. Many saints carry books as symbols of learning, for example, the apostles often appear with a roll (early) or a codex. However, in the hands of an Evangelist or the founder of a monastic order, a book becomes a gospel or a monastic rule, an attribute which is not definitive by itself, but can, when used with other clues, establish identity. The martyrs' symbols are the palm, used by the pagans to represent victory over death; and the crown, the "crown of glory" (first Epistle of Peter 5:4).

Attributes, intended to be unique, were introduced into the context of a saint's image for identification. The iconographical program of the great Gothic cathedrals made attributes essential: now, for the first time, the images of the Apostles began to be provided with specific emblems, as for example, on the south portal of Chartres, Paul, Andrew, Bartholomew, and James the Less hold the instruments of their martyrdom. Few early saints had individual attributes, but by the 14th century, practically all the saints on the calendar had one or more attributes making them identifiable at a glance.

Attributes can be divided into four categories based on (1) instruments of torture or death: Lawrence's grill; (2) legend: Magdalen's jar of ointment; (3) occupation: Thomas's T-square; (4) saint's name: the lamb for Agnes (Latin *agnus*, lamb).

Naïve congregations, misunderstanding artistic conventions, at times misinterpreted them, giving rise to new legends, for example, the cephalophore who is shown holding his severed head to indicate that he was decapitated, inspired the legend that the saint had picked up his head and carried it after it was cut off (Denis was one to whom this applied). The dragon George vanquished symbolized the devil or sin originally, but people believed it was real, and a legend was born, incorporating in its written form elements obviously derived from the story of Perseus.

The Protestant Reformers' reaction in the 16th century

St. Sophia Cathedral, Novgorod, bronze doors, detail.

against the veneration of images and relics of the saints had been anticipated by the Iconoclastic Controversy in the Byzantine Empire and by Western intellectuals, such as Fulbert's pupil Bernard of Angers, who considered the veneration of all images other than the crucifix a superstition. The Church countered with a new iconographical program to be represented by a revised list of saints: a few old favorites such as Francis of Assisi and Antony of Padua were retained, but particular attention was focused on then-current figures such as Ignatius Loyola, Francis de Sales, and Theresa. Instead of the miracles so popular in pre-Reformation art, the new iconography stressed mystical ecstasies and heavenly visions, works of mercy, and the sacraments, especially the Holy Eucharist.

BIBLIOGRAPHY. P. Guérin, *Les Petits Bollandistes; vies des Saints . . . d'après le père Giry*, 7th ed.,. 17 vols., Paris, 1885; E. Mâle, *L'Art religieux du XIIᵉ siècle en France*, Paris, 1922; K. Künstle, *Ikonographie der christlichen Kunst*, 2 vols., Freiburg im Breisgau, 1926–28; E. Mâle, *L'Art religieux de la fin du moyen âge en France*, 4th ed., Paris, 1931; E. Mâle, *L'Art religieux du XIIIᵉ siècle en France*, 7th ed., Paris, 1931; E. Mâle, *L'Art religieux après le Concile de Trente*, Paris, 1932; Jacobus de Voragine, *The Golden Legend*, tr. G. Ryan and H. Ripperger, New York, 1941; M. Davenport, *The Book of Costume*, 2 vols., New York, 1948; G. Kaftal, *Iconography of the Saints in Tuscan Painting*, Florence, 1952; L. Réau, *Iconographie de l'art chrétien*, 6 vols., Paris, 1955–59; H. Roeder, *Saints and Their Attributes*, London, 1955.

ANGELA B. WATSON

SS. NEREO E ACHILLEO, ROME. Originally erected in A.D. 337, SS. Nereo e Achilleo was rebuilt (ca. 800) by Pope Leo III and entirely reconstructed in the 15th and 16th centuries. On the triumphal arch is a mosaic of the time of Leo III (795–816) with the Transfiguration, the Annunciation, and the Madonna and Child with an Angel.

BIBLIOGRAPHY. A. Guerrieri, *La chiesa dei SS. Nereo ed Achilleo*, Vatican City, 1951.

ST. SOPHIA, *see* HAGIA SOPHIA, CONSTANTINOPLE; KIEV; THESSALONIKA.

ST. SOPHIA, MISTRA. Mid-14th-century church in Mistrá, the late Byzantine capital of southern Greece. It is of small scale, with a decoratively patterned stone and brick exterior and high narrow interior spaces. Some of the richly worked Byzantine mosaic pavement has been preserved here, as have some frescoes, including one of the birth of the Virgin.

ST. SOPHIA CATHEDRAL, NOVGOROD: BRONZE DOORS. Splendid pair of Russian cathedral doors. They represent an important work of Romanesque art at its height. Although local Novgorod tradition ascribes the doors to Byzantine craftsmen working at Cherson in the Crimea, it is known that they were originally made for the Polish town of Plock. Bishop Alexander of Plock is depicted as the patron on one field of the doors, and Wichmann, the archbishop of Magdeburg, appears on another. Historical and technical considerations suggest that the doors were executed by Saxon craftsmen between 1152 and 1154. Together, the doors measure 11 feet 8 inches in height and 7 feet 9 inches in width.

The scenes were cast as separate panels and then nailed onto the wooden core of the doors. Heavy framing divides each of the two halves into twelve square fields surmounted by a broad rectangular field (twenty-six fields in all). Most of the relief scenes in these fields are clearly identified by

inscriptions in regular Latin characters, which evidently belong to the cast; these are supplemented by Cyrillic inscriptions added at a later date. Iconographically, most of the scenes depict the life of Christ, from the Annunciation to the Ascension; there are also some Old Testament episodes and some allegorical figures. An interesting feature is the portraits of the bronze founders Riquinus and Waismuth. The tubular surrounds framing the scenes are richly decorated with rinceau motifs. Two ferocious lions' heads, serving as handles of the doors, hold the heads of the damned in their mouths. The later Russian repairs include the supple figure of a centaur drawing a bow. The Russian bronze founder Abram added his own portrait to those already on the doors.

BIBLIOGRAPHY. A. Goldschmidt, *Die Bronzetüren von Nowgorod und Gnesen*, Marburg an der Lahn, 1932; *Die Bronzetür von Nowgorod*, Nachwort von W. Sauerländer, Munich, 1963.

WAYNE DYNES

SS. PETER AND PAUL, CATHEDRAL OF, WORMS, see WORMS CATHEDRAL.

SS. SERGIUS AND BACCHUS, CONSTANTINOPLE.

Byzantine church of the Justinianian period. It is a central plan, domed building with an irregular, rectangular basis and a semicircular apse. Built from 525 to 536, it has an octagonal nave separated from the aisle by eight massive piers. The areas between the piers are alternately niched and straight arcades. This plan is repeated in the gallery, with the entire edifice covered by a "pumpkin" dome (made of alternating flat and curved sections), a device that eliminates the need for pendentives to vault an octagon with a dome.

Spatially, a dynamic rhythm is created by the alternation of piers with arcaded areas, and is enhanced by the light and dark effects of the deeply cut capitals, archivolts, and moldings. Little or nothing of the original color (marbles, mosaics, and so on) remains, but a total impression of its original appearance may be gotten from the closely related Church of S. Vitale, Ravenna.

ST. STEPHEN'S CATHEDRAL (Stephansdom), VIENNA.

Austrian church, one of the largest medieval monuments in central Europe. Located in what is now the middle of the Inner City, it was founded in 1137 as a parish church outside the city walls. Its present form is largely that given it in a reconstruction started in the 14th century, supported by Duke Rudolf IV, though it reflects numerous other alterations. Although damaged by bombardment and artillery fire in 1945, by 1952 the Cathedral had been fully restored. Its steeply pitched, patterned roof of glazed tiles and its multipinnacled tower dominate the skyline of Vienna.

The late Romanesque west façade with its "Giant's Doorway" is the oldest part of the present structure, dating from before the fire of 1258. In 1422 it was pierced by the tall Gothic window in the center. The Gothic period of building had begun in 1304 with the choir, which was consecrated in 1340. After the completion of the choir, the late Gothic nave and the two side aisles were started, their construction continuing until 1446, when the vaulting, designed by Hanns Puchsbaum, was completed. The compound piers, each bearing three canopied statues, support an elaborate net vault.

SS. Theodore, Mistrá, probably dating from the 13th century.

The soaring tower attached to the south transept (1359–1433) was designed by Michael Chnab of Klosterneuburg and rises 446 feet from the ground. It was to have been matched by one on the north side, construction of which was started in 1467 after a design by Puchsbaum. The north tower was discontinued about 1511, and in 1579 it was topped by a cupola by Hans Saphoy.

The choir and St. Eligius's Chapel were enriched with a number of famous early and High Gothic sculptures, mostly standing figures in tabernacles. Many are *in situ*; others are in the Archiepiscopal Cathedral and Diocesan Museum. Perhaps the most celebrated feature of the interior is the late Gothic pulpit (ca. 1510), whose designer, Anton Pilgram, included his own portrait as if peering out of a window below the steps, humbly subordinate to the busts of the four fathers of the church that figure boldly within the elaborate tracery of the pulpit. Also of interest is the marble tomb of the emperor Frederick III (d. 1493); the tomb was begun in 1467 and completed in 1513.

BIBLIOGRAPHY. R. Ernst and E. Garger, *Die früh- und hochgotische Plastik des Stefansdoms*, Munich, 1928; R. K. Donin, *Der Wiener Stephansdom und seine Geschichte*, Vienna, 1946.

MADLYN KAHR

ST. STEPHEN WALBROOK, LONDON.

Church built by Sir Christopher Wren in 1672–87. It was essentially a trial effort to solve the problem, which presented itself on a grander scale at St. Paul's, of combining a central dome with an aisled nave and transepts. The solution, arrived at empirically, is a dome contained within the church and resting on eight arches supported by eight Corinthian columns. Four of the arches open into the nave and transepts, and the other four into triangular spaces covered with half-groin vaults. By adding an extra column in each of the four corners, and including these in the straight entablature, a square space is created in which the circular dome is inscribed. These baroque solutions and the some-

what ambiguous experience of both longitudinal and centralized spaces are met again in St. Paul's.

BIBLIOGRAPHY. N. Pevsner, *London*, vol. 1: *The Cities of London and Westminster*, Harmondsworth, 1957.

SS. THEODORE, MISTRA. Church of the Monastery of Vrontochion in the late Byzantine capital in southern Greece. It is probably of the 13th century. Its architecture is similar to that of Daphni and Hosios Loukos. Fragments of the original frescoes remain.

SS. TRINITA DI DELIA. Sicilian 12th-century church just west of Castelvetrano. SS. Trinità di Delia combines Byzantine and Islamic elements of design. The geometry of the Constantinople churches is enlivened here by a variety of Muslim forms. Inside, there are tombs of the Saporito.

BIBLIOGRAPHY. G. Patricolo, "La Chiesa della Trinità di Delia," *Archivio storico Siciliano*, V, 1880.

SS. VINCENZO E ANASTASIO, ROME. Small church overlooking the Trevi Fountain. It is noteworthy for its *mouvementé* two-story façade, which was executed in the full baroque manner by Martino Longhi (Il Giovane) in 1646–50.

ST. THEODORE, *see* ATHENS: MEDIEVAL.

ST. THEODORE, FIGURE OF. Gothic stone sculpture, in the Cathedral of Chartres.

ST. THEODORE STRATELATES, NOVGOROD. Russian church built in the merchants' quarter of Novgorod in 1361–62. It is an example of a local variant of the late Byzantine tradition, the Novgorod type, in which German influence plays a decisive role. Its characteristic features are the single apse and the roof with four steeply pitched gables and surmounted by a central drum and dome.

BIBLIOGRAPHY. G. H. Hamilton, *The Art and Architecture of Russia*, Baltimore, 1954.

ST. THEOTOKOS PAMMAKARISTOS, CONSTANTINOPLE. The construction of the Church of the All-Blessed Virgin has been dated between the 8th and 11th centuries. During the latter century a certain John Comnenus is believed to have lived there. The building is an abbreviated form of the domed Byzantine-cross basilica. During the 14th century a parekklesion in the form of a cross-in-square church was added to its southern side. After the fall of Constantinople in 1453 the Theotokos Pammakaristos became the cathedral of the Greek Patriarch. It was transformed into the Fetijé-djami, the Mosque of the Conqueror, under the rule of Sultan Murad II. The 14th- and 15th-century Byzantine mosaics in the building are among the finest surviving examples of the period.

BIBLIOGRAPHY. J. A. Hamilton, *Byzantine Architecture and Decoration*, 2d ed., London, 1956.

ST. THOMAS, CHURCH OF, NEW YORK, *see* CRAM, GOODHUE AND FERGUSON.

SAINT-TROPHIME, ARLES. Cathedral in southeastern France. Admired particularly for its 12th-century portal, a masterpiece of Provençal Romanesque art, the Cathedral of St-Trophîme is also renowned for its cloister enriched by superb sculpture. Frederick Barbarossa received the royal crown of Arles at St-Trophîme in 1178, and almost 300 years later the great art patron King René was married to his second wife, Jeanne de Laval, there.

Some remnants are still to be seen, particularly in the transept, of the original 7th-century church, which was dedicated to the preacher of Greek origin who evangelized Provence. The transept dates from the 11th century; the high, dark nave, with its extremely narrow vaulted aisles, from the middle of the 12th century; and the Gothic choir from the middle of the 15th.

In general composition and in many details the portal reflects Roman antiquity. Like the other great sculptural ensemble with which it is often compared, the abbey church of St-Gilles, St-Trophîme also betrays debts to the Romanesque carvings of Languedoc, to Lombard sculpture, and to the proto-Gothic art of the Ile-de-France.

Under a Roman gable on modillions opens the arched bay of the portal, divided by a *trumeau* and surmounted by a tympanum that is framed with a deep *voussure* (coving) and an elaborate archivolt. Encompassing the lintel is a magnificent frieze: the left part portrays a proces-

St-Trophîme, Arles. The cloister and bell tower of the Cathedral.

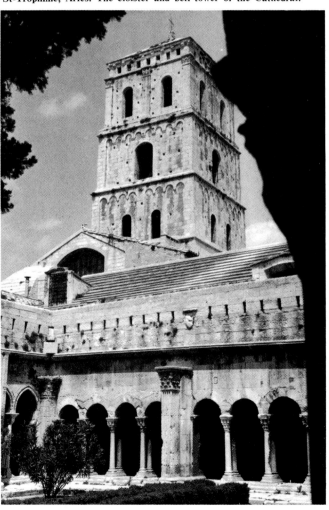

sion of the blessed and an angel placing souls of the elect in Abraham's bosom, with Isaac and Jacob seated beside him; the right part shows an angel repulsing sinners from the gates of paradise and demons dragging the damned to hell. Under this frieze a narrower figured band shows at the left the Magi before Herod and the Massacre of the Innocents and at the right the Adoration of the Magi and shepherds with their flocks. Below, in niches defined by engaged columns, stand large figures of saints that are separated by pilasters ornamented with rinceaux. The columns have fine capitals and curious historiated socles.

In the tympanum Christ in Majesty is represented surrounded by the symbols of the Evangelists, with the twelve apostles, seated, on the lintel. The *voussure* is lined by a double rank of bust-length angels, with three trumpet-playing angels of the Last Judgment at the summit.

The cloister, one of the finest in France, was intended for the canons of the Cathedral, whose refectory, dormitory, and chapter house surround it. The north and east galleries are entirely Romanesque (12th cent.); the south and west galleries are wholly Gothic (14th cent.). Justly famed are the historiated and foliate capitals of the paired columns, as well as the pillars with their large figures in relief. The figure of St-Trophîme, carved out of the angle of a pillar with an inscription dated 1180, has been called the finest and most typical creation of the Provençal Romanesque style.

BIBLIOGRAPHY. R. de Lasteyrie, *L'Architecture religieuse en France à l'époque romane*, 2d ed., Paris, 1929; L. H. Labande, *L'Eglise Saint-Trophîme d'Arles*, Paris, 1930; A. Villard, *Art de Provence*, Grenoble, 1958.

MADLYN KAHR

SAINT-URBAIN, TROYES. French church founded by Pope Urban IV in 1262. Its choir was completed about 1277 but was damaged by a fire in that year. The reconstruction and building of the rest of the church were terminated in 1290 when only three bays of the nave had been completed. St-Urbain, whose elevation contains neither gallery nor triforium, is one of the earliest and most extreme examples of the Gothic Rayonnant style with its replacement of the wall by the slenderest possible glazed tracery work.

BIBLIOGRAPHY. R. C. de Lasteyrie, *L'Architecture religieuse en France à l'époque gothique*, vol. 1, Paris, 1926.

ST. URSULA, LEGEND OF. Oil painting by Carpaccio, in the Academy, Venice. *See* CARPACCIO, VITTORE.

ST. URSULA, SHRINE OF. Flemish reliquary casket painted by Hans Memling (Bruges, St. John's Hospital). It was consecrated on Oct. 21, 1489, the feast day of the 1,000 virgin martyrs. The gabled casket, richly gilded and ornamented with Gothic tracery and spires, was designed to house an earlier reliquary containing relics of the life and Passion of Christ, as well as relics of the 1,000 martyred companions of St. Ursula.

Memling painted six scenes of the legend of St. Ursula, three on each of the long sides. One end panel depicts St. Ursula standing, sheltering her companions under her robe; the other end panel depicts the Virgin. The legend, as Memling depicts it, is incomplete. The first scene shows the arrival of Ursula and her companions in Cologne and Ursula's dream. The second scene shows Ursula's arrival

in Basel. The third depicts her reception in Rome by the Pope and her prayers. On the other side of the chest, the fourth scene depicts Ursula and her companions, accompanied by the Pope, bishops, and various ecclesiastics, embarking on the return voyage to Basel. The fifth panel presents us with a quietly staged scene of the martyrdom of the virgins upon their return to Cologne. The last panel is devoted to a presentation of the martyrdom of Ursula herself.

Not only does Memling add no iconographic innovations to the pictorial tradition of the Ursula legend, but he abbreviates it to its barest essentials. However, there is one particularly interesting aspect to his presentation. In Scenes 1, 5, and 6 Memling presents accurate historic views of Cologne. One can identify in these scenes the Cathedral, shown under construction, St. Martin's Church, and the Church of St. Maria im Kapitol.

Stylistically, the work is typical of Memling's calm, extremely competent, but unexciting manner. The rich, brilliant colors, the painstaking care for minor details, and the high degree of craftsmanship manifest themselves here as in other Memling works. Certain aspects of the work suggest Memling's workshop rather than the master himself. In Scenes 1 and 6 the incomplete upper portions of the west façade of the Cathedral are presented in so nearly identical a fashion as to suggest one's being a workshop copy of the other. Despite the limitations of each individual scene, the ensemble within its brilliant gilded tracery setting is a handsome and rewarding sight.

BIBLIOGRAPHY. W. H. J. Weale, *Hans Memlinc, zijn leven en zijne schilderwerken*, Bruges, 1871; G. de Tervarent, *La Légende de Sainte Ursule*, 2 vols., Paris, 1931.

STANLEY FERBER

SAINT VAAST ABBEY, ARRAS. French Benedictine abbey. Originally founded in 667 to serve the funeral chapel

Shrine of St. Ursula. Reliquary casket painted by Hans Memling. St. John's Hospital, Bruges.

of St. Vedast (Vaast), it later became a Benedictine abbey. After developing into one of the largest and richest in France, it was suppressed during the French Revolution. The convent buildings now serve as a museum, library, and treasury. The vast range of monastic buildings was designed by Contant d'Ivry in a rather dry and repetitive neoclassical style (begun in 1746). The abbey church, with its columned façade and nave, is even more classical although traditional in form. It was rebuilt between 1754 and 1833 and is now a cathedral.

SAINT-VINCENT-DE-PAUL, PARIS.
Church begun in 1824 by Lepère and completed in 1844 by his son-in-law Hittorff. The church is basilican in plan, with a portico. It is approached by two facing horseshoe-shaped ramps which embrace a central stairway, at whose head stands the portico. The portico consists of twelve fluted Ionic columns that support a pediment whose tympanum, carved in low relief, shows St. Vincent between Faith and Charity. On each side are square towers (177 ft. high).

The spacious nave (282 ft. long) of twelve bays is flanked by double aisles: the outer is divided into chapels, and the inner is surmounted by galleries that continue around the apse. The aisle windows are of stained glass. A painted frieze, *The Procession of the Blessed*, by Hippolyte Flandrin, winds around the nave under the galleries.

BIBLIOGRAPHY. J. Bayet, *Les édifices religieux XVIIe, XVIIIe, XIXe siècles*, Paris, 1910; Y. Christ, *Eglises de Paris*, Paris, 1956.

ST. VITUS CATHEDRAL, PRAGUE.
One of the key monuments of late Gothic architecture in Czechoslovakia. It has been called the last great work of French cathedral Gothic. When St. Vitus (svatý Vit) was built, Prague was one of the great capitals of Europe, a center for painting that, with the rest of Bohemia, produced many important works of the International Gothic style. Emperor Charles IV, who grew up in France, chose Prague as his residence in 1333.

In 1344 Charles called Mathieu d'Arras, the builder of the Cathedral of Narbonne, to Prague to erect a new cathedral on the left bank of the Vltava at the highest part of the city, the Hradčany. Mathieu began the new cathedral at the east end, and between 1344 and his death in 1352 he had nearly completed the five radiating chapels of the *chevet* and four more chapels to the west.

In 1353 Peter Parler was called to Prague. Between 1355 and 1360 he created the present sacristy by joining two chapels on the north side. A square chapel, that of St. Wenceslas, was built between the choir aisle and the transept. About 1368 Parler created the lovely south porch, a tripartite structure with a portal having only two doorways and an ingenious vault with flying ribs joined to the piers between the doors. His greatest innovations were in new and imaginative ways of vaulting interior spaces. In the Chapel of St. Wenceslas and the sacristy with its two completely different vaulting systems, as well as in the choir, he invented ingenious forms of late Gothic vaulting. After 1369 the missing piers in the choir were completed and the choir aisles vaulted. In 1374 the triforium was begun. Parler's work came to an end when the vault was finished in 1385. Although there is no evidence that Parler was in England, the vaulting shows that he must have had extensive knowledge of English examples. Parler also created the gallery of portrait busts in the triforium, including a self-portrait that exemplifies the realistic Prague school of Gothic sculpture.

BIBLIOGRAPHY. K. H. Clasen, *Deutsche Gewölbe der Spätgotik*, Berlin, 1958; P. Frankl, *Gothic Architecture*, Baltimore, 1962; B. Knox, *The Architecture of Prague and Bohemia*, London, 1962.
EDWARD P. LAWSON

SAITIC RENAISSANCE, *see* EGYPT (SCULPTURE); MEMPHITE STYLE.

SAITO, KIYOSHI.
Japanese print designer (1907–). Saitō is one of the most popular printmakers of modern Japan. Dramatic designs in a semiabstract manner and bold color contrasts characterize his landscape series showing the ancient temples and gardens of Japan.

BIBLIOGRAPHY. O. Statler, *Modern Japanese Prints, an Art Reborn*, Rutland, Vt., 1956.

SAKAKURA, JUNZO.
Japanese architect (1904–). In 1929 he went to Paris to study architecture, and spent eight years there, mainly with Le Corbusier. In his designs for the Japanese pavilion at the Paris World's Fair of 1937, Sakakura demonstrated the successful fusion of Western technology and the traditional Japanese sensitivity for light and graceful design. Sakakura's works after World War II include such public projects as the Museum of Modern Art in Kamakura and the Senri Newtown Neighborhood Center in Osaka prefecture, which was designed for a population of 130,000. In collaboration with other Japanese architects, Sakakura executed Le Corbusier's design for the Museum of Modern Art in Tokyo.

BIBLIOGRAPHY. U. Kultermann, *New Japanese Architecture*, New York, 1961.

SAKJEGOZU.
Ancient wealthy city in northern Syria, at the foot of the Taurus Mountains. It fell under Assyrian domination between the 9th and 7th centuries B.C. Ruins of buildings, among them a palace built by the Assyrian king Tiglath-pileser III about 743 B.C., are typical of the Syro-Hittite architecture and art of the period, but with Assyrian influences. Wall bases have basalt and limestone orthostates with crudely carved scenes from the King's life and achievements. The palace's throne room was entered through a portico, from which stairs led to the second story. A distinctly Syrian double-sphinx base stands at the palace gates, guarded by Assyrian double lions. Two carved slabs at the portico show a griffin bearing the Assyrian water bucket and sprinkler and two deities flanking a sacred tree under a winged disk.

BIBLIOGRAPHY. H. Frankfort, *The Art and Architecture of the Ancient Orient*, Baltimore, 1954; S. Lloyd, *The Art of the Ancient Near East*, London, 1961.

SAKTI.
Wife or female energy of a Hindu deity. The name Sakti refers especially to evī, consort of Siva.

SAKYAMUNI (Chinese, Shih-chia-mou-ni or Shih; Japanese, Shakamuni).
Epithet of Gautama Buddha, meaning "Sage of the Sākya Clan."

SAKYAMUNI (granite).
Buddhist statue of the 8th century, located in Sokkulam cave, near Kyungju, Korea. The statue, about 11 feet high overall, is carved out of solid

granite in almost stark simplicity. The folds of the drapery are indicated merely by shallow cuttings. The *uṣṇīṣa* and the *ūrṇā* are present but quite inconspicuous. The right hand, with palm downward and touching the pedestal, is in *bhūmisparśa* mudrā, the "gesture of calling the earth to witness." The left hand is simply laid palm up on the lap in the mudrā of meditation.

BIBLIOGRAPHY. Ministry of Foreign Affairs, *Korean Arts*, vol. 1: *Painting and Sculpture*, Seoul, 1956.

SAKYASIMHA. Epithet of Gautama Buddha, meaning "Sākya Lion."

SALAI (Jacopo dei Caprotti). Milanese painter (1480–1524). He was an assistant to Leonardo. No certain works are known, but he is probably the artist of a group of interrelated pictures labeled his, at least by the 18th century. They are very soft in texture, even among the many Milanese imitations of the master. His unreliable but charming character is reflected in Leonardo's notebooks.

BIBLIOGRAPHY. W. Suida, *Leonardo und sein Kreis*, Munich, 1929.

SALAMANCA: NEW CATHEDRAL. Spanish late Gothic cathedral adjacent to the Romanesque Old Cathedral. Designed by Antón Egas and Alonso Rodríguez, the New Cathedral was begun in 1513. Construction continued into the 18th century, with Rodrigo Gil de Hontañón erecting the fan vaults of the high, clerestoried nave and four side aisles (1538–40), Juan de Ribero Rada the unusual rectangular east end (1588), Joaquín de Churriguera the crossing dome (1714–24), and Pedro de Ribera the great tower (ca. 1733–38).

SALAMANCA: OLD CATHEDRAL. One of the least altered late Romanesque churches of Spain (begun ca. 1140). The plan is typically Romanesque: three apses east of the transept to which the tripartite body is appended. The semidomes over the apses and the pointed barrel vault before the center apse were completed probably about 1155. The cruciform piers of the nave arcades with their attached half columns suggest that groin vaults were planned throughout. Probably between 1160 and 1170 a new master, perhaps from Aquitaine, closed the aisles with heavy four-part rib vaults and, soon after, the nave. He may have been Petrus Petriz, active in 1163 and possibly the designer of the Torre del Gallo (1180–1200), the wonderful lantern over the crossing, which, though its immediate model was that of the Cathedral of Zamora, suggests an ultimate derivation from Angoulême.

The sculpture is of extraordinary quality. The capitals show a mixture of figural and vegetable forms, and there are over-life-size figures in the round, standing on brackets at the spring of the rib vaults in the nave, crossing, and transepts. They suggest the late Romanesque style of the pilgrimage roads. A Master Gundisalvas, active in 1164, may have been responsible for some of them.

In the Chapel of St. Martin are wall paintings by Antón Sánchez de Segovia (dated 1262), including a Pantocrator, a Last Judgment, and scenes from the Passion, and the painted tomb of Bishop Rodrigo Diaz (14th cent.). The great retable of the high altar consists of eleven tiers of painted panels, attributed to Dello di Niccolò Delli (before 1445); the fifty-three panels depict the life of the Virgin and the life and miracles of Christ. The Last Judgment frescoed in the vault is also by Dello (begun 1445). The retable enshrines the Virgen de la Vega, a gilded silver and jeweled figure of the Virgin and Child seated on a throne adorned with Limoge enamels.

The cloister (1162–78), much damaged in the earthquake of 1755, retains part of its fine sculptured capitals and many tomb monuments, including the wall tomb of Gutierrez de Castro (ca. 1540), attributed to Juan de Juni. Off the cloister is the Chapel of Talavera (1180), whose octagonal dome is supported by interlaced ribs springing from attached colonnettes suggesting the Torre del Gallo and also the vaults of Cordova. The chapter house has a rich collection of works by Fernando Gallegos and Juan de Flandes.

BIBLIOGRAPHY. C. K. Hersey, *The Salmantine Lanterns, Their Origin and Development*, Cambridge, Mass., 1937; *Ars Hispaniae*, vol. 5, Madrid, 1948; J. Camón Aznar, *Salamanca; guía artística*, 2d ed., Salamanca, 1953; J. E. Cirlot, *Salamanca y su provincia*, Barcelona, 1956.

JOHN D. HOAG

SALEMME, ANTONIO. Italian-American sculptor and painter (1892–). He was born in Gaeta, Italy. Arriving in Boston at the age of eleven, he studied at the Museum of Fine Arts there and then returned to Rome for eight years of study with Angelo Zanelli. After working in both Paris and New York he settled in the United States and was awarded Guggenheim fellowships in 1932 and 1936. Works by Salemme are to be found in the Metropolitan Museum of Art in New York City, the Newark Museum, and other institutions. His portraits and nudes were often thought conventional and academic until recently, when his directly conceived and simply modeled plaster figures were compared with avant-garde efforts. Salemme's delicately modeled and luminous landscape paintings, which he has produced since the early 1950s, owe something to the tradition of Cézanne.

SALEMME, ATTILIO. American painter (b. Boston, 1911; d. New York City, 1955). A self-taught artist, he began to paint in the late 1930s, and by the early 1940s had developed the mysterious, flatly colored forms whose enigmatic characters and relationships were to be the subjects of his paintings. These forms—geometric, mostly slim rectangles with occasional references to hats, limbs, and facial features—are statically and evocatively set in an ambiguously clear space, as in *The Oracle* (1950; Philadelphia Museum of Art) or *The Inquisition* (1952; New York, Whitney Museum). In his late works some of the tension is dispelled by the use of softer color, less ritualistic composition, and playfully constructed abstract organic shapes.

BIBLIOGRAPHY. Institute of Contemporary Art, *Attilio Salemme*, Boston, 1958.

SALERNO CATHEDRAL. Italian Romanesque monument dedicated in 1084. Salerno Cathedral is essentially of a conservative, three-aisled basilican plan. It reflects a type of building developed at Montecassino under Abbot Desiderius. *See* MONTECASSINO, ABBEY OF.

Dedicated to St. Matthew, the Cathedral was built under the aegis of the Norman duke Robert Guiscard. A magnificent atrium preceding the building contains twenty-eight antique columns taken from Paestum. Along the walls of

the atrium are antique sarcophagi used by the Normans and their successors, the Hohenstaufens, as their burial places. The church is entered through portals containing nielloed bronze doors made in Constantinople (donated in 1099 by Landolfo Butromile). The lunette above the portal contains a Norman mosaic of St. Matthew in the Sicilo-Byzantine style.

Restoration in 1768 diminished a good deal of the Romanesque significance of the church, but parallel structures can be seen in the Cathedrals of Benevento (1114–1279) and Amalfi (completed by 1156).

BIBLIOGRAPHY. E. Bertaux, *L'Art dans l'Italie méridionale*, 2 vols., Paris, 1904; C. Ricci, *Romanesque Architecture in Italy*, London, 1925.

STANLEY FERBER

SALIAN ART. One of the major periods of German Romanesque art. It followed the Ottonian period and corresponded to the reigns of the four Salian emperors (1024–1125). The important monuments are Speyer Cathedral, the *Imad Madonna* (Paderborn, Diocesan Museum), the portable altar by Roger von Helmarshausen (Paderborn, Cathedral Treasury), and the Hitda Codex (Darmstadt, Hessian Landesbibliothek). See ROGER VON HELMARSHAUSEN; SPEYER CATHEDRAL.

BIBLIOGRAPHY. W. Pinder, *Die Kunst der deutschen Kaiserzeit bis zum Ende der staufischen Klassik*, 5th ed., 2 vols., Frankfurt, 1952.

SALIBA, ANTONELLO DE, see ANTONELLO DE SALIBA.

SALIMBENI, VENTURA. Italian painter and etcher (b. Siena, 1567/68; d. there, 1613). Salimbeni was widely traveled. In 1596 he was in Rome, and from there he traveled to Siena, Lucca, Perugia, and Pisa. He was back in Rome in 1603, and he stayed there also in 1607 and 1609. In 1605 and 1608 he was in Florence, and in 1610 and 1611 in Genoa. In Siena he painted in fresco the ceiling of S. Trinità (1595–1602) and in Genoa, in S. Siro, scenes from the life of St. Matthew (1610). At the end of his career his colors became darker (*Crossbearing*, 1612; Siena, Picture Gallery). His art, especially the more loosely conceived prints dating from 1590, had the greatest influence in the north.

SALIMBENI DA SANSEVERINO, JACOPO AND LORENZO. Italian painters, brothers and frequent collaborators: Lorenzo (1374–ca. 1420); Jacopo (d. after 1427). No independent works by Jacopo are known. The only authentic work of any importance entirely by Lorenzo is a signed and dated (1400) altarpiece, *The Mystic Marriage of St. Catherine with Two Saints*, from S. Lorenzo, now in the gallery at Sanseverino. The most notable works on which the brothers collaborated are the frescoes, *The Story of St. John the Baptist* in S. Giovanni Battista, Urbino, signed and dated 1416; *The Story of St. Andrew* in the crypt of S. Lorenzo in Doliolo, Sanseverino; and *The Legend of St. John the Evangelist* in the Old Cathedral, Sanseverino. Full of lively movement and episodic detail, inspired partly by northern Italian and northern European manuscript illustration and partly by the art of Gentile da Fabriano, these works are completely in the spirit of the International Gothic style.

BIBLIOGRAPHY. R. van Marle, *The Development of the Italian Schools of Painting*, vol. 8, The Hague, 1927.

SALIM CHISTI'S TOMB, FATEHPUR SIKRI, *see* FATEHPUR SIKRI.

SALINI, TOMMASO (Mao). Italian painter (b. Rome, 1575; d. there, 1625). He formed his style under the influence of Caravaggio. While a very few large-scale religious works, such as *S. Nicola da Tolentino* (Rome, S. Agostino), illustrate his typically chiaroscuro style in history painting, Salini is better known as a painter of still lifes. In this genre, Salini was praised by his contemporaries (such as Baglione) as being the first to paint flowers in vases as well as to introduce the half-length figure into purely decorative pieces. In the still-life works that can be safely attributed to Salini, it is evident that he combined the clarity of Caravaggio's designs with the more decorative style of Mario dei Fiori. Despite the documented popularity of Salini's flower pieces, few works of this genre can be attributed to his hand with any assurance; recently, a number of heretofore accepted works have been reassigned to Simone del Tintore.

BIBLIOGRAPHY. L. Salerno, "Di Tommaso Salini, un ignorato caravaggesco," *Commentari*, III, 1952; G. Testori, "Nature morte di Tommaso Salini," *Paragone*, V, March, 1954; W. Friedländer, *Caravaggio Studies*, Princeton, 1955; *La natura morta italiana, catalogo*, Milan, 1964.

SALISBURY CATHEDRAL. English cathedral built after Bishop Poore removed the See of Old Sarum to the Avon Valley (Wiltshire) in 1219. The erection of a Gothic cathedral on an entirely new site was a unique occurrence. A start was made in 1220, and by 1225 the Lady chapel had been built. It is almost certain that the whole cathedral was conceived on an overall plan that may have been due to Elias of Dereham in at least an administrative capacity and certainly to the master mason Nicholas of Ely.

The Lady chapel sets the pattern for the rest of the Cathedral: grouped Purbeck marble shafts, remarkably elongated, and with a sense of preciousness about the whole design. The choir followed (1225–37) and then the great transept and nave (1237–58). The west front (put up ca. 1258–66) may have been part of the preconceived design. It follows the screen type front of the towerless tradition, such as that in Rochester Cathedral.

Master Richard, the mason, appeared from 1267, but by then the style had changed from Early English to Geometrical Decorated. To that phase and to that designer belong the magnificent cloisters and chapter house built between 1263 and 1284. They set a fashion for cathedral cloisters, yet were in many ways unsurpassed both in size and in quality of design.

The tower of Salisbury was begun about 1334 by the designer Master Richard of Farleigh. This is the supreme moment in the conception of the Cathedral. The construction shows Farleigh as the great medieval empiricist and is on a par with the octagon at Ely. The spire was finished by about 1380. The height of the tower and spire was 404 feet, producing problems affecting the 13th-century crossing piers. These were not finally solved until straining arches were inserted in the east transept and beneath the tower. The Cathedral was finally completed by the crossing vault put up from 1479 by the mason Henry Stevens.

Salisbury is perhaps unique in the feeling for unity of design between the two contributions of Early English and

Geometrical Decorated designers. The site contributed much, for the close is one of the most perfect in terms of cathedral-scape. The restorations carried out (1787–93) under James Wyatt brought many criticized alterations, including the destruction of the Hungerford and Beauchamp Chantry Chapels, the demolition of the detached bell tower, the tidying up of the tombs by placing them between the nave arcades, and the unfortunate destruction of the great porches from Old Sarum Cathedral that had been incorporated in the transept ends.

BIBLIOGRAPHY. J. H. Harvey, *The English Cathedrals*, 2d ed., London, 1956; G. H. Cook, *The English Cathedral through the Centuries*, London, 1957.

JOHN HARRIS

SALISH INDIANS. Indians of the Salishan linguistic group living in settlements from the Columbia River area in Washington to Vancouver Island and the nearby coast of British Columbia in Canada. Tribal structure among the Salish was less definitive than that of most Northwest Coast groups, though rituals and ceremonies were generally similar to those of non-Salishan peoples. Tribes or settlements of the Salishan area include the Songish, Comox, Cowichan, Sanetch, Klallam, Thompson, Lillooet, Nooksack, Puyallup, Snoqualmie, Samish, Suquamish, Nanaimo, Skagit, Skokomish, Muskwium, Quinault, and Chehalis.

Although the best-known Salishan art forms—large plank houses and monumental sculpture in cedar—date from early pre-European times, the styles are essentially prehistoric in development. Salishan house posts combining human and animal forms are distantly related to the totem poles of more northerly areas.

See also BRITISH COLUMBIAN INDIANS; COWICHAN INDIANS; NORTH AMERICAN INDIAN ART (NORTHWEST COAST).

BIBLIOGRAPHY. M. W. Smith, "The Coast Salish of Puget Sound," *American Anthropologist*, XLIII, April–June, 1941; P. S. Wingert, *American Indian Sculpture: A Study of the Northwest Coast*, New York, 1949.

SALJUK (Seljuk) ARCHITECTURE (Iran). By the middle of the 11th century a group of Turkish nomads had, through conquest, established a Saljuk kingdom. Recognized by the Abbasid caliph in Baghdad, Tughril Beg, first ruler of this dynasty, selected Rayy on the Iranian plateau as his capital. These Saljuks soon took over most of western Asia and, as newly fervent Muslims, sponsored architecture and patronized learning. By the end of the 11th century Syria and Asia Minor had been split off from the kingdom, which was in full decay by 1155, when Sanjar, last ruler of the line, died. *See* RAYY.

The plan types and structural methods of Islamic religious architecture in Iran became standardized quite early in this period. In early centuries, existing pre-Islamic structures had been converted into mosques, and then in the Samanid and Ghaznavid periods the plans and vaulting systems of the Sassanian period just prior to the Islamic invasions had influenced the nascent style. The Saljuk builders developed such Sassanian devices as the enclosed open court; the ivan, a rectangular tunnel-vaulted hall with one façade open on the court; and the dome constructed on squinches over a square plan. A rectangular open court with an ivan at the midpoint of each of its four sides now became the core of the plan of the Saljuk mosque and madrasa. In back of the court façades were prayer halls,

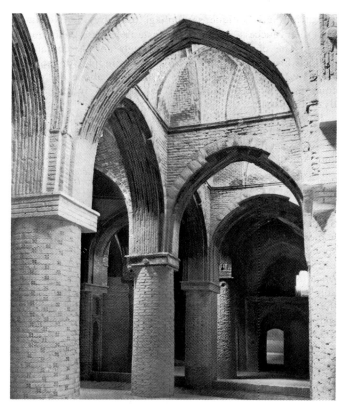

Saljuk architecture. Interior court of the Masjid-i-Jami, Isfahan.

each with numerous columns or piers supporting vaulted ceilings and roofs. At one of the shorter ends of the rectangular plan was the entrance, more and more often flanked by minarets, and the other end was the sanctuary area with its mihrab; this area featured the square chamber crowned by a dome. This development was paralleled around the eastern shores of the Mediterranean, where the four-ivan plan sprang from other origins, for there was an exchange of craftsmen throughout these regions. The basic plan was adapted to the Saljuk caravansaries, located along the highways a long day's travel apart.

The square chamber crowned by a dome appeared not only as the sanctuary of a mosque but in freestanding structures serving either as mosques or as mausoleums. In addition, the dome chamber was sometimes erected as the initial element of a typical four-ivan plan, with the other sections added at later times within the Saljuk period. The Saljuk period also featured the construction of tomb towers: square, circular, octagonal, or multiple-flanged structures rising to a considerable height, with interior domes and exterior tent-shaped roofs. Secular buildings, in addition to the many caravansaries, included *nizamiyyas*, or religious schools, named after their patron, Nizam ol-Mulk, a renowned prime minister of the Saljuk rulers, and royal palaces. Erected in haste, often of unbaked brick, most of these palaces disintegrated in short order, and none have survived to the present day.

Some cut-stone and rubble masonry, following the tradition of the Sassanian period, was used, but the majority of the monuments were constructed of brick, either sun-dried or baked in kilns. Always square in shape and rela-

tively thin, the very large bricks previously favored gave way to ones about 1 foot square. Arches and vaults were highly developed in experimental forms. The elliptical and round arches of the Sassanian period were displaced by the characteristic pointed arch of Islamic architecture. The ingenuity of the constructors of vaults, which were erected without supporting centering, reached its height in the great variety of vaults used to crown the bays of the prayer halls of the major mosques of the period. There was less variety in domes on squinches, although such domes tended to increase in size and they became conspicuous landmarks.

Decoration of the fabric of the monuments featured brick bonding patterns, with a variety of bonds created with standard-size, cut, and molded bricks. Additional interest was established by raked, flush, and buttered joints and by so-called brick-end patterns, executed in plaster.

Saljuk monuments in Iran convey an impression of solidity and massiveness. Walls are thick, openings few, projections minimized, and the structures seem tied to the ground rather than rising from it. The most important monument is the Masjid-i-Jami in Isfahan, which displays the standard four-ivan plan with a vast open court flanked by a series of prayer halls with nearly 500 individual vaults over as many bays. Both pre-Saljuk and post-Saljuk periods are represented, while the elements of the Saljuk period include many vaults in the older prayer halls and two dome chambers. The sanctuary dome chamber was erected by order of Nizam ol-Mulk a few years earlier than 1089, the date of a smaller chamber at the northern end of the complex. These two chambers are most typical of the period in the use of shallow reveals and engaged colonnettes, in the interest displayed in the zone of transition, and in the inscriptions surrounding the base of the domes. *See* MASJID-I-JAMI, ISFAHAN.

Other important mosques on the four-ivan plan include that of Nizam ol-Mulk in Khargird, sometimes called a madrasa, or college; the Masjid-i-Jami in Ardistan; and the Masjid-i-Jami in Qazvin. With the exception of Khargird, these structures were expanded in later periods, but the distinctive elements of the Saljuk period survive. At a number of sites impressive dome chambers were erected as the initial element of a standard mosque plan. In Gulpayagan the court with its ivans was not completed until the 19th century; in Qazvin the dome chamber of the Masjid-i-Haydariya may have been tied in to a madrasa; and in Sengbest the dome chamber was related to now vanished structures. The freestanding dome chamber was also used for shrines and mausoleums such as the shrine of the Duvazdah Imam in Yazd, the mausoleum of Khwaja Sa'd in Isfahan, and the great mausoleum of Sultan Sanjar in Marv. *See* MARV: MAUSOLEUM OF SULTAN SANJAR; SENGBEST: DOMED MAUSOLEUM.

The many surviving tomb towers of the period display considerable variety in plan types, exterior treatment, and decoration. Notable is a distinctive series in Maragha, Azerbaijan, which includes the Gunbad-i-Surkh of 1148, the Gunbad-i-Kabud of 1197, the Round Tower, and the Gunbad-i-Ghaffariya. Each has a basement story in which the remains were entombed. Other important towers are in Rayy, Damghan, Demavand, and Abarquh.

It is tempting to try to define regional styles of building and decoration within the Saljuk period, such as the bold, rather unadorned structures of Khurasan, the monuments of Azerbaijan, which use a rather bright red brick and a sparing amount of faïence tilework, and the plaster and painted interiors of the south-central part of the country. It is, however, too early in the study of this period, with monuments still coming to light, to make firm characterizations of regional styles.

BIBLIOGRAPHY. A. U. Pope, ed., *A Survey of Persian Art*, London, 1939.

DONALD N. WILBER

SALJUK (Seljuk) ARCHITECTURE (Konia or Konya).

From 1092 until 1308 the Saljuk sultans of Anatolia were in power. Their first capital was Iznik, but after 1116 Konia was selected, and at this time the Anatolian sultans became independent of the great Saljuk sultans reigning at Isfahan, in Iran. A smashing defeat of a Byzantine force consolidated their kingdom until about 1240, when the region came under the sovereignty of the Mongol Il-khans of Iran. Konia flourished as the seat of government and as a center of architecture, scholarship, and culture, and its surviving monuments comprise a distinctive style. However, the Konia style also appeared in many splendid structures erected in such other towns in Anatolia as Sivas, Kayseri, Iznik, Amasya, Tokat, and Niğde.

The plan forms of the mosques, religious schools, and caravansaries (also called khans) of this period were influenced by the somewhat earlier structures built by the Saljuks of Iran. However, a more severe climate worked to alter these forms, and only the type of octagonal towerlike tomb, with its tent dome, was carried over without change. Other influences came from earlier Christian architecture, notably the stone churches of Armenia. Construction materials included rubble masonry, cut stone, and baked brick, although less use was made of brick than in Saljuk Iran. Stone carving in relief characterized the exterior details of the structures, with great variety in patterns and in methods of treatment of the material. The use of faïence-coated tiles and bricks derived from Iranian models. These models stressed light and dark blues, but in Konia green, relieved by brown and black, was the predominant color.

Much of the wealth of these sultans went to the construction of splendid buildings, but only fragments of the palaces in Konia have survived. Religious structures for the Muslim faith were in the great majority, but the highly developed commercial activity of the period was reflected in the large number of caravansaries which lined the highways radiating from Konia.

Under Sultan Kiliçarslan II (r. 1156–92) massive walls were built around Konia and work was begun on the Alauddin Mosque, named after a later ruler of this line. Within fortresslike walls, the mosque fronts on an irregularly shaped court. It is rectangular in plan, with thirty-six stone columns supporting a flat wooden roof and pointed arches of stone masonry spanning the bays in one direction. The plan and construction are typical of very early mosques in other Muslim countries. In one corner of the enclosure is a typical octagonal tomb, executed in cut stone and dated 1220. The Iplikçi Mosque, constructed by a vizier of Kiliçarslan II in 1162, displays a more developed form. It is rectangular in plan, with twelve stone piers arranged in two rows. Pointed arches spanning each intercolumniation

support vaults, with the exception of the three bays of the central aisle, which are crowned by shallow domes. Traces of a brick minaret suggest that this monument may have been the earliest in Anatolia to display this feature.

Alauddin Keykubad I (r. 1219–36) was devoted to building, but most of his structures were erected in other towns, notably in his new city of Kubadabad, in the vicinity of Konia near Beyşehir, where parts of his palaces remain. Of his period is the Khan of the Sultan, erected on the road from Konia to Aksaray in 1229. The huge structure is in two parts: a gateway opens into an open court flanked by rows of rooms, and beyond is a large covered structure supported by thirty-two stone piers, more suitable than the first area for winter weather.

During the reign of Giyasuddin Keyhusrev II (1236–46) the major structure erected in Konia was the Sirçali madrasa of 1243. The plan form of this religious school was to become typical of the region, reappearing in the Karatay madrasa and in the Ince minareli madrasa at Konia. Beyond an open court, flanked by rows of rooms, were three large chambers; one, on the central axis, was an open ivan covered by a tunnel vault, and on either side of it were square, domed rooms. The entrance portal displays interlacing patterns carved in low relief. The surfaces of the ivan were covered with faïence in which green predominates. The entire dado area is coated with octagonal tiles, and above are inscription bands and areas of interlace patterns. An inscription records that the faïence was executed by an Iranian from Tus, and this structure was one of the first in Anatolia to adopt this type of decoration from Iran.

Three important monuments have survived from the period of Izzuddin Keykaus II (r. 1246–61). The plan of the Karatay madrasa (1252) is a compressed version of that of the Sirçali madrasa but with the court covered by a lantern cupola. The decoration is quite elaborate. The cut-stone portal is highly carved, with attention concentrated upon a shallow stalactite niche above the entrance. The walls of the ivan are clad in faïence, and the interior surfaces of the domes of its flanking chambers are completely covered by an elaborate interlace pattern constructed around twenty-four pointed stars; the tiles are green, brown, and black. The plan of the Ince minareli madrasa (1258) is almost identical with that of the Karatay madrasa. Noteworthy is the use of a well-developed example in the dome over the court of the so-called Turkish triangle, a filling element employed to establish a smooth transition zone between the upper walls of a square room and the circular base of its dome. The name of its architect, Kaluk, is carved on the façade. The stone carving on the entrance portal of the façade represents a real tour de force in this material; exuberant, unorganic, and restless, it has a baroque quality far ahead of its time. The portal is flanked by an extremely tall minaret, decorated with patterns picked out in blue and black faïence-coated bricks.

The Sahib Ata Mosque in Konia (1258), sometimes called the Laranda Mosque because it is near the city gate of that name and sometimes called the Energhe Mosque, was designed by the architect Kaluk. Wood columns support the main area of the mosque. The entrance façade is of sandstone, carved in high relief, with a deep stalactite

niche above the portal. A decorated minaret of brick flanks the portal, and faïence is extensively used on interior surfaces. Just opposite the mosque is a typical public bath of the period, the Sultan Hamami, with separate and duplicate quarters for men and women. Finally, Konia is the site of the Yeshil Qubbe, the tomb of the renowned pantheistic writer Jalal ad-Din Rumi, built by the architect Badr ad-Din of Tabriz in 1273.

The Konia style quite early settled on plan forms, usually modest in scale, which were altered but little in later years. Characteristic was the contrast between cut-stone façades with elaborately carved portals and the concentration of faïence decoration on interior surfaces. Just as distinctive was the continued use of minarets of baked brick. By the end of the period much of its vitality had drained away, and it remained for the Ottoman empire to revitalize architecture.

BIBLIOGRAPHY. F. Sarre, *Konia, Seldschukische Baudenkmäler*, Berlin, 1936; B. Unsal, *Turkish Islamic Architecture*, London, 1959.

DONALD N. WILBER

SALJUK (Seljuk) METALWORK, PAINTING, POTTERY, RUGS, TEXTILES, *see* Saljuk period under Islamic Metalwork; Islamic Painting; Islamic Pottery and Tiles; Islamic Textiles; Rugs, Near and Middle Eastern.

SALLAERT, ANTOON. Flemish painter (ca. 1590–1657). Sallaert was active in Brussels. He painted large-size religious compositions in the manner of Rubens, as well as festivities and processions peopled with numerous small figures. The latter paintings are of topographical and cultural interest.

SALMEGGIA, IL, *see* TALPINO, ENEA.

SALMON, ROBERT. American painter (b. Scotland, ca. 1775; d. Boston, ca. 1842). He settled in Boston about 1828 and painted more than 500 harbor and ship scenes from his wharf studio. His style is photographically factual and is characterized by a crystalline atmosphere of plastic shadows and saturating lights.

BIBLIOGRAPHY. R. Salmon, "British Fleet at Algiers," *Boston Museum of Fine Arts Bulletin*, XLI, February, 1943.

SALO, PIETRO DA. Italian sculptor (fl. Venice, ca. 1550–1600). A pupil of Il Sansovino, Salò is mentioned from 1535 on in the Scuola di San Rocco. From 1555 to 1558 he collaborated with Danese di Michele Cattaneo and Alessandro Vittoria on a tomb designed by Michele Sanmicheli in the Contarini Chapel (Padua, S. Antonio). Salò's first unassisted work was the *Mars* (1536) on the balcony of the Doge's Palace. He collaborated with Girolamo and Tommaso Lombardo and Cattaneo (1537) on the arches of Sansovino's Library of San Marco and in 1540 on the attic. His style is Venetian High Renaissance in the manner of Sansovino.

SALON. The Salon des Artistes Français emerged shortly after the creation of the Royal Academy of Fine Arts under Louis XIV. Starting in 1667 in the Louvre's Salon d'Apollon, from which it derives its name, exhibitions were to be held every two years at the expense of the

King. They were restricted to artists of the academy. The schedule lagged between 1675 and 1737 but was put on a regular basis under the patronage of Mme de Pompadour. Juries were introduced in 1748. The French Revolution brought about the liberalization of admission rules. In 1791 all artists were accepted for exhibition, but the old exclusive policy was soon reinstated with greater intent. Juries were appointed and prizes given by the Académie des Beaux-Arts, with its conservative, classical bias.

After the 1848 Revolution the Salon became accessible to such artists as Courbet and Daumier but again came under the control of the academy in 1857. While Jongkind, Manet, and other advanced artists were sparsely represented at the Salons, the large number of rejections in 1863 led to the establishment of the official Salon des Refusés and some minor reforms in selecting juries. This special dispensation was rescinded the next year, however, and the Salon resumed its conservative ways, remaining the final arbiter in official and public eyes. In 1881 the Salon was taken over by the Société des Artistes Français and slowly lost its predominance to independent salons— Salon des Indépendants (1884), Salon d'Automne (1903), Salon des Réalités (1939), Salon de Mai (1945)—and to the growing body of art dealers. *See* SALON DES INDEPENDANTS; SALON DES REFUSES.

BIBLIOGRAPHY. N. Pevsner, *Academies of Art, Past and Present*, Cambridge, 1940; J. Rewald, *The History of Impressionism*, rev. ed., New York, 1961.

DONALD GODDARD

SALON DES INDEPENDANTS. The Société des Artistes Indépendants was organized in 1884 in response to the continual rejection of avant-garde artists by the official Salon. Hundreds of artists participated in the first Salon des Indépendants in that year. It had no jury and awarded no prizes. The prime movers were Redon, Seurat, and Signac. In succeeding years the exhibition became the showcase of the postimpressionist generation and the leading art event in Paris. The Salon remained fairly progressive until World War II; it now shows an overwhelming number of works, all of them figurative.

BIBLIOGRAPHY. G. Coquiot, *Les Indépendants*, Paris, 1921; J. Rewald, *Post Impressionism*, New York, 1956.

SALON DES REFUSES. Exhibition held in Paris by order of Napoleon III, in 1863, for those who had been refused entry to the official Salon by a jury more dominated than in the past by the Ecole des Beaux-Arts and the partisans of academic classicism. Manet, Pissarro, Whistler, Jongkind, and Fantin-Latour exhibited their works, which met with public hostility or indifference. The most important painting at the Salon des Refusés, Manet's *Le Déjeuner sur l'herbe*, which the Emperor himself had declared indecent, established this great artist as the leader of the new generation of painters soon to be known collectively as the impressionists.

BIBLIOGRAPHY. J. Rewald, *The History of Impressionism*, rev. ed., New York, 1961.

SALONIKA, *see* THESSALONIKA.

SALTBOX. Frame dwelling popular in colonial New England, generally two stories high with a lean-to. Its gable roof meets in a common ridge, the front section of the roof being short and the rear section, the longer of the two, extending back over the lean-to. The name derives from its resemblance to old salt boxes. It is called a "catslide" in Virginia.

SALVADOR CARMONA, LUIS. Spanish sculptor (b. Nava del Rey, 1708; d. Madrid, 1767). He studied in Madrid (1720–25) under Juan Ron. During the next six years Salvador was in partnership with Ron's son-in-law, Josef Galván. Salvador then established his own studio and became Spain's last inspired image maker. He was among the founders of the Academy of San Fernando and was named as a lieutenant-director of sculpture in 1752. Although the then current academic taste for neoclassicism was at variance with his own late baroque style, he never lacked royal and ecclesiastical commissions. His most outstanding student was Francisco Gutiérrez.

Salvador worked in stone and stucco for the royal palaces in Madrid and La Granja, but his fame rests mainly on polychromed wood statues executed for churches. Although he was a Castilian, his art is in the tradition of the Sevillian sculptors Montañés, Cano, Pedro de Mena, and Duque Cornejo. In his intricately draped figures in motion Salvador combined virtuosity with rococo grace, aristocratic charm, and a deep humanity. An example is the *Virgin of the Column* (1745–50; La Granja, S. Maria del Rosario). His stylistic elegance could also lend poignancy to a somber theme, as in the *Christ of the Redemption* (1751; S. Maria del Rosario).

BIBLIOGRAPHY. E. Lord, "Luis Salvador Carmona en el Real Sitio de San Ildefonso," *Archivo español de arte*, XXVI, 1953.

EILEEN A. LORD

SALVANH, ANTOINE. French architect (ca. 1478–1552). He was architect of the Cathedral of Rodez from 1513 to 1551. In 1508/09 he built, in association with G. Desmazes, the portal and the rose window of St-Jean-Baptiste at Espalion, and in 1521–24 Salvanh executed the portal of St-Côme near Espalion. All of Salvanh's works are in the Flamboyant style.

SALVI, GIOVANNI BATTISTA, *see* SASSOFERRATO.

SALVI, NICOLA. Italian architect (b. Rome, 1697; d. there, 1751). A pupil of Antonio Canevari, Salvi was later connected with Teodoli and Vanvitelli. He became a member of the Academy of St. Luke in 1733. Salvi's greatest work is the Trevi Fountain in Rome, upon which he worked from 1732 to his death and which was completed by Giuseppe Pannini. Its originality lies in the wedding of classic architectural detail and sculptured figures to a palace façade. In 1745 Salvi modified Bernini's Odescalchi Palace in Rome, and in 1746 he was among those consulted in relation to the new façade for SS. Apostoli in Rome. From 1754 to 1769 he is posthumously mentioned in connection with plans for church façades. He greatly admired Michelangelo and was the last practitioner of the Roman baroque style in the manner of Bernini, transforming the style into marginal rococo. Salvi's introduction of the Roman triumphal arch motif into palace architecture was influential in later architectural developments in Europe. *See* TREVI FOUNTAIN, ROME.

BIBLIOGRAPHY. A. Schiavo, *La fontana di Trevi e le altre opere di Nicola Salvi*, Rome, 1956.

Francesco Salviati, *Carità*. Uffizi, Florence.

SALVIATI, FRANCESCO (Francesco or Cecchino de' Rossi). Italian painter (b. Florence, 1510; d. Rome, 1563). After studying with various Florentines (Bugiardini, Andrea del Sarto, and others), Francesco moved to Rome in 1531. The surname "Salviati" came from his first Roman patron, Cardinal Giovanni Salviati. In 1539 Salviati went to Florence, to Bologna, and to Venice where he did minor frescoes for the Grimanis and a portrait (lost) of Aretino. In Rome again by 1541, he began frescoes in S. Maria dell'Anima. Restless, he left Rome for Florence (ca. 1544), where he did frescoes in the Palazzo Vecchio, the *Carità* panel (Florence, Uffizi), and the *Deposition from the Cross* (Florence, Museo dell'Opera di Sta Croce). In Rome again after 1548, Salviati decorated for Cardinal Alessandro Farnese the Chapel of the Pallio in the Cancelleria Palace; and in the Salone of the Farnese Palace he painted allegorical and narrative "eulogies" of the Farnese family. He went next to the court of Francis I, but soon returned, disgruntled, to Rome. Probably in 1553 or 1554 he frescoed the Salone of the Sacchetti Palace with scenes from the life of David. During his last years he executed some frescoes for the Sala Regia in the Vatican.

Salviati was highly regarded in his time and, together with Vasari, was to a large extent responsible for the development and diffusion of the Roman-Florentine mannerist style of fresco decoration in the 1540s and 1550s, wherein a figurative vocabulary drawn from Michelangelo and the Raphael school reappeared in decorative compilations of historical scenes and allegorical or ornamental figures. Salviati's early *Visitation* fresco (1538) for S. Giovanni Decollato in Rome shows Florentine crispness of drawing, with ceremonious movement and elaborate architecture stemming from Raphael's Roman workshop. His finest frescoes, the *Triumph of Furius Camillus* and the *Pact between the Romans and the Gauls* (ca. 1544–46; Florence, Palazzo Vecchio, Sala d'Udienza), are full of spirited ancient Roman trappings, rich with mannered movement in the style of Polidoro da Caravaggio, and embellished with tightly filled surfaces designed with the incisive ornamental quality of Florentine goldsmith works. The later frescoes seem to gain in resonance yet lose in distinction and clarity.

His excellent portraits are heightened by a sharp, nervous definition of the features and a sober, misanthropic gaze. There exist engravings and some color woodcuts after his drawings and paintings.

BIBLIOGRAPHY. G. Vasari, *Le Vite...*, ed. G. Milanesi, vol. 7, Florence, 1881; H. G. Voss, *Die Malerei der Spätrenaissance in Rom und Florenz*, vol. 1, Berlin, 1920; A. Venturi, *Storia dell'arte italiana*, vol. 9, pt. 6, Milan, 1933; F. Antal, "Around Salviati," *The Burlington Magazine*, XCIII, 1951; M. Hirst, "Francesco Salviati's 'Visitation,'" *The Burlington Magazine*, CIII, 1961; I. H. Cheney, "Francesco Salviati's North Italian Journey," *Art Bulletin*, XLV, 1963.

ALTHEA BRADBURY

SALVIN, ANTHONY. English architect (1799–1881). He was trained by John Nash. An intense study of medieval building made him a brilliant restorer of castles, including Caernarvon, the Tower of London, and Windsor. He was the master of the asymmetric façade, no better exemplified than in the Burleigh House at Harlaxton (1834–55). He shared the country-house field with William Burn.

BIBLIOGRAPHY. "The Late Mr. Anthony Salvin, Architect," *The Builder*, XLI, December 31, 1881.

SALY (Sailly), JACQUES-FRANCOIS-JOSEPH. French sculptor (b. Valenciennes, 1717; d. Paris, 1776). Saly was a pupil of Antoine Joseph Pater and perhaps Guillaume Coustou, and was in Rome from 1740 to 1748. He was elected to the Royal Academy in 1751. A *Hébé* commanded by Mme de Pompadour appeared in the Paris Salon of 1753. The same year Saly went to Copenhagen to do an equestrian statue of Frederick V (Place Amalienborg), which he completed in 1766. He was director of the Copenhagen Art Academy from 1754 to 1771. He worked in a vigorous 18th-century French style with classical overtones.

BIBLIOGRAPHY. H. Jouin, "Jacques Saly," *Nouvelles Archives de l'Art français*, series 3, XI, January–June, 1895.

SALZBURG. City on the Salzach River in western Austria. Salzburg is noted for its baroque architecture and its associations with Mozart. The city flourished in Roman times (mosaics and other remains have been found in the area near the Cathedral) and in the Middle Ages, when it was a center of manuscript illumination and the minor arts. The Franciscan Church presents a striking combination of a late Romanesque nave with a late Gothic choir. The Cathedral, a domed basilica with a twin-tower façade, was built by Santino Solari (1611–28). The great Austrian architect J. B. Fischer von Erlach erected the oval-plan Dreifaltigkeitskirche (1694–1702), the Kollegienkirche (1694–1717), and the Johannesspitalkirche (1699–1704). Noteworthy among the secular buildings are the Hohensalzburg Castle (1077–1519), the Residenz (chiefly 16th–18th cent.), and Schloss Mirabell, which was imaginatively

remodeled by J. L. von Hildebrandt in the baroque style in 1721–27. *See* SALZBURG: CATHEDRAL; SALZBURG: FRANCISCAN CHURCH.

See also SALZBURG: RESIDENCE GALLERY.

BIBLIOGRAPHY. F. Fuhrmann, *Kirchen in Salzburg*, Vienna, 1949; F. Martin, ed., *Salzburg*, 4th ed. (Dehio-Handbuch, Die Kunst-denkmäler Österreichs, 3), Vienna, 1954; H. Schwartz, *Salzburg und das Salzkammergut*, 3d ed., Vienna, 1957.

SALZBURG: CATHEDRAL. Austrian church built by Santino Solari between 1611 and 1628 on the site of the large, 12th-century Romanesque cathedral that burned in 1598. It was the first structure in the Italian baroque style to be built in central Europe. The two-story façade and its 270-foot-high flanking towers are of marble. The façade has three portals, in front of which are statues of St. Rupert, St. Peter, St. Paul, and Vergil. An octagonal cupola rises 240 feet over the crossing. The nave is 333 feet long, and the transept 229 feet wide. Each of the two aisles consists of four small chapels with ornately stuccoed ceilings. Piers with double pilasters and galleries support a barrel-vaulted nave. The Cathedral is decorated with paintings, sculptures, and frescoes by major Italian baroque artists; it also has modern bronze doors by Giacomo Manzù.

BIBLIOGRAPHY. A. Riegl, *Salzburgs Stellung in der Kunstgeschichte*, Vienna, 1921; F. Fuhrmann, *Kirchen in Salzburg*, Vienna, 1949; F. Martin, ed., *Salzburg*, 4th ed. (Dehio-Handbuch, Die Kunstdenkmäler Österreichs, 3), Vienna, 1954.

SALZBURG: FRANCISCAN CHURCH. Church of the Franciscan order in Salzburg, Austria. Its low, dark nave of three square, cross-vaulted bays, with cross-vaulted aisles, was built in a Gothicized Romanesque style as late as about 1220. The nave expands strikingly into a light and airy choir built in late Gothic style. The choir is the result of a rebuilding of the original one by Hans Stethaimer of Burghauser, between 1408 and 1450. Five slender piers, each 70 feet tall and 4 feet in diameter, support the reticulated vaulting, forming a hall 66 feet in width by 100 feet in length, exclusive of the baroque ambulatory chapels which surround the choir in two stories. The baroque high altar was executed by J. B. Fischer von Erlach in 1709.

BIBLIOGRAPHY. J. Fergusson, *A History of Architecture in All Countries*, 3d ed., New York, 1907; F. Fuhrmann, *Kirchen in Salzburg*, Vienna, 1949.

SALZBURG: RESIDENCE GALLERY. Austrian collection of paintings, including works from the Czernin Gallery in Vienna, dating mostly from the 17th through the 19th century. They are housed in the former archiepiscopal Residenz, built between 1596 and 1619 and enlarged in the 18th century. Some of the artists represented are the Italians Bordone, Solimena, and Batoni; the Fleming Rubens; the Dutch Rembrandt, Honthorst, Van Cleve, Bloemaert, Dou, Metsu, Ostade, Cuijp, Potter, Ruisdael, and Heem; and the Austrians Rottmayr, Amerling, Waldmüller, Makart, and Klimt.

BIBLIOGRAPHY. *Katalog der Residenzgalerie Salzburg mit Sammlung Czernin*, Salzburg, 1955.

SALZILLO (Zarcillo), FRANCISCO. Spanish sculptor (1707–83). He was born in Murcia, where his father Nicolás Salzillo, a sculptor from Naples, had started a school for sculpture since a market for religious statues existed in the guilds and pious fraternities. Francisco received whatever training he had from his father. This stopped when he was very young, when he became a Dominican novice. He was obliged to leave the monastery in 1727, upon the death of his father, to take charge of the family studio.

Francisco became the master of a sentimental naturalism and dressed his polychromed wood statues with the assistance of his brothers and sister. Although his works were popular through the 19th century, he may be considered as basically an excellent folk artist who never learned significant form. Certain works indicate a talent that might have matured with proper tutelage and creative inspiration. At the same time it is easy to understand the appeal of his work for an uncultivated, sincerely devout public, in such works as the *Agony in the Garden* (1754; Murcia, Salzillo Museum).

BIBLIOGRAPHY. A. Angulo Iñiguez, *La escultura en Andalucía*, 3 vols., Seville, 1927–36; E. Gómez-Moreno, *Breve historia de la escultura española*, 2d ed., Madrid, 1951.

EILEEN A. LORD

SAMANTABHADRA (Chinese, P'u-hsien; Japanese, Fugen). Bodhisattva of Universal Kindness; the first Dhyāni-Bodhisattva, reflex of Vairocana. He is represented with a blue lotus at his left shoulder, holding a *cintāmaṇi* (magic jewel) in his left hand, with his right hand in a *vitarka* mudrā (symbolic gesture of argument). In Chinese sculpture he is often shown riding an elephant, as described in the Lotus Sūtra. Along with Mañjuśrī, he seems to be better known in China than elsewhere in the Buddhist world. *See* DHYANI-BODHISATTVA; VAIROCANA.

SAMARIA (Sebastie). Royal city of the 1st millennium B.C. in northern Syria. It was captured and destroyed by Sargon II in 722 B.C., and the city of Sebastie was built over parts of it. The 30,000 inhabitants of Samaria were dispersed by Sargon, some settling in Medean towns.

Remnants of a temple, palace, and hippodrome still remain, the palace dating from the reign of Ahab, the king of Israel (875–852 B.C.). Assyrian, Syrian, Phoenician, Egyptian, and some Mycenaean influences characterize Samaria's art. Large quantities of ivory have been found, carved in relief, some inlaid with colored stones and partly gold-plated. Among other objects found in Samaria are a stone vase of Pharaoh Osorkon II (8th cent. B.C.); a graceful frieze of palm trees; an ivory miniature showing a woman at a window, probably the goddess Astarte, which is reminiscent of the Khorsabad ivory of the same subject; and furniture inlaid with ivory.

BIBLIOGRAPHY. H. Frankfort, *The Art and Architecture of the Ancient Orient*, Baltimore, 1954; L. Woolley, *The Art of the Middle East*, New York, 1961.

SAMARQAND (Samarkand), ARCHITECTURE OF. Long a center of Islamic culture, this city, now the capital of the Uzbek S.S.R., was embellished with monuments at the end of the 14th century as the capital of the world conqueror Timur (Tamerlane), who brought craftsmen from many countries to work on palaces, pavilions, religious buildings, and tombs. The mausoleum of Timur (1404), crowned by a bulbous, blue-tiled dome, is well preserved; the mosque, madrasa, and tomb of Bibi Khanum, one of his wives, are in ruins. A stepped lane called Chah-Sindeh

Architecture of Samarqand. The domed tombs of Olja Aim and her daughter in the Chah-Sindeh.

Samarra. Baked-brick wall of the Great Mosque, the largest structure of this type ever built, begun 847.

is flanked by more than a dozen splendid domed tombs of this period. Noteworthy are the ruins of the madrasa of Ulugh Beg, a grandson of Timur, on the west side of the Rigistan, or main square of the city.

See also CHAH-SINDEH: MOSQUE OF QASIM IBN-ABBAS.

BIBLIOGRAPHY. J. Smolik, *Die timuridischen Baudenkmäler in Samarkand aus der Zeit Tamerlans*, Vienna, 1929.

SAMARRA. Capital of the Abbasid dynasty, situated on the Tigris River some 75 miles north of Baghdad, Iraq. From its foundation in 836 by the caliph al-Mu'tasim until 892, it was known as Surra-manraa, meaning "who sees it rejoices." The walls of ruined structures are strewn over a vast area, with the monumental plan and the main structures clearly visible from the air. Excavations begun in 1913 have been continued in recent years.

The first structure erected, the Jausaq al-Khaqani, the palace of al-Mu'tasim, was approached from the river past a great pool and up a broad flight of steps which ended at a triple-arched portal. This portal stood before a square court, flanked by apartments. Beyond was a great court of honor which gave access to the throne room, a square hall, originally domed, and its huge auxiliary chambers. Other courts gave access to serdabs (great pits hewn deep into the rock to provide deep shade and coolness in the heat of the summer), to the polo ground, and to a racecourse set within a vast game preserve. Craftsmen and materials were brought to the site from near and far, and the decoration of the palace was of great magnificence. Fragments of painted frescoes, stucco relief, and marble tiles have been recovered in the excavations.

In 847 the caliph al-Mutawakkil ordered the construc-tion of a great mosque. A rectangle some 785 feet by 510 feet, it is the largest mosque ever erected. Within very high walls of baked brick, rows of supports run along the four sides of the vast open court. On the sanctuary side of the mosque twenty-four rows of nine brick piers supported a flat, beamed roof. The minaret to the north of the mosque is freestanding: modeled upon the ancient Babylonian ziggurat, an ascending spiral ramp flanked a brick core to a high point of 165 feet.

In 860 al-Mutawakkil had work started on a new city, called Ja'fariya, to the north of older Samarra. It was completed in 861, but the caliph lived in his extensive new palace only nine months before he was assassinated; the site was abandoned by his successors. The greatest monument erected in Ja'fariya was the Mosque of Abu Dulaf, somewhat smaller and similar in plan to the Great Mosque of Samarra. Most of the exterior walls of mud brick have vanished, but the interior piers are quite well preserved. Signs of hasty construction are apparent. Across the river is the Qubbat as-Sulaibiya, erected after 861 as a mausoleum for the caliphs. A square chamber crowned by a dome is set within an octagon and surrounded by an octagonal ambulatory.

BIBLIOGRAPHY. E. Herzfeld, *Sâmarrâ: Aufnahmen und Untersuchungen*, Berlin, 1907; E. Herzfeld, *Geschichte der Stadt Sâmarrâ*, Berlin, 1948; K. A. C. Creswell, *A Short Account of Early Muslim Architecture*, Harmondsworth, 1958.

DONALD N. WILBER

SAMBACH, CASPAR FRANZ. Austrian painter (b. Breslau, 1715; d. Vienna, 1795). Sambach studied with the sculptor Donner in Vienna and at the Vienna Academy, later becoming its director (1772). In altarpieces and fres-

statues on top of the volutes, stressing rhythmic alternations by doubling the arched windows which the volutes separate, and emphasizing the polygonal outline of the plan rather than the original circular form. He made the various levels more distinct, while at the same time drawing them together through vertical elements which create an overall pattern of strong projections and dramatic contrasts of light and shadow.

A second, smaller cupola, which echoes the main dome, adds a new dimension to the basically simple central plan; flanking this are two slender campaniles, which again show in their arcading and domes Longhena's affinity for the circle. Shell shapes are a not unexpected source of inspiration for this sea-girt architecture; water literally laps at the foundations of this church on its dominating site at the end of the Grand Canal. Designed to be seen from the Piazzetta or the Grand Canal, the Salute is not entirely successful from other points of view.

The decorative elements of the interior are carefully organized. Reflections of Palladio are unmistakable, but the end result falls short of his classical balance and repose. In Longhena, undigested eclecticism tends to lead to excesses. Tintoretto's *Marriage at Cana* may be seen in the sacristy.

BIBLIOGRAPHY. G. A. Moschini, *La Chiesa e il Seminario di Sta. Maria della Salute in Venezia*, Venice, 1842; C. Semenzato, *L'Architettura di Baldassare Longhena*, Padua, 1954.

MADLYN KAHR

SANTA MARIA DELLA SPINA, PISA.

Small rectangular Italian Gothic church (1325–27) built in the form of a reliquary casket. The building is a plain rectangular enclosure covered by a single-trussed timber roof of very low pitch, but the outward appearance of this miniature church is given great vivacity by striped façades of colored marbles and pinnacled false gables. The latter give tactile expression to the thorn from the Crown of Thorns, for which the church is named and a relic of which it guards. In decoration S. Maria della Spina shows how the spirit of the Romanesque lived on in Tuscan Gothic.

BIBLIOGRAPHY. C. H. Moore, *Development and Character of Gothic Architecture*, 2d ed., New York, 1899; K. J. Conant, *Carolingian and Romanesque Architecture, 800–1200*, Baltimore, 1959.

SANTA MARIA DELLE CARCERI, PRATO, *see* SANGALLO FAMILY.

SANTA MARIA DEL MAR, BARCELONA.

Spanish parish church begun in 1329 and vaulted by 1384. It is of typical Catalan Gothic form: transeptless and tripartite, with a wide nave of four nearly square bays. There are nine polygonal radiating chapels around the ambulatory, and three square chapels flank each aisle bay. The west façade is flanked by polygonal towers.

SANTA MARIA DEL POPOLO, ROME.

Church founded in 1099 by Pope Paschal II and enlarged under Gregory IX (1227–41). It was reconstructed under the guidance of Baccio Pontelli and Andrea Bregno for Sixtus IV (1472–77). The plan consists of a nave and side aisles flanked by lateral chapels. Bramante lengthened the apse during the time of Julius II (1503–13). The early Renaissance façade, simple and organic, was enriched by Bernini's addition of large volutes, which flank the gable in characteristic Roman baroque style. Bernini is also responsible for the baroque interior.

In the Della Rovere Chapel are frescoes by Pinturicchio. The Chigi Chapel was designed by Raphael. The main chapel contains tomb monuments by Andrea Sansovino. S. Maria del Popolo contains two superb paintings by Caravaggio: the *Conversion of St. Paul* and *Crucifixion of St. Peter*.

BIBLIOGRAPHY. G. Lafenestre and E. Richtenberger, *La peinture en Europe (Rome, le Vatican, les églises)*, Paris, 1903; E. Lavagnino, *Santa Maria del Popolo*, Rome, 1928.

SANTA MARIA DE MUR FRESCOES.

Romanesque painting, in the Museum of Fine Arts, Boston.

SANTA MARIA DI CAPUA VETERE, *see* SANTA MATRONA, CHAPEL OF.

SANTA MARIA IN COSMEDIN, ROME.

Early Christian basilica, erected in the 5th century. It was remodeled in the 8th century and stands, for the most part, in this condition. The basilica is flanked by a 12th-century Romanesque campanile. The interior (8th cent.) is richly decorated with 13th-century work by the Cosmati family.

SANTA MARIA IN DOMNICA, ROME.

Early Christian basilican church. It was rebuilt by Pope Paschal I (817–824), who commissioned the famous Byzantine mosaics. In the apse the Virgin and Child appear, guarded by crowds of angels; the Pope kneels at the Virgin's feet. The apostles flank Christ on the triumphal arch above.

BIBLIOGRAPHY. J. Wilpert, *Die römischen Mosaiken und Malereien der kirchlichen Bauten vom IV. bis XIII. Jahrhundert*, 2d ed., 4 vols., Freiburg im Breisgau, 1917.

SANTA MARIA IN TRASTEVERE, ROME.

Church built in the 3d or 4th century and reconstructed by Pope Innocent II (1130–43). In plan it follows the Early Christian churches of the 5th century: a three-aisled basilica, a semicircular apse, a clerestory, and a trabeated rather than an arcaded nave colonnade. The apse mosaics (1291) by Cavallini are a synthesis of Early Christian and Byzantine styles. *See* CAVALLINI, PIETRO.

BIBLIOGRAPHY. E. Mâle, *The Early Churches of Rome*, London, 1960.

SANTA MARIA IN VALLE, TEMPIETTO OF.

Proto-Romanesque Lombard church at Cividale del Friuli, Italy, situated directly behind the abbey church. Erected during the reign of Peltruda (762–776), it consists of a nave and presbytery. The latter is divided into three tunnel-vaulted compartments that rest on two rows of columns with architraves. The nave (ca. 20 ft. square) is groin-vaulted and richly embellished. High on its west wall stands a famous stucco frieze of six perfectly preserved figures, three on each side of a now unoccupied niche. The expressive power and technical excellence of these figures, as well as of the moldings of the interior, bespeak Byzantine execution. The exterior, decorated only by blind arches around the windows, contrasts with the rich interior, indicating possible Muslim influence from southern Italy.

BIBLIOGRAPHY. H. Decker, *Romanesque Art in Italy*, London, 1958; K. J. Conant, *Carolingian and Romanesque Architecture, 800–1200*, Baltimore, 1959.

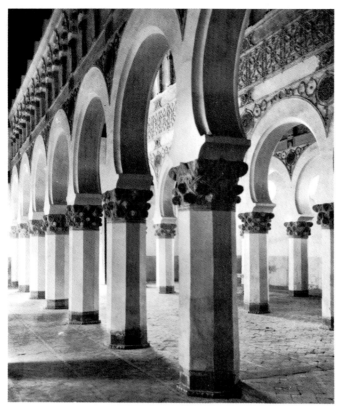

S. Maria la Blanca, Toledo, Spain. The arcades of horseshoe arches separating the five aisles.

S. Maria Maggiore, Rome. The column-flanked nave of this well-preserved Early Christian basilica.

SANTA MARIA LA BLANCA, TOLEDO, SPAIN. Synagogue in Toledo, probably begun in the late 12th century. Redecorated after a fire in about 1250, it became a church in 1405. The five aisles are separated by stuccoed brick arcades of seven rounded horseshoe arches on octagonal tiled piers. Above them are blind arcades of lobed arches and elaborate carved plaster ornament of Andalusian inspiration. The roof is of open wooden beams. The forms of the arcades suggest that 12th-century Mudejar art in Toledo retained the forms of the Cordovan caliphate, resisting Almohad and other North African innovations. The three eastern apses, the center one with a cupola, were added about 1550, in Renaissance style, as is the retable of 1556 by Bautista Vázquez and Nicolás de Vergara the Elder, both from Seville.

BIBLIOGRAPHY. J. Ainaud de Lasarte, *Toledo*, Barcelona, 1947; *Ars Hispaniae*, vol. 4, Madrid, 1949.

SANTA MARIA LA REAL, SANGUESA. Spanish church dating from the first half of the 13th century. The present building is a renovation of a Romanesque structure of a century earlier and shows the transition from the Romanesque to the Gothic style. The interior has a nave of two bays with two aisles divided by column clusters supporting rib vaults. The crossing is surmounted by a ribbed dome on squinches encased in an exterior tower culminating in a spire. Three semicircular apses terminate the building. An ogival portal, with recessed archivolts and two rows of blind arcades above it, decorates the entrance.

BIBLIOGRAPHY. V. Lampérez y Romea, *Historia de la arquitectura cristiana española en la edad media*, vol. 2, Madrid, 1909.

SANTA MARIA MAGGIORE, ROME. Early Christian basilica built on the site of a pagan basilica and enlarged early in the 5th century. Despite much Renaissance remodeling, it remains one of the best-preserved examples of Early Christian architecture.

A three-aisled columnar basilica, S. Maria was originally roofed with open timber trusswork; the present coffered ceiling dates from the Renaissance. The basilica, without galleries, has large clerestory windows. Architectural motifs on clerestory and triforium wall are Renaissance additions. S. Maria's architrave is carried by antique marble columns and capitals of the Ionic order. The wide light open space within the basilica and the columnar rhythm of the nave, culminating in a semicircular apse, give us one of the clearest ideas of the impressive spatial effect of an Early Christian basilica. The vaulting of the aisles was not part of the original construction.

Perhaps the most significant aspect of S. Maria Maggiore is its mosaics. The basilica contains the earliest mosaic Old Testament cycle extant. Done between 432 and 440 under Pope Sixtus III, the cycle comprised forty-four scenes, of which twenty-nine have been preserved (this figure includes the apse mosaics as well as those on the nave walls). The cycle, composed of separate, independent scenes, is devoted to the stories of Abraham, Jacob, Moses, and Joshua. Stylistically, the mosaics show the transitional nature of Early Christian art at this time, the figures being treated in a manner familiar in Roman imperial art. In both clothing and gestures, the Old Testament patriarchs and heroes suggest Roman senators or knights. The colors and

modeling are those of late-antique illusionism. Forms are fully plastic and are achieved by the juxtaposition of different-colored tesserae, while at the same time there is a competent, accurate presentation of aerial perspective, landscapes, and spatially handled city and crowd scenes. On the other hand, the new aesthetic demanded by Christianity is also manifest in varied ways. In many scenes, for example, Abraham and Melchizedek, the naturalistic and plastic treatment of figures and landscape is overridden by a space-negating gold background. The introduction and frequent use of gold backgrounds are an omen of what is to come, as is the frequent and "unnatural" use of the new Christian symbols. Within the broad terms of their stylistic qualities, the mosaics relate to contemporary manuscript illuminations in the Vatican Vergil and the Quedlinburg Itala.

The basilica also contains mosaics of the end of the 13th and the beginning of the 14th century. Produced by the Roman workshop of Pietro Cavallini and done by his assistant, Jacopo Toritti, they show a return to Early Christian style much influenced by the contemporary Italo-Byzantine school of painting.

BIBLIOGRAPHY. C. Cecchelli, *I mosaici della basilica di S. Maria Maggiore*, Turin, 1956; A. Grabar and C. Nordenfalk, *Early Medieval Painting...*, New York, 1957. STANLEY FERBER

SANTA MARIA NOVELLA, FLORENCE.

Italian Dominican Gothic church begun in 1278. The interior was completed after 1350. S. Maria Novella is a Latin cross in plan, with a nave, two side aisles, and a transept, and is vaulted throughout. Four small chapels, two on each side of the choir, border the east side of the transept. One of these, the Chapel of Filippo Strozzi, has frescoes by Filippino Lippi (finished in 1502). The choir is decorated with frescoes by Ghirlandajo (1485–90). At the ends of the transept are two large chapels: at the south end, the Rucellai Chapel, for which Duccio painted his famous *Madonna* (1285); at the north end, the Strozzi Chapel, decorated by Nardo di Cione (ca. 1357). In the nave is the famous *Trinity* fresco by Masaccio (ca. 1428).

The adjoining cloisters of the church include the Chiostro Verde, with frescoes by Paolo Uccello (first half of 15th cent.). The former chapter hall, now called the Spanish Chapel, contains frescoes (1365–69) by Andrea da Firenze. The unfinished Gothic façade of the church was completed by Leon Battista Alberti (1456–70), who meant to give an archaeological reconstruction of a medieval façade but actually used proto-Renaissance forms. *See* ALBERTI, LEON BATTISTA.

BIBLIOGRAPHY. W. Paatz, *Die Kirchen von Florenz*, new ed., vol. 3, Frankfurt am Main, 1952; R. Wittkower, *Architectural Principles in the Age of Humanism*, 2d ed., London, 1952.

SANTA MARIA PRESSO SAN SATIRO, MILAN, *see* BRAMANTE, DONATO.

SANTA MARIA SOPRA MINERVA, ROME.

Gothic church built by the Dominicans in the 13th century on the site of a Roman temple once dedicated to Isis. It is the only Gothic church in Rome. Its plan, with a nave, side aisles, and a transept off which rectangular chapels open, relates it to a family of Cistercian churches, of which S. Maria Novella in Florence is the most famous.

BIBLIOGRAPHY. E. Mâle, *The Early Churches of Rome*, London, 1960.

SANTA MATRONA (Santa Maria di Capua Vetere), CHAPEL OF.

Late-5th- or early-6th-century chapel attached to the side of the Church of S. Prisco in ancient Capua, Italy. A vaulted ceiling and three of the four lunettes retain part of their original Early Christian mosaic decoration, consisting of ceiling sections with decorative still lifes, and a bust of Christ with the symbols of Luke, John, and Matthew in the lunettes.

BIBLIOGRAPHY. J. Wilpert, *Die römischen Mosaiken und Malereien der kirchlichen Bauten vom IV. bis XIII. Jahrhundert*, 2d ed., 4 vols., Freiburg im Breisgau, 1917.

SANT'AMBROGIO, MILAN.

Italian church, the most important architectural monument of the Lombard Romanesque style. It raises many significant questions relative to the development of Romanesque architecture. Portions of the main apse, dating from the 9th and 10th centuries, are the earliest extant parts of the church. The same 10th-century date applies to the two flanking apses and to parts of the choir. The main portion of the basilica (nave and aisles) dates, for the most part, from the 12th century (ca. 1128–86), while the church is preceded by a spacious open atrium of the end of the 11th century (ca. 1098) that is attached directly to a narthex of the same period. Flanking the first bay, on the south, is the simple Monks' Tower of the 10th century, while to the north is the handsome Canons' Tower of the 12th century. Although these rough dates appear to give a clear picture of the sequential stages of S. Ambrogio's construction, each of the assigned dates may be questioned and qualified. Interrupted periods of construction, earlier foundations (Carolingian, under the atrium), and remodeling in the course of construction have all left their confusing marks on S. Ambrogio. The accurate dating of this church is significant, for it displays elements important in the evolution of Romanesque architecture, and its role in this evolution hinges on the question of date.

The nave and aisles probably dated, originally, from about 1080 but were remodeled during the 12th century. However, all evidence indicates that the nave was vaulted from the outset with domical rib vaults, each nave bay encompassing two aisle bays. The three bays of the nave are separated from each other by transverse arches. Because of the semicircular ribs, each attaining the same height, the bays are arranged in a square scheme, two aisle bays to one nave bay, thus creating a system of alternating supports. The aisles and triforium gallery are groin-vaulted. The height of aisle and gallery relative to the rather low domical nave vaults allows no clerestory space; hence the church formerly was rather dark. The fourth bay of the nave, originally vaulted like the first three, was subsequently opened above into an octagonal lantern tower, which now provides the necessary interior light.

The entrance to the church is through an impressive rib-vaulted narthex (1095–96), topped by a tribune and covered by a low, sweeping gable. The tribune and narthex are faced with open arcades, giving the whole the appearance of a two-story porch. The west wall of the groin-vaulted atrium is faced with a blind arcade, and the north and south walls are reinforced and articulated by spur buttresses. The entire exterior, especially the early three apses in the east, is replete with a rich and effective use of decorative motifs, known throughout the Romanesque

period as Lombard. Pilaster strips and engaged shafts are used for the careful definition of vertical divisions, while deep corbel tables enrich the horizontal delineations. The octagonal crossing lantern is enriched by deep-set blind arcades. The south (Monks') tower is a simple square mass with none of the decorative motifs just described. The north (Canons') tower, built almost two centuries later, epitomizes the sophisticated use of all the motifs. Engaged shafts divide the face of the tower into three vertical units, while corbel tables divide it into five stages above the eaves of the church. The upper stage is pierced by the three large arches of the belfry. The entire tower shows the beautiful effect obtained by the careful and restrained handling of these Lombard motifs.

Among the questions raised by S. Ambrogio is one concerning the relation of its rib vaulting to other early examples of this structural technique. Durham Cathedral, vaulted in 1104, is most often cited in relation to S. Ambrogio. It has even been asserted that Durham's ribs were prior to those of the Milan church, arguing that S. Ambrogio did not receive its ribs until the rebuilding from 1128 to 1186. Norman-Lombard relationships can be traced through William of Volpiano, while Norman-English relationships are obvious. However, there is an essential difference in the nature of the rib-vaulting systems employed in the respective churches. Durham shows a proto-Gothic vaulting system which effectively ties the walls to the vaulting zone. This is achieved by adjusting all ribs to attain nave height, making a completely flexible system and not a square, static scheme. S. Ambrogio's ribs, tied to a square scheme, are completely static, emphasizing the segregation of bays and the separation of vaulting zone from wall surface. In this respect S. Ambrogio is related to Speyer, whereas Durham, with its clerestory as well as a gallery, is more clearly related to the Norman architecture of Caen.

Another pertinent question raised by S. Ambrogio is the development and spread of Lombard decorative motifs, for example, the exterior dwarf gallery that is found here and in other churches of the 9th and 10th centuries. A possible prototype of this motif is a 3d-century Roman form. Historical evidence shows that Roman construction had continued in a cruder folk architecture, the *premier roman*, which had become widespread. The Lombard style developed on the basis of that earlier tradition, and Lombard masons carried their own style to other parts of Europe. This analysis in no way diminishes the importance of Lombard style in the development of Romanesque architecture nor underestimates the significance of S. Ambrogio. *See* LOMBARD STYLE.

S. Ambrogio presents a picture of Romanesque concepts at the turn of the 11th century, when the first phase of Romanesque had already passed. Initially, Romanesque structures were concerned with a clear spatial articulation (compartmentalization) and development of plastic masses and groupings. The next phase (S. Ambrogio) shows Romanesque embracing expanded spatial concepts and diminishing wall surfaces in an attempt at greater, more complex articulation. And, finally, S. Ambrogio indicates the high degree of sophisticated decorative achievement Romanesque was capable of within a framework of architectonic, nonfigural plastic surfaces. For its rib vaulting, for its alternating system of piers, and for its admirable use of decorative motifs, S. Ambrogio remains a key structure in Romanesque architecture.

BIBLIOGRAPHY. A. K. Porter, *Lombard Architecture*, 4 vols.. New Haven, 1915–17; F. Reggiori, *La basilica di Sant'Ambrogio a Milano*, Florence, 1945.

STANLEY FERBER

SANT'ANDREA, MANTUA. Church on the Piazza Mantegna in central Mantua. It is one of the most important creations of the early Renaissance in Italy. S. Andrea was designed in 1470 by Leon Battista Alberti, the great theoretician and architect of the Renaissance, to replace a Gothic church on the same site. The square tower to the left of the façade is a remnant of the earlier church.

The completion of S. Andrea took two centuries. Building was begun in 1472 from Alberti's designs by the architect Luca Fancelli, who erected the façade and the body of the church up to the crossing (1472–94). Work was not resumed until the very end of the 16th century, when Antonio Maria Viani finished the two arms of the transept. Finally, the dome was erected over the crossing by Filippo Juvara, beginning in 1732. Paolo Pozzo completed the structure at the end of the 18th century.

The façade of S. Andrea displays Alberti's interest in the architectural forms of Roman antiquity; it represents a reinterpretation of Roman motifs, which Alberti studied carefully and incorporated in his treatise on architecture. In earlier churches Alberti had experimented with the temple front (S. Sebastiano, also in Mantua) and with the triumphal arch (the Church of S. Francesco in Rimini). In the façade of S. Andrea he combined these two motifs. A colossal order of pilasters topped by an entablature and a low pediment provide the temple-front effect. This grid is in turn pierced by one main entrance archway and by smaller openings in the side bays, a schema obviously inspired by Roman monuments such as the Arch of Titus in Rome and the Arch of Trajan in Ancona. By employing the architectural motif of pilasters, Alberti reconciled the classical concept of the column with the flat plane of the façade wall.

Behind the façade lies a shallow vestibule through which one enters the church. The plan of the church is in the form of a Latin cross. The wide nave is covered majestically by a high coffered barrel vault. The nave walls are organized on the same scheme as the façade, with narrow strips of wall flanked by colossal pilasters and alternating with broad archways. On either side of the nave is a single aisle composed of three main vaulted chapels alternating with smaller chapels covered by cupolas. The crossing is lighted by the dome that Juvara erected in the 18th century. Beyond the dome, the east end terminates in the ample curve of the apse.

S. Andrea contains much fine sculpture, as well as mural painting by such artists as Rinaldo Mantovano, Benedetto Pagni, and Giorgio Anselmi. The great Mantuan painter Andrea Mantegna (1431–1506) is buried in the first chapel of the left aisle. *See* ALBERTI, LEON BATTISTA.

BIBLIOGRAPHY. R. Wittkower, *Architectural Principles in the Age of Humanism*, 2d ed., London, 1952.

SPIRO KOSTOF

S. Ambrogio, Milan. An important Lombard Romanesque monument.

S. Andrea al Quirinale, Rome. A small oval-plan church by Bernini.

SANT'ANDREA AL QUIRINALE, ROME. Church commissioned from Bernini by Cardinal Camillo Pamphili for the novices of the Jesuit order. It was begun in 1658, and the elaborate interior decoration was completed in 1670. Bernini's oval plan for the small building has a longer transverse than a longitudinal axis. The entrance bay and apse niche are flanked by hollowed-out chapels, but the two bays on either side of the transverse axis are closed by pilasters. In this way attention is unswervingly focused on the columned aedicule in front of the apse and on the figure of S. Andrew soaring to heaven from the convex opening of the aedicule pediment. The walls are faced with multicolored marbles; the dome, by contrast, is white and gold. Angels on clouds and bearing festoons surmount the windows between the ribs of the dome. The convex exterior entrance portico is flanked by a concave oval wall. Through the continual play of movement and countermovement Bernini has achieved a dynamic integration of interior and exterior.

BIBLIOGRAPHY. R. Wittkower, *Art and Architecture in Italy, 1600–1750*, Baltimore, 1958.

SANT'ANDREA DELLA VALLE, ROME, *see* MADERNO, CARLO; RAINALDI, GIROLAMO AND CARLO.

SANT'ANGELO, CASTEL, ROME. Ancient Roman building, originally Hadrian's mausoleum. It stands next to the Pons Aelius (today the Ponte Sant'Angelo) on the right bank of the Tiber. The mausoleum was built on the property of the Gardens of Domitia. It was consecrated A.D. 139 by Antoninus Pius, who dedicated it to Hadrian and his deified wife, Diva Sabina.

In antiquity, this monument was called the Hadrianeum or the Sepulcrum Antoninorum. It served as the burial place of the Antonine emperors until the time of Caracalla. Originally, the building consisted of a square podium (340 ft. square and 30 ft. high), over which rose a circular drum (ca. 69 ft. high and ca. 210 ft. in diameter) that enclosed the burial chamber. From the center of the drum and above the burial chamber there rises on a square base a smaller cylindrical structure recently proved to have belonged to the ancient structure. The top of this circular structure was probably crowned with a chariot group. The mausoleum followed in plan an earlier circular type of sepulchral building such as the tomb of Cecilia Metella and the mausoleum of Augustus. The origin of this type dates back to the sepulchral tumuli of the Etruscans. *See* CECILIA METELLA, TOMB OF, ROME.

The burial chamber was placed in the center of the drum; it was almost square and had a barrel vault. Access to it was by a spiral passage. The chamber was constructed of travertine lined with blocks of marble. Above the central chamber were other square rooms that served for the burial of the Antonine emperors. Radiating chambers with concrete vaulting were built between an inner brick wall and the cylindrical drum, inside the square base. The podium was constructed of concrete with travertine walls faced with blocks of marble. This marble revetment was still *in situ* as late as the end of the 16th century. Drawings of the 16th century show a frieze of bucrania and garlands on the upper part of the base wall. The exterior wall of the main drum was constructed of concrete faced with *opus quadratum*. The entrance to the mausoleum was in the center of the side facing the river. Over the main entrance door was the inscription dedicating the building to Hadrian.

The building was converted into a fortress at the beginning of the 5th century, perhaps under the emperor Honorius, who joined the building to the Aurelian Walls. To Procopius, a historian of the 6th century, we owe the earliest description of the monument. According to him, the exterior of the main drum was encircled by marble statues set on a balustrade. These statues were hurled down on the heads of the besieging Ostrogoths in A.D. 537. The building derived its name from the archangel Michael, who appeared in the vision of Pope Gregory the Great during the plague in 590. A marble statue of the archangel Michael now crowns the building. At the end of the 14th century the Castel Sant'Angelo became the private residence of the popes. Traces of the ancient structure still exist in the podium, the central chamber, and portions of the circular drum.

BIBLIOGRAPHY. S. B. Platner, *The Topography and Monuments of Ancient Rome*, 2d rev. ed., Boston, 1911; S. Rowland Pierce, "The Mausoleum of Hadrian and the Pons Aelius," *The Journal of Roman Studies*, XV, 1925; D. M. Robathan, *The Monuments of Ancient Rome*, Rome, 1950.

EVANTHIA SAPORITI

SANT'ANGELO IN FORMIS. Church near Capua, in southern Italy. This unpretentious building contains a fresco cycle that is outstanding in medieval Italian art for ar-

tistic quality, preservation, and extent. The church was built shortly after 1072 by Desiderius of Montecassino on the site of a temple of Diana. Stylistic analysis suggests that the frescoes followed in a series of stages extending little further than 1100. The figures over the entrance portal are the most Byzantine in style and therefore probably the earliest. Within, the severe Byzantine trend is blended, in varying degree, with a vigorous Campanian realism. The apse displays Christ in Majesty, and the inner west wall facing it shows the Last Judgment. The nave and aisle walls are decorated with narrative scenes from the Old and New Testaments.

BIBLIOGRAPHY. J. Wettstein, *Sant'Angelo in Formis et la peinture médiévale en Campanie*, Geneva, 1960; O. Morisani, *Gli affreschi di S. Angelo in Formis*, Cava dei Tirreni, 1962.

SANT'ANTONIO, BASILICA OF, PADUA. Italian church under construction from 1231, following the death of St. Anthony, to 1307. It is transitional from Romanesque to Gothic in style, with a Byzantine flavor added by its later (1475) tiered domes. The spacious interior is enriched with many works of art, chief among them being sculptures (1447–50) for the altar by Donatello, whose great equestrian statue (1444–47) of Erasmo da Narni, known as Gattamelata, stands on the square before the basilica. Also noteworthy are 14th-century frescoes by Altichiero and Avanzo.

The tomb of St. Anthony, with early-16th-century reliefs depicting scenes from his life, is greatly venerated. Among other noteworthy tombs is that of Pietro Bembo, who died in 1547. In the Treasury Chapel are relics of the saint and goldsmith work of high quality. The cloisters date from the 13th through the 16th century.

BIBLIOGRAPHY. B. Gonzati, *La Basilica di S. Antonio di Padova*, Padua, 2 vols., 1852; G. C. Argan, *L'architettura italiana del duecento e trecento*, Florence, 1938.

SANT'APOLLINARE IN CLASSE, RAVENNA. Italian basilican church in Classe, the old port of Ravenna. It was built between 536 and 549 under the aegis of Julianus Argentarius, a wealthy Christian church patron.

The church is a simple basilica with three aisles, a nave flanked by side chambers, and two towers. The apse exterior is polygonal (a Byzantine feature), and the masonry is similar to that of S. Vitale; that is, it consists of narrow bricks with wide mortar beds. This type of masonry is of Constantinopolitan derivation and in the Ravenna area was used only in buildings associated with Julianus Argentarius.

The nave is separated from the aisles by an arcade resting on antique marble columns. These columns are capped by deeply undercut, "windblown" foliate capitals, whose style was most prevalent in the late 5th century. This style had been outmoded by the delicate lacework basket capitals of Justinianian architecture in Ravenna. Like the Cathedral of Parenzo (ca. 550), S. Apollinare in Classe shows the continuation in Italy of a basically conservative 5th-century basilican tradition, one that proceeds alongside, but independently of, 6th-century Justinianian innovations. *See also* DOSSERET.

The interior decorations of S. Apollinare in Classe are confined to a band of mosaic portrait plaques lining the triforium level of the nave, mosaics on the apse arch, and mosaics within the apse itself. All but the apse mosaics belong to the church construction period and are of a con-

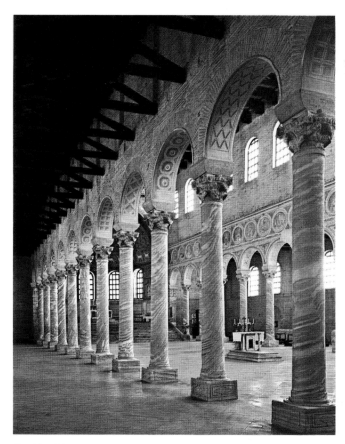

Sant'Apollinare in Classe, Ravenna.

sistently 5th-century *retardataire* style. They show a degenerated, incompletely understood use of late-antique formulas in single-statement iconlike portraits. The apse mosaics are, for the most part, of the 7th century and show the early degeneration of the Justinianian mosaic tradition found in S. Apollinare Nuovo and S. Vitale (this tradition reached its peak in the period 530–40).

The interest of S. Apollinare in Classe lies in its proximity to the great Justinianian buildings of Ravenna. As such, it points out the danger of assuming stylistic relationships or dependencies solely because of geographical or chronological proximity. Conversely, it illustrates how two styles, "advanced" and *retardataire*, can exist side by side in the same ambience, independently of each other.

BIBLIOGRAPHY. O. M. Dalton, *Byzantine Art and Archaeology*, Oxford, 1911; G. Bovini, *Ravenna Mosaics*, Greenwich, Conn., 1956.
STANLEY FERBER

SANT'APOLLINARE NUOVO, RAVENNA. Italian church built between 490 and 510 by Theodoric, king of the Goths, for the Arian sect. A wide-naved basilica with two aisles, it represents a basilican type found in Ravenna as early as the first quarter of the 5th century (S. Giovanni Evangelista). However, S. Apollinare owes its importance to the 6th-century mosaics still on its walls. The church was transformed from Arian to Catholic worship under Archbishop Agnellus in about 527. By this time it had already been partially decorated with mosaics by Theodoric's workmen. The mosaic decoration was thus completed

under the influence of the Byzantine Justinianian style, and it now affords the opportunity of contrasting contemporary Byzantine and non-Byzantine mosaics in the same monument, side by side.

The Arian mosaics of Theodoric's time, done between 493 and 526, are the prophets and apostles between the clerestory windows and the small panels with New Testament scenes above the windows. Their style is still strongly reminiscent of Hellenistic illusionism. The modeling of the figures is done primarily with color. Strong linear contours are, for the most part, absent. Occasionally they appear on the dark, shadowed side of the figures, while the opposite side is treated with light values of mosaic tile. Figures are arranged according to the tasks they perform, no special rhythm or movement being established. In this sense, each figure or panel is compositionally self-sufficient. The figures rest their feet upon a tangible ground which is spatially distinct from the background. In the New Testament scenes some attempt at illusionistic landscape presentation is made.

The Justinianian mosaics (527–65) cover both walls of the nave above the arcading and below the clerestory windows. They depict processions of saints, with the male saints on the south wall in procession toward Christ, while the female saints on the north wall, preceded by the three Magi, proceed toward the seated Virgin. These figures have lost most vestiges of classical illusionism. Each has a strong linear contour and is dressed in robes whose folds are linear and stylized. A ground space is not firmly established, and feet appear to dance lightly upon their toes. The figures are presented frontally with a palmlike tree between each of them. But no natural landscape can be assumed, for the trees function as minor stops in the continuous rhythm established by the processions. The rhythmic, moving surface quality of the processions is emphasized by the rich surface color. Jeweled gowns, golden haloes, and delicate fanlike tree branches combine to keep the eye moving across the surface with the processions rather than attempting to penetrate the visual surface. The excellence and finesse of execution, together with the subtlety of compositional unity, almost assure that the mosaics were the work of Constantinopolitan craftsmen rather than the product of a provincial workshop.

BIBLIOGRAPHY. G. Bovini, *Ravenna Mosaics*, Greenwich, Conn., 1956.

STANLEY FERBER

SANTA PRASSEDE, ROME.
Church founded in the 5th century and rebuilt by Pope Paschal I (817–824). The mosaics were commissioned by him. The apse mosaic depicts Jesus with apostles, saints, and the Pope. The little Chapel of S. Zeno, a mausoleum built by Paschal I for his mother, Theodora, is a Byzantine structure; the vault is completely covered with mosaics, and the pavement is one of the oldest examples of *opus sectile* extant. *See* OPUS.

BIBLIOGRAPHY. A. Grabar and C. Nordenfalk, *Early Medieval Painting*, New York, 1957.

SANTA PUDENZIANA, ROME.
Early Christian church, located upon the ruins of a house that may have been used by Christians in the earliest times. The present building is of the 4th and 16th centuries, with a bell tower of the 12th century and a façade of the 19th. It is a three-aisled basilica in plan, the central aisle, or nave, terminating in a large apse. Drastic reconstruction, which dates from the 16th century, produced many changes in the original structure.

S. Pudenziana is chiefly famous for the apse mosaic, dating from the very late 4th century. Though later reduced somewhat in size and partially restored, it preserves its original composition and much of its original effect and is the earliest remaining monumental Christian mosaic. The composition, framed by the curving arch of the apse, is symmetrical and balanced in the Roman fashion. Precisely upon the center line appears a majestic figure of Christ, elevated upon a jeweled imperial throne. Above Him, both compositionally and spatially (because of the inward curve of the rising surface of the apse), is an immense jeweled cross, aligned exactly with the central axis of Christ's body. To the right and left of the Saviour appear the apostles; behind them are two women who symbolize the church of the Jews and the church of the Gentiles. Nearest Christ are Peter and Paul. The levels of the apostles' heads are arranged in a low triangle, like a temple pediment, and this format emphasizes the commanding nature of the central figure.

The scene is one of teaching; it is taking place before an arcaded and tiled stoa, or gallery. Directly behind the tiled roof a number of buildings are depicted that are generally considered to represent the structures of the Holy Sepulchre in Jerusalem and the Church of the Nativity in Bethlehem, placed there as a visual metaphor upon the heavenly Jerusalem and Bethlehem. On either side of the cross are symbols of the Evangelists (winged man, lion, ox, and eagle, for Matthew, Mark, Luke, and John), set against a richly colored sky. Thus the composition forms two horizontal zones, or registers, and these contrast a historical reality with the doctrine of salvation. Yet the common axis of the figure of Christ and the great cross introduce a unifying vertical which, aided by the shape of the vault, helps to make a whole out of the various parts. Some parallels with imperial iconography, as seen for example upon the Arch of Constantine in Rome, are apparent, but the importance of the mosaic is in its early date and its prefiguration of so much that was to become accepted in Christian art.

BIBLIOGRAPHY. J. Wilpert, *Die römischen Mosaiken und Malereien der kirchlichen Bauten vom IV. bis XIII. Jahrhundert*, 2d ed., 4 vols., Freiburg im Breisgau, 1917; C. R. Morey, *Early Christian Art*, 2d ed., Princeton, 1953; W. F. Volbach, *Early Christian Art*, New York, 1962.

WILLIAM L. MAC DONALD

SANT'AQUILINO, CHAPEL OF, MILAN.
Octagonal chapel attached to the Church of S. Lorenzo by an atrium-like area, probably dating from the mid-5th century. The chapel today holds two Early Christian apsidal mosaics dating from the third quarter of the 5th century, from which time also comes the mosaic fragment recently discovered in the same area.

BIBLIOGRAPHY. P. Verzone, *L'Architettura religiosa dell'alto medio evo nell'Italia settentrionale*, Milan, 1942.

SANTA RESTITUTA, NAPLES.
Oldest surviving Neapolitan church, whose original fabric dates from the 4th century. It was incorporated into the present Cathedral in Angevin times, and alterations were carried out in the

17th century. Within S. Restituta is S. Giovanni in Fonte, called the Baptistery of Soter. *See* SOTER, BAPTISTERY OF.

SANTA SABINA, ROME. A 5th-century basilica dedicated to a Roman martyr of the 2d century. The structure is three-aisled with an arcaded nave of Corinthian columns. It still contains part of the original decoration, consisting of a dedicatory mosaic panel and eighteen wooden door panels showing Biblical images.

BIBLIOGRAPHY. C. R. Morey, *Early Christian Art*, 2d ed., Princeton, 1953.

SANTAS CREUS MONASTERY. Cistercian abbey in Catalonia, Spain, founded in 1150 and moved to its present site in 1158 by Ramón Berenger IV. The church was constructed in 1174–1221. It has two cloisters, a Romanesque one of 1163 and a Gothic one, begun in 1313, whose south walk was designed by the English architect Raynard Fonoyll in 1331–41.

SAN-TA-TIEN, *see* PEKING.

SANT'ELIA, ANTONIO. Italian architect (1888–1916). Born in Como, he studied in Milan and Bologna, but worked mostly in Milan. He was a key figure in the futurist movement for his unexpected designs for a Città Nuova and for his "Manifesto of Futurist Architecture."

Santiago de Compostela Cathedral. The west façade, or Obradoiro, 1738–50.

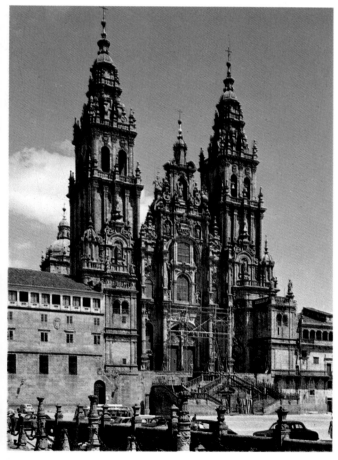

Both produced in 1914, they were prophetic of the ideas and work of the 1920s and 1930s. *See* FUTURISM.

BIBLIOGRAPHY. R. T. Clough, *Futurism*, New York, 1961.

SANTERRE, JEAN-BAPTISTE. French painter of allegorical portraits and religious subjects (b. Magny-en-Vex, 1651; d. Paris, 1717). A pupil of F. Lemaire and Bon de Boullogne, he became an academician in 1704. At Versailles the King had him organize a private drawing academy for the court ladies. The diminutive scale of his figures and his fluid technique and light treatment of subject matter immediately anticipate Watteau.

SANT'EUSTORGIO, MILAN. Three-aisled Italian basilica, dating mainly from the 12th and 13th centuries. Between 1462 and 1468 the Portinari Chapel, a gem of early Renaissance art, was added to the church. It displays frescoes by V. Foppa and a sculptured tomb by Giovanni Balduccio.

BIBLIOGRAPHY. R. Cipriani et al., *La Cappella Portinari in Sant'Eustorgio a Milano*, Milan, 1963.

SANTI, ANDRIOLO, *see* ANDRIOLO DE SANCTIS.

SANTI, GIOVANNI. Italian painter (b. Colbordolo, Urbino; d. Urbino, 1494). The father of Raphael, he worked at the courts of Urbino and Mantua and is the author of a rhymed chronicle dedicated to Duke Guidobaldo. His dated works, belonging to the last years of his life, are altarpieces of *The Madonna and Child with Saints* in the Municipio at Gradara, signed, 1484; in the monastery of Montefiorentino, near Piandimeleto, 1489; and in the National Gallery of the Marches, Urbino (from S. Francesco in that city), also 1489.

These and such other works as the *Annunciation* from S. Maria Maddalena at Senigallia, now in the Brera Picture Gallery, Milan; the *Visitation* in S. Maria Nuova, Fano; the *Madonna* in the Municipal Picture Gallery, Fano; and the *St. Jerome* from S. Bartolo at Pesaro, in the Vatican Picture Gallery, Rome, all signed, reveal Santi as a provincial artist under the influence of Piero della Francesca, Melozzo da Forlì, and Justus of Ghent, who worked at Urbino.

BIBLIOGRAPHY. R. van Marle, *The Development of the Italian Schools of Painting*, vol. 15, The Hague, 1934.

SANTI, GIOVANNI DE, *see* SANTI FAMILY.

SANTI, RAFFAELLO, *see* RAPHAEL.

SANTI (SS.), alphabetized as Saints.

SANTIAGO, MIGUEL DE. Ecuadorian painter (b. Quito, ca. 1625; d. there, 1706). A major painter of the school of Quito, he was influenced by Zurbarán and Murillo. Miguel de Santiago painted thirteen canvases of the life of St. Augustine, assisted by his pupils (1656; Quito, S. Agustín). Probably his best work is *La Inmaculada con la Santísima Trinidad* (ca. 1680; Quito, S. Francisco).

BIBLIOGRAPHY. E. Marco Dorta and D. Angulo Iñiguez, *Historia del arte hispanoamericano*, vol. 2, Barcelona, 1950.

SANTIAGO DE COMPOSTELA CATHEDRAL. One of the greatest pilgrimage shrines of the Middle Ages, in

Galicia, northwest Spain. Its most ancient foundation, which goes back to the Dark Ages, was modified and rebuilt beginning about 1075 by Bishop Diego Peláez, whose work was continued in the 12th century under Archbishop Gelmírez and his successors. The Cathedral was consecrated about 1128, although it was not completed until 1211.

The plan resembles that of St-Sernin in Toulouse, with two aisles, a transept, and a choir with ambulatory and radiating chapels. The interior elevation has triforium galleries but no clerestory. The aisles run continuously around both nave and transept. Inside the 18th-century west façade is the tripartite Pórtico de la Gloria with a complete program of portal sculpture—Old Testament and apostle figures and reliefs, with Christ in Glory over the central doorway—executed by Mateo, master of the works from 1168 to 1217, and his shop. All the figures show traces of polychromy (applied in 1651).

The interior of the church is plain and dark, with the exception of the carved capitals of the arcade columns. There are two crypts, a Romanesque one by Mateo and one under the choir containing the relics of St. James of Compostela and two of his disciples. The sacristy off the south transept was built in 1527–38 by Juan de Alava, who also began (in 1521) the late Gothic cloisters to the south of the Cathedral (finished in 1590 by Rodrigo Gil de Hontañón).

During the 17th and 18th centuries the exterior was refaced, with the exception of the south door, known as the Puerta de las Platerías (1104). The west façade, or Obradoiro, is the masterpiece of the Churrigueresque style in Spain. It was designed in 1738–50 by Fernando Casas y Novoa. The clock tower, concealing part of the south door, was built in 1676–80. The Puerta Santa at the east end of the building dates from 1611, and the Fachado de la Azabachería on the north was reworked by Ventura Rodríguez in 1765–70.

BIBLIOGRAPHY. K. J. Conant, *The Early Architectural History of the Cathedral of Santiago de Compostela*, Cambridge, Mass., 1926; S. Alcolea, *La Catedral de Santiago*, Madrid [194?].

HELLMUT WOHL

SANTI DI TITO. Italian painter (b. Borgo San Sepolcro, 1536; d. Florence, 1603). He was a pupil of Bastiano de Montecarlo, Bronzino, and Bandinelli. After working in Rome (1558–62), he returned to Florence, where he became a much sought-after portrait, history, and religious painter, working in the elegant and abstruse style of late mannerism. Among his many works in Florence are a painting executed for the Studiolo of Francesco I de' Medici (1570–72) and ceiling paintings for the Academy (1592).

SANTI FAMILY. Italian sculptors (fl. Venice, 14th cent.). Andriolo di Pagano Santi (d. before 1375) is mentioned in the archives of SS. Giovanni e Paolo as executing a crucifix in 1328. In 1351 he collaborated with Francesco Bonaventura and Alberto Ziliberto di Pietro Santo on the grave of Jacopo da Carrara in S. Agostino (Padua, Eremitani). About 1345 he probably executed the grave of Albertino da Carrara, opposite that of Jacopo da Carrara.

The masterpiece of Giovanni de Santi (d. 1392) is the tomb of Enrico Scrovegni in the Arena Chapel in Padua.

It is supposed that he made a trip to Venice in 1366, but no work of the period has been identified. By 1370 Giovanni had established himself at Padua. The Santis and their pupils marked a new and vital period of Venetian sculpture.

BIBLIOGRAPHY. A. Venturi, *Storia dell'arte italiana*, vol. 4, Milan, 1906.

SANTISSIMA (SS.), alphabetized as Saints.

SANT'IVO, *see* BORROMINI, FRANCESCO.

SANTO. Religious figure or panel, usually carved from cottonwood or pine, for use in the devotions of the Spanish and Indian population of the American Southwest. Most of the surviving examples were made in New Mexico from 1750 to 1840. Both the pictorial panels (*retablos*), which may be painted or relief, and the angular, jointed statues (*bultos*) were coated with gesso and brightly painted. *Retablos* were sometimes done on canvas, metal, paper, or leather, as well as on wood. *Santos* form a distinctive type of folk art, derived from the Spanish artistic tradition and filled with the intense feeling of primitive sculptors and painters. *See* BULTO; RETABLE.

BIBLIOGRAPHY. M. A. Wilder and E. Breitenbach, *Santos*, Colorado Springs, 1943; W. Hougland, *Santos, A Primitive American Art*, [n. p.], 1946.

SANTO CRISTO DE LA LUZ, TOLEDO, *see* CRISTO DE LA LUZ, TOLEDO.

SANTO DOMINGO CATHEDRAL. Church in the capital of the Dominican Republic. Begun in 1512, the Cathedral was consecrated in 1541. It is the earliest American cathedral, and its forms derive from Spanish late Gothic and Renaissance vocabularies. The plan has three vaulted naves flanked by lateral chapels with an appended *chevet*.

BIBLIOGRAPHY. G. Kubler, *Art and Architecture in Spain and Portugal and Their American Dominions, 1500–1800*, Baltimore, 1959.

SANTOMASO, GIUSEPPE. Italian abstract painter (1907–). He was born in Venice, where he studied and now lives. A founder-member of Fronte Nuovo, he joined The Eight in 1953. Influenced by Braque and Jean Lurçat, Santomaso reduced still-life objects to flat patterns, translating their contours into arabesques. Recently, he has emphasized painterly values through texture.

BIBLIOGRAPHY. U. Apollonio, *Giuseppe Santomaso*, Amriswil, 1959.

SAN TORPE, MASTER OF, *see* MASTER OF SAN TORPE.

SANTOS DE CARVALHO, EUGENIO DOS. Portuguese architect (1711–60). Santos de Carvalho was chief designer of the rebuilding of downtown Lisbon after the earthquake of 1755. He is responsible for the group of buildings facing the Tagus around the Praça do Comércio, and he conceived the grid plan for the business and residential buildings of the section adjoining the square to the north.

SANTO SPIRITO, FLORENCE, *see* BRUNELLESCHI, FILIPPO.

SANTO STEFANO (San Sepolcro), BOLOGNA. Picturesque complex of four buildings, in northern Italy. It

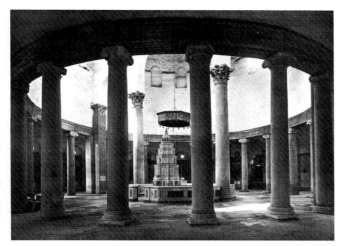
S. Stefano Rotondo, Rome. The cylindrical nave surrounded by columns.

emulates the original layout of the Church of the Holy Sepulchre in Jerusalem. The churches, which are now dedicated to the Holy Cross, Calvary, the Trinity, and SS. Vitalis and Agricola, belong mainly to the 11th to the 13th century.

BIBLIOGRAPHY. A. Raule, *Le chiese di S. Stefano in Bologna*, Bologna, 1955.

SANTO STEFANO ROTONDO, ROME. Early Christian central-plan church, dating from about 480. The central cylindrical nave is encircled by two aisles that are formed by continuous rows of columns. The columns are topped by Ionic capitals and by an architrave. A clerestory level rising above the inner row of columns originally contained windows, most of which are now walled in, and probably carried a light dome. The nave and aisles are now roofed in wood. A high triple arcade, resting on two piers and two columns and crossing the sanctuary, dates from the 9th century. Intersecting the circular plan is a Greek cross, formed by chapels that project at the four cardinal points. The structure may have been built as a martyrium to house a relic of a saint.

The exterior of S. Stefano is of typical Roman brick-work of the 5th century. S. Stefano is one of the earliest extant central-plan churches in the West; in its dimensions it appears to have been intended as a copy of the Church of the Holy Sepulchre, Jerusalem.

BIBLIOGRAPHY. F. W. Deichmann, *Frühchristliche Kirchen in Rom*, Basel, 1948; E. Mâle, *The Early Churches of Rome*, London, 1960.

SAN-TS'AI WARE, *see* THREE-COLOR WARE.

SANTULLANO, OVIEDO, *see* OVIEDO: SAN JULIAN DE LOS PRADOS.

SANTVOORT, DIRCK DIRCKSZ. VAN. Dutch portrait painter (b. Amsterdam, 1610/11; d. there, 1680). Santvoort was probably the pupil of his father, Dirck Pietersz. Bontepaert. He and his brothers adopted the surname "Santvoort." He was recorded as a member of the Amsterdam painters' guild in 1636. His work occasionally shows the influence of Rembrandt, with whom he may have studied. In 1618 his son was baptized with the name "Rembrandt." His Portraits and group portraits are in the style of such painters as Cornelis van der Voort and Nicolaes Eliasz. Pickenoij.

BIBLIOGRAPHY. D. van Santvoort, "A Portrait by Dirck van Sant voort," *Princeton University, Department of Art and Archaeology, Bulletin*, II, 1928.

SAN VICENTE, AVILA, *see* AVILA: SAN VICENTE.

SAN VICENTE DE CARDONA, CHURCH OF. Spanish church poised on the top of a fortified hill, the site of the castle of Cardona, near Barcelona. It consists of three square bays covered with rough barrel vaults and crossed by heavy transverse arches between groin-vaulted aisles. The whole is preceded by a heavy groin-vaulted narthex of five bays. The crossing has a solidly built cupola on squinches. Each bay of the slightly projecting transept consists of a small chapel with a semicircular eastern apse. The handsome choir and apse, with its unusual decoration of tall, narrow semicircular niches, is raised over a crypt. On the exterior blind arcades, with double corbel tables in the first Romanesque style above, completely unify the exterior. The massive piers, rectangular section, and simple harmonious architectonic decoration of this monumental church class it as one of the prime examples of the earliest Catalan Romanesque style.

BIBLIOGRAPHY. *Catalogue roman*, text by E. Junyent, vol. 1 [La Pierre-qui-Vire (Yonne)], 1960.

SAN VITALE, RAVENNA. Italian Byzantine church of Justinianian foundation. Started about 530 and dedicated in 548 by Bishop Maximian, it is one of the most important completely preserved Byzantine monuments extant. S. Vitale is a central-plan church closely related to the slightly earlier Constantinopolitan Church of SS. Sergius and Bacchus. Because of its closeness to its Constantinopolitan prototype, some scholars have suggested that it was the product of Constantinopolitan artisans working in Ravenna—this despite certain significant differences in construction. Other scholars, however, have presented convincing arguments for the execution of S. Vitale by extremely capable Western craftsmen who modified and adapted a Constantinopolitan plan according to their own concepts.

The church is octagonal in plan. The exterior octagon is accentuated by strongly defined buttresses at each of the corners, each side being subdivided by two pilasters. This division is carried through ambulatory and gallery levels, while the clerestory is simply articulated by pilasters at each corner. A clear exterior relationship is thus indicated: division into threes on the first two levels opposed to a single statement on the upper level. This arrangement of masses carries the eye of the beholder from part to part while, at the same time, explaining the disposition of the interior.

The subtlety and refinement of S. Vitale are most apparent with regard to the disposition of the narthex in relation to the church itself. The narthex is set at about a 50-degree angle to the church, creating an off-square axis. Only by entering the left entrance of the narthex to the church does one find himself on the main axis with the apse. When going through the right door of the narthex, one is faced with a niched arcade screening the aisle from

S. Vitale, Ravenna. Deeply cut impost capital with floral motif.

the nave. The seven niched arcades (the eighth side has straight arcades connecting with the apse and thus demarcating the chancel), along with the massive, irregularly shaped piers, serve to separate the nave from the aisle. The triple arcades of the niches, with their finely proportioned antique columns, form a striking contrast to the monumentality of the piers. The central area is vaulted by a low dome set on pendentives. The dome construction is important as evidence of the Western origin of S. Vitale's builders, for it is made of hollow amphorae placed one within the other—a strong, lightweight method of construction of Western, not Eastern, usage.

The entire building is complex in its spatial concept, a concept which involves the statement and denial of space. The view from the nave is simple and direct, emphasizing the strength of the massive piers. The view from the aisle or gallery, through the arcade screen, denies this strength and simplicity. The light from its main source, the central dome, dissolves through the arcaded niches into semidarkness, suggesting a weightlessness that denies the solidity of the piers. This contrast of light and dark is further carried out by the delicately and deeply cut capitals and the elaborately undercut tendril design of the choir screen. The alternating light and dark pattern is reinforced by the varicolored matched-grain marble revetments and mother-of-pearl and mosaic decorations on walls and floors.

The mosaics are of an overall green tonality which, despite separately framed scenes with local color, imparts a coloristic unity to the whole. Iconographically, S. Vitale's mosaics have a monumental nonnarrative program. This program emphasizes the imperial connections of the church (the sidewall apse mosaics) and the idea of sacrifice (the Eucharist). The latter aspect is seen in the arched areas above the chancel arcades. On the north wall are scenes of Abraham and the Angels and the Sacrifice of Isaac; on the south wall, the meeting of Abraham and Melchizedek. These scenes are placed in naturalistic settings that create a limited space within their respective frames. This space works in dynamic tension to the flat surface patterns of the foliate and rinceaux borders.

Perhaps the most famous mosaics in S. Vitale are the scenes in the apse. The conch has an image of Christ seated on the globe of the world, flanked by saints and archangels. On the sidewalls of the apse are two panels. One panel portrays Justinian, Bishop Maximian, and their suite. Opposite it, the other panel shows the empress Theodora and her entourage. The portraits of Justinian and Theodora are two of the most remarkable early Christian portraits, and the one of Theodora serves to date the mosaics. The empress died in 548, and the thin, hollowed face with its deep-set eyes indicates that she was near death at the time of the portrait. Therefore, 547 serves as an accurate terminal date for the mosaics.

In the borders, backgrounds, and floor mosaics, there is frequent and consistent use of floral motifs and ornate leaf rinceaux, which further unifies the various parts of the edifice. Historically, as a prime monument of Byzantine art, and aesthetically, as evidence of Byzantine art at its height, S. Vitale remains a monument unique in its field and of its type.

BIBLIOGRAPHY. O. G. von Simson, *Sacred Fortress: Byzantine Art and Statecraft in Ravenna*, Chicago, 1948; G. Bovini, *Ravenna Mosaics*, Greenwich, Conn., 1956. STANLEY FERBER

SAN VITTORE IN CIEL D'ORO, CHAPEL OF, MILAN. Originally a mid-5th-century chapel of one small bay and an apse, but now connected to the basilica of S. Ambrogio. Early Christian mosaics exist, probably dating from the third quarter of the 5th century. The gold-ground ceiling gives this chapel its descriptive title, and the walls hold six standing figures, four Milanese martyrs and two bishops.

BIBLIOGRAPHY. P. Verzone, *L'Architettura religiosa dell'alto medio evo nell'Italia settentrionale*, Milan, 1942.

SAN ZACCARIA, VENICE. Italian church founded by the doge Giustinian Partecipazio in the 9th century. It was rebuilt in the 10th, 11th, and 15th centuries. The façade is a typical example of the Venetian Renaissance.

SAN ZENO, BASILICA OF, VERONA. Italian church, a prime example of Lombard Romanesque architecture. A wooden-roofed structure completed about 1138, S. Zeno incorporates fragments from a century earlier. Except for the late-14th-century apse, the interior retains its Romanesque character. It is basilican in plan, with a small clerestory and no triforium. The elevated choir with the crypt visible beneath it and their dramatic span of stairways give the sanctuary a sense of remoteness and mystery as it is seen from the nave.

Basilica of S. Zeno, Verona. An exorcism scene from the 11th- and 12th-century bronze doors.

The serenely proportioned Romanesque façade has an early-13th-century "wheel-of-fortune" rose window. Famous reliefs of about 1140 by Nicolaus and Guglielmo da Modena flank the fine 11th- and 12th-century bronze doors. Characteristic of Lombard Romanesque style are the small entrance porch with its columns supported by lions and the independent campanile, which stands at the south side, near the east end of the church.

On the high altar is a celebrated triptych by Mantegna (1459). The cloisters, which are Romanesque on two sides and Gothic on the other two, and the 14th-century tower of the former abbey stand at the north side of the basilica.

BIBLIOGRAPHY. A. K. Porter, *Lombard Architecture*, 4 vols., New Haven, 1915-17; F. Winzinger, *Das Tor von San Zeno in Verona*, Munich, 1958.

MADLYN KAHR

SANZIO, RAFFAELLO, *see* RAPHAEL.

SAO, *see* AFRICA, PRIMITIVE ART OF (WEST AFRICA; CAMEROONS).

SAO PAULO: MUSEUM OF ART. Brazilian collection, housed in a modern building that also contains a film library of screen classics. The painting collection emphasizes 19th and 20th-century art, including works by Renoir, Cézanne, Van Gogh, Picasso, and Portinari.

SAQQARA. Vast Egyptian necropolis in the Memphis area, whose name is probably derived from Sokaris, god of the dead. It extends 4.3 miles along the edge of the desert plateau bordering the west bank of the Nile. There are mastabas and pyramids from the 1st through the 3d dynasty and from the 5th and 6th dynasties; Persian tombs; a Serapeum with underground tombs of bulls; a cat cemetery; and the Coptic monastery of St. Jeremiah. All the superstructures of the Egyptian tombs are oriented north and south, but there is no regular plan, although some of the mastabas are set along short streets.

The archaic mastabas are those of kings and high officials from the 1st and 2d dynasties. They are larger than the contemporary ones at Abydos. Some of the kings seem to have had two mastabas, one at Saqqara and a second at Abydos, the latter probably only a cenotaph. The most important royal mastabas, all from the 1st dynasty, are those of Hor-aha, Queen Mer-neit, consort of Djer, Queen Meryet-neit, and 'Andj-ib. The mortuary complex of Pharaoh Neterikhet (Djeser) of the 3d dynasty, consisting of a stepped pyramid, a southern tomb, and several dummy buildings, was imitated in the unfinished complex of his successor, Sekhemkhet. The unique Mastaba Fara'un of Shepseskaf, in the shape of a huge vaulted coffin, shows the transition from the 4th-dynasty type to that of the 5th dynasty. *See* DJESER'S COMPLEX AT SAQQARA.

The other pyramids date from the 5th dynasty (Userkaf, Isesi, and Unas) and 6th dynasty (Teti, Pepi I, Merenre', and Pepi II), each within its brick enclosure and containing a funerary temple on its eastern side. The size of the royal pyramid decreased and its inner apartments were simplified till they assumed, with Unas, a standard arrangement copied by his successors. The Pyramid Texts, ritual funerary inscriptions, were carved on the walls of the burial chamber, beginning with Unas, and on the corridor walls (Pepi I).

The mastaba-tombs of the 5th dynasty (Ti and Ptahetep-Akhethetep) and 6th dynasty (Mereruka, Kagemni, Neferseshemre', and 'Ankhamahor) belong to high officials who were allowed to build their tombs in the vicinity of the pyramids. The general trend was to enlarge the superstructure and increase the number of rooms for the use of the different members of a family interred in more than one burial chamber. The outline is often irregular. The repertory of scenes in painted low relief was enriched with new items.

The Serapeum, which is northwest of the necropolis, consists of an underground gallery and lateral chambers, each containing the huge coffin of an Apis bull, sacred to Ptah, god of the arts and crafts in Memphis. Founded by Prince Kha'mwas, the archaeologist son of Rameses II, it was enlarged first by Psammetichos I and later kings, down to the Ptolemies. Two temples were built at the entrance of the galleries, and the Serapeum became a pilgrimage center of Osiris-Apis, identified with Serapis. A semicircle of eleven beautiful statues of Greek philosophers and poets, done in the Hellenistic style, was erected by Ptolemy II at the end of an avenue leading to the Serapeum.

The extensive monastery of St. Jeremiah is of significance for the study of Coptic art (5th–6th cent. of our era), especially sculpture (capitals of original design deeply drilled) and painting (portraits of saints and decorative patterns). *See* SAQQARA, CHURCH OF.

BIBLIOGRAPHY. A. Mariette, *Le Sérapéum de Memphis*, Paris, 1882-83; W. B. Emery, *Great Tombs of the First Dynasty*, 3 vols., Cairo, London, 1949-58; J.-P. Lauer and C. Picard, *Les statues ptolémaïques du Serapieion de Memphis*, Paris, 1955; W. B. Emery, *Archaic Egypt*, Harmondsworth, 1961.

ALEXANDER M. BADAWY

SAQQARA, CHURCH OF. Former Early Christian basilica in Upper Egypt. The Church of the Jeremiah Cloister, which dates from the 6th century, is an example of a Coptic provincial type of East Christian basilica. Archaeological remains show a three-aisled basilica with, as its peculiar local feature, a sort of inner narthex separated from the body of the basilica by a transverse row of columns. There is also an additional enclosed tripartite narthex. The building is constructed of limestone, with the exception of the decorative articulation and sparse wall supports. Capitals recovered from the site show the typical basket form of East Christian architecture in Upper Egypt. They are carved with a highly stylized, overall foliate pattern, creating a rich light-and-dark effect.

BIBLIOGRAPHY. O. K. Wulff, *Altchristliche und byzantinische Kunst*, 2 vols. in 1, Berlin, 1914.

SARACCHI FAMILY, *see* SARACHI FAMILY.

SARACENI, CARLO (Carlo Veneziano). Italian painter (ca. 1580/85-1620). Born in Venice, he was a close follower of Caravaggio and spent most of his career in Rome. His style has close affinities with that of Gentileschi and Elsheimer, whom he knew in Rome and from whom he derived the mode of idyllic and romantic landscapes. After the death of Caravaggio in 1610, Saraceni's work shows an increasing emphasis on the contrasts between light and dark, as in *St. Cecilia and the Angel* (Rome, National Gal-

lery of Ancient Art), while retaining his distinctive Venetian quality of luminosity.

BIBLIOGRAPHY. P. Zampetti, G. Mariacher, and G. M. Pilo, *La pittura del Seicento a Venezia*, Venice, 1959.

SARACENIC ART, *see* ISLAM.

SARACHI (Saracchi) FAMILY. Italian glyptographers and goldsmiths: Simone (b. 1548), Giovanni Ambrogio (b. 1550), Stefano (d. 1595), and Michele. The Sarachi brothers are noted for their carved and engraved crystal vessels which show the strong influence of the mannerist glyptography of A. Fontana. A rock crystal cup, with mounts of a later date, made for Albrecht V of Bavaria (1579; Munich, Residenz Treasury) identifies their engraved work. In addition the Sarachi carried out all the operations necessary for cutting and mounting their work, as in the carved and engraved rock crystal *Josephs-Kanne* with enameled gold mounts (1570–80; Residenz Treasury), and an engraved rock crystal tumbler and cover with enameled gold mounts (late 16th cent.; Vienna, Museum of Art History). In their Milanese workshop they produced commissions for the courts of Saxony and Spain as well as for the emperors Maximilian II and Rudolph II. In 1573 Giovanni Ambrogio, Stefano, and Simone were in Bavaria working for the Wittelsbach prince, Albrecht V.

BIBLIOGRAPHY. E. Strohmer, *Prunkgefässe aus Bergkristal*, Vienna, 1947.

SARAGOSSA (Zaragoza). Spanish city on the right bank of the Ebro River on the central plain of Aragón. It is the provincial capital and the seat of an archbishop and a university. Saragossa is the ancient Iberian Salduba. Augustus turned it into a military colony with the name Caesaraugusta. It was converted in the 1st century by St. James and held by the Goths in the 5th century. As Sarakusta under the Moors it was built up to become the rival of Toledo and Cordova. In 1118 it became the capital of the Christian kingdom of Sobrarbe. Under the Catholic Kings it ceased to be a royal residence.

Saragossa has two cathedrals: La Seo, built between 1119 and 1550 in the Gothic and Mudejar styles; and Nuestra Señora del Pilar (begun in 1681 after plans by Francisco Herrera and continued by Ventura Rodríguez), which was erected on the site of a chapel built by St. James to the miraculous image of the Virgin he had seen there in the year 40. The Lonja (Stock Exchange) is a remarkable mixture of Gothic and Plateresque forms. The Church of Sta Engracia retains Mudejar elements in its tower and has a splendid Plateresque portal (1505–19) with the figures of the Catholic Kings adoring the Virgin. *See* SEO, LA.

See also ALJAFERIA; SARAGOSSA: PROVINCIAL MUSEUM OF FINE ARTS.

HELLMUT WOHL

SARAGOSSA: PROVINCIAL MUSEUM OF FINE ARTS. Spanish collection. The museum houses archaeological material from prehistory to the early Middle Ages (noteworthy are the Roman mosaic depicting Orpheus and the architectural fragments from the Aljaferia) and Spanish paintings (by Jaime Serra, Goya, and others).

BIBLIOGRAPHY. Museo Provincial de Bellas Artes, *Catálogo: Sección pictórica*, Saragossa, 1928; Museo Provincial de Bellas Artes, *Catálogo: Sección arqueológica*, Saragossa, 1929.

SARAH SIDDONS AS THE TRAGIC MUSE. Oil painting by Reynolds, in the Huntington Library and Art Gallery, San Marino, Calif. *See* REYNOLDS, SIR JOSHUA.

SARAJEVO: MUSEUM OF SARAJEVO. Large-scale Yugoslavian collection of natural history, ethnography, and archaeology. Its central and largest pavilion was erected for the collection of prehistoric, ancient, and medieval objects. The collection of Bronze Age art (metal and ceramic objects) is one of the finest in Europe; in the collection of ancient art there are significant Latin inscriptions with Illyrian elements, well-preserved floor mosaics, and late-antique decorated sculpture from Early Christian churches in Bosnia. In the courtyard are some of the most beautiful medieval grave markings found anywhere.

SARASOTA, FLA.: RINGLING MUSEUM OF ART. Mainly the collection of John Ringling, bequeathed to the state in 1936. The collector's circus life and sense of public display make the museum unique in the United States in numerous ways: it was opened to the public during the owner's lifetime (1930); its emphasis, baroque painting, reflects personal taste rather than standard fashion; and it is almost the only large museum situated in a small American town, thus attracting many tourists.

There are isolated small collections of Gandhara and pre-Columbian sculpture, among others, but paintings of the 17th century, and almost as many of the 16th and 18th, dominate in bulk and significance. There are approximately 700 paintings, including individually important works by such artists as Gentile Bellini, Ercole de' Roberti (a copy of *The Death of the Virgin* from the lost fresco cycle in the Garganelli Chapel, Bologna, S. Pietro, now the only record of it), Granacci (*Assumption of the Virgin*, the altarpiece Vasari called his best), Gaudenzio Ferrari, Sebastiano del Piombo, Pordenone, Veronese (two major works), Bassano (a large group), Moroni, Guercino, Salvator Rosa (three major works), Tiepolo, Guardi (important figure paintings), Rubens (nine major works), Hals, Rembrandt, Steen, Cranach, Ribera, Carreno, Vouet, Poussin (two major works), Bourdon (a set of seven, the base of his catalog), Reynolds, and Gainsborough, as well as handsome typical examples of other major artists such as Mostaert, Tintoretto, El Greco, and Canaletto, and individually important works of slightly lesser artists such as Stanzione, De Heem, Dujardin, and Pellegrini. The heart of the collection is no doubt the four large works by Rubens. The Ringling Museum is one of the two places in the world where large Rubenses in a matching set can be seen. This series, enlarged from sketches for the use of tapestry makers, was long discounted as school work, but it has recently been more and more held autograph by specialists (Puyvelde, Norris, Jaffe) on observing its constant brilliance of touch after cleaning. As a museum of large pictures, in contrast to the small and less representative works of this period usually found in American collections, it also reflects its forming taste. Notable recent additions are a Bernini terra cotta and a small 18th-century Italian theater (in constant use), the only one of its age in the country.

BIBLIOGRAPHY. W. Suida, *A Catalogue of Paintings*, Sarasota, 1949; C. Gilbert. *The Asolo Theater*, Sarasota, 1959; K. Donahue, "The Ringling Museums—Baroque Art and Circus History," *Museum News*, XXXIX, October, 1960.
CREIGHTON GILBERT

SARASVATI. Primarily a river but also a deity in the Hindu Vedas. In later times Sarasvatī (Saraswatī) is the wife of Brahmā, the goddess of speech and learning, inventress of the Sanskrit language and the Devanāgarī letters, and patroness of the arts and sciences. Her river is now called Sarsuti.

SARAZIN, JACQUES, *see* SARRAZIN, JACQUES.

SARCOPHAGUS. Stone coffin whose name, meaning "eating flesh," derives from the special properties of a type of limestone from Assos, in Asia Minor, which was used to make or line coffins in late antiquity. The term is also applied to the massive Egyptian funerary container designed to house a wooden coffin within it. Sarcophagi became numerous during the Early Christian period, providing a valuable source for the study of changing styles and compositions in relief sculpture of the time.

BIBLIOGRAPHY. C. R. Morey, *Mediaeval Art*, New York, 1942.

SARCOPHAGUS, ANTHROPOID. Type of Egyptian coffin made in the shape of the mummy itself. It was derived from the cartonnage, a sort of mask which reproduced the features of the deceased and which was fitted over the head and shoulders of the mummy. Worked in wood, metal, or stone, painted and inlaid for the Pharaohs in the New Kingdom (and later also for other high personages), the anthropoid sarcophagus became the typical coffin, characterized by the flat features of the face, during the Saitic dynasty. Several coffins were set within one another so that the outer one reached a size considerably greater than the mummy it held.

SARDI, GIUSEPPE. Italian architect (b. Sant'Angelo in Vado, ca. 1680; d. Rome, 1753). He often acted as clerk of the works of other architects. The most important of his original works is the façade of S. Maria Maddalena in Rome (1735).

BIBLIOGRAPHY. V. Golzio, "La chiesa di Santa Maria Maddalena a Roma," *Dedalo*, XII, January, 1932.

SARDINIA. Large island west of the Italian mainland. Probably first occupied in the late 3d or early 2d millennium B.C., Sardinia has yielded many Chalcolithic and Bronze Age sites, including impressive nuraghi. The Greeks seem never to have colonized the island, though they apparently thought highly of it (Herodotus 5.106). The reason perhaps was that Phoenicians had already established numerous colonies and trading settlements there as early as the 8th century B.C. By the 6th century Carthage had established its control over the island. From 238 B.C. until the 5th century Sardinia was a Roman province, and its mines and grain fields supplied Rome throughout most of the late Republican period and the Empire. *See* NURAGHE.

A number of structures in Pisan Romanesque style date from the 11th through the 14th century, when Sardinia was partly subject to Pisa and Genoa. Perhaps the finest example of Pisan Romanesque architecture is the abbey church of SS. Trinità di Saccargia (12th cent.) near Sassari. Dating from the 14th through the 16th century, when the kings of Aragón controlled the island, are many monuments in the Catalan Gothic style, for example, the Monastery of S. Maria di Betlem (15th–16th cent.) in Sassari;

the Church of the Purissima (16th cent.) in Cagliari; and the portal and campanile of Alghero Cathedral (16th cent.).

BIBLIOGRAPHY. M. Guido, *Sardinia*, London, 1963.

EVANTHIA SAPORITI

SARDIS, *see* LYDIA.

SARGENT, JOHN SINGER. American painter (b. Florence, Italy, 1856; d. London, 1925). Sargent was born of wealthy expatriate parents and all his life moved with ease among the socially fashionable. From 1874 to 1876 he studied with Carolus-Duran in Paris and, with his natural artistic gifts, soon developed the incredibly facile technique of seemingly instantaneous vision and recording with which he made an enormous reputation as a portraitist. Sargent's virtuosity is evident as early as *The Oyster Gath-*

John Singer Sargent, *Madame X (Mme Gautreau)*, 1884. Metropolitan Museum of Art, New York (Arthur H. Hearn Fund, 1916).

erers of Cancale (1878; Washington, D.C., Corcoran Gallery), where his obvious interest in light is subordinated to the picturesqueness of his genre subject. The impressionistic tendency of his style at this period is more apparent in *Luxembourg Gardens at Twilight* (1879; Minneapolis Institute of Fine Arts). The flashing *El Jaleo* (1882; Boston, Isabella Stewart Gardner Museum) is a souvenir of his 1880 trip to Spain, where he studied the paintings of Velázquez.

The rapid decline in Sargent's reputation which set in after his death is largely due to his later, numerous portrait commissions in which he was bored and indifferent to his sitters but rendered their superficial likenesses with all his accustomed brilliance. The psychological penetration of which he was capable can be seen in the poignant *Mrs. Charles Gifford Dyer* (1880; Art Institute of Chicago) or in the portrait of Mme Gautreau known as *Madame X* (1884; New York, Metropolitan Museum) that was rejected by both the client and the French art public because Sargent had lowered his subject's décolletage as well as exposed the vanity of her personality. The strong criticism of this painting caused Sargent to move to London, where he remained, except for travel, for the rest of his life.

In other portraits, Sargent showed a compositional boldness to match his style, as in the daring voids of the snapshot placing and depiction in *The Daughters of Edward Darley Boit* (1882; Boston, Museum of Fine Arts) or in *Robert Louis Stevenson* (1885; New York, John Hay Whitney Collection), where the diagonals of Stevenson's stance and a reclining model interrupt a Whistlerian arrangement of horizontals and verticals. In 1890 Sargent was commissioned to paint murals for the Boston Public Library and, later, for the Museum of Fine Arts in Boston. Examples of Sargent's later society portraits are *The Wyndham Sisters* (1900; Metropolitan Museum) and *Mrs. Asher Wertheimer* (1904; London, Tate). He devoted most of his last years to impressionistic water colors of scenes and architecture on the Continent.

BIBLIOGRAPHY. C. M. Mount, *John Singer Sargent*, New York, 1955; D. McKibbin, *Sargent's Boston*, Boston, 1956.
JEROME VIOLA

SARGON II, PALACE OF, KHORSABAD.
One of the most significant palaces of the Late Assyrian period. Built on a platform which protruded on both sides of the northwest city wall to control riots and attacks from the outside, it was a complex of several units, each containing a central courtyard. Curiously enough, the outline is rather irregular and the corners are not right angles.

The largest, squarish courtyard was at the front of the complex, flanked by administrative buildings to the north and temples to the south. At the rear, two doorways gave access to a large court forming the approach to the throne room and the residence. The use of architectural sculpture, such as high reliefs of genii on large blocks, man-headed bulls flanking the entrance to the throne room, and figures converging toward Sargon, was calculated to impress the foreign ambassadors who were introduced in the court with the power of the Assyrian monarch. In the narrow, shallow throne room itself, the location of the throne against the small end of the room and the walls painted with bril-

Sārnāth. Ruins of a monastery and the Dhāmekh stūpa.

liantly colored high bands of repeated motifs enhanced this impression.

See also KHORSABAD; KHORSABAD: WINGED BULL.
BIBLIOGRAPHY. G. Loud, *Khorsabad*, II, Chicago, 1938.
ALEXANDER M. BADAWY

SARMATIAN ART, *see* SCYTHIAN ART; VISIGOTHIC ART.

SARNATH.
Town near Benares, in Uttar Pradesh, India. Sārnāth was the site of the Deer Park, where Buddha preached his first sermon after his enlightenment, and thus it became a sacred place to Buddhists. It was a center of Buddhist religious activity from the rise of Buddhism in the 5th century B.C. until the invasion of the Muslims in the 12th century of our era. The area is considered sacred also by the Jains, as the site of the austerities and death of Sreyāmsanātha, the eleventh Tīrthankara.

Extensive building activity at Sārnāth, from the Maurya period through the Gupta, produced a great array of shrines, temples, monasteries, and stūpas (all later in ruins). The sculpture workshops, particularly in the Gupta period, produced some of the finest examples of Buddhist sculpture in India and exerted a strong influence on the Buddhist sculpture of Thailand, Cambodia, and Java. Most of the sculpture has been placed in the Archaeological Museum at Sārnāth; a few objects are in the museums of Delhi and Calcutta.

Among the architectural remains at Sārnāth are the foundations of the Dharmarājikā stūpa, built by Aśoka and destroyed in the 18th century; the Dhāmekh stūpa, a large stone and brick structure built in the Maurya period and faced in the Gupta period with elegantly carved stone slabs; and the foundations of several monasteries and

a large temple, all originally of Gupta times. Best known among the sculptures are the lion pillar of Aśoka, the capital of which has been adopted by India as her national emblem, and a Gupta carving of Buddha seated in the teaching pose before a large, delicately carved halo. *See* Asoka Columns.

Also in the Archaeological Museum are a great many other figures of Buddha and relief carvings of scenes from the life of Buddha, of the Gupta period; a monumental statue of Sākyamuni Buddha, carved at Mathurā and set up at Sārnāth by Friar Bala in the Kushan period; and several carved stone railing pillars of Suṅga date. There are a few post-Gupta Buddhist and Hindu carvings. A modern Buddhist temple has been erected in Sārnāth near the ancient remains by the Maha Bodhi Society of India, Japan, and Ceylon. *See* Friar Bala.

BIBLIOGRAPHY. B. Majumdar, *A Guide to Sārnāth*, Delhi, 1937; V. S. Agrawala, *Sārnāth*, Delhi, 1957.

<div align="right">CHARLES D. WEBER</div>

SARRAZIN (Sarazin), JACQUES. French sculptor (b. Noyon, 1592; d. Paris, 1660). He was a pupil of Nicolas Guillain in Paris and worked under him at the Church of the Feuillants. Sarrazin went to Rome in 1610 and did not return to France until 1628. He executed sculptures for the Chapel and Gallery of Chilly, Seine-et-Oise, for the Maréchal d'Effiat in 1630. About 1635 he delivered eight models for caryatids, personifications of fame, and trophies for the Grand Pavillon de l'Horloge by Jacques Lemercier at the Louvre in Paris. In 1639 he did a silver *Anne of Austria and Louis XIV* for the Holy House at Loreto, and in 1656–57, statues of Cardinal de Bérulle (Louvre). Contemporary literature cites paintings by Sarrazin, but none has survived. He and Simon Guillain are the strongest French sculptors of the first half of the 17th century.

BIBLIOGRAPHY. L. Dussieux, ed., *Mémoires inédits sur la vie et les ouvrages des membres de l'Académie royale de Peinture et de Sculpture*, vol. 1, Paris, 1854; A. Michel, *Histoire de l'art*, vol. 6, pt. 2, Paris, 1922; M. Digard, *Jacques Sarazin, son oeuvre, son influence*, Paris, 1934.

SARTAIN, JOHN. English-American engraver, mezzotinter, and miniature painter (b. London, 1808; d. Philadelphia, 1897). Sartain studied in London with John Swaine and Henry Richter. In 1830 he came to Philadelphia. He produced a number of periodicals for which he also wrote and illustrated, designed bank notes, and planned public monuments to Lafayette and Washington.

BIBLIOGRAPHY. D. M. Stauffer, *American Engravers Upon Copper and Steel*, 2 vols., New York, 1907.

SARTO, ANDREA DEL. Italian painter (b. Florence, 1486; d. there, 1530). Andrea reportedly was apprenticed to a goldsmith at the age of seven. His talent for drawing attracted a now unknown painter who recommended him after three years to the master Piero di Cosimo. Piero was highly interested in the revolutionary innovations of such men as Michelangelo and Leonardo. Since Piero's style was already formed, their influence on him was limited, but this interest was developed with more far-reaching results by his young pupil Andrea. Franciabigio, a painter somewhat older than Andrea, was also an early influence, and the two shared an atelier for several years in the Piazza del Grano. About 1511 they moved their workshop to the Sapienza, a group of buildings between

Andrea del Sarto, *Madonna of the Harpies*, 1517. Uffizi, Florence.

SS. Annunziata and S. Marco, where the sculptor Il Sansovino joined them. Andrea's pupils at this time included Pontormo and, perhaps, Rosso Fiorentino. The workshop appears to have been dissolved about 1517.

In 1518 or 1519 Andrea left Florence for Fontainebleau at the summons of Francis I, who sought his services as a court painter. His stay there was short, and only one painting from this period, the *Caritas* (1518; Paris, Louvre), is known. About 1520 he left Florence again, perhaps in connection with the decoration of the Villa Medici at Poggio a Caiano, and went to Rome. Other journeys by Andrea have been proposed by various scholars and are not unlikely.

In 1520 Andrea purchased land in Florence with the intention of building a house on it. The building was completed in 1523 and is still standing today. Late in 1523 he fled Florence because of the plague and settled in Luco Mugello, where he executed some works for the nuns of S. Piero. He returned to Florence in November, 1524. Little is known of his activities after that date.

Andrea's earliest works, though they display a preference for advanced tendencies in painting, are somewhat conservative and even tentative in conception. The *Icarus* (ca. 1507; Florence, Davanzati Palace), for example, is obviously inspired by a study of Michelangelo's cartoon for the *Battle of Cascina* and by the *David*, but the composition

leaves much to be desired. The five scenes depicting the life of S. Filippo Benizzi (1510) in the atrium of SS. Annunziata, Florence, hark back to the style of Domenico Ghirlandajo. Andrea here shows himself still weak in figure composition, but he does introduce the device of architectural structures in the backgrounds of three of the series to emphasize the main groups and to provide a central accent for the compositions.

From 1511 to 1526 Andrea was intermittently occupied with the decoration of the Cloister of the Scalzo. Twelve of the frescoes in grisaille portray scenes from the life of St. John the Baptist, ten by Andrea and two by Franciabigio. Those by Andrea show an increasing mastery of both form and composition and a progression from a linear to a more painterly style. This cycle has been called Sarto's finest achievement and the core of his life's work. In his long struggle with the problem of a monochrome medium, the technique was developed to its highest powers of expression.

The *Madonna of the Harpies* (1517; Florence, Uffizi), considered one of the artist's greatest paintings, is a triumph of composition and expressiveness. The Madonna, holding the Child in her right arm and a book in her left hand, stands upon a pedestal-like altar raised on a single step in a shallow niche. She is flanked by SS. Francis and John the Evangelist. The figure of the Madonna has a decidedly classical *contrapposto*, and the saints are varied in movement, Francis turning toward her while looking out of the picture and John turning away from her toward the spectator. A satisfying unity embraces this variety, and a hushed feeling of reverence pervades the scene.

Andrea painted few portraits, but among them is one undisputed masterpiece, the so-called *Portrait of a Sculptor* (ca. 1517; London, National Gallery). The compactness of the figure and its pose relate it stylistically to the saints of the *Madonna of the Harpies*. It is a psychologically penetrating characterization, intimately realized. In the *Disputa* (1517–18, Florence, Pitti Palace) the figures of SS. Augustine, Lawrence, Peter Martyr, and Francis stand boldly against a generalized space. Before them kneel St. Sebastian and Mary Magdalen. In boldness and broadness of modeling and in variety of texture, Andrea created a group that was perhaps inspired by Nanni d'Antonio di Banco's *Quattro Santi Coronati* at Or San Michele and that excells even the *Madonna of the Harpies*.

The almost casual composition of the *Madonna del Sacco* (1525) in the cloister of SS. Annunziata belies its geometric balance. Indeed, the relative placing of the figures is bold, and vivacity is achieved by the painterly treatment of the drapery. In this work Andrea realized one of his liveliest compositions. In the Gambassi altarpiece, *Madonna with Six Saints* (1527–28; Pitti Palace), we encounter a somewhat lowered vitality. The color is pale, and the principle of composition has been borrowed from Fra Bartolommeo, but Andrea has used it in such a way that the energy of the figures has been restrained.

The youthful *St. John the Baptist* (ca. 1528; Pitti Palace) presents a physical presence rather than a spiritual one. Because the painting is considerably damaged, the intended contrast between the luminous flesh and the dark background is almost lost. Here, rather than presenting a statement of character, Andrea seems to have been interested in painterly values and abstract composition. The Vallombrosa altarpiece, *Four Standing Saints* (1528; Uffizi), offers the curious phenomenon of two outer panels of a triptych having been joined together to form a single painting. The result is the confrontation of two pairs of flanking saints without the central panel of the Madonna and Child. As awkward as this arrangement is, the painting reasserts a strong classicism and energy that for a time had seemed submerged in Andrea's work. Each saint is portrayed as a definite personality.

Andrea del Sarto's place in 16th-century painting was an important one. He established the classical style in Florence at the time when Michelangelo and Raphael were active in Rome. His was not a chilly classicism, but one that vibrated with warmth and color. If his humanity caused occasional defects in his work, it also afforded him an uncommon insight into the world of childhood, youth, and maternity. He was also one of the master engravers of the age. A leading master of the High Renaissance style in Florence, he finally turned toward mannerism—under the influence of his own pupils, for example, Pontormo.

BIBLIOGRAPHY. H. Wölfflin, *Classic Art*, New York, 1952; S. J. Freedberg, *Andrea del Sarto*, 2 vols., Cambridge, Mass., 1963; J. Shearman, *Andrea del Sarto*, 2 vols., Oxford, 1965.

FRANKLIN R. DIDLAKE

SARVISTAN. Town in south-central Iran near which stands the palace of the Sassanian ruler Bahram V (ca. 420–440). The palace has a three-liwan façade and barrel-vaulted and semidomed rooms arranged around a central dome.

SARZANA, IL, *see* FIASELLA, DOMENICO.

SASSANIAN ART. The Sassanian dynasty in Iran (224–642) succeeded the Parthian. King Ardashir replaced the former loose administration with a centralized monarchy controlling a feudal society, and he created a powerful state religion, Mazdaism, which was a revival of the Zoroastrian religion of the Achaemenids. The influence of Sassanian Iran is evidenced in mural paintings in Afghanistan and Turkestan and in illuminated Manichaean books and manuscripts. In the West, relations with the Roman Empire are shown by the representation of the Iranian bodyguards of the Roman emperor on the Arch of Galienus at Salonika, and in the use of frontal representation of the figure in sculpture both in Iran and in the West.

Sassanian architecture replaced the Achaemenid apadana with a large vaulted liwan derived from the Assyrian type, which opened on a courtyard and was flanked by two closed rooms. This primary unit, which formed the peasant house, could be doubled and quadrupled around the sides of a courtyard to assume the shape of a sophisticated palace. Extensive gardens and artificial ponds, sometimes a large park (Palace of Khusru II) or hunting grounds (symbolizing paradise), stretched out near the residence. The reception apartments were separated from the harem, located at the rear, which consisted of smaller rooms built around one or more courtyards. The house itself sometimes had a columned portico in front. The "paradise" of Khusru II at Qasr-i-Shirin is a park of 300 acres fortified by a ditch and an enclosure wall of plastered rubble masonry with bastions. Inferior materials such as brickwork were

even used for columns, and the use of carved stucco became current. *See also* DOME.

The mural decoration generally followed Hellenistic tradition by employing superimposed blind arcades springing from engaged columns (Taq-i-Kisra at Ctesiphon). Sculpture consisted of rock-cut high reliefs, representing the victories of the king, which were derived from Parthian painting through the Sassanian graffiti on the walls at Persepolis and Dura Europus. Later reliefs (Khusru II at Taq-i-Bustan) were in shallow carving or engraving and showed frontal figures. In the minor arts one should mention Sassanian textiles and silver bowls with repoussé motifs in the center representing animals, or the king in battle. Continuous scrolls of Hellenistic type (acanthus, doves, vines, pine cones), Achaemenid elements (cavetto with rows of palmettes), allegorical figures of monsters, and geometric ornament are among the characteristics of this decoration. *See* CHOSROES, PALACE OF, CTESIPHON; TAQ-I-BUSTAN.

See also BISHAPUR; DAMGHAN.

BIBLIOGRAPHY. E. Herzfeld, *Archaeological History of Iran*, London, 1935; A. U. Pope, ed., *A Survey of Persian Art*, 6 vols. in 12, New York, 1938–39. ALEXANDER M. BADAWY

SASSETTA (Stefano di Giovanni). Italian painter of the Sienese school (ca. 1400–50). Sassetta is one of the great masters of Sienese painting. He received his artistic education in Siena and became a member of the painters' guild there before 1428.

His first documented work is an altarpiece for the Sienese guild of wool merchants (Arte della Lana) painted between 1423 and 1426. The greater part of it is lost, but two sets of pilasters from its frame, with the *Patrons of Siena* and the *Fathers of the Church* (Siena, National Picture Gallery), and five of its seven predella panels have survived. The panels are the *Flagellation of St. Anthony* and *Last Supper* (both Siena, National Picture Gallery), *St. Thomas Aquinas before an Altar* (Budapest Museum), *St. Thomas before a Crucifix* (Rome, Vatican Museums), and *Miracle of the Sacrament* (Barnard Castle). The luminous and precise figural, architectural, and landscape constructions in these pictures reveal a remarkably fine, original plastic imagination. Its sources are difficult to establish.

Sassanian art. Ruins of the Taq-i-Kisra at Ctesiphon.

In 1426 Sassetta worked for the Sienese Cathedral. In 1427 he was paid for a drawing for the baptismal font in the Baptistery. His next altarpiece was the *Madonna of the Snows* (1430–32; Florence, Contini-Bonacossi Collection), painted for the Chapel of S. Bonifazio in the Cathedral. It consists of a large panel with the *Madonna and Child with Four Angels* in the center under a round, cusped arch; two saints at the left (*John the Baptist* and *Peter*) and two at the right (*Francis* and *Paul*) under pointed arches; and a predella depicting the *Story of the Miracle of the Snow*, four of whose seven panels are completely or partially effaced. An *Annunciate Angel* (Massa Marittima, Gallery) and a *Virgin Annunciate* (New Haven, Yale University Art Gallery) are believed to have stood above the sides. The *Madonna of the Snows* is not a Gothic altarpiece but a Renaissance one. It parallels the works of those Florentine painters who were at that time striving to forge a new style on the basis of the innovations of Masaccio.

In 1433 Sassetta painted a *Crucifix* for the Church of S. Martino. All that remains of the work are the ends of its cross pieces and base (Siena, Chigi-Saraceni Collection) representing the Virgin, St. John the Evangelist, and St. Martin and the Beggar.

Sassetta's next documented work is the *Franciscan Polyptych* for the high altar of S. Francesco in Borgo San Sepolcro, commissioned in 1437 and completed in 1444. It was painted on both sides. The front (Settignano, Berenson Foundation) is divided into three large panels: *St. Francis in Ecstasy* in the middle and a *Franciscan Saint* (the Blessed Ranieri Rasini?) and *St. John the Baptist* on the sides. On the back were eight scenes from the life of St. Francis: the *Mystic Marriage of St. Francis* (Chantilly, Condé Museum) and the *Renunciation by St. Francis of His Father*, *St. Francis before the Pope*, *St. Francis before the Sultan*, the *Funeral of St. Francis*, the *Charity of St. Francis*, the *Stigmatization of St. Francis*, and *St. Francis and the Wolf of Gubbio* (all London, National Gallery). This altarpiece shows Sassetta's continued contact with Florentine art, though the focus of its relevance to him has shifted from Masaccio to Domenico Veneziano. The panels have a remarkably articulated differentiation of compositional elements and a wonderfully clear fusion of narrative and form. They also reveal a most refined and subtle colorism.

In 1440 Sassetta received a payment from the authorities of the Cathedral of Siena for two rejected drawings for the large circular window at its west end. In 1442 he and members of his by-then sizable studio executed seventeen processional banners for the Cathedral. In 1444 he painted a figure of *St. Bernardino* for S. Maria della Scala in Siena (lost). Various documents recount other decorative commissions in 1445 and 1447. In 1447 he received the commission to paint a fresco of the *Coronation of the Virgin* on the Porta Romana (Siena). It was finished after his death by Sano di Pietro in 1459.

A considerable number of pictures have been attributed to Sassetta, with varying degrees of agreement by students of the master's work. The uncontested works, whose chronology is problematic, include a signed *Madonna and Child* (Siena, National Picture Gallery); an altarpiece of the *Madonna and Child with Four Saints* (Cortona, S. Domenico); an *Adoration of the Magi* (upper part, the *Journey of the*

Sassetta, *The Last Supper*, predella panel from the altarpiece painted for the Sienese Arte della Lana, 1423–26. National Picture Gallery, Siena.

Magi, New York, Metropolitan Museum; lower section, Chigi-Saraceni Collection); three panels from the predella of a *Crucifixion* altarpiece (*Agony in the Garden* and *Christ Carrying the Cross*, both Detroit Institute of Arts; *Betrayal of Christ*, London, Mrs. F. Mason Perkins Collection); and several Madonna and Child panels (Grosseto, Diocesan Museum of Sacred Art; Berlin, former State Museums; New York, Metropolitan Museum and Frick Collection; Washington, D.C., National Gallery; Zagreb, Strossmayer Gallery).

The most important of Sassetta's disputed works are (1) the altarpiece of the *Madonna and Child with Two Saints* in the Church of the Osservanza near Siena, (2) the *Birth of the Virgin* altarpiece (Asciano, Museum of Sacred Art), and (3) a series of seven narrative panels from the *St. Anthony Altarpiece—St. Anthony Distributing His Money to the Poor*, the *Meeting of St. Anthony and St. Paul the Hermit*, and the *Departure of St. Anthony from a Monastery* (all Washington, D.C., National Gallery); *St. Anthony Beaten by Devils* and *St. Anthony Tempted by the Devil in the Form of a Girl* (both New Haven, Yale University Art Gallery); *St. Anthony at Mass* (Berlin, former State Museums); *St. Anthony and the Porringer* (New York, Lehman Collection)—as well as a fragment of its central figure, *St. Anthony* (Paris, Louvre). The Osservanza and Asciano altarpieces are attributed by some scholars to an anonymous contemporary of Sassetta who has been called the Master of the Osservanza, by others to Sano di Pietro. The panels of the *St. Anthony Altarpiece* are by several hands, one of which may be the Master of the

Osservanza and another Sassetta himself. The question is far from settled, however, and additional or different painters may have been involved in their execution. The problem of these three altarpieces hinges on whether or not Sassetta, in the five years between the *Madonna of the Snows* and the *Franciscan Polyptych*, reverted to a conservative Gothic manner. Until this is decided, neither the authorship nor the chronology of these and other works associated with Sassetta can be established with certainty.

The role of Sassetta in the 15th century is analogous to that of Duccio in the 14th, for it was through Sassetta that Sienese painting turned from the Gothic to the Renaissance style. His work is the most sophisticated, poetic formulation of Christian legend in his time.

BIBLIOGRAPHY. B. Berenson, *A Sienese Painter of the Franciscan Legend*, London, 1909; J. Pope-Hennessy, *Sassetta*, London, 1939; E. Carli, "Sassetta's Borgo San Sepolcro Altarpiece," *The Burlington Magazine*, XLIII, May, 1951; C. Seymour, Jr., "The Jarves 'Sassettas' and the St. Anthony Altarpiece," *Journal of the Walters Art Gallery*, XV–XVI, 1952–53; J. Pope-Hennessy, "Rethinking Sassetta," *The Burlington Magazine*, XLVIII, October, 1956; F. Zeri, "Towards a Reconstruction of Sassetta's Arte della Lana Triptych, 1423–6," *The Burlington Magazine*, XLVIII, February, 1956; E. Carli, *Sassetta e il Maestro dell'Osservanza*, Milan, 1957.

HELLMUT WOHL

SASSOFERRATO (Giovanni Battista Salvi). Italian painter (b. Sassoferrato, 1609; d. Rome, 1685). Although he learned the rudiments of painting from his father, the most decisive influence came from the young artist's study, particularly of Raphael and the Carraccis, in Rome. While there he is believed to have been associated with Domenichino, whom he may well have followed to Naples in the early 1630s. During the 1660s Sassoferrato was in Venice, although he

was active mainly in Urbino, Perugia, and Rome. Throughout his life he copied the works of other artists. It is noteworthy that he was as attracted to the works of certain late-15th-century painters as he was to those of Raphael. The works of Perugino had a special appeal for him from the point of view both of content and of form. In every instance his faithful records were of religious themes. He concentrated exclusively on subject matter of this nature and particularly Madonnas and ecclesiastical portraits. His close adherence to the serene Peruginesque-Raphaelesque linear style seemed so convincing to connoisseurs in the 18th century that they thought he was a 16th-century artist. Today his self-conscious archaism and faultless purity recall instead works of the Pre-Raphaelites. Nevertheless, within the precise classicistic forms, the rather too sweet sentiment, and the smooth handling of the surface, we easily recognize typical aspects of late baroque classicism.

To arrange a chronology of his works is particularly difficult because of the uniformity of his style. The variations which are most readily observed occur in his palette. *The Mystic Marriage of St. Catherine* (London, Wallace Collection), for which a black-and-white chalk study exists in the Royal Library, Windsor Castle, evinces a relatively warm coloration in contrast to the pale tonality usually associated with his work. When we consider the subject matter which he obviously preferred, it comes as a surprise

Sassoferrato, *The Madonna of the Rosary*, **1643. S. Sabina, Rome.**

that few of his paintings seem to have been intended for churches. *The Madonna of the Rosary* (1643; Rome, S. Sabina) is one of only four of his works known to exist in the churches of Rome. His commissions evidently came instead from patrons who desired devotional paintings for private chapels.

By far the largest group of his drawings is found in the Royal Library, Windsor Castle. The majority of these are either finished religious or portrait studies, squared for transfer. Four works in this collection, however, are large-scale drawings of heads, executed in a range of colored chalks. Their particular importance lies in the fact that they seem to have been an end in themselves rather than preparatory designs for paintings. If this is indeed the case, they would be almost without precedent in 17th-century Italian art.

BIBLIOGRAPHY. A. Blunt and H. L. Cooke, *The Roman Drawings of the XVII & XVIII Centuries in the Collection of Her Majesty the Queen at Windsor Castle*, London, 1960.

NORMAN W. CANEDY

SATSUMA POTTERY. Japanese pottery of a somewhat somber type, produced in Satsuma. It was made for the tea ceremony in the early Edo period and was at first strongly influenced by the Karatsu wares. The later type of Satsuma was characterized by an ivory glaze over a white body, which provided an excellent background for the brocade-style decoration in overglaze enamels and gold. Large quantities of ivory-glazed Satsuma, with a garish, unrestrained brocade decoration, were exported during the Meiji period. Although this is also called "Old Satsuma," most of it is neither old nor made in Satsuma.

BIBLIOGRAPHY. M. Feddersen, *Japanese Decorative Art*, London, 1962.

SATURN, TEMPLE OF, ROME. Ancient temple in the Roman Forum. First built in 497 B.C. on the spot where an ancient altar to Saturn had stood, it was restored several times, finally after a fire in A.D. 284. The temple was Ionic, hexastyle, and prostyle with two columns on each side. Throughout the Republican and imperial periods it housed the Aerarium Saturni, or state treasury.

BIBLIOGRAPHY. S. B. Platner, *The Topography and Monuments of Ancient Rome*, Boston, 1904.

SATURNIN (Saturninus), ST., *see* SERNIN OF TOULOUSE, ST.

SATURNUS. Etruscan god of agriculture, adopted by the Romans. His feast, the Saturnalia, was celebrated in December, and was a period of great rustic merrymaking. From the 3d century B.C. Saturnus was identified with the Greek god Cronos.

SATYR. Mythological creature thought by the ancient Greeks to inhabit woodland areas. Satyrs occupied themselves by sleeping, playing musical pipes, dancing with nymphs, and drinking wine. They were portrayed until the Hellenistic period with human bodies but later were shown with goat legs and small forehead horns which accentuated their animalistic qualities.

BIBLIOGRAPHY. G. M. A. Richter, *The Sculpture and Sculptors of the Greeks*, new rev. ed., New Haven, 1957.

SAUK AND FOX INDIANS. At the time of European contact in the 17th century the northern Mississippi Valley

contained several tribes that combined Algonquian and Great Plains cultural traits. Among these were the Sauk and Fox, who ranged northward into the upper Great Lakes area and as far south as Oklahoma. The Fox led the Illinois confederacy of tribes during the 18th century. Tribal government typically consisted of a village council of families which vied in authority with a civil and a military chieftain.

The outstanding art objects of the Sauk and Fox were storage bags and hide-carrying boxes painted with geometrical patterns which included the triangle, rectangular strip, and cross. Containers of basswood-bark fiber and twined wool thread, closely resembling those of the Menomini with their strongly heraldic designs, were used for storing ceremonial and personal articles.

BIBLIOGRAPHY. D. I. Bushnell, *Villages of the Algonquian, Siouan, and Caddoan Tribes West of the Mississippi* (Bur. of Amer. Ethnology, Bull. 77), Washington, D.C., 1922; F. J. Dockstader, *Indian Art in America*, Greenwich, Conn., 1961.

SAULIEU: SAINT-ANDOCHE. French Burgundian Romanesque church under the influence of Cluny. St-Andoche is particularly noted for its sculpture. Dating from before 1119, its figural capitals relate stylistically to the early sculpture of Autun and perhaps most closely to that of Cluny. *See* CLUNY.

BIBLIOGRAPHY. V. Terret, *La sculpture bourguignonne aux XIIe et XIIIe siècles... Cluny*, Autun, 1914.

SAULNIER, JULES. French architect (1829–1900). He worked near Paris. His outstanding work is the factory he built at Noisiel-sur-Marne, consisting of an exposed metal skeleton, diagonal bracing, and varicolored brick infilling. Popularized by Viollet-le-Duc, the "Saulnier system" was used widely in France by the 1890s.

SAUVAGE, HENRI. French architect and interior designer (b. Rouen, 1873; d. Paris, 1932). Sauvage worked mainly in ferroconcrete in the tradition of Auguste Perret and Tony Garnier. His Paris apartment blocks in the rue Vavin (1913) and the rue des Amiraux (1925) reflect this style.

SAVAGE, EDWARD. American painter and engraver (b. Princeton, Mass, 1761; d. there, 1817). Savage was a pupil of Benjamin West. He engraved mainly in the line and dotted techniques and painted in small or miniature format. His main works are *Family of George Washington* (New York, Metropolitan Museum) and *Self-Portrait* (Worcester Art Museum).

BIBLIOGRAPHY. D. M. Stauffer, *American Engravers Upon Copper and Steel*, 2 vols., New York, 1907.

SAVERY (Xavery), JAN BAPTIST. Flemish sculptor (1697–1742). Savery was born in Antwerp. He was a pupil of his father, Albert Xavery, and then trained in Italy. Later he was active in The Hague as a court sculptor, making many sculptures for the gardens and palaces of Prince William IV. Besides reliefs and standing figures for public buildings and churches, he created numerous tombs in various parts of the Netherlands. His bust of William IV (signed and dated 1733) is in the Mauritshuis Art Gallery in The Hague, along with the bust of William's wife, Anne of England (dated 1736).

Satsuma pottery. The goddess Kuan-yin, 1780. Private collection.

SAVERY (Xavery), ROELANT-JACOBSZ. Flemish painter of landscapes, animals, and flowers (b. Courtrai, 1576; d. Utrecht, 1639). He was a pupil of Jacob Savery I and of Hans Bol, in Amsterdam. He traveled to Paris, then to Prague, and stayed in the Tyrol for more than two years. After returning from abroad, he first stayed in Amsterdam but ultimately settled in Utrecht, where he became a member of the Guild of St. Luke in 1619. He is known and widely appreciated for forest scenes that are strongly influenced by Gillis van Coninxloo and enlivened by a variety

of animals, and for delicately executed flower pieces that rival those of Jan Breughel I. The little-known, signed *Hunting Scene* (Washington, D.C., Georgetown University Art Collection) constitutes an excellent example of his "forest interiors."

BIBLIOGRAPHY. K. Erasmus, *Roelandt Savery: Sein Leben und seine Werke*, Halle, 1908.

SAVERY (Xavery) FAMILY. Flemish artists (fl. 16th–17th cent.). All the members of the family were painters of landscapes and animal scenes; they were also active as engravers and/or etchers. The first mention of a painter of this family occurs in relation to Jacob Savery I (b. ca. 1545; d. Amsterdam, 1602). He had a son Jacob Savery II (b. Amsterdam, ca. 1592; d. there, 1627). Jacob Savery I was either the brother or the father of Roelant-Jacobsz. Savery, the principal artist of the family (b. Courtrai, 1576; d. Utrecht, 1639). There were also two nephews, Salomon Savery (b. Amsterdam, ca. 1594; d. there, after 1664) and Jan (Hans) Savery (b. Courtrai, 1597; d. Utrecht, 1655). *See* SAVERY, ROELANT-JACOBSZ.

BIBLIOGRAPHY. K. Erasmus, *Roelandt Savery: Sein Leben und seine Werke*, Halle, 1908.

SAVINNIERES, CHURCH OF. French Merovingian structure of the 7th or 8th century. It exemplifies the decorative masonry work typical of Merovingian buildings. The church of Savinnières is a rather simple gabled structure with a single entrance. The masonry is executed in large horizontal areas of uneven stone and brick, articulated by courses of regular brickwork laid in a herringbone pattern. The entire surface is reminiscent of the enamel and metalwork of the Barbarian peoples.

SAVIN OF POITOU, ST. Missionary (5th or 6th cent.). Savin and his brother Cyprian left their home in Lyonnais to undertake a voluntary apostolate. In Poitou, their preaching displeased the Visigoths who pursued them, captured Savin, and subjected him to cruel torments. He tried to convert his persecutors who, to silence him, cut off his head. (Cyprian also died a martyr's death.) The legend of the two saints is represented in 12th-century frescoes in St-Savin-sur-Gartempe, Paris. His attributes are a wheel and a whip. His feast is July 11. *See also* SAINTS IN ART.

SAVOLDO, GIOVANNI GIROLAMO. Venetian painter (ca. 1485–after 1548). Savoldo was born in Brescia. During a short stay in Florence in 1508, he was attracted to Leonardo, but his main source of forms is probably Cima and the Vivarini tradition of hard shapes in light. This pattern is sometimes called "Lombard," because of his birthplace and because it is unlike the dominant Giorgionesque trend in Venice. Early works are the *Hermits* (1510; Venice, Academy; Washington, D.C., National Gallery), powerful, aged figures; and the recently discovered *Temptations of St. Anthony* (Moscow, Tretyakov; London, private collection), which reinforce theories about his interest in Flemish motifs.

Mature work begins in the 1520s, typically with one or a few quiet figures whose solid form is constant, even though the unified atmosphere of Giorgione and Titian is adopted more and more frequently. The *Shepherd* (Florence, Contini Collection) and *St. Jerome* (London, National Gallery) are striking examples. In harmony with the importance given to light, form is later reduced to a color plane, but not broken as Titian would have it. This can be seen in *St. George* (Washington, D.C., National Gallery) and in *Tobias and the Angel* (Rome, Borghese). In a companion to the last, *Matthew and the Angel* (New York, Metropolitan Museum), he introduces his nocturnal motif. Savoldo was the first artist to exploit nocturnes as a style. The strongly colored figure and black environment make distinction and continuity of mass and void possible.

Later work often repeats older designs, but shifts color and tone subtly, notably in the three versions of *Mary*

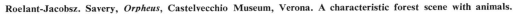

Roelant-Jacobsz. Savery, *Orpheus*, Castelvecchio Museum, Verona. A characteristic forest scene with animals.

Magdalene (Berlin, former State Museums; Florence, Contini Collection; London, National Gallery) and in versions of the *Nativity* (Brescia, Gallery; Terlizzi, Franciscan church; 1540, Venice, S. Giobbe). Like Lotto, Savoldo was unsuccessful in his career in Venice, and probably for the same reason—the dominance of Titian's methods.

BIBLIOGRAPHY. C. Gilbert, *The Works of Girolamo Savoldo* (microfilm), Ann Arbor, Mich., 1955; A. Boschetto, *Giovan Girolamo Savoldo*, Milan, 1963.

CREIGHTON GILBERT

SAVOYE HOUSE, POISSY-SUR-SEINE. Designed and built by Le Corbusier (1929–30) near Paris. A ferroconcrete cubic volume supported on stilts, with an open plan and sculptured roof garden, the building is the consummation of the architect's seminal aesthetic of the 1920s, particularly reminiscent of his Citrohan project of 1922. *See* LE CORBUSIER.

On ground level are miscellaneous mechanical functions, such as garage and laundry; above are bedrooms, kitchen, and a large living-dining space, contiguous with a generous terrace—inside and outside volumes are thus continuously related; on the top level is a solarium. The three levels, linked by sweeping ramps as well as conventional stairs, are also fused in the space continuum. Various colors were introduced on different wall surfaces to emphasize the identity of each element and to help define the volumes. Throughout are dramatic contrasts: open against closed; curved against straight; natural against mechanical; and so forth.

With its precise geometric form, its aloofness from nature, and its objective, mechanical austerity, the house is a perfect embodiment of the artistic direction of the 1920s, as well as the expression of Le Corbusier's classical discipline of this period.

BIBLIOGRAPHY. Le Corbusier, *Le Corbusier, Architect, Painter, Writer*, ed. S. Papadaki, New York, 1948; P. Blake, *The Master Builders*, New York, 1960.

THEODORE M. BROWN

SAXE PORCELAIN, *see* MEISSEN PORCELAIN.

SAXONY. Historic region of Germany. The original areas of settlement of the Saxon tribes, the present Westphalia and Lower Saxony, were brought into the orbit of Western civilization by the conquests of Charlemagne. In Westphalia medieval culture developed around the four episcopal cities of Minden, Paderborn, Münster, and Osnabrück; in Lower Saxony the secular power of the dukes of Brunswick (and later those of Hannover) was dominant. A later area of settlement, Upper Saxony (now in East Germany), flourished in the 16th to the 18th century, when the capital, Dresden, became a leading center of the arts. *See* BRUNSWICK; DRESDEN; MINDEN: ST. PETER'S; MUNSTER, GERMANY: CATHEDRAL; OSNABRUCK, CHURCH OF; PADERBORN CATHEDRAL; PADERBORN RATHAUS.

BIBLIOGRAPHY. *Die Kunstdenkmäler des Landes Niedersachsen*, ed., O. Karpa, vol. 1– , Munich, 1956– ; W. Hentschel, *Bibliographie zur sächsischen Kunstgeschichte*, Berlin, 1960.

SAYING GRACE. Oil painting by Chardin, in the Louvre Museum, Paris. *See* CHARDIN, JEAN-BAPTISTE-SIMEON.

SBARRI, MANNO (Alemanno) DI BASTIANO (Sebastiano). Italian goldsmith (fl. 1548–61). A pupil of Cellini, Sbarri worked in Florence and Rome. His mannerist gold-

Giovanni Girolamo Savoldo, *Portrait of a Cavalier*. National Gallery, Washington, D.C. (Samuel H. Kress Collection).

smithery on the silver gilt, rock crystal, and lapis lazuli *Cassetta Farnese*, made for Cardinal Alexander Farnese (1548–61; Naples, National Museum), was once attributed to Cellini. It consists of figures of Mars, Minerva, Diana, and Bacchus at the corners, a finial in the form of the *Farnese Hercules*, and reliefs surrounding six rock crystal plaquettes, the latter engraved by G. B. Castelbolognese with scenes of classical history and mythology.

BIBLIOGRAPHY. A. di Rinaldis, "Il Cofanetto Farnesiano del Museo di Napoli," *Bollettino d'Arte*, 2d series, XVII, 1923–24.

Savoye House, Poissy-sur-Seine. Ferroconcrete residence designed and built by Le Corbusier, 1929–30.

SCACCO, CRISTOFORO. Italian painter of Verona (known work 1493–1500). He introduced modern methods to the Naples area. Along with gold ornament and curling line, he used massive modeling, recalling Girolamo da Cremona.

BIBLIOGRAPHY. R. Causa, *Pittura napoletana dal XV al XIX secolo*, Bergamo, 1957.

SCAENA. Wall in an ancient Greek theater which closed off the stage from behind. It acted as a backdrop on which scenery was painted. The scaena had three doors, through which the actors entered: the protagonists through the center door, the other actors through the two side doors.

SCAGLIOLA. Imitation marble made by combining finely ground gypsum with glue, marble, and granite dust to form a plaster which is then highly polished. Said to have been invented in Italy during the first half of the 17th century, scagliola work is still widely used.

SCALA, ALESSANDRO. Italian sculptor (b. Carona; fl. Genoa, early 16th cent.). His chief works are a statue of Eliano Spinola (1511) in the Compere di S. Giorgio Palace in Genoa and a low relief, *Madonna with Saints* (1519), in the Church of the Madonna di Tirano (Valle Tellina).

SCALA, PIER ANGELO DELLA. Italian sculptor (b. Carona; fl. Genoa, 1st half of 16th cent.). He was possibly related to Alessandro Scala. The artistic activity of Pier Angelo della Scala is unclear; he appears to have been associated with the Aprile family of southern Italy and Spain.

SCAMOZZI, VINCENZO. Italian architect of the school of Vicenza (1552–1616). Scamozzi was a pupil of his father, Domenico Scamozzi, and a disciple of Andrea Palladio, according to whose plans he completed the Teatro Olimpico at Vicenza (1579–84). His other buildings there include the Trissino, Trento, Porto, and Godi palaces. In Venice Scamozzi built the Procuratie Nuove (which was begun in 1584; adjoining and following the design of Il Sansovino's Library of San Marco), the Church of S. Lazzaro dei Mendicanti (begun in 1602), and the Corner, Contarini (1609), and Duoda palaces. He was also active in Rome, Bologna, and elsewhere.

Scamozzi's style is based on the idea of eclecticism and strives to follow and selectively synthesize the achievements of Serlio, Palladio, and Il Sansovino. Of these, however, Palladio was his chief platform. Scamozzi's treatise *Idea dell'architettura universale* (1615) defends the position that the orders and principles of classical architecture are absolute and ideal, as it were, Platonic forms of beauty. Thus, the two main characteristics of Scamozzi's influential aesthetic position were classical purism and academicism.

HELLMUT WOHL

SCANDINAVIA: ANCIENT ART. The ancient art of Scandinavia began in the Mesolithic period as man occupied this area after the retreat of the glaciers. The Maglemosian culture (ca. 7000–5500 B.C.) developed in southern Scandinavia and extended over the area of the North and Baltic Seas, which was then above water. These fishers and hunters decorated bone and antler tools with barbed lines, net and checker patterns, and other geometric motifs, only rarely with schematized figures of animals. A change to moister climatic conditions and the subsidence of the Baltic and North Sea basins brought an end to Maglemosian culture. The later forest cultures (5500–3500 B.C.) included the Ertebølle, which is known from kitchen middens found along the coast. In northern Scandinavia, there were the Komsa and Fosna cultures, dating to the Mesolithic and probably surviving until after the Neolithic had reached southern Scandinavia. The naturalistic rock engravings of the north are usually associated with these two cultures.

The art of the early Scandinavian neolithic, like that of all neolithic cultures, is known best from its pottery. In the course of time it was transformed by outside influences. Toward the beginning of the 3d millennium, megalithic culture arrived from the west and can be traced through dolmen, passage-grave, and cist-grave phases, while in the later 3d millennium peoples who made battle axes and cord-impressed pottery penetrated Scandinavia from the south.

Trade with central Europe brought the use of bronze to Scandinavia between 1600 and 1500 B.C. By the end of the 2d millennium there had developed a brilliant bronze civilization, which is famous for metalwork decorated with concentric circles, then spirals, and finally involved wave patterns. *See* TRUNDHOLM SUN CHARIOT.

The return of moist climatic conditions and the consequent spread of forests may explain in part the abrupt decline of Scandinavian art and culture after 500/400 B.C. The Iron Age cultures were influenced by La Tène culture and then Roman civilization. Everywhere the archaeological remains give an impression of poverty. Beginning in the 5th century, after trade with the Roman world had been destroyed by the Germanic migrations, an isolated Scandinavia began to create the beautiful metalwork of the

Scandinavia, ancient art. Runic stone with graffiti of a warrior. National Museum, Stockholm.

North Sea style, which is well known from finds such as those of Nydam. Gradually, influences from the new barbaric states of Merovingian Europe found their way to the north to inspire the Vendel style (600–800).

See also MIGRATION STYLE.

During the Carolingian period Scandinavia entered the Viking Age, in which these northern peoples expanded westward to the British Isles and beyond to Iceland, and eastward into Russia. This was the period of the magnificent ship burials, such as that found at Oseberg, an age which came to an end in the 11th and 12th centuries with the spread of Christianity. *See* VIKING STYLE.

BIBLIOGRAPHY. H. Shetelig, *Préhistoire de la Norvège*, Oslo, 1926; H. Shetelig and H. Falk, *Scandinavian Archaeology*, Oxford, 1937; J. Brondsted, *Danmarks oldtid*, 3 vols., Copenhagen, 1957–60.

HOMER L. THOMAS

SCANNABECCHI, DALMASIO, *see* LIPPO DALMASIO DE' SCANNABECCHI.

SCARAB. Representation of a beetle, usually in faïence or stone, commonly used by the ancient Egyptians as amulets and talismans. The scarab is the symbol of Khepera, the god of transformation; thus it was frequently placed on mummy cases to symbolize resurrection.

SCARAVAGLIONE, CONCETTA. American sculptor (1900–). Born in New York, Concetta Scaravaglione studied at the National Academy of Design and the Art Students League of New York. She won a Prix de Rome and spent three years in Rome (1947–50). She has exhibited in New York at the Whitney Museum of American Art and at the Museum of Modern Art. In the Metropolitan Museum's National Sculpture Exhibit of 1951, she was represented by *Icarus*, a smooth figure spiraling through space, which she created in 1949–50 in Rome. She has taught at Vassar College.

She is a realistic sculptor working within a classic tradition. Like Maillol, she has sculpted many large nude female figures with impersonal faces. Modern critics include her among the romantic realists.

BIBLIOGRAPHY. R. Pearson, *The Modern Renaissance in American Art*, New York, 1954.

SCARSELLINO, LO (Ippolito Scarsella). Italian painter of Ferrara (1551–1620). Though he produced large formal works, he is better known for small pictures (many in Rome, Borghese) with figures in intense colors and hazy space. He retains Giorgionesque arcadianism, but with a slight brashness of the early baroque.

BIBLIOGRAPHY. M. A. Novelli, *Lo Scarsellino*, Bologna, 2d ed., 1964.

SCEAUX, CHATEAU OF. French château on the outskirts of Paris. Begun in 1673 for J.-B. Colbert, it was altered in the 19th century. Surviving from the earlier ensemble are the Orangerie by J.-H. Mansart and the Pavillon de l'Aurore, which has a dome frescoed by Charles Le Brun. The château now houses the Museum of the Ile-de-France.

BIBLIOGRAPHY. G. Poisson, *Sceaux, histoire et visite, le château, le parc, la ville, les environs. Guide officiel*, 2d ed., Paris, 1959.

SCENE, *see* SKENE.

SCENOGRAPHY. In general, the art of rendering the illusion of three-dimensional reality, through the use of perspective, on a two-dimensional plane. In a more restricted sense, the term applies to the painting of illusionistic stage scenery, particularly as practiced by the ancient Greeks.

SCHADOW, GOTTFRIED. German sculptor (1764–1850). A leading exponent of German classicism, Schadow received his early training under the baroque artist Pierre-Antoine Tassaert, whom he succeeded as court sculptor in Berlin in 1788. His style is sober and realistic, as seen in the monument of Frederick the Great in Stettin, combined with a graceful and fluent naturalism evinced by his harmonious group of Crown Princess Louise and her sister.

BIBLIOGRAPHY. F. Novotny, *Painting and Sculpture in Europe, 1780–1880*, Baltimore, 1960.

SCHADOW, WILHELM VON. German painter (b. Berlin, 1788; d. Düsseldorf, 1862). He was a son of the sculptor Gottfried Schadow and a pupil of Weitsch in Berlin. In 1811 he traveled to Rome, where he became involved with the Nazarenes and joined the St. Luke Brotherhood in 1813. He participated with the group in fresco decoration of the Casa Bartholdy (formerly Zuccari Palace, now Hertziana Library) in Rome (1816; *The Bloodstained Coat* and *Joseph in Prison*, Berlin, National Gallery). After returning to Germany, Schadow taught at the Berlin Academy from 1819 and became director of the Düsseldorf Academy in 1826. There he promulgated the romantic, archaizing principles of the Nazarenes and painted a number of monumental works as well as portraits.

SCHAEFER, CARL FELLMAN. Canadian painter (1903–). He studied in Toronto, where he has taught

Château of Sceaux. Residence begun in 1673 for Colbert, now the Museum of the Ile-de-France.

since 1931, now heading the Painting Department of the Ontario College of Art. Influenced by Charles Burchfield, he paints for the most part stylized landscapes and still lifes in water color.

BIBLIOGRAPHY. G. Johnston, "Carl Schaefer," *Canadian Art*, XVII, 1960.

SCHAFFHAUSEN: MUSEUM OF ALL SAINTS. Swiss museum that presents a historical survey of the area of Schaffhausen, with prehistoric and Roman finds as well as arts and crafts of the medieval, Renaissance, and later periods through the 20th century. Swiss paintings of the 15th through the 19th century, and particularly the works of the Schaffhausen artist Tobias Stimmer, which survived an air raid in 1944, form an important part of the collection.

SCHAFFNER, MARTIN. German painter and sculptor (b. Ulm, ca. 1480; fl. there, until 1541). He was the major master of Ulm painting in the early 16th century. Stylistically he is close to Hans Holbein the Elder. His major works were the *Hutz Altar* (1521; Ulm, Minster), the *Wettenhausen Altar* (1524; Munich, Old Pinacothek), and portraits of Itel and Bernard Besserer (1513; Berlin, former State Museums).

BIBLIOGRAPHY. J. Baum, *Die Ulmer Plastik um 1500*, Stuttgart, 1911.

SCHALCKE, CORNELIS SYMONSZ. (Simonsz.) VAN DER. Dutch painter of landscape, animals, and genre (b. Haarlem, 1611; d. there, 1671). Van der Schalcke's few surviving works are mostly landscapes dating from 1640 to 1664. In 1636 he succeeded his father as verger of St. Bavo in Haarlem. He painted in the style of Jan van Goijen as well as such Haarlem artists as Pieter Molijn, Salomon van Ruysdael, and Isaak van Ostade. His late works suggest the influence of Philips Koninck.

BIBLIOGRAPHY. J. Q. van Regteren Altena, "Cornelis Symonsz. van der Schalcke," *Oud-Holland*, XLIII, 1926.

SCHALKEN, GOTFRIED (Godfried) CORNELISZ. Dutch painter of genre and portraits (b. Made, 1643; d. The Hague, 1706). Schalken was probably a pupil of Samuel van Hoogstraten at Dordrecht and of Gerrit Dou at Leyden (1663–64). He was recorded back in Dordrecht by 1665. Schalken was a member of Pictura, the painters' confraternity in The Hague, in 1691, but he was also recorded as living at Dordrecht in the same year.

He went to England in 1692, and there are portraits painted by him with the inscription "Londini." He may have remained in England until 1697, but English sources note that he was in the country on two separate occasions. He painted several portraits of King William III. About 1703 he seems to have been working at Düsseldorf for the Elector of the Palatine. Schalken returned to The Hague in 1704.

He had great success with his artificially lighted genre scenes as well as his portraits. His style was based on that of Dou, although he also seems to have been influenced by Adriaen van der Werff. Schalken's pupil Arnold Boonen imitated his candlelight paintings.

BIBLIOGRAPHY. W. Martin, *De Hollandsche schilderkunst in de zeventiende eeuw*, vol. 2, Amsterdam, 1936.

LEONARD J. SLATKES

SCHAMBERG, MORTON. American painter and photographer (b. Philadelphia, 1881; d. there, 1918). Schamberg studied with Chase in Europe and was in Paris in 1906. Influenced by Duchamp, he painted mechanical objects, preserving their forms but using a cubist-derived compositional scheme.

BIBLIOGRAPHY. Walker Art Center, *The Precisionist View in American Art*, Minneapolis, 1960.

SCHARFF, EDWIN. German sculptor (b. Neu-Ulm, 1887; d. Hamburg, 1955). He studied painting at the Munich Academy (1904–07). In France (1911–13) he began to work in sculpture. Scharff had his first exhibition in 1913 and became a member of the New Secession in Munich. In 1933 the Nazis dismissed him from his teaching position at the Berlin Art School, and he served on the Düsseldorf Academy faculty until he was forbidden to work. After World War II he taught at the Hamburg Academy. His sculpture is close to the classicism of Maillol.

SCHARL, JOSEF. German painter and graphic artist (b. Munich, 1896; d. New York City, 1954). He studied at the Munich Academy and later emigrated to the United States (1938). Generally expressionistic, Scharl's portraits, figures, and religious scenes are stylized, decorative, and colorful.

BIBLIOGRAPHY. A. Neumeyer, *Josef Scharl*, New York, 1945.

SCHATZKAMMER GOSPELS, see GOSPELS OF CHARLEMAGNE.

SCHAUFELEIN, HANS LEONHARD. German painter and designer of woodcuts (b. Nürnberg, ca. 1480; d. Nördlingen, 1539). After 1515 he was city painter in Nördlingen. Schäufelein studied in Dürer's circle and was active in Augsburg, where he was influenced by Hans Holbein the Elder and Jörg Breu. His major work is the *Ziegler Altar* (1521; Nördlingen Museum). His greatest importance is as the creator of a large woodcut production, mostly for book illustration. Among these works are the 100 illustrations to the *Theuerdank* and the 200 illustrations to the *Weiskunig*. His woodcuts are a valuable source for the history of costume.

BIBLIOGRAPHY. E. Buchner, "Der junge Schäufelein als Maler und Zeichner," *Festschrift für Max J. Friedländer, zum 60. Geburtstage*, Leipzig, 1927; E. Schilling, "Zeichnungen des Hans Leonhard Schäufelein," *Zeitschrift für Kunstwissenschaft*, vol. 9, 1955.

Hans Leonhard Schäufelein, *Susanne*, from *L'Histoire de Susanne*. Woodcut.

SCHAW (Shaw), WILLIAM. Scottish architect (b. Sauchie, Scotland, 1550; d. Edinburgh, 1602). A mason and a courtier, he was Master of Works in the court of James VI. It is known that he was an accomplished architect although no buildings can be attributed to him. He worked at Holyroodhouse (ca. 1589–90) and at Stirling and Dunfermline.

BIBLIOGRAPHY. J. N. Summerson, *Architecture in Britain, 1530–1830*, 4th rev. ed., Baltimore, 1963.

SCHEDONI, BARTOLOMEO. Italian painter (b. Formigine, 1578; d. Parma, 1615). He was in Parma in 1600, Modena in 1602–06, and Parma again from 1607 until his death. After initially being influenced by Niccolò dell'Abbate he turned toward Correggio and Caravaggio, painting realistic figures in brilliant colors against a neutral background, as in the *Entombment* (1614; Parma, National Gallery).

BIBLIOGRAPHY. Bologna, Palazzo dell'archiginnasio, *Maestri della pittura del seicento emiliano* [3d] Biennale d'arte antica, catalog, ed. F. Arcangeli [et al.], Bologna, 1959.

SCHEEMAKERS, PETER. Sculptor (b. Antwerp, 1691; d. there, 1789), working mostly in England. His fame was established in 1741 by his statue of Shakespeare in Westminster Abbey. He never really usurped Rysbrach as the leading practitioner, although he was a prolific maker of monuments; that of Lady Newton (1737) at Heydour is typical.

SCHEFFAUER, PHILIPP. German sculptor (b. Stuttgart, 1756; d. there, 1808). He studied in Stuttgart and traveled with his friend the sculptor Johann Dannecker to Paris and then to Rome in 1785 where both sculptors enthusiastically adopted the style of Canova. After his Italian journey he worked for the Stuttgart court, producing portraits and smooth neoclassical works with classical themes.

SCHEFFER, ARY. French painter, sculptor, and graphic artist (b. Dordrecht, Netherlands, 1795; d. Argenteuil, 1858). He went to Paris about 1811 and studied with Pierre Guérin. In 1829 he journeyed to the Netherlands. Scheffer painted history and genre subjects and portraits. He combined a tightly drawn, classical painting style with a sentimental emphasis on gesture and emotional facial expression of a weakly romantic nature, for example, *St. Augustine and St. Monica* (1845; London, National Gallery). The subjects for his later works were drawn from Goethe, Dante, and the romantic poets. His sole sculptural effort was a figure for his mother's tomb (ca. 1839).

SCHEIBE, RICHARD. German sculptor and etcher (1879–1965). Born in Chemnitz, he studied with Pohle in Dresden and with Knirr and Fehr in Munich (1897–99). He also spent some time in Rome and was influenced by Maillol. A friend of Kolbe, and like him a classicist, Scheibe produced portraits and figural sculpture.

SCHELER, ARMIN. German-American sculptor (1901–). Born in Sonneberg, he studied at the State Academy of Fine Arts in Munich after technological training in design. He worked in Switzerland in the early 1920s, then emigrated to the United States, where he worked in industrial design after 1926. He exhibited portrait heads at the National Academy of Design in the 1930s and received public commissions during this period, especially from the Federal government. Since 1942 he has been teaching sculpture and design at Louisiana State University in Baton Rouge. Scheler has won many regional awards. His sculptures, carried out in a variety of media, are remarkably finely finished and suggest influence from the more fluid aspects of Lipchitz and of Arp and Brancusi.

BIBLIOGRAPHY. Louisiana State University, *Sculpture: Armin Scheler*, Baton Rouge, 1958.

SCHELFHOUT, LODEWIJK. Dutch painter and printmaker (b. The Hague, 1881; d. Amstelveen, 1944). A pupil of Theodore de Bock, he was influenced in Paris (1903–13) first by Van Gogh and impressionism and then more strongly by Cézanne and cubism in landscapes, still lifes, and portraits. From 1914 he turned to religious painting.

SCHIAFFINO, BERNARDO. Italian sculptor (b. Genoa, 1678; d. there, 1725). A student of Domenico Parodi and a friend of the painter Piola, Schiaffino developed a style that is precise, calm, and remote from the frenzy of his times. His marble bust of the doge Giovanni Francesco Brignole-Sale is in the Gallery of the Palazzo Rosso, Genoa.

SCHIAVO, PAOLO, see BADALONI, PAOLO DI STEFANO.

SCHIAVONE ANDREA (Andrea Meldolla). Venetian painter and etcher (ca. 1522–ca. 1563). Schiavone was born in Sibenik, Dalmatia. Little is known of his biography, and some historians date his birth much earlier. His career has been surrounded with legends; they make much of his obscurity, with some justice, but exaggerate in calling him a neglected artist who was reduced to ornamenting furniture. A higher status is suggested by his three roundels on the San Marco Library ceiling. This was part of a well-known project (1556–57), judged by Titian, in which the most talented younger artists competed for a prize. From at least 1547, Schiavone was active as an etcher. In his prints and numerous drawings he seems to have been dominated by Parmigianino, especially in his decorative mythological aspect, and produced mannerist figures of dainty scale and grace.

Schiavone was a key figure in introducing mannerism into Venice, but in the process he and Tintoretto gave it a Venetian variant, reducing its tension and spatial pressure. They used its elongated types in conjunction with atmospheric and color richness, and Schiavone developed a fluid brushstroke of long, winding pattern which resulted in a scarflike effect. More than in the roundels, this concept is apparent in the adjacent *Philosophers.* Tintoretto conformed to the casual twists of these standing figures when he finished the set after Schiavone's death. It also appears in the important *Adoration of the Magi* (Milan, Ambrosiana) and especially in the numerous works in Belluno (in the Cathedral and especially S. Pietro), whose recent identification and cleaning has clarified our image of his more monumental work.

But Schiavone is most frequently associated with the vast production of cornice friezes for rooms and other decorations of cassone shape, with pastoral and mythological themes. They belong to the Giorgione-Titian tradition of

Andrea Schiavone, *The Adoration of the Magi*. Ambrosiana, Milan. An artist who helped to introduce mannerism to Venice.

sensuous celebration, and vary greatly in quality. Museums which "represent" Venetian culture with these decorations have too often found his name an easy label. They are connected with him by the 17th-century image of him as a poor, neglected painter of minor works, even more so by their colorful mannerism of approach. No detailed study has separated the few probably by his hand from the others.

BIBLIOGRAPHY. A. Venturi, *Storia dell'arte italiana*, vol. 9, pt. 4, Milan, 1929; G. Fiocco, "Nuovi aspetti dell'arte di Andrea Schiavone," *Arte Veneta*, IV, 1950.

CREIGHTON GILBERT

SCHIAVONE, GIORGIO. Dalmatian painter (1433/36–1504). He went to Italy and in 1456 was apprenticed to Francesco Squarcione in Padua, but he returned to Sibenik about 1460 and remained there except for short trips. He was active in business and is thought to have virtually abandoned painting. Five signed works with no dates indicate his style. The London polyptych, the triptych divid-

ed between the former Berlin State Museums and Padua Cathedral, and the Turin *Madonna* show intense color but awkward modeling, even cruder than that of Squarcione. Most of the works thought his are of this type. But another *Madonna* (Baltimore, Walters Gallery) and a portrait (Paris, Jacquemart-André) are more accomplished and harmonious.

SCHIAVONI, MICHELE (Il Chiozzotto). Italian painter (fl. 1751–71). Schiavoni was active in his native city of Chioggia and in Venice. One of the many followers of Giovanni Battista Tiepolo, he created frescoes and paintings on a smaller scale as suited his more modest commissions and imagination.

SCHICK, GOTTLIEB. German painter (1776–1812). He was a pupil of J. L. David from 1798 to 1802, and lived in Stuttgart and Rome. In Rome he developed a radically severe, linearist-abstractionist version of neoclassicism that was related to the works of the *Barbus* (followers of David)

and the young Ingres. His most impressive works are his portraits.

BIBLIOGRAPHY. K. Simon, *Gottlieb Schick*, Leipzig, 1914.

SCHIELE, EGON. Austrian expressionist painter (b. Tulln, 1890; d. Vienna, 1918). Schiele attended the Vienna Academy of Fine Arts, where he studied under Gustav Klimt and knew Kokoschka, from 1907 to 1909. His style was strongly influenced by Art Nouveau-Jugendstil arabesque, but to this idiom he added a remarkably intense, nervous linearity and spotting of his own original fashioning. This manner was applied to an extraordinary series of male and female nudes, as well as to landscapes, between 1908 and the year of his death; and into those ten years he pressed an incredible creativeness. He was drafted into the Austrian army in 1915 but managed to continue painting at a fairly productive level.

Although his talent did not receive adequate recognition, he was not altogether unnoticed in his time. He was befriended by the critic Rössler, who encouraged several patrons to collect his work; he exhibited at the Vienna International in 1909, the Mietke Gallery Kunstsalon in 1911, the Cologne Sonderbund in 1912, the Goltz Gallery, Munich, and the Folkwang Museum, Hagen, in 1913, and, rather successfully, in a special room accorded him at the Vienna Secession exhibition of 1918. Moreover, he published a number of lithographs. Despite its general relation to Klimt and Kokoschka, Schiele's style is unique among expressionist idioms.

BIBLIOGRAPHY. O. Nirenstein, *Egon Schiele; Persönlichkeit und Werk*, Vienna, 1930; P. Selz, "Egon Schiele," *Art International*, IV, 1960; A. Werner, "Schiele and Austrian Expressionism," *Arts*, October, 1960; Marlborough Fine Art Limited, *Egon Schiele* (catalog; statements, W. Fischer and R. Leopold), London, 1964; O. Kallir, *Egon Schiele*, Vienna, 1966.

JOHN C. GALLOWAY

SCHIFANOIA PALACE, FERRARA. Italian palace begun in 1385 and enlarged in the second half of the 15th century. Schifanoia is celebrated for its Sala dei Mesi, which contains the frescoes of the months by Francesco del Cossa and his assistants. Other rooms of interest are the Sala degli Stucchi (imposing ceiling by Bongiovanni de Geminiano), the Sala delle Imprese (*bozzetto* of Michelangelo's *Moses*), the Saletta dei Bronzi (Etruscan, Roman, and Renaissance bronzes), the Sala delle Ceramiche (Ferrarese majolica, 15th and 16th cent.), and the Salette della Numismatica (coins and medals). *See* COSSA, FRANCESCO DEL. (See illustration.)

BIBLIOGRAPHY. G. Bargellesi, *Palazzo Schifanoia*, Bergamo, 1945.

Egon Schiele, *Houses with Drying Laundry*. Collection of Mrs. Ala Story, New York. An example of this Austrian expressionist's work.

Schifanoia Palace, Ferrara. Francesco del Cossa, detail of *The Month of March*, in the fresco cycle for the Sala dei Mesi, 1469.

SCHILLING, JOHANNES. German sculptor (b. Mittweida, 1828; d. Klotzsche, 1910). He studied in Berlin with Drake and in Dresden with Hähnel. Schilling was a popular neoclassic sculptor and teacher, producing both small-scale and monumental works.

SCHINKEL, KARL FRIEDRICH VON. German architect (1781–1841). He worked in Berlin. A pupil of Gilly, he traveled in France and Italy in 1803. He was first associated with romantic paintings and stage sets, which often included Gothic buildings in a landscape setting. However, his architectural works, which followed his appointment as state architect by Frederick William III in 1815, are primarily Greek in style and rational in philosophy. Within ten years he designed what are regarded as his masterpieces. His 1816 project for the Neue Wache, Unter den Linden, Berlin, is conceived in geometric cubic masses with Greek detail. The Schauspielhaus (1819–21) shows an advance in the handling of more complex elements of vocabulary in a rational manner, while his most famous work, the Altes Museum (1824–28), very similar to a Durand design for a museum with colonnades and a Pantheonlike dome, organizes extremely simple elements of Roman and Greek origin with logic and elegance. There all architectural vocabulary is subordinate to clarity of expression, while the rear façade is expressed in a utilitarian manner without any extraneous vocabulary.

From 1826 on Schinkel worked for the royal family in Potsdam, in close association with the future Frederick William IV. During this period his treatment of the Greek style became very free, and by the 1830s his classic architecture had become picturesque, placed within landscape settings.

Schinkel's theory that the form (style) of a building should be related to its function caused him to design in medieval and heterogeneous styles and even to consider a "new style" based on modern needs. He died before the possibilities of iron and glass had been widely exploited, but he had already used iron on some designs and had emphasized the possibilities of exposed brick, especially in his Bauakademie. Possible English influences can be seen in two English Tudor gatehouses he designed and in his court gardener's house on the Charlottenhof estate (1829–30), which stands as a forerunner of the new informal, asymmetrical, towered Italian-villa style in Germany. Although he was later dismissed by many critics as an "archaeological" architect, he is now recognized to have been concerned with many architectural problems that are prophetic of later developments.

BIBLIOGRAPHY. K. F. Schinkel, *Aus Schinkel's Nachlass; Reisetagebücher, Briefe und Aphorismen,* 4 vols., Berlin, 1862–64; A. Grisebach, *Karl Friedrich Schinkel,* Leipzig, 1924; N. Pevsner, "Schinkel," *Royal Institute of British Architects Journal,* LIX, 1952; H. R. Hitchcock, *Architecture, Nineteenth and Twentieth Centuries,* Baltimore, 1958.

DORA WIEBENSON

SCHLEGEL, FRIEDRICH VON. German critic and philosopher (1772–1829). Concluding that art had declined with Titian, Correggio, and Andrea del Sarto, he came to judge works not by their artistic merit but by their religious content. He held that the pre-Renaissance artists created a more authentic Catholic spirit.

BIBLIOGRAPHY. K. Andrews, *The Nazarenes*, Oxford, 1964.

SCHLEICH, EDUARD. German painter (1812–74). He lived in Munich and began painting dramatic romantic landscapes in the manner of Rottmann. After a visit to Paris (1851) he turned to a more intimately realist study of common landscape motifs, treating them with a quiet lyricism reminiscent of the Barbizon school.

SCHLEISSHEIM/MUNICH: SCHLEISSHEIM CASTLE AND STATE PICTURE GALLERY. German museum housed in a charming 18th-century residence-castle, surrounded by a park, in the French baroque style. Begun in 1701 by the Italian E. Zuccalli and, after an interruption of about ten years, continued by Joseph Effner in 1715, it shows the latter's style, especially in the interior decoration. The present main façade results from a reduction of Effner's plans by Leo von Klenze in 1819. The interior—the stately rooms as well as the smaller ones and the staircase—clearly mirrors the rich imagination of 18th-century interior decoration. The ceiling frescoes, stucco decoration, and wooden paneling blend harmoniously together; the subject matter shifts from mythology to allegory, from ornamental grotesques to historical glorification. The noteworthy picture gallery, with approximately 350 paintings by French, German, Italian, and Netherlandish artists, shows another aspect of the rich Bavarian State Collections.

BIBLIOGRAPHY. H. Jedding, *Keysers Führer durch Museen und Sammlungen*, Heidelberg, Munich, 1961.

SCHLEMMER, OSKAR. German painter, sculptor, stage designer, teacher, and writer (b. Stuttgart, 1888; d. Baden-Baden, 1943). He studied at the Stuttgart Academy with Adolf Hölzel and taught at the Bauhaus (1920–29), at the Breslau Academy (1929–32), and at the Berlin Academy (1932–33). His early paintings, influenced by Cézanne and related to cubism, exhibit in essence his lifelong concern for pictorial structure and the realization of form. During and after World War I he began to experiment with the organizational possibilities of space, both two-dimensional, in abstract paintings of geometric shapes, and three-dimensional, in architectural reliefs of cement and wire.

In the 1920s Schlemmer began to paint his most characteristic subject, the human figure in space. Schlemmer's treatment of this theme was extraordinarily complex. Ultimately humanistic in derivation, it yet allowed expression of his strong mystical feelings in paintings of stiff and seemingly mechanized figures whose formal handling owed much to archaic Greek sculpture and to the abstracting principles of purism, for example, *Concentric Group* (1925; Stuttgart, State Gallery) or *Group of Fourteen in Imaginary Architecture* (1930; Cologne, Wallraf-Richartz Museum). In these paintings, severe control carefully adjusts the free perspective depth of figures and architectural set-

tings to the surface tension of two-dimensional composition, as in *Bauhaus Staircase* (1932; New York, Museum of Modern Art). Schlemmer's important designs for the theater and ballet can be seen as extensions of the same aesthetic concerns manifested in the paintings. His later works showed softer forms and colors and a more personal handling of media.

BIBLIOGRAPHY. H. Hildebrandt, *Oskar Schlemmer*, Munich, 1952; O. Schlemmer, *Briefe und Tagebücher*, Munich, 1958.

JEROME VIOLA

SCHLIEMANN, HEINRICH. German businessman and archaeologist (1822–90). His career was marked by an incomparable blend of romanticism, luck, and scientific acumen. He was born into a poor family, spent part of his boyhood as a grocer's apprentice, but finally became established in 1846 in his own trading business in St. Petersburg. Through various commercial projects, he amassed a huge fortune which, in 1868, he began to devote to archaeological researches in Greece.

His excavation at Troy in 1873 first stirred the world with the realization that the Homeric epics were based on history, and subsequent excavations at Mycenae (1876) and Tiryns (1885) first brought to light a whole new era of history—the Greek Bronze Age. Schliemann's excavations were crudely executed by modern archaeological standards, but his intuition and energy must be credited with creating the field which others have refined.

BIBLIOGRAPHY. C. Schuchardt, *Schliemann's Excavations, an Archaeological and Historical Study*, trans. E. Sellers, London, 1891; P. R. S. Payne, *The Gold of Troy*, New York, 1959 (popular biography).

SCHLUTER, ANDREAS. German architect and sculptor (ca. 1660–1714). Schlüter worked as a sculptor in Warsaw before going to Berlin (1694), where he became the leading court architect and sculptor of Frederick III. In 1696 Schlüter was put in charge of building the arsenal in Berlin (destroyed). He provided more than 100 sculptured keystones for the façade but was relieved of his supervisory post when a pier collapsed during construction. In his

Oskar Schlemmer, *Group of Fourteen in Imaginary Architecture*, 1930. Wallraf-Richartz Museum, Cologne.

designs for the Royal Palace (1698–1707), the Kamecke House (1711–12), and other buildings in Berlin (all destroyed), Schlüter used undulating surfaces, monumental sculptures, giant orders, and a dynamic grouping of forms in an almost Michelangelesque manner. In structural matters he was somewhat less successful; the collapse of the water tower for the Royal Palace (1706) led to official disfavor. He finally left Berlin in 1714 for St. Petersburg, where he died in the same year. He was connected with the design for the second Winter Palace there. *See* WINTER PALACE, THE, LENINGRAD.

As a sculptor Schlüter created a number of powerful baroque works, including the bronze equestrian statue of Frederick III (1696–1709; Charlottenburg Palace), several tomb monuments, and of course, individual figures for his architectural projects.

BIBLIOGRAPHY. C. Gurlitt, *Andreas Schlüter*, Berlin, 1891; H. Ladendorf, *Der Bildhauer und Baumeister Andreas Schlüter*, Berlin, 1935.

SCHMALKALDEN: CASTLE CHURCH OF THE WILHELMSBURG. Distinguished example of a type of castle church developed in Germany during the 16th century. The Wilhelmsburg was constructed between 1584 and 1610 by Landgraf William IV of Hessen in the Renaissance style on the site of an earlier fortress. The castle church, designed by Wilhelm Verukkens in 1587 and consecrated in 1590, has a rectangular plan divided into three naves. Three-storied arcades decorated with Renaissance pilasters and grotesque ornamentation run continuously around the four sides of the interior.

SCHMIDT, FRIEDRICH VON. Austrian architect (1825–91). He worked in Vienna. Considered the most important Gothic revivalist in Austria after 1860, he worked under Zwirner on the restoration and completion of the Cologne Cathedral and built the Academische Gymnasium and the Fünfhaus parish church.

BIBLIOGRAPHY. C. von Lützow, *Friedrich von Schmidt*, Vienna, 1891.

Karl Schmidt-Rottluff, *Woman Resting*. New Pinacothek and New State Gallery, Munich.

SCHMIDT, GEORG FRIEDRICH. German engraver, etcher, and pastel artist (b. Schönerlinde, near Berlin, 1712; d. Berlin, 1775). Next to Johann Meil and Chodowiecki, Schmidt was the main figure in Berlin engraving in the 18th century. In 1743 he was made court engraver at Berlin, and from 1757 to 1762 he worked in St. Petersburg at the request of Czarina Elizabeth. His specialty was the portrait, but he also treated other subjects, especially after Rembrandt.

BIBLIOGRAPHY. E. Bock, *Die deutsche Graphik*, Munich, 1922.

SCHMIDT (Kremser-Schmidt), MARTIN JOHANN. Austrian painter (1718–1801). He executed numerous works in the style of the Austrian rococo. Of his large decorative frescoes, *Christ in the House of Simon* (1775; Stift Durnstein) represents a stylistic high point in its characteristic piled-up composition revolving about a central axis, its rapid, loose brushwork, its pastel coloring, and its brilliant luminosity. Among the numerous altarpieces that Schmidt executed, his earliest work reflects the light experiments of Troger, and later, a new lyricism enters through the artist's contact with Daniel Gran and B. Altomonte. In Schmidt's latest works a real sensation of vision is attained through the suppression of realistic detail, the evocation of a dreamlike ambience, the almost impressionistic use of color, and the constantly shifting patterns of light.

BIBLIOGRAPHY. B. Grimschitz, R. Feuchtmüller, and W. Mrazek, *Barock in Österreich*, Vienna, 1960.

SCHMIDT-ROTTLUFF, KARL. German painter (1884–). Born in Rottluff, he attended the Gymnasium in Chemnitz (1897–1905). He painted his first oils at the local Kunstverein while still in school. In 1904 he met Kirchner, whose encouragement of his early woodcuts Schmidt-Rottluff gratefully acknowledged later. The technique of his first efforts in this medium, for example, *Cityscape* (1904), was impressionistic. In 1905 he began to study at the Technische Hochschule in Dresden, and in the same year his woodcuts tended more toward abstract patternization of blacks and whites. Although his *Woman with Hat* (1905) recalls the work of Munch and Toulouse-Lautrec, it is as far removed from impressionism as possible. Here, shape and line have been disengaged from the subject matter, achieving an almost independent existence.

In 1905 Schmidt-Rottluff, Heckel, Kirchner, and Bleyl formed what Schmidt-Rottluff called Die Brücke (The Bridge), "... the bridge which would attract all the revolutionary and surging elements" (letter to Nolde, 1906, inviting him to join Die Brücke). The group followed no formal program, but its general tendency was an expressionism very close to Fauvism. It disbanded in 1913.

Schmidt-Rottluff's paintings about 1908 were characterized by simplified color that gained in effect through expressive contrasts. By 1910 he had arrived at a decorative style reminiscent of Gauguin. In *Firs Before a White House* (1911; Cologne, Wallraf-Richartz Museum) contours and surfaces take on the structure of the picture space. *Rising Moon* (1912; St. Louis, City Art Museum) seems to summarize the concise and definite form achieved thus far.

Between 1917 and 1919 he produced twenty important woodcuts on New Testament themes, of which the *Road to Emmaus* (1918) is justly famous. In these he strove for rigidity of gesture and movement and the total contrast

of the black-and-white areas. The influence of woodcut technique, cubism, and African sculpture converged in *Self-Portrait with Hat* (1919; Detroit Institute of Arts), the head hewn, as it were, out of slabs of color.

Schmidt-Rottluff visited Italy in 1923, Paris in 1924, and Rome in 1930 (a visit of several months). These travels may have contributed to the transformation of his style into something more gentle and picturesque. The vibrance of color and life began to have ever-increasing significance for him.

During World War II he was proscribed by the Nazis as a decadent artist and was forbidden to paint. After the war he set to work anew. The salient characteristic of his late style is the large-scale simplicity apparent in *Full Moon in the East* (1951; collection of the artist).

BIBLIOGRAPHY. W. Grohmann, *Karl Schmidt-Rottluff*, Stuttgart, 1956; B. S. Myers, *The German Expressionists*, New York, 1957.

FRANKLIN R. DIDLAKE

SCHMITZ, BRUNO. German sculptor and architect (b. Düsseldorf, 1858; d. Berlin, 1916). He studied at the Düsseldorf Academy. Schmitz was primarily a designer of massive, often Romanesque-derived architectural monuments which usually overpowered their sculptural insertions. He did the Soldiers' and Sailors' Monument in Indianapolis.

BIBLIOGRAPHY. H. Schliepmann, *Bruno Schmitz*, Berlin, 1913.

SCHNORR VON CAROLSFELD, JULIUS. German painter (b. Leipzig, 1795; d. Dresden, 1872). One of the chief exponents of German academic romanticism, he began his career as a student of his father, Hans Veit Schnorr von Carolsfeld. In 1811 Julius entered the academy in Vienna and studied under Füger. He was a member of the Nazarenes in Rome (1817–27) and worked with them on murals for the Casino of the Villa Giustiniani-Massimo.

In 1827 Schnorr von Carolsfeld became a professor at the Munich Academy, where he remained until 1846. He then went to Dresden as a professor at the academy and director of the Picture Gallery. While in Munich he received his most important mural commission: to execute a series of frescoes depicting the Nibelungenlied in the Munich Residenz (finished by his students in 1867). The major work of his Dresden period was the 240 designs for woodcut illustrations to the Bible (published 1853–60). Schnorr von Carolsfeld began as a devout follower of Cornelius; later he changed to a monumental classical style more in keeping with his academic position and inclinations.

BIBLIOGRAPHY. H. W. Singer, *Julius Schnorr von Carolsfeld*, Bielefeld, Leipzig, 1911; K. Gerstenberg and P. O. Rave, *Die Wandgemälde der deutschen Romantiker im Casino Massimo zu Rom*, Berlin, 1934.

SCHOCKEN DEPARTMENT STORE, STUTTGART, see MENDELSOHN, ERIC.

SCHOEVAERDTS, MARTEN. Flemish painter (b. Brussels, ca. 1665; d. after 1694). A pupil of Adriaen Frans Boudewijns I, Schoevaerdts painted numerous landscapes, processions, kermises, and similar subjects. Colorful little figures are characteristic of his scenes. He was dean of the Guild of St. Luke from 1692 to 1694.

SCHOLA. Latin word meaning "school." Scholae as lecture rooms of Roman philosophers have been seen as precedents for Early Christian basilicas.

SCHOLZ, GEORG. German painter and graphic artist (b. Wolfenbüttel, 1890; d. Waldkirch, Baden, 1945). He studied at the Karlsruhe Academy. Scholz was a painter of the naturalistic Neue Sachlichkeit group. His social irony is especially strong in his lithographs.

SCHOLZ, WERNER. German painter (1898–). He was born in Berlin and studied there. An expressionist, Scholz was strongly influenced by Die Brücke group, especially Emil Nolde, in his figures, landscapes, and religious subjects of very simplified forms and colors.

BIBLIOGRAPHY. H. Köhn, *Werner Scholz*, Essen, 1955.

SCHON, ERHARD. German painter and woodcutter (b. Nürnberg, after 1491; d. there, 1542). His early training is not known. He worked for a long period under Hans Springinklee. Schön's artistic progress was closely allied to the Nürnberg printing industry. His best works were done in the 1530s at the height of Nürnberg's publishing eminence, and as the quality of book production declined in the years shortly after, he turned from the highly decorative, worldly style of the post-Dürer generation to the more modern style of Virgil Solis, losing some integrity in the change. Schön made more than 1,200 woodcuts for books and pamphlets, some drawings, and a few paintings. In general, he is more important as an illustrator than as an artist, although he influenced Brosamer and Niclaus Stör.

BIBLIOGRAPHY. H. Röttinger, *Erhard Schön und Niklas Stör, der Pseudo-Schön*, Strasbourg, 1925.

SCHONBRUNN CASTLE. Imperial castle on the outskirts of Vienna, Austria. The brilliant first project for Schönbrunn, drawn up by J. B. Fischer von Erlach in 1692–93, could not be undertaken, and the building was begun according to a simplified scheme in 1695–96. Fischer's son Joseph Emanuel introduced modifications about 1737, and these in turn yielded to a thoroughgoing redesign by Nikolaus Paccassi (1744–49). As a result of these changes

Schönbrunn Castle. A reception room of the palace, begun 1695–96.

the exterior of the main block lacks the force originally intended. Within is a chapel with frescoes by Daniel Gran (1744) and richly decorated imperial apartments. Work was begun in 1765 on the park, which was laid out in a grandiose manner by Ferdinand von Hohenberg. Notable features of the park are Hohenberg's gloriette, a columnar arcade that provides a visual focus for the whole, and the circular menagerie by J. N. Jodot de Ville-Issey.

BIBLIOGRAPHY. O. Raschauer, *Schönbrunn*, Vienna, 1960.

SCHONER BRUNNEN, NURNBERG. One of the most beautiful fountains in Nürnberg, Germany. It was erected on the north side of the marketplace between 1385 and 1396 by Heinrich Beheim, the architect of St. Sebald, Nürnberg. The Schöner Brunnen consists of a stone pyramid with over-life-size figures of the seven electors and seven heroes and smaller figures of prophets and seated Evangelists (the originals are in the German National Museum, Nürnberg). The figures show influences of the Parler sculpture in Prague.

BIBLIOGRAPHY. A. Feulner and T. Müller, *Geschichte der deutschen Plastik*, Munich, 1953.

SCHONGAUER, MARTIN. German painter and engraver (b. Colmar, ca. 1430–45; d. Breisach, 1491). Few facts are known about his early life and training. His father, Caspar, is recorded in the Bürgerbuch of Colmar as a goldsmith from Augsburg, where he was a citizen in 1445. It is believed that Martin received his early training from his father; this would account for his proficiency as an engraver. Nothing is known about his training as a painter. Perhaps he studied with the painter Caspar Isenmann, who had a workshop in Colmar when Schongauer was a youth. No documentation supports this assumption, but it is consistent with the evidence of early familiarity with Flemish painting in Schongauer's art and the Netherlandish style of Isenmann's art. In 1489 Schongauer was called to Breisach to paint the frescoes for the Minster; he died there just after the completion of the commission.

The style of Rogier van der Weyden is the prime influence in Schongauer's art. Contact with Rogier's art was very easy for Schongauer; from Colmar he could have traveled to Flanders or to Burgundy, where works by Rogier and his immediate followers were abundant. His earliest works show derivations from Rogier; the *Christ in Glory* (1469; Paris, Louvre) drawing is a copy from Rogier's altarpiece at Beaune (ca. 155 mi. from Colmar), and the engraving of the *Schmerzensmann* is derived from Rogier's *Crucifixion Triptych* (Vienna, Museum of Art History). Schongauer transforms the Flemish style into a purely German one. He stands completely apart from the lesser German painters who merely imitated the Flemish motifs in a misunderstood and slavish manner that all but submerges their individual personalities.

With one exception, the *Madonna of the Rose Arbor* (1473; Colmar, St. Martin), all the paintings attributed to Schongauer are contested. The *Madonna of the Rose Arbor* is one of the masterpieces of German painting; it is the climax of late Gothic painting. The figures of the Virgin and the Christ Child together form a beautifully united whole, achieved by the use of contrasting diagonals.

It is likely that many of Schongauer's paintings were destroyed, as they were located in an area constantly exposed to warfare. It is likely, too, that he employed many assistants in his workshop who were very close imitators of the master's hand. Among his contested attributions are the *Nativity* (Munich, Old Pinacothek) and the *Holy Family* (Vienna, Museum of Art History).

Schongauer is best known for his engravings; they spread his influence all over Europe, even as far as Spain. He created 115 engravings, almost all of religious subjects. The most famous are the *Temptation of St. Anthony* (ca. 1475), the *Death of Mary*, the *Great Carrying of the Cross*, the twelve-plate series of the *Passion*, the *Great Crucifixion*, and the double sheet of the *Annunciation*. These engravings are characterized by an expressive treatment of Christian themes by means of strong forms, dynamic outline, and richness of detail. They were deeply influential on Dürer's early graphic development.

BIBLIOGRAPHY. J. Baum, *Martin Schongauer*, Vienna, 1948; A. Stange, *Deutsche Malerei der Gotik*, vol. 7, Munich, 1955.

DONALD L. EHRESMANN

SCHOOL OF ART. A school of art comprises a geographic unit; its most important feature is continuity of place. The common denominator of a school is the recurrent use of certain formal conventions (sometimes difficult to specify) that are rooted in the place where it exists. This distinguishes a school from a style, which can exist quite independently of place. A school is either national, regional, or local (for example, Italian, Lombard, and Florentine schools). One may also speak of the school of an individual artist, but this is a secondary use of the term, interchangeable with "shop" or "manner," that should not be confused with its primary geographic connotation. Unlike individual artists or styles, a school cannot travel. When it moves from the place to which it belongs, it tends to assume the characteristics of its new home and thus to become a different school.

See also STYLE.

SCHOOL OF ATHENS, THE. Fresco painting by Raphael, in the Stanza della Segnatura of the Vatican, Rome. *See* RAPHAEL.

SCHOOTEN, FLORIS GERRITSZ. VAN. Dutch still-life painter (b. Haarlem, ca. 1590? d. after 1655). Van Schooten was married in Haarlem in 1612 and is mentioned on several occasions until 1655. He appears to have been extremely prolific, and numerous works, mostly still-life paintings of the "breakfast-piece" type, have come down to us. His earliest work of this type is dated 1617 (Switzerland, private collection).

BIBLIOGRAPHY. I. Bergström, *Dutch Still-Life Painting in the Seventeenth Century*, New York, 1956.

SCHOTANUS, PETRUS. Dutch painter of still life and genre (fl. Leeuwarden, ca. 1650–1700). Little is known of Schotanus. He painted vanitas still lifes with little variation in composition and objects, and may have been an amateur.

BIBLIOGRAPHY. A. P. A. Vorenkamp, *Bijdrage tot de geschiedenis van het Hollandsch stilleven in de zeventiende eeuw*, Leyden, 1934.

Martin Schongauer (attrib.), *The Holy Family*. Oil on panel. Museum of Art History, Vienna.

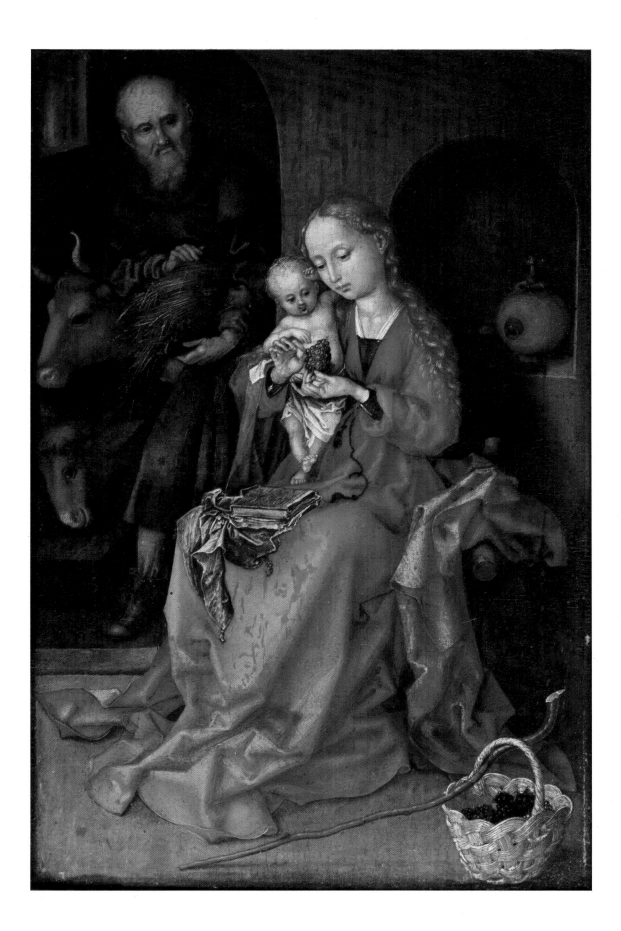

SCHOUBROECK, PIETER. Flemish painter (b. Herzheim, 1570; d. Frankenthal, 1607). Schoubroeck was active in Nürnberg and Frankenthal. He painted landscapes as well as Biblical and mythological themes, enlivened by small figures. All his work was in the manner of Gillis van Coninxloo's German period, but with the addition of strong light effects.

BIBLIOGRAPHY. J. A. Graf Raczyński, *Die flämische Landschaft vor Rubens*, Frankfurt am Main, 1937.

SCHRAG, KARL. German-American painter and print-maker (1912–). Born in Karlsruhe, he studied in Germany, Switzerland, and Paris before going to the United States in 1938. In 1950 he became director of Atelier 17 in New York City, and he joined the faculty of Cooper Union in 1954. His oils, water colors, gouaches, and intaglio prints explore the relationship between the forms of nature and art.

BIBLIOGRAPHY. J. Gordon, *Karl Schrag*, New York, 1960.

SCHREIN. German for "shrine." The term is used to denote the wooden cabinet that forms the innermost stage of a German winged altar. Almost invariably, this shrine is filled with sculpture complementary in subject matter to the painted scenes on the wooden shutters that cover it.

BIBLIOGRAPHY. W. Wegner, *Der deutsche Altar des späten Mittelalters*, Munich, 1941.

SCHRIECK, OTTO MARCELLIS (Marseus) VAN. Dutch painter of insects, reptiles, and butterflies (b. Nijmegen, 1619/20; d. Amsterdam, 1678). Van Schrieck traveled to Italy with Matheus Withoos and was visited in Rome (1652) by Samuel van Hoogstraten. He belonged to the painters' organization in Rome. He also visited England and was active in Florence (for the Grand Duke of Tuscany) and Paris. He lived in a villa on the outskirts of Amsterdam, which had a park with snakes, lizards, waterfowl, and so on, which he used as subject matter for his paintings. Willem van Aelst was his pupil.

BIBLIOGRAPHY. V. C. Habicht, "Ein vergessener Phantast der holländischen Malerei," *Oud-Holland*, XLI, 1923-24.

SCHRIMPF, GEORG. German painter and graphic artist (b. Munich, 1889; d. Berlin, 1938). Before he was twenty, Schrimpf had traveled through Germany, Holland, and Belgium, and in 1909 he returned to Munich. In 1913, on Lake Maggiore, Schrimpf copied nudes from Raphael and Michelangelo. In 1915 he was in Berlin, where he was impressed with the work of Franz Marc. Before 1917, Schrimpf's work featured flat patterns and forms that were delineated by sharp contours, as may be seen in *Girl with Cat* (1916).

By 1918, Schrimpf had combined his powerfully outlined figures with a deeper perspective. The starkness of the figures, combined frequently with wide-eyed stares (*Self-Portrait*, 1918; *Portrait of Oskar Maria Graf*, 1918), contribute to the spectator's awareness of tension. Yet Schrimpf wedded his monumentality to a meticulous precisionism, which might justify the application of the term "magic realism" (an extreme factualness from which emanates a certain haunting intensity).

Historically, Schrimpf is important as a member of Germany's New Objectivity group, which flourished after World War I. Schrimpf's references to social injustices and post-war suffering, however, are more obliquely made than those of Dix and Grosz and contain little of the caricature and morbid observation that color much of their work.

Schrimpf's grandiose figures frequently suggest something of the Italian Renaissance. His Madonnalike women, often shown looking off toward a distant landscape with their backs to the observer, convey ultimately a feeling not of despair but of poetic nostalgia. It is the accentuation of the linear design and the cold, clear color, rather than the prevailing mood, that link Schrimpf with the New Objectivists, for example, his *Mother and Child in a Courtyard* (1923). In *Girls on a Balcony* (1927), two girls are placed on a balcony, their backs toward the spectator, whose glance travels past them into the surrounding landscape. As in other paintings, there is a strange juxtaposition between nature and rather forbidding man-made objects. Most of Schrimpf's works are in Germany—in Berlin, Leipzig, Mannheim, and Munich.

BIBLIOGRAPHY. B. S. Myers, *The German Expressionists*, New York, 1957.

ABRAHAM A. DAVIDSON

SCHRODER HOUSE, UTRECHT. Netherlandish house built by Gerrit Rietveld in collaboration with Truss Schröder, the patron, in 1924. Designed of colored, rectangular panels, interlocking on a perpendicular, three-dimensional coordinate system, it is the mature embodiment of the de Stijl formalistic aesthetic and one of the landmarks of contemporary architecture. *See* DE STIJL; RIETVELD, GERRIT THOMAS.

BIBLIOGRAPHY. T. M. Brown, *The Work of G. Rietveld, Architect*, Utrecht, 1958.

SCHUCH, KARL. Austrian painter (b. Vienna, 1846; d. there, 1903). Schuch studied at the Vienna Academy and traveled widely in Europe throughout his life. In 1870 he was in Munich, where he came under Leibl's influence; from 1882 to 1894 he was in Paris and there was strongly affected by Courbet's style. Schuch is best known for his fine landscapes and still lifes that stylistically bridge the gap between Leibl's romanticism and the early impressionism of Austria.

BIBLIOGRAPHY. E. Waldmann, *Die Kunst des Realismus und des Impressionismus im 19. Jahrhundert*, Berlin, 1927.

SCHUCHLIN, HANS. German painter (b. Ulm? 1469; d. 1503). Documents attest to his prolific workshop in Ulm, although only one work, the high altar in the church of Tiefenbronn, is extant. Stylistically, Schuchlin's art is closely related to that of Michael Wolgemut in Nürnberg.

BIBLIOGRAPHY. A. Stange, *Deutsche Malerei der Gotik*, vol. 8, Munich, 1957.

SCHULE, CHRISTIAN. Danish draftsman and engraver (b. Copenhagen, 1764; d. Leipzig, 1816). He studied at the Copenhagen Academy and with Johan Clemens. Between 1787 and 1816 Schule worked in Leipzig, mainly engraving for book publishers. Among his works are *Promenade in the Rosenborg Garden* (1785) and five vignettes in the *Collected Works* of J. H. Wessel (1781).

SCHULTZE-NAUMBERG, PAUL. German architect and painter (1869–1949). He worked in northern Germany. Dealing primarily with domestic architecture, he emphasized

Georg Schrimpf, *Girl Reading at a Window*, 1925. Oil on canvas. Art Gallery, Mannheim.

materials and local style, feeling that art must be related to the culture and climate of its environment.

SCHULZE, WOLFGANG, *see* WOLS.

SCHUMACHER, FRITZ. German architect and writer (b. Bremen, 1869; d. Hamburg, 1947). Before World War I Schumacher executed many buildings in a simplified, monumental manner, including a number of schools in Hamburg. In 1917 he published *Das Wesen des neuzeitlichen Backsteinbaues.*

SCHUT, CORNELIS. Flemish painter (1597–1655). Born in Antwerp, he worked in the Rubens tradition and was perhaps a member of the master's studio from the 1620s on. His painted *oeuvre,* presumably consisting of a number of religious and historical subjects, is currently undergoing clarification.

BIBLIOGRAPHY. H. Gerson and E. H. ter Kuile, *Art and Architecture in Belgium, 1600–1800,* Baltimore, 1960.

SCHUTZ, CHRISTIAN GEORGE, THE ELDER. German landscape painter (1718–91). He was a major figure in the development of German rococo landscape painting and a member of the Frankfurt group of painters. Schutz's work characteristically rejects the dramatic, decorative elements of baroque landscape. It concentrates on a new intimate viewpoint, based on the study of Dutch 17th-century painting, which lends a sense of realism to his art.

BIBLIOGRAPHY. R. Hamann, *Die deutsche Malerei vom Rokoko bis zum Expressionismus,* Leipzig, 1925; F. Novotny, *Painting and Sculpture in Europe, 1780–1800,* Baltimore, 1960.

SCHWABISCH-GMUND: HOLY CROSS CHURCH. The most important 14th-century church in Lower Swabia, Germany. From about 1320 to 1330 the original Romanesque structure was changed into a Gothic hall church by the architect Heinrich Parler, founder of the famous Parler family of artists from Cologne. By 1351 the uniquely Parleresque choir structure with its multiple radiating chapels was finished. This choir complex is separated from the nave by the two original Romanesque choir towers. The vaulting of the nave and choir was not finished until 1521. Of equal importance with the architecture are the sculptures adorning the exterior, which are sources for the International Gothic style of about 1400.

BIBLIOGRAPHY. K. M. Swoboda, *Peter Parler,* Vienna, 1940; O. Schmitt, *Das Heiligkreuz Münster in Swäbisch Gmünd,* Stuttgart, 1951.

SCHWANTALER, LUDWIG. German sculptor (b. Munich, 1802; d. there, 1848). The son of the sculptor Franz Schwantaler, he studied at the Munich Academy. He was a prolific producer of monuments and architectural sculpture in a dry neoclassic style.

SCHWARTZ, CHRISTOPH. German painter (b. Munich, ca. 1545; d. there, 1597). He was a pupil of Melchior Bockberger and later probably also of Titian. Schwartz was an early precursor of the baroque, owing his style both to Venetian painting and to southern German schools, especially the Danube school. During his lifetime he was well known as a façade painter, and he made decorations for churches in Munich, Augsburg, Landshut, and elsewhere. His major work is the main altar of the Jesuit church of St. Michael in Munich, inspired by Tintoretto and Raphael.

SCHWARZ (Schwartz), HANS. German medalist and sculptor of miniatures (b. Augsburg, ca. 1492/93). He was probably apprenticed to his father, Stephan Schwarz, as early as 1506, and he was active in Augsburg (1516). Hans's portrait medals, made from carved wooden models, are in an individual style, neither Italian nor German (for example, *Portrait of Hans Burgkmair,* 1518). From 1519 to 1535 he visited Nürnberg, Heidelberg, Poland, France, and possibly the Netherlands, making medals and statuettes. It is thought that he is not the Schwarz recorded in Ottingen in 1540.

BIBLIOGRAPHY. G. Habich, *Die deutschen Schaumünzen des XVI. Jahrhunderts,* vol. 1, pt. 1, Munich, 1929; E. F. Bange, *Die Bildwerke in Holz, Stein und Ton: Kleinplastik* (Die Bildwerke des Deutschen Museums, IV), Berlin, 1930.

SCHWARZRHEINDORF: DOPPELKIRCHE. German Romanesque church near Bonn. It was begun in 1151 by Archbishop Arnold of Wied as his burial chapel. The nave was completed by 1175. The church is in the form of a modified Greek cross, with the east and west arms longer than the north and south ones. The east arm terminates in a round apse; the other arms terminate in niches set into the thickness of the masonry. The church is roofed with groin vaulting and half domes. A high open tower rises above the central crossing. The exterior is enriched with blind arcading and corbel-table friezes. The masses and volumes are clearly articulated in a High Romanesque fashion.

There have been varied opinions as to the degree of Byzantine influence in Schwarzrheindorf. Although the plan

suggests Eastern sources, this is not conclusive, for by the mid-12th century it was a generally available architectural type.

SCHWEIKHER, PAUL. American architect (1903–). Born in Denver, Colo., Schweikher was first a student of painting at the Art Institute in Chicago but later switched to architecture, in which he received his training at Yale University, New Haven (1927–29). He worked in the office of Work and Walcott in Chicago and then joined with Ted Lamb (1936) and Winston Elting (1938). The firm of Schweikher and Elting operated between 1945 and 1953. Although the two architects have worked independently since 1953, they have been associated on several commissions, including Chicago Hall at Vassar College, Poughkeepsie, N.Y. (1957).

Schweikher's early work (his own house in Roselle, Ill., 1938) shows the influence of Frank Lloyd Wright's prairie-style houses. Later works retain horizontality (Fine Arts Center, Maryville, Tenn.) but achieve strength, delicacy, and rhythmic unity from Schweikher's distinctive use of columnar supports. The architect has also been chairman of the department of architecture at Yale University (1953–55) and at the Carnegie Institute (since 1955) in Pittsburgh, where he lives and works.

<div align="right">DONALD GODDARD</div>

SCHWIND, MORITZ VON. Austrian painter and draftsman (b. Vienna, 1804; d. Munich, 1871). One of the most important German romantic artists, he began his career as a student at the University and at the Academy of Vienna, from 1821 to 1827. At that time he was influenced most strongly by Julius Schnorr von Carolsfeld and Peter Krafft, and he also came into contact with a wider circle of Viennese artists, most notably the composer Franz Schubert and the dramatist Franz Grillparzer. In 1835 he traveled to Rome. Upon his return he painted *Ritter Kurts Brautfahrt* (1835–40; destroyed), which established his name. In 1839 he moved to Karlsruhe, where he was commissioned to decorate the stairway of the State Art Gallery. Between 1844 and 1847 he was in Frankfurt; following that he was appointed a professor at the Munich Academy.

To many, Schwind is the epitome of German romanticism in painting. He concentrated on subjects drawn from old German legends and fairy tales, capturing the directness of their sentiment with a vivid linear style. Among his masterpieces are *Der Ritt des Falkensteiners* (1843–44; Leipzig, Museum of Fine Arts), *Sängerkrieg auf der Wartburg* (1844–46; Frankfurt am Main, Städel Art Institute), and the woodcut illustrations to Scherer's *Alte und neue Kinderlieder* (1848–49).

BIBLIOGRAPHY. O. Weigmann, *Schwind*, Stuttgart, 1906; G. Keyssner, *Schwind*, Stuttgart, Berlin, 1922; E. Kalkschmidt, *Moritz von Schwind*, Munich, 1943.

<div align="right">JULIA M. EHRESMANN</div>

SCHWITTERS, KURT. German artist specializing in collage (b. Hannover, 1887; d. Ambleside, Eng., 1948). He attended the Dresden Academy for six years, and it was there that he received a sound background in traditional art theory and technique. He painted portraits in an academic manner throughout his life to make a living. Schwitters saw the art of Kandinsky and Franz Marc after World

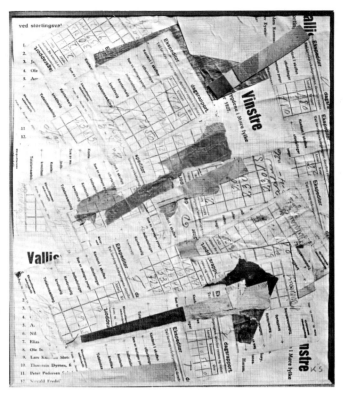

Kurt Schwitters, *Collage*. Private collection.

War I and was so impressed that he went through an expressionist phase.

Schwitters painted his first abstract pictures about 1918, and a year later made his first collage. About this time, while making a collage from a newspaper advertisement with the heading *Kommerz und Privat Bank*, he cut off the first three letters of *Kommerz* and was left with the term *Merz*, which he exploited as a label to specify his kind of art and as the title of a magazine he published in 1923. The name actually connotes nothing; it was merely the product of chance. Schwitters was connected with avant-garde movements as early as 1918, when he exhibited at the Berlin art gallery Der Sturm along with Mohlzahn and Klee. By 1919, he began to write the poem *Anna Blume*. He was active in Dada demonstrations, especially in Holland, by 1920.

In the same year he constructed his first *Merz-bau* in his home in Hannover. It was a giant construction made of trash, which he found fascinating. It grew and grew until it consumed so much space that one could not enter the room that held it. This first *Merz-bau* was destroyed in the bombing of World War II. Schwitters made two more *Merz-bau* constructions, one in Norway, the other in Ambleside. He received a grant from the Museum of Modern Art in New York City to help with the latter, which he never finished.

Schwitters's magazine was to go through twenty-four issues, the last in 1932. Such notables as Jean Arp, Hannah Hoch, Francis Picabia, and Theo van Doesburg contributed to it. In 1925 Schwitters composed a *Lautsonate* (phonetic poem), to be read and placed on a phonograph record. His works were exhibited widely. In 1932 he became a mem-

Scopas, *Meleager*, a Roman copy. Vatican Museums, Rome.

ber of the Paris Abstraction-Création group. In 1935 he was represented in the New York Museum of Modern Art's exhibition "Cubism and Abstract Art" and, later, in their "Fantastic Art, Dada, and Surrealism" show. In 1937 his work was shown in the Nazi-promoted show of so-called "degenerate" art. He went to England in 1940. He exhibited at the Modern Gallery in London in 1945 and two years later gave two poetry readings. A retrospective exhibition of his work was given at the San Francisco Museum of Art in 1966.

Schwitters's best-known works are his small collages, composed largely of such evanescent bits of commonplace trash as subway tickets, bus transfers, newspapers, shreds of cloth, and the like. He exploited their color and texture, their power to evoke associations, and the surprise which comes from discovering the vernacular in an essentially poetic context.

BIBLIOGRAPHY. H. Bolliger, *Kurt Schwitters, collages*, Paris, 1954; S. Themerson, *Kurt Schwitters in England*, London, 1958; H. Janis and R. Blesh, *Collage: Personalities, Concepts, Techniques*, Philadelphia, 1962. ROBERT REIFF

SCIARPELLONI, LORENZO, *see* CREDI, LORENZO DI.

SCIENTIFIC IMPRESSIONISM, *see* NEOIMPRESSIONISM.

SCIPIONE (Gino Bonichi). Italian painter (b. Macerata, 1904; d. Rome, 1933). With Mario Mafai, he was a founder of the Roman school. Scipione's visionary paintings of street scenes and figures, for example, *The Apocalypse* (1930; Turin, Museo Civico), began the expressionist strain in modern Italian art.

BIBLIOGRAPHY. G. Marchiori, *Scipione*, Milan, 1939; U. Apollonio, *Scipione*, Venice, 1945.

SCIPIONE DI GUIDO. Italian sculptor (fl. late 16th–early 17th cent.). One of a family of artists from Carrara, Scipione worked as a wood carver in Sicily. He executed choir stalls for the Cathedral of Catania (1587–1604), the housing and podium for an organ and a base for a statue of St. Jacob in a parish church in Caltagirone (1589), and a coffered ceiling for a church in Enna.

SCOPAS. Greek sculptor from Paros, one of the great masters of the 4th century B.C. He worked both as chief architect and as a sculptor on the Temple of Athena Alea at Tegea, between 370 and 355, and later was one of several sculptors to work on the frieze of the Mausoleum of Halicarnassus, begun after 351. Thus his period of activity is best placed in the second and third quarters of the fourth century.

Pausanias (VIII, 45, 4) tells us that Scopas executed figures of Aesculapius and Hygieia to flank the cult image in the temple at Tegea, but does not say who was responsible for the pedimental sculptures—the Calydonian boar hunt in the east pediment and the battle of Achilles and Telephus in the west. Fragments of these sculptures, presumably from the east pediment, have been found (Tegea, Museum; Athens, National Archaeological Museum), and since they are the works of a powerful, original sculptor, they are usually ascribed to Scopas, or at least to his workshop. The heads of these pedimental figures reveal an interest in the expression of emotion through physiognomic features, a quality hitherto not conspicuous in Greek art. By rendering the lips slightly parted and by carving the eye rather deeply into the skull, thereby producing heavy shadows which give the impression of a concentrated gaze, the sculptor of these heads endowed them with a feeling of excitement and intensity that is best described as the capacity for emotion rather than any particular emotion.

Pliny (XXXVI, 30) relates that Scopas executed the reliefs on the east side of the Mausoleum of Halicarnassus. Four slabs in the British Museum, London, showing a battle of Greeks and Amazons, were found on the east side of the Mausoleum and fit our notion of Scopas's style quite well. They reveal the same intensity noted in the Tegea heads, both in facial features and in gesture, controlled, however, by established classical principles of balanced composition. *See* MAUSOLEUM OF HALICARNASSUS.

A huge column drum decorated with reliefs from the Temple of Artemis at Ephesus (British Museum) is often attributed to Scopas on the basis of a reference in Pliny (XXXVI, 95). If this drum actually is by Scopas, it was probably executed at about the same time as the Mausoleum frieze, to which it bears certain similarities.

Several other works by Scopas, known through literary descriptions, have been identified in Roman copies. Perhaps the most convincing of the attributions is the *Pothos* (Yearning) in the Capitoline Museums, Rome, mentioned by Pausanias, even if this work reveals a style somewhat different from that of the Tegea heads. Other common attributions are the *Frenzied Maenad* (Dresden, State Art Collections), the Landsdowne *Heracles*, and the heads of Meleager (Cambridge, Mass., and Rome, Villa Medici). All such attributions, of course, are based on the stylistic index provided by the Tegea and Mausoleum sculpture,

Jan van Scorel, *Christ on the Cross*. Detroit Institute of Arts.

which cannot with certainty be identified as the work of Scopas.

BIBLIOGRAPHY. M. Collignon, *Scopas et Praxitèle*, Paris, 1907; C. A. Neugebauer, *Studien über Skopas*, Leipzig, 1913; P. E. Arias, *Skopas*, Rome, 1952. JEROME J. POLLITT

SCOREL, JAN VAN. Dutch painter and architect (1495–1562). Scorel was born near Alkmaar; after an apprenticeship in Haarlem with Cornelis Buys, he is believed to have visited Dürer and Jan Gossaert on his way to Italy. In 1520 he made a trip to the Holy Land, returning to Venice in 1521. Called to Rome by his countryman Pope Adrian VI, he was able to study the works of Michelangelo and Raphael and the antique ruins and sculpture of that city. His successful synthesis of the idealism of the Italian Renaissance and the naturalism of the north, which seems to have had far-reaching consequences for the mannerist style in Holland, is exemplified by *Christ on the Cross* (Detroit Institute of Arts).

BIBLIOGRAPHY. M. J. Friedländer, *Die altniederländische Malerei*, vol. 12, Berlin, 1935.

SCORZA, SINIBALDO. Italian painter (b. Voltaggio, 1589; d. Genoa, 1631). Scorza studied under Paggi in Genoa and Fiasella in Florence, but his most distinctive works are animal paintings and rustic landscapes in the Flemish manner. His water colors of animals, now in the Uffizi Gallery in Florence, the Louvre in Paris, the British Museum in London, and the Czartoryski Collection in the National Museum in Cracow, influenced Castiglione and Vassallo.

SCOTIA. Concave molding (from the Greek *skotia*, "darkness") forming a comparatively deep and dark hollow. Approximately semicircular in Greek Ionic bases and at

times a quarter circle, as in the Doric cornice, the scotia is most often associated with the concave molding found in classical and Renaissance column bases.

SCOTT, DAVID. Scottish history painter and, up to 1828, also an engraver (1806–49). He was the son of the engraver Robert Scott (1771–1841) and worked most of his life in his native Edinburgh. He painted mainly subject pictures and historical themes in the tradition of Benjamin West, although he was more stylistically influenced by the Venetians, particularly Giorgione and Titian. He was elected a member of the Royal Scottish Academy in 1832.

SCOTT, SIR GEORGE GILBERT. English architect (1811–78). Popularly the archpriest of the High Victorian Gothic, Scott probably had talent but little else. He typifies the super organizer-architect, who because of this ability secured the plums of official commissions. His work is respectable but there are no flights of genius. Pugin and Street outdid him in "correctness," and he only tentatively followed the paths of the Camden Society. His influence lies in his vast practice, especially church restoration, and in the prominence of many of his buildings, such as the Albert Memorial (1863–72) and the Midland Hotel, St. Pancras (1865), both in London. His office has been compared to the "plan factories" of the 20th century, and, as with the latter, it is difficult to distinguish responsibility for design.

BIBLIOGRAPHY. H. R. Hitchcock, *Architecture, Nineteenth and Twentieth Centuries*, 2d ed., Baltimore, 1963.

SCOTT, GEORGE GILBERT, II. English architect (1839–97). He was a mediocre Gothic revivalist who followed in the footsteps of his more illustrious father, Sir George Gilbert Scott. He designed St. Agnes (1877), Kennington, in a curvilinear mode and the New Building, Pembroke College, at Cambridge (1883).

SCOTT, SIR GILES GILBERT. English architect (1880–1960). He won the Liverpool Anglican Cathedral competition in 1902. Although a stylist in the Gothic and classical traditions of his time, he was of limited power. Liverpool Cathedral illustrates this, and so did his rejected design for Coventry Cathedral.

BIBLIOGRAPHY. "Giles Gilbert Scott," *The Observer*, No. 8317, October 29, 1950.

SCOTT, MACKAY HUGH BAILLIE-, see BAILLIE-SCOTT, MACKAY HUGH.

SCOTT, SAMUEL. English landscape painter (ca. 1702–72). He belongs to the tradition of topographical view painters and is the most distinguished native English exponent of that style in the middle of the 18th century. This type of painting was popularized in England by Canaletto, who was there almost continually from 1746 to 1755. Scott undoubtedly learned much from Canaletto, but he retains a distinct personality. Artistically, he was never a serious rival to the Venetian, but he has more feeling for the English atmosphere in his scenes. Scott left the London area in the mid-1760s and retired to western England. He painted very little during the later years of his life.

BIBLIOGRAPHY. E. K. Waterhouse, *Painting in Britain, 1530–1790*, Baltimore, 1953.

SCOTT, WILLIAM. English painter (1913–). One of England's leading abstract painters, Scott has described his childhood in Scotland as simple and austere. He studied at Belfast College of Art in Northern Ireland. Before World War II he spent considerable time in France, where he painted several figure and still-life pictures, which owe much to Cézanne, Derain, and Bonnard. After the war, still life became his chief preoccupation. By 1953 his work was almost entirely abstract, except for a few nudes, though he has said that all his shapes derive from square tabletops and round frying pans. Scott is chiefly interested in the relationship between broad, simple forms and dense, rich, luminous colors. The way he actually applies the paint is important in his effort to combine sensual color with starkness of form.

BIBLIOGRAPHY. R. Alley, *William Scott*, London, 1963; A. Bowness, ed., *William Scott: Paintings*, London, 1964.

SCOTT, WILLIAM BELL. English painter (b. Edinburgh, 1811; d. Penkill Castle, 1890). The son of an engraver and the younger brother of David Scott, William Bell Scott was a painter, poet, and critic. His first show was at the Scottish Academy in 1833; he went to London in 1837. He was a friend of Rossetti and was associated with the Pre-Raphaelites. Most of Scott's subjects are romantic and historical, though some are contemporary, as in *Iron and Coal* (England, private collection). *See* Scott, David.

SCRAPER (Graphics). A leather-covered block of hardwood or other material used in the printing of stones; an integral part of the lithographic press. Many different-size scrapers are necessary in the printing of lithographs, because the scraper is required to be larger than the drawing but smaller than the outside width of the stone. The term also refers to a three-sided, hollow-ground knife used for making corrections on an etching plate.

SCRAPER, THE (Apoxyomenos), *see* Lysippus.

SCREEN. In church architecture, a pierced, wall-like structure that separates the nave from the choir or ambulatory; it may also shut off side chapels from the nave. A screen is also a piece of furniture consisting of adjustable panels, frequently with painted or embroidered decoration, used to ward off the direct heat or light of an open fireplace.

SCRIBES, EGYPTIAN. The position of the scribe in Egypt was very high, comparable to that of the priest and well above that of all other professions. This appraisal, however, seems to be contradicted by the typical posture of the scribe as represented in numerous statues from the 4th dynasty on, for example, *The Seated Scribe* (Paris, Louvre). The man is squatting on the ground with legs crossed, head bent, holding a reed pen ready to write on a papyrus roll stretched out on his lap. His attitude has been described as submissive; he waits for the master's dictation. Yet royal sons, for example, Kawab, son of Cheops, and the sons of Radedef and Mycerinus, are regularly shown as scribes.

The statues are smaller than life size and fairly naturalistic portraits; they are usually made of painted limestone and some have inlaid eyes. The posture remains traditional through the ages. Some variants are known, usually featuring the baboon, which is sacred to Thoth, patron of the scribes. The animal is either perched on the shoulders behind the head of a scribe like Ramsesnakht, protecting him with its forepaws, or it is shown as a statue of the baboon of Thoth, on its pedestal, facing the scribe.

ALEXANDER M. BADAWY

SCRIMSHAW. Nautical term referring to small works of art created by sailors on bone, ivory, shell, and other materials. On decorative or practical objects scenes or emblems were engraved with a knife; the engraved lines were then often filled with ink. This form of folk art was particularly popular among American whalers of the 19th century, who used the bones and teeth of the whale.

SCRIPTORIUM. Room in a monastery reserved for the use of scribes engaged in the production of handwritten manuscripts. At least three classes of workers used the scriptorium: the *scriptor*, who did the calligraphy for books; the *illuminator*, who specialized in painting decorative initials and miniatures; and the *notarius*, who worked chiefly on legal documents. In the broader sense the term designates a specific school of manuscript illumination.

SCULP. Abbreviation for *sculpsit* (Latin for "he or she carved or engraved it"). Sculp. is found after the name of the engraver on a print. It is used chiefly to distinguish the engraver from the designer, whose name, also given on the print, is followed by "delin." *See* Delin.

SCUMBLE. Oil painting technique in which one layer of opaque paint is applied over another of a different color. The second layer is applied loosely enough to reveal some of the underlying color. Scumble is the counterpart in opaque work to glazing, a technique employed to produce transparent effects.

Scotia. Concave molding forming a deep, dark hollow.

SCYPHOS. Type of Greek drinking vessel. It has two handles like the cylix, but, unlike that more formal drinking cup, the scyphos has no foot and its body is deeper and narrowed toward the base.

SCYTHIAN (Scytho-Sarmatian) ART. About 700 B.C. the Scythians appeared upon the steppes of southern Russia, and during the 7th century B.C. they invaded the Near East. The origins of Scythian art have long been debated. Scholars have variously postulated that it arose in Mongolia near China, in Turkestan on the frontier of Iran, or in southern Russia under Greek influence, depending upon which of these regions was thought fundamental in the formation of the famous Scythian animal style. Borovka was undoubtedly right when he postulated that Scythian art arose on the border between the forest and steppe zones of Eurasia, for only such an origin would account for the presence of motifs based on both steppe and forest animals such as the horse and the reindeer. The slant or beveled carving of the animal forms, particularly in earlier Scythian work, suggests that the first steps toward later work in metal were made in a wood medium.

The Scythians, whose racial and linguistic affinities are equally disputed, spread out over the Eurasiatic steppe.

Scythian art. Reindeer finial for a banner or pike. British Museum, London.

They created a style that was to extend from the Ordos region, on the frontier of China, westward across Turkestan and southern Russia to Hungary. Historically as well as archaeologically, the Scythians—the Scythae of Herodotus and the Sakas of the Achaemenid inscriptions—are best known in southern Russia. At first they occupied the southern Russian steppe and the northern slopes of the Caucasus. During the 7th century B.C. they pushed southward through the Caucasus into northwestern Persia, where their presence is marked by objects found in the now famous treasure of Zawiyeh. They also moved westward across the Dnieper and through the Carpathians into Hungary and raided northwestward to reach Vettersfelde in eastern Germany. During this expansion through Eurasia they must have come into contact with many settled peoples, which would explain the Chinese, Near Eastern, and Greek elements that appear in their art. *See* VETTERSFELDE GOLD FIND; ZAWIYEH TREASURE.

The art of the Scythians comes largely from their well-known kurgan, or mound, burials. These burials were not confined to a few simple widespread types, as suggested by many authors, but varied both regionally and chronologically. They can be divided into several regional groups. The North Caucasian group is known from kurgans such as those of Ul, Kelermes, Kostromskáya, and Voronezhskaya. The early tombs are characterized by timber construction that is sometimes suggestive of a tent, as at Kostromskáya. These graves, with their accompanying horse burials, have yielded the magnificent deer plaque of Kostromskáya and the lioness figure of Kelermes. In the later kurgans, as at Yelizavetovskaya, the timbered burial chamber gave way to one in stone, obviously as a result of Greek influence. The kurgans of the Taman peninsula and the Crimea belong largely to the later Scythian period; here both tomb construction and funerary remains display obvious signs of Greek influence.

On the steppe north of the Sea of Azov, from the lower Don to the lower Volga, there are relatively few Scythian graves, but kurgans such as the one at Mastyugino have rectangular burial chambers built of planks and wooden posts, quite different from those of the North Caucasus. The lower Dnieper group of kurgan burials is again different in that the Scythians reused older burial mounds. Kurgans of this group, as at Chertomlyk, are more famous for Greek works of art than for Scythian. The kurgans of the Kiev region form still another group, in which pottery displays both Greek and Lusatian influences, which come from the west. These groups, together with others in the Poltava, eastern Polish, eastern German, and Hungarian areas in the west and in the lower Volga, Volga-Saratov, and Ural areas in the east, each of them with its local peculiarities, suggest the great regional diversity of Scythian culture.

Each of these groups has its own distinct development of style. In general, however, the Scythian art of the 7th and 6th centuries B.C., which can be judged from the Kostromskáya deer, the enrolled animal found at Temir Gora, and the Kelermes lioness, retains much of its nomadic spirit and form, although it already shows Assyrian and Iranian motifs and techniques. Toward the end of the 6th century Greek influence can be seen in the handling of form and in an increasing freedom of movement. In

the 5th and 4th centuries the animal style was overwhelmed by Greek influence. The animal lost its earlier sense of form, as in the Kul Oba deer, or became a repeated decorative element, as on the Kelermes ax. Away from the Pontic coast, which was dominated in turn by archaic, classical, and Hellenistic Greek civilization, Greek influence was less insistent, to judge from works such as the carved tusks and altar tables from the lower Volga. Few kurgans have been excavated east of the lower Volga, but an art related to that of the Scythians is known from stray finds in Kazakhstan and above all from the Tagar culture, which arose from the older Karasuk culture in the region of Minusinsk as a result of Scythian influence.

See also RUGS, NEAR AND MIDDLE EASTERN.

At the beginning of the 3d century B.C. the movements of the Yuech (Yüeh-chih) into Turkestan may well have pushed the Sarmatians and the Alans into southern Russia and the northern Caucasus respectively, where they dislodged the Scythians, driving them into the Crimea and the Dobruja. The Sarmatians, who were to occupy the steppes of southern Russia from the 3d century B.C. to the 4th century of our era, brought an art that was markedly different from that of the Scythians. While it was free from the woodland element found in Scythian art, it made use of animal forms: birds' heads, horse and lion motifs, and enrolled animals. There is a strong Iranian element in the use of inset stones and cloisonné. Gradually the Sarmatians came into contact with the craftsmen of the cities of the Bosporan kingdom, who gave them first a Hellenistic and then a Greco-Roman style as models for their art. The florid decorative style of Sarmatian art can be seen in oval brooches with inset stones and filigree decoration.

In later times, when the Sarmatians began to drift into the Bosporan cities, their animal forms became increasingly conventionalized, and the ornamental surfaces were set with stones fitted in cloisons. In fact, there was almost an anticipation of the medieval idiom. Whereas the animal style of the Sarmatians was finally transformed by Greco-Roman influence, the art of nomadic peoples to the east, such as the Huns, fell under the influence of the Han art of China. Sarmatian art lasted until the arrival of the Huns, when the world of the steppe entered the Migration period. *See* MIGRATION STYLE.

BIBLIOGRAPHY. E. H. Minns, *Scythians and Greeks*, Cambridge, Eng., 1913; M. Ebert, *Südrussland im Altertum*, Bonn, 1921; M. I. Rostovtsev, *Iranians and Greeks in South Russia*, Oxford, 1922; G. I. Borovka, *Scythian Art*, London, 1928; K. Schefeld, "Der skythische Tierstil in Südrussland," *Eurasia Septentrionalis Antiqua*, XII, 1938; E. H. Minns, "The Art of the Northern Nomads," *Proceedings of the British Academy*, XXVIII, 1942; Akademiia nauk SSSR, Institut istorii Material'noĭ Kul'tury, *Voprosy skifo-sarmatskoĭ arkheologii*, Moscow, 1954; T. T. Rice, *The Scythians*, London, 1957; A. L. Mongait, *Archaeology in the U.S.S.R.*, Moscow, 1959.

HOMER L. THOMAS

SEALS: STAMP AND CYLINDER. Seals were first used in the ancient Near East to mark objects with a sign of ownership. Later they were impressed on clay tablets that recorded various transactions.

Near Eastern seals. The earliest seals are from Mesopotamia and Syria of the 6th millennium B.C. and were stamp seals. One surface was generally carved with a simple geometric design and somewhat later with fairly crude representations of animals. The seals were ovoid, square, or triangular pieces of stone, metal, or bone, and some had upright knob handles. Occasionally the shape was that of a part of or a whole animal, bird, or fish.

About 3200 B.C. the first seals of cylindrical shape appeared in Mesopotamia. They were pierced vertically to hold a metal pin or a loop of string and had a carved outer surface. From that time until the Neo-Babylonian period (6th cent. B.C.) the cylinder was the commonest form of seal in Mesopotamia, Iran, and Syria. It also spread to Egypt, where, in the predynastic and Old Kingdom periods, it had a limited popularity. The shapes of the cylinders vary: some are short (1 in.) and squat; others are long (about 2 in.) and thin. In the Akkadian period the sides were frequently concave. There is also great variety in the type of stone used: steatite, chalcedony, hematite, and limestone were common; lapis lazuli, amethyst, and carnelian were also used; bone, shell, and bronze cylinder seals were less frequently employed.

The carvings on cylinder seals show a series of different styles and subjects, and because the seals are so numerous and so well classified they have become a major dating criterion in Mesopotamian archaeology. The subjects are frequently religious or mythological, and gods, heroes, natural and fantastic animals, and landscape ele-

Seals. Impressions from Mesopotamian cylinder seals. Louvre, Paris.

ments are included in the scenes. More rarely the designs are purely geometric. The style of carving in some periods, such as the Akkadian (ca. 2340–2180 B.C.) and Middle Assyrian (13th cent. B.C.), is particularly fine, and the results are extremely naturalistic. In other periods, however, the exclusive use of the drill or point makes the design almost abstract. Different styles also coexist within a single period. In Iran and Syria the styles frequently reflect strong Mesopotamian influence.

See also KASSITE ART; MITANNIAN ART.

Although cylinder seals occurred in Anatolia, the stamp seal was the predominant form there. In Syria and Palestine stamp seals as well as imported or imitation Egyptian scarabs were also used. Less is known of the stylistic development of the simpler designs on stamp seals, but the number of reliably excavated examples from Syria and Anatolia is increasing and will aid in the reclassification and understanding of other stamp seals.

In the Assyrian period (911–612 B.C.) the stamp seal gained in importance in Mesopotamia, and by the Neo-Babylonian period it had become the major seal form. After the Achaemenian period (539–331 B.C.) cylinder seals were no longer generally used in the Near East.

BIBLIOGRAPHY. H. Frankfort, *Cylinder Seals*, London, 1939; *The Collection of the Pierpont Morgan Library*, cataloged and ed. by E. Porada (Committee of Ancient Near Eastern Seals, Corpus of Ancient Near Eastern Seals in North American Collections, vol. 1. The Bollingen Series, vol. 14) [New York], 1948; R. J. and L. S. Braidwood, *Excavations in the Plain of Antioch* (Univ. of Chicago, Oriental Inst. Publs., vol. 61), Chicago, 1960; P. Amiet, *La Glyptique Mésopotamienne Archaïque*, Paris, 1961.

PRUDENCE O. HARPER

Islamic seals. In spite of the Muslim proscription of the images of living beings, early Islamic seals from Egypt, Syria, and Asia Minor sometimes bear the representations of animals, horsemen, and local saints. These images are not found, however, on later Arabic seals, which show merely the owner's name and a religious inscription. Both signet rings and seals mounted on handles were used and were often carried in the breast pocket or hung around the owner's neck. Signet rings were made of precious or semiprecious stones mounted in silver or copper.

In Islamic Constantinople a special group of engravers produced individually styled seals for their patrons. Different types of seals (red hematite set in silver, emeralds set in gold, and so on) were used for various court purposes by the sultans. Ottoman imperial seals bore the *tughra*, a calligraphic symbol, along with the sultan's titles and a religious inscription.

The shahs of Persia reused the seal of their predecessors by scraping the surface and imprinting the new shah's name. Stamps or ring seals were made by means of a drill and emery wheel. In India the Mughal rulers employed personal seals in various ways; for instance, for messages to foreign rulers, Akbar used a round seal bearing his name and those of his predecessors back to Tamerlane. For other purposes he used differently shaped, simpler seals with suitable inscriptions. Court dignitaries also had personal seals. In the 18th and 19th centuries even English officials in India used seals that carried their names in Arabic characters.

Indian and Chinese seals. In India seals have been discovered dating back to the 4th to 3rd centuries B.C. Various materials were used, such as stone, terra cotta, glass, and carnelian (mounted in gold). They often represent religious symbols (tridents, conches, wheels), sacred animals, anthropomorphic deities, and later (9th–10th cent. of our era) the names of persons and Buddhist formulas.

Impressions of Chinese seals have been found on pottery dating to the Chou dynasty. Official seals seem to have appeared in the Ch'in dynasty, and individual seals were in use by the Han dynasty. The art of seal production became highly refined, and the materials employed included jade, silver, gold, ivory, and rhinoceros horn. During the Sung dynasty seals were very popular; painters used them to sign their works, and collectors applied their own seals to paintings in their collections. This custom helped to authenticate and document the history of such paintings.

Western seals. In ancient Greece engraved stones, gems, and other materials were widely used for making identification marks. Such engravings had subjects similar to those current in other Greek art forms and were often of the highest quality. This art reached its zenith in Greece in the 5th and 4th centuries B.C.

Portrait seals were in favor in Republican Rome, particularly in ruling families, which revered the images of their ancestors. Later, living heroes and emperors were also portrayed. The likeness of a king was used as a state seal; this custom persisted into late antiquity and was imitated by Barbarian kings through whom the usage was transmitted to the Middle Ages. Portrait seals of noble and lay persons became frequent from the 11th century onward; they show busts, full-length figures, and riders on horseback.

By the 12th century in Europe seals were used for validating documents by towns, colleges, and laymen; their use then became subject to regulation. In medieval times (and later) the matrix of a seal was generally made of metal, often bronze. A handle of ivory, gold, or rare stones was sometimes attached, which might also be carved with various representations. In the 15th and 16th centuries engraved stones were fashionable as seals for private correspondence, and heraldic themes became most prevalent. The use of seals declined by the late 18th century, except for state papers. Thereafter they continued to have diminishing personal usage, although portrait seals of the Napoleonic era were highly finished decorative objects.

SEATTLE, WASH.: ART MUSEUM. The Seattle Arts Society was founded in 1908 and the present museum was opened in 1933. The collection includes some Egyptian, ancient Near Eastern, Greek, Roman, Byzantine, and medieval works. In the Kress Collection are works by Pietro Lorenzetti, Daddi, Lorenzo Monaco, Giovanni di Paolo, Fra Bartolommeo, Tintoretto, Veronese, Rubens, Magnasco, Steen, Canaletto, and Tiepolo, among others. Some modern painters represented are Léger, Duchamp, Picabia, Moholy-Nagy, Pollock, Francis, and the Washington artists Tobey and Graves. Of particular interest are the comprehensive Oriental collections, with many masterpieces of Chinese, Japanese, Indian, and Islamic art. Fine groups of pre-Columbian and African art are also on view.

BIBLIOGRAPHY. Seattle Art Museum, *Handbook*, 1951; Seattle Art Museum, *European Paintings and Sculpture from the Samuel H. Kress Collection*, Seattle, 1954.

SEBASTIAN, ST. Christian martyr, usually represented tied to a tree or column and pierced with arrows. A Ro-

Sebastiano del Piombo, *The Death of Adonis*. Uffizi, Florence. Probably a work from early in this artist's Roman period.

man soldier who converted to Christianity, he was eventually ordered put to death. When he miraculously survived being shot with arrows, he was clubbed to death. As one of the saints whose protection against sickness and the plague is most commonly invoked, St. Sebastian appears frequently in Western art.

SEBASTIANO DEL PIOMBO (Sebastiano Luciani). Venetian painter (ca. 1485–1547). He first appears as one of the most talented young artists in the Giorgione circle. Sebastiano's organ shutters for S. Bartolomeo a Rialto (1507–09) and his high altar for S. Giovanni Crisostomo (1508–10), both in Venice, completely absorb Giorgione's atmospheric form and its poetic, meditative mood. However, the figures are large and standardized. In 1511 Sebastiano went to Rome, where he remained the rest of his life.

In his mythological frescoes (1511) at the Farnesina his Venetian airy poetry is modified with Raphael's rounded solutions of figure composition. This modification recurs in the *Death of Adonis* (Florence, Uffizi), with its view of Venice. The gray tone used here became usual with Sebastiano. He became a notable portraitist, developing new spatial motifs and experimenting with double portraits. Examples of this stage of his work are *Cardinal Antonio Ciocchi del Monte Sansovino* (Dublin, National Gallery of Ireland) and *Cardinal Ferry Carondelet with His Secretaries* (Lugano, Thyssen-Bornemisza Collection). Soon though, he was much more affected by Michelangelo, who

encouraged him with suggestions and probably with drawings; thus he acted as Michelangelo's executant for painting. Monumental works of anatomical force and clarity resulted, including the *Raising of Lazarus* (1519; London, National Gallery), the *Flagellation* (1516–24; Rome, S. Pietro in Montorio), and the *Lamentation* (Leningrad, Hermitage). Later works in this vein are dry and complex, except for the Michelangelesque *Pietà* (Viterbo, Municipal Museum).

After 1520 the most notable works other than the surprisingly Venetian *Birth of the Virgin* (Rome, S. Maria del Popolo; finished by others) are portraits. Chief of these are *Andrea Doria* (1526; Rome, Doria Pamphili), *Cardinal Salviati with His Servant* (Sarasota, Ringling Museum of Art), *Clement VII* (1526; Naples, Capodimonte), and *Cardinal Pole* (Hermitage). A *Christ Carrying the Cross* became a popular devotional image and exists in many versions. After he was awarded a church sinecure, Sebastiano worked little, completing only a few works in the last ten years of his life.

BIBLIOGRAPHY. L. Dussler, *Sebastiano del Piombo*, Basel, 1942; R. Pallucchini, *Sebastiano Viniziano*, Milan, 1944.

CREIGHTON GILBERT

SEBASTIE, *see* SAMARIA.

SECONDARY COLOR, *see* COLOR, SECONDARY.

SECRET DECORATION, *see* AN-HUA DECORATION.

SECTION. In architectural drawing, the representation of a structure as if it were cut by a vertical plane to show construction. When the intersecting plane cuts lengthwise, the section is called a "longitudinal section"; one perpendicular to the longitudinal section or in the shorter direction is a "transverse section." A transverse section is sometimes called a "cross section," although the term is also used interchangeably with section.

SECTION D'OR. French term meaning "golden section." It refers to the ideal proportion between the side and the diagonal of a square, a proportion present in many natural as well as man-made forms and therefore of great interest to the cubist painters who participated in the Section d'Or Exhibition at the Galerie La Boétie in Paris (1912). They were Jacques Villon (promoter of the movement and one of the organizers of the exhibition), Marcel Duchamp, Gris, Léger, Duchamp-Villon, Picabia, Lhote, Delaunay, La Fresnaye, Marcoussis, Gleizes, Dumont, Metzinger, Herbin, Segonzac, and others. The importance of the exhibition and the short-lived magazine of the same name lay in the fact that this was the largest grouping of cubist artists to exhibit together up to that date. The exhibition itself was in nature of a tribute to Cézanne, in admiration of the great influence he had exercised on the cubist movement. Gris showed his work to an important public for the first time and was never to forget the lesson he derived. *See* Gris, Juan; Villon, Jacques.

However, it was Jacques Villon who remained at the head of the Section d'Or movement. Carrying color to its highest intensity, he achieved a version of analytical cubism that met his need for order and discipline, the two outstanding characteristics of the Section d'Or principles. Composition is carefully arranged according to the principle of a pyramidal vision formulated by Leonardo da Vinci: an object and its various parts come toward us in pyramids, whose apex is in our eyes and whose base is in the object or in a section of the object. Villon used this principle with conviction (*Soldats en marche*, 1913).

The title "Section d'Or" was suggested by Villon during meetings at his studio in Puteaux with a number of artists who were passionately interested in problems of rhythm and proportion. He borrowed it from the treatise of the Bolognese monk Luca Pacioli, *The Divine Proportion*, published in Venice in 1509 and illustrated by Leonardo. The golden section, or divine proportion, was taken up during the Renaissance, having been formulated by Vitruvius.

Although distorted by incomprehension or hostility on the part of the critics, the Section d'Or Exhibition had immense avant-garde success in France and other countries. The group itself was dissolved after the war. Gris went on to architectural lyricism, Delaunay and Léger to the prestige of colored forms, Herbin to pure signs, and Gleizes to cubist mural art. Villon alone remained entirely faithful to the principles of geometrical discipline. *See* Delaunay, Robert; Gleizes, Albert; Leger, Fernand. *See also* Duchamp, Marcel; Duchamp-Villon, Raymond; La Fresnaye, Roger de; Lhote, Andre; Marcoussis, Louis; Metzinger, Jean; Picabia, Francis; Segonzac, Andre Dunoyer de.

BIBLIOGRAPHY. A. H. Barr, Jr., *Cubism and Abstract Art*, New York, 1936; P. Eluard and René-Jean, *Jacques Villon: Ou L'Art glorieux*, Paris, 1948; M. Raynal et al., *Histoire de la peinture moderne*, vol. 3: *De Picasso au Surréalisme*, Geneva, 1950.
ARNOLD ROSIN

SEDDON, JOHN POLLARD. English architect (1827–1906). He was in partnership with John Pritchard (1852–62), succeeding him as architect for Llandaff Cathedral. Seddon was a High Victorian architect with a large ecclesiastical practice. University College in Aberystwith, Wales, begun in 1864, is one of the finest and boldest of collegiate groups.

BIBLIOGRAPHY. "The Late Mr. J. P. Seddon," *The Builder*, XC, February 10, 1906.

SEDERBOOM, *see* Quellinus, Jan Erasmus.

SEDILIA. Seats for clergy (from the Latin *sedile*, "seat"). In English churches they were usually placed on the south side of the chancel and were used during intervals of the service. There were generally three sedilia in the group, often built of masonry recessed in the wall and framed by arches, as in St. Mary, Leicester, and Merton College, Oxford.

SEDILLE, PAUL. French architect (1836–1900). Sédille worked in Paris and is of interest because of his early department store in iron and glass, the Printemps (1881–89). He visited England in the 1880s and published a book on English architecture. This work, although lacking in discrimination, constitutes one of the early treatments of the subject.

BIBLIOGRAPHY. E. Luc, *La Vie et les oeuvres de Paul Sédille*, Paris, 1900.

SEEHAUS, PAUL ADOLF. German painter and etcher (b. Bonn, 1891; d. Hamburg, 1919). A representative of the Rhenish school of German expressionism, Seehaus was influenced by the softer, curvilinear expression of the French Fauves as well as by the German Die Brücke and Blaue Reiter groups. A self-taught artist, he gained experience by sketching from nature during an early trip through Scandinavia and the British Isles. His use of brightly colored and cubistic, interpenetrating planes in broad land-

Giovanni Segantini, *Love at the Source of Life*. Modern Art Gallery, Milan.

scapes indicates his debt to the work of his friends Franz Marc and August Macke.

BIBLIOGRAPHY. P. O. Rave, "Paul Adolf Seehaus," *Wallraf-Richartz Jahrbuch*, II, 1925.

SEEKATZ, JOHANN CONRAD. German painter (b. Grünstadt, Pfalz, 1711; d. Darmstadt, 1768). He was a member of the Frankfurt circle of artists who frequented the home of Goethe's father. After 1753 he was court painter in Darmstadt. A rococo painter, Seekatz executed portraits, such as the *Portrait of the Goethe Family* (Weimar, National Museum), and small genre scenes, such as the one in the Frankfurt Städel Art Institute.

BIBLIOGRAPHY. A. Feulner, *Skulptur und Malerei des 18. Jahrhunderts in Deutschland*, Potsdam, 1929.

SEEZ CATHEDRAL. Norman Gothic edifice in Séez, France, begun about 1270 and dedicated in 1322. It was the object of several restorations. Of special interest is the relationship of its *chevet* to those of Amiens and Beauvais. Its elevation inspired that of the *chevet* of St-Ouen at Rouen.

BIBLIOGRAPHY. R. de Lasteyrie du Saillart, *L'Architecture religieuse en France à l'époque gothique*, vol. 1, Paris, 1926.

SEGAL, GEORGE. American sculptor (1924–). Segal was born in New York City and attended New York University. He later studied at Rutgers University where he became associated with Allan Kaprow, Lucas Samaras, and other artists, and participated in the early staging of "happenings" (1959). It was then that Segal turned to sculpture from figural painting. In characteristic works he creates entire scenes, in which figures produced by taking plaster casts of living people are placed in desolate settings, such as gas stations, diners, and buses. The anonymous white figures, with their features smoothed over, are pictorially united by the physical and emotional consistency of enervation and isolation.

SEGALA, FRANCESCO. Italian sculptor and brass founder (d. ca. 1593). Segala was active chiefly in Padua, where he operated a brass foundry. In the 1570s he worked for the Hapsburgs in the Tyrol. Among his chief works are a bronze statue of St. Catherine (1564; Padua, S. Antonio); a figure of St. John the Baptist (1565) on a baptismal font (Venice, St. Mark's); and a wax model of a relief depicting Archduke Ferdinand of Tyrol.

BIBLIOGRAPHY. L. Planiscig, *Venezianische Bildhauer der Renaissance*, Vienna, 1921.

SEGALA, GIOVANNI. Italian painter (b. Murano, 1663; d. Venice, 1720). A student of Pietro Muttoni, Segala worked throughout northern Italy and in the churches of Venice. His solemn, sometimes awkwardly monumental figures are representative of the transitional period between baroque and rococo.

SEGALL, LASAR. German-Brazilian painter (b. Vilna, Lithuania, 1891; d. São Paulo, 1957). Segall attended the Berlin Academy (1906–09) and taught at Dresden. He developed an expressionist style, often depicting Jewish themes. In 1913 he visited Brazil and exhibited the first modern art seen there (São Paulo, Campinas). He participated in the expressionist movement in Dresden (1914–23) and settled in Brazil in 1923. Suffering emigrants were a main theme (for example, *Navire d'émigrants*, 1939–41; São Paulo, Museum of Art).

BIBLIOGRAPHY. P. M. Bardi, *Lasar Segall*, Milan, 1959.

SEGANTINI, GIOVANNI. Swiss painter (b. Arco, Italy, 1858; d. Pontresina, 1899). He studied in Milan. Segantini was known for rural and peasant subjects, somewhat in the spirit of Millet and Bastien-Lepage, and for his later Swiss mountain landscapes and religious-symbolic scenes. His early work was done in an individually developed divisionist style. In his symbolic paintings, he combined some of the brilliance and bright color of impressionist effects of light with a firmness of outline and drawing.

BIBLIOGRAPHY. F. Servaes, *Giovanni Segantini*, Vienna, 1902; G. Segantini, *Giovanni Segantini*, 5th ed., Munich, 1923.

SEGERS, HERCULES, see SEGHERS, HERCULES.

SEGESTA. Ancient city in northwestern Sicily, the site of a well-preserved Greek temple and theater. Founded by the Elymi, the city appears to have been thoroughly Hellenized by the 6th century B.C. Its Greek name was Egesta. The unfinished Doric temple is hexastyle and probably dates from between 425 and 415 B.C. Its cella was never built, and its columns are unfluted. Thirty-six columns and the trabeation still exist. The theater in its present form is early Roman (probably 1st cent. B.C.), but traces of an earlier Hellenistic theater have been found.

BIBLIOGRAPHY. R. Koldowey and O. Puchstein, *Die griechischen Tempel in Unteritalien und Sicilien*, Berlin, 1899; M. Bieber, *The History of the Greek and Roman Theatre*, 2d ed., Princeton, 1961.

SEGHERS, DANIEL. Flemish painter of flowers (b. Antwerp, 1590; d. there, 1661) He was a pupil of Jan Breughel I, became a master in 1611, and joined the Society of Jesus as a lay brother in 1614. After a sojourn in Italy, he returned to Antwerp, there to become a renowned painter of bouquets and flower garlands. Such well-known masters as Peter Paul Rubens, Cornelis Schut, Abraham van Diepenbeeck, Erasmus Quellinus, and Theodoor van Thulden did the insets for the garlands. An example is the *Portrait of St. Ignatius of Loyola* (the portrait is by Schut, the flowers by Seghers; Antwerp, Fine Arts Museum). Like the Caravaggists, Seghers preferred dark backgrounds, against which his excellently characterized flowers stand out. The leaves are for the most part hastily done and lack precision.

BIBLIOGRAPHY. W. Bernt, *Die niederländischen Maler des 17. Jahrhunderts . . .*, vol. 3, Munich, 1948; M. L. Hairs, *Les Peintres flamands de fleurs au 17e siècle*, Brussels, 1955.

SEGHERS, GERARDO, see ZEGERS, GEERAARD.

SEGHERS (Segers), HERCULES (Herkeles). Dutch painter and etcher (b. Haarlem, 1589/90; d. The Hague? 1633/38). Only a few facts are known concerning Seghers's life. In 1606 he was serving an apprenticeship with Gillis van Coninxloo in Amsterdam. He entered the Haarlem Guild of St. Luke in 1612, but by 1614 he had moved again to Amsterdam. By 1615 he had married, and four years later he purchased a large house in Amsterdam. Foreclosure was brought on the house in 1631. He is next heard of dealing in paintings, first in Utrecht in 1631, then in The

Hercules Seghers, *River in a Valley*. Rijksmuseum, Amsterdam.

Hague in 1633. There is no record of his activity after this date, but a notice in 1638 mentioning his widow (although she does not have the same name as his first wife) has been discovered. His death, therefore, occurred sometime between 1633 and 1638.

There are at least four signed paintings by Seghers, among them *River in a Valley* (Amsterdam, Rijksmuseum). None of the signed works or those that can be attributed to him on the basis of composition are dated, however.

Seghers's activity as an etcher is much better known. His etchings are unique in the art of his time. He often printed on linen or tinted paper and colored the prints by hand; identical impressions from one plate are almost never found. The subject matter of his etchings, like that of his paintings, is most often landscape. Seghers seems to have played a significant role in the development of Dutch romantic and realistic landscape painting. While there is evidence that Rembrandt was an admirer of both Seghers's etchings and his paintings (eight of which were known to have been in Rembrandt's collection), Rembrandt may have influenced the older artist in turn.

BIBLIOGRAPHY. J. Springer, *Die Radierungen des Herkules Seghers*, Berlin, 1910.

NORMAN W. CANEDY

SEGNA DI BONAVENTURA. Italian painter (fl. 1298–1331). One of Duccio's immediate pupils, Segna faithfully imitated his master's work during the early years of his activity, but later introduced certain modifications. He created new facial types and expressions, forms, gestures, and proportions. He was at his best when painting single figures. A signed panel of *Four Saints* (Siena, National Picture Gallery) indicates his types. His *Madonna* (Castiglion Fiorentino, Collegiata) bears comparison with that of Duccio's *Maestà*. His own *Maestà* (ca. 1316; Massa Marittima Cathedral) is his masterpiece.

BIBLIOGRAPHY. H. B. W., "An Altarpiece by Segna," *Metropolitan Museum of Art Bulletin*, XIX, August, 1924; G. H. Edgell, *A History of Sienese Painting*, New York, 1932.

SEGONZAC, ANDRE DUNOYER DE. French painter and engraver (1884–). Segonzac was a native of Boussy-Saint-Antoine. He showed such an early passion for drawing that in 1901 he was admitted to Luc-Olivier Merson's personal academy in Paris. Segonzac frequented the School of Oriental Languages and later met Boussingault and Luc-Albert Moreau. In 1905 he entered the Académie Julian, where he studied with Jean-Paul Laurens, and in 1906 he shared a studio with Boussingault. Two years later Segonzac discovered Saint-Tropez and in the same year sent two maritime landscapes, *Tartanes* and *Nu*, to the Salon d'Automne. His work was noticed in 1912 by Claude Roger-Marx, and in 1914 he had his first exhibition, which had only mild success.

After World War I he regularly submitted his work to

Segna di Bonaventura, *The Virgin and SS. Paul, John, and Bernard*. National Picture Gallery, Siena.

André Dunoyer de Segonzac, *Still Life with Bread and Wine*. National Museum of Modern Art, Paris.

the Salon des Indépendants and the Salon d'Automne. His early work (*Les Buveurs*, 1910) is a kind of homage to Cézanne's *Joueurs de cartes*, but already in *La Vénus de Médicis* (1913) he shows that geometry in space is not incompatible with the refined expression of a sensuality that is no less abstract. Segonzac's art developed toward maturity and revealed his sensitive and poetic realism rooted in the countryside (*La Maison blanche*, 1919; *Le Printemps*, 1920; *La Ferme dans les terres*, 1923). The forms are simply and boldly treated, and the warm colors reflect the painter's love of nature. Although he is not considered a Fauve, Segonzac may be classified as generally in that area.

In his water colors Segonzac, like Signac and Jongkind, willingly lets the drawing appear beneath the color, and in his etchings and drypoints he produced a number of superb prints that alone grant him a first-rank place in modern art. His forms are serious but never sad. The still lifes, portraits, nudes, and landscapes reveal great taste and sensitivity (*Fernande les mains croisées*, etching, 1925; *Le Pont de Couilly*, water color, 1925).

Segonzac has made designs for the stage and opera (Ballets Russes, *Danses d'Isadora Duncan*, 1912) and has executed portraits of many famous French writers and poets, including Jules Romains, Colette, Léon-Paul Fargue, and André Gide. His best-known illustrations are of Charles-Louis Philippe's *Bubu de Montparnasse*, Colette's

La Treille muscate, and Vergil's *Georgics*, considered by many to be his masterpiece. Segonzac is a member of the Royal Academy of Brussels. His realism and love of human form have influenced many painters who have turned to nature for inspiration.

BIBLIOGRAPHY. M. Gauthier, *Dunoyer de Segonzac*, Paris, 1949; C. Roger-Marx, *Dunoyer de Segonzac*, Geneva, 1951; B. Dorival, *Twentieth-Century French Painters*, 2 vols., New York, 1958.

ARNOLD ROSIN

SEGOVIA. City in Old Castile, central Spain, called Segobriga by the Romans. The major monument is the Roman aqueduct, although the city is primarily medieval in character. The walls date from the 12th century on. Additions were made to the Alcazar (11th–12th cent.) from the 14th to the 16th century and the whole was restored in the 19th century. There are a number of Romanesque churches, including S. Millán (1111–23), S. Martín, S. Esteban, and the Church of La Vera Cruz (ca. 1204–08), with its 12-sided nave modeled on the Church of the Holy Sepulchre in Jerusalem. *See* SEGOVIA, AQUEDUCT OF.

The principal Gothic structure, the latest in Spain, is the Cathedral, designed by Juan Gil de Hontañón (1525) and completed by his son Rodrigo. The cloisters (1472–91) by Juan Guas, were transferred from the site of the old 12th-century Cathedral (destroyed). Among the several monasteries of the city are the Convent of Sta Cruz (now the Hospicio), with buildings by Juan Guas (1480–92); the

Monastery of El Parral; and the Monastery of S. Antonio Real (rebuilt 1455).

BIBLIOGRAPHY. S. Alcolea Gil, *Segovia y su provincia*, Barcelona, 1958. EVANTHIA SAPORITI

SEGOVIA, AQUEDUCT OF. Most impressive Roman aqueduct in Spain. It conducted water from the Sierra Fuenfría for about 10 miles to the tower called El Camerón. The aqueduct was possibly constructed under Augustus and dates from about A.D. 10. Built of granite stonework, it is about 2,388 feet long, with two rows of arches, the lower story containing 44 and the upper story 190 arches. The upper arches are about one-third the size of the lower ones. The three interior central arches of the lower row are crowned by a lintel, giving the impression of a triumphal arch. The piers of the lower arches have slight projections at irregular intervals, which somewhat diminish the monumental effect of the aqueduct.

BIBLIOGRAPHY. *Ars Hispaniae*, vol. 2: *Arte romano, arte paleocristiano, arte visigodo, arte asturiano*, Madrid, 1947.

SEICENTO. Italian for "six hundred," used as a shortened designation for the 17th century. Like Quattrocento and other Italian designations for centuries, Seicento has been adopted in art history as a term encompassing the entire artistic and even cultural climate of Italy during that period.

BIBLIOGRAPHY. D. Mahon, *Studies in Seicento Art and Theory*, London, 1947.

SEKHMET. Bloodthirsty and lion-headed goddess of war in ancient Egypt. She is also identified with Mut, a local deity of Thebes. With her husband, Ptah, and her son Nefertem, she formed the triad of Memphis. Her attributes typify the destructive rays of the sun. A series of black basalt statues of Sekhmet was found in Amenhotep III's Temple of Mut at Karnak.

SELAMLIK. Men's quarters in a Turkish house, adjoining the owner's private apartment. Here guests were received. The women's quarters in the harem system were called the haremlik.

SELEY, JASON. American sculptor (1919–). Born in New Jersey, Seley studied architecture at Cornell University and sculpture with Zadkine at the Art Students League in New York City (1943–45). He traveled to Haiti in the late 1940s on a U.S. Department of State grant and to Europe in 1950 on a Fulbright fellowship. Seley's work is represented in many New York collections, including that of the Museum of Modern Art. He works chiefly in welded steel, creating abstract compositions utilizing automobile parts, as in *Baroque Portrait* (1961) and *The Boys from Avignon* (1963).

BIBLIOGRAPHY. D. C. Miller, ed., *Americans 1963*, Garden City, N.Y., 1963.

SELINUS (Selinunte). Archaeological site on the south coast of western Sicily. This Greek city, which was founded in the 7th century B.C., was the farthest western outpost of the Greeks against the Carthaginians and the Elymi; it was sacked by Carthage in 250 B.C. The site is noteworthy for the ensemble of temples. East of the city lie Temples E, F, and G; on the ancient acropolis are Temples A, B, C, D, and O. With the exception of the small Hellenistic Temple B, they all represent the archaic phase of Greek architecture. Some of the sculptures found at Selinus are displayed in the National Museum of Sicily in Palermo.

BIBLIOGRAPHY. M. Santangelo, *Selinunte*, Rome, 1953.

SELJUK, *see* SALJUK.

SELLAIO, JACOPO DEL. Italian painter of the Florentine school (1442–93). Jacopo was the son of Arcangelo del Sellaio, a saddler in Florence. According to Vasari he was a pupil of Fra Filippo Lippi. His style is difficult to define since he closely imitated his contemporaries Domenico Ghirlandajo, Filippino Lippi, and Botticelli.

A great number of pictures have been ascribed to Sellaio, though a dependable criterion for evaluating such attributions has not yet been established. Authenticated works are an *Annunciation* (ca. 1473; Florence, S. Lucia dei Magnoli), a *Pietà* (ca. 1483; formerly Berlin, State Museums, destroyed during World War II) from S. Frediano in Florence and a *Crucifixion Surrounded by Saints* (ca. 1490 or later) in S. Frediano. Many narrative panels from *cassoni*, such as the *Story of Acteon* (New Haven, Conn., Yale University Art Gallery), have been attributed to him. A painter of considerable quality, he is the most gifted and attractive eclectic master of the late Quattrocento in Florence.

BIBLIOGRAPHY. B. Berenson, *The Drawings of the Florentine Painters*, 2 vols., New York, 1903; H. Horne, "Jacopo del Sellaio," *The Burlington Magazine*, XIII, 1908; R. van Marle, *The Development of the Italian Schools of Painting*, vol. 12, The Hague, 1931.

Aqueduct of Segovia. A monumental Roman structure, built ca. A.D. 10.

SELVA, GIOVANNI ANTONIO. Italian architect (1751-1819). A pupil of Temanza, he traveled in Europe and England and was prominent in official architecture and at the local academy in Venice. He turned from traditional Venetian design to international European classicism, and is best known for his remodeling of the Teatro La Fenice (1786-92) in Venice and Canova's temple at Possagno (1819-20).

SEMINO (Semini), ANDREA (Semino il Vecchio). Italian historical, religious, and portrait painter (b. Genoa, ca. 1525; d. there, ca. 1595). The son and pupil of Antonio Semino, he worked alone and with his brother Ottavio for many churches and palaces in Genoa, Milan, and Savona. His works, done in the style of Raphael, were sufficiently effective to win out in a crucial competition over the Calvi brothers.

SEMPER, GOTTFRIED. German architect (1803-79). He worked mainly in Dresden, Zurich, and Vienna. Born in Hamburg, he studied in Göttingen, Munich, and Paris. His early work is eclectic, borrowing from the Renaissance and medieval periods. He was in London from 1851 until 1855, when he became professor at the Zurich Polytechnic School. He executed two buildings there, both stylistically *retardataire*. In 1871 he was called to advise on the Hofburg Palace extension in Vienna, where he also built the distinguished Burgtheater. Both buildings have a baroque character; the theater, especially, is related to Second Empire style. His later Museums of Art History and Natural History exhibit a more academic classicism. His clarity of organization and disposition of masses and his affinity with contemporary French styles illustrate his classical *école* training. *See* BURG THEATER, VIENNA.

BIBLIOGRAPHY. L. Ettlinger, *Gottfried Semper und die Antike*, Bleicherode am Harz, 1937.

SENECA INDIANS. One of the Five (later Six) Nations of the Iroquois confederation of the 16th to the 18th century. It is possible that their present location, the Northeast, was reached after migrations from the South through the Midwest. Although they are perhaps better known for numerous crafts, their strongest art form is the wooden grotesque mask, usually with distorted eyes and mouth and with actual hair from the manes or tails of horses.

See also NORTH AMERICAN INDIAN ART (EASTERN UNITED STATES AND CANADA).

BIBLIOGRAPHY. W. N. Fenton, *Masked Medicine Societies of the Iroquois* (Smithsonian Inst., Annual Report for 1940), Washington, D.C., 1940

SENEFELDER, ALOIS. Bavarian inventor of lithography (b. Prague, 1771; d. Munich, 1834). His father was a court actor in Munich. Although compelled to study law, Senefelder resolved to become a playwright and actor, having had a few minor experiences in both fields. But the impecunious author had difficulty in having his work printed, a problem that activated his inventive capabilities. His first experiments in printing involved writing on copper plates in reverse, a technique on which he spent considerable effort. Copper, however, was expensive, and his next trials involved the use of stone as a printing surface. By 1796 he had invented a gallows, or lever, press; an ink resistant to acid for writing on stone; and a method

Jacopo del Sellaio, *The Triumph of Chastity*, detail. Bandini Museum, Fiesole.

for inking the slightly raised letters obtained by etching away the stone around the resistant ink. It was not until 1798, after several thousand experiments, that he discovered the process of chemical printing, or, as it is now called, lithography.

The following years were filled with disappointment and tribulation in his attempts to establish patents that could have resulted in financial success. These difficult times were compensated for by his further success in refining his invention.

He first went into partnership with Franz Gleissner, court musician at Munich, and obtained the sole privilege of using his new printing process in Bavaria. He next joined with Joachim Anton André, music printer at Offenbach, whose considerable financial support was offered to establish similar franchises in Paris, London, Berlin, and Vienna. Senefelder's trip to London with André's brother, Philip, was not financially rewarding, but it did prepare the ground for the *Specimens of Polyautography* (1803) in which appears the earliest artist's lithography, by Benjamin West, dated 1801. The attempt to establish franchises elsewhere was equally unremunerative. In about 1817 Senefelder met Friedrich von Schlichtergroll, general secretary of the Royal Bavarian Academy of Sciences, who helped him the following year to publish the story of his vicissitudes along with a complete description of his lithographic invention, *Vollständiges Lehrbuch der Steindruckerey*. Later Senefelder was more successful in capitalizing on the commercial aspects of his invention. *See* LITHOGRAPHY.

BIBLIOGRAPHY. A. Senefelder, *The Invention of Lithography*, New York, 1911; C. Wagner, *Alois Senefelder, sein Leben und Wirken*, Leipzig, 1914; W. Weber, *A History of Lithography*, New York, 1966. KNEELAND MC NULTY

SENGBEST: DOMED MAUSOLEUM. Iranian mausoleum of the Saljuk period, located southeast of Meshed. Typical of the Persian domed buildings commemorating saints, it is a square building with thick walls and four doors. The

squat and heavy dome, with the adjoining minaret, dates from between 997 and 1028. The exterior is asymmetrical, with rounded corners that make it appear octagonal.

BIBLIOGRAPHY. A. U. Pope, ed., *A Survey of Persian Art*, vol. 2, New York, 1939.

SENJIRLI, *see* SINDJERLI.

SENLIS CATHEDRAL. French Gothic church begun in 1153. The choir was well under way by 1168. Still unfinished in 1191, the Cathedral was nevertheless dedicated, and the Archbishop of Reims urged those present to complete their church. In the middle of the 13th century the transepts and the elegant south spire were finished. After the disastrous fire of 1504 much of the church was rebuilt in the Flamboyant Gothic style. Additional chapels were added as late as the 19th century. The chapter house, with its vaults springing from a central column, and its capitals decorated with a band of madmen dancing to the music of an organ played by two canons, is especially interesting. The Cathedral was dedicated to the Virgin when her cult was just developing, as is attested by the sculptures of the west door.

BIBLIOGRAPHY. M. Aubert and S. Goubet, *Gothic Cathedrals of France and their Treasures*, London, New York, 1959.

SENS, WILLIAM DE, *see* CANTERBURY CATHEDRAL.

SENS: ARCHIEPISCOPAL PALACE. French palace (now a museum), built about 1240 by the archbishop Gauthier Cornu. It extends the south façade of the Cathedral. The west façade has six bays divided by heavy buttresses. The upper stage of each bay has two deep, pointed windows surmounted by a rose window. On the interior the lower floor is divided into two rib-vaulted naves, containing the law court and prison cells, with their interesting graffiti. A stone stair leads to the upper hall whose six quadripartite vaults have ribs that sweep almost to the floor without interruption.

SENS: SAINT-ETIENNE. Gothic cathedral (ca. 1125–75) in northern France. The archbishopric of Sens has been of great importance in the ecclesiastical history of France; the bishopric of Paris was dependent on it until 1627. St-Etienne represents one of the earliest and most distinctive

Hôtel de Sens, Paris. One of the city's oldest examples of domestic architecture.

monuments of the Gothic style. The broad nave is noteworthy for its unique twin columns. The transept was rebuilt by the architect Martin de Chambiges in the Flamboyant style (1490–1513). The portals of the west façade display sculpture from the 13th and 14th centuries, and the windows have stained glass of the 12th, 13th, and 16th centuries. The Chapel of the Ste-Colombe contains a monumental group (1777) by G. Coustou the Younger. In the Cathedral Treasury are old textiles of considerable interest.

BIBLIOGRAPHY. E. Chartraire, *The Cathedral of Sens*, Paris, 1926.

SENS, HOTEL DE, PARIS. French mansion, one of the oldest examples of domestic architecture in Paris. The Hôtel de Sens was built by Tristan de Salazar, archbishop of Sens, between 1474 and 1519. For many years it served the episcopate, often housing royalty. Under Henry IV it became the residence of Marguerite de Valois. It was neglected after the Revolution but has been restored.

SENUFO, *see* AFRICA, PRIMITIVE ART OF (WEST AFRICA: IVORY COAST).

SEO, LA, SARAGOSSA. Five-part brick Gothic cathedral in Spain. Parts of the Romanesque structure (12th cent.) that replaced the original mosque can be seen in the present church, begun in 1316–18. It displays Mudejar details that are seen also in the stellar vaulted crossing lantern rebuilt in 1501. The present complex rib vaults were completed in 1490, except for those of the two western bays added in 1556–59. There are many fine Renaissance tombs and a rich treasury. *See* MUDEJAR ART.

BIBLIOGRAPHY. A. Gascón de Gotor, *La Seo de Zaragoza*, Barcelona, 1939.

SEO DE URGEL: CATHEDRAL. Spanish church in the First Romanesque style. It was begun in 1175, according to a celebrated contract between the Bishop and canons of Urgel and the architect known as Raymond the Lombard, who combined technical direction of the construction with administration of finances. Raymond carried out the work over a period of seven years in collaboration with four other Lombards. The First Romanesque style of the Cathedral illustrates the diffusion of northern Italian influence. It is especially evident on the exterior of the *chevet*, where an arched and colonnaded gallery encircles the upper part of the apse, as in the Cathedrals of Modena, Pavia, and Bergamo.

The cloister shows links with the Roussillon school of Romanesque sculpture. Three sides of the original arcade remain; the eastern columns were replaced in the 17th century with eight unornamented pillars. The altar frontal of the Cathedral (Barcelona, Museum of Catalonian Art) was the product of a workshop strongly influenced by the unknown fresco painter of the Church of S. Miguel, which stands at the edge of the cloister.

BIBLIOGRAPHY. M. Durliat, *L'Art roman en Espagne*, Paris, 1962.

SEO DE URGEL: SAN MIGUEL (San Pedro). Small Catalan Romanesque church at the southeastern corner of the cloister of the Cathedral of Seo de Urgel, Spain. It has been called a work of either the 9th or the 11th century. Its plan is a Latin cross with a single nave and three apses. "Lombard" bands and blind corbel arches decorate the exterior, as is characteristic of the First Romanesque style.

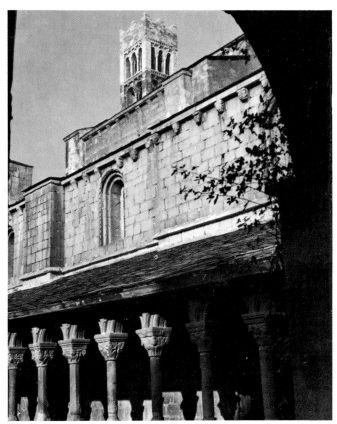

Seo de Urgel, S. Miguel. Cloister of this Catalan Romanesque church.

Frescoes from this church (Barcelona, Museum of Catalonian Art) show Christ in Majesty with symbols of the Evangelists, surmounting a register of figures of the Virgin, St. John, St. Peter, and St. Andrew. The frescoes reveal a strong artistic personality whose influence is also felt in the altar frontal from the Cathedral of Seo de Urgel (Museum of Catalonian Art) and in the work of other artists who decorated churches in the surrounding countryside, in Andorra, and in Sardinia.

BIBLIOGRAPHY. V. Lampérez y Romea, *Historia de la arquitectura cristiana española en la edad media . . .*, 2d ed., vol. 2, Madrid, 1930.

SEOUL: MUSEUMS. Important public art collections in Seoul, Korea, are located in the museums listed below.

National Museum of Korea. It was opened in 1915 as the Government General Museum of Korea on the grounds of the Kyongbok Palace. After the Korean War the museum was transferred to a new building on the grounds of the Toksu Palace. It is primarily an archaeological and historical museum, containing materials collected largely by Japanese scholars during the archaeological survey of the country. There are also outstanding collections of gold objects, early stoneware and tiles, gilded-bronze statues (for example, a 6th- or 7th-cent. Maitreya), ceramics, and paintings of the Yi period (1392–1910). The National Museum of Korea has three branch museums in South Korea: Kyongju Branch Museum, Puyo Branch Museum, and Kongju Branch Museum. The Kaesung Branch Museum is now in North Korea. *See* MAITREYA OF NATIONAL MUSEUM, SEOUL.

BIBLIOGRAPHY. Korean National Museum, *Guide Book*, Seoul, 1964.

Toksu Palace Museum of Fine Arts. Originally known as the Yi Household Art Gallery, the museum is housed in a Western-style building on the grounds of the Toksu Palace. There are important collections of gilded-bronze statues (such as a 7th-cent. Maitreya), ceramics (both stoneware and celadon), and paintings of the Yi period (1392–1910). *See* MAITREYA OF TOKSU PALACE, SEOUL.

BIBLIOGRAPHY. M. Komiya, *Prince Yi Household Museum, Catalogue of the Collections*, 3 vols., Seoul, 1912.

SEPESHY, ZOLTAN. Hungarian-American painter (1898–). Born in Kassa, Sepeshy studied in Budapest, Paris, Prague, and Venice, and went to the United States in 1920. He paints landscapes, figures, and urban genre in an original tempera technique. His recent works have been semiabstractions.

SEPIA DRAWING. Type of pen or brush drawing done with a reddish-brown pigment originally derived from the ink sac of the cuttlefish. Sepia drawing was particularly popular during the 19th century; Delacroix was a master of the technique.

SEPIK RIVER. Area of northern New Guinea in Melanesia; one of the richest centers of world primitive art. The men's polychromed spirit house of lashed pole and thatched fiber construction, sponsored by such cults as the Tambaran of the Maprik and Middle Sepik districts, symbolized the perpetuation of religious tradition and tribal stability. A profusion of masks, *korwar* (*korovar*), or ancestor figures, and functional objects, usually polychromed in curvilinear designs, form a singularly powerful contribution to South Seas art. The primary medium is wood.

See also MELANESIA; OCEANIC ART (MELANESIA: NEW GUINEA); NEW GUINEA.

BIBLIOGRAPHY. O. Reche, *Der Kaiserin-Augusta-Fluss* (Ergebnisse

Sepik River. Crocodile-head canoe prow from northern New Guinea in Melanesia. Wood.

der Südsee-Expedition, 1908–1910, hrsg. von ... G. Thilenius, II. Ethnographie: A. Melanesien, vol. 1), Hamburg, 1913; J. G. K. Söderström, *Die Figurstühle vom Sepic-Fluss auf Neu-Guinea* ([Stockholm] Statens etnografiska museum, Smärre Meddelanden, no. 18), 1941.

SEPTASTYLE, *see* HEPTASTYLE.

SEPTIMIUS SEVERUS, ARCH OF, ROME. Triumphal arch erected in the Roman Forum in A.D. 203 to celebrate the Emperor's Parthian victories and the ten-year anniversary of his reign. It consists of a central and two side arches flanked by detached columns of the Composite order; the columns rest on pedestals decorated with reliefs. An entablature separates the arches from the attic, which has a long inscription on the two main sides. The arch is decorated with bas-reliefs depicting war episodes. Bird's-eye perspective is used for the relief panels, which are divided by irregular horizontal lines. The style of these reliefs is opposed to the classical conventions of traditional Roman state art. The sculptural composition shows great similarities to the style of the reliefs on the Column of Marcus Aurelius.

BIBLIOGRAPHY. W. J. Anderson, R. P. Spiers, and T. Ashby, *The Architecture of Greece and Rome*, vol. 2: *The Architecture of Ancient Rome*, London, 1927; D. E. Strong, *Roman Imperial Sculpture*, London, 1961.

SEPTIMIUS SEVERUS, PALACE OF, ROME. Ruined imperial Roman palace on the Palatine hill, raised on an impressive superstructure. Its façade may have been the Septizodium, a monumental structure of three colonnaded stories dedicated A.D. 203. In the 16th century, only three stories of the eastern corner of the façade still stood; it was torn down in 1588/89.

SEPTIZODIUM (Septizonium), ROME, *see* SEPTIMIUS SEVERUS, PALACE OF, ROME.

SEPTUAGINT. Most important Greek version of the Hebrew Old Testament, produced in the 3d or 2d century B.C. Several books not in the Old Testament were added to the Septuagint. The most important of these is the so-called Old Testament Apocrypha, from which some later Christian iconography was drawn, for example, the story of Tobias. One of the outstanding Greek manuscripts of the Septuagint is the 4th-century Codex Vaticanus (Rome, Vatican Libraries).

BIBLIOGRAPHY. F. G. Kenyon, *The Text of the Greek Bible*, London, 1937.

SEPULCHRAL MONUMENT. General term for any tomb monument, although it usually connotes a large monument, often in the form of a tabernacle or mausoleum. The most elaborate sepulchral monument is the church built by Constantine over the site of the Holy Sepulchre in Jerusalem.

SEQUEIRA, DOMINGOS ANTONIO DE. Portuguese painter (b. Lisbon, 1768; d. Rome, 1837). Sequeira studied at the Royal Academy of Design in Lisbon, winning a scholarship to Rome in 1788. He returned to Lisbon in 1795, tried unsuccessfully to found his own academy, and was made First Court Painter (1802) and director of the Oporto Academy (1805). His style during this period is sculptural and neoclassical in such works as *The Foundation of the Casa Pia by Pina Manique* (1792–94; Lisbon,

Séraphine, *Paradise Tree*, 1928. National Museum of Modern Art, Paris.

National Museum of Antiquities). After 1803 his work developed in a romantic vein, with an emphasis on subtly harmonized colors, delicate effects of light, and momentary poses. His portraits seem spontaneous revelations of character. The constitutional struggle became the subject for many allegories during this period. Like Goya, he was forced to flee his country in 1824 because of his liberal sympathies. Competing against Delacroix, Géricault, and others, he won a prize at the Paris Salon of 1824 with *The Last Days of Camões*. From 1826 he lived in Rome, where he painted mostly religious works in which light plays a transfiguring role.

BIBLIOGRAPHY. R. dos Santos, *Sequeira y Goya*, Madrid, 1929.

SERAFINO SERAFINI. Italian painter (1320/25–after 1384). A native of Modena, he worked there and in Ferrara. Serafino's only known work is a polyptych with the *Coronation of the Virgin* in Modena Cathedral (1384), which combines the traditional Venetian composition for this theme with the graceful linearity characteristic of Bolognese painting.

SERAPEUM. In Egyptian, Greek, and Roman antiquity, a sanctuary sacred to Serapis, who was associated with the myth of the Apis bulls and part of a triad with Isis and Harpocrates. The cult of Serapis grew with Greco-Egyptian religion and spread through the Roman world, dying out in Christian times. The most famous Serapea were in Memphis and Alexandria.

See also SAQQARA.

SERAPHIM. Member of the highest of the nine orders of angels. Isaiah saw these six-winged angels hovering above the throne of Jehovah in the vision he describes in the Old Testament (Isa. 6:2–7).

SERAPHINE (Seraphine Louis). French painter (b. Assy, 1864; d. Clermont, 1942). Completely untutored in artistic styles and techniques, Séraphine began to paint, at the age of forty, the products of her obsessive imagination and the visions seen in trancelike states. She was discovered by Wilhelm Uhde about 1911, and was thus ensured an audience and the means to paint the large pictures she desired. Her works, usually organized around a tree trunk, are overall compositions of fruit, flowers, and leaves that are strongly reminiscent of tapestries, for example, *Paradise Tree* (1928; Paris, National Museum of Modern Art).

BIBLIOGRAPHY. W. Uhde, *Five Primitive Masters*, New York, 1949.

SERBIAN PAINTING. The great period of painting in Serbia, which covers most of the southern half of present-day Yugoslavia, dates from the time of independence from the Byzantine Empire in 1217 to the early 15th century, when the Ottoman Turks virtually controlled the country. A large number of churches were constructed under the independent Serbian kings; they were covered with complex cycles of wall paintings that derived from the Byzantine tradition but developed in a distinctive direction. From the beginning, in the paintings in the Church of the Virgin at the monastery of Studenica (ca. 1220), the style is less rigid and austere than in Byzantine painting, with greater emphasis on naturalism in form, color, and expression and more fluid composition. This fluidity is particularly evident in the paintings in the Church of the Trinity at the monastery of Sopoćani, Yugoslavia (ca. 1265). In those works a forceful rhythmic flow is created by the complex patterns of billowing draperies.

Serdab. **Plan showing the serdabs of the Mastaba tomb of Ti at Saqqara.**

The period of greatest activity occurred during the reign of King Milutin, when such churches as St. Mary Peribleptos in Ohrid, Macedonia (1295), the Church of Bogorodica Ljeviška in Prizren (1307–09), and churches at the monasteries of Studenica (1314), Gračanica (ca. 1321), and Dečani (1327) were built. During this time artists began to sign their work; they seem to have been Slavs, whereas the earlier artists were often Greeks. There are many stylistic variations; some of the artists, such as those at Gračanica, handle form, texture, and color with great richness. In another vein, the paintings at the Macedonian churches of Lesnovo (1341) and the Marko Monastery, Skoplje (1349), tend toward caricature and compositional simplicity. During the last period of Turkish encroachment and until Ottoman domination, the paintings in such churches as those of the monasteries of Ravanica (1377), Ljubostinja (end of 14th cent.), and Manasija (1407–18) become more subtle, delicate, and elegant in every respect. *See* GRACANICA, MONASTERY OF.

BIBLIOGRAPHY. V. R. Petković, *La Peinture serbe du moyen âge*, 2 vols., Belgrade, 1930–34; S. Radojčić, *The Icons of Serbia and Macedonia*, Belgrade, 1961.

DONALD GODDARD

SERDAB. Egyptian architectural term meaning "cellar." It was a small chamber included in the aboveground structure of an ancient Egyptian mastaba tomb for the housing of portrait statues of the deceased and members of his family. This sealed area was inaccessible to visitors but could be reached from the offerings chamber by means of a small slit. It was believed that the spirit of the deceased, or *ka*, could thereby look out in order to enjoy the offerings of food, incense, and prayers.

BIBLIOGRAPHY. W. Hayes, *The Sceptre of Egypt*, pt. 1, New York, 1953.

SERGEL, JOHAN TOBIAS. Swedish sculptor (1740–1814). Sergel lived in Italy from 1767 to 1778, when he was recalled to Sweden as court sculptor. In all his work, including such historic monuments as that of Gustav III (in front of the Royal Palace in Stockholm), portraits, classic compositions, and several hundred lively drawings, neoclassic clarity and baroque vitality are combined in a warm and personal style.

BIBLIOGRAPHY. G. Göthe, *Johan Tobias Sergels skulpturverk*, Stockholm, 1921; O. Antonsson, *Sergels ungdom och romtid*, Stockholm, 1942; R. Josephson, *Sergels Fantasi*, 2 vols., Stockholm, 1957.

SERIGRAPH, *see* SILK SCREEN.

SERLIO, SEBASTIANO. Italian architect and painter (1475–1554). Born and trained in Bologna, he went to Rome about 1514 and became a pupil of Baldassare Peruzzi, who bequeathed his plans and drawings to Serlio. After the sack of Rome in 1527 he left for Venice, where he remained until 1540. Then he went to France, first as a consultant on the building of the château at Fontainebleau. He also built a house for the Cardinal of Ferrara there (destroyed) and designed a château at Ancy-le-Franc near Tonnerre (begun in 1546), neither of which was important or influential. His original design for Ancy-le-Franc called for a massive central block framed by taller pavilions, with a rusticated ground story and rhythmic alternation of forms.

Changes were made, mostly by Serlio, to make this Italian model conform to French taste: pilasters were applied throughout to create a more delicate and bland effect, and a high-pitched roof was added.

Serlio had an enormous influence, however, as the author of *L'Architettura* (published in six parts, 1537–51; augmented 1575). It was the first book that was not chiefly theoretical but practical in dealing with architecture. It codified the five classical orders, spread the style of Bramante throughout Europe, and contained a repertory of motifs and designs that were profusely imitated by French mannerist architects.

BIBLIOGRAPHY. A. Blunt, *Art and Architecture in France, 1500–1700*, Baltimore, 1954.

SERMONETA, GIROLAMO DA, *see* SICIOLANTE, GIROLAMO.

SERNIN (Saturnin; Saturninus) OF TOULOUSE, ST. First bishop of Toulouse (3d cent.). Sernin preached in Pamplona, Spain. Pope St. Fabian sent him to Toulouse (ca. 245). About 257, pagans there attached his feet to a wild bull, and he was dragged to death. Apocryphal tradition has him as the son of King Aegeus of Achaia, a disciple of St. John the Baptist, and a follower of St. Peter. Sernin's attribute is a wild bull. His feast is November 29.

See also SAINTS IN ART.

SERODINE, GIOVANNI. Italian history painter (b. Ascona, ca. 1594; d. Rome, 1631). Possibly formed in Milan in the circle of Cerano, Morazzone, and Procaccini, Serodine soon assimilated the art of Caravaggio and his followers in Rome (before 1615?); most influential were Terbrugghen and Orazio Borgianni. In 1619 he painted two altarpieces for S. Lorenzo fuori le Mura, Rome, and in 1622 the famous portrait of his father (1628; Lugano, Municipal Museum), executed with remarkable freedom. Later he decorated many churches, including S. Pietro in Montorio and S. Salvatore in Lauro, both in Rome. Serodine may be singled out as the greatest colorist among the leading Caravaggisti.

BIBLIOGRAPHY. W. Schoenenberger, *Giovanni Serodine, Pittore di Ascona*, Basel, 1957.

SEROUX D'AGINCOURT, JEAN. French archaeologist (b. Beauvais, 1730; d. Rome, 1814). In his youth a cavalry officer, he spent the latter part of his life in Rome studying the remains of Christian antiquity. Part of his great work, *Histoire de l'art par les monuments depuis sa décadence au quatrième siècle jusqu'à son renouvellement aù seizième*, was published posthumously (6 vols., Paris, 1823; English ed. by O. Jones, London, 1847). He strove to imitate in Christian art history Winckelmann's work in ancient art. He lacked, however, the acumen of the great German scholar.

SEROV, VALENTIN A. Russian painter (1865–1911). Serov portrayed fashionable men and women. About 1900 he depicted the Princess Yusupova prettified in her finery within a lavish interior. He was a facile but not a penetrating portraitist. *The Girl with Peaches* (1887) is one of his best-known works. He also painted some landscapes.

BIBLIOGRAPHY. G. H. Hamilton, *The Art and Architecture of Russia*, Baltimore, 1954.

SERPA, IVAN. Brazilian abstract painter (1923–). Serpa studied privately in his native Rio de Janeiro. He has exhibited in the Salão Nacional (1947), in Rio de Janeiro's Museum of Modern Art (1961), in all the São Paulo Bienal shows since 1951, and in the Pan American Union in Washington, D.C. (1954), among other places. He is a leader of the informalist wing of Brazilian abstract art.

BIBLIOGRAPHY. L. de Almeida Cunha, *Brasil* (Art in Latin America Today, vol. 1), Washington, D.C., 1960.

SERPOTTA FAMILY. Italian stucco sculptors (fl. Palermo, 17th–18th cent.). Giacomo Serpotta (b. Palermo, 1656; d. there, 1732) probably went to Rome, and it is thought that he was also influenced by antique statuary. His greatest works were done for churches, cloisters, and oratories in Palermo: the Oratories of the Rosary of S. Zita (1714–17), of S. Lorenzo (1707), and of S. Domenico and the Church of S. Agostino (1711–13 and 1726–28). The National Gallery of Sicily in Palermo has some works by Giacomo in its collections.

His brother Giuseppe (b. Palermo, 1653; d. there, 1719) and Giacomo's son Procopio (b. Palermo, 1679; d. Caccamo, 1755) were also stuccoists. The Serpottas are among the most significant stuccoworkers of their era, especially for the region in which they worked.

SERRA FAMILY. Spanish painters: Jaime (fl. ca. 1361–95) and his brother Pedro (1343?–after 1405). They were the leading Catalan painters of the second half of the 14th century. In Barcelona Jaime directed the studio at which both Pedro (1363–70) and Juan, their younger brother, worked. Jaime's only authenticated work is the retable for the tomb of Fray Martín de Alpartil, eight panels of which are now in the Provincial Museum of Fine Arts, Saragossa. Pedro first worked independently in 1368 and created his major work, the *Retable of the Holy Spirit* in

Serpotta family. Giacomo Serpotta, stucco putti, 1707. Oratory of S. Lorenzo, Palermo.

Manresa Cathedral, in 1393–94; Borrassà probably completed the predella for it. Like Ferrer Bassa, the brothers were influenced by Sienese painting, probably owing in part to the proximity of the papal court in Avignon. The late Gothic tendency toward abstraction is evident in Jaime's use of over-all patterns of sweeping lines. Linearity characterizes Pedro's art as well, although his figure style and compact spatial and compositional structures are more advanced. Nothing is known of the work of Juan.

BIBLIOGRAPHY. J. Gudiol i Ricart, *El retablo del "Sant Esperit" de la seo de Manresa*, Manresa, 1954.

SERT, JOSE LUIS. Spanish-American architect, planner, writer, and educator (1902–). Born in Barcelona, Sert was educated there at the School of Architecture. He worked in Paris for Le Corbusier and Jeanneret (1929–30), and was in private practice in Barcelona until 1937. He went to the United States in 1939 (naturalized 1951). Sert was professor of city planning at Yale (1944–45) and, since 1953, has been professor of architecture and dean of the Graduate School of Design at Harvard University.

Among Sert's architectural works are the apartment houses in Barcelona (1931), the housing group for the government of Catalonia (1933–36), and the Spanish Pavilion at the International Exposition, Paris (1937). He also designed master plans for several Latin American cities, the United States Embassy in Baghdad, Iraq (1955–60), the Married Students Dormitories at Harvard University, Cambridge, Mass. (1962–64), and the Charles River Campus of Boston University (1960–65).

Sert has published *Can Our Cities Survive?* (London, 1942; 3d ed., 1947) and (with J. Tyrwhitt and E. N. Rogers) *The Heart of the City* (London, 1952).

BIBLIOGRAPHY. K. Bastlund, *José Luis Sert*, Zurich, 1967.

THEODORE M. BROWN

SERT Y BADIA, JOSE MARIA. Spanish painter (b. Barcelona, 1874; d. Paris, 1945). José Maria Sert y Badia painted many large mural decorations in oil on canvas. His most important work is perhaps the ensemble in the Cathedral of Vich. In Barcelona he carried out important commissions for the Palace of Justice and the Palace of the Marqués de Alella. As his fame spread, he executed decorations for large rooms in Buenos Aires, Geneva (Assembly of the League of Nations), London, New York (RCA Building in Rockefeller Center), and San Sebastián.

BIBLIOGRAPHY. A. Dezarrois, "Artistes contemporains: José Maria Sert," *La Revue de l'Art*, L, 1926; A. del Castillo, *José Maria Sert, su vida y su obra*, Barcelona, Buenos Aires, 1947.

SERUSIER, PAUL. French postimpressionist painter (b. Paris, 1864; d. Morlaix, 1927). He forsook philosophy for art, and studied at the Académie Julian in 1886. His training was academic. He met Gauguin at Pont-Aven in 1888 and painted a picture in the manner of Gauguin that he showed to his fellow students in Paris: Bonnard, Vuillard, Denis, Roussel, and Ranson. A year later this group founded the Nabis, or "prophets."

Sérusier stayed at Le Pouldu in Brittany with Gauguin in 1889–90. He met Jean Verkade in 1891 and became interested in theosophy. In 1895 he traveled to Italy with Denis and saw Sienese art, Fra Angelico, and Giotto. He was influenced by religious symbolism in 1897 and again

Giovanni Niccolò Servandoni, façade of St-Sulpice, Paris, 1733–49.

later, after a visit with Verkade, then a monk, and Father Desiderius Lenz, founder of the Beuron school of religious art. In 1908 Sérusier taught at the Académie Ranson at the same time as Denis and had La Fresnaye and Georg as students.

Like Gauguin and other practitioners of *cloisonnisme*, Sérusier bound his forms with sharply defined contours and favored areas of unmodulated, bright color. His compositions, which feature contemplative, idealized Brittany peasants and, in his late works, a kind of mystical symbolism, are often weak in design and lack conviction.

BIBLIOGRAPHY. M. Denis, *Sérusier, sa vie, son oeuvre*, Paris, 1943.

ROBERT REIFF

SERVAES, ALBERT. Belgian painter (1883–). Born in Ghent, he studied at the academy there before moving to Laethem-Saint-Martin in 1904. Although he has painted landscapes and portraits, Servaes's principal works have been scenes of peasant life and religious subjects from the New Testament, painted, since about 1910, in an expressionistic style, for example, *Pietà* (1920; Brussels, Museum of Modern Art).

SERVANDONI, GIOVANNI NICCOLO. Italian-French architect, decorator, and painter (b. Florence, 1695; d. Paris, 1766). A pupil of Pannini in painting and J. J. Rossi

in architecture, Servandoni went to Paris in 1726, where he worked first as a stage designer. His architecture, such as the façade of St-Sulpice in Paris (1733–49), has a sobriety not found in his decoration, which was influenced by the Bibienas.

BIBLIOGRAPHY. L. Hautecoeur, *Histoire de l'architecture classique en France*, vol. 3, Paris, 1950.

SERVRANCKX, VICTOR. Belgian painter and sculptor (1897–). Born in Dieghem, he studied at the Brussels Academy from 1912 to 1917. A pioneer Belgian abstractionist, he was at first loosely allied to constructivism and later to surrealism. His recent works are in a more geometric and simplified abstract style.

SESOSTRIS I, STATION CHAPEL OF, KARNAK. Egyptian chapel recovered from within the foundations of the third pylon of the Temple of Amun and restored by H. Chevrier. It is a peripteral chapel of white limestone with twelve piers and intercolumnar walls along the edges of a square podium. Ramps ascend axially to the front and back. In the middle, surrounded by four piers, was a stand for a sacred bark or a throne for the jubilee festival of the Pharaoh. The style of the low relief in fine limestone, representing Sesostris and several gods, is remarkable for its refined draftsmanship and sensitive carving. The scenes giving the names of the territorial divisions (nomes) of Upper Egypt are exceedingly important for the study of geography.

BIBLIOGRAPHY. P. Lacau and H. Chevrier, *Une Chapelle de Sésostris Ier à Karnak*, Cairo, 1956.

SESSA AURUNCA CATHEDRAL. Fine Romanesque cathedral of a small town in southern Italy. It dates from the 12th century. Noteworthy are the ornate reliefs of the façade, the 13th-century pulpit incrusted with mosaics, and the Easter candlestick in the same technique.

SESSHU TOYO. Japanese painter (1420–1506). Sesshū's early life is not well known and is sometimes identified with that of another painter whose name, although written in different characters, is pronounced the same. As a youth, he went to live in the Shōkokuji in Kyoto, and it is believed that he was trained there by Shūbun. From 1467 to 1469 he traveled in Ming China, where he studied Chinese painting and decorated the walls of a palace building in Peking. On his return to Japan he went to Yamaguchi and built a studio under the patronage of Lord Ouchi, for whom he painted many pictures. He broke away from the influence of the Zen priests and the Zen theory of painting, and established an independent landscape painting, perfecting the tradition started by Josetsu, and continued by Shūbun. *See* JOSETSU; SHUBUN.

BIBLIOGRAPHY. J. E. H. C. Covell, *Under the Seal of Sesshū*, New York, 1941; T. Akiyama, *Japanese Painting*, [Geneva?], 1961.

SESSON (Shukei Sesson). Japanese painter (1504–after 1589). Sesson was born and lived in northern Japan. He was a self-taught artist but claimed to be the spiritual and artistic successor of Sesshū. Rough, nervous brushstrokes used against a bold ink splash create a sharp contrast of value and an intensity of expression. *See* SESSHU TOYO.

BIBLIOGRAPHY. T. Akiyama, *Japanese Painting*, [Geneva?], 1961.

Sesson, *Wind and Waves*. Ink and light color on paper. Nomura Collection, Kyoto.

Georges Seurat, *Le Cirque*, 1891. Louvre, Paris. An example of this artist's pointillist technique.

SESTO, CESARE DA. Italian painter (b. Sesto Calende, 1477; d. Milan, 1523). He was active in Rome, southern Italy, and Milan. Suggestions from the work of Peruzzi, Raphael, and Leonardo played a considerable role in his development. Of Leonardo's followers, Sesto shows perhaps the most intelligent understanding of that master's stylistic principles in painting.

SETO, *see* Japan: Ceramics.

SETTIGNANO, DA, *see* Desiderio da Settignano.

SETUBAL: JESUS CHURCH. Portuguese church built between 1492 and 1498 at the order of Justa Rodrigues Pereira, the nurse of Manuel I, on the designs of the architect Diogo Boytac. It is one of the most imaginative examples of the Portuguese late Gothic style known as Manueline, particularly in its twisted nave supports.

BIBLIOGRAPHY. R. dos Santos, *O estilo manuelino*, Lisbon, 1952.

SEURAT, GEORGES. French postimpressionist painter (b. Paris, 1859; d. there, 1891). He copied plaster casts at a Paris municipal school until he was eighteen and then entered the Ecole des Beaux-Arts. For two years he stud-

ied with Ingres's pupil Henri Lehmann. Independent of mind, Seurat was attracted to the art of Monet and Pissarro and read the works of Delacroix and the Goncourt brothers. He was especially fascinated by the scientific treatises of Charles Blanc, Michel Eugène Chevreul, Hermann von Helmholtz, and others who sought to bring order to conceptions of color. Seurat formulated his own theory of expression and applied it first to *Une Baignade, Asnières* (1883–84; London, Tate), which he exhibited in the first Salon des Indépendants. For the next two years he was occupied in painting his masterpiece, *A Sunday Afternoon on the Island of La Grand Jatte* (Chicago Art Institute). This picture was shown in 1886 at the eighth and last impressionist exhibition.

Seurat developed pointillism, a system of painting by applying color in dots of relatively uniform size. In 1884 he met Signac and Cross, and, in 1885, Pissarro, all of whom adopted a pointillist manner. In 1887 Seurat spent the summer at Le Havre and Honfleur, where he painted several port scenes. He did fifteen in all before his death. In 1887 he exhibited in Brussels along with Pissarro, Morisot, and Sickert. This show was sponsored by the avant-garde group Les Vingt. In 1890 he attended the celebrated symbolist banquet at Gravelines, which was presided over by Mallarmé.

Little is known of Seurat's private life. He kept largely to himself and worked incessantly. In a portrait of his mistress, Madeleine Knobloch, called *La Poudreuse* (*Young Woman Powdering Herself*, 1889–90; London, National Gallery), X-rays have revealed that his own portrait is concealed under a flower piece.

The synthetic, often austere, character of much of Seurat's art resulted from his reaction to impressionism. He wanted to retain its vitality, subject matter, use of broken color, and luminosity; but he sought a monumentality, an architectonic precision, and an art of harmony through geometrizing form and studied control of color and composition. *See* NEOIMPRESSIONISM; POINTILLISM.

BIBLIOGRAPHY. J. Rewald, *Georges Seurat*, New York, 1946.

ROBERT REIFF

SE VELHA, COIMBRA, *see* COIMBRA: OLD CATHEDRAL.

SEVEN AND FIVE SOCIETY. Loose society of English artists (originally seven painters and five sculptors) formed in 1919 in London to promote impressionism in England. With the election of many members and under the influence of Nicholson (elected in 1924) the group became more oriented toward nonrepresentational art. Members included Hitchens, P. J. Jowett, David Jones, Hepworth, and Moore. They last exhibited as a group in 1935 or 1936. *See* HEPWORTH, BARBARA; HITCHENS, IVON; JONES, DAVID; MOORE, HENRY; NICHOLSON, BEN.

BIBLIOGRAPHY. J. Rothenstein, *Modern English Painters: Lewis to Moore*, London, 1956.

SEVERINI, GINO. Italian painter (1883–1966). Born in Cortona, he lived chiefly in Paris after 1906. Severini was instrumental in formulating the Italian futurist movement, although he remained in Paris during its advent and development. He was responsible for the first publication of

Gino Severini, *Pas de Danse*. Musée du Petit Palais, Paris.

Marinetti's general futurist manifesto of 1909 in the Parisian journal *Le Figaro*.

Severini studied with Balla in Rome (1900–01), where he met Boccioni; both were influenced by Balla's Italian divisionism, or neoimpressionism. Severini went to Paris in 1906, where he met Braque and the writer Max Jacob. Severini's first characteristic works date from early 1910, concurrently with his signing of the "Technical Manifesto of Futurist Painting." He was especially productive during 1912, the year of the initial Parisian showing of futurist works (Galerie Bernheim-Jeune) and the spread of the movement to London, Berlin, and elsewhere. The cubist influence upon his work, which had been evident in lesser degree from 1910, became more firmly assimilated from 1915 and lasted until about 1921, the year of publication of his *Du Cubisme au classicisme*. During the 1920s Severini sought an individual neoclassical idiom, invoking elaborate mathematical analyses of figural proportions. He made many decorative panels and mosaics for private homes and churches during the late 1920s and 1930s. He won a Rome Quadriennale prize in 1935 and first award at the Venice Biennale in 1950.

Like most futurists, Severini paid verbal homage to the machine, but in fact more often than not he used the human figure as the source of image and rhythm. His 1912 works on the Bal Tabarin dancer theme (such as the characteristic version in the Museum of Modern Art, New York) are cases in point. These are, moreover, relevant to the concern of certain cubists, especially Duchamp, Picabia, and Léger, with simultaneous or sequential mobility of similar subjects. *The Armored Train* (1915; New York, private collection) is one of the relatively few works by Severini in which the futurist glorification of war and the machine is made obvious. His *Harlequin* series of the 1920s totally abandoned the futurist style.

Severini was important in the founding of the theory as well as the practice of futurist style, working with Boccioni on the cogent principles: by introducing his fellow nationals to French artists, he was instrumental in the acceptance of futurism outside Italy.

BIBLIOGRAPHY. G. Severini, *Du Cubisme au classicisme*, Paris, 1921; G. Severini, *Gino Severini*, ed. P. Courthion, 3d ed., Milan, 1946; G. Severini. *Tutta la vita di un pittore*, Milan, 1946; G. Ballo, *Modern Italian Painting, from Futurism to the Present Day*, New York, 1958; J. C. Taylor, *Futurism*, New York, 1961.

JOHN C. GALLOWAY

SEVERY. Compartment or bay of a vault, particularly one in Gothic architecture.

SEVILLE (Sevilla). Spanish city on the Guadalquivir River in western Andalusia. It is the capital of the province of Sevilla and the seat of an archbishop. The Hispalis of Phoenician times, it was later in the hands of the Greeks and the Carthaginians. Under Roman rule it was the most important Iberian city; in 461 it was the capital of a Visigothic kingdom. The Moors took the city in 712 and made it the capital of one of their kingdoms until the 11th century. During the Almohades dynasty (1147–1269) Seville became the showplace of Moorish art and architecture, and much of what was built at that time has survived. The city was liberated by Ferdinand III in 1248 and developed as one of the most important commercial centers of Spain.

Seville's greatest subsequent flowering occurred after the discovery of America and at the time of Philip II (1560–1600). A great school of painting flourished there during the 17th century. *See* SEVILLE SCHOOL.

The Gothic Cathedral of Seville, begun in 1401 and consecrated in 1506, is the largest in Europe. The minaret known as the Giralda, which belonged to the 12th-century mosque that had previously occupied the site of the Cathedral, was crowned with an elaborate turret in the 16th century. Such incorporations of the Moorish past in architectural programs of later periods are characteristic of Seville and produce a unique sense of continuity in the successive styles of building and decoration. The Alcázar, begun by the kings of the Beni Abad dynasty in the 11th century, was both fortress and royal palace. Its 14th-century façade is the joint work of Christians and Muslims. In the 16th century further alterations were made for the wedding of Charles V; it was one of his and Philip II's favorite residences. The Casa de Pilatos (begun 1492; completed 16th cent.) and the 15th-century Casa de las Dueñas (the residence of the Duke of Alba) display an elegant mixture of Mudejar, Gothic, and Renaissance elements. Seville's main monuments of later periods are the Lonja, built in the 16th century after plans by Juan de Herrera, the 17th-century Hostel of the Venerables Sacerdotes, and the Church of S. Salvador, built in the Churrigueresque style. *See* ALCAZAR.

Like Cordova, Seville has preserved its old ghetto, the present Barrio de Santa Cruz, with narrow streets and whitewashed houses harboring quiet courtyards filled with fountains and flowers.

See also AYUNTAMIENTO; SEVILLE: MUSEUMS.

BIBLIOGRAPHY. R. Murube, *Séville: Ville d'art*, Paris, 1959.

HELLMUT WOHL

SEVILLE: MUSEUMS.

Important public art collections in Seville, Spain, are located in the museums listed below.

Provincial Archaeological Museum. The core of the collection comprises four rooms exhibiting finds from the rich Roman site of Italica. These include a statue of Hermes (after Cephisodotos), a 4th-century Greek torso of Diana, a Dionysiac mosaic, and Roman imperial portraits.

BIBLIOGRAPHY. C. Fernández Chicarro y de Dios, *El Museo Arqueológico Provincial de Sevilla*, Madrid, 1951.

Provincial Museum of Fine Arts. Located in the 17th-century Monastery of La Merced, the museum is notable chiefly for its baroque paintings, especially those of the school of Seville. The highpoint is the sumptuous group of religious paintings by Zurbarán (among others, *Virgin of the Rosary, Apotheosis of St. Thomas Aquinas, Crucifixion,* and *Christ Crowning St. Joseph*). Other painters represented are Murillo (*St. Anthony of Padua* and *St. Thomas of Villanueva Distributing Alms*), Valdés Leal (*Immaculate Conception*), and El Greco (*Portrait of the Artist's Son*). Pietro Torrigiano's *St. Jerome* is outstanding in the small collection of sculpture.

BIBLIOGRAPHY. J. Gestoso y Pérez, *Catálogo de las pinturas y esculturas del Museo Provincial de Sevilla*, Madrid, 1912.

SEVILLE SCHOOL.

One of the major artistic centers of Andalusia, Seville first became important as a center of painting in the mid-15th century when a group of painters, including Sánchez de Castro, Nuñez, and Fernández, were among the first Spaniards to adopt the new Hispano-Flem-

ish style. Netherlandish influence persisted for a century until a gradual Italian influence dominated, particularly among painters such as P. Campaña and his pupil Vargas. Campaña (Kempener) was born a Fleming, studied in Italy, and spent nearly thirty years in Seville, where he was influential in introducing the Italian High Renaissance style. *See* CAMPANA, PEDRO; FERNANDEZ, ALEJO; NUNEZ, JUAN; SANCHEZ DE CASTRO, JUAN; VARGAS, LUIS DE.

The great flowering of the Seville school came in the first half of the 17th century. The artist-historian Pacheco lived in Seville, where he taught Velázquez. Juan del Castillo, teacher of Murillo and Cano and a contemporary of Pacheco, was one of Seville's leading painters. Velázquez left Seville for Madrid early in his career, leaving the direction of the Seville school to Murillo, its last great painter. *See* CANO, ALONZO; MURILLO, BARTOLOME ESTEBAN; PACHECO, FRANCISCO; VELAZQUEZ, DIEGO RODRIGUEZ DE SILVA Y.

BIBLIOGRAPHY. C. R. Post, *A History of Spanish Painting*, 14 vols. in 20, Cambridge, Mass., 1930–66.

DONALD L. EHRESMANN

SEVRES PORCELAIN, *see* VINCENNES-SEVRES PORCELAIN.

SEYFER, HANS (Hans von Heilbronn). German sculptor (fl. Upper and Middle Rhine areas; d. Heilbronn, 1509). His style is based on two documented works, the *Crucifixion* in St. Leonard, Stuttgart, and the *Mount of Olives* formerly in Speyer Cathedral (destroyed; preserved in engravings). Both show iconographical similarities to Schongauer.

SEZESSION. Name taken by various groups of artists in Germany and Austria at the end of the 19th century when

Sfumato. Leonardo da Vinci, *Mona Lisa (Gioconda)*. Louvre, Paris.

they resigned from official academies and exhibiting societies in order to have freedom to pursue the then controversial impressionist and Art Nouveau styles. The first Sezession ("secession") was composed of Stuck, Trübner, and Uhde in Munich in 1892. Sezession movements followed in Vienna under Klimt (1897) and in Berlin under Liebermann (1899). *See* KLIMT, GUSTAV; LIEBERMANN, MAX; STUCK, FRANZ VON; TRUBNER, WILHELM; UHDE, FRITZ VON.

SFORZA CASTLE (Castello Sforzesco), MILAN. Castle in Northern Italy. Now an art museum, it was originally the fortress-residence of the Viscontis. The castle is a picturesque structure with crenelated walls, towers, moat, and greensward. Galeazzo II Visconti started to build it against the medieval city walls in 1368, and his successors enlarged and enriched it. Sacked by the mob when the republic took over Milan (1447), it was rebuilt (1450) by Francesco Sforza into a luxurious and impregnable stronghold. At this time Filarete designed the central tower (destroyed; the present tower is a reproduction). Under Lodovico Sforza (Il Moro) a number of great artists contributed to the castle's decoration. A graceful loggia, the Ponticello of Lodovico, is attributed to Bramante; he executed a fresco in the Sala del Tesoro. In the Sala delle Asse are frescoes by Leonardo (1498).

In 1893 the architect Luca Beltrami began to restore the castle; the restoration was completed in 1911. Damaged in 1943, the castle was remodeled to house a collection of sculpture and paintings. *See* MILAN: MUSEUMS (MUSEUM OF ANCIENT ART).
BIBLIOGRAPHY. L. Beltrami, *Il Castello di Milano*, Milan, 1894.
MADLYN KAHR

SFREGAZZI. Italian term for technique of painting shadows that was adopted by Titian and his followers. The finger instead of the brush is used to apply a thin and uniform layer of color over shadow areas so that the resulting transparent glaze gives a luminosity to the shadows.

SFUMATO. Italian term meaning "evaporated, disappeared as in smoke." *Sfumato* refers to a central principle of Leonardo's artistic theory and practice, whereby all objects are seen in the context of varying degrees of shade. Each form is subtly shaded off into its surrounding atmosphere in terms of lighter and darker tones of the same color. *Sfumato* had been used before, particularly by Masaccio, who powerfully modeled figures in terms of their atmospheric tonality, but it was Leonardo's ideas about, and application of, the effects of light and shade that had a widespread influence on European painting, although the pure use of *sfumato* is seldom found outside his own work. Notable among those who applied it in a general way are the northern Italian and Venetian painters, particularly Correggio, Giorgione, and some Spanish painters of the 16th century, such as Morales.

SGRAFFITO (Graffito). Italian term meaning "scratched" or incised by a sharp point (from *graffio*, "scratching") applied to an art medium in which a surface layer, such as a glaze or plaster, is scratched through to a contrasting undercoat. Sgraffito as scratching is found in ancient Egypt. The term is also applied to the scratching in Pompeian remains

Angle shaft. Corner molding of the Doge's Palace, Venice.

and in the catacombs. As an art form, it is found in ancient Greek vase painting and particularly in Renaissance architecture, for example, in the Loggia del Consiglio, Verona.

SHADBOLT, JACK LEONARD. Canadian painter (1909–). Born in England, Shadbolt has lived in Victoria and Vancouver since his youth, and recently worked in southern France. He was influenced by Emily Carr, Victor Pasmore, William Coldstream, and André Lhote. He paints landscape abstractions in oil and water color.
BIBLIOGRAPHY. Ottawa, National Gallery of Canada, *Catalogue of Paintings and Sculpture*, ed. by R. H. Hubbard, vol. 3: *Canadian School*, 1960.

SHADING. Device used to model painted forms and lift them from their backgrounds. Shading was first employed in Greece in the 5th century B.C., and it marked a major step toward realism in painting. Polygnotus and Apollodorus used shading in their monumental paintings, as did many vase painters of the latter half of the century.
BIBLIOGRAPHY. M. H. Swindler, *Ancient Painting*, New Haven, 1929.

SHAFT. Section of a column between base and capital. The term also denotes a small column in medieval architecture, as in a clustered pier supporting a vaulting rib.

SHAFT, ANGLE. Corner molding developed in the form of a shaft having, at times, both base and capital.

SHAH JAHAN (Jehan), *see* INDIA; MUGHAL ARCHITECTURE OF INDIA; MUGHAL PAINTING OF INDIA; RUGS, NEAR AND MIDDLE EASTERN (MUGHAL PERIOD).

SHAHN, BEN. American painter (1898–1969). Born in Kaunas, Lithuania, he went to the United States in 1906. A major advocate of politically significant art but also an individual stylist, Shahn studied at the National Academy of Design. He visited Europe in 1925 and 1927, practicing book illustration during that period. His first one-man show

Ben Shahn, *Epoch*, 1950. Philadelphia Museum of Art.

was held at the Downtown Gallery in 1930. Shahn's art attracted much attention in 1931–32, when he painted a series of twenty-three gouaches on the theme of the Sacco-Vanzetti trial, a politically significant case which found Shahn taking the side of the condemned defendants. These pictures are striking for their primitivizing, although essentially realistic, imagery and great economy of pictorial elements. A similar series followed in 1933 on the Tom Mooney case. Shahn was by that time an artist of established reputation, by no means exclusively because of the topical nature of his themes but also because of his peculiarly personal style. He became even better known publicly after he assisted the Mexican artist Diego Rivera with the vehemently attacked mural project in Rockefeller Center (never completed).

Shahn was assigned to several mural designs under the Federal Art Project of the mid-1930s and early 1940s; an important example is located in the Federal Security Building in Washington, D.C. (1940–42). (His composition *Handball*, 1939; New York Museum of Modern Art, relates to that mural.) Shahn worked with the Office of War Infor-

mation during the 1940s, executing a series of dramatic posters. His style became increasingly imaginative, more colorful, and more evidently based upon some principles of abstract design; but that tendency, even when carried further in paintings of the 1950s and 1960s, has served to corroborate rather than obscure the impact of his socially conscious themes. His *Father and Child* (1946), the ironic *Epoch* (1950; Philadelphia Museum of Art), and *The Physicist* (1960; New York, Downtown Gallery), with its grim, symbolical overtones of nuclear threat, remain, despite their charm of technique, as characteristically provocative as Shahn's early commentaries on the inequities of society.

Shahn has had retrospectives at the Museum of Modern Art, New York, in 1947, and at the Municipal Museum in Amsterdam, and has been represented in major exhibitions at the Whitney Museum of American Art, the São Paulo Bienal (with awards), the Carnegie International, and elsewhere. He is a major figure in the socially concerned art of the United States.

BIBLIOGRAPHY. J. T. Soby, *Ben Shahn*, West Drayton, Middlesex, 1947; J. I. H. Baur, *Revolution and Tradition in American Art*, Cambridge, Mass., 1951; S. Hunter, *Modern American Painting and Sculpture*, New York, 1959; J. T. Soby, *Ben Shahn: His Graphic Work*, New York, 1963; J. T. Soby, *Ben Shahn: Paintings*, New York, 1963.

JOHN C. GALLOWAY

SHAH ZINDA, *see* CHAH-SINDEH: MOSQUE OF QASIM IBN-ABBAS; SAMARQAND, ARCHITECTURE OF.

SHAKA IN MUROJI, NARA. Japanese wood sculpture (9th cent.). The Shaka (historic Buddha) was once polychromed, but now the natural color of the wood is exposed, creating an impression of serenity and purity. The strong body is covered by drapery, whose folds are executed sharply and crisply in the *hompa* (rolling-wave) style of carving, in which the rounded and more prominent folds alternate with sharply chiseled ridges in low relief. The head was once covered with spiral curls of hair, but they are now lost, leaving only a smooth surface.

BIBLIOGRAPHY. R. T. Paine and A. Soper, *The Art and Architecture of Japan*, Baltimore, 1955; *Masterpieces of Japanese Sculpture*, introd., text, and commentaries by J. E. Kidder, Jr., Rutland, Vt., 1961.

SHAKAMUNI, *see* SAKYAMUNI.

SHANG ART, *see* CHINA: ARCHITECTURE, BRONZES, CALLIGRAPHY, CERAMICS, JADE, SCULPTURE, SILK.

SHANNON, CHARLES HASLEWOOD. English figure and portrait painter and illustrator (1863–1937). Born in Quarrington, Lincolnshire, Shannon studied at the Lambeth School of Art in London, where he met Charles Ricketts, of whom he became a follower and close friend. Shannon later contributed illustrations to Ricketts's Vale Press publications and to *The Dial*. He was elected an associate of the Royal Academy of Arts in 1911 and became a full academician in 1920. His painting style owes much to the old masters, in particular, Giorgione and Titian.

BIBLIOGRAPHY. J. Rothenstein, *Modern English Painters: Sickert to Smith*, London, 1952.

SHARAKU (Toshusai Sharaku). Japanese Ukiyo-e printmaker (fl. 1794–95). Sharaku's life remains a mystery. He

suddenly appeared in May, 1794, produced more than 140 prints of actors and wrestlers, and then disappeared just as abruptly in February, 1795. His prints date entirely from this 10-month period, and nothing is known of him before or after. His standing figures reveal a basic debt to the art of Shunshō; yet his work is highly subjective and shows individualized expression. *See* SHUNSHO.

His psychological probing of actors and the characters they portray was hitherto unknown in Ukiyo-e prints. Individual characteristics of actors are exaggerated to the point of caricature and stand out sharply against colored flat backgrounds, often sprinkled with powdered mica. The exaggeration and distortion of the actor's personality and physical features impress modern viewers with their remarkable freshness. However, these aspects of his work might have been considered offensive to the Kabuki actors and their patrons, and may account for his sudden disappearance. *See* UKIYO-E.

BIBLIOGRAPHY. H. G. Henderson and L. V. Ledoux, *The Surviving Works of Sharaku*, New York, 1939; L. V. Ledoux, *Japanese Prints, Sharaku to Toyokuni, in the Collection of Louis V. Ledoux*, Princeton, 1950.

SHARIDEN. Japanese Zen temple, in the Enkakuji in Kamakura. The Enkakuji was founded in 1281 by Tokimune, a member of the Hōjō family. The Shariden (Hall to Store Sacred Ashes) was built about 1285, and is the oldest and purest example of *karayō* (Chinese style) architecture, which was introduced from China together with Zen Buddhism. It served as a model for later Zen monasteries.

BIBLIOGRAPHY. Tokyo National Museum, *Pageant of Japanese Art*, vol. 6: *Architecture and Gardens*, Tokyo, 1952.

Sharaku, *Two Actors*, 1794. Ukiyo-e print.

SHARP, WILLIAM. English engraver (b. London, 1749; d. there, 1824). He was a pupil of Barak Longmate. Beginning as a writing engraver, Sharp evolved a pictorial style from many contemporary sources. During his time he appears to have been fairly popular, but history has judged him only mediocre. He engraved and copied portraits in line engraving, mostly after other masters.

BIBLIOGRAPHY. A. M. Hind, *A Short History of Engraving and Etching*, 2d rev. ed., London, 1911.

SHARP, WILLIAM. American graphic artist (1900–65). Born in Lemberg (now Lvov), Sharp studied in Poland (Cracow), England, France, and Germany (Munich and Berlin). He then began his career as a newspaper caricaturist in Berlin. Moving to the United States in 1934, he took up lithography in 1937 and, later, etching and aquatint. He was staff artist for the *New York Post*, *PM*, and *Esquire* and produced satirical etchings on the legal and medical professions, fascism, and other themes.

SHARRER, HONORE. American painter (1920–). She was born at West Point, N.Y., studied for a year at the Yale School of Fine Arts, and now lives in Cambridge, Mass. Her small paintings of meticulously detailed scenes of American genre were shown in 1946 at the Museum of Modern Art's exhibition "Fourteen Americans."

BIBLIOGRAPHY. A. C. Ritchie, *The New Decade*, New York, 1955.

SHAW, RICHARD NORMAN. English architect (1831–1912). He was the spearhead of a revolt against the High Victorian style of the mid-19th century, although he practiced the style himself in such early works as the church at Bingley, Yorkshire (1866–68). After working for William Burn and G. E. Street, he formed a partnership with William Eden Nesfield (1862–1868). These were formative years when Shaw was influenced by such "early Georgian baroque" buildings as Nesfield's Kinmel Park (1866–68). Shaw's later half-timber style and his interpretation of the early-17th-century brick classicism, as in Lowther Lodge, London (1873; now Royal Geographical Society), made him famous and influential. In a sense it was the rediscovery of an English national style. It has been shown that his later essays in a Neo-Palladian revival, such as the Piccadilly Hotel (1905–08), contributed to the backward-looking British official styles of the 1920s and 1930s.

BIBLIOGRAPHY. N. Pevsner, "Richard Norman Shaw, 1831–1912," *The Architectural Review*, XCIX, March, 1941.

SHAW, WILLIAM, *see* SCHAW, WILLIAM.

SHEATHING. Layer on walls and roofs to which an outer covering, such as shingles and siding, is attached. Sheathing in wood construction usually consists of wood boards, although manufactured products are now widely used.

SHECHEM (Tell Balatah). Site at Balâtah (now western Jordan), Palestine, with massive fortifications of the Bronze Age. The cyclopean walls, about 33 feet high, had a fortress gate with three gateways, wide enough for the passage of a single chariot. A temple, with walls 17 feet thick, stood at the north gate. Cuneiform tablets have also been found in Shechem.

BIBLIOGRAPHY. W. F. Albright, *The Archaeology of Palestine*, rev. ed., Harmondsworth, 1954.

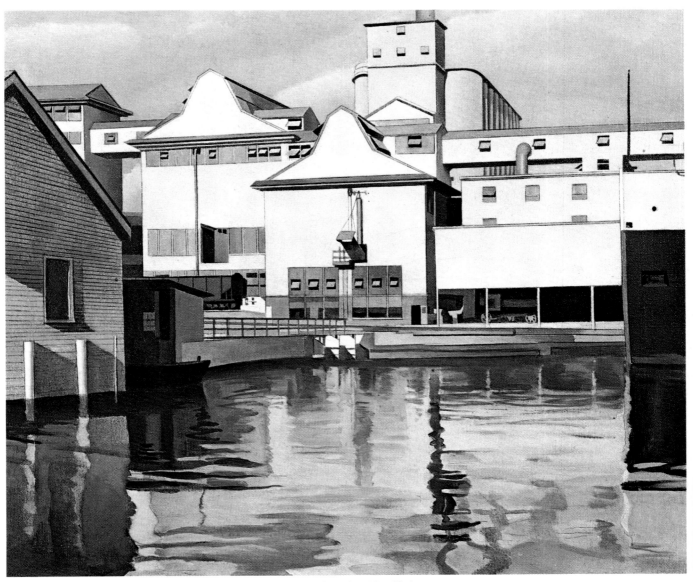

Charles Sheeler, *River Rouge Plant*, 1932. Whitney Museum of American Art, New York.

SHEELER, CHARLES. American painter and photographer (1883–1965). Born in Philadelphia, he studied there at the School of Industrial Art and at the Pennsylvania Academy of Fine Arts with William Merritt Chase, whom he twice accompanied to Europe. Sheeler began professional photography in 1912. He exhibited paintings at the 1913 Armory Show and in 1920 collaborated with Paul Strand on the film *Mannahatta*. Sheeler did several series of photographs: African Negro masks (1918), Ford Plant, River Rouge (1927), Chartres Cathedral (1929), and Assyrian reliefs in the Metropolitan Museum (1942).

Sheeler's early paintings, mostly still lifes, were influenced by Cézanne. For a few years after the Armory Show, he experimented with cubism, as in *Landscape* (1915; Leominster, Mass., William H. Lane Foundation). He derived from cubism a feeling for the formal order implicit in abstraction, but he sought this order in the painting of recognizable objects.

In the 1920s he concentrated on the clean depiction of the surfaces of subjects that already contained an abstract structure (interiors, stairways, architecture, and barns), for example, *Bucks County Barn* (1923; New York, Whitney Museum). The characteristics of Sheeler's painting—simple presentation of volumes, clean edges, and sharp images—which, along with his subjects, he shared with such other artists as Demuth and O'Keeffe, led to the application of the terms "precisionist" and, later "cubist realist" to their work. *See* CUBIST REALISM.

The first phase of Sheeler's mature work culminated in *Upper Deck* (1929; Cambridge, Mass., Fogg Art Museum), where each bit of nautical apparatus takes its place in the strong design. *Upper Deck* also marked the transition to machine and industrial subjects and those paintings most generally associated with Sheeler and precisionism, such as *River Rouge Plant* (1932; Whitney Museum), loosely based on the Ford photographs of 1927, and *City Interior*

(1936; Worcester Art Museum). In the best work of this period Sheeler managed to fuse exact painting with his basically abstract vision.

Abstraction predominates in his later paintings, where even industrial forms are vigorously purified of naturalistic detail and just as rigorously arranged, as in *Incantation* (1946; Brooklyn Museum). No longer tied to the literal view, for example, in *Architectural Cadences* (1954; Whitney Museum), he used nonlocal color and transparencies, overlays, and intersecting shapes. A little of the artistic sensuousness usually absent from Sheeler's impersonal paintings may be found in his crayon drawings, such as that of a sleeping cat in a chair called *Feline Felicity* (1934; Fogg Art Museum).

BIBLIOGRAPHY. C. Rourke, *Charles Sheeler, Artist in the American Tradition*, New York, 1938; New York, Museum of Modern Art, *Charles Sheeler*, New York, 1939.

<div style="text-align:right">JEROME VIOLA</div>

SHEETS, MILLARD OWEN. American painter and graphic artist (1907–). He was born in Pomona, Calif., and studied in California. Sheets paints stylized and decoratively composed figures and landscapes. His graphic works are more naturalistic.

BIBLIOGRAPHY. A. Millier, H. B. Alexander, and M. Armitage, *Millard Sheets*, Los Angeles, 1935.

SHELDONIAN THEATRE, *see* OXFORD.

SHELL CONSTRUCTION, *see* CONSTRUCTION, SHELL.

SHEN, PILLARS OF. Pair of stone pillars located near Ch'u-hsien in Szechwan Province, China. They are among the best-preserved examples of the monuments employed by the Chinese to mark the entrance to the "spirit road," which led from the edge of the sacred enclosure to the tomb mound. More than twenty of these pillars have survived from the Han period (206 B.C.–A.D. 221), and all imitate wooden watchtowers.

The pair erected outside the tomb of an official named Shen are not dated by inscription but are usually accepted as of the late 2d century of our era. The ancient form of the lookout tower is duplicated at the top of the pillars by beams, brackets, and imitation-tile roof, all carved in stone. Beneath the eaves of the roof are scenes of combat, running figures, and horsemen, all executed in high relief. In the corners are atlantean figures carved almost in full

round, supporting the structure on their backs. The elaborately decorated top structures are carried on rectangular columns which are decorated in lower relief with the animal symbols of the four directions: the tiger of the west, dragon of the east, phoenix of the south, and tortoise-snake of the north. In the complexity of iconography and the quality of execution, the Pillars of Shen are among the best funerary monuments preserved from the Han dynasty.

BIBLIOGRAPHY. V. Ségalen et al., *Mission archéologique en Chine (1914)*, vol. 1, Paris, 1923.

<div style="text-align:right">MARTIE W. YOUNG</div>

SHEN CHOU (Shen Shih-t'ien). Chinese painter and poet (1427–1509). His *tzu* was Ch'i-nan. Shen Chou was the dominant artistic personality in his native Su-chou region in the late 15th century and is usually considered the founder of the Wu school. His lasting reputation is based on his paintings, but in his own time he was greatly admired as a person as well. Shen Chou was born into a distinguished family and was from an early age schooled in the accomplishments of the true scholar. He also wrote poetry, but painting was his overriding passion. He studied under several teachers and devoted much of his painting to studies of early Sung and Yüan masters, and his creative reworkings of earlier painters as well as his own unique style won for him the honor of a place among the "Four Great Masters" of the Ming dynasty.

In his earlier years Shen Chou drew inspiration from a variety of sources, including such divergent styles as those of Tai Chin, the Che-school painter so much denounced by later *wen-jen* painters. But Shen Chou, although the leading light of the *wen-jen* movement, was far less rigid in his view of other painters, more willing to explore and probe for the real meaning of art. Behind his works, even those of his early years, there is the constant well-disciplined intellect. *See* CHE SCHOOL; TAI CHIN; WEN-JEN-HUA.

Gradually his paintings took on more and more of the "rough" style which later historians so admired, and his brush became more dynamic and spontaneous, his compositions bolder and freer. He turned more to the great Yüan masters, particularly Wu Chen and Ni Tsan. The powerful stroke of Wu Chen, with its uncompromising deliberateness and somewhat amateurish quality, appealed as much to Shen Chou as did the sparse, pristine, open paintings of Ni Tsan. And it is no coincidence that both Wu Chen

Shen Chou, *Landscape with Trees and Farm Buildings*. Museum of Fine Arts, Boston. An album painting by this Ming master.

and Ni Tsan led the life of the recluse, pure and lofty figures in the eyes of the later *wen-jen* school, and Shen Chou could admire these qualities in their works as well as their components of style. His studies of these two Yüan painters were often pursued in the album or hand-scroll format, and on such a small, intimate scale Shen Chou was at his best. In no sense can Shen Chou be called a dazzling technician or a painter of "pretty" scenery with idealized and charming forms. His inexhaustible imagination and his sincere devotion to nature combined to produce works of the highest poetical order, always uncompromising in their objective interpretation of visual phenomena. The true strength of Shen Chou lay in the simplicity and straightforwardness of the man. *See* NI TSAN; WU CHEN. *See also* TS'UN.

Shen Chou is well represented in American collections, notably in the fine album paintings mounted in hand-scroll form in the William Rockhill Nelson Gallery, Kansas City, the scroll entitled *Watching the Mid-autumn Moon* in the Museum of Fine Arts, Boston (where another excellent album by Shen Chou can be seen), and the *Fishing Village* in the Freer Gallery, Washington, D.C., to indicate only a few masterpieces of the Ming painter.

BIBLIOGRAPHY. G. Ecke, "Comments on Paintings and Calligraphies," *Monumenta Serica*, III, 1938; R. Edwards and Tseng Hsien-chi, "Shên Chou at the Boston Museum," *Archives of the Chinese Art Society of America*, VIII, 1954; O. Sirén, *Chinese Painting, Leading Masters and Principles*, vol. 4, London, 1958; R. Edwards, *The Field of Stones: A Study of the Art of Shen Chou (1427–1509)*, Washington, D.C., 1962.

MARTIE W. YOUNG

SHEN CH'UAN (Shen Nan-p'ing). Chinese bird-and-flower painter (fl. 1725–80). A native of Wu-hsing in Chekiang Province, he was a contemporary of Lang Shih-ning (Giuseppe Castiglione), the Italian painter at the court of Ch'ien-lung, and his paintings of birds and animals are considered as belonging in the same meticulous realistic style. Shen Nan-p'ing did not work at the court, however, and he is not represented in the imperial collection. He was invited to Japan in 1731 by an admiring patron and spent three years at Nagasaki, where he was to have considerable influence on Japanese painters. As a consequence of his stay, Shen Nan-p'ing's paintings are well represented in Japanese collections today. *See* CASTIGLIONE, GIUSEPPE.

SHENG MOU. Chinese painter (fl. Chia-hsing, Chekiang Province, 1st half of 14th cent.). He was a prolific painter who enjoyed considerable popularity in his lifetime. A skilled, eclectic painter, Sheng Mou was a great commercial success compared with his next-door neighbor Wu Chen, the painter-recluse who was ultimately to gain recognition as one of the "Four Great Masters" of the Yüan dynasty while Sheng Mou was accorded only modest recognition by later Chinese critics. A number of fine large landscapes by Sheng Mou that show a remarkable technical skill are preserved in the Sun Yat-sen Museum, Formosa.

SHEN HSIN-YU, *see* MUSTARD-SEED-GARDEN PAINTING MANUAL.

SHEN NAN-P'ING, *see* SHEN CH'UAN.

SHEN SHIH-T'IEN, *see* SHEN CHOU.

SHEN TZU-FAN, *see* K'O-SSU.

SHEPHERDS IN ARCADIA (Et in Arcadia Ego . . .). Oil painting by Poussin, in the Louvre Museum, Paris. *See* POUSSIN, NICOLAS.

SHEPLEY, RUTAN, AND COOLIDGE. American architectural firm of George F. Shepley (1860–1903), Charles Hercules Rutan (1851–1914), and Charles Allerton Coolidge (1858–1936). Shepley worked in the office of H. H. Richardson until Richardson's death in 1886, at which time he organized this firm. As Richardson's successor, it completed such important works as Trinity Church in Boston, the Allegheny County Buildings in Pittsburgh, and the Glessner house and the Marshall Field Warehouse in Chicago. The firm also designed the more academic Chicago Public Library and the Art Institute of Chicago.

BIBLIOGRAPHY. H.-R. Hitchcock, *The Architecture of H. H. Richardson and His Times*, rev. ed., Hamden, Conn., 1961.

SHERATON, THOMAS. English furniture designer (b. Stockton, 1751; d. London, 1806). Evidently trained as a cabinetmaker, he never is known to have had his own shop. He earned a very poor living at various jobs, preaching, teaching, and writing, but was one of the most influential furniture designers in English furniture history. The Sheraton style is characterized by pieces with slim legs, large plain surfaces, and simple outlines.

Sheraton's *The Cabinet Maker and Upholsterer's Drawing Book* was published first in 1791. These designs were in the neoclassical style, and Adam and Hepplewhite were obvious sources of many of the ideas. Sheraton developed designs in the same vein, using motifs in smaller scale with the results more crisp. He suggested improvements to trick

Thomas Sheraton, card table. Temple Newsam House, Leeds.

pieces like the Harlequin Pembroke Table, which was a breakfast table with a group of pigeonholes and drawers that would pop up from the center. In the *Cabinet Dictionary* of 1802 are designs showing Directoire or Empire influence. The antique became the inspiration for furniture forms rather than merely the ornament. The klismos, the curving Greek chair, was the model of several Sheraton chair designs. Designs for the *Cabinet Encyclopaedia*, which was not complete when he died, were heavier and more like the Empire, which was coming into fashion.

Each of Sheraton's books was well received, and the influence of these books was extensive. As compilations of practical designs to be followed by cabinetmakers, they were used by craftsmen in England, on the Continent, and in the New World, with the modifications that made them suitable to the differing taste of each region.

BIBLIOGRAPHY. R. Edwards and M. Jourdain, *Georgian Cabinet-Makers*, rev. ed., London, 1955.

MARVIN D. SCHWARTZ

SHERBORNE, ABBEY CHURCH OF. English late Romanesque church, which has been altered but retains a great tower arch. The nave was rebuilt about 1486–93, designed perhaps by William Smyth, and the earlier choir, of 1430–35, perhaps by Richard Pope. The choir is one of the noblest vaulted spaces of the English Perpendicular.

SHER SHAH SUR, MAUSOLEUM OF, SASARAM. Indian mausoleum located in a town of Bihar State. Completed in 1540, it is the masterpiece of the builder Aliwal Khan, who erected several structures for the ruling Suri family. Set in the middle of an artificial lake, the sandstone building rises in five distinct levels (the lower ones have kiosks) and is crowned by a dome. Traces of tiles and painted decoration indicate that it was originally brilliantly decorated.

BIBLIOGRAPHY. P. Brown, *Indian Architecture*, vol. 2: *Islamic Period*, 4th ed., Bombay, 1959.

'S HERTOGENBOSCH: CATHEDRAL OF SINT JAN. Netherlandish church, begun about 1350 on the site of an earlier church. It was almost completed before 1415, but a fire in 1419 destroyed most of the building. Willem van Kessel began the reconstruction in 1419, following the old plan. Alart du Hameel was the architect from 1478 to 1494. The Cathedral was completed in its present form in the early 16th century. The plan is that of a five-aisled, cruciform basilica with a nave of seven bays, a long choir of four bays, and an ambulatory with seven radiating chapels; the whole follows in the path of the great cathedrals at Amiens and Cologne. In essence, St. Jan is a fascinating combination of Flemish and French influences, with some admixture of the English Perpendicular style of the time. The tower (St. Janstoren) is all that remains from the original 13th-century church.

BIBLIOGRAPHY. J. Harvey, *The Gothic World, 1100–1600*, London, 1950.

SHERWIN, WILLIAM. English engraver and mezzotinter (ca. 1645–1711?). Sherwin, who was born in London, probably studied with Prince Rupert and was named "engraver to the king by patent." He is known from a number of line-engraved portraits of nobility, medical doctors, and clergy, such as the mezzotints of Charles II and Queen Catherine, the first English engraved companion pieces. He is also credited with engraving the first mezzotint in England.

BIBLIOGRAPHY. A. M. Hind, *A Short History of Engraving and Etching*, 2d rev. ed., London, 1911.

SHIBUEMON. Japanese ceramic artist (fl. ca. 1700). Uncle of Kakiemon V and reputedly director of the Nabeshima Kiln during the Genroku era (1688–1703). The sixth member of the Kakiemon family, Shibuemon continued its tradition in porcelain production, using more lavish designs.

BIBLIOGRAPHY. R. A. Miller, *Japanese Ceramics*, Rutland, Vt., 1960; Brooklyn Institute of Arts and Sciences, Museum, *Japanese Ceramics from the Collection of Captain and Mrs. Roger Gerry*, New York, 1961.

SHIGARAKI. Japanese reddish-brown stoneware with a clear, drippy glaze, first made during the Kamakura period (1185–1333). It attained its highest level as a tea ceremony ware in the late 16th and early 17th century. Shigaraki shows a great similarity to Iga ware but, because of its early origin, is usually grouped with the "Six Ancient Kilns."

See also JAPAN: CERAMICS.

BIBLIOGRAPHY. R. A. Miller, *Japanese Ceramics*, Rutland, Vt., 1960; M. Feddersen, *Japanese Decorative Art*, London, 1962.

SHIGEFUSA IN MEIGETSUIN, KAMAKURA. Japanese wood sculpture (13th cent.). One of the finest of the true secular sculptures of Japan, it represents Shigefusa, the founder of the important 13th-century warrior family Uesugi. A warrior, dressed in court costume with tall hat and large trousers, is seated with legs folded. The geometric treatment of his costume, composed in a triangle, and the realistic rendering of his facial features reflect a type of portraiture in court costume that was very common in the painting of the time.

BIBLIOGRAPHY. Tokyo National Museum, *Pageant of Japanese Art*, vol. 3: *Sculpture*, Tokyo, 1952; *Masterpieces of Japanese Sculpture*, introd., text, and commentaries by J. E. Kidder, Jr., Rutland, Vt., 1961.

SHIGEMASA (Kitao Shigemasa). Japanese Ukiyo-e print designer and the founder of the Kitao school of printmakers (1739–1820). The son of an Edo publisher, Shigemasa was largely self-taught. Although he was considered a great artist by his contemporaries, and was an important teacher, he is not well known today because his signed work is scarce. *See* UKIYO-E.

BIBLIOGRAPHY. L. V. Ledoux, *Japanese Prints, Bunchō to Utamaro, in the Collection of Louis V. Ledoux*, New York, 1948.

SHIGENAGA (Nishimura Shigenaga). Japanese Ukiyo-e print designer (d. 1756). He followed the style of Kiyonaga, and was also influenced by Sukenobu and Okumura Masanobu. Shigenaga was one of the first Ukiyo-e artists to experiment with the technique of European perspective, which he used in many prints of interior scenes. *See* KIYONAGA; MASANOBU (OKUMURA MASANOBU); SUKENOBU; UKIYO-E.

BIBLIOGRAPHY. J. A. Michener, *Japanese Prints*, Rutland, Vt., 1959.

SHIGISAN ENGI SCROLLS. Japanese *emaki* (12th cent.). The set of three scrolls is in the Chōgosonji near Nara, a temple which was restored at the end of the 9th century by the hero of the story, the priest Myōren. The first scroll, the *Flying Storehouse*, is probably the most famous. As the scroll is unrolled, the storehouse is seen transported through the air amidst a scene of wild confusion. The frenzy of the people crowded below is vividly expressed by their wide-open mouths and excited gestures. Although the scroll was originally thickly covered with heavy pigments, only the outline drawings in ink are now exposed, revealing the artist's remarkable skill in the handling of his brush to convey not only form but emotion in the quickest and simplest manner possible. The fast-changing tempo of the story, from the wild emotional outbursts of the lower classes, to an idyllic country scene, and then to the hushed atmosphere of the imperial palace, makes this *emaki* one of the most exciting narrative pictures of Japan.

BIBLIOGRAPHY. *Nihon emakimono zenshū (Japanese Scroll Paintings)*, vol. 2: *Shigisan engi*, Tokyo, 1958; H. Okudaira, *Emaki (Japanese Picture Scrolls)*, Rutland, Vt., 1962; National Commission for the Protection of Cultural Properties, *Kokuhō (National Treasures of Japan)*, 6 vols., Tokyo, 1963–

SHIH-CH'I, *see* K'UN-TS'AN.

SHIH-CHIA-MOU-NI (Shih), *see* SAKYAMUNI.

SHIH CHUNG. Chinese painter (1437–1517). His *tzu* was T'ing-chih and his *hao* Ch'ih-weng. Shih Chung spent most of his life in Nanking but was a good friend of Shen Chou and was known and liked in the circle of Su-chou painters. He was called the "Fool from Nanking" or the "Immortal Fool," a reference to his disposition and occasional eccentric behavior. Shih Chung is best known in the United States for a remarkable hand scroll in the collection of the Museum of Fine Arts in Boston, dated 1504, which depicts a snow landscape in a free ink-wash style. *See* SHEN CHOU.

BIBLIOGRAPHY. K. Tomita, "Snowscape by Shih Chung . . .," *Boston Museum of Fine Arts, Bulletin*, XXXVIII, April, 1940.

SHIH K'O. Chinese painter (fl. late 10th cent.). A painter of Buddhist and Taoist subjects, Shih K'o was active in the Five Dynasties and early Sung period. Literary sources all agree on describing him as an eccentric, somewhat "untrammeled" spirit, witty and satirical in his dealing with contemporaries, and he was as much admired for these reasons as for his paintings. Of his extant attributed works, the two sections of a hand scroll depicting two monks (often titled *Two Patriarchs with Minds in Harmony*) in the Shohoji, Kyoto, may reflect something of Shih K'o's free, bold style as described in early literary sources.

BIBLIOGRAPHY. S. Shimada, "Concerning the I-P'in Style of Painting," pts. 2–3, *Oriental Art*, n.s., VIII, Autumn, 1962, n.s. X, Spring, 1964.

SHIH-T'AO, *see* TAO CHI.

SHIJO SCHOOL. School of Japanese painters. Its name derives from the *Shijō* (Fourth Street) of Kyoto, where its founder, Goshun (1752–1811), lived. It is often regarded as a sister school of the Maruyama school because of its tendency toward naturalism. The realism of the Maruyama school was enriched by Goshun, who incorporated the

Shih K'o (attrib.), detail of the hand scroll *Two Patriarchs with Minds in Harmony*. Shohoji, Kyoto.

sophisticated lyricism of the Nanga school. The Shijō school found enthusiastic patrons among the more educated, refined intellectuals of Kyoto, where its influence is still strongly felt even today. Among the important members of the school were Keibun, Shibata Zeshin (1807–91), Toyohiko, and Kōno Bairei (1844–95), who revived the school. *See* GOSHUN; KEIBUN; MARUYAMA SCHOOL; NANGA SCHOOL; TOYOHIKO.

BIBLIOGRAPHY. T. Akiyama, *Japanese Painting* [Geneva?], 1961.

SHIKO (Watanabe Shiko). Japanese painter (1683–1755). Shikō first studied with a Kanō master but later was influenced by Kōrin's works. His color paintings have a less decorative flatness and a more compact composition than Kōrin's. There is a sense of naturalism that was later admired by Okyo. *See* KANO SCHOOL; KORIN.

BIBLIOGRAPHY. R. T. Paine and A. Soper, *The Art and Architecture of Japan*, Baltimore, 1955.

SHIMOMURA, KANZAN. Japanese painter (1873–1930). He was first trained by Hōgai and Gahō but later studied extensively the arts of China and Japan, which he adapted to create his own style. He became one of the leaders of the new art movement in Japan and taught at the Tokyo Fine Arts School. He also cooperated with Taikan and others to found the Nihon Bijutsuin. *See* HASHIMOTO, GAHO; HOGAI.

BIBLIOGRAPHY. N. Ueno, ed., *Japanese Arts and Crafts in the Meiji Era* (Centenary Culture Council Series, Japanese Culture in the Meiji Era, vol. 8), Tokyo, 1958.

SHINDEN-ZUKURI. Japanese term for a type of residential architecture that includes a group of buildings built

in a garden. The *shinden-zukuri* (*shinden* style of architecture) reflected the taste of the wealthy and sophisticated court society of the late Heian period (898–1185), but it gradually went out of fashion in the Kamakura period (1185–1333), when the influence of the court aristocracy declined.

No actual example of this type of architecture has survived, but descriptions of it may be found in literature and in the illustrated narrative scrolls (*emaki*). A typical *shinden-zukuri* house had the buildings to the north and the garden to the south. The master of the house lived and received guests in the central hall (*shinden*), an oblong block which opened to the garden. In the east, west, and north the *shinden* was connected by verandalike corridors to the *taino-ya* (subsidiary living quarters), which were used by other members of the household. Open kiosks called *tsuri-dono* (fishing halls), built over the pond, were connected to the rest of the building complex by covered corridors. For roofing, cypress barks were used, and the wooden floors of the rooms were covered with mats (*tatami*) according to need.

BIBLIOGRAPHY. R. T. Paine and A. Soper, *The Art and Architecture of Japan*, Baltimore, 1955.

MIYEKO MURASE

SHINGEI, see GEIAMI.

SHINGLE. Piece of wood of tapered cross section applied on roofs and walls in overlapping rows. Shingles were used in 17th-century Dutch colonial architecture and were cut radially from logs. The term is also applied to materials similarly used, such as asbestos shingles.

SHINGLE STYLE. Domestic architectural style developed in the United States in the 1870s. It derived from older Colonial modes and from the English Queen Anne style. Its innovations include open planning, new relationships of interior-exterior spaces, and use of light wooden exterior walls. Bruce Price and H. H. Richardson were its leading exponents. *See* PRICE, BRUCE; RICHARDSON, HENRY HOBSON.

BIBLIOGRAPHY. V. J. Scully, *The Shingle Style, Architectural Theory and Design from Richardson to the Origins of Wright*, New Haven, 1955.

Shingle style. House in the Bronx, New York, ca. 1890.

SHINGON. Japanese term for a form of Tantric Buddhism, in which the solar divinity Vairocana (Japanese, Dainichi Nyorai) is worshiped as the supreme deity. It regards the whole universe as a manifestation of the Supreme Buddha (Vairocana), who is present everywhere and in everything. The Shingon sect, known in China as Chenyen (True-word), was introduced into Japan by Kūkai (774–836), who is posthumously known as Kōbō Daishi. Kūkai studied in China under a Chinese priest, Hui-ko, who was a disciple of an Indian monk, Amoghavajra. Upon his return from China in 806, Kūkai founded the Shingon sect of Japan. As the lofty and mystical ideas of the Shingon sect were difficult to explain in words, visual arts were called into service. In this respect the Shingon sect and its teachings played an important role in the history of Buddhist art in Japan. *See* VAIROCANA.

See also FUDO MYO-O.

BIBLIOGRAPHY. E. D. Saunders, *Buddhism in Japan*, Philadelphia, 1964; D. Seckel, *The Art of Buddhism*, New York, 1964.

SHINN, EVERETT. American painter, illustrator, and decorator (b. Woodstown, N.J., 1876; d. New York City, 1953). He studied at the Pennsylvania Academy of Fine Arts. First interested in mechanics, he worked as a draftsman. Later he did newspaper illustrations, in Philadelphia from 1896 to 1901 and then in New York City. A member of The Eight, Shinn began as a realistic painter of urban genre and theatrical scenes, such as *The Hippodrome, London* (1902; Art Institute of Chicago). Subjects from the theater became more important in his work, and his less realistic style was increasingly influenced by Degas. His decorations for theaters and private homes were in the French rococo style.

BIBLIOGRAPHY. M. W. Brown, *American Painting: From the Armory Show to the Depression*, Princeton, 1955.

SHINNO, see NOAMI.

SHINO, see JAPAN: CERAMICS.

SHINSO, see SOAMI.

Everett Shinn, *The Hippodrome, London.* Art Institute of Chicago.

SHIN YUN-BOK (Hae-won). Korean painter (b. 1758). He was the foremost painter of genre scenes of the Yi period. His genre paintings are characterized by their true-to-life portrayal of everyday activities of average people. Shin Yun-bok was a member of the Royal Academy, and in spite of his originality in composition, he was not free from certain formal, academic habits. Some of his better-known works are *Boating Scene, Wine Seller, Gathering in the Courtyard*, and *Kisaeng Party*, all in the collection of Mr. Chun Hyung-pil, Seoul.

BIBLIOGRAPHY. E. McCune, *The Arts of Korea*, Rutland, Vt., 1962.

SHIRAZ. City in southwestern Iran. Shiraz grew in size and importance after the Arab conquest of Iran in the 7th century, in part because of its good climate, abundant water, and location at the intersection of trade routes. It has been long renowned for its pleasant gardens and as the birthplace of the famed poets Sa'di and Hafiz, whose tombs draw many visitors. Most notable of its Islamic monuments is the Masjid-i-'Atiq, a mosque erected at the end of the 9th century and enlarged at several later periods. After a period of decline the city revived in the second half of the 18th century under the local ruler, Karim Khan Zand. Structures of his reign include a vaulted bazaar, the Masjid-i-Vakil, and a pavilion which now houses a museum. Shiraz produced fine miniatures in the 14th century, and in recent times its artists executed flower paintings, lacquerwork, and a type of fine inlay work.

BIBLIOGRAPHY. J. A. Arberry, *Shiraz: Persian City of Saints and Poets*, Norman, Okla., 1960; L. Lokhart, *Persian Cities*, London, 1960.

SHIRLAW, WALTER. American painter and graphic artist (b. Paisley, Scotland, 1838; d. Madrid, 1909). Shirlaw went to the United States in 1841. He began his career as a banknote engraver and took his formal training in painting at the Munich Academy (1870–77). Active in New

Shiraz. Mausoleum of Imam Sa'di.

York City from 1877 on as a muralist, illustrator, and stained-glass designer, he was a founder and the first president of the Society of American Artists. Shirlaw painted figures in the dark Munich style and, with Duveneck, taught that style in the United States.

SHISHINDEN. Inner throne hall in the traditional Japanese palace. It dates back to at least the 9th century and is based on a Chinese prototype. A throne chamber, rectangular in plan, is framed on each side by long rooms called *hisashi*.

SHI TENNO, *see* LOKAPALA.

SHITENNO IN GOLDEN HALL OF HORYUJI. Japanese wood sculpture (7th cent.). The Shitennō, guardians of the four directions and the Buddhist Law, are Jikokuten (Guardian of the East), Kōmckuten (West), Tamonten (North), and Zōchōten (South). They are shown in an immobile frontal position, standing on demons and holding appropriate attributes. Kōmokuten and Tamonten bear the inscription of Oguchi-no-Atai, who seems to have been the author of the statues. The shallow carving of the drapery folds, arranged in a symmetrical manner, the cylindrical aspect of the bodies, and the sense of spiritual calm relate these statues stylistically to the Kudara Kannon in the same temple. *See* KUDARA KANNON OF HORYUJI.

BIBLIOGRAPHY. Tokyo National Museum, *Pageant of Japanese Art*, vol. 3: *Sculpture*, Tokyo, 1952; *Masterpieces of Japanese Sculpture*, introd., text, and commentaries by J. E. Kidder, Jr., Rutland, Vt., 1961; National Commission for the Protection of Cultural Properties, ed., *Kokuhō (National Treasures of Japan)*, vol. 1: *From the Earliest Time to the End of the Nara Period*, Tokyo, 1963.

SHITENNOJI, OSAKA. Japanese Buddhist temple built as a thank offering to the Four Guardians (*shitennō*) by Prince Shōtoku after his victory in the civil war of 588. Although the original structure of the temple is no longer visible today, its general layout is still preserved, revealing the archaic arrangement of the monastery in which the pagoda, the Golden Hall, and the Lecture Hall stand in a north-south axial relationship.

BIBLIOGRAPHY. R. T. Paine and A. Soper, *The Art and Architecture of Japan*, Baltimore, 1955.

SHITOMIDO. In Japanese architecture, a horizontally hinged wall panel which may be lifted and fastened to ceiling rods, thereby opening room areas.

See also AMADO; SHOJI.

SHITTA TAISHI, *see* SIDDHARTHA.

SHOEI (Kano Shoei; Tadanobu). Japanese painter (1519–92). He was the son of Motonobu and father and teacher of Eitoku. Less heroic in composition and quieter in brushstroke than Eitoku's works, Shōei's paintings are elegant and pleasing to the eye. *See* EITOKU; MOTONOBU.

BIBLIOGRAPHY. R. T. Paine and A. Soper, *The Art and Architecture of Japan*, Baltimore, 1955.

SHOGA (Takuma Shoga). Japanese painter (fl. 12th cent.). Shōga was the son of Tametō, who founded the Takuma school of painting. A set of the Twelve Devas in the Tōji of Kyoto is the only surviving work by him. It shows a

Chinese influence, especially in the handling of brushstrokes that vary freely in thickness. *See* TAKUMA SCHOOL.

BIBLIOGRAPHY. R. T. Paine and A. Soper, *The Art and Architecture of Japan*, Baltimore, 1955.

SHOHAKU (Soga Shohaku). Japanese painter (1730–81). Shōhaku first studied with a Kanō master. He called himself the tenth descendant of Jasoku and founded his art on the traditional principles of 15th-century ink painting. His powerful, explosive brushstrokes reflect his eccentric and rebellious personality. *See* JASOKU; KANO SCHOOL.

BIBLIOGRAPHY. R. T. Paine and A. Soper, *The Art and Architecture of Japan*, Baltimore, 1955.

SHOIN-ZUKURI. Japanese term for a type of residential architecture that made its first appearance late in the Muromachi period (1336–1573). The *shoin* was a study in a priest's house where the illumination of the interior was improved by a bay window. Later it developed to include the *tokonoma*, shelves to display paintings or other art objects, and a built-in desk. A house in *shoin-zukuri* (*shoin* style) at first looked like a modest and simplified version of a *shinden-zukuri* house, the difference being that the *shoin-zukuri* house had smaller rooms with the floor covered permanently by *tatami*. Rooms in a *shoin-zukuri* house are divided by sliding wooden doors, *shoji* (paper screens on wooden frames), or *fusuma* (sliding screens covered with decorated paper). Among the best examples of the *shoin* buildings are the Kangaku-in and Ko-jo-in, both subtemples of the Onjoji in Otsu, near Kyoto. *See* SHINDEN-ZUKURI.

See also NIJO PALACE, KYOTO; NISHI HONGANJI, KYOTO.

BIBLIOGRAPHY. R. T. Paine and A. Soper, *The Art and Architecture of Japan*, Baltimore, 1955; H. Kitao, *Shoin Architecture in Detailed Illustrations*, Tokyo, 1956.

SHOJI. Panels of translucent rice paper fastened to wood frames. Sliding *shoji* are used extensively as movable walls in Japanese architecture. *See also* FUSUMA.

SHOKADO SHOJO. Japanese calligrapher and painter (1584–1639). Shōkadō was one of the three greatest calligraphers of his time, and a skilled painter as well. He cultivated friendships among many Zen priests and tea masters, through whom he acquired considerable political influence. His paintings in ink reflect the arts of Mu Ch'i and Yin T'o-lo of Sung China and indicate a native decorative spirit. *See* MU CH'I.

BIBLIOGRAPHY. R. T. Paine and A. Soper, *The Art and Architecture of Japan*, Baltimore, 1955.

SHOKEI (Kenko Shokei; Kei Shoki). Japanese painter (fl. late 15th cent.). Shōkei was a priest of the Kenchōji of Kamakura and went to Kyoto to study with Geiami. Returning to Kamakura in 1480, he was given a painting, *Viewing Waterfall* (Tokyo, Nezu Art Museum), by Geiami as a parting gift. It influenced his own landscape painting. *See* GEIAMI.

SHO KWANNON, *see* PADMAPANI.

SHORE TEMPLE, *see* MAMALLAPURAM.

SHOSOIN BIWA PAINTING. Japanese painting (8th cent.). In the Shōsōin Storehouse at the Tōdaiji in Nara there are four *biwa* (a kind of lute), whose sound boxes

Shōsōin of Tōdaiji. Imperial storehouse within the temple compound.

are fitted with leather plaques decorated with paintings. The subject matter varies, with the one of three musicians and a dancer on a white elephant surpassing all the others. A cascade falling from a crag, a flight of birds in the distance, and a deep valley suggesting a distant landscape set the stage for the journey of the group. Two of the figures are shown in Chinese costumes, but the third, beating a tabour, is dressed in Iranian style. The painting is of particular importance since it reflects an earlier stage of the landscape painting in T'ang China.

BIBLIOGRAPHY. T. Akiyama, *Japanese Painting* [Geneva?], 1961; Shōsōin, *Treasures of the Shōsōin*, 3 vols. in 1, Tokyo, 1960–62.

SHOSOIN OF TODAIJI. Storehouse attached to the Tōdaiji in Nara, Japan. *Shōsōin* originally signified the area where the *shōsō* (main storage house of a temple) stood; the term is now used exclusively to refer to the imperial warehouse within the compound of the Tōdaiji. Two log-constructed warehouses of the Nara period were later connected by a third structure to form the *shōsōin*. It houses various art objects used in the "eye-opening" ceremony (752) of the Great Buddha of the Tōdaiji, together with items treasured by the emperor Shōmu (r. ca. 724–748), all of which were bequeathed to the Tōdaiji by his widow in 756. *See* TODAIJI, NARA.

See also SHOSOIN BIWA PAINTING; SHOSOIN SCREEN WITH LADIES UNDER TREES.

BIBLIOGRAPHY. Japan, Imperial Treasury (Shōsōin), *The Shōsōin, an Eighth Century Treasure-House*, compiled by M. Ishida and G. Wada, Tokyo, 1954; National Commission for the Protection of Cultural Properties, ed., *Kokuhō (National Treasures of Japan)*, vol. 1: *From the Earliest Time to the End of the Nara Period*, Tokyo, 1963.

SHOSOIN SCREEN WITH LADIES UNDER TREES. Eighth-century Japanese folding screen, in the Shōsōin Storehouse at the Tōdaiji, Nara. Each of the six panels is decorated with the figure of a woman, standing, or seated on a rock under a tree. Although only an ink outline drawing is visible today, originally the figures were entirely covered with colorful feathers. The ladies, reflecting the T'ang ideal of beauty, have plump faces and hands; and their costumes and makeup also conform to the court taste of that time.

BIBLIOGRAPHY. T. Akiyama, *Japanese Painting* [Geneva?], 1961; Shōsōin, *Treasures of the Shōsōin*, 3 vols. in 1, Tokyo, 1960–62.

SHOSOIN WARE, T'ANG-TYPE GLAZES, *see* JAPAN: CERAMICS (NARA AND HEIAN PERIODS).

SHOTOKU, PRINCE, PORTRAIT OF, *see* PRINCE SHOTOKU.

SHREVE, LAMB AND HARMON. American architectural firm of Richard H. Shreve (1877–1946), William Lamb (1883–1952), and Arthur Loomis Harmon (1901–). Shreve, who was the senior member, joined with Lamb in 1920; Harmon became affiliated in 1929. They designed the world's tallest skyscraper, the Empire State Building (1929–31) in New York City. *See* NEW YORK.

SHREWSBURY CASTLE. English castle on a Romanesque motte and bailey plan, forming part of the town fortifications overlooking the river Severn. The walls are probably 13th century. The present towers are later, and the keep tower is 19th century by Thomas Telford.

BIBLIOGRAPHY. E. S. Armitage, *The Early Norman Castles of the British Isles*, London, 1912.

SHRIMP GIRL, THE. Oil painting by Hogarth, in the National Gallery, London. *See* HOGARTH, WILLIAM.

SHRINE. Any of a variety of closable cabinets used to contain some sacred object. The reliquary and sacraments shrines are the principal types found in Christian art. The latter was frequently built into the wall of an apse; in the

Shreve, Lamb and Harmon, Empire State Building, New York, 1929–31

late Middle Ages they were often elaborately decorated architectural creations. An example is Adam Kraft's tabernacle in St. Lorenz, Nürnberg.

BIBLIOGRAPHY. R. Wesenberg, *Das gotische Sakramentshaus*, Giessen, 1937.

SHUBUN (Tonsho Shubun). Japanese artist (fl. mid-15th cent.). Shūbun was a painter, priest, sculptor, and accountant in the Shōkokuji in Kyoto. (He is sometimes incorrectly identified with another Shūbun, a painter of the mid-16th century.) Succeeding Josetsu, he became the official painter of the shogun, and was regarded as the greatest ink painter of the period. He is also known to have taught Sesshū.

In 1423 he joined a Japanese mission to Korea and returned home in 1424. Although his sculptural works do not pose an identification problem, there are no paintings that can be attributed to him with assurance. Landscape paintings in ink associated with his name show the strong influence of Ma Yüan and Hsia Kuei of Sung China, and are often accompanied by poems written by Zen priests. *See* HSIA KUEI; JOSETSU; MA YUAN.

BIBLIOGRAPHY. T. Akiyama, *Japanese Painting* [Geneva?], 1961.

SHUGAKUIN PALACE GARDEN, KYOTO. Japanese garden at the Shugakuin Imperial Villa. A large garden, commanding a panoramic view of the city and the neighboring mountains, was built about 1659 for the emperor Gomizunō as a part of his villa. The garden was extensively repaired in the early 19th century. It consists of three tiers, the lower, middle, and upper compounds, which are connected by walks covered with white sand and flanked by low pine trees. Its unusually large size and magnificent views of the countryside make this garden unique in Japan.

BIBLIOGRAPHY. Tokyo National Museum, *Pageant of Japanese Art*, vol. 6: *Architecture and Gardens*, Tokyo, 1952; Kokusai Bunka Shinkōkai, *Tradition of Japanese Garden*, Tokyo, 1962.

SHUGETSU TOKAN. Japanese painter (fl. 15th cent.). Shūgetsu came from Kyūshū to study with Sesshū about 1490 and became his most famous pupil. About 1496 he traveled to China, where he stayed for three years. His birds-and-flowers and landscape paintings show a Ming influence in the use of fine lines and delicate colors. *See* SESSHU TOYO.

BIBLIOGRAPHY. R. T. Paine and A. Soper, *The Art and Architecture of Japan*, Baltimore, 1955.

SHUMMAN (Kubo Shumman). Japanese Ukiyo-e printmaker (1757–1820). Shumman was a pupil of Shigemasa but later was influenced by Kiyonaga. A quiet range of orange hues, and graceful gestures and poses, typify his prints of women. After the late 1780s, when Utamaro began to dominate the field of printmaking, Shumman ceased to make prints and devoted himself to book illustration and the writing of satirical poems. *See* KIYONAGA; SHIGEMASA; UKIYO-E.

BIBLIOGRAPHY. L. V. Ledoux, *Japanese Prints, Bunchō to Utamaro, in the Collection of Louis V. Ledoux*, New York, 1948.

SHUNKO (Katsukawa Shunko). Japanese Ukiyo-e print designer (fl. ca. 1780–95). Shunkō was the most gifted pupil of Shunshō, and, like his teacher, specialized in realistic portraits of Kabuki actors. His main contribution

to Ukiyo-e is the introduction of large heads of actors as a subject. In the late 1780s, although his right arm was paralyzed, he continued to produce quantities of prints, using his left hand. *See* SHUNSHO; UKIYO-E.

BIBLIOGRAPHY. L. V. Ledoux, *Japanese Prints, Bunchō to Utamaro, in the Collection of Louis V. Ledoux*, New York, 1948.

SHUNSHO (Katsukawa Shunsho). Japanese Ukiyo-e printmaker, and painter (1726–92). Although today Shunshō is better known as a specialist in actor prints, his portraits of women rank high among the works of his contemporaries. He overshadowed the hitherto dominant Torii school in the field of actor prints by introducing a new type of Kabuki portrait in which he strove to express the individual facial characteristics and acting styles of the performers. *See* UKIYO-E.

BIBLIOGRAPHY. L. V. Ledoux, *Japanese Prints by Harunobu and Shunshō in the Collection of Louis V. Ledoux*, New York, 1945; J. A. Michener, *Japanese Prints*, Rutland, Vt., 1959.

SHURUPPAK, *see* FARA.

SHUSH (Shushan), *see* SUSA.

SIA (Zia) INDIANS, *see* PUEBLO INDIANS.

SIALK. Prehistoric and protohistoric site on the Iranian Plateau near Kashan, south of Teheran, where the earliest traces of human habitation have been dated to the 5th millennium B.C. It is the first site to yield the art of vase painting which underwent development in the 5th and 4th millenniums B.C. Various invaders left their mark on the art of Sialk. Here, at the beginning of the 3d millennium B.C., the Elamites introduced writing and the use of clay tablets and cylindrical seals. On a massive polygonal terrace, constructed on the site of the prehistoric Sialk, fragments of architectural decoration were found, consisting of fantastic animals in the round. The area was divided into an upper town for the ruler and nobility and a lower town for the populace, both fortified with walls. Two cemeteries (2d and 1st millenniums B.C.) have yielded rich treasures of funerary furniture, painted glazed pottery, graceful vases with long spouts, reliefs and statuettes, toilet articles, and silver and bronze jewelry.

BIBLIOGRAPHY. A. Parrot, *Sumer: The Dawn of Art*, New York, 1961; R. Ghirshman, *The Arts of Ancient Iran: From Its Origins to the Time of Alexander the Great*, New York, 1964.

SIAM (Thailand). Country in southeast Asia, which from the 7th until the 13th century was under the empire of Angkor. Major influences upon Siam came from India through the Cambodian cultures and, later, from the Thai people. The early art forms in stone have the serene and simplified style of Indian prototypes, modified by the art of the Khmers, through which they had passed; in contrast, the later styles of Siam in the 15th century have the visual impact of ornateness, flamboyance, and weightlessness in both contour and surface treatment.

Chinese pressures in the 8th century forced the Thai into northern Siam. The migrating Thai, unable to threaten the Khmer empire, assimilated themselves with it instead, adopting an Indianized tradition at Dvāravati and becoming the empire's logical heirs when the turmoil surrounding

Angkor and southeast Asia allowed them to unify the country under Rāma Kamheng in 1287. The Thai identity as a nation has since continued.

The earliest styles in Siam, which were blunt and Indianesque, slowly evolved into a seemingly extravagant style under the Thais. In all the art of Thailand, this exuberance takes its special form in line. In painting, either in books with accordion-folded pages or in hanging banners, this line appears of fairly even thickness, acting as an outline, which sometimes shifts in color from figure to figure and sometimes glints as a gold edge. It thus modifies the seen object but always as a containing and restraining line, twisting from curves to sharp points. The subject is never lost, because with the use of an active contour line the Thai painter employed flat color for the interior of his forms, achieving a flowerlike stylistic device. Thai colors of reds, blues, and gold dance and vibrate next to each other. The combination of active silhouettes with serene interiors presents a dreamlike quality of light-heartedness that reduces the most ferocious subjects, such as demons, to playfulness.

The logic of the Thais' fluid line was extended to their architecture, resulting in an impression of flight. The multiple overlap of large organic building forms suggests flames, birds, or flowers, all about to lift themselves by their edges from their slender columns. This feeling of lightness is caused by the upward-reaching curves and verticals and the sharpness of the carvings, as well as by the strength of the overall contour. The ornamental details contribute

Siam. Ruins of Ayudhyā.

to extensions far beyond the scope and seemingly normal edge of a building. The long line of a roof sometimes continues in a returning curve, as at the Nagāra Srī Dharmarāja (Great Relic Monastery), culminating in dragon or flame forms. Very often the influences of Chinese pagodas are cited in reference to the buildings of Siam, but this judgment ignores the Thais' particular inspiration, which respected a building as a living entity and allowed them to bring a fuller fantasy to their images, so much in keeping with their Buddhist beliefs of a world in constant flux. *See* BANGKOK; SUKHODAYA.

BIBLIOGRAPHY. A. B. Griswold, *Dated Buddha Images of Northern Siam*, Ascona, Switzerland, 1957; T. Bowie, ed., *The Arts of Thailand*, Bloomington, Ind., 1960; B. P. Groslier, *The Art of Indochina*, New York, 1962 (Amer. edition). JOHN BRZOSTOSKI

SIAN, *see* CH'ANG-AN.

SIBERECHTS, JAN. Flemish painter of landscapes (b. Antwerp, 1627; d. London, ca. 1703). It was only on his return from Italy in 1648/49 that he became a master. His early style remained very close to the Italianizing landscapes of Jan Both, Karel Dujardin, and Adam Pijnacker. Subsequently, Siberechts's Flemish temperament came to the fore, and he specialized in views of rivulets and fords, animated by milkmaids and cattle. The palette turns silvery, and red, blue, white, and yellow highlights accentuate the scene (*Ford with Cart*, Antwerp, Fine Arts Museum). After about 1672 he settled in England, there to produce bird's-eye views and renderings of local estates. Although the color scheme fades into a paler and more monochromatic gamut, his productions from these years remain essential to a comprehension of the development of English landscape art.

BIBLIOGRAPHY. T. H. Fokker, *Jan Siberechts*, Brussels, 1931; E. K. Waterhouse, *Painting in Britain, 1530–1790*, Baltimore, 1953.

SIBYL, TEMPLE OF THE (Temple of Vesta), TIVOLI. Italian temple near Rome, erected in Sulla's time (138–78 B.C.). The temple is circular and is raised on a podium. The cella walls are built of concrete and are lined with *opus incertum*; the rest of the structure is of travertine. The cella is 21 feet in diameter. It is surrounded by a peristyle of eighteen Corinthian columns that support an entablature decorated with a frieze of festoons of fruit and ox skulls. The carving of the foliage of the capitals and of the frieze is of excellent workmanship. The cella wall has been preserved, as have a window and a doorway with a flight of steps leading up to the cella. Still standing also are several of the exterior columns.

BIBLIOGRAPHY. W. J. Anderson, R. P. Spiers, and T. Ashby, *The Architecture of Greece and Rome*, vol. 2: *The Architecture of Ancient Rome*, London, 1927.

SIBYL OF THE RHINE, *see* HILDEGARD OF BINGEN.

SIBYLS. In Greek and Roman mythology, a group of inspired prophetesses of uncertain number inhabiting diverse parts of the ancient world. The most famous of them is the Cumaean sibyl, who was consulted by Aeneas and who sold Tarquin the Sibylline Books. Other sibyls mentioned in literature are the Babylonian, or Persian, Libyan,

Jan Siberechts, *Ford with Cart*. Fine Arts Museum, Antwerp.

Delphian, Cimmerian, Erythraean, Samian, Hellespontine, Phrygian, and Tiburtine.

BIBLIOGRAPHY. Lactantius, *The Divine Institutes*, tr. Sister M. F. McDonald, Washington, D.C., 1964.

SICHEM, CHRISTOFFEL I VAN. Dutch woodcutter and engraver (b. Amsterdam, ca. 1546; d. there, 1624). Sichem was most prolific and accomplished as a woodcutter. He was one of the foremost interpreters of Hendrick Goltzius and issued a large number of small pages after Goltzius in 1613.

BIBLIOGRAPHY. A. von Wurzbach, *Niederländisches Künstler-Lexikon*, vol. 2, Vienna, 1910.

SICHEM, CHRISTOFFEL II VAN. Dutch draftsman, engraver, and woodcutter (b. Basel, ca. 1580; d. Amsterdam, 1658). The son of Christoffel I van Sichem, he probably studied with Hendrick Goltzius. The works of father and son are often confused. Both used the cipher "CVS," and both engraved after Goltzius. Unlike his father, Christoffel II was a better engraver than a woodcutter, and his best plates are after Dürer, not Goltzius.

BIBLIOGRAPHY. A. von Wurzbach, *Niederländisches Künstler-Lexikon*, vol. 2, Vienna, 1910.

SICIOLANTE, GIROLAMO (Girolamo da Sermoneta). Italian painter (b. Sermoneta, 1521; d. Rome, ca. 1580). A student of Leonardo da Pistoia, Siciolante was influenced by the mannerist decorator Perino del Vaga in Rome and later by Sebastiano del Piombo. Siciolante's portraits best reveal his talent.

SICKERT, WALTER RICHARD. English painter (b. Munich, 1860; d. Bath, 1942). He studied briefly at the Slade

Walter Richard Sickert, *Ennui*, ca. 1913. Tate Gallery, London.

School, London. For a time he was a friend and studio assistant of Whistler, through whom he met Degas in Paris in 1883. Sickert was in Dieppe from 1900 to 1905 and was a founder of the Camden Town Group in 1911. Inspired by the impressionists, he borrowed some of their technique. His early paintings, subdued tonal studies of urban scenes, were influenced by Whistler. However, Sickert's lifelong admiration for Degas can be seen in the solid compositional structure and cutoff views of many of his paintings, for example, *Ennui* (ca. 1913; London, Tate).

BIBLIOGRAPHY. R. Emmons, *The Life and Opinions of Walter Richard Sickert*, London, 1942; L. Browse . . ., ed., *Sickert*, London, 1943.

SICYONIAN TREASURY, DELPHI. One of the small treasury buildings that once lined the Sacred Way of the Sanctuary of Apollo in Delphi, Greece. Built at the end of the 5th century B.C. to display the offerings of the city of Sicyon, it was a Doric anta temple measuring about 21 by 28 feet. Only the foundation remains in place today. Of considerable interest is the fact that the builders of the 5th-century temple used remains of at least two earlier poros structures in their construction. One of these was a 6th-century tholos, or rotunda, structure. The other was a building of about 560 B.C. from which the later builders took twelve high-quality metopes, Doric capitals, column shafts, and other parts. This earlier structure may have been a treasury or similar building of the Sicyonians or perhaps of the Syracusans. Though its basic design is disputed, its early style is obvious in that it had no intercolumnial triglyphs and consequently had very wide metopes.

BIBLIOGRAPHY. W. B. Dinsmoor, *The Architecture of Ancient Greece*, 3d ed., London, 1950.

SIDAMARA SARCOPHAGUS. Greek sculpture of the Hellenistic period, neo-Attic style, in the former State Museums, Berlin.

SIDDHARTHA (Chinese, Hsi-ta-to; Japanese, Shitta Taishi). Proper name of Gautama Buddha.

SIDE CHAIR. Chair with back but no arms, encountered in modern times from the Renaissance on. Although the klismos, the Greco-Roman form, is a side chair, the type was not used in the Middle Ages, possibly because the chair was a symbol of an authority reserved for the head of the house. The side chair was introduced in Italy in the 15th century and in England in the 17th century, becoming particularly common all over Europe in the 18th century.

BIBLIOGRAPHY. R. Aloi, *Esempi di arredamento moderno di tutto il mondo*, 2d ser.: *Poltrone, divani*, Milan, 1953.

SIDI OKBA (Sidi Uqba), MOSQUE OF, KAIRWAN, see KAIRWAN: MOSQUE OF SIDI OKBA.

SIDON. Phoenician town (modern Saida) on the coast of Lebanon, north of Tyre. It had two harbors, a northern, trapezoidal one bordered by quays between islands, and a larger, rectangular one, or "Egyptian harbor," on the south. Sidon superseded Byblos and later gave way to Tyre about the 12th century B.C. Alexander the Great connected it to the coast by a dike almost 200 feet wide.

Among the rare Phoenician ruins in the city are those of the Temple of Eshmun. Excavations have turned up a number of sarcophagi from this civilization. More important, perhaps, are the sarcophagi showing Egyptian influence, and those from the period of Hellenistic domination (four in the Archaeological Museum, Istanbul, including the Alexander Sarcophagus). *See* ALEXANDER SARCOPHAGUS.

Sidon was captured several times by the Crusaders, who were able to erect the Castle of St. Louis (12th cent.; rebuilt). The Qal'at al-Bahr fortress dates from the 13th century.

SIEGEN, LUDWIG VON. German engraver, painter, and medalist (b. near Cologne, 1609; d. Wolfenbüttel, ca. 1680). Von Siegen, and not Prince Rupert, is now credited with the invention of mezzotint sometime before 1642, the date of his first of seven or possibly nine known plates. His education and occupations were typical of a 17-century minor noble: Rittercollegium in Kassel (1621–26) and services for a number of landgraves, including young Landgrave William VI (1639–41). Between 1641 and 1644, Von Siegen was in Amsterdam, and after 1644 he served as a military officer for various bishops and electors. The latter part of his life is obscure, but it is likely that he was in the service of the Duke of Wolfenbüttel at the time of his death. Although records indicate that Von Siegen produced a considerable number of plates, today only these are undisputed: *Amalia Elizabeth*, landgravine of Hesse-Kassel (1642); three portraits after Honthorst, *Elizabeth of Bohemia*, mother of Prince Rupert (1643), *William II of Orange*, and *Henrietta Maria* (both 1644); *Ferdinand*

III (1654); *St. Bruno in a Grotto* (1654) and a *Holy Family* after Annibale Carracci.

BIBLIOGRAPHY. P. Seidel, "Ludwig von Siegen, der Erfinder des Schabkunstverfahrens," *Jahrbuch der Königlich preussischen Kunstsammlungen*, X, 1889.

<div align="right">JULIA M. EHRESMANN</div>

SIEMERING, LEOPOLD RUDOLF. German sculptor (b. Königsberg, 1835; d. Berlin, 1905). He studied in his native city and in Berlin. His monuments and figures show a moderate realism combined with a taste for sturdy Roman sculpture. Siemering did the Washington Monument in Fairmount Park, Philadelphia (unveiled 1897).

BIBLIOGRAPHY. B. Daun, *Siemering*, Leipzig, 1906.

SIENA. Italian city in Tuscany. Siena was a Roman city, founded by Augustus as Colonia Julia Saenensis, but it did not rise to importance until the 13th century. From that time on it was a center of artistic activity closely rivaling Florence. *See* SIENESE SCHOOL.

Among the wealth of monuments in Siena, some of the earliest and finest examples of secular architecture are the Tolomei Palace (1205), the Palazzo Pubblico (1289–1310), and the Salimbeni Palace (14th cent.). All are in the Tuscan Gothic style, with its distinctive crenelated walls. *See* PUBBLICO, PALAZZO.

The Cathedral, begun in the 12th century and completed in 1382, is brilliant with its bands of red, white, and black marble. The façade was probably designed by Giovanni Pisano. The octagonal pulpit was executed by Nicola and Giovanni Pisano (1266–68). Bernini did two statues (1661) in the Chigi Chapel (Chapel of the Madonna del Voto). The interior of the Cathedral is further enriched with sculptures attributed to Michelangelo, at the Altar of the Piccolomini, and a *St. John* by Donatello, in the Chapel of S. Giovanni, which also contains frescoes by Pinturicchio (1504). The Piccolomini Library opening off the Cathedral is a magnificent Renaissance building, completed in 1495; it is decorated with frescoes by Pinturicchio and his pupils (1505–07). The Baptistery (1317–82), near the Cathedral, has a font by Jacopo della Quercia adorned with sculptures by Ghiberti, Donatello, and others.

In S. Domenico (1226–1465) is the Chapel of S. Caterina with frescoes by Sodoma (1526). S. Agostino was erected in 1258; the interior was restored by Luigi Vanvitelli in 1775; it has paintings by Perugino, Sodoma, and Simone Martini. S. Francesco (1326–1475) contains frescoes by Pietro and Ambrogio Lorenzetti (1330s).

Della Quercia executed the Fonte Gaia (1409–19). The fountain was restored in 1868, and the original sculptures are in the loggia of the Palazzo Pubblico.

Later Renaissance buildings include the Church of S. Maria del Carmine (rebuilt in 1517), with its cloister and campanile, all designed by Peruzzi; the Nerucci Palace (1463), by Bernardo Rossellino; the Spannocchi Palace (1473), by Giuliano da Maiano; and the Piccolomini Palace. *See* PICCOLOMINI PALACE.

See also SIENA: MUSEUMS.

BIBLIOGRAPHY. M. Meiss, *Painting in Florence and Siena after the Black Death*, Princeton, 1951.

<div align="right">STANLEY FERBER</div>

SIENA: MUSEUMS. Important public art collections in Siena, Italy, are located in the museums listed below.

Metropolitan Museum (Museo dell'Opera Metropolitana). The Cathedral museum contains two Sienese cycles of the first importance: Duccio di Buoninsegna's great altarpiece, the *Maestà* (1308–11; restored in the 1950s), and the surviving statues carved by Giovanni Pisano for the façade of the Cathedral. There are also other paintings and sculpture, as well as gold- and silverwork, church vestments, illuminated manuscripts, and drawings and documents pertaining to the Cathedral fabric.

BIBLIOGRAPHY. E. Carli, *Il Museo dell'opera e la Libreria Piccolomini di Siena*, Siena, 1946.

National Picture Gallery (Pinacoteca). Collection begun toward the end of the 17th century and transferred to the state in 1930; it is housed in the beautiful Buonsignori Palace (early 15th cent.). The nearly 700 paintings, chronologically arranged in forty rooms, offer an outstanding survey of Sienese painting from the 12th through the 16th century. Included are excellent works by such masters as Duccio di Buoninsegna, Memmi, Pietro and Ambrogio Lorenzetti, Simone Martini, and Sassetta, in addition to examples of the Florentine school and non-Italian works, notably Dürer's *St. Jerome* of 1514.

BIBLIOGRAPHY. E. Carli, *Guide to the Pinacoteca of Siena*, Milan, 1958.

Palazzo Pubblico. The imposing Town Hall of Siena (1298–1310) is renowned for its 14th-century frescoes. The Sala del Mappamondo boasts two masterworks by Simone Martini: the *Maestà* (1315), depicting the Virgin enthroned among angels and saints, and the secular fresco of the *condottiere* Guidoriccio da Fogliano at the siege of Montemassi. The adjacent Sala della Pace contains a cycle of allegorical frescoes, *Good Government* and *Bad Government* (1338), by Ambrogio Lorenzetti. There are also frescoes by Taddeo di Bartolo, Spinello Aretino, Vecchietta, Sano di Pietro, Sodoma, and Beccafumi. In the loggia may be seen the ruined panels of the outstanding work of Sienese Renaissance sculpture, Jacopo della Quercia's Fonte Gaia (1409–19).

See also PUBBLICO, PALAZZO, SIENA.

SIENESE SCHOOL. One of the most important early Italian schools of painting. In the 13th century a flourishing school already existed in Siena, although all the masters of this period were anonymous with the exception of Guido da Siena. The Sienese school reached its high point in the 14th century with Duccio and Simone Martini. At this time Sienese painting influenced many centers of Italian, as well as French and even Netherlandish, art. The 15th century saw a decline of the Sienese school as most of its painters were limited by narrow provincialism. The Renaissance and mannerist styles flourished in the works of Sodoma and Beccafumi. *See* BECCAFUMI, DOMENICO; DUCCIO DI BUONINSEGNA; GUIDO DA SIENA; SIMONE MARTINI; SODOMA.

See also SASSETTA.

BIBLIOGRAPHY. E. S. Vavalà, *Sienese Studies*, Florence, 1953.

SIERRA LEONE, see AFRICA, PRIMITIVE ART OF (WEST AFRICA).

SIGALON, ALEXANDRE FRANCOIS XAVIER. French painter (b. Uzès, 1787; d. Rome, 1837). He studied in Nîmes and Paris. His first success was *The Young Cour-*

Sienese school. Duccio di Buoninsegna, *Maestà*, detail, 1308–11 (restored in 1950). Cathedral Museum, Siena.

Paul Signac, *The Seine River at Herblay*. Musée du Jeu de Paume, Paris. A typical work by the classical pointillist painter.

tesan (Paris, Louvre) in the 1822 Salon. A painter of history, genre, and portraits, Sigalon was influenced by earlier Italian artists, particularly Titian and Giorgione.

SIGILLOGRAPHY. The study of seals. Sigillography has traditionally been concerned with the authentication of seals to facilitate the historical study of documents. Recently, however, it has become a valuable aid to art historians because many seals, particularly those of the Middle Ages, are large and elaborately decorated, and reflect the contemporary sculpture and architecture. *See* SEALS: STAMP AND CYLINDER.

SIGNAC, PAUL. French painter (b. Paris, 1863; d. there, 1935). Signac's parents wanted him to become an architect, but the visit he made to the Monet exhibition in 1880 decided his career. He wrote to Monet and received his advice. Guillaumin, who had met Signac while painting along the Seine, also encouraged him. In 1883 Signac frequented the free Bing academy, was awarded the Prix de Rome, and became mayor of Montmartre. He greatly admired Jules Vallès and Huysmans. In 1884 he participated in the first Salon des Indépendants with his *Pont d'Austerlitz*.

After a decisive meeting with Cross and Seurat, whose friend he became, he abandoned the impressionist palette and wanted to paint only with the colors of the prism according to Seurat's pointillist method. In contrast to Seurat, however, Signac was exuberant and passionate; he loved audacities and struggles. Every Monday his neoimpressionist friends met at his studio, where they had long discussions for which Signac was the theoretician. He was living in Montmartre at that time, with Seurat as his neighbor. In 1885 he shared a studio with Henri Rivière and was secretary for the newspaper *Le Chat noir*. *See* POINTILLISM.

The year 1886 marked his first contact with southern France, where he visited Collioure and was deeply impressed by its vivid colors. In 1888 he painted *Portrieux* (Otterlo, Kröller-Müller Museum). The technique is based on the principles of Seurat, yet already there is evidence of Signac's strong personality. In the same year he was invited to the Salon des Vingt in Brussels. He adhered to the avant-garde principles of the group and became a member of Les Vingt in 1891. In 1889 he visited Van Gogh in Arles, the latter having shown an interest in neoimpressionism.

A sailor as well as a painter, Signac made frequent voyages along the Atlantic coast and the Mediterranean. He discovered Saint-Tropez and purchased La Hune, a villa to which he returned each year. Gradually his technique was transformed; he abandoned pointillism for a kind of square, mosaic brushwork and violent color harmonies. The series of water colors which he began in 1900, both simple and spontaneous, are among his best work. In 1896 he began to visit other countries: Holland (1896–98, 1906), Italy (1904, 1905, 1907, 1908), and Turkey (1907). Throughout his life Signac was an exhibitor at various salons. From 1898 to the year of his death he was president of the Salon des Indépendants. He was also a writer and published a theoretical treatise, *D'Eugène Delacroix au néo-impressionnisme* (1899). His important study of

Jongkind is a model of its kind. A painter of great poetic sensibility, Signac made an important contribution to modern French art.

BIBLIOGRAPHY. F. Fénéon, "Paul Signac," *Les Hommes d'Aujourd'hui*, VIII, 1890; L. Cousturier, *Paul Signac*, Paris, 1922; C. Roger-Marx, *Paul Signac*. Paris, 1924; G. Besson, *Paul Signac*. Paris, 1935; M. Raynal et al., *History of Modern Painting*, vol. 1: *From Baudelaire to Bonnard*, Geneva, 1949. ARNOLD ROSIN

SIGNATURES, GREEK AND ROMAN, *see* ARTISTS' SIGNATURES, GREEK AND ROMAN.

SIGNIFICANT FORM. Term invented by Clive Bell to designate the essential element in successful works of art. By significant form Bell meant certain combinations of lines, colors, and spatial elements that excite pure aesthetic emotion.

BIBLIOGRAPHY. C. Bell, *Art*, London, 1914.

SIGNORELLI, FRANCESCO. Italian painter (d. 1559). He was the nephew and pupil of Luca Signorelli and was his assistant for a long time. Francesco's works include a *Madonna and Child with Saints* (1520; Cortona, Diocesan Museum) and a *Doubting Thomas* (Cortona, Cathedral).

SIGNORELLI, LUCA. Italian painter of the Umbrian school (ca. 1441–1523). Signorelli is reported by Vasari to have been eighty-two when he died. He was a pupil and collaborator of Piero della Francesca. Signorelli is first recorded in 1470 when he executed a panel (now lost) for a church in his native Cortona. In 1472 he worked in S. Lorenzo at Arezzo, but what he did there is no longer extant. In 1474 he painted a fresco of the *Madonna and Child with SS. Jerome and Paul* for the municipal tower of Città di Castello, of which only the fragmentary figure of St. Paul has survived (Città di Castello, Gallery).

After 1479 Signorelli's name occurs frequently. In that year he was first named a *priore* in Cortona, a position that, together with others, he held virtually continually until his death. In 1482 and 1491 he was called to work in Volterra. In 1482, 1496, and 1498 he was in Città di Castello and in 1484 in Perugia. In 1488 he painted a processional banner (lost) for Città di Castello and in 1491 another one (also lost) for S. Spirito in Urbino. In 1491 he was on a panel judging drawings and models for the façade of the Cathedral of Florence. In 1498 he worked in Siena, and in 1506 he was there to make a cartoon for the pavement of the Cathedral (not executed). The frescoes in the Cathedral of Orvieto, Signorelli's most important works, were executed in the main part between 1499 and 1504, though they were not completed until 1506. In 1503 he was in Rome to decorate the papal apartment of Julius II. During the last two decades of his life he lived chiefly in Cortona, though he continued to work in neighboring cities such as Perugia (1518) and Arezzo (1519 and 1520).

Signorelli's early works fall in the decade of the 1470s. Besides the *St. Paul* of 1474 in Città di Castello, there are the fresco of the *Annunciation* (Arezzo, S. Francesco), which, like the *St. Paul*, is strongly indebted to Piero della Francesca, and the two panels of the *Flagellation* and the *Madonna and Child* (Milan, Brera). The style of the *Madonna and Child* is less connected with Piero della Francesca than with Florentine art, particularly that of Verrocchio and the Pollaiuoli. These influences are predominant in Signorelli's frescoes of about 1480 in the Sacristy of St. John in the Holy House at Loreto: the *Evangelists and the Church Fathers with Angels with Musical Instruments* in the vault and five pairs of Apostles, *Christ and the Doubting Thomas*, and the *Conversion of St. Paul* on the walls.

It is believed that the Loreto frescoes led to Signorelli's inclusion among the painters called by Pope Sixtus IV to decorate the walls of the Sistine Chapel in the Vatican. Vasari states that he painted the *Testament and Death of Moses* there. It was painted with the assistance of Bartolommeo della Gatta, Signorelli's assistant at Loreto, between 1482 and 1484. Signorelli also completed Perugino's *The Consignment of the Keys to St. Peter* in the chapel.

The first major work of Signorelli's mature style is the altarpiece *Madonna and Child with Four Saints and an Angel* (1484; Perugia, Cathedral). It is characterized by powerful, knotty forms, intense deep colors, and a monumentally constructed figural composition close to the picture plane. His next dated works are the altarpieces *Annunciation* and *Madonna and Child with Saints* (1491; Volterra, Municipal Picture Gallery).

He is also recorded in Florence in 1491, where he may have remained until 1492. During this time he painted two pictures for (according to Vasari) Lorenzo de' Medici: *Pan* (formerly in Berlin, destroyed in World War II) and the *Madonna and Child tondo* (Florence, Uffizi). *Pan* is an allegory alluding to the so-called "Platonic Academy" of Lorenzo de' Medici at his villa of Castello, where the picture originally was. Its principal figures are nudes (as are some figures in the background of the Uffizi *tondo*), and they show Signorelli's mastery of and power in rendering the human form, which had such an impact on the young Michelangelo. *Pan* also reveals Signorelli's dramatic talent in the use of light.

At the same time as the Florentine pictures, he painted a *Circumcision* (London, National Gallery) in which the Christ child was repainted by Sodoma. His next important dated picture is the *Nativity* (1496; London, National Gallery). The *Martyrdom of St. Sebastian* (1498; Città di Castello, Gallery) shows a renewed contact with Florentine art, particularly with the work of Antonio del Pollaiuolo, whose version of the same subject (London, National Gallery) it partly adapts. Between 1497 and 1499 Signorelli and his atelier executed nine frescoes of the *Life of St. Benedict* in the cloister of the monastery of Monte Oliveto Maggiore (a cycle continued in 1505 by Sodoma). Their posing and grouping of figures and their background landscapes have a typically Umbrian character, reminiscent of Fiorenzo di Lorenzo and Pinturicchio.

In 1499 Signorelli contracted to finish the vault decorations of Fra Angelico in the Cappella Nuova (Chapel of S. Brizio) in the Cathedral of Orvieto, and in the following year he undertook the complete decoration of the chapel. Its wall frescoes depict with unprecedented violence the events of the end of the world: the *Teachings of the Antichrist*, the *Resurrection of the Dead*, the *Condemned Taken to Hell*, and the *Reward of the Elect*. Their chief source of inspiration was Dante's *Divine Comedy*. The poet himself is represented in grisaille in one of the fields of the ornamental borders that surround the

main subjects. The frescoes contain the most rigorous studies of the nude before Michelangelo, the culmination of the Quattrocento's factual investigations of anatomy. In their exacerbatedly harsh character they convey with unparalleled intensity the terror of the events whose fearful pantomime they enact.

During the first decade of the 16th century Signorelli painted the following major altarpieces: a *Deposition* (1502; Cortona, Diocesan Museum), a *Magdalen* (1504; Orvieto, Cathedral Museum), a *Crucifixion* with *SS. Anthony Abbot and Eligius* on the back (Sansepolcro, Municipal Picture Gallery), a *Madonna and Child with Four Saints* (Uffizi), a *Madonna and Child with Four Saints* (1508; Brera), a large polyptych (1507), and a *Baptism of Christ* (1508; both Arcevia, S. Medardo). Among later altarpieces are the *Institution of the Eucharist* (1512; Cortona, Diocesan Museum), the *Madonna and Child with Saints and Angels* (1515; Cortona, S. Domenico), the *Deposition* (1516; Umbertide, S. Croce), the *Madonna in Glory* (1519; Arezzo, Picture Gallery), the *Immaculate Conception* (1521; Cortona, Diocesan Museum), and the *Coronation of the Virgin* (1523; Foiano della Chiana, S. Martino). In these post-Orvieto works of Signorelli's late style, the compositions become increasingly crowded, heavily laden, and ornamented. There are three splendid portraits by him, one in the former State Museums, Berlin, and two, of Camillo Vitelli and Vitellozzo Vitelli, in the Berenson Collection in Settignano.

Signorelli's influence on the painting of the High Renaissance was more considerable than that of any of his Florentine contemporaries (with the exception, of course, of Leonardo). Both Raphael and Michelangelo found a liberating and inspiring example in his work.

BIBLIOGRAPHY. M. Cruttwell, *Luca Signorelli*, London, 1899; A. Venturi, *Luca Signorelli, interprete di Dante*, Florence, 1921; L. Dussler, *Signorelli*, Stuttgart, 1927; *Mostra di Luca Signorelli* (catalog), Florence, 1953; M. Salmi, *Luca Signorelli*, Novara, 1953.

HELLMUT WOHL

SIGUENZA CATHEDRAL. Spanish cathedral begun in the Romanesque style about 1160. Work continued in the Gothic style from about 1200 through the 14th century. The fortresslike, tripartite, clerestoried basilica has an ambulatory of the late 16th century and a crossing lantern rebuilt in the 20th. The Cathedral contains many chapels in the Plateresque style, rich tomb monuments, and fine *rejas*. The cloister is in the late Gothic style. The sumptuous Renaissance sacristy is by Alonso de Covarrubias and other artists.

BIBLIOGRAPHY. *Ars Hispaniae*, vol. 7, Madrid, 1952.

SIKHARA. Tower in the Hindu temple (for example, at Khajurāho), pyramidal and sometimes with convex sides. It became one of the more distinctive features of the temple, developing from the upper story of early shrines and being crowned by a *sringa* (cupola) or a wagon roof. The śikhara was part of the Hindu temple microcosm of the world. (Compare the Buddhist stūpa.) The temple plinth was the altar, and its superstructure the world-mountain Meru on which the gods lived. The temple cella was a cave, or *guha*, in which the image of the deity was hidden, and surrounding it were the chapels of other deities in their cosmic order.

See also AMALAKA.

SILANION. Greek sculptor of Athens (fl. ca. mid-4th cent. B.C.). His famous portrait of Plato, dedicated in the Academy by Mithridates the Persian, is known through many Roman copies. He was the author of a treatise on symmetry, which, like all his work except the portrait of Plato, is lost.

BIBLIOGRAPHY. R. Boehringer, *Platon, Bildnisse und Nachweise*, Breslau, 1935.

SILHOUETTE. The word, meaning "reduction to a minimum," derives from a satirical reference to the stringent economic policies of Etienne de Silhouette (1709–67), comptroller general of France. The silhouette is a profile portrait done in solid black on white or vice-versa. Popular in the late 18th and early 19th century, it anticipated the development of photography in its emphasis on the direct image. The term may also refer to any defined flat areas of color in painting.

SILK. Translucent fiber unwound from the softened cocoon of the mulberry silkworm. The yellowish fiber is then reeled into thread and twisted into yarn. Frequently it must also be bleached, dyed, and weighted before it can be woven into fabrics. These can be airy and lightweight or heavy and deep-piled. Culture of the silkworm began in ancient China, was carried to medieval Byzantium, and was introduced eventually to Greece, Sicily, Italy, and France. *See* CHINA: SILK.

SILK SCREEN (Serigraph). An original, multicolored print having a real paint quality; the newest medium in the field of printmaking. Essentially a stencil process, silk screen employs transparent, semitransparent, and opaque color effects in the finished prints.

Silk or bolting cloth is stretched across a wooden frame that is fastened to a baseboard. Each stencil and color run adds one color to the print; that is, a stencil is prepared for each color. The colors are mixed by adding a transparent base to the oil paints or inks.

A sheet of paper is placed between the printing frame and the baseboard, and a squeegee is employed to push the paint through the silk and onto the paper. The entire color run is pulled in this manner, and the same procedure is repeated for each color in the print.

BIBLIOGRAPHY. H. Sternberg, *Silk Screen Color Printing*, New York, 1942; J. Heller, *Printmaking Today*, New York, 1958.

SILL. Base, especially in timber construction, supporting a wall. In New England colonial houses sills resting on top of foundation walls carried the frame above. The term also denotes a member at the bottom of a window or door opening: a threshold.

SILOE, DIEGO DE. Spanish sculptor and architect (ca. 1495–1563). He was the son of Gil de Siloe. It is believed that Diego studied sculpture in Florence, where he may have been particularly influenced by the works of Desiderio da Settignano. Italy was also where he learned architecture, but his unique style does not permit reference to a specific Italian master. Diego excelled in both arts, was prolific, and had numerous students in his na-

Luca Signorelli, *Crucifixion with the Magdalen*, ca. 1500–05. Oil on canvas. Uffizi, Florence.

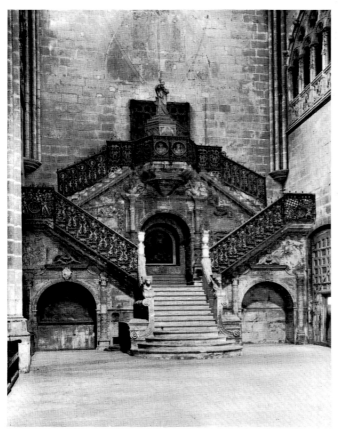

Diego de Siloe, Golden Stairway, Burgos Cathedral, 1519–26.

tive Burgos and in Granada. Although his works and influence are found throughout Spain, it may be said that in Burgos he was chiefly occupied as a sculptor and in Granada, as an architect.

He is first documented as collaborating with Ordóñez and Santacroce on the *Caraccioli Altarpiece* (1514–15; Naples, S. Giovanni a Carbonara), the major part of which is his. Diego's sculptural style, undeniably Italianate, is also a highly personal blending of the florid Gothic and the Mudejar (Christian-Moorish) of the traditional art of Spain. Rather than introducing a revolutionary new style into Spain, his art brought an artistic compromise or a stylistic fusion. At times, the presence of fragility, imbalance, or nervous languor in his statues and reliefs warrants the theory that he may have had knowledge of the school of Fontainebleau of Francis I.

The marble *St. Sebastian* (Burgos, Parish Church of Barbadillo de Herreros) is a High Renaissance work in which the ordeal of the saint is merely the excuse for a study of classic beauty in the male form. A later work in polychromed wood, *Christ at the Column* (Granada, S. José), departs from idealized naturalism and makes the nude figure an instrument for the expression of pathos. Hispanic concern for the values of the inner life, as opposed to visual harmony, probably motivated Diego to exploit the drama of fretful chiaroscuro, as in the wood relief *St. John the Baptist* (ca. 1528) from the choir stalls of S. Benito Convent (now a museum), Valladolid; or of calligraphic tension, as in the wood relief *Madonna*

and Child (1528–30) for the Prioral Chair in S. Jerónimo, Granada.

Diego left Naples in 1519 for Burgos, where he collaborated with the sculptor Felipe Bigarny on the main altarpiece (1523–26), in polychromed wood, for the Chapel of the Constable, Burgos Cathedral. Combining his two arts, he created the Golden Stairway (*Escalera Dorada*, 1519–26) in Burgos Cathedral; it is an impressive forked stairway that connects the Cathedral's lateral door (high up on a side wall due to a sharply inclined street) with the ground floor of the interior. Both the iron balustrade and the stone reliefs were originally gilded and painted. This colorful exuberance provided the natural environment for the fantastic subjects inspired by Italian grotesques.

The apex of his architectural designs was Granada Cathedral (1528–43). Several of its various elements were present in his previous and later works. The Cathedral is classified as an expression of the first phase of the so-called "Plateresque" (silverwork-like) style, combining Gothic, Renaissance, and Mudejar features. The influence of Granada Cathedral was perpetuated in the works of Diego's pupil Andrés Vandelvira. *See* GRANADA.

BIBLIOGRAPHY. E. Gómez-Moreno, *Breve historia de la escultura española*, 2d ed., Madrid, 1951; E. Rosenthal, *The Cathedral of Granada*, Princeton, 1961.

EILEEN A. LORD

SILOE, GIL DE (Gil Siloe; Gil de Urliones or Urlienes; Gil de Emberres or Amberes). Spanish sculptor (d. ca. 1501). Little is known of his life. His disputed origin is evident in the various names by which he is known: Urliones or Urlienes are generally understood as Orléans, and Emberres or Amberes as Antwerp. It is also speculated that he might have been Abraham de Nürnberg. Abraham was brought to Spain from Nürnberg by the prelate Alonso de Cartagena, and is said to have changed his name to Gil de Siloe. Gil's son was the sculptor and architect Diego de Siloe.

Gil has been called the greatest Spanish sculptor of the 15th century. His style makes it possible to support any one of the probabilities regarding his origin. Some of his iconography has been traced to northern French art, and his figural sculpture shows relationships to the art of both Flanders and the Lower Rhine. He worked in alabaster and in polychromed wood. In the latter medium, Diego de la Cruz was responsible for the painting. It is evident in all the works that Gil designed the ensemble and executed the major parts but left the remainder to many assistants, whom he supervised so sedulously that only the closest study reveals degrees of inferiority.

In the four extant works authenticated by documents, there is exuberant variety. Ornamentation is rich in heavy brocades, embroidered and bejeweled. Openwork vines intermingle with sportive *putti* and imaginary animals or animated heraldry. Iconographical whimsy occurs in the figure of St. Mark wearing spectacles and St. Matthew's ox obligingly lending his horns as a lectern. Compositional surprises are met in unexpected shapes for a sepulchre or for altarpiece panels. This assault on the eye and the mind is accomplished in a harmonious union of plastic values with careful attention to the refining of details, as in the star-shaped *Sepulchre of John II and Isabel of Por-*

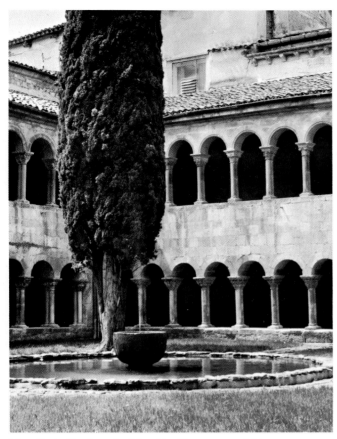

Silos. Santo Domingo de Silos. The Romanesque cloister.

tugal (1489–93; Miraflores, La Cartuja). The unique form of this tomb of the parents of Isabel of Spain may be an adroit adaption of the influence of Mudejar art prevalent in Castile at that time. Gil de Siloe's art was a triumphant farewell to the Gothic style in Spanish sculpture.

BIBLIOGRAPHY. H. E. Wethey, *Gil de Siloe and His School*, Cambridge, Mass., 1936; B. G. Proske, *Castilian Sculpture, Gothic to Renaissance*, New York, 1951.

EILEEN A. LORD

SILOS: SANTO DOMINGO DE SILOS.

Spanish church, begun by S. Domingo (d. 1073). It was almost entirely replaced by the present church (1756–1816). The Romanesque church, dedicated in 1088, seems to have been similar in style to S. Vicente at Avila. Part of a remarkable gold and enamel reliquary is still at Silos; another section is in the Burgos Museum. This reliquary almost certainly dates from the 12th century.

The two-story Romanesque cloister has extraordinarily fine narrative capitals (1083–1100). The oldest, on the north and east sides on the lower level, are the most beautiful. The cloister, even though not completed, seems to have been dedicated in 1088 at the same time as the church. Moorish influence is present in the transepts and in the cloister. It is the peculiar charm of these sculptures that Mozarabic delicacy is curiously linked with Christian archaism and vigor.

Among the most significant of the sculptures of the cloister are the angle piers. One of these shows Christ clad as a pilgrim of St. James in the scene of the jour-

ney to Emmaus. This has an 11th-century counterpart in the frescoes of the southern Italian Church of S. Angelo in Formis. Another unusual pier represents the Entombment and the Three Marys at the Tomb in the same scene, an iconographical error that would scarcely have been made in the 12th century. The angle piers with representations of Doubting Thomas and of Pentecost are strongly reminiscent of 11th-century frescoes and manuscripts, especially in the spatial arrangement of the rows of figures one above the other. The story of the Descent from the Cross is told with especial tenderness and an amazing sense of freedom and movement on another pier.

The capitals reflect vitality and variety of expression. Delicately carved birds, flowers, and vines are contrasted with monstrous creatures created from an imagery of the purest fantasy. Others are of rich lacertine designs reminiscent of Celtic and Christian Irish art.

BIBLIOGRAPHY. E. Mâle, *L'Art religieux du XIIe siècle en France*, Paris, 1922; A. K. Porter, *Spanish Romanesque Sculpture*, New York, 1929.

ALDEN F. MEGREW

SILPASASTRA. Hindu treatise on art, especially one having to do with images or sculpture, though including architecture and the other arts. The Silpaśāstras were compiled in India mainly during the period from the 6th to the 12th century.

SILVANI, GHERARDO. Italian architect and sculptor of the Florentine school (1579–1675). Silvani was the most important and prolific baroque architect in Florence for the greater part of the 17th century. His major work is S. Gaetano, whose façade (1645) is the most pronounced high baroque design in Florence.

BIBLIOGRAPHY. R. Wittkower, *Art and Architecture in Italy, 1600–1750*, Baltimore, 1958.

SILVER. In heraldry, silver is one of the metal colors and is called argent. Throughout Christian art, silver has been a general symbol for chastity and purity; more specifically, silver is symbolic of the eloquence of the evangelist.

SILVER AND GOLD. Regarded as precious metals all through history, both silver and gold have been used for the special objects in cultures employing religious or political ritual. In the history of style, silver and gold objects provide illustrations of the finest expression of any period except the 20th century, when significant artistic expression has tended to be revolutionary and in defiance of official taste. Present-day silver and gold objects are in the main conservative in design, but a small group of artist-craftsmen has been working in the current, less conservative artistic styles.

The prime characteristics of silver and gold are malleability and ductility. These qualities make the metals easy to shape and to work on the small scale that is generally used because of cost. Court furniture—from the gold pieces in the palace of King Solomon to the silver ones of Louis XIV—is the major exception to the use of these metals on a small scale. Hammering (referred to as "raising") and casting are the two most important techniques for shaping silver. Gold was worked in similar ways, but in ancient times special methods of working decoratively with gold wire were developed, and grains of gold were

applied to smooth surfaces in special ways. Because they were among the earliest metals known to man, and the easiest to work, silver and gold jewelry is found on prehistoric sites all over Europe, and objects have been uncovered in prehistoric Scandinavian sites. The use of gold seems to have been introduced by the 4th millennium, while silver came in between 4000 and 3000 B.C. *See* GOLD, ANCIENT USES OF; JEWELRY, HISTORY OF.

Egypt. In ancient Egypt, records show that an enormous amount of precious metal was brought to the Pharaohs as tribute. Gold was mined in Nubia, and silver came from Asia Minor and was relatively rare and rather similar to gold in value. The treasures of tombs from the first few dynasties have contained gold and not silver, but this is in part owing to the fact that personal objects were buried with the dead more often than household possessions. Representations in reliefs and frescoes show the use of silver and gold objects such as plates and vases which are sometimes elaborately decorated and at other times relatively simple. In later tombs, Minoan influence seems to have inspired the design of gold and silver vessels.

In the main, the repertory of ornament generally used in Egypt can be found on the gold and silver. A gold patera in the Louvre Museum, Paris, once in the possession of an officer of Thutmosis III, is decorated with repoussé fishes surrounded by a lotus-flower border. It resembles blue-glazed faïence bowls in the decorative scheme. Goldwork found in the mummy case of Queen Hatshepsut and dating from about 1500 B.C. shows the richness of the work. There is a poniard with a gold blade on which is engraved a battle between a lion and a bull that shows the skill of the craftsmen of the period. Gold and silver were also used for statuary and as inlay.

Mycenae and Greece. The wealth of fine work in the Mycenaean civilization has been displayed in museums in the West since several hoards were uncovered in the late 19th century. Typical are the vessels decorated with high relief representing battle scenes. The British Museum in London has representations of the period. The tradition continued to the time of the Ionian migration in about 1000 B.C., or the period of Homer, when gold is described as the material for beds, thrones, ornaments on chariots, armor, and the more usual vases and cups. In later years, in the classical age, a technique of using gold grains was developed for small objects. The use of gold in sculpture is documented in the descriptions of Pausanias, who speaks of the elaborate idols covered in ivory with inlays of gold. An alloy called "electrum," which was gold with a fifth part of silver, was used in this period and is represented by a vase in Leningrad, while the British Museum has some Greek gold and silver.

Rome. During the imperial period Rome was the scene of luxurious living with all the proper accouterments. Greek craftsmen were popular, and their work was particularly desirable. The Romans sought the older products of Greece, and there is evidence of their paying high prices at auction for early Greek silver. In the work uncovered at Pompeii and in the imperial silver from the Treasure of Hildesheim, one sees that Roman work was typified by a preference for classical forms and decoration. Repoussé work was popular in overall vine patterns.

Animal-form cups and animal forms for handles were also used extensively.

The shift of the capital of the empire of Rome to the East marked a new development in design. More richly decorated surfaces were preferred, and the tendencies to a flatter decoration which is Eastern were exploited more fully.

Byzantine and medieval eras. With the adoption of Christianity and the emergence of the Byzantine culture, the richness of the Eastern classical style was notable and was a steady source of inspiration for the West. When Charlemagne in A.D. 800 sought luxurious gold and silver articles, he had Eastern or Byzantine craftsmen provide them. As a complete contrast, in about the same period there was a moment of strong Celtic influence in the 8th and 9th centuries when Irish work was particularly significant, bringing with it a love of abstract geometric decoration and interlaced patterns to create vibrant surfaces.

In the 11th century Europe underwent a great resurgence of interest in building churches, and for these new establishments schools of ecclesiastical goldsmiths at abbeys in England, France, Italy, and Germany provided altar fronts and a variety of ritual objects. There was a certain homogeneity in the work done everywhere, reflecting a similarity of approach from both a technical and a decorative point of view. The Romanesque architectural style was a factor in design, although Byzantine influences introduced some classical ideas. Enamel decoration was used. Benedictine monks were among the most influential in this period and their motherhouse at Montecassino was a prime source of direction and inspiration.

The use of enamel increased with the development of centers in Cologne and Limoges that produced secular and ecclesiastical work. Furniture was made along with smaller work such as ewers and basins, pyxes, chalices, and the like. The Gothic style came into fashion in gold- and silverwork in the 13th century, and the pointed arch was a much-used decorative motif. One religious form added in the 13th century was the pax, a tablet with a handle on the back which was kissed by the priest and people during the Mass to communicate the kiss of peace. This often had an architectural frame and was of silver, gold, or a gilded metal. The importance of gold and silver secular work increased in the 13th century. Precious table and personal ornaments were used more. Salt containers and spice containers were prominent pieces, the latter often in the shape of a ship.

Guilds in most of Europe controlled the quality of output. In England the goldsmiths received royal patronage in 1327, and regulations for quality introduced then have been retained to modern times, except for a period in the 16th and 18th centuries. Approved silver and gold objects are marked by the guilds of the city in which they were made.

Renaissance. With the advent of the Renaissance many artists were involved in designs in the new style, and names famous in painting and sculpture were also goldsmiths, as Domenico Ghirlandajo and Andrea del Verrocchio. Damascene work, with decorative surfaces, became particularly important in the 16th century when the clas-

sical designs of the Renaissance were introduced in the north and important centers were established at Nürnberg and Augsburg, to mention two. Through generous patronage from the court, England developed a fine group of goldsmiths in the 16th century. Many Flemish, German, and Italian craftsmen had been invited to work there and to assist in the creation of an English style employing Renaissance details. *See* DAMASCENE.

17th and 18th centuries. In the 17th century the flamboyance of the baroque was expressed well in goldwork in the German shops, and Dutch and Flemish craftsmen did decorative work in relief patterns that was influential. The period marked an important moment in the development of the English shops because, although many craftsmen migrated to England from the Continent, an English style emerged in the course of the 17th century and England remained important in the 18th century.

In silver, although designs and decorative schemes reflected the major innovations in style that began on the Continent, English work is distinctive and fine. The quality of the metal and the desire to use it to its best advantage are factors in the English approach that have made it great. Every piece is well executed and both handsome and durable. Although in the 18th century the Parisian silversmiths were sometimes the significant innovators in design, their English competitors were more consistent in quality.

Modern period. In the 19th century mass production brought mediocre plated silver to the masses, who mistook it for the real thing, but craftsmen continued to produce fine work in styles not understood today. With the craft revival, design was affected and the mass market was also affected to some degree. The disappearance of the craftsman's shop occurred as the artist-craftsman began to play an important role in the 1870s. Today a small number of valiant artist-craftsmen work hard to influence mass-market design.

Although not influential on the whole field, the American approach to silver has been distinctive. Earlier American craftsmen tended to be simple and forthright in design and to exaggerate the English tendency to use good metal well. In work that reflects the rococo at its extreme, the American craftsman tended to retain the functional elements of a shape and to work within his limitations in rendering the details of a design.

BIBLIOGRAPHY. J. H. Pollen, *Ancient and Modern Gold and Silversmiths' Work in the South Kensington Museum*, London, 1878; C. J. Jackson, *An Illustrated History of English Plate*, 2 vols., London, 1911; M. Rosenberg, *Der Goldschmiede Merkzeichen...*, 3d ed., 4 vols., Frankfurt am Main, 1922–28.

MARVIN D. SCHWARTZ

SILVERPOINT DRAWING. The metal points, of which silverpoint is by far the most important in the history of drawing, were the forerunners of the modern pencil. Lead point and gold point are the other, but less used, metal points. The silverpoint technique employs two materials: a silver wand sharpened to a fine point and a paper that has been coated with a priming material to harden its surface. As the silver point is pushed along the surface, the priming coat breaks, leaving a delicate, light gray line. In time, the color of the line deepens to a darker and warmer shade of gray. The fragile nature of the treated paper makes retouching or erasure almost impossible. The

Silverpoint drawing. Jan van Eyck, *Portrait of an Unknown.*

silverpoint drawing is therefore delicate, even in the hands of a powerful master such as Raphael. The technique came into use in the 15th century. Some of the finest of all silverpoint drawings were Pisanello's animal studies. Leonardo and Raphael used silverpoint, and Dürer is credited with the widespread use of silverpoint in the north, where its popularity outlasted that in Italy.

SILVERSMITHS, ARCH OF THE, ROME. Monumental gateway erected in the Forum Boarium in A.D. 204 by the guild of the *argentarii* in honor of Septimius Severus and his family. The arch consists of a passageway and a lintel supported by piers. It is decorated with floral pilasters and reliefs representing sacrificial scenes.

BIBLIOGRAPHY. S. B. Platner, *The Topography and Monuments of Ancient Rome*, Boston, 1904.

SILVER WEDDING, HOUSE OF THE, POMPEII. One of the most splendid houses in Pompeii, Italy, excavated in 1893 in honor of the silver wedding of the King and Queen of Italy. The house, of Samnite origin, was remodeled under Augustus and later under Nero and the Flavians. It consists of a tetrastyle atrium with an impluvium; a vaulted tetrastyle oecus, Hellenistic in plan, with wall decorations of the second Pompeian style; and cubicula (bedrooms) decorated with wall paintings of the third style.

BIBLIOGRAPHY. A. Maiuri, *Pompeii*, Novara, 1960.

SILVESTRE, ISRAEL. French etcher (1621–91). Born in Nancy, Silvestre was sent to Paris at the age of ten. He formed his drawing style on that of Callot. Turning to landscapes exclusively, he made numerous views of the environs of Paris, and journeyed throughout France and to Italy and England. The style and quality of his etchings came to the attention of Louis XIII, who commissioned him to etch views of all the royal houses as well as of all the places that the King had conquered. Silvestre rarely made pictures of nature; he preferred man-made gardens, palaces, and fortresses. His work was delicate, neat, and accurate. He created strong contrasts of light and dark, biting his plates two times or more in the manner of Callot. Backgrounds were lightly bitten; dark *repoussoir* figures were used in the foreground. He made more than 1,000 etchings.

BIBLIOGRAPHY. L. E. Faucheux, *Catalogue raisonné de toutes les estampes qui forment l'oeuvre d'I. Silvestre*, Paris, 1857.

SILVESTRE, LOUIS, THE ELDER. French painter and etcher (b. Paris, 1669; d. there, 1740). The second son of Israel Silvestre, he was probably trained by his father and Charles Le Brun. Strictly a landscapist, he was a painter to the king and a member of the Royal Academy (1706).

SILVESTRE, LOUIS, THE YOUNGER. French history and portrait painter and decorator (b. Sceaux, 1675; d. Paris, 1760). He was the pupil of his father, the engraver Israel Silvestre, of Charles Le Brun, of Bon de Boullogne, and, in Rome (1693–1700), of Carlo Maratta. In 1752 he became director of the Royal Academy. From 1716 to 1748 he chronicled, in diminutive rococo scale, state occasions and painted portraits at the courts of Dresden and Warsaw.

SIMA. Stone molding which forms the gutter of the upward-sloping part of the roof of an ancient Greek temple. At the outer edge, the sima often bears gutter spouts and decorative acroteria.

SIMON, ST. Apostle and possibly a member of the "Zealots," an anti-Roman party. He preached in Egypt. Pseudo-Abdias's History of the Apostles says that Simon and Judas Thaddeus, the brothers of Simeon of Jerusalem and James the Less, went to Babylon, confounded the magi-

cians with their prophecies, and exonerated those falsely accused of sin. In Persia, they broke images of idols and were put to death. Simon was cut in two by a saw. His attributes are a saw and a cross. His feast is October 28.

See also JUDAS THADDEUS, ST.; SAINTS IN ART.

SIMON, JOHN (Jean). French-English engraver (b. Normandy, 1675; d. London, 1751). Simon studied line engraving in Paris, then migrated to London at the beginning of the 18th century. There he took up mezzotint under the tutelage of Godfrey Kneller. More than 200 plates are presently ascribed to him; especially numerous are portraits after a variety of rococo painters.

BIBLIOGRAPHY. A. M. Hind, *A Short History of Engraving and Etching*, 2d rev. ed., London, 1911.

SIMON, LUCIEN. French painter (b. Paris, 1861; d. there, 1945). He studied briefly at the Académie Julian. Simon painted genre, portraits, and popular scenes of Brittany life in a style derived from Hals.

BIBLIOGRAPHY. L. F. Aubert, *Peintures et aquarelles de Lucien Simon*, Paris, 1924.

SIMON, PIERRE. English draftsman and engraver (before 1750–ca. 1810). A native of London, Simon was one of England's better engravers in the dotted manner. His output was not large, and the best of it appeared in John Boydell's *Shakespeare Gallery*.

SIMONE DA PESARO, *see* CANTARINI, SIMONE.

SIMONE DEI CROCEFISSI. Italian painter (ca. 1330–99). He was a member of the Bolognese school and a follower of Vitale da Bologna. He was mentioned as *"magister ... pictor"* in 1355 and was commissioned for fresco work in 1366. Simone's name resulted from his having painted the Crucifixion motif many times, though he might easily be known as Simone of the Coronations, for a large number of his surviving paintings represent that subject. Some of his works may be confused with those of Vitale because of similarity in style. His best fresco work is in the Mezzaratta Church in Bologna. Most of the paintings ascribed to him are in Bologna, including a *Coronation of the Virgin* (1368–70; National Picture Gallery). He may be described as a journeyman par excellence of the 14th century.

BIBLIOGRAPHY. E. Sandberg-Vavalà, "Vitale delle Madonne e Simone dei Crocefissi," *Rivista d'arte*, XI, XIII, 1929, 1930.

SIMONE MARTINI. Sienese painter (b. Siena, ca. 1280–85; d. Avignon, 1344). Simone's brother, Donato, was also a painter, with whom he sometimes collaborated. In 1315 Simone executed his earliest-known painting, the great *Majestas* in the Sala del Mappamondo of the Palazzo Pubblico in Siena. The work, signed and dated July 23, established his reputation.

He probably left for Naples in 1317. An annual salary was granted by Robert of Anjou to one Simone Martini, probably the painter. There is also evidence that he maintained a temporary residence at the court of Naples. It is possible that Simone painted the *St. Louis of Tou-*

Israël Silvestre, Place Hôtel-de-ville, Lyon. Etching.

Simone Martini, detail of the *Annunciation.* **Altarpiece executed in 1333 for the Chapel of S. Ansano, Cathedral of Siena. Uffizi, Florence.**

louse Crowning Robert of Anjou (ca. 1317; Naples, Capodimonte) in Siena and sent it to Naples, but it seems more likely that the artist executed it there.

In or before 1320 Simone returned to central Italy and executed a polyptych for the high altar of S. Caterina in Pisa and a signed altarpiece, *Madonna and Saints*, for Orvieto Cathedral (Cathedral Museum). Again, it appears that he visited these towns in person, for extant work by his pupils there seems to attest to his presence. In December, 1321, he was paid for renovating the *Majestas* of 1315. In the same month he produced a *Madonna* (now lost) for the Chapel of the Nove in the Palazzo Pubblico. Again, in April, 1322, he was paid for several frescoes in the Loggia of the Palazzo. In June of the same year he had completed a *St. Christopher* and the coat of arms of the podestà.

He married Giovanna, daughter of the painter Memmo di Filippuccio and sister of Lippo Memmi, in 1324. It was probably between 1320 and 1325 that Simone completed the cycle of frescoes in the Chapel of St. Martin in the Lower Church of S. Francesco, Assisi. Documentary evidence for the next three years exists for various miscellaneous compositions. In August, 1328, he produced one of his most outstanding works, the equestrian portrait of the Sienese captain general *Guidoriccio da Fogliano*, victor at Montemassi (Siena, Palazzo Pubblico). The polyptych of *Beato Agostino Novello* (Siena, Sacristy of S. Agostino) has been attributed to Simone on the basis of the four scenes on the wings. It dates between 1328 and 1333. His next major effort was the altarpiece of the *Annunciation* (Florence, Uffizi), executed in 1333 for the chapel of S. Ansano in Siena Cathedral. Here, he collaborated with his brother-in-law, Lippo Memmi. Simone produced the central panel, and Lippo gilded the frame and the haloes and perhaps executed the paintings of the saints on the side panels. Between 1333 and 1339 there is no definite knowledge of Simone's activities.

Probably in 1339, he left Siena for Avignon with his wife and his brother, Donato. In May, 1342, he painted *Christ Returning from the Temple* (Liverpool, Walker Art Gallery). During his sojourn in Avignon he made friends with Petrarch, and this friendship was of importance for his later fame. The poet's regard for the master is reflected in two sonnets in which he refers to Simone as the painter of Laura del Sade's portrait. This painting has not as yet been identified. Simone enjoyed considerable popularity at Avignon and founded a school there, his chief assistant being Matteo da Viterbo.

What we have in Simone's "first extant painting," the *Majestas*, is of course the renovation of 1321. It is not known how extensive this renovation was, but criticism favors the view that it was slight, leaving the painting's overall character unchanged. It reveals a master already possessed of an assured personal style. Its importance implies that his was already a reputation to be dealt with. Traces of Duccio's influence are present, but the work shows considerable humanization of the severe Ducciesque Byzantine style.

St. Louis of Toulouse Crowning Robert of Anjou is truly grandiose in conception. The frontal position of the saint, together with his rich vestments, contributes to a monumental effect. The contrast between the idealized saint and the realistic rendering of Robert is striking. However, Simone's most ambitious contribution to narrative painting is the series of frescoes depicting scenes from the life of St. Martin. The cycle is neither signed nor documented, but it is clearly related to the master's early period. Certain disparities of style show that Simone did not work unaided; it is possible that his brother, Donato, was responsible for some of the figures. Though the cycle suffers from unevenness and even awkwardness, it is noteworthy for its admirable treatment of groups and for the expression of the saint's spirituality, which makes itself felt amid the courtly splendor surrounding him.

The magnificent equestrian portrait of *Guidoriccio da Fogliano* exemplifies the trend toward realism prevalent in all of Italy at the time. No attempt has been made to idealize the portly general who arrogantly sits astride his sturdy mount. The drapery pattern of both horse and rider as well as the outline of the former employs and repeats a graceful S curve which makes the group a masterpiece of decorative art.

In the S. Ansano *Annunciation* Simone reached the peak of his creative achievement and produced the greatest work of the Sienese school. The drama of the scene is expressed in the hushed adoration of the angel Gabriel and in the Virgin's agitation, realized in the diffidence of her glance. Little in Western art matches the elegant and expressive linearity of these figures. Equivalents must be sought in the paintings of the Chinese and Japanese masters. The popularity of the *Annunciation* was immediate, and its fame spread throughout northern and central Italy where, for a hundred years, imitations and reflections of it repeatedly appeared.

Most of what little remains of Simone's Avignon period is in a very poor state of preservation. However, his influence there is clearly to be seen in the work of his pupils. A signed and dated panel, *Christ Returning from the Temple*, illustrates a marked departure from the S. Ansano *Annunciation*. The influence of the Flamboyant Gothic is found in the new emotionalism of the figures, in the voluminousness of the drapery, and in brighter and warmer colors. A related work, dating from about 1339, is a small polyptych whose six extant panels are in Antwerp, Berlin, and Paris. *The Way to Calvary* (Paris, Louvre) is justly celebrated as a tour de force of color.

To Simone, problems of form, plasticity, and exact imitation of nature were not of primary importance. His genius turned rather to drawing and linear expressiveness; in this field he has few equals in Western art. Nobility and aristocratic reserve expressed by meticulous decorative schemes and brilliant colors were his legacy to Italian painting.

BIBLIOGRAPHY. R. van Marle, *Simone Martini et les peintres de son école*, Strasbourg, 1920; G. H. Edgell, *A History of Sienese Painting*, New York, 1932; G. Paccagnini, *Simone Martini*, Milan, 1955.

FRANKLIN R. DIDLAKE

SIMONINI, FRANCESCO. Italian painter (b. Parma, 1686; d. Venice, 1753). A student of the battle painter Flavio Spolverini, Simonini also became a specialist in this genre. He first worked for English clients and then for the aristocracy in and around Venice, creating frescoes as well as oil paintings. With his knowledge of military strategy

he painted lively scenes of clashing figures in deep space, often focusing the composition on a climactic meeting of mounted soldiers at the center. His lighting effects, spatial compositions, and brushstrokes have the bravura typical of the Venetian school. Works of Simonini are to be found in many of the museums of Italy as well as in other parts of Europe.

BIBLIOGRAPHY. G. Delogu, "Disegni di Francesco Simonini a Venezia," *Dedalo*, XI, May, 1931.

SIMON OF TRESK. English architect (fl. ca. 1260–90). His early work is the Angel Choir of Lincoln Cathedral, begun about 1256 and completed by 1280. This is one of the crowning achievements of the English Gothic, with sculptures of angels that are closely linked to the Westminster school.

BIBLIOGRAPHY. J. Harvey, comp., *English Mediaeval Architects*, London, 1954.

SIMONS, MICHIEL. Flemish(?)-Dutch painter of still life (d. Utrecht, 1673). The date of Simons's birth is uncertain, but he may have been born and trained in Antwerp. He is recorded in Utrecht in 1669 and 1671. There are dated works by him from 1651 to 1657. He specialized in still-life paintings with flowers, fruit, dead birds, and lobsters.

BIBLIOGRAPHY. A. P. A. Vorenkamp, *Bijdrage tot de geschiedenis van het Hollandsch stilleven in de zeventiende eeuw*, Leyden, 1934.

SIMONSON, LEE. American scenic designer (1888–). He was born in New York City. Among the many plays for which he has designed stage sets are *Heartbreak House* and *Back to Methuselah*. He directed an exhibition of American textiles and fashions held in the Metropolitan Museum of Art in 1945, and has written several books on stage design.

SIMS, CHARLES. English figure and landscape painter, mural painter, and water-colorist (1873–1928). Born in Islington, London, in 1890 he entered the National Art Training Schools, South Kensington, and during 1891–92 studied at the Académie Julian in Paris under Benjamin Constant and Jules Lefèbvre. He failed to establish himself as a landscape painter on his return to England and took up studies at the Royal Academy schools in 1893.

Sims exhibited at the Royal Academy for the first time in 1896 and at the Paris Salon in 1900. His painting *Childhood* was bought for the Musée du Luxembourg. With some successes behind him, he settled in Essex and, later, Sussex and began his series of figures in landscapes and studies of mothers and children, which earned him some popularity.

In 1907 Sims was elected an associate of the Royal Academy and made a full academician in 1920. He won the gold medal at the International Exhibition at Pittsburgh in 1912 and another at the International Exhibition, Amsterdam. By 1914 two of his paintings had been purchased for the Tate Gallery, London. He was made an official war artist during World War I and was keeper of the Royal Academy schools from 1920 to 1926.

His work shows a wide variety of influences; his early decorative style owes much to Puvis de Chavannes and the Italian primitives. He is best known for his exuberant open-air portraits and studies. *The Kite* (1905) and *The Fountain* (1908; purchased for the Tate) are typical examples of his landscape style, although his compositions are not always well coordinated. His book, *Picture Making: Technique and Inspiration*, was published posthumously in 1934 and shows him to have been very experimental in matters of technique, particularly in the mixture of oil and tempera.

BIBLIOGRAPHY. C. Sims, *Picture Making: Technique and Inspiration*, London, 1934.

JOHN K. D. COOPER

SIMULTANEITY. Concept of the spatio-temporal element in painting embodied in orphism and futurism. Toulouse-Lautrec, Seurat, and Munch had attempted dynamic expression of movement in their work, and Picasso and Braque anticipated the problem of simultaneity in analytical cubism. But it remained for a small group of dissenters, including the three Duchamp brothers and Robert Delaunay, to formulate the problem clearly and to find solutions. Color was a primary factor in orphism's realization of movement—Fauve color combined with cubist form. Delaunay's *St. Severin* series (1909) and *Eiffel Tower* series (1910), Marcel Duchamp's *Nude Descending a Staircase* (1912), and Jacques Villon's *Marching Soldiers* (1913) are typical products of the movement. Their aim is to present simultaneous views of different aspects of the same object, either at the same moment in time or at successive moments in time.

BIBLIOGRAPHY. W. Haftmann, *Painting in the Twentieth Century*, 2 vols., New York, 1960.

SINAN, QOJA MI'MAR. Turkish architect (1490–1558). The most renowned architect of Turkey, he came from a family of builders. After receiving military training in his native Istanbul, he became chief architect of the Ottoman court and with his colleagues built 360 mosques, hospitals, mausoleums, and baths, including his masterpiece, the Sulaimaniye Mosque in Istanbul. *See* SULAIMANIYE MOSQUE, ISTANBUL.

See also OTTOMAN ARCHITECTURE; SULTAN SELIM II MOSQUE, ADRIANOPLE.

BIBLIOGRAPHY. L. A. Mayer, *Islamic Architects and Their Works*, Geneva, 1956.

SINCLAIR BALLESTEROS, ALFREDO. Panamanian painter (1916–). Sinclair, who was born in Panama City, began art studies there in 1944, then studied in Buenos Aires, where he first exhibited (1950; Antú Gallery). He has exhibited widely (for example, São Paulo Bienal, 1961). His work is expressionistic and abstract, with geometric forms.

BIBLIOGRAPHY. University of Kansas, Museum of Art, *Pintores centroamericanos* (exhibition catalog), Lawrence, Kans., 1962.

SINDING, STEFAN. Norwegian sculptor (b. Trondheim, 1846; d. Paris, 1922). Sinding spent many years in Paris after studies in Oslo, Berlin, and Rome. His style ranges from the overbearing realism of portraits such as that of Ibsen (1899; Oslo, National Theater) to the angular, stylized, and modernized motion of the equestrian *Valkyrie*. Like the late works of Rodin, Sinding's sculptures make metaphorical use of figures in such works as *Mother Earth* (1906; Copenhagen, Ny Carlsberg Glyptothek).

Gustave Singier, *Dutch Town*. Guggenheim Museum, New York.

SINDJERLI (Senjirli; Sinjerli; Zincirli; Zinjirli). Ancient city at the junction of Anatolia and North Syria, in Turkey, capital of the Aramaean state of San'al. The later city (founded ca. 900 B.C.) was surrounded by a perfectly circular double enclosure with 100 towers projecting at regular intervals and three gateways equidistant from each other. The citadel on the central hill had a polygonal enclosure wall with semicircular projecting towers. There were four terraces at various levels, approached from the south and separated by walls and gateways.

On the uppermost terrace were the palaces, each with a columned shallow portico flush with the front wall and forming the entrance to the main structure. This *bit-hilani* was probably of Syrian origin. There were bathrooms (Assyrian influence) and movable hearths on rails in the large front halls of the winter quarters. Construction in stone (in the lower levels) and brick was reinforced with a wooden framework and lined with carved orthostates; sometimes there were lions at the gateways.

BIBLIOGRAPHY. R. Naumann, *Architektur Kleinasiens*, Tübingen, 1955.

SINGIER, GUSTAVE. French painter and graphic artist (1909–). Born in Warneton, Belgium, he went to Paris in 1919 and later became a French citizen. Singier first worked as a decorator and designer while painting in an expressionistic manner. His more recent abstractions, grounded in natural forms, consist of well-defined, linear, flatly colored shapes in strong, often large decorative compositions with patterned effects derived from Miró and Klee. In style, he is associated with the French artists Jean Le Moal and Alfred Manessier.

BIBLIOGRAPHY. C. Bourniquel, *Trois peintres*, Paris, 1946.

SINHALESE ART, *see* CEYLON.

SINIBALDI, *see* MONTELUPO, BACCIO DA; MONTELUPO, RAFFAELE DA.

SINJERLI, *see* SINDJERLI.

SINOPE GOSPELS. East Christian illuminated manuscript, in the National Library, Paris.

SINTENIS, RENEE. German sculptor (b. Silesia, 1888; d. Berlin, 1965). She studied with Von Koenig and Haverkamp at the Arts and Crafts School in Berlin. Although Sintenis interprets the human figure with sensitivity (as in her bronze *Daphne* in the Museum of Modern Art, New York), she is at her best in sympathetic studies of animals of various kinds, usually in the medium of bronze. Her style is a personal blending of impressionist and expressionist values with a strong basis in naturalism. Following a dislocated life during the Nazi ascendancy of the 1930s and World War II, Renée Sintenis was appointed professor of art at the Berlin Academy, where she was deeply influential as a teacher.

BIBLIOGRAPHY. C. Giedion-Welcker, *Contemporary Sculpture*, New York, 1955.

SIOUX INDIANS. The art of the Sioux, like that of other Plains tribes or nations, was strongly affected by the highly mobile existence which followed their acquisition of the horse. Typical works are of lightweight materials, especially buffalo and antelope skins. Combining native materials with European glass beads and commercial paints, the Sioux produced handsome garments and containers.

Renée Sintenis, *Daphne*, 1930. Bronze. Museum of Modern Art, New York (Abby Aldrich Rockefeller Fund).

Siphnian Treasury, Delphi. The gigantomachy frieze on the exterior of this small Ionic structure.

See also NORTH AMERICAN INDIAN ART (PLAINS); PLAINS INDIANS.

BIBLIOGRAPHY. C. Wissler, "Decorative Art of the Sioux Indians," *American Museum of Natural History, Bulletin*, XVIII, pt. 3, 1904.

SIPHNIAN TREASURY, DELPHI. Small Ionic Greek temple, built of island marble and dedicated to Apollo by the inhabitants of the island of Siphnos in 530/525 B.C. The treasury consisted of a cella and of a distyle-in-antis porch (restorations in the Louvre, Paris, and the Delphi Museum). Two caryatids supported the roof of the porch. The treasury had a pediment carved with sculpture representing Apollo and Hercules fighting for the possession of the tripod. On the exterior, on all four sides of the building, ran a frieze carved in relief, which represented the following themes: Gigantomachy, the assembly of the gods, and the Rape of the Leucippides. The south and west sides of the frieze were executed by an earlier artist who used incision in the rendering of details. The north frieze, a masterpiece of archaic sculpture, and the east frieze are ascribed to a different master, who shows a more advanced technique in the modeling of his figures and in the organization of the planes. An elaborately carved cornice decorated the doorway to the cella. All sculptures are now in the Delphi Museum.

BIBLIOGRAPHY. F. Poulsen, *Delphi*, London, 1920; P. Frotier de la Coste-Messelière, *Delphes*, Paris, 1957. EVANTHIA SAPORITI

SIPORIN, MITCHELL. American painter (1910–). Born in New York City, he studied at the Art Institute of Chicago. Siporin is a well-known muralist and painter of social subjects. With Edward Millman he did the large St. Louis Post Office mural (1939–41).

SIQUEIROS, DAVID ALFARO. Mexican painter (1896–). He was born in Chihuahua. A political activist and technical innovator, this pioneer of the Mexican mural renaissance is one of the so-called "Big Three": Orozco, Siqueiros, and Rivera. Siqueiros's youthful participation in strikes at the Mexican Academy was followed by military service under Carranza. Posted to Europe (1919–22), Siqueiros drew from his studies there the conviction that Mexico needed a democratic, public art adapted to its revolutionary mood.

Among those presiding over the birth of the mural movement at the National Preparatory School (1922–24), only Siqueiros, with his *Burial of a Worker*, achieved true monumentality and social significance. He helped to organize his colleagues into a unionlike "Syndicate" and to publish its fiery organ, *El Machete*. After this group dissolved, Siqueiros concentrated on union activities in Guadalajara until 1930, when, at Taxco, he resumed painting wholeheartedly.

During the 1930s he further developed his concepts of proletarian art by organizing assistants into mural teams who sprayed pigment on outdoor concrete. Their works included the Plaza Art Center in Los Angeles (1932). In 1933, in Argentina, he applied weather-resistant plastics, such as Duco and ethyl silicate, to the problem of externalizing murals so as to achieve maximum communication. In 1937, after having established his Experimental Workshop in New York City for diffusion of these new techniques, Siqueiros consummated his antifascist activities by service with the International Brigades as divisional commander in Spain.

After returning to Mexico in 1939, he devoted increasing time to art. Since then his major works (in Mexico City) have been the *Trial of Fascism* (1939; Electrical Workers Union), *Cuauhtemoc against the Myth* (1944; Sonora ♯ 9), *New Democracy* (1945; Palace of Fine Arts), *Patricians and Patricides* (1945; ex-Customs House), *Ascent of Culture* (1952–56; University of Mexico), and *Future Victory of Medical Science against Cancer* (1958; Medical Center). During this period his most distinguished mural outside Mexico was *Death to the Invader* (1941; Chillán, Chile). Meanwhile Siqueiros executed many easel pictures, including portraits, and prints. At the Venice Biennale of 1950 he won second prize. From 1960 to 1964 he was imprisoned by the Mexican government for the crime of "social dissolution," but he subsequently completed a government commission for a mural at Chapultepec Castle.

Film projectors, airbrushes, spray guns, and cinematic techniques have enabled Siqueiros to implement his theories of "dynamic realism" and "kinetic perspective." Thus, he has resolved the conventional divisions of wall, corner, and ceiling into a spatial unity (unparalleled even in baroque frescoes) which envelops the spectator in an all-embracing

David Alfaro Siqueiros, *Self-portrait*. Pyroxilin paint. National Museum of Fine Arts, Mexico.

visual experience. Ingenious foreshortenings of simplified, "Indianesque" forms, lacquered on concrete or on masonite surfaces of concave profile, correct the visual distortions of traditional murals, at the same time projecting illusions of shifting images.

BIBLIOGRAPHY. B. S. Myers, *Mexican Painting in Our Time*, New York, 1956; A. Reed, *The Mexican Muralists*, New York, 1960; R. Tibol, *Siqueiros, introductor de realidades*, Mexico City, 1961.
JAMES B. LYNCH, JR.

SIRANI, ELISABETTA. Italian painter (b. Bologna, 1638; d. there, 1665). She was first trained by her father, Giovanni Andrea Sirani, and was later strongly influenced by Guido Reni. Her virtue and her mysterious death gave her a reputation which had no relationship to her modest talent. The *Baptism of Christ* in the Certosa, Bologna, is one of her best productions.

BIBLIOGRAPHY. *Maestri della pittura del Seicento emiliano* (catalog), ed. F. Arcangeli et al., 2d ed., Bologna, 1959.

SIRENS. In Greek mythology, the daughters of Achelous or Phorkys, noted for their beautiful singing, which in some tales, notably the *Odyssey* (12.41ff), lured sailors to their doom. They are generally portrayed as birds with women's heads and sometimes with breasts and arms. Though their names vary, common forms are Parthenope, Leucosia, Ligeia, Thelxiereia, Aglaopheme, and Pasinoë.

BIBLIOGRAPHY. C. Kerenyi, *The Gods of the Greeks*, New York, 1951.

SIRONI, MARIO. Italian painter (b. Tempio Pausania, Sassari, 1885; d. Milan, 1961). He studied in Rome. After early association with the futurists, Sironi moved toward more traditional figure paintings. He was a founder-member of the Novecento group.

BIBLIOGRAPHY. A. Pica, *Mario Sironi, Painter*, Milan, 1955.

SISLEY, ALFRED. English painter (b. Paris, 1840; d. Moret-sur-Loing, 1899). Sisley's parents were English, and although he spent most of his life in France, he never became naturalized. In 1862 he enrolled at Gleyre's studio, where he met Monet, Renoir, and Bazille. Sisley was a regular exhibitor at the Salons from 1866 to 1870. Prior to 1872 his work was influenced by Courbet, as may be seen in the *Alley of Chestnut Trees* (1867; Southampton, Eng., Southampton Art Gallery), and by Corot, whom he never ceased to admire.

By 1873, however, Sisley was associating himself more and more with the vanguard of the impressionist movement. *The Seine at Argenteuil* (1872; New York, Mr. and Mrs. Richard J. Bernhard Collection) and *The Bridge of Villeneuve-La-Garenne* (1872; New York, Ittleson Collection) reveal a new lyricism and an awareness of changes of local color under varying atmospheric conditions. *The Street at Argenteuil* (1872; New York, Mrs. Mellon Bruce Collection) suggests Monet in the blurring of detail and the casualness of approach. Sisley and Monet worked together at Argenteuil in 1872, and in 1873 both painted the same road on a hillside with flowering trees. Sisley was one of those who participated in the historic exhibition in 1874 at Nadar's Galleries in Paris.

From 1879 on Sisley lived at Moret-sur-Loing. Occasionally he visited England, where he painted at Hampton Court and elsewhere on the Thames. But he painted chiefly the country around Paris, especially on the road to Versailles and St-Germain—Meudon, St-Cloud, Port Marly, Bougival. Sisley, in a sense, always remained the pupil of Corot. He adopted a light coloring but did not dissolve form or adopt exceptional lighting effects to the extent that Monet did. A fineness of drawing is usually to be found in his paintings, and, quite often, a remarkable poetic feeling. Not a revolutionary to the extent of Monet or even Renoir, during his lifetime Sisley never attained the attention he deserved.

Sisley's water seems almost always limpid, and his clouds, agitated but not driven, are wonderfully light, as in *The Flood at Port-Marly* (1876; Paris, Louvre). The building at the left of the canvas is rendered with loving detail, and though placed seemingly haphazardly, it beautifully balances the masses of trees to the right. In *Louveciennes, Winter* (1874; Washington, D.C., Phillips Collection) he caught the subtle luminosity from the snow under gray skies. Sisley's finest work was done between 1870 and 1880. A lack of assimilation is shown in the rough impasto and the cold blue-green of the trees in *Moret and the Banks of the Loing* (1892).

BIBLIOGRAPHY. P. du Colombier, *Alfred Sisley in the Musée du Louvre*, Paris, 1947; F. Daulte, *Alfred Sisley*, Paris, 1959; J. Rewald, *The History of Impressionism*, rev. ed., New York, 1961.

ABRAHAM A. DAVIDSON

Alfred Sisley, *The Flood at Port-Marly*, **1876. Louvre, Paris. An English painter associated with the beginnings of the impressionist movement.**

SISTINE CHAPEL, *see* MICHELANGELO BUONARROTI; ROME: MUSEUMS (VATICAN MUSEUMS); VATICAN, THE, ROME.

SISTINE MADONNA. Oil painting by Raphael, in the State Art Collections (Picture Gallery), Dresden. *See* RAPHAEL.

SISTRUM. Musical instrument consisting of a wire loop with a handle; metal rods were loosely attached through the sides of the loop so that when the sistrum was shaken, the rods vibrated to produce its characteristic jingle. The sistrum was used in ancient Egyptian ceremonies dedicated to the goddess Isis.

SITA. Wife of the Hindu god Rāma. Sītā is said to have sprung from the plow as her father, Janaka, was tilling his land. Accused of infidelity by Rāma, she calls upon her earth-mother to attest to her purity and herself returns into the ground.

SITTOW (Sitium), MICHIEL (Master Michiel). Flemish painter (b. Tallinn, Estonia, ca. 1469; d. there, 1525). Although of Baltic origin, Michiel Sittow belongs to the Flemish school of painting. He was in Bruges by 1482 and probably worked with the Master of the St. Lucy Legend; Memling's influence is also traceable in his early works. He is often associated with the group of painters working in the orbit of Hugo van der Goes, as his works have much in common with artists such as the Master of Moulins, Jean Hey, Juan de Flandes, and the Master of St. Giles.

Michiel was much in demand and traveled extensively. In 1492 he was at the court of Queen Isabella of Castile and painted at least three panels for an oratory in collaboration with Juan de Flandes: an *Assumption* (Washington, D.C., National Gallery), an *Ascension* (Yarborough

Collection), and a *Coronation of the Virgin* (Paris, Heugel Collection). In 1504 Michiel was back in the Netherlands in the employ of Philip the Fair; in 1505 he was in England briefly, in the service of Catherine of Aragon.

The years from 1506 to 1514 were spent in his native Estonia, and in 1514 he traveled to Denmark, where he painted the portrait of Christian II (1515; Copenhagen, State Museum of Fine Arts). He returned to the Netherlands, working in Mechlin at the court of Margaret of Austria, but later went back to Spain, working for King Ferdinand VII in Valladolid and for Charles V. In 1518 he returned finally to Tallinn.

Besides a few exquisite religious works painted in brilliant but subtle colors (in a style reminiscent of that of Juan de Flandes), a number of beautiful, highly perceptive portraits have survived, notably those of Diego de Guevara (Washington, D.C., National Gallery) and of Catherine of Aragon (Vienna, Museum of Art History).

BIBLIOGRAPHY. P. Johanson, "Meister Michiel Sittow," *Jahrbuch der preussischen Kunstsammlungen*, LXI, 1940; C. Eisler, "The Sittow Assumption," *Art News*, LXIV, 1965.

PHILIPPE DE MONTEBELLO

SITULA. Cone-shaped bronze vessel commonly produced in the Hallstatt period of the Ice Age in south-central Europe. Situlae appear to have been made chiefly in the region of Venice. Many were elaborately decorated with reliefs of fantastic animals as well as scenes of banquets and sporting events. Important examples were found at Bologna and at Kuffarn on the northern Danube.

BIBLIOGRAPHY. J. Kastelic, *Situla Art*, New York, 1965.

SIVA. Third person of the Hindu trinity. The Destroyer, whose destruction permits the new process to come forth, Siva is identified with Rudra (from the root *rud*, "to weep"), the wielder of the thunderbolt, "the lord of songs, the lord of sacrifices, who heals, remedies, is brilliant as the sun, the best and most bountiful of gods, who grants prosperity and welfare to horses and sheep, men, women and cows" in the Vedas. Although he is usually thought of as a personal deity, in some passages of Hindu literature Siva is lauded as the Supreme Being, Mahādeva. He is Iśāna (Ruler), Paśu-pati (Lord of Animals), Kāla (Time), Mrtyunjaya (Vanquisher of Death), and Mahāyogī (Great Yogi), the patron of ascetics.

Siva is represented with a third eye in the middle of his forehead and a crescent moon on his head. He is four-armed, holding the *paraśu* and a deer and making *abhaya* and *vara* mudrās (symbolic gestures); he wears the skin of a tiger, deer, or elephant. A special form of representation is Naṭarāja, Lord of the Dance. Siva is often shown with his consort, Devī, and sometimes with one or the other of their two sons, Kārttikeya and Gaṇeśa. Siva's mount is Nandi the bull; his principal symbol, the liṅgam. *See* ABHAYA; LINGAM; VARA.

CLAY LANCASTER

SIVORI, EDUARDO. Argentine painter (b. Buenos Aires, 1847; d. there, 1918). Sívori turned to art after touring Italy in 1874. He studied in Buenos Aires, won a gold medal in the Paris Salon of 1880, and studied in Paris with Laurens (1882–88). He taught in and directed the academy at Buenos Aires. Realistic (for example, *La Levée de la bonne*, 1887; Buenos Aires, National Museum of

Situla. Example in the Municipal Museum of Archaeology, Bologna.

Fine Arts) and impressionistic styles were used by Sívori.

BIBLIOGRAPHY. M. L. San Martín, *Pintura argentina contemporánea*, Buenos Aires, 1961.

SIX CANONS, *see* SIX PRINCIPLES OF CHINESE PAINTING.

SIXDENIERS, CHRISTIAN. Flemish architect (fl. 1529–45). Sixdeniers was a resident of Bruges and worked on a number of buildings there in the Flamboyant style. His principal works are the façade of the St-Sang Church, built between 1529 and 1534 to plans by Willem Aerts and Benoit van Kerkhove, and the Greffe de Franc (old record office), built between 1535 and 1537 to plans by Jean Wallot, both of which show the influence of Italian Renaissance architecture.

SIX DYNASTIES, *see* CHINA: ARCHITECTURE, CALLIGRAPHY, JADE, PAINTING, SCULPTURE.

SIX PRINCIPLES OF CHINESE PAINTING. As first set forth by Hsieh Ho at the end of the 5th century of our era in his treatise entitled the *Ku-hua p'in-lu* (Old Records of the Classification of Painters), the six principles of painting (widely known also as the six canons, six elements, or six laws) have been of supreme importance in the history of Chinese aesthetic theory. For subsequent generations of critics and theoreticians the principles enumerated by Hsieh Ho remained a kind of magic touchstone, constantly cited and sometimes reinterpreted. In more recent years the scholarly labors of W. R. B. Acker, A. C. Soper, and J. F. Cahill have begun to isolate the meaning of the six principles in the context of the time in which they were formulated.

The six principles may be summed up as follows: (1) animate through spirit consonance; (2) follow the "bone method" in the use of the brush; (3) be truthful to objects in depicting forms; (4) conform to kind in setting forth colors; (5) divide and plan in positioning and arranging; and (6) convey the past through copying and transcribing.

Basically the principles are quite generalized, and they could be considered essentially nothing more than admonitions by Hsieh Ho as to methods, with the exception of the first principle, the most important of the six. The transliteration of the four Chinese characters employed in the first canon is *ch'i-yün sheng-tung*. The compound *sheng-tung* is usually rendered literally as something like "life movement," while *ch'i-yün* has the more mystical ring of "spirit consonance." Taken together, their implications seem to extend well beyond the exhortation as to a method of painting, and the four characters imply a qualitative measure or standard, something desirable but not always present in a given painting. Thus later critics, in discussing the merits of a painting or a painter, had recourse to the term *ch'i-yün*. Paintings that had the capacity to move the observer, to come alive with that special rhythmic vitality or resonance, were said to possess *ch'i-yün*. The whole range of intangible aesthetic qualities associated with the spirit and life of a great work of art is evoked in *ch'i-yün sheng-tung*, and in the final analysis these were the qualities that separated the great master from the competent or merely skillful painter.

The second of Hsieh Ho's principles seems to be almost of equal importance since it deals with qualities of brushwork, the most fundamental aspect of all Chinese painting. The term *ku-fa*, literally "bone method," refers certainly to strength and vigor in the handling of the brush. The use of the words "bone method" might be misleading since they imply something like following a set of standardized procedures or rules. In actuality the reference is to inner strength of a particular line, the gifted "touch" again of the great master versus that of the less talented pupil. The character and quality of the individual brushstroke, therefore, was the measure of the painting, and the fact that Hsieh Ho has accorded this a higher rank than qualities of composition or color in his listing of the six principles is revealing of the standard of judgment to be applied in looking at Chinese paintings.

The third and fourth of Hsieh Ho's principles are perhaps more closely related to normal Western criteria. On the surface both laws seem simply to be advocating that the paintings have verisimilitude; rocks should have the shape and appropriate colors of rocks. Cahill has suggested a number of interesting possibilities regarding the real meaning of the third and fourth canons, centering on the nature of the visual response in the time of Hsieh Ho. However, Chinese critics for the most part seem to take the third and fourth of Hsieh Ho's principles at face value.

The fifth canon, dealing with the planning and placing of forms, comes close to the Western concept of composition. Again Hsieh Ho is not very explicit as to what makes a good "composition," but there is an implied reference to the first principle, for certainly the basic concept of the first law could not be achieved in any given painting without reference to composition.

In following the last canon, veneration of the past by copying old masters, the process of copying supplied in part the necessary discipline by which the young painter trained his hand and his eye. At the same time the tradition of past masters was kept alive, reflecting the Chinese preoccupation with the past. This last principle was not to go unchallenged in succeeding periods, but the copying of old masters remained an acceptable procedure throughout most of Chinese painting history for the acknowledged master as well as for the student. In the hands of the master painter the copy of an earlier style was a sincere expression of gratitude, a testimony of his indebtedness to some source of inspiration from the great past traditions that had made his art possible. *See* CHINA: PAINTING (COPIES).

Later painters added their own nuances to the principles, enlarging the problem of trying to understand what the principles really mean in Chinese painting theory. But the importance of the canons cannot be denied, and as long as painting is practiced in China, there will probably always be a reference to the magic of these statements from the dim past.

BIBLIOGRAPHY. G. Rowley, *Principles of Chinese Painting*, Princeton, 1947; O. Sirén, *Chinese Painting, Leading Masters and Principles*, 7 vols., London, 1956–58. MARTIE W. YOUNG

SIYALK, *see* SIALK.

SIZING. Layer of glue applied to the bare canvas before application of the priming and subsequent layers of paint.

Skene. Plan of the Roman theater in Orange, France.

Sizing fills the pores of the canvas, making it less absorbent and therefore a better ground for paint.

SKANDA. Alternate name for the Hindu god Kārttikeya.

SKARA CATHEDRAL. Swedish church, built in the Gothic style between 1312 and 1350 and completely restored in 1886–94. The nave, with a triforium gallery in the upper part of the arcade wall, shows French influence and is unusual for Swedish buildings of the time.

BIBLIOGRAPHY. A. Hahr, *Architecture in Sweden*, Stockholm, 1938; E. Lundberg, *Byggnadskonsten i Sverige under Medeltiden, 1000–1400*, Stockholm, 1940.

SKEAPING, JOHN. English sculptor (1901–). He achieved prominence in the 1930s, working in a cubist style in various materials, and is best known for his animal sculptures and for wood panels in the United Nations Building, New York City. He has exhibited throughout Europe, the United States, Mexico, and elsewhere and is a Royal Academician.

SKELETON CONSTRUCTION, *see* CONSTRUCTION, SKELETON.

SKENE (Scene). Greek theatrical term, meaning "tent," assumed to have been applied first to the players' booth and subsequently to the structure that replaced it. The skene was subdivided in the Greek theater into a complex including proscenium, episcenium, and parascenium.

The action in the archaic Greek theater took place in a circular orchestra terrace. Later, a skene of wood, probably a simple flat wall, was introduced at the back of the orchestra, perhaps for acoustic reasons. The skene was developed to display artificial scenery painted on wood or canvas. In its later form, the skene was changed from a wood to a stone structure having a permanent character, as in the theater of Epidaurus.

SKEWBACK. Masonry block on which the end voussoir of a segmental arch abuts. The abutting face of the skew-back is inclined. The term is also applied to the inclined face of the springer of an arch.

SKIAGRAPHOS, *see* APOLLODOROS.

SKIDMORE, OWINGS, AND MERRILL. American architectural firm of Louis Skidmore (1897–1962), Nathaniel A. Owings (1903–), and John O. Merrill (1896–). Founded in Chicago during the 1930s, Skidmore, Owings, and Merrill (SOM) is today one of the largest design offices in the world, with branches in New York, Chicago, and other cities, serving primarily American big business. Gordon Bunschaft (1909–), who became a partner in 1945, has designed many of their major buildings.

SOM first gained international recognition with its design for Lever House (1951–52) on Park Avenue in New York City. The prototype of postwar, glazed, curtain-wall commercial buildings, Lever House is not only important for its elegant aesthetic quality; it also began a new era in urban planning of the skyscraper. Only one-quarter of its expensive site is occupied by the vertical slab; the balance is covered by a horizontal rectilinear volume suspended above a pedestrian plaza, resulting in a humanized pedestrian environment without sacrifice of functional efficiency. *See* LEVER HOUSE, NEW YORK.

The Manufacturer's Trust (1953–54) in New York is a cubical, glazed open volume that established a new form for banks. Among the firm's more successful large-scale works is the Connecticut Life Insurance Company office buildings (1954–57) in Bloomfield, Conn., a 280-acre administrative village outside the insurance city of Hartford. Another large composition is the United States Air Force Academy, completed in 1962, in Colorado Springs, Colo., a coldly efficient complex, which culminates in a 17-spired chapel designed to accommodate three faiths. One of the other significant SOM works is the Chase Manhattan Bank (1957–61) in New York, a masterfully coordinated urban pedestrian-commercial-office complex in the Lever House tradition. *See also* CHICAGO.

Skidmore, Owings, and Merrill, the Connecticut Life Insurance Company office buildings, Bloomfield, Conn., 1954–57.

SOM manipulates a contemporary idiom with skill and sophistication to produce large quantities of consistently high-quality work.

BIBLIOGRAPHY. Skidmore, Owings & Merrill, *Architecture of Skidmore, Owings & Merrill, 1950–1962*, introd. by H.-R. Hitchcock, New York, 1963.

THEODORE M. BROWN

SKILLYNGTON, ROBERT. English architect. His work at Kenilworth Castle in the 1390s consists of the great hall and state apartments. It has been suggested that this is stylistically related to the choir of St. Mary's, Warwick (1381–90), and also to the tower of St. Michael's, Coventry (1373–94).

BIBLIOGRAPHY. J. H. Harvey, comp., *English Mediaeval Architects* London, 1954.

SKIN, STRESSED. Thin panel acting integrally with a framing member to resist stress. Found in light metal construction, it is associated especially with plywood construction in which a core of wood members is bonded to a "skin" of top and bottom plywood panels. Stressed-skin plywood panels have been used extensively in prefabricated structures as floor and wall components.

SKOPLJE MONASTERY, *see* MARKO MONASTERY, SKOPLJE.

SKRIPOU. Town near Levádhia in Boeotia, Greece. It is the site of two Byzantine churches. The earlier is of the late 9th century, with a cross-in-square plan and massive vaults. The other is perhaps of the 12th century and is related in design to the monastery church of St. Luke in Stiris (Hosios Loukos).

BIBLIOGRAPHY. R. W. Schultz and S. H. Barnsley, *The Monastery of St. Luke of Stiris*, London, 1901; J. A. Hamilton, *Byzantine Art and Decoration*, 2d ed., London, 1956.

Stressed skin. Vertical section of stressed-skin plywood panels.

SKYSCRAPER. Tall structure, generally an apartment or office building. The definition according to height is elastic; formerly structures ten stories high were called skyscrapers; today the term is commonly limited to structures of more than twenty stories. Apartment buildings from seven to twenty stories are now termed "high-rise."

See also CONSTRUCTION, SKELETON.

SLABBAERT, KAREL. Dutch painter and etcher of genre, still life, and portraits (b. Zierikzee, ca. 1619; d. Middelburg, 1654). Slabbaert was active in Leyden about 1640. He was at Middelburg before 1642, and in Amsterdam for a short time in 1645. His style is strongly influenced by the work of Gerrit Dou, especially in his genre and interior scenes.

BIBLIOGRAPHY. E. M. van Oyen-Kastner, "Een Teruggevonden Kinderportret door Karel Slabbaert," *Oud-Holland*, LXVII, 1952.

SLAB TECHNIQUE. Method of using flattened sheets of fairly coarse-grained clay in forming ceramics. It employs horizontal slabs that are cut into geometric segments, a technique used since ancient times for tile manufacture. The segments are also suitable for making trays, boxes, and shallow dishes and can be joined by slip to produce figure sculpture of abstract construction.

BIBLIOGRAPHY. H. H. Sanders, *The Practical Pottery Book*, London, 1955.

SLAVIC ART: PROTOHISTORIC PERIOD. The first appearance of the Slavic peoples is associated with the Neuri, who dwelt in the Vistula-Middle Dnieper region in late Roman times. The Slavic peoples of the 5th to the 9th century may be divided into western (eastern Germany and Poland), southern (Balkans), and eastern (Russia) groups. Their art is known from pottery, ornaments, tools, and weapons found in fortified settlements and burials. Its early development was influenced by the art of steppe peoples such as the Huns, Bulgars, and Avars. In the 9th century Viking influence penetrated from the north, and Byzantine influence, marking the end of the protohistoric period, poured in from the south.

BIBLIOGRAPHY. L. Niederle, *Manuel de l'antiquité slave*, 2 vols., Paris, 1923-26; J. Strzygowski, *Die altslawische Kunst*, Augsburg, 1929.

Slavic art, protohistoric period. Ornamental plaque with a lion-headed griffin assaulting a dying horse, 4th century B.C. The Hermitage, Leningrad.

Max Slevogt, *Self-portrait*. Private collection, Schweinfurt.

SLEEPING SATYR. Celebrated Hellenistic statue in the State Antiquities Collection, Munich. An original work of the Pergamene school (ca. 200 B.C.), it was found in the 17th century near the Castel Sant'Angelo in Rome. It has had many restorations. The satyr is depicted reclining on a rock, sinking into sleep. The modeling of the face and body is excellent.

BIBLIOGRAPHY. M. Bieber, *The Sculpture of the Hellenistic Age*, New York, 1955.

SLEVOGT, MAX. German painter and graphic artist (b. Landshut, Bavaria, 1868; d. Neukastel, Pfalz, 1932). Slevogt's early work is marked by dark tonalities reflecting the influence of Wilhelm Dietz, under whom he studied at the Munich Academy. In 1889, when studying at the Académie Julian in Paris, he came to know the work of the French impressionists, but was most captivated by the old masters in the Louvre. Slevogt's *Danaë* of 1895, an unembellished nude, was foreshortened in the manner of Mantegna's *Dead Christ*. Before returning to Munich in 1890, Slevogt studied the work of Rembrandt in Holland, and under the influence of the Dutch master his line took on new life. The *Prodigal Son* of 1898, a variation of Rembrandt's theme, shows a solid conception of form, but the treatment of light remains on a preimpressionistic level.

Slevogt went to Berlin in 1899 at the invitation of Max Liebermann and in 1901 settled there and became a member of the Secession. He then studied the works of Manet, Pissarro, Monet, and Degas with new intensity. The influence of the French impressionists exposed him to the problems of plein-air painting. In his landscapes he came to show a lightness and airiness removed from the stormy impressionism of his contemporary, Corinth; perhaps he always retained something of the heritage of the frescoes of Tiepolo in Würzburg, where he had spent his adolescence. As a result of a trip to Egypt in 1913-14 he pro-

duced a series of water colors showing a remarkable transparency and freedom of handling.

Slevogt's power of invention was demonstrated in his decorations for *Don Giovanni* for the Dresden opera (1902–12), for which he made a set of portraits of the singer D'Andrade in the leading role. He worked extensively as an illustrator, decorating *The Magic Flute, Faust,* the *Iliad, Ali Baba,* and *The Last of the Mohicans,* among others. The books Slevogt chose to illustrate featured tales of adventure for which the vivacity of his draftsmanship was ideally suited. He was perhaps at his best as a graphic artist, for here the full power of his lyrical impressionism comes to the fore. The marginal designs for *The Magic Flute* (1920) show dancing figures that seem to reconstitute the very movement of the printed notes. The lithograph *Achilles Rescuing the Prisoners* (1906) features a brooding landscape, sketchily treated; Achilles himself has little of the benign nobility usually attributed to him, but seems an appalling barbarian more in keeping with his martial prowess.

BIBLIOGRAPHY. W. R., "Max Slevogt (died 20th September, 1932)," *Apollo,* XVII, January, 1933; E. Waldmann, "The Graphic Art of Max Slevogt," *The Print Collectors Quarterly,* XXIII, July, 1936; P. Selz, *German Expressionist Painting,* Berkeley, 1957.
ABRAHAM A. DAVIDSON

SLINGELANT (Slingeland), PIETER CORNELISZ. VAN. Dutch painter of genre, still life, and portraits (b. Leyden, 1640; d. there, 1691). Van Slingelant was a pupil of Gerrit Dou in Leyden. In 1684 and 1690 he was an official of the Leyden Guild of St. Luke. In 1691 he was dean of the organization. He worked mainly in the style of his teacher.

BIBLIOGRAPHY. W. Bernt, *Die niederländischen Maler des 17. Jahrhunderts...,* vol. 3, Munich, 1948.

SLIP (Engobe). Mixture of clay and water to thick-cream consistency that is used to coat dry but unbaked pottery. Often of the same clay as the underlying piece, it can be employed for sealing joints, attaching handles, and so on. It serves also to smooth the pottery surface, can act as a base for underglaze painting, and can be tinted for decorative purposes.

BIBLIOGRAPHY. B. Leach, *A Potter's Book,* London, 1940.

SLOAN, JOHN. American genre painter (b. Lock Haven, Pa., 1871; d. New York City, 1951). He studied with Anschutz at the Pennsylvania Academy of Fine Arts and worked as an illustrator for Philadelphia newspapers. He

John Sloan, *Fifth Avenue Critics.* Whitney Museum of American Art, New York.

moved to New York in 1905, where he was employed by *Collier's*, *The Century*, and *Harper's Weekly* and was art editor of the old *Masses*. His earliest drawings show the influence of the then fashionable Art Nouveau style. He changed his style after Robert Henri introduced him to the drawing of the English illustrators Leech and Keene and to the art of Daumier, Guys, Gavarni, and Goya.

About 1907 Sloan began to paint seriously. He joined Luks, Glackens, Shinn, and Henri, all from Philadelphia, to form a group that was dubbed the "Ashcan school," because its members painted scenes of New York slums, among other things. In 1908 Sloan exhibited as a member of The Eight at the Macbeth Gallery. This group, composed of the Ashcan artists plus Ernest Lawson, Maurice Prendergast, and Arthur B. Davies, was opposed to the dominant role played by the National Academy and was in favor of representing the contemporary scene realistically. In 1913 The Eight played an active role in organizing the celebrated Armory Show, which introduced modern art to the United States. Sloan was elected president of the Society of Independent Artists, and was re-elected several times. He taught at the Art Students League in New York from 1914 to 1938, and was its president in 1931. In 1938 he wrote *The Gist of Art*, in which he reminisces and gives his philosophy of art.

Sloan is generally considered the most vital and gifted of the Ashcan painters. He reveals his sympathy for the workingman and -woman and his interest in social reform without bitterness or sentimentality. He never preaches, nor does he use his art as a weapon. His shop girls are seen drying their hair on a rooftop not far from a clothesline, scurrying under the El, or entering a popular theater such as the Haymarket. His laborers drink their ale in the cool dark of their neighborhood saloon, feed pigeons, and gorge on Chinese food while keeping their hats on. Sloan reduced detail, softened contours, and depended on tone to define his forms. In general, his figures express their emotions through posture. Atmosphere is largely evoked by an accurate delineation of locale. Grays, browns, and other neutrals prevail. His style derives from late-19th-century European art.

In 1914–18 he began to paint in Gloucester, Mass., and later in Taos, N.Mex. His style changed, most critics think for the worse, when he became preoccupied with artistic expression and more conventional themes. He extended his palette and often adopted garish harmonies. In the 1930s and thereafter he concentrated on painting the female nude figure.

BIBLIOGRAPHY. L. Goodrich, *John Sloan*, New York, 1952; V. W. Brooks, *John Sloan*, New York, 1955.

ROBERT REIFF

SLODTZ, RENE-MICHEL (Michel-Ange). French sculptor (b. Paris, 1705; d. there, 1764). He was in Rome from 1728 to 1736. Although he was much influenced by Bernini, his style parallels that of the painter Anton Raphael Mengs because of its classicizing vein. Slodtz executed seven reliefs for St-Sulpice, Paris, and with his brothers was in the service of Menus-Plaisirs, executing fireworks and funeral and festival décor. His greatest works are the tombs of the archbishops Montmorin and La Tour d'Au-

vergne (1740–47) in St-Maurice, Vienne, and the décor of the choir of Bourges Cathedral (begun in 1754; completed by L. Vassé).

SLUTER, CLAUS. Dutch-Burgundian sculptor (b. Haarlem, ca. 1340; d. Dijon, ca. 1405). He accomplished his master works in Dijon under the patronage of the Duke of Burgundy. Sluter was the greatest and most influential innovator among northern artists toward the end of the 14th and in the early years of the 15th century. Panofsky says that it is "the concentrated emanation of Claus Sluter's style which we mean when we speak of a 'Burgundian school of sculpture in the 15th century.'"

His earliest-known work was a set of seated prophets for the Brussels Town Hall, whose remaining consoles (Brussels, Musée Historique Communal) are closely related in style to those that support the jamb figures Sluter later carved for the portal at the Chartreuse de Champmol in Dijon. His interest in surface texture and physiognomical individualization may be credited to his formative years in Brussels.

Through the 1390s and until his death Sluter was engaged in his great projects for the Chartreuse de Champmol. He had arrived at Dijon in 1385 to work for Philip the Bold under the sculptor Jean de Marville, and soon became the latter's assistant. Jean de Marville built most of the Chartreuse, working on it until his death in 1389,

Claus Sluter, bust of Christ, fragment of *The Well of Moses*. Museum of Fine Arts, Dijon.

Jan Sluyters, *Maternité*, 1948. Municipal Museum, Amsterdam.

when Sluter took his place to create the portal sculptures and the *Well of Moses*. Sluter's group of freestanding figures for the portal of the church centers on the Virgin and Child of the *trumeau*, which dominate space with a protobaroque independence. The kneeling donor, Philip the Bold, and his wife, Margaret of Flanders, are presented by St. John the Baptist and St. Catherine respectively. Though all the figures are similar in scale, the four flanking ones contribute to the dominance of the central group through their postures of genuflection, which lower the level of their heads, as well as by their positions and the direction of their gaze. Independent of their architectural background in a way that was novel at the time, the sculptures nevertheless are unified to a remarkable degree, compositionally and conceptually, both with each other and with the portal for which they were designed.

Sluter's other major work for Champmol, the *Well of Moses*, formed the plinth of a Calvary that stood in the center of the great cloister. Carved in stone, originally polychromed and gilded by the celebrated painter Jean Malouel, it incorporated the prophecy of the Passion of Christ with the event itself in a single visual frame of reference. At the base stand six Old Testament prophets, the very model of the Sluterian style that later made itself so widely felt. The style is characterized most obviously by amplitude of drapery so solidly rendered that it seems to invoke no structure beneath to support it, a canon of proportion featuring stocky forms and heavy heads, and powerfully individualized physiognomies. A mystery play has been identified in which the prophets depicted on the *Well of Moses* play roles; the inscriptions on the scrolls they hold are quotations from the play. Above the prophets are mourning angels whose wings support the corbeling on which the Crucifixion stood. Of this only a fragment remains, an intensely moving bust of Christ, which is now in the Dijon Museum of Fine Arts.

Sluter began as early as 1385 to work on the tomb of Philip the Bold, which was completed by associates, including his nephew, Claus de Werve, in 1411. Here, too,

are seen Sluter's extraordinary combination of realism and bravura theatricalism, along with the pathos embodied in the famous *pleurants* (mourning monks). The tomb was removed from the Chartreuse during the French Revolution. It is now in Dijon (Museum of Fine Arts); a few of the mourners are missing (three in Cleveland Museum of Art).

BIBLIOGRAPHY. G. Tröscher, *Claus Sluter und die burgundische Plastik um die Wende des XIV. Jahrhunderts*, Freiburg im Breisgau, 1932; H. David, *Claus Sluter*, Paris, 1951; E. Panofsky, *Early Netherlandish Painting*, 2 vols., Cambridge, Mass., 1953. MADLYN KAHR

SLUYTERS, JAN. Dutch painter (b. 's Hertogenbosch, 1881; d. Amsterdam, 1957). He studied at the Amsterdam Academy and won the Prix de Rome in 1904. Sluyters began as an impressionist. About 1916 his style became more expressionistic, in paintings of religious subjects, landscapes, and figures. For a time his formal treatment was influenced by cubism, probably his nearest approach to abstraction, although he retained a personal use of color, ultimately owed to the Fauves. His later work, mostly figures and nudes, became freer and more simplified in paint handling and composition, for example, the soft and airy *Maternité* (1948; Amsterdam, Municipal Museum).

BIBLIOGRAPHY. H. Luns, *Jan Sluijters*, Amsterdam, 1941.

SMET, GUSTAVE DE. Belgian painter (b. Ghent, 1877; d. Deurle, 1943). He studied at the Ghent Academy and

Gustave de Smet, *Béatrice*, 1923. Fine Arts Museum, Brussels. A stylized portrait by this Belgian painter.

in 1901 went to Laethem-Saint-Martin, where he was associated with the second group of Belgian expressionists. He painted simplified and stylized landscapes and portraits, for example, *Paysage de neige au clair de lune* (1918; The Hague, Gemeentemuseum) and *Béatrice* (1923; Brussels, Fine Arts Museum). In his later paintings, the flat treatment sometimes gave way to a greater volume and solidity, as in *Still Life with Herrings* (1938; Antwerp, Fine Arts Museum).

BIBLIOGRAPHY. P. G. van Hecke and E. Langui, *Gustave de Smet: Sa vie et son oeuvre*, Brussels, 1945; L. van Puyvelde, *Gustave de Smet*, Antwerp, 1949.

SMEYERS, GILLIS. Flemish painter (1635–1710). Born in Mechlin, he was a pupil of Jan Verhoeren. Smeyers painted mainly religious subjects in the later Rubens tradition. His works can be distinguished only with difficulty from those of Gillis Joseph Smeyers (1697–1769).

BIBLIOGRAPHY. C. Leurs, ed., *Geschiedenis van de Vlaamsche Kunst*, vol. 2, Antwerp, 1939.

SMIBERT, JOHN. Scottish-American portrait painter (b. Edinburgh, 1688; d. Boston, 1751). The son of a dyer, Smibert was apprenticed to a house painter and plasterer in Edinburgh. At the age of twenty-one he moved to

London, where he first worked as a coach painter and then as a copyist; he also studied art at the academy in Great Queen Street. In 1717 Smibert returned briefly to Edinburgh, then went to Italy, where he remained until 1720. From 1720 to 1728 Smibert practiced portraiture in London, producing works such as *Sir Francis Grant, Lord Cullen* (ca. 1725–26; Edinburgh, Scottish National Portrait Gallery) in the late baroque manner of Kneller.

In 1728 Smibert left London for America in the company of George Berkeley, later bishop of Cloyne, whom he had met in Italy. Berkeley intended to found a college in Bermuda for Indians and invited Smibert to come as professor of art and architecture. The party reached Newport, R.I., on January 23, 1728, and decided to wait until a parliamentary grant was definite. During this time Smibert painted his most ambitious work, *Bishop Berkeley and His Entourage* (1729; New Haven, Yale University Art Gallery). When it appeared likely that the delay might be indefinite, Smibert moved to Boston (November, 1729) and established himself as a portrait painter and owner of a paint shop.

Smibert's importance lies not only in the fact that he was the first significant baroque painter in New England,

John Smibert, *Bishop Berkeley and His Entourage*, 1729. Yale University Art Gallery, New Haven, Conn. (Gift of Isaac Lothrop).

but also in the influence of his copies of old masters and his casts of ancient statuary. As an artist, Smibert worked in the baroque style of Kneller, with thick paint and flourishes (*Jane Clark*, ca. 1739; Boston, Massachusetts Historical Society), but he tended more and more toward looser, rougher, and more realistic painting (*Nathaniel Byfield*, 1730; New York, Metropolitan Museum). Through his work, but even more through his painting hall, Smibert exerted a tremendous influence. As early as 1730 he had exhibited his own work as well as the antique casts and old master copies—Raphael, Poussin, and Van Dyck among them—that he had acquired in Italy. During his lifetime, his influence is seen on Feke and Greenwood, but even after his death his painting hall and its contents remained intact to inspire such artists as Copley, Peale, and Trumbull.

Smibert also tried his hand at architecture, his only work being Boston's Faneuil Hall (built 1742).

BIBLIOGRAPHY. A. Burroughs, "Notes on Smibert's Development," *Art in America*, XXX, April, 1942; H. W. Foote, *John Smibert; Painter*, Cambridge, Mass., 1950.

DAMIE STILLMAN

SMIRKE, SIR ROBERT. English architect (1781–1867). One of the most successful early-19th-century architects, he worked in a dignified but uninspired classical style, influenced by Schinkel. His design for the British Museum, London (1823–47), is important in the development of the European museum building.

SMITH, DAVID. American metal sculptor and painter (b. Decatur, Ind., 1906; d. Albany, N.Y., 1965). He lived and worked at Bolton's Landing, N.Y. Smith was an important innovator in contemporary American sculpture, creating monumental abstractions in welded iron and steel. In 1925 he was a riveter in the South Bend, Ind., Studebaker plant, an experience that was important for his later metalwork. In 1926–27 he became a painting student at the Art Students League, New York City, studying with John Sloan and Jan Matulka. From the latter he became aware of Mondrian, Picasso, and Kandinsky. In 1930, partly influenced by Stuart Davis and Jean Xceron, he worked in an abstract surrealist style. In 1931 he attached objects of various materials to his paintings. In the Virgin Islands that year he made constructions with found and carved coral forms and did his initial freestanding wooden and painted constructions. He sustained these experiments the following year, adding soldered lead and iron forms to a wooden base.

Seeing a *Cahiers d'Art* reproduction of Picasso's metal sculpture in 1933, Smith made his first welded iron sculpture. The following year he acquired studio space in the Terminal Iron Works in Brooklyn, where he worked for six years. In 1935 he traveled to London, Paris, Greece, Crete, and Russia, becoming interested in ancient art and numismatics. Between 1937 and 1940, during the Spanish Civil War, he did his *Medals for Dishonor* series. His first show was at the East River Gallery, in New York, in 1938. He exhibited with the American Abstract Artists and worked for the Works Progress Administration. After 1940 he built a studio at Bolton's Landing. During World War II he was a machinist and worked on tanks and locomotives. He taught at several schools: Sarah Lawrence

David Smith, *Hudson River Landscape*, 1951. Steel. Whitney Museum of American Art, New York.

College, Bronxville, N.Y., in 1948; the University of Arkansas, Fayetteville, in 1953; and Indiana University, Bloomington, in 1954.

David Smith was perhaps the first and most influential American sculptor to realize the potentials of openwork in iron. His imagery was tough but molded by a strong fantasy that produced uncanny figural conceptions (*Head*, 1938, New York, Museum of Modern Art; *Detroit Queen*, 1957, Connecticut, private collection) and lyrical landscapes (*Hudson River Landscape*, 1951; New York, Whitney Museum), as well as militant birds (*Royal Bird*, 1948; Minneapolis, Walker Art Center), witty still lifes (*The Banquet*, 1951; New York, private collection), and foreboding totemic images (*Tank Totem* series, mid-1950s). He did several surrealist compositions, for example, *Song of an Irish Blacksmith* (1950) and *Oculus* (1947; New York, Mr. and Mrs. R. John Collection).

Smith's metaphorical imagery comes from machines and machine-made parts as well as from botanical nature. The *Agricola* series of 1951–52 is an example of the latter source. His materials lose their distinct identity through Smith's wit and through his power to fuse them into a new art object. In 1959 Smith returned to painting and to painting his sculpture. In 1964 he received a Brandeis University medal for lifetime achievements in the creative arts.

BIBLIOGRAPHY. New York, Museum of Modern Art, *David Smith*, New York, 1957; J. H. Cone, *David Smith, 1906–1965, A Retrospective Exhibition*, Cambridge, Mass., 1966.

ALBERT ELSEN

SMITH, EDDY. German painter and graphic artist (b. Berlin, 1896; d. there, 1957). He studied in Berlin and traveled in Switzerland, Romania, and France. Influenced by Renoir and Manet, Smith was best known for his portraits.

SMITH, JACK. English painter (1928–). Born in Sheffield, he studied at the Royal College of Art, London, and had his first one-man exhibition in London in 1953. He was first attracted to Cézanne's paintings, but adopted a more somber domestic genre style not without some social symbolism (*Mother Bathing Child*, 1953; London,

Tate). By the late 1950s he had abandoned his "social realist" or "kitchen sink" style to adopt a more abstract imagery with more rigid forms and a predominating interest in light and color (*Black, White and Grey Movement, No. 2*, 1962; Tate). He was represented in the British Pavilion at the Venice Biennale in 1956 and was awarded a prize at the John Moores's Liverpool exhibition in 1957.

SMITH, JOHN. English mezzotinter (b. Daventry, 1652; d. Northampton, 1742). A pupil of Isaac Beckett and Jan van der Vaart, Smith was a protégé of Kneller until John Simon replaced him. His works are a portrait gallery of English officialdom (mostly after paintings) and also include some plates after Correggio, Titian, and others.

BIBLIOGRAPHY. J. Leisching, *Schabkunst*, Vienna, 1913.

SMITH, JOHN RAPHAEL. English draftsman, engraver, and painter (b. Derby, 1752; d. Worcester, 1812). He learned mezzotint in London and became a leading English master in that technique. About three hundred portraits are now attributed to him, most of them after Romney, Gainsborough, and Reynolds, with some after his own design. In addition, Smith copied and made genre scenes and mythological and historical plates. He assisted some of London's leading painters, Morland among them, and at one time traveled as an itinerant painter. Among his pupils were William Hilton and Peter de Wint. A number of Smith's pastels are in the Victoria and Albert Museum, London, and a self-portrait is in the National Gallery, London.

BIBLIOGRAPHY. J. Frankau, *An Eighteenth-Century Artist and Engraver, John Raphael Smith*, 2 vols., London, 1902.

Matthew Smith, *Cyclamen*. Tate Gallery, London.

SMITH, JOHN "WARWICK." English water-colorist (1749–1831). He was nicknamed Warwick because of the extensive patronage of the Second Earl of Warwick. Smith's father was a gardener. The employer's brother first taught him and then passed him on to his son, Sawrey Gilpin. About 1775 he met Lord Warwick, who admired his work and paid for a visit to Italy from 1776 to 1781. On his return he settled for a while in the town of Warwick, but was in London by 1797.

His Italian scenes dated after 1781 are almost certainly worked-up versions and not evidence of a later visit. Of the water colors done for Lord Warwick, the best are spacious mountainscapes in luminous blues and grays. Otherwise, many of his Italian scenes are rather pinkish in color and tame in composition. He toured frequently in Wales and in the English Peak and Lake Districts, painting views in which he frequently varied the topography to suit his composition. Smith is represented in most collections of English water colors and by an excellent example in the National Gallery of Canada, Ottawa.

BIBLIOGRAPHY. B. S. Long, "John 'Warwick' Smith," *Walker's Quarterly*, XXIV, vol. 3, 1920/32; I. Williams, "John 'Warwick' Smith," *Old Water-Colour Society's Club*, XXIV, 1946; R. and S. Redgrave, *A Century of British Painters*, repr., London, 1947; G. Reynolds, *British Water-Colours*, London, 1951; I. Williams, *Early English Watercolours*, London, 1952.

PATRICIA M. BUTLER

SMITH, MATTHEW. British painter (1879–1959). Smith was born in Halifax. His parents were strict nonconformists; his father was a prosperous industrialist. Smith went into business, and only after a struggle against family opposition was he able to go to the Manchester School of Art. He later went to the Slade School in London, but as a result of poor health was sent to Pont-Aven in 1908; he moved to Paris in 1910. The influence of Gauguin, especially his emphasis on strong colors, was of the greatest importance to the maturing Smith. In Paris he exhibited at the Salon des Indépendants and enrolled in Matisse's academy. The influence of these two great colorists led to Smith's adoption of Fauvism, which he was to retain throughout his career, adding his own vigorous brushwork. He spent many years in France, mainly in Provence, and was an important channel of influence for French art in England.

BIBLIOGRAPHY. F. Halliday, P. Hendy, and J. Russell, *Matthew Smith*, London, 1962.

SMITH, RICHARD. English painter (1931–). Smith was born in Letchworth and attended the Royal College of Art. On his first trip to Paris (1956) he was influenced by abstract expressionism. He turned to a more concrete style, drawing on techniques of advertising design, particularly attention-getting perspectives. In 1967 he was awarded the Grand Prize of the São Paulo Bienal for a series of shaped canvases.

SMITH, THOMAS. American portrait painter (fl. Massachusetts, ca. 1650–90). A Major Thomas Smith is known to have worked at Harvard College in 1680. He has been identified with a Captain Thomas Smith, Puritan mariner, who came to Boston from Bermuda in 1650 but apparently did not remain. The Worcester Art Museum has a

number of bold and broadly modeled portraits attributed to him.

BIBLIOGRAPHY. L. Dresser, *Seventeenth-Century Painting in New England*, Worcester, 1935; W. P. Belknap, Jr., *American Colonial Painting*, Cambridge, Mass., 1959.

SMITH, TONY (Anthony Peter). American sculptor, architect, and painter (1912–). After studying at the Art Students League in New York City and the New Bauhaus in Chicago, Smith supervised a number of architectural projects as an assistant to Frank Lloyd Wright. Between 1940 and 1960 he became an influential teacher and designed a number of houses in his own architectural practice. He produced his first sculptures in Germany in 1953–55 and, after 1960, evolved one of the most original forms of sculptural expression in the United States. In 1966 he was given a one-man exhibition split between the Wadsworth Atheneum in Hartford, Conn., and the Institute of Contemporary Art in Philadelphia. Made of plywood painted black and meant to be translated into steel, his works use a modular system and basic geometric shapes, but evoke a primordial power, especially when set in a landscape. Smith has also painted since the early 1930s, using the medium as a means of experimentation with space, shape, and formal relationships.

SMITH COLLEGE MUSEUM OF ART, see NORTHAMPTON, MASS.: SMITH COLLEGE MUSEUM OF ART.

SMITHSON, PETER AND ALISON, see BRUTALISM, NEW.

SMITS, JAKOB. Belgian painter and graphic artist (b. Rotterdam, 1855; d. Moll, 1928). Smits studied in Rotterdam and Munich. He did dusky, thickly painted, and emotionally expressive genre, landscapes, and religious subjects.

SMOLNY INSTITUTE, LENINGRAD, see BAZHENOV, VASILI IVANOVICH.

SMYTHSON, ROBERT AND JOHN. English architects: Robert (d. 1614) and his son John (d. 1634). In the 1570s Robert prepared the final model of Longleat House, which has been described as the "High Renaissance" of Elizabethan architecture. There followed many houses in the Midlands: Wolloton Hall (1580), Worksop Manor (1570s), and a particularly fine work, Hardwick Hall (1590s). John's most outstanding work was Bolsover Castle, built from about 1612 in a distinct romantic castle revival style. It was affected in part by contemporary building in London recorded by him on a visit there in 1618. The corpus of the Smythson drawings is preserved at the Royal Institute of British Architects, providing a unique survey of late Elizabethan and Jacobean design. *See* LONGLEAT HOUSE.

BIBLIOGRAPHY. J. N. Summerson, *Architecture in Britain, 1530–1830*, 4th rev. ed., Baltimore, 1963.

SNAITH, WILLIAM. American industrial designer, scenic designer, architect, and painter (1908–). Born in New York City, he was trained as an architect at New York University, where he was influenced by Lloyd Morgan, and at the Ecole des Beaux-Arts in Fontainebleau. Snaith joined the Raymond Loewy Corporation in 1936 and became its president in 1959.

BIBLIOGRAPHY. G. Dunne, "Gallery 1: William T. Snaith," *Industrial Design*, VI, September, 1959.

SNAKE GODDESS, CRETE, see CRETAN SNAKE GODDESS.

SNAYERS, PIETER. Flemish painter (b. Antwerp, 1592; d. Brussels, after 1666). A painter of hunting and battle scenes, he was a pupil of Sebastiaen Vrancx and the master of Adam Frans van der Meulen. He represents the transition between those two artists and must be credited with introducing panoramic views and bird's-eye perspective into the genre.

BIBLIOGRAPHY. F. J. van den Branden, *Geschiedenis der Antwerpsche Schilderschool*, Antwerp, 1883.

SNEIS, FRANS, see SNYDERS, FRANS.

SNELLINCK (Snellincx), JAN. Flemish painter of religious and military scenes (b. Mechlin, 1549; d. Antwerp, 1638). Snellinck was active in Antwerp. In military scenes he was a forerunner of Sebastiaen Vrancx. The religious paintings were done in the mannerist style of the pre-Rubensian generation. Snellinck was also an art dealer.

BIBLIOGRAPHY. F. J. van den Branden, *Geschiedenis der Antwerpsche Schilderschool*, Antwerp, 1883.

SNYDERS (Snyers; Sneyders; Sneis), FRANS. Flemish painter of figures, animals, and still lifes (b. Antwerp, 1579; d. there, 1657). He was a pupil of Pieter Brueghel the Younger, became a master in 1602, and spent some time (one year?) in Italy. He returned to Antwerp in 1609.

Snyders's early endeavors seem to have been in the field of still life, although there exists more than a presumption that he also tried his hand at figure painting. His first authenticated works are *Fruit and Game* (1603; Brussels, Art Market) and *Vegetable and Game Dealer* (1610; Brussels, private collection). In them the artist appears as a follower of the mannerists, exploiting the style of Pieter Aertsen and Joachim Beuckelaer. Considering that Jan Breughel I introduced him in this period to Cardinal Borromeo as "one of the first painters of Antwerp," it becomes understandable that critics attempt to link his name with paintings of better quality, such as *Pots and Pans* (Stuttgart, State Gallery), which has been variously attributed to Snyders or to Rubens.

Snyders's development attained fulfillment during the second decade of the century. It was then that Rubens and Van Dyck (and later on, also Jacob Jordaens) called upon him to paint the animals in their large canvases. The best-known documented example is the eagle in Rubens's *Prometheus* (Philadelphia Museum of Art). Among Snyders's independent works of the period, the four *Markets* (Leningrad, Hermitage) stand out.

Rubens also furnished the master with sketches such as *Philopomen* (Paris, Louvre), which Snyders translated into large-size canvases (for example, *Philopomen*, Madrid, Prado). In fact, Rubensian motifs continued to play a large part in Snyders's conception, as evidenced by the repeatedly used dead swan from the same composition.

Finally, mention must be made of Snyders's hunting pictures, which have such a conspicuous role in his *oeuvre*. They resemble Rubens's late works, and instances of col-

Frans Snyders, *The Boar Hunt*. Uffizi, Florence. A frequent motif in this artist's oeuvre.

laboration between the two masters became increasingly frequent. Snyders's brushwork is solid, vigorous, and warm, and features juxtaposition of unbroken colors. He had great painterly gifts that occasionally led him to improve on Rubens's technique of handling reflected light.

BIBLIOGRAPHY. E. Larsen, *P. P. Rubens*, Antwerp, 1952; E. Greindl, *Les Peintres flamands de nature morte au XVIIᵉ siècle*, Brussels, 1956; H. Gerson and E. H. ter Kuile, *Art and Architecture in Belgium, 1600–1800*, Baltimore, 1960.

ERIK LARSEN

SNYERS, PIETER. Flemish painter of portraits, still lifes, and genre and market scenes (1681–1752). Born in Antwerp, he was a pupil of Alexander van Bredael. For compositions such as his ambulant musicians, he drew occasional inspiration from Giacomo Ceruti.

BIBLIOGRAPHY. F. J. van den Branden, *Geschiedenis der Antwerpsche Schilderschool*, Antwerp, 1883.

SOAMI (Shinso). Japanese painter (d. 1525). Sōami was the son of Geiami and inherited the position of art counselor to the shogun from his father. In 1476 he completed the catalog *Kundaikan Sayū Chōki* (Notebook of the Shogun's Art Secretary), begun by Nōami, of Chinese paintings in the shogunal collection. *See* GEIAMI.

BIBLIOGRAPHY. R. T. Paine and A. Soper, *The Art and Architecture of Japan*, Baltimore, 1955.

SOANE, SIR JOHN. English architect (1753–1837). He received his early training with George Dance and Henry Holland. Soane studied at the Royal Academy of Arts, where he was awarded many honors, including the silver medal in 1772, the gold medal in 1776, and a traveling studentship that enabled him to study abroad (mostly in Italy) from 1778 to 1780. Following his return from Italy, Soane was occupied with comparatively small projects, and his style does not show any striking developments. However, in 1788 he was appointed surveyor of the Bank of England, which he ultimately rebuilt. A happy and productive phase of his career ensued, lasting for about fifteen years, during which his personal style developed and matured. There followed an official appointment to the Office of Works in 1791. He was elected associate of the Royal Academy in 1795, and full academician in 1802; in 1806 he was appointed professor of architecture.

Most of Soane's best work dates from these years. The earliest structure to exhibit his fully developed style was the Bank Stock Office (1792; demolished 1925). The terse economy of the decorative vocabulary, the unclassical proportions of the space, and the general lightness of effect are all highly personal. These qualities characterize the interiors that Soane did throughout much of his career. His exterior designs are also very personal, although they are different in character and more varied in vocabulary than the interiors. The famous "Tivoli Corner" of the Bank of England (1804–07) exhibits an effect almost deliberately opposed to the earlier works. The surface is handled in a rich sculptural manner, involving a freestanding classical order and an impression of great mass.

Soane's later work, particularly the Dulwich College Art Gallery, and his own house, 13 Lincoln's Inn Fields, London, continued to exhibit great variety and invention, although remaining within the tenets of Soane's general style. His last years, from 1820 until his death, were less productive. He was then much involved in drawing schemes for large public buildings, practically none of which were executed.

Soane must also be remembered as a distinguished if somewhat eccentric collector, whose interests ranged widely from classical antiquities to paintings by Hogarth. His house and collection are now a public museum, a fascinating monument to one of England's most individual architects. *See* LONDON: MUSEUMS (SOANE MUSEUM).

BIBLIOGRAPHY. J. Summerson, *Sir John Soane*, London, 1952; D. Stroud, *The Architecture of Sir John Soane*, London, 1961.

ROBERT R. WARK

SOCIAL REALISM. American art movement of the 1930s. Largely as a result of the Depression and the increasing involvement of the United States in global affairs, some leading artists, notably Shahn, Soyer, Gropper, Grosz, and Evergood, used art as a vehicle for messages of social protest. Since the works produced were narrative and exhortative, all the artists worked in a representational idiom, although there was a variety of personal styles. Outstanding works within this loosely constructed category are Shahn's *The Passion of Sacco and Vanzetti* (1930–31; series of 23 paintings) and Evergood's *Lily and the Sparrows* (1939; New York, Whitney Museum). More recently, as in the work of Jack Levine, social realism has been infused with more overtly imaginative forms. *See* EVERGOOD, PHILIP; GROPPER, WILLIAM; GROSZ, GEORGE; LEVINE, JACK; SHAHN, BEN; SOYER, ISAAC.

BIBLIOGRAPHY. L. Goodrich and J. I. H. Baur, *American Art of Our Century*, New York, 1961.

SOCIETY ISLANDS, *see* OCEANIC ART (POLYNESIA).

SOCLE. Slightly projecting base, or foot, of a wall or pier. The socle is sometimes distinguished from the plinth or pedestal itself. At times the term has been used to designate the projecting dado of a wall.

SODOMA (Giovanni Antonio Bazzi). Italian painter (b. Vercelli, 1477; d. Siena, 1549). At thirteen he entered the studio of the glassmaker Martino Spanzotti and remained there for seven years. In 1497, on the death of his father, a cobbler, Sodoma left Spanzotti; he settled in Siena in 1501. His whereabouts between 1497 and 1501 have not been definitely established; reputedly he was in Milan, where Leonardo was the reigning artist: something of the haunting sweetness of Leonardo's women may occasionally be detected in Sodoma.

During his first residence in Siena, Sodoma painted a *Descent from the Cross* (1502; Siena, National Picture Gallery) in which a placid landscape and an overly obvious symmetry are curiously juxtaposed with agitated draperies. Between 1503 and 1507 he worked in the Bene-

Sir John Soane, Dulwich College Art Gallery, London.

Socle. Slightly projecting base of a wall or pier.

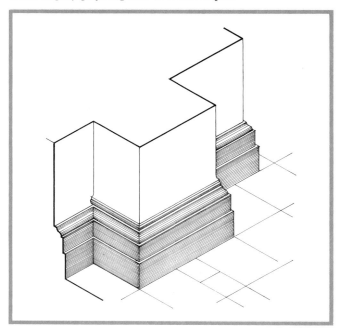

dictine monastery of Monte Oliveto Maggiore, just outside the confines of Siena, where he painted thirty-one frescoes to complete the series on the life of St. Benedict that had been abandoned by Signorelli in 1498.

In 1507 Sodoma was taken to Rome by Agostino Chigi, the treasurer of Pope Julius II, but he did little for the great program of artistic renovation. He did decorate part of the ceiling of the Stanza della Segnatura; the central octagon with its *putti* and the eight polygons between the circles are his work. In 1512 Sodoma decorated the bedroom of Chigi in the Farnesina with the *Marriage of Alexander and Roxana* and other scenes from the life of Alexander. A compositional focus is lacking in the *Marriage*;

the principal figures and many vivacious *putti* are distributed loosely across the frontal plane.

In 1518, with the assistance of his followers Peruzzi and Ricci, Sodoma began to decorate the S. Bernardino Oratory near San Francesco, but he returned to Siena before completing the task. About 1525 he did scenes from the life of St. Catherine for the Chapel of St. Catherine in S. Domenico in Siena. The individual figures are handsomely done, sometimes, as in the *Vision of St. Catherine*, conveying an intense fervor. The suggestion of space, however, is unconvincing and the handling of composition clumsy. Yet, in spite of incongruous relationships between figures and setting, Sodoma's draftsmanship is sure. Often his

Sodoma, *The Three Fates*. Oil on canvas. Barberini Palace (Galleria Nazionale d'Arte Antica), Rome.

heroes strike forceful poses, as in a *St. Sebastian* (1525; Florence, Uffizi).

BIBLIOGRAPHY. E. H. and E. N. Blashfield et al., "Sodoma," *Masters in Art*, VII, April, 1906; C. Ricci, *North Italian Painting of the Cinquecento: Piedmont, Liguria, Lombardy, Emilia*, Florence, 1929; S. Freedberg, *Painting of the High Renaissance in Rome and Florence*, 2 vols., Cambridge, Mass., 1961.

ABRAHAM A. DAVIDSON

SOEN (Josui Soen). Japanese priest-painter (fl. late 15th cent.). Sōen was from the Engakuji in Kamakura. He became the most beloved pupil of Sesshū, who in 1495 gave him the celebrated painting *Ink-Splash Landscape* (Tokyo, National Museum). Only a few of his paintings have survived. *See* SESSHU TOYO.

BIBLIOGRAPHY. R. T. Paine and A. Soper, *The Art and Architecture of Japan*, Baltimore, 1955.

SOEST: CHURCH OF MARIA ZUR WIESE. German church founded in 1314 and completed in the 15th century. It represents a union of the Westphalian type of hall church and High Gothic construction. The architect was Johannes Schendeler.

SOEST: SANKT PATROKLUS. German church built by Archbishop Bruno, brother of Otto the Great, before 965. It was almost totally remodeled in the 12th and 13th centuries. The 10th-century church was one of the few Ottonian single-aisled cruciform-plan churches. A single eastern apse opened directly off the nave, and the transept arms, lower in height than the nave, were separated from it by north and south framing arches. From about 1060 to 1080 an imposing westwork was added, perhaps under the influence of St. Pantaleon, Cologne. The westwork, with a groin-vaulted two-storied interior, is dominated by a magnificent tower and spire, suggestive of full Romanesque monumental developments.

SOESTERMANS, JOSSE, *see* SUSTERMAN, JUSTUS.

SOFFICI, ARDENGO. Italian painter (1879–1967). Born in Rignano sull'Arno, Soffici studied painting at the Florence Academy and worked in Paris from 1900 to 1907. After returning to Italy he contributed articles on modern art to the magazine *La voce* and in 1913 founded, with Giovanni Papini, *Lacerba*, which became the principal publication of the futurists, whom Soffici had initially opposed. His style of painting during this period, while futuristic in its concern with the dynamic forces of movement and light, is closer to the cubist use of static structure and modeled forms. In 1915 Soffici broke with the futurists and after World War I adopted a conservative figurative style.

BIBLIOGRAPHY. A. Soffici, *Opere, I*, Florence, 1959.

SOFFIT. Exposed underside of an architectural member, as of an arch, the cornice of an entablature, a stair, or a ceiling.

SOFIA: HAGIA SOPHIA. One of the best-preserved monuments of early Byzantine architecture in Bulgaria, it is believed to date from the 6th century. A vaulted Latin-cross basilica with a shallow dome over the crossing, the church is preceded by a narthex originally flanked by tow-

Soffit. Exposed underside of an arch or other element.

ers. The exterior, devoid of ornamentation, has a harsh and severe aspect.

BIBLIOGRAPHY. M. Bichev, *Architecture in Bulgaria*, Sofia, 1961.

SOFT GROUND ETCHING. In the etching process, the use of a ground that contains a nonhardening substance. This produces grainy lines and makes possible a variety of textures. The ground is made by melting together equal parts of hard ground and a substance such as tallow, automobile cup grease, or vaseline.

A sheet of thin charcoal paper is placed on the soft grounded plate and the drawing is made. The etcher uses a lead pencil with enough pressure to lift the ground from the plate to the underside of the paper. When the paper is turned over, the drawing is seen as a grainy silver or copper line on a dark ground, and even shows the texture of the paper. The plate is etched, printed, and reworked in the same manner as in etching.

See also ETCHING.

BIBLIOGRAPHY. J. Heller, *Printmaking Today*, New York, 1958.

SOFT STYLE, *see* WEICHER STIL.

SOGARI, PROSPERO, *see* SPANI, PROSPERO.

SOGLIANI, GIOVANNI ANTONIO. Italian painter (b. Florence, 1492; d. there, 1544). His *tondo Madonna with St. John* (ca. 1515; Baltimore, Walters Art Gallery) shows the influence of Lorenzo di Credi, but in the *S. Acasio Altar* of 1521 (Florence, S. Lorenzo), he adopted the style of Fra Bartolommeo.

BIBLIOGRAPHY. S. J. Freedberg, *Painting of the High Renaissance in Rome and Florence*, 2 vols., Cambridge, Mass., 1961.

SOHAG. Site in Upper Egypt. It contains Coptic churches of two monasteries, called the White and the Red, perhaps dating from the 4th or the 5th century. They com-

bine ancient Egyptian with late classical forms. The Church of the White Monastery, in an East Christian style, was founded, according to tradition, by St. Helena, rebuilt under the Abbot Schenute in 430–440, and is so called because of its white limestone exterior. It is a three-aisled basilica with a series of chambers at the east end that form a polyfoil plan. The capitals of the nave colonnade are of antique inspiration, while the design of the fortresslike exterior derives from traditional Egyptian usage. The sanctuary vaults replaced the original wooden roofs at a later date.

BIBLIOGRAPHY. A. J. Butler, *The Ancient Coptic Churches of Egypt*, vol. 1, Oxford, 1884; U. Monneret de Villard, *Les Couvents près de Sohag*, 2 vols., Milan, 1925–26.

SOHIER, HECTOR. French architect (fl. 1521–54). Sohier built the choir of St-Pierre at Caen (1521–45); it is Gothic in scheme but combines Gothic and Renaissance elements in its opulent decoration. The Renaissance portions of St-Sauveur at Caen are attributed to him (choir of 1546).

SOIRON, FRANCOIS-DAVID. French etcher (b. Geneva, 1764). Soiron studied at the Geneva Academy and with Johann Georg Wille in Paris. He is known to have been a citizen of Geneva in 1790, although he also worked in London at some period in his life. He engraved in the dotted manner, especially after Lawrence, Morland, and H. W. Bunbury.

Soissons Cathedral. The nave and the choir of this Gothic edifice, mainly 13th century.

SOISSONS, BERNARD DE. French Gothic architect (13th cent.). Bernard was the fourth master of Reims Cathedral (1255–90). His work included the great "O," or rose, of the west façade and the five eastern vaults of the nave.

BIBLIOGRAPHY. R. Branner, "Jean d'Orbais and the Cathedral of Reims," *Art Bulletin*, XLIII, June, 1961.

SOISSONS CATHEDRAL. French cathedral. The oldest existing part is the apsidal end of the south transept, which dates from the 12th century. Most of the building belongs to the Gothic period of the 13th century. As in the famous sixth pier of Notre-Dame in Paris, the vaulting shafts spring from a single engaged colonnette. The shaft in Soissons, however, is slenderer and more harmoniously related to the pier than that in Paris. The north transept façade and the upper parts of the towers were not completed until the 14th century. The Cathedral was finally dedicated in 1479. The triforium and clerestory (with two windows to each bay) are similar to the ones at Chartres. Badly damaged during World War I, the Cathedral was admirably restored.

BIBLIOGRAPHY. M. Aubert and S. Goubet, *Gothic Cathedrals of France and their Treasures*, London, New York, 1959.

SOISSONS GOSPELS. Carolingian illuminated manuscript, in the National Library, Paris.

SOJARO, IL, *see* GATTI, BERNARDINO.

SOKKULAM. Rock-cut Buddhist chapel about 1 mile from Pulguksa temple, in North Kyungsang Province, Korea. It was built by the same group of architects who constructed the temple. The chapel is round, and its ceiling is domed. It was cut from the living rock with a few additional members to complete it, like the ancient rock-cut chapels of India. As in India, there is space inside for circumambulation of the main Buddha statue. Such an arrangement, however, is a clear departure from the usual temple plan of both China and Japan. Sculptures of remarkable elegance decorate the entrance passage, the vestibule, and the walls of the interior. *See* PULGUKSA TEMPLE.

See also SAKYAMUNI (GRANITE).

BIBLIOGRAPHY. E. McCune, *The Arts of Korea*, Rutland, Vt., 1962.

SOLANA, JOSE GUTIERREZ. Spanish painter (b. Madrid, 1886; d. there, 1945). Although he attended art school in Madrid for a short period, Solana was mostly self-taught. Turning to writing as a young man, he presented corrosive views of Spanish life in *Scenes and Costumes of Madrid* (1912 and 1918). Solana's paintings reflect his intense involvement in the back alleys as well as in the intellectual life of Madrid, and his black sense of death in life places him in the tradition of Goya. This is conveyed by the primitive strength of his draftsmanship and the repetitive arrangements of figures and forms, particularly in group portraits ranging from prostitutes (*Claudia's Place*; Madrid, private collection) to literary groups (*Reunion at the Café Pombo*, 1920; Madrid, Museum of Modern Art).

BIBLIOGRAPHY. R. Goméz de la Serna, *José Gutiérrez-Solana*, Buenos Aires, 1944; J. Gutiérrez-Solana, *Obra literaria*, Madrid, 1961; M. Sánchez-Camargo, *Solana, vida y pintura*, 2d rev. ed., Madrid, 1962.

SOLAR. Medieval term for an upper chamber (from the Latin *solarium*, "sunny place," "balcony"). Usually it was

Cristoforo Solari, monument of Lodovico il Moro and Beatrice d'Este, 1497–99. Certosa of Pavia.

the chamber of the owner, as in Stokesay Castle, Shropshire, whose solar is over the great hall. In medieval keeps, often several stories high, the solar was a withdrawing room above the hall on the main floor. In later medieval architecture, it became a private chamber on an upper floor of large houses. In the 15th-century manor house of Great Chalfield, Wiltshire, the solar had spy holes from which the master could scan the hall below.

SOLARI (Solario), CRISTOFORO (Il Gobbo). Italian sculptor and architect (d. Milan, 1527). Mentioned in Venice in 1489, he worked chiefly in Lombardy and in 1506 was appointed magister at the Cathedral of Milan. His best-known work, the monument of Lodovico il Moro and Beatrice d'Este (1497–99), of which the recumbent effigies are preserved at the Certosa of Pavia, combines strong modeling and unrestrained use of detail.

SOLARI, GIORGIO DE. Italian sculptor (b. Solario; fl. 15th cent.). He worked on the Milan Cathedral in 1403–04 and was later joined by Giacomo and Corrado Solari, both also stonemasons. He executed a statue of St. George that is thought to be a portrait of Gian Galeazzo Visconti.

SOLARI, GIOVANNI. Italian architect (b. ca. 1410; d. Milan, 1480). He was active as an architect on the major Sforza projects in Lombardy. In 1428 he was appointed to the fabric of the Certosa of Pavia and is perhaps responsible for the large cloister, whose construction continued for twenty years. Some scholars believe that he shared in the planning of the church with his son Guiniforte. In 1445 Solari was hired by the Republic of Milan for work on the castle at Porta Giovia (later the Sforza Castle). In 1450 Francesco Sforza appointed him ducal architect, and in the same year Solari was appointed to the fabric of the Milan Cathedral. In his later years he worked primarily on engineering projects for the Duke outside the city of Milan. *See* SOLARI, GUINIFORTE.

BIBLIOGRAPHY. F. Malaguzzi-Valeri, "I Solari architetti e scultori lombardi del XV secolo," *Italienische Forschungen*, I, 1906.

SOLARI, GUINIFORTE. Italian architect (b. Milan, 1427; d. there, 1481). A son of Giovanni Solari, Guiniforte maintained the strong Lombard traditions of his father's generation. In 1459 he was appointed to the fabric of the Cathedral of Milan and in 1462 he was attached to the work on the Certosa of Pavia. With the departure of Filarete from Milan in 1465, he was named architect of the Ospedale Maggiore, and in 1471 he was made ducal engineer. The contrast between Filarete's lower story at the Ospedale Maggiore and the upper one by Guiniforte indicates the strong hold of Lombard tradition on the latter. The interiors of the Certosa at Pavia and of the Milanese churches of S. Maria delle Grazie, S. Pietro in Gessate, and S. Maria della Pace are also his work.

BIBLIOGRAPHY. A. Venturi, *Storia dell'arte italiana*, vol. 8, pt. 1, Milan, 1923.

SOLARI, PIETRO, *see* LOMBARDO, PIETRO.

SOLARI, TULLIO, *see* LOMBARDO, TULLIO.

SOLARIO, ANDREA. Milanese painter (fl. 1495–1522). He was also active in Venice (1495) and France (1507–09). Influenced by Leonardo in design, Solario is more colorful, as can be seen in his anthology piece, the *Virgin with the Green Cushion* (1507; Paris, Louvre). Brilliant portraits include *Chancellor Morone* (1522; Milan, Scotti Collection). He also used Flemish motifs.

BIBLIOGRAPHY. K. Badt, *Andrea Solario*, Leipzig, 1914.

SOLARIO, ANTONIO. Venetian painter (fl. 1495?–1518?). Influenced by Vittore Carpaccio, Solario worked in the Marches and in Naples. Besides ruined frescoes at SS. Severino e Sosio in Naples, his most notable work is the triptych for Paul Withipole (1514; Bristol, City Art Gallery; London, National Gallery). He signed one painting with the name Lo Zingaro.

SOLARIO, CRISTOFORO, *see* SOLARI, CRISTOFORO.

SOLAR SHIPS (Solar Barks). Full-sized wooden ships buried by Old Kingdom rulers of Egypt as part of their tomb equipment. Such a vessel, 120 feet in length, was unearthed near the Cheops Pyramid at Giza in 1954. The ship's purpose was to permit the deceased king to sail across the sky each day and under the earth at night, thus duplicating the glorious travels of the sun god, Amun.

Portable ships were also used in priestly processions to mark the ritual passage of the sun god from one temple to another.

BIBLIOGRAPHY. W. C. Hayes, *The Scepter of Egypt*, pt. 1, New York, 1953.

SOLIMENA, FRANCESCO. Neapolitan painter and architect (b. Canale di Serino, 1657; d. Barra, 1747). He studied under his father, the painter Angelo Solimena, but went to live in Naples about 1674. There he quickly developed a bold, decorative style stemming from Lanfranco and Giordano. His first important mural commission, the frescoes in the Chapel of St. Anne in the Gesù Nuovo, was carried out in 1677. He was active throughout a long life, influencing the progress of late baroque painting throughout Italy and in Germany and Austria. Of his considerable output, some of the most important works are the frescoes in S. Paolo Maggiore (1689–94) and the Gesù Nuovo (1725), both in Naples.

BIBLIOGRAPHY. F. Bologna, *Francesco Solimena*, Naples, 1938.

SOLIS, VIRGIL. German engraver and draftsman for the woodcut (1514–62). Except for a brief period spent in Zurich, Solis worked in Nürnberg and belonged to the Kleinmeister group of graphic artists; his style, like theirs, was essentially dependent on Dürer. Solis was influenced also by J. Breu, Burgkmair, and A. Hirschvogel. His output was especially prolific and includes prints of mythological and allegorical subjects, genre, landscapes, and ornamental prints which frequently served as models for

Francesco Solimena, *The Fall of Simon Magus*, 1689–94. Fresco. Sacristy of S. Paolo Maggiore, Naples.

German painters, sculptors, and goldsmiths. His most important woodcut book illustrations are for a Bible (1560), the *Wolf Bible* (1565), Ovid (1563), and Aesop (1566), most posthumously published in response to the continuing interest in his work.

See also MASTER H. W. G.

BIBLIOGRAPHY. M. J. Friedländer, *Der Holzschnitt*, 3d ed., Berlin, 1926.

SOLOMON, KING. King of Israel in the 10th century B.C.; son of David and Bathsheba. He is represented in art in two episodes: the Judgment of Solomon (I Kings 3:16–25) and Solomon and the Queen of Sheba (I Kings 10:1–13). He is usually shown as a bearded old man, richly dressed in the manner of an Oriental king. *See* SOLOMON'S TEMPLE, JERUSALEM.

SOLOMON, SIMEON. English painter (1840–1905). He was born in London; most of his family were artists. He was a close friend of Swinburne and Rossetti, both of whom stimulated his imagination and aesthetic tendencies. Solomon's early work was chiefly devoted to Biblical episodes and scenes of Jewish ceremonials, which he treated in a highly imaginative and individual style. Italian art influenced him later, particularly Leonardo and his followers, and this influence is best seen in his *Bacchus* (Birmingham Art Gallery), which was mentioned by Pater. Solomon was very popular with the early aesthetes and was considered dangerously avant-garde and decadent, but he ended his life in obscurity.

BIBLIOGRAPHY. R. Ironside and J. Gere, *Pre-Raphaelite Painters*, London, 1948.

SOLOMON ISLANDS, *see* OCEANIC ART (MELANESIA).

SOLOMON'S TEMPLE, JERUSALEM. The great temple erected by King Solomon to house the Ark of the Covenant. It was placed on the rocky ridge overlooking the old town and was probably connected closely with the sacred rock above which the Dome of the Rock now stands; nothing remains of the original temple (the traditional Western Wall is from a later era). According to the Bible, it took seven years to build the Temple, with wood brought from Lebanon, stone quarried near Jerusalem, and carpenters and stonemasons imported from Phoenicia. Hiram, king of Tyre, cast the two pillars and other bronzes in the Jordan Valley. *See* DOME OF THE ROCK, JERUSALEM.

Contemporaneous descriptions of the building are not detailed, but apparently it was a long structure, open on one of the short sides. The interior was divided into a vestibule (*Ulam*), a room for worship (*Hekal*), and a rear portion for the Ark (*Debir*). The two bronze pillars stood at the entrance to the vestibule. A separate construction surrounded the Temple on three sides and, like some Egyptian and Mesopotamian temple adjuncts, was used for storage of offerings. Like other Semitic sanctuaries, the Temple stood in an inner courtyard within the great court that enclosed the palace.

Above the Ark of the Covenant in the *Debir* were two huge gold-plated wooden figures of cherubim, portrayed as winged animals with human heads like the Syro-Phoenician winged sphinxes. In the *Hekal* stood the altar of incense, the table of shewbread, and ten candlesticks. The

bronze altar of sacrifices stood in front of the Temple. In the court there were also an enormous bronze purification basin, supported by twelve statues of bulls, and ten wheeled pedestals supporting bronze basins for washing the sacrifices.

BIBLIOGRAPHY. R. de Vaux, *Ancient Israel*, New York, 1961.

SOLUTREAN PERIOD. Upper Paleolithic period that falls at the end of the Aurignacio-Perigordian, or Aurignacian, and before the rise of the Magdalenian. Geologically it is placed during the dry cold interval (Paudorf interstadial) between the second and last maxima of the last glaciation (Würm II and III). This climate produced an environment ideal for the rapid spread of the Solutrean hunters, who sought in particular the wild horse. The origin of the Solutrean culture is disputed, some placing its beginning in Spain, others locating it in Hungary. Unfortunately, these hunters are thought to have lived, as at the type site in Solutré in eastern France, mostly in open camps of which little survives. Cave sites are few. There is little art that can be associated with these hunters beyond the disputed sculptures of sites such as Fourneau du Diable and Le Roc de Sers. Their sense of form, however, is well known from their famous laurel- and willow-leaf points. The Solutrean period was a brief episode in the Upper Paleolithic created by a hunting people whose culture has a limited distribution in comparison with that of other paleolithic cultures.

HOMER L. THOMAS

SOMA. Milky juice of a climbing plant (*Asclepias acida*), extracted and fermented, forming a beverage offered in libations to the Vedic deities. It was drunk by the Brāhmans. Soma was the equivalent of the haoma of the Persians.

SOMER (Someren), PAUL I VAN. Flemish painter (b. Antwerp, ca. 1577; d. London, 1621/22). He was active successively in Amsterdam (1604), Leyden (1612 and 1614), The Hague (1615), Brussels (1616), and London (1616). A portrait painter, he was sometimes employed by the English Crown, and his style remained close to that of Daniel Mijtens.

BIBLIOGRAPHY. E. K. Waterhouse, *Painting in Britain, 1530–1790*, Baltimore, 1953.

SOMER, PAUL II VAN. Flemish painter and engraver (b. ca. 1649; d. ca. 1694). He was born in Amsterdam. Except for the years 1671–74 and 1681, when he was in Paris, Somer worked mostly in London. Wessely attributed 189 etchings and 31 mezzotints to Somer, mostly portraits, Biblical representations, book illustrations, and decorations after his own designs and those of other painters.

BIBLIOGRAPHY. J. E. Wessely, "Paul van Somer," *Archiv für die zeichnenden Künste*, XV, 1870.

SOMEREN, PAUL I VAN, *see* SOMER, PAUL I VAN.

SOMNATHPUR. Site in Mysore State, India. The Keśava temple, erected in 1268, is the most typical example of the Hoyśala style of architecture. The main features of the temple are the stellate plan of the sanctuary and the rich sculptural relief decoration carved of a dark chloritic schist.

BIBLIOGRAPHY. P. Brown, *Indian Architecture*, vol. 1: *Buddhist and Hindu Periods*, 4th ed., Bombay, 1959.

Solutrean period. Flints. National Museum of Antiquities, Saint-Germain-en-Laye.

SOMPTING, CHURCH OF. Church in Sussex, England, important for the unique survival of the original capping to its tower. It has pitched gables on each face, with a pyramidal roof whose faces are formed as four flanking lozenges. Characteristic long and short work and pilaster strips occur. This Anglo-Saxon tower can be dated to the very early 11th century, and the type may have been commoner in England than this unique example would suggest. The source for the roof can be found in the Rhineland, particularly the abbey of Maria Laach, and the Church of the Holy Apostles, Cologne. The other parts of the church—nave, north and south transepts, and chancel—are 12th century.

BIBLIOGRAPHY. A. W. Clapham, *English Romanesque Architecture before the Conquest*, Oxford, 1930.

SON, JORIS VAN. Flemish painter (1623–67). Born in Antwerp, he painted still lifes in the manner of Jan Davidsz. de Heem. Son became a free master of the Guild of St. Luke in 1644 and enjoyed a considerable reputation during his lifetime.

BIBLIOGRAPHY. F. J. van den Branden, *Geschiedenis der Antwerpsche Schilderschool*, Antwerp, 1883.

SONJE, JOHANNES (Jan) GABRIELSZ. Dutch landscape painter (b. Delft, 1625; d. Rotterdam? 1707). He was a pupil of Adam Pijnacker, probably in Delft. Sonjé painted Italianate landscapes in the manner of his master.

BIBLIOGRAPHY. T. von Frimmel, "Ein unbeschriebenes Bild von Jan Gabrielsz. Sonjé," *Oud-Holland*, XX, 1902.

SONNETTE, JEAN MICHEL AND GEORGES DE LA. French sculptors (fl. mid-15th cent.). They are known only for their work on the nearly life-size *Entombment* (1451–54) in the chapel of the former hospital at Tonnerre. This monument, with its heavily draped figures arranged almost casually around the sarcophagus, expresses the somber and realistic mid-15th century style and reflects the influence of scenes from the mystery plays.

SOOLMAKER, JAN FRANS. Flemish landscape painter (b. 1635; d. after 1665). After 1654 he lived for some time

in Amsterdam, then journeyed to Italy. His works are in the manner of Nicolas Berchem, but are weaker and lack the Dutchman's coloristic mastery.

SOPHILOS. Attic black-figured vase painter (fl. ca. 575 B.C.). He is the first Attic painter whose signature is preserved. Fragments of two deinoi (vases) in Athens indicate that he was an innovator in subject matter, substituting large mythological scenes (the funeral games for Patroclus; the marriage of Peleus and Thetis) for traditional decorative patterns, and thus paving the way for the achievement of Cleitius.

BIBLIOGRAPHY. J. D. Beazley, *The Development of Attic Black-Figure*, Berkeley, Calif., 1951.

SOPRAPORTE. A painting, usually large, designed to be placed above a doorway. Such paintings were commonly landscapes, and were most popular in the décor of baroque and rococo palaces.

SORBONNE, UNIVERSITY AND CHURCH, PARIS. Originally created as a college of theology in 1253, it gradually became the center of the faculty of theology and in the 19th century assumed the role of an entire university. In 1622 Richelieu was made *proviseur*, or headmaster, of the college, and commissioned Lemercier to make plans for remodeling the buildings. The plans were approved in 1626, and the work was finished in 1648. *See* LEMERCIER, JACQUES.

The most important building of the complex is the church, the other buildings being utilitarian in character. The desire to make a balanced, harmonious, and apparently symmetrical composition of the church, which had both a street and a college-court entrance, led to the use of devices such as placing the dome forward in the nave for the sake of symmetry for both façades. During the 19th century the university outgrew the Lemercier build-ings, and in 1883 plans by H. P. Nenot were adopted; by 1901 only the church remained of the original complex.

BIBLIOGRAPHY. Paris, University, *L'Université de Paris du moyen âge à nos jours*, Paris [1933].

SORDECCHIO, IL, *see* PINTURICCHIO, IL.

SORDO MADALENO, JUAN. Mexican architect (1916–). Born in Mexico City, he studied at the University of Mexico. He worked on the architecture of University City, designing the Geological Institute (with Certucha and Negrete). Sordo Madaleno also designed the Calle Lieja Office Building in Mexico City (1956) and the Hotel Presidente, Acapulco, Guerrero (1959; with Escandón).

BIBLIOGRAPHY. M. L. Cetto, *Modern Architecture in Mexico*, Teufen, 1961.

SORGH, HENDRIK MARTENSZ. (Hendrick Maertensz.). Dutch genre painter (b. Rotterdam, ca. 1611; d. there, 1670). His father's surname was originally Rochusse or Rokes, but Sorgh does not seem to have used it. Arnold Houbraken states that he was a pupil of David Teniers the Younger and Willem Buijtenwegh. Sorgh's early works, however, are closer stylistically to those of Adriaen Brouwer, and there is no connection with Buijtenwegh's work. Most of Sorgh's works are peasant interiors and, in his later years, market scenes. In the 1650s he was influenced by the works of Cornelis Saftleven, and even later he shows some dependence upon the Leyden painters, and even Jan Steen.

BIBLIOGRAPHY. P. Haverkorn van Rijsewijk, "Rotterdamsche schilders (Hendrick Maertensz. Sorgh, Arent Diepraem, Cornelis Pietersz. Mooy)," *Oud-Holland*, 1892.

SORIA, GIOVAN BATTISTA. Italian woodworker and architect (1581–1651). He was early associated with G. B. Montano. Soria's architectural career in Rome was fostered by Cardinal Scipione Borghese, for whom he designed the façade of S. Gregorio Magno (1629–33). Later façades by him are those of S. Carlo ai Catinari (1635–38) and S. Caterina da Siena (1638–40), both in Rome.

BIBLIOGRAPHY. R. Wittkower, *Art and Architecture in Italy, 1600–1750*, Baltimore, 1958.

SOROLLA Y BASTIDA, JOAQUIN. Spanish painter (b. Valencia, 1863; d. Cercedilla, 1923). A precocious child, his early absorption with drawing led to studies at the Academy of San Carlos in Valencia at fifteen and to further studies in Rome and Paris. Settling in Valencia, he became an illustrator as well as one of the most popular painters of his day. He worked prodigiously on a tremendous range of subject matter—genre, landscape, history, portrait, and so on—with great virtuosity. His work is always dramatically posed and composed with sharp contrasts of light and shade, brilliant colors, and bravura brushstrokes. Because all elements are consistently high-keyed, the effect is often diminished. Between 1911 and 1920 Sorolla completed a series of fourteen mural panels for the Hispanic Society of America in New York City. Depicting typical scenes of the provinces of Spain, the panels display his illustrative talent. The Society owns many of his smaller works as well.

BIBLIOGRAPHY. B. de Pantorba, *La vida y la obra de Joaquín Sorolla*, Madrid, 1953.

Joaquín Sorolla y Bastida, *Walking along by the Sea*, 1907. Sorolla Museum, Madrid.

Sōtatsu, *The Visit of Gengi*. Seikado Foundation, Tokyo. A work by this 17th-century Japanese master.

SOSEN (Mori Sosen). Japanese painter (1749–1821). Sosen was particularly fascinated by monkeys, which he studied and painted with the greatest curiosity and an almost scientific care. Although trained in the Kanō tradition, he later combined it with Okyo's realism, developing an extremely personal style of painting with greatly detailed brushwork. *See* KANO SCHOOL; OKYO.

SOTAN (Oguri Sotan). Japanese painter (1413–81). Sōtan studied with Shūbun and succeeded to Shūbun's position of official painter to the shogun in the Shōkokuji of Kyoto. No certain works by Sotan exist, but his name appears frequently in literary records of 1449–66, when he was busily engaged in the decoration of temples in Kyoto. *See* SHUBUN.

BIBLIOGRAPHY. T. Akiyama, *Japanese Painting* [Geneva?], 1961.

SOTATSU. Japanese painter (fl. early 17th cent.). Although he is one of the greatest painters of Japan, almost nothing is known about his life. A group of paintings with the signature of Sōtatsu can stylistically be linked to another group of works bearing the seals of Inen, suggesting that there might have been a painter who used both names. A connection with Kōetsu through marriage has also been postulated. Before 1614 he was known as Tawaraya Sōtatsu. In 1630 he copied a scroll, the *Tales of Saigyō*, for a courtier of Kyoto (the original was made in 1500 and was then in the imperial collection). Many paintings attributed to Sōtatsu show his familiarity with and indebtedness to the art and literature of the past. He also designed poem scrolls, in which the calligraphy was done by Kōetsu. *See* KOETSU.

BIBLIOGRAPHY. R. T. Paine and A. Soper, *The Art and Architecture of Japan*, Baltimore, 1955; T. Akiyama, *Japanese Painting* [Geneva?], 1961.

SOTATSU-KORIN SCHOOL. School of Japanese painters, deriving its name from that of its leading spirit, Kōrin. It is known also as Rimpa. Kōrin found spiritual and artistic inspiration in the art of Kōetsu and of Sōtatsu, and he became the guiding force for many younger artists who worked in a bold and decorative manner of painting. Among the important members of this school were Fukae Roshū, Hōitsu, Kenzan, Shikō, Sōsetsu, Suzuki Kiichi (1796–1858), and Tatebayashi Kagei (fl. mid-18th cent.). *See* HOITSU; KENZAN; KOETSU; KORIN; SHIKO; SOTATSU.

BIBLIOGRAPHY. T. Akiyama, *Japanese Painting* [Geneva?], 1961.

SOTER, BAPTISTERY OF (San Giovanni in Fonte), NAPLES. Italian fifth-century structure (named for a contemporaneous bishop) in S. Restituta, the original cathedral that adjoins the present Cathedral. Each of the four corners of the Baptistery is squinched, creating an octagonal drum upon which a domed roof rests. Approximately half the area is covered by mosaics that may date from the last quarter of the 5th century.

BIBLIOGRAPHY. E. Lavagnino, *L'arte medioevale*, Turin, 1949.

SOTO, JESUS. Venezuelan abstract painter (1923–). Jesús Soto studied at the School of Plastic Arts in Caracas (1942–47). He has exhibited in New York and in Venice (Biennale, 1958 and 1960). Constructivist and optical art traditions merge in his work (for example, *Espiral*, 1958; Caracas, Dr. Carlos Raúl Villanueva Collection). He has used Plexiglas and attached wires against colored planes.

BIBLIOGRAPHY. Museo de Bellas Artes, *Pintura venezolana, 1661–1961*, Caracas, 1961.

SOUBISE, HOTEL DE, PARIS, *see* ROCOCO ART.

SOUFFLOT, JACQUES. French architect (1713–80). A pupil of Servandoni in Paris, he studied also in Lyons and

Rome, returning to Italy in 1749 on a trip that was influential in establishing a more classical style in French architecture. His most famous building, the Church of Ste-Geneviève (called the Panthéon since the Revolution), marks a transitional point between late French baroque and early 19th-century romantic classicism. His interest in the sciences of archaeology and geometry helped to promote the classical revival, while his concern with French Gothic architecture may have been instrumental in the initiation of the romantic revival of that style. *See* PANTHEON, LE, PARIS.

BIBLIOGRAPHY. J. Mondain-Monval, *Soufflot, sa vie, son oeuvre, son esthétique, 1713–1780*, Paris, 1918.

SOUILLAC, CHURCH OF. French church first mentioned in 909. The present structure dates essentially from between 1075 and 1130. Souillac came under the archepiscopal see of Cahors and reflects the same style. The church is built on the Latin-cross plan, with transepts culminating in apsidioles. The three radiating chapels open out from the broad apse. As at Cahors, the main body of the church consists of two domed bays. The domes rise from low drums and culminate in cupolas rather similar to those of the Aquitanian churches.

The sculptures for the intended doorway were never completed; a few fragments are preserved inside the church. It is believed that the sculptures were executed shortly before 1130. The most famous are the figures of the prophets Isaiah and Jeremiah, which are stylistically almost identical to the figures of Isaiah and St. Peter from the side panels of the doorway at Moissac. The curious and elegant grace of these figures, with their swirling and richly decorated garments, creates not only a powerful sense of movement but also something of the dance. The richness of the embroidery of the collar and scarf of Isaiah suggest not only Byzantine motifs but those of Irish art as well. This is not too surprising, considering the innumer-

Church of Souillac. The apse and radiating chapels.

Pierre Soulages, *5/4*. Private collection.

able Teutonic decorative devices that appear in Languedoc sculptures, as is also evidenced at Moissac, Carennac, Beaulieu, and Conques.

Other details suggesting the closeness of the Souillac sculptures to those of Moissac may be seen in the fragments of lionesses devouring a bull, almost exactly repeated on a pier at Moissac. Another group of sculptures, of poorer quality, represents the legend of Theophilus, a deacon who sold his soul to the devil but was saved by his devotion to the Virgin.

The *trumeau* is a fascinating work. Its outer face consists of interlocking beasts and men, lizards and fantastic monsters, in the act of devouring one another. A magnificent series of ravens on the left dominates the entire scene in fearsome yet wonderfully imaginative fashion. The left side of the *trumeau* tells the story of the sacrifice of Isaac by Abraham in a compact yet complete fashion. The right side shows a group of people clasping one another, treading on a serpent at the bottom, and clawed by a monstrous bird at the top. The broken-column device of Moissac is again evident here.

BIBLIOGRAPHY. P. Deschamps, *French Sculpture of the Romanesque Period...*, Florence 1930(?).

ALDEN F. MEGREW

SOULAGES, PIERRE. French abstract painter (1919–). He was born in Rodez, Aveyron, and now lives in Paris. While a student at the lycée in Rodez, he painted and took an interest in local Romanesque art. In 1939 he saw the art of Cézanne and Picasso in Paris. In 1946 he began to paint regularly, and exhibited in the Salon de Mai in 1947

and every year thereafter. In 1949 he had his first one-man show and in 1951 he designed decor for Louis Jouvet's production of *The Power and the Glory*. Soulages's first New York one-man show was at the Kootz Gallery in 1954. He has been represented in several international exhibitions, including the Venice Biennale and the New York Museum of Modern Art's "The New Decade" in 1955.

Soulages composes by piling up, one on the other, large rectangles that resemble close-up views of brushstrokes and that are usually as black and shiny as patent leather. These appear to hover before a brightly colored luminous ground.

BIBLIOGRAPHY. H. Juin, *Pierre Soulages*, Paris, 1958.

SOULAS, JEAN. French sculptor (fl. ca. 1500–50). Soulas is first mentioned in connection with the now destroyed *Deposition* and *Resurrection* (1505) of the Notre-Dame Chapel near St-Germain l'Auxerrois in Paris. In 1519 he executed four nearly life-size reliefs of the *Birth of the Virgin* in the choir of Chartres Cathedral. A *Nativity of Christ* sculpture (Paris, Louvre), painted in 1543 by Etienne Le Tonnelier, is attributed to him. Soulas's style is transitional from the 15th century to the Renaissance.

SOUNION, CAPE, *see* SUNIUM.

SOUSSE (Sousa; Susa): **GREAT MOSQUE.** Tunisian mosque built about 850, with a nave and twelve aisles. Cross-shaped piers carry barrel vaults and higher transverse arches in the first three bays, and groin vaults and round arches in the next three. The cupola preceding the mihrab is supported on an octagonal drum with concave faces.

SOUTH AMERICAN INDIAN ART, PRIMITIVE. Outside the strip of Pacific coastal land that contained the high civilizations of ancient South America, the rest of the continent produced far less developed cultures, whose artistic expressions were on a relatively primitive level.

The Indians in the vast region of the Amazon River in northern Brazil had a tropical forest culture that was artistically underdeveloped because their agriculture remained in a rudimentary form and their settlements were frequently moved. Typical of this culture were the Arawaks. The high humidity of the Amazonian forest has destroyed most of the ancient artifacts that were produced, except for pottery and some carved stone objects.

A pottery center of fine quality, indicating a specialized craftsmanship, developed on the large island of Marajó at the mouth of the Amazon. Dishes, vases, and idols have been found here with champlevé decoration or painted designs in white, red, black, or gray. Burial urns are sometimes anthropomorphic in shape. The uniform and skillfully applied geometricized designs cover the surface of the objects. North of the Amazon Delta is found the so-called Mazagão culture, whose burial urns have allover decorations of dots or parallel white lines. There are also cylindrical urns, either zoomorphic or anthropomorphic (men seated on stools).

Farther inland along the Amazon is found the Tapajós culture, centering on the city of Santarém. Vases appear here with naturalistic representations. The shapes, though standardized, are complex and interesting. By the time of the arrival of Europeans, the Tapajós people were producing the carved jadeite *muiraquitã* in the shape of toads or frogs.

Northern Brazil is to this day the domain of the Arawaks, the Caribs, and continuing smaller groups. The well-known and exciting dance masks of the Arawaks are made of bark in the shapes of bird, fish, and animal heads. The mask forms a sort of hood and is worn with a fiber garment. The ancient pottery tradition still persists among the Arawaks. Throughout this region the art of featherwork is highly developed, as is the practice of plaiting palm leaves in geometrical patterns. The same patterns are applied to clay or wooden objects and to *tangas*, small beadwork rectangles in black, red, and blue. Carib ceremonial robes are painted with lines, dots, and zigzags, but their wooden stools are zoomorphic. Other groups in the area decorate their huts with brightly painted human figures or geometric designs and produce disks with vividly colored mosaics of frogs and monsters.

The southern portion of Brazil, from Rio Grande do Sul to the area of São Paulo, exhibits a large number of ancient stone objects of some importance, such as axes, whetstones, funerary urns, and so on. There are stone idols, conical stone mortars with pestles, and perforated stone disks that were used as jewelry. Shell mounds (sambaquis) are found along the entire Atlantic coast and include a large number of these stone objects.

In Argentina there was comparatively sparse artistic activity. The northwestern area, along the border with Chile and Bolivia, is perhaps the most important, with objects dating from pre-Inca times. Petroglyphs appear throughout northwestern Argentina, as do cave paintings with vigorously depicted scenes of hunting and war. The ancient Atacameño of this region, centered on oases at the edge of the Atacama Desert, produced a wood culture. Wooden carvings of idols, sometimes mounted on tablets, are the most evolved form. Some of the ceramics found at La Paya represent the Casa Morada style which developed during the Inca period under the influence of artisans from Cuzco, Peru.

The Diaguita, the next-largest group in the northwestern region of Argentina, have left a wide variety of art forms. Among the fine examples of metalwork, especially noteworthy are the bronze plaques showing a deity with two feline attendants, the ornamented bronze bells, and the scepterlike bronze axes. Individual Diaguita cultures are represented by different forms of pottery. Among the various types are the Calchaquí children's funerary urns in the shape of a human figure holding a vessel; these are painted in polychrome with stylized figures and geometrical designs. Los Barreales shows vases painted or incised with a stylized dragonlike feline, sometimes having a human head. The rather widespread Belén culture presents a lizardlike serpent decoration executed with great freedom and variety. Another outstanding art form of the Diaguita is the clay figurine, skillfully portraying a number of different subjects. There are also stone carvings with human and animal figures as well as interesting stone masks and ceremonial axes.

See also AMERICAS, ANCIENT: ART OF (ECUADOR AND COLOMBIA; PERU AND BOLIVIA).

BIBLIOGRAPHY. H. D. Disselhoff and S. Linné, *The Art of Ancient America*, New York, 1960; D. Fraser, *Primitive Art*, New York, 1962.

SOUTHAMPTON TOWN WALLS. Circuit of curtain wall punctuated by towers and gates that enclosed the old town of Southampton, England. The Norman work was rebuilt in the 13th century. The bargate retains a Norman archway. The Arcades are a spectacular stretch of 14th-century wall pierced by blank arcades.

BIBLIOGRAPHY. J. C. Cox, *Hampshire*, rev. by R. L. P. Jowitt, 7th ed., London, New York, 1949.

SOUTH ITALIAN SCHOOL. Provincial and roughhewn adaptation of the Byzantine style adopted in the architecture and painting of Calabria and Apulia after their submission to the Byzantine Empire in 970 and the subsequent settlement of the Basilian monks. The period ended with the Norman Conquest of 1071, although the style flourished into the 13th century. Typical manifestations are the murals in cave churches and small domed churches, such as the Cattolica near Stilo.

SOUTHWARK CATHEDRAL, LONDON. Gothic church built on the site of the Norman church (1106) of the Augustinian priory of St. Mary Overie. The church burned down about 1212 and was rebuilt in the 13th and 14th centuries. The nave portal and fragments in the north transept are the only remains of the Norman building. The Cathedral is a good example of well-balanced Gothic style.

SOUTHWELL CATHEDRAL. English cathedral begun in 1108. The main part of the church, from the crossing to the west front, including the nave, with its massive round-arched two-story arcades, seems to follow a single plan and was executed about 1120 or 1130. The west front is a unique survival of the twin-towered pyramidal cap type. Rebuilding of the chancel and east parts began in 1234, and probably was complete by 1260. The airy polygonal chapter house was added in 1290.

BIBLIOGRAPHY. N. Pevsner, *The Buildings of England*, vol. 2: *Nottinghamshire*, Harmondsworth, 1951.

Southwark Cathedral, London. A 13th- and 14th-century Gothic structure.

SOUTINE, CHAIM. Russian-French painter (b. Smilowitchi, near Minsk, Russia, 1894; d. Paris, 1943). His style is an individual form of expressionism. Although born into a poor family, Soutine managed to study at the Vilna art school in 1910 by assisting with photographic work. He went to Paris in 1913 after the sale of several of his earliest pictures and attended the Ecole des Beaux-Arts, studying with Cormon and independently acquiring an admiration for Courbet and Rembrandt.

Although Soutine knew Chagall, Lipchitz, Modigliani, and the poet Cendrars, he was too introverted, or perhaps too independent, to seek help from them. He became severely undernourished, and at one point he attempted suicide. He met the dealer Zborowski through Modigliani, however, and the resulting sale of several paintings enabled Soutine to paint from 1919 to 1922 in Céret, in southern France. The landscapes of this period are unexcelled in intensity of feeling; their violently distorted forms and vivid colors express an almost irrational emotionality. Soutine had produced some 200 canvases by the time he returned to Paris, and, in 1923, the American collector Dr. Albert Barnes bought half of them. Many of Soutine's admirers hold that this sudden prosperity adulterated the spirit of his art, although several forceful landscapes, still lifes with butchered meats (harking back to a theme he had painted soon after arriving in France), and the famous *Choir Boy* series of 1927 attest to his fundamentally superior talents.

Among these talents was his great gift for portraiture. Soutine's *Self-Portrait* (1918; New York, private collection) and *Child with a Toy* (Geneva, private collection) are among his major works of the earlier period. These match in turbulence of brushwork and disquietude of psychological content the stronger portraits by Kokoschka, the Austrian expressionist. Soutine frequently used brilliant reds and greens with powerful echoes in his gray tonalities, the handling often being violently expressive. Rouault may have been an influence, but there is a decided empathy with the most vigorous of the German Brücke styles. In later works, pictorial design plays a stronger part than before, with relatively more equilibrium between design and emotional power.

For a time after 1929 Soutine found contentment with the Marcel Castaings near Chartres and produced a fine portrait of Mme Castaing (1929, New York, private collection); but he rejected his Parisian acquaintances, ceased exhibiting, and was unproductive by the time he became a refugee in Touraine during World War II. Soutine's painting, which may be related to unspecific expressionist origins, is at its best a strongly personal enrichment of modern art.

BIBLIOGRAPHY. M. Wheeler, *Soutine*, New York, 1950; C. Soutine, *Chaim Soutine*, introd. by R. Cogniat, Geneva, 1952; D. Hall, "Modigliani and Soutine," *Art International*, VII, November, 1963; A. Forge, *Soutine*, London, 1965; M. Tuchman, *Chaim Soutine*, Los Angeles County Museum of Art, 1968.

JOHN C. GALLOWAY

SOUTMAN, PIETER CLAESZ. Netherlandish painter and etcher (b. Haarlem, ca. 1580; d. there, 1667). He learned painting in Antwerp in the circle of Rubens's school and probably studied etching with Jacob Matham. Soutman's subjects were mainly Rubens's hunting scenes and Rubens's

Soutine, *Page Boy at Maxims*. A. de Rothschild Coll., Paris.

drawings after Italian masters, which he made to serve as the immediate basis for reproductive engraving. He used a combination of engraving and cold-needle techniques.

BIBLIOGRAPHY. A. von Wurzbach, *Niederländisches Künstler-Lexikon*, vol 2, Vienna, 1910; J. Byam Shaw, *Pieter Soutman's Portrait of William II of Orange as a Boy* (Old Master Drawings, 3), 1928-29.

SOVIET REALISM. The official style of painting adopted by the Soviet government soon after the Revolution. The government insisted that the function of art was social: to glorify the state and its leaders or to teach the virtues of hard work and other Soviet aims.

SOWER, THE. Oil painting by Millet, in the Museum of Fine Arts, Boston. *See* MILLET, JEAN-FRANCOIS.

SOYER, ISAAC. American painter and lithographer (1907–). The younger brother of Moses and Raphael Soyer, Isaac was born in Tambov, Russia. He studied at Cooper Union, the National Academy, and the Educational Alliance, all in New York City. Soyer paints primarily working-class genre subjects, for example, *Employment Agency* (1937; New York, Whitney Museum).

SOYER, MOSES. American painter (1899–). The twin brother of Raphael Soyer and older brother of Isaac, he was born in Tambov, Russia, and studied in New York City. He paints sympathetic urban genre, dancers and models, and figures, such as *Girl in Orange Sweater* (1953; New York, Whitney Museum).

BIBLIOGRAPHY. B. Smith, *Moses Soyer*, New York, 1944.

SOYER, RAPHAEL. American painter and lithographer (1899–). He was born in Tambov, Russia, and was the twin brother of Moses Soyer and older brother of Isaac. He studied at the National Academy and the Art Students League in New York City. His subjects are melancholy urban genre and figures.

BIBLIOGRAPHY. American Artists Group, *Raphael Soyer*, New York, 1946; N. Krueger, ed., *Raphael Soyer: Paintings and Drawings*, New York, 1960.

SPACAL, LUIGI. Italian graphic artist (1907–). Born in Trieste, he studied in Venice, Monza, and at the Brera Academy in Milan. His works were first shown in Trieste in 1940, and he achieved great success at a 1942 Milan exhibition. The style of his woodcuts and engravings, for which he won an international prize at the Venice Biennale of 1958, is abstract with figurative suggestions.

SPADA, *see* MARESCALCHI, PIETRO DEI.

SPADA, LIONELLO. Italian painter (b. Bologna, 1576; d. Parma, 1622). Although he was initially a product of the Carracci Academy in Bologna, between 1608 and 1614 Spada probably went to Rome and Malta, where he fell under Caravaggio's influence (*St. Sebastian*; Valletta Cathedral). In his last years, spent working for Ranuccio Farnese in Reggio and Parma, Correggiesque and Bolognese (Reni and Domenichino) elements dominate his paintings (*Marriage of St. Catherine*; Parma, National Gallery). Spada, like many of the *Caravaggisti*, had but a passing flirtation with *tenebroso* and realism, which he did not continue beyond the second decade of the century.

BIBLIOGRAPHY. R. Wittkower, *Art and Architecture in Italy, 1600-1750*, Baltimore, 1958; J. Hess, "Caravaggio's Paintings in Malta, Some Notes," *The Connoisseur*, CXLII, 1958-59; Bologna, Palazzo dell'Archiginnasio, *Maestri della pittura del seicento emiliano*, [3d] Biennale d'arte antica (catalog), ed. F. Arcangeli et al., Bologna, 1959.

SPADA PALACE, ROME. Private residence begun in 1550 for Cardinal del Monte (Pope Julius III), later passing to Cardinal Capodiferro and then to Cardinal Spada. It is now the seat of the Council of State and the Spada Gallery. The palace is attributed to Girolamo da Carpi and to Giulio Mazzoni, master stuccoist, with the possible assistance of Mangone. The façade is based on Raphael's Branconio dell'Aquila Palace. A rich garniture of

Lionello Spada, *Concert*. Borghese Art Gallery, Rome.

figurative and decorative sculpture adorns the façade and the courtyard. Later work by Francesco Borromini, in the 1630s, includes the celebrated illusionist colonnade at the rear.

BIBLIOGRAPHY. G. Chierici, *Il palazzo italiano dal secolo XI al secolo XIX*, Milan, 1957; R. Wittkower, *Art and Architecture in Italy, 1600-1750*, Baltimore, 1958.

SPAGNA, LO (Giovanni di Pietro). Italian (?) painter (d. Spoleto, 1528). Although we are completely uninformed about his early years, he is perhaps to be identified with a Spanish painter, Johannes Petri, noted in Perugia by 1470. Working in a Peruginesque mode, he became the head of a sizable school of painters around Spoleto.

SPAGNOLETTO, LO, *see* RIBERA, JUSEPE DE.

SPAGNUOLO, LO, *see* CRESPI, GIUSEPPE MARIA.

SPAGNUOLO, PIETRO, *see* BERRUGUETE, PEDRO.

SPAIN, MUSEUMS OF. See entries under the names of the following cities:
Barcelona. Archaeological Museum; Museum of Catalonian Art; Museum of Modern Art; Picasso Museum.
Bilbao. Fine Arts Museum.
Cadiz. Provincial Museum of Fine Arts.
Cordova. Provincial Archaeological Museum.
El Escorial. Museums.
Granada. Museum of the Royal Chapel.
Madrid. Lázaro Galdiano Museum; National Archaeological Museum; Prado; Royal Academy Museum of Fine Arts of San Fernando; Royal Palace.
San Sebastian. Municipal Museum of San Telmo.
Saragossa. Provincial Museum of Fine Arts.
Seville. Provincial Archaeological Museum; Provincial Museum of Fine Arts.
Toledo. El Greco Museum; Parish Museum of San Vicente; Provincial Archaeological Museum.
Valencia. Provincial Museum of Fine Arts.
Vich. Episcopal Archaeological Museum.

Spada Palace, Rome. The façade is richly decorated with sculpture.

Spandrel. Space between an arch and the adjacent molding.

SPALATO, *see* SPLIT.

SPAN. Distance between the supports of a beam, arch, or roof.

SPANDREL. Triangular space contained within the boundaries of an arch, defined by a horizontal line through its apex, a vertical line from its springing, and the line of the arch. The term also denotes the area between arches in an arcade.

SPANI, BARTOLOMMEO (Clementi; Il Clemente). Italian architect, sculptor, and goldsmith (b. Reggio Emilia, 1468; d. after 1538). The pupil of Antonio Casotti, Spani may have been in Rome from 1485 to 1490. Afterward, he specialized in tomb sculptures: the cenotaph of Bertrando Rossi (1528; Parma, Steccata) and the tomb of Francesco Molza (1512; Modena Cathedral). His great work is the *Madonna and Child with the Donors Giroldo Fiordibelli and Antonia Boiardi* (1522–23; Reggio Emilia Cathedral). Spani worked in a solid northern Italian version of the Renaissance.

BIBLIOGRAPHY. G. Ferrari, "Bartolomeo Spani architetto, scultore ed orefice," *L'Arte*, II, 1899.

SPANI (Sogari), PROSPERO (Clementi; Il Clemente). Italian sculptor (b. Reggio Emilia, 1516; d. there, 1584). He was the nephew and pupil of Bartolommeo Spani. Prospero executed a number of colossal pieces, among them the statues of Lepidus and Hercules in front of the Ducal Palace, Modena, and the Rangone monument and other works in the Cathedral in Reggio Emilia. His figures are often characterized by the muscular overdevelopment and strained attitudes considered symptomatic of Renaissance decadence.

SPANISH SCHOOL. School of painting that had its beginnings in the 14th century, when influences from Italy stimulated the production of panel painting. The centers were in Barcelona, Valencia, and Seville. The Catalan painters Ferrer Bassa and Jaime and Pedro Serra intro-

duced Sienese and Florentine 14th-century style into Spanish painting. The Italian influence continued until the first half of the 15th century, when Netherlandish painting began to be influential. The major Spanish painters of the Netherlandish phase were Luis Dalmau, Fernando Gallegos, Jaime Huguet, and Pedro Berruguete. See BASSA, FERRER; BERRUGUETE, PEDRO; DALMAU, LUIS; GALLEGOS, FERNANDO; HUGUET, JAIME; SERRA FAMILY.

See also SEVILLE SCHOOL; VALENCIAN SCHOOL.

In the 16th century, with the possible exception of Castile, the Netherlandish influence was replaced by a general Italian orientation. Philip II, for example, collected paintings by Titian and Veronese. Among the notable Spanish painters of this period were Luis de Vargas, Luis de Morales, Juan Masip the Elder, and his son Juan de Juanes. The end of the century was dominated by El Greco who, although a Greek and trained in Venice, developed a style remarkably reflective of the Spanish temperament. See GRECO, EL; JUANES, JUAN DE; MASIP, JUAN VICENTE, THE ELDER; MORALES, LUIS DE; VARGAS, LUIS DE.

The great period of Spanish painting was the 17th century; the zeal shown by the Spaniards in the Counter Reformation was reflected in the great development of Spanish baroque religious painting by Ribera, Murillo, and Zurbarán. Velázquez, the greatest of Spanish painters, developed a cooler, more discrete approach to subject matter, yet in a style full of sensuous treatment of textures and atmosphere. See MURILLO, BARTOLOME ESTEBAN; RIBERA, JUSEPE DE; VELAZQUEZ, DIEGO RODRIGUEZ DE SILVA Y; ZURBARAN, FRANCISCO DE.

A general decline gripped the Spanish school in the 18th century, to be broken momentarily by Goya. Several 20th-century Spanish painters have achieved international stature: Picasso, Gris, Miró, and Dali. See DALI, SALVADOR; GOYA Y LUCIENTES, FRANCISCO JOSE; GRIS, JUAN; MIRO, JOAN; PICASSO, PABLO.

BIBLIOGRAPHY. C. R. Post, *A History of Spanish Painting*, 14 vol. in 20, Cambridge, Mass., 1930–66; G. Rouchès, *La Peinture espagnole...*, Paris, 1929?–

DONALD L. EHRESMANN

SPANZOTTI, GIOVANNI MARTINO. Northern Italian painter (fl. 1480–1526/28). He was the teacher of Sodoma and others. An early signed triptych (Turin, Sabauda Gallery) shows a simplified court Gothic style; Spanzotti's later *Baptism* (1508–10; Turin Cathedral) anticipates Gaudenzio Ferrari.

BIBLIOGRAPHY. V. Viale, *Gotico e rinascimento in Piemonte* (catalog), Turin, 1939.

SPAVENTO, GIORGIO. Italian architect (fl. after 1486; d. 1509). Spavento was a follower of Mauro Coducci and one of the masters of the early Renaissance in Venice. In 1486–90 he built the sacristy of St. Mark's. He is responsible for the Chapel of S. Teodoro and the Cortiletto dei Senatori in the Doge's Palace, and designed the Church of S. Salvatore (begun in 1506; executed after 1507 under the direction of Tullio Lombardo).

SPEAR, RUSKIN. English painter (1911–). He studied at the Royal College of Art and was influenced by the Camden Town painters, especially Sickert. Spear's works are thick, somewhat loosely painted figures, still lifes, and urban scenes, such as *Hammersmith Broadway* (1950; London, Arts Council of Great Britain).

BIBLIOGRAPHY. N. Wallis, "Riverside Nights: The Art of Ruskin Spear, A.R.A.," *The Studio*, CXLIII, May, 1952.

SPECCHI, ALESSANDRO. Italian architect of the Roman school (1668–1729). He was a pupil of Carlo Fontana. Specchi is responsible for the De Carolis Palace (now the Banco di Roma; 1716–22) on the Corso and was the first designer of the Spanish Stairs in the Piazza di Spagna (where he was succeeded by Francesco de Sanctis in 1723–25).

BIBLIOGRAPHY. R. Wittkower, *Art and Architecture in Italy, 1600–1750*, Baltimore, 1958.

SPECTRUM. The range of colors produced when white light is passed through a prism. The colors, ranging from red to violet, correspond to various wavelengths from 760 to 385 mμ. Some of the impressionists, particularly Renoir, and more systematically the neoimpressionists, used a palette of colors of the spectrum to achieve a more accurate approximation of light and greater luminosity.

SPECTRUM PALETTE, see RAINBOW PALETTE.

SPECULUM HUMANAE SALVATIONIS (Mirror of Human Salvation). Book containing a series of pictures from the most important scenes in the life of Christ. It is arranged in typological fashion with additional pictures from the Old Testament and explanatory text in Latin and sometimes German. It appeared first as a manuscript in the 14th century and became one of the most important block books of the early 15th century.

BIBLIOGRAPHY. E. Breitenbach, *Speculum Humanae Salvationis*, Strasbourg, 1930.

SPECULUM VIRGINUM (Mirror of the Virgin). Work written for the edification of young Christian women by Conrad of Hirsau in the 12th century. It contained twelve chapters, each prefaced with a schematic drawing. The earliest preserved Speculum Virginum is in the British Museum (Arundel 44), London.

BIBLIOGRAPHY. A. Watson, "The 'Speculum Virginum' with Special Reference to the Tree of Jesse," *Speculum*, III, 1928.

SPEICHER, EUGENE. American painter (1883–1962). Born in Buffalo, N.Y., he studied there and in New York City with DuMond and Chase and, in 1908, with Robert Henri. Speicher's work consists mostly of portraits and figure paintings of girls and women, but he has also painted nudes and still lifes of flowers. Despite his early association with American realism, his paintings exhibit little that is specifically modern, except for a certain monumentality of composition and a simplified treatment of planes, both remote echoes of Cézanne. These elements can be seen in the sturdy *Lilya* (1930; Cincinnati Art Museum).

BIBLIOGRAPHY. F. J. Mather, *Eugene Speicher*, New York, 1931; American Artists Group, *Eugene Speicher*, New York, 1945.

SPENCER, NILES. American painter (b. Pawtucket, R.I., 1893; d. Sag Harbor, N.Y., 1952). He studied in Rhode Island and at the Art Students League in New York City with Henri and Bellows, and was in Europe in 1921–22 and 1928–29. Spencer was associated with the precisionist (cubist realist) group, which painted industrial or urban

Stanley Spencer, *The Resurrection: Port Glasgow*. Tate Gallery, London. A modern artist whose main interest was religious scenes.

landscapes with smoothly simplified geometric forms, as can be seen in his *City Walls* (1921; New York, Museum of Modern Art), where a structural order is imposed on an urban scene. In the 1930s he painted other subjects in a realistic but highly formal manner, for example, *The Green Table* (1930; New York, Whitney Museum). After the mid 1940s he again painted architecture in flat-colored rectilinear shapes derived from the motif.

See also CUBIST REALISM.

BIBLIOGRAPHY. Walker Art Center, *The Precisionist View in American Art*, Minneapolis, 1960.

SPENCER, STANLEY. English painter (1891–1959). Born in Cookham, he studied at the Slade School, London (1909–12). Although he also painted realistic landscapes and portraits, his main interest was religious scenes, usually with his native village as the ultimate source for their setting. In these works, expressively distorted massive figures and realistic detail are combined for an almost mystical effect. His murals (1926–32) for a chapel at Burghclere, Berkshire, depict the resurrection of soldiers. His late work was increasingly personal and savage in symbolism.

BIBLIOGRAPHY. E. Rothenstein, *Stanley Spencer*, Oxford, 1945.

SPERANDIO SAVELLI OF MANTUA. Italian medalist, goldsmith, sculptor, and architect (fl. 1445–1504). The son of a Roman goldsmith, he worked in Ferrara, Mantua, Faenza, Bologna, and Venice, and is known principally for his vigorous, though somewhat roughly executed, medal portraits. He also modeled the terra-cotta monument of Pope Alexander V in S. Francesco, Bologna, completed in 1482.

SPERANZA, GIOVANNI. Northern Italian painter of Vicenza (1480–1532). He began as a skilled imitator of Montagna (*Assumption Altarpiece*, Vicenza, Municipal Museum), but later echoed remotely more modern Giorgionesque moods (*Blessing Christ*, Baltimore, Walters Art Gallery).

SPEYER (Spires) CATHEDRAL. Middle Rhenish German church, of great significance in the development of German Romanesque architecture. Founded by Conrad II about

1030, it underwent its first building campaign until 1060. The second building campaign was from about 1082 to 1182. Rebuilt in large part after the wars of 1689 and in the 19th century, the Cathedral has been restored in the 20th century.

The church has a cruciform plan, with a nave and two aisles, a crossing tower, an east apse, and a massive west end. The crypt (dating from the first building campaign), beneath the entire transept, is divided into three large bays by massive piers. Heavy columns, engaged on all faces of the piers, carry the connecting arches and groin vaulting of the crypt. The simple, massive delineation of space in the crypt already shows characteristics of the High Romanesque in Germany.

The nave originally had a flat timbered ceiling, and the aisles were groin-vaulted. But the simplicity of the vaulting belies the sophisticated plasticity of the wall articulation. The nave is separated from the aisles by a succession of near-square, massive undifferentiated piers, supporting an arcade. A respond travels the height of the nave wall from the springing of the nave arcade to an arcade framing the clerestory windows. An engaged shaft rises from floor level in a continuous unbroken line to the height of the springing of the arcade around the windows. Thus, at the lower level the pier section is nearly square with the half round of the shafts on the nave and aisle faces of the pier. The upper nave wall has a more complex articulation: the nave wall, the thickness of the respond carried around the windows, the thickness of the shaft carried as a superimposed arcade around the windows, and, finally, the accents of the cubic capitals capping the shafts. Other such accents include molding atop the piers at the arcade springing and a stringcourse at the triforium level. The total effect is one of a balanced horizontal and vertical rhythm along the nave created by a careful repetition of plastic elements.

During the second building campaign the nave was vaulted with immense unribbed groin vaults, each spanning two bays and separated by transverse arches. To carry the vaulting and transverse arches, alternate piers had to be strengthened, giving the nave an alternation of supports not initially present. During this building campaign the exterior was given its significant decorative elements: gal-

leries under the eaves, decorative arcading, corbel tables, and pilaster strips, mostly of Lombard origin.

Speyer Cathedral, as dedicated in 1060, represented a new stage in the development of Romanesque architecture. The east and west ends were marked by strong plastic groupings (a Carolingian tradition) joined by well-articulated exterior wall surfaces. The delineation of the interior into a well-defined bay system was consistent with the exterior definition. Speyer is the culmination of a development of fifty years, starting with Strasbourg Cathedral and continuing with Limburg on the Hardt.

BIBLIOGRAPHY. P. W. Hartwein, *Der Kaiserdom zu Speyer*, 2d ed., Speyer am Rhein, 1927; H. Weigert, *Die Kaiserdome am Mittelrhein*, Berlin, 1933.

STANLEY FERBER

SPHINX. Fabled creature half man and half animal. In Egyptian art the sphinx has the body of a lion and the head of a man, frequently that of a Pharaoh. In Greek art the sphinx has the head, or head and torso, of a woman. The meaning of the sphinx is not completely clear. In Egypt the identification of the ruler with the strength of an animal is probably involved; in Greece the sphinx is apparently a symbol of death, often appearing on gravestones. *See* SPHINX, GREAT, GIZA.

BIBLIOGRAPHY. S. Hassan, *Le Sphinx*, Cairo, 1951.

SPHINX, GREAT, GIZA. Colossal Egyptian reclining limestone statue of a sphinx (a creature with the body of

Speyer Cathedral. The groin-vaulted nave is bounded by massive piers.

a lion and the head of a man). It was created in the 4th dynasty (ca. 2680–2565 B.C.), probably as part of the pyramid complex of Chephren. Its dimensions, though huge, are dwarfed by the great pyramids that rise nearby. Until 1926 the Sphinx was covered with sand up to the neck level, but excavations since that time have bared most of it, plus a nearby but apparently unassociated temple. *See* SPHINX, TEMPLE OF THE, GIZA.

The Sphinx, strictly speaking, is not a statue at all but a carved mass of natural rock, for it was originally a shapeless hill of soft stone that remained in the quarry from which the pyramid builders had extracted their materials. Rather than remove the residual rock, the planners had it carved into a form suitable to its prestigious location. Later rulers were forced to repair the fast-eroding stone with support blocks. Originally symbolizing the king, the Sphinx became the center of its own cult during the New Kingdom.

BIBLIOGRAPHY. S. Hassan, *Excavations at Giza*, vol. 8: *The Great Sphinx and Its Secrets*, Oxford, 1953; A. Fakhry, *The Pyramids*, Chicago, 1961.

SPHINX, TEMPLE OF THE, GIZA. Ruined mortuary temple of the Egyptian king Chephren of the 4th dynasty (ca. 2680–2565 B.C.). The temple was situated below the Pyramid of Chephren. It consisted of an anteroom, a broad, long hall, an open court containing twelve shrines with royal statues, five adjoining chapels in which stood five idols, magazines, the sanctum, and the actual tomb behind an enclosure wall. The pillars in the temple halls were monoliths of red granite from Aswan. The floor was of alabaster. The temple was constructed for ritual purposes.

BIBLIOGRAPHY. I. Woldering, *The Art of Egypt*, New York, 1963.

SPICRE, PIERRE. French painter (d. 1478). Probably born in Dijon, he was first mentioned in 1470. In 1473 he was commissioned to paint an altarpiece for the Cathedral of Lausanne, and in 1474 he drew the cartoons from which were executed the remarkable tapestries depicting the *Life of the Virgin* in the Church of Notre-Dame in Beaune. Some scholars attribute the fresco of the *Raising of Lazarus* in this church to Spicre.

BIBLIOGRAPHY. G. Ring, *A Century of French Painting, 1400–1500*, London, 1949.

SPIERINCX, FRANS. Tapestry weaver and dealer (b. Antwerp, 1551; d. Delft, 1630). Trained in Brussels, he worked there, and after 1591 in Delft. Karel van Mander II and Hendrik C. Vroom provided cartoons for Italianate baroque tapestries that Spierincx executed. His shop included his four sons and was patronized extensively by foreign noblemen.

BIBLIOGRAPHY. "A New Gallery of Tapestries and Textiles," *Bulletin of the Metropolitan Museum of Art*, X. May, 1915.

SPILIMBERGO, LINO ENEAS. Argentine painter (b. Buenos Aires, 1896; d. there, 1964). Spilimbergo studied in Buenos Aires and in Italy and France (1925–28). He exhibited internationally. His figure and landscape painting can be seen in the National Museum of Fine Arts, Buenos Aires (for example, *Figura*, ca. 1938). His style emphasizes sculpturesque plastic form.

BIBLIOGRAPHY. J. L. Pagano, *Historia del arte argentino*, Buenos Aires, 1944.

SPINA. Spine or low wall set in the center of the ancient hippodrome to make a longitudinal division of the space.

SPINARIO, LO, see THORN EXTRACTOR.

SPINAZZI, INNOCENZO. Italian sculptor (b. Rome; d. Florence, 1798). A pupil of Giovanni Maini, Spinazzi executed many sculptures for the churches of Rome and Florence. The Pitti Palace, Florence, contains a bust of Grand Duke Leopold by him. His work represents the transition from the late baroque and rococo styles to the neoclassic.

BIBLIOGRAPHY. R. Wittkower, *Art and Architecture in Italy, 1600–1750,* Baltimore, 1958.

SPINELLI, NICCOLO DE FORZONE, see FIORENTINO, NICCOLO.

SPINELLI, PARRI, see PARRI SPINELLI.

SPINELLO ARETINO (Spinello di Luca di Spinelli). Italian painter of the Florentine school (ca. 1346–1410). A native of Arezzo, he received the name "Spinello Aretino." He was a pupil of Agnolo Gaddi and was influenced by the school of Andrea Orcagna and Nardo di Cione. His career is well documented from 1373 until his death.

Spinello's earliest dated work is an altarpiece of 1385 painted for Monte Oliveto, near Siena (now dispersed among the galleries of Budapest; Cambridge, Eng.; and Siena). He was mainly a fresco painter. There are cycles of frescoes by him at S. Miniato al Monte in Florence (1386–87), in the Chapel of St. Catherine in Antella near Florence (1387–88), in the Camposanto in Pisa (1391–92), and in the Palazzo Pubblico in Siena (1408–10). Some murals by him have survived in S. Francesco in Arezzo. Spinello is one of the most rewarding and substantial of the late Giottesque painters because of the freshness, vigor, and sturdiness of his style. His son Parri Spinelli assisted him toward the end of his life.

SPIRAL. Extremely common decorative motif found particularly among the barbaric tribes of northern Europe in the Bronze Age. It appears to have entered the European area from China (Yangshao Culture).

SPIRAL AND TRUMPET. Purely Celtic ornament in which the end of the spiral widens into a trumpet shape. It occurs as early as the 5th century B.C. on crude stone carvings and reaches its climax in the 9th-century Book of Kells (Dublin, Trinity College Library).

SPIRE. Elongated tapering pyramidal or conical termination of a tower (from the Old English *spir,* "blade of grass"), as in Salisbury and Litchfield Cathedrals. Spires in German Romanesque architecture resemble folded pyramids and include the distinctive helm roof, typified in the Church of the Apostles, Cologne. A unique type of octagonal spire, called a broach, was developed in 13th-century England; it rests on angle squinch arches and surmounts a square tower. Renaissance and baroque spires, such as those by Wren in London (for example, Bow Church and St. Bride's Fleet Street), are often called steeples. See SPIRE, BROACH.

See also FLECHE.

SPIRE, BROACH. Octagonal spire, especially in early English churches, rising from a square tower without an intervening parapet. The transition between square and octagon is made with pyramidal forms at the corners of the tower, as in St. Andrew, Heckington, Lincolnshire.

SPIRES CATHEDRAL, see SPEYER CATHEDRAL.

SPIRIT HOUSE, see SEPIK RIVER.

Spinello Aretino, *Pope Alexander III and Frederick Barbarossa,* detail of the fresco cycle in the Palazzo Pubblico, Siena.

SPIRIT OF 1776. Oil painting by an unknown American artist, in a private collection, Marblehead, Mass.

SPIRIT OF THE DEAD WATCHING. Oil painting by Gauguin, in the Museum of Modern Art, New York. *See* GAUGUIN, PAUL.

SPIRO (Temple) MOUND, OKLA. Prehistoric site of the Caddo Indians, probably an important center of ritual and ceremony. This mound, excavated in 1936 by Forrest Clements, yielded several excellent sculptures, some made of incised shell and others in the form of stone pipes. Some of the pipes were shaped like human figures. The style combines naturalism and conventionalization and compares well in quality with Hopewell art of mounds in Ohio and elsewhere.

See also MOUND BUILDERS; NORTH AMERICAN INDIAN ART (EASTERN UNITED STATES AND CANADA).

BIBLIOGRAPHY. E. K. Burnett, *The Spiro Mound Collection in the Museum* (Mus. of the Amer. Indian, Contributions, vol. 14), New York, 1945.

SPITZWEG, KARL. German romantic painter (b. Munich, 1808; d. there, 1885). One of the leading Biedermeier-style painters, Spitzweg did not study painting but was trained as a pharmacist at the University of Munich (1830–32). His interest in art began in 1833 at the spa of Bad Sulza, where at the inducement of the painter Christian Heinrich Hansonn he took up painting as an avocation. In the following years, Spitzweg studied the old masters in Munich and widened his artistic horizons with travel to Italy (1850), Paris (1851, together with Eduard Schleich), London, and Antwerp. In addition to the old Dutch masters, the Barbizon school had great influence on Spitzweg's art.

Back in Munich, where he remained in relative obscurity, Spitzweg produced many small oil paintings and contributed drawings to popular periodicals such as the *Fliegende Blätter*. At his death a large number of paintings were discovered in his effects and reproduced in two portfolios (*Spitzweg Mappe*, 1887; *Neue Spitzweg Mappe*, 1888) which established his position in the history of German romantic painting.

From his very first painting, *The Poor Poet* (1837; Munich, New Pinacothek), Spitzweg specialized in subjects drawn from life of the Biedermeier *bourgeoisie*, which he represented with either a humorous or a poignant sentimentality. Other well-known paintings include *The Hermit* (Munich, Schack Gallery), *The Departure* (1864; Schack Gallery), and *The Old Man on the Terrace* (Hamburg, Art Gallery).

BIBLIOGRAPHY. H. Uhde-Bernays, *Carl Spitzweg*, Munich, 1913; G. Roennefahrt, *Karl Spitzweg*, Munich, 1960.

JULIA M. EHRESMANN

SPLIT (Spalato): MUSEUMS. Important public art collections in Split, Yugoslavia, are located in the museums listed below.

Archaeological Museum of Split. One of the most beautiful and varied archaeological museums in the Mediterranean area. It is noted for outstanding antique sculpture, Early Christian sarcophagi, and a large, systematically organized lapidarium.

Spiral and trumpet. Detail of this purely Celtic ornamental motif on a helmet from Amfreville, France. Louvre, Paris.

Karl Spitzweg, *Old Man on the Terrace*. Art Gallery, Hamburg.

Split, Palace of Diocletian. Roman fortresslike palace, built A.D. 305.

Everett F. Spruce, *Pigeons on a Roof.* Metropolitan Museum, New York.

Palace of Diocletian. In the center of the town are an outstanding peristyle and the Cathedral (the former mausoleum of the palace of Diocletian), constituting a monumental museum in the midst of the old city. The Cathedral Treasury has works dating from the 8th to the 18th century. *See* SPLIT: PALACE OF DIOCLETIAN.

SPLIT (Spalato): PALACE OF DIOCLETIAN. Roman palace on the Dalmatian coast in Yugoslavia. It was built by the emperor Diocletian near his native town of Salona as a place of retirement in A.D. 305. Major elements of the huge palace still exist.

The palace was constructed like a fortress. Rectangular in form, it was surrounded by high walls with towers on all except the south side, which faced the sea. It measured

Springing. Line from which an arch appears to spring.

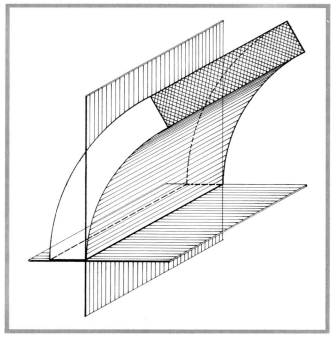

705 feet from north to south. On each of the three walls was a tower-flanked gate. The principal gate was the north gate (Porta Aurea). It had an ornamental façade and was flanked by octagonal towers. The palace complex was crossed by three avenues with covered arcades on each side. The approach to the palace itself was through an arcaded street in which the arches were supported directly by the capitals without an entablature. The entrance to the imperial apartments was through a domed room with a tetrastyle porch in which the Emperor appeared to receive homage. The palace contained a small tetrastyle prostyle temple raised on a podium (the latest ancient temple to be preserved) and the mausoleum (now the Cathedral), octagonal in form and decorated internally with niches and detached marble Corinthian columns. Some of the architectural features of the palace are considered precursors of the Byzantine style.

BIBLIOGRAPHY. W. J. Anderson, R. P. Spiers, and T. Ashby, *The Architecture of Greece and Rome*, vol. 2: *The Architecture of Ancient Rome*, London, 1927; H. Kähler, *The Art of Rome and Her Empire*, New York, 1963.

EVANTHIA SAPORITI

SPORKMANS (Sporckmans), HUYBRECHT. Flemish painter of historical and religious subjects (1619–90). Born in Antwerp, he is to be ranged among the minor followers of the Rubens tradition. Two canvases are extant: an *Anatomy Lesson* (Antwerp, Medical Circle) and *The City of Antwerp Asking Emperor Ferdinand to Reopen the Scheldt* (Antwerp, Fine Arts Museum).

BIBLIOGRAPHY. C. Leurs, ed., *Geschiedenis van de Vlaamsche Kunst*, vol. 2, Antwerp, 1939.

SPRANGER, BARTHOLOMEUS. Flemish painter (b. Antwerp, 1546; d. Prague, 1611). He began his training with Jan Mandijn, but his mature work is indebted primarily to the stylistic precepts of Parmigianino. He worked at the court of Emperor Rudolf II at Prague after serving Pope Pius V in Rome (1570) and Emperor Maximilian II in Vienna (1575). His elegant mannerist style, subsequently transmitted throughout the north by means of engravings, proved to be one of the most influential of the period.

BIBLIOGRAPHY. Amsterdam, Rijks-Museum, *Le Triomphe du maniérisme européen...* (exhibition), Amsterdam, 1955.

SPREEUWEN, JACOB VAN. Dutch genre painter (fl. Leyden, mid-17th cent.). In 1650 Van Spreeuwen is recorded as marrying the widow of the painter Pieter Quast in Leyden. His *Seated Philosopher* (1645; Amsterdam, Rijksmuseum) shows him to be a follower of Gerrit Dou, and perhaps the early Rembrandt.

BIBLIOGRAPHY. C. Boeck, "Rembrandt og Saskia i hjemmet," *Kunst og Kultur*, VI, 1916–17.

SPRING, *see* PRIMAVERA, LA.

SPRINGER, FERDINAND. German-French painter, illustrator, and graphic artist (1907–). Born in Berlin, he studied painting with Carlo Carrà in Milan and at the Académie Ranson in Paris. He worked with Stanley William Hayter in Paris from 1934 to 1936. An abstract painter, he has also done illustrations and designed tapestries.

SPRINGING. Line from which an arch appears to spring. The springing line is usually horizontal and is drawn through the points where the arch is tangent to the vertical at the impost.

SPRUANCE, BENTON MURDOCH. American painter, lithographer, and educator (1904–1967). Born in Philadelphia, he studied at the University of Pennsylvania and at the Pennsylvania Academy of Fine Arts. He was pro-fessor of fine arts at Beaver College, Glenside, Pa., from 1933 until his death. He was also director of the Division of Graphic Arts at the Philadelphia Museum College of Art. Spruance is primarily known as a color lithographer of social, religious, and mythological subjects; the *Anabasis* series (1959) is an outstanding example of his work. Many of his lithographs are in museums and library collections in the United States.

BIBLIOGRAPHY. Woodmere Art Gallery, *Lithographs 1928–1953 by Benton Spruance*, Philadelphia, 1954.

SPRUCE, EVERETT FRANKLIN. American painter (1908–). Born near Conway, Ark., he studied at the Dallas Art Institute. Although he has painted other subjects, such as still lifes, Spruce is best known for his regional landscapes of Texas and the Ozark country, tightly painted in a simplified and stylized manner, for example, *The Hawk* (1939; New York, Museum of Modern Art). Since the 1940s, in landscapes, genre, and figures, he has used brighter color and looser handling, as in *Pigeons on a Roof* (1947; New York, Metropolitan Museum), at times approaching expressionism.

BIBLIOGRAPHY. G. Danes, "Everett Spruce: Painter of the Southwest," *Magazine of Art*, XXXVII, Jan., 1944.

SQUARCIONE, FRANCESCO. Italian painter of Padua (1397–ca. 1468). His life is well documented by some commissions, but especially by many contracts with pupils,

Francesco Squarcione, polyptych with saints. Municipal Museum, Padua. One of two surviving works by this artist.

sometimes followed by records of lawsuits when they left him. Other records show that he adopted some of his pupils. One contract of 1467 specifies that he will teach perspective.

His supposed trip to Greece is a myth, but he collected fragments of ancient Roman carving and, more exceptionally, drawings by living artists. Unlike most Renaissance masters, his importance as a teacher is not based on his own painting. His two preserved paintings (Padua, Municipal Museum; Berlin, former State Museums) are provincial late Gothic works with borrowings from Donatello. His importance lies in his having conveyed to many northern Italian artists an interest in classical antiquity, as well as knowledge of the Florentine artists who had worked in Padua, for example, Donatello. His chief pupil was Mantegna, but many of the outstanding Venetians (Crivelli, B. Vivarini, and the Bellinis) were also influenced.

BIBLIOGRAPHY. L. Testi, *La storia della pittura veneziana*, 2 vols., Bergamo, 1909–15; R. van Marle, *The Development of the Italian Schools of Painting*, vol. 18, The Hague, 1936.

SQUARE CAPITALS, see CAPITALS, SQUARE.

SQUARING. Mechanical aid to the reproduction of drawings on a larger scale, usually preparatory to painting. The drawing is divided into equal squares; the area on which the copy is to be made is divided into corresponding squares of a larger size. The lines of the original drawing that fall within each square are then easily copied in the corresponding squares of the larger surface.

SQUEEGEE. In serigraphy, a strip of hard, medium, or soft rubber set in a wooden handle, used to pull the paint from one end of the frame holding the silk stencil across to the other end. Some pressure is required to force the paint through the fabric onto the paper beneath it.

SQUIER, JACK. American sculptor (1927–). Born in Dixon, Ill., he studied at Indiana University and at Cornell University, where he has taught. Squier's abstract bronzes are organic, hieratic forms somewhat influenced by primitive sculpture, such as *Oracle* (1958; New York, Whitney Museum).

BIBLIOGRAPHY. Whitney Museum of American Art, *Forty Artists Under Forty*, New York, 1962.

SQUINCH. Generally an arch or corbel diagonally spanning an inside corner and thereby effecting a transition between a square plan and an octagonal or circular superstructure. The dome on a square plan, connected with the development of the squinch, was used in early wooden huts of the Middle East and was adopted in Mesopotamia and Armenia. Corner transitions from square to dome were made by using slabs. The arched and corbeled squinch was used in the pre-Islamic architecture of the Sassanian period in southern Persia, in Sarvistan and Firuzabad (3d to 5th cent. A.D.), and was commonly employed in Armenia and Asia Minor to support a dome on a square. The Baptistery of Soter in Naples (5th cent.) is one of the earliest Western examples.

SRAVANA BELGOLA, see GOMATESVARA, SRAVANA BELGOLA.

Squaring. Mechanical aid for reproducing drawings on a larger scale.

SRI, see LAKSHMI.

SRINGA, see SIKHARA.

SRIRANGAM TEMPLE, see TRICHINOPOLY.

SS., alphabetized as Saints.

STAAL, ARTHUR. Dutch architect and writer (1907–). Staal was the son of the prominent Amsterdam school architect, Jan Frederik Staal. After studying at the Building Trade School in Haarlem and the Technical School, Utrecht, he won the Prix de Rome in 1935. Among his writings are *Nederlands Pleinen in Nederland* (1937) and *Bouwen van Woning tot Stad* (1947).

STAAL, JAN FREDERIK. Dutch architect (1879–1940). Born in Amsterdam, he was a follower of Hendrik Berlage. Like Michel de Klerk and others, Staal worked in the manner of the Amsterdam school at the beginning of the century. His works include housing in Amsterdam (1922) and the Dutch Pavilion at the Paris Exposition of 1925. A later work of merit is the Stock Exchange in Rotterdam, designed in 1929 and built in the 1930s.

STABILE. Stationary abstract sculpture or construction of a type created by Alexander Calder and first exhibited at the Galerie Percier (Paris, April 27–May 9, 1931). It is typically made of wire and sheet metal or wooden forms attached to a base. Jean Arp is credited with inventing the term to describe Calder's work.

BIBLIOGRAPHY. J. J. Sweeney, *Alexander Calder*, rev. ed., New York, 1951.

STADEL ART INSTITUTE, FRANKFURT AM MAIN, see FRANKFURT AM MAIN: MUSEUMS (STADEL ART INSTITUTE AND MUNICIPAL GALLERY).

STADIUM. Racecourse used for foot races and subsequently for other athletic performances. The ancient Greek stadium was based on a fixed dimension of 600 Greek

feet, although the value of the foot varied in different states. The typical plan of the stadium was U-shaped, with the starting place at the squared end. Early stadiums were built in a hillside or between two hills on which were placed tiered seats for spectators, as in Olympia, Thebes, and Epidaurus; those at Delphi, Athens, and Ephesus were set on relatively flat ground. Some stadiums were large, the one in Athens being said to have accommodated between 40,000 and 50,000 people.

STADLER, TONI. German sculptor (1888–). Born in Munich, Stadler was a pupil of August Gaul in Berlin and of Herman Hahn at the Munich Academy. He visited Paris (1925–27), received the Prix de Rome (1934), and twice won the Villa Romana prize in Florence. In his early work he was influenced by Maillol and usually represented the female body. After World War II he turned to bronze, and an appreciation of Etruscan art is reflected in his recent work.

BIBLIOGRAPHY. W. Haftmann et al., *German Art of the Twentieth Century*, New York, 1957.

STAEL, NICOLAS DE. French painter (b. St. Petersburg, Russia, 1914; d. Antibes, France, 1955). After his parents' deaths in 1922, De Staël attended Jesuit schools in Brussels. He studied at the Brussels Academy of Fine Arts and in 1936 with Léger in Paris. By 1942 he had begun to paint abstractly. In 1944 he became a friend of Braque and of Lanskoy and exhibited with Kandinsky, Domela, and Magnelli at the Galerie L'Esquisse, where he had his first one-man show that same year. In 1948 De Staël became a French citizen. He traveled widely, visiting North Africa, the United States, Italy, Spain, and England. In 1950 he had his first one-man show in New York. He was represented at the Venice Biennale and the São Paulo Bienal. In 1956 the Paris National Museum of Modern Art gave a retrospective exhibition of his art, and in 1966 another was held at the Guggenheim Museum, New York.

His somber, blocky abstractions in a tachist manner with thickly troweled-on paint were abandoned in 1952 for

Nicolas de Staël, *Composition*, 1944. Private collection.

broadly abstracted figures of athletes, musicians, nudes, and still lifes. Forms were reduced to color spots and bright reds and electric blues and blacks were favored.

BIBLIOGRAPHY. A. Tudal, *Nicolas de Staël*, Paris, 1958; R. V. Gindertael, *De Staël*, Boston, 1965.

ROBERT REIFF

STAFFAGE. Animal or human figures in a baroque landscape painting that are painted in by an assistant or by a specialist in such figures, not by the master who painted the overall landscape. The practice of *staffage* was common in the production of small-scale landscapes in Holland during the 17th and 18th centuries.

STAG AT SHARKEY'S. Oil painting by Bellows, in the Museum of Art, Cleveland. *See* BELLOWS, GEORGE WESLEY.

STAGI, LORENZO. Italian sculptor (b. Pietrasanta? ca. 1455; d. there, 1506). From 1497 to 1502 he worked on the baptismal font for the Church of S. Michele, Farnócchia, and also executed a marble tabernacle and marble balustrades for the choir of Pietrasanta Cathedral (1502–06). Other works mentioned in the contemporary literature have not survived. His marble-carving tradition was perfected in the work of his son, Stagio Stagi.

Squinch. Means of supporting a dome on a square.

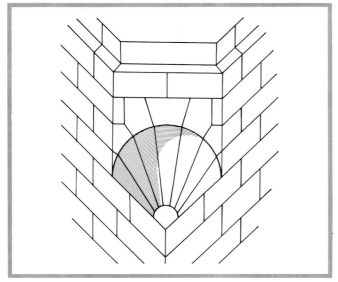

STAGI, STAGIO. Italian sculptor (b. Pietrasanta? ca. 1496; d. Pisa, 1563). Evidently a pupil of Giuliano di Taddeo and Bastiano Nelli, Stagi was active on the Cathedral at Pisa from 1523 to 1563, completing many of Pandolfo Fancelli's works there, such as the *Altar of St. Biagio.* He also executed five marble altars at Pietrasanta and a paschal candlestick in the Cathedral of Pisa. Stagi is one of the most significant marble carvers of northern Italy during the early 16th century.

STAINED GLASS. Translucent glass colored through the mixture of oxide pigments into the molten glass or by firing them onto the surface of clear glass. In the process of building up a window design, many pieces of colored glass are held together by strips of metal, usually lead. Despite the antiquity of colored glass and the use of clear glass for windows in Roman times, there is no real proof that stained-glass windows existed before the 10th century. Byzantine and Islamic prototypes are presumed, however, and in the West the art of enameling, especially cloisonné work, may have suggested the idea of holding bits of colored glass in a metallic framework. It is recorded that, during the rebuilding of Rheims Cathedral in 988, pictorial glass windows were installed, but the earliest examples extant date from the 11th century.

The process of making stained glass was difficult and complicated. Once the colored glass was in a molten state, it was blown into disks or cylinders and cut to rough shape by running a hot iron along the proposed line of fracture. Much additional shaping of the edges was then necessary. After 1500 a diamond cutter replaced this method, and today an ordinary steel glass cutter is used. Cartoons with color notations were used as patterns for the glass. To secure additional detail in each colored fragment, the surface was covered with glass dust and oxide pigment and then scraped, stippled, or scratched. The glass was fired again to make these modifications permanent, and then all pieces were assembled and joined together with lead strips. The joints were soldered, and smaller units were combined to form the whole window.

The weight and flexibility of the construction, especially with large windows, was such that reinforcing rods of iron were introduced at intervals to form a framework. These rods were attached to the masonry frame of the window with iron bars. Such iron and lead strips do not interfere with the pictorial clarity of the scene, as might be supposed, but act to define strongly some areas and to unify others. It is to the credit of the medieval artist that he could utilize this framework to the advantage of his total composition. Even at close range, the strips serve as settings for the glowing bits of glass which have long reminded observers of some great jeweled work. Their visual affinity with the gold, enamel, and precious-stone-encrusted book covers of the period is striking. In an illiterate age they were indeed an awe-inspiring and dramatic adjunct to the familiar sermons.

Storms, fires, vandals, and wars throughout the centuries have taken their toll, and few medieval churches have all their original glass. Some of the earliest existing examples are the windows at Augsburg Cathedral and Le Mans (ca. 1065–80). Of a strongly Romanesque character, they show large, single figures of facing monks holding inscribed scrolls and are mainly in green, yellow, red, and blue. Simple and austere, the figures form a compact, geometric unit within the tall lunette shape of the window frame. Numerous 12th-century windows exist: the west windows at Chartres, Bourges, and Poitiers, as well as those in Canterbury Cathedral in England and Strasbourg in Germany. *See* CHARTRES CATHEDRAL.

By the middle of the 12th century more pictorial scenes replaced the simplicity of these earliest examples. The Madonna and Child and martyrdoms of saints and kings, often in architectural settings, transformed the function of windows from that of an icon to that of a narrative. In this High Gothic period the new breadth of theme resulted in a complexity of color and detail that produced a truly jeweled effect. As the Gothic was perfected in architecture, the exterior wall no longer had a load-bearing function and glass replaced stone between each buttress. This led to such structures as Ste-Chapelle in Paris, which is literally a cage of glass. The increased size of the windows allowed the main scene to be surrounded by medallions and geometric forms. *See* SAINTE-CHAPELLE, PARIS.

An increasing naturalism in the treatment of anatomy and plant forms is seen during the 13th century, although after about 1270 there was a taste for the grisaille in linear patterns. The limited tones of brown and black were perhaps a religious reaction to the opulence of the 12th-century windows. Some of the finest glass from this period is in Canterbury, although many windows there were damaged by iconoclasts during the 17th century. Characteristic, too, is the greater sense of the dramatic and emotional, especially in scenes of the Crucifixion and martyrdoms. This new sentiment is not restricted to glass design but is especially noticeable in sculpture of the same period.

The 14th century saw the development of regional styles, and schools of window design grew up around the major cathedrals under construction. It becomes possible to speak of the style at York and Winchester or at Evreux as well as in terms of broader national characteristics. The Cistercian opposition to pictorial windows and the wider use of clear glass in this period resulted in an increased brightness of interior lighting and the exploitation of decorative tracery of the most delicate nature. In those pictorial windows executed under the aegis of the Franciscans there is, in the late 14th century, an emphasis on graceful realism, especially in contemporary fashions of dress and even portraits of donors. *See* EVREUX: CATHEDRAL OF NOTRE-DAME; YORK CATHEDRAL.

There was a return to the use of color in the 15th century, and the late Gothic taste for fantastic foliage is amply represented. Heraldic arms, first seen in 14th-century windows, became common and were treated with an exuberance typical of the age. The regional schools were even more sharply differentiated from one another as a parallel to the rise of nationalism and the power of monarchies. By the end of the century the art of stained glass began to suffer from the increasing popularity of oil painting. All over Europe the glaziers, like the manuscript illuminators, began to imitate the effects of oil painting, and the strictly pictorial dominates the decorative during the 16th century. Important schools of stained-glass production existed in the Lowlands, Switzerland, and Italy, where the most prominent artists created window designs.

Stalactite. Vaulting of the Green Mosque, Bursa, Turkey.

See also GOTHIC ART (ARCHITECTURE; STAINED GLASS, PAINTING, AND THE MINOR ARTS).

During the next centuries decorative glass windows remained popular but were conceived of almost solely as paintings. The trend toward stained-glass making during the late 18th and the 19th century is largely due to the Gothic revival. Perhaps the best-known 19th-century stained-glass works are those made by the pre-Raphaelite painter Burne-Jones for William Morris. His particular combination of piety, realism, and antiquarianism, together with the superior workmanship insisted on by Morris, resulted in some of the most successful windows produced since the Renaissance.

The new appreciation of pure color and form in 20th-century art has stimulated a resurgence of stained-glass designs, especially in Germany and France. In exploiting the abstract beauty of the medium there has been a tendency to treat the windows as a translucent mosaic, often in nonobjective patterns. Modern expressionism, feeling a kindred spirit with the glass designers of the 11th to 13th centuries, has drawn from the power and intensity of the figures in early pictorial windows to considerable advantage. The results have been most successful and have given a new lease on life to a once-great art that had been growing moribund.

BIBLIOGRAPHY. H. Arnold, *Stained Glass of the Middle Ages in England and France*, London, 1939; C. Woodforde, *English Stained and Painted Glass*, Oxford, 1954; E. L. Armitage, *Stained Glass: History, Technology and Practice*, Newton, Mass., 1959.
MARVIN D. SCHWARTZ

STALACTITE. Pendant architectural form suggestive of a stalactite. In Muslim architecture, of which they were a common feature, stalactites were formed by overlapping and intersecting quarter domes acting as squinches. The Alhambra in Granada has roofs formed of stalactite vaults.

STALBEMT, ADRIAEN VAN. Flemish painter (1580–1662). Born in Antwerp, he traveled in Holland. This versatile artist is known mainly for his landscapes in the style of Jan Breughel I. He occasionally also drew upon Gillis van Coninxloo and Paul Bril. Some religious and mythological subjects are extant, as well as rare instances of collaboration with Pieter Brueghel the Younger.

BIBLIOGRAPHY. Y. Thiéry, *Le Paysage flamand au XVIIe siècle*, Brussels, 1953.

STALL. Section of fixed seats for clergy and choir. The bishop's seat is called the throne. Medieval stalls are often elaborately carved and have overhanging canopies. They are sometimes furnished with misericords, carved with grotesques.

STAM, MART. Dutch architect (1899–). Born in Purmerend, he studied in Amsterdam, Berlin, Zurich, Thun, and Rotterdam; since 1928, he has been an independent architect in Frankfurt am Main, Berlin, and Amsterdam. His work includes a project for a railroad station (1924) and housing for the Weissenhof Exhibition (1927). He also contributed to the design of the famous Van Nelle factory near Rotterdam (1927–28) for the firm of Brinkman and Van der Vlugt. *See* BRINKMAN, J. A., AND VAN DER VLUGT, L. C.; WEISSENHOF EXHIBITION.

BIBLIOGRAPHY. G. A. Platz, *Die Baukunst der neuesten Zeit*, 2d ed., Berlin, 1930.

STAMBHA (Lat). Pillar in Indian architecture. It may be monolithic, bearing emblems and edicts, as at Sārnāth and Kārle; in series encircling a stūpa, as at Junnār; in series as a railing carved with Bodhisattvas, yakshīs, mortal women, or earth goddesses (Lucknow Museum; Philadelphia, University of Pennsylvania Museum); or in series indicating divisions within a temple. The term *stambha* may also refer to the wall surface proper, a subdivision of the perpendicular wall of the small temple of south India.

STAMMEL, JOSEF THADDAUS. Austrian sculptor (b. Graz, 1695; d. Admont, 1765). He studied with J. J. Schoy. After visiting Rome, Stammel lived in the Benedictine monastery of Admont (after ca. 1725). His principal work is at Admont, where he decorated the library with four sculpture groups: *Death*, *Judgment* (signed and dated 1760), *Heaven*, and *Hell*. There is a rococo flavor to the figures, combined with a precise attention to the qualities of the natural, unpainted wood.

STAMNING. Term describing certain Swedish landscape paintings done under the influence of the Fontainebleau and Düsseldorf schools by their chief Swedish exponent, Alfred Wahlberg (1834–1906). *Stämning* is a spiritual quality, the transient essence of a scene.

STAMNOS. Ancient Greek vessel used to contain wine or water. It is a wide-mouthed vase similar to the amphora, but its two handles are set horizontally at the shoulders.

BIBLIOGRAPHY. G. M. A. Richter, *A Handbook of Greek Art*, 3d ed., London, 1963.

STAMOS, THEODOROS. American abstract painter (1922–). He was born in New York City, where he studied at the American Artists School in 1948–49. He had his first one-man show in 1953. In his recent work, biomorphic shapes, hovering over an atmospheric ground, have lost their similarity to vegetation, fossils, sea anemones, and the like through further abstraction.

BIBLIOGRAPHY. T. B. Hess, *Abstract Painting*, New York, 1951.

STAMPFER (Stampf), JAKOB (Hans J.). Swiss goldsmith, medalist, and die engraver (b. Zurich, 1505/06; d. there, 1579). The son of the goldsmith Hans Ulrich Stampfer I,

Jakob became a master goldsmith (1533) and City Warden of the Mint (1539) in Zurich. Aside from his work at the mjnt, he is primarily noted for portrait and religious medals for which he made models in stone. Examples in Zurich (Landesmuseum), Bern (History Museum), and Munich (Bavarian National Museum) reveal influences from the German Renaissance masters P. Flötner and F. Hagenauer.

BIBLIOGRAPHY. G. Habich, *Die deutschen Schaumünzen des XVI. Jahrhunderts*, vol. 1, pt. 1, Munich, 1929.

STAMP SEALS, *see* SEALS: STAMP AND CYLINDER.

STANDARD, *see* BLOEMEN, PIETER VAN.

STANFIELD, WILLIAM CLARKSON. English painter (b. Sunderland, 1793; d. London, 1867). Stanfield began to draw and paint as a young seaman. After his early retirement from the service, owing to an injury, he was successfully employed as a scenery painter for the London stage. At the same time he painted small sea pieces, of an authenticity derived from his early experience, for which he gradually acquired a reputation. He left stage painting about 1829 and the next year made his first tour of Europe. During his lifetime, Stanfield achieved great popularity for his marines and landscape views and for such nationalistic subjects as *The Battle of Trafalgar* (1836; London, United Service Club). He was elected to the Royal Academy in 1835.

STANKIEWICZ, RICHARD. American sculptor (1922–). Born in Philadelphia, he studied with Hans Hofmann in New York (1948–49), at Léger's school in Paris (1950), and at the Atelier Ossip Zadkine in Paris (1950–51). With eleven other artists, he opened the Hansa Gallery, in New York, in 1952. The Museum of Modern Art, New York, owns his *Instruction* (1957), and *Diving to the Bottom of the Sea* (1958) is in the Rubin Collection, New York. Stankiewicz is one of the best and most influential of the "manipulators" working with junk and objects of his own manufacture to produce a witty, urbane art.

BIBLIOGRAPHY. New York, Museum of Modern Art, *Sixteen Americans*, ed. D. C. Miller, 1959.

STANZA. As used in Italian architecture, a room or chamber, for example, Raphael's Stanze in the Vatican.

STANZIONE, MASSIMO (Cavaliere Massimo). Italian history painter (b. Naples, 1585; d. there, 1656). He was a student of G. B. Caracciolo and F. Santafede. In Rome Stanzione was strongly influenced by the Carraccis and Guido Reni and later by Artemisia Gentileschi. Upon his return to Naples, Stanzione became one of the city's leading painters. Most of his works have darkened as a result of his excessive use of bituminous underpainting, but some still display vivid tones and strong chiaroscuro. Among his followers are Bernardo Cavallino and P. de Rosa.

BIBLIOGRAPHY. H. Schwanenberg, *Leben und Werk des Massimo Stanzioni*, Bonn, 1937.

STARGARD: CHURCH OF ST. MARY. German Gothic church, the most notable in Pomerania (Poland since 1945). Begun in 1292 and completed in the 14th and 15th centuries, it was originally intended to be a hall church and

was later changed to a basilica. Its history accounts for its somewhat awkward yet powerful interior space.

BIBLIOGRAPHY. P. Frankl, *Gothic Architecture*, Baltimore, 1962.

STARK, JAMES. English landscape painter of the Norwich school (1794–1859). Born in Norwich, Stark was the father of the painter Arthur James Stark (1831–1902). After receiving encouragement from John Crome and his son, Stark attended the Royal Academy schools in 1817. He was principally influenced by Richard Wilson and the Dutch landscape painters, but derived his subjects from the Norfolk countryside. He was a regular exhibitor at the Royal Academy and at the British Institution.

STARNINA, GHERARDO (Gherardo di Jacopo). Italian painter of the Florentine school (d. 1409/13). He is first mentioned in Florence in 1387. In 1398 and 1401 he is recorded in Toledo and Valencia. In 1404 he was again in Florence and completed the frescoes in the Chapel of St. Jerome in S. Maria del Carmine, of which only fragments survive. His frescoes of 1409 in S. Stefano at Empoli are not extant. On the basis of a statement of Vasari's and comparison with the Carmine frescoes, several murals with *Scenes from the Legends of SS. Anthony and Nicholas* in the Castellani Chapel in Sta Croce, Florence, have been attributed to him. From them it appears that he was trained in the shop of Agnolo Gaddi. He shows himself as an impressively independent, formally and psychologically advanced painter. A panel of *The Thebaid* (Florence, Uffizi) has been associated with him, though there seems little reason to accept it as his work.

BIBLIOGRAPHY. C. Gamba, "Induzioni sullo Starnina," *Rivista d'arte*, IV, January, 1932; U. Procacci, "Gherardo Starnina," *Rivista d'arte*, V, April, 1933, VII, October, 1935, VIII, January, 1936.

STAROV, IVAN YEGOROVICH. Russian architect (1743–1808). After studying in Moscow and St. Petersburg, he became a pupil of De Wailly in Paris and traveled in Italy until 1768. Starov introduced a freer treatment of the neoclassical vocabulary to Russia, committing that country to the Empire style. He designed the famous and influential Tauride Palace (1783–88) for Catherine the Great.

BIBLIOGRAPHY. G. H. Hamilton, *The Art and Architecture of Russia*, Baltimore, 1954.

STARRY NIGHT. Oil painting by Van Gogh, in the Museum of Modern Art, New York. *See* VAN GOGH, VINCENT WILLEM.

STASOV, VASILI PETROVICH. Russian architect (1769–1848). He studied in Moscow and was sent to France, England, and Italy by Alexander I (1802–08). His work combines the international classical tradition emanating from France with a distinctly Russian flavor. He is best known for his triumphal gate in St. Petersburg (1833–38), an early cast-iron structure designed as a Greek propylaeum.

BIBLIOGRAPHY. G. H. Hamilton, *The Art and Architecture of Russia*, Baltimore, 1954.

STATE (of Print). One version, complete in itself, of an edition of prints. If an edition has been pulled, any change, even of one line, constitutes another state.

Gherardo Starnina, *The Thebaid*. Tempera on panel. Uffizi, Florence. A work that has been attributed to this painter.

STATIONS OF THE CROSS. Series of representations of episodes of Christ's last hours erected as devotional images in a cloister church or along a road to a cemetery. The idea was devised in the late Middle Ages under the influence of the Via Crucis, which was set up for the pilgrims in Jerusalem. In the Middle Ages seven stations were the usual number, but subject matter was not standardized. The most frequent combination' was (1) Christ before Pilate, (2) St. Veronica wiping the face of Christ, (3) Carrying of the Cross, (4) Nailing to the Cross, (5) Crucifixion, (6) Descent, and (7) Entombment. Another grouping uses three falls of Christ at the second, fourth, and sixth stations. By the 17th and 18th centuries the number of stations had risen to fourteen. Stations of the Cross are most frequently executed in relief sculpture.

BIBLIOGRAPHY. P. W. Keppler, *Die XIV Stationen des heiligen Kreuzwegs...*, 4th ed., Freiburg im Breisgau, 1904.

STATTMULLER, PATER BEDA. German painter and musician (b. Ottobeuren, 1699; d. Weingarten, 1770). A monk at the Benedictine monastery of Weingarten, Stattmüller is known for his drawing of an ideal plan for the monastery (1723), after a plan by the architect Frisoni. This added to the already existing palace-church complex by Moosbrugger a lower perimeter wall of rococo configuration that was never executed.

STAURIS, RINALDO DE'. Italian sculptor (fl. 1461–90). Stauris worked in his native Cremona and at the Certosa of Pavia (1464–80). Among his works are terra-cotta decorations for the arcade of the small cloister at the Certosa, done in collaboration with Amadeo.

STAVANGER CATHEDRAL. Romanesque church in Norway, started about 1123. The nave and the west front were completed about 1150, and the sanctuary was finished about 1303.

The Ronanesque style of the Cathedral basically reflects the Anglo-Norman style of such English cathedrals as Norwich, Ely, and Durham. The Anglo-Norman style was brought to Norway by English churchmen and missionaries in the 10th century, but prior to about 1100 most Norwegian church construction continued in the indigenous timber tradition. In contrast to the sharp verticality of the traditional Norwegian stave churches (as in Borgund), Stavanger Cathedral is basically horizontal in appearance despite its two east towers. It is a large, wide-aisled, low basilica, with a wide west porch and two flanking east towers. The stone walls are thick, with small windows and low, steeply pitched roofs. There is no transept. Certain features are traceable to Cluniac and German influences, which arrived in Norway by way of Denmark (Cluny and German Hirsau influence) and Sweden (Rhineland influence). The wide, low west porch speaks of Cluny and Hirsau, while the east towers flanking the Cathedral suggest the German Rhineland.

The decorative architectural detail is much in the nature

of a provincial variation, imbued with the vigorous Nordic geometric quality, of the more sophisticated Continental Romanesque forms. This stylistic quality is equally apparent in the crude figural sculpture, always kept to a minimum and not infringing upon the massive, simple, and impressive bulk of the church. Hence, the Cathedral well exemplifies the changeover from an indigenous timbered architecture to the new, not fully mastered forms of Romanesque stonework. In this respect it differs from Uppsala Cathedral in Sweden, where there is evidence of work by traveling companies of masons from Lombardy and the Rhineland.

BIBLIOGRAPHY. *Norwegian Architecture throughout the Ages*, comp. E. Alnaes et al., Oslo, 1950.

STANLEY FERBER

STAVE CHURCH. Type of wooden church built with upright planks (or staves) during the early Middle Ages in Norway. It has a very steep pointed roof and gables, often with dragon heads decorating the peaks. The upper part of the second story is usually broken by blind arcades. The plan is similar to that of a basilica without transept. The earliest stave church, built at Garmo, dates from the 11th century.

BIBLIOGRAPHY. A. R. Bugge, *Norwegian Stave Churches*, Oslo, 1953(?).

STAVELOT, *see* MOSAN ART.

STAVEREN, JOHAN (Jan) ADRIAAENSZ. VAN. Dutch painter of genre, landscape, and portraits (b. Leyden, before 1620; d. there, after 1668 [1669?]). He was a follower, and perhaps a pupil, of Gerrit Dou. In 1645 Van Staveren was recorded as a member of the Leyden painters' guild; however, a painting entitled *A Hermit* (Leyden, Stedelijk Museum "De Lakenhal") is signed and dated 1637. He was also a burgomaster of Leyden.

BIBLIOGRAPHY. S. J. Gudlaugsson, "Jacob van Staver(d)en," *Oud-Holland*, LXXI, 1956 and LXXII, 1957.

STEATITE. Very soft stone—red, gray, or green in color—used as a material for small-scale sculpture and sometimes for vessels. Steatite was especially popular in Chi-

Stavanger Cathedral. Norwegian Romanesque church reflecting the Anglo-Norman style.

Stave church. The 12th-century church at Gol, Hallingdal, Norway.

nese, Cretan-Mycenaean, and Byzantine art. Byzantine artists used it as a substitute for ivory, as, for example, in the Monstrance of Pulcheria (11th cent.; Mt. Athos).

STEDELIJK MUSEUM, AMSTERDAM, *see* AMSTERDAM: MUSEUMS (MUNICIPAL MUSEUM).

STEEL CONSTRUCTION, *see* CONSTRUCTION, STEEL.

STEEN, JAN HAVICKSZ. Dutch painter of genre, history, landscape, and portraits (b. Leyden, 1625/26; d. there, 1679). Steen was a pupil of Nicolaas Knüpfer at Utrecht, then of Adriaen van Ostade at Haarlem, and last, of Jan van Goijen at The Hague. He married Van Goijen's daughter in 1649. Stylistic relationships between the early works of Steen and the circle of Van Ostade are to be found in Steen's *Winter Landscape* (Skokloster, Baron Rutger von Essen Collection), which must date in the late 1640s, or, in any case, before 1651. The picture, however, shows greater affinities with the work of Isaak van Ostade, the younger brother and pupil of Adriaen. Steen painted a portrait of Isaak (now lost). Some stylistic confirmation of a relationship between Knüpfer and Steen is to be found in the 1667 *Marriage of Tobias* (Brunswick, Herzog-Anton-Ulrich Museum, Picture Gallery) and Knüpfer's 1654 rendering of the same subject (Utrecht, Centraal Museum).

In 1646 Steen was registered at Leyden University, and from 1649 to 1654 he was living at The Hague. He was in Delft for a time in 1654, and his father, a brewer, leased a brewery for him in that town. His artistic activity in Delft is represented by a 1655 painting, the so-called *Delft Burgomaster* (London, Lady Janet Douglas-Pennant Collection). From 1656 to 1660 Steen was living in Warmond; in 1661 he entered the guild in Haarlem, but he does not seem to have spent much time there. In 1670 he inherited a house in Leyden, where he apparently remained until his death. In 1672 he received permission

to run an inn; he also held various official positions in the Leyden painters' guild, including dean (1674).

Steen is best known for his genre-like rendering of popular Dutch folk proverbs such as his *As the Old Sing, So Pipe the Young* (The Hague, Mauritshuis Art Gallery). He also painted a number of more classically composed "serious" genre compositions, such as *The Morning Toilet* (1663; London, Buckingham Palace), as well as a large number of religious and mythological subjects, such as *The Capture of Sampson* (Cologne, Wallraf Richartz Museum), a late work.

BIBLIOGRAPHY. A. Bredius, *Jan Steen*, Amsterdam, 1927; W. Stechow, "Bemerkungen zu Jan Steens künstlerischen Entwicklung," *Zeitschrift für Bildende Kunst*, LXII, 1928–29; C. H. de Jonge, *Jan Steen*, Amsterdam, 1939; W. Martin, *Jan Steen*, Amsterdam, 1954; N. Maclaren, *National Gallery Catalogues: The Dutch School*, London, 1960.

LEONARD J. SLATKES

STEENWIJCK (Steenwyck), HARMEN EVERTSZ. VAN. Dutch still-life painter (b. Delft, 1612; d. there? after 1656). He and his brother Pieter were pupils of their uncle David Bailly in Leyden (1628–33). Van Steenwijck was reported living in Delft by 1644. In 1654 he was in the East Indies, but he returned the following year. His work is related stylistically to that of Pieter Claesz. and Willem Claesz. Heda as well as to that of Pieter Potter.

BIBLIOGRAPHY. A. Bredius, "De schilders Pieter en Harmen Steenwyck", *Oud-Holland*, VIII, 1890.

STEENWIJCK, HENDRIK VAN, I. Flemish painter (b. Steenwijck, ca. 1550; d. Frankfurt am Main, 1603). A pupil of Hans Vredeman de Vries, he won renown for his architectural paintings of church interiors, palace courts, and so on. Unlike his predecessors, he fused purely schematic solutions with genuinely experienced observation.

STEENWIJCK, HENDRIK VAN, II. Flemish painter (b. Antwerp, ca. 1580; d. London, 1649). He was a pupil and follower of his father, Hendrik van Steenwijck I. His work is distinguished from his father's by its greater emphasis on architectonic detail, and the choice of a lower horizon. Figures in his paintings were sometimes contributed by Frans Francken the Younger.

STEENWINKEL FAMILY. Flemish architects, sculptors, and painters (fl. Denmark, late 16th–18th cent.). The most important members of the family were three architect-sculptors named Hans.

Hans Steenwinkel I (ca. 1545–1601) was trained in Antwerp under his father, Lourens Steenwinkel. In 1578 he went to Denmark and became a protégé of Tycho Brahe, who employed him as an architect and introduced him to optics and mathematics as well as to the works of Vitruvius, Palladio, and Serlio. His style came to be closely based on these models; in its harmonious classicism it is related to that of Cornelius Floris.

Hans Steenwinkel II (1587–1639) was at first apprenticed to his father but later worked in the offices of Willem Cornelisz. and Hendrik de Keyser in Holland. He returned to Denmark about 1612/13 and was appointed royal architect in 1619. His work represents the second phase of the Flemish Renaissance style in Denmark in its use of early baroque elements (as in the Stock Exchange in Copenhagen, 1623–40).

Hans Steenwinkel III (ca. 1639–1700) was named royal architect in 1669. His work as an inspector of buildings for Christian V is well documented, but little is known about his activity as an architect. He is credited with the designs for the Naval Hospital in Copenhagen (1684–86).

HELLMUT WOHL

STEEPLE. Tower surmounted by a spire, sometimes consisting of several stories diminishing toward the top, as in Wren's St. Stephen Walbrook, London, of the 17th century.

STEER, PHILIP WILSON. English painter (b. Birkenhead, 1860; d. London, 1942). He studied in Paris from 1882 to 1884 under Bouguereau and Cabanel and was influenced by impressionism, but not consistently. His landscapes after 1900 are broadly painted views in the English tradition. (See illustration.)

BIBLIOGRAPHY. R. Ironside, *Wilson Steer*, London, 1943; D. S. MacColl, *Life, Work and Setting of Philip Wilson Steer*, London, 1945.

Jan Havicksz. Steen, *Young Woman Dressing*. Rijksmuseum, Amsterdam. A classically composed genre work by this Dutch painter.

STEFANO, FRANCESCO DI, see Pesellino, Francesco.

STEFANO DA VERONA. Italian painter (1375–after 1438). He is wrongly called "da Zevio." Many frescoes of his once seen in Verona are lost; documents are numerous in that city and indicate a visit to Trent. His signed *Adoration of the Magi* (1435; Milan, Brera) and numerous signed drawings show him to be the author of several Madonnas. Examples of these can be seen in the museums of Verona (*Madonna of the Rose Garden*) and Worcester, Mass. Linear rhythms of great sophistication, boneless figures, and vivid plants and animals show him to be an International Gothic artist closely akin to those of Cologne and Prague, in contrast to almost all other Italian artists of the age, in whose work local traces are visible.

BIBLIOGRAPHY. R. van Marle, *The Development of the Italian Schools of Painting*, vol. 7, The Hague, 1926.

STEFANO DI GIOVANNI, see Sassetta.

STEFANO FIORENTINO. Italian painter (fl. early 14th cent.). No authenticated works by this Florentine follower of Giotto have survived. He is highly praised in the writings of Ghiberti for his frescoes in the Convent of S. Agostino and the cloister of S. Maria Novella in Florence.

STEINBACH, ERWIN VON. German(?) Gothic architect (d. 1318). He was master of the west façade (excluding the towers) and the Chapel of the Virgin (built in 1316) of Strasbourg Cathedral from about 1276 until his death. His work is praised in Goethe's essay *Von Deutscher Baukunst* (1772).

BIBLIOGRAPHY. G. Delahache, *La Cathédrale de Strasbourg*, 25th ed., Paris, 1910.

STEINBERG, SAUL. American painter and graphic artist (1914–). Born in Romania, he studied in Milan, Italy, and served in the United States Navy during World War II. In drawings and cartoons, he uses an incisive, graphic wit to illustrate the fantasies and follies of humanity. Several collections of his drawings have been published in book form.

STEINHARDT, JAKOB. German expressionist printmaker and illustrator (1887–). Born in Zerkow, Prussia, he studied in Berlin with Lovis Corinth and Hermann Struck and later with Matisse and Steinlen in Paris. He was a member of the Berlin Secession group. Migrating to Israel in 1933, Steinhardt headed the Bezalel School of Art in Jerusalem. His work is primarily in woodcut.

BIBLIOGRAPHY. Stedelijk Museum, *Jakob Steinhardt*, Amsterdam, 1957.

STEINHAUSEN, PILGRIMAGE CHURCH OF. Church near Ulm, in southern Germany. Dominikus Zimmermann was commissioned in 1727 to replace a decrepit Gothic church; the new building was consecrated in 1733. It is oval in plan and has a ring of tall piers forming an am-

Philip Wilson Steer, *What of the War?*, 1883. Tate Gallery, London.

Saul Steinberg, drawing from *The Art of Living*.

bulatory and supporting the vault; square projections at the east and west ends provide for the choir and the entrance under the tower. The brevity of the chancel and the solidity of the ring of piers assert the centrally planned character of the interior. Zimmermann's brother Johann Baptist painted the frescoes. The exterior of the church is relatively modest; only Zimmermann's idiosyncratic window forms suggest the richness within.

BIBLIOGRAPHY. H. Koepf, *Steinhausen, die Wieskirche Oberschwabens*, Stuttgart, 1954.

STEINLE, BARTHOLOMAUS. German wood carver (fl. Weilheim, after 1605; d. there, 1628). His major work, the high altar in the Zisterzienstiftskirche in Stams, Austria (completed in 1612), exhibits an interesting combination of late Gothic and manneristic styles.

STEINLEN, THEOPHILE-ALEXANDRE. French graphic artist and painter (b. Lausanne, 1859; d. Paris, 1923). Steinlen might be called a chronicler if he had not treated his subjects with biting sarcasm. Yet neither was he strictly a satirist. After his arrival in Paris in 1882 he soon became part of the artistic ambience of Montmartre. He adopted an asocial point of view and gained his reputation through his graphic derision of the Paris working class and proletariat. In 1901 he became a naturalized French citizen. He was competent as a draftsman, etcher, and lithographer, and his work appeared regularly in *Chat noir, Le Mirliton* (under the pseudonym Jean Caillou), *Le Croquis, La Revue illustrée, La Caricature, Le Rire*, and *Le Gil Blas illustré*. In addition, he did illustrations for Anatole France's *Histoire du chien de Jean Brisquet* (1900) and Maupassant's *Le Vagabond* (1902). He drew in water color, pastel, and oil and also lithographed posters. His style shows the influence of both Daumier and Millet.

BIBLIOGRAPHY. E. de Crauzat, *L'Oeuvre gravé et lithographié de Steinlen*, Paris, 1913; G. Auriol, *T.-A. Steinlen*, 1930.

STELE. Carved slab of stone set upright in the ground and used by the Greeks as a gravestone. By extension, the term denotes any upright slab used for sculptured reliefs or inscriptions; also a carved area of a wall. Upright slabs of stone were used in primitive Attica, and in Sparta marble stelae were carved with representations of the dead. The Greek stele was usually carved in bas-relief and was capped by an anthemion.

STELE OF ARISTION, see ARISTOCLES.

STELLA, FRANK. American painter (1936–). Born in Malden, Mass., he studied painting with Stephen Greene and William Seitz while at Princeton University, but in his early work Stella was influenced primarily by Hans Hofmann. In 1958 Stella turned from abstract expressionism to a drastically reduced and severely ordered style that has been in the forefront of minimal art in the 1960s. Adopting an uncompromising approach to abstraction, he first painted only concentric rectangles of white line that echo the frame of the canvas against a black background, but in more recent works he uses a searing range of colors and a variety of canvas shapes.

BIBLIOGRAPHY. M. Fried, *Three American Painters*, Cambridge, Mass., 1965.

T.-A. Steinlen, *Marche vers l'arrière*. Engraving. National Library, Paris.

STELLA, JACQUES. French history painter and engraver (b. Lyons, 1596; d. Paris, 1657). He was the son of François Stella the Elder, with whom he studied before going to Florence in 1619. In Florence he learned to engrave in the manner of Jacques Callot, and worked for the court of Cosimo II and for Ferdinando II de' Medici. In Rome in 1623 he was a friend and imitator of Nicolas Poussin. In 1634 he returned to France and became the leading advocate of Poussinesque classicism before the emergence of Laurent de La Hire and Charles Le Brun. Stella worked mostly for religious orders and churches (*Holy Family*, ca. 1650; Toulouse, Museum of the Augustinians). At Cardinal Richelieu's order he executed a series of engravings illustrating the life of St. Philip Neri (1635). In 1644 he was named First Painter to the King, and was knighted in the Order of St. Michael.

STELLA, JOSEPH. American painter (b. Muro Lucano, near Naples, 1877?; d. New York City, 1946). Stella went to the United States in 1896 and studied for a while at William Merritt Chase's New York School of Art. From 1905 to 1910 Stella produced illustrations for the magazines *Outlook* and *Survey*. His *Pittsburgh, Winter* (1908) is an aerial view of the city subsumed in a Whistlerian haze. But early drawings of miners, steelworkers, and immigrants are hard and linear and done with a meticulous realism.

In Europe in 1910–12, Stella came into contact with several of the Italian futurists, and upon his return to America he became, in effect, America's leading futurist painter. A landmark was the *Battle of the Lights, Coney Island* (1913; Lincoln, Nebr., Sheldon Memorial Art Gallery), a work suggesting an assimilation of Severini. Here, amid the fragmented objects, one finds an occasional bit of a printed word. Usually, however, Stella preferred to show, not the kaleidoscopic effects of much of European futurism, but a crystallized, frozen aspect of industrial forms, as may be seen in *The Bridge* (Newark Museum), done for his *New York Interpreted* series of 1920–22. In work of about 1915 Stella was forecasting the shiny surfaces of the precisionists. In spite of the quiet, jeweled mood that *The Bridge* evokes, Stella spoke of "the steely

Joseph Stella, *The Brooklyn Bridge: Variation on an Old Theme,* **1939.** Whitney Museum of American Art, New York.

fully centralized form and lush, intense, cool color. Stella also produced assemblages of bits of paper rubbish from 1920 on, which anticipated much abstract art of the 1950s and 1960s.

BIBLIOGRAPHY. J. I. H. Baur, "Joseph Stella Retrospective," *Art in America,* LI, October, 1963; E. C. B., "The Consistent Inconsistency of Joseph Stella," *Art News,* LXII, December, 1963.

ABRAHAM A. DAVIDSON

STELLA, PAOLO. Italian sculptor (b. Milan; d. Prague, 1552). Stella completed a relief (1529) that had been begun by Giovanni Maria Mosca for a chapel in S. Antonio in Padua. From 1537 to his death he was active on the Belvedere in Prague. He may also be identical with a Paolo da Milano who executed (with Antonio Lombardo) *SS. Thomas Aquinas and Peter Martyr* (formerly S. Giustina, Venice) and other works in SS. Giovanni e Paolo, Venice.

STEPHANSDOM, VIENNA, *see* ST. STEPHEN'S CATHEDRAL, VIENNA.

STEPHANUS. Greek sculptor (fl. 2d half of 1st cent. B.C.). He was a follower of Pasiteles. Stephanus's signature appears on a classicistic statue of a youth (perhaps Orestes) in the Villa Albani, Rome. It is an eclectic work, based on early classical models, but incorporating many stylistic features of later periods.

BIBLIOGRAPHY. M. Bieber, *The Sculpture of the Hellenistic Age,* rev. ed., New York, 1961.

STEPHEN, ST. First Christian martyr (d. 35 A.D.). He was a deacon, one of the first elected by the apostolic community in Jerusalem, and was assigned to distribute food to the needy. His preaching and miracles antagonized the Jews, who brought him before a council, accusing him of blasphemy. Stephen incensed them by proclaiming Christianity and was cast out and stoned to death. Usually he is shown as a youthful saint in a dalmatic, paired with the deacon St. Lawrence of Rome. His attribute is a stone. His feast is December 26.

See also SAINTS IN ART.

STEPHENSON, GEORGE. English engineer (1781–1848). He developed the major elements of the modern railroad station. Stephenson's two-storied Crown Street Station (1830), a narrow oblong in plan, contained waiting rooms and ticket offices below and accommodations for the station officials above. Along the building's right-hand side a columned porch covered the single platform. His Victoria (Hutsbank) Station of 1840–42 at Manchester provided the longest platform in the world at that time. Stephenson was noted as a locomotive builder and was consulted in the building of railroads and bridges in England and other countries. His son, Robert Stephenson, was also an engineer.

BIBLIOGRAPHY. H. R. Hitchcock, *Early Victorian Architecture in Britain,* vol. 1, New Haven, 1954.

STEPHENSON, ROBERT. English engineer (1803–59). He was the son of the noted engineer George Stephenson. Robert's early work was on locomotives—one was the Rocket (1827); but he is renowned for his bridges—the High Level at Newcastle, and the later Conway and Britannia bridges, which were of the tubular girder type of the 1840s.

orchestra of modern constructions." During this period he also presented some total abstractions, which were less pretentious and more spontaneously rendered than the futurist pieces, such as *Orange Bars* (1919; Mr. and Mrs. Emanuel M. Turner Collection). In 1939 he painted another version of *The Bridge* (New York, Whitney Museum), again showing a view of the girders and the steel network, which appears more static than the first.

Stella spent the years 1926–35 mostly abroad, in Naples, North Africa, and especially Paris. In 1936 he was back in New York; in 1937–39 he was in Europe again and in Barbados, but after 1939 he remained in New York. In Barbados he painted landscapes abounding in lush and exotic vegetation with occasional phallic centralized images. His *Full Moon (Barbados)* (1940; Sergio Stella Collection) features a fully saturated, almost perfectly circular yellow moon above a strange blue thistle flanked by tropical birds. Stella's transformations of plants and fruits might prompt a surrealist classification. The forms are heavily outlined and rendered without modeling. The earlier gouache *Sunflower* (1929; Terner Collection) similarly features a power-

STEREOBATE. Substructure of the Greek temple.

STERILISM, *see* CUBIST REALISM.

STERN, RAFFAELE. Italian architect (1774–1820). He worked in Rome. He is best known for his addition to the sculpture museum at the Vatican, the Braccio Nuovo (1817–22), which is a distinguished example of the classicist style in museum work of the first half of the 19th century.

BIBLIOGRAPHY. P. Marmottan, *Les Arts en Toscane sous Napoléon*, Paris, 1901.

STERNBERG, HARRY. American graphic artist (1904–). Born in New York City, he studied at the Art Students League and with Harry Wickey. Sternberg is one of the leading graphic artists in the United States, as an etcher and lithographer and in the mass medium of silk-screen printing. Sternberg's early etchings are eclectic and show the influence of Marsh in crowded, vigorously drawn city scenes, Goya in incisively caricatured parables, and Blake in cosmological themes. During the depression and World War II his work developed toward a more direct expression of social commentary in terms of simplified and monumental forms. After the war he turned increasingly to serigraph, woodcut, and mixed media, stressing lyrical themes, decorative effects, and flat areas. Sternberg has taught widely in New York and has written several books on the graphic arts.

BIBLIOGRAPHY. A. C. A. Gallery, *Sternberg: 25 Years of Print Making*, New York, 1953.

STERNE, MAURICE. American painter and sculptor (b. Libau, Latvia, 1878; d. Mount Kisco, N.Y., 1957). He went to the United States in 1889 and studied mechanical drawing at Cooper Union. From 1894 to 1899 he studied painting at the National Academy, where he also took anatomy classes with Eakins. Sterne won a traveling fellowship in 1904 and for the next ten years traveled in France, Italy, Greece, and the South Seas, spending three years in Bali. His early paintings were influenced by Whistler. The Gauguin-influenced Bali paintings, ambiguous in space and decoratively composed, for example, *Bali Bazaar* (1913–14; New York, Whitney Museum), were well received. His later paintings, landscapes, figures, and still lifes, are strongly composed and are influenced, on the whole, by Cézanne.

BIBLIOGRAPHY. New York, Museum of Modern Art, *Maurice Sterne*, New York, 1933.

STERZING ALTAR, *see* MASTER OF THE STERZING ALTAR; MULTSCHER, HANS.

STEVENS, ALFRED. Belgian painter (b. Brussels, 1823; d. Paris, 1906). He lived in Paris from the age of seventeen and studied at the Ecole des Beaux-Arts. Manet and other impressionists were among his friends. Stevens designed a huge panorama for the 1889 World's Fair in Paris. His fashionable paintings of society life are a blend of genre, academism, and restrained impressionism.

STEVENS, ALFRED. English sculptor and painter (b. Blandford, 1817; d. London, 1875). In 1833 Stevens traveled to Italy to study the old masters. He stayed longest in Florence (four years). While in Rome in 1840 he met Thorwaldsen and worked in his studio for two years before returning to England.

Stevens's most famous work is the monument to the Duke of Wellington in St. Paul's Cathedral, London. He won the commission in an international competition (1857) and thirteen months later was ordered to begin by making a full-scale model. The monument was unfinished at his death; the equestrian statue of the Duke was added in 1912. *Valor and Cowardice*, plaster models for the bronze sculpture in the Wellington Monument, are in the Tate Gallery, London.

Stevens executed sculpture for several English mansions including Dorchester House, from which only the caryatids of the mantelpiece remain (Tate). He was asked to make designs for mosaics in St. Paul's dome but carried out only one, the mosaic of Isaiah.

He worked in an Italian style. His sculpture is derived from Michelangelo, and his portraits are High Renaissance in feeling.

BIBLIOGRAPHY. T. S. R. Boase, *English Art, 1800–1870*, Oxford, 1959.

STEVENSON, JOHN JAMES. English architect (1831–1908). From the office of Sir George Gilbert Scott he became a prolific designer of domestic buildings, particularly London houses. He also designed churches in Glasgow and Stirling and made a famous restoration of the Mausoleum of Halicarnassus.

BIBLIOGRAPHY. "Mr. Stevenson," *The Builder*, XCIV, May 9, 1908.

STIACCIATO RELIEF, *see* RELIEF, STIACCIATO.

STIEGLITZ, ALFRED. American photographer and gallery owner (b. Hoboken, N.J., 1864; d. New York City, 1946). He was educated in the United States and later (1882–85) at the Berlin Polytechnic, where he began to study photography. On his return to the United States, he bought into a photoengraving firm, which pioneered early three-color work. Stieglitz edited *American Amateur Photography* (1892–96). He founded *Camera Notes* in 1897, on which he worked until 1903, and then became editor and publisher of the sumptuous *Camera Work*, which later contained material on art as well as photography (it discontinued publication in 1917). In 1902 he founded the Photo-Secession group and in 1905 opened the Photo-Secession Gallery at 291 Fifth Ave. (later known as "291"). *See* PHOTOGRAPHY, HISTORY OF.

Stieglitz's photography was technically meticulous as well as imaginative. He was among the first to take rain and night scenes, before fast lenses and plates; he pioneered studies of texture and psychological drama in photographing trees and clouds; and he was an ardent recorder of the buildings and people of New York City. All his negatives were destroyed after his death; only a few perfect prints, made by Stieglitz himself, and eleven photogravures created under his supervision, from his negatives, remain. Often small in size, the prints are exquisite documents of sensitive craftsmanship and human insight. Three retrospective exhibitions of his photographs were held at Anderson Galleries (1921, 1923, and 1924).

Stieglitz held pioneer exhibitions of many great modern

European artists, but was especially interested in certain Americans. He held the first exhibitions in the United States of Matisse (1908), Toulouse-Lautrec (1909), Cézanne (1910–11), Renoir (1910), Rousseau (1910), Picasso (1911), Nadelman (1915), and African sculpture (1914). Among the American painters he championed were Weber, Macdonald-Wright, Walkowitz, and his beloved "five": Marin, Hartley, Dove, Demuth, and Georgia O'Keeffe, who later became his wife.

After the close of 291 and a period of organizing exhibitions for other galleries, Stieglitz opened the Intimate Gallery, after 1925, as part of the Anderson establishment in New York. In 1929 he opened An American Place, where he continued to show his favorites and new discoveries. Stieglitz was a rare dealer-connoisseur who exhibited only those he believed in and materially aided them to achieve financial and spiritual success.

BIBLIOGRAPHY. W. Frank et al., eds., *America and Alfred Stieglitz*, New York, 1934; Philadelphia Museum of Art, *History of an American, Alfred Stieglitz: 291 and After*, Philadelphia, 1944.

JOSEPH A. BAIRD, JR.

STILL, CLYFFORD. American painter (1904–). Born in Grandin, N. Dak., Still attended Spokane University and Washington State College at Pullman and has taught at Hunter College, Brooklyn College, and elsewhere. His first one-man show was held at the San Francisco Museum of Art in 1941. He has been represented in major exhibitions at the Museum of Modern Art, New York ("Fifteen Americans," and "The New American Painting"), the Walker Art Center, Minneapolis, and Seattle (1962 World's Fair). A retrospective of his work was held in 1959 at the Albright-Knox Art Gallery, Buffalo. Still's compositions, usually executed on enormous canvases, are of large, ragged shapes of few colors, totally abstract and at first glance reposeful; but subtle overlappings of contrasting light and dark tones or hues afford an intriguing tension. Characteristic paintings are *Number 1* (1951; Utica, N.Y., Munson-Williams-Proctor Institute) and the similar *Painting* (New York, Museum of Modern Art). Still's work is central to the establishment of the New York school's action aesthetic.

BIBLIOGRAPHY. New York, Museum of Modern Art, *15 Americans*, ed. D. C. Miller, New York, 1952; M. Schapiro, "The Younger American Painters of Today," *The Listener*, XV, Jan. 26, 1956; S. Hunter, *Modern American Painting and Sculpture*, New York, 1959; Los Angeles County Museum of Art, *New York School*, ed. M. Tuchman, Los Angeles, 1965.

STILL LIFE (Nature morte). In painting, the portrayal of flowers, fruit, vases, musical instruments, and other inanimate objects as an independent subject. Although such elements have appeared in Western art since the Hellenistic period, it was not until the 17th century that the genre emerged, divorced from larger themes or a decorative function. The term still life was first used in the 17th century in the Netherlands, where the genre attained its greatest status. The equivalent Italian term *natura morta* (French, *nature morte*) originated in the 18th century as a means of invidious comparison with more noble subjects. In China and Japan, still life—birds and flowers, bamboos, and vegetables and fruit—has been a respected category of painting since the Sung period (960–1279).

BIBLIOGRAPHY. C. Sterling, *La Nature morte de l'antiquité à nos jours*, 2d ed., Paris, 1959.

STILTED ARCH, *see* ARCH, STILTED.

STIMMER, TOBIAS. Swiss painter and designer of woodcuts and stained glass (b. Schaffhausen, 1539; d. Strasbourg, 1584). He was possibly a student of Hans Asper in Zurich. From 1565 Stimmer operated a workshop in Schaffhausen. He was well known as a portrait painter, and received most of his commissions from Swiss patrons. His portrait style is modeled after Hans Holbein the Younger, with influences from Asper. Stimmer's woodcuts include a series entitled *Neue kunstliche Figuren biblischer Historien* (1576). Among his works are the façade painting on the Haus zum Ritter in Schaffhausen (1570; original in Schaffhausen Museum), paintings for the astronomical clock in the Strasbourg Cathedral (1571–74), and *Portrait of Konrad Gesner* (1564; Schaffhausen Museum).

BIBLIOGRAPHY. M. Bendel, *Tobias Stimmer, Leben und Werk*, Zurich, 1940.

STIPPLE. A refinement of the crayon engraving or chalk manner; primarily a reproductive, not an original, technique, used mainly as a rapid means of copying pencil and water-color drawings. The stippling technique may be identified in prints by very small dots, strokes, or flicks placed close together.

A ground may be laid on the plate before it is worked, or roulettes and a curved stipple engraving tool may be employed on an ungrounded plate. On a grounded plate, a combination of etching needles and roulettes is used to create a myriad of small strokes and dots. However, many prints have been worked entirely with the stipple graver, which is an unusual, curved burin that can flick the surface of the plate in short, distinguishing strokes. In some cases, both techniques are employed on a single plate, producing a combination of etching, engraving, and mezzotint. The plate is printed in the same way as in all other intaglio processes.

See also CRAYON ENGRAVING.

BIBLIOGRAPHY. British Museum, *A Guide to the Processes and Schools of Engraving*, rev. ed., London, 1933; W. M. Ivins, *How Prints Look*, repr., Boston, 1958.

STIRLING CASTLE. The two baileys and parts of the curtain wall of this Scottish castle are of early medieval date. The Parliament Hall is late 15th century. On the west side of the lower court are the Royal Palace, begun in 1496 in the Franco-Scottish Renaissance style, and the Chapel Royal of 1594.

BIBLIOGRAPHY. S. Toy, *The Castles of Great Britain*, 2d ed., London, 1954.

STOA. Portico (Latin, *porticus*) in Greek architecture, usually long, with a wall on one side and a colonnade fronting on an open space. Providing shelter from sun and rain, stoas connected public structures, protected pilgrims visiting shrines, and were used as promenades and as meeting places. The Stoa of Eumenes in Athens was contiguous to the Odeum of Herodes Atticus; the stoas in Epidaurus sheltered patients at the Shrine of Aesculapius.

STOC (Stock), VRANCKE VAN DER, *see* STOCKT, VRANCKE VAN DER.

STOCK, IGNATIUS VAN DER. Flemish painter and etcher (fl. Brussels, 2d half of 17th cent.). A pupil of Lodewijk de Vadder, Stock became a master in 1660. He painted decorative and broadly brushed landscapes in the manner of Jacques d'Arthois. Stock produced numerous etchings of great quality; some were after Jacques Fouquières and others were independent compositions.

BIBLIOGRAPHY. Y. Thiéry, *Le Paysage flamand au XVIIe siècle*, Brussels, 1953.

STOCKHOLM. Capital of Sweden. The city was founded about 1255 and rapidly developed into an important commercial center. The Gamla Stan (Old Town) retains its medieval aspect. The city was originally surrounded by walls with fortified towers; two 15th-century towers still stand.

The Great Church (St. Nicholas), founded in the 13th century, has a Gothic interior; the exterior was remodeled in the mid-18th century. It contains an exuberant polychromed wooden *St. George and the Dragon* (1489) by Bernt Notke. The Franciscan church on the Riddarholm (ca. 1280–1310; altered 17th cent.) is the burial place of the Swedish kings.

The Riddarhus (House of the Nobility), which has a steep roof with giant pilasters, was erected in the mid-17th century by Simon and Jean de la Vallée and Justus Vinckeboons. St. Jacob's Church, completed in 1645, has a southward-turned façade. Flying buttresses and a steeply slanted roof give the structure a Gothic look, but the walls are not opened in large panes of glass in the Gothic fashion. The Royal Palace, destroyed by fire in 1697, was rebuilt after designs of Nicodemus Tessin the Younger and was completed in 1754. Planned as a quadrangle, the palace is severe and fortresslike in appearance; the Pitti Palace of Florence may have served as its prototype. Eric Palmstedt's Börhus (Stock Exchange; 1773–76) is rococo.

Carl Westman's Law Courts (1909–15) evoke the heavy style of the 16th century—masses of white masked brick are rhythmically grouped around a mighty central tower—and Lars Wahlman's Engelbrekt Church (1906–11) follows late Gothic models. But Gunnar Asplund's Crematorium (1935–40) in the Forest Cemetery uses modern forms to create an ensemble of remarkable individuality. Under Asplund's direction, the Stockholm Exhibition of 1930 ensured prestige for various modes of functionalism.

The baroque Drottningholm Palace, on the outskirts of Stockholm, was begun in 1662 by Nicodemus Tessin the Elder and completed in 1700 by Tessin the Younger. The Court Theater here was built in 1764–66. On the grounds is the Chinese Pavilion (Kina Slott; 1769) by C. F. Adelcrantz, an outstanding example of the rococo style.

The National Museum in Stockholm contains works by many masters of Western art. The National Historical Museum has a rich collection of prehistoric and medieval art. The Nordiska Museum displays Swedish arts and crafts from the Middle Ages to the present. Old buildings from all over Sweden have been reerected in Skansen, an open-air museum. The home of Carl Milles on Lidingö, near Stockholm, contains a great collection of that sculptor's works. *See* STOCKHOLM: NATIONAL MUSEUM.

See also STOCKHOLM: TOWN HALL.

BIBLIOGRAPHY. J. Roosval, *Swedish Art*, Princeton, 1932.

ABRAHAM A. DAVIDSON

STOCKHOLM: NATIONAL MUSEUM. Swedish collection. The present museum evolved from the Royal Museum, which was established in 1792 and opened to the public in 1794. The National Museum was opened in 1866 and houses a distinguished collection (painting, sculpture, prints and drawings, and decorative arts) belonging to the state, with whose history that of the museum is closely interwoven, particularly during the reigns of Gustav Adolf, Kristina, Lovisa Ulrika, and Gustav III.

The museum's greatest strength lies in its superb 18th-century French collection, which includes paintings and drawings of top quality by Chardin (8 paintings), Boucher (6 paintings, 41 drawings), Watteau, Lancret, Pater, and so on. More than half of the French works now in the National Museum were acquired, either for himself or for the Royal collections, by Count Carl G. Tessin, one of the 18th century's great connoisseurs. The one serious gap in this collection was filled in 1953, when the museum acquired Watteau's *La Leçon d'amour*. The second area of distinction is Dutch and Flemish painting; included are such treasures as Rembrandt's *The Oath of the Batavians*, Ruben's *Bacchanal at Andros* after Titian, and Hals's *Daniel van Aken Playing the Violin*. Modern French painting is well represented by, among others, Manet, Cézanne, Renoir, Léger, and Matisse. The art of Sweden constitutes a large part of the collection; of particular significance are 18th-century artists (Sergel, Roslin, Pilo) and those of the second half of the 19th century (especially Josephson and Hill). There is also a good collection of Norwegian (6 Munch oils), Danish, and Finnish work.

The collection of more than 40,000 drawings is excellent (many of its gems were acquired by Tessin from the Crozat sale in 1741), and the print collection numbers about 100,000. Other notable areas include decorative arts, Chinese paintings (housed in the museum for Far Eastern art), and Russian icons. Paintings and sculptures from about 1909 have been installed in the Moderna Museet (Modern Museum), a short distance from the National Museum, of which it is a branch. The National Museum is also in charge of the National Portrait Gallery, in Gripsholm Castle.

BIBLIOGRAPHY. G. Serner, *A Key to the Museums of Sweden*, Stockholm, 1960.

ELLEN JOHNSON

Stoa. Plan of the Stoa of Eumenes, Athens.

STOCKHOLM: TOWN HALL. Swedish municipal building (1909–23) by Ragnar Ostberg, one of the last great romantic structures in Europe. Built of red brick, it is arranged around two courts; at the south-east corner is a 348-foot tower. The Golden Hall, with magnificent mosaics, and the Blue Hall are outstanding.

BIBLIOGRAPHY. R. Ostberg, *The Stockholm Town Hall*, Stockholm, 1929.

STOCKMAN, JAN GERRITS. Dutch landscape painter (fl. Haarlem, 1637–70). Little is known of Stockman's early training. He was recorded as a member of the Haarlem painters' guild in 1637. In 1670 his son Leendert was a member of the same organization. Stockman painted landscapes in the Italianate style. He seems to have been somewhat influenced by the works of Claude Lorraine.

BIBLIOGRAPHY. W. Bernt, *Die niederländischen Maler des 17. Jahrhunderts...*, vol. 3, Munich, 1948.

STOCKT, BERNARD VAN DER, *see* MASTER OF THE MAGDALEN LEGEND.

STOCKT (Stock; Stoc), VRANCKE VAN DER (Master of the Prado Redemption). Flemish painter (ca. 1420–before 1496). He was the official painter of the city of Brussels after Rogier van der Weyden. Van der Stockt dominated painting in Brussels during the years between Van der Weyden's death and the beginning of the dominance of the contemporaries of Colijn de Coter. Van der Stockt was also the author of an important series of tapestry cartoons and of panel paintings.

STOEP (Stoop). In Dutch colonial architecture, a low platform with a bench on either side of the entrance door. The Dutch stoep has given its name to the stoop as an exterior flight of stairs leading to a raised entrance.

STOFFE, JAN JACOBSZ. VAN DER. Dutch painter of military scenes, battles, and hunts (b. Leyden, ca. 1611; d. there, 1682). In 1644 Van der Stoffe was a master in the Leyden guild, and four years later he was a member of the Guild of St. Luke in that city. He held various official positions in the guild, including dean (1669). His style is related to that of Esaias van de Velde and Palamedes Palamedesz. Stevens.

BIBLIOGRAPHY. J. C. Overvoorde, "Eenige bijzonderheden over den Leidschen schilder Jan Jacobsz. van der Stoffe," *Jaarboekje voor geschiedenis en oudheidkunde van Leiden en Rijnland*, XVII, 1920.

STOLA. In ancient Roman and Byzantine civilization the stola was a woman's long gown decorated with wide borders. Later the term was applied to a priestly vestment— the long, narrow, richly embroidered and jeweled piece of silk worn across the shoulders.

STOLDO DI GINO, *see* LORENZI, STOLDO.

STOMER (Stom), MATTHIAS. Flemish history painter (b. Amersfoort, ca. 1600; d. Sicily? after 1651). A student of Honthorst, Stomer spent most of his life in Italy. In 1630 he was in Rome; in 1631, in Naples, he painted a Passion series for S. Efremo Nuovo; later he is recorded in Messina and Palermo. Stomer's works are often so close to those of Honthorst that they are attributed to him. Generally, however, they are more dramatic and stronger in chiaroscuro. Stomer's style in Sicily grew closer to that of Caravaggio's late period.

BIBLIOGRAPHY. H. Pauwels, "De Schilder Mattias Stomer," *Gentse bijdragen tot de Kunstgeschiedenis*, XIV, 1953.

STOM FAMILY. Italian painters (fl. 1688–1733): Matteo, Giovanni, Giuseppe, and Antonio. Originally from Val Gardena, they are recorded in Venice. These artists were employed primarily in the creation of works depicting scenes that appealed to the lighter tastes of the Venetian aristocracy: battle scenes, bacchanalia, and views of Venice. The views were often mistaken for and passed off as works by major artists, particularly Francesco Guardi.

BIBLIOGRAPHY. F. Mauroner, "Collezionisti e vedutisti settecenteschi in Venezia," *Arte Veneta*, 1947.

STONE, EDWARD DURRELL. American architect (1902–). Born in Fayetteville, Ark., he attended the University of Arkansas (1919–23), studied architecture at Harvard (1925–26) and the Massachusetts Institute of Technology (1926–27), traveled in Europe on a Rotch Fellowship (1927–29), and started independent practice after working in several offices (1933).

An important early work is the Museum of Modern Art in New York (with Philip Goodwin, 1939). Later, he designed the United States Embassy in New Delhi, India (1958), and the United States Pavilion at the Brussels World's Fair (1958).

BIBLIOGRAPHY. I. R. M. McCallum, *Architecture USA*, New York, 1959.

STONE, NICHOLAS. English sculptor and mason (ca. 1587–1647). He studied under Hendrik de Keyser in Amsterdam (1606–13) and became the leading English sculptor of his time. In London he was closely connected with the Court and the circle of Inigo Jones. He was Master Mason at the Banqueting House in London from 1619 to 1622. Among his many tomb monuments is the one to Dr. Donne (1631; London, St. Paul's Cathedral).

BIBLIOGRAPHY. W. L. Spiers, ed., "The Note-book and Account Book of Nicholas Stone...," *Walpole Society, Annual Volume*, VII, 1918/19.

Edward Durrell Stone, United States Embassy, New Delhi, India, 1958.

Stonehenge. The "horseshoe of Trilithons" (*center*), surrounded by the "circle of Sarsens."

STONE AGE. The use of the term "Stone Age" has undergone a considerable change. At the end of the 19th century Mortillet and others divided the Stone Age into two periods: the Paleolithic, or Old Stone Age, and the Neolithic, or New Stone Age. The discovery in the late 1880s of an intervening Mesolithic phase led to the division of the Stone Age into Paleolithic, Mesolithic, and Neolithic periods. In the early 20th century this system became rigid and schematic as a result of being used to define chronological periods as well as levels of cultural achievement. Today the terms "paleolithic" and "mesolithic" are used to define hunting and collecting types of culture, while "neolithic" refers to a sedentary culture based upon agriculture and herding. Archaeological fieldwork has shown that cultures of these three types may overlap in time; consequently the terms have no chronological significance. *See* NEOLITHIC ART; PALEOLITHIC ART.

See also PREHISTORIC ART, EUROPEAN.

STONEHENGE. Neolithic monument located on Salisbury Plain, north of Salisbury, in Wiltshire, England. The main elements of this unique monument are a long avenue leading to a northeast entrance in a ditch; a low circular bank running inside the ditch; a circle of filled pits (the Aubrey Holes) inside the bank; two other circles of filled pits (Y and Z holes); and four ranges of stones, the outer two circular, the third and fourth horseshoe-shaped. Additional stones include the Heelstone, within the avenue; the Slaughter Stone, at the entrance of the ditch; the Altar Stone, in the center of the innermost horseshoe; and two Station Stones on the inner edge of the ditch.

The outermost stone circle originally consisted of thirty upright sarsen (sandstone) blocks, averaging 13½ feet in height and forming a circle approximately 100 feet in diameter. They were capped by a continuous ring of thirty lintels that were shaped into a curve. Projecting knobs on the uprights fitted into corresponding holes at either end of each lintel. The second circle, composed of smaller bluestones, originally contained about sixty stones.

The outer horseshoe, of sarsen trilithons (two uprights topped by a lintel), shows a measured increase in height from trilithons of about 20 feet, including lintels, to the 25 feet, including the lintel, of the great central trilithon. The innermost horseshoe, originally of nineteen bluestones, also shows gradation in height, from 6 feet up to about 8 feet.

The Altar Stone, so called from its present horizontal position, is on an axis, sighting northeast between the main pillars of the sarsen circle, with the rise of the midsummer sun, leading to speculations that Stonehenge was used primarily for sun-worship rituals. The Heelstone, named for the large heel-like nick near its base, is also used in support of the sun theory since the summer-solstice sun rises very near its peak. The Slaughter Stone, lying near the Heelstone, was named from early human-sacrifice myths.

The bluestones at Stonehenge are thought to have been transported, possibly by a combination of water and overland hauls, from Presely Mountain, in Pembrokeshire. The sandstone type represented by the sarsens is found on Marlborough Downs, about 20 miles north of Stonehenge, and may have been dragged from there. A great many of the stones were dressed by pounding with stone mauls.

Although no one prehistoric culture can be named as the builder of Stonehenge, it has been fairly well established

that the monument was built in three main periods from about 1800 to about 1400 B.C. The fifty-six Aubrey Holes, named after their 17th-century discoverer John Aubrey, may once have held wooden posts. The two Station Stones, originally four, seem to have been used as construction devices. The dating of the end of the final building period may be indicated by representations of bronze ax blades and a bronze dagger incised on some of the stones. These may represent cult symbols indicating a link between the Stonehenge builders and early Greek civilizations dating back to the middle half of the 2d millennium B.C.

BIBLIOGRAPHY. R. J. C. Atkinson, *Stonehenge*, London, 1956; Great Britain, Ministry of Works, *Stonehenge and Avebury and Neighboring Monuments, an Illustrated Guide*, text by R. J. C. Atkinson, London, 1959; R. S. Newall, *Stonehenge, Wiltshire*, 3d ed., London, 1959.

LYNNE S. MAYO

STONEWARE. Highly vitrified and nonporous ware of great durability. It is made from refractory feldspathic clay with quartz sand or crushed flint added to promote fusion. Tan, red brown, or grayish in color, it is frequently slip- or salt-glazed in Europe and the United States but is usually treated with alkaline or feldspathic glazes in the East. Its firing temperature lies between 1200 and 1350°C, but the borderline between the hardest-fired stoneware and porcelain is indistinct enough for such stoneware to be termed "porcelaneous."

BIBLIOGRAPHY. W. E. Cox, *The Book of Pottery and Porcelain*, vol. 1, New York, 1944; W. B. Honey, *The Ceramic Art of China and Other Countries of the Far East*, London, 1945.

STONOROV, OSCAR. German-American architect (1905–). Born in Frankfurt am Main, he studied in Florence and under Karl Moser at the Polytechnic Institute in Zurich. He worked in the Paris office of André Lurçat before moving to the United States in the late 1920s. In partnership with A. Kastner (1932–35), he won second prize in the competition for the design for the Palace of the Soviets.

BIBLIOGRAPHY. New York, Museum of Modern Art, *Built in USA, 1932–1944*, ed. E. Mock, New York, 1944.

STOOP, DIRCK. Dutch painter of landscapes, rider battles, and cityscapes (b. Utrecht? ca. 1618; d. there? 1686). He was the son, and pernaps the pupil, of the glass painter Willem Jansz. Stoop. In 1638 Dirck or his brother Maerten was listed as a pupil in the records of the Utrecht Guild of St. Luke. He may have been in Italy between 1635 and 1645; he is reported in Utrecht from 1647 to 1652. In 1661/62 Stoop was in Portugal as court painter to the infanta Catherine of Braganza. He followed her to England in 1662 and painted the decorations for the celebration of her marriage to Charles II. He painted in the style of Pieter van Laer, whom he also copied.

BIBLIOGRAPHY. G. von Térey, "Dirck (Rodrigo) Stoop," *Kunst-chronik*, XXVIII, 1917.

STOOP, MAERTEN. Dutch painter of genre and of landscapes with riders and horses (b. Rotterdam? ca. 1620; d. Utrecht, 1647). He was the son, and perhaps the pupil, of the glass painter Willem Jansz. Stoop. In 1638 Maerten or his brother Dirck was listed as a pupil in the records of the Utrecht Guild of St. Luke. In a document of 1647 he was listed as *mudig* (over twenty-five years old). His work was influenced by Abraham Bloemaert, Leonard Bramer, and most strongly by Nicolaas Knüpfer.

BIBLIOGRAPHY. W. Bernt, *Die niederländischen Maler des 17. Jahrhunderts...*, vol. 3, Munich, 1948.

STOOP, *see* STOEP.

STOPPING-OUT. In the intaglio field in graphics, a procedure which limits the biting of a linear or tonal area. A fast-drying, acid-proof substance is brushed on the area to be protected, and then the plate is placed back in the acid bath. In serigraphy, a similar act prevents paint from being squeegeed through the silk screen.

STORCK (Sturck; Sturckenburg), ABRAHAM JANSZ. Dutch painter of seascapes and harbor scenes (b. Amsterdam, 1644; d. there? after 1704). He was the son of the Amsterdam painter Jan Jansz. Sturck (later Sturckenburg). Storck was a member of the Amsterdam painters' guild. He is last mentioned in 1695, when he was living in Amsterdam. However, Arnold Houbraken, writing in 1721, stated that Storck painted a picture of the reception for the Duke of Marlborough on the Amstel River in December, 1704. Storck painted in the manner of Jan van de Velde III and Ludolf Bakhuysen.

BIBLIOGRAPHY. I. H. van Eeghen, "De Schildersfamilie Sturck, Storck of Sturckenburch," *Oud-Holland*, LXVIII, 1953.

STORY, WILLIAM WETMORE. American sculptor (b. Salem, Mass., 1819; d. Italy, 1895). The son of a Supreme Court Justice, he practiced law before turning to sculpture. Story studied in Italy, returned briefly to Boston, and then settled in Rome. His style is one of uninspired neoclassicism; most of his figures are pedestrian.

BIBLIOGRAPHY. H. James, *William Wetmore Story and His Friends*, Boston, 1903.

STORY, BLIND, *see* TRIFORIUM.

STOSS, VEIT. German sculptor (b. Swabia, ca. 1447; d. Nürnberg, 1533). His early training was in Nürnberg. He became a master in painting, engraving, engineering, and architecture as well as in sculpture. Stoss was invited to design and execute the high altar for St. Mary's Church in Cracow, Poland. He went there in 1477 and stayed nineteen years. During this period he also produced tomb monuments for King Casimir IV (1492; Cracow Cathedral) and for Archbishop Zbigniew Oleśnicki (1493; Gniezno Cathedral). He was known in Poland as "Wit Stwosz."

Stoss returned to Nürnberg in 1496, prosperous from his Polish projects. In 1503 he became implicated in a fraudulent scheme and was tortured, forbidden to leave Nürnberg, and deprived of all his civic rights. In 1506 the emperor Maximilian restored his citizenship. In 1517–19 he produced another of his important works, the Annunciation group (Nürnberg, St. Lorenz). Following this, he carved a Crucifixion for St. Sebald (1520). His last great undertaking was an altar (Bamberg Cathedral) for the Carmelite monastery in Bamberg, which was never completed or delivered because of the Protestant Reformation.

The Cracow altarpiece is perhaps the most spectacular of Stoss's large-scale works. Its complexity and size required all of the master's ingenuity and energy for more than twelve years. Dedicated to the Virgin Mary, the altar nar-

rates the Passion of Christ and the death of Mary. The overall design of the altar is High Gothic in style. Innumerable figures and ornamented devices are built up into an overwhelming ensemble. The central triptych contains more than fifty painted wooden figures.

The Nürnberg group is of an entirely different character. The Annunciation is novel in conception. Basically it is composed in an oval form (12 ft. 2 in. by 10 ft. 6 in.), suspended on a slender cable from high in the vault. The Annunciation figures are surrounded by a wreath of fifty roses and a paternoster rosary of sixty pearls. Five medallions are arranged symmetrically on the wreath, and two are on either side of a crowned Christ at the top of the oval. Angels carrying musical instruments are suspended in the open spaces. At the very bottom a convoluting sea serpent denotes the waters of the world. The work is a tour de force of wood carving and a significant late Gothic monument.

Stoss was one of the greatest European wood carvers working in the late Gothic style. His style, closely related to that of Nikolaus Gerhard, is characterized by a virtuosity of technique and a flamboyancy of form that place him at the climactic point of late Gothic sculpture.

BIBLIOGRAPHY. E. Lutz, *Veit Stoss*, Munich, 1952.

BEN P. WATKINS

STOTHARD, THOMAS. English painter (b. London, 1755; d. there, 1834). He was brought up in York and began his artistic career as a book and magazine illustrator. He produced more than 5,000 designs, which were influential on painters, sculptors, and goldsmiths. He attended the Royal Academy schools and exhibited at the Academy from 1778. In 1794 he was elected full academician. He also worked on a grand scale on walls and panels, in a somewhat mannered style.

BIBLIOGRAPHY. A. C. Coxhead, *Thomas Stothard, R. A.*, London, 1906.

STRAET (Stradanus), JAN VAN DER (Giovanni Stradano). Flemish-Italian painter (b. Bruges, 1523; d. Florence, 1605). Stradanus was a pupil of Pieter Aertsen in Antwerp, where he became a master in 1545. For a short time he worked with Corneille de Lyon at Lyons, but spent most of his extremely active career from about 1548 in Italy. Attaching himself to Vasari, he assisted the master in decorating the Sala Regia in the Vatican (after 1551) and the Palazzo Vecchio in Florence (1561–62). For the Medicis in Florence he participated in the decoration of the *studiolo* in the Palazzo Medici and designed tapestries for Duke Cosimo I. Other patrons included Don Juan of Austria in Naples. His work provided a link between Florentine and international mannerism.

STRALSUND: RATHAUS. German town hall, dating from the 13th century (the oldest parts are dated 1278). It has an imposing 15th-century two-part façade which fronts on the marketplace. In plan it is essentially a variant of the Lübeck Rathaus.

BIBLIOGRAPHY. K. Gruber, *Das deutsche Rathaus*, Munich, 1943.

STRANG, WILLIAM. Scottish graphic artist and painter (b. Dumbarton, 1859; d. Bournemouth, 1921). Although Strang painted intermittently after 1883 and was recognized by the Royal Academy in London for his paintings, he deserves recognition mainly for his powerful and technically superior etchings and illustrations. His subjects were wide ranging, from fantastic imaginings in his early graphic works to illustrations of standard authors and, above all, to his sensitive and powerful portrait etchings. His style reflects the teachings of Legros, although in his later years his graphic works show greater kinship to Rembrandt and Daumier. Strang's more than 700 etchings include illustrations to Bunyan's *Pilgrim's Progress*, Milton's *Paradise Lost*, and Cervantes' *Don Quixote*; and his etching series *The War, Death and the Plowman's Wife*, and *Dance of Death*. His portraits—which were etched, drawn, or painted—include those of Thomas Hardy, Chamberlain, Kipling, and Tennyson.

BIBLIOGRAPHY. L. Binyon, introd., *William Strang: Catalogue of His Etched Work*, Glasgow, 1906.

STRANGE, SIR ROBERT. English graphic artist and miniature painter (b. Kirkwall, 1721; d. London, 1792). Strange worked in engraving and mezzotint in a soft, painterly style after paintings by Guercino, Poussin, Rembrandt, Reni, and Titian. He was influenced by Wille and was in direct rivalry with Bartolozzi for the position of London's leading graphic artist.

STRANGFORD APOLLO. Armless Greek torso, from the head to the knees, of Parian marble, in the British Museum, London. It came from the collection of the 6th

Veit Stoss, *Annunciation*, 1517–19. Wood. St. Lorenz, Nürnberg.

Viscount Strangford. It is one of G. M. A. Richter's Kouroi of the Ptoon 20 group (ca. 510–500 B.C.). The statue represents the climax of the late development of the kouros type and is believed to have come originally from Anaphe. The pose is symmetrical and frontal, though based on a four-sided conception with a rounded chest and back and sensitive modeling. Abstract simplicity has been retained.

BIBLIOGRAPHY. G. M. A. and I. A. Richter, *Kouroi*, 2d ed., London, 1960.

STRANGNAS CATHEDRAL. Swedish cathedral, originally built in the Romanesque style, and consecrated in 1291. As a result of several fires it has been much altered, which accounts for the unusually wide interior supports. Strängnäs Cathedral was restored in 1907–10. It is related to the Cathedral of Västeras in type and style.

BIBLIOGRAPHY. A. Hahr, *Architecture in Sweden*, Stockholm, 1938.

STRAPWORK. Type of ornamental motif consisting of long bands or fillets which are rolled into scrolls at their ends and criss-cross, or sometimes intertwine, with one another. Strapwork, like roll work, originated in the Fontainebleau school during the early 16th century. It was particularly popular in German and Flemish baroque art.

STRASBOURG: CATHEDRAL. Gothic cathedral in France, begun in 1176 or 1190. Strasbourg, a metropolitan see as early as the 4th century, possessed a church on the site of the present cathedral as early as 510, which is traditionally considered to have been founded by Clovis. This building, with 9th-century restorations and additions, was destroyed in 1002–07, and a great Romanesque church, built under Bishop Wernher, replaced it between 1015 and 1028. A century later this second structure was in ruins, following a series of fires.

In 1176 or 1190 the present Gothic church was undertaken; the present crypt and single-apse choir (much restored) date from this time. The transept arms were remodeled about 1235, and the nave was put up between about 1240 and 1275, when the westernmost keystone in the main vault was installed. In 1276 the foundations for the west façade were laid, and Master Erwin von Steinbach (d. 1318) was associated with the work from about this time. The design of the façade (up to the tower bases) seems to be his, and Plan "C" of the façade (Strasbourg, Notre-Dame Museum) may be from his hand. The spire of the north tower was begun in 1399 by Ulrich von Ensingen. Despite many restorations and disasters (never-completed south spire, fires, German bombardment of 1870), the delicacy of design, the rose-colored stone, and the great height (466 ft.) combine to make the façade of Strasbourg one of the most impressive of all medieval façades.

In 1772, praising the work of Master Erwin, Goethe claimed that Strasbourg was "German architecture," but the nave is almost altogether French Rayonnant. The tracery in the glazed triforium, the clerestory window tracery, the clusters of colonnettes, unbroken from floor to vault, and the dado passage along the side-aisle walls all reflect the arrangement in the nave of St-Denis, but the reduction of interior height (to 101 ft.) and the intensified verticality of Strasbourg look forward rather than backward.

The sculptures of Strasbourg Cathedral (some of which are copies of the originals preserved in Notre-Dame Museum) represent the diffusion in Germany of the style of the Reims workshop in the mid-13th century. They are fine expressions of Gothic Rayonnant naturalism. The "Pilier des anges" in the south transept is justly famous.

BIBLIOGRAPHY. G. Delahache, *La Cathédrale de Strasbourg*, 25th ed., Paris, 1910; H. Haug et al., *La Cathédrale de Strasbourg*, Strasbourg, 1957.

CARL F. BARNES

STRASBOURG: DER NEUE BAU. Early Renaissance building commissioned by the city of Strasbourg, now in France, and designed by Hans Schoch. Constructed between 1582 and 1585, it has one story of arches on piers and two of rectangular fields with windows divided by pilasters. A vast pitched roof dotted with dormers surmounts the building. In its simplicity, clarity, and grandeur of form it belongs to the group of German buildings that initiated the style of the 17th century.

BIBLIOGRAPHY. K. Bauch, *Strassburg*, Berlin, 1941.

STRASBOURG: MUSEUMS. Important public art collections in Strasbourg, France, are located in the museums listed below.

Fine Arts Museum. The elegant 18th-century Château de Rohan houses a collection of paintings from Italy (Cima da Conegliano, Correggio, Veronese, and Tiepolo), Spain (El Greco, Zurbarán, and Goya), the Low Countries (Memling, Lucas van Leyden, Maerten van Heemskerck, Rubens, and Van Dyck), and France (Simon Marmion, Valentin, Vouet, Watteau, and Chardin), as well as a comprehensive selection of the work of painters active in Paris in the late 19th and the 20th century. The Château also contains the Museum of Decorative Arts, which is notable for ceramics produced at the Hannong factory (1721–82).

BIBLIOGRAPHY. Strasbourg, Musée des Beaux-Arts, *Catalogue des peintures anciennes*, Strasbourg, 1938.

Strapwork. Ornamental motif found in the Louis XIV style.

Notre-Dame Museum (Musée de l'Oeuvre Notre-Dame).
The nucleus of the collection consists of sculptures removed from the Cathedral for preservation, including the famous personifications of the Church and the Synagogue. Other important sculptures are by Nikolaus Gerhard from Leyden and his school. Stained glass includes the head of Christ from Wissembourg (ca. 1070), one of the earliest specimens of stained glass in western Europe, and work by the 15th-century master Peter Hemmel of Andlau. There are paintings by Witz, Schongauer, Grünewald, Baldung-Grien, and the Strasbourg still-life painter Sebastian Stosskopf and interesting displays of Alsatian minor arts and folk art.

BIBLIOGRAPHY. V. Beyer, *Catalogue de la sculpture médiévale du musée de l'oeuvre Notre-Dame à Strasbourg*, Strasbourg, 1956.

STRATFORD-UPON-AVON. Town in Warwickshire, England; Shakespeare's birthplace. The streets retain their 17th- and 18th-century appearance. Shakespeare Memorial Center (20th cent.) consists of a theater, library, and picture gallery. Other buildings are Shakespeare's childhood home; King Edward VI's Grammar School; Holy Trinity Church, begun in the 13th century; and the Guildhall, founded in 1269 and rebuilt in the 15th century.

STRATONICE MASTER. Italian painter (fl. 15th cent.). This master is named for two charming *cassone* paintings (San Marino, Calif., Huntington Library and Art Gallery) illustrating the story of Stratonice. Earlier attributed to Matteo Giovanni, they are now considered to be by an unknown artist influenced by Francesco di Giorgio.

STRAUB, JOHANN BAPTIST. German sculptor (b. Wiesensteig, 1704; d. Munich, 1784). Trained by his father, Straub then studied with Gabriel Luidl in Munich (1722–26). Straub assisted Christoph Mader at the Karlskirche in Vienna (1728–34). Straub was appointed court sculptor at Munich in 1736, and established and operated for the remainder of his life a large workshop where many important younger sculptors, including Ignaz Günther, were trained. Between 1751 and 1753 Straub was in charge of the sculptural decorations for the Residenz Theater. Some of his more important altarpieces and figures were designed for churches in Diessen (ca. 1739), Berg am Laim (1745), Schäftlarn (1755–64), Ettal (1757–65), Altomünster (ca. 1760), and Polling (1771–74). His figures became progressively attenuated as they were adapted to the decorative schemes of German rococo architecture.

BIBLIOGRAPHY. C. Giedion-Welcker, *Bayrische Rokokoplastik: J. B. Straub und seine Stellung in Landschaft und Zeit*, Munich, 1922.

STRAWBERRY HILL. English Gothic-revival home of Horace Walpole, who bought it in 1747, and by 1749 was converting the cottage into a castellated residence. His Committee of Taste comprised John Chute, Thomas Pitt, Richard Bentley, and James Essex, all in an advisory capacity on Gothic matters. The house was influential in the Gothic revival of that time. Rooms were added in 1753–54, the Holbein Chamber with the Little Cloister in 1759, the round tower from 1761, the Long Gallery wing and tribune from 1763, the great bedchamber from 1772, and the Beauchamp turret from 1776.

Walpole's attitude to the Gothic is succinctly summed up by the virtual accumulation of the exterior effects: no cohesion of pattern and therefore the possibility of addition and subtraction without altering the composition. Walpole speaks of the "Chinese want of symmetry," and the way the house felicitously rambles about is essentially a rococo approach, in distinction from the archaeological seriousness of the later generations. The main rooms of the interior are the staircase hall, mostly Bentley's design; the library by Chute with bookcases based upon parts of the screen in Old St. Paul's; the Holbein Chamber by Bentley with borrowings from the choir gates at Rouen and the Wareham tomb at Canterbury; the gallery by Thomas Pitt with borrowings from St. Albans Cathedral and Westminster Abbey; the great bedchamber with a chimney based on the Westminster Dudley tomb; the Beauclerk room, partly by Robert Adam with details from the Westminster Confessor's tomb and Old St. Paul's; and the tribune, mostly by Chute. It is a colossal borrowing job, and even when compared with James Essex's own works, can be seen as a highly idiosyncratic creation.

The grounds have been much altered, and elements such as the rustic cottage, the sham bridge, and the shell seat have gone. The Chapel in the Wood, which was intended to house Walpole's stained glass and a 13th-century shrine from Rome, remains. The art collection was sold in 1842. In the 1860s, when the house belonged to the Waldegrave family, a ballroom was added in the Neo-Gothic style. Strawberry Hill is now St. Mary's Catholic Training College. See WALPOLE, HORACE.

BIBLIOGRAPHY. H. Walpole, *Strawberry Hill Accounts*, with notes... by P. Toynbee, Oxford, 1927; W. S. Lewis, "The Genesis of Strawberry Hill," *New York, Metropolitan Museum of Art, Metropolitan Museum Studies*, vol. 5, pt. 1, 1934; N. Pevsner, *Middlesex*, Harmondsworth, 1951.

JOHN HARRIS

STREEK, JURRIAEN VAN. Dutch painter of portraits and still life (b. Amsterdam, ca. 1632; d. there, 1687). In 1655 Streek was married in Amsterdam, and he was recorded in that city on several other occasions. His still-life paintings are in the manner of Willem Kalf. Streek's son Hendrik was also a painter.

BIBLIOGRAPHY. I. Bergström, *Dutch Still-Life Painting in the Seventeenth Century*, New York, 1956.

STREET, GEORGE EDMUND. English architect (1824–81). An advocate of the High Victorian Gothic in England, he followed the path of Ecclesiologist philosophy and practice. His detail is correct and could be termed "Brutalist" in its forthrightness. His best-known work is the Law Courts, a prominent London group, designed in 1866. He is important not only as an architect but as an archaeologist and teacher. He was the master of Richard Shaw, Philip Webb, and William Morris, and in this sense can be regarded as one of the sources of the modern movement. He stands, with George Scott and William Butterfield, as an archinfluence of the 19th century.

BIBLIOGRAPHY. H.-R. Hitchcock, *Architecture, Nineteenth and Twentieth Centuries*, 2d ed., Baltimore, 1963.

STRICKLAND, WILLIAM. American architect and engineer (b. Philadelphia, 1788; d. Nashville, Tenn., 1854). Trained by the architect Benjamin Latrobe from 1803 to 1805, Strickland was also a scene painter in New York City early in his career. His work, reflecting the various revival styles of the day, includes the Gothic Masonic

Hall (1808–11; rebuilt 1819–20), the Second Bank of the United States (1819–24), derived from the Parthenon, and the Egyptoid Mikveh-Israel Synagogue (1822–25; destroyed 1860), all in Philadelphia. He designed the Providence Athenaeum (1836–38) and the Tennessee State Capitol (1845–55) in Nashville. Allied to his feeling for structure was a sure sense of design, graceful handling of detail, and respect for the site. His best-known pupils were Thomas U. Walter and Gideon Shryock. His lectures on architecture, given in 1824 and 1825, were perhaps the first in the United States.

BIBLIOGRAPHY. A. E. A. Gilchrist, *William Strickland, Architect and Engineer*, Philadelphia, 1950.

STRIEP, CHRISTIAEN JANSZ. Dutch still-life painter (b. 's Hertogenbosch, 1634; d. Amsterdam, 1673). In 1655 Striep was married in Amsterdam. He was also recorded as a citizen of that city in the following year. He painted still-life subjects in the manner of Otto Marcellis van Schrieck and Willem Kalf.

BIBLIOGRAPHY. A. P. A. Vorenkamp. *Bijdrage tot de geschiedenis van het Hollandsch stilleven in de zeventiende eeuw*, Leyden, 1934.

STRIGEL, BERNHARD. German painter (b. Memmingen, 1460/61; d. there, 1528). Coming from an old Swabian family of painters, Strigel studied with Bartholomäus Zeitblom in Ulm. He painted large altarpieces in the tradition of his teacher, although he is better known for his fine portraits. Strigel was preferred as portrait painter by Emperor Maximilian, and his works include the *Portrait of Emperor Maximilian* (1507; copies in Strasbourg, Fine Arts Museum, and elsewhere). Strigel attempted to combine in his style the late Gothic elements of his teacher with the new Renaissance style emanating from Dürer. His major works are the *Holy Family* from St. Stephen's at Mindelheim (ca. 1505; Nürnberg, Germanic National Museum), *Portrait of the Imperial Family* (ca. 1515; Vienna, Museum of Art History), and *Portrait of Konrad Rehlinger* (1515; Munich, Old Pinacothek).

BIBLIOGRAPHY. A. Schädler, "Bernard Strigels Devotionsdiptychon in der Alten Pinakothek," *Münchener Jahrbuch der bildenden Kunst*, vol. 5, 1954.

STRIGIL. Ornament resembling the instrument used to scrape the skin after athletic activities in ancient Greece and Rome. It appears especially in Roman work as a channeled bar with a slight curve. When grouped together, strigils resemble S-shaped flutes.

STRINGCOURSE, see COURSE, BELT.

STROBL, ALAJOS. Hungarian sculptor (b. Királylehota, 1856; d. Budapest, 1926). He studied with Zumbusch in Vienna. Achieving great success after 1882, he created many powerfully modeled monuments in Budapest, as well as lively, realistic portraits.

STROBL, ZSIGMOND DE KISFALUDI, see KISFALUDI-STROBL, ZSIGMOND.

STROGANOV MASTERS. The term "Stroganov Masters" was the invention of ill-informed 19th-century enthusiasts of Russian art who assumed that those artists who painted for the exceedingly wealthy and powerful 16th-century Stroganov family were either local masters in the Stroganov-dominated towns of Siberia or actually members of the Stroganov family. While the family did have two enthusiastic patrons (the cousins may have been amateur artists as well) in Maxim Yakovlevich (ca. 1550–1623) and Nikita Gregorievich (ca. 1550–1619), the inscriptions on works of art state that they were executed for and not by the Stroganovs. Most of the artists who worked for the family migrated from either Moscow or Novgorod, and therefore the style tends to be a blend of the Novgorod and Moscow schools. However, the icons and precious objects made for the wealthy patrons tended to be smaller, more portable, and generally very richly ornamented, in accordance with the lavish commissions.

BIBLIOGRAPHY. G. H. Hamilton, *Art and Architecture of Russia*, Baltimore, 1954.

STROZZI, BERNARDO (Il Cappuccino; Prete Genovese). Italian painter (b. Genoa, 1581; d. Venice, 1644). He studied with Pietro Sorri (1595–97), entered the Capuchin order (1597–1610), and in 1630 moved to Venice, where he spent the rest of his life. His art, before Venice, reflects the numerous styles to be found in Genoa at the time: those of Cigoli, Barocci, and Luca Cambiaso; Dutch and Flemish realism; Cerano and Procaccini; Caravaggism; and Rubens. Strozzi's painterliness, already apparent in such late Genoese works as *St. Cecilia* (Genoa, Palazzo Bianco), became the keystone of his style in Venice, of which the *Annunciation* (Budapest, Museum of Fine Arts) and *St. Sebastian* (Venice, S. Benedetto) are examples. Strozzi, Liss, and Feti form the triumvirate that revitalized Venetian painting of the 17th century.

BIBLIOGRAPHY. A. M. Matteucci, "L'attività veneziana di Bernardo Strozzi," *Arte Veneta*, IX, 1955; L. Mortari, "Su Bernardo Strozzi," *Bollettino d'Arte*, XL, 1955; Venice, Mostra della pittura del seicento a Venezia, 1959, *La pittura del seicento a Venezia* (catalog), 1959.

STROZZI, ZANOBI. Italian painter (b. Florence, 1412; d. there, 1468). He is noted primarily as a student and close follower of Fra Angelico. Strozzi's style is generally derivative of his master's, with emphasis on the traditional rather than the innovating aspects of Fra Angelico's style. The *Annunciation* (Madrid, Prado) and the *SS. Cosmas and Damian* predella (Florence, S. Marco Museum) are representative of Strozzi's derivative style.

BIBLIOGRAPHY. R. van Marle, *The Development of the Italian Schools of Painting*, vol. 10, The Hague, 1928; J. Pope-Hennessy, *Fra Angelico*, London, 1952.

STROZZI PALACE, FLORENCE. Italian palace, begun in 1489 by Benedetto da Maiano for Filippo Strozzi and continued by Il Cronaca, to whom the interior courtyard is attributed. The work was not completed until 1533.

The three-story rusticated astylar façade, capped by an oversized cornice, is given a particular elegance by the smooth and supple moldings that separate the window and door openings from the rough-textured stonework. The interior court provides on the ground level an open arcade carried on round columns. The capitals and *doseret* blocks

Bernardo Strozzi, *Lute Player*, from this painter's Venetian period. Museum of Art History, Vienna.

Strut. Structural member designed to resist pressure.

of the columns are combined in a typical Florentine ensemble of the early Renaissance.

BIBLIOGRAPHY. C. M. von Stegmann and H. A. Geymüller, *Die Architektur der Renaissance in Toscana*, vol 4, Munich, 1890–1906; A. Venturi, *Storia dell'arte italiana*, vol. 8, pt. 1, Milan, 1923.

STRUT. Structural element in compression, shortening under stress. Struts are usually of smaller dimension than columns or posts.

STUART, GILBERT. American portrait painter (b. North Kingston, R.I., 1755; d. Boston, 1828). Stuart spent his youth in Newport, R.I., where about 1769 or 1770 he met Cosmo Alexander, his first teacher. Impressed with the young painter, Alexander took him to Scotland in 1772, but Alexander's death a short time later left Stuart stranded in Edinburgh. He returned home in 1773 but departed again two years later, this time for London, where he tried to work on his own (*Dr. Benjamin Waterhouse*, 1776; Newport, Redwood Library). Unsuccessful, in 1777 he entered the studio of Benjamin West, with whom he worked until 1782. During this time he exhibited at the Royal Academy (1779, 1781, and 1782). For the next ten years he was a portrait painter in London (1782–87) and Dublin (1787–92). Among his best works of this period is *The Skater* (1782; Washington, D.C., National Gallery). In 1792 Stuart returned to America, practicing first in New York City (1793–94) and then in Philadelphia (1794–1803), Washington (1803–05), and Bordentown, N.J. (1805), before settling permanently in Boston in 1805.

Stuart's fame is largely associated with the three portraits of George Washington which he executed from life and the many replicas of these that he painted for years thereafter. The first of these, the *Vaughan Portrait* of 1795 (Washington, D.C., National Gallery), is perhaps the finest, for its sharp characterization and clear coloring are most representative of Stuart's quiet, almost remote manner. In 1796 he painted both the *Lansdowne Portrait* (Philadelphia, Pennsylvania Academy of Fine Arts), a full-length portrait commissioned by William Bingham for the marquess of Lansdowne, and the *Athenaeum Portrait* (Boston, Museum of Fine Arts, on loan from the Boston Athenaeum), the most famous of the three portrayals of Washington.

Despite Stuart's connection with the Washington portraits, he is at his best in other works, such as *Mrs. Richard Yates* (1793; Washington, D.C., National Gallery). Here the analytical portrait with its crisp clear lines, detached atmosphere, and emphasis on facial structure is characteristic of Stuart at his finest. Most of his later work is of this type, with relatively little attention to background, though occasionally he shows more of the surroundings, as in the portraits of *Josef de Jaudenes* and his wife, the former *Mathilda Stoughton* (ca. 1794; New York, Metropolitan Museum). Even here, clarity and detachment are Stuart hallmarks.

Gilbert Stuart, *Mrs. Richard Yates*, 1793. National Gallery, Washington, D.C. A characteristic analytical portrait.

George Stubbs, *A Gray Hack with a White Greyhound and Groom*. Tate Gallery, London. Typical work by a distinguished painter of animals.

Famous for his portraits of Washington, Stuart was a consummate portraitist whose neoclassical emphasis on crisp outlines, clear, even light, and the structure of his sitters' faces set a standard for the new United States.

BIBLIOGRAPHY. W. T. Whitley, *Gilbert Stuart*, Cambridge, Mass., 1932; J. T. Flexner, *Gilbert Stuart: A Great Life in Brief*, New York, 1955; C. M. Mount, *Gilbert Stuart: A Biography*, New York, 1964.

DAMIE STILLMAN

STUART, JAMES. English architect (1713–88). He was famous as coauthor with Nicholas Revett of the *Antiquities of Athens* (1762, 1789, 1795), the first accurate survey of Athenian buildings and an important factor in the fashionable "Greco-gusto." His small architectural practice centered on garden buildings, as at Shugborough (1764–70), and interior decoration.

STUBBINS, HUGH, JR. American architect (1912–). Born in Birmingham, Ala., he studied architecture at the Georgia Institute of Technology (B.S. 1933) and Harvard (M.Arch. 1935), where he became an instructor under Gropius (1939). Among the major works to come from his busy office in Lexington, Mass., is the Congress Hall for the Interbau exhibit in Berlin (1957), with a hung-roof solution similar to Matthew Nowicki's Livestock Arena at Raleigh, N.C.

BIBLIOGRAPHY. I. R. M. McCallum, *Architecture USA*, New York, 1959.

STUBBS, GEORGE. English painter (b. Liverpool, 1724; d. London, 1806). Stubbs received little formal training as a painter. During the 1740s he painted portraits, first at Leeds and then at York, but he was not destined to follow the normal pattern of development for a portrait painter. He was passionately interested in anatomy and pursued this study with intensity. By 1746 he was sufficiently advanced to be giving lectures on anatomy to the students at York Hospital. In 1754 he made a brief visit to Italy, but the contact with Renaissance and ancient art seems only to have convinced him that nature is always superior to art.

After his return to England, Stubbs remained in Liverpool until 1756. He then moved to Lincolnshire and began work on his magnum opus, *The Anatomy of the Horse* (1766). This book gained for Stubbs an international reputation, and it has since remained a fundamental work in its field. The research and writing, the preparation of the drawings, and the engraving of the plates were all done by Stubbs himself. From then on, his reputation as a painter of animals, particularly of horses, was firmly established, and he enjoyed the support of distinguished and powerful patrons.

In the early 1770s, however, Stubbs gave more emphasis to subject pictures (especially those in which animals might be legitimately introduced). He also painted small full-length portraits of the conversation-piece variety, although

here again he nearly always showed the figures in conjunction with animals. He waited until 1780 to be elected an associate of the Royal Academy of Arts; his election as full academician in the following year was never brought to completion because Stubbs refused to deposit the required diploma picture with the Academy.

Stubbs's scientific interests led him into some experimental techniques, particularly painting in enamels on porcelain. In this venture he was assisted by Josiah Wedgwood, who went to great pains to create the thin plaques that Stubbs required.

BIBLIOGRAPHY. W. S. Sparrow, *Stubbs and Ben Marshall*, London, 1929; E. K. Waterhouse, *Painting in Britain, 1530–1790*, Baltimore, 1953; B. Taylor, *Animal Painting in England*, Harmondsworth, 1955. ROBERT R. WARK

STUBE. Living room in colonial houses in the United States, particularly 18th-century Pennsylvania Dutch dwellings.

STUBER, NIKOLAUS GOTTFRIED. German painter (b. Munich, 1688; d. there, 1749). Trained by his father, Kaspar Gottfried Stuber, he continued his studies in Rome (1712–23). As court painter in Munich from 1723, Stuber became one of the leading architectural decorators of his day in Bavaria, executing altarpieces and murals for a number of churches, designing decorations for the Nymphenburg and Residenz in Munich, the Schloss Schleissheim, the Schloss Augustusburg in Brühl, and other palaces, and creating décors for theatrical productions and other displays.

STUCCO (opus albarium). Fine-grained hard plaster made of gypsum blended with pulverized marble. In architecture it is used as a coating to cover walls; it can take a marble-like polish. Stucco has been employed in interior decoration and relief sculpture since Roman times. It was the *opus albarium* of the Romans, who applied it as a finish to concrete surfaces. They shaped moldings to divide an area into geometric sections that enclosed figures, spirals, or other motifs. The Romans worked in wet stucco, freehand or with stamps (especially the moldings).

During the Renaissance in Italy and France, stucco was popular as a ground for modeling and fresco painting. In the 17th and 18th centuries it was particularly common in interior decoration. It was also used on exterior walls in London by the Adam brothers, John Nash, and Decimus Burton.

STUCK, FRANZ VON. German painter, graphic artist, sculptor, and architect (b. Tettenweis, 1863; d. Tetschen, 1928). Stuck studied at the school of Applied Art (1882–84) in Munich with a view to becoming a drawing teacher. In 1885 he transferred to the Munich Academy, where he studied for a short time under Lindenschmit. During his formative years he was strongly influenced by Diez, Böcklin, and Lenbach. In 1893 Stuck participated in the founding of the Munich Secession, and two years later he succeeded his former teacher as professor at the Academy. His public career culminated in 1906, when he was ennobled.

Stucco. Decoration by Giacomo Serpotta in the Oratory of S. Lorenzo, Palermo.

As a painter Stuck is best known for his many allegorical and symbolic paintings which, like Böcklin's, feature monumental yet sensuous nudes (*The Sphinx*, 1895; Munich, Bavarian State Picture Galleries; and the *Procession of the Bacchants*, 1897; Bremen, Art Gallery) and fine portraits (*Self-Portrait with Wife and Daughter*, 1909; Brussels, Museum of Modern Art). His major works as a draftsman include the popular series *Die 12 Monate* (1887) and many illustrations for the magazines *Jugend* and *Fliegende Blätter*. His major architectural work is his villa in Munich.

BIBLIOGRAPHY. H. Vollmer, *Franz von Stuck*, Berlin, 1902; O. J. Bierbaum, *Stuck*, 3d ed., Bielefeld, 1908; G. Nicodemi, *Franz von Stuck*, Bergamo, 1936. JULIA M. EHRESMANN

STUDIO, *see* LINT, HENDRIK FRANS VAN.

STUEMPFIG, WALTER. American painter (1914–). Born in Germantown, Pa., he studied at the Pennsylvania Academy of Fine Arts in Philadelphia. Although the fine detail with which Stuempfig paints his genre figures and urban landscapes is more usually associated with magic realism, the loneliness and bleak isolation of the scenes appear closer to the sad moods of the neoromantics, by whom he was influenced. Their effect on his work can be seen in the near-surreal atmosphere of *Cape May* (1943; New York, Museum of Modern Art) and the empty beach scene called *Thunderstorm II* (1948; New York, Metropolitan Museum).

Gherardo Starnina, *The Thebaid*. Tempera on panel. Uffizi, Florence. A work that has been attributed to this painter.

STATIONS OF THE CROSS. Series of representations of episodes of Christ's last hours erected as devotional images in a cloister church or along a road to a cemetery. The idea was devised in the late Middle Ages under the influence of the Via Crucis, which was set up for the pilgrims in Jerusalem. In the Middle Ages seven stations were the usual number, but subject matter was not standardized. The most frequent combination was (1) Christ before Pilate, (2) St. Veronica wiping the face of Christ, (3) Carrying of the Cross, (4) Nailing to the Cross, (5) Crucifixion, (6) Descent, and (7) Entombment. Another grouping uses three falls of Christ at the second, fourth, and sixth stations. By the 17th and 18th centuries the number of stations had risen to fourteen. Stations of the Cross are most frequently executed in relief sculpture.

BIBLIOGRAPHY. P. W. Keppler, *Die XIV Stationen des heiligen Kreuzwegs...*, 4th ed., Freiburg im Breisgau, 1904.

STATTMULLER, PATER BEDA. German painter and musician (b. Ottobeuren, 1699; d. Weingarten, 1770). A monk at the Benedictine monastery of Weingarten, Stattmüller is known for his drawing of an ideal plan for the monastery (1723), after a plan by the architect Frisoni. This added to the already existing palace-church complex by Moosbrugger a lower perimeter wall of rococo configuration that was never executed.

STAURIS, RINALDO DE'. Italian sculptor (fl. 1461–90). Stauris worked in his native Cremona and at the Certosa of Pavia (1464–80). Among his works are terra-cotta decorations for the arcade of the small cloister at the Certosa, done in collaboration with Amadeo.

STAVANGER CATHEDRAL. Romanesque church in Norway, started about 1123. The nave and the west front were completed about 1150, and the sanctuary was finished about 1303.

The Ronanesque style of the Cathedral basically reflects the Anglo-Norman style of such English cathedrals as Norwich, Ely, and Durham. The Anglo-Norman style was brought to Norway by English churchmen and missionaries in the 10th century, but prior to about 1100 most Norwegian church construction continued in the indigenous timber tradition. In contrast to the sharp verticality of the traditional Norwegian stave churches (as in Borgund), Stavanger Cathedral is basically horizontal in appearance despite its two east towers. It is a large, wide-aisled, low basilica, with a wide west porch and two flanking east towers. The stone walls are thick, with small windows and low, steeply pitched roofs. There is no transept. Certain features are traceable to Cluniac and German influences, which arrived in Norway by way of Denmark (Cluny and German Hirsau influence) and Sweden (Rhineland influence). The wide, low west porch speaks of Cluny and Hirsau, while the east towers flanking the Cathedral suggest the German Rhineland.

The decorative architectural detail is much in the nature

of a provincial variation, imbued with the vigorous Nordic geometric quality, of the more sophisticated Continental Romanesque forms. This stylistic quality is equally apparent in the crude figural sculpture, always kept to a minimum and not infringing upon the massive, simple, and impressive bulk of the church. Hence, the Cathedral well exemplifies the changeover from an indigenous timbered architecture to the new, not fully mastered forms of Romanesque stonework. In this respect it differs from Uppsala Cathedral in Sweden, where there is evidence of work by traveling companies of masons from Lombardy and the Rhineland.

BIBLIOGRAPHY. *Norwegian Architecture throughout the Ages*, comp. E. Alnaes et al., Oslo, 1950.

<div style="text-align:right">STANLEY FERBER</div>

STAVE CHURCH. Type of wooden church built with upright planks (or staves) during the early Middle Ages in Norway. It has a very steep pointed roof and gables, often with dragon heads decorating the peaks. The upper part of the second story is usually broken by blind arcades. The plan is similar to that of a basilica without transept. The earliest stave church, built at Garmo, dates from the 11th century.

BIBLIOGRAPHY. A. R. Bugge, *Norwegian Stave Churches*, Oslo, 1953(?).

STAVELOT, *see* MOSAN ART.

STAVEREN, JOHAN (Jan) ADRIAAENSZ. VAN. Dutch painter of genre, landscape, and portraits (b. Leyden, before 1620; d. there, after 1668 [1669?]). He was a follower, and perhaps a pupil, of Gerrit Dou. In 1645 Van Staveren was recorded as a member of the Leyden painters' guild; however, a painting entitled *A Hermit* (Leyden, Stedelijk Museum "De Lakenhal") is signed and dated 1637. He was also a burgomaster of Leyden.

BIBLIOGRAPHY. S. J. Gudlaugsson, "Jacob van Staver(d)en," *Oud-Holland*, LXXI, 1956 and LXXII, 1957.

STEATITE. Very soft stone—red, gray, or green in color—used as a material for small-scale sculpture and sometimes for vessels. Steatite was especially popular in Chi-

Stavanger Cathedral. Norwegian Romanesque church reflecting the Anglo-Norman style.

Stave church. The 12th-century church at Gol, Hallingdal, Norway.

nese, Cretan-Mycenaean, and Byzantine art. Byzantine artists used it as a substitute for ivory, as, for example, in the Monstrance of Pulcheria (11th cent.; Mt. Athos).

STEDELIJK MUSEUM, AMSTERDAM, *see* AMSTERDAM: MUSEUMS (MUNICIPAL MUSEUM).

STEEL CONSTRUCTION, *see* CONSTRUCTION, STEEL.

STEEN, JAN HAVICKSZ. Dutch painter of genre, history, landscape, and portraits (b. Leyden, 1625/26; d. there, 1679). Steen was a pupil of Nicolaas Knüpfer at Utrecht, then of Adriaen van Ostade at Haarlem, and last, of Jan van Goijen at The Hague. He married Van Goijen's daughter in 1649. Stylistic relationships between the early works of Steen and the circle of Van Ostade are to be found in Steen's *Winter Landscape* (Skokloster, Baron Rutger von Essen Collection), which must date in the late 1640s, or, in any case, before 1651. The picture, however, shows greater affinities with the work of Isaak van Ostade, the younger brother and pupil of Adriaen. Steen painted a portrait of Isaak (now lost). Some stylistic confirmation of a relationship between Knüpfer and Steen is to be found in the 1667 *Marriage of Tobias* (Brunswick, Herzog-Anton-Ulrich Museum, Picture Gallery) and Knüpfer's 1654 rendering of the same subject (Utrecht, Centraal Museum).

In 1646 Steen was registered at Leyden University, and from 1649 to 1654 he was living at The Hague. He was in Delft for a time in 1654, and his father, a brewer, leased a brewery for him in that town. His artistic activity in Delft is represented by a 1655 painting, the so-called *Delft Burgomaster* (London, Lady Janet Douglas-Pennant Collection). From 1656 to 1660 Steen was living in Warmond; in 1661 he entered the guild in Haarlem, but he does not seem to have spent much time there. In 1670 he inherited a house in Leyden, where he apparently remained until his death. In 1672 he received permission

STUGA. Large room, comparable to the living room of a Swedish house, adopted in colonial houses by 17th-century Swedish settlers on the Delaware River in the United States. The *stuga* was the largest of three rooms, the others being the *förstuga*, or entry, and the *kammara*, or bedroom.

STUMP. Pencil-like roll of paper pointed at both ends, used to rub charcoal and chalk drawings to produce a soft transition of tone.

STUPA. Buddhist or, less frequently, Jain memorial monument deriving from prehistoric funeral monuments in India. The name comes from the Sanskrit word for "mound." The stūpa contains a small, inaccessible room made of stone or brick to house a holy relic (a bone, say, of Buddha or of one of his early followers). The mound is in the shape of a hemispherical calotte covered with plaster or stone slabs and is topped by an inaccessible cubic altar and by a ritual parasol symbolizing the sovereignty of Buddha. The lower part of the monument consists of a low terrace which may be reached by steps onto a gallery for *pradakṣiṇā* (circumambulation). The stūpa is surrounded by a stone "hedge" built in imitation of timber construction. This hedge or railing is pierced by four gates called toraṇas, which typically have a triple architrave. *See* TO-RANA.

The stūpa is not a place of worship but a commemoration of a holy dwelling or visitation (that is, of the Buddha). An example is the Great Stūpa at Sānchī. The architectural form appears in miniature at the apsidal end of Buddhist chaitya halls and is often employed to represent the Buddha in aniconic (that is, early) Buddhist reliefs (for example, Amarāvatī). *See* AMARAVATI; SANCHI.

JANET S. R. HILL

STURCK (Sturckenburg), ABRAHAM JANSZ., *see* STORCK, ABRAHAM JANSZ.

STUTTGART: MUSEUMS. Important public art collections in Stuttgart, Germany, are located in the museums listed below.

Sonnenhalde Artists House. The private collection of Hugo Borst, open to the public in a newly rebuilt gallery (the original one was destroyed in World War II). The collection consists of paintings and sculptures, especially from the first third of the 20th century, with works of the Stuttgart Secession (by Bernhard Pankok, for example), of the Stuttgart Hölzel School (including some by Willi Baumeister), and of German expressionism in general (by Hofer, Kirchner, Nolde, Pechstein, and others). Among the sculptures, works by Kolbe and Lehmbruck deserve special mention.

BIBLIOGRAPHY. H. Jedding, *Keysers Führer durch Museen und Sammlungen*, Heidelberg, Munich, 1961.

State Gallery. Museum founded in 1843 and still housed in its original building (additions in 1881–88). The emphasis of the collection is on painting. Among the German artists, anonymous Swabian painters of the 14th century are well represented, as are painters of the 16th century (including Burgkmair and Cranach), of classicism and romanticism (for example, Blechen, C. D. Friedrich, and

Schwind), of the 19th century (Böcklin, Feuerbach, Thoma, and others), and of the 20th century, especially of expressionism (such as Beckmann, Corinth, Feininger, Kirchner, and Nolde). French painters, mainly of the 19th and 20th century (Braque, Cézanne, Chagall, Gauguin, Monet, Renoir, Rouault, and others), and Italian artists, especially Venetian masters of the 15th to the 18th century (Bellini, Carpaccio, Titian, Tintoretto, Canaletto, and Tiepolo, among others), are also represented. Paintings from Holland and Flanders (by Memling, Hals, Rembrandt, Van Dyck, Rubens, and others) and some English works (by Raeburn and Reynolds, for example), as well as drawings and works of graphic arts of the 15th to the 20th century, round out the collection. In comparison, the collection of 19th- and 20th-century sculpture is of lesser importance.

BIBLIOGRAPHY. H. Jedding, *Keysers Führer durch Museen und Sammlungen*, Heidelberg, Munich, 1961.

LOTTE PULVERMACHER-EGERS

Wurttemberg Landesmuseum. Collection founded in 1862 and housed in the Old Castle, which once (beginning in 1482) was the residence of the rulers of Württemberg. The building was considerably enlarged in the 16th century. The museum is dedicated to the art and civilization of the region, from prehistory and early history (Roman times) to the 18th century. The painting collection consists mainly of 15th- and 16th-century altarpieces. The col-

Stūpa. Miniature stūpa in a chaitya hall at Karli, India.

lection of sculpture starts with architectural fragments from Carolingian and Romanesque times and includes reliefs and round sculptures from the 15th and 16th centuries (by Jörg Syrlin the Younger and Tilman Riemenschneider, among others) as well as charming rococo groups by J. A. Feuchtmayr (*Annunciation*) and Ignaz Günther (*Guardian Angels*). These collections combine with the many works of applied arts—furniture (especially hope chests), stained glass with religious scenes and coats of arms, textiles (mainly 16th cent.), and religious and secular metalwork in bronze, copper, silver, and gold—to make this one of the outstanding museums in southwestern Germany.

BIBLIOGRAPHY. H. Jedding, *Keysers Führer durch Museen und Sammlungen*, Heidelberg, Munich, 1961.

LOTTE PULVERMACHER-EGERS

STUTTGART: RAILROAD STATION. German train station (1911–28) by Paul Bonatz, who was responsible for the design, and F. E. Scholer. It was an important step in the direction of the unadorned, cubic architecture that came to dominate Europe after World War I. The bulky façade of rough-surfaced stone features an arch, set into the central entrance block, and a tower toward the right, both persistently used symbols in the design of passenger stations at the time. The plan is in the shape of a U, as in many European stations. The train sheds are built of wood and iron.

BIBLIOGRAPHY. C. L. V. Meeks, *The Railroad Station, an Architectural History*, New Haven, 1956.

STYLE. Configuration of artistic elements that together constitute a manner of expression peculiar to a certain epoch, people, or individual. The manner developed during a particular period or within a culture, considered standard for that time or culture, constitutes its specific artistic character or style. For example, the difference in relative dimensions and ways of interpreting space distinguishes the Romanesque period from the Gothic. When the term is applied to a people, as to the Italians, it may also be called a school of art. The individual characteristics and idiosyncrasies of an artist's work make up his personal style. It may be a particular treatment of details, composition, or handling of materials that remains a constant in his expression and indicates his individual manner of working, as the style of Raphael.

See also SCHOOL OF ART.

STYLE FLAMBOYANT, *see* FLAMBOYANT STYLE.

STYLE MECANIQUE, LE. Style of the 1920s and 1930s deriving from angular, machinelike forms employed in painting and sculpture of the time and applied to architecture and interior décor. Called by Ozenfant "the style of the typewriter," it took on a debased character as *le style jazz* in industrial design, where triangles, half circles, and zigzags were used in a superficial manner.

STYLE POMPADOUR, *see* ROCOCO ART.

STYLOBATE. Uppermost step of the stereobate, or platform supporting columns in classical architecture. The term "stylobate" is sometimes used to designate all three steps of the base of some temples, as that of the Parthenon in Athens, although *crepidoma* is more appropriate.

Stylobate. In classical architecture, the uppermost step of a platform on which columns rest.

SUARDI, BARTOLOMMEO, *see* BRAMANTINO.

SUAVIUS, *see* ZUTMAN, LAMBERT.

SUBFLOOR. Wood floor that is laid over floor joists and on which a finish floor is applied.

SUBLEYRAS, PIERRE. French religious, history, and portrait painter, active in Rome (b. St-Gilles, 1699; d. Rome, 1749). He was born of a family of woodworkers and metalworkers. Following brief study with his father, he went to Toulouse and entered the shop of A. Rivalz the Younger, aiding his master, anonymously, in numerous religious and historical commissions. In 1726 he left for Paris and zealously pursued his studies at the Royal Academy. He won the Prix de Rome in 1727 for *The Serpent of Brass* (Paris, Louvre). He left Paris the following year, never to return to France; he declined to exhibit at the Paris Salon, even after his reputation had become international.

N. Vleughels, director of the French Academy in Rome, saw promise in him. In order to erase from his style any vestige of the provincialism with which Rivalz had indoctrinated him, Subleyras was made to study and copy the Roman baroque masters, an experience which henceforth set his style, technically and tonally. At the intervention of Princess Pamphili, his three-year sojourn as pensioner at the French Academy was extended another year, enabling him to establish his reputation by copying works by Nicolas Poussin and the Bolognese painters for the King and for the French ambassador, the Duc de Saint-Aignan.

Finally, in 1735, he was obliged to seek his own means of support. The demand for his work increased as he learned to vary his style according to the mood of the subject. *St. Benedict Reviving a Child* (1744; Rome, S. Francesca Romana) follows the Italian formulas of Feti

and Ricci, to which he added French religious (Jansenist) fervor. *Jerome Vaini Receiving the Order of the Saint-Esprit* (1737; Paris, Museum of the Legion of Honor), on the other hand, is closely akin to G. P. Pannini's lively festival paintings, and *Wedding at Cana* (1737; Louvre), commissioned by the Church of St. John Lateran, shows his familiarity with Paolo Veronese's style and color. In 1739 he married the miniaturist Felicia Maria, daughter of the celebrated musician Tibaldi (her portrait, Worcester Art Museum). His portraits, such as *Pope Benedict XIV* (1757; Chantilly, Condé Museum; Munich, Old Pinacothek; and others) and *Cardinal Valenti-Gonzaga* (1747; Mantua, Gallery and Museum of the Ducal Palace), are rendered in the solid Roman baroque tradition exemplified by the work of Pompeo Batoni. Subleyras's art elicits the total visual effect, but is enhanced by dramatic chiaroscuro. *The Studio of the Artist* (Vienna, Academy of Fine Arts) summarizes his art.

BIBLIOGRAPHY. L. Dimier, *Les Peintres français du XVIIIe siècle...*, vol. 2, Paris, 1930.

GEORGE V. GALLENKAMP

SUBPURLIN. Secondary member usually resting on rafters and running longitudinally on roofs.

SUBURBAN-ALTAR WARE, *see* CHIAO-T'AN.

Pierre Subleyras, *St. Benedict Reviving a Child*, 1744. S. Francesca Romana, Rome.

SUDAN. An area of the sculpture-producing region of Negro Africa comprising the former political limits of British and French Sudan (Mali) and the territory lying west of the large bend of the Niger River. Prominent among the tribes whose sculpture is outstanding are the Bambara, Dogon, Bobo, Senufo, Kurumba, and Mossi. The Baga, too, are sometimes considered part of the Sudan complex.

Secret societies and religious beliefs are sufficiently similar among most of these tribes to have produced art objects related in form, though remarkably diversified in technique. Both human figures and masks representing various animal nature deities are typical of Sudanese wood carvings.

See also AFRICA, PRIMITIVE ART OF (WEST AFRICA: MALI).

BIBLIOGRAPHY. M. Griaule, *Masques Dogons*, Paris, 1938; P. S. Wingert, *The Sculpture of Negro Africa*, New York, 1950.

SUDARIUM. Handkerchief of St. Veronica with which Christ is said to have wiped His face on His way to Calvary, miraculously leaving on it the image of His face. The sudarium has been represented by itself in art, but more frequently it is shown being held by St. Veronica.

SUDATORIUM. Very hot room in ancient Roman thermae. Used for sweating, the sudatorium was a relatively small chamber. Sudatoria adjoin the caldarium, or hot room, in the Baths of Diocletian, Rome.

SUE, *see* JAPAN: CERAMICS.

SUESS, HANS, *see* KULMBACH, HANS SUSS VON.

SUGER OF SAINT-DENIS, ABBOT, *see* SAINT-DENIS, ABBEY OF.

SU HAN-CHEN. Chinese painter of genre scenes (fl. early 12th cent.). Born in K'ai-feng, he was active at the Northern Sung court of Hui-tsung and, during its early years, at the Southern Sung Academy at Hang-chou. Su Han-chen was known mainly for his marvelous depictions of children at play, and for this reason, perhaps, he is one of the least controversial of painters, being highly praised by later artists of all schools. His most famous painting today is probably the large hanging scroll (Formosa, Sun Yat-sen Museum) representing children playing with a cricket in an outdoor garden.

BIBLIOGRAPHY. O. Sirén, *Chinese Painting, Leading Masters and Principles*, vol. 2, London, 1956.

SUI ART, *see* CHINA: ARCHITECTURE, JADE, SCULPTURE.

SUIBOKU. Japanese painting technique employing black ink on paper. It was introduced from China during the Sung and Yüan dynasties (960–1368) and continues to be used in both China and Japan today. There were originally two schools of *suiboku*: the Northern, with its powerful and precise brushwork, and the Southern, characterized by soft brushwork and hazy tones. Josetsu, Shūbun, and Motonobu were the chief masters of the first, Sōami and Tōhaku of the second. Sesshū worked mostly in the Northern style but was expert in the Southern as well. The

Japanese considered *suiboku* a far more effective vehicle for expressing spirituality than paintings executed in colors. *See* JOSETSU; MOTONOBU; SESSHU TOYO; SHUBUN; SOAMI; TOHAKU.

BIBLIOGRAPHY. R. T. Paine and A. Soper, *The Art and Architecture of Japan*, Baltimore, 1955; Y. Yashiro, *2000 Years of Japanese Art*, New York, 1958.

SUKENOBU (Nishikawa Sukenobu). Japanese Ukiyo-e print designer (1671–1751). Sukenobu first studied painting of the Kanō and Tosa schools. Later he turned to printmaking and, influenced by Moronobu, worked primarily in the field of book illustration. Only a few prints by him are known today. *See* KANO SCHOOL; MORONOBU; TOSA SCHOOL; UKIYO-E.

SUKHODAYA. City of northern Thailand. From the 13th to the 15th century, when the capital was at Sukhodaya, Siamese culture found its supreme artistic definition in an admirable eclecticism that blossomed as an invention of new forms. There is an extraordinary feeling of the rational in the conclusions the Thai artists brought to the Indian influences on their art. The unique accomplishment of the Sukhodaya period is the particular transformation of the Buddha image. Though some Buddhist images came to them fixed by tradition, the Thai artists moved beyond the adopted conventions. They enlarged upon the subtle Indian Gupta style that had reached them by way of Khmer art.

Life-size seated Buddhas seem to hold the sum of Buddhist thought in a solid flow shown through a density of curvilinear form. This means that often an arm, a limb, or a torso flows in the larger-than-life gilded bronzes as if it were a tangible brushstroke, a flow of water, or the true body of a serpent. Broad shoulders and full chests characterize these figures. The sharp facial features are both Thai characteristics and signs of a type of breath yoga, which is also shown in the downward-pressing roundness of the abdomen.

The mark of the Thai style is a mixture of elements. In the walking Buddha, which is a Thai invention, we find long, almost boneless arms, lines suggesting both water and flame, smoothness of torso, and garments clinging so closely as to appear to be one with the body. The long curves of the contours of these figures carry the presence of weight in the stepping posture, yet they hold a sense of the lack of substance. The lines of the figure pull upward, and the backward leaning of the tilting bronze upper torso lifts the head, where serenity is seen in clearly placed features. The face tops all the movement of the sculpture. However, all motions culminate above the face, past the twists of hair curls akin to swirling mountains, in a pointed jewellike flame projecting from the top of the head. This idea of fire, in combination with the glittering bronze, helps contribute to the concept of an emanation of light. There is an actual bouncing of light from the bronze, with reflections of the environment. These qualities also exist in the other permissible postures in which a Buddha is shown: standing and lying down.

A combination of opposites is the essential Thai quality, artistic and philosophical, fluid and flamelike, heavy yet light, with curves downward and points lifting. Sukhodaya art thus compresses and restrains an artistic energy.

BIBLIOGRAPHY. T. Bowie, ed., *The Arts of Thailand*, Bloomington, Ind., 1960; J. Brzostoski, "Art From the Ends of the Earth," *Arts*, XXXV, March, 1961.

JOHN BRZOSTOSKI

SUKIYA. Japanese architecture associated with Zen and Taoist doctrines. *Sukiya* signifies that the true reality of a room lies in the emptiness contained within the walls rather than the walls themselves. Reflecting the transience, imperfection, and incompleteness of the world, teahouses in the *sukiya* style were made of unfinished materials. Ceilings were of bamboo and roofs of thatch, and walls were the natural color of earth. Wood columns were left unpolished, or sometimes with their bark unpeeled.

SULAIMANIYE (Suleymaniye) MOSQUE, ISTANBUL. Ottoman mosque erected (1550–57) for Sultan Sulaiman I, the masterpiece of the architect Sinan. It is the largest and most conspicuous mosque in Istanbul. It is approached by a forecourt flanked by four minarets, and the main area is crowned by a great dome, with half domes along the main axis. Colored marbles line the interior walls of a structure whose general type derives in the main from Hagia Sophia.

BIBLIOGRAPHY. M. A. Charles, "Hagia Sophia and the Great Imperial Mosques," *Art Bulletin*, XII, 1930.

SUL-AK, *see* YI CHONG.

SULEYMANIYE MOSQUE, ISTANBUL, *see* SULAIMANIYE MOSQUE, ISTANBUL.

SULLIVAN, LOUIS HENRI. American architect (b. Boston, 1856; d. Chicago, 1924). Regarded as the first great modern architect, Sullivan rejected historic eclecticism in favor of an attempt to understand the social requirements of architecture in an industrial society. To that end, he sought to mirror the needs and ideals of people within a modern technological framework.

He studied at the Massachusetts Institute of Technology in 1872, and during a stay in Philadelphia in 1873 was a draftsman for Furness and Hewitt. A year later he worked for William Le Baron Jenney in Chicago and then

Louis Sullivan (with D. Adler), Auditorium Building, Chicago, 1887–89.

studied at the Ecole des Beaux-Arts in Paris. Rebelling against traditionalist instruction, he returned to Chicago in 1876, entered the office of Dankmar Adler in 1879, and became a partner in 1881, remaining until 1895. Their Borden Block (1879–80), with its narrow piers and wide bays, was an early attempt to break away from solid-wall construction. In other buildings of this period, however, Sullivan emphasized the vertical (perhaps influenced by Philadelphia commercial architecture of the 1850s) or Richardsonian elements, as in the Walker Warehouse (1888–89). The firm's reputation was considerably enhanced by the Auditorium Building (1887–89), one of the largest and most complex buildings in the country at the time, in the interior of which Sullivan's highly personal and vaguely Celtic ornamental vocabulary appeared.

The Wainwright Building in St. Louis (1890–91), the firm's first skeletal structure, represented a major attempt, which can be termed expressive functionalism, to create a special form appropriate to the skyscraper. The building was erected around a U-shaped court, and Sullivan employed a system of closely ranked piers, every other pier in front of a structural member, to give the exterior a pronounced vertical effect in order to make it the "proud and soaring thing" he thought a tall building ought to be. This effect is seen also in the Guaranty Building in Buffalo (1894–95) and the Condict Building in New York City (1897–99). On the other hand, in the Carson Pirie Scott and Company Store in Chicago (1899–1904) the structural grid is revealed and dictates the cell-like appearance of the façades. At the street level there is profuse ornamentation designed by George G. Elmslie, who was also largely responsible for much of Sullivan's putative later work, including the National Farmers' Bank in Owatonna, Minn. (1907–08).

Sullivan's never-erected Odd Fellows' Temple, designed in 1891, and perhaps the first cruciform skyscraper plan, demonstrated his concern for the skyscraper as a plastic problem. He said that the Chicago World's Columbian Exposition of 1893 set American architecture back fifty years, but he contributed the design of the Transportation Building, its only fresh and original building. Unfortunately neglected in his later years, he turned to writing and produced two books, *The Autobiography of an Idea* and *Kindergarten Chats*.

See also ADLER AND SULLIVAN.

BIBLIOGRAPHY. H. Morrison, *Louis Sullivan*, New York, 1952.
MATTHEW E. BAIGELL

SULLY, THOMAS. American painter (b. Horncastle, Lincolnshire, Eng., 1783; d. Philadelphia, 1872). He went to Charleston, S.C., in 1792 and received early painting lessons in the miniaturist tradition from relatives. In 1801 he began his career as a portrait painter in Norfolk and Richmond. He settled in Philadelphia in 1808. In 1809 he went to London for a year of study with Benjamin West, but absorbed more of Sir Thomas Lawrence's facile color and drawing and his taste for feminine prettiness. On his return to Philadelphia Sully rapidly became that city's most popular portraitist.

The artistic elegance that made Sully popular also brought him dangerously near to the superficial and to an artificial idealism. When these dangers are avoided in his female portraits, the result can be totally charming, as

Thomas Sully, *Fanny Kemble as Beatrice*, 1833, detail. Pennsylvania Academy of the Fine Arts, Philadelphia.

in *Fanny Kemble as Beatrice* (1833; Philadelphia, Pennsylvania Academy of Fine Arts). Less successful perhaps is the well-known *Queen Victoria* (1838–39; Philadelphia, Society of the Sons of St. George). At times his portraits of men reveal a surprising strength and force, for example, *Colonel Jonathan Williams* (1815; West Point, N.Y., U.S. Military Academy) or the formally gracious *Marquis de Lafayette* (1824; Philadelphia, Independence Hall).

BIBLIOGRAPHY. E. Biddle and M. Fielding, *The Life and Works of Thomas Sully*, Philadelphia, 1921; Pennsylvania Academy of Fine Arts, *Catalogue of the Memorial Exhibition of Portraits by Thomas Sully*, 2d ed., Philadelphia, 1922.

SULLY, HOTEL DE, PARIS. French mansion by Jean du Cerceau (1624–29). The Hôtel de Sully is a typical example of the Parisian town house of the time of Louis XIII. The exuberant relief decoration of the façade is noteworthy.

BIBLIOGRAPHY. G. Pillement, *Les Hôtels de Paris*, Paris, 1945.

SULTAN AHMAD (Ahmet) MOSQUE, CONSTANTINOPLE, see AHMEDIYE MOSQUE, CONSTANTINOPLE.

SULTAN BARQUQ (Barkok), MOSQUE OF, CAIRO. Mamluk four-liwan (four-porched) mosque-madrasa, built between 1388 and 1399. It has a polychrome portal with superb bronze and silver doors. A sculptured dome shelters the attached tomb of a daughter of the Circassian Mamluk sultan Barquq. The street façade's shallow relief and small-scale ornament accord with the relatively late date.

BIBLIOGRAPHY. M. S. Briggs, *Muhammadan Architecture in Egypt and Palestine*, Oxford, 1924.

SULTAN BAYAZID (Beyazit) MOSQUE, ISTANBUL. Ottoman mosque built (1501–06) for Sultan Bayazid II. It

established the type of mosque in which the main area is covered by a dome and two half domes along the main axis. Sinan employed this model in the Sulaimaniye Mosque, Istanbul. Comparatively low, the mosque is surrounded by a bath and other structures.

BIBLIOGRAPHY. B. Unsal, *Turkish Islamic Architecture*, London, 1959.

SULTANIEH. City in northwestern Iran built in the early 14th century to replace Tabriz as the capital. In 1306 Sultan Muhammad Oljeitu Khudabanda (Uljaitu Khudabanda Muhammad), Il-khanid (Mongol) ruler of Iran, ordered construction begun at Sultanieh. The site lay in an extensive plain. By 1313 most of the buildings had been completed. Among the major structures were a citadel, a hospital, a college, and numerous mosques. The courtiers financed the erection of other public buildings and of residential quarters. Dominating the new city was the mausoleum of Sultan Muhammad, erected between 1307 and 1313. After the middle of the 14th century, the capital fell into ruin, and today the damaged mausoleum rises above the drab houses of a small village. *See* SULTANIEH: TOMB OF SULTAN MUHAMMAD.

BIBLIOGRAPHY. D. N. Wilber, *The Architecture of Islamic Iran: The Il-Khānid Period*, Princeton, 1955.

SULTANIEH: TOMB OF SULTAN MUHAMMAD. Octagonal mausoleum (built 1307–13) of the Mongol sultan Muhammad Oljeitu Khudabanda (r. 1304–17) on walled Sultanieh's massive citadel. It is the finest known example of Persian Islamic architecture. The exterior is decorated with ornamental colored glazed bricks, and it is crowned by a great dome ringed by eight minarets. Faïence mosaics, polychrome tiles, and relief inscriptions covered the interior walls.

BIBLIOGRAPHY. D. N. Wilber, *The Architecture of Islamic Iran: The Il-Khānid Period*, Princeton, 1955.

SULTAN MUHAMMAD NUR, *see* ISLAMIC PAINTING (SAFAVID PERIOD).

SULTAN SELIM II MOSQUE, ADRIANOPLE. Ottoman mosque built in Adrianople (Edirne), Turkey, by the architect Sinan (1569–75). It is noteworthy architecturally because the designer took an older type of form, used in small structures, and established a single dome on circular piers within an open-square plan of imposing size.

BIBLIOGRAPHY. B. Unsal, *Turkish Islamic Architecture*, London, 1959.

SUMATRA, *see* INDONESIA.

SUMER. The name "Sumer" refers to southern Babylonia; it was first used for this part of Mesopotamia by the Semitic Akkadians who ruled over the non-Semitic Sumerians from an area directly to the north. Etymologically, it is possible that the word is derived from Nippur, the chief religious center of the Sumerians.

See also MESOPOTAMIA.

BIBLIOGRAPHY. T. Jacobsen, "The Assumed Conflict Between Sumerians and Semites in Early Mesopotamian History" (Footnote, no. 11), *Journal of the American Oriental Society*, LIX, December, 1939; I. J. Gelb, "Sumerians and Akkadians in Their Ethno-Linguistic Relationship," Geneva, VIII, 1960.

SUMERU, *see* MERU.

SUMIYOSHI SCHOOL. School of Japanese painters. It was founded by Jokei, who in 1662 broke with the Tosa school and started using the name Sumiyoshi in hopes of restoring the Sumiyoshi school of the Kamakura period. Jokei's son Gukei (1631–1705) moved to Edo, where he was appointed the first official painter of the Tokugawa shoguns to work in the Yamato-e manner of painting. The school was active as the leader of Yamato-e in Edo, but it never became a dynamic creative force. Among its leading painters were Hiromori (1705–77) and Hirotsura (1793–1863). *See* JOKEI; TOSA SCHOOL; YAMATO-E.

BIBLIOGRAPHY. T. Akiyama, *Japanese Painting* [Geneva?], 1961.

SUNDAY AFTERNOON AT LA GRANDE JATTE. Oil painting by Seurat, in the Art Institute of Chicago. *See* SEURAT, GEORGES.

SUNDAY PAINTERS. Amateur painters who paint during leisure hours. The Sunday painter was particularly common in the late 19th century; Gauguin began as one. Most of the self-taught, or unschooled, primitivistic artists of the 19th and 20th centuries (for example, Henri Rousseau, Camille Bombois), at first painted only in the spare time allowed them by their regular work.

SUNFLOWERS. Oil painting by Van Gogh, in the V. W. van Gogh Collection, on permanent loan to the Municipal Museum, Amsterdam. *See* VAN GOGH, VINCENT WILLEM.

SUNG ART, *see* CHINA: ARCHITECTURE, CALLIGRAPHY, CERAMICS, INK, JADE, LACQUER, PAINTING, PAPER, SCULPTURE, SILK.

SUNG IMPERIAL CATALOG, *see* HSUAN-HO HUA-P'U.

SUNIUM (Cape Sounion). Rocky cape on the southeast tip of the Attic peninsula in Greece. It formed part of one of the rural Athenian demes and was always under Athenian control. It has long been famous as an archaeological site, chiefly because of the prominent marble Temple of Poseidon, which in antiquity, as today, served as a landmark for mariners approaching Athens.

The earliest substantial archaeological remains at Sunium date from about 600 B.C. That it was a well-known landmark well before this date, however, is attested by Homer (*Odyssey*, III, 269).

The Temple of Poseidon stands on the very tip of the cape, within a walled precinct at the southeast corner of the fortification walls, which date primarily from 413 B.C. The Poseidon Temple dates from about 440 B.C. and has been thought to be the work of the same architect who built the Theseum in Athens. Twelve of its delicate, slender columns are still standing. The grayish-white marble employed for it came from the nearby quarries at Agrileza. Traces of an earlier temple made of limestone have been found beneath the marble temple. The earlier temple dates from 490 B.C. and is thought to have been destroyed by the Persians. Also visible are the foundations of a Doric propylaeum, leading into the precinct of Poseidon, which probably dates from the same period as the early temple. Several other small structures, including the traces of dry

docks for the Athenian ships, have been excavated within the circuit of the fortification walls.

Outside the fortification walls to the north, on a more level part of the cape, lay the sanctuary of Athena, in which the foundations of two more temples have been excavated. The earlier of these, dating from the first half of the 6th century, was a small prostyle-distyle structure made of local stone. The later and larger temple (mentioned by Vitruvius, IV, 8, 4) is unusual in that its pteron of Ionic columns runs only along its east and south sides. This temple was built, at least in part, about 470 B.C., and recent evidence suggests that it was dismantled in the Julio-Claudian period and that parts of it were built into a smaller temple in the Athenian agora.

The excavations at Sunium have also produced a number of fine marble sculptures, especially the colossal *Sunium Kouros* (ca. 600 B.C.) and a relief of a youth crowning himself (ca. 480 B.C.). Both of these works are now in the National Museum of Athens. *See* KOUROS TYPE.

BIBLIOGRAPHY. V. Staïs [To Sounion], Athens, 1920 (in Greek); W. B. Dinsmoor, *The Architecture of Ancient Greece*, 3d ed., London, 1950. JEROME J. POLLITT

SUN K'O-HUNG. Chinese painter (1532–1610). His *tzu* was Yün-chih. Sun K'o-hung served for a time as the governor of Hupei Province, but after his retirement he built a magnificent house in Hua-t'ing, the area where the late Ming *wen-jen* school of painting was flourishing, and became known as a discriminating as well as wealthy collector and amateur painter. His best-known work is a series of small and beautiful paintings mounted in handscroll form (Formosa, Sun Yat-sen Museum), which are devoted to the idyllic theme of elegant pleasures and diversions of the scholar-gentlemen. *See* WEN-JEN-HUA.

SUPER-REALISM, *see* SURREALISM.

SUPPER AT EMMAUS. Theme based on the appearance of Christ after the Resurrection to two of His disciples in the village of Emmaus, where He ate with them in a manner symbolic of the Eucharist (Luke 24:13–35). Represented at an early date in Byzantine art, this subject appeared in the West at the end of the 10th century (Codex Egberti, Trier, Municipal Library).

BIBLIOGRAPHY. L. Rudrauf, *Le Repas d'Emmaüs*, 2 vols., Paris, 1955.

SUPREMATISM. Name given by Malevich to his version of extreme geometric abstractionism derived from cubism. The elements of suprematism were the rectangle, the circle, the triangle, and the cross. The first public appearance of suprematism (dedicated to the supremacy of pure form) took place in 1913, when Malevich exhibited his perfect square, black on a white background, causing a great sensation. The movement's manifesto, not published until 1915, was drawn up by the Russian poet Mayakovsky and other avant-garde writers. Before 1918 Malevich painted his *White on White* (New York, Museum of Modern Art). Suprematism, within a few months of its beginnings, gained and continued to gain ardent supporters. Later painting styles that take as their groundwork exact geometrical forms, without any attempt at representation, ultimately derive from suprematism.

BIBLIOGRAPHY. A. H. Barr, Jr., *Cubism and Modern Art*, New York, 1936.

SURFACE. Two-dimensional plane of the canvas. During the Renaissance, with the development of the techniques of illusionism, the surface became a window through which an artificial spatial world was to be viewed. Surface design nonetheless remained important, particularly in the work of the great Venetians, Bellini, Titian, and others. In the late 19th and the 20th centuries, with the demise of illusionism, the objective has been increasingly to "retain the surface," to use the inherent qualities of color, line, and form rather than perspective and other means to create a spatial world. The use of brush, knife, and collage techniques emphasizes the surface, making the work itself an object.

SURREALISM. Movement in art and literature which is concerned with giving expression to the poetry of the subconscious. Such surrealists as De Chirico, Dali, Tanguy, and Magritte composed pictures based on the kind of images experienced in dreams, nightmares, or a state of hallucination. They attempted to present them in as graphic a manner as possible. In order to make the bizarre or fantastic believable, they favored a sharp-focus realism. They frequently depicted a dream situation in a deep vista totally free of any beclouding atmospheric effects, revealing the improbable in a late-afternoon light which renders objects clearly and with long-cast shadows, suggesting the palpability of weight and substance.

Dali exploited the shock value of combining the mechanistic with the obscene, convulsed, and tortured. De Chirico evoked dream states of longing, anguish, and despair. Another group of surrealist artists, such as Arp, Miró, and Masson, painted works of a more abstract nature. The forms in their pictures are the products of a self-induced automatism.

Just as handwriting is thought to reveal the personality

Suprematism. Kasimir Malevich, *Woman with Water Pails: Dynamic Arrangement*, 1912. Oil on canvas. Museum of Modern Art, New York.

of the writer, so were linear configurations, color combinations, patterns, and textures keys to the subconscious being of the artist. Some forms have the potency of fetishes or signs. These appear atavistic and primeval. They seem to have been induced by strata of experience deep within all people, but which very few individuals are conscious of. These revelations, appearing as forms in the picture, may have been produced by mere chance or by yielding to such acts of free association as doodling. The artist takes the raw material dredged from the subconscious and uses it to make works of art. Ernst is one of the few surrealists to express himself in a veristic manner (collages derived from engravings in mid-19th-century popular and scientific books) as well as in an abstract manner (landscapes using *frottage*).

Art that derives its character from internal psychological forces, it has been frequently noted, is as old as art itself. The surrealist movement as a conscious effort to give expression to irrational and subconscious realms was formally instituted in 1924. The ideas of Freud gave impetus and authority to its doctrine. André Breton, in his first surrealist manifesto (1924), defined the scope of the movement, but the term "surrealist" was used as early as 1917 by Guillaume Apollinaire, who had already applied "supernatural" (*surnaturel*) to Chagall's work in 1911–12. Breton defined surrealism as "pure, psychic automatism." His former connection with Dadaism, against which he rebelled, no doubt contributed the idea that the denial of logic, reason, law, and morality was fundamental to the realization of a greater truth, a superreality or surreality.

Breton expanded his philosophy in a second manifesto. Artists rallied to his side, a magazine was published at intervals, and a surrealist gallery was established in Paris. There were many surrealist exhibitions and demonstrations in Paris, London, and New York prior to World War II. After that the organized movement seemed played out. The influence of Arp, Masson, and Miró, however, was felt to be critical in the work of Gorky, Calder, Pollock, and other artists of the succeeding generation.

See also MAGIC REALISM.

BIBLIOGRAPHY. M. Jean, *The History of Surrealist Painting*, New York, 1960; P. Waldberg, *Surrealism* [Geneva?], 1962; N. Nadeau, *The History of Surrealism*, New York, 1965; New York, Museum of Modern Art, *Dada, Surrealism, and Their Heritage*, by W. Rubin, New York, 1968.

ROBERT REIFF

SURRENDER OF BREDA. Oil painting by Velázquez, in the Prado Museum, Madrid. *See* VELAZQUEZ, DIEGO RODRIGUEZ DE SILVA Y.

SURYA. Hindu solar deity, one of the three chief gods in the Vedas. Sūrya, like Apollo, rides in a chariot which is drawn by seven horses, with Aruṇa or Vivaswat as charioteer. His wives are Sanjñā, daughter of Viśvakarmā, and Usas, the Dawn. His images bear a striking resemblance to those of Vishnu but are distinguished by the presence of the sun disk. Sūrya has many epithets, the most common being Savitṛ (the Nourisher).

SURYA DEUL, KONARAK, *see* KONARAK.

SURYA TEMPLE, MODHERA, *see* MODHERA.

SUSA. Capital of Elam, the first civilized state to emerge on the Iranian Plateau toward the end of the 4th millennium B.C. The Elamite palaces and temples on the acropolis of Susa (modern Shush, Biblical Shushan) were destroyed when the Assyrian king Assurbanipal (ca. 640 B.C.) conquered and sacked the city. Toward the end of the 6th century Susa fell to the Babylonians, and a century later it was taken over by the Achaemenian Persians and became the center of a mixed population. Iranians and Mesopotamians mingled with Greeks and Macedonians, and later with Parthians as well.

In 521 B.C. Darius chose Susa as his capital. On its acropolis he built a strong citadel, and on a nearby mount he built his palace and the apadana, or audience hall. These buildings, together with the city proper, formed a great complex surrounded by a strong wall of unbaked bricks, with projecting towers. A large moat, surrounding the wall, made of the city an impregnable island.

The palace, of Babylonian architecture, had rooms and living quarters opening onto courts and surrounded by long corridors. The unbaked brick walls were decorated with enameled bricks representing royal guards, lions, bulls, and fantastic beings. A tablet from the ruins of the palace, in Old Persian cuneiform writing, describes how the work was accomplished. Stone pedestals, some with Greek inscriptions, and fragments of statues in Greek marble have also been found. Darius also built roads connecting his great capital with Sardis, Ecbatana, Persepolis, and other great centers of his kingdom. The palace was destroyed in the reign of Artaxerxes I (465–424) and rebuilt under Artaxerxes II (404–358), probably in the same form.

All forms of art, including sculpture, pottery, painting, metalwork, and silk weaving flourished in Susa. Its palaces and tombs contained Persian rock sculptures and reliefs. Pottery dating from 3000 B.C. is painted on lustrous black ground, with stylized silhouettes of animals, birds, and human figures, showing imagination and originality. Glazed brick relief panels show griffins and warriors in brilliant colors. A heavy bronze votive offering has an archaic Ionic inscription, and great quantities of Sumerian figurines and stelae, and Parthian statuettes, were also found in Susa. A stele, now in the Louvre in Paris, shows King Sargon of Sumer (2d half of 3d millennium). Others show Elamite gods, kings, and queens: one bronze statue of Queen Napir-Asu, although weighing almost two tons, has elegance and dignity.

In the 4th millennium the painted vases of Susa were famous. The Louvre has superb collections of exquisitely painted and decorated bowls and cups, as well as magnificent silver dishes and goblets and superb rhytons in bronze or silver with the stand representing an ibex or a goat.

Persian jewelry in bronze and gold, inlaid with turquoise and lapis lazuli, gives evidence of the charm and individuality of Achaemenian art, which was able to adopt foreign influences and styles—Greek, Mesopotamian, Oriental—and create a style all its own.

BIBLIOGRAPHY. R. Ghirshman, *Iran: From the Earliest Times to the Islamic Conquest*, Harmondsworth, 1954; S. Lloyd, *The Art of the Ancient Near East*, London, 1961; A. Parrot, *Sumer: The Dawn of Art*, New York, 1961; R. Ghirshman, *The Arts of Ancient Iran: From Its Origins to the Time of Alexander the Great*, New York, 1964.

LUCILLE VASSARDAKI

Susa. Archers of the guard, relief in glazed brick from the palace at Susa. Louvre, Paris.

SUSA (Tunisia): GREAT MOSQUE, *see* SOUSSE: GREAT MOSQUE.

SUSENIER, ABRAHAM. Dutch still-life painter (b. Dordrecht or Leyden? ca. 1620; d. after 1664). In 1646 Susenier was married in Dordrecht and was reported to be from Leyden. In the same year he was recorded as a member of the Dordrecht painters' guild. His work is sometimes confused with that of Abraham van Beijeren.

BIBLIOGRAPHY. A. P. A. Vorenkamp, *Bijdrage tot de geschiedenis van het Hollandsch stilleven in de zeventiende eeuw*, Leyden, 1934.

SU SHIH (Su Tung-p'o). Chinese poet, philosopher, painter, calligrapher, and critic (1036–1101). One of the truly great men of Chinese history, Su Shih probably can be placed beside any mortal with a claim to fulfilling the concept of the "universal genius." His career was long and checkered, but his contributions to the history of painting can be defined in two basic areas: his paintings of bamboos and related subjects and his role in formulating the literati theory of art (*wen-jen-hua*). Of his paintings little seems to have remained save for several modest and somewhat questionable studies of trees, rocks, and bamboos. Thus any discussion of Su Shih's "style" in painting

must rest on conjecture. But his importance is testified to in other ways, namely, in the numerous references to him throughout the long history of literature on painting in China. *See* WEN-JEN-HUA.

BIBLIOGRAPHY. Y. Lin (Lin Yu-t'ang), *The Gay Genius, The Life and Times of Su Tungpo*, New York, 1947; J. Cahill, *Chinese Painting, XI–XIV Centuries*, New York, 1960.

SUSINI, ANTONIO. Italian sculptor (d. Florence, 1624). He was a student of Traballesi and of Giovanni Bologna, with whom he also collaborated. Susini's work is characterized by a late mannerist and early baroque style. Several signed bronzes are in the Victoria and Albert Museum, London, and in the Detroit Museum of Art.

SUSTERMAN (Sutterman; Soestermans), JUSTUS (Joost; Josse). Flemish portrait painter (b. Antwerp, 1597; d. Florence, 1681). He spent most of his life abroad. He met Frans Pourbus the Younger after 1610 in Paris, and studied and collaborated with him. By 1620 Susterman had become court painter to Duke Cosimo II de' Medici in Florence, after which he worked there as well as in other Italian cities, and even in Innsbruck and Vienna. Three generations of Medicis sat for his thorough and conven-

Graham Sutherland, *The Crucifixion*, 1946. St. Matthew's Church, Northampton. Austere treatment of a religious theme by this semiabstract painter.

tional portraits, which were done in numerous replicas to be sent to allied courts. His best achievements are portraits of children, such as *Anna Luisa de' Medici* (Florence, Uffizi), in which Anna Luisa is shown in a satin dress with lace decorations. The artist exemplifies Flemish competence as it was appreciated abroad; he shows no trace of Rubensian influence.

BIBLIOGRAPHY. P. Bautier, *Juste Sustermans, peintre des Médicis*, Brussels, 1912.

SUSTRIS, FEDERICO. Italian painter and architect (b. Italy? ca. 1540; d. Munich, 1599). He was the son and pupil of Lambert Sustris. Federico assisted Vasari from about 1563 to 1567 in the Palazzo Vecchio, Florence. By 1568 Federico was in Augsburg, and in 1573 he entered the service of Duke William V in Bavaria, where he distinguished himself with mannerist works of a distinctly northern quality.

SUTHERLAND, GRAHAM. English semiabstract painter (1903–). He was born in London and now lives in Trottiscliffe, Kent. He entered Epsom College in 1914. From 1919 to 1921, he served as an apprentice at the Midland Railway Works. He then became a student, until

1928, at the Goldsmiths' College School of Art of the University of London, where he specialized in the graphic arts. In 1925 he had his first exhibition of prints in London. The next year he was elected a member of the Royal Society of Painter-Etchers and Engravers.

Sutherland turned from etching to teaching and took a post at the Chelsea School of Art in 1930. Three years later he began to paint. He made some posters for Shell Mex and London Transport. He exhibited his paintings for the first time in 1938 at the Rosenberg and Helft Gallery in London. He had a second show at the Leicester Gallery two years later. In 1941 he was appointed an official war artist, a post he held throughout the war. In 1946 he had his first one-man show in New York, at the Buchholz Gallery. That year he painted a *Crucifixion* for St. Matthew's Church, Northampton.

He painted Somerset Maugham's portrait in 1949 and, later, portraits of Sir Winston Churchill and Lord Beaverbrook. These works brought a fame which his more austere pictures never attained. He was given a retrospective exhibition in 1952 at the Venice Biennale. He was also given important shows at the National Museum of Modern Art in Paris and, in 1953, at the Tate Gallery in London. He had a one-man show at the São Paulo Bienal in 1955. In 1960 he was awarded the British Order of Merit. In 1962 his 74-foot long tapestry, *Christ in Majesty*, was installed in Coventry Cathedral.

Sutherland's early etchings and book illustrations bear the mark of Blake's influence and that of Blake's follower Samuel Palmer. From about 1935 to 1940 he made a number of water colors in a semiabstract manner of landscapes with rocks, tree trunks, craggy ledges, and the like. His color choice was arbitrary, brilliant in treatment and palette, and yet suggestive of nature. His techniques recall those of Henry Moore in some cases. By 1944, under the influence of Picasso, Sutherland supplanted his lyrical animistic landscapes with views of horny, spiked shapes which protrude from a vinelike tangle. These hostile plants have claws, teeth, and animal parts. In 1949 Sutherland did a series of *Standing Forms*, which are column-like yet appear to be potentially alive.

BIBLIOGRAPHY. D. Cooper, *The Work of Graham Sutherland*, New York, 1962.

ROBERT REIFF

SUTRA. Sanskrit term meaning "thread" or "string." The sūtra is a rule or aphorism or a religious verse.

SUTRAS OF PAST AND PRESENT KARMA. Japanese painting of the 8th century, the oldest known example of *emaki*. The scrolls illustrate the past and present lives of the Buddha, with the narrative pictures placed on the upper half of the scroll and the text on the lower half. There were probably eight scrolls originally, of which only four complete scrolls and a few fragments survive in various collections. Despite its date, the painting preserves the archaic features of the art of Northern Wei China, in its stylized rocks and mountains, its comb-shaped foliage, and the ethereal beauty of the slender figures.

BIBLIOGRAPHY. Tokyo National Museum, *Pageant of Japanese Art*, vol. 1: *Painting*, pt. 1, Tokyo, 1952; T. Akiyama, *Japanese Painting* [Geneva?], 1961.

SUTRAS ON PAINTED FANS. Japanese sūtras written on paper fans (late 12th cent.). They are now in the National Museum of Tokyo, in the Shitennōji of Osaka, and in other, smaller collections. The sacred texts of the Lotus Sūtra are written on paper decorated with gold and silver squares and spicules, in the tradition of courtly art. The figures, however, are often drawn from the lower class. The outlines of these paintings are sometimes applied by wood block, a technique that was ideally suited to mass production and that was to develop into the Ukiyo-e printmaking of the Edo period. *See* UKIYO-E.

BIBLIOGRAPHY. Tokyo National Museum, *Pageant of Japanese Art*, vol. 1: *Painting*, pt. 1, Tokyo, 1952; National Commission for the Protection of Cultural Properties, ed., *Kokuhō (National Treasures of Japan)*, 6 vols., Tokyo, 1963– ; M. Ishida, *Japanese Buddhist Prints*, New York, 1964.

SUTTERMAN, JOOST, *see* SUSTERMAN, JUSTUS.

SUTTON HOO. Archaeological site near Woodbridge, in Suffolk, England. The eleven barrows of Sutton Hoo are situated on a sandy heath. Three of the barrows were opened in 1938. In 1939 a large barrow was excavated and within were found the remains of a large ship, 80 feet long and 14 feet in beam. Nothing remained of the ship except the iron clinch nails, whose positions enabled the excavators to reconstruct its plan. Amidships there was a wooden cabin, below which was found the burial deposit, consisting of weapons, silver dishes, caldrons, and ornaments. The style of the jewelry is only partly Jutish, for there are Scandinavian, Celtic, and Frankish elements. This combination created a new style, which flourished in

Sutton Hoo. Reconstruction of the front of a wooden shield with metal ornaments. British Museum, London.

East Anglia about A.D. 650, featuring typical Barbarian style motifs such as spirals, interlaces, and lacertine forms.

BIBLIOGRAPHY. British Museum, Dept. of British and Medieval Antiquities, *The Sutton Hoo Ship-Burial, a Provisional Guide*, by R. L. S. Bruce-Mitford, London, 1947.

SU TUNG-P'O, *see* SU SHIH.

SUYDERHOEF, JONAS. Dutch engraver (b. Leyden, ca. 1613; d. Haarlem, 1686). A student of Soutman, Suyderhoef is best known for his engravings after Brouwer, Ostade, Terborch, and particularly Hals. His renditions of Hals's portraits capture the vigor of the master's brushstrokes with an amazing freshness. Suyderhoef became commissioner of the Haarlem guild in 1677.

SUZOR-COTE, AURELE DE FOY. Canadian painter and sculptor (1869–1937). Suzor-Coté received academic training in Paris and lived chiefly in Montreal and Arthabaska. A painter of impressionist landscapes and figure studies, he also executed sculptures of French-Canadian *habitants*.

BIBLIOGRAPHY. M. Barbeau, *Painters of Quebec*, Toronto, 1946.

SVASTIKA, *see* SWASTIKA.

SWAG. Festoon of leaves, flowers, and fruit used in the ornamentation of classical friezes. The term also denotes wood and metal festoons used to decorate furniture, pewter, and brass, especially in the late 18th century.

SWAN, JOHN MACALLAN. English painter and, occasionally, sculptor (1847–1910). He studied in Royal Academy schools and from 1874 in Paris at the Ecole des Beaux-Arts under Gérôme, Bastien-Lepage, and Dagnan-Bouveret. He was influenced by the sculptors Frémiet and Barye. He worked out-of-doors in the summer in the Barbizon district, and when in England he frequently studied animals in the Zoological Gardens, London. He traveled in Italy and Holland. His work was shown at exhibitions in London and Paris, and he was a gold medalist.

His animal paintings are mainly representational and lack the fictional quality of those of Landseer. His many studies and drawings show a selective generalization in handling which is distinct from the photographic accuracy of later 19th-century "animaliers." Swan also painted a number of more genre type landscapes. He is widely represented in English and Continental public collections.

SWANENBURGH, ISAAK NICOLAI VAN. Dutch painter of history, genre, and portraits and designer of glass windows (b. Leyden, 1538; d. there, 1614). Swanenburgh, who was known as Meester Isaak Nicolai, was probably a pupil of Frans Floris in Antwerp. Between 1582 and 1606 Swanenburgh held various municipal posts in the city of Leyden, including burgomaster (1596). As a painter he is best known for his series representing various aspects of the clothmaking industry at Leyden (Leyden, Stedelijk Museum "De Lakenhal"); it was painted in a moderate late mannerist style which recalls his training at Antwerp. He also designed painted glass windows for the church at Gouda.

Among Swanenburgh's pupils were Otto van Veen, who was later the teacher of Peter Paul Rubens. He also taught his son Jacob van Swanenburgh, a painter of architectural views and hell scenes, who became Rembrandt's teacher.

BIBLIOGRAPHY. G. J. Hoogewerff, *De Noorde-Nederlandsche schilderkunst*, vol. 4, The Hague, 1942; Leyden, Stedelijk Museum, *De Lakenhal*, 2d ed., 1951.

SWANEVELT, HERMAN VAN. Dutch painter of landscape, history, and genre (b. Woerden, ca. 1600?; d. Paris, 1655). Little is known of Swanevelt's early years and training. In 1623 he arrived in Paris, where he seems to have been active. The exact time of Swanevelt's arrival in Rome is not certain, and various dates from 1624 on have been suggested. It should be noted that he cannot be documented in Rome until 1629, and from that date on his name appears frequently in Roman archives. In Rome he was a member of the Northern painters' association and lived with various members of the organization such as Jan van der Camp. He also was friendly with Michelangelo Cerquozzi and Pieter van Laer. Swanevelt appears to have remained in Italy until at least 1641. In 1644 he was living in Paris and was named *peintre ordinaire du Roy*, and in 1651 he became a member of the Royal Academy. During these years he seems to have made a number of journeys to his native Woerden, but Paris was his main residence.

Swanevelt is best known for his Italianate landscape paintings, which begin as early as 1630 (*Jacob Taking Leave of His Family*[?], The Hague, Bredius Museum). The date on the Bredius picture seems to indicate that a reciprocal relationship existed between Claude Lorraine and Swanevelt rather than, as is usually stated, that Claude directly influenced the Netherlander. Swanevelt's *Campo Vaccino* (1631?; Cambridge, Eng., Fitzwilliam Museum) also may have directly influenced Claude's rendering of the same subject (1636; Paris, Louvre). It was not until the late 1630s that Swanevelt's work became what might be termed "Claudian."

BIBLIOGRAPHY. M. R. Waddingham, "Herman van Swanevelt in Rome," *Paragone*, no. 121, 1960; M. E. Houtzager et al., *Nederlandse 17e eeuwse Italianiserende Landschapschilders*, Utrecht, 1965; W. Stechow, *Dutch Landscape Painting of the Seventeenth Century*, London, 1966.

LEONARD J. SLATKES

SWASTIKA (Svastika). Ancient decorative motif and mystic symbol. The swastika is shaped like a cross with the four arms bent into right angles, all going in the same direction. In Buddhism, it is one of the sixty-five marks of Buddhahood found on the Buddha's footprint; sometimes it appears on images over the heart of a Buddha. It is also common in Germanic art.

SWATOW (Fukien) WARE. Class of Chinese porcelains of rather robust shape, usually large plates and bowls, decorated freely in red, turquoise, and black enamels or, most frequently, in underglazed blue-and-white. The glaze is thick, and the blue used is more nearly a grayish green in appearance. The pieces are usually roughly finished, with sand and grit adhering to the bases. The wares were made for export principally to southeast Asia, Indonesia, India, and Japan and date mostly from the late 16th and the 17th centuries. They were known in Europe in the 18th century, although they were not in great demand. The name "Swatow" refers to a small village on the south-

east coast of China through which, it was believed at one time, these export wares made for the Asian market passed. But the village does not appear in contemporary records, and there is no indication that foreign ships ever plied this small port. The wares should be called generally "Fukien" wares, referring to the province where most of the kilns producing them were located in this period.

BIBLIOGRAPHY. M. Beurdeley, *Chinese Trade Porcelain*, Rutland, Vt., 1962.

SWAYN, WILLIAM. English architect (d. 1525). He was a Cambridge mason, responsible for work at Trinity Great Court (1490), at Christ's College (early 16th cent.), and possibly at St. John's (1510). He was an executant for designs by John Wastell.

BIBLIOGRAPHY. J. H. Harvey, comp., *English Mediaeval Architects*, London, 1954.

SWEBACH (Fontaine; Swebach-Desfontaines), JACQUES-FRANCOIS-JOSEPH. French painter (b. Metz, 1769; d. Paris, 1823). A pupil of Duplessis, Swebach exhibited at the Salon de la Correspondance when he was only fourteen, using the pseudonym "Fountein." He was primarily a landscape and battle painter who excelled in the depiction of horses in action. Such scenes provided the subjects for his ceramic designs, and from 1802 to 1814 he was director of the works in Sèvres. After 1815 he served in a similar capacity for Alexander I of Russia until his return to France in 1820. His connection with the regime of Napoleon was close, and he produced many panoramic Napoleonic battle scenes, for one of which he was given the grand prize at the Salon of 1810. Earlier, in 1800, he had been commissioned to paint an equestrian portrait of Josephine Bonaparte for the Château of Malmaison. Works by Swebach are to be found in many French museums, including those of Versailles, Montpellier, Abbeville, Dijon, and Lyons. Much of his prolific output was reproduced in five volumes of his own engravings, the *Encyclopédie pittoresque*, published in 1806.

SWEDEN, MUSEUMS OF. See under the names of the following cities:
Goteborg. Art Gallery.
Stockholm. National Museum.

SWEELINCK, GERRIT PIETERSZ. (Gerhard Sweeling). Netherlandish painter and engraver (1566–before 1645). He appears to have studied with Jacob Lenards in his native city of Amsterdam and with Cornelis Cornelissen in Haarlem. Sweelinck's engravings of nude women were most famous in his lifetime, but his *oeuvre* also includes portraits, group scenes, and some Biblical subjects.

SWEERTS, MICHAEL. Flemish painter (b. Brussels, 1624; d. Goa, India, 1664). He had a lengthy sojourn in Italy, and a shorter stay in Amsterdam. He was an impressive and versatile painter of genre, portraits, and *bambocciante* scenes, drawing on both the Caravaggisti and Dutch painting in the manner of Johannes Vermeer.

BIBLIOGRAPHY. H. Gerson and E. H. ter Kuile, *Art and Architecture in Belgium, 1600–1800*, Baltimore, 1960.

SWING, THE. Oil painting by Fragonard, in the Wallace Collection, London. *See* FRAGONARD, JEAN-HONORE.

SWITZERLAND, MUSEUMS OF. See entries under the names of the following cities:
Basel. Public Art Collections.
Bern (Berne). Art Museum.
Geneva. Museum of Art and History.
Lausanne. Cantonal Museum of Fine Arts.
Lucerne. Art Museum.
Lugano-Castagnola. Thyssen-Bornemisza Museum.
St. Gall. Art Museum.
Saint-Moritz. Segantini Museum.
Schaffhausen. Museum of All Saints.
Winterthur. Art Museum; Reinhart Foundation (Stiftung Oskar Reinhart).
Zurich. Art Gallery; E. G. Bührle Foundation Collection; Graphics Collection of the Federal Technical College.

SWORDS. Swords frequently appear as symbols in Christian art. The sword is the attribute of St. Paul, of the Archangel Michael, and of some of the Virtues. Many saints are also symbolized by the sword: Agnes, Catherine of Alexandria, Euphemia, Justina (through her throat), and Peter Martyr (in his head).

SYLVESTER, ST. Pope (314–335). He is said to have baptized the emperor Constantine, received the Donation of Constantine, and founded the Lateran as the Cathedral of Rome. Sylvester is represented in art in pontifical dress, wearing the tiara, and with a bull at his feet.
See also SAINTS IN ART.

SYMBOLISM. Term loosely used to refer to the style of a group of French artists but more accurately descriptive of a crucial tendency of European art in the late 1880s and the 1890s. Instead of the accepted definition of art as the imitation of reality (a definition which had easily covered impressionism), a new generation of artists proposed to define painting as the vehicle for the direct communication of individual moods, emotions, and ideas, not through the tradition of allegorical pose, gesture, and attribute but, rather, through the expressive possibilities of form, color, and line in themselves. This concentration on the formal means of painting necessarily involved a departure from naturalistic depiction toward a greater abstraction and the increasing importance of and reliance on certain primitive and non-European arts in which representation, in the Western academic sense, had never played an essential role.

Although Seurat, in his last works, was approaching a similar end (but by a different direction), perhaps the first important manifestation of these ideas was synthetism, the style developed by Gauguin and Emile Bernard at Pont-Aven in 1888. In the hands of the painters Sérusier and Denis, the critic Albert Aurier, and others, the ideas of synthetism rapidly became fused (and confused) with the theories of the symbolist movement in poetry begun by Jean Moréas in 1886, and the resulting amalgam, disseminated through exhibitions and periodicals, was a strong influence on the younger artists of Europe. *See* DENIS, MAURICE; SERUSIER, PAUL; SYNTHETISM.

Both this influence (as well as such independent parallels as Munch, Ensor, and Hodler) and the extraordinary variety of artists associated with these ideas are indications

that symbolism was not a specific, isolable style, but more a period trend that also had, as a by-product, the creation or reanimation of the reputations of older artists, for example, Redon, Moreau, and Puvis de Chavannes, who were reexamined in the light of the new theories. Much of the original impetus of synthetism-symbolism was dissipated by its spread: the mood-tinged atmosphere and decorative qualities of the Nabis' works, for example, do not exhibit aims as intense as Van Gogh's wish to express emotion and even thought by the mingling or the opposition of color and light. *See* NABIS; VAN GOGH, VINCENT WILLEM.

While it is customary to point out the surrealist debt to symbolist theories and examples, it is less often mentioned that symbolism provided the ideological ground for the growth of varieties of 20th-century abstraction, either universal, as in Kandinsky or Mondrian, or personal, as in abstract expressionism.

BIBLIOGRAPHY. S. Lövgren, *The Genesis of Modernism*, Stockholm, 1959; H. R. Rookmaker, *Synthetist Art Theories: Genesis and Nature of the Ideas of Gauguin and His Circle*, Amsterdam, 1959; J. Rewald, *Post-Impressionism from Van Gogh to Gauguin*, 2d ed., New York, 1962.

JEROME VIOLA

SYMMETRY. Beauty of form arising from a harmony of proportion. In the strictest sense, symmetry is the balance achieved through the correspondence in size, shape, position, and even color of parts on opposite sides of a median line. Symmetry played an important role in the architecture of ancient Greece and the Italian Renaissance, while other periods, the Celtic, for instance, were not especially aware of it.

SYNAGOGA, *see* CHURCH AND SYNAGOGUE.

SYNAGOGUE. Jewish house of prayer, from the Greek *synagōgē*, meaning "assembly" (the Hebrew term is *bet keneset*). In the United States the synagogue is often a community center as well as a place of worship.

The synagogue is assumed to have developed among Babylonian exiles. The Great Synagogue of Alexandria, famous in Roman times, had separate sections for each trade guild. With the Christian era, following the destruction of the Second Temple in A.D. 70, synagogues were often placed on high ground, one end being oriented toward Jerusalem, the site of the original Temple. Galleries for women were provided about the 3d century of our era, when synagogues were places for study and prayer. The separation of men and women by partitions or galleries was common in medieval synagogues and is practiced in many Orthodox congregations today. The ark, at one time a portable cupboard, was later more often built into a wall facing Jerusalem. In the adjacent courtyards of some synagogues law cases were tried and marriages celebrated. Organs were introduced in synagogues with the Reform movement of 19th-century Judaism, the separation between men and women was gradually abolished, and a type of synagogue more analogous to Protestant churches was developed, the older Orthodox synagogues remaining more closely attached to medieval precedents.

BIBLIOGRAPHY. R. Wischnitzer, *The Architecture of the European Synagogue*, Philadelphia, 1964.

MILTON F. KIRCHMAN

SYNCHROMISM, *see* MACDONALD-WRIGHT, STANTON; ORPHISM; RUSSELL, MORGAN.

SYNDICS OF THE CLOTH DRAPERS' GUILD. Oil painting by Rembrandt, in the Rijksmuseum, Amsterdam. *See* REMBRANDT HARMENSZ. VAN RIJN.

SYNTHETIC CUBISM, *see* CUBISM.

SYNTHETISM. Style of painting that developed out of the meeting of Gauguin and Bernard at the Breton village of Pont-Aven in the summer of 1888. Both men had been independently working in similar directions before 1888, and each probably acted as a catalyst for the other's ideas: Bernard's theorizing furnished a rationale for Gauguin's intuitions, and Gauguin's superior painting ability demonstrated to Bernard the transmutation of theory into practice. *See* BERNARD, EMILE; GAUGUIN, PAUL.

Rejecting naturalism but not representation, synthetism begins with the assumption that the fundamental aesthetic elements of line, form, and color have expressive meaning in and of themselves, whether or not they are used to produce a recognizable image of something in reality. By using various simplifying devices which allowed the abstracted expressive elements to play a greater role, the painters hoped to fuse both the technical composition of a painting and the idea, or meaning, of its subject into an indissoluble unity. The stylistic characteristics of synthetism—heavy contour lines, broad areas of intensified color, flat, patterned spatial treatment which emphasizes decorative effects, and general simplification of shapes and elimination of detail—are derived from many sources, all sharing certain antinaturalistic, primitivistic features: Japanese prints; folk art, including peasant sculpture and the popular woodcut *images d'Epinal*; and the strongly outlined stained glass of the Middle Ages. (The term *cloisonnisme*, so called after the dividing walls in medieval enamels and often incorrectly used as synonymous with synthetism, was first applied by the writer Edouard Dujardin to the paintings of Louis Anquetin, who, with his friend Bernard, was working in a compartmented manner late in 1887.)

Probably the outstanding monument of the early phase of synthetism is Gauguin's *The Vision after the Sermon—Jacob Wrestling with the Angel* (1888; Edinburgh, National Gallery of Scotland), with its close-up figures strongly silhouetted against the up-tipped brilliant vermilion ground. At the hands of the younger members of the school of Pont-Aven, particularly the theoretically minded Sérusier and Denis, synthetism was apparently absorbed by the more literary symbolism. It reappeared, stripped of Gauguin's urge to combine meaning and matter, with the primarily decorative style of the Nabis, directly on the road to the Art Nouveau style of the turn of the century. *See* NABIS; SYMBOLISM.

The search for the synthesis of form and content is at the heart of the revolutionary change in attitude toward painting which began with the different styles of postimpressionism and continued into the 20th century. With the public vocabulary of gesture, pose, and iconographical attribute no longer viable, the artist has increasingly tended to find his vehicle of espression in the means of painting itself; the question "How is that painting made?" gradually became identical with the question "What does that painting mean?"

BIBLIOGRAPHY. S. Lövgren, *The Genesis of Modernism*, Stockholm, 1959; H. R. Rookmaker, *Synthetist Art Theories: Genesis

and Nature of the Ideas of Gauguin and His Circle, Amsterdam, 1959; J. Rewald, *Post-Impressionism from Van Gogh to Gauguin*, 2d ed., New York, 1962. JEROME VIOLA

SYNTHRONUS. In Eastern churches, the joint throne of the bishop and his presbyters.

SYRACUSE. Italian city in Sicily, the greatest city of Magna Graecia. Founded by colonists from Corinth in 734 B.C. (Thucydides, VI, 3), it was one of the earliest Greek cities in the West. In 480 B.C. Syracuse defeated the Carthaginians and became one of the great powers of the Greek world. The repulse by the Syracusans of the great Athenian invasion of 415–413 B.C. led to the downfall of Athens as a great power. Syracuse became an ally of Rome in the 3d century B.C. and enjoyed a favored position in Sicily. The city was seized by the Roman general Marcellus in 211 B.C. and became a prosperous provincial city ruled by a Roman governor.

On the small harbor island of Ortygia the foundations of the Doric Temple of Apollo (ca. 575 B.C.), one of the earliest in Magna Graecia, have been excavated, and a number of well-preserved Doric columns from a later Temple of Athena (ca. 470 B.C.) have been incorporated into the Cathedral of Syracuse. *See* SYRACUSE: CATHEDRAL.

In the mainland area of Achradina are the remains of the Greek agora and a gymnasium dating from the time of the Roman Empire. To the northwest are the site of an extremely well-preserved Greek theater begun by Hieron I in 475 B.C. and expanded about 335 B.C. and an extensively preserved Roman amphitheater dating from the 2d century B.C. To the northeast there are remains of early Christian catacombs. Farther to the northwest are the spectacular remains of the military stronghold of Dionysius I (r. 406–367 B.C.), now called the "Castle of Euryalus." South of Syracuse is the site of the colossal Temple of Zeus Olympios (ca. 575 B.C.), of which two columns still stand. The National Museum in Syracuse has a rich collection of antiquities dating from all relevant periods.

BIBLIOGRAPHY. D. R. MacIver, *Greek Cities in Italy and Sicily*, Oxford, 1931. JEROME J. POLLITT

SYRACUSE: CATHEDRAL. Italian cathedral in Sicily. The present church incorporates the Doric columns of the Greek Temple of Athena (ca. 470 B.C.) in the inner face of the wall fabric. The transformation of the temple into a church took place in the 7th century. After earthquake damage in 1693 the Cathedral was redecorated in baroque style. Although much of this decoration has been removed by 20th-century restorers, the lively two-story façade, built by Andrea Palma between 1728 and 1752 and decorated with statues by Ignazio Marabitti, remains. Among the interior furnishings is a panel painting attributed to Antonello da Messina and statues by members of the Gaggini family.

BIBLIOGRAPHY. M. Minniti, *Siracusa, guida artistica...*, 3d ed., Syracuse, 1954.

SYRIA, ANCIENT. The lack of continuity in Syrian art results from many factors: a natural environment subject to frequent earthquakes; the contrast between the coastal area and the interior; the frequent raids of nomads; and, finally, the domination of the great powers, Egypt, Babylonia, the Hittites, and Assyria.

From the period before the 2d millennium B.C. bronze statuettes representing standing figures from Tell Jedeida and a stone mask from Tell Brak show Mesopotamian influence. The Pharaohs of the 12th dynasty (2000–1775 B.C.) established strong trade relations with Syrian rulers, whom they considered their vassals. The local craftsmen were influenced by Egyptian works of art and, in their eclectic way, chose motifs which they used as decorative elements in works of varying quality. Steles show imitations of Egyptian figures, but the influence is clearer in jewelry in niello and in an embossed dagger and its sheath. *See* BRAK.

Egyptian predominance was replaced by Babylonian (1800–1700 B.C.), conspicuously influencing architecture, with the typical central courtyard as in the palaces at Ugarit (Ras Shamra) and Tell Atchana (Alalakh). When North Syria fell under the sway of the Indo-European Mitanni (1450–1360 B.C.), mixed influences, reminiscent mostly of Egyptian and to some extent of Mesopotamian sources, appeared in glazed lions, mural painting from Nuzi, ivories from Tell Atchana, and engraved gold bowls from Ras Shamra. The *hilani*, a shallow entrance hall with one or more columns in the doorway, which was a characteristic Syrian invention, appeared for the first time in the palace of Niqmepa at Tell Atchana. *See* ALALAKH; RAS SHAMRA.

Later, Aegean elements permeated North Syrian art, while a pseudo-Egyptian style was preeminent in South Syria under the Ramessides (1273–1150 B.C.), as can be seen from the ivories, both carved and in openwork. Ras Shamra had tombs of the shaft type, and later those of a Mycenaean type with dromos (entrance passage) and corbel vaults. There were also small brick shrines, such as those at Tell Atchana, which consisted of an antecella and a cella, each with a *hilani*, and which later acquired a square court in front.

After a dark period (1200–900 B.C.), when nomads superseded the great powers, North Syria entered an era of Assyrian domination, with vague influences appearing in the 9th century and more definite ones later. Tiglathpileser III (743 B.C.) built palaces (at Tell Barsip, Arslan Tash, and Tell Tayanat) and established garrisons, and the North Syrian rulers were replaced by Assyrian governors between 732 and 680 B.C. Palaces were characterized by the entrance building (*bit-hilani*) and two independent aisles for summer and winter quarters; the latter had an iron hearth mounted on two rails in the main hall. At Sindjerli several palaces were built on the uppermost northern terrace. The use of timber reinforcement in the masonry was also a local custom, as perhaps was the motif of the double animal (lion and griffin) to support a column or statue column. The carved orthostates and colossal guardians of gates derived from Assyria. *See* ARSLAN TASH; SINDJERLI.

Sculpture showed more Assyrian influence than did architecture both in its subjects—mostly in relief as semidetached guardians of gates—and in its style (Sindjerli, Tell Halaf, Sakjegozu, and Carchemish). Stylistic trends are, however, mixed: the cylindrical shape of the standing figure, as in Mesopotamia, contrasted with the cubical one for the seated figure. In its composition and treatment, relief carving showed the influence of the minor arts, as in the rough outline with engraved details. *See* CARCHE-

MISH; SAKJEGOZU; TELL HALAF. *See also* DURA EUROPOS; SYRIA, CLASSIC AND CHRISTIAN.

BIBLIOGRAPHY. C. F. A. Schaeffer, *Stratigraphie comparée et chronologie de l'Asie Occidentale*, Oxford, 1948; H. T. Bossert, *Altsyrien*, Tübingen, 1951; H. Frankfort, *The Art and Architecture of the Ancient Orient*, Baltimore, 1954.

ALEXANDER M. BADAWY

SYRIA, CLASSIC AND CHRISTIAN.

Syria was an extremely productive artistic center from the classic era through the early Christian centuries. Hellenistic sculpture (portraits of the Seleucid kings) and Roman imperial architecture (Palmyra; Baalbek) flourished there. *See* BAALBEK; PALMYRA.

There was an important Syrian school of Christian architecture and architectural carving in the 5th and 6th centuries, for example, at Bosra and Gerasa in the south and at such sites as Der Tourmanin (a basilica with twin façade towers) and St. Simeon Stylites (Kalat Seman, four basilicas converging upon a central octagon) in the north. The visual qualities of this art resulted partly from the use of an extremely hard stone. *See* KALAT SEMAN: CONVENT OF ST. SIMEON STYLITES; TOURMANIN, DER.

Early Islamic art flourished in Damascus. Syria's central geographical position accounts in part for its influence upon Christian (especially Byzantine) and Muslim art. *See* DAMASCUS; EAST CHRISTIAN ART AND ARCHITECTURE; ISLAM. *See also* DURA EUROPOS.

BIBLIOGRAPHY. H. C. Butler, *Early Christian Churches in Syria*, ed. and completed by E. B. Smith, Princeton, 1929; K. J. Conant, *Early Medieval Church Architecture*, Baltimore, 1942; C. R. Morey, *Early Christian Art*, 2d ed., Princeton, 1953.

Classic Syria. Monumental arch at Palmyra, erected at the intersection of four colonnaded streets, A.D. 1st century.

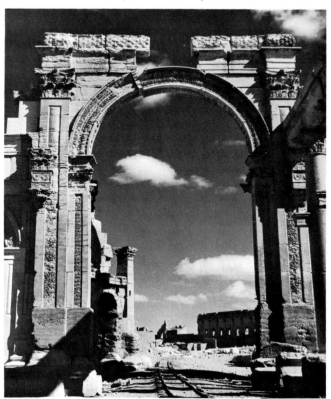

SYRLIN, JORG, THE ELDER. German cabinet maker and sculptor (b. Ulm, 1424; d. there, 1491). He was active mainly in Ulm, where he created his masterpiece, the choir stalls of the Cathedral (1469–74), one of the great monuments of late Gothic realism. Two other hands can be detected in the work, and they are assumed to be Syrlin's assistants. The sculptural decoration is in the form of busts which represent historical figures in the prophecy of Christ, that is, sibyls, prophets, and so on. The whole is united in a well-integrated architectonic system. Influential in Syrlin's art is the work of Nikolaus Gerhard from Leyden, the major personality in German late Gothic realism. Syrlin's other works include the shrine of the high altar of the Ulm Cathedral (destroyed in the iconoclasm of the 16th cent.) and the Christofel Fountain in Ulm.

BIBLIOGRAPHY. G. Otto, *Die Ulmer Plastik der Spätgotik*, Reutlingen, 1927.

SYRLIN, JORG, THE YOUNGER. German sculptor (b. Ulm, ca. 1455; d. there, ca. 1521). He was the son of the famous late Gothic sculptor Jörg Syrlin the Elder, whose workshop he continued after his father's death in 1491. Syrlin the Younger was active between 1475 and 1521. He continued his father's style, but with an awareness of the new Renaissance, especially Düreresque, innovations. His most important works are the *Madonna of the Half Moon* (Vienna, Museum of Art History), the choir stalls in the church of Ennetach (1506), and an altar shrine (Stuttgart, Württemberg Landesmuseum).

BIBLIOGRAPHY. A. Feulner and T. Müller, *Geschichte der deutschen Plastik*, Munich, 1953.

SYSTYLE. Architectural term derived from the Greek *systolos*, meaning "close-standing columns." It is used to describe intercolumniation in classical architecture when the columns are spaced fairly closely together or, more specifically, when the space between two columns is two diameters.

SZINYEI MERSE, PAL. Hungarian painter (b. Szine-Ujfalu, 1845; d. Jernye, 1920). His studies took place at the Munich Academy and under Piloty. Szinyei Merse was influential as the first Hungarian artist to adopt a kind of impressionism. His seminal work is *Picnic in May* (1873; Budapest Museum), on which he worked for three years. The central concerns are the effects of light and the play of colors, although the scene is anecdotal and the colors seem artificial. The poor reception accorded him in his country led him to give up painting until the end of the 19th century, by which time the principles of impressionism had been accepted. In 1900 he won a gold medal at the Paris Salon and subsequently was made director of the School of Fine Arts in Budapest (1905–20).

SZYSZLO, FERNANDO DE. Peruvian painter (1925–). Born in Lima, Szyszlo studied there and in France and Italy. He has exhibited widely (for example, at the Guggenheim International of 1964, in New York). *Cajamarca* (1963; Lima, Walter Gross Collection) is a subtly colored abstraction with Peruvian regional content.

BIBLIOGRAPHY. S. Catlin and T. Grieder, *Art of Latin America since Independence*, New Haven, 1966.

T

Tabriz. Carpet with characteristic medallion surrounded by a pattern of flowers and tendrils, 19th century. Private collection, Milan.

"T", see TOURNIERES, ROBERT LEVRAC.

T'A. Chinese pagoda. *See* PAGODA.

TABACHETTI, GIOVANNI, see WESPIN, JEAN.

TABERNACLE. Dwelling place (from the Latin *taberna*, "hut"). Among Jews, the tabernacle was once identified with the *mishkan*, a portable sanctuary containing the Ark, which was carried through the wilderness during the Exodus. The tabernacle in Christian churches was a receptacle or niche for sacred objects (for example, the consecrated Host), the recessed, ornately arched structure in Exeter Cathedral and Orcagna's tabernacle in Or San Michele, Florence, being representative of more elaborate examples. Medieval tabernacles were related to the German sacrament house, a comparatively huge interior structure housing the Eucharistic pyx. The tabernacle in its simplest form is an ornamental box on the altar. *See also* AMBRY.

TABLINUM. Room or alcove in the ancient Roman house, used for family records. The tablinum in the House of Pansa, Pompeii, was an open room curtained off between the atrium and the peristyle. A passage at the side of the tablinum was called the "fauces." (See illustration.)

TABRIZ. City situated in extreme northwestern Iran. Long the capital of the province of Azerbaijan, it lay on the great trade road from the Mediterranean Sea to the Orient as well as on an important route from north of the Caucasus Mountains toward the Persian Gulf. Scholars believe that the site was occupied from ancient times, although there has been no firm identification of its name prior to the Islamic period.

Until the end of the 13th century Tabriz remained smaller and of less importance than its near neighbors, Ardabil and Maragha. Then, in 1295, Sultan Mahmud Ghazan Khan, Il-khanid (Mongol) ruler of Iran, moved the capital of his realm from Maragha to Tabriz. A new wall enclosed a much more spacious area, and caravansaries, bazaars, and public baths were constructed at each new city gate. In 1297 work was begun in Shenb (Ghazaniya), a western suburb, on the mausoleum of Ghazan Khan, and the ruler, an ardent Muslim, provided Shenb with religious colleges, a hospital, a palace, and an observatory. The tomb of Ghazan, a monumental structure crowned by a lofty dome, later fell into ruins, and today is a mound of crumbling bricks.

Rashid ad-Din Fazl Allah, a vizier of Ghazan Khan and the latter's successor, Oljeitu (Uljaitu), undertook the construction of a suburb, the "Quarter of Rashid," east of the city. There he assembled scholars, theologians, and miniaturists. Many of the paintings have survived in manuscript copies of Rashid's universal history of the world. They reflect the earlier style of the Baghdad school overlaid with Chinese influence in technique and details. Another vizier, Taj ad-Din 'Ali Shah, began a great mosque in 1310; its principal feature was a vaulted hall some 98 feet in width and 213 feet in depth. Shortly after the mosque was completed in 1320 the great vault collapsed, and in later centuries its massive walls were converted to a fortress. Marco Polo and Ibn-Battuta, an Arab geographer, visited Tabriz at this period and were extravagant in their praise of the city. At this time colonies of merchants from Venice and Genoa handled the city's trade with Europe.

Before the middle of the 14th century Tabriz fell into the hands of a local dynasty, and for some time its control changed hands from the so-called White Sheep to the Black Sheep rulers. The Blue Mosque, built in 1465, is the most important extant monument from this period; the Mosque of Ustad Shagird of 1342 also remains. *See* TABRIZ: BLUE MOSQUE.

In 1502 Tabriz became the capital of the Safavid dynasty. It lay directly in the path of the warring armies of Iran and the Ottoman Turks and after it was captured by the Turks in 1514 the capital was moved to Qazvin. In 1603 Tabriz was recovered by Iran.

Tablinum. Ground plan of the House of Pansa, Pompeii, showing the position of the tablinum.

Since the 16th century Tabriz and its vicinity have been notable centers of carpet weaving.

BIBLIOGRAPHY. D. N. Wilber, *The Architecture of Islamic Iran: The Il-Khānid Period*, Princeton, 1955; L. Lockhart, *Persian Cities*, London, 1960. DONALD N. WILBER

TABRIZ: BLUE MOSQUE. Iranian mosque of the Timurid period. The Timurid renaissance, which was almost exactly coextensive with the 15th century, reached its zenith with the Blue Mosque (1465). The architect was Ni'mat Allah; the patron, Saliha Khanum. The rectangular plan, covered by a large dome (52 ft. 6 in. in diameter) and eight smaller peripheral domes, may have been derived from Byzantine architecture. The edifice owes its popular name to the ultramarine blue faïence, illuminated with gold, that covers the masonry surfaces.

BIBLIOGRAPHY. A. U. Pope, ed., *A Survey of Persian Art*, vol. 2, New York, 1939.

TABULAE ILIACAE. Group of Roman works in stone carved in relief with representations of the sack of Troy (*Iliupersis*) and Greek inscriptions. They probably served a practical purpose, as aids in schoolrooms for the teaching of Homer. Their representation is rather cartographic, an effect achieved by the wide use of the bird's-eye view. These panels present one of the few remnants of Roman popular art. Nineteen examples are extant, the most famous of which is the panel in the Capitoline Museums in Rome.

TABULARIUM, ROME. Record office on the Capitoline hill in which the archives of the Roman state were kept. It was built in 78 B.C. by the consul Catulus. The building was a trapezoid in form and had façades on its two long sides. It consisted of a gallery with a Doric colonnade on the first floor and of a superposed Corinthian order. The Tabularium preserves the oldest surviving examples of concrete vaulting.

BIBLIOGRAPHY. D. S. Robertson, *A Handbook of Greek and Roman Architecture*, 2d ed., Cambridge, Eng., 1959.

TACCA, FERDINANDO. Italian sculptor (b. Florence, 1619; d. there, 1686). He was the son and pupil of Pietro Tacca. In 1642 Ferdinando took his father's place as court sculptor, and from 1659 to 1665 he executed the *Fontana del Bacchino* (Prato, Galleria Comunale). He created crucifixes and festival apparatus from 1652 to 1670 and the ballets (1661) for the wedding of Cosimo II de' Medici. The choir and altar of S. Stefano in Florence are attributed to Ferdinando. He worked in a solid Florentine 17th-century idiom.

BIBLIOGRAPHY. E. Lewy, *Pietro Tacca*, Cologne, 1928.

TACCA, PIETRO. Italian bronze caster, sculptor, and architect (b. Carrara, 1577; d. Florence, 1640). He entered the atelier of Giovanni Bologna in 1592. On Pierre Franqueville's departure in 1601 Tacca became Bologna's favored pupil, working on the equestrian statue of Henri IV of France for the Pont Neuf (1611; destroyed 1792). In 1613 he executed an equestrian statue of Philip III of Spain (Madrid, Plaza Mayor). His most renowned works are the four *Slaves* on the socle of the statue of Ferdinand I (1620–23; Livorno, Piazza della Darsena) and the statue of Philip IV of Spain (1635–40; Madrid, Plaza de Oriente). The latter was the first model in recent times of a leaping horse. To his equestrian statues he brought baroque realism. He was the father of Ferdinando Tacca.

BIBLIOGRAPHY. E. Lewy, *Pietro Tacca*, Cologne, 1928.

TACCONE, PAOLO DI MARIANO DI TUCCIO, *see* ROMANO, PAOLO.

TACCONI, FRANCESCO. Northern Italian painter (fl. 1458–1500). He worked first in his native Cremona and Milan and then in Venice and Parma. Since his organ shutters at St. Mark's, Venice, disappeared, his only known work is a *Madonna* (1489; London, National Gallery), a copy of Giovanni Bellini.

TA CH'ENG MIAO, *see* CONFUCIUS, TEMPLE OF, PEKING.

TACHISM. Name derived from the French *tache*, meaning "spot" or "blob," and given to a mid-20th-century style of painting that is not concerned with natural representation (portrait, figure, nude, landscape, still life) or composition (perspective, light, and shade). Tachism seeks above all to create a suggestion of nonstatic construction and relies essentially on unconscious, accidental manipulations of color, including dripping. In France tachism has become synonymous with gestural painting (where the gesture or movement is more important than the technique of drawing). The leading exponents of tachism are Wols (*Composition en vert*) in France, Pollock (*No. 21949*) and Francis (*Eté No. 1*; New York, Martha Jackson Gallery) in the United States, K. R. H. Sonderborg in Denmark, Schultze in Germany, and Davie in England. Tachism with its roots in Japanese calligraphy has become the favorite means of expression of a whole group of French painters, exemplified by Hartung. *See* DAVIE, ALAN; FRANCIS, SAM; HARTUNG, HANS; POLLOCK, JACKSON; WOLS.

See also ABSTRACT EXPRESSIONISM.

BIBLIOGRAPHY. M. Ragon, *L'Aventure de l'art abstrait*, Paris, 1956; B. Dorival, *Twentieth-Century French Painters*, 2 vols., New York, 1958; H. Read, *A Concise History of Modern Art*, London, 1959.

TACTILE VALUES. Those qualities in painting that appeal to the sense of touch, perceived through the artist's rendering of depth and three-dimensionality. The term was

first used by Bernard Berenson in his discussion of the qualities of Florentine painting. He cited the paintings of Giotto, Masaccio, and Michelangelo as being rich in tactile values. *See* BERENSON, BERNARD.

BIBLIOGRAPHY. B. Berenson, *The Italian Painters of the Renaissance*, 2d ed., London, 1952.

TADANOBU, *see* SHOEI.

TADDA, FRANCESCO DEL, *see* FERRUCCI, FRANCESCO DI SIMONE.

TADDEO DA SESSA. Romanesque portrait bust, in the Capua Museum.

TADDEO DI BARTOLO. Sienese painter (1362/63–1422). A widely traveled artist, Taddeo di Bartolo is most significant for his introduction into Tuscany of the northern International Gothic style. The most recent comprehensive analysis of his work has divided his *oeuvre* into three basic periods: a formative phase dating from about 1389 to 1400; the span from about 1400 to 1409 when his art was most indebted to the International Style; and a final phase, from 1409 to 1422, which witnessed the weakening of his creativity as a painter.

Characteristic of Taddeo's early work is the altarpiece with Madonna and saints (1389) executed for the Church of S. Paolo in Collegarli. The composition is based on the earlier-14th-century formula of Duccio and Simone Martini, seen in the stiff, hieratic figure of the Madonna and Child; but onto this foundation Taddeo has grafted the stylistic experiments of his older contemporaries, such as Bartolo di Fredi and Giacomo di Mino (in whose shop Taddeo may have been trained). Thus the figures of the lateral saints are swathed in voluminous draperies, their facial contours are crisply drawn, and their expressions are somber, nearly morose. In an attitude that is also characteristic of Taddeo's work, the saints are turned slightly inward as if actually saluting the Virgin, This style, constructed out of various influences, was compounded in 1393 by Taddeo's trip to Genoa, where he came into contact with Barnaba da Modena. The archaistic elements

Taddeo di Bartolo, *The Assumption,* from the fresco cycle *Life of the Virgin.* Palazzo Pubblico, Siena.

of that master's style frequently appear in Taddeo's works after 1393, for instance, in the use of gold striations on garments. Finally, an important example of the developed eclecticism of Taddeo's early phase is the S. Donnino *Crucifixion* (1395; Pisa, National Museum of St. Matthew). Again, a fundamentally Ducciesque formula has been rearranged in order to isolate the figure of Christ at the top, while the attendant figures are massed into two tightly packed groups below and are depicted with great attention to intensity of emotion and genre-like detail. As before, onto the traditional Sienese framework the artist has fused a surface layer made up of elements from the works of Barnaba da Modena, Giacomo di Mino, Bartolo di Fredi, and even Andrea Vanni.

By 1397, however, Taddeo had obviously begun to experiment with the northern International Style, which was to dominate his work from 1400 onward. For instance, in the *Baptism* in the collegiate church in Triora, Liguria, aspects of Giovanni da Milano's style (encountered by Taddeo in Genoa) begin to transform Taddeo's simple broad draperies into more complicated, "Gothic" convolutions. This form of the International Style is fully developed in the 1403 altarpiece executed for S. Domenico in Perugia and reaches its climax in the fresco cycle in the Palazzo Pubblico in Siena. In the latter, Taddeo's greatest achievement, the scenes from the *Life of the Virgin* are set within slender Gothic architectural frameworks, the figures are animated and dramatic in their expressions, and the drapery is rendered in a series of deeply sculptured folds, drawn horizontally and masking the plasticity of the form beneath to fall in heavy masses at the sides. The compositions are refined and elegant, and the coloring is warm and reddish in tone.

Taddeo's last period is generally characterized by the loss of those ennobling and refined elements seen in his mature style, although he does experiment with new and varied iconographic themes. However, his last style, seen as early as the *St. Christopher* (1412) in the Palazzo Pubblico, shows a new monumentality (perhaps Giottesque), but one without real grandeur or grace. This ponderous, arid, and sometimes coarsened mode may be seen as well in the *Volterra Altarpiece* (Volterra, Pinacoteca) and in the large series of *Famous Men* executed in the Palazzo Pubblico in 1414. Fundamentally, Taddeo in all his later works has simply reduced his earlier experiments to rather mediocre standard types, neither idealistic nor realistic, which tends to give them an air of bland uniformity. His speed of execution and large workshop of assistants may also have contributed to Taddeo's artistic decline.

BIBLIOGRAPHY. G. H. Edgell, *A History of Sienese Painting*, New York, 1932; C. Brandi, *Quattrocentisti senesi*, Milan, 1949; R. Krautheimer, *Lorenzo Ghiberti*, Princeton, 1956; N. Rubinstein, "Political Ideas in Sienese Art: The Frescoes by Ambrogio Lorenzetti and Taddeo di Bartolo in the Palazzo Pubblico," *Journal of the Warburg and Courtald Institutes*, XXI, July, 1958; E. Borsook, *The Mural Painters of Tuscany*, London, 1960; S. Symeonides, *Taddeo di Bartolo*, Siena, 1965. PENELOPE C. MAYO

TADMOR, *see* PALMYRA.

TAENIA. Projecting band or fillet (from the Greek *tainia*, "fillet") separating the architrave from the frieze above it in the Doric entablature.

TAEUBER-ARP, SOPHIE. Swiss sculptor (b. Davos, 1889; d. Zurich, 1943). She studied at the School of Applied Arts in St. Gall and at the Debschitz School in Munich and taught in Zurich at the School of Arts and Crafts (1916–29). Active in the Dada movement, she was married to Jean Arp. Her best sculptures are of the 1935–38 period.

BIBLIOGRAPHY. M. Seuphor, *The Sculpture of This Century*, New York, 1960.

TAFI, ANDREA, *see* ANDREA TAFI.

TAFKA, BASILICA OF. Syrian (East Christian) church, probably dating from the late 4th century. The basilica is an unusual masonry structure. Almost square in plan, it is a low edifice with a barrel-vaulted nave and side aisles.

Tahull. Detail of the Pantocrator, 12th-century apse fresco from S. Clemente. Museum of Catalonian Art, Barcelona.

The vaulting springs from low squat piers, and the aisles and galleries are similarly vaulted. A single "flattened" semicircular apse extends axially with the nave, and a tower in three stages abuts the exterior wall to the left of the main entrance. The structure may originally have been built for pagan use.

BIBLIOGRAPHY. O. K. Wulff, *Altchristliche und byzantinische Kunst*, 2 vols. in 1, Berlin, 1914.

TAFT, LORADO. American sculptor (1860–1936). Born in Illinois, he studied at the University of Illinois and with Dumont, Bonnassieux, and Thomas at the Ecole des Beaux-Arts in Paris (1880–85). Taft settled in Chicago in 1886 and soon won recognition in the field of public memorial and allegorical sculpture. His awards and prizes included those given by the Chicago Exposition in 1893, the Buffalo Exposition in 1901, and the St. Louis Exposition in 1904. He was accepted by the National Academy of Design in 1909 and was director of the American Federation of Arts from 1914 to 1917. Taft wrote a famous book, *The History of American Sculpture*, and became influential both as teacher and as lecturer. He taught during most of his career at the Art Institute of Chicago.

Among Taft's best-known works are *Washington Memorial* (Seattle, Wash.); the *Trotter Fountain* (Bloomington, Ill.); war memorials (Oregon, Ill., and Danville, Ill.); and a marble group, *Solitude of the Soul* (Chicago, Art Institute). *Fountain of Time* (1920; Chicago) is among his most complex and meaningful compositions, conceived as passing groups of figures representing various phases of history. Taft's style combined both neoclassical and Rodinesque influences, his fundamental tendency aligning itself with realism softened somewhat by impressionism.

BIBLIOGRAPHY. L. Taft, *The History of American Sculpture*, rev. ed., New York, 1930. JOHN C. GALLOWAY

TAHITI. One of the Society Islands, southwest of the Marquesas in French Polynesia. Its most characteristic arts are tapa cloth, which in recent times has become commercialized; handle ornaments of wooden functional and ceremonial objects carved in the form of the human figure, usually in strongly geometric style; and occasional three-dimensional figures, possibly of deities, with an implicit mobility in space that is unusual in Polynesian art. Tahitian sculptural style is generally related to that of the Marquesas, and, like the latter, lacks the surface ornamentation prevalent in much Oceanic art. Polychromy is seldom used.

See also OCEANIC ART (POLYNESIA); POLYNESIA.

BIBLIOGRAPHY. T. Henry, *Ancient Tahiti*, Honolulu, 1928; M. Leenhardt, *Arts d'Océanie*, Paris, 1947.

TAHOTO OF ISHIYAMADERA. Japanese Buddhist pagoda in the Ishiyamadera near Kyoto. The idea of a Tahōtō (Pagoda of Many Treasures) was imported from China by the Shingon and Tendai priests in the Heian period (794–1185). No example from that period remains. The Tahōtō in the Ishiyamadera dates from 1194, and is the oldest and most beautiful of all existing Tahōtō. Its cylindrical form rises into a dome that is covered with plaster and surmounted by a wide roof.

BIBLIOGRAPHY. Tokyo National Museum, *Pageant of Japanese Art*, vol. 6: *Architecture and Gardens*, Tokyo, 1952; R. T. Paine and A. Soper, *The Art and Architecture of Japan*, Baltimore, 1955.

Tai Chin, *Autumn River*, from the *Fishermen* scroll. Freer Gallery, Washington, D.C.

TAHULL (Taull). Town in the Pyrenees region of Catalonia, Spain. Tahull is notable for two Romanesque churches, S. Clemente and S. María, both consecrated in 1123. Each has three aisles terminated by three semicircular apses, and each is covered by a double pitched roof. At S. Clemente the tower is detached; at S. María it is built onto the south wall. The decorative details and fine massing of S. Clemente, the better preserved of the two, reveal strong Lombard influence. The apse frescoes of both churches (Barcelona, Museum of Catalonian Art) are among the masterpieces of Catalan Romanesque painting. One fresco shows the Pantocrator surrounded by an unusual representation of angels with the symbols of the Evangelists above four male saints and the Virgin. The Museum of Catalonian Art also displays sculpture and other furnishings from the Tahull churches.

BIBLIOGRAPHY. *Catalogne Romane*, text by E. Junyent, vol. 1 [La Pierre-qui-Vire (Yonne)], 1960.

TAI CHIN (Tai Wen-chin). Chinese landscape painter (fl. early 15th cent.). His *hao* was Ching-an. Born at Ch'ien-t'ang near Hang-chou in Chekiang Province, he was summoned to the Ming court of Hsüan-tsung (r. 1426–35). When Tai Chin returned to Chekiang after a few years, he became the most important member of a local school of painting that was to be known ultimately as the Che school. *See* CHE SCHOOL.

Tai Chin is usually considered the founder of the Che school, although his varied output sets him apart from other members of this group. He did revitalize the Ma-Hsia tradition that had never quite died out in the Hang-chou area, and this continuation of the Southern Sung academic style was the main contribution of the Che school. In some of Tai Chin's best works in the Ma-Hsia manner, such as *Returning Late from a Spring Outing* (Formosa, Sun Yat-sen Museum), the polish and verve of his per-

formance seem to be an even further refinement of the Southern Sung works. But others of Tai Chin's masterpieces, such as the *Fishermen* scroll (Washington, D.C., Freer Gallery), reveal his gift for accurate recording and brilliant spontaneous brushwork, elements that are foreign to so many Che-school paintings. *See* MA-HSIA SCHOOL.

BIBLIOGRAPHY. O. Fischer, "Ein Werk des Tai Wên-chin?" *Ostasiatische Zeitschrift*, I, 1912/13; G. Exke, "Comments on Calligraphies and Paintings," *Monumenta Serica*, III, 1938; J. F. Cahill, *Chinese Painting*, New York, 1960.

MARTIE W. YOUNG

TAIGA (Ike Taiga). Japanese calligrapher and painter (1723–76). In his youth Taiga studied the Tosa style and made his living by selling the fans he painted. He was also influenced by the European manner of handling space, and a faint suggestion of European perspective is seen in many of his landscapes. Taiga traveled widely, making sketches of actual scenery. He finally became a true painter of the Nanga tradition and often extolled the beauty and joys of country life. In this vein are albums called *The Ten Advantages* and *The Ten Pleasures* (1771; Kawabata Collection), made by him in collaboration with Buson to illustrate poems by Li Li-wêng, a Chinese artist of the early Ch'ing dynasty. *See* BUSON; NANGA SCHOOL; TOSA SCHOOL.

BIBLIOGRAPHY. R. T. Paine and A. Soper, *The Art and Architecture of Japan*, Baltimore, 1955; T. Akiyama, *Japanese Painting* [Geneva?], 1961.

T'AI-HO-TIEN, *see* PEKING.

T'AI-TS'UNG HORSES. Chinese bas-reliefs of the T'ang dynasty (618–906). During this period a number of the imperial tombs were decorated with sculptural figures of horses, lions, and court officials. The best-known examples of such imperial secular sculpture are the bas-reliefs from

T'ai-ts'ung horses. Relief from the tomb of the first T'ang emperor. University Museum, Philadelphia.

the tomb of the first T'ang emperor, Tai-ts'ung, commissioned in 637 and presumably installed in a separate building near the burial mound proper. Of the six reliefs, which were devoted to depictions of the favorite horses of the Emperor, two are now in the collection of the University of Pennsylvania Museum, Philadelphia. They stand more than 5 feet high, the horse and groom being beautifully adapted to the rectangular shape of the stone. There is a long-standing tradition that the reliefs were carved after a design by the famous T'ang court painter Yen Li-pen; if this is true, the T'ai-ts'ung reliefs are rare examples of

Taj Mahal, Agra. The white marble mausoleum seen from the entrance.

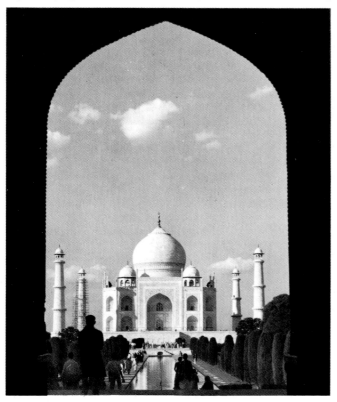

close cooperation between painter and sculptor in China. *See* Yen Li-pen.

BIBLIOGRAPHY. O. Sirén, *Chinese Sculpture, From the Fifth to the Fourteenth Century*, vol. 3, London, 1925.

TAIWAN: SUN YAT-SEN MUSEUM, *see* Formosa: Sun Yat-sen Museum.

TAI WEN-CHIN, *see* Tai Chin.

TA-JIH, *see* Vairocana.

TAJ MAHAL, AGRA. World-renowned Indian mausoleum of Mumtaz Mahal, wife of Shah Jahan, emperor of India. It was erected between 1632 and 1643. The structure, set on a platform above the Jumna River, is of white marble and square in plan. There is a shallow dome over the central tomb chamber, and an outer bulbous dome soars some 200 feet above the platform. On the exterior the marble is carved in low relief, and on the interior it is inlaid. with semiprecious stones.

TAKANOBU (Fujiwara Takanobu). Japanese portrait painter (1142–1205). Takanobu was also a courtier and poet. He is believed to have collaborated with Mitsunaga and to have filled in faces for the pictures of court processions of 1173. The portrait of Yoritomo (the founder of the Kamakura shogunal government) in the Jingoji near Kyoto is generally accepted as the best surviving example of his work. *See* Mitsunaga.

BIBLIOGRAPHY. T. Akiyama, *Japanese Painting* [Geneva?], 1961.

TAKAYOSHI (Fujiwara Takayoshi). Japanese painter (fl. mid-12th cent.). Takayoshi was a courtier and a renowned painter of the period. His name appears often in literary records of the time, but no certain works by him remain. The traditional attribution of the *Tale of Genji Scroll* to him has generally been rejected in recent studies.

BIBLIOGRAPHY. R. T. Paine and A. Soper, *The Art and Architecture of Japan*, Baltimore, 1955.

TAKUMA SCHOOL. School of Japanese painters. It was founded by Tametō (fl. 1132–74), but it soon branched out into two groups. One group, established by Shōga, Tametō's eldest son, worked mainly for Buddhist temples in Kyoto. The other, founded by the third son of Tametō, Tamehisa (fl. late 12th cent.), settled in Kamakura and worked for the shoguns. The Takuma school revitalized Buddhist painting of the Kamakura period by introducing into it a new influence from Sung China. In the 14th century, however, with Eiga its last important painter, the school ceased to be a significant creative force in Japan. Among the more noted members were Chōshō (d. 1332), Ryōzen (fl. mid-14th cent.), and Tameyuki (fl. mid-13th cent.). Shunga and Jōnin, who worked at the Kōzanji in the early 13th century, may also have belonged to this school. Tamenari, who in some literature is recorded as having painted the walls of the Hōōdō in Uji, is sometimes credited with founding the Takuma school, but this theory lacks historical evidence. *See* Ryozen; Shoga.

BIBLIOGRAPHY. R. T. Paine and A. Soper, *The Art and Architecture of Japan*, Baltimore, 1955; T. Akiyama, *Japanese Painting* [Geneva?], 1961.

Takanobu, *Portrait of Fujiwara Mitsuyoshi*, Fujiwara period. Color on silk. Jingoji, Kyoto.

TALA. Unit of measure used in giving prescribed proportions (*tālamāna*) for various Hindu images. The *tāla* is the height of the face from chin to hairline.

TAL COAT PIERRE. French painter (1905–). A native of Clohars-Caoët, Brittany, Tal Coat was influenced by the French and foreign painters who frequented this fishing village. In 1931 he participated in the activities of the Forces Nouvelles group. The Spanish Civil War left a deep impression on his art and was reflected in his violent colors and tortured forms. In 1940 he settled in Aix-en-Provence, where he continued his experiments in light and movement. From 1947 onward his painting, influenced by his interest in old walls and surrounding vegetation, acquired the flavor of Oriental painting, especially that of the Sung dynasty. Tal Coat seeks above all to express the hidden mysteries of nature. Typical of his technique of dripping colors on a neutral background is *Souvenir de Dordogne* (1955; Paris, private collection).

BIBLIOGRAPHY. H. Maldiney, "Tal Coat," and A. Du Bouchet, "Ecart, non déchirement," *Derrière le Miroir*, no. 64, 1954; B. Dorival, *Twentieth-Century French Painters*, 2 vols., New York, 1958.

TALENTI, FRANCESCO. Italian architect and sculptor (b. ca. 1300; last mentioned in a document dated July 31, 1369, in Florence). He may have been connected with the building of the Cathedral of Orvieto, according to a document of 1325. All attributions of sculpture to him are doubtful. He was active in the construction of the Cathedral of Florence, perhaps beginning immediately after Andrea Pisano left, about 1343; Talenti was probably occupied with this work until the end of 1364. In April, 1357, he was in Siena. At the beginning of 1365 he was released for an uncertain period from his position as *capomastro* at the Cathedral of Florence, but by 1369 he had resumed his work there. He was the father of Simone di Francesco Talenti.

BIBLIOGRAPHY. M. Weinberger, "The First Façade of the Cathedral of Florence," *Journal of the Warburg and Courtauld Institutes*, IV, October–January, 1940–41.

TALENTI, SIMONE DI FRANCESCO. Italian sculptor and architect (b. ca. 1340–45; last mentioned in a document on Mar. 23, 1381, in Florence). He was the son of Francesco Talenti, in whose workshop Simone learned his craft. A document gives evidence of his activity there on Feb. 16, 1358, when he was working on a capital for the Cathedral of Florence. In 1366 he entered the competition for a plan for the choir of the Cathedral. The following year he received a commission for work on Or San Michele, Florence. He was inscribed in the stonemasons' guild in 1368. Like his father, he played an important part in designing the Cathedral, for which, together with Taddeo Ristori, he was *capomastro* from Mar. 1, 1376. He also worked on the Loggia dei Lanzi and the small Church of S. Michele (now S. Carlo dei Lombardi).

TALE OF GENJI SCROLL. Japanese *emaki* (early 12th cent.). The scroll, now separated into individual sheets, was originally in much larger form. The nineteen sheets of pictures and thirty-seven sheets of text are in the Tokugawa Reimeikai and Gotō Museum of Tokyo. The scroll illustrates the celebrated love story of Prince Genji, written in the early 11th century by Lady Murasaki. The colors are laid on in thick, opaque coats, creating abstract patterns; roofs of buildings are often shown blown off to allow an unobstructed view of the interiors; and the facial features of the figures are drawn in ink in the simplest possible manner, disregarding sex and individual differences. The artist, in the past erroneously thought to be Takayoshi, sought to convey not so much the action of the story but rather something of the lyricism and sentiment that inform it. This scroll is the best example of the paintings that reflect the refinement, sophistication, and splendor of the court life of the Fujiwara period.

BIBLIOGRAPHY. A. C. Soper, "The Illustrative Method of the Tokugawa 'Genji' Pictures," *Art Bulletin*, XXXVII, March, 1955; *Nihon emakimono zenshū (Japanese Scroll Paintings)*, vol. 1: *Genji monogatariemaki*, Tokyo, 1958; H. Okudaira, *Emaki (Japanese Picture Scrolls)*, Rutland, Vt., 1962; National Commission for the Protection of Cultural Properties, ed., *Kokuhō (National Treasures of Japan)*, 6 vols., Tokyo, 1963– .

TALLER DE GRAFICA POPULAR (Workshop for Popular Graphic Art). Contemporary Mexican graphic artists' group formed in 1937 for purposes of communal activity. These artists were influenced strongly by Posada (as in the *corridos*) and by the dynamic expressionism of Orozco. Beginning under the leadership of Méndez, O'Higgins, and Arenal, with the encouragement of Siqueiros, the group soon had sixteen members and has since attracted other artists from Mexico, the United States, and Europe. Individually and collectively, Taller members have turned out a large amount of graphic work, much of it political or social in nature (*Deportation to Death*, 1943; by Méndez) and some in the fine-arts print tradition (*Estampas de Yucatán*, 1945; series by Zalce). *See* ARENAL, LUIS; CORRIDO; MENDEZ, LEOPOLDO; O'HIGGINS, PABLO; ZALCE, ALFREDO.

BIBLIOGRAPHY. *El Taller de gráfica popular, doce años de obra artística colectiva*, Mexico, 1949; B. S. Myers, *Mexican Painting in Our Time*, New York, 1956.

Pierre Tal Coat, *Composition*. Private collection, Paris.

Tale of Genji Scroll. Sheet no. 1 of the *emaki* illustrating a celebrated love story by Lady Murasaki. Tokugawa Reimeikai and Gotō Museum, Tokyo.

TALLINN: ST. OLAI, *see* REVAL: ST. OLAI.

TALMAN, WILLIAM. English architect (1650–1719). He was the country-house architect *par excellence*, monopolizing big projects between 1680 and 1700. His innovations were mainly in planning and in applying baroque façades to country houses, exemplified by Chatsworth (1685). *See* CHATSWORTH.

TALPINO, ENEA (Il Salmeggia). Italian painter (b. Salmeggia, ca. 1550; d. Bergamo, 1626). A student of Campi in Cremona, Talpino in his many religious paintings in and around Bergamo combined the graceful figure style of Raphael, whose work he ardently studied during fourteen years in Rome, and the dynamic compositions and light effects of Procaccini.

TALUD-TABLERO. Type of ancient Mexican architectural motif stemming from the Teotihuacán culture. It consisted of a rectangular panel with an inset over a sloping section.

TAMAGNI, VINCENZO (Vincenzo da San Gimignano). Italian painter (b. San Gimignano, 1492; d. there, ca. 1530). Although his early training was probably with Sebastiano Mainardi, a student of Ghirlandajo, Tamagni changed his direction entirely while working with Sodoma in Monte Oliveto (1505–06). Tamagni made recurrent trips to Rome, during one of which he is thought to have worked with Raphael. In 1527 Tamagni returned to Tuscany and was again influenced by Florentine and Umbrian painting. His paintings, such as *The Nativity of Mary* (1523; San Gimignano, S. Agostino), are eclectic and show limited talent, but his drawings have a personal stamp.

BIBLIOGRAPHY. A. Venturi, *Storia dell'arte italiana*, vol. 9, pt. 5, Milan, 1932.

TAMAGNINI, ANTONIO (Antonio della Porta). Italian sculptor (fl. Milan, 1475). He was a principal decorator of the Certosa in Pavia; the angels at either side of the great door may be ascribed to him, as well as several of the larger façade statues and the right-hand tabernacle by the high altar. He also worked at Brescia, chiefly in S. Maria dei Miracoli.

BIBLIOGRAPHY. W. G. Waters, *Italian Sculptors*, 2d ed., London, 1926.

TAMAMUSHI SHRINE. Japanese painting of the 7th century, on a small household shrine in the Hōryūji near Nara. The shrine stands on a tall base, and its openwork metal edging was once inset with the iridescent wings of *tamamushi* (beetles), which gave the shrine its name. Painted

Tamamushi shrine. Small household shrine, dating from the 7th century, in the Hōryūji, near Nara.

panels on four sides of the shrine are done in lacquer in red, yellow, and green against a black background. They show Buddhist guardian figures, monks in worship, and two narrative scenes from the Jātaka stories (tales of Buddha's previous existences). These scenes are the earliest examples in Japan of pictures done in a narrative manner. They represent a series of successive moments within the story seen against a unified background. This technique later developed into the highly sophisticated *emaki* art. The style of the painting also reflects the art of Northern Wei China, especially in the sinuous elegance and grace of the slender figures. They stand on a fantastic C-shaped cliff, seemingly built up from a series of straight and curving ribbons of several colors.

BIBLIOGRAPHY. Tokyo National Museum, *Pageant of Japanese Art*, vol. 1: *Painting* [pt.] 1, Tokyo, 1952; T. Akiyama, *Japanese Painting* [Geneva?], 1961; National Commission for the Protection of Cultural Properties, ed., *Kokuhō (National Treasures of Japan)*, vol. 1: *From the Earliest Times to the End of the Nara Period*, Tokyo, 1963.

TAMAYO, RUFINO. Mexican painter (1899–). Tamayo was born in Oaxaca and went to school in Mexico City, where he also learned to draw. He attended the Academy of San Carlos for three years, but, like others of his generation, he was uninspired by the traditional academic art program and later studied intensively on his own. In 1921 he became head of the department of eth-

nographic drawing in the National Museum of Anthropology. The association with Aztec, Maya, and Toltec sculpture was to have a deep impact on his later work.

His first show was held in an empty shop in Mexico City in 1926, and in the fall of that year he took the exhibition to New York, where he sold several pictures and received much acclaim. In 1929 a show of his work was one of the first gallery exhibitions of younger artists in Mexico City. Throughout his career he has held various official posts connected with the arts and has divided his time, working in Mexico City, New York, and, more recently, Paris.

Early in his development Tamayo reacted against the domination of the prominent Mexican muralists and sought a more modernist technique. He first created small, intimate canvases. Influenced by Matisse and later, more lastingly, by Braque, his low-keyed early work has a decided personality of its own. In 1929 he began to paint brighter pictures and to deal with social themes, for example, the portrait of Juárez (1932; Mexico City, private collection). Spatial relationships became a preoccupation, as in the *Women of Tehuantepec* (1939; private collection). His drawings and paintings of animals achieve real power through calculated dislocations. Tamayo's paintings were shown at the Venice Biennale in 1950.

It was not until 1933 that he turned to murals; in 1943 he painted a fresco for the Hillyer Art Library of Smith

Rufino Tamayo, *The Cry*, 1953. National Gallery of Modern Art, Rome.

Tanagra. Terra-cotta figurine of a draped woman. Louvre, Paris.

T'ang figurines. Small pottery sculptures of fighting horses, examples of the type of figurine placed in tombs during the T'ang dynasty.

College in Northampton, Mass. His two most celebrated Mexicanist murals were done in 1952 and 1953 in the Palace of Fine Arts in Mexico City. Executed in vinylite on canvas, they are the *Birth of Nationality* and *Mexico Today*. A *Prometheus* mural for the library of the University of Puerto Rico was completed in 1957. During the next two years Tamayo worked on large-scale murals, using plastic paints, for UNESCO headquarters in Paris.

Tamayo's work synthesizes the vibrant colors and forms of his native Mexico, a bold and solid composition, and the sophistication absorbed from the school of Paris.

BIBLIOGRAPHY. R. Goldwater, *Rufino Tamayo*, New York, 1947; B. S. Myers, *Mexican Painting in Our Time*, New York, 1956; A. M. Reed, *The Mexican Muralists*, New York, 1960.

FRANKLIN R. DIDLAKE

TAMBA. One of the Six Ancient Kilns in Japan. It began operations in the Kamakura period (1185–1333) and continued to modern times. The vessels are made of heavy stoneware with reddish-brown bodies and thick, glassy, grayish-green drippy glazes resembling those of Iga and Shigaraki. *See* JAPAN: CERAMICS.

BIBLIOGRAPHY. R. A. Miller, *Japanese Ceramics*, Rutland, Vt., 1960.

TAMBOUR. Architectural term for the wall of any round structure, such as the drum-shaped element that rests on pendentives and supports the dome of St. Peter's in Rome. It is also used to denote the bell of a Corinthian capital upon which acanthus leaves are carved.

TAMECHIKA (Reizei Tamechika). Japanese painter (1823–64). He was prominent among the Japanese painters who attempted to revive Yamato-e. Greatly attracted to the life and culture of Heian Japan, he set out to copy many scroll paintings from that period. His enthusiasm for history aroused the antagonism of the royalists, by whom he was assassinated. *See* YAMATO-E.

TAMI ISLAND, *see* OCEANIC ART (MELANESIA: NEW GUINEA).

TA-MO, *see* BODHIDHARMA.

TANAGRA. Greek city on the border between Attica and Boeotia. It was subject to the influence of both Athens and Thebes. Tanagra is important in art history as the site of a Hellenistic terra-cotta industry famed for its miniature sculpture. The Tanagra workshops specialized in elegant statuettes of draped women, which are conventionally known today as Tanagra figurines. Most of the examples come from graves at Tanagra. Some were found at Alexandria and at Myrina in Asia Minor, where Theban refugees set up new workshops after the destruction of Thebes in 335 B.C. by Alexander the Great. The whole series appears to date from about 340 B.C. to 150 B.C. and to follow the general evolution of Hellenistic sculpture.

BIBLIOGRAPHY. G. Kleiner, *Tanagrafiguren*, Berlin, 1942; D. B. Thompson, "Tanagrafiguren by G. Kleiner" [Book Review], *American Journal of Archaeology*, series 2, LIV, 1950; D. B. Thompson, "The Origin of Tanagras," *American Journal of Archaeology*, LXX, January, 1966.

TANDAVA. Wild dance of the Hindu God Siva performed with Devī in cemeteries and burning grounds. The *tāṇḍava* is quite distinct from Siva's dance as Naṭarāja.

T'ANG ART, *see* CHINA: ARCHITECTURE, BRONZES, CALLIGRAPHY, CERAMICS, JADE, LACQUER, PAINTING, PAPER, SCULPTURE, SILK.

TANGE, KENZO. Japanese architect (1913–). His interest in large community projects found a dramatic expression in the designs for the gymnasium and annex built for the Tokyo Olympics of 1964. Although the influence of Le Corbusier is evident, particularly in the handling of natural concrete, his works exhibit the grace and drama of the native architectural tradition. His works include the Hiroshima Peace Center and town halls in Kurashiki, Shimizu, and Tokyo. In 1966 his designs for office and broadcasting centers initiated his plan for reorganizing Tokyo. (See illustration.)

BIBLIOGRAPHY. U. Kultermann, *New Japanese Architecture*, New York, 1961.

TANGERMUNDE RATHAUS. German town hall of the first half of the 15th century. A fine example of Brandenburgian tile architecture, the Tangermünde Rathaus is re-

lated to the Fronleichnam Chapel of the Church of St. Catherine, Brandenburg. The architect is considered by some to be Heinrich Brunsberg. The intricate tracery is in striking green-glazed brick.

BIBLIOGRAPHY. H. Müther, *Baukunst in Brandenburg bis zum beginnenden 19. Jahrhundert*, Dresden, 1955.

T'ANG FIGURINES. During the T'ang period in China it was the practice to place small sculptures of glazed or unglazed pottery in tombs. The number, quality, and arrangement of the figurines depended on the rank of the deceased. These lively representations of animals (particularly horses and lions), court ladies, musicians, merchants, and other types provide an interesting record of the activities and fashions of the day. At their best, the figurines are the most naturalistic works of Chinese art of the time, but their quality and manufacture seem to have declined toward the end of the period. (See illustration.)

T'ANG LIU-JU, *see* T'ANG YIN.

TANGUY, YVES. French-American painter (1900–57). Tanguy was born in Paris. His father was a naval officer from Brittany, and Tanguy sailed with the merchant marine in his youth. He saw a painting by De Chirico in Paul Guillaume's gallery and at once, self-taught in painting, began his career as an artist. After joining the surrealists in 1925, he participated in their major exhibitions, including the 1936 London and 1938 Paris International Exhibitions. He lived in the United States after 1939.

Despite his lack of formal training in art, Tanguy was one of the most orthodox of stylists in the surrealist group. His was a smooth, painstakingly modeled and lighted naturalism, not at all in sympathy with the technical innovations of Ernst, Miró, Arp, and others who came to surrealism by way of Dada. The quality of fantasy in his themes is distinctly more advanced than his aesthetic.

Among Tanguy's characteristic paintings, all of them executed in a mode related to that of Dali, Magritte, and Delvaux, are *Extinction of Useless Lights* and *Mama, Papa is Wounded!* (both 1927; New York, Museum of Modern Art), *Untitled Landscape* (1927; France, private collection), and *Four O'Clock in Summer: Hope* (private collection). His *Fear* (1949; New York, Whitney Museum) and a few

Yves Tanguy, *Palais aux rochers de fenêtres*, 1942. National Museum of Modern Art, Paris.

later works disclosed Tanguy's potential—never fully exploited—as a more liberated and provocative stylist. Tanguy is among the most programmatic of surrealist imagists, creating deliberately illogical, dreamlike objects and situations that have been likened to Bretonese folk mysteries and superstitions.

BIBLIOGRAPHY. A. Breton, ... *Le Surréalisme et la peinture...*, 2d ed., New York, 1945; A. Breton, *Yves Tanguy*, New York, 1946; P. Waldberg, *Surrealism* [Geneva?], 1962. JOHN C. GALLOWAY

T'ANG YIN (T'ang Liu-ju). Chinese painter (1470–1523). He was known by his *tzu* Po-hu but more frequently by his *hao* which was Liu-ju. A native of the Su-chou region, he is counted among the "Four Great Masters" of the Ming dynasty and had some skill in poetry as well as painting. He was born of a merchant-class family but was taken under the tutelage of Wen Cheng-ming's father and became friendly with the various masters of the Wu school of painting. He was a brilliant and precocious child, and at the age of twenty-eight he took the state examination at Peking, hoping for a place in the government. A scandal over cheating involved T'ang Yin in some manner, and he returned to Su-chou somewhat embittered and in disgrace. He then took up painting as his profession, living a precarious existence that included a great deal of drinking on the one hand and Ch'an Buddhist meditation on the other. *See* WEN CHENG-MING.

The stormy career of T'ang Yin did not greatly affect the quantity of his output, and he is among the better-represented Ming painters in terms of existing paintings. Since he was at one time a pupil of Chou Ch'en, it is

Kenzo Tange, Tokyo Metropolitan Festival Hall.

not surprising that some of the Li T'ang mannerisms of his teacher are retained by T'ang Yin. But T'ang Yin is difficult to classify or sum up simply, and like another of the Four Masters, Ch'iu Ying, he has quite a wide range. He gained some reputation for his paintings of pretty women, but it is questionable that even this prolific painter could have executed the number of mediocre works of the court-lady type that bear his signature today. *See* CH'IU YING; CHOU CH'EN; LI T'ANG.

Of the variety of paintings that T'ang turned out in his lifetime, a small core of related works stand out at least as significant achievements: these are the large landscapes, both hand scrolls and hanging scrolls, in which the Li T'ang style is transformed in conspicuous terms. Such paintings as *Whispering Pines on a Mountain Path* (Formosa, Sun Yat-sen Museum) are majestic evocations of an earlier spirit molded by a 16th-century vocabulary. T'ang Yin is aptly described by Sherman Lee as "the last voice of the monumental style," and perhaps this alone justifies T'ang Yin's reputation in Chinese history.

BIBLIOGRAPHY. W. Speiser, "T'ang Yin" [pt. 2], *Ostasiatische Zeitschrift*, XXI (N.F.XI), 1935; Y. Tseng, "Notes on T'ang Yin," *Oriental Art*, n.s., II, Spring, 1956; S. E. Lee, *Chinese Landscape Painting*, 2d rev. ed., Cleveland, 1962. MARTIE W. YOUNG

TANIS. Site of the residence city (Djanet in Egyptian) of Rameses II on the outskirts of the eastern delta of the Nile. It is marked by the ruins of a temple of Seth, patron god of the 19th dynasty, and the tombs of the Pharaohs of the 21st and 22d dynasties (1090–745 B.C.), containing colossal anthropoid sarcophagi with their inner coffins of silver. *See* SARCOPHAGUS, ANTHROPOID.

BIBLIOGRAPHY. W. F. Petrie, *Tanis Excavations*, 2 vols., London, 1888; P. Montet, *La nécropole royale de Tanis*, Paris, 1947-60.

TANJORE. City in southern Madras state, India. It was the capital of the Chola dynasty (ca. A.D. 900–1150). The great Hindu temple dedicated to the god Siva, the Rājrājeśvara (ca. 1000), the largest, highest, and most ambitious structure hitherto erected in India, was built under Rājarāja the Great (r. 985-1018). The main structure is 180 feet long and the massive pyramidal tower is 190 feet high. The temple comprises several buildings, axially arranged, which are aligned in the center of a spacious walled enclosure. The surface of the tower is covered with a richly plastic decoration divided by the horizontal lines of the tiers and intersected by ornamental shrines vertically placed. The Rājrājeśvara is considered by many to be the finest creation of the southern Indian craftsman. It contains fine Chola paintings. The modern city is noted for its handicrafts: carpets, silks, jewelry, and copperware.

BIBLIOGRAPHY. H. R. Zimmer, *The Art of Indian Asia*, 2 vols., New York, 1955; P. Brown, *Indian Architecture*, vol. 1: *Buddhist and Hindu Periods*, 4th ed., Bombay, 1959.

TANKA. Tibetan temple-banner painting. (See illustration.)

TANKEI. Japanese sculptor (1173–1256). The oldest son of Unkei, he was influenced by his father and by Kaikei, with whom he often cooperated. Less dynamic than his father's works, Tankei's sculptures are quieter and more refined, as seen in the *Bishamon Triad* of the Sekkeiji in Kōchi prefecture. *See* KAIKEI; UNKEI.

BIBLIOGRAPHY. R. T. Paine and A. Soper, *The Art and Architecture of Japan*, Baltimore, 1955.

TANNER, HENRY OSSAWA. American painter (b. Pittsburgh, 1859; d. Paris, 1937). He studied with Thomas Eakins. As a Negro he felt himself subject to racial persecution, and in 1891 he went to Europe. He settled in Paris and became a student of Constant and Laurens. In 1892 he visited America, but returned to Paris the following year.

His first paintings were academically hard genre pieces such as *The Banjo Lesson* (Hampton, Va., Hampton Institute) and *The Sabot Makers*. Later he turned to romantic religious subjects. *The Annunciation* (1895) and *Disciples Healing the Sick* (1930–35) illustrate his warm, glowing tones, fluid impastos, massive forms, and dramatic light-and-dark contrasts. He gave a deep, psychological Rembrandtesque interpretation to Scripture, imbuing his oils with a sacred and poetic introspection.

BIBLIOGRAPHY. J. A. Porter, *Modern Negro Art*, New York, 1943.

TANNYU (Kano Tannyu). Japanese painter (1602–74). The grandson of Eitoku, he was first called Morinobu but took the priestly name Tannyū in 1636. He became the shogun's official painter in 1617 and was given a house at Kajibashi in Tokyo, where he established the Kajibashi line of the Kanō family. He laid the foundation for the unrivaled prosperity of the school, which monopolized all the important commissions to decorate official buildings of shoguns and residences of feudal lords. Tannyū was a prolific artist, but only a few of his larger works have survived, those in Nijō Palace, Kyoto (1926). The paintings that had been preserved in Nagoya Castle (1633) were destroyed in World War II. Tannyū's paintings, although less bold than Eitoku's, nonetheless have strength and beauty of line; they set the tone that all the later Kanō artists were to follow. *See* EITOKU; KANO SCHOOL.

BIBLIOGRAPHY. R. T. Paine and A. Soper, *The Art and Architecture of Japan*, Baltimore, 1955; T. Akiyama, *Japanese Painting* [Geneva?], 1961.

TANTRA. Sanskrit term meaning "rule" or "ritual." It is the title of certain Indian religious and magical writings in which prominence is given to the female energy of the deity. Tantric forms of deities are many-armed and sometimes polycephalic. *See* VAJRAYANA.

See also MIKKYO; SHINGON; VAIROCANA.

TAN-WON, *see* KIM HONG-DO.

T'AN-YAO CAVES, *see* YUN-KANG.

TANZIO DA VARALLO (Antonio d'Errico). Italian painter (b. Varallo, ca. 1575; d. there, ca. 1635). He probably visited Rome, but his principal works are in the chapels of the Sacro Monte, Varallo, where he painted fresco backgrounds for his brother's lifelike figure groups. Tanzio also executed altarpieces for several churches, including S. Gaudenzio, Novara.

BIBLIOGRAPHY. Turin, Museo Civico, *Tanzio da Varallo...* (catalog), ed. Testori, 1959.

TAO-CHI (Shih-t'ao). Chinese painter (1630–ca. 1717). Born near Wu-chou in Kuangsi Province, he was a descendant of the Ming royal house and a distant relative of Chu Ta, the painter who ranks with Tao-chi as the foremost of the "eccentric" painters of China. Tao-chi be-

Tanka. Tibetan temple-banner painting, 18th century. National Museum of Eastern Art, Rome.

came a Buddhist monk after the fall of the Ming dynasty in 1644 and took to the life of a wandering monk, but he also designed rock gardens for wealthy merchants in Yang-chou. *See* CHU TA.

Tao-chi was acknowledged as one of the great spokesmen of his day. He wrote a short treatise on painting, the *Hua-yü*, in which he claimed his own genius and partly denied much of earlier traditional art with such startling ideas as "The best method is no method." He was equally

known for his poetry, painting, and calligraphy—the skills of the traditional scholar in China—and at the same time was considered slightly mad for his unorthodox behavior. His paintings show a wide variety of styles, and his handling was far from uniform. Despite the divergence of methods, however, there is the common denominator in his paintings of a totally free expressive quality.

BIBLIOGRAPHY. O. Sirén, "Shih-t'ao, Painter, Poet, and Theoretician," *Stockholm, Ostasiatiska samlingarna (Museum of Far Eastern Antiquities) Bulletin*, no. 21, 1946; V. Contag, *Zwei Meister chi-*

nesischer Landschaftsmalerei: Shih-t'ao und Shih-ch'i, Baden-Baden, 1956.

<div align="right">MARTIE W. YOUNG</div>

TAORMINA. Italian town on the east coast of Sicily. It is the ancient Tauromenium. Occupied as early as the 8th century B.C., it was refounded in 397/396 B.C. by Himilco, the Carthaginian general. In 392 B.C. Dionysus I of Syracuse occupied it. Hieron II of Syracuse controlled it during the First Punic War; when he died in 215 B.C. the city submitted to Rome but remained an "independent ally." Taormina was heavily damaged by warring troops in 132 B.C. and again when Augustus captured it in 36 B.C. Augustus then made the city a *colonia,* and it prospered during the Roman Empire.

The most famous monument in Taormina is the Roman theater, with awe-inspiring views of Mt. Etna and, across the water, the Calabrian mountains. Erected by the Greeks (probably in the 3d cent. B.C.), the theater was completely rebuilt in a purely Roman fashion; the stage and a two-story wall behind it are extant. The ruins of a Greek temple (3d cent. B.C.) dedicated to Serapis have been found under the modern Church of S. Pancrazio. Roman remains include a smaller theater, cisterns, a large open bath, and various houses and tombs.

The small palaces, churches, and houses preserve interesting Gothic and Renaissance architectural details.

<div align="right">EVANTHIA SAPORITI</div>

T'AO-T'IEH. Chinese term used principally in connection with ceremonial vessels of the Shang and early Chou dynasties. The name means "glutton" and refers to the animal-type monster or ogre mask, which appears as a ubiquitous motif in the décor of the early bronze vessels. The precise meaning of the term was lost probably before the 4th century B.C., but there is no question that it is the most important single motif in Shang art. The name first appears in the literature of the 5th century B.C., where it is referred to as a symbol of retribution, and the t'ao-t'ieh is traditionally considered a warning against greed (or overindulgence).

There has been considerable speculation among modern scholars, both in China and in the West, as to the significance of the mask and its relation to conventionalized motifs in other parts of the world. Although it appears on Shang bronzes in a variety of forms, ranging from an easily distinguishable raised mask to an intricate pattern of interlaced lines with only the eyes protruding in high relief, most authorities do agree that the general components of the mask are drawn from bovine and feline elements: horns (in the shape of the letter C turned lengthwise), snout, eyes, upper jaw, fangs, and ears. The lower jaw is conspicuously absent, and the mask is always seen frontally and symmetrically, as though the creature had been split precisely down the center line of the snout and flattened out against the surface of the vessel. Of all the various animal motifs which occur on early vessels, the t'ao-t'ieh mask is the only one which appears consistently seen from the totally frontal position. The sense of abstraction in the design of the mask suggests that from the earliest times the t-ao-t'ieh was conceived in symbolic rather than naturalistic terms, and whatever its real meaning, it represented something powerful and well understood by all the Shang people.

One frequent type of t'ao-t'ieh mask deserves special mention. This type employs a secondary motif within the general configuration of the mask, and when examined closely, the motif appears as a form of an independent animal seen in profile. Two of these animals serve to outline the image of the t'ao-t'ieh, resembling two creatures standing on their heads and butted together nose to nose while their bodies stand vertically forming the outer edge of the t'ao-t'ieh. The animal is usually called the *k'uei* dragon and occurs independently or in combination to form the t'ao-t'ieh. *See* K'UEI DRAGON.

BIBLIOGRAPHY. A. Waley, "The T'ao-t'ieh," *The Burlington Magazine,* XLVIII, February, 1926; G. Gombaz, "Masques et dragons en Asie," *Mélanges chinois et bouddhiques,* VII, 1939–45; B. Karlgren, "Notes on the Grammar of Early Chinese Bronze Decor," *Bulletin of the Museum of Far Eastern Antiquities,* XXIII, 1951.

<div align="right">MARTIE W. YOUNG</div>

TAPA, *see* MELANESIA; OCEANIC ART (MELANESIA; POLYNESIA).

TAPESTRY. A worsted or ribbed cloth into which a picture or patterns have been woven. Several techniques are used to achieve the same effect, and the type of loom can be either a high- or a low-warp loom. On the high-warp loom the warp is vertical; on the low-warp loom the warp is horizontal. The low warp is simpler and faster to operate, although the weaver has greater difficulty examining his output as he works, since the face of the tapestry is toward the floor. Generally, a tapestry is conceived as a woven picture, but the tapestry weave has been used to make patterned cloth for clothing, too.

Weaving began in prehistoric times. Although there are no surviving tapestries of that period, representations of patterned cloth in sculpture and frescoes may very well have been tapestry-woven rather than embroidered. The use of this kind of cloth in primitive cultures of recent

T'ao-t'ieh. Vessel with mask motif. Guimet Museum, Paris.

times supports that hypothesis. In ancient Egypt, tapestry-woven patterns were uncovered in the Middle Kingdom tomb of Thutmosis IV (r. 1420–1411; Cairo, Egyptian Museum). The evidence of the use of tapestry hangings in ancient Israel, not much later, is found in Biblical descriptions (for example, Ex. 26). Literary descriptions are supported by a small number of fragments to prove that there was a tradition of tapestry weaving in Greece and Rome and that Egypt was a center of the craft in the Roman imperial period. The fragments of clothing from Kouban (ca. 400 B.C.; Leningrad, Hermitage) have small woven patterns and are a good illustration of one aspect of the craft. Egypto-Roman fabrics with designs in the classical vocabulary of ornament (London, Victoria and Albert) were used for hangings, furniture coverings, and clothing. *See* WEAVING, TEXTILE, GREEK AND ROMAN.

Both the Orient and South America produced forms of weaving in the first centuries of the modern era, with small evidence surviving. Peruvian embroideries of the Ica and Nazca from that period are predominantly highly stylized in symbolic animal and figure patterns. Tapestry itself was introduced later at Tiahuanaco. Silk tapestries were made in China. One surviving from the Han dynasty (206 B.C.–A.D. 220) is richly colored and decorated with a tree-of-life motif that suggests it might have been made for the Iranian market. Silk tapestries from the 10th and 11th centuries made in Turkestan are evidence of a continuation of the Oriental silk technique.

The tapestry technique was used for small-scale work that has survived in Coptic Egypt as well as in Europe, but it is thought by some historians to have been too heavy and subdued a medium to express Byzantine elegance. The mosaics in the Baptistery at Ravenna show rich hangings that could have been either tapestries or some kind of needlework. No tapestries have come down from the court of Charlemagne and, again, there is some thought that the technique did not offer the necessary qualities of elegance. This theory is supported by the fact that the single Ottonian tapestry (Tapestry of St. Gereon, 10th–11th cent.; Berlin, former State Museums) known is almost an imitation of a Byzantine silk, since it is unusually thin and based on a silk design. By the 12th century there is ample evidence of a tapestry tradition. The three tapestries at Halberstadt Cathedral, in which the painting of the time determined the tapestry style, date from the 12th or early 13th century. They have been attributed to the Abbey of Quedlinburg, near Halberstadt, which was famous for its tapestries and was one of the many monastic centers where tapestries were made, according to records of the period.

From the 13th through the 18th century a number of factories in different parts of Europe produced tapestries. Essentially French and Flemish weavers dominated, and when shops were opened in Italy, Spain, and other countries Flemish workmen were often brought in to oversee. Arras, a northern French town whose name came to be used as a synonym for tapestries, was one of the first centers, but little that is documented has survived. In the famous *Apocalypse* series (Angers, Château), made in Paris, the 14th-century style may be seen. A Gothic architectural setting is an environment for figures in the linear style of that movement. In the 15th century various French

centers vied with the Flemish for primacy as the more complex spatial conception of the International Gothic style was applied to tapestries. Scenes from Greco-Roman history and mythology were represented along with religious subjects, but the style was not classical so that the Trojan Wars were depicted in cartoons by Fouquet with all the trappings of Gothic pageantry. This style was also characterized by a practice of using almost no border to frame the picture. Where the Italianate Renaissance conception is encountered, as in the work produced in Ferrara, borders of architectural details, for example, columns and lintels, were employed. *See* ARRAS.

Tapestries were also composed of flat leaf or floral patterns with figures, animals, or emblems shown isolated against the pattern. The 16th century saw a continuation of the flat, decorative compositions along with the fuller use of Renaissance space for tapestries and the resulting use of architectural borders. Famous artists supplied the cartoons, for example, the *Acts of the Apostles* (ca. 1515–19; Rome, Vatican Museums) from cartoons by Raphael. Tapestry centers included Brussels, Paris, Fontainebleau, and Delft, to name just a few. The various centers developed distinctive styles in showing preferences for certain color schemes and frame decorations.

In the 17th century the borders generally became more elaborate and reflected the baroque style of the time. A more painterly approach by artists providing cartoons and the effort by the tapestry makers to be faithful to the cartoons resulted in a style that has been criticized for not following the limitations of the medium. At its best the 17th-century tapestry is as colorful and bright as the painting of the period. Brussels and Paris were the particularly significant centers, and Rubens provided cartoons for many different factories. Besides the work done in the shop in Brussels, his cartoons for Louis XIII were executed by Marc de Comans and François de La Planche in Paris, and his *History of Achilles* (1630–35), probably for Charles I, was done at the Mortlake looms in England. In 1662 the Gobelins property was taken over by Colbert for Louis XIV, and Charles Le Brun, Painter to the King, was put in charge of the group of Flemish workmen that had been settled there in 1601. Gobelins thereafter produced large wall hangings that were renowned in their day and overshadowed the other state-subsidized tapestry works such as Beauvais, which became most famous for small pieces such as sofa and chair coverings. A third factory, Aubusson, was helped after 1665, but it did not attain importance until the 18th century. *See* BEAUVAIS.

In the 18th century decorative hangings were popular in arabesques and other small, whimsical patterns that were provided by artists such as Berain, Huette, and Boucher for Gobelins and Beauvais. Chinoiseries were popular as well, and one done at Soho, England, is properly flat and decorative. Goya did cartoons for the Santa Barbara looms in Spain, which were executed unimaginatively. In the 19th century, the period before 1870 is as yet not understood because there is a need for reappraisal of the style revivals in the early part of the century. Since 1870 the craft revival and the work of men such as William Morris and his followers have been inspirational in revivals of tapestry making in western Europe, England, and even the Bronx, N.Y. These tapestries were

influenced by earlier styles to varying degrees, with the Pre-Raphaelite efforts among the most interesting. Cartoons have been commissioned from modern painters; the Aubusson workshop under Jean Lurçat has been particularly active. On the American scene there are a few designer-craftsmen producing their own designs in tapestry and following the latest contemporary trends. *See* LURCAT, JEAN.

BIBLIOGRAPHY. W. G. Thomson, *A History of Tapestry from the Earliest Times until the Present Day*, London, 1930; P. Ackerman, *Tapestry, the Mirror of Civilization*, Oxford, 1933.

MARVIN D. SCHWARTZ

TAPIES, ANTONIO. Spanish abstract painter (1923–). He was born in Barcelona and now lives in Madrid. In 1943 Tápies began training for the law at the University of Barcelona, but in 1946 abandoned it to paint. He is largely self-taught. In 1948 he became a founding member of a group, Dau Al Set (The 7th Side of the Die), which published a magazine of the same name. He had his first one-man show in Spain in 1950. In that year he also visited Paris and saw the art of Dubuffet. Tápies visited Belgium and Holland in 1951 and New York City in 1953, when he had his first New York show. In 1962 he was given retrospective exhibitions at the Hannover Landesmuseum and the Guggenheim Museum in New York.

His art prior to 1950 shows the influence of Klee and Torres García. In his better-known, starkly spare "matter" abstractions, he frequently scratches into neutral, earth-colored layers of oil or latex paint to which grit or sand has been added.

BIBLIOGRAPHY. M. Tapié, *Antonio Tápies*, Barcelona, 1959.

TAQ-I-BUSTAN. Site near Kermanshah, in western Iran, where Sassanian rock reliefs have been found. They depict events from the reigns of three Sassanian kings.

The bas-relief depicting the investiture of Ardashir II (379–383) is carved in a rock face. The King is shown between two gods: Ahura Mazda hands him the diadem and Mithras stands on a lotus flower holding a barsom. The bodies face front, with heads in three-quarter view and feet in profile.

In the reliefs in the "little" cave Shapur III (383–388) is depicted with his father Shapur II (309–379). The reliefs in the "large" cave, probably the last reliefs of the Sassanian period, date from the time of Firuz II (459–484) or Chosroes II (590–628). The back wall of the cave is divided into two registers, the upper depicting the King's investiture, the lower, the King on horseback. Precious stones adorn the richly embroidered costumes. The side walls are decorated with painted reliefs of hunting scenes.

BIBLIOGRAPHY. A. U. Pope, ed., *A Survey of Persian Art*, 6 vols. in 12, London, 1938–39; R. Ghirshman, *Persian Art, the Parthian and Sassanian Dynasties*, New York, 1962.

TAQ-I-KISRA, *see* CHOSROES, PALACE OF, CTESIPHON.

TARA. Buddhist goddess known as the Savioress. Tārā was enrolled among the northern Buddhist gods in the 6th century and soon became very popular. Her name comes from the Sanskrit *tārā*, a "crossing" or "passage," from her function of helping souls to cross the ocean of existence. The principal Tārā is the consort of Avalokiteśvara, but there are many Tārās, the accepted number

Taq-i-Bustan. Detail of the rock reliefs depicting events from the reigns of three Sassanian kings.

Tara Brooch. Personal ornament in gold filigree with enamel, amber, and amethyst, ca. 800, from County Meath. National Museum, Dublin.

being twenty-one, of whom the most famous are the White Tārā and the Green Tārā, who, in earthly incarnations, had become the wives of King Srong Tsan Gampo and were responsible for introducing Buddhism into Tibet, the White Tārā being a Chinese and the Green Tārā a Nepalese princes. Tārā is represented in dress appropriate to her rank as a Bodhisattva. Her special symbol is a lotus held in her left hand, the blossom at her shoulder. Seated, the White Tārā has legs locked (padmāsana), whereas the Green Tārā has one leg pendant.

TARA BROOCH. Irish metalwork in the National Museum, Dublin. *See* HIBERNO-SAXON ART.

TARANTO (Taras), *see* TARENTUM.

TARASCAN ART, *see* AMERICAS, ANCIENT, ART OF (MEXICO).

TARBELL, EDMUND CHARLES. American painter (b. West Groton, Mass., 1862; d. New Castle, N.H., 1938). He studied at the school of the Boston Museum of Fine Arts and in Paris with Boulanger and Lefebvre. After returning to America, he became an instructor at the Boston Museum school (1889–1912), headed the Corcoran School of Art, Washington, D.C. (1918–26), and was a member of The Ten.

He painted portraits and figure pieces of Boston society. The portrait of Justice John W. Hammond reveals a con-

siderable power of character observation. The intimate genre interiors, such as *Girl Crocheting* (ca. 1905), show a happy arrangement, a melodious rendition of serene mood, and a precise recording of genteel life against the beauty of inanimate objects. His oils possess an intelligence of figure selectivity and a poetic charm of color harmony.

BIBLIOGRAPHY. J. E. D. Trask, "About Tarbell," *American Magazine of Art*, IX, 1918.

TARDIEU, NICOLAS-HENRI. French engraver (b. Paris, 1674; d. there, 1749). One of a large family of French engravers, Tardieu studied with Lepautre and Audran. Next to Audran, he was the best-known engraver of Watteau. He worked in a painterly, almost silvery combination of engraving and cold-needle etching.

BIBLIOGRAPHY. E. Dacier, *Jean de Julienne et les graveurs de Watteau, au XVIIIe siècle*, vols. 2, 3, 4, Paris, 1922–24.

TARENTUM. Ancient city (modern Taranto), originally a Greek colony called Taras, located in southern Italy, on the northwestern coast of the Gulf of Taranto. It was founded about 700 B.C. by political refugees from Sparta. Finds of late Mycenaean pottery, however, indicate that the site was used by Greek traders at an even earlier date.

In spite of conflicts with neighboring Italic peoples, the city reached its zenith during the 4th century B.C. In the second half of that century it was forced to protect itself by hiring Greek mercenaries. This new contact with Greece had the result of bringing the sculptor Lysippus to Taras. He was commissioned to adorn the city with two colossal statues, one of Zeus, the other of Hercules, which became the most famous monuments of ancient Tarentum (the later Roman name).

The heart of the ancient city is now covered by the buildings of modern Taranto, and its topography is thus little known. Scattered remains, however, have been found in many places. Among the earliest of these are the fragments of a Doric temple dating from about 575 B.C. (hence one of the earliest in the Greek west) and dedicated perhaps to Artemis. Other architectural fragments come from tombs in the Tarentine necropolis.

Among the many works of sculpture found in and around Tarentum, the best known is the late archaic seated goddess (Berlin, former State Museums). An outstanding treasure of silver vessels, discovered in Tarentum in 1896, indicates that the Tarentine ateliers had reached a high degree of skill in this field. It is also likely that Tarentum played an important role in the development of the red-figured "Apulian" vase painting of southern Italy in the 4th century B.C.

BIBLIOGRAPHY. P. Wuilleumier, *Tarente, des origines à la conquête romaine* (Bibliothèque des Ecoles françaises d'Athènes et de Rome, 148), Paris, 1940.

JEROME J. POLLITT

TARQUINIA. Town in the province of Viterbo near the east coast of Italy. Tarquinia, the ancient Tarquinii, was the oldest of the Etruscan cities, but even before the arrival of the Etruscans the site had been occupied by Villanovan peoples. On the nearby hill of Monterozzi is a rich necropolis containing tombs of Villanovans and Etruscans dating from as early as the 10th century B.C. More than sixty of the later rock-hewn chamber tombs contain frescoes, some of them well enough preserved to yield invalu-

able depictions of Etruscan culture. Tarquinia came into early contact with Rome and was the home of Tarquinius Priscus and Tarquinius Superbus. Several periods of warfare erupted between the two cities, with Rome eventually triumphant in the 3d century B.C.

BIBLIOGRAPHY. R. Bloch, *The Etruscans*, London, 1958.

TARRAGONA. Mediterranean port in Catalonia, in eastern Spain. From the flourishing Roman city of Tarraco there survive vestiges of the *praetorium*, an amphitheater, and the city walls. The austere Cathedral, which was begun in the second half of the 12th century, represents a transition between the Romanesque and the Gothic styles. The Archaeological Museum and the Romano-Christian necropolis are important for their antiquities. In the environs of Tarragona are the 4th-century mausoleum of Centcelles, with its fine mosaics, and the remains of a Roman aqueduct. *See* TARRAGONA, AQUEDUCT OF.

BIBLIOGRAPHY. J. A. Guárdias, *Tarragona*, 2d ed., Tarragona, 1955.

TARRAGONA, AQUEDUCT OF. Roman aqueduct in Catalonia, Spain, near Tarragona. Erected in the 1st century of our era, it has eleven arches on the lower level and twenty-five arches on the upper level. The aqueduct, which was restored in the 18th century, once supplied the flourishing Roman city at Tarragona from the Gayá River.

TARRASA (Egara): CATHEDRAL COMPLEX. Group of three buildings in northeastern Spain, built in the Visigothic period. Despite later additions, this complex ranks as one of the few surviving monuments of its age. The main Church of S. María has an apse that is rectangular on the exterior and round on the interior. The plan of the adjacent baptistery (S. Miguel) follows that of the frigidarium of the Roman bath. The Martyrium of S. Pedro displays an interesting triconch on the east end; the barrel vault of the nave was added in the 12th century. The buildings are constructed mainly in the Roman *opus emplecton* technique with large quoins framing the small stones of the wall.

BIBLIOGRAPHY. J. Puig y Cadafalch, *La Seu visigótica d'Egara*, Barcelona, 1936.

TARSIA, *see* INTARSIA.

TARSUS (Gozlukule). City in Cilicia (Lesser Armenia), Turkey, which had an extensive pottery industry, underwent many invasions, and reached great prosperity in the 8th century B.C. Pre-Hittite buildings of western Anatolian influence, Iron and Bronze Age and Roman walls, massive stone foundations, and Hittite, Assyrian, Persian, Ionian, Aegean, Roman, and Islamic remains reveal many occupations and fire destructions. Buildings, streets, paved courtyards, mosaic floors, temples, columns, tombs with burial jars, and finely carved wooden knobs have been unearthed. Marble architectural fragments and inscriptions, lamps with ancient gods in relief, carved terra-cotta figurines (one engraved with a monkey eating grapes), clay, stone, and marble seals with Hittite hieroglyphs, cuneiform inscriptions, Egyptian motifs, and metal, glass, and ivory jewelry have been discovered. Persian and Alexander the Great gold, silver, and bronze coins minted in Tarsus were also found, some with Aramaic inscriptions.

BIBLIOGRAPHY. J. Garstang, *Prehistoric Mersin*, Oxford, 1953; H. Goldman, ed., *Excavations at Gözlü Kule, Tarsus*, 3 vols., Princeton, N.J., 1950–63.

TARTU CATHEDRAL, *see* DORPAT CATHEDRAL.

TARUGI PALACE, MONTEPULCIANO, *see* SANGALLO FAMILY (ANTONIO DA SANGALLO).

TASSEL (Tasset), JEAN. French history, genre, and portrait painter (b. Langres, 1608; d. there, 1667). He was the son of Richard Tassel. Jean was in Rome before 1634, where he copied Raphael's *Transfiguration* and was influenced by Caravaggism. Back in Langres (1647), he painted *bambochades* (small genre paintings) that betray knowledge of the Neapolitan school. In 1648 he decorated churches in Dijon, and in 1650 he worked as an engineer in Langres. His best work is the portrait of Catherine de Montholon (ca. 1648) in the Museum of Fine Arts, Dijon.

BIBLIOGRAPHY. Dijon, Musée Municipal, *Les Tassel, peintres langrois du XVIIᵉ siècle*, 1956?.

TASSEL (Tasset), RICHARD. French history painter and architect (b. Langres, ca. 1582; d. there, 1660). After a brief trip to Rome and Venice (ca. 1600), Tassel returned to Langres, where he worked on triumphal entries. In 1631 he was in charge of fortifications and worked as a military engineer. His *retardataire* academic style, unaffected by tenebrism, is close to that of Nicolas d'Hoey. Tassel's realistic portraits are based on those of Frans Pourbus the Younger.

BIBLIOGRAPHY. Dijon, Musée Municipal, *Les Tassel, peintres langrois du XVIIᵉ siècle*, 1956?.

TASSILO, CHALICE OF. Merovingian metalwork, in Kremsmünster Abbey, Bavaria.

Chalice of Tassilo. Merovingian metalwork, ca. 780. Kremsmünster Abbey, Bavaria.

TASSO, BARTOLOMMEO, *see* TRIACHINI, BARTOLOMMEO.

TATAMI. Japanese term for mats used as floor coverings. The mats are made of rice straw faced with woven rushes and have cloth bindings at the long ends. The usual dimension is about 3 feet by 6 feet, but slight variations are found. It was only in the 15th century that tatami were used to cover the entire floor permanently. Before that they were placed on the floor only when and where needed.

BIBLIOGRAPHY. T. and K. Ishimoto, *The Japanese House, Its Interior and Exterior*, New York, 1963.

TATHAGATA (Chinese, To-t'o-chia-to; Japanese, Nyorai). General designation for all Buddhas, one of whom is the historical Buddha Sākyamuni.

TATLIN, VLADIMIR EVGRAFOVITCH. Russian sculptor (b. Moscow, 1885; d. Novo-Devitch, 1956). He studied at the School of Painting and Sculpture in Moscow. His figurative style yielded to the influences of cubism, futurism, and other abstract tendencies peculiar to the first decade of the 20th century. In 1912 he visited Picasso's studio in Paris, and upon returning to Moscow he enthusiastically began experiments with various nonaesthetic industrial materials, which played a major role in Russian constructivism. *See* CONSTRUCTIVISM.

From 1918 to 1920 Tatlin taught at the Studios for Training in the Liberal Arts and Techniques. He sought the utilitarian in art and proclaimed the productive role of the artist in society. A *Monument for the Third International* was projected by him in 1919; the model for this huge structure was astonishingly abstract and revolutionary, but the decline of nonfigurative art resulting from government policies in Russia prevented the construction of the building. During his last years Tatlin was employed in an aircraft factory.

BIBLIOGRAPHY. C. Gray, *The Great Experiment, Russian Art, 1863–1922*, New York, 1962.

CHARLES MC CURDY

TATLINISM. Term for the Russian constructivism founded by the sculptor Vladimir Tatlin about 1913. Tatlin, who had studied cubism and futurism in Paris, concentrated on relief constructions of glass, metal, and wood. *See* CONSTRUCTIVISM.

TATTI, JACOPO, *see* SANSOVINO, IL.

TATTOOING. Skin-decoration procedure almost universally practiced among primitive peoples but also by more advanced civilizations such as the Arabs. The skin is cut or punctured in various patterns and a coloring matter is introduced. The purposes of tattooing are many, including magic, as a sign of sexual maturity, as a proof of courage, and purely for ornament.

TA-T'UNG, *see* HUA-YEN-SSU, TA-T'UNG; YUN-KANG.

TAUBES, FREDERIC. American painter (1900–). Born in Lvov, U.S.S.R., he studied in Vienna, at the Munich Academy, and at the Weimar Bauhaus. He came to the United States in 1930. Taubes paints colorful and volumetric landscapes, figures, and still lifes. As a teacher and writer, he has been a strong critic of abstract tendencies in modern art.

BIBLIOGRAPHY. American Artists Group, *Frederic Taubes*, New York, 1946.

TAULL, *see* TAHULL.

TAUNAY, FELIX-EMILE. Brazilian landscape painter (b. Montmorency, France, 1795; d. Rio de Janeiro, 1881). He went to Brazil with his father, Nicolas-Antoine Taunay, in 1816. Félix-Emile studied landscape with his father and succeeded him as teacher of landscape in the Academy of Fine Arts in 1821. He was director of the academy from 1834 to 1851 and began its annual general exhibitions in 1840. Taunay's work is shown in the National Museum of Fine Arts, Rio de Janeiro.

BIBLIOGRAPHY. J. M. dos Reis, *História da pintura no Brasil*, São Paulo, 1944.

TAUNAY, NICOLAS-ANTOINE. French painter (b. Paris, 1755; d. there, 1830). He was a founding member of the Institute of France (1795) and a close friend of Empress Josephine. After Napoleon's fall Taunay was the leading member of the French artistic mission to Brazil (1816). He helped found the Academy of Fine Arts in Rio de Janeiro, where he remained for five years. His landscapes (for example, *O largo carioca*, 1816; Rio de Janeiro, National Museum of Fine Arts) were influential in Brazil.

BIBLIOGRAPHY. A. de Escragnolles Taunay, *A Missão Artística de 1816*, Rio de Janeiro, 1956.

Vladimir Tatlin, model for the *Monument for the Third International*, 1919.

TAURISKOS, *see* FARNESE BULL.

TAVANT: SAINT-NICOLAS. French church founded in 987 as a priory of Marmoutier. The first church was burned in 1070. At some time between the end of the 11th and the beginning of the 12th century the present structure was built as the parish church, but it still had many connections with the former priory. The church itself is in the shape of a single-aisled Latin cross, with a heavy tower over the crossing. Former traces of aisles on either side of this central aisle can still be seen. The nave, over the five bays, contains a barrel vault on transverse arches. A handsome cupola on squinches covers the crossing, beyond which extends the choir and apse raised above the crypt below. Sculptured capitals at the springing of the transverse arches contain grotesque animals and carved heads.

This little church has a great ensemble of mural paintings. Those in the choir and semidome of the apse, discovered in 1945–46, show Christ in Majesty in a mandorla with four symbols of the Evangelists. Below are eight angels. In the choir are vestiges of Infancy scenes. The most important series of paintings is that in the unusual three-aisled crypt below. Divided into three bays plus an apse by a series of columns, the whole is covered with crude groin vaulting, on the surfaces of which are represented some of the most individual Romanesque frescoes ever created. The frescoes are unusual in their expressive qualities and in many of their iconographical aspects. The dominant elements are directness in handling and forcefulness of brushwork; the colors are mostly yellow, red ocher, green earth, white, and black. These frescoes essentially relate a sort of psychomachia with much of the symbolism of the Prudentius poem. Beginning at the west end of the crypt with the idea of the mystery of Christ, spiritual struggle is introduced with scenes of David. There are various other scenes showing a Virtue and a Vice from the *Psychomachia*, Luxury piercing her breast with a lance, and Adam and Eve, as well as a number of scenes from the story of Christ, including the Deposition from the Cross and the Christ in Limbo.

Both in subject matter and execution these frescoes show us a fresh approach by an artist who is not so restricted as most of his contemporaries. Dated anywhere from the end of the 11th century to the middle of the 12th, they have at times been ascribed to a different hand than that of the choir and apse frescoes above. Upon closer examination both series of paintings seem to be by the same hand and can probably be dated about the first quarter or third of the 12th century.

BIBLIOGRAPHY. M. Webber, "The Frescoes of Tavant," *Art Studies, Medieval, Renaissance and Modern* [III], 1925; C.-P. Duprat, "La Peinture Romane en France," *Bulletin Monumental*, CI, 1942; P. H. Michel, *Les Fresques de Tavant*, Paris, 1944; P. Deschamps and M. Thibout, *La Peinture murale en France: Le Haute moyen âge et l'époque romane*, Paris, 1951. EDWARD P. LAWSON

TAVARONE, LAZZARO. Italian portrait and religious painter (b. Genoa, 1556; d. there, 1641). He was a favored disciple and assistant of Luca Cambiaso, whom he accompanied to Spain in 1585. When Cambiaso died, many of his works were completed by Tavarone. After serving the King of Spain for several years, he returned to Genoa a wealthy man and did many frescoes there, including some at the Cathedral.

TAVERNA, GIULIO. Gem and crystal cutter (fl. Milan, 1550). Mentioned in the Lomazzo Treatise on painting (1584) as the second most famous gem cutter, he worked in the late Renaissance style doing both classical and religious subjects. The Louvre has a vase with crystal reliefs by him.

BIBLIOGRAPHY. E. Kris, "Zur Mailänder Glyptik der Renaissance...," *Pantheon*, VI, 1930.

TAVERNER, WILLIAM. English painter (b. Canterbury, 1703; d. 1772). He succeeded his father as an ecclesiastical lawyer and was essentially an amateur water-color painter who was little known to contemporaries because of shyness in exhibiting his pictures. For a long time he remained a shadowy figure to art historians. He specialized in wooded scenes which are unmistakably English in feeling.

TCHAMBULI, *see* OCEANIC ART (MELANESIA).

TCHELITCHEW, PAVEL. Russian-American neoromantic artist (b. Moscow, 1898; d. Frascati, Italy, 1957). As a

Pavel Tchelitchew, study for *The Blue Clown*, 1929. Museum of Modern Art, New York.

child he was fascinated by the book illustrations of Gustave Doré. In 1918 his family fled to Kiev because of the Revolution, and there he received his first art lessons. He was introduced to abstract art and stage design by Alexandra Exter, a student of Léger, and took private lessons with Basil Tchakrigine and Isaac Rabinovitch, two artists who worked in the constructivist-cubist manner. It was with Rabinovitch that Tchelitchew constructed theater sets.

In 1920 he left Kiev for Odessa, and then for Istanbul, Berlin, and finally, in 1923, for Paris, where, nearly at once, he renounced his cubist-derived style. He first painted landscapes and then did a series of portraits in highly keyed color of certain friends such as Glenway Westcott, Nicolas Nabokov, and Margaret Anderson. Gertrude Stein was struck by his work, which she saw in the 1925 Salon d'Automne, and sought him out. Tchelitchew saw her collection and the Picassos of the Blue and Pink periods; he was very much moved by them, and they influenced his art. By 1925 he reduced his palette to earth colors, black, and white.

His painting, with its somber themes and mood of revery and despair, was in accord with that of another group of artists who were to be known as "neoromantics." They exhibited at the Galerie Druet in 1926. Included in the group were Eugène Berman, his brother Léonide, Kristians Tonny, and Christian Bérard. It was at this time that Tchelitchew began to combine several views of a single face simultaneously in a single image.

In 1926 he moved to the south of France and then to Algiers. He began to paint circus figures there and to achieve textured effects by adding sand and coffee grounds to pigment. In 1928 he started to use extremes of foreshortening and perspective. He would, for instance, show a reclining figure with the feet close to the beholder so that they would appear abnormally large. That same year he had his first one-man show, in London, and a year later his second, in Paris. In the late 1920s he painted a number of still lifes which were evocative of the human figure by the selection of objects and their arrangement.

In the early 1930s he did a series of paintings of tattooed circus figures, then tennis players, then bull fighters. Julien Levy gave him his first American one-man show in 1934. Tchelitchew also designed sets for the ballet. In 1941 he moved to the United States, and in 1954 he established a studio in Italy at Frascati. His best-known painting of this late period is *Hide and Seek* (1940–42; New York, Museum of Modern Art).

BIBLIOGRAPHY. J. T. Soby, *Tchelitchew: Paintings, Drawings*, New York, 1942.

ROBERT REIFF

TCHOGA-ZANBIL, *see* CHOGA-ZAMBIL.

T. D. L., *see* TERRE DE LORRAINE.

TE, PALAZZO DEL, MANTUA, *see* ROMANO, GIULIO.

TEAGUE, WALTER DORWIN. American industrial designer (b. Decatur, Ind., 1883; d. New York City, 1960). Teague has been credited with making the design of mass-produced goods a respected profession in the United States. He studied at the Art Students League in New York City and in 1907 began his career as an artist, designing books, advertisements, and magazines. He did not really become an industrial designer until 1926, when Eastman Kodak Company invited him to act as its design consultant. In the thirty years that followed, Teague designed service stations, railway equipment, plane interiors, heating appliances, business machines, machine tools, offices, and furniture, making his own firm among the largest and best known in the American design world. He designed the classic Marmon 16 automobile in 1930, and was on the Design Board of the 1939 World's Fair. When World War II broke out, the Navy asked him to perfect its 16-inch guns to eliminate the possibility of explosions caused by loading malfunctions.

Whether Teague was designing the interior of the Boeing 707 or an office machine for A. B. Dick, he liked to apply five principles to what he was doing: better operation, more convenience, proper use of materials for efficient production, no extraneous ornament, and pleasurable design. He lectured about these principles at various universities. To consolidate designers into a professional organization, Teague helped found the American Society of Industrial Design, of which he was the first president. He also served as president of the American Institute of Graphic Arts and was a member of the Royal Society of Arts.

BIBLIOGRAPHY. W. D. Teague, *Design This Day*, New York, 1940; W. D. Teague and R. Teague, *You Can't Ignore Murder*, New York, 1942.

ANN FEREBEE

Teatro Olimpico, Vicenza. The original perspective scenery.

TEAHOUSE. Small building for the Japanese tea-drinking ceremony. It was built around a hearth placed asymmetrically within the room, the size of the room being governed by the number of tatami (mats), each about 6 feet by 3 feet. Valued works of art, examples of calligraphy, and a vase with flowers were placed in the *tokonoma* (alcove).

TEATRO OLIMPICO, VICENZA. Italian Renaissance theater. This splendid building was begun by Andrea Palladio in 1580 and completed by Vincenzo Scamozzi four years later. The interior still retains the original perspective scenery, which is richly decorated.

BIBLIOGRAPHY. L. Puppi, *Il Teatro Olimpico*, Venice, 1963.

TEBESSA, MONASTERY OF. Algerian monastery, one of the most important Early Christian foundations in North Africa. It dates from the 5th century. Its church was a three-aisled basilica with an unusual arrangement of coupled piers and columns, undoubtedly necessary to support the galleries. The nave culminated in an apse, while the basilica was preceded by an atrium.

BIBLIOGRAPHY. O. K. Wulff, *Altchristliche und byzantinische Kunst*, 2 vols. in 1, Berlin, 1914.

TECTON GROUP, *see* LUBETKIN, BERTHOLD.

TECTONIC. That quality in a work of art which emphasizes structural composition and coherence. By nature, architecture is the most tectonic of the arts; hence, "architectonic" is often used as a synonym for tectonic.

TEDESCO, ADAMO, *see* ELSHEIMER, ADAM.

TEE, *see* RELIC BASKET.

TEFFT, THOMAS. American architect (1826–59). He was born in Rhode Island. After working for Tallman and Bucklin, Tefft designed many churches, dominated by tall spires, and, in 1848, the Lombard Romanesque Union Station in Providence. The rich texture and color of his works indicate the mid-century reaction to the Greek revival.

TEGEA: TEMPLE OF ATHENA ALEA, *see* SCOPAS.

TEGLIACCI, NICCOLO DI SER SOZZO. Italian miniaturist and painter (fl. from 1332? d. 1363). The known illuminated works of this Sienese master are a leaf with the *Assumption of the Virgin* (1336 or late 1340s; Siena, State Archives) and three choir books (San Gimignano, Municipal Museum) done in great part by his workshop. Tegliacci is extremely delicate and pure in his use of color. His figure style is monumental in the vein of Ambrogio Lorenzetti, although the overall work has the decorative elegance of Pietro Lorenzetti and Simone Martini. His paintings, notably a polyptych done in collaboration with Luca di Tommè (1362; Siena, National Picture Gallery), have more of the hard angularity of Luca.

TEHERAN: MUSEUMS. Important public art collections in Teheran, Iran, are located in the museums listed below.

Archaeological Museum. On the ground floor are objects found at Tepe Sialk, near Kashan, by a French archaeolog-

Niccolò di Ser Sozzo Tegliacci, illuminated page with the *Assumption of the Virgin*. State Archives, Siena.

ical expedition. These objects are classified into two large groups corresponding to the two principal phases of civilization that developed at Tepe Sialk. The first group dates from the 4th millennium and consists of a number of vases decorated with floral or geometric designs and monochrome vases. The second group dates from the second half of the 2d millennium to 800 B.C. and consists of long-spouted vases decorated with geometric designs. Other objects in the museum's collection are pottery and other objects from Bakoun, near Persepolis (3500–3000 B.C.); pottery, jewelry, and bronzes from Hasanlu (2d millennium); and seals and cylinder seals from Susa, dating from the proto-Elamite period (3500/3000 B.C.) to the Achaemenian period (550–331 B.C.). One of the most famous Achaemenian works is the cylinder seal of King Darius the Great. There are also objects from Susa (4000–3500 B.C.); pottery from Tepe Giyan, near Hamadan, and from Rayy, near Teheran; objects and bronze arms from Tepe Hissar (2400–2000 B.C.); Luristan bronzes consisting of arms, figurines, mirrors, jewelry, and pins (2500–1800 B.C.); bronze objects of the Achaemenian period; a large relief from Persepolis (6th cent. B.C.) representing King Darius seated on his throne and accompanied by Xerxes I and court dignitaries; objects of the Parthian period (250 B.C.–A.D. 224) imitating Hellenistic art of the period; Sassanian objects (A.D. 226–651) such as coins, jewelry, and silver plates with hunting scenes; mosaics from Nishapur; and art of the Islamic period.

EVANTHIA SAPORITI

Golestan Palace. A small museum in the palace contains a Sèvres service given by Napoleon I to Fath Ali Châh as well as Chinese porcelain, cameos, vases in blue porcelain, and the famous Peacock Throne, which was made in India in 1639 and ornamented with a multitude of

precious stones. This throne is still used by the Iranian kings on the day of their coronation. There are also arms and armor, stone vases from Meshed, and the crown of King Aqa Muhammad Qadjar.

TE-HUA (Blanc de Chine). Term used to refer to a white Chinese porcelain distinguished by a thick creamy glaze with a slight ivory or rose tone. The glaze blends into the body to produce a particularly rich effect when it is touched. The name Te-hua is derived from a town in southern Fukien Province where, in the 17th century, a local clay of exceptional quality was discovered. The wares produced at the kilns of Te-hua became renowned in the West as *blanc de chine* and were imitated at Saint-Cloud and Chantilly, France. The best-known Te-hua wares are the figurines, Buddhist or Taoist, the Kuan-yin images being particularly popular.

BIBLIOGRAPHY. M. Farley, "The White Wares of Fukien and the South China Coast," 2 parts, *Far Eastern Ceramic Bulletin*, no. 7 [i.e. II], September, 1949, no. 9 [i.e. II], March, 1950.

TELAMON, *see* ATLANTES.

TELEPHONE COMPANY BUILDING, NEW YORK, *see* NEW YORK TELEPHONE COMPANY BUILDING, NEW YORK.

TELESTERION. Hall for the initiation into mysteries rather than a temple for the dwelling of a divinity. The most famous, the telesterion in Eleusis, was connected with the mysteries, or rites, in the worship of Demeter.

TELFORD, THOMAS. English engineer (1757–1834). After apprenticeship as a mason and following minor architectural works, he saw great possibilities in the use of cast iron. The Pont y Cysylte aqueduct (1795–1803) is an early expression of his use of stone and iron. His canals are numerous, and by 1825 he was a consultant for many Continental works. Perhaps his best-known bridge is Conway (1822–26), castellated to blend with the castle, yet with an iron suspension of great elegance. He designed and altered docks—St. Katherine's (1819–26); roads—Holyhead (1817), including the Menai suspension bridge; and tunnels—Hardcastle (1824–27). His last work was the North Level drainage of the Fens (1834).

TELL (Tepe). The Arabic word tell means mound; tepe is hill in Turkish. Mounds in the Near East are usually sites of ancient habitation where centuries of human occupation have raised such hillocks from the surrounding land. Tell and tepe often form part of place names, as Tell Asmar or Horoztepe.

TELL AGRAB. Site on the Diyala River, Iraq, 15 miles east of Tell Asmar. The Iraq expedition of the University of Chicago conducted excavations there in 1936 and 1937. The site produced late protoliterate (3200–3000 B.C.) and Early Dynastic (3000–2340 B.C.) remains in its northern part and Akkad-Larsa (2350–1763 B.C.) remains in its southern part. The excavations concentrated on the Shara Temple, a temple-house complex in the center of the site, in which the Early Dynastic building levels overlie the unexcavated protoliterate deposits. Because of erosion, only the west half of the temple plan was traced. Discoveries of copper objects, stone sculptures and vases, numerous stone mace heads, and other art objects, mostly in fragmentary and incomplete condition, suggest that Tell Agrab was an active artistic center in the Diyala region in the Early Dynastic period.

BIBLIOGRAPHY. H. Frankfort, *Sculpture of the Third Millennium B.C. from Tell Asmar and Khafājah*, Chicago, 1939; P. Delougaz and S. Lloyd, *Pre-Sargonid Temples in the Diyala Region*, Chicago, 1942; H. Frankfort, *More Sculpture from the Diyala Region*, Chicago, 1943; H. Frankfort, *Stratified Cylinder Seals from the Diyala Region*, Chicago, 1955.

TELL AHMAR, *see* TIL BARSIP.

TELL ASMAR (Eshnunna). Site in Iraq located northeast of Baghdad on the Diyala River. The Iraq expedition of the University of Chicago conducted systematic excavations there from 1930 to 1935. The date of the earliest settlement at Tell Asmar is probably the late 4th millennium B.C., since the pottery finds beneath the Earliest Shrine of the Abu Temple in the northern part of the site come from that period. Above the Earliest Shrine, datable to the Jamdet Nasr period (3200–3000 B.C.), there are successive building levels of the temple through the Early Dynastic period (3000–2340 B.C.). The most important art objects discovered in the Early Dynastic levels are a group of alabaster statues that may represent two deities and a priest and worshipers. Stylistically, they are good examples of the crude yet vigorous geometric style that Frankfort, one of the excavators, felt was characteristic of the sculpture of the 2d Early Dynastic period (ca. 2700 B.C.). It is possible, however, that this is merely a provincial style.

An Akkadian palace (2350–2180 B.C.) with elaborate arrangements for sanitation was also excavated, and gold jewelry and copper objects were discovered in it. Excavations in the area of the private houses in the center of the town prove the existence of a well-populated town from the Akkad through the Isin-Larsa period (to 1763 B.C.). The Akkad level is interesting not only because it preserved features of domestic architecture but also because it produced objects probably imported from the Indus Valley. Their discovery in a dated archaeological context supplied for the first time a firm chronological basis for the study of the Indus civilization.

In the southern part of the town a palace-temple complex, known as the Gimilsin Temple and the Palace of Rulers, was excavated. Its foundation goes back to the Ur III period (ca. 2125–2025 B.C.). The temple was built for the worship of a deified living monarch, Gimilsin of the 3d dynasty of Ur, by his local governor at Eshnunna. After the overthrow of the dynasty the palace was rebuilt and reused in the Isin-Larsa period by the independent rulers of Eshnunna, who seem by their names to have been related to the Elamites. Archaeological evidence from the palace shows traces of the violent upheavals that occurred at this time with the rise to power of the Elamites and the Amorites.

BIBLIOGRAPHY. H. Frankfort et al., *Tell Asmar and Khafaje*, vol. 1– , Chicago, 1932– ; H. Frankfort, *Sculpture of the Third Millennium B.C. from Tell Asmar and Khafājah*, Chicago, 1939; H. Frankfort et al., *The Gimilsin Temple and the Palace of the*

Tell Halaf. Winged beast with human head and body of a scorpion, from the palace gateway. National Museum, Damascus.

Rulers at Tell Asmar, Chicago, 1940; P. Delougaz and S. Lloyd, *Pre-Sargonid Temples in the Diyala Region*, Chicago, 1942; H. Frankfort, *More Sculpture from the Diyala Region*, Chicago, 1943; H. Frankfort, *Stratified Cylinder Seals from the Diyala Region*, Chicago, 1955. AYAKO IMAI

TELL ATCHANA, *see* ALALAKH.

TELL BALATAH, *see* SHECHEM.

TELL-EL-AMARNA PERIOD, *see* AMARNA PERIOD.

TELL EL QEDAH, *see* HAZOR.

TELL EL-YAHUDIAH, *see* YAHUDIYAH.

TELL HALAF (Guzana). Provincial Hittite town in the Khabur Valley in northern Mesopotamia, where traces of a protohistoric culture of the 5th millennium and handmade painted pottery of high quality were discovered. The pottery, fired in well-designed kilns capable of giving heat of more than 800°, dates from the middle of the 4th millennium B.C. This richly decorated pottery disappeared almost completely at the beginning of the 3d millennium, when the site was abandoned. A new town was built on its ruins (ca. 11th cent. B.C.), with stately buildings decorated with hundreds of reliefs.

An unknown cultural and artistic phase of ancient civilization was revealed by the Tell Halaf discoveries in 1911. The artists had abandoned the strictly classical form of Hittite art and had introduced many rather crude innovations. Temples and palaces filled the acropolis, and in one palace striking examples of the new Tell Halaf art have been found, powerful and majestic sculptures of coarse-grained basalt carved flat. The palace stood on a terrace reached through a gateway guarded by winged beasts with human heads and bodies of scorpions. Three grotesque female statues in the round, standing on ferocious animals, a lion, a lioness, and a bull, supported the roof of a portico in front of the palace, which was guarded by two winged sphinxes and two winged griffins.

Great orthostates were adorned with various scenes: a bull hunt, a stag hunt, genies holding up a winged disk, lions passant (Aleppo, Syrian National Museum). A god holding a mace and boomerang and a magnificent winged, human-headed bull are in Berlin (former State Museums).

Hundreds of smaller basalt and pink limestone reliefs, with figures in profile, adorned the bottom of the palace wall: foot soldiers, mounted warriors, hunters in chariots, camel drivers, various animals, winged genies, fantastic beings, and religious rites. The most interesting is a limestone slab from the palace depicting an animal orchestra.

Several statues in the round, all of basalt, have been found in Tell Halaf: a couple, male and female, seated side by side on a low bench; a goddess adorned with many necklaces and bracelets and holding a small receptacle (both Syrian National Museum); and a king or god armed with a boomerang and a dagger (Adana Museum). Inside the wall of the acropolis a female statue with a very repulsive face was found. But the most striking of all the statues in the round was one of a large grotesque female that was discovered in the same wall of the acropolis. Known as the "goddess with hanging braids," she holds a cup, her ugly face framed by two long braids. A plaster

cast of this statue is in the former State Museums in Berlin; the original was destroyed in 1943.

BIBLIOGRAPHY. A. Parrot, *Sumer: The Dawn of Art*, New York, 1961; A. Parrot, *The Arts of Assyria*, New York, 1961; L. Woolley, *The Art of the Middle East*, New York, 1961. LUCILLE VASSARDAKI

TELL MUQQAYYIR, *see* UR.

TELL OBEID, *see* AL-'UBAID.

TELLOH (Lagash). Village in Iraq, site of the ancient Lagash, approximately 160 miles southeast of Baghdad. It was excavated by the French archaeologists De Sarzec, Cros, De Genouillac, and finally A. Parrot in twenty seasons, from 1877 to 1933. The most important remains come from the Early Dynastic period (3000–2350 B.C.) and from the reign of Gudea (ca. 2160–2125 B.C.), but Telloh was occupied from the Ubaid period until the 2d century B.C. The site consists of a number of tells, only a few of which have been extensively excavated. The early excavators accidentally destroyed much of the evidence; as a result, little is known about the architecture of Telloh.

Remains of the Ubaid period include pottery, figurines, and clay bent nails. From the succeeding Uruk and Jamdet Nasr periods there are pottery and stone vessels, axes, maces, and cylinder and stamp seals. The finds from the Early Dynastic levels are more numerous. There is evidence of a temple of Ningirsu, and a number of objects were found near or in this structure on Tell K. The stone relief called "Personnage aux Plumes" (Early Dynastic I, ca. 2900 B.C.) is important because of the early inscription it bears. Other Early Dynastic objects from Tell K include the mace-head of Mesilim of Kish (Early Dynastic II, ca. 2700 B.C.) and a large copper lance with an engraved lion on the blade (Early Dynastic II). The vast majority of Early Dynastic remains, however, come from the final phase of that period (Early Dynastic III, 2450–2350 B.C.). Many of the so-called genealogical reliefs of Ur-Nanshe, square plaques pierced with a central hole, part of Eannatum's stele of the vultures, and Entemena's silver vase were found on Tell K. A building ascribed to Ur-Nanshe and a massive construction of Entemena also occupy this tell. *See* EANNATUM; STELE OF THE VULTURES; ENTEMENA, VASE OF.

At the end of the Early Dynastic period, Telloh came under the rule of the Akkadians (2340–2180 B.C.). Fragments of a stele of this period were found on Tell K. The second great period of prosperity for Telloh came with the rule of Gudea and his son Ur-Ningirsu. Again, little of their architecture was found—only parts of a rampart; the remains of the temples of Ningirsu, Ningizzida, and Geshtin-anna; and a curious structure that may have been used for the burial and worship of the rulers. Quantities of forcefully stylized diorite statues of Gudea, both standing and seated, have been found, as well as fragments of a historical stele, a number of statues of women, and a ritual vase with intertwined snakes, probably symbolic of Gudea's patron god Ningizzida. Statues of Ur-Ningirsu were also excavated. Other finds were bronze foundation figurines of gods, men, and bulls surmounting pointed nails, cylinder seals, clay plaques, and figurines. *See* GUDEA, PORTRAIT STATUES OF.

From the succeeding periods there are fewer remains.

A stone sculpture of a dog comes from the Larsa period (ca. 1890 B.C.). After this period Telloh fell to Hammurabi of Babylon (1792–1750 B.C.), but its days of importance were over. From the middle of the 2d millennium B.C. to the 2d century B.C. it was only sparsely inhabited. Seals and figurines are almost the only objects that have been found from this long span of time. A palace of Adad-nadin-akhe, an Aramaean, overlies a construction of the time of Gudea. It is a large building divided into official and living quarters, datable to the 2d century B.C.

BIBLIOGRAPHY. E. de Sarzec, *Découvertes en Chaldée*, publié par les soins de L. Heuzey, 2 vols., Paris, 1884–1912; G. Cros et al., *Nouvelles fouilles de Tello*, Paris, 1910–14; H. de Genouillac, *Fouilles de Telloh*, 2 vols., Paris, 1934–36; A. Parrot, *Tello*, Paris, 1948; H. Frankfort, "Tello, by A. Parrot" [Book Review], *Journal of Near Eastern Studies*, VIII, January, 1949. PRUDENCE O. HARPER

TELLUS, PERSONIFICATION OF. Italian earth goddess, protectress of marriage and fecundity. Tellus had her own temple in Rome after 268 B.C. Her personification on the Ara Pacis is in the form of a beautiful woman holding two children on her lap. The idealism with which she is depicted contrasts with the naturalism of the surrounding animals and plants on the monument.

TEMENOS, *see* HIERON.

TEMMOKU (Chien Ware). Type of Chinese ceramic ware. The word is the Japanese reading for the Chinese T'ien-mu, a mountain range near Hang-chou, where the Japanese monks who went to China to study Zen Buddhism first found a distinctive black teabowl. The term "Temmoku" became common in reference to the ware that the Chinese call "Chien ware" after the name of two towns in Fukien Province where this ware was produced in the Sung dynasty. Chien ware is distinguished by a heavy, coarse body with a black or blue-black glaze. The glaze was dipped and allowed to run in such a manner that it formed a heavy blob at the foot, an effect that became much admired in Japan with the development of tea-ceremony aesthetics. The bowls are often streaked with silvery and brown markings, caused by the ferric oxide in the glaze material; this finish is known as hare's-fur or hare's-foot glaze.

BIBLIOGRAPHY. J. M. Plumer, "Note on the Chien yao (temmoku) kiln-site," *Ostasiastische Zeitschrift*, XXI (N.F. XI), 1935.

TEMPEL (Temple), ABRAHAM LAMBERTSZ. VAN DEN. Dutch painter of history and portraits (b. Leeuwarden, 1622/23; d. Amsterdam, 1672). He was the son and pupil of the painter Lambert Jacobsz. Tempel seems also to have studied with Jacob Backer, who had been his father's pupil, and with Joris van Schooten. The name "Tempel" is an assumed one, taken from the gablestone he designed for his house. Tempel was active in Leyden from at least 1648, and in 1652 he was listed in the records of Leyden University. He held various official positions in the Leyden Guild of St. Luke in 1657 and 1658, and in 1659 he was dean of the organization. By 1660 he had moved to Amsterdam.

His style, especially after his move to Amsterdam, is strongly under the influence of the Amsterdam portrait painter Bartholomeus van der Helst. This can be seen in Tempel's *Portrait of a Vice-Admiral and His Wife* (1671; Rotterdam, Boymans-Van Beuningen Museum). He had a

number of pupils, including Michiel van Musscher, Ary de Vois, Frans van Mieris, and Carel de Moor.

BIBLIOGRAPHY. H. F. Wijnman, *Uit de kring van Rembrandt en Vondel*, Amsterdam, 1959. LEONARD J. SLATKES

TEMPERA. Type of painting using a mixture of water and some gelatinous substance as a vehicle for the pigments. Various gums, egg yolk, and wax have been used as the binder in tempera media, but egg yolk was by far the most popular. Nearly all medieval paintings before the 15th century were executed in egg tempera. In contrast with oil painting, tempera dries fast and leaves a mat, opaque surface.

BIBLIOGRAPHY. D. V. Thompson, *The Practice of Tempera Painting*, New Haven, 1936.

TEMPEST, THE. Oil painting by Giorgione, in the Academy, Venice. *See* GIORGIONE.

TEMPESTA, ANTONIO. Italian painter (b. Florence, 1555; d. Rome, 1630). He spent most of his life working in Rome. A student of the Flemish master Stradanus, Tempesta concentrated on perfecting detailed and realistic scenes of battle and the hunt, rendered in a mannerist style. He also executed frescoes in the Casino of the Pallavicini-Rospigliosi Palace, Rome (1612–13).

BIBLIOGRAPHY. R. Wittkower, *Art and Architecture in Italy, 1600–1750*, Baltimore, 1958.

TEMPIETTO. Small temple, such as the Tempietto of S. Pietro in Montorio, Rome, by Bramante. *See* SAN PIETRO IN MONTORIO, TEMPIETTO OF, ROME.

TEMPIO MALATESTIANO, RIMINI, *see* RIMINI: SAN FRANCESCO.

TEMPLE, ABRAHAM LAMBERTSZ. VAN DEN, *see* TEMPEL, ABRAHAM LAMBERTSZ. VAN DEN.

TEMPLE. Place of worship (from the Latin *templum*, "sanctuary"); a structure dedicated to the worship of a deity or, in some religions, the residence of a deity. A temple is a church in Christian faiths. Among Jews, the term is used interchangeably with synagogue, although it is sometimes reserved for the two destroyed temples of Jerusalem. The First Temple was built by Solomon and destroyed by Nebuchadnezzar. Rebuilt in the 6th century B.C., it was enlarged in successive generations and was destroyed in A.D. 70. *See* SOLOMON'S TEMPLE, JERUSALEM.

Egyptian temples were sanctuaries used only by priests and kings, for arcane rather than public ritual; only a few persons could pass beyond the sometimes vast hypostyle hall. The Temple of Khons, Karnak, with its entrance pylons, courts, and hypostyle hall leading to a sanctuary, all enclosed by high walls, is typical.

See also TEMPLE TOMB.

The Greek temple was usually a small rectangular structure standing in a temenos, or sacred enclosure, and was considered the sacred dwelling of a god. The entrance door to the temple was usually in the center of the east wall, associated with the rising sun. One end of the naos, or enclosure, was often entered through a pronaos, a portico with columns set *in antis* between the extended walls of the naos; the other end had a similar portico called a posticum or an opisthodomos. The naos was generally surrounded by a peristyle, or colonnade.

Roman temples were dedicated to gods, although the cella, or naos, was sometimes used to house Greek statuary. Roman temples were generally rectangular. Little attention was given to orientation, the temples being placed to face the forum on which they stood. The typical prostyle portico and the raised podium approached by a flight of steps are said to derive from Etruscan precedents. Of the several types, the pseudo-peripteral temple, with columns attached to walls instead of a freestanding peristyle and with the prostyle portico in front, is most characteristic. Circular and polygonal temples were also erected.

Chinese temples, such as that of the Great Dragon, Peking (ca. A.D. 1420), a circular and triple-roofed structure, were frequently set in enclosures containing priests' quarters. The Temple of Ho-nan, Canton, is typically enclosed by a wall with a gateway. The characteristic Chinese temple is of the *t'ing* type, whose concave roofs are set on posts. Monastery churches are also enclosed by a wall and are approached through a p'ai-lou, or entrance gateway. The monastery may contain a temple, a dāgoba or relic shrine, bell tower, pagoda, library, and monks' dwellings.

Japanese temples were isolated structures generally set within three concentric enclosures, the outer one being a low wall, the next a priests' promenade, and the inner one containing the temple itself. Usually set on a raised stone base, the Japanese temple was reached by a flight of stairs leading to a veranda protected by the projecting roofs of the temple. The Japanese Buddhist temple of Hōryūji and those in Nara and Nikko were closely related to their Chinese precedents. *See* HORYUJI; NARA.

In Indian architecture, Jain temples, associated with Mahāvīra, the founder of the religion, his saintly predecessors, and the veneration of such animals as bulls, elephants, lions, monkeys, and crocodiles, contained many image cells. Often set on hillsides and in valleys, Jain temples contain a square cell for the image of the jina, or saint, roofed with a curved pyramidal śikhara, or tower. Porticoed pillars and pointed domes further distinguish them. Larger temples stand in large open courts surrounded by numerous cells, each containing a statue of the jina to whom the temple is dedicated.

Hindu temples are similar in plan to Jain examples. They have small vimānas, or shrine cells, roofed over in northern temples with curved pyramidal structures. In contrast, the Dravidian vimāna has a stepped pyramid, quite high, as in the Great Temple, Tanjore. Dravidian temples are further distinguished by their choultries, or "halls of 1,000 columns." *See* TANJORE.

Buddhist chaityas were cut in rock, their façade being the face of the rock. The interiors of such temples resemble Christian cathedrals with nave and aisles separated by rows of columns and with a semicircular sanctuary. The choir of the rock-cut temple of Kārle (1st cent. B.C.) has been compared in size and plan to Norwich Cathedral. *See* CHAITYA HALL; KARLE; ROCK-CUT TEMPLE.

MILTON F. KIRCHMAN

TEMPLE CHURCH, LONDON. One of five English churches with a circular nave, dating, with the porch, from about 1160–85. This church, probably the earliest expres-

sion of the Gothic style in England, is notably avant-garde in its replacement of a gallery by a triforium. The finely proportioned chancel dates from about 1220.

BIBLIOGRAPHY. N. Pevsner, *London*, vol. 1: *The Cities of London and Westminster*, Harmondsworth, 1957.

TEMPLE MOUND, OKLA., *see* SPIRO MOUND, OKLA.

TEMPLE TOMB. Temple attached to or nearby a burial site where special rituals were performed for the dead. This type of temple was basic to ancient Egyptian architecture. The tomb of Mentuhotep at Deir el Bahari is a good example. *See* DEIR EL BAHARI.

TEMPTATION OF ST. ANTHONY. Oil painting by Bosch, in the National Museum, Lisbon. *See* BOSCH, JEROME.

TEN, THE. Group of American painters who, dissatisfied with the enormous size and increasing mediocrity of the annual exhibitions of the National Academy of Design and the Society of American Artists, organized a group show in New York City in 1898 and continued to exhibit for the next twenty years. The name was arrived at by a simple count of the participants. The prime organizer of the group was Childe Hassam (1859–1935), closely seconded by J. Alden Weir (1852–1919) and John H. Twachtman (1852–1902). The other members were Thomas W. Dewing (1851–1938), Edmund C. Tarbell (1862–1938), Frank W. Benson (1862–1951), Joseph De Camp (1855–1923), Willard L. Metcalf (1858–1925), E. E. Simmons (1852–1931), and Robert Reid (1862–1929). William M. Chase replaced Twachtman on the latter's death.

By disassociating themselves from the other artistic groups, The Ten hoped to place their work more conspicuously, and more profitably, before the American public. They were radical neither in subject matter nor technique; the various, but related, styles they practiced had already met with considerable success. Most of The Ten—Hassam, Weir, Metcalf, Reid, and, with certain important differences, Twachtman—worked in an American version of impressionism which used the high palette and broken paint application of the French movement but nevertheless retained the relatively firm outline of the objects depicted. Besides Simmons, who was primarily a muralist and decorator, the others of The Ten were mostly tonalist painters, influenced by Whistler, of figures and interiors, quiet, poetic, and placid. The influence of The Ten was largely in its example of independent action consistently and sincerely sustained. *See* BENSON, FRANK WESTON; CHASE, WILLIAM MERRITT; DEWING, THOMAS WILMER; HASSAM, FREDERICK CHILDE; TARBELL, EDMUND CHARLES; TWACHTMAN, JOHN HENRY; WEIR, J. ALDEN.

BIBLIOGRAPHY. E. Simmons, *From Seven to Seventy*, New York, 1922; D. W. Young, *The Life and Letters of J. Alden Weir*, New Haven, Conn., 1960.
JEROME VIOLA

TEN-BAMBOO STUDIO, ALBUM OF. Famous album of Chinese wood-block color prints. The Chinese title is *Shih-chu-chai shu-hua-p'u*, usually translated literally as *Collection of Paintings and Writings from the Ten-bamboo Studio*. The author of the work was Hu Cheng-yen, better known by his *tzu* Hu Yüeh-ts'ung, a noted scholar who, after his retirement from government service, gathered together a number of painter friends in the Anhui region

and produced the album under the name of his studio, or study. The work was apparently started in about 1619 (the earliest date which appears on any of the leaves), and there is a preface dated 1633; another preface of 1643 comments on the edition of ten years earlier. However, the question of editions is difficult since no complete version of the first impression has thus far been located. The album went through a number of revisions and printings, and a systematic study of the work has only begun. The basic intent of Hu Cheng-yen, however, seems clearly to have been that of producing a usable manual for students, and in this respect the work is similar to the later and perhaps more widely circulated *Mustard-seed-garden Painting Manual*. *See* MUSTARD-SEED-GARDEN PAINTING MANUAL.

The eight volumes comprising the work cover such categories as plum blossoms, birds, garden stones, fruits, bamboos, and orchids as well as including selections of various poems. Although the leaves are produced by the wood-engraving process, the best-preserved pages from the album reveal a remarkable delicacy of coloristic effect which is reminiscent of water colors. The high quality of the printing and the lack of overt instructions (as in the case of the *Mustard-seed-garden*) make the work appear less as a didactic piece than as a collector's item worthy in its own right as a work of art. Among the painters who helped in the preparation of the volumes were Kao Yang, Wei Chih-huang, and Kao Yu. Some of the pages were intended to reproduce famous masters of old, while others were signed and sealed by Hu Cheng-yen himself or by one of his contemporaries.

BIBLIOGRAPHY. J. Tschichold, *Der frühe chinesische Farbendruck*, Basel, 1940; R. T. Paine, "The Ten Bamboo Studio," *Boston Museum of Fine Arts, Bulletin*, XLVIII, December, 1950; R. T. Paine, "The Ten Bamboo Studio," *Archives of the Chinese Art Society of America*, V, 1951.
MARTIE W. YOUNG

TEN CATE, SIEBE JOHANNES, *see* CATE, SIEBE JOHANNES TEN.

TENDAI. Japanese name of a Buddhist sect, known in China as the T'ien-t'ai sect. The T'ien-t'ai sect was not of Indian origin, but developed in China as a reaction against the older, established sects of Buddhism. Although it places primary emphasis on the teachings of the Lotus Sūtra, it also introduces the doctrines of other schools. Its eclectic nature was made even stronger by Saichō (posthumously known as Dengyō Daishi, 767–822), who introduced it into Japan in 805. Saichō's Enryakuji at Mt. Hiei, to the northeast of Kyoto, became the center of Tendai teachings, and this temple played an increasingly important role in the history of Japanese Buddhism. In Saichō's time esotericism formed only one aspect of Tendai teachings. After his death, however, more esoteric practices were introduced into the Tendai ritual by two of Saichō's followers, Ennin (also known as Jikaku Daishi, 794–864) and Enchin (also known as Chishō Daishi, 814–91). *See* LOTUS SUTRA.

BIBLIOGRAPHY. E. D. Saunders, *Buddhism in Japan*, Philadelphia, 1964; E. Seckel, *The Art of Buddhism*, New York, 1964.

TENEBROSI. Italian term applied to those painters who were influenced by the strong, dramatic contrasts of light and dark in the work of Caravaggio. The style is found most frequently in the work of 17th-century Italian baroque masters; it spread from Italy to France (Georges

David Teniers the Younger, *Fête champêtre*. Louvre, Paris. A middle-class genre scene by this productive Flemish painter.

de La Tour) and Spain (Jusepe de Ribera). *See* LA TOUR, GEORGES DE; RIBERA, JUSEPE DE.

TENELLI, TIBERIO. Italian portrait and historical painter (b. Venice, 1586; d. Florence? 1638). He was a student of G. Contarini and L. Bassano. Tenelli's imaginative, usually cabinet-size paintings were quite popular, and even won the favor of Louis XIII, who knighted him. Especially distinctive are his portraits done with the sitters in historical disguises. He also worked with mythological subjects.

TENGBOM, IVAR. Swedish architect (1878–). Born in Vireda, Småland, Tengbom settled in Drottningholm and studied at the Chalmer Institute and the Academy in Stockholm. One of the better traditional architects in Europe, he executed in Stockholm, among other works, the Högalide Church (1916–23) and the Concert Hall (1920–26).

TEN GREAT DISCIPLES IN KOFUKUJI, NARA. Japanese lacquer sculptures (8th cent.). The Ten Great Disciples of the Shaka Buddha are represented as monks having a youthful expression of purity. Although these sculptures existed as a complete set until 1717, only six of the original ten remain. They can be attributed to the shogun Mampuku, who made a set of the eight supernatural guardians (Hachibushū), and can be dated about 734. *See* HACHIBUSHU IN KOFUKUJI, NARA.

BIBLIOGRAPHY. Tokyo National Museum, *Pageant of Japanese Art*, vol. 3: *Sculpture*, Tokyo, 1952; *Masterpieces of Japanese Sculpture*, introd., text, and commentaries by J. E. Kidder, Jr., Rutland, Vt., 1961.

TENIERS, DAVID, THE ELDER. Flemish painter of religious subjects, landscapes, and genre scenes (b. Antwerp, 1582; d. there, 1649). He is said to have studied under Rubens and then in Italy with Elsheimer. By 1606 Teniers had returned to Antwerp, where he became a master. With the exception of two religious paintings at St. Paul's, Antwerp, and a *Transfiguration* at the Church of Our Lady, Dendermonde—all done in a Romanist manned such as that of Frans Francken the Younger—we know of no authentic works from his brush. Certain landscapes and genre scenes, done in the manner of his son David Teniers the Younger, but cruder in execution and bearing the authentic monogram, may well be by him, but this attribution is not certain.

BIBLIOGRAPHY. C. Leurs, ed., *Geschiedenis van de Vlaamsche Kunst*, vol. 2, Antwerp, 1939.

TENIERS, DAVID, THE YOUNGER. Flemish painter of genre scenes, landscapes, and portraits; also an engraver (b. Antwerp, 1610; d. Brussels, 1690). He studied under his father, David Teniers the Elder, and became a master in Antwerp in 1633. Four years later he married Anna Breughel, a daughter of Jan Breughel I, and in 1644 was elected dean of the Guild of St. Luke. After Adriaen Brouwer's death (1638) Teniers became the most important Flemish genre painter. Because he lifted the social level of his subjects from the lower strata, carousing in taverns, to the middle and upper classes, shown in more genteel, occupations, his works became acceptable to courts and society—with the sole exception of Louis XIV, who did not favor them.

In 1651 Teniers moved to Brussels, having become Gentleman of the Chamber to Archduke Leopold-William, Governor of the Low Countries. He was also put in charge of the Duke's picture gallery. He painstakingly copied and then engraved all the Duke's Italian paintings for a monumental catalog. Leopold-William's successor, Don Juan of Austria, maintained Teniers in his favor and made him, in 1656, "painter to his chamber." From these years date Teniers's so-called gallery pictures, for example, the signed *Archduke Leopold-William in His Gallery* (1651; Brussels, Fine Arts Museum; other versions are in Madrid, Munich, and Vienna). An attempt at obtaining patents of nobility, however, was acceded to by the Spanish court solely on condition that he cease and desist from painting for money.

The painter became affluent, however, and in 1662 he acquired as a summer residence Three Towers, the castle at Perk, near Vilvorde. Henceforth the towers often appeared in his landscapes. The following year he founded the Brussels Academy of Fine Arts. During his later years Teniers painted less and was mostly occupied with supplying works of art for his patrons.

The early genre paintings, such as *Five Senses* (Brussels, Fine Arts Museum), are reminiscent of Frans Francken the Younger, but are superior in handling of color. During the 1630s we find a number of ribald peasant scenes that show Brouwer's influence. After Brouwer's death Teniers regained his initial colorful palette and changed the tone and level of his subject matter. Finally, in the monumental processions and landscapes (for example, *Forest with Highwaymen*, Berlin, former State Museums, Picture Gallery), he attained a high level of personalized interpretation of nature, following the tradition of Jan Breughel I. Kermis scenes and excellent small portraits round out his production. Although the artist was extremely fertile (estimates range from 700 to 2,000 authentic works), many imitations also circulate under his name. (See illustration.)

BIBLIOGRAPHY. A. Rosenberg, *Teniers der jüngere*, Bielefeld, 1895; R. Oldenbourg, *Die flämische Malerei des 17. Jahrhunderts*, 2d ed., Berlin, 1922. ERIK LARSEN

TENNIEL, SIR JOHN. English painter, illustrator, and caricaturist (b. London, 1820; d. there, 1914). Tenniel is most popularly associated with illustrations to Lewis Carroll's *Alice's Adventures in Wonderland* and *Alice through the Looking-glass* (1865; modern ed., New York, 1947), despite his regular and prolific contributions to *Punch* and his contemporary fame as a water-colorist. Tenniel studied in the Royal Academy schools and after maturity exhibited regularly at the Royal Academy (1851–1901). He was a member of the Royal Institute of Painters in Water Colour and was ennobled in 1893. His paintings include the fresco *St. Cecilia* (1846; London, Parliament Building, Hall of the Poets), a water-color *Pygmalion* (1878; London, Victoria and Albert), and illustrations to *Aesop's Fables* (1848) and *Ingoldsby Legends* (1864). His most memorable weekly political cartoon for *Punch* was called "Dropping the Pilot," referring to Bismarck's removal.

BIBLIOGRAPHY. M. H. Spielmann, *The History of "Punch,"* London, 1895.

TENNIS COURT OATH. Oil painting by David, in the Louvre Museum, Paris. *See* DAVID, JACQUES-LOUIS.

TEN O'CLOCK LECTURE, THE, *see* WHISTLER, JAMES ABBOTT MCNEILL.

TENRI: MUSEUM. Japanese museum, located in Nara Prefecture. It was founded by the late Shōzen Nakayama, the founder of a religious group known as the Tenri sect. Its unusual collection is focused on ethnological and archaeological objects from all over the world, with special emphasis on Japan, China, the South Pacific, and South America. It also includes objects related to different religious practices found in various districts of Japan.

BIBLIOGRAPHY. S. Kaneko, *Guide to Japanese Art*, Rutland, Vt., 1963.

Teotihuacán art. Mosaic-covered funeral mask. Pigorini Museum, Rome.

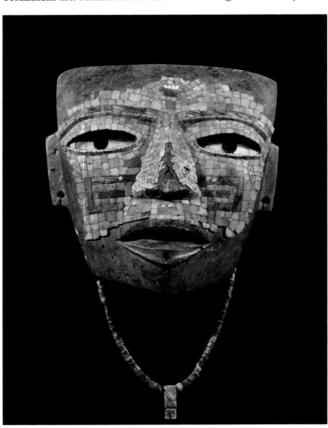

TENRYUJI GARDEN. Japanese garden in Kyoto. The temple was founded about 1340 by Takauji, the founder of the Ashikaga shogunal government, on the site of the Kameyama imperial detached palace of the late Kamakura period. The garden, often attributed to the Zen national master Musō Soseki (1275–1351), survived a series of fires that destroyed the Tenryūji itself, but it must have undergone some changes. The pond in the garden was originally much larger, and it has a rock arrangement that was once used to create a waterfall but is now dry.

BIBLIOGRAPHY. Tokyo National Museum, *Pageant of Japanese Art*, vol. 6: *Architecture and Gardens*, Tokyo, 1952; Kokusai Bunka Shinkōkai, *Tradition of Japanese Garden*, Tokyo, 1962.

TEOTIHUACAN ART. Teotihuacán is a pre-Columbian archaeological center northeast of Mexico City. Several stages of culture, now known as the Teotihuacán culture, developed there from about 500 B.C. to about A.D. 900. The principal remains (the Pyramid of the Sun, the Pyramid of the Moon, and the Citadel) are connected by the axis of a north-south ceremonial passageway lined with remains of lesser buildings. An old temple base, embellished with fierce, painted sculptures of the deities Tlaloc and Quetzalcoatl, has been uncovered in the Citadel enclosure. Ceremonial masks of jadeite, sculpture, fine ceramics, and fresco paintings are among the many artifacts recovered at this site. Remains of secular buildings surround the area. *See* AMERICAS, ANCIENT, ART OF (MEXICO: TEOTIHUACAN CULTURE).

BIBLIOGRAPHY. P. Kelemen, *Medieval American Art*, New York, 1943; S. K. Lothrop et al., *Pre-Columbian Art* (Robert Woods Bliss Coll.), New York, 1957; I. Marquina, *Arquitectura prehispánica*, 2d ed., Mexico City,, 1964.

TEPE, *see also* TELL.

TEPEACA: SAN FRANCISCO. Church and convent in the state of Puebla, Mexico, founded before the middle of the 16th century and completed in 1580. The church has a single nave of four bays and a raised sanctuary and is rib-vaulted throughout. The exterior has a fortress-like appearance, with four pinnacled buttresses on each side and two at the corners of the apse.

BIBLIOGRAPHY. G. Kubler, *Mexican Architecture of the Sixteenth Century*, vol. 2, New Haven, 1948.

TEPE GAWRA. Site in north Iraq. Excavations were conducted by the University of Pennsylvania Museum and the American Schools of Oriental Research from 1927 to 1938. Systematic examination of the mound led to the revelation of habitations from the middle of the 2d millennium B.C. back into the 5th to 4th millennium B.C., represented by a total of twenty-four levels and sublevels, which still overlay several additional unexcavated occupational levels. The remains of material culture from the early periods are important archaeological discoveries in which the development of civilization from prehistoric times to the protohistoric period was followed.

The chronological sequence of this development in the Halaf (ca. 5000 B.C.), Ubaid (ca. 4000–3500 B.C.), and Uruk and Jamdet Nasr (3200–3000 B.C.) periods is well presented through stratified pottery assemblages. At the base of the mound and in Level XX, polychrome and bichrome Halaf pottery occurred exclusively. In Levels XX to XVII monochrome northern early Ubaid pottery was predominant. The Ubaid pottery gradually declined in workmanship through Level XII, which marked the violent termination of the Ubaid culture. At Level XI-A the Uruk culture was introduced and continued to Levels VIII-A and VII, which represent the Jamdet Nasr period.

In the Halaf and Ubaid levels two types of architecture were discovered: the tholoi of Levels XX and XVII, similar in character to the tholoi in the Halaf levels at Tell Arpachiyah, and an oblong square temple in Levels XIX and XVIII. The basic elements of the latter recurred in the temples of Levels XI-A and VIII. In late Ubaid Level XIII, three temple buildings, the finest architecture at Tepe Gawra, surrounded a large open court about 59 by 49 feet in size. The most prominent structure in Level XI-A was a massive circular construction about 59 to 62 feet in diameter, which might have been a citadel. The number of architectural remains from these early periods at Tepe Gawra makes it one of the most important sites in the north.

A number of stamp seals and impressions of the early periods were also excavated at Tepe Gawra. Those from the Halaf and early Ubaid levels are mostly decorated with simple geometric designs. With the exceptions of a few puzzling examples showing animal motifs from Levels XX, XVIII, and XV, representational motifs, including human and animal figures, were absent before Level XIII of the late Ubaid period, where a variety of seal designs was discovered in the temple deposit. While geometric patterns survived through the early Uruk period, representational motifs became commoner from this time on, and a more complex form of narrative composition was developed.

See also TEPE GAWRA, TEMPLE OF.

BIBLIOGRAPHY. Joint Expedition of the Baghdad School, the University Museum and Dropsie College, 1931–1938, *Excavations at Tepe Gawra*, 2 vols., Philadelphia, 1935–50; A. L. Perkins, *The Comparative Archaeology of Early Mesopotamia*, Chicago, 1949; R. W. Ehrich, ed., *Relative Chronologies in Old World Archaeology*, Chicago, 1954.
AYAKO IMAI

TEPE GAWRA, TEMPLE OF. One of the earliest temples (ca. 3200 B.C.) in northern Mesopotamia, consisting of a central cella, with four corner rooms projecting from the main outline. At that experimental stage some of the characteristics of Mesopotamian architecture had already appeared: orientation of the corners to the compass, and pilasters on the outer and inner faces, here still functional, but later evolving into the typical recessed paneling.

BIBLIOGRAPHY. A. J. Tobler, *Excavations at Tepe Gawra*, II, Philadelphia, 1950.

TEPE GIYAN, *see* GIYAN.

TEPE HISSAR. Important archaeological site in northeastern Iran. Three major prehistoric levels have been excavated, yielding pottery and works in bronze. A Sassanian palace and fire temple also stood here.

TEPIDARIUM. Warm room in Roman thermae. Its temperature was intermediate between that of the frigidarium, or cold room, and the caldarium, or hot room. The tepi-

Tepidarium. Warm room in Roman thermae.

darium occupied the central space of the thermae and was a dominant feature of the plan.

TEPOTZOTLAN (Tepozotlan). Small town near Mexico City, notable for the former Jesuit seminary of S. Martín (founded 1584). The cornerstone of the present church was laid in 1670, and the structure was completed by 1682. A magnificent Churrigueresque façade was added in 1760–62, although construction may have begun earlier and continued later. The buildings were abandoned following the expulsion of the Jesuits from Hispanic dominions in 1767. The church is maintained as a national monument today. It houses the Virreinato Museum, which con-

Tepotzotlán. The façade of the former church of S. Martín, 1760–62.

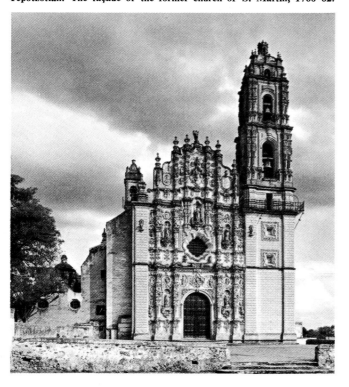

tains many fine examples illustrating three centuries of Mexican-Spanish colonial and religious art.

Although the façade has often been attributed to Lorenzo Rodríguez, it was probably designed by someone whose style is close to Rodríguez's. The sumptuous interior has elaborate gilded ornamentation and carved wooden walls of Moorish-derived design. The retables are of great splendor and perfection in preservation: those in the apse and transepts are apparently by one designer (with a large shop of craftsmen), still unknown, and those in the nave are possibly by I. V. Balbás; both date from the 1750s. There are other sumptuous chapels, and nearby is a lovely 18th-century *camarín* (church treasure house).

BIBLIOGRAPHY. R. H. Valle, *El convento de Tepotzotlán*, Mexico, 1924; A. von Wuthenau, *Tepotzotlán*, Mexico City, 1940 (English ed., 1941); P. C. de Gante, *Tepotzotlán*, Mexico City, 1958; J. A. Baird, Jr., *The Churches of Mexico, 1530–1810*, Berkeley, 1962.

JOSEPH A. BAIRD, JR.

TEPOZTLAN: CHURCH AND MONASTERY. Dedicated to the birth of the Virgin and located near Cuernavaca, Mexico, it was founded by 1559. The church was completed in 1588. In its valley setting, below towering mountains with a major pre-Conquest shrine, Tepoztlán is isolated but accessible. The exterior of the church has a fine façade with relief carvings of the Virgin and Child, flanked by St. Dominic and St. Catherine of Siena, over the portal. The atrium chapels (*posas*) are in a ruined state. The church interior is simple. The abandoned adjacent monastery is structurally interesting, with impressive views from the upper levels.

BIBLIOGRAPHY. G. Kubler, *Mexican Architecture of the Sixteenth Century*, 2 vols., New Haven, 1948; E. W. Weismann, *Mexico in Sculpture*, Cambridge, Mass., 1950.

TER BORCH, GERARD. Dutch painter of genre and portraits (b. Zwolle, 1617; d. Deventer, 1681). Ter Borch received his first training from his father, Gerard ter Borch the Elder, a painter who had been in Italy as a youth. Later he studied with Pieter Molijn at Haarlem. Ter Borch seems to have entered the Harlem painters' guild in 1635; later the same year, however, he was in England. He was reported back in Zwolle in 1636. Dutch sources tell us that Ter Borch traveled extensively through Germany, Italy, France, and Spain as well as in the Netherlands and England. In 1648 he went to Münster, where he painted portraits of various representatives engaged in peace negotiations as well as the actual ratification ceremony (*The Swearing of the Oath of Ratification of the Treaty of Münster, 15 May 1648*; London, National Gallery). In 1655 he became a citizen of Deventer and settled there.

Ter Borch's earliest works, such as *Soldiers in a Guard Room* (ca. 1638–40; London, Victoria and Albert), are generally in the style of such Haarlem painters as Pieter Codde and Willem Duijster. During the 1640s he painted a number of beautifully rendered miniature portraits, such as *Helena van der Schalke as a Child* (Amsterdam, Rijksmuseum). After 1650 Ter Borch began to paint the magnificently rendered interiors with figures for which he is best known (*The Parental Admonition*, ca. 1654/55; Ber-

Gerard Ter Borch, *Helena van der Schalke as a Child.* Rijksmuseum, Amsterdam.

lin, former State Museums). Some of his later works, such as the *Music Lesson* (ca. 1675; Cincinnati, Art Museum), appear to reflect the works of Johannes Vermeer, especially in the quality of light effects. Ter Borch had few pupils, and of these only Caspar Netscher is well known.

BIBLIOGRAPHY. S. J. Gudlaugsson, *Gerard ter Borch*, 2 vols., The Hague, 1959–60; N. Maclaren, *National Gallery Catalogues: The Dutch School*, London, 1960; J. Rosenberg, S. Slive and E. H. ter Kuile, *Dutch Art and Architecture, 1600 to 1800*, Baltimore, 1966.

LEONARD J. SLATKES

TERBRUGGHEN, HENDRICK. Dutch history and genre painter (b. near Deventer? 1588; d. Utrecht, 1629). Several Dutch sources tell us that Terbrugghen studied with the Utrecht painter Abraham Bloemaert. Little is known of Terbrugghen's earliest years in Utrecht. He traveled to Italy while still quite young and spent ten years in Rome, returning to Utrecht via Milan in 1614. Although there is documentation on his compatriots Honthorst and Baburen, nothing certain is known of Terbrugghen's activity in Rome and no painting executed by him in Italy has survived. He was the first of the school of Utrecht painters to travel to Rome and the only one to be there while Caravaggio was still alive. Like the other Utrecht painters of his generation, Terbrugghen found his major source of inspiration in the works of Caravaggio and his followers. He was perhaps a member of the artistic circle of the Giustiniani in Rome, and he may be identical with the "Enrico" mentioned in Vincenzo Giustiniani's famous letter to Theodor Ameyden.

Although Terbrugghen was back in Utrecht by 1614, no painting by him can be dated with any certainty before his *Crowning with Thorns* (1620; Copenhagen; State Museum of Fine Arts). Extremely important for the development of the Utrecht half-length, single-figured composition are Terbrugghen's series of four paintings representing the *Evangelists* (1621; Deventer, Stadhuis). In the same year (1621) Terbrugghen executed two canvases of half-length *Flute Players* (1621; Kassel, State Picture Collections), which, along with a similar rendering by Dirck van Baburen (1621; Utrecht, Centraal Museum), introduced this particular genre into Dutch art.

Hendrick Terbrugghen, *Duet*. Barberini Palace, Rome.

Terbrugghen's interest in the art of Caravaggio can be best demonstrated in such works as his genre-like rendering of the *Calling of St. Matthew* (1621; Utrecht, Centraal Museum), which helped popularize the table grouping as a standard compositional format in Utrecht. His only certain public commission was *Emperor Claudius* (1622; Berlin, Jagdschloss Grünewald), executed for the House of Orange as part of a series of the twelve Roman emperors. Other painters represented by works in the series are Rubens, Baburen, Moreelse, and Bloemaert.

The influence of Honthorst's candlelight scenes can be discerned in Terbrugghen's work from 1623 on, for example, the *Boy Lighting a Pipe from a Candle* (Erlau Museum). Although he turned to his Utrecht colleagues for inspiration, Terbrugghen was never dependent upon them. In his magnificent *St. Sebastian Tended by Women* (1625; Oberlin, Ohio, Dudley Peter Allen Memorial Art Museum) Terbrugghen shows himself to be superior to his compatriots.

In his last years Terbrugghen simplified his compositional devices and color range and executed several of his most beautiful and subtle paintings, including *Duet* (Rome, Barberini Palace) and the *Liberation of St. Peter* (Schwerin State Museum). His contribution to Utrecht painting was considerable, but it is difficult to separate his influence on Dutch art from the contributions of the school of Utrecht as a whole.

BIBLIOGRAPHY. A. von Schneider, ... *Caravaggio und die Niederländer*, Marburg an der Lahn, 1933; B. Nicolson, *Hendrick Terbrugghen*, London, 1958; W. Stechow and L. J. Slatkes, *Hendrick Terbrugghen in America* (exhibition catalog), Dayton, Ohio, 1965.

LEONARD J. SLATKES

TERECHKOVICH, CONSTANTIN (Kostia). Russian-French painter and theatrical designer (1902–). Born at Metcherskoe, near Moscow, Terechkovich studied at the Academy of Fine Arts in Moscow (1917), and emigrated to Paris in 1920. Primarily a painter, he designed the scenery and costumes for the Ballet Russe de Monte Carlo's *Choreartium* (1933).

BIBLIOGRAPHY. J. P. Crespelle, *Terechkovitch*, Geneva, 1958.

TERESA OF AVILA, ST. Spanish Carmelite nun and mystic (1515–82). In 1533 she entered the Carmelite Convent of the Incarnation at Avila, where she began to have trances accompanied by visions that continued throughout her life. She founded the Discalced (unshod) Carmelites, which later expanded, through the work of St. John of the Cross, to include friars. The congregation lived in extreme poverty, slept on straw, and was strictly cloistered. Teresa wrote her autobiography, a history of the order, and mystical treatises. She may be shown with Christ or with an angel about to pierce her heart with an arrow or as interceding for the souls in Purgatory. She is usually portrayed wearing a crown of thorns and with IHS on her heart. Her feast is October 15.

See also SAINTS IN ART.

TERM. Bust on a tapered pedestal, used in antiquity as termini (hence "term"), or boundaries of fields, and as ornamental sculpture. It is also called herm. *See* HERM.

TERRACE. Any elevated platform, usually surrounded by a balustrade. In garden architecture, a terrace is an ele-

Terra cotta. Luca della Robbia, *The Madonna and Child with Saints*. Sta Croce, Florence.

vated walk rising by steps above the ground in front of it. In Roman architecture, the solarium was a form of terrace.

TERRA COTTA. Ceramic product made of baked clay, often brownish red or buff in color and usually unglazed. Its name means "cooked earth." Terra cotta has been in use since prehistoric times for modeled figurines and also for pots and vases. The material reached an artistic peak in the Tanagra figurines of ancient Greece, where it was also widely utilized in making architectural details. It has been employed for large-scale sculpture by the Etruscans, in Renaissance Italy, principally through the efforts of the Della Robbia family, and in 18th-century France. *See* ROBBIA, LUCA DELLA; TANAGRA.

TERRAGINI, GIUSEPPE. Italian architect (1904–43). His Casa del Fascio (1932–36) in Como embodies the fascism of which he was a proponent. Of rectangular plan, it consists of stacks of floors of offices built around the sides of an internal court. Most arresting is the formality of the rectangular subdivisions of the façade.

BIBLIOGRAPHY. R. Banham, *Guide to Modern Architecture*, London, 1962.

TERRANOVA, GUGLIELMO, *see* NIEULANDT, WILLEM VAN.

TERRA SIGILLATA. Ancient Italian tableware of lustrous pottery, often red. It is known also as Arretine or Samian ware. Terra sigillata provided an inexpensive version of embossed silver bowls by the use of *sigilla*, individual stamps of convex profile which were pressed into the inner surface of the molding vessel. In Italy the ware was made from about 2000 B.C. to A.D. 100, but it persisted in Gaul until about A.D. 250.

BIBLIOGRAPHY. W. E. Cox, *The Book of Pottery and Porcelain*, 2 vols., New York, 1944.

TERRAZZO. Material made of marble chips, cement, and water which, on hardening, is generally polished by grinding. To limit cracking, terrazzo is separated into panels by metal or plastic dividing strips. Terrazzo formed before being applied is precast.

TERRE DE LORRAINE (T. D. L.). The mark on the sentimental figures made by Paul-Louis Cyfflé at his factory in Lunéville from about 1766 to 1777. Cyfflé agreed

to refer to his ware, made of biscuit porcelain, as *terre-cuite*, to avoid conflict with the royal factory's monopoly on the production of porcelain. The Lunéville factory was famous at first for faïence and later for the production of creamware.

BIBLIOGRAPHY. M. P. Morey, *Les Statuettes dites terre de Lorraine...*, Nancy, 1871.

TERREMARE. Mounds of earth found in the plains of northern Italy containing remains of prehistoric settlements. Dating principally from the Bronze Age, these settlements consisted of wooden houses built upon stakes above land which was subject to inundations from rivers. The Terremare culture was similar to that of the nearby Lake Dwellers of Switzerland.

TERRENI, GIUSEPPE MARIA. Italian fresco painter and etcher (b. Livorno, 1739; d. there, 1811). He was a pupil of I. Hugford. Commissioned by the Grand Duke of Tuscany to restore ceiling paintings in the Uffizi Gallery, Florence, Terreni was highly lauded and received many other commissions. His style of ornament was both original and imaginative. He also published a book on his native city (1783) illustrated with his own engravings.

TERRIBILIA, see MORANDI FAMILY.

TERWESTEN, AUGUSTINUS. Dutch painter of history and of ceiling and wall decorations; also graphic artist (b. Ouderkerk, 1649; d. Berlin, 1711). Terwesten's first activity was as a modeler with his father, Jacob, a silversmith. He studied painting with N. Wieling and Willem Doudijns. He was active in Italy (1672–74), France, England, and Holland (1678–91). In 1682 Terwesten was one of the founders of the drawing academy in The Hague. In 1694 he was made director of the academy in Berlin.

BIBLIOGRAPHY. W. Bernt, *Die niederländischen Maler des 17. Jahrhunderts...*, vol. 3, Munich, 1948.

TESSAI (Tomioka Tessai). Japanese painter (1836–1924). Tessai was also a poet and Confucian scholar. He stood apart from the main current of contemporary Japanese art. As a youth, he studied the Tosa style but later moved to Nanga. In true literati fashion, he painted in a bold, free, and extremely personal manner. *See* NANGA SCHOOL; TOSA SCHOOL.

TESSARO, GIROLAMO, see GIROLAMO DEL SANTO.

TESSELATED. Formed of small, approximately square pieces, as in Roman mosaics.
See also OPUS (OPUS TESSELATUM).

TESSENOW, HEINRICH. German architect (b. Rostock, 1876; d. 1950). He studied with Hocheder and Thiersch in Munich and later became a teacher in Dresden and Berlin. Among Tessenow's executed works are the row houses at Dresden-Hellerau (1910), the Festival Theater (1910–13), and the Landeschule at Dresden-Klotzsche (1927).

BIBLIOGRAPHY. G. A. Platz, *Die Baukunst der neuesten Zeit*, 2d ed., Berlin, 1930.

TESSERA. Latin term, meaning "square piece," used to designate a small piece of marble, glass, or stone in mosaics, as in Roman pavements and walls.

TESSIN, NICODEMUS, THE YOUNGER. Swedish architect (1654–1728). He studied in Italy and France and became the chief baroque architect in northern Europe. Tessin's major designs include Kalmar Cathedral; projects for the Louvre, Paris (not executed); and the Stockholm Royal Palace, his most impressive monument, which is distinguished for its characteristic blend of grandeur in scale and grace in proportion.

BIBLIOGRAPHY. R. Josephson, *Tessin—Nicodemus Tessin d. y.*, 2 vols. (Sveriges allmänna Konstförenings, nos. 38 and 39), Stockolm, 1930–31.

TESTA, PIETRO. Italian painter, etcher, and theorist (b. Lucca, 1607/11; d. Rome, 1650). He was in Rome by 1630 and studied with Domenichino and Pietro da Cortona before coming under Poussin's influence in such works as *Shepherd's Dream* (Rome, Colonna Gallery). His imaginative and often pastoral etchings, however, link him with the romantic trend of Rosa and Mola.

BIBLIOGRAPHY. L. Lopresti, "Pietro Testa, incisore e pittore," *L'Arte*, XXIV, 1921 (2 articles); A. Petrucci, "Originalità del Lucchesino," *Bollettino d'arte*, XXIX, 1935–36.

TETRASTYLE. Denoting a portico of four columns. When framed by end walls, or antae, the portico is called "tetrastyle in antis," as in Temple A on the Acropolis, Athens; when part of an encircling colonnade, it is called "peripteral tetrastyle," as in the Nereid Monument in Xanthus. When the columns are in front only, the structure is identified as prostyle tetrastyle, as that of Temple B, Selinus; when four columns are at front and at rear, without side colonnades, it is amphiprostyle tetrastyle, as the temple on the Ilissus River, Athens.

TETRODE (Tetroede; Tetteroede), WILLEM DANIELSZ. VAN. Architect and sculptor (16th cent.). Tetrode's nationality is not absolutely certain, but it is most likely that he was born in Delft. In 1559–60 he worked on the castle of Pitigliano in southern Tuscany on a "cabinet ornamented with figurines," which was intended as a gift to Philip II of Spain. Earlier, about 1550, he had worked with Cellini in Florence on repairing the antique statue of Ganymede owned by Cosimo I de' Medici. While in Italy he became known as "Guglielmo Tedesco," which is the way Vasari speaks of him in his *Lives*. Tetrode was also called "Il Fiammingo" because he was Netherlandish. In 1568 he worked on the Chapel of the Oude Kerk (St. Hippolyt), Delft; and in the same year, he began its high altar, which became the chief masterwork of his life. The altar, completed in 1571, was made of jasper and alabaster and was decorated with bronze ornaments; it was pronounced the most beautiful altar in the world by some of his contemporaries. Tetrode's other major work was the architecture and decoration of the palace of the Archbishop of Kuf and Cologne (at one time Salantin von Isenburg). The building was decorated with mythological figures in the Italianate style.

PATRICIA F. MANDEL

TEUNISSEN, CORNELIS, see ANTHONISZ., CORNELIS.

TEXIER, JEAN (Jean de Beausse). French architect (d. 1529). Jean Texier rebuilt the upper part of the north tower of the Cathedral of Chartres, which had been destroyed by fire, in the Flamboyant Gothic style (1507–13; with Thomas Levasseur). In 1514–29 he executed the ambulatory at Chartres, and in 1520 he designed the clock pavilion next to the north tower in the Renaissance style.

TEXTILE WEAVING, GREEK AND ROMAN, *see* WEAVING, TEXTILE, GREEK AND ROMAN.

TEXTURE. Surface quality of a work of art. Texture can be real, as in most sculpture and even in architecture, or illusionary, as in painting. Michelangelo utilized almost every nuance of texture in his marble sculpture, from rough, unfinished areas to the most brilliant polish. Painters such as Holbein were noted for their great skill in rendering subtleties of texture.

THAILAND, *see* SIAM.

THAI STYLE, *see* SIAM.

THALAMUS. Inner chamber of the ancient Greek house. Thalami were used as bedrooms, apartments for women, and storerooms. The later thalamus was accessible from an open court.

THALISCH CATHEDRAL. Seventh-century church typical of early Armenian (East Christian) domed central-plan structures. The type probably came to Armenia from Syrian prototypes. The church contains wall paintings of the 8th or 9th century, showing Syrian influence both stylistically and iconographically.

Theater. Ground plan of La Scala Opera House, Milan, designed by Giuseppe Piermarini.

THAYER, ABBOTT HANDERSON. American painter (b. Boston, 1849; d. Monadnock, N.H., 1921). His early paintings were of cattle. In 1875 Thayer went to Paris with the intention of studying with Auguste Bonheur, the animal painter. He soon realized the need for wider training, particularly in rendering the figure, and enrolled at the Ecole des Beaux-Arts under Jean-Léon Gérôme.

Thayer eventually became best known for his paintings of women, sometimes in portraits, most often as allegorical personifications and large-winged angels, for example, *Winged Figure* (1889; Northampton, Mass., Smith College Museum of Art). Thayer's figures, such as *Caritas* (1897; Boston, Museum of Fine Arts) and *The Virgin Enthroned* (1891; Washington, D.C., Smithsonian Institution), show great sentimentality, in spite of his classicizing search for ideal beauty, and not even the wind-blown vigor of his children in *The Virgin* (1893; Washington, D.C., Freer Gallery) can dispel the sweetness of their rosy purity. Thayer's best figure paintings are probably his portraits. In them he was able to combine his sound technique and skillful handling of tone with a sensitive depiction of mood; a fine example is *The Stillman Sisters* (1884; Brooklyn Museum). Also notable are such later, broadly painted landscapes as *Winter Sunrise, Monadnock* (1918; New York, Metropolitan Museum).

Thayer's strong interest in nature led to research and experiments which resulted in the publication in 1909 of *Concealing Coloration in the Animal Kingdom*, a summary of his ideas, by his son, Gerald H. Thayer. His theories of obliterative shading and concealing pattern were important contributions to animal studies and were the basis for the development of camouflage techniques for combat use.

BIBLIOGRAPHY. N. Pousette-Dart, ed., *Abbott H. Thayer*, New York, 1923; N. C. White, *Abbott H. Thayer: Painter and Naturalist*, Hartford, Conn., 1951.

JEROME VIOLA

THEATER. Structure for performances (from the Greek *theatron*, "seeing place"). The modern usage of the name is associated with The Theater, London, which James Burbage built in 1576. Shakespeare's plays were performed in the Globe, erected in 1599, modeled on Burbage's circular wooden building with seating galleries. The Globe, an octagonal structure partly open at the top, had galleries extending around it on three sides. Its *pit*, at ground level, was occupied by the poorer class, its galleries and the extra seats on the stage itself being patronized by the gentry.

The theater derives from ancient Greek structures which were dedicated to the worship of Dionysos, as in Athens. Generally cut into hillsides and attaining considerable size, the Greek theater had concentric seats in tiers on an approximately semicircular plan accommodating as many as 16,000 people, as in Epidaurus and Megalopolis. Actors and chorus performed in the orchestra, a circular area in which was placed an altar to Dionysus, the focus of the plan. The early Greek theater is said to have had no stage at first, the stage developing later in front of a background building called a *skene* (hence scene) and between *parascenia*, wings at the ends of the skene which usually projected towards the orchestra to frame the stage. The skene, at first a booth in which actors could change, be-

came a permanent two-storied structure which served as a setting and a place of action. The later Greek theater brought the stage forward into the orchestra. *See* DIONYSOS, THEATER OF, ATHENS; PARASCENIUM; SKENE.

More frequently built on level ground than against hillsides as were Greek theaters, the theater in Rome had seats, or *spectacula*, raised on scaffolding; masonry construction was used in later theaters. The Roman theater was distinguished from the Greek by a slightly raised stage, or *pulpitum*; its seating section, called the *cavea*, was a semicircle or less, to enable spectators to see the stage. *Scaena* and auditorium were combined. Auxiliary scenery called *periaktoi* was placed at side entrances to the stage, and an *aulaeum*, or drop curtain, was adopted. The more elaborate and permanent theater developed in Rome about the 1st century B.C. Inspired by the Greek theater at Mytilene, Pompey in 55 B.C. built a stone theater in the Campus Martius.

A fixed theater was usually lacking in the performance of medieval mysteries: in Spain, stages had been put up in courtyards with buildings serving as a backdrop. Roman prototypes were taken up in the Renaissance, particularly in Italy. Based on Greek and Roman precedents, viewed through Vitruvius, a theater was built in the late 15th century in the ducal court of Ferrara. Palladio's Teatro Olimpico, Vicenza (1580–83), is a small semicircular building with an elaborate stone skene consisting of receding architectural elements, progressively reduced in size to intensify the sense of distance. With its gallery above the highest tier of seats, it served as a model for Scamozzi's Theater at Sabbioneta (1588), designed for intimate drama. *See* TEATRO OLIMPICO, VICENZA.

The use of galleries, observable in The Theater and the Globe, was extended with the spread of opera. Ferdinando Galli da Bibiena's Teatro Delli Quattro Cavaglieri, Pavia, has four tiers of arcaded boxes above the auditorium floor (compare Covent Garden, London, and the Comédie-Française, Paris). Boxes during the 18th century had become private drawing rooms where diversion could be found in playing cards or dominoes. The Burg Theater, Vienna, of the 19th century, is in this idiom. *See* BIBIENA FAMILY; BURG THEATER, VIENNA.

The modern theater, with its new media of entertainment, has produced the motion-picture theater whose seats in some instances slope down and away from the screen. The conventional stage and proscenium has been abandoned in the arena theater, or theater-in-the-round, in which the action takes place in a central area surrounded by spectators, who are thereby brought more immediately into the play.

MILTON F. KIRCHMAN

THEBES, EGYPT. City of ancient Egypt, now in ruins. Luxor, Karnak, and Qurna occupy parts of its site. *See* KARNAK; LUXOR.

See also AMUN; TUTANKHAMEN, TOMB OF; VALLEY OF THE KINGS.

THEBES, GREECE. City situated on the plain of Boeotia. One of the most ancient Greek cultural centers, it is rich in myth and legend. Tradition told of Thebes's having first been settled by the Phoenician king Cadmus. A suc-

ceeding legendary dynasty, the Labdacidae, is the subject of many mythological cycles, the most famous of which is the story of Oedipus and his children. The rich mythology which surrounds Thebes undoubtedly took shape in the Mycenaean period, when, as the archaeological remains indicate, the city was an important power until its destruction sometime during the 13th century B.C.

During the 1st millennium B.C. Thebes grew from an obscure pastoral town to a thriving cultural center which produced the poet Pindar. The splendid archaic sculptures from the nearby sanctuary of Apollo Ptoos probably reflect the growing prosperity of Thebes in the 6th century B.C. In the 4th century B.C. Thebes opposed and defeated Sparta and enjoyed for a short time the role of the leading city in Greece. In 335 B.C., however, it was razed by Alexander the Great, and never regained its greatness.

The heart of the city of Thebes was always its low citadel, the Cadmea. Traces of a Mycenaean palace here were first excavated between 1909 and 1917; more finds from the palace, notably a hoard of Oriental cylinder seals, came to light in 1964. The Cadmea was undoubtedly surrounded by a wall in the Mycenaean period, and it was probably this wall which was equipped with the seven gates made famous by Aeschylus's *Seven against Thebes*. The walls which are now visible date from the classical period. A well-preserved gate in this later wall, located to the south of the Cadmea, is generally thought to stand on the spot where the "Electra gate," known from Aeschylus's play, once stood. Thebes was also equipped in the classical period with a large city wall which formed a wide semicircular arc to the north of the old citadel and eventually joined up with the south wall of the Cadmea. A number of Mycenaean tombs have been discovered within this circuit to the east of the Cadmea.

The most important of the classical finds at Thebes is the sanctuary of Ismenian Apollo, located to the southeast of the Cadmea. Traces of a series of Doric temples have been found here. The fragments of the oldest temple date from the early 7th century B.C. and are perhaps the oldest traces of Doric stone architecture known. The most complete remains, however, come from the third temple on the site, a Doric hexastyle structure dating from about 370 B.C.

BIBLIOGRAPHY. Pausanias, *Pausanias's Description of Greece*, book 5, tr. J. G. Frazer, 2d ed., London, 1913; A. D. Keramopoulos, "Thebaïka" [*Archaiagikon Deltion*], III, 1917 (in Greek—the only thorough study of the antiquities of Thebes).

JEROME J. POLLITT

THECLA, ST. The apocryphal *Acts of Paul and Thecla* say that Thecla was converted by Paul at Iconium. Condemned to be burned, she was saved by a storm from heaven and escaped to join Paul in Antioch. The governor had her thrown to the lions, which lay down and licked her feet; she remained unharmed in a pit filled with snakes. Thecla preached with Paul at Myra in Libya. She is sometimes shown partly naked, arms upraised in prayer. Her attributes are a small Greek cross and a lion's head. Her feast is September 23.

See also SAINTS IN ART.

THEODON, JEAN BAPTISTE. French sculptor (b. 1646; d. Paris, 1713). A major part of his life was spent in Rome,

Tomb of Theodoric, Ravenna. Circular mausoleum with monolithic dome, built ca. 525.

where he worked in the Italian baroque tradition. In the style of Bernini, he designed a sculptured group, *Faith Overcoming Idolatry*, for Il Gesù in Rome. Upon his return to France Théodon executed a statue of St. Andrew for the chapel at Versailles.

THEODORE PSALTER. Byzantine illuminated manuscript, in the British Museum, London.

THEODORIC, TOMB OF, RAVENNA. Mausoleum of Theodoric, king of the Goths, in Italy. It was erected by his daughter about A.D. 525. The tomb is a circular building, its most remarkable feature being the monolithic dome, 36 feet in diameter, which roofs it. Around the dome and carved from the same block of stone are "handles," giving the appearance of right-angled flying buttresses, which were in all probability used for hoisting the immense stone into position. Decorative elements of the mausoleum follow the barbaric interlace and lacertine patterns. The interior contains a porphyry basin used as the sarcophagus of Theodoric.

THEODORIC OF PRAGUE. Bohemian painter (fl. Prague, 1359–80). Theodoric was active at the court of Emperor Charles IV in Prague. Nothing is known of his origin or training. His major works are the paintings executed in the Chapel of the Holy Cross of Karlstein Castle (1357–67). One of the principal creators of the so-called Weicher Stil (soft style), Theodoric is closely related to the Italian Tom-

maso da Modena, who is thought to have worked at Karlstein. *See* KARLSTEIN CASTLE; TOMMASO DA MODENA.

BIBLIOGRAPHY. A. Stange, *Deutsche Malerei der Gotik*, vol. 2, Berlin, 1936; A. Friedl, *Magister Theodoricus*, Prague, 1956.

THEODORUS. Greek sculptor, painter, and architect from Samos (fl. ca. 550 B.C.). He is perhaps a partly legendary figure. Ancient writers attribute many remarkable inventions and achievements to him, such as the technique of bronze casting, the introduction into Greece of Egyptian sculptural principles, and the authorship of architectural treatises, notably one on the Heraeum of Samos.

BIBLIOGRAPHY. H. S. Jones, ed., *Select Passages from Ancient Writers Illustrative of the History of Greek Sculpture*, London, 1895; J. J. Pollitt, *The Art of Greece, 1400–31 B.C.*, Englewood Cliffs, N. J., 1965.

THEOPHANES THE GREEK. Byzantine fresco and icon painter (fl. 1378–1405). He was an elder colleague of Rublev and may have been Rublev's teacher. The only work that can be assigned to Theophanes with certainty is a fresco (1378) in the Church of the Transfiguration, Novgorod. It is a virtuoso piece executed in a technique that seems to be a continuation of late-antique illusionism. In 1405 Theophanes worked with Rublev and Prochor of Gorodets on a fresco cycle (destroyed) for the Cathedral of the Annunciation, Moscow, and on the iconostasis of the Cathedral. Theophanes and his apprentices apparently executed the icons of the *deësis* tier of the iconostasis. A panel preserved in the Cathedral, *The Virgin of the Don* (ca. 1380), has been attributed to Theophanes. That he usually worked without reference to models astounded his contemporaries. His brilliant conversation earned him the title "philosopher."

THEOPHILUS PRESBYTER (Rugerus). Benedictine author (fl. early 12th cent.). His *De diversis artibus* is the earliest known and most systematic book on art and techniques of the medieval period. The treatise is divided into three books: the first is devoted to the materials and techniques of painting, the second to the art of glass, and the third to the arts of metalworking. The greater length and the knowledgeability of the last book has led modern scholars to the conclusion that Theophilus was himself a metal craftsman, possibly to be identified with Roger von Helmarshausen. He was, in any case, a Benedictine monk and priest; his name in religion was Rugerus (Roger). It seems probable that he lived in northwestern Germany during the first half of the 12th century. The Greek name Theophilus was adopted as a pseudonym, a not uncommon practice at that time. *See* ROGER VON HELMARSHAUSEN.

Drawing on sources of international scope, the body of the text is extremely detailed in describing every aspect of a craftsman's work, from the setting up of a workshop to the creation of the final product, with all manner of materials, recipes, and techniques discussed. The treatise also provides an invaluable source for the study of medieval technology in its dissertations on metallurgical processes, the making of paper, the building of an organ, and so forth. Its use was recognized throughout Europe for several centuries, and it was therefore widely reproduced in manuscripts, a number of which have come down to us.

BIBLIOGRAPHY. C. R. Dodwell, ed. and tr., *Theophilus: The Various Arts*, New York, 1961; J. G. Hawthorne and C. S. Smith, ed. and tr., *On Divers Arts*, Chicago, 1963. DONALD GODDARD

THEOTOCOPULI, JORGE MANUEL. Spanish painter and architect (b. Toledo? 1578; d. there, 1631). The illegitimate son of El Greco, he learned painting and architecture from his father, whom he assisted until the great artist died in 1614. Theotocopuli may be portrayed, as a boy of eight, as the page in *The Burial of the Count of Orgaz* (1586; Toledo, S. Tomé). On his own he often copied his father's works, received commissions for retables in and around Toledo, and became master of the Cathedral of Toledo in 1625. In the latter capacity he was responsible for the construction of a new cupola (1626–31).

BIBLIOGRAPHY. J. Martín González, "El Greco, arquitecto," *Goya*, XXVI, September–October, 1958.

THEOTOKOPOULOS (Theotocopuli), DOMENIKOS (Domenico), *see* GRECO, EL.

THERMAE. Baths, particularly in ancient Rome. Roman baths, presumably derived from Greek gymnasiums, were large structures containing facilities for bathing, recreation, lectures, and relaxation. They were an important part of the daily life of the city, about eight hundred being said to have existed in ancient Rome.

Thermae were generally erected on a high enclosed platform under which were furnaces and utility rooms. They were composed of three main elements, typified in the Baths of Caracalla (212–216) and Diocletian (completed 305) in Rome. The first was the central structure containing the tepidarium, a warm room dominating the plan; the laconicum, for hot dry air; the caldarium, or hot room, with hot-water bath; a sudatorium for sweating; and a frigidarium, a cold room with a piscina, or swimming pool. Allied with these rooms were apodyteria, or dressing rooms, and unctoria, for applying oils and unguents. Ball was played in a sphaeristerium; a library and a small theater were sometimes included. *See* CARACALLA, BATHS OF, ROME; DIOCLETIAN, BATHS OF, ROME.

The second component of the plan was an open space surrounding the central structure and planted with trees,

ornamented with statues and fountains, and used in part for a stadium with raised seats at the side. The third component was an outer ring of apartments, with lecture rooms, exedrae for discussions, colonnades, shops, and accommodations for slaves attached to the thermae. Larger and more diversified than earlier structures, the Baths of Caracalla could accommodate 1,600 bathers, had hypocausts and hot-air ducts for heating the buildings, and contained a large vaulted reservoir for storing water. The baths were open to the public for a small entrance fee, and they became the meeting place of poets, philosophers, and ·the young athletes who exercised there. Mixed baths for men and women were prevalent in Rome.

MILTON F. KIRCHMAN

THERMES, PALAIS DES, PARIS. Ruins of Roman baths that adjoined the Palace of the Emperors supposedly founded by Constantinius Chlorus, who lived in Gaul from 292 to 306. Nothing remains of the palace, which is now the site of the Cluny Museum. The largest hall of the baths, which is connected to the museum, was the frigidarium. It is roofed with a central groin vault and contains some Roman statues and inscriptions. *See* PARIS: MUSEUMS (CLUNY MUSEUM).

BIBLIOGRAPHY. P. M. Duval, *Paris antique des origines au troisième siècle*, Paris, 1961.

THESAUROS, *see* TREASURY.

THESEUM (Hephaesteum; Hephaisteion). The Temple of Hephaestus in Athens, popularly known as the Theseum, begun in 449 B.C. and completed thirty years later. The Theseum, whose architect is unknown, is a Doric hexastyle temple of Parian marble. It is peristylar, with six columns on the ends and thirteen on the flanks, and it contained a cella with a pronaos and an opisthodomus.

The external metopes were decorated with sculptural reliefs representing the exploits of Hercules (east side) and Theseus (south side). Above the walls of the porch and opisthodomus ran a frieze with themes of gigantomachia and centauromachia. The reliefs on the metopes and friezes still remain in their original positions. Fragments of pedimental sculpture, including a male torso and an acroterion group of two female figures, have been excavated. The bronze cult images of Hephaestus and Athena (now lost) stood inside the cella (421–415 B.C.). Except for its badly damaged sculptural decoration, the Theseum is the best-preserved Greek temple.

BIBLIOGRAPHY. W. B. Dinsmoor, "Observations on the Hephaisteion," *Hesperia*, Suppl. V, 1941; H. Koch, *Studien zum Theseus-tempel in Athen*, Berlin, 1955.

THESEUS (Parthenon Figure), *see* MOUNT OLYMPUS.

THESSALONIKA (Salonika). City in northern Greece. It is the site of important late-antique and Byzantine art. The circular domed tomb of the emperor Galerius (A.D. 310) was transformed in the 5th century into the Church of St. George and decorated with mosaics. Some of the sculpture of Galerius's triumphal arch is preserved. There are two fine 5th-century basilicas, both restored: St. Paraskevi Church and Hagios Dimitrios. The 7th-century mosaics of Hagios Dimitrios are, like those in the domed church of S. Sophia (perhaps early 8th cent.), rare examples of By-

Thermae. Ground plan of the Baths of Caracalla, Rome.

Theseum. The Doric hexastyle Temple of Hephaestus, in Athens, built of Parian marble, begun in 449 B.C.

zantine work from their periods. The Holy Apostles (1315) is one of the city's typical five-domed late Byzantine churches. There is an archaeological museum. The art of Thessalonika deeply influenced that of the Serbs. *See* HA-GIOS DIMITRIOS; ST. PARASKEVI CHURCH.

BIBLIOGRAPHY. O. Tafrali, *Thessalonique au quatorzième siècle*, Paris, 1913; C. Diehl et al., *Les Monuments chrétiens de Salonique*, Paris, 1918; W. F. Volbach, *Early Christian Art*, New York, 1962.

THESSALY, *see* AEGEAN ART.

THIELEN, JAN PHILIPS VAN. Flemish painter (1618–67). Born in Mechlin, he was active in Antwerp from 1632 to 1660 as a disciple of Daniel Seghers. Thielen gained a reputation as a painter of flowers in his master's manner. The medallions in his flower garlands were often from the brush of his brother-in-law Jan Erasmus Quellinus.

BIBLIOGRAPHY. F. J. van den Branden, *Geschiedenis der Antwerp-sche Schilderschool*, Antwerp, 1883.

THIENEN, JACOB VAN. Flemish architect and sculptor (fl. ca. 1370–1406). Before 1377 Thienen was architect of St-Gudule in Brussels; he is credited with its south aisle. In that year he was registered in the stonemasons' guild at Brussels, and in 1405 he worked as a sculptor and architect on the Hôtel de Ville there.

THINKER, THE. Bronze sculpture by Rodin, in the Rodin Museum, Paris. *See* RODIN, AUGUSTE.

THIRD-CLASS CARRIAGE. Oil painting by Daumier, in the Metropolitan Museum of Art, New York. *See* DAUMIER, HONORE.

THIRY, LEONARD. Flemish painter (d. Antwerp, 1550). A pupil of Rosso, Thiry worked at Fontainebleau from 1536 to 1550. Although no paintings by him are known, numerous prints after his drawings were made by René Boyvin (*Story of Jason*; ornamental panels with antique divinities), J. A. du Cerceau (*Antique Ruins*), and Léonard Davent (*The Rape of Prosperina*; *The Fable of Callisto*).

BIBLIOGRAPHY. F. Herbert, "Les Graveurs de l'école de Fontaine-bleau," *Annales de la Société Historique & Archéologique du Gati-nais*, XVIII, 1900.

THOENERT, MEDARUS. German engraver (b. Leipzig, 1754; d. there, 1814). He studied with Bause and Geyser at the Leipzig Academy. Thoenert illustrated a number of books (among them three volumes of *Theorie der Garten-kunst* by Hirschfeld, after Aberli, Brandt, and Moreau), almanacs, and picture series (of Leipzig personalities, 1789).

BIBLIOGRAPHY. M. Stübel, ed., *Chodowiecki in Dresden und Leipzig*, Dresden, 1920.

THOLOS. Early Greek building, generally a beehive-shaped dome. Tholoi in Crete were large ceremonial tombs, the

Tholos. Ruins of the Old Tholos in Delphi, ca. 390 B.C.

earliest suggestions for the type being attributed to 2700–2000 B.C. Mycenaean tholoi from the end of the 2d millennium B.C. are shaped like beehives and are built of overlapping stones in successive rings. The so-called tomb of Agamemnon, or Treasury of Atreus, is approached by a dromos, or passage, leading to the inner beehive chamber. The Old Tholos in Delphi was a Doric structure with a circular peristyle; the tholos in Athens was a circular building without outside columns that served as a *prytaneum*, or dining hall, for the Athenian Senate. The tholos in Epidaurus had a circular cella with an outer and an inner ring of columns. *See* ATREUS, TREASURY OF, MYCENAE.

THOMA, HANS. German painter (b. Bernau, 1839; d. Karlsruhe, 1924). He began his studies at the Karlsruhe Academy with J. W. Schirmer. In 1866 Thoma was in Düsseldorf, and in 1868 he traveled with Scholderer to Paris. There Thoma was introduced to Courbet, who exercised a strong influence on him. From 1870 to 1874 Thoma was active in Munich, where he met Leibl, Trübner, and Böcklin. From Munich he traveled to Italy, returning in 1876 to Frankfurt. From 1899 on he remained in Karlsruhe as the director of the Städel Art Institute and professor at the academy. He continued the *volkstümlich* (popular) tradition of German romantic painting begun by Schwind. Thoma painted portraits (*Self-Portrait with Wife*, 1887; Hamburg, Art Gallery), genre subjects (*Märchenerzählerin*, lithograph, 1893), and, above all, sensitive landscapes (*Rhine Falls at Schaffhausen*, 1876; Bremen, Art Gallery; *Rhine by Laufenberg*, 1883; Frankfurt am Main, Städel Art Institute and Municipal Gallery; and *Taunus Landscape*, 1890; Munich, Bavarian State Picture Galleries).

BIBLIOGRAPHY. F. von Ostini, *Thoma* (Künstler-Monographien, XLVI), Bielefeld, 1900; O. J. Bierbaum, *Hans Thoma* (Die Kunst, XXVII), Berlin, 1904; H. E. Busse, *Hans Thoma: Leben und Werk*, Berlin, 1935.

THOMAR, *see* TOMAR.

THOMAS, ST. Apostle, Galilean fisherman, and carpenter who doubted the Resurrection till he touched Christ's wound. As an apostle in India, he gave the poor the money he received from King Gundaphorus to build a palace, explaining to the king that by doing so he was building a palace for him in heaven. He was put in prison and tortured for persuading the queen to practice chastity. His attributes are a T-square, a lance (instrument of martyrdom), and the Virgin's girdle (received after the Assumption). His feast is December 21.

See also SAINTS IN ART.

THOMAS À BECKET, ST. Archbishop of Canterbury (1118–70). Of Norman parents, he studied canon law. As chancellor to Henry II, he subordinated the church's interests to the King's; but as archbishop, his uncompromising stand led to a dispute with the King, and flight to France. Six years later under papal pressure, the King agreed to a truce, but Thomas à Becket on his return home continued his defiance. He was murdered by courtiers acting independently, and is shown martyred by a sword before the high altar. His feast is December 29.

See also SAINTS IN ART.

THOMAS AQUINAS, ST. Doctor of the Church (1225–74). Born near Aquino, Italy, he entered the Dominican order in 1243. He studied with Albertus Magnus and settled in Paris, where he won fame as a teacher, a leader of scholasticism, and an opponent of the Averroists. His most important work, *Summa Theologica*, is now church doctrine. Aquinas gave priority to faith but attempted to reconcile Aristotelian rationalism with Christianity. His attributes are a dove, star on his breast, chalice with Host, and church model. His feast is March 7.

See also SAINTS IN ART.

THOMAS CARLYLE, PORTRAIT OF. Oil painting by Whistler, in the Art Gallery and Museum, Glasgow. *See* WHISTLER, JAMES ABBOTT MCNEILL.

THOMASSIN, PHILIPPE. French engraver (b. Troyes, 1562; d. Rome, 1622). He was the most notable of the three Thomassins, a family of French artists: Simon Thomassin (b. Troyes, 1655; d. Paris, 1732), Philippe's nephew, and Henri-Simon Thomassin (b. Paris, 1687; d. there, 1741), Simon's son. Philippe worked as a goldsmith and jeweler, first in Troyes and later in Rome. Arriving in the papal city in 1585, he met the print publisher Claudio Duchetti, heir of Antonio Lafreri, and began to engrave on copper. He imitated the style of Cornelis Cort, which was itself ultimately derived from Marcantonio Raimondi. Long, precise, evenly spaced lines render form, and light and dark, at the expense of texture. Philippe spent the rest of his life in Rome engraving and publishing prints in partnership with his brother-in-law. These are signed "Apud Phil-Turp." He worked after the prominent Italian and French painters—Barocci, Federico Zuccari, Martin Fréminet, and Francesco Vanni. More than 400 prints are attributed to him.

BIBLIOGRAPHY. E. Bruwaert, *La Vie et les oeuvres de Philippe Thomassin graveur troyen, 1562-1622*, Troyes, 1914.

THOMIRE, PIERRE PHILIPPE. French bronze caster and chiseler (b. Paris, 1751; d. there, 1843). He studied sculpture under Pajou and Houdon, but in 1774 apprenticed himself to P. Gouthière. As chief rival of Gouthière after 1776, Thomire made a vast range of finely chiseled gilded-bronze furniture mounts, firedogs, candelabra, and bronze statuettes in both neoclassical and Empire styles for Louis XVI (sphinx and lion firedogs, 1786; Paris, Louvre), Napoleon I (cradle of the King of Rome, 1811; Vienna, Imperial Treasury), and Louis Philippe.

BIBLIOGRAPHY. J. Niclausse, *Thomire...*, Paris, 1947.

THOMON, THOMAS DE. Russian architect of French birth (1754–1813). Educated in Paris, he traveled to Italy, where he was influenced by Piranesi's work and the architecture of Paestum. He went to St. Petersburg in 1790. In his Stock Exchange in St. Petersburg, which is called the major monument of the international classical revival of its time, he revived the use of the archaic Doric order.

BIBLIOGRAPHY. G. Loukomski, "Thomas de Thomon," *Apollo*, XLII, 1945.

THOMPSON, FRANCIS. English architect and engineer (19th cent.). His great achievement was the Britannia Bridge (1845–50) in collaboration with Robert Stephenson.

Also with Stephenson, he was responsible for the façade of the Derby Trijunct Station (1831–41).

BIBLIOGRAPHY. H.-R. Hitchcock, *Architecture, Nineteenth and Twentieth Centuries*, 2d ed., Baltimore, 1963.

THOMSON, ALEXANDER. Scottish architect (1817–75). He was responsible for the three greatest Greek romantic revival churches in Europe, all in Glasgow. They are the Caledonian Road (1856–57), Vincent Street (1859), and Queen's Park (1867) Churches. He can be described as a C. F. Schinkel follower but displays immense originality.

BIBLIOGRAPHY. H.-R. Hitchcock, *Architecture, Nineteenth and Twentieth Centuries*, 2d ed., Baltimore, 1963.

THOMSON, TOM. Canadian painter (1877–1917). He had little formal training but was a commercial artist in his youth. From 1905 he painted scenes of the Canadian northland, evolving a broad patterned style, and associated with the future "Group of Seven" members.

BIBLIOGRAPHY. B. Davies, *A Study of Tom Thomson . . .*, Toronto, 1935.

THON, WILLIAM. American painter (1906–). He was born in New York City. Thon paints landscapes, marines, and architectural subjects. His early paintings stress mood; later works are marked by the slightly cubistic structure of his scenes and a delicately worked surface.

THONET, MICHAEL. German furniture designer and manufacturer (b. Boppard, 1796; d. Vienna, 1871). Thonet was a pioneer in the design and manufacture of light, mass-produced furniture. Starting in business at Boppard in 1823, he produced furniture in the popular Biedermeier style. Between 1836 and 1840 Thonet developed the first bent-veneer chair, still using a conventional design. This new process involved the use of thick bundles of veneer that were saturated in glue and then heated and bent into shape. Unable to find backing in Germany, he settled in Vienna in 1842, where, after some difficulty, he achieved patent rights and began to fill large orders. A new workshop was established in 1849 with his sons, who, as Thonet Brothers, largely took over the business in 1853. The first factory was set up in 1857 in Moravia, and the business quickly grew into a vast industry, acquiring forests for materials and employing thousands of workers. During this time, the basic chair design with its many variations was simplified and modernized, culminating in the chair of 1876, which is still familiar today. The company is active and has, in the 20th century, produced chairs designed by Le Corbusier and other important figures.

THORN (Torun): TOWN HALL. Oldest town hall in Poland, begun in 1259. Built of red brick in the Gothic style, it is a large block with a tower at one corner and narrow arcades decorating the five-storied exterior. The interior was destroyed during the Swedish bombardment of Thorn in 1702.

THORN EXTRACTOR (Lo Spinario). Bronze statue representing a boy removing a thorn from his foot (Rome, Capitoline Museums, Palazzo dei Conservatori). It is a Roman copy (1st cent. B.C.) of a famous Greek original (ca. 470 B.C.). This type was popular in the Hellenistic period, as the several adaptations of it in terra cotta (*Street Boy from Priene*) and in marble (*Thorn Extractor*; London,

British Museum) attest. This posture was revived in the early Italian Renaissance (for example, Brunelleschi's *Competition Plaque* for the Florence Baptistery).

BIBLIOGRAPHY. M. Bieber, *The Sculpture of the Hellenistic Age*, New York, 1955.

THORNHILL, SIR JAMES. English decorative painter (1675–1734). Little is known about his early training. He may possibly have been associated with Louis Laguerre, the French decorative painter who, with the Italian An-

Sir James Thornhill, ceiling of the Painted Hall, Royal Hospital, Greenwich, England.

tonio Verrio, dominated the field of mural painting during the late 17th century in England.

Thornhill's earliest important commission, in many respects his best work, was to decorate the so-called Painted Hall at Greenwich, east of London. The work, started in 1708, has recently been cleaned and shows him to be a decorator of no mean abilities. The style is reminiscent of Sebastiano Ricci, who was active for several years in England at that time. The paintings include scenes from almost current history, and Thornhill evidently debated with himself whether or not these should be represented realistically with the actors in contemporary dress. He decided on an idealistic interpretation, but the fact that the problem occurred to him at all is interesting in view of the dimensions this approach attained later in the century.

In May, 1716, Thornhill began work on the grisaille paintings in the cupola of St. Paul's Cathedral, a series of eight huge pictures devoted to episodes from the life of the saint. His position as a respected painter of historical subjects may have affected Hogarth's aspirations in that direction, since Hogarth was his pupil and became his son-in-law.

To modern taste, probably the most attractive facets of Thornhill's work are his small oil sketches and his gouache drawings. Usually preparatory studies for his large paintings, these have a lively dash and brilliance that are rare in early-18th-century English drawings.

BIBLIOGRAPHY. E. K. Waterhouse, *Painting in Britain 1530–1790*, London, 1953; E. Croft-Murray, *Decorative Painting in England, 1537–1837*, vol. 1, London, 1962.

ROBERT R. WARK

THORN-PRIKKER, JOHANN. Dutch painter, decorator, and designer (b. The Hague, 1868; d. Cologne, 1932). He studied in The Hague. Beginning with impressionistic work, he moved, influenced by synthetism and the Nabis, toward the linear, symbolic style associated with Art Nouveau, for example, *The Bride* (1893; Otterlo, Kröller-Müller Museum). From 1904 on Thorn-Prikker taught in various German schools and was an important force in the development of modern religious art. The style of his murals and stained-glass windows fuses linear ornament with the formal stylizations of the Christian past.

BIBLIOGRAPHY. A. Hoff, *Johan Thorn Prikker*, Recklinghausen, 1958.

THORNTON, WALLACE. Autralian painter (1915–). He is a leading figurative painter and art critic in Sydney, where he has been influential in maintaining art standards. In this endeavor he has been joined by his colleagues, James Gleeson, a critic and surrealist painter, and Robert Hughes, a critic and expressionist painter.

THORNTON, DR. WILLIAM. American amateur architect (1759–1828). Born in the British West Indies, Thornton designed the Library Company Building in Philadelphia (1789–90; destroyed 1884) from an Abraham Swan pattern-book plate. In 1793 his Roman-domed scheme won the competition for the United States Capitol. He based Tudor Place in Georgetown, Md. (ca. 1815), on Regency models. *See* CAPITOL, THE, WASHINGTON, D.C.

THORNTON ABBEY. Founded in England for Augustinian canons in 1139. The church building was begun in 1282 and the choir was covered by 1315. The chapter house was also begun in 1282; existing fragments show it as a perfect example of its type. The great gatehouse dates from 1380 and is one of the most imposing structures of its kind in England.

THORNYCROFT, SIR WILLIAM HAMO. English sculptor (1850–1925). He was the son of Thomas and Mary Thornycroft, whose fame as sculptors is eclipsed by Sir William's success. His major works are sepulchral panels, public monuments, and portrait busts, among them the Edward VII memorial, in Karachi, and that of Queen Victoria, in the Royal Exchange, London.

THORPE, JOHN. English mason and surveyor (ca. 1563–ca. 1655). Many buildings have been attributed to him, but he was probably not an architect. His importance lies in the book of drawings of contemporary buildings (London, Sir John Soane's Museum) that he compiled in his post as surveyor; it is a rare and invaluable document of the period.

BIBLIOGRAPHY. J. Summerson, "John Thorpe and the Thorpes of Kingscliffe," *The Architectural Review*, CVI, Nov., 1949.

Johann Thorn-Prikker, *The Bride*. Kröller-Müller Museum, Otterlo.

THORVALDSEN'S MUSEUM, COPENHAGEN, *see* Co-penhagen: Museums (Thorvaldsen's Museum).

THORWALDSEN (Thorvaldsen), ALBERT BERTEL. Danish sculptor (b. 1768/70; d. Copenhagen, 1844). The son of an Icelandic woodcarver, he was raised in Copenhagen, where he attended the academy from childhood. He went to Rome on a grant in 1797 and remained in that city, except for a triumphal visit to Denmark (1818–19), until 1838. His first deliberately classical work, *Jason*, marked the opening of a successful international career when it was commissioned in marble in 1803 by an English collector. Ranked second only to his contemporary Canova, Thorwaldsen was perhaps most deeply influenced by archaic Greek sculpture as typified in the statues *Hebe* (1806) and *Ganymede* (1804) and the relief *Priam Entreating Achilles to Deliver the Body of Hector* (1815; all works mentioned in Copenhagen, Thorvaldsen Museum). His interpretation of antique repose and grandeur as dreamy romanticism is at best self-contained in composition but, when coupled with his highly finished technical mastery of marble, betrays a mechanical lifelessness.

BIBLIOGRAPHY. P. O. Rave, *Thorvaldsen*, Berlin, 1944; F. Novotny, *Painting and Sculpture in Europe, 1780–1880*, Baltimore, 1960.

THRASYMEDES. Greek sculptor from Paros (fl. ca. 375 B.C.). His chryselephantine cult statue of Aesculapius at Epidaurus is described in detail by Pausanias (II, 27, 2). The pictures of this work on Epidaurian coins suggest that Thrasymedes' style, like that of his coworker Timotheus, was influenced by Attic sculpture of the late 5th century.

BIBLIOGRAPHY. G. M. A. Richter, *The Sculpture and Sculptors of the Greeks*, rev. ed., New Haven, 1957.

THREE-COLOR (San-ts'ai) WARE. Term applied to several historic categories of Chinese polychrome ceramic wares involving lead-glazing techniques. In the T'ang dynasty the term *san-ts'ai* referred to pottery usually involving the colors blue, green, yellow, and amber. The pottery forms—bowls, plates, and cups as well as figurines—were dipped into glaze containing coloring agents; this was allowed to run freely at times to create a streaked or dappled effect. A second category of *san-ts'ai* ware arose in the Ming and Ch'ing dynasties. In these later wares the porcelain body was fired first without any glaze and then decorated with lead silicate enamel colors. The piece was then refired at a lower temperature in a muffle kiln, the colors being kept separate from each other by simple incisions or by the use of thin threads of slip material. This later porcelain was particularly popular in the K'ang-hsi period (1662–1722), when the term *san-ts'ai* was applied to it presumably because of the resemblance to the earlier, classic T'ang-dynasty pieces. In both categories, the earlier T'ang pottery and the later porcelains, the term "three-color ware" should be taken as indicative of a technique and type since the actual number of colors employed varied considerably.

BIBLIOGRAPHY. W. B. Honey, *The Ceramic Art of China and Other Countries of the Far East*, London, 1945.

MARTIE W. YOUNG

THREE JEWELS, *see* TRIRATNA.

THREE-QUARTER LENGTH. Painted portrait that shows the sitter from the hips up and commonly measures 30 by 25 inches. This type of portrait was especially popular in the 19th century.

THREE TREES. Etching by Rembrandt. *See* REMBRANDT HARMENSZ. VAN RIJN.

THRONDJEM CATHEDRAL, *see* TRONDHEIM CATHEDRAL.

THRONE (Cathedra) OF MAXIMIANUS. Throne (546–556) covered with ivory reliefs, in the Archiepiscopal Museum, Ravenna. *See* BYZANTINE ART AND ARCHITECTURE.

THROWING. Technique of shaping pottery by the manipulation of wet clay against a revolving potter's wheel which is powered by hand or foot motion or other mechanical means. The process involves considerable skill and begins with the centering of a lump of clay against the wheel head. When the clay rises to a cone, it is flattened, and the thumb is used to make a depression which is continuously enlarged until a circular vessel is formed.

BIBLIOGRAPHY. B. Leach, *A Potter's Book*, London, 1940; H. H. Sanders, *The Practical Pottery Book*, London, 1955.

THULDEN, THEODOOR VAN. Flemish painter of religious, allegorical, and mythological scenes (b. 's Hertogenbosch, 1606; d. there, 1669). A pupil and collaborator of Rubens, Thulden was active in Antwerp, Paris, and the Netherlands. He was a talented and versatile artistic personality, whose style and evolution have been accurately worked out from numerous signed and often dated works.

BIBLIOGRAPHY. H. Schneider, "Theodoor van Thulden en Noord-Nederland," *Oud-Holland*, XLV, 1928; C. Leurs, ed., *Geschiedenis van de Vlaamsche Kunst*, vol. 2, Antwerp, 1939.

THULE CULTURE, *see* ESKIMO ART; NORTH AMERICAN INDIAN ART (ESKIMO).

THUMB, PETER. Swiss architect (1681–1766). The leading architect of the Vorarlberg school, Thumb first worked for Franz Beer and later became an important figure in Constance. He gave the complicated rococo style, with its curvilinear elements, interpenetrating ovals, and interior buttressing, a sturdy form in his major works: the pilgrimage church of Birnau (1746–58) and the Collegiate Church (begun 1755) and monastic library of St. Gall (1758–67).

BIBLIOGRAPHY. N. Lieb and F. Diedl, *Die Vorarlberger Barockbaumeister*, Munich, 1960.

THUNDER PATTERN, *see* LEI-WEN.

THURIBLE, *see* INCENSE BURNER.

THYMELE. Greek architectural term referring to an altar, usually that of Dionysos, in the center of the orchestra of the ancient Greek theater. Around it the thymelici danced.

THYROMA. In ancient Greek architecture, a large doorway. The term is sometimes applied to the monumental

north doorway of the Erechtheum in Athens. The large openings in the episcenium of the Greek theater are also called *thyromata*.

THYRSUS. Staff held by Bacchus and his devotees. It usually terminated in either a pine cone or, more often, in grape leaves surmounted by a clump of grapes themselves arranged in the form of a pine cone.

THYS (Tyssens), PIETER. Flemish painter (1624–77). A native of Antwerp, Thys painted religious and historical subjects and portraits; he became a master in 1645. Although he enjoyed a considerable reputation during his lifetime, he is now considered a weak follower of the Rubens tradition, intermingled with borrowings from Anthony van Dyck.

BIBLIOGRAPHY. F. J. van den Branden, *Geschiedenis der Antwerpsche Schilderschool*, Antwerp, 1883.

TIAHUANACO. Tiahuanaco is a pre-Columbian archaeological site in Bolivia, southeast of Lake Titicaca, near the Peruvian border. Recent excavations have indicated that the culture developed there may date from about 500 B.C. The name Tiahuanaco is also applied to a phase of pre-Columbian culture dated about A.D. 1000–1300, which

Tiahuanaco. Detail of the low-relief carving on the inner side of the Gateway of the Sun.

spread over the southern part of the Andean and coastal regions of pre-Inca Peru. The art products of this culture had a high degree of stylization and precision and in many cases were adapted from more naturalistic previous sources.

The Tiahuanaco archaeological site was probably a ceremonial location rather than a commercial or residential center. The present austerity of the Tiahuanaco region, at an elevation of 13,000 feet, allows little more than grazing and has prompted rather fantastic theories about great geological and physical changes since its florescence, in order to support ideas of a great antiquity and to explain the quality and extent of the remains. A single terraced pyramid, the Akapana, has been stripped of its covering stones. Beside it is a large rectangular area, more than 400 feet on a side, surrounded by upright stone slabs which are the remains of a wall. One entrance to this enclosure was by way of a monolithic gateway, the Gateway of the Sun (10 by 12 ft.), which is delicately carved in low relief on its inward side with a god figure, possibly Viracocha, god of creation, and smaller figures that are stylized much like the textile designs found over a broad region.

Numerous stylized carvings in stone, often of anthropomorphic derivation, have been excavated at Tiahuanaco and removed to the outdoor museum in La Paz. The largest, the Bennett Stele, is more than 20 feet high, made of red sandstone, shaped like a squared Atlantean column, and covered with a pattern of fine relief decoration. There are also several large primitive figures in stone with a more pronounced primitive realism. Precisely carved doorframes and other fragments of carved stone of a similar appearance incorporated into the structures of the present village at the site, as well as continued discoveries from archaeological excavations, indicate a long occupation by a highly skilled population. *See* AMERICAS, ANCIENT, ART OF (PERU).

The Tiahuanaco styles of decoration have been found intermixed with local styles of ceramics and weaving over an extensive region down to the Pacific coast, but no buildings that are definitely from the Tiahuanaco period have been found along the coast, and textiles have not survived in the severe Andean climate. Although the exact relationships are uncertain, the stylistic parallels and similarities of religious symbols between Andean Tiahuanaco and stylizations found along the coast at such places as Ancón and Pachácamac have led to the designation Coastal Tiahuanaco for the lowland examples.

BIBLIOGRAPHY. P. Kelemen, *Medieval American Art*, New York, 1943; W. C. Bennett, *Ancient Arts of the Andes*, New York, 1954; S. K. Lothrop et al., *Pre-Columbian Art* (Robert Woods Bliss Coll.), New York, 1957; W. C. Bennett and J. B. Bird, *Andean Culture History*, 2d and rev. ed. (Amer. Mus. of Natural History, Handbook Series, no. 15), New York, 1960. LESTER C. WALKER, JR.

TIARA, PAPAL. Headdress worn by the pope at official ceremonies. In the early Middle Ages the tiara was a simple white hat; in the 12th century it was given a decorative band that encircled the wearer's forehead; later this band was transformed into a crown. Under Urban V the tiara received its present triple-crown form.

TIARINI, ALESSANDRO. Italian painter (b. Bologna, 1577; d. there, 1668). He worked with Prospero Fontana and Cesi in Bologna, Passignano in Florence, and then

returned to Bologna (ca. 1606), where he remained except for trips within Emilia. Tiarini's most powerful works, such as the *Funeral of the Virgin* (ca. 1614–15; Bologna, National Picture Gallery), combine Caravaggism with an otherwise Bolognese style.

BIBLIOGRAPHY. Bologna, Palazzo dell'archiginnasio, *Maestri della pittura del seicento emiliano,* [3d] Biennale d'arte antica (catalog), ed. F. Arcangel [et al.], Bologna, 1959.

TIBALDI, DOMENICO. Italian architect, painter, and engraver of the school of Bologna (1541–83). Domenico was the younger brother and pupil of Pellegrino Tibaldi. Beginning in 1575 he directed the rebuilding of the Cathedral (S. Pietro) of Bologna, where he also designed the portal of the Palazzo Comunale, the Palazzo Magnani (begun in 1576), the courtyard of the Palazzo Arcivescovile (1577), the Palazzo Mattei (1578; now the Banco di Roma), and the Soccorso di Borgo church (begun in 1581). Domenico's buildings continue the strict and articulated classicistic mannerist style of his brother Pellegrino. In painting, Domenico is said to have collaborated with his brother on the frescoes Pellegrino painted in Bologna, and as an engraver he was a follower of Bonasone and the Paduan school.

TIBALDI, PELLEGRINO. Italian painter of Bologna (1527–96). He was the elder brother and teacher of Domenico Tibaldi. In his youth (1547–50) Pellegrino served as assistant to several painters in Rome and developed an elegant, late mannerist style in which there are traces of Michelangelesque forcefulness. His part in Perino del Vaga's frescoes in Castel Sant'Angelo has been exaggerated. Settling in Bologna, he painted (1550 and after) his most remarkable frescoes, the stories of Ulysses (Palazzo Poggi) with an ornamental version of the Sistine Ceiling, a strange approach carried off with dash. After 1562 he almost abandoned painting, becoming the architect for Milan Cathedral. But later (1587–96) he was a lionized court painter of Philip II of Spain, producing relatively dull frescoes in the Escorial courtyard and more whimsical ones on science and literature in its library.

BIBLIOGRAPHY. G. Briganti, *Il Manierismo e Pellegrino Tibaldi,* Rome, 1945.

TIBERIO D'ASSISI. Italian painter (b. ca. 1470? d. 1524). An unpretentious religious artist, Tiberio belongs among the lesser Umbrians who painted with felicity of feeling. He was no innovator, but, influenced by Perugino and Pinturicchio, he produced canvases notable for their freshness of color.

TIBERIUS, PALACE OF, ROME. Palace constructed by the emperor Tiberius (r. 14–37) on the northwestern part of the Palatine hill. It was built around a central court surrounded by a colonnade. After a fire in 80, it was reconstructed by Domitian. The site of the palace is now occupied by the Farnese Gardens. Hardly anything but some remains of the substructure is visible today.

BIBLIOGRAPHY. S. B. Platner, *The Topography and Monuments of Ancient Rome,* Boston, 1904.

TIBET. Country in central Asia, bordered on the south by India, Nepal, Sikkim, and Bhutan and on the north by China. In the 7th century King Srong Tsan Gampo united many small princely territories. His two wives, Princess Wen Ching of China and Bribsun of Nepal, were instrumental in Tibet's conversion to Buddhism. Buddhist art and teachers were brought to Tibet from India. The two wives, as well as early teachers such as Padmasambhava, became deified and are often depicted in Tibetan art. The art of Tibet is almost totally connected to the religion of the country, which is the Lamaistic form of Buddhism. There is room for demons and magic; monstrous and serene visions appear together in this art for a religious purpose. The tight Tibetan technique in painting creates a vigorous and shimmering richness.

Paintings and sculptures were used in great numbers as ritual objects by the Tibetans, either in the monasteries or in the homes. These came in a variety of sizes, some as large as buildings, the average being about 2 feet high. Whatever the size, the *tankas* (banner paintings) were rectangular, and the *mandalas* (magic-circle paintings) were square. The fabric was usually cotton. Sometimes the linear aspect was printed from wooden blocks. A transfer method was used in eastern Tibet. The artist was usually a lama who had to know the scriptures very well, for his entire production was a sacred ceremony. There was a constant recitation, either by himself or by assistants. His own image-making ability would be controlled by this recitation. The paintings became incarnations of certain sounds; it was hoped that the viewer would get these mantras from the art. There was a strict enforcement of details and subjects, which left only a narrow margin for the artist-lama to work within. But here he managed to create a difference of interpretation that came from his own purification rituals.

The preparation of the linen canvas included polishing it to create a smooth surface which is referred to as a "mirror." The artist painted upon this so-called mirror and took his images from it. He was involved in more than painting; his work was an invocation of deities as well. Before he painted, the god, demon, or teacher had to be conjured up as a presence. The entire work was finished to the last detail in the painter's mind before a stroke was put down, and the execution was merely a technical matter of less importance. Observing the complexity of these paintings, even in a simple rendering of a golden Buddha sitting in his paradise surrounded by buildings, helps to bring an understanding of what is meant by concentration and meditation.

The structure of the paintings is ordered on an off-symmetrical balance, which makes them seem, at first, more geometric than they are. One almost anticipates the motion in them, but they always avoid the obvious. The richness in their mineral colors does not preclude soft passages that please and surprise. In paintings such as the *Mandala of Amoghapaca,* which becomes a dwelling place for Avalokiteśvara, we have a device more for magic than for decoration, to be used in reaching certain states of mind. These works are more than objects of ritual meditation; they are instruments of power for various ends. They are full paintings with multiple figures and ever more scenes appearing when the observer believes he has already seen the work completely. But they are never crowded, for all these elements come bit by bit, unfolding in time.

The artist does not depend upon iconography for his

Tibet. Fragment of an 18th-century painting with a scene from the life of the Buddha. National Museum of Eastern Art, Rome.

response. The methods of repetition of similar forms, larger and smaller, are artistic and open to any viewer. Such an open painting of the god Samvara and his Sakti in coition deals with what seems to be just a sexual subject. However, as a Tibetan depiction of a superior reality in which subject-object differences are lost, this is the only way in which the subject can accurately be shown. This many-armed figure with his multiple attributes and various weapons and powers, crowned in skulls, semidressed in the skins of elephants and tigers, decorated with a necklace of human heads, standing on human bodies, and surrounded by a shield of flames, receives his powers from his goddess, who is embracing him. In one painting or another, all entities depicted in Tibetan art, including Buddhas, appear in this manner.

BIBLIOGRAPHY. G. Tucci, *Tibetan Painted Scrolls*, 2 vols., Rome, 1949; New York, Riverside Museum, *Collection of Tibetan Art*, with commentary and historical essay by J. Brzostoski, 1963.

JOHN BRZOSTOSKI

TIDEMANN, PHILIPP. German history painter (b. Hamburg, 1657; d. Amsterdam, 1705). He was a student of Nicolas Raes and of Gerard de Lairesse, whose collaborator he became. Tidemann painted historical and allegorical pictures in the style of his second master. He decorated a house in Hoorn with a history of Aeneas.

TIE. Structural element acting in tension, or tending to lengthen under stress, such as a tie beam or collar beam connecting rafters and preventing them from spreading.

T'IEH-T'A (Iron Pagoda), K'AI-FENG. Pagoda of the Yu-kuo-ssu temple in K'ai-feng, Honan Province, China. The only remaining structure of the temple, it takes its name from the color of the bricks employed in the building rather than from the nature of the material. The original structure dates from about 1044, but there have been many restorations.

The outer walls of the octagonal pagoda are covered with glazed tiles containing Buddhist decorations. The pagoda is more than 150 feet high and is constructed of a solid core of material around which a staircase spirals to connect each of the thirteen stories. Each story is marked by arched windows facing each of the four directions and by pseudobalconies. For its total height the pagoda is rather slim, measuring about 30 feet in diameter, adding to the sense of gracefulness that is the major feature of this Sung monument.

BIBLIOGRAPHY. E. Boerschmann, *Die Baukunst und religiöse Kultur der Chinesen*, vol. 3: *Pagoden, Pao Tá*, Berlin, 1931.

TIELENS (Tilens), JAN (Hans). Flemish painter (1589–1630). Tielens was born in Antwerp. He painted romantic mountain and river landscapes that are structurally close to those of Josse de Momper. His palette is reminiscent of Lucas van Uden; the figures are mostly by collaborators, such as Hendrik van Balen.

TIEN, *see* Ts'UN.

T'IEN-LUNG-SHAN. Cave complex located southwest of T'ia-yüan in Shansi Province, China. It contains Buddhist sculpture of the Northern Ch'i (550–577) and T'ang (618–906) periods. The caves were rediscovered by Japanese scholars in 1918 and were photographed and studied by Osvald Sirén shortly before they were largely despoiled by antique hunters. The local sandstone was admirably suited for carving, giving the soft, sensuous effect in the full-bodied Buddhas and Bodhisattvas which is so typical of the sculptures from this site.

BIBLIOGRAPHY. O. Sirén, *Chinese Sculpture, From the Fifth to the Fourteenth Century*, 4 vols., London, 1925; S. Yamanaka, *Tenryūzan Sekibutsu (The Stone Buddhas of T'ien-lung-shan)*, Osaka, 1928.

T'IEN-T'AI, *see* TENDAI.

T'IEN-WANG, *see* LOKAPALA.

TIEPOLO, GIOVANNI BATTISTA. Italian painter (b. Venice, 1696; d. Madrid, 1771). He learned the fundamentals of painting from Lazzarini. The contemporaries who influenced Tiepolo's style were Piazzetta, Federighetto, Ricci, and Magnasco. By the time Tiepolo was twenty-one he was a member of the guild of Venetian painters. His earliest works are characterized by diagonal composition and sharp contrast of light and shade, as in *The Sacrifice of Abraham* (ca. 1715–16) in the Church of the Ospedaletto, Venice. From about 1720 to 1725 he established

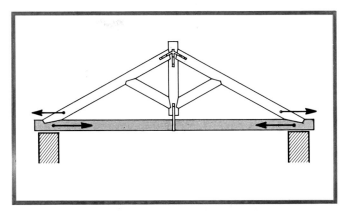

Tie. A beam between rafters to prevent spreading.

the mechanics of his ceiling decorations with *The Glory of St. Theresa*, a fresco in the vault of a side chapel in the Church of the Scalzi, Venice. From then on until his death he executed a long series of ceiling frescoes, most of them having the dramatic *di sotto in su* perspective (figures foreshortened from below upward to give the illusion of great aerial space and height).

The period 1731 to 1740 saw the establishment of Tiepolo's classic style. Equilibrium replaced the earlier agitation of line, transparent color the dark 17th-century tonality. He could produce quietly spiritual religious pictures as well as ceilings brimming with baroque theatricality. In *The Road to Calvary* (1738–40) in S. Alvise, Venice, the colors are muted in accordance with the theme, but the impetuosity of the composition is unexpected. A ceiling fresco (1740) of the Clerici Palace, Milan, shows a new method of arranging the figures: the central field is cleared and the figures appear in groups around the edges.

Between 1741 and 1750 Tiepolo reached full artistic maturity. He maintained his essentially classical ideal in balanced decoration and transparency of color. *The Miracle of the Holy House of Loreto* (1743–44) in the Church of the Scalzi was his major religious fresco (destroyed 1915). The *Cleopatra* frescoes (1745–50) executed for the Labia Palace, Venice, are visions of both clarity and precision.

During a stay at Würzburg (1751–53) Tiepolo executed three frescoes in the Kaisersaal and the ceiling fresco over the staircase in the Residenz. These works served to increase the master's fame beyond the Alps and resulted in the imitation of his style in southern Germany and Austria. *See* WURZBURG: RESIDENZ.

His most notable post-Würzburg paintings before his departure for Madrid are the decorations for the Villa Valmarana (1757; Vicenza, Municipal Museum), and *The Apotheosis of the Pisani Family* (1761–62) in the Villa Pisani, Strà. He was in Madrid from 1762 to 1770; there he decorated the ceiling of the Throne Room in the new Royal Palace with *The Apotheosis of Spain* (1762–64), the Guardroom with *The Apotheosis of Aeneas* (1764–66), and the Saleta with *The Apotheosis of the Spanish Monarchy* (1764–66).

Tiepolo realized himself as an artist in the inexhaustible variety and freshness that he brought to his ceiling decorations. Sky, clouds, light, and air, peopled with countless

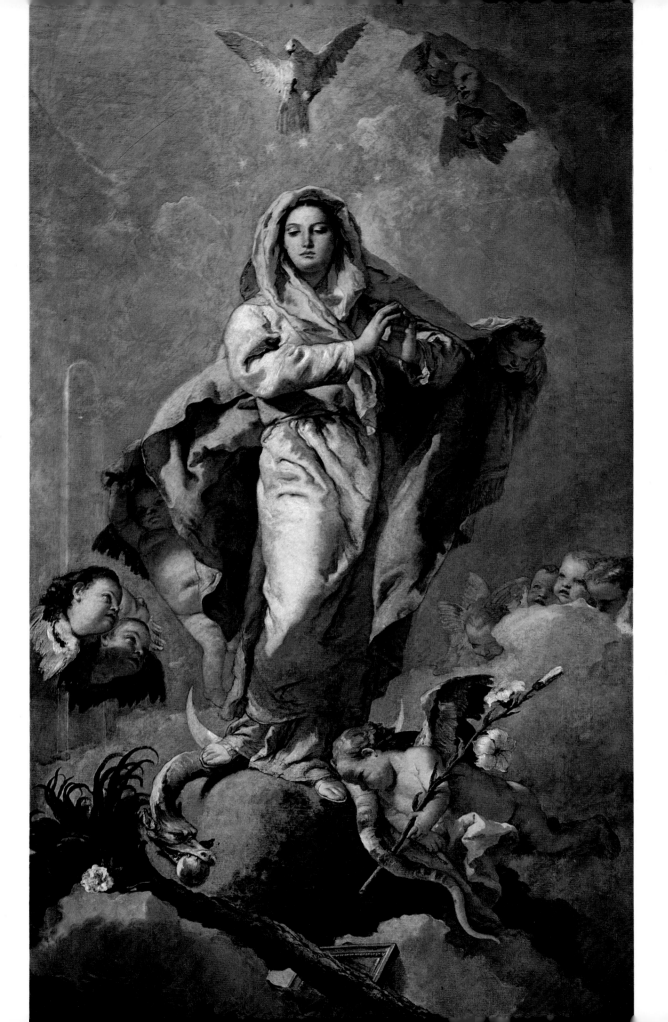

mythological and allegorical figures, afforded him the perfect vehicle for the exercise of his genius.

BIBLIOGRAPHY. A. Morassi, *G. B. Tiepolo, His Life and Work*, London, 1955; P. d'Ancona, *Tiepolo in Milan: The Palazzo Clerici Frescoes*, Milan, 1956; V. Crivellato, *Tiepolo*, Bergamo, 1962.

FRANKLIN R. DIDLAKE

TIEPOLO, GIOVANNI DOMENICO. Italian painter (b. Venice, 1727; d. there, 1804). For a long time his genius for genre painting was held in check by his collaboration with his father, Giovanni Battista Tiepolo. However, the left-hand portion of Giovanni Domenico's *Lot and Abraham* (Rome, Albertini Collection), showing an irrelevant but lively scene from northern Italian country life, clearly indicates the direction of his real interest. Several years later, in 1757, he executed the frescoes in the guesthouse of the Villa Valmarana in Vicenza. Among these, *The Peasants' Meal* and *Peasants Reposing* convey an enthusiastic appreciation of rustic informality. Brilliance and freshness of color, felicitous composition, and the device of showing figures from behind, as seen in *A Trio Walking* (Venice, Academy), are the hallmarks of his style.

BIBLIOGRAPHY. M. Levey, *Painting in XVIII Century Venice*, London, 1959.

TIERCERON. Intermediate rib between transverse and diagonal ribs. It is used in vaulting to give additional support to panels, as in Westminster Abbey. Tiercerons, springing from the piers that support the principal arch ribs, lay in the plane of the vault. Unlike main ribs, they do not make the intersection of vaulting surfaces. Tiercerons were used in Early English architecture and were part of a later Gothic trend to proliferate vaulting ribs.

See also LIERNE.

TIFFANY, LOUIS COMFORT. American painter and designer (b. New York City, 1848; d. there, 1933). He was the son of the goldsmith and jeweler Charles Tiffany, who ran the famous Tiffany's. Louis studied with George Inness in 1866 and later in Paris. Tiffany achieved some success as a painter before being attracted to the decorative arts at time of the Philadelphia Centennial (1876). His first interest in the decorative arts was stained glass and he worked at the Heidt glass house in Brooklyn. In 1880 he applied for a patent for iridescent glass, which he used for vases, windows, and lampshades.

In 1879 he had formed a partnership, "Louis C. Tiffany Company, Associated Artists," with Candace Wheeler, Samuel Colman, and Lakewood de Forrest, all artists. In the manner of William Morris and his circle, the company decorated interiors in the then current eclectic style. In 1883 Candace Wheeler departed and the company was renamed Tiffany Glass Company in 1885. Stained glass was their field of concentration, although they continued decorating to assist in creating settings for the glass. Tiffany designed a number of interiors, including a chapel for the Chicago World's Columbian Exposition (1893) that reflected H. H. Richardson's influence. In 1892 he opened a new glass factory, and in 1894 he registered the name "Favrile" to describe his product.

Giovanni Battista Tiepolo, *The Immaculate Conception*, ca. 1767–69 Prado, Madrid.

Tiffany's relation with and awareness of Art Nouveau is documented by his association with the famous Bing of Paris. Bing's shop, famous for the new style, was the European source for Tiffany glass and lamps. The sinuous vase shapes and casual patterns are closely allied to the better-known phases of the style. Ceramics and metal were used by Tiffany for lamps in particular, in which a variety of naturalistic forms were exploited. Tiffany's importance lies in the work he did in his most successful period, before World War I.

BIBLIOGRAPHY. R. Koch, *Louis C. Tiffany, Rebel in Glass*, New York, 1964.

MARVIN D. SCHWARTZ

TIJEN, W. VAN. Dutch architect (1894–). He pioneered the slab residential unit promulgated by the Bauhaus during the 1920s. In collaboration with Brinkman and Van der Vlugt, Van Tijen designed the freestanding Bergpolder (1933–34) and the Plaslaan (1937–38) in Rotterdam, tall apartment slabs surrounded by ample space.

BIBLIOGRAPHY. S. Giedion, *Space, Time and Architecture*, 4th ed., Cambridge, Mass., 1962.

TIJOU, JEAN. French ironsmith (b. France; d. after 1712). A French Huguenot living in the Netherlands, Tijou probably went to England under the patronage of King William and Queen Mary in about 1690. In 1693 he published *A New Booke of Drawings* (London), which contained designs for baroque ironwork, among them one for a panel of the Fountain Screen at Hampton Court

Louis C. Tiffany, Favrile-glass vase, ca. 1900. Museum of Modern Art, New York.

Tiki. Maori image of carved wood. British Museum, London.

Palace (finished ca. 1700). In addition to receiving private commissions in England, he was employed for about seventeen years, ending in 1711, at St. Paul's Cathedral, London, for which he made a chancel screen. He had left England by 1712, and his burial place is unknown.

BIBLIOGRAPHY. J. S. Gardner, *English Ironwork of the XVIIth and XVIIIth Centuries...*, London, 1911.

TIKI. In Polynesian mythology, the god who made the first man from the clay of the earth. A tiki is also a wood or stone image thought to be the abode of a god or an ancestor; such tiki are not worshiped as idols.

See also OCEANIC ART (POLYNESIA); POLYNESIA.

TIL BARSIP (Tell Ahmar). Site on the left bank of the Euphrates about 60 miles from Aleppo. It was excavated by Thureau-Dangin (1929–31) for the Louvre Museum, Paris. The ancient caravan route which linked Syria and Mesopotamia crossed the Euphrates at this point. A provincial palace of the Assyrian period (9th–7th cent. B.C.), built of unbaked brick, was constructed there with courts, throne rooms, baths, and storerooms. Many of these were decorated with scenes of the king hunting or receiving tributaries or prisoners, painted on plaster in black, red, and blue. The paintings (Aleppo, National Museum) date from two different periods, the mid-8th and the late 7th century B.C.

Achaemenian tombs, Aramean and Assyrian sculptures, and a large funerary cave of the late 3d or early 2d millennium B.C. were also excavated. Some prehistoric painted pottery was found.

BIBLIOGRAPHY. F. Thureau-Dangin, *Til-Barsip* (Haut-commissariat de la république française en Syrie et au Liban, Service des antiquités, Bibliothèque archéologique et historique, vol. 23), Paris, 1936; A. Parrot, *The Arts of Assyria*, New York, 1961.

TILBORGH, GILLIS (Egidius) VAN. Flemish painter (1625–78). A native of Brussels, Van Tilborgh painted peasant scenes, kermises, and portraits, first under the influence of Joos van Craesbeek, then evolving toward more elegant renderings in the manner of Gonzales Coques. Occasional single figures closely approach David Teniers the Younger in style.

TILE. Fired clay, asbestos cement, or similar materials formed into various shapes for covering roofs, floors, and walls. The term applies to structural-clay elements used in walls, as well as to resilient surfacing materials such as vinyl and cork tile. Preformed units of mineral fibers and perforated metal with glass-wool backing are generally called "ceiling tile" or "acoustic tile," according to function.

The use of kiln-burned and glazed brick was known to the Babylonians, who applied it as a wall surface in their palaces and temples. Persian tiles were known for their color and texture. Tile as a roofing material was used by the Greeks. *See* IMBREX; MESOPOTAMIA (BRICK RELIEFS); PERSIA, ANCIENT.

The more common types of wall and floor tile include ceramic, an unglazed and usually small-sized tile; glazed tile, whose body, bisque or biscuit, is burned, then glazed and fired; encaustic, with a pattern of one color baked on a field of another color; promenade, or quarry, a relatively thick unglazed tile used on flat roofs and floors; and faïence, a glazed tile in whose manufacture an uneven surface is obtained.

See also ISLAMIC POTTERY AND TILES; TILES, LUSTERED.

MILTON F. KIRCHMAN

TILE, COVER, *see* IMBREX.

TILENS, HANS, *see* TIELENS, JAN.

Timgad. Arch of Trajan.

TILES, LUSTERED. Made in the Near East, lustered tiles were used separately as wall decoration and in groups to form niches. Luster, used for vessels as well as tiles, was an invention of Muhammadan potters of the 8th or 9th century in Mesopotamia, Iran, or Egypt. It is made of a fine yellowish clay covered with an opaque tin enamel. After firing, it is painted over with metallic oxides. A second firing is administered at low temperature to transform the oxides into a thin layer of metal or luster. The Abbasid potters of Baghdad and Samarra were the first to produce lustered tiles. Their best output was in polychrome luster. The Saljuk potters of the 12th century revived the luster technique. Rayy in the 12th century and Kashan in the 13th and 14th centuries were the Iranian centers of production. *See* RAQQA; RAYY.

See also ISLAMIC POTTERY AND TILES.

BIBLIOGRAPHY. M. S. Dimand, *Handbook of Muhammadan Art*, New York, 1944; London, Victoria and Albert Museum, *A Guide to the Collection of Tiles*, London, 1960.

TILGNER, VICTOR OSCAR. Austrian sculptor (b. Pressburg, 1844; d. Vienna, 1896). He studied at the Vienna Academy from 1859 to 1871. In 1874 he visited Italy with the painter Hans Makart. Makart's influence may be seen in Tilgner's preference for the rococo, his feeling for light on a surface, and his frequent use of polychromy. Tilgner was first successful with portrait busts, and he later produced statues, fountains, tombs, and popular architectural decorations. His figures have a crisp animation, and the drapery is especially skillful. A fine late example of his work is the *Memorial to Mozart* (1896) in the *Burggarten*, Vienna, which contains cherubs, musical instruments, and the standing figure of the composer.

BIBLIOGRAPHY. L. Hevesi, *Victor Tilgners ausgewählte Werke*, Vienna, 1897.

TILIUS (Fielius), JAN. Dutch genre painter (b. Hilvarenbeek, ca. 1660; d. The Hague, 1719). He may have been a pupil of Pieter van Slingelant. Tilius was reported in The Hague in 1683. He worked in the style of his master, but his conversation pieces also recall the works of Gabriel Metsu and Frans van Mieris.

TIMGAD. Roman imperial town of Thamugadi, located in northeastern Algeria. It was founded by Trajan in A.D. 100. Timgad is the best-preserved Roman town in Africa, excepting Leptis Magna. It was built by Trajan's soldiers and flourished until the 4th century. A rectilinear grid plan extends from two intersecting main streets, the *cardo* and the *decumanus*. At the intersection of these streets the forum, basilica, and local senate house were placed. In typical imperial fashion the town was furnished with several baths or social centers, a theater, a large marketplace, and a library. Timgad clearly exhibits all the features of imperial colonial planning and combines Hellenistic and Roman architecture.

BIBLIOGRAPHY. A. Ballu, *Les Ruines de Timgad*, 2d ed., Paris, 1904; C. Courtois, *Timgad*, Algiers, 1951.

TIMNA' (Kohlan). Walled trading city in southern Arabia, prominent during the great period of Sabaean civilization in the last three and a half centuries B.C. Structures in this ancient Qatabān city date from the 7th to the 1st century B.C. Caravan trade with other countries was responsible for the foreign influences—Hellenistic, Achaemenid, and Roman—on Sabaean art. Skilled Sabaean craftsmen copied foreign works of art, as can be seen in bronze lamps in the form of ibexes and in statues and reliefs.

Two Hellenistic high-relief bronze groups of infant riders on lionesses have inscriptions identifying them with the Sin god, father of Ishtar, and his son. Remnants of the city wall, with north and south gates, an obelisk, a Temple of Ishtar in an ancient wall, and a Temple of An (Anum) on top of the wall—all bearing inscriptions—and some well-built irrigational works still stand.

BIBLIOGRAPHY. R. L. Bowen, Jr., *Archaeological Discoveries in South Arabia*, Baltimore, 1958; L. Woolley, *The Art of the Middle East*, New York, 1961.

TIMOTHEUS. Greek sculptor (fl. 1st half of 4th cent. B.C.) He is known to have executed acroteria for the Temple of Aesculapius at Epidaurus and portions of the frieze of the Mausoleum of Halicarnassus. His style shows the influence of Attic sculpture of the late 5th century B.C. *See* MAUSOLEUM OF HALICARNASSUS.

BIBLIOGRAPHY. G. M. A. Richter, *The Sculpture and Sculptors of the Greeks*, rev. ed., New Haven, 1957.

TIMURID ARCHITECTURE (Iran and Turkestan). Notable monuments of Islamic architecture were erected under Timur and his line from near the end of the 14th until the middle of the 15th century. During Timur's life construction centered in Samarqand and is represented by his mausoleum, the Gur-i-Mir, structures built by Bibi Khanum, one of his wives, and tombs along the Shah Zinda. Gauhar Shad, wife of one of his sons, erected an elaborate complex of structures in Herat, including a now ruined madrasa and her own tomb, and in Meshed the splendid mosque bearing her name within the shrine of Imam Riza. *See* GAUHAR SHAD, MOSQUE OF, MESHED; SAMARQAND, ARCHITECTURE OF.

Other shrines, mosques, and tombs of the period survive along the eastern frontier of Iran. Many of the monuments were freestanding and clad in brilliant faïence, while the use of cut stone, marble, and papier-mâché decoration reflected the efforts of craftsmen from many parts of the Timurid kingdom.

BIBLIOGRAPHY. D. N. Wilber, *Iran: Past and Present*, 4th ed., Princeton, 1958.

TIMURID POTTERY, RUGS, SCHOOL OF PAINTING, TEXTILES, *see* ISLAMIC PAINTING (TIMURID PERIOD); ISLAMIC POTTERY AND TILES (TIMURID PERIOD); ISLAMIC TEXTILES (MONGOL AND TIMURID PERIODS); RUGS, NEAR AND MIDDLE EASTERN (MONGOL AND TIMURID PERIODS).

TING. Chinese term for one of the more common classes of containers found among early bronze ritual vessels. The body of the *ting* may be round or rectangular, with three or four cylindrical legs. This particular class of caldrons may be as old as the *li* (tripod vessel with hollow legs), and examples of *ting* vessels have been found in pottery form from the neolithic Yang-shao period. This popular

class of vessels was produced throughout the Bronze Age and into Han times.

BIBLIOGRAPHY. K. Jung, *Shang Chou i-ch'i t'ung-k'ao* (The Bronzes of Shang and Chou), 2 vols., Peking, 1941.

TINGUELY, JEAN. Swiss sculptor (1925–). Born in Fribourg, Tinguely studied under Julia Ris at the Art School in Basel, where he was exposed to Schwitters, Klee, and the Bauhaus school. In the late 1940s he began to incorporate motion into his work, using small motors to drive wire sculptures. He has since produced highly complicated and eccentric machines, some of which have been self-destroying, including the famous *Homage to New York*, performed at the Museum of Modern Art (1960). In the 1950s Tinguely became one of the New Realists, a group led by the French painter Yves Klein.

TING WARE. Chinese designation for a thin white porcelain with cream-colored glaze produced at the imperial kilns of Ting-chou, Chihli Province, in northern China. The kiln site was active as early as the 10th century, and Ting was adopted as an imperial ware in the Northern Sung period, being the earliest of the "classic" imperial Sung wares. According to early Chinese literary sources, the Ting wares were eventually replaced in imperial favor and patronage by the famous Ju wares because of flaws that developed in the Ting glazes. There is no evidence to substantiate this claim, and Ting ware seems to have remained a much-admired class of ceramics in China through the 14th century. The ware is characterized by the use of molded or carved designs, usually of floral motifs, and the rims of bowls and saucers were left bare of glaze to be bound with copper after the firing. Other subcategories of Ting are the black, red, and purple Ting wares; the white Ting, however, was the most widely appreciated and the finest in quality.

BIBLIOGRAPHY. W. B. Honey, *The Ceramic Art of China and Other Countries of the Far East*, London, 1945.

Ting Ware. Porcelain basin with incised peony design and ivory-white glaze, Sung dynasty, 11th–12th century. Percival David Foundation, London University.

TING YUN-P'ENG. Chinese painter (fl. late 16th–early 17th cent.). His *tzu* was Nan-yu, and he came from Hsui-ning in Anhui Province. Ting Yün-p'eng enjoyed a great reputation in his time for his paintings after old masters, and Tung Ch'i-ch'ang, the foremost critic of the age, conferred a special seal on him. He is best known in the West for his figure paintings, particularly of Kuan-yin and arhats, executed in a highly personal and archaistic style. Among the fine examples in American collections of Ting Yün-p'eng should be noted the hand scroll of Kuan-yin in the William Rockhill Nelson Gallery, Kansas City. *See* TUNG CH'I-CH'ANG.

TINO DI CAMAINO. Italian sculptor (b. Siena, 1280/ 85; d. Naples, 1337). It is probable that he served in the studio of Giovanni Pisano and may therefore have assisted on the pulpit in Pisa Cathedral. The earliest work that might be ascribed to Tino is the *Altar of S. Ranieri* in the Camposanto (1306). However, his first documented work is the baptismal font for the Cathedral (1311), of which only relief fragments in the National Museum of St. Matthew, Pisa, and the Camposanto now exist. Through the rest of his career Tino was preeminent as a sculptor of sepulchral monuments in Pisa, Siena, Florence, and Naples.

In 1315 Tino was made *capomastro* of Pisa Cathedral and commissioned for the tomb of Emperor Henry VII. From the dispersed and partly destroyed tomb, the seated figure of Henry with his four flanking advisers in the Camposanto and the sarcophagus with its reclining effigy in Pisa Cathedral are ascribed to Tino. The impassioned movement and fluidity of Giovanni Pisano's art is here replaced by the massive blocklike forms that characterize Tino's style.

As *capomastro* of Siena Cathedral in 1319–20 Tino designed the tomb of Riccardo Cardinal Petroni. Rather than creating an architectural framework for the sculptured figures, Tino uses them as the building blocks. The whole is a pictorial tableau of resurrection. Four caryatids, standing on a platform, support the sarcophagus, which is decorated with reliefs of the *Noli me Tangere*, the *Resurrection*, and *Christ and St. Thomas*. Above this two angels draw back the flaps of a tent revealing the reclining effigy of the Cardinal, and the composition is crowned by a small Gothic tabernacle enclosing the Madonna and Child and two saints. One level flows into the next in a painterly fashion, with no movement into depth, creating a buoyant vertical ascension that recalls Gothic architectural form.

In Florence (1321–23) Tino did the tombs of Gastone della Torre and Antonio Orso, bishop of Florence. Fragments of the latter are scattered through Europe. The exaggerated poses of the caryatids indicate more graphically the weight that they bear. The seated figures of the Madonna and Child in the Cathedral Museum and of Orso in the Cathedral are massive blocks swaddled in harmonious linear patterns, somewhat resembling the Madonnas of the Lorenzettis. In contrast to contemporary Florentine figures, little of the body is revealed.

Probably at the request of King Robert of Anjou, Tino spent his remaining years in Naples, where he created numerous tombs. These include the tombs of Catherine of Austria (1323) in S. Lorenzo Maggiore; Mary of Hun-

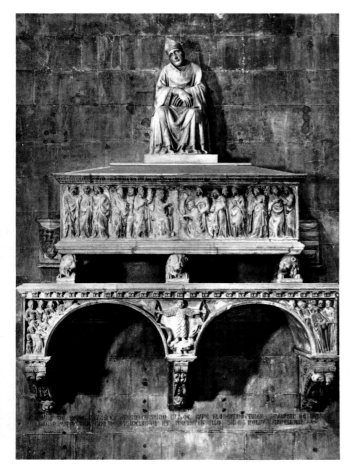

Tino di Camaino, tomb of Bishop Antonio Orso, 1321–23. Cathedral, Florence.

gary (1325) in S. Maria Donna Regina; Mary of Anjou (1329), Charles of Calabria (1332–33), and Mary of Valois (ca. 1335) in S. Chiara; and Philip of Taranto and John of Durazzo (ca. 1335) in S. Domenico Maggiore. The general form of earlier tombs is maintained, but these tombs are enclosed within Gothic tabernacles, probably designed by Neapolitan architects, subordinating the sculpture. French Gothic influence is increasingly evident in the graceful, stylized drapery folds and slender proportions of the figures themselves.

BIBLIOGRAPHY. W. Valentiner, *Tino di Camaino, a Sienese Sculptor of the Fourteenth Century*, Paris, 1935; O. Morisani, *Tino di Camaino a Napoli*, Naples, 1945; J. Pope-Hennessy, *Italian Gothic Sculpture*, London, 1955.

DONALD GODDARD

TINTERN ABBEY. Cistercian church in Wales, founded in 1131. The foundations of the original church are beneath the present north transept and aisle. About 1220 the refectory was rebuilt in the accepted Cistercian fashion, and the church was rebuilt from 1270 on a site slightly to the south of the Norman one. The altar was used in 1288, and by 1340 the church had been completed and the abbot's hall built to the north of the infirmary cloister.

The church, although a ruin, is intact except for its roof. It has a four-bay aisled presbytery, a crossing with transepts and north aisles, and a six-bay aisled nave. Ow-

ing to the proximity of the river, the monastic buildings are on the north side of the church.

BIBLIOGRAPHY. H. Brakspear, *Tintern Abbey, Monmouthshire*, London, 1938.

TINTING TOOL. Engraving tool similar to a burin but with a triangular section for cutting series of lines to produce tones. The tinting tool came into heavy use in wood engraving.

TINTORETTO (Jacopo Robusti). Venetian painter (b. Venice, 1518; d. there, 1594). He was the son of Giovanni Battista Robusti, a dyer (*tintore*). Except for one trip to Mantua in 1580, Tintoretto spent his whole life in his native city. Some of his children were painters. *See* TINTORETTO FAMILY.

Titian's dominance had crowded out other painters from fame and commissions for some thirty years, up to 1548. At that time, however, Tintoretto's increasing work for foreign princes opened the way for him rapidly to become the leading painter for Venetian churches and patricians. The huge number of his works (about 300 paintings survive, most of them large) is related to his constant eagerness for new work; he often offered to accept low prices, sometimes arranged for an annuity, and entered competitions even late in life. Evidently he never felt financially secure, though he became famous and was continually in demand.

His exceptional gifts were early recognized and are recorded in the letters of Pietro Aretino (who became, in 1545, his first important patron) and in 1548 in Paolo Pino's *Dialogue of Painting*. Aretino, however, criticized his haste and sketchiness; he also complained that Titian was sketchy in a portrait of him because he was paid less than usual. A correlation between Tintoretto's lower price scale and his sketchy style should be considered on one level only, because his sketchiness was also a true factor in his inventive style.

Another effect of his urgency for projects was his willingness to modify his style to match other artists' work. His *Miracle of the Lame* (1559; Venice, Church of S. Rocco) made a set with an earlier work by Pordenone not only in size and theme but more intimately. His first work for the Church of S. Rocco, *St. Roch among the Plaguestricken* (1549), was probably modified (1567) to match his own many later works there; this was a very unusual step. Specifically, when he was in danger of losing a job to Veronese, he successfully offered to paint in the latter's style (*Assumption*, Venice, Church of the Jesuits). Later, as winner of a competition for the huge *Paradise* (Venice, Doge's Palace) among four artists whose sketches are all preserved, he clearly modified his final version in relation to the other sketches. Surprisingly he was no eclectic; the personal qualities are constant, alive, and unmistakable, carried by the swift linear brushstroke; his concessions to other styles only served as enriching stimuli.

Of his working methods, besides the famous use of small wax models arranged on a stage with candles, it is significant that he studied the lighting and other factors where the works were to be installed, and bent his style to the type of location—in particular in his late years when the two large series for the Doge's Palace and the Scuola

di S. Rocco diverge between the formal, slow and solid, and the brilliantly improvised. His portraits throughout his life have their own special style, a practice later known as static composition, which grew less usable in the baroque age for any other themes. These factors make developmental study difficult and controversial.

The following discussion is limited mainly to the minority of dated works. A perhaps legendary report makes him a pupil of Titian for a few days, after which the independent-minded pupil left; Bonifazio de' Pitati is usually considered his chief teacher. The first surviving dated work is *Apollo and Marsyas* (1545; Hartford, Conn., Wadsworth Atheneum). Its elegant Parmigianinesque mannerism was being developed at the time also by the young Andrea Schiavone. (However, according to one theory, Schiavone was older and was Tintoretto's teacher.) The first major work, the *Last Supper* (1547; Venice, S. Marcuola), and its probable mate, the *Washing of the Feet* (Madrid, El Escorial), show the same pasty, shaping stroke and rich color, but an original mastery of large composition, open but vibrant.

While similar patterns recur in the formal image of *St. Marcellinus* (1549; Venice, S. Marziale) and the sinuous *Four Evangelists* (1552; Venice, S. Maria Zobenigo), a new style bursts forth fully formed in *St. Mark Freeing a Slave* (1548; Venice, Academy), the masterpiece that made him famous. Intense local color marks figures which are more solidly modeled than any seen in Venice before; they are shown in virtuoso foreshortenings and diagonals. Poses and colors give life to these sculptural figures. Bright air absorbs the twists of motion, preventing mannerist compression, although specific poses are mannerist. Tintoretto had discovered not only Michelangelo but also Titian. The later legend that the motto "Titian's color, Michelangelo's form" was over his door must be matched with Pino's use of the slogan in 1548, but not in connection with Tintoretto. Tintoretto had by now seen and probably drawn Michelangelo's clay model owned by Aretino (drawing, Sarasota, Ringling Museum of Art), for he and his apprentices later constantly drew from bronze casts after ancient and modern statues. The *Genesis Scenes* (1550–51; Venice, Academy) modestly repeat the fresh color and structured poses; one borrows a Titian design. This style also marks the *Saints*, done for a city office (1552; Venice, Academy). It conforms with Bonifazio's earlier works on this theme, and can be contrasted with his own sketchy *Evangelists* of that year, which are of like scale and theme but for a different location.

Secular pictures with sculptural, sensuous nudes and side-weighted designs include the great *Susanna and the Elders* (Vienna, Museum of Art History) and *Arsinoë* (Dresden, State Art Collections), probably of these years. Notable early portraits are the Hampton Court *Man* (1545), with its Giorgionesque poetry and tonal simplicity, and the bright, sketchy *Nicola Priuli* (Venice, Cà d'Oro).

In the next dated work, the 1559 S. Rocco *Miracle of the Lame*, mentioned above, individual color and form are toned down, and thick crowds of figures are organized in groups by strong light and broad compositional lines.

Tintoretto, *Paradise*, detail, ca. 1565–70. Louvre, Paris.

This type of space design—anticipated in the *Presentation in the Temple* (S. Maria dell'Orto; commissioned 1551)—is developed with massive diagonals in the *Crucifixion* (Venice, S. Trovaso). It grows spectacular in the three *Miracles of St. Mark* (1562; Venice, Academy; Milan, Brera), where space design employs fewer figures, and in the *Marriage at Cana* (Venice, S. Maria della Salute). In 1564, when the Scuola di S. Rocco set a competition for paintings in its meeting hall, Tintoretto won by submitting a finished work. His huge *Crucifixion* and other Passion scenes (1565–66) climax his diagonal chiaroscuro space design. The *Limbo* and *Crucifixion* (1568; Venice, S. Cassiano) immerse the figures in a deeper, broader air, with two-dimensional diagonals only.

Many portraits of the 1550s and 1560s have their own form of broad simplicity; in the 1570s they are smaller and brighter. Following the thin, mannerist *Philosophers* (1571–72; Venice, Library of S. Marco), a bow to Schiavone's works there, he took his biggest project for an annuity (1575–81), the walls and ceiling of the Scuola di S. Rocco's great hall. He delivered fourteen large and many smaller canvases. At the peak of his power in these works, Tintoretto composes spontaneously on old themes, bathing his diagonally thrusting figures in shifting light, exploiting depth and height in new ways, and evoking unity by an overall textural glitter. These paintings and the uncomfortable Mantua series (1580; Munich), which depicted historic battles and was done with assistants, contrast with the famous small Greek myths (1578; Venice, Doge's Palace), where a return to solid figures is modified by airy merger and foreground emphasis. Still later, formal battles and versions of the doges kneeling to saints (done with assistants) in the Doge's Palace contrast with the personal scenes in the lower hall of S. Rocco, where the rich surface contains the figures as a unity, either against vibrant walls or, in the famous *Flight into Egypt* and *SS. Mary the Egyptian and Magdalene*, in large evocative landscapes (1583–87). A similar world of mobile light brackets the crowds in the final masterpieces, the huge *Last Supper* and *Gathering of Manna* (1592–94; Venice, S. Giorgio Maggiore).

BIBLIOGRAPHY. H. Tietze, ed., *Tintoretto*, New York, 1948.

CREIGHTON GILBERT

TINTORETTO FAMILY. Venetian painters: Domenico (fl. 1577–1635), Marco (fl. 1583–1637), and Marietta (ca. 1556–90). The children of Tintoretto, they were trained by him as successors. Marietta painted a portrait of her grandfather and small cousin (probably the work in Vienna, Museum of Art History) and signed a drawing from a Roman bust of Vitellius that was owned by her father; this was one of numerous studio practice drawings after sculpture. Domenico, as a trusted helper, was bequeathed his father's materials, with a request to share them with Marco. Besides rigid group portraits, the *Magdalen* (Rome, Capitoline Museums), and similar works of orange tonality, can be assigned to him. No works by Marco can be identified.

BIBLIOGRAPHY. A. Venturi, *Storia dell'arte italiana*, vol. 9, pt. 4, Milan, 1929.

TIRTHANKARA. Jain guide. Twenty-four of these embodied souls have preached Jainism. The last Tīrthaṅkara

was Mahāvīra, who lived in India during the 6th century B.C. and who was the founder of Jainism there.

TIRUCHCHIRAPPALLI (Tiruchirapalli), *see* TRICHINO-POLY.

TIRYNS. Ancient Greek city near the Gulf of Argolis in the Peloponnesus. The acropolis was inhabited from the neolithic through the middle Helladic period, but it was not until the Mycenaean period that Tiryns reached the status of a major fortified palace-city. The palace was built on the crown of the acropolis in the late Middle Helladic period and rebuilt in the early 14th century B.C. In the late 13th century B.C., the massive, Cyclopean walls surrounding the palace were extended around the lower part of the acropolis to the north. The walls, which are up to 36 feet thick, form an ingenious system of fortification. Access could be gained to the palace only through a narrow passageway that follows the natural slope of the acropolis between two walls on the east side. This led through two gates to the first propylon, which gave onto a large court. A second propylon led to the central court, around which were ranged, as in a Minoan palace, the rooms of the palace, including a large and a small megaron. The palace was richly decorated with wall paintings, the most famous of which is the scene of a boar hunt (Athens, National Archaeological Museum). Although much of the walls of Tiryns remain, the palace itself has been reduced to its foundations.

BIBLIOGRAPHY. G. Karo, *Führer durch Tiryns*, 2d ed., Athens, 1934.

DONALD GODDARD

TISCHBEIN, JOHANN FRIEDRICH AUGUST, German portrait painter (1750–1812). He belonged to an eminent family of Hessian painters who specialized in court portraits. A pupil originally of his father, Johann Valentin Tischbein, and of his better-known uncle, Johann Heinrich Tischbein the Elder, he formed his early style in the prevailing rococo manner, characterized by a rapid and free brushwork applied with real bravura. Later in his career, Tischbein was subject to the influence of a number of artists of the growing classical trend—Mengs, David, and the English portraitists—and his paintings from this period are typically infused with an atmosphere of languid charm.

BIBLIOGRAPHY. R. Hamann, *Die deutsche Malerei vom Rokoko bis zum Expressionismus*, Leipzig, 1925; F. Novotny, *Painting and Sculpture in Europe, 1780–1880*, Baltimore, 1960.

TISCHBEIN, JOHANN HEINRICH, THE ELDER. German painter (1722–91). He was a member of a large family of Hessian court painters working in the style of the restrained German rococo. As the head painter in Kassel, he produced numerous court portraits as well as charming mythological works. The latter, with their soft graceful forms, elegant female types, and hazy pastel atmospheres, reveal the influences of the French rococo masters, such as Boucher.

BIBLIOGRAPHY. R. Hamann, *Die deutsche Malerei vom Rokoko bis zum Expressionismus*, Leipzig, 1925; F. Novotny, *Painting and Sculpture in Europe, 1780–1880*, Baltimore, 1960.

TISI, BENVENUTO, *see* GAROFOLO.

TISSOT, JAMES JOSEPH JACQUES. French painter and etcher (b. Nantes, 1836; d. Buillon, 1902). He began his career in 1857 as a student of L. Lamotte and Hippolyte Flandrin. Tissot made his debut in the Salon in 1859 with *Promenade dans la neige*, a painting in encaustic. In 1871 he moved to London, where he gained considerable fame as a painter of English society, specializing in scenes of elegant outings on shipboard (*La Galerie du "Calcutta"; souvenir d'un bal à bord*). Tissot later returned to Paris, where he made an abrupt change to mystical religious paintings and etchings (for example, the etching *L'Apparition médianimique*, 1884). The culmination of this period came in 1896 with the publication of the first volume of the Tissot Bible, illustrated with 865 compositions, many derived from studies made in Palestine (most of the original sketches and oil paintings are now in the Brooklyn Museum). Tissot's religious works show strong influence from the English Pre-Raphaelites and occasionally from Japanese graphics.

BIBLIOGRAPHY. E. Knoblock, "James Tissot and the 'Seventies," *Apollo*, XVII, June, 1933; J. Laver, *"Vulgar Society"; the Romantic Career of James Tissot*, London, 1936.

TITHE BARN. Barn built originally to collect ecclesiastical tithes in kind. Medieval English tithe barns, such as the Abbots Barn, Glastonbury, a simple stone structure with stiffening buttresses, and Fullstone Farm, Kent, a wood building with a thatch roof, are distinguished by their simplicity and craftsmanship.

TITIAN (Tiziano Vecellio). Venetian painter, the greatest of his time (ca. 1487–1577). In his old age Titian thought he was still older, which meant that he would have been born in 1478 and thus would have died at 99, but this is now usually doubted. From his native Pieve di Cadore he came to Venice as a boy apprentice. After perhaps working with the mosaicist Sebastiano Zuccato and both Bellinis, he was associated with Giorgione in the frescoes (lost) for the Fondaco dei Tedeschi, Venice, in 1508.

Titian's independent career is a calm series of triumphs. As he grew older he worked less for Venice and more for kings and potentates elsewhere, such as the dukes of Ferrara and Urbino, Pope Paul III, Francis I of France, the emperor Charles V, and Philip II of Spain. But he generally corresponded with them and shipped the pictures; the chief trips were to Rome (1545–46) and to the court of Charles V at Augsburg (1547–48 and 1550–51). His wife, Cecilia (married in 1525; died in 1530), gave him several sons, all unimportant painters.

The following list of works is limited to those of special artistic or historical interest. After the Bellinesque but urbane *St. Peter with Donor* (Antwerp, Fine Arts Museum), formerly thought to have been done in 1503, the first surviving dated work is of 1511, the three frescoes of the *Miracles of St. Anthony* (Padua, Scuola del Santo). Except for the restraint in color typical of the unusual medium, they show his basic original style: physically vigorous people move freely and effectively (unlike the frustrated power of central Italian art of the time) in an airy, fresh world.

More typical is a group of canvases very close to Giorgione. They include the portrait called *Ariosto* (London, National Gallery), the *Gypsy Madonna* (Vienna, Museum

Titian, *Venus with a Mirror*, ca. 1555. National Gallery, Washington, D.C.

of Art History), the *St. Mark Altarpiece* (Venice, S. Maria della Salute), *Salome* (Rome, Doria Pamphili), *Girl at Her Toilet* (Paris, Louvre), the *Concert* (Florence, Pitti Palace), and other portraits and Madonnas. He utilizes fully Giorgione's technical innovation of atmospheric unity of space through color, but instead of the natural result of small absorbed figures, he produces strong, extroverted people who are yet fully within the lighted space. "Life through colored light" is a useful formula for this presentation; it is basic to all his later painting.

About 1515–20, this early phase culminates in works of heroic grandeur, including the famous *Three Ages of Man* (Edinburgh, National Gallery), *Sacred and Profane Love* (Rome, Borghese), and the huge *Assumption Altarpiece* (1516–18; Venice, Frari). The exploitation of muscular movement in the altarpiece reflects Michelangelo, as does, and even more so, the *Resurrection Altarpiece* (1522; Brescia, SS. Nazaro e Celso).

In 1516 Titian had started to work for the Duke of Ferrara and produced for him the mythological pictures often thought of as his special vein. The myth seems a fitting vehicle for these sensuous, sometimes erotic paintings, with their swinging motion and sunny air. The first group includes the *Feast of Venus* and the *Bacchanal* (Madrid, Prado), followed by the great *Bacchus and Ariadne* (1523; London, National Gallery). Major religious works of the time include the *Ancona Altarpiece*, where Mary looks down through clouds to the solid saints; the *St. Christopher* fresco (Venice, Ducal Palace); the colorful and shadowy *Entombment* (Louvre); and the lost *Death of Peter Martyr* (1528). A more formal, relaxed pattern begins in the *Pesaro Altarpiece* (1526; Frari), with its upright donors and columns, in simple, rich portraits, and in many small groups of Mary with saints in the open air. Slight action with glittering color dominates the 1530s, in *La Bella* (Pitti Palace), the famous *Venus of Urbino*, and the great processional *Presentation of the Virgin in the Temple* (1534–38; Venice, Academy); this is varied in the moonlit *St. Jerome* (Louvre) and in the gray *Portrait of Charles V at Mühlberg* (Prado). But the pendulum soon swings back; these alterations may be seen as personal artistic choices and experiments by an artist now so famous that he had no concern about acceptance.

The intricate, fluid *Battle of Cadore* (1538; known from copies), with motifs from Roman sarcophagi; the Roman and unbalanced *General del Vasto and His Troops* (Prado); the floating *Annunciation* (Venice, Scuola di S. Rocco); the episodic *Pardo Venus* (Louvre); the great *Ecce Homo* (1543; Vienna, Museum of Art History), which has many of these qualities; and the corkscrew *Crowning with Thorns* (Louvre)—all lead to the ceiling scenes of Cain and Abel, Abraham and Isaac, and David and Goliath (S. Maria della Salute), whose virtuoso tension has rightly been linked to mannerism. But for the first time portraits of almost standardized simplicity now run a separate course, as can be seen often in later artists, for example, in *Francis I* (Louvre); the Giorgionesque *Young Englishman* (Pitti Palace); and the so-called *Catherine Cornaro* (Florence, Uffizi). But the fantastic *Paul III and His Nephews* (1545; Naples, Capodimonte) shares the involuted mobility of its period. Of this mobility, the first *Danaë* (Capodimonte) is a sensuous variant, with its capricious composition and painterly surface. Other novelties are the huge equestrian *Charles V at Mühlberg* (Prado); a portrait of Charles in an armchair before a landscape (1548; Munich, Alte Pinacothek); Philip II in armor (1550; Prado); and the brilliant *Vendramin Family Kneeling* (London, National Gallery).

The 1550s appear to most effect in the Prado, which now owns the paintings commissioned by Charles and Philip. Willful, loose composition with freely moving figures is now joined by willful, stucco-like brushwork and by unexpectedly reduced, flickering color. *Sisyphus and Tityus*, with its mannerist sprawl; *St. Margaret*, like an arrow in the dusk; the second *Danaë*, with its spatter of gold paint for the exploding gold; the *Glory of the Trinity*, with its bodies in abstract air, are there. Other great works of this phase are the nocturnal *Martyrdom of St. Lawrence* (Venice, Gesuiti), *Perseus and Andromeda* (London, Wallace Collection), and the *Rape of Europa* (Boston, Gardner Museum). Still later, the pair of myths of Diana from Bridgewater House (1550; Edinburgh, National Gallery) seem a relief surface of bodies in a frieze, scuffily painted, with little interest in their arrangement.

Religious works show gray tone and a milder surface in the *Pentecost* (S. Maria della Salute) and in *The Transfiguration* and *The Annunciation* (both in Venice, S. Salvatore). Yet zestful color elegance returns after 1560 in *The Adoration of the Magi* (Prado), the *Education of Love* (Borghese), and the second *Martyrdom of St. Lawrence* (Madrid, El Escorial), which also show tight-knit patterns of dramatic action. The former trend moves to works which consist of a few large, plain figures in neutral poses. Here, a mottled surface carries the life, in, for example, the *St. Sebastian* (Leningrad, Hermitage), the *Adam and Eve* (Prado), and a second *Crowning with Thorns* (Munich, Pinacothek), which is based on flecks and glimmers and a thirty-year-old composition. The *Allegory of the Battle of Lepanto* (Prado) is a forced symbol with an unresolved disproportion of parts, while *Religion Aided by Spain* (Prado) adds units together loosely. These do not exhaust the phases; the one thread is toward sketchy execution, the technique which carried through Rubens to future generations.

See also OIL PAINTING.

BIBLIOGRAPHY. H. Tietze, *Tizian: Leben und Werk*, 2 vols., Vienna, 1936; H. Tietze, *Titian; the Paintings and Drawings*, 2d rev. ed., London, 1950. CREIGHTON GILBERT

TITO, SANTI DI, *see* SANTI DI TITO.

TI-TSANG, *see* KSHITIGARBHA.

TITUS, ARCH OF, ROME. Roman triumphal arch erected in A.D. 81, after Titus's death, to commemorate the taking of Jerusalem. It consists of a central archway flanked by semidetached columns of the Composite order; the columns rest on a podium. On the attic is a dedicatory inscription. The barrel vault of the archway is coffered and has in its center a relief representing the apotheosis of Titus. The two sculptured panels in the passage below the vault are outstanding examples of Roman illusionistic style. This "illusionism" is achieved by a skillful superimposition of relief planes, thus giving an impression of depth. One panel depicts the triumphal procession of Titus

and the spoils taken from the Temple of Jerusalem. The other represents the Emperor in his chariot, crowned by Victory.

BIBLIOGRAPHY. W. J. Anderson, R. P. Spiers, and T. Ashby, *The Architecture of Greece and Rome*, vol. 2: *The Architecture of Ancient Rome*, London, 1927; D. E. Strong, *Roman Imperial Sculpture*, London, 1961.

TIVOLI. Picturesque Italian town some 20 miles east of Rome. Tivoli (ancient Tibur) preserves two Roman temples from the late republican period, the round Temple of the Sibyl (the so-called Temple of Vesta) and the Temple of Hercules. The Cathedral (Romanesque but rebuilt in the 17th century) contains a wooden group of the *Deposition* (13th cent.) and a Romanesque painted triptych. The Villa d'Este, constructed in the mid-16th century by Pirro Ligorio for Cardinal Ippolito d'Este, is celebrated for its gardens, fountains, and waterworks. Nearby are traces of the villas of Cassius, Horace, and Maecenas. The fanciful architecture of Hadrian's Villa (125–133), where the Emperor erected various ensembles of buildings to record his extensive travels, has largely survived. *See* ESTE, VILLA D'; SIBYL, TEMPLE OF THE.

BIBLIOGRAPHY. H. Kähler, *Hadrian und seine Villa bei Tivoli*, Berlin, 1950; D. R. Coffin, *The Villa d'Este at Tivoli*, Princeton, 1960; S. Aurigemma, *Villa Adriana*, Rome, 1962.

TJI-WARA (Chi-Wara), *see* AFRICA, PRIMITIVE ART OF (WEST AFRICA: MALI).

TLINGIT (Tlinghit; Tlinkit) INDIANS. The Tlingit were the northernmost of the Northwest Coast Indians, exchanging influences with both the Eskimo in southern Alaska and various Indian groups to the north in British Columbia. Like most peoples in this region, the Tlingit believed in the existence of supernatural spirits in all organic beings or creatures. Their highly stratified social system joined with religious attitudes and the prestige associated with the acquisition of wealth to support a dramatic, flourishing art.

The blankets (actually dance aprons or capes) of the Chilkat, a subtribe in Alaska, are an important Tlingit tradition. The distinctive Tlingit art, however, is sculpture in red cedar or cedar combined with metal and shell. The Tlingit were probably the first Northwestern people to adapt European metals, notably iron and steel, to art. Their masks, which join those of other British Columbian tribes in their spectacular conceptual and technical qualities, are often figured with relief or superposed animal

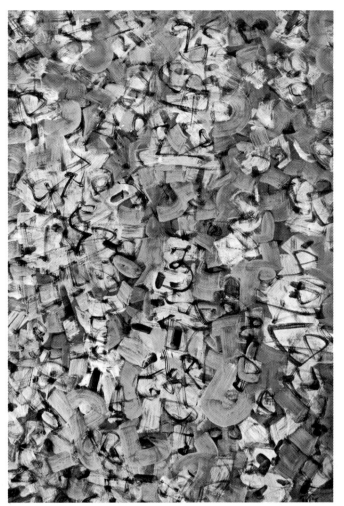

Mark Tobey, *New Life (Resurrection)*, 1957. Whitney Museum of American Art, New York.

designs. Tlingit artists are distinguished no less for their rich, variegated interpretation of human and animal forms than for the splendid finish of their masks, house posts, and decorative objects.

See also BRITISH COLUMBIAN INDIANS; NORTH AMERICAN INDIAN ART (NORTHWEST COAST).

BIBLIOGRAPHY. G. T. Emmons, *The Chilkat Blanket* (Memoirs of the Amer. Mus. of Natural History, vol. 3), New York, 1907; A. Krause, *The Tlingit Indians*, Seattle, 1956. JOHN C. GALLOWAY

TOBA SOJO. Japanese painter (1053–1140). Toba Sōjō, whose real name was Kakuyū, was the abbot of Miidera of the Tendai Sect near Kyoto. Because of his renowned skill as a painter of humorous and satirical sketches, he has traditionally been regarded as the author of the *Shigisan Engi Scrolls* and *Animal Caricature Scrolls*. Recent studies, however, show that these attributions lack positive proof. *See* ANIMAL CARICATURE SCROLLS; SHIGISAN ENGI SCROLLS.

BIBLIOGRAPHY. R. T. Paine and A. Soper, *The Art and Architecture of Japan*, Baltimore, 1955.

TOBEY, MARK. American painter (1890–). Born in Centerville, Wis., he lives in Seattle and in Switzerland.

Tlingit Indians. Carved bone shaman's charm, representing a "spirit canoe." Museum of the American Indian, New York.

Except for brief study with Kenneth Hayes Miller after he had already begun his career, Tobey is a self-taught artist. His delicately spun "white writing" abstractions, indirectly related to the more vigorously handled works by Jackson Pollock (which they precede), are thought by many authorities to derive from his study of fine calligraphy during his visit to China and Japan in the early 1930s. Actually, the total effect of these nonfigurative, handsome temperas and gouaches is closer to the Western tradition of Anglo-Celtic manuscript illuminations of the 8th century; but Tobey has been a serious student of Oriental religion (he converted to the Bahá'í World Faith in 1918) as well as of Eastern art, and there can be no doubt of a linkage, at least philosophically.

Tobey's first one-man show was held in 1917 at M. Knoedler & Co. in New York. Since 1940 his work has been included in many important annuals and internationals: the Museum of Modern Art's "Fourteen Americans," the Whitney Museum's "Nature in Abstraction," the Venice Biennale, and others, and he has had one-man shows in San Francisco, Seattle, New York, and Paris. His painting is a distinctly personal force in contemporary American abstract art.

BIBLIOGRAPHY. J. I. H. Baur, *Revolution and Tradition in American Art*, Cambridge, Mass., 1951; J. Flanner, "Tobey, mystique errant," *L'Oeil*, no. 6, 1955; W. C. Seitz, *Mark Tobey*, New York, 1962.

JOHN C. GALLOWAY

TOBI SEIJI, *see* LUNG-CH'UAN WARE.

TOCQUE, LOUIS. French portrait painter (b. Paris, 1696; d. there, 1772). He was the son of an architectural painter, Luc Tocqué. He also studied with Nicolas Bertin and Jean-Marc Nattier the Younger, whose daughter he married. Tocqué became a member of the Royal Academy in 1734 and councillor in 1744. From 1737 to 1759 he exhibited regularly at the Salon. From 1756 to 1759 he held posts as court painter at St. Petersburg and Copenhagen. His treatise, *Réflexions sur la peinture...* (1750), had an important influence on the development of naturalistic portrait painting. Though tritely synchronizing the grand-manner formulas of Hyacinthe Rigaud and Nicolas de Largillière, his characterizations are, respectively, less austere and less arch than theirs. The portraits of the *Dauphine, Marie-Thérèse* (1748; Versailles Museum), and her husband, the *Young Dauphin* (1739; Paris, Louvre), reveal Tocqué's typical sweetness.

BIBLIOGRAPHY. Count A. Doria, *Louis Tocqué...*, Paris, 1929.

TODAIJI, NARA. Japanese Buddhist temple. In accordance with the emperor Shōmu's decree of 741, provincial temples were to be built throughout the country and administered by the Tōdaiji. The construction of the Tōdaiji started in 745, and it was virtually completed by 752 when the "eye-opening" ceremony of the gilt bronze statue of the Great Buddha (53 ft. high) was conducted. Although badly damaged, the heroic figure of the Great Buddha Rushana (Sanskrit, Locana) is still housed in the Daibutsuden (Great Buddha Hall). The figure is seated upon a lotus flower of a thousand petals, each representing a universe inhabited by a multitude of Shaka and attendants.

The monastery suffered serious damage in the civil wars of 1180 and 1567. Its Great Buddha Hall, reconstructed

Tōdaiji, Nara. The south gate, 12th century.

in 1709, is now much smaller than the original structure (7 by 11 bays), but it remains the largest wooden building in the world. A large compound embraces many other buildings, among which the Hokkedō, the Tegaimon, the Shōsōin, and other storage buildings have survived intact from the beginning of the monastery's history. Many excellent examples of Nara art can be found here. *See* HOKKEDO; SHOSOIN OF TODAIJI. *See also* LANTERN, BRONZE, IN TODAIJI, NARA; NANDAIMON; NIKKO AND GAKKO BOSATSU IN TODAIJI, NARA.

BIBLIOGRAPHY. R. T. Paine and A. Soper, *The Art and Architecture of Japan*, Baltimore, 1955; National Commission for the Protection of Cultural Properties, ed., *Kokuhō (National Treasures of Japan)*, vol. 1: *From the Earliest Times to the End of the Nara Period*, Tokyo, 1963.

MIYEKO MURASE

TOEPUT, LODEWYCK (Lodewijck; Ludovico Pozzoserrato). Flemish history, portrait, and landscape painter (b. Mechlin, ca. 1545; d. Treviso, before 1605). Formed as an artist in Flanders, he probably studied in Antwerp with Martin de Vos (whose influence is visible in *The Tribute Money*, in the Bailo Museum, Treviso). Pozzoserrato left for Italy about 1573 and was certainly in Venice by 1577, the year he painted *The Burning of the Palace of the Doge*, known today only from a Hoefnagel engraving. He visited Rome and Florence but worked most of his life in Treviso. There he painted a number of large undistinguished altarpieces (he worked better on a smaller scale) and did frescoes, few of which have been preserved. His frescoes in the Monte di Pietà, Treviso, show strong Venetian influence, mostly that of Veronese. Fragments of later frescoes remain in S. Maria dei Battuti, Conegliano, and in the Casa Zignoli, Treviso. Pozzoserrato's portraits, for example, *Portrait of a Podestà* (Venice, Cà d'Oro), are hard and uninspired.

Pozzoserrato was more famous for his landscapes, some of which are small, often painted on copper, minute in detail, and bright in color. Though painted in Italy, these are very Flemish in style. Later Pozzoserrato turned to larger, fantastic mannerist landscapes with vistas of cities, mountains, rivers, and small figures; these are painted in a broader, more impressionistic manner. They suggest the

landscapes of Josse de Momper, who studied with Pozzo-serrato. He also influenced Gillis van Coninxloo and is important for the mark he left on the school of landscape painting in Flanders until the time of Rubens.

BIBLIOGRAPHY. L. Menegazzi, "Ludovico Pozzoserrato," *Saggi e Memorie di Storia dell'arte*, I, 1957. PHILIPPE DE MONTEBELLO

TOGAN (Unkoku Togan). Japanese painter (1547–1618). Tōgan worked for Lord Mōri and restored Sesshū's studio in Yamaguchi, styling himself the third generation from Sesshū. He was a rather conservative artist, and his landscape paintings tend to be decorative, reflecting the spirit of his time. He was the founder of the Unkoku school. *See* SESSHU TOYO; UNKOKU SCHOOL.

BIBLIOGRAPHY. R. T. Paine and A. Soper, *The Art and Architecture of Japan*, Baltimore, 1955.

TOHAKU (Hasegawa Tohaku). Japanese painter (1539–1610). His life is not well recorded, but the youthful Tōhaku is sometimes identified as Hasegawa Nobuharu, the painter who specialized in Buddhist themes and portraits in delicate colors. He later claimed to be of the fifth generation descended from Sesshū, whose works he admired.

With the help of his son, Kyūzō, and other artists, he founded the Hasegawa school, which decorated many palaces and temples around Kyoto. He excelled in both monochrome and polychrome paintings. The walls of the Chishakuin in Kyoto were decorated by Tōhaku and Kyūzō in brilliant colors against a gold-leaf background, and the Ryūsenin and many other temples of Kyoto were decorated by him with screen paintings in ink alone. *Screens of Pines* (Tokyo National Museum) shows a return to the standard of ink painting in the manner of Mu Ch'i of Sung China. His remarks on painting were compiled by the priest Nittsū and published under the title *Tōhaku Gasetsu* (Tōhaku's Theories on Painting). *See* MU CH'I; SESSHU TOYO.

BIBLIOGRAPHY. T. Akiyama, *Japanese Painting* [Geneva?], 1961; J. E. H. C. Covell, *Masterpieces of Japanese Screen Painting: the Momoyama Period (late 16th Century)*, New York, 1962.
 MIYEKO MURASE

TOILERS OF THE SEA. Oil painting by Ryder, in the Metropolitan Museum of Art, New York. *See* RYDER, ALBERT PINKHAM.

TOKALI KILISE, *see* TOQALE KILISSE.

TOKONOMA. Japanese term for an alcove built in either the guest room or the main room of a house. It is suggested that the prototype of the *tokonoma* is the grouping found in a priest's private chapel. The grouping consists of a hanging icon with a narrow wooden board placed before it to hold a flower stand and other ritual objects. This later became an essential feature in Japanese houses. A *tokonoma* is usually a rectangular space set aside in one corner of a room, with a slightly raised floor, in which a flower arrangement or small objects may be placed. The wall of the *tokonoma* is used to display a scroll of painting or calligraphy.

BIBLIOGRAPHY. R. T. Paine and A. Soper, *The Art and Architecture of Japan*, Baltimore, 1955; H. Kitao, *Shōin Architecture in Detailed Illustrations*, Tokyo, 1956.

TOKYO. Capital of Japan since 1868. Its history goes back to 1457, when Ota Dōken built a small fortress in this city, then called Edo. It remained relatively insignificant until 1590, when Tokugawa Ieyasu established the seat of his military government in Edo Castle (the site of the present imperial palace). Although the imperial court remained in Kyoto throughout the Edo period, Edo enjoyed prestige as the *de facto* capital of Japan until 1867. That year imperial rule in Japan was restored, and the name of the city was changed to Tokyo. *See* EDO CASTLE.

By 1787 Edo had become one of the largest cities in the world, with a population of almost a million and a half. In contrast to Kyoto, where artists were more tradition-bound, Edo produced an impressive number of artists who were willing to experiment with new techniques and styles. The art of wood-block prints, called Ukiyo-e, epitomizes the character of the city. *See* UKIYO-E.

Tokyo suffered total destruction twice in the 20th century: in the great earthquake of 1923 and during World War II. The buildings are therefore mostly postwar works, reflecting every style current in European and American architecture. Although Tokyo lacks ancient monuments, it has a large number of important art museums. *See* TOKYO: MUSEUMS.

BIBLIOGRAPHY. S. Kaneko, *Guide to Japanese Art*, Rutland, Vt., 1963. MIYEKO MURASE

TOKYO: MUSEUMS. Important public art collections in Tokyo, Japan, are located in the museums listed below.

National Museum. The largest and oldest art museum in Japan, it was founded in 1871, and the present building was constructed in 1938. It was formerly known as the Tokyo Imperial Household Museum; the present name was adopted in 1947, when it came under the jurisdiction of the Ministry of Education. Its vast collection contains about 86,000 objects, mainly Chinese and Japanese works, especially from periods before the 19th century. It also has a small but rapidly expanding collection of works from other countries. A separate building, Hyōkeikan, was added in 1908 to exhibit archaeological specimens. A collection of sculptures and other works once belonging to Hōryūji was given to this museum, and it is housed in a new building, Hōryūji Hōmotsukan, which is exclusively devoted to the display of this collection. Another new building devoted to the exhibition of Oriental arts, exclusive of Japanese, is being constructed within the compound.

BIBLIOGRAPHY. J. Harada, *Examples of Japanese Art in the Imperial Household Museum*, Tokyo, 1934; S. Kaneko, *Guide to Japanese Art*, Rutland, Vt., 1963.

National Museum of Western Art. The building was designed by Le Corbusier. It houses a collection of modern French art assembled in Europe by the late Kōjirō Matsukata, a Tokyo businessman. A large part of the collection that was then in England was destroyed during World War II. Another section was requisitioned by the French government, but these works were returned to Japan in 1959 and are now housed in the National Museum. Fifty-three sculptures by Rodin and 19th-century French paintings by Delacroix, Courbet, Monet, Gauguin, and Renoir are among the most important items in this museum.

BIBLIOGRAPHY. S. Kaneko, *Guide to Japanese Art*, Rutland, Vt., 1963.

Nezu Art Museum. Founded in 1941 to house the private collection of Kaichirō Nezu, a Tokyo businessman,

the museum contains a number of important Japanese and Chinese art objects. The Buddhist paintings and ink paintings of China and Japan, the Chinese bronze vessels, and the Japanese tea-ceremony utensils are among the finest to be found anywhere. Mu-Ch'i's *Fishing Village in the Evening Glow* and the *Nachi Waterfall* are among the most treasured items in the collection.

BIBLIOGRAPHY. Nezu Art Museum, ed., *Seizansō Seishō (Illustrated Catalogue of the Nezu Collection)*, 10 vols., Tokyo, 1939–43; S. Kaneko, *Guide to Japanese Art*, Rutland, Vt., 1963.

TOL, DOMINICUS VAN. Dutch painter of genre and portraits (b. Bodergraven, ca. 1635; d. Leyden, 1676). He was a pupil of his uncle Gerrit Dou in Leyden. In 1664 Van Tol was reported as a member of the Leyden Guild of St. Luke. In 1669 he was in Amsterdam, but the following year he was married in Leyden, where he opened a beer and wine business shortly before his death. His works reflect the influence of Gerrit Dou.

BIBLIOGRAPHY. W. I. C. Rammelman Elsevier, "Dominicus van Tol, schilder te Leiden," *Obreen's Archief*, V, 1882–83.

TOLEDO, JUAN BAUTISTA DE. Spanish architect (d. 1567). Trained in Italy, he was one of Michelangelo's assistants in the construction of St. Peter's, Rome. Engaged in vice-regal commissions in Naples, Toledo was called to Spain by Philip II in 1559 and began to design El Escorial, the monastery-palace dedicated to St. Lawrence, in 1561. He chose the grid plan, probably derived from Filarete's project for the Ospedale Maggiore, Milan. His design introduced, in opposition to the contemporaneous Plateresque style, an austere grandeur governed by the abstract geometry of number, measure, and proportion. Although it is often criticized as inhumanly cold, the exterior has an awesome beauty. At Toledo's death the completion of the vast interior was put in the hands of Juan de Herrera. *See* EL ESCORIAL: MUSEUMS.

BIBLIOGRAPHY. S. de Zauzo Ugalde, *Los orígines arquitectónicos del real monasterio de San Lorenzo del Escorial*, Madrid, 1948; F. Chueca Goitia, *Ars Hispaniae*, vol. 11: *Arquitectura del siglo XVI*, Madrid, 1953.

TOLEDO, OHIO: MUSEUM OF ART. Founded in 1901 by Edward Drummond Libbey, who had brought the glass industry to Toledo in 1888. The center section of the present building was completed in 1912, enlarged in 1926, and extended to include two wings in 1938.

The museum's glass collection is outstanding, and contains hundreds of examples of ancient, European, and American glass. Other holdings are the Stevens Gallery, which traces the history of writing and printing; the Swiss Room, which contains a colorful porcelain stove and works of decorative art from Switzerland; and a medieval cloister with Romanesque and Gothic arcades. The entire history of art from ancient Egypt to the 20th century is well illustrated at Toledo, and its painting collection is rich in quality as well as quantity.

Outstanding among the collection of more than 1,000 American and European paintings are works by Allston (*Italian Landscape*), Bellini, Bellows, Bierstadt, Cézanne, Cole, Copley (*Portrait of Mary Warner*), Constable, Courbet, Gerard David (*The Three Miracles of St. Anthony*), Delacroix (*Return of Christopher Columbus from the New World*), Eakins, Feke (*Portrait of Josiah Martin*), Frago-

nard, Gainsborough (one of his rare landscapes), Gauguin, Van Gogh, Goya (*The Bull Fight*), Homer, Hals, Inness, Kensett, Manet, Marin, Marsh, Monet, Matisse, Morse, Peale, Picasso (*Woman with a Crow*), Rembrandt, Renoir, Reynolds, Rouault, Rubens, Sargent, Smibert, Stuart (*George Washington*), Sutherland, Tiepolo, Tobey, Turner, Velázquez (*Man with a Wine Glass*), West, and Wyeth.

Among acquisitions made since 1960 are a number of unusual works of decorative art and sculpture, including a small earthenware duck from 7th-century Greece, a gilded ostrich-egg cup and cover from 16th-century England, a gilded-bronze baroque French clock, and an 18th-century German sundial of engraved brass.

BIBLIOGRAPHY. J. D. Morse, *Old Masters in America*, Chicago, 1955; E. Spaeth, *American Art Museums and Galleries*, New York, 1960.

JOHN D. MORSE

TOLEDO, SPAIN. Historic city on the Tagus River and capital of Toledo province in central Spain. The city (ancient Toletum), conquered by the Romans in 193 B.C., figured prominently in the introduction of Christianity into Spain and was the Visigothic capital (579–711). Under Moorish rule (712–1085) it prospered. After the reconquest, Toledo became the residence of the kings of Castile and was a center of Moorish, Spanish, and Jewish culture.

Dating from the Roman period are the circus (2d cent.), an aqueduct, and two bridges (heavily restored). Traces of Visigothic domination remain in parts of the city wall and in the capitals in the Church of Cristo de la Luz, formerly a mosque (10th cent.; additions 12th cent.), and the columns of S. Sebastián (10th cent.; rebuilt 13th cent.), which date from the Muslim period. *See* CRISTO DE LA LUZ.

After Toledo was recaptured from the Moors the Mudejar style became prominent. S. María la Blanca (12th–13th cent.; 16th-cent. additions), a synagogue until 1405, is Toledo's earliest monument in that style. The aisles are separated by stuccoed brick arcades of rounded horseshoe arches on octagonal tiled piers. Another synagogue, El Tránsito (1356), a chapel since 1492, has a galleried aisle-less interior with a magnificent open-beamed ceiling with chamfered corners. The 16th-century portal by Cristobal de Palacios and a *Nativity* attributed to Juan de Borgoña are noteworthy. Churches in the Mudejar style include Cristo de la Vega (frequently restored); Santiago del Arrabal (13th cent., with Moorish tower ca. 1179); S. Vicente (1595; now a museum), with works by El Greco, Velázquez, Juan de Arfe; and S. Tomé (1300–20), which contains El Greco's *Burial of the Count of Orgaz*. *See* SANTA MARIA LA BLANCA; TRANSITO, EL. *See also* MUDEJAR ART.

The Gothic Cathedral (1227–1492; major additions up to 18th cent.) follows the models of Bourges and Le Mans. The exterior has little unity. The central portal of the main (west) façade (begun 1418), the Puerta del Perdón, has a pediment relief of the Virgin with St. Ildefonso and a representation of the Last Supper. The five square stories of the North Tower (1380–1440) support an octagonal story, terminating in a spire with bands of rays symbolizing the Crown of Thorns. The domed South Tower (1519), designed by Enrique de Egas, is much lower. The Puerta de los Leones (15th cent.; south façade) is richly decorated

with Gothic sculpture; the Puerta del Reloj (ca. 1300) is the oldest door in the Cathedral. The nave, with seven bays, has double aisles, extended as a double apse ambulatory behind the Capilla Mayor (enlarged 1498–1504). The large altarpiece (1502–04), with New Testament scenes, is flanked by royal tombs.

The *Trasparente* (1732) by Narciso Tomé in the ambulatory is an outstanding example of the Spanish baroque style. Side chapels contain works by Bigarny, Alonso de Covarrubias, Juan de Borgoña, and many other artists. Giordano executed the vault frescoes for the main sacristy, which contains paintings by El Greco, Goya, Bellini, Van Dyck, and others, as well as illuminated manuscripts and lace, embroidery, and weaving (13th–18th cent.).

The choir has two tiers of stalls, the upper (1495) by Rodrigo Alemán and the lower (1539–45) by Bigarny and Alonso Berruguete, who also did the *Transfiguration* group for the choir. The Reliquary Room, the Cathedral Treasury, and the Capilla de la Virgen del Sagrario contain gold- and silverwork and Romanesque and Gothic reliquaries.

Among the many other churches are San Juan de los Reyes (completed 1495), executed for Ferdinand and Isabella by Juan Guas; and S. Andrés, with a sanctuary (1513) executed by Juan de Borgoña and retablo by Francisco de Amberes. *See* SAN JUAN DE LOS REYES.

Other noteworthy monuments include the 18th-century Archbishops' Palace; the Ayuntamiento, with alterations (1599–1618) by Jorge Manuel Theotocopuli (El Greco's son), who also constructed a cupola (1626–31) for the Cathedral; the Hospital of S. Juan Bautista (begun 1541) by Alonso de Covarrubias and Bustamente; and the ruins of the Alcazar (16th cent.), heavily damaged in 1936. Toledo's museums, housed in historic buildings, contain art treasures reflecting the cultural and historical importance of the city. *See* TOLEDO, SPAIN: MUSEUMS.

DONALD GODDARD

TOLEDO, SPAIN: MUSEUMS. Important public collections in Toledo are located in the following museums.

El Greco Museum. Collection housed in the only surviving example of the 14th-century palaces that were situated on the Paseo del Tránsito (in one of which El Greco lived). The marqués Benigno de la Vega-Inclán y Flaquer, who owned this building early in the 20th century, restored it as the official Casa del Greco and built an addition as a museum. He enriched the monument with parts from other old Toledan buildings and imported a Mudejar ceiling from Old Castile. It appears that the cellars, at least, were part of the houses of Samuel Levi, the famous treasurer of Peter I; they contain interesting Mudejar vaults. Another survival of the same palace compound of Levi is the adjacent El Tránsito, originally a synagogue. *See* TRANSITO, EL.

Vega-Inclán presented the memorial to the nation to house the paintings by El Greco that were then in the Provincial Museum and the Institute: portraits of Antonio and Diego Covarrubias, the topographical *View of Toledo* (the manuscript annotations for which contain the only known record of El Greco's ideas on art), the *Apostolados* (single portraits of the Twelve Apostles including the outstanding *Tears of St. Peter*), *St. Bernard*, and *St.*

John of Avila. They are works generally assigned to the last and most expressionistic phase of El Greco's art (1610–14).

The museum has since acquired a few paintings by other artists: Juan Bautista Martínez del Mazo, Juan Carreño de Miranda, Pedro Berruguete, and Joaquín Sorolla y Bastida.

BIBLIOGRAPHY. M. B. Cossío, *Toledo*, Madrid, 1933; J. B. Trend, *The Civilization of Spain*, 5th ed., London, 1952.

EILEEN A. LORD

Parish Museum of San Vicente. Collection of paintings, sculpture, and ecclesiastical arts, housed in the former Church of S. Vicente. Among the paintings are a number of works by El Greco and others by Tristán and Masip.

Provincial Archaeological Museum. Varied collection, mostly from the area of Toledo, occupying the Renaissance Hospital of Santa Cruz (1514–44) by Enriques Egas. Of particular interest are the rooms devoted to exhibits of prehistoric, Iberian, Roman, Visigothic, Arab, and Mudejar art and artifacts. Works by Correa and his followers, Tristán, Maino, Ribera, and Murillo highlight the collection of Spanish paintings. Notable among the works of Spanish sculpture is a series of reliefs by Berruguete. Also on view are Spanish decorative arts (16th–19th cent.) and textiles (15th–20th cent.).

BIBLIOGRAPHY. *Museo Arqueológico de Toledo*, 2d ed., Toledo, 1958.

TOLSA, MANUEL. Spanish-Mexican architect and sculptor (b. Enguera, Spain, 1757; d. Mexico City, 1816). Trained in Spain, Tolsá studied at the Academy of Valencia. He arrived in Mexico City in 1791, and was named *maestro mayor* of the Cathedral (after 1793) and director of sculpture at the Academy of S. Carlos (founded 1785). His sophisticated neoclassical style quickly set a new fashion for Mexico City, replacing the 18th century's mixed artistic language with a purer grammar of Roman and Renaissance forms. The scale and size of Tolsá's projects, however, were still late baroque, as were individual features such as staircases. He finished the upper center of the Cathedral façade, added bell-shaped tops to the towers, and designed the dome.

Tolsá's finest building is the Minería Palace in the capital (1797–1813 and later); his best-known sculpture is the *Caballito* (little horse), an equestrian monument of Charles IV, the last Spanish king to rule Mexico (1803; Mexico City, Plaza de la Reforma). As teacher and practitioner of refined neoclassicism, Tolsá, along with the great provincial Tresguerras, brought academic sobriety into prominence—which had many good effects but more bad on later-19th- and 20th-century Mexican art. *See* MINERIA PALACE, MEXICO CITY.

BIBLIOGRAPHY. A. Escontría, *Breve estudio de la obra y personalidad del escultor y arquitecto don Manuel Tolsá*, Mexico City, 1929; J. Contreras y López de Ayola Lozoya, *Historia del arte hispánico*, vol. 4, Barcelona, 1945; E. W. Weismann, *Mexico in Sculpture*, Cambridge, Mass., 1950; J. Fernández, *El palacio de Minería*, Mexico City, 1951.

JOSEPH A. BAIRD, JR.

TOLSTOI, THEODORE. Russian sculptor and painter (b. St. Petersburg, 1783; d. there, 1873). He studied sculpture at the Academy of St. Petersburg. In painting he followed the realistic principles of Venetsianov rather than the prevalent romanticism and painted scenes of Russian middle-class families in their homes. His sculpture is more ro-

mantic. Examples are his marble head of Morpheus and his bas-reliefs of the Ulysses epic (Moscow, Tretyakov).

BIBLIOGRAPHY. C. G. E. Bunt, *A History of Russian Art*, London, 1946; D. T. Rice, *Russian Art*, West Drayton, Middlesex, 1949.

TOLTEC ART. The Toltecs were a pre-Columbian Indian group of Mexico who rose about A.D. 900. Their capital was near the present Tula, which was sacked in 1168. The Toltecs spread throughout Mexico, especially to Cholula, Teotihuacán, and Chichén Itzá, and provided one of the major influences in the development of Aztec art. *See* AZTEC ART; CHICHEN ITZA; CHOLULA.

Toltec legends refer to a ruler and/or god, Quetzalcoatl, who is generally associated with a florescent period of pre-Columbian history about the 10th century. Because the influence of the vigorous Toltec architectural and sculptural style is so widespread, excavations at Tula are especially important to an understanding of the pre-Columbian art of Mexico. Atlantean figures, reclining Chac Mool figures, and relief carvings from Tula are duplicated in late work at Chichén Itzá. *See* AMERICAS, ANCIENT, ART OF (MEXICO: TOLTEC CULTURE).

BIBLIOGRAPHY. P. Kelemen, *Medieval American Art*, New York, 1943; F. A. Peterson, *Ancient Mexico*, New York, 1959; I. Marquina, *Arquitectura prehispánica*, 2d ed., Mexico City, 1964.

TOMAR (Thomar). Portuguese city in Ribatejo province. The Cristo Monastery of Tomar (12th–17th cent.), founded by the Knights Templars, is the largest in Portugal. The Church of the Templars has an octagonal sanctuary (3d quarter of 12th cent.); the remarkable nave and chapter house were built in Manueline style (1510–14) by Diogo de Arruda. The south façade with a beautiful portal was designed by João de Castilho (1515). The main cloister of the Cristo Monastery, in the Renaissance style, was begun by Diogo de Torralva after 1557 and completed by Filippo Terzi. The Church of S. João Batista (15th cent.) has a fine Manueline tower. The Church of S. Maria de Conceição (16th cent.) is in the Renaissance style.

BIBLIOGRAPHY. J. M. de Sousa, *Notícia descriptiva e histórica da cidade de Tomar*, Tomar, 1903.

Toltec art. Pyramid of Quetzalcoatl at Tula, with remains of pillared portal in the foreground.

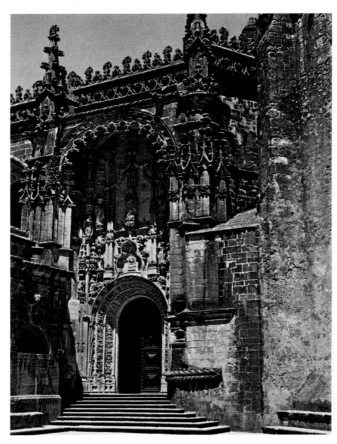

Tomar. Church of the Templars, south portal by João de Castilho, 1515.

TOMB, ROCK-CUT, *see* ROCK-CUT TOMB.

TOMBARA, *see* NEW IRELAND.

TOMLIN, BRADLEY WALKER. American painter (b. Syracuse, N.Y., 1899; d. New York City, 1953). He studied at Syracuse University from 1917 to 1921 and in Paris in the middle 1920s. Tomlin practiced an essentially realistic art until about 1939, arriving slowly but with distinctive purpose at abstraction about 1946. His style, identifiable as abstract expressionist, or action, painting, consists of rapidly brushed, long strokes, either interwoven or giving an overlaid effect, enlivened by a quick, darting line. *Number 9: In Praise of Gertrude Stein* (1950; New York, Museum of Modern Art) is characteristic of his late manner. Tomlin received special mention in the 1946 Carnegie International and won a Tiffany fellowship the same year. He won the 1949 purchase prize at the University of Illinois and was represented in major group exhibitions in New York in 1952–53, as well as in several large posthumous shows. His work was significant to the widespread acceptance of the action style and is notable for its elegance of form and touch.

BIBLIOGRAPHY. New York, Museum of Modern Art, *Fifteen Americans*, ed. D. C. Miller, New York, 1952; Whitney Museum of American Art, *Thirty-Five American Painters and Sculptors*, New York, 1955; J. I. H. Baur, *Bradley Walker Tomlin*, New York, 1957; Los Angeles County Museum of Art, *New York School*, ed. M. Tuchman, Los Angeles, 1965.

TOMMASO, *see* FINIGUERRA, MASO.

TOMMASO DA MODENA. Italian painter and miniaturist (b. Modena, 1325/26; d. before 1379). He worked in Modena, Bologna, and elsewhere in Italy, showing the influence of Vitale da Bologna and Simone Martini. Caricature and mimicry are characteristics of his style, which influenced contemporary Venetian and Veronese painters. Tommaso's works include a series of frescoes of noted Dominicans (from 1352) for the Chapter House and a St. Ursula cycle for S. Margherita (both Treviso) and the *Decapitation of John the Baptist* (Trent Cathedral). Whether he worked in Bohemia with Theodoric of Prague on Karlstein Castle (1357–67) for Emperor Charles IV is contested, but his style is related to Bohemian art of the period. *See* KARLSTEIN CASTLE; THEODORIC OF PRAGUE.

TOMMASO DI STEFANO DETTO GIOTTINO, *see* GIOTTINO.

TOMME, LUCA, *see* LUCA DI TOMME.

TONALISTS. Group of American painters working mostly before 1930. They were once well known but are now obscure. In contrast to the impressionists they worked in warm tones, trying to evoke in subject matter and color a quiet, elegiac mood. The tonalists included J. Francis Murphy, Bruce Crane, Henry Ranger, and Lendall Pitts. *See* RANGER, HENRY WARD.
BIBLIOGRAPHY. E. P. Richardson, *Painting in America*, New York, 1956.

TONALITY, *see* TONE.

TONDO. Circular painting, sculptured relief, medallion, fresco, or the like. Michelangelo's *Doni Holy Family* (ca. 1504; Florence, Uffizi) is a famous example in painting. In ceramics a tondo is a circular plaque or plate of ornamental ware, such as majolica, having an unusually wide rim in proportion to a flat or bowl-like center section.

TONE. Tint or shade of a color, as a light, medium, or dark tone of blue. Tone values are independent of local (actual) color, and the interplay of tone and color value is an important part of pictorial unity, particularly in non-representational painting.

TONGA ISLANDS, *see* OCEANIC ART (POLYNESIA).

TONKS, HENRY. English painter (b. Solihull, Warwickshire, 1862; d. London, 1937). Tonks began a career as a surgeon and took lessons at the Westminster School of Art in his spare time. His increasing contact with artists led to his giving up medicine. He became an assistant in the Slade School in 1892 and remained there until 1930, becoming a professor in 1918. His influence on generations of students was of the greatest importance because of his inspiration as a teacher and as an artist. He painted both oils and water colors and was fond of making sketches, often of medical subjects. In water color he came under the influence of Steer and employed broad bold washes of color, interpreting this traditionally English medium in the light of developments in Continental painting. His oils reveal more clearly and directly the influence of impressionism.
BIBLIOGRAPHY. J. Hone, *The Life of Henry Tonks*, London, 1939.

TONNANCOUR, JACQUES DE. Canadian painter (1917–). He was born in Montreal, painted in Brazil (1945–46), and now lives in Montreal. He has been influenced by Alfred Pellan, Matisse, and Picasso. At first Tonnancour painted figure studies, but he now devotes himself almost exclusively to landscapes, working in a continually more abstract manner.
BIBLIOGRAPHY. D. W. Buchanan, *The Growth of Canadian Painting*, London, 1950.

TOOKER, GEORGE. American painter (1920–). Born in New York City, he studied at the Art Students League with Reginald Marsh, Kenneth Hayes Miller, and Harry Sternberg, and received lessons in tempera technique from Paul Cadmus. Tooker paints haunting imaginative scenes in a realistic style, for example, *The Subway* (1950; New York, Whitney Museum).
BIBLIOGRAPHY. J. I. H. Baur, ed., *The New Decade*, New York, 1955.

TOORENVLIET, JACOB, *see* TORENVLIET, JACOB.

TOOROP, CAROLINE (Charley). Dutch painter (b. Katwijk aan Zee, 1891; d. Bergen, 1955). She was the daughter of the symbolist painter Jan Toorop. Her first interests were musical, but she began painting about 1914, and was self-taught. Her first exhibition was in Amsterdam in 1916. After her early softly painted, warmly colored portraits of children, her subjects took on new philosophical and social meaning in strongly drawn Dutch land- and cityscapes and firmly three-dimensional urban genre and peasant portraits.

TOOROP, JOHANN (Jan) THEODORUS. Dutch painter, illustrator, and graphic artist (b. Poerworedjo, Java, 1858; d. The Hague, 1928). He studied at the academies of Amsterdam and Brussels. His early work was influenced by Manet and Ensor, and in the late 1880s he sometimes worked in a pointillistic style, for example, *Seduction* (1886; Otterlo, Kröller-Müller Museum). He joined the Belgian group Les Vingt in 1887.

Bradley Walker Tomlin, *Still Life*, 1939. Whitney Museum of American Art, New York.

About 1890 his friendship with the writers Maeterlinck and Verhaeren moved Toorop toward symbolism and a mystical point of view. He was a convert to Catholicism in 1905, and his art then became primarily religious. Toorop's importance lies mainly in his work of the 1890s, mostly carefully planned drawings related to symbolism in approach and content and to the patterns and arabesques of Art Nouveau in design, as in *The Three Brides* (1893; Kröller-Müller Museum).

BIBLIOGRAPHY. A. Plasschaert, *Jan Toorop*, Amsterdam, 1925; J. B. Knipping, *Jan Toorop*, Amsterdam, 1947.

TOOTH ORNAMENT, *see* DOGTOOTH.

TO-PAO, *see* PRABHUTARATNA.

TOPE. Buddhist relic mound. *See* STUPA.

TOP KAPU SERAI (Top Kapu Saray; Topkapi Palace), ISTANBUL. Residence of Ottoman sultans from the 15th until the 19th century. Within high walls is a complex of courts and of buildings which includes apartments with 348 rooms, baths, mosques, schools, libraries, and pavilions. Since 1925 the palace has been a state museum, and its famous collections contain fabulous treasures. These include the Cinili Kiosk, the Assyrian-Babylonian Museum, and the collections of miniatures, pottery, tapestries, and other arts. *See* ISTANBUL: ARCHAEOLOGICAL MUSEUM.

BIBLIOGRAPHY. B. Unsal, *Turkish Islamic Architecture*, London, 1959.

TOPOGRAPHICAL PAINTING. Type of painting that pictorially describes a landscape in terms of its geographical location, particular land configurations, and buildings. From its origin in the 15th-century woodcut chronicles topographical painting developed into a specialized form, particularly at 17th- and 18th-century courts of Europe.

TOPRAK KALEH. Stronghold of Urartu, on a hill near the Urartian capital of Tushpa on Lake Van, in eastern Asia Minor, used as a second capital by the Urartian kings after 730 B.C. Excavations have yielded examples of the Urartian metalworkers' art, such as shields ornamented with motifs and hieroglyphic inscriptions, and bronze worshiper statuettes and plaques. A bronze plaque (8th–7th cent. B.C.; London, British Museum) represents an Urartian

Toraṇa. Freestanding gateway before a sanctuary, Bhuvaneśvara, India.

building with three stories. A bronze cauldron handle (British Museum) of the same period is in the form of a bull's head in relief, flanked by wings. A sphinx wearing a pectoral below the neck and a lion's head (British Museum) formed part of a bronze throne. Strong Assyrian influence appears in a bronze statuette (Berlin, former State Museums) wearing a pectoral decorated with animals, mythical beings, and sacred trees.

BIBLIOGRAPHY. S. Lloyd, *The Art of the Ancient Near East*, London, 1961; R. Ghirshman, *The Arts of Ancient Iran: From Its Origins to the Time of Alexander the Great*, New York, 1964.

TOQALE KILISSE (Tokali Kilise). Rock-hewn Cappadocian church, the most important of a group of such monuments in the Göreme Valley, Turkey. Although the church itself may date from the 8th century, the figural frescoes covering the walls and ceiling are dated to the first half of the 10th century.

BIBLIOGRAPHY. G. de Jerphanion, *Une Nouvelle province de l'art byzantin: Les Eglises rupestres de Cappadoce*, vol. 1 (2 pts.), Paris, 1925–32.

TORAH. The first five books of the Old Testament, called the Pentateuch. Traditionally, these books are referred to as the Books of Moses, although modern scholarship no longer attributes them to Moses. The Torah constitutes the basis of Jewish belief. Through the centuries it has been presented in the form of a highly venerated scroll manuscript on heavy parchment, embellished with chased silver ornaments and encased in a purple velvet cover.

TORANA. Freestanding gateway within the Indian temple outside the door of the sanctuary. It consists of two upright pillars and one to three lintels, framing the image in the sanctuary. The toraṇa was one of the prescribed subservient parts of the Indian temple from the mid-6th to the 12th century. It was usually decorated with religious reliefs suggesting unrolled scrolls with the face of glory in the keystone position.

TORBIDO, FRANCESCO (Il Moro). Italian painter (b. Venice, ca. 1482; d. Verona, ca. 1561). He was a pupil of Giorgione in Venice. Torbido first imitated the style of the master in an angular, provincial way, for example, in the *Portrait of a Youth* (1512; Munich, Old Pinacothek). In his later works Veronese influences are apparent. His portraits do not change (Milan, Brera; Verona, Castelvecchio Museum), but his compositions are eclectic. His most important works are the altarpiece from S. Maria in Organo (Potsdam Palace; Augsburg, State Gallery) and the altarpiece in S. Zeno, Verona; their crowded weightiness reflects Pordenone.

BIBLIOGRAPHY. D. Viana, *Francesco Torbido detto il Moro, pittore veronese*, Verona, 1933.

TORCELLO. Island in the lagoon of Venice, Italy. It was the seat of a bishop and was commercially important until after the 9th century and the rise of Venice. The Church of S. Fosca (11th cent.) is an octagonal central-plan structure surrounded by a peristyle. The columnar capitals are Veneto-Byzantine in style. The Cathedral was founded in the 7th century and rebuilt in the 9th and 11th centuries. The interior is richly decorated with a tesselated pavement, Byzantine low reliefs on an 11th-century iconostasis, and magnificent 12th- or 13th-century mosaics of the Last

Francesco Torbido, *The Archangel Raphael with Tobias.* Castelvecchio Museum, Verona.

Torii school. Kiyonaga Torii, *The Geisha Tachibana.* Woodcut. National Museum, Tokyo.

Judgment on the interior of the west façade. These mosaics, as well as the one in the apse, are excellent examples of the Italo-Byzantine style. *See* SANTA FOSCA, TORCELLO.

TORELLI, FILIPPO DI MATTEO, *see* FILIPPO DI MATTEO TORELLI.

TORENVLIET (Toorenvliet), JACOB. Dutch genre and portrait painter, etcher, and engraver (b. Leyden, 1640; d. there, 1719). He was the son and pupil of Abraham Torenvliet. In 1670 Jacob traveled to Rome, where he remained for about three years and was a member of the northern artists' association, the "Bentvueghels." He was also in Venice and Vienna. In 1685 he was reported as a member of the Leyden Guild of St. Luke.

BIBLIOGRAPHY. T. von Frimmel, "Zu den Malern Toorenvliet," *Blätter für Gemäldekunde,* IV, 1908.

TOREUTICS. Process of making sculpture, usually in metal, that is embossed, chased, or hammered into relief (from the Greek *toreutiké,* meaning to "bore through"). The Greeks mastered this technique very early, and by 1600 B.C. they were creating masterpieces of toreutic work. The vessels of silver and gold that have been found in royal Helladic tombs are examples of toreutics, as is the shield of Achilles mentioned in Homer's *Iliad.* In the ancient toreutic process, a design was worked into a mold with tools; then a sheet of bronze, gold, or silver was put on the matrix and hammered into the design. When finished, the embossed surface was polished and sometimes engraved.

BIBLIOGRAPHY. C. Seltmann, *Approach to Greek Art,* New York, London, 1948.

TORI BUSSHI. Japanese sculptor (fl. early 7th cent.). The son of the sculptor Tasuna, he was born to a family that was believed to be descended from Chinese immigrants and that was distinguished for its service in popularizing Buddhism in Japan. Tori is the earliest Japanese sculptor whose works are extant.

A large statue of the Shaka Buddha in the Gangōji near Nara (606) and a Shaka Triad in the Golden Hall of the Hōryūji (623) are the oldest surviving examples of Japanese Buddhist sculpture.

BIBLIOGRAPHY. R. T. Paine and A. Soper, *The Art and Architecture of Japan,* Baltimore, 1955; National Commission for the Protection of Cultural Properties, ed., *Kokuhō (National Treasures of Japan),* vol. 1: *From the Earliest Time to the End of the Nara Period,* Tokyo, 1963.

TORII. Japanese term for a type of gateway peculiar to Shinto shrines. It is built in the simplest type of post-and-lintel construction, with two upright posts supporting two beams of different length. Traditionally, *torii* and other buildings of Shinto shrines are unpainted, preserving the natural quality of the wood. Some, however, are painted in bright red, reflecting the influence of Buddhist temples.

BIBLIOGRAPHY. R. T. Paine and A. Soper, *The Art and Architecture of Japan,* Baltimore, 1955.

TORII SCHOOL. School of Japanese Ukiyo-e printmakers. It was started by Kiyomoto, the father and teacher of Kiyonobu I, in the 17th century. Kiyonobu I created a distinctive style of actor portraits, which became a trademark of this school. He had many talented pupils, among them Kiyomasu I, Kiyomasu II, Kiyomitsu, Kiyonaga, and Kiyonobu II. They preserved the tradition of portray-

ing beautiful women and Kabuki actors. The school continues even today to make billboards for Kabuki theaters. *See* KIYOMASU I; KIYOMASU II; KIYOMITSU; KIYONAGA; KIYONOBU I; KIYONOBU II; UKIYO-E.

BIBLIOGRAPHY. R. D. Lane, *Masters of the Japanese Print*, Garden City, N.Y., 1962.

TORO, OSVALDO LUIS, AND FERRER, MIGUEL. Puerto Rican architectural team: Osvaldo Toro (1914–) and Miguel Ferrer (1915–). Both were trained in the United States. They designed the Caribe Hilton Hotel in San Juan (1947–49) and the San Juan Airport (completed 1955; with Torregrossa).

BIBLIOGRAPHY. H.-R. Hitchcock, *Latin American Architecture since 1945*, New York, 1955.

TORO: COLLEGIATE CHURCH. Spanish Romanesque building of the 12th century, with suggestions of the Byzantine and Gothic styles. Its three semicircular apses and interior dome on pendentives tend toward the Romanesque, while the nave and aisles of three bays with pier clusters and rib vaulting in the aisle bays are closer to the Gothic. The building is preceded by a square entrance bay surmounted by an octagonal tower. The squat, circular crossing tower, with two stories of recessed windows and round turrets at the four corners, anticipates that of the Cathedral of Salamanca.

BIBLIOGRAPHY. V. Lampérez y Romea, *Historia de la arquitectura cristiana española en la edad media*, vol. 2, Madrid, 1909.

TORRENTIUS, JOHANNES (Jan Simonsz. van der Beeck). Dutch painter of still life and history (b. Amsterdam,

Jacopo Torriti, apse mosaic representing the Coronation of the Virgin, S. Maria Maggiore, Rome.

1589; d. there, 1644). Little is known of Torrentius's early career and training. He worked primarily in Amsterdam, but he is known to have been active in Leyden and later in Haarlem. His unorthodox religious views and his bad character brought him into conflict with the authorities at Haarlem, and in 1628 he was sentenced to twenty years in prison after having been tortured. Many of his paintings were publicly burned. On the intercession of Prince Frederick Henry and King Charles I, however, Torrentius was set free in 1630. He immediately went to England and seems to have remained there until 1641 or 1642, when he returned to Amsterdam.

Torrentius is known to have made use of various optical devices in his painting, including the camera obscura. Of the few paintings by Torrentius that have come down to us the best known is his *Vanitas Still Life* (1614; Amsterdam, Rijksmuseum), which, ironically, is an allegory of temperance.

BIBLIOGRAPHY. A. Bredius, *Johannes Sijmonsz. Torrentius...*, The Hague, 1909; B. W. F. van Riemsdijk, "Een schilderij van Johannes Torrentius," *Feest-bundel Abraham Bredius aangeboden den 18den April 1915*, Amsterdam, 1915; A. Rehorst, *Torrentius*, Rotterdam, 1939. LEONARD J. SLATKES

TORRES GARCIA, JOAQUIN. Uruguayan constructivist painter (b. Montevideo, 1874; d. there, 1949). Joaquín Torres García was trained in Barcelona and worked in Paris and New York City until 1932, when he settled in Montevideo. He was a major theoretician and practitioner of the constructivist style who arranged evocative images in a pictographic format. *Arte universal* (1937; Montevideo, Torres García Family Collection) is typical.

BIBLIOGRAPHY. Musée national d'art moderne, *Joaquín Torrès García*, Paris, 1955; Centro de Artes Visuales, *Joaquín Torres García*, Buenos Aires, 1964.

TORRES STRAIT, *see* MELANESIA; OCEANIC ART (MELANESIA: NEW GUINEA).

TORRIGIANI, PIETRO (Pedro Florentin y Torrigiano). Italian sculptor (b. Florence, 1472; d. Seville, 1528). He was a fellow-apprentice of Michelangelo and broke the latter's nose in a fist fight. Torrigiani fled Florence in 1492 and became a military officer in the service of Cesare Borgia. Torrigiani was in England in 1509, where he worked on the tomb of Henry VII (1512–19; London, Westminster Abbey). Similarities to the style of Benedetto da Maiano, that is, to the style of the late Quattrocento in Florence, may be noted in the tomb. From 1521 on Torrigiani was in Seville.

In the short span of six years he telescoped changes of style from the High Renaissance to early mannerism. Two polychromed terra-cotta statues in the Provincial Museum of Fine Arts, Seville, show this development. The *Virgin and Child* (ca. 1521) is in the High Renaissance style. The mannerist *St. Jerome* (ca. 1525) is uncompromisingly realistic in its depiction of the anatomy of the aged ascetic. It expresses a new note of tense anguish in the *contrapposto* of the figure, the pain of the weather-beaten flesh drawn dryly across a dehydrated form, and the *terribilità* of the raised head's expression of spiritual force caged in a decrepit body. The influence of this interpretation may have reverberated in the baroque works of such artists as Montañés, Velázquez, and Zurbarán.

BIBLIOGRAPHY. J. M. Azcarate, *Ars Hispaniae*, vol. 13: *Escultura del siglo XVI*, Madrid, 1958; G. Kubler and M. Soria, *Art and Architecture of Spain and Portugal and Their American Dominions, 1500–1800*, Baltimore, 1959. EILEEN A. LORD

TORRITI, JACOPO. Italian painter and mosaicist (fl. ca. 1280–96). Although nothing as yet is known of Torriti's life, he was evidently one of the leading painters of the Roman school in the late 13th century. His only surviving works in Rome, identifiable by his signature, are the apse mosaics of St. John Lateran (1291) and S. Maria Maggiore (1295/96). On the basis of stylistic comparison, it has universally been agreed that the half figures (Christ, the Virgin, St. John the Baptist, and St. Francis) in the second vault from the transept in S. Francesco at Assisi are also by his hand.

On the whole, Torriti's style represents the culmination of the late-Italo-Byzantine style in Rome, a style that had first emerged toward the beginning of the 12th century under the impetus of large-scale decorative programs in Rome. What makes Torriti's work outstanding is the high quality of his production in this mode, the elegance and grace of his figures, and the delicate tonal harmonies of his color schemes.

Although Torriti's work in St. John Lateran has most frequently been discussed as his "restoration" of the presumed Early Christian program, it can only be generally conceded that the scheme reproduces certain elements of a possible 5th-century work. Moreover, a number of modern restorations in the apse have made Torriti's work almost indecipherable except in the most obvious respects of composition.

On the other hand, it is clear that the apse of S. Maria Maggiore represents an original scheme, commissioned during the program of redecoration in that church during the reign of Nicholas IV (1288–92) and carried out in the years following the Pope's death. The apse mosaic, representing the Coronation of the Virgin, is one of the earliest monumental examples of this iconographic type in Italy. Particularly individualistic in Torriti's composition is the enclosure of the enthroned figures of Christ and the Virgin, in a star-studded mandorla, set against a field of delicate vine scrolls. Flanking the mandorla, small groups of angels, saints, and donors worship the Coronation. Below the major figural groups, the apse is decorated with an idyllic landscape, symbolizing the River Jordan and populated by *putti* riding dolphins and fishing. This type of representation was drawn from Early Christian sources, such as the cupola of S. Costanza, Rome. Torriti also executed the five mosaic panels between the windows of the apse with scenes of the life of the Virgin; these, as well as the major apse mosaic, reveal his close adherence to Byzantine models, both in form and in the skillful manipulation of silvery blue and green tonalities against the gold ground.

Characteristic of Torriti's style are thin figures, enveloped in transparent drapery that is organized in schematic angular folds, which have a precious, doll-like quality. The shading of faces, bodies, and drapery is minimal, reducing any sense of plasticity and giving the participants a peculiar aloof, ghostlike effect. Similarly, in the vine scrolls, the plants are elegantly conceived but rigidly schematized.

Torriti's graceful aristocratic style appears also in the

Torus. Convex molding at the base of a column or pilaster.

fresco decorations of S. Francesco at Assisi, where he worked with a number of other Roman artists. At their least diluted, in the half figures mentioned above, Torriti's forms exhibit a characteristic lifeless serenity. In adjacent narrative scenes (for example, *The Sacrifice of Noah*) his style appears cruder, as if he had attempted to merge his classic Byzantine designs with the stronger naturalism of Cavallini.

Among Torriti's numerous followers in Rome was Filippo Rusuti, who executed the façade mosaic of S. Maria Maggiore.

BIBLIOGRAPHY. R. van Marle, *The Development of the Italian Schools of Painting*, vol. 1, The Hague, 1924; G. Wilpert, "La decorazione costantiniana della Basilica Lateranense," *Rivista di archeologia cristiana*, VI, 1929; A. Nicholson, "The Roman School at Assisi," *Art Bulletin*, XII, September, 1930; P. D'Ancona, *Les Primitifs italiens du XI^e au XIII^e siècle*, Paris, 1935; G. Coor-Achenbach, "The Earliest Italian Representation of the Coronation of the Virgin," *The Burlington Magazine*, XCIX, October, 1957. PENELOPE C. MAYO

TORROJA, EDUARDO. Spanish engineer-architect (1899–1961). He graduated as an engineer in 1923 and worked independently as an engineer from 1927. His most important works are the Racecourse and Sports Hall, both built in Madrid in 1935. One of the significant engineers of the 20th century, he was a pioneer of shell structures, elevating structure to an independent aesthetic.

BIBLIOGRAPHY. F. Newby, "Obituary [of] Eduardo Torroja," *The Architectural Review*, CXXX, October, 1961.

TORUN: TOWN HALL, *see* THORN: TOWN HALL.

TORUS. Architectural term (from the Latin, meaning "swelling") designating a convex molding of convex profile, larger than an astragal, found commonly above the plinth at the base of a column or pilaster. The torus was sometimes ornamented in classical architecture.

TORY, GEOFFROY. French typographer and engraver (b. Bourges, ca. 1480; d. Paris, 1533). On an early trip to Italy he learned both from antiquities and from the Humanists. The spread of Renaissance decorative forms in France owes much to his use of them in such works as the *Book of Hours of the Virgin*, printed in 1524 by the great Paris printer Simon de Colines. In Tory's major work, *Champfleury, or The Art and Science of the Proportion of Letters* (1529), he proposed important orthographic innovations, with letters designed on the basis of a module associated with the proportions of the human body.

BIBLIOGRAPHY. J. Adhémar, ed., *Les Graveurs français de la Renaissance*, Paris, 1946.

TOSA SCHOOL. School of Japanese painters, the most influential and the longest-lasting school of Yamato-e painters. The Tosa family claimed a line of descent from the late Heian period. Historically, Yukihiro (early 15th cent.) was the first artist to use this family name and to work as a court painter in Kyoto. Mitsunobu (16th cent.) solidified the family's position, and it controlled the official style of painting in court circles. In 1569 the head of the school, Mitsumoto, was killed in battle, and the Tosa family's position declined. Some of its members managed to survive in Sakai, a commercial port near Osaka, until Mitsuoki moved back to Kyoto and regained the position of court painter in 1654. Other well-known members of the school are Mitsushige (also known as Mitsumochi, fl. early 16th cent.), Mitsunori (1583–1638), Mitsusada (1738–1806), and Mitsuzane (1780–1852). *See* MITSUNOBU; MITSUOKI; YAMATO-E.

BIBLIOGRAPHY. R. T. Paine and A. Soper, *The Art and Architecture of Japan*, Baltimore, 1955; T. Akiyama, *Japanese Painting* [Geneva?], 1961.

TOSCANELLA: SAN PIETRO. Italian Romanesque church built in the late 11th century. It has a Roman basilica plan and a façade in the Lombard manner, resembling some at Pisa, with three portals and a blind gallery over the central one.

BIBLIOGRAPHY. C. Ricci, *Romanesque Architecture in Italy*, New York, 1925.

TOSHIRO, *see* KATO SHIROZAEMON KAGAMASA.

TOSHODAIJI. Japanese Buddhist temple in Nara. The Tōshōdaiji was founded in 759 by the Chinese priest Chienchên (Japanese, Ganjin). Its Golden Hall, dating shortly after 759, is the largest surviving Buddha hall of the Nara period (48 ft. by 92 ft.). The simplicity and strength of its roof form, which was less steep in the original, and the clarity of the design of its open colonnade, make this hall one of the most beautiful temple buildings in Japan. There are excellent examples of powerful sculptures in wood from the late 8th century. *See* GANJIN IN TOSHODAIJI, NARA.

BIBLIOGRAPHY. Tokyo National Museum, *Pageant of Japanese Art*, vol. 6: *Architecture and Gardens*, Tokyo, 1952; R. T. Paine and A. Soper, *The Art and Architecture of Japan*, Baltimore, 1955.

TOSHOGU. Mausoleum in Nikkō, in central Japan. Ieyasu, the founder of the Tokugawa shogunal government, was first buried at Mt. Kunō in 1616, but his burial site was moved to Nikkō in 1617. The improvement and enlarge-

ment of this mausoleum were carried out between 1634 and 1636, under the supervision of Kōra Bungo-no-kami Munehiro, and another major improvement was made in 1654. There are more than forty important buildings within the Tōshōgū compound, including Buddhist temples and Shinto shrines. The buildings in the area between the Yōmeimon and the main hall are richly decorated with polychromed sculptures. The architectural ornaments and plan of the main hall, to which the separate sanctuary and worship halls are connected by a wide, roomlike corridor, set the standard for subsequent Tokugawa mausoleums.

BIBLIOGRAPHY. Tokyo National Museum, *Pageant of Japanese Art*, vol. 6: *Architecture and Gardens*, Tokyo, 1952.

TOSI, ARTURO. Italian painter (b. Busto Arsizio, 1871; d. Milan, 1956). He studied in Milan. Although Tosi belonged to the neoclassical Novecento group from its inception in 1922, he was more interested in recent French painting than in either Italian nationalism or rightist politics. With a vital impasto paint handling, he did still lifes and landscapes, for example, *The Valley* (1925; Rome, National Gallery of Modern Art), in which the motif is lyrically but quietly rendered in a mild, personal impressionism with compositional devices influenced by Cézanne and by his own Lombard past.

BIBLIOGRAPHY. G. C. Argan, *Tosi*, Florence, 1942; G. Scheiwiller, *Arturo Tosi*, Milan, 1942.

TOSINI, MICHELE (Michele di Ridolfo del Ghirlandajo). Italian painter (b. Florence, 1503; d. there, 1577). According to Vasari, Tosini was first in Lorenzo di Credi's workshop, then worked closely with Ridolfo Ghirlandajo, and later worked with Vasari himself. He was the father of Baccio Tosini, also a painter.

BIBLIOGRAPHY. G. Vasari, *Le vite . . .*, ed. G. Milanesi, vols. 5–8, Florence, 1880–82; H. Furst, "Art News and Notes," *Apollo*, XIII, May, 1931; B. Degenhart, "Die Schüler des Lorenzo di Credi," *Münchner Jahrbuch der bildenden Kunst*, IX, 1932.

TOTALITARIAN ART. The official art of totalitarian governments. Almost invariably, such art takes the form of realism that glorifies the state and its rulers. Frequently, as in the case of German art under the Nazi regime and of early Soviet art, there is a preference for a severe and grossly monumental neoclassicism, particularly in architecture.

TOTENTANZ, *see* DANCE OF DEATH.

TOTNES, CASTLE OF. Circular English castle, built on a steep artificial mound in Devonshire by the Normans in 1080. It was used to defend the adjacent town of Totnes. The keep is a shell of irregular contour with an internal diameter of about 70 feet, but all its internal structure has been destroyed. Its two curtain walls fan out to enclose an ovoid bailey and join the town walls at two points. Further protection was afforded by a deep, wide ditch or moat.

BIBLIOGRAPHY. C. Oman, *Castles*, London, 1926; S. Toy, *The Castles of Great Britain*, 3d ed., London, 1963.

TO-T'O-CHIA-T'O, *see* TATHAGATA.

TOTONAC ART, *see* AMERICAS, ANCIENT, ART OF (MEXICO: GULF COAST CULTURES).

TOTSUGEN (Tanaka Totsugen). Japanese painter (d. 1823). Trained by Kanō and Tosa masters, he attempted to revive the Yamato-e tradition and copied such works as the *Annual Court Ceremonies Scrolls* and the wall paintings at the Hōōdō of Uji. He was also influenced by Kōrin. *See* KANO SCHOOL; KORIN; TOSA SCHOOL; YAMATO-E.

TOU. Chinese term for a class of ancient ritual bronze vessels found chiefly in the late Chou period (ca. 600–206 B.C.). The *tou* has a spherical bowl raised on a high stem with a spreading foot. The bowl is normally divided into two parts, the top part being a cover that can be inverted for use as a separate vessel. Pottery prototypes for this vessel have been found in the late neolithic cultures of Lung-shan and Yang-shao, but few authentic specimens of bronze vessels employing this shape that date earlier than the late Chou period have been discovered.

TOULOUSE. French city on the Garonne River. The former capital of Languedoc and Aquitaine, Toulouse was originally a holy city of the Gauls. Known as Tolosa, it became successively a Roman town and the seat of a Christian archbishopric. From 419 to 506 it was the capital of the Visigothic kingdom. Now the fourth largest city of France, it centers on the Place du Capitole, which includes the Donjon (1529), the fortress-like Church of Notre-Dame-du-Taur (14th cent.), and the Capitole (1753), housing the Hôtel de Ville and a theater. The most famous building in the city is the Basilica of St-Sernin, one of the greatest examples of Romanesque church construction (11th–13th cent.; restored 19th cent.). *See* SAINT-SERNIN.

Three other noteworthy churches are the Gothic brick Church of the Jacobins (1260/65–1304), Notre-Dame-de-la-Dalbade (1503–45), and the baroque basilica Notre-Dame-de-la-Daurade (1773–90), whose name derives from a Gallo-Roman shrine decorated with gold mosaic that once occupied the site. The town contains several fine 16th-century private mansions that have inspired the term "Toulouse Renaissance" because of the lavish use of decorative devices such as caryatids, grotesques, and columns. Examples include the Hôtel de Bernuy, the Hôtel de Béringuier-Maynier, and the Hôtel d'Assézat. The Museum of the Augustinians contains paintings and medieval sculpture. *See* BERNUY, HOTEL DE; JACOBINS, CHURCH OF THE; TOULOUSE: MUSEUM OF THE AUGUSTINIANS.

BIBLIOGRAPHY. Société Archéologique du Midi de la France, *L'Oeuvre des architectes toulousains aux XVIe, XVIIe et XVIIIe siècles*, Toulouse, 1923; P. Mesplé, *Vieux hôtels de Toulouse*, Toulouse, 1948.

EMMA PAPERT

TOULOUSE: MUSEUM OF THE AUGUSTINIANS. French museum housed in the delightful Gothic cloister (14th cent.) and remnants of buildings of the former Augustinian monastery. The museum contains a peerless collection of Romanesque sculpture from the important cloisters of Toulouse (La Daurade, St-Etienne, and St-Sernin). There are also fine examples of Gothic art, including the celebrated statue *Notre-Dame-de-Grâce* of about 1450. The adjoining 19th-century building houses paintings of various schools from the 16th century to the present.

BIBLIOGRAPHY. P. Mesplé, *Toulouse*, rev. ed., Paris, 1961.

TOULOUSE-LAUTREC, HENRI DE. French painter, graphic artist, and designer of posters (b. Albi, 1864; d. Malromé, 1901). The family was descended from the counts of Toulouse. In 1873 the family moved to Paris, and Henri went to a fashionable school. There he met Maurice Joyant, who became his lifelong friend and his biographer. Toulouse-Lautrec was an able student but had to leave school because of delicate health. Afterward he studied with private tutors. He developed a fondness for drawing. In 1878 he broke his left thigh and the following year his right; his legs ceased to grow, but his torso matured. His grotesque appearance affected his entire life; it isolated him, restricted his activities, and caused him to be hypersensitive and to turn inward.

He began to paint in 1878 and to study with René Princeteau, a painter of equestrian and military subjects. Toulouse-Lautrec's choice of subjects and the sketchy manner characteristic of his early period derive from Princeteau. Toulouse-Lautrec painted several pictures of spirited, well-bred horses, usually mounted by a young aristocrat or pulling a carriage (Albi, Toulouse-Lautrec Museum). These scenes, depicted with such freedom and sparkle, suggested the early indirect influence of impressionism. They are extraordinarily accomplished, especially for a man under twenty.

When Toulouse-Lautrec failed his baccalaureate examinations his parents allowed him to study art. In 1881 he entered Bonnat's studio, and the following year, Cormon's. While studying under Cormon, Toulouse-Lautrec executed a parody of *The Sacred Wood* by Puvis de Chavannes. This painting (New York, Mr. and Mrs. Henry Pearlman Collection) is an early example of his biting wit and satirical thrust, which were central to much of his later work. He admired the art of Daumier, Forain, and Degas, and was one of the first to assess the value of Van Gogh, whom he met and respected.

By 1885 Toulouse-Lautrec was developing a style of his own. *At the Cirque Fernando: Circus Rider* (1888; Art Institute of Chicago) heralds his mature period. He had found a theme in public entertainment, and a manner of representation emphasizing line, pattern, and areas of relatively unmodulated color—a manner strongly related to the Japanese print. At this time he began to haunt the dance halls and entertainment spots in Montmartre. He immortalized such establishments as the Cabaret Mirliton, operated by the ballad singer Aristide Bruant; the Cabaret Artistique; and the Moulin Rouge (Art Institute of Chicago).

By 1890, certainly, Toulouse-Lautrec had found his style. It developed out of impressionism and is closest to Degas. His choice of a heightened palette, a dependence on a virtuoso line to conceive form, and the dominance of active figures from the contemporary scene caught in characteristic poses at unguarded moments ally him to Degas. Toulouse-Lautrec also worked slavishly to acquire the look of the easy, casual sketch. Forms are frequently so completely reduced to essentials that they are little more than silhouettes. He favored a long brushstroke. His paintings are, in essence, line drawings. The area of the head is invariably more refined in treatment than is the rest of the body. It is as if Toulouse-Lautrec were a camera eye, focusing on a certain area, causing all else to appear

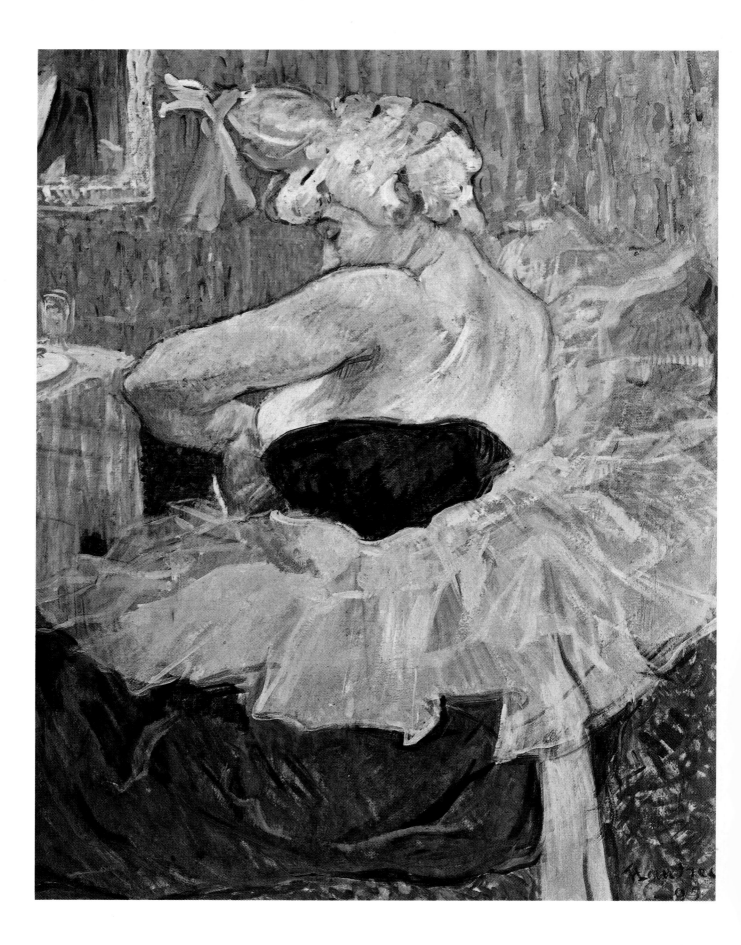

relatively marginal. He tended to reject shadow and modeling. He often employed a descending, sharp perspective, which recalls both the Japanese print and the photography of his time.

His color is theatrical and fanciful: he was fond of purple and green. He was not a plein-air artist; the light in his few outdoor scenes is muted and unnatural. He excels in expressing the gaudy atmosphere of night life: the artificial, the sordid, and the cosmetic. At times his pigment suggests grease paint. His color is often harsh and edgy, especially when compared with that of Degas.

Unlike the impressionists, Toulouse-Lautrec made use of facial expression to communicate character or an emotional state. He exaggerated features to the point of caricature. He was fascinated by marginal types such as prostitutes and by rejected and unloved people who were grotesque and yet were skilled in virtuoso movement, such as the entertainers in the mean cafés he frequented. At all times he is direct, candid, and detached. The bite of his irony is tempered by his acute sensibility. He never emphasizes the erotic, nor does he censure; the models he chose were in conditions analogous to his own. In fact, in several paintings he included himself as part of the scene.

In 1891 Toulouse-Lautrec designed his first poster, a commission from the Moulin Rouge to advertise the dancers La Goulue and Valentin le Désossé (Toulouse-Lautrec Museum). He employed an elliptical and decorative manner, which he later transferred to his paintings. He made immortal such figures of the popular stage as May Belfort, Yvette Guilbert, the female clown Cha-U-Kao, Jane Avril, Loïe Fuller, and others. In 1892 he painted a series of views of houses of prostitution. He caught the melancholy of the apathetic women as they waited for clients in the static atmosphere of the salon. Even here he sustained his objectivity. Never cold but never sentimental, he could see them as creatures of misfortune, as his counterparts.

In 1893 he exhibited his paintings of Montmartre and won Degas's approval. The following year Toulouse-Lautrec did a number of lithographs of the music hall and the theater, including an album exclusively devoted to Yvette Guilbert. In 1895 he went to London, where he painted a portrait of Oscar Wilde. Toulouse-Lautrec was most prolific in the next two years. In 1897 he gave up poster painting. He had begun to drink heavily, his health began to fail, and he entered a clinic in 1899. That year, though, he illustrated Jules Renard's *Histoires naturelles* and did a series of paintings on circus themes from memory. After his death, his work was collected by his mother and given to the town of Albi to establish a museum devoted to his art. *See* ALBI: TOULOUSE-LAUTREC MUSEUM.

BIBLIOGRAPHY. M. Joyant, *Henri de Toulouse-Lautrec*, 2 vols., Paris, 1926–27; G. Mack, *Toulouse-Lautrec*, New York, 1938; J. Lassaigne, *Lautrec*, Geneva, 1953; P. Huisman and M. G. Dortu, *Lautrec by Lautrec*, New York, 1964; J. Adhémar, *Toulouse-Lautrec: His Complete Lithographs and Dry Points*, New York, 1965.

ROBERT REIFF

TOUR D'AIGUES, LA, CHATEAU OF.

French château, situated in the Department of Vaucluse, north of Aix-en-Provence. It is remarkable for its imitation, particularly in

Toulouse-Lautrec, *The Female Clown Cha-U-Kao*, 1895. Louvre, Paris.

its triumphal-arch gateway (1571), of Roman originals in southern France. The main building is somewhat earlier (ca. 1560) and is adapted from Lescot's new buildings at the Louvre in Paris.

BIBLIOGRAPHY. A. Blunt, *Art and Architecture in France, 1500–1700*, Baltimore, 1954.

TOUR MAGNE, NIMES.

Roman monument in southern France. Probably dating from the end of the 1st century, it may be a trophy. This octagonal tower adjoins an important Roman complex, including a spring and baths, a theater, and the so-called Temple of Diana, now in ruins, in which there can still be seen vaulted rooms buttressed with aisles that may well have played a role in the development of the Romanesque architecture of Provence.

BIBLIOGRAPHY. A. Dupont, *Nîmes*, Paris, 1956.

TOURMANIN (Turmanin), DER.

Ruined East Christian 5th-century basilica in northern Syria. Constructed of heavy trimmed masonry, the church is a three-aisled basilica with a polygonal apse. The apse is flanked by two square chambers that are entered from the side aisles. Columns separate the nave from the aisles, and the nave wall rises to a clerestory. The church is preceded by a narthex, which is flanked by two small attached chambers. Short pedimented towers rise above the narthex chambers and flank an open central arcade. The disposition of the forms and masses on the façade have led some scholars to see the origin of the Romanesque twin-tower façade in Syrian churches of this type.

BIBLIOGRAPHY. H. C. Butler, *Early Christian Churches in Syria . . .*, ed. and completed by E. B. Smith, Princeton, 1929.

Der Tourmanin. Ruined 5th-century basilica in northern Syria.

TOUR MAUBERGEON, POITIERS, *see* Maubergeon Tower, Poitiers.

TOURNAI. City in Belgium about 35 miles southwest of Brussels. From the old Roman town of Turnacum there are remains of buildings and walls dating from the 1st to the 4th century. The city is dominated by its cathedral, dating from the 12th century on, with its five monumental towers. Other architectural monuments include a 12th-century belfry; the Pont des Trous, of the same period; and the Romanesque Church of St-Piat (11th–12th cent. and later). *See* Tournai: Cathedral.

The Cathedral Treasury is noted for its 5th- or 6th-century Byzantine gold and enamel cross, as well as for the magnificent reliquary chest of St. Eleuthère (1247), and the ivory diptych of St. Nicaise (11th cent.). Of the numerous museums in the city, the most impressive is the new Fine Arts Museum. *See* Tournai: Fine Arts Museum. *See also* Tournai School.

TOURNAI: CATHEDRAL. Belgian Romanesque church. The nave and transept date from the 12th century (1110–71 and later). The enormous church (total length 440 ft.) is particularly noted for its grouping of five monumental towers (12th–13th cent.). Two towers flank each transept arm, and one is at the crossing.

BIBLIOGRAPHY. J. Warichez, *De Kathedraal van Doornik...*, 2 vols., Antwerp, 1934–35.

TOURNAI: FINE ARTS MUSEUM. Belgian collection, housed in a building designed by the Art Nouveau architect Victor Horta. It contains a large group of paintings by the 19th-century Belgian artist Louis Gallait; works by Gossaert, Rubens, Jordaens, Watteau, Rigaud, Raffaelli, Jacques Louis David, Monet, Manet, and Ensor; and others attributed to the Master of Flémalle, Rogier van der Weyden, and Hugo van der Goes.

TOURNAI SCHOOL. Group of anonymous sculptors working in Tournai in the first quarter of the 15th century who produced a large number of epitaph stone reliefs. The epitaphs are very pictorial in style and some scholars have felt they influenced the early development of Flemish panel painting.

TOURNIER, NICOLAS. French religious and genre painter (b. Montbéliard, 1590; d. Toulouse, 1657). He lived in Rome from 1619 to 1626 and then settled in Toulouse. He painted with intense religious sentiment in the manner of Caravaggio, whose naturalism he imbued with a mannered elegance of pose.

BIBLIOGRAPHY. R. Mesuret, "L'Acte de baptême de Nicolas Tournier," *Bulletin de la Société de l'Histoire de l'Art Français, Année 1951*, 1952.

TOURNIERES, ROBERT LEVRAC ("T"). French portrait and historical painter (b. Ifs, 1667; d. Caen, 1752). His first teacher was a Carmelite monk. In Paris he studied with Bon de Boullogne and Hyacinthe Rigaud. Tournières married mother of François Lemoyne and became his stepson's master (1693). Tournières was a member of the Royal Academy both as a portraitist (1702) and as a history painter (1716), and was a favorite of the Regent. He

painted diminutive prerococo group portraits in the manner of Rigaud and Jean-François de Troy, though his technique is more mellow and has more sheen.

BIBLIOGRAPHY. L. Dimier, *Les Peintres français du XVIIIe siècle...*, vol. 1, Paris, 1928.

TOURNUS: SAINT-PHILIBERT. French basilican church begun in 950 by monks from Noirmoutier. It was among the first to employ an ambulatory with radiating chapels, a still-new feature found slightly earlier in the Cathedral of Clermont-Ferrand. The nave was originally wooden-roofed, but after a fire of 1007 or 1008 it was vaulted (after 1066). The nave vaulting is of an interesting and unusual type: transverse barrel vaults, each spanning one bay, rest on diaphragm arches. There is a fully developed three-bay narthex surmounted by a chapel dedicated to St. Michael. The narthex is groin-vaulted, while the chapel is barrel-vaulted, with groin vaults over the aisles. This portion of the Romanesque church dates from about 1020.

BIBLIOGRAPHY. K. J. Conant, *Carolingian and Romanesque Architecture, 800–1200*, Baltimore, 1959.

TOURS. French city on the Loire River. Its history dates from Roman times, but it is most richly associated with the art of medieval France. A famous scriptorium was started under the aegis of Alcuin (796–804). It was responsible for the reform of writing, producing the noted Caroline minuscule and many famous illuminated Bibles, such as the First Bible of Charles the Bald (Paris, National

Tournus, St-Philibert. The barrel-vaulted nave.

Library). The Municipal Library has an extremely rich collection of early medieval illuminated manuscripts. *See* TOURS SCHOOL.

Of the city's earliest Christian architecture, the Basilica of St. Martin, founded in the 6th century, only two towers (11–14th cent.) and a Renaissance cloister are extant. The Cathedral was begun in 1246, with additions through the 16th century. Its choir contains fine examples of 13th-century stained glass. The Church of St-Julien is mostly 13th century. The Archaeological Museum has a fine collection of Merovingian artifacts and other local archaeological finds. *See* ST. MARTIN, BASILICA OF; TOURS: CATHEDRAL.

Despite great damage during World War II, the rebuilt Tours has preserved much of its original stylistic character, the style of the Poitevin school of Romanesque architecture.

See also TOURS: FINE ARTS MUSEUM.

STANLEY FERBER

TOURS: CATHEDRAL. French church dedicated to St. Gatien, who introduced Christianity to Touraine. It stands on the site of two earlier churches in which St. Martin (d. ca. 397) and St. Gregory of Tours (d. 595) had once officiated. The present structure dates largely from the 13th century, when much of the work was accomplished with the aid of Louis IX (St. Louis). At the beginning of the 14th century new transepts and the last two bays of the nave were erected; the nave vaults were not completed until 1465. In the 16th century, when Tours was a flourishing center of Renaissance art, the north tower was given its Renaissance crown by Pierre de Valence, and in 1547 the south tower was finished by Pierre Gadier. The Cathedral is famous for its stained-glass windows.

BIBLIOGRAPHY. M. Aubert and S. Goubet, *Gothic Cathedrals of France and Their Treasures*, London, 1959.

TOURS: FINE ARTS MUSEUM. French collection. It exhibits two masterpieces by the Paduan painter Mantegna, *Christ in the Garden of Olives* and *The Resurrection*, as well as French painting and sculpture of the 17th and 18th centuries.

BIBLIOGRAPHY. P. Vitry, *Le Musée de Tours*, Paris, 1911; B. Lossky, *Peintures du XVIIIᵉ siècle*, Paris, 1962.

TOUR SAINT-JACQUES, PARIS. The only remaining portion of the late Gothic Church of St-Jacques-de-la-Bouchérie, constructed in Paris by Jean de Félin from 1508 to 1522. This tower rises to a great height, permitting its present use as a weather station, and is decorated by tall double windows, buttresses, and Flamboyant Gothic traceries. The original church was one of those on the pilgrimage route to Santiago da Compostela, but was destroyed during the Revolution. A statue of St. James ornaments the topmost pinnacle.

BIBLIOGRAPHY. B. R. Brown, *Five Cities: An Art Guide to Athens, Rome, Florence, Paris, London*, New York, 1964.

TOURS SCHOOL. The important Carolingian center of art and learning located at the Abbey of St. Martin, Tours, was responsible for much of the Carolingian reform in script as well as for the production of many sumptuous illuminated manuscripts. The periods of activity of the Tours school correspond roughly to the hegemony of the

following abbots: Alcuin (796–804), Fridogisus (807–834), Adelhard (834–843), and Vivien (844–851). Under Alcuin the major script reforms that resulted in the Caroline minuscule took place. During the time of Adelhard and Vivien the Bible of Moutier-Grandval (ca. 840; London, British Museum), the First Bible of Charles the Bald (ca. 846), and the Lothair Gospels (ca. 850; both Paris, National Library) were produced.

See also MANUSCRIPT WRITING; MINIATURES.

BIBLIOGRAPHY. W. Koehler, *Die karolingischen Miniaturen*, vol. 1 (2 pts.): *Die Schule von Tours*, repr., Berlin, 1963.

TOU-TS'AI. Chinese term, meaning "contrasting (or contending) colors," used in describing certain types of ceramic wares. It refers to the technique of combining underglaze blue with overpainting in bright enamel colors. The contrast of the softer underglaze blue with the harsher tones of overpainted reds, greens, and yellows produced the much admired effect of *tou-ts'ai*. *Tou-ts'ai* porcelain was first produced during the reign of Ch'eng-hua (1465–87) in the Ming dynasty and enjoyed particular popularity during the Wan-li period (1573–1620) of the Ming and the Yung-cheng period (1723–35) of the Ch'ing dynasty.

BIBLIOGRAPHY. S. Jenyns, *Later Chinese Porcelain, the Ch'ing Dynasty, 1644–1912*, London, 1951.

TOVAR Y TOVAR, MARTIN. Venezuelan painter (b. Caracas, 1828; d. Paris, 1902). Martín Tovar y Tovar studied in Caracas, then in Spain and France until 1855. In 1865 he opened an art and photographic studio in Caracas. He painted battles of the War of Independence for the government (from 1874 on) and excelled at portraiture (for example, *Juana Verrue*, 1877; Caracas, Museum of Fine Arts). His work is notable for its sobriety and dignity.

BIBLIOGRAPHY. Museo de Bellas Artes, *Pintura venezolana 1661–1961*, Caracas, 1961.

TOWER, MARTELLO. Circular masonry fort. Its name is derived from Cape Martello, Corsica, where such a tower helped resist a British fleet in 1794.

TOWER, PEEL (Bastel House). Type of medieval fortress built by the English on the borders of Scotland and Wales. Usually it had projecting angle turrets and contained a series of single rooms one above the other, accessible by a turnpike, or winding stairs.

TOWER OF BABEL. This monument of Biblical fame was the ziggurat "Etemenanki" located in the main temple of the city god Marduk, on the east bank of the Euphrates in Babylon. The study of its scanty remains is supplemented by a cuneiform tablet giving its measurements and by Herodotus's and Strabo's descriptions. It had seven stories, each painted a different color. The total height was equal to one side of the base, and it had three stairways.

BIBLIOGRAPHY. A. Parrot, *Ziggurats et Tour de Babel*, Paris, 1949.

TOWER OF LONDON. English structure whose nucleus was the Norman White Tower built by William I from 1078. This is surrounded by an inner curtain punctuated by thirteen towers, mostly 13th century although of varying dates and rebuildings. Beyond this and the outer ward is another wall with six towers skirting the moat. There was a further line of defense marked by the Middle Tower

and part of the outer moat where the Lion Tower stood. St. John's Chapel in the White Tower, completed by 1097, is of special interest. The other chapel is that of St. Peter ad Vincula, rebuilt in the 13th century and again in the 16th century. Beneath St. Thomas's Tower is the famous Traitor's Gate. *See* ST. JOHN'S CHAPEL.

BIBLIOGRAPHY. Great Britain, Ministry of Works, *The Tower of London, Official Guide*, London, 1954.

TOWER OF THE WINDS (Horologium of Andronicus), ATHENS. Ancient Greek public clock tower situated in the Agora of Julius Caesar. It was built about 40 B.C. by Andronicus of Cyrrhus. The building is octagonal and is 25½ feet in diameter and 47 feet high. A figure of a personified wind is represented in relief at the top of each side. The roof consists of twenty-four triangular slabs radiating downward from a central point on which rose an octagonal Corinthian capital supporting a large bronze Triton working on a pivot. On the façade of the tower were sundials, and the interior contained the water clock (clepsydra). Access to the interior was by two entrances. In front of each entrance stood a porch with two prostyle Corinthian columns carrying an entablature and pediments. This building is noteworthy for the originality of its design.

BIBLIOGRAPHY. W. B. Dinsmoor, *The Architecture of Ancient Greece*, 3d ed., London, 1950; A. W. Lawrence, *Greek Architecture*, Baltimore, 1957.

TOWN, HAROLD BARING. Canadian painter and printmaker (1924–). He studied in Toronto, where he now lives. After working as a commercial artist, he began mak-

Tower of the Winds, Athens. An ancient public clock tower.

ing nonobjective prints, and more recently has become the leading Canadian painter of abstract expressionist oils and collages. He was a "Painters Eleven" member.

BIBLIOGRAPHY. Ottawa, National Gallery of Canada, *Catalogue of Paintings and Sculpture*, ed. by R. H. Hubbard, vol. 3: *Canadian School*, Ottawa, 1960.

TOWN, ITHIEL. American architect and engineer (1784–1844). He was born in Connecticut, studied in Boston, and worked in New England before going to New York City in the winter of 1826–27. In collaboration with his partner, Alexander J. Davis, he designed many important buildings, including the state capitols at New Haven, Conn. (1828–31; destroyed), Indianapolis, Ind. (1831–35; destroyed), Raleigh, N.C. (1833–40), and Columbus, Ohio (1839–61), all in Greek revival style.

TOWNE, FRANCIS. English landscape painter (b. Exeter, 1740; d. London, 1816). He began painting in oils at the age of fourteen. He was trained for a while in London at Shipley's School and was a pupil of John Shackleton, the early Georgian portrait painter, and possibly also of William Pars, whom Towne accompanied to Rome in 1780. He visited Wales in 1777, Italy and Switzerland in 1780–81, and the English lakes in 1786.

Towne was drawn to the grandiose aspect of nature—large mountain masses in Wales and Italy, glaciers massed between rocks in the Alps. He drew on the spot, recording the most impressive views he could find, and held a large exhibition of these scenes in 1805. His landscapes are tightly constructed and occasionally, especially in the Roman drawings, so admirably simplified that Cézanne comes to mind. Towne was attracted by the spaciousness of the Roman Campagna, which was incised only by the roads winding from the distant hills. In Rome itself he recorded ruins overgrown with bushes; sometimes these assume the character of mountains. He could capture well the heat of a Roman afternoon, and yet a certain dryness, an almost topographical impersonality, pervades, closely reminiscent of the American luminists of about 1860. However, a great forcefulness manages to radiate from this precision; sometimes shadowed masses convey an almost sinister force.

In the Swiss drawings and paintings of about 1780, Towne's sense of structure is even more evident. *The Source of the Arveiron* is a related series of curves: two shoulders of the mountain slope down, crossed in front by curves of the glacier. Yet, as opposed to Cozens or Pars, Towne approached nature directly, at close quarters, not at a distance through a veil of nostalgia. In *The Salmon Leap* (1777; Merivale Collection), the precise texture of the bare rock is rendered. Much of Towne's work is in the British Museum and in the Victoria and Albert Museum, London.

BIBLIOGRAPHY. L. Binyon, *English Watercolours*, London, 1933; T. S. R. Boase, *English Art 1800–1870*, Oxford, 1959.

ABRAHAM A. DAVIDSON

TOWN HALL, *see* name of city.

TOWN PLANNING. In its fullest sense the planning of towns and cities, either in part or in whole, involves an incredible number of factors, including sociological, religious, economic, political, technological, hygienic, aesthetic, and environmental. As a purposeful activity it has

been practiced since the Neolithic period, when man first settled in villages. The science, with its concentrated and detailed study of each problem, developed only in the late 19th century, with the emergence of the vast complex urban areas after the Industrial Revolution.

Neolithic settlements were usually contained within a circular or oval perimeter wall, with buildings or huts of uniform circular or rectangular plan, clustered within the wall, an arrangement still used in modern primitive settlements in Africa and elsewhere. This pattern might be explained by its symbolic significance: the village represents a microcosm protected from exterior forces by an outer barrier.

In the ancient civilizations of the Nile, Tigris-Euphrates, and Indus valleys, cosmological considerations played an important role in the planning of cities, although such practical items as sewer, water, and street systems were also developed for the new, more complex urban areas. In ancient Mesopotamia, from the protoliterate period (3200–3000 B.C.) on, the dominating element of the city-state was an enclosed temple precinct. In such cities as Warka and Khafaje, the temple, oriented to the cardinal points of the compass, was raised above the rest of the city on a series of terraces. This terraced structure developed into the stepped ziggurat, a man-made mountain that symbolized the earth and served as the residence of the god to whom the city was dedicated. The ziggurat remained the dominant structure through the Assyrian and Neo-Babylonian periods. Around the temple area streets and houses were arranged on a rectilinear plan. Houses were generally enclosed structures with an open central court. *See* KHAFAJE; MESOPOTAMIA (TOWN PLANNING); WARKA; ZIGGURAT. *See also* ANATOLIA; INDUS VALLEY CIVILIZATION; UR.

The planning of ancient Egyptian cities was based on the fundamental practical and religious importance of the Nile River, which was conceived of as the axis of the earth. Settlements of the living were built on the east side of the river, where the sun rises, while the necropolises occupied the west side, where the sun sets. Although such early cities as Memphis and Hierakonpolis may have been surrounded by walls, the usual scheme was an open one, with simple, functional houses ranged in a continuous rectilinear pattern along the river, much like the irrigation system. *See* EGYPT (TOWN PLANNING); HIERAKONPOLIS.

Minoan and Mycenaean civilization saw the ascendance of the royal palace as the central structure around which the rest of the urban complex was arranged. The principal characteristic of such palaces as those at Cnossus and Phaestos is the great central court which gives access to various parts of the structure. Mycenaean cities follow a similar pattern but are often built on acropolises and heavily fortified with Cyclopean walls, as at Mycenae and Tiryns. Both Minoan and then Mycenaean cities were influenced by Mesopotamian and Egyptian palace complexes going back to the 3d millennium B.C., but they tend to be more complex, dynamic, and mazelike, owing in part to the conditions of a more mountainous terrain. *See* CNOSSUS; MYCENAE; PHAESTOS; TIRYNS.

Although most Greek cities, from the geometric period on, grew organically according to present need rather than a preconceived plan, the Greeks seem to have been

the first to have thought of planning cities rationally to achieve the greatest functional efficiency. Plato, Aristotle, and other philosophers describe ideal cities. Because of the increasing complexity of social, political, and economic intercourse, Greek cities were highly diversified rather than hierarchic entities composed of repetitive units, as in older civilizations. In addition to sacred precincts, such as the Acropolis in Athens, it became necessary to have political meeting places and a market, both usually in and around a large open area called the agora; gymnasiums and stadiums for educational and athletic activities; fountains for water supply; monuments for heroes; and theaters for the staging of plays. The principal areas of the city had to be interconnected with streets. Houses were generally simple and conceived in the old rectilinear pattern. All of this was made more rational by the introduction of the grid plan from such Ionian cities as Miletus. Hippodamus, whom Aristotle called the father of city planning, developed this plan at Piraeus and elsewhere. During the Hellenistic period it was widely used, for instance at Priene, although the reintroduction of autocratic rule brought with it the monumentalization of the royal palace and its dependencies, as at Pergamon. *See* ACROPOLIS; AGORA; HIPPODAMUS; MILETUS; PERGAMON; PIRAEUS; PRIENE.

The Romans were really the first to plan cities on a massive scale with every detail considered, particularly in colonial outposts where there had been no cities before. The grid system was often rigidly adhered to, and the main roads were in the form of an axis that divided the city into quarters. Axiality was the rule in the construction of Imperial forums, and houses were built in rectangular blocks, or insulae. Roman technological achievements enabled them to build on a massive scale and to introduce strict organization in city planning.

It was not until the Romanesque period that the cities of Europe revived. Many of them grew up again along the lines of the old Roman plan, but cities were now more independent. They developed their own trade, industries, and crafts and social and political life, dependent more on the surrounding countryside than on a distant imperial entity. Cities were highly individual and their street plans highly eccentric. The church or cathedral became the dominant structure about which the rest of the community clustered. But there were other focal points—particularly the town hall and the market place—related to each other in a dynamic way that expressed the flux and flow of city life in an age of growing commerce.

Rational mathematical planning was reintroduced in the Renaissance, starting in 15th-century Italy. Treatises on city planning were written by Alberti, Francesco di Giorgio, Leonardo da Vinci, and others, and various ideal cities were proposed in the 15th and 16th centuries, usually in the form of such geometric configurations as circles, polygons, and squares. Wherever possible, parts of cities were conceived as units, interlocking in orderly fashion with other units, as in the Piazza S. Marco, Venice. Squares, thoroughfares, and controlled vistas became important elements, as in Pope Sixtus V's (1585–90) reordering of Rome with main thoroughfares connecting the principal churches of the papal city.

The baroque and rococo periods fostered a more dynamic concept, upsetting the equilibrium and symmetry

of Renaissance planning. The growing strength of absolute monarchy brought with it a new emphasis: extended palace façades, infinite vistas, and all manner of intervening theatrical effects, including fountains and other monuments, monumental enclosed squares, and elaborate stairways.

The Industrial Revolution, starting in the early 19th century, brought with it the decline of the historic city. Factories, crowded housing for workers, and a tremendous increase in commerce made the city a congested and chaotic place, unfit for most of its inhabitants and lacking in spatial breadth. One solution was introduced by Haussmann in his replanning of Paris. Whole areas were simply demolished to make way for broad avenues linked up in a radial system. Since the end of the 19th century town planning has become a great deal more sophisticated and complex in the effort to deal with the problems of the 19th century and of continuing urban growth. Meeting with some success, particularly in such European cities as Stockholm and Amsterdam, planners have attempted to relieve the pressures on cities with highly diversified programs for the creation of satellite and garden cities, the decentralization of a city's activities, the use of parks and cultural centers, and the planning of mass transportation.

The challenges of new urban growth in developing countries have evoked imaginative designs from leading architects and city planners. Chandigarh, new capital of the Punjab in India, is a totally planned arrangement of modern buildings. Le Corbusier was the chief designer of the dramatically effective structures. In Brazil, Lúcio Costa evolved a monumental plan for the new national capital at Brasília, which is remarkable for the grandiosely conceived architecture of Oscar Niemeyer. *See* BRASILIA; CHANDIGARH.

BIBLIOGRAPHY. P. Lavedan, *Histoire de l'urbanisme*, new ed., Paris, 1952; R. E. Wycherley, *How the Greeks Built Cities*, rev. ed., London, 1962; J. W. Reps, *The Making of Urban America*, Princeton, 1965. DONALD GODDARD

TOWNSEND, CHARLES HARRISON. English architect (1850/52–1928). Townsend was born in London. He was one of the first European architects to show the influence of the American H. H. Richardson, particularly in Whitechapel Art Gallery (1897–99; London), his major work, and in Horniman Museum (1900–02; London).

BIBLIOGRAPHY. N. Pevsner, *Pioneers of Modern Design*, 2d ed., New York, 1949.

TOYOHARU (Utagawa Toyoharu). Japanese Ukiyo-e printmaker and painter (1735–1814). Toyoharu founded the Utagawa school of print designers. Many of his extant works are paintings of beautiful women, and his prints are chiefly a special type of landscape known as *uki-e* (perspective pictures), which show a strong European influence in the handling of perspective. *See* UKIYO-E; UTAGAWA SCHOOL.

BIBLIOGRAPHY. J. A. Michener, *Japanese Prints*, Rutland, Vt., 1959.

TOYOHIKO (Okamoto Toyohiko). Japanese painter (1773–1845). He studied with Goshun and became one of the most influential painters of the Shijō school. Toyohiko was especially skilled in landscape paintings, which reflect some influence of the Nanga school, particularly in the soft and lyrical handling of ink wash. *See* GOSHUN; NANGA SCHOOL; SHIJO SCHOOL.

TOYOKUNI I (Utagawa Toyokuni I). Japanese Ukiyo-e print designer (1769–1825). He was a pupil of Toyoharu. Most of Toyokuni I's best works date before 1800, when he established the Utagawa style of actor prints, in which his debt to Sharaku is apparent. Toyokuni I's late works are rather uninspired, marked by crude colors and mannered composition. *See* SHARAKU; TOYOHARU; UKIYO-E; UTAGAWA SCHOOL.

BIBLIOGRAPHY. L. V. Ledoux, *Japanese Prints, Sharaku to Toyokuni, in the Collection of Louis V. Ledoux*, Princeton, 1950.

TOYOKUNI III, *see* KUNISADA.

TOYONOBU (Ishikawa Toyonobu). Japanese Ukiyo-e print designer (1711–85). A pupil of Shigenaga, Toyonobu first published a series of *urushi-e* (lacquer prints) in the manner of Okumura Masanobu. Toyonobu excelled in studies of half-nude figures of women, which are marked by grace and sensitivity combined with sensuality. *See* MASANOBU (OKUMURA MASANOBU); SHIGENAGA; UKIYO-E.

BIBLIOGRAPHY. L. V. Ledoux, *Japanese Prints of the Primitive Period in the Collection of Louis V. Ledoux*, New York, 1942.

TRABEATED. System of construction based on the use of beams (from the Latin *trabs*, "beam"), as distinguished from arch construction (arcuated). Greek architecture, using post and lintel, is often characterized as trabeated.

TRACERY. Ornamental openwork, usually in stone. It is classified in two types: plate tracery, in which the pattern is cut through a flat plate of stone, as in the 13th-century English example in Castle Hall, Winchester; and developing from it, bar tracery, in which the pattern is composed of molded geometric or curvilinear elements, as in the French Gothic windows of Ste-Marie, Dinan. Branch tracery imitates boughs and rustic work, as in 15th- and 16th-century German Gothic church windows.

Tracery. Example of ornamental openwork with curvilinear elements.

TRACHELIUM. Neck of the Greek Doric capital (from the Greek *trachelos*, "neck"). It is between the annulets on the echinus and the grooves, or hypotrachelium, at the junction of capital and shaft.

TRADATE, IACOPINO DA, see IACOPINO DA TRADATE.

TRAINI, FRANCESCO. Italian painter of the Pisan school (fl. 1321–ca. 1350/75). Traini was the most important Pisan painter of the 14th century. In 1344 and 1345 he received payments for an altarpiece installed in S. Caterina in Pisa in 1345 (Pisa, National Museum of St. Matthew). Its central panel represents St. Dominic, and there is a bust of God in the gable. Each side panel contains four scenes from the legend of St. Dominic, and there are four prophets in the gables. The base has the inscription FRANCISCUS TRAINI PIN[XIT]. The *Glorification of St. Thomas* altarpiece that a "Francischo pittore" contracted to paint in 1363 for the monks of S. Caterina (National Museum of St. Matthew) is not, despite its traditional attribution to Traini, by him.

His major works are the frescoes in the Camposanto, executed with assistants about 1350. They were badly damaged by incendiary bombs during World War II but were subsequently detached from the wall, transferred to canvas, and restored. On the wall behind them appeared the underdrawings that had been done in preparation for the paintings, called *sinopie*. The frescoes are the *History of the Anchorites*, the *Triumph of Death*, the *Last Judgment*, *Hell*, the *Passion of Christ*, and the *Crucifixion*. All but the last, which was executed at some later date, are the work of Traini and his shop. Without question they constitute the most impressive and dramatic fresco cycle that has survived in Italy from the 14th century.

Traini's blunt, harsh, often violent style rejects both the humanity and restraint of Giotto and the grace of the Sienese. It is related to Orcagna and belongs to the exaggeratedly emotional, tense, and melodramatic style of Florentine and Sienese painting in the period after the Black Death (1348). Other works ascribed to Traini are a *Madonna and Child with St. Anne* in the Princeton University Art Museum and a fresco of *St. George Killing the Dragon* in the Baptistery at Parma. Both the themes and the form of Traini's art had profound repercussions in Florentine and Sienese art during the third quarter of the 14th century.

BIBLIOGRAPHY. M. Meiss, "The Problem of Francesco Traini," *The Art Bulletin*, XV, June, 1933; M. Meiss, *Painting in Florence and Siena after the Black Death*, Princeton, 1951.

HELLMUT WOHL

TRAJAN, ARCH OF, BENEVENTO. Roman triumphal arch in southern Italy. Begun A.D. 114 at the opening of the Via Traiana, it was finished in 117 under Hadrian. Like the Arch of Titus in Rome, it consists of a central archway flanked by semidetached columns of Composite order, resting on a podium. The attic has a dedicatory inscription. The sculptural decoration, a successful example of the allegorical type of composition, alludes to Trajan's campaigns in Dacia.

BIBLIOGRAPHY. W. J. Anderson, R. P. Spiers, and T. Ashby, *The Architecture of Greece and Rome*, vol. 2: *The Architecture of Ancient Rome*, London, 1927; D. E. Strong, *Roman Imperial Sculpture*, London, 1961.

Francesco Traini, *The Last Judgment*, detail, ca. 1350. Fresco transferred to canvas. Camposanto, Pisa.

TRAJAN, BATHS OF, ROME. Baths constructed by the emperor Trajan (r. A.D. 98–117), who destroyed a considerable part of the Golden House of Nero for the purpose. Very little remains now of the original building. The plan of the baths was rectangular and symmetrical around a main axis, and it corresponded in general to that of other thermae. A large central hall was enclosed by a peristyle on three sides. The main building contained a tepidarium, a caldarium with dressing rooms, palaestrae, and other rooms of various purposes; it was surrounded on three sides by a peribolos, which contained the libraries and the gymnasiums. A restored plan by Charles A. Leclere shows on one of the longer sides an oblong stadium and, adjacent to it, a semicircular theater. In the central hall were the earliest-known examples of concrete cross vaulting supported by columns.

BIBLIOGRAPHY. S. B. Platner, *The Topography and Monuments of Ancient Rome*, Boston, 1904; W. J. Anderson, R. P. Spiers, and T. Ashby, *The Architecture of Greece and Rome*, vol. 2: *The Architecture of Ancient Rome*, London, 1927.

TRAJAN, COLUMN OF, ROME. Finest example of Roman historical relief, erected A.D. 113 in the Forum of Trajan to commemorate Trajan's wars against the Dacians on the Danube frontier. Raised on a base and crowned by a capital, it is of Parian marble and is about 125 feet high and about 13 feet in diameter. It is decorated with a spiral frieze 164 feet long, carved in low relief and representing, in the manner of continuous narrative, scenes

Column of Trajan, Rome. Detail of the spiral frieze.

alluding to the two Dacian campaigns of the Emperor. The figure of Victory writing on a shield separates the two campaigns. The artist has crowded in 2,500 figures of Roman and barbarian soldiers and has made wide use of architectonic settings, houses, fortresses, and landscape. The conventions of perspective have been abandoned; instead, a bird's-eye view is used quite often. The reliefs are believed to be the translation into stone of an illustrated book roll. This monument served as the inspiration for the Column of Marcus Aurelius.

BIBLIOGRAPHY. K. Lehmann-Hartleben, *Die Trajanssäule*, 2 vols., Berlin, 1926; P. Romanelli, *La Colonna Traiana*, Rome, 1942.

TRAJAN, FORUM OF, ROME. Ancient forum designed by the architect Apollodorus of Damascus. Dedicated A.D. 112, it was the last and the most impressive of the Roman forums. It consisted of the forum proper, the Ulpia Basilica, and the Temple of Trajan. The forum was enclosed by a wall and was flanked by two hemicycles; the northern hemicycle had shops several stories high, and for symmetrical reasons the southern hemicycle had a similar arrangement.

The forum was entered through a triumphal arch. The Column of Trajan stood in a central court beyond the Ulpia Basilica. Two libraries, one for Greek and the other for Latin manuscripts, occupied the sides of the central court. The Temple of Trajan, dedicated by Hadrian to the deified Trajan, was of the Corinthian order, octastyle, peristyle, and mounted on a podium. See TRAJAN, COLUMN OF, ROME; ULPIA BASILICA, ROME.

BIBLIOGRAPHY. S. B. Platner, *The Topography and Monuments of Ancient Rome*, Boston, 1904; W. J. Anderson, R. P. Spiers, and T. Ashby, *The Architecture of Greece and Rome*, vol. 2: *The Architecture of Ancient Rome*, London, 1927.

TRANI. City in Apulia, southern Italy. It has important Romanesque churches. The Cathedral was begun in 1094 and consecrated in 1143. The 12th-century bronze doors are by Barisano da Trani. The campanile was erected in the 13th and 14th centuries. S. Andrea (11th cent.) is basically Byzantine in inspiration, having four central columns on a square plan supporting the central high roof. The Church of Ognissanti (12th cent.) has a 13th-century portal. S. Francesco (12th cent.) is related to the contemporary style of Palermo. See SAN NICOLA CATHEDRAL, TRANI.

BIBLIOGRAPHY. C. A. Willemsen and D. Odenthal, *Puglia*, Bari, 1959.

TRANSEPT. Transverse section of a church intersecting the nave to form a cruciform plan. Transepts may have developed from Early Christian bemata, with precedents also seen in such cruciform tombs as that of Galla Placidia, Ravenna. Transepts as developed in medieval cathedrals usually run north and south. Those in France generally project slightly, as in Paris and Amiens. English cathedral transepts are pronounced, as in York and Winchester, where the transepts separate nave from choir and altar. Salisbury has a double transept with two arms, the eastern arm being smaller than the western transept at the crossing. Lincoln and Worcester have comparable double transepts.

TRANSFIGURATION, THE. Christ with the Apostles Peter, James, and John on a high mountain, where His clothes shone with heavenly light and Moses and Isaiah appeared in the sky and spoke to Him. This scene, which most often introduces the episodes of the Passion, first occurs in 6th-century Byzantine art, where Christ is shown in a mandorla. Giotto was the first artist to show Christ floating free, without a mandorla.

TRANSFIGURATION, CHURCH OF THE, NOVGOROD. Medieval Russian church (1374) with a rectangular plan, gabled roofs, a central raised dome, and a single apse. It contains the only surviving fresco by Theophanes the Greek (1378). The elongated prophets are executed in a vivid "impressionistic" style closely allied to the Palaeologan Renaissance art of Constantinople.

BIBLIOGRAPHY. V. N. Lazarev, *Iskusstvo Novgoroda*, Moscow, 1947.

TRANSITIONAL STYLE. Term applied to a period in English architecture from about 1145 to 1190. It is so named because it possesses not only features of the earlier Norman Romanesque style, such as massive columns and characteristic ornament, but also features that anticipate the new Gothic elements in the Early English style to follow, such as pointed arches and rib vaulting.

BIBLIOGRAPHY. G. F. Webb, *Architecture in Britain: The Middle Ages*, Baltimore, 1956.

TRANSITO, EL, TOLEDO, SPAIN. Synagogue built in 1356 for Samuel ben Meir ha-Levi Abulala, finance minister of Pedro the Cruel; in 1492 it became the chapel of the Order of Calatrava. The stuccoed brick building consists of a single rectangular chamber covered with a magnificent open-beamed ceiling with chamfered corners. Below this

is a zone of blind lobed arches on marble colonnettes, some opening to windows. Below this area are panels of polychrome carved stucco and bands of inscription in Hebrew and Arabic. The Mudejar ornamental forms closely follow contemporary Nazari examples, as in the Court of the Lions in the Alhambra. There is a fine mid-16th-century portal of Renaissance style signed by Cristobal de Palacios and a *Nativity* attributed to Juan de Borgoña.

BIBLIOGRAPHY. J. Ainaud de Lasarte, *Toledo*, Barcelona, 1947; *Ars Hispaniae*, vol. 4, Madrid, 1949.

TRANSOM. Horizontal division or crossbar in a window. Notable examples are found in the medieval tracery window of Castle Hall, Winchester, England, and the French Renaissance dormer of the Château of Chambord. The term also denotes the horizontal member over a door or window and the sash above it, and it is applied, in addition, to the sash or light above a door.

TRANSPORTATION BUILDING, CHICAGO WORLD'S COLUMBIAN EXPOSITION, 1893, *see* SULLIVAN, LOUIS HENRI.

TRANSVERSE RIB, *see* RIB.

TRASCORO. In Muslim architecture, a choir wall or choir screen.

TRAU: ST. LAWRENCE, *see* TROGIR: ST. LAWRENCE.

TRAVERSI, GASPARE. Italian genre painter (fl. Naples, 1749, Rome 1752/53; d. Naples, 1769). He specialized in scenes of lower-class embarrassment and violence. His work is sometimes confused with that of G. Bonito. Examples can be seen in the Wadsworth Atheneum, Hartford, Conn., and in the Ringling Museum of Art, Sarasota, Fla.

TRAVERTINE. Variety of stone composed of calcium carbonate and formed by deposition from hot spring water. In Italy it has been used since ancient times for building. There are two types: a hard, colored variety known as onyx marble, and a soft, porous variety known as calcareous tufa.

TREASURY (Thesauros). In ancient Greece the treasury was a building, usually in the form of a small, distyle-in-antis temple, used to store the treasures of a city-state. They were particularly prevalent at Delphi; examples of the 6th and 5th centuries B.C. are the Treasuries of the Athenians, the Siphnians, and the Sicyonians. The opisthodomos and pronaos of temples were also often used as treasuries. The term is mistakenly applied to such Mycenaean structures as the "Treasury of Atreus" at Mycenae and the "Treasury of Minyas" at Orchomenus, which were actually royal tholos tombs. *See* ATREUS, TREASURY OF, MYCENAE; SICYONIAN TREASURY, DELPHI; SIPHNIAN TREASURY, DELPHI.

TREBON ALTAR, MASTER OF THE, *see* MASTER OF WITTINGAU.

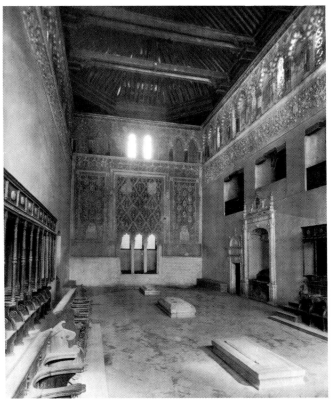

El Tránsito, Toledo, Spain. Former synagogue, built in 1356.

TREBON (Wittingau) FRIARY. Bohemian cloister church. It was built by St. Egidius in 1367 on a basilican plan. The nave was given Gothic cross ribs in the 15th century, and the choir was redone in 1781 in baroque style. The church of Třeboň was renowned in Bohemia for its rich decoration of sculpture and painting, the most famous of which was the altarpiece of the Passion of Christ (ca. 1390) by the Master of Wittingau, now in the Prague Museum.

Treasury. Distyle-in-antis Treasury of the Athenians in Delphi.

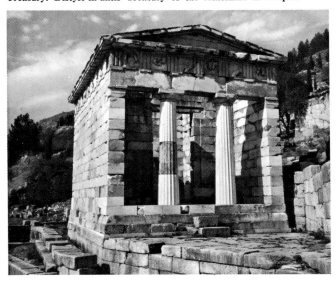

TRECENTO. In ordinary speech the Italian word *trecento* means "the fourteenth century." As an art-historical term it has other meanings as well. It is used in all languages to designate Italian painting, sculpture, and architecture from 1300 to 1400, though it is associated most particularly with Florence and Siena. As a descriptive term it suggests the style founded by Giotto, in which the backgrounds of altarpieces are gilded, colors are clear and luminous, and figures and space are represented according to the conventions described in Cennini's *Craftsman's Handbook*. The *trecento* is the period of Gothic influence in Italy. It is the last phase of the Middle Ages, the strict guild system, and the primacy of the craft tradition. *See* CENNINI, CENNINO; GIOTTO DI BONDONE.

BIBLIOGRAPHY. R. Offner, *Studies in Florentine Painting...*, New York, 1927; P. Toesca, *Florentine Painting of the Trecento*, Florence, 1929; E. Cecchi, *The Sienese Painters of the Trecento...*, tr. L. Penlock et al., New York, 1931; F. Antal, *Florentine Painting and Its Social Background*, London, 1948; P. Toesca, *Il trecento*, Turin, 1951; J. White, *Art and Architecture in Italy, 1250–1400*, Baltimore, 1966.

TRECK, JAN JANSZ. Dutch still-life painter (b. Amsterdam, ca. 1606; d. there, 1652). He may have been a pupil of his brother-in-law, the still-life painter Jan Jansz. den Uyl. Treck worked in Amsterdam and was first mentioned as a painter in 1623. He painted in Uyl's style, which is a continuation of the manner of the Haarlem still-life painters.

BIBLIOGRAPHY. A. P. A. Vorenkamp, *Bijdrage tot de geschiedenis van het Hollandsch stilleven in de zeventiende eeuw*, Leyden, 1934.

TREFOIL. Having three foils, or leaf-shaped divisions (from the French *trois feuilles*, "three leaves"; Latin *trifo-*

Trefoil. Example in a medieval traceried window.

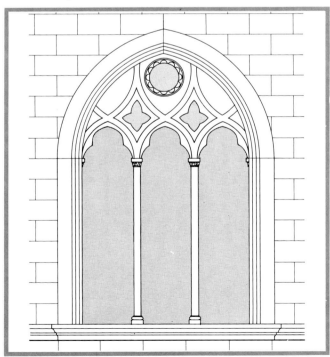

lium, "clover"), as in medieval traceried openings. St. Mary Magdalen Church, Oxford, for example, has trefoil arches.

TREMBLAY, BARTHELEMY. French sculptor (b. Louvres, 1578; d. Paris, 1629). He was a portrait sculptor, but little else is known of this artist. A statue and bust of King Henri IV by Tremblay are in the Louvre Museum, Paris. He worked in the late mannerist style, combining Flemish and Roman concepts characteristic of the school of Fontainebleau.

BIBLIOGRAPHY. A. Blunt, *Art and Architecture in France, 1500–1700*, Baltimore, 1954.

TREMOLIERES (Tremolliere), PIERRE CHARLES. French religious, allegorical, and decorative painter, engraver, and illustrator (b. Cholet, 1703; d. Paris, 1739). He was a pupil of Jean-Baptiste van Loo and a protégé of the Comte de Caylus in Rome (1726–34). He was assistant professor of the Royal Academy (1737). His sensuously smooth style is important in the transition to rococo art. Emulating Charles-Antoine Coypel, his work is more academic than that of Boucher.

BIBLIOGRAPHY. L. Dimier, *Les Peintres français du XVIIIe siècle...*, vol. 1, Paris, 1928.

TREMPER MOUND, OHIO. American Indian earthwork structure of the Hopewell culture, excavated by Shetrone in 1915. It dates from well before the arrival of Europeans. Tremper Mound yielded a rich cache of ceremonial carvings, especially well represented in the Ohio State Museum in Columbus, which includes stone pipes in animal and human form. These are distinguished for their simplified naturalism and for the completeness of their finish.

See also HOPEWELL CULTURE; MOUND BUILDERS; NORTH AMERICAN INDIAN ART (EASTERN UNITED STATES AND CANADA).

BIBLIOGRAPHY. H. C. Shetrone, *The Mound Builders*, New York, 1930.

TRENTO, ANTONIO DA, *see* ANTONIO DA TRENTO.

TRESGUERRAS, FRANCISCO EDUARDO. Mexican architect, painter, and poet (1759–1833). After a youth spent in the Bajío area, where he participated in a number of late-18th-century ecclesiastical projects, Tresguerras emerged as the greatest provincial neoclassical architect of Mexico. In Querétaro he probably added the dome to the Church of S. Rosa and designed the Neptune Fountain, near S. Clara, and Las Teresitas church. His principal center was Celaya, which he made into a microcosm of the classical revivals of Europe and Mexico City. There he designed numerous churches, including S. Francisco and El Carmen; palaces; and a diversity of public projects such as the bridge over the Laja River—all attesting to his mastery of late-baroque rhythms and neoclassical ornamental forms. At San Luís Potosí he designed a reservoir in the shape of large urns and the Teatro Alarcón. His paintings are in various churches (notably S. Rosa at Que-

Francisco Eduardo Tresguerras, El Carmen, Celaya, Mexico.

rétaro and El Carmen at Celaya); he was buried in a neoclassical temple of his own design adjacent to S. Francisco at Celaya. His poems and occasional writings (*Ocios*) are valuable guides to the taste of the period.

BIBLIOGRAPHY. M. Romero de Terreros, "El arquitecto Tresguerras," *Anales del Museo Nacional de Arqueología, Historia y Etnografía*, V (series 4), 1927-28. JOSEPH A. BAIRD, JR.

TRESK, SIMON OF, *see* SIMON OF TRESK.

TRES RICHES HEURES DU DUC DE BERRY. Illuminated manuscript by the Limbourg brothers, in the Condé Museum, Chantilly, France. *See* LIMBOURG BROTHERS.

TRESSINI, DOMENICO. Russian architect of Swiss birth (1670–1734). After working in Copenhagen on the palace of Frederick IV, Tressini was called to St. Petersburg in 1703 to work for Peter the Great. He designed sensible, utilitarian residences that gave a homogeneity of style to the new city of St. Petersburg, as well as fortifications, churches, hospitals, and palaces. *See* LENINGRAD.

BIBLIOGRAPHY. G. H. Hamilton, *The Art and Architecture of Russia*, Baltimore, 1954.

TRETYAKOV GALLERY, MOSCOW, *see* MOSCOW: MUSEUMS (TRETYAKOV GALLERY).

TREVES, *see* TRIER.

TREVI FOUNTAIN, ROME. Fed since antiquity by a Roman aqueduct, this fountain was first monumentalized by Pope Nicholas V, who selected Alberti as designer. The resulting simple, utilitarian structure was enlarged in the 16th century to form a half-oval basin. In the 17th century numerous projects were proposed, many of which are associated with Pietro da Cortona and Bernini. The present fountain is the result of a competition held in 1732, which Nicola Salvi won. He worked on the fountain until his death (1751), and it was completed in 1762 by Giuseppe Pannini.

The fountain is built against the façade of the Palace of the Dukes of Poli, a two-storied building with basement, attic, and a high central section. Three bays flank each side of the central section, which is treated with a giant order of engaged columns like a Roman triumphal arch; the columns are topped by allegorical statues. The figure of Oceanus is in the central niche. The niche on either side of the central one contains an allegorical figure; each side niche has a plaque above it. Tritons, marine horses, and sculptured vegetation beneath the central niche contribute to the illusion of a natural setting. Pietro Bracci executed the Oceanus and Tritons sculptures, Filippo della Valle the Fecundity and Health figures.

The idea of an architectural order growing out of a natural setting is Berninesque. Salvi used his theatrical experience to place emphasis on its dramatic nature. Oceanus is seen as a source of power that becomes divided into smaller units and eventually returns to itself. The weather phenomena of evaporation and condensation, which this fountain represents, had been scientifically demonstrated prior to the competition. The baroque double purpose of instruction and entertainment is thus fulfilled.

BIBLIOGRAPHY. H. L. Cooke, "The Documents Relating to the Fountain of Trevi," *Art Bulletin*, XXXVIII, 1956; A. Schiavo, *La Fontana di Trevi e le altre opere di Nicola Salvi*, Rome, 1956.
 DORA WIEBENSON

TREVISANI, ANGELO (Angelo Barbier). Italian painter and engraver (b. Venice or Treviso, 1669; d. 1753/55).

Trevi Fountain, Rome. A baroque sculpture complex, completed 1762.

Trained by Antonio Zanchi, Trevisani possessed a modest talent and became a member of the Venetian Academy by 1739. Several of his altarpieces are still in place in Venice, including SS. *Roch and Sebastian* in S. Vitale.

BIBLIOGRAPHY. R. Pallucchini, *La pittura veneziana del Settecento,* Venice, 1960.

TREVISANI, FRANCESCO. Italian painter (b. Capodistria, 1656; d. Rome, 1746). Trained in Venice under Antonio Zanchi and Joseph Heintz the Younger, Trevisani worked in Rome from 1678 on. His cabinet pictures were widely acclaimed, but he also carried out a number of impressive altarpieces, including the *Martyrdom of St. Andrew* in S. Andrea delle Fratte, Rome.

TREVISO, DOMENICO DA. Italian cabinetmaker (fl. Venice, 2d half of 16th cent.). His chief works are in the Church of S. Sebastiano, Venice, and include the organ case made after Veronese's designs and the paneling of the wall of the choir after Jacopo di Piero's designs.

BIBLIOGRAPHY. O. Mothes, *Geschichte der Baukunst und Bildhauerei Venedigs,* vol. 2, Leipzig, 1860.

TREZZO, JACOPO (Nizzola) DA, THE ELDER (Jacometrezo, or Jacome de Trezzo, el Viejo). Italian medalist, sculptor, architect, and glyptographer (b. Milan, 1519 or 1514?; d. Madrid, 1589). Uncle of the sculptor Jacopo Trezzo the Younger, Jacopo was first distinguished as a gem engraver in the style of F. Negroli and the Miseroni.

Niccolò Tribolo, grotto sculpture, Villa di Castello, near Florence.

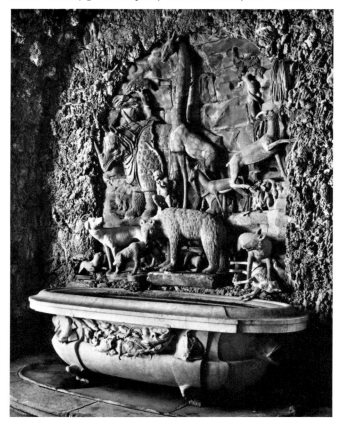

A group of cameos in the Vienna Museum of Art History (*Aurora, Lucretia, Johanna of Portugal*) has been identified as his work. In 1555 Jacopo entered the service of Philip II of Spain, while Philip was in the Netherlands, and made a series of medals of Philip and Mary Tudor, including a gold one of the latter (ca. 1555–58; London, British Museum). In 1559 he accompanied Philip to Spain, where he was employed at El Escorial. Among other things, he worked on the architectural frame for a reredos in the main chapel of S. Lorenzo (ca. 1558), with paintings and sculpture by Federico Zuccari and Leone and Pompeo Leoni. In addition Jacopo was active as a jeweler, goldsmith, and glyptographer to the Spanish court.

BIBLIOGRAPHY. J. Babelon, *Jacopo da Trezzo...*, Paris, 1922.

TRIACHINI (Tasso), BARTOLOMMEO. Italian architect (fl. after 1534; d. 1587). Triachini was a mannerist architect in Bologna. A number of palaces there, in a variety of styles, have been attributed to him, such as the Vizzani-Sanguinetti, Palvezzi de' Medici, Poggi (now the University), and Bentivoglio palaces.

TRIANONS, THE, *see* PETIT TRIANON, VERSAILLES; VERSAILLES: PALACE.

TRIBHANGA. Sanskrit term meaning "three breakings" or "three bendings." The *tribhanga* is the easy standing pose of an image or figure with hip thrust to one side, the torso "bent" counter to the legs, and the head "bent" counter to the torso.

TRIBOLO (Pericoli), NICCOLO. Italian sculptor (b. Florence, 1500; d. there, 1550). He was trained under Nanni Unghero and Il Sansovino. Tribolo worked on the tomb of Pope Adrian VI in Rome. In 1525–27 he executed sculptures for the façade of S. Petronio in Bologna. After a brief period in Pisa and Florence he settled in Loreto to decorate the Holy House. In 1533 he was summoned to Florence to assist Michelangelo in the completion of the Medici Chapel. He was contracted to carve the *Assumption* relief in S. Petronio in 1536. Cosimo I commissioned him to execute fountains at Castello, and in 1546 Tribolo installed some of the Medici Chapel sculptures.

His chief works can be seen in Bologna and Florence. His fame rests on his work as an assistant to Michelangelo, but he was an artist in his own right.

BIBLIOGRAPHY. J. Pope-Hennessy, *Italian High Renaissance and Baroque Sculpture,* 3 vols., London, 1963.

TRIBUNE. Raised platform generally within a semicircular recess in Roman basilicas where praetors, assessors, and other officials sat. The Basilica of Trajan, Rome, had two large tribunes, one at each end of the central hall. The bishop's throne set in Early Christian apsidal recesses is assumed to have derived from the Roman tribune.

TRIBUNE TOWER, CHICAGO, *see* CHICAGO TRIBUNE BUILDING.

TRIBUTE MONEY, THE. Fresco painting by Masaccio, in the Brancacci Chapel, S. Maria del Carmine, Florence. *See* MASACCIO.

TRICHINOPOLY (Tiruchchirappalli; Tiruchirapalli). City and district in central Madras State, India. The city, on the Kaveri (Cauvery) River, is the site of a rocky hill containing various Brahmanic and Jain temples and carvings, the most important being the rock-cut Siva and Vishnu temples carved during the reign of Mahendra (A.D. 610–640) of the Pallava dynasty. Other monuments of interest in Tiruchchirappalli District are the Chola temple of Koranganatha at Srinivasanalur, the Pāṇḍya temple of Jambukeśvara on the isle of Srīraṅgam in the Kaveri River, and the Madura-type Ranganatha temple complex, also on Srīraṅgam.

BIBLIOGRAPHY. P. Brown, *Indian Architecture*, vol. 1: *Buddhist and Hindu Periods*, 4th ed., Bombay, 1959.

TRICHORA. Triple-apsed space, early examples of which have been found in Roman thermae, as in Thélepte, Tunisia, and the caldarium in Lambèse, Algeria. It was also found in 3d- and 4th-century mausoleums, as in SS. Xystus and Cecilia and St. Soter. The earliest and largest example in the East is in the Church of St. John the Baptist, Jerusalem (450–460); the earliest basilica with a trefoil apse is the Basilica Paulinus, Nola (401–403). Because of changes in liturgy two apses had been added, one on each side of the central apse, as in the Greek Church of St. Nicholas, Myra, in the time of Justin II (564–574).

TRICHT, ARNOLD (Arnt) VON. Dutch sculptor (fl. mid-16th cent.). He has been variously identified as Aert van Tricht, who worked in Maastricht from 1501, and as Aert's son. Arnold von Tricht worked later in Germany, creating statuary in wood and stone for the Pfarrkirche in Calcar (1543) and the Cathedral in Xanten (to 1556).

TRICLINIUM. Couch for reclining at meals in Roman times. Usually consisting of three sections, the triclinium extended around three sides of the dining table. The term is also applied to the dining room containing the triclinium.

TRIDENT. Bronze fork with three prongs, used by ancient fishermen for the spearing of fish. It was possibly used by other groups for the preparation of sacrificial meat. The trident was the symbol of the Greek sea god, Poseidon. By striking it against the earth, he could produce springs of water when he was in a kindly mood or bring about terrible earthquakes and tidal waves when he became angry.

TRIER (Treves). Oldest city in Germany, located on the Moselle River near the border of Luxembourg. Founded by the Romans in about 15 B.C., it has had a long-lasting and important place in the history of art.

As the most important Roman city in northern Europe, it was known as Augusta Treverorum or, more popularly, Roma Secunda and Roma Transalpina. Its numerous Roman remains include a large amphitheater (seating 30,000), dating from the time of Trajan or Hadrian and still well preserved; the Porta Nigra, the fortified northern city gate, of the mid-3d century and also well preserved; baths and bridges of the 2d and 4th centuries, now in a ruined state; and two basilicas of Constantine's time. One basilica

Trier. Porta Nigra, fortified north gate, mid-3d century.

served as the palace of the Frankish kings, who conquered Trier about 455, and was restored in the 19th century. The other was originally built under the emperors Valentinian I and Gratian, and after Constantine's Peace of the Church was converted into a church (4th cent.).

Trier achieved prominence during the Middle Ages as a center of art, building, and learning. In Carolingian and Ottonian times the Abbey of St. Maximin had a noted scriptorium credited with the production of many beautiful illuminated manuscripts. The Cathedral, a fine example of German Romanesque architectural development, was built on the core of another Roman basilica by Archbishop Poppo and his successors from the 11th through 13th centuries. *See also* ST. MAXIMIN'S, TRIER: CAROLINGIAN FRESCOES.

An interesting and unusual example of Romanesque civil architecture survives in Trier in the Frankenturm, a two-story tower house dating from about 1050. Gothic architecture is represented by the Church of Our Lady (Liebfrauenkirche), built between 1235 and 1270 and reputedly the oldest Gothic church in Germany. It is connected to the Cathedral by a 13th-century cloister. German Renaissance architecture is represented by a 16th-century town hall, the Rotes Haus, and a beautiful fountain, the Petersbrunnen, of 1595. A great baroque church, St. Paulinus (1732–57), by the master Balthasar Neumann, still exists. There are, in addition, many diverse samples of antique and Christian art in the city.

The Rheinisches Landesmuseum is devoted to the many rich antique and medieval finds of the area, and the Municipal Library is especially noted for its illuminated manuscripts. Prime among these are the Trier Codex Aureus, better known as the Ada Gospels, a 9th-century Carolingian manuscript; and the 10th-century Ottonian Codex Egberti.

See also TRIER: CATHEDRAL TREASURY.

STANLEY FERBER

TRIER: CATHEDRAL TREASURY (Domschatzkammer). German collection of fine works of religious and applied art. It is housed in a separate, centrally planned building (1702–16) behind the choir of the Cathedral. Byzantine ivories, illuminated Gospel manuscripts from the 8th to the 12th century, reliquaries, metalwork, and carved statuettes make this collection outstanding.

TRIER SCHOOL, *see* OTTONIAN ART.

TRIFORIUM (Blind Story). Gallery above the side aisle of a church. Lying above the aisle vaulting and generally under a sloping roof, the triforium opened into the nave. Because it commonly had no outside windows, it is called a blind story. The term is assumed to have been first applied to the Norman arcades of Canterbury Cathedral which had three openings toward the nave. Early Christian churches lacked triforia. Medieval examples are in Amiens Cathedral and Westminster Abbey; the triforium of Peterborough Cathedral has windows. The triforium virtually disappeared in later medieval churches, which had heightened nave arcades and flattened aisle roofs.

TRIGLYPH. Greek architectural term meaning "three channels." It is used to designate a rectangular block set in the Doric frieze and generally alternating with metopes, spaces which were often ornamented with sculpture. The triglyph has two vertical V-section grooves, or glyphs, and is chamfered on each of its vertical sides, each chamfer presumably accounting for one-half of the third glyph. The triglyph is assumed to be a survival of the wooden beam end of earlier Greek architecture. In Greek work the channels are usually rounded at the top.

TRIKAYA. Mahāyāna Buddhist term meaning "three bodies." The trikāya is a threefold embodiment as of a Buddha, who may be simultaneously in mortal (nirmāṇakāya), heavenly (sambhogakāya), and abstract or nirvanic (dharmakāya) existences.

TRIMURTI. Triad of deities, or a trinity, as in Hinduism.

TRINITA DEI MONTI, ROME. Church at the top of the Spanish Stairs. It was begun in 1495 on the order of Charles VIII of France and consecrated in 1585 by Pope Sixtus V. Basilican in plan, it has a two-tower façade. A series of frescoes by Daniele da Volterra and others adorns the interior.

TRINITE, LA, CAEN, *see* ABBAYE-AUX-DAMES, CAEN.

TRINITE, LA, PARIS. French church built by Théodore Ballu in 1861–67 in the Renaissance revival style. Its

Triforium. Gothic example in Amiens Cathedral.

façade has a porch with three arches and is surmounted by a clock tower flanked by two lanterns.

TRINITY. The Trinity—Father, Son, and Holy Spirit—has been represented in art since the 5th century, at first symbolically in the form of the empty throne, book, and dove and the three men seen by Abraham. The three standing male figures first appear in the 10th century (Pontifical from Sherborne; Paris, National Library); later the more familiar type of Trinity came into use, with God the Father, Christ as man, and the Holy Spirit in the form of a dove. After the Reformation, the Trinity was often represented as a triangle with the eye of God in the center.

TRINITY CHURCH, BOSTON. American Episcopal church in Copley Square, built of granite by H. H. Richardson between 1872 and 1877. A free version of French Romanesque architecture, it was widely influential. Its plan is a Latin cross with an apse on the west arm. The polychromy on the outside of the apse is specifically Auvergnat, the lantern is derived from the Old Cathedral of Salamanca in Spain, and the double-curved wooden roof and the stained glass in the interior are derived from Bourges and the work of some of the Pre-Raphaelites. Windows by John La Farge light the rich interior.

BIBLIOGRAPHY. W. Andrews, *Architecture, Ambition and Americans,* New York, 1955.

TRINITY CHURCH, NEWPORT, R.I., *see* NEWPORT, R.I.: TRINITY CHURCH.

TRINITY CHURCH, NEW YORK. Designed in 1839 by Richard Upjohn and built between 1841 and 1846. Its deep chancel, large clerestory, raised altar, and the omission of a balcony place Trinity Church at the start of the mature Gothic revival in the United States, despite its plaster vaulting. Built in the Perpendicular style, the building secured Upjohn's reputation.

BIBLIOGRAPHY. E. M. Upjohn, *Richard Upjohn, Architect and Churchman*, New York, 1939.

TRINITY COLLEGE LIBRARY, *see* CAMBRIDGE, ENGLAND; DUBLIN: MUSEUMS (TRINITY COLLEGE LIBRARY).

TRIPPEL, ALEXANDER. Swiss sculptor (b. Schaffhausen, 1744; d. Rome, 1793). Trained in Copenhagen under Wiedewelt, Trippel settled after 1776 in Rome, where he emerged as an important practitioner of the restrained classical style. Most of his works are portraits and classical figures.

TRIPTERAL. Denoting a temple front with three rows of columns. The Corinthian Olympieion in Athens has a tripteral front and rear. At the sides it is dipteral, being lined with two rows of columns on each side.

TRIPTYCH. Altar retable composed of three panels. Frequently the center panel is the larger and fixed, and the two side panels, called wings, are half the size of the center panel and fold over it.

TRIRATNA. Three jewels of Buddhism: the Buddha, his law (dharma), and the order of monks (sangha).

TRISTAN DE ESCAMILLA, LUIS. Spanish painter (b. near Toledo, ca. 1586; d. Toledo, 1624). He studied with El Greco (1603–07). That Tristán's style is Caravaggesque is probably due to the influence of his fellow pupil, the Italian Borgianni. The use of chiaroscuro is pronounced in his earliest known works, the *Beheading of St. John the Baptist* in the Carmelite Church, Toledo, and the *Holy Family* in the Contini Bonacossi Collection, Florence (both 1613). Later paintings, such as the *Adoration of the Magi* in the Museum of Fine Arts, Bilbao (1620), introduce genre elements in a context of earthy realism and subdued colors. These new qualities in Spanish painting probably influenced the art of Velázquez.

BIBLIOGRAPHY. F. B. San Román, "Noticias nuevas para la biografía del pintor Luis Tristán," *Real academia de bellas artes y ciencias históricas de Toledo, Boletín*, V, 1924; A. Aragonés, "El pintor Luis Tristán," *Real academia de bellas artes y ciencias históricas de Toledo, Boletín*, VI, 1925.

TRISTYLE IN ANTIS. Having three columns between antae, or flanking walls, as in the Propylaea, Athens, and the later Temple of Artemis, Ephesus.

TRIUMPHAL ARCH, *see* ARCH, TRIUMPHAL.

TRIUMPH OF DEATH. Fresco painting by Traini, in the Camposanto, Pisa. *See* TRAINI, FRANCESCO.

TRIVULZIO IVORY. Early Christian sculpture in the Trivulzio Collection, Milan.

TROBRIAND ISLANDS, *see* OCEANIC ART (MELANESIA).

TROCADERO, PARIS. French multistoried pavilion built in permanent form (but since replaced) for the Paris Exhibition of 1878 by Davioud. Situated on the Chaillot heights above the Seine River, it provided an architectural backdrop, a vigorous silhouette, for the exhibition field below.

BIBLIOGRAPHY. G. J. A. Davioud and J. D. Bourdais, *Le Palais du Trocadéro*, Paris, 1878.

TROGER, PAUL. Austrian painter (1698–1762). He was a major figure in the development of Austrian rococo ceiling decoration. After a trip to Italy during his youth, where he studied the work of Crespi, Piazzetta, Pittoni, and Solimena, Troger returned to Austria to develop the style of the Venetian rococo. His particular stylistic approach toward the rococo may be seen in one of his major works, the *Last Judgment* dome fresco (1732–34) of the monastery church in Altenburg, in which the elongated figures move in agitated rhythms against brilliantly luminous rays of light, and display the dramatic gestures and expression which Troger learned from the work of Johann Michael Rottmayr. In the capacity of teacher and then director of the Vienna Academy (1753–59), Troger became a major influence in decorative painting, and his numerous students continued his light and airy style throughout the 18th century.

BIBLIOGRAPHY. B. Grimschitz, R. Feuchtmüller, and W. Mrazek, *Barock in Osterreich*, Vienna, 1960.

TROGIR (Trau): ST. LAWRENCE. Cathedral in Dalmatia, in western Yugoslavia. This church is one of the most important monuments of medieval and Renaissance art in Dalmatia. It was begun about 1180 and completed about

Triglyph. Grooved and chamfered block found in Doric friezes.

1250. The magnificent west portal, dated 1240, was executed by the sculptor Radovan. The bell tower was built in the 15th and 16th centuries. Renaissance architecture and sculpture can be seen in the 15th-century Chapel of St. Ivan, executed by Andrija Aleši, Nikola Firentinac (Niccolò di Giovanni Cocari), and Giovanni Dalmata. Aleši also executed the Baptistery.

BIBLIOGRAPHY. C. Fisković, *Radovan, portal katedrale u Trogiru*, Zagreb, 1951.

TROIA CATHEDRAL. Italian church begun in 1093 and finished in the 13th century. The architecture of the Cathedral of Troia is Apulian Romanesque under strong Pisan influence. Its exterior displays two pairs of bronze doors by Oderisius of Benevento (1119 and 1127) and a carved south portal. Within is an ornate pulpit (1169).

BIBLIOGRAPHY. H. Korte, *Troia, Trani, Lecce*, Oldenburg, 1959.

TROIJEN (Troyen), ROMBOUT VAN. Dutch landscape painter (b. Amsterdam? ca. 1615; d. there, 1650). Troijen may have been a pupil of Jan Pijnas. However, his renderings of Italianate landscapes with ruins and of mythological and Biblical figures at times recall the manner of Abraham van Cuijlenburgh and Cornelis van Poelenburgh.

TROJAN WAR. Siege and capture of Troy, traditionally dated 1184 B.C. and immortalized in Homer's *Iliad*. Excavations of Troy have shown that the city known as Troy VIIa was in fact captured at about this time, but the scale of the city and the war was far smaller than that portrayed by Homer. Of the heroes made famous by Homer there is no historical record.

BIBLIOGRAPHY. C. W. Blegen, *Troy* (Fascicule of the *Cambridge Ancient History*, vols. 1–2), Cambridge, 1961.

TROMPE L'OEIL. French term meaning "deceive the eye," applied to paintings in which objects in still-life arrangement are depicted with such clever mimicry of their counterparts in nature as to confuse the spectator. Probably the best modern examples of trompe l'oeil are to be found in the work of the 19th-century American painter William Harnett. *See* HARNETT, WILLIAM MICHAEL.

TRONDHEIM (Throndjem) CATHEDRAL. The first Cathedral of Trondheim, Norway, was a simple basilica of the 11th century built by Olaf Kyrie on the site of the burial place of St. Olaf. Under Archbishop Eystein (1161–68) the transept, crossing tower, and chapter house on the north side of the choir were built in the Romanesque style. The present choir and freestanding octagonal apse are Gothic, partly the work of English architects, and were completed in about 1240. The ruined Gothic nave was erected from about 1248 to 1300.

BIBLIOGRAPHY. O. Krefting, *Om Thronhjems Domkirke*, Trondheim, 1885.

TROOST, CORNELIS. Dutch painter of portraits, genre, and decorations (b. Amsterdam, 1697; d. there, 1750). Troost was the pupil of Arnold Boonen in Amsterdam, where he worked his entire life. In approach and style his work is comparable to that of his English contemporary William Hogarth. Many of Troost's works are executed in a combined technique of gouache and pastel; he also executed room and theater decorations in oil. One of his daughters, also an artist, copied her father's work; another daughter married the graphic artist and collector Cornelis Ploos van Amstel.

BIBLIOGRAPHY. A. Ver Huell, *Cornelis Troost en zijn werken*, Arnhem, 1873.

TROTTI, GIOVAN-BATTISTA (Il Malosso). Italian painter of Cremona (1555–1619). The traditional Cremonese dependence on Parma took the form, in Trotti's case, of admiration for Correggio and was reinforced by his working in Parma late in life. Though old-fashioned, he was thus in tune with the emerging baroque.

BIBLIOGRAPHY. Cremona, Museo Civico, Pinacoteca, *La Pinacoteca di Cremona*, ed. A. Puerari, Cremona, 1951.

TROY, JEAN-FRANCOIS DE. French painter of historical, allegorical, and mythological subjects and of portraits; also decorator (b. Paris, 1679; d. Rome, 1752). He was the son of a portrait painter, François de Troy, his first teacher, who sent him to Italy about 1699. In Rome he studied the works of Guercino and the 16th-century Venetians, and probably knew Pierre Subleyras. In 1706 he returned to Paris, where he became a member of the Royal Academy in 1708 and professor in 1719. For some time thereafter he was a history painter (*The Plague at Marseilles*, 1722; Welbeck Abbey). With François Lemoyne, in 1727, he shared a special prize offered by the King for open competition in painting. This rivalry spurred him to productivity as a decorator (hôtels of Jacques-Samuel Bernard and of A. L. La Live de Jully) and genre painter. He chronicled the mores of contemporary French society in an elegant consummation of the Netherlandish tradition. In *Luncheon of Oysters* (1734; for the *petits appartements* at Versailles, pendant to Nicolas Lancret's *Luncheon of Ham*, both at Chantilly, Condé Museum), Dutch-portrayed gluttony is transformed into a French gourmandism. Such a work is an intermediate ancestor of the English hunt breakfasts.

In 1738 De Troy was appointed director of the French Academy in Rome. He enjoyed a spectacular career, socially and professionally. He completed tapestry cartoons for the Gobelins manufactory in Paris (*History of Esther* and *History of Jason*, seven pieces in each series); the oil sketches for the cartoons (*The Triumph of Mordecai*, New York, Metropolitan Museum) brilliantly synthesize Rubens's fluid technique and Veronese's festive opulence. He also painted altarpieces for Roman churches (*Resurrection*, 1739; Rome, S. Claudio dei Borgognoni) and prepared splendid festivals (Carnival of 1748) and receptions (1751, for Mme de Pompadour's brother, the Marquis de Vandières). An inspired teacher, he encouraged his charges to seek the ideal of beauty, not the slavish imitation of antiquities. His sudden replacement as director by Charles Joseph Natoire in 1751 embittered him.

His *oeuvre* is versatile in both style and subject matter. *Ex-voto of Ste-Geneviève* (1726; Paris, St-Etienne-du-Mont) is a *style rocaille* (French rococo) extension of similar late-17th-century themes by Nicolas de Largillière, while *Bathsheba at the Bath* (1727; Angers, Fine Arts Museum), one of the most voluptuous sultanas of all French painting, emulates the diminutive scale of Jean-Baptiste Santerre's paintings. De Troy is often classed as a minor painter, but

his complexity and usual brilliance make the study of his work rewarding.

Other works are in Berlin, Compiègne, London (National Gallery and Victoria and Albert Museum), Neufchâtel, New York, Paris (Louvre and Musée des Arts Décoratifs), Rome, St-Quentin, and many French private collections.

BIBLIOGRAPHY. *Vies d'artistes au XVIIIe siècle...*, introd. and notes by A. Fontaine, Paris, 1910; L. Dimier, *Les Peintres français du XVIIIe siècle...*, vol. 2, Paris, 1930. GEORGE V. GALLENKAMP

TROY. Name given by modern scholars to the Bronze Age city located on the mound of Hissarlik in western Asia Minor, 3.5 miles inland from the opening of the Dardanelles into the Aegean Sea. Scholars are almost unanimous in identifying this site with the Troy or Ilion of Homer's *Iliad*. Three teams of archaeologists have excavated the site, beginning in 1871 with that led by the famous Heinrich Schliemann.

Between 1872 and 1874 Schliemann proved by his archaeological discoveries that the stories of the Trojan War were not groundless myth. Using the *Iliad* as his guide, he was convinced that Hissarlik was the location of Troy, and here he found a number of cities and fortresses (now nine) built one upon the ruins of another; he also found evidence of their destruction by fire. Wilhelm Dörpfeld, who had ably assisted Schliemann, led his own excavations there in 1891–92. Dörpfeld, in 1892, discovered at Hissarlik a fortress on the mound contemporary with Mycenae, the city from which Agamemnon and Achilles were said to have sailed to avenge the abduction of Helen.

Lastly, the great American archaeologist Carl Blegen led another expedition to Troy in 1932–38. It is to Blegen and his colleagues that we owe the definitive report on the ancient city, published in four volumes under the general title *Troy*. Blegen's excavations revealed a complex of forty-six strata representing as many phases in the long life of the city. In his numbering system for the various strata, following Schliemann's general plan, Blegen identified eight major occupation levels, which he designated Troy I to VIII, numbering from the bottommost or oldest stratum. The eight "cities" were then divided into subphases of occupation designated by lower-case letters. Thus the oldest occupation level, Troy I, was found to contain ten subphases, Troy Ia to Ij. A summary of Blegen's findings about each of the eight cities follows.

Troy Ia–j (ca. 3000–2600 B.C.). The lowest level of Troy was found to contain ten consecutive phases, all showing a continuity of ceramic and architectural style. Inside a modest city wall were clusters of small two-room houses arrayed along crooked and narrow streets, but the town had some large buildings as well. Judging from the architectural remains, it is likely that even in this earliest phase the city was governed by strong rulers who dominated the northwest corner of Asia Minor and the straits to the Black Sea. Foreign objects found in the remains show that trade was carried on with Aegean cultures, almost certainly by sea, and also with the peoples of central Anatolia. A general conflagration ended the settlement of Troy I, but it was probably a "natural" fire rather than one associated with attack by an alien people, for the culture of the succeeding city is continuous with that of Troy I.

Troy IIa–h (ca. 2600–2300 B.C.). The second city of Troy was apparently a far more important settlement than its predecessor. Though Troy II was not large, it was protected by a major system of fortifications. A large megaron dwelling dominated the city, indicating an oligarchical or, more likely, a monarchical social structure. Hoards of jewelry found in these strata suggest that the city had become very rich and that the wealth was in the possession of only a few citizens. Troy II had probably become a great trading center because of its strategic position astride both land and sea routes. The demise of Troy II, like that of its predecessor, seems to have been due to a vast conflagration, whether of human or natural origin is unknown.

Troy IIIa–d (ca. 2300–2200 B.C.); Troy IVa–e (ca. 2200–2050 B.C.); Troy Va–d (ca. 2050–1900 or 1800 B.C.). The third, fourth, and fifth cities of Troy bear many resemblances to one another and to Troy II and may be treated together for most purposes. While the third city was much smaller than its predecessors, Troy IV and V again showed growth and sophistication. Many of the cultural traditions of Troy II were retained, but a few innovations appeared as well. Commerce continued with the Aegean and with central Anatolia, though far below its Troy II levels; Troy V saw new trading contacts with Cyprus and eastern Anatolia. Troy III and IV were destroyed by their inhabitants as part of rebuilding programs that ushered in the next phases. While the fate of Troy V is still open to scholarly dispute, it was probably captured by an invading people sometime between 1900 and 1800 B.C.

Troy VIa–h (ca. 1900 or 1800–1275 B.C.). The greatest and longest-occupied city of Troy shows many fundamental differences from its predecessors. Thus, Blegen has posited the arrival of a whole new people at the site, perhaps the same Greek-speaking people who apparently occupied Greece at about the same time. The new city was much enlarged and surrounded by new and stronger walls. Houses larger than before were built on concentric terraces, which rose to the midpoint of the citadel. At the top stood what was probably a king's palace. Other new elements in Troy VI were an entirely new kind of pottery called gray Minyan ware, the use of horses, and the practice of cremation. The new Trojan culture seems to have increased its trade extensively, especially with the West. While not a single Hittite artifact has been found at Troy, Cycladic and Helladic objects are increasingly common. In the late phases of Troy VI, the city probably enjoyed extensive commercial relations with the city of Mycenae itself. Troy VI apparently had a long, prosperous, and peaceful existence, brought to a sudden end by a devastating earthquake in about 1275 B.C.

Troy VIIa–b (ca. 1275–1100 B.C.). The first phase of the seventh settlement was a reconstruction by the survivors of the earthquake. About the only difference from Troy VI was that the new city was made to hold a greater population, but the town's commerce seems to have fallen off sharply. Troy VIIa was destroyed, apparently after siege and capture by an enemy sometime about 1240 B.C. This date is in the period assigned by Greek tradition to the Trojan War, and some scholars believe that Troy VIIa was the Troy of Homer. If so, the city was far less grand

and important than Homer would have us believe. Still, it can be said, at the very least, that there is no evidence at Troy to disprove the theory that Homer's works are in the final analysis based on fact.

In Troy VIIb the city was at first rebuilt along the lines of the destroyed city, apparently by survivors of the carnage. Not long afterward, however, a new and alien population began settling in the city. These people, less highly developed than the contemporary Trojans, eventually took control of the citadel without a struggle and let the native population be assimilated in their new but atavistic culture. Soon even this new culture abandoned Troy, and the city lay virtually unoccupied for about 400 years. The general picture we get of the cities of Troy VI and VII is that of a powerful city (Troy VI) succumbing to a natural disaster, then being attacked and sacked while in a weakened state (Troy VIIa); the survivors (early Troy VIIb) were so weak that they could not resist an incursion of alien peoples, who took over (late Troy VIIb) and later abandoned the site.

Troy VIII (from ca. 700 B.C.). When Troy was occupied again, it was essentially as a Greek city, one showing strong affinities with east Greek and Aeolic settlements along the Anatolian coast. It was moderately prosperous in the 7th and 6th centuries but stagnated in the 5th and 4th centuries B.C.

Whether Troy is the city of Homer or not makes little difference. What is important is that Blegen and his excavators have revealed ruins corresponding to 2,000 years of a truly great city, one that profoundly affected the history and development of the entire Anatolian and Aegean region around it.

BIBLIOGRAPHY. C. W. Blegen et al., *Troy*, vols. 1–4, Princeton, 1950–53; H. L. Lorimer, *Homer and the Monuments*, New York, 1951; H. Frankfort, *The Art and Architecture of the Ancient Orient*, 2d ed., Baltimore, 1958.

EVANTHIA SAPORITI

TROYEN, ROMBOUT VAN, see TROIJEN, ROMBOUT VAN.

TROYES. French city, the Roman Augustobona. In the 12th and 13th centuries it was the residence and capital of the counts of Champagne.

Among its monuments are the Gothic Church of St-Urbain (1262–1300), a jewel-like building strongly reminiscent of Ste-Chapelle, Paris. The Cathedral, dedicated to St. Peter, is imposing in size and has an interesting admixture of styles ranging from the 13th to the 16th centuries. The choir, with its original 13th-century stained glass, is most impressive. The Cathedral Treasury is especially rich in reliquaries with ornate enamel work and in ivories, some dating from as early as the 9th century. The oldest church in Troyes, that of Ste-Madeleine, was founded in the 12th century, but it has been largely rebuilt and restored from the 16th century on. *See* SAINT-URBAIN.

The Fine Arts Museum is noted for its collection of 18th-century French canvases; the Municipal Library has a rich collection of manuscripts. *See* TROYES: FINE ARTS MUSEUM.

TROYES: FINE ARTS MUSEUM. French collection. In addition to a noteworthy ensemble of barbaric jewelry, the museum is important for paintings associated with Champagne, among which Jean Malouel's *Deposition* is outstanding. Its fine collection of 18th-century French paintings includes works by Watteau.

BIBLIOGRAPHY. L. Morel-Payen, *Le Musée de Troyes et la bibliothèque*, Paris, 1929.

TROYON, CONSTANT. French painter (b. Sèvres, 1810; d. Paris, 1865). One of the greatest animal painters of his time, Troyon was mostly self-taught, having received only elementary training from his father, an ornament painter at the Sèvres porcelain factory. His early works were chiefly landscapes, like the *View of Sèvres* with which he debuted in the Salon of 1833. Camille Roqueplan introduced Troyon to the Barbizon school, whose members, particularly Diaz and Dupré, exercised a strong influence on Troyon's development. After a trip in 1847–48 to Holland, where he was influenced by Cuijp's work, Troyon began to introduce farm animals and peasants into his landscapes, which soon became very popular. In 1855 he won a first-class medal for *Les Boeufs allant au labour* (Paris, Louvre). His later works assumed colossal size (*Le Retour à la ferme*, 1859; Louvre) and correspondingly high prices.

BIBLIOGRAPHY. A. Hustin, *Constant Troyon*, Paris, 1880s; W. Gensel, *Corot und Troyon*, Bielefeld, Leipzig, 1906.

TRUBETSKOI, PRINCE PAUL PETROVICH. Russian sculptor (b. Intra, 1867; d. Suna, 1938). Trubetskoi was self-taught. When he visited Paris, he was impressed with the light and shade of the impressionists and with the sculpture of Rodin. He received international attention for his contributions to the Paris Exposition of 1900 and the Mir Iskusstva (World of Art) exhibition in St. Petersburg in 1900. He taught sculpture at Moscow College, and among his pupils was Natalie Gontcharova. His sculpture was exhibited at the American Numismatic Society, New York, in 1911.

His most ambitious project was the equestrian statue of Alexander III in Leningrad. It is conceived more as an enlarged statuette than as a monumental composition. Characteristic of his work is the bronze, seated figure of

Constant Troyon, *Les Boeufs allant au labour*, 1855. Louvre, Paris.

John Trumbull, *The Declaration of Independence*, 1818. Yale University Art Gallery, New Haven, Connecticut.

S. Iu. Vitte with his dog (1901), which is in the Russian Museum in Leningrad.

BIBLIOGRAPHY. G. Hamilton, *The Art and Architecture of Russia*, Baltimore, 1954.

TRUBNER, WILHELM. German painter (b. Heidelberg, 1851; d. Karlsruhe, 1917). In 1868 Trübner began his studies as a student at the Karlsruhe Art School, where he worked under Rudolf Schick and Hans Canon. In the following year he transferred to the academy at Munich, where he studied for a brief time under Alexander von Wagner and Wilhelm von Diez. In Munich Trübner became friends with Karl Schuch, Leibl, and Thoma; he traveled with Schuch to Italy in 1872. He lived in Munich until 1896, when he moved to Frankfurt am Main to become professor at the Städel Art Institute. In 1903 he became the director of the Karlsruhe Academy. Recognition came late to Trübner; only after 1909 was he accepted as one of the leading painters of Germany.

Trübner's career passed through many phases. He began as a close follower of Leibl and then turned to painting realistic interiors inspired by Courbet (*In the Atelier*, 1872; Munich, New Pinacothek). In the late 1870s he painted large mythological scenes inspired by Feuerbach and Böcklin (*Battle of the Amazons*, 1879; Karlsruhe, State Art Gallery), and in his last period he turned wholeheartedly to impressionism, painting *plein-air* landscapes, such as his

Portal of Stift Neuberg near Heidelberg (1913; Mannheim, Municipal Art Gallery).

BIBLIOGRAPHY. W. Schäfer, *Wilhelm Trübner*, Düsseldorf, 1910; J. A. Beringer, *Trübner*, Stuttgart, 1917.

JULIA M. EHRESMANN

TRUE FRESCO, *see* FRESCO.

TRUJILLO, GUILLERMO. Panamanian expressionist painter (1927–). Born in Horconcitos, Trujillo was trained as an architect at the University of Panama and as a painter at the academy in Madrid. He has painted murals in Panama City, as well as his better-known oils. He has had one-man shows in Washington, D.C. (1961), Caracas, São Paulo (1959), Madrid, and Panama City.

BIBLIOGRAPHY. University of Kansas, Museum of Art, *Pintores centroamericanos* (exhibition catalog), Lawrence, Kans., 1962.

TRUMBULL, JOHN. American historical and portrait painter (b. Lebanon, Conn., 1756; d. New York City, 1843). In 1773 John Trumbull graduated from Harvard, the youngest in his class. While there, he had been influenced by Copley's portraits, Piranesi's engravings, and Hogarth's *Analysis of Beauty*. After graduation he returned to Lebanon, Conn., to teach school (1773–75), but in 1775 he joined the Revolutionary Army, serving briefly as Washington's aide-de-camp. He found a pretext to resign his commission in 1777, and returned home to paint por-

traits. He then moved to Boston, where he rented Smibert's old painting room and used Smibert's copies of old masters. Typical of Trumbull's work during this period is his *Self-Portrait* (1777; Cambridge, Mass., Harvard University).

In 1780 he went to London, only to be imprisoned and sent back to America in retaliation for the hanging of Major André as a spy. Trumbull returned to London in 1784 to work in Benjamin West's studio. In 1786 he began the series of scenes from the American Revolution which was to be his major concern for much of his life. Before returning to America in 1789, Trumbull twice visited Paris (1787 and 1789), where he met David and Vigée-Lebrun. Between 1789 and 1794 Trumbull was in America painting portraits of people involved in the Revolution (*Alexander Hamilton*, 1792, New York, Chamber of Commerce of State of New York; replica, 1805–06, Washington, D.C., National Gallery). He was again in London from 1794 to 1804 on a diplomatic mission with John Jay, but the years 1804–08 were spent in New York, where he maintained a studio. He went back to England for the last time in 1808, practicing there as a painter, though not very successfully.

In 1816 Trumbull settled in New York, and in 1817 he was finally commissioned to do four of his Revolutionary War scenes for the Capitol in Washington, a commission which he had desired since the 1780s. Begun when Trumbull was past the age of sixty, these large pictures lack the spirit and freshness of the early sketches. Among

the scenes are the *Declaration of Independence* (1818) and the *Surrender at Yorktown* (completed 1824), both of which suffer by comparison with the sketches at Yale executed before 1797. These sketches and others related to them, especially *The Battle of Bunker's Hill* (1786; New Haven, Yale University Art Gallery), show a liveliness, sparkle, and bravura; they also reflect the influence of Rubens, a quality unusual in neoclassical painting.

From 1816 to 1835 Trumbull was president of the American Academy of Fine Arts in New York. In 1831 he deeded to Yale College his historical sketches and other paintings, and this remains the most important collection of his works.

BIBLIOGRAPHY. T. Sizer, *The Works of Colonel John Trumbull, Artist of the American Revolution*, New Haven, 1950; T. Sizer, ed., *The Autobiography of Colonel John Trumbull*, New Haven, 1953.
DAMIE STILLMAN

TRUMEAU. In medieval architecture, the large center pillar of a portal that divides the doorway and supports the tympanum. Frequently, in French Romanesque and Gothic churches, the trumeau is the site for sculptured representations of Christ or the Madonna and Child since it is the natural center for the surrounding iconographical program of prophets, saints, and other personages on the jambs and archivolts.

TRUNDHOLM SUN CHARIOT. Bronze work of the 14th century B.C. (Copenhagen, National Museum), found in Zealand, one of the most impressive finds of Denmark's Bronze Age. The chariot (ca. 22 in. long) consists of a large bronze disk, gold-plated on one side, drawn by a bronze horse, both of which are supported on six wheels. The horse is modeled in the round, and its neck is decorated with a series of fine lines representing the mane. The disk is ornamented with a series of circles and spirals; it probably represents the sun, and has connotations of sun worship, which was a popular practice among primitive people. There was an ancient belief that the sun was drawn by a horse.

BIBLIOGRAPHY. O. Klindt-Jensen, *Denmark before the Vikings*, New York, 1957.

TRUSS. Framed structure composed of members joined at their ends and so arranged that when loads are applied at the joints the members are stressed in the direction of their length. Such stresses are called "direct." The simplest form of truss is a triangle or a combination of triangles. The pedimented Greek roof is a truss. Reactions at truss supports are vertical for vertical loads. When reactions are inclined for vertical loads, the structure, though composed of triangular elements, is an arch, sometimes being called an "arch truss." *See* ARCH.

A "Vierendeel truss" is not properly a truss. It is a rigid frame resembling a ladder. Lacking diagonals, it consists of top and bottom chords connected by verticals in fixed rather than hinged joints.

TRYON, DWIGHT WILLIAM. American landscape painter (b. Hartford, Conn., 1894; d. South Dartmouth, Mass., 1925). He studied with Chevreuse in Paris and with the Barbizon painters. A onetime director of the Hartford School of Art, he became a member of the Hudson River school toward the end of the movement. His landscapes

Trumeau. Central pillar of a portal, supporting the tympanum.

Trundholm Sun Chariot. A relic of Denmark's Bronze Age, dating from the 14th century B.C. National Museum, Copenhagen.

are dreamy, poetic visions cloaked in vaporous mists of impressionistic, muted tones.

BIBLIOGRAPHY. H. C. White, *The Life and Art of Dwight William Tryon*, Boston, 1930.

TS'AI LUN, *see* CHINA: PAPER.

TSARSKOE SELO, PALACE OF. Palace in Pushkin, U.S.S.R. (formerly Tsarskoe Selo), built on the site of a Finnish settlement, 16 miles from Leningrad. Peter I offered the site to his wife, Catherine, as a country estate, which was given its present name, meaning "imperial village." First planned for construction by M. G. Zemtsov under Peter, the Great Palace, later called the Catherine Palace, was constructed by Kvasov early in the 18th century as a three-story block with slightly projecting pavilions at the center and ends.

Rastrelli was commissioned to add larger state apartments to the relatively modest core in 1749–56. On the insistence of the czarina, Elizabeth Petrovna, the original structure had to be preserved, creating the problem of treating a façade of disproportionate extension—almost 1,000 feet—unbroken by significant projections in depth or height. As built, the wings form almost interminable extensions of the main core, although they are accented at the midpoints and the terminals for relief. Great im-

portance is placed on decorative motifs such as alternating pilasters and strongly projecting engaged columns, elaborate window frames, gilded sculpture, and the color of the building—yellow with white trim—to enhance the effect of lively interest in detail at the expense of the total massing.

The palace contains some apartments designed by Charles Cameron, of which the Agate Pavilion (1782–85)

Truss. Triangular arrangement in the simplest form of truss.

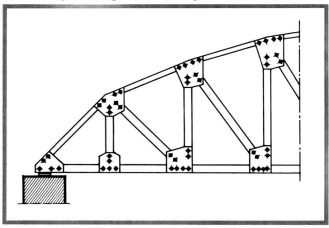

and the Cameron Gallery are the most classical achieved in Russia at the period and show a high level of taste in the choice of materials and the quality of the ornament.

On the grounds is the Alexander Palace (1792–96), which was designed as a residence for Catherine's favorite grandson, the future Alexander I, by Quarenghi. It is considered a major architectural work of the 18th century.

Originally the park and gardens followed the example of Versailles. Rastrelli designed three domed pavilions, now demolished. The most interesting of them, the Monbezh (1750) had a complex arrangement of flights of steps and a dome with a fantastic bulbous cupola that made it the high point of Rastrelli's studies of baroque space, closely related to the work of the Bibienas. Later, Catherine II followed English landscape solutions in arranging the grounds. First they were peppered with monuments symbolizing contemporary Russian battles, to which were added Velten's famous Gothic ruin of 1774 (a colossal half-buried column with a small Gothic pavilion on its capital), Cameron's Chinese Village (with Neelov, ca. 1774–96; completed by Stasov, 1817–22), Neelov's Chinese Theater and Gothic Admiralty (1773–77), and Quarenghi's "Great Caprice" (ca. 1785), among others. Under Nicholas I the gardens were given structures that reflect the most eclectic phase of European romanticism.

BIBLIOGRAPHY. A. Benois, *Tsarskoe Selo v tsartvovanie imperatritsy Elisavety Petrovny*, St. Petersburg, 1910; S. N. Vilchovski, *Tsarskoe Selo*, St. Petersburg, 1911; S. S. Bronstein, *Arkhitektura goroda Pushkina*, Moscow, 1940; G. H. Hamilton, *The Art and Architecture of Russia*, Baltimore, 1954. DORA WIEBENSON

TSCHACBASOV, NAHUM. American painter and graphic artist (1899–). He was born in Baku, Russia, and went to the United States in 1907. Originally an accountant, he began painting about 1930, studying at the Lewis Institute, at the Armour Institute of Technology, and in Paris with Leopold Gottlieb, Gromaire, and, briefly, Léger. His paintings of the 1930s, apart from a short excursion into abstraction, were satiric treatments of social subjects in an expressionistic, at times naïve, style, with rich color and surface. Beginning in the 1940s, his subjects became more imaginative, often including fantastic animals, in a manner comparable to that of Chagall. Tschacbasov is also known for his experiments in encaustic painting.

BIBLIOGRAPHY. D. Goddard, *Tschacbasov*, New York, 1964.

TSCHORNY, DANIIL, see CHORNY, DANIEL.

TSENG YU-HO. Chinese painter (1923–). She was born in Peking and was a pupil of P'u Chin. Tseng Yu-ho's work is difficult to classify since she has worked in traditional as well as modern styles of painting. She is well represented in public and private collections in the United States and Europe. Currently she lives in Honolulu with her husband, Gustav Ecke, a well-known scholar of Chinese art.

TSIMSHIAN INDIANS. Group of tribes inhabiting the central region of the northwestern coast of British Columbia, located between the Tlingit to the north, the Haida on the Queen Charlotte Islands to the west, and the Kwakiutl and other tribes to the south. Their social structure was based on a fourfold family of clans: the Wolf, Bear, Eagle, and Raven. The acquisition of wealth was important among the Tsimshian, and artists were supported, as elsewhere in the Northwest, by rich chiefs and families.

Sculpture is the principal Tsimshian art, executed, as among other Northwest Coast groups, in cedar or maplewood often combined with copper and shell. The ceremonial mask, sometimes framed by miniature images of symbolical faces or by tufts of human hair, is an outstanding form. These works bear a general stylistic resemblance to the whole complex of masks of the Northwest, but Tsimshian sculpture involving the human face is typically more subtle in its naturalism than, for example, is the art of the Kwakiutl. Tsimshian sculptors are among the most form-conscious of Northwest Coast artists.

See also BRITISH COLUMBIAN INDIANS; NORTH AMERICAN INDIAN ART (NORTHWEST COAST).

BIBLIOGRAPHY. V. Garfield, *The Tsimshian: Their Arts and Music*, New York, 1951. JOHN C. GALLOWAY

TSOU FU-LEI. Chinese painter of plum blossoms (fl. mid-14th cent.). Tsou Fu-lei is seldom recorded in standard Chinese biographical sources. An apparent Taoist recluse, he is known chiefly for the excellent painting in the Freer Gallery, Washington, D.C., entitled *Breath of Spring*. This marvelous evocation of the magic that accompanies the blossoming plum tree is a well-documented painting and contains colophons dating to the mid-14th century. According to the inscriptions, Tsou Fu-lei lived as a hermit in the mountains and was active as a painter and poet as well as musician at least into the 1360s.

BIBLIOGRAPHY. A. G. Wenley, " 'A Breath of Spring' by Tsou Fu-Lei," *Ars Orientalis*, II, 1957.

TSUBA. Japanese sword guard. Simple and direct designs emphasized the functional nature of the *tsuba* in the Muromachi and Momoyama periods, represented by the work of the noted artisans Kaneie and Nobuie (16th cent.), Koike Yoshirō (16th cent.), and Umetada Myōju (1558–1631). During the long period of relative peace in the Edo period (1615–1867) weapons and other paraphernalia of the warrior class became increasingly decorative, and greater attention was given to the finer decorative details on the *tsuba* and other sword fittings. *Tsubas* were treasured as *objets d'art* rather than as instruments of war. Among the numerous *tsuba* makers of the Edo period were Shimizu Jingo (d. 1675), Yokoya Sōmin (1651–1733), Nara Toshihisa (or Nara Toshinaga, d. 1736), Tsuchiya Yasuchika (1670–1744), Sugiura Jōi (1701–61), Tsu Jimbo (1721–62), Ichinomiya Nagatsune (1722–86), and Kanō Natsuo (1828–98). There are many large and important collections of *tsubas* in Europe and the United States.

BIBLIOGRAPHY. Tokyo National Museum, *Pageant of Japanese Art*, vol. 4: *Ceramics and Metalwork*, Tokyo, 1952.

TS'UI PO. Chinese painter of birds and flowers (fl. 2d half of 11th cent.). Ts'ui Po was employed to decorate many of the interior walls of the temples and palaces around the capital of K'ai-feng and held a high official position in the Painting Academy. He was held in great esteem by later critics, so much so that his name appears on many mediocre exercises in large-scale bird paintings. Several fine paintings by Ts'ui Po that may well be authentic are in the Sun Yat-sen Museum, Formosa.

BIBLIOGRAPHY. J. Kuo, *Experiences in Painting* ... [ed. by] A. C. Soper, Washington, 1951.

TSUN. Term used to describe a particular class of Chinese bronze ritual vessels. In general the name has been applied by most museum curators and collectors to a large vessel having a wide flaring mouth and divided into three distinct sections. This vessel resembles a squat *ku* but is too large to function as a drinking goblet. The term *tsun*, however, has also been applied to other types of vessels in animal form, and Chinese literary sources indicate that a rather wide variety of shapes is covered by this particular designation. *See* KU.

BIBLIOGRAPHY. W. Willets, *Chinese Art*, vol. 1, Harmondsworth, 1958.

TS'UN. Term used in connection with Chinese landscape painting. Although *ts'un* is widely used, it is difficult to translate, having been variously equated with words such as wrinkles, modeling, markings, and shading. The reference in every case is to the method of texturing with lines that are contained within the general outline or contour of the shape, to give substance and mass to various elements of the landscape. A considerable number of *ts'un* have evolved in the long history of Chinese painting, and in each instance when a particular type of *ts'un* became part of the general vocabulary of brushstrokes, it became known by a designated name. There are more than twenty-five distinctive types of *ts'un* not counting minor variants, and these have been classified by Japanese and Western scholars under three broad headings: thread-shaped lines, broad bandlike lines, and dots. The Chinese painter, over the centuries, perfected each type of *ts'un* for a special purpose, to depict some particular aspect of nature: fissures, erosion, weathering, barks of trees, vegetation, surfaces of stone—the whole range of natural visual phenomena can be described by various combinations of *ts'un*.

The most common of all the *ts'un* is probably the *p'i-ma ts'un*, or strokes like "spread-out hemp fibers," long and wavy, capturing the visual effect of erosion in soil, of weathering in rocks. The variations within this broad designation of the hemp-fiber stroke are considerable: *ts'un* like "confused" hemp fibers, unraveled rope, lotus veins, or torn fishnet—each type of *ts'un* is appropriately described by some visual parallel to the natural world, adapted now to the world of the two-dimensional surface.

Chinese connoisseurs of the art of painting have always paid close attention to the nuances of *ts'un*, often assigning painters to a particular school of painting based on the special employment of *ts'un*. Western art historians also accord the use of *ts'un* a high place in their criteria for judging Chinese paintings. Certain kinds of *ts'un* are obviously more favored than others by groups of artists, as, for example, the "ax-stroke" *ts'un*, which appears to have developed in the Northern Sung dynasty (960–1127). In this particular *ts'un* the side of the brush is used to apply a broad wash of ink to create the effect of a sharp, angular rock façade, as though the rock (or the mountain face) had been cleanly split by an ax. The broad ax stroke became a feature of the Southern Sung landscapes produced by the academy. Other *ts'un* usage carries more individual connotations, associated with particular artists. The Ming-dynasty artist Shen Chou, for example, employed *tien*, or dots like pepper, sprinkled on the surface to effect accents of vegetation, a distinctive element in his personal style. *See* SHEN CHOU.

The development and use of *ts'un* are closely linked to the entire spirit and philosophy of Chinese landscape painting. The rich vocabulary of *ts'un* is directly related to the memory-image approach of the Chinese painter; to distill the elements of nature, to create order in the visual world, these were the essential goals that led to the creation of the special language of the *ts'un*.

BIBLIOGRAPHY. K. Tomita, "Brush-Strokes in Far Eastern Painting," *Eastern Art*, III, 1931; B. March, *Some Technical Terms of Chinese Painting*, Baltimore, 1935; F. van Briessen, *The Way of the Brush: Painting Techniques of China and Japan*, Rutland, Vt., 1962.

MARTIE W. YOUNG

TSURINGA STONES, *see* CHURINGA STONES.

TUCKER, ALBERT. Australian painter (1914–). He was born in Melbourne, but worked and exhibited in Europe and America from 1948 to 1960. In 1960 he was brought back to Australia by the movement for a museum of modern art in Melbourne. His expressionist art derives a rugged power from the stony savagery of its forms. He has produced a unique series of psychological portraits.

TUDELA CATHEDRAL. Spanish collegiate church (formerly with cathedral status) in Navarre that marks an important moment in the transition from the Romanesque to the Gothic. While the plan results from Cistercian Poitevin influence, the curious lancet windows of the transepts suggest English influence. The Cathedral, dedicated in 1204, has a Romanesque cloister with extraordinarily fine narrative capitals.

TUDOR STYLE. Designation for a period in English art, especially architecture, corresponding to the reigns of the Tudor monarchs (16th cent.). It is a transitional period, bridging the late Gothic and the Renaissance. Renaissance influence, however, was restricted mainly to details of ornament.

BIBLIOGRAPHY. J. N. Summerson, *Architecture in Britain, 1530–1830*, 4th rev. ed., Baltimore, 1963.

TUFA. Porous rock formed from the deposits of springs or streams. Since antiquity, tufa has often been used as a building material and sometimes, principally in the Middle Ages, as a material for sculpture because of its soft yet durable qualities.

TUGENDHAT HOUSE, BRNO. Czechoslovakian structure designed and built in 1930 by Mies van der Rohe; later destroyed. It was situated on a slope with a handsome view; one entered from the top floor to find a conventional arrangement of enclosed bedrooms, bathrooms, and the like. Below, bounded on two sides by enormous glass walls, was a volume that could be opened to convert the living area to a semienclosed terrace. This living-dining-recreational area was unconventionally subdivided by fixed, free-standing walls and columns. The entire work, executed in extremely elegant materials such as onyx, ebony, and chromed steel, was designed by Mies in every detail, including furniture, lighting, and door handles. This classic

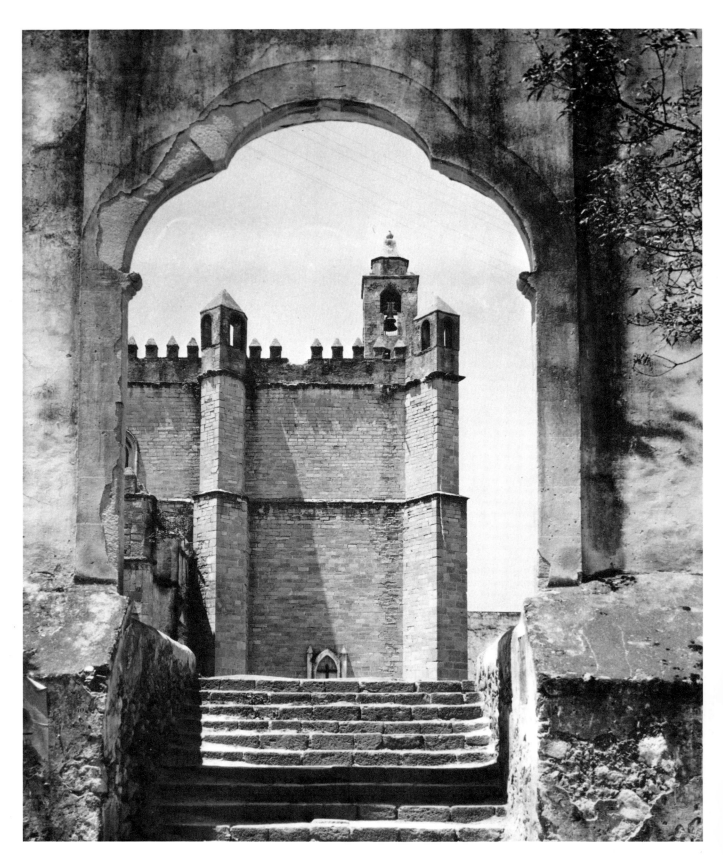

Monastery church of Tula. The austere façade, completed 1554.

expression of the art of the time was a consummate masterpiece of modern architecture.

BIBLIOGRAPHY. New York, Museum of Modern Art, *Mies van der Rohe*, by P. C. Johnson, 2d ed., 1953; P. Blake, *The Master Builders*, New York, 1960.

TUILERIES PALACE, PARIS. Former French royal residence. In 1564 Catherine de Médicis commissioned De l'Orme to build the Tuileries Palace near the Louvre and at right angles to the river. Little was done by 1570 when De l'Orme died. He was succeeded by Bullant, then by Du Cerceau, who built the Pavillon de Flore in 1595. Later Le Vau and François d'Orbay built the Pavillon Marsan (1660–65). Finally, a wing along the Rue du Rivoli was built under Napoleon I. The Tuileries Palace was set on fire in May, 1871, by the Commune. The site is now occupied by the Tuileries Gardens. *See* LOUVRE PALACE, PARIS.

BIBLIOGRAPHY. L. Hautecoeur, *L'Histoire des châteaux du Louvre et des Tuileries*, Paris, 1927.

TULA, MONASTERY CHURCH OF. Monastery church north of Mexico City. The early foundations date to the 1530s and 1540s. The church was finished in 1554, under Fray Antonio de San Juan; the monastery, in 1553–61. The church exterior is simple with a refined Renaissance-inspired portal on the façade, at the end of a large rectangular atrium. The interior follows a single-aisled plan, related to the Hieronymite monastic church at Yuste, Spain. Revisions, additions, and decorative enrichment of the monastery continued in later centuries.

BIBLIOGRAPHY. G. Kubler, *Mexican Architecture of the Sixteenth Century*, 2 vols., New Haven, 1948.

TULUNID TEXTILES (Egypt), *see* ISLAMIC TEXTILES (ABBASID AND TULUNID PERIODS).

TUMULUS. Latin term meaning "hillock," used to designate a mound, particularly over a grave in ancient times. Prehistoric tumuli are seen as prototypes of Egyptian pyramids. The beehive huts of Wales, Cornwall, Scotland, and Ireland are said to derive from ancient tumuli.

TUNA EL GEBEL, *see* HERMOPOLIS WEST.

TUNG CH'I-CH'ANG. Chinese painter, writer, and government official (1555–1637). Born in the then small town of Shanghai, he moved to Hua-t'ing before the age of seventeen. He gained a measure of recognition while in his teens for his natural intelligence as well as his literary talents, and he was soon accepted into the small circle of intellectual elite in Hua-t'ing. Tung studied painting, calligraphy, poetry, and Ch'an Buddhism, all with equal enthusiasm, and he rapidly acquired the skills associated with the scholar-gentleman class. His friendship with Mo Shih-lung and Ch'en Chi-ju, the latter his lifetime comrade, was to have great consequences in the history of Chinese painting. In 1589 Tung Ch'i-ch'ang passed the examinations for the *chin-shih* degree and was appointed a member of the Han-lin Academy in Peking. He had a varied career in the official government, was disillusioned often with politics, and returned on leave several times for extended periods to his former home, where he prac-

ticed his art and also began the accumulation of a substantial collection of older masterpieces of painting. He submitted his resignation on a number of occasions but was called back to Peking after various periods in Hua-t'ing. He died at the age of eighty-two, having earned a substantial place in the official dynastic history (*Ming shih*). *See* CH'EN CHI-JU; MO SHIH-LUNG.

Although paintings of Tung Ch'i-ch'ang do exist in some numbers in both Asian and Western collections, his role in the development of Chinese painting was more that of a theoretician than of a practitioner. His formulation of the hypothesis of northern and southern schools of painting was essentially an art-historical re-evaluation of Chinese painting history. The obvious bias in favor of *wen-jen*, or literati, painting colored the view of Tung Ch'i-ch'ang and his colleagues Mo Shih-lung and Ch'en Chi-ju, but Tung's attempt to bring some kind of order to the accumulation of tradition in Chinese painting was a significant achievement and was to have a lasting impact on the work of successive generations of painters. Tung Ch'i-ch'ang's writings on art took the form principally of inscriptions on his own paintings and on those of older masters as well, and his various notes were collected and edited after his death. He was revered for being a connoisseur and collector as well as a painter. *See* NORTHERN AND SOUTHERN SCHOOLS OF CHINESE PAINTING; WEN-JEN-HUA.

In his own paintings Tung purposefully limited his subject matter to landscapes, which were often variations on a theme. He stressed the technical aspects of painting and gave great attention to the specific characteristics of brush style which he had observed from his numerous studies of ancient masters. The total effect of Tung Ch'i-ch'ang's landscape paintings is often one of labored studiedness, with little in the way of refined elegance or minute detail. Rather, his paintings, like his writings, stress the notion that virtue resides in self-expression and not in a flamboyant display of technical virtuosity. His paintings are carefully structured, with complicated compositions; yet they could never be labeled examples of skillful or facile brush control. Occasionally lines cross each other, passages blur together where ink runs, and forms assume rather strange shapes that are not always pleasing. These characteristics of Tung Ch'i-ch'ang's painting style led many earlier Western writers to see him as the perfect example of the general "decline" in later Chinese painting, particularly in view of the fact that so many of Tung's paintings were works "in the style" of earlier masters. But it was precisely for his versatility in handling earlier styles and for his insistence on the study of great painters of the past that the Chinese have accorded him such high esteem; and there is no doubt that Chinese painting was never the same after his influential writings.

BIBLIOGRAPHY. N. I. Wu, "Tung Ch'i-ch'ang: Apathy in Government and Fervor in Art," in A. F. Wright and D. Twitchett, eds., *Confucian Personalities*, Stanford, 1962. MARTIE W. YOUNG

TUNG WARE. Chinese term applied to a class of imperial ceramic wares produced during the Northern Sung period. The term "Tung," which means "eastern," presumably refers to the location of the kiln outside the capital of K'ai-feng. The ware includes those known as northern celadon in Europe and the United States. The term "Tung ware" is somewhat confusing today since the kiln site has

Tung Yüan, *Clear Weather in the Valley*, a hand scroll formerly attributed to this painter. Museum of Fine Arts, Boston.

never been found and evidence from literary sources has not as yet been corroborated by existing examples.

See also CELADON, NORTHERN.

TUNG YUAN. Chinese painter (fl. late 10th cent.). His *tzu* was Shu-ta and his *hao* Pei-yüan. He spent his life mostly in Nanking and served as a minor official under the Southern T'ang dynasty (937–975). His reputation as a landscape painter was established relatively early, and he was considered the principal master in the Nanking region during his time.

He is best known to the Western world for the remarkable hand scroll in the Museum of Fine Arts, Boston, entitled *Clear Weather in the Valley*, long attributed to Tung Yüan but more recently considered a later work. Another painting with a long-standing attribution to the master is the large hanging scroll in the Sun Yat-sen Museum, Formosa, representing a landscape with small figures in some kind of festival activity. This painting reflects some of the elements associated with Tung Yüan's name, notably a distant space and resonant, soft hills.

Tung Yüan's landscapes were rich and luxuriant, an echo of southern China and the scenery encountered in such regions as Nanking. He painted in two styles: one "rough" and broad, the other more meticulous and coloristic, in the older T'ang idiom developed by Li Ssu-hsün. The latter paintings were largely overlooked by the Ming-dynasty critics since Tung Yüan was placed by them in the so-called "southern school" of monochromatic landscapists. *See* LI SSU-HSUN; NORTHERN AND SOUTHERN SCHOOLS OF CHINESE PAINTING.

BIBLIOGRAPHY. O. Sirén, *Chinese Painting, Leading Masters and Principles*, vol. 1, London, 1956. MARTIE W. YOUNG

TUN-HUANG (Ch'ien-fo-tung; Cave of 1,000 Buddhas). Name given to a cave complex in the northwestern province of Kansu, China. It lies on the eastern edge of the great desert trade route that linked China to the regions of Central Asia, India, and the West. The cave temples, which are located a few miles southeast of the ancient oasis of Tun-huang, are the largest and among the oldest

existing cave complexes in China. The caves were begun in the Six Dynasties period (4th cent.) and became an extremely active center of Buddhism during the T'ang dynasty (7th–8th cent.), when more than 200 caves were constructed. Work at Tun-huang was continued well into the Yüan period (14th cent.). Taken as a whole, the caves of Tun-huang are an invaluable record of Buddhist history and a prime source for the study of early Buddhist painting. The sculptures from Tun-huang are numerous, but because of the brittle nature of the stone at this site they are composed mainly of mud, clay, and straw. This limitation on sculpture was responsible for the extensive use of murals, which appear as decorations on the interior walls in place of the numerous sculptural niches or carved reliefs seen at such cave temples as Yün-kang, Lung-men, and elsewhere.

At the turn of the 20th century large quantities of documents, books, and scrolls were discovered sealed in one of the Tun-huang caves that had apparently served as a library, and in 1907 Sir Aurel Stein led an expedition to Tun-huang and acquired a good portion of this treasure (now divided between the British Museum, London, and the National Museum of India, New Delhi). The French Sinologist Paul Pelliot visited Tun-huang in 1908, bringing back with him a part of the remaining books and paintings from the sealed chamber (now in the Guimet Museum, Paris). Pelliot also photographed and later published many of the caves (1920–24), making this site available to students of Chinese art for the first time. In 1943 the Chinese government founded the Tun-huang Research Institute for the systematic study of this great cave series, a project that continues to the present day. However, Pelliot's earlier publication still remains the standard (and only available) source for the study of the wall paintings for Western students.

See also LOTUS SUTRA.

Of the total of approximately 470 caves that make up the Tun-huang complex, 23 are datable to the period of Northern Wei dominance or earlier, 95 to the Sui dynasty, and 213 to the T'ang period. The earliest surviving paintings are in Cave 101 (by Pelliot's numbering system, which varies from that employed by the Tun-huang Research Institute), dated to the late 5th century. As might be expected, the earlier caves in Tun-huang were heavily influenced by foreign styles, chiefly from Central Asia, and Cave 101 reveals a stiff, hieratic "icon" approach featuring the Buddha and attendants arranged symmetrically and frontally, drawn with heavy outlines. Cave 135, slightly later in time, is less oriented toward the creating of icons but more toward instructing the uninitiated, hence the popularity of the Jātaka tales, legends of the Buddha's earlier incarnations, on the walls of the chapel. Cave 102N, dated by inscription to 538–539, shows a marked stylistic change from Cave 101. Central Asian conventions are replaced by a lively exuberance that is much more typically Chinese in spirit and execution, testifying to the rapidity with which the new religion had been assimilated.

Since it was situated so far from the main urban centers, Tun-huang has been considered a provincial site of artistic activity during the Six Dynasties period, although there is little doubt that its key position on the caravan route must have given the oasis an international and

somewhat urbane character. But by the time of the T'ang dynasty the artists at work decorating the new temples in Tun-huang were probably drawn from the same skilled class of artisans as those working around the major cities of Ch'ang-an and Lo-yang. The style of both sculpture and painting from Tun-huang in the 7th and 8th centuries reflects the highly internationalized nature of Buddhist art in general. Cave 139A, with its magnificent Western Paradise of Amitābha, certainly captures the rich complexity and splendor of most T'ang Buddhist art, and the change from the simple icons or the moralizing tales of the Six Dynasties period is significant. The color range increases in the T'ang, as do the compositions with their crowded details and various landscape elements. Some notion of the T'ang-dynasty Tun-huang style can be obtained in the examples of actual wall painting taken by Langdon Warner from Cave 139A and now in the collection of the Fogg Art Museum, Cambridge, Mass. The Fogg collection includes a kneeling "newborn soul," a nearly life-size T'ang clay figure also obtained by Langdon Warner from Cave 143 of Tun-huang.

BIBLIOGRAPHY. P. Pelliot, *Les Grottes de Touen-Houang*, 6 pts. (Mission Pelliot en Asie centrale, sér. in quarto, vol. 1), Paris, 1914–24; M. A. Stein, *Serindia*, vols. 2–3, Oxford, 1921; A. Waley, *A Catalogue of Paintings Recovered from Tun-huang by Sir Aurel Stein*, London, 1931; C. Hsieh, *Tun-huang i-shu hsü-lu*, Shanghai, 1955; B. Gray and J. B. Vincent, *Buddhist Cave Paintings at Tun-huang*, Chicago, 1959; *Tun-huang pi hua*, Peking, 1959; *Tun-huang wên wu yen chiu so, Tun-huang ts'aisu*, Peking, 1960.

MARTIE W. YOUNG

TUNIS. North African city, capital of the Republic of Tunisia. The city comprises two parts: the well-preserved Muslim city, or Medina, whose narrow streets climb a group of low hills in the east, and the modern quarters laid out in checkerboard plan along the lagoon of el-

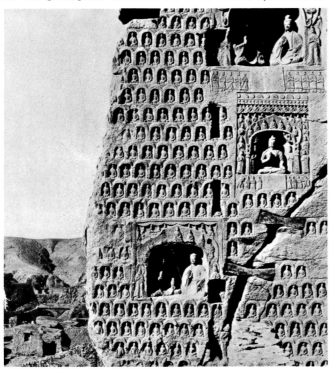

Tun-Huang. Sculptures on the rock face of the Cave of 1,000 Buddhas.

Bahira (Lake of Tunis). Tunis existed in antiquity under the name of Tunes, though it was eclipsed by the nearby metropolis of Carthage. Only toward the end of the 9th century did it replace Kairwan as the capital of the country. The city attained its height of prosperity during the later Middle Ages, when a number of noteworthy mosques were built.

Although the Great Mosque (Jama el-Zaytuna) goes back to the 9th century, much of the visible part is later (13th–15th cent.). The prayer hall and other features of the building recall the Mosque of Sidi Okba in Kairwan. El-Ksar Mosque, which is relatively plain, was built in the early 12th century. Although the prayer hall of the Mosque of the Casbah (ca. 1233) follows established Tunisian precedent, the minaret, with its complex surface patterning, reveals the influx of ideas from western North Africa. Other mosques of historic importance include the Mosque of Yusuf Bay (1614) and the Mosque of Sidi Mahrez (ca. 1675). A number of the madrasas, or residence halls, of the Islamic university attached to the Great Mosque date from the 17th and 18th centuries.

Funerary monuments include the tomb of the Banu Khorasan (1093), the tomb of Qura Mustafa (1718), and the Turbet el-Bey (1718). The former palace of the bey, the Dar el-Bey, dates from the 18th century. The Palace of the Bardo (18th–19th cent.), just outside the city, houses the Alaoui Museum, which has important holdings in the fields of prehistoric, ancient, and Islamic art. Islamic art is also displayed in the Dar Abdallah, the Dar Othman, and the Dar el-Monasteri.

BIBLIOGRAPHY. G. Marçais, *Tunis et Kairouan*, Paris, 1937.

WAYNE DYNES

TUNNARD, JOHN. English painter and lithographer (1900–). Born in Sandy, he studied at the Royal College of Art, London, and worked as a textile designer before devoting himself to painting. Tunnard's paintings, although nonrepresentational, are based upon the traditional receding space of landscape, for example, *Fugue* (1938; New York, Museum of Modern Art). He sets subtly colored mechanical or abstracted natural forms against a background of land or sea and sky, at times playing upon perplexing positional relationships, as in *Project* (1946; London, British Council).

TUNNEL VAULT, *see* VAULT.

TUOTILO IVORIES. Carolingian diptych in the library of the former Monastery of St. Gall. It is now the cover of an Evangelium longum. According to Ekkehard's history of St. Gall, a monk called Tuotilo (fl. 895–912) carved these ivory reliefs, which are among the finest creations of Carolingian art. One panel shows the Assumption of the Virgin and scenes from the life of St. Gall; the other, Christ in Majesty.

BIBLIOGRAPHY. E. T. De Wald, "Notes on the Tuotilo Ivories in St. Gall," *Art Bulletin*, XV, 1933; A. Goldschmidt, *Die Elfenbeinskulpturen...*, vol. 1, Berlin, 1914.

TURA, COSIMO. Italian painter, founder of the Renaissance school of Ferrara (before 1430–95). He was court painter to the Duke of Ferrara. Many documents record Tura's works (almost all lost), from designs for dishes and

Cosimo Tura, *St. Dominic in Prayer*, detail. Uffizi, Florence.

banners to large paintings. Later he painted increasingly for churches, and many of these works survive. Hardly any dates of works are known.

Tura's major paintings are *Allegorical Figure* (London, National Gallery), done for a ducal decoration, probably early; *Two Saints* (Philadelphia Museum of Art); *Madonna with Sleeping Child* (Venice, Academy); a small altarpiece (Ajaccio, Fesch Museum); organ doors for Ferrara Cathedral (1468–69); *Madonna in a Garden* (Washington, D.C., National Gallery); *Pietà* (Venice, Correr Museum); *Roverella Altarpiece* (perhaps 1474, or later; parts in London, National Gallery; Rome, Colonna Gallery; San Diego, Fine Arts Gallery; and small pieces elsewhere); saints from an unidentified altarpiece (Berlin, Caen, Paris, Florence, Nantes, and New York); and *St. Anthony* (probably 1484; Modena, Este Gallery). The view that he worked on the frescoes of the Schifanoia Palace is incorrect.

Tura's style is unmistakable, almost mannered; it is enamel-like and brilliant, with intricate twisted lines. Since no strong artist preceded him in Ferrara, his inspiration has been much debated. There is not very much basis for connecting him with the Squarcione school or with Piero della Francesca. He was evidently affected by Andrea Mantegna, much impressed by Rogier van der Weyden's color and figure style during the latter's visit to Ferrara in 1450, and perhaps fundamentally influenced in modeling and expression by Antonio Pisanello, the leading visitor to Ferrara in the 1440s.

Tura's development is equally uncertain and disputed. A possible definition would take as signposts the London allegory, with its relatively thin line and rounded rhythms, for the early phase; the *Roverella Altarpiece*, with its relatively solid and squarish forms, for a mature work; and the *St. Anthony*, where the willful twists of pasty drapery are most familiar, as a late work. The majority of his works are of this last type, and not surprisingly have been dated throughout his whole life. He was neglected in his late years and soon forgotten, but is attractive to modern taste because of his nervous stylization and brilliant color.

BIBLIOGRAPHY. S. Ortolani, *Cosmè Tura, Francesco del Cossa, Ercole de' Roberti*, Milan, 1941; E. Ruhmer, *Tura: Paintings and Drawings*, London, 1958. CREIGHTON GILBERT

TURCHI, ALESSANDRO (L'Orbetto). Italian painter (b. Verona, 1588/90; d. Rome, ca. 1648). He was in Rome by 1620, and after an initial Caravaggesque phase (*Hercules*, ca. 1620; Munich, Old Pinacothek), he moved in the direction of Bolognese classicism (*S. Ubaldo and S. Carlo Borromeo*, Camerino, S. Venanzio).

BIBLIOGRAPHY. Venice, Mostra della pittura del seicento a Venezia, 1959, *La pittura del seicento a Venezia* (catalog), 2d ed., 1959.

TURIN: MUSEUMS. Important public art collections in Turin, Italy, are located in the museums listed below.

Egyptian Museum (Museo Egizio). Founded in 1824, this museum ranks as one of the leading Egyptological collections of Europe. The black granite statue of Rameses II is the most imposing of a number of important pieces of royal statuary. There are also paintings, funerary objects, and papyri.

BIBLIOGRAPHY. E. Scamuzzi, *Egyptian Art: Paintings, Sculpture, Furniture, Textiles, Ceramics, Papyri*, New York, 1965.

Alessandro Turchi, *SS. Ubaldo and Carlo Borromeo*. S. Venanzio, Camerino, Italy.

Municipal Museum of Ancient Art (Palazzo Madama). The extensive collections of this museum, which is housed in the Palazzo Madama, include paintings, wood carvings, furniture, tapestries, glass, ceramics, and ivories. Its two most famous possessions are the *Portrait of a Man* by Antonello da Messina and the Turin-Milan Hours illuminated by Jacquemart de Hesdin and others.

BIBLIOGRAPHY. M. Bernardi, *Il Museo Civico d'Arte Antica, di Palazzo Madama a Torino*, Turin, 1954; L. Mallé, *I Dipinti del Museo d'Arte Antica: Catalogo*, Turin, 1963.

Sabauda Gallery. Reopened in 1959 in a striking modern installation, the Sabauda Gallery ranks as the main collection of paintings in Turin. It is remarkable among Italian museums for its Flemish primitives (Jan van Eyck, Rogier van der Weyden, Memling, and Petrus Christus) and Flemish and Dutch 17th-century works (Van Dyck, Rubens, and Rembrandt). Apart from the local Piedmontese artists, the Italian contingent includes Fra Angelico, Bronzino, Tintoretto, Veronese, Savoldo, Carracci, Guercino, Tiepolo, and Bellotto. The gallery incorporates the former Gualino Collection, which is noteworthy for a *Madonna* attributed to Cimabue. There is also a small group of paintings from the French, Spanish, and German schools.

BIBLIOGRAPHY. C. Aru and E. de Geradon, *La Galerie Sabauda de Turin* (*Les Primitifs flamands*, vol. 1), Antwerp, 1952.

TURIN-MILAN HOURS (Tres belles heures de Notre Dame). Franco-Flemish illuminated manuscript by Jacquemart de Hesdin and others. The surviving part is in the Municipal Museum of Ancient Art, Turin; two lost parts were formerly in the Royal Library, Turin, and the Rothschild Collection, Paris. *See* HESDIN, JACQUEMART DE; VAN EYCK, JAN.

TURKEY, NATIONAL MUSEUM OF, ISTANBUL, *see* ISTANBUL: ARCHAEOLOGICAL MUSEUM.

TURKISH ARCHITECTURE, *see* ISLAMIC ARCHITECTURE (TURKISH ARCHITECTURE); OTTOMAN ARCHITECTURE.

TURKISH CERAMICS, RUGS, SCHOOL OF PAINTING, TEXTILES AND EMBROIDERY, *see* ISLAMIC PAINTING (TURKISH SCHOOL); ISLAMIC POTTERY AND TILES (TURKISH CERAMICS); ISLAMIC TEXTILES (TURKISH TEXTILES); RUGS, NEAR AND MIDDLE EASTERN (TURKISH RUGS).

TURKOMAN RUGS, *see* RUGS, NEAR AND MIDDLE EASTERN (TURKOMAN RUGS).

TURKU (Abo) CATHEDRAL. Most important Gothic church in Finland, built about 1286, largely of brick. The plan consists of three aisles of nearly equal height. The western tower was added in 1310.

TURMANIN, DER, *see* TOURMANIN, DER.

TURNBULL, WILLIAM. British sculptor (1922–). Turnbull was born in Dundee, Scotland. He studied at the Slade School in London (1947–48), following military service. He has exhibited at the Galerie Maeght in Paris, at

the Venice Biennale, and in London and New York. His style is abstract, with personal, cryptic symbolism.

BIBLIOGRAPHY. M. Seuphor, *The Sculpture of This Century*, New York, 1960.

TURNER, CHARLES. English engraver (b. Woodstock, 1773; d. London, 1857). Turner made more than 900 plates, 638 of them mezzotint portraits. He also did aquatints and dotted engravings after leading contemporary English painters.

BIBLIOGRAPHY. A. Whitman, *Charles Turner*, London, 1907.

TURNER, JOSEPH MALLORD WILLIAM. English painter (b. London, 1775; d. there, 1851). His father, a barber, encouraged his early efforts in art, hanging up the boy's drawings in his shop and selling them for a few shillings apiece. In 1789 Turner enrolled in the Royal Academy schools, where he worked intermittently for four years. He also studied with Thomas Malton, Jr., who taught him perspective and trained him in the art of the topographical water color. Beginning in 1790, he regularly exhibited water colors at the Royal Academy. For three years, from about 1794, he was employed, together with Girtin, by Dr. Thomas Monro, the famous connoisseur, in copying drawings by J. R. Cozens.

In 1791 Turner visited Bristol. This was the first of a long series of sketching tours which took him to all parts

Turku Cathedral. Important Gothic edifice in Finland.

J. M. W. Turner, *The Fighting Téméraire*. National Gallery, London.

of Great Britain. Eventually his trips extended to the Continent as well, starting with a trip to France and Switzerland in 1802. From 1817 he made frequent visits that continued until old age prevented him from traveling.

While always basically a water-colorist, Turner became increasingly occupied with oil painting, especially since it was essential for the gratification of his academic ambitions. He was elected an associate of the Royal Academy in 1799 and a full academician in 1802. The following year he exhibited *Calais Pier*, among the first of his great seapieces, which, though criticized, caused a sensation and accelerated the growing demand for his work. To facilitate meeting this demand, he opened a gallery of his own at his establishment in Queen Anne Street. In 1807 he was appointed professor of perspective at the Academy, a post he held for thirty years in spite of the fact that he delivered required courses of lectures with the utmost irregularity.

During these years Turner acquired several aristocratic patrons, some of whom also became close personal friends, notably Walter Fawkes and the Earl of Egremont. These men faithfully continued to purchase his work despite a gradually rising flow of adverse criticism. The chief instigator of this criticism was Sir George Beaumont, the influential collector, whose sense of Claudian propriety was offended by Turner. But he also had defenders, among them Sir Thomas Lawrence and many of the younger artists. At Lawrence's urging he first visited central Italy in 1819, producing some 1,500 pencil drawings in the vicinity of Rome and Naples. On this occasion he also paid the first of his three visits to Venice, which was to become a perennial inspiration in his later years.

Turner devoted much time to drawing for engraving. In the 1790s he executed topographical drawings for Walker's *Copper Plate Magazine* and in later years produced numerous illustrated volumes and series, of which *The History of Richmondshire* (1818) and the *Picturesque Views of England and Wales* (1827–28) are outstanding examples. The unfinished *Liber Studiorum* (1807–19), inspired by Claude Lorraine's *Liber veritatis*, is unique in that the artist himself worked on the plates, in some cases performing the entire operation of etching and mezzotinting.

As his art gradually became more luminous and visionary, criticism mounted and demand abated. The critics were dismayed by the dazzling color of his great fantasy machine, *Ulysses Deriding Polyphemus* (London, National Gallery), which was exhibited in 1829. His later, more abstract paintings baffled them even more, though occasionally he still scored successes with popular subjects, such as *The Fighting Téméraire* (1839; London, National Gallery). A few writers defended him, notably Ruskin, whose first volume of *Modern Painters* (1843) was essentially a vindication of the later Turner. Such writing helped to arouse the interest of a new group of patrons, middle-class merchants and manufacturers such as Joseph Gillott, the pen maker. But it was chiefly the earlier work that these men purchased.

Always solitary to a degree, Turner now verged on the recluse, and apart from his work only two matters interested him. One was the activities of the Royal Academy, which he served as deputy president in 1845–46

during the illness of Sir Martin Shee; the other was his frequently revised will, through which he hoped to leave his unsold pictures to the nation, housed in a permanent gallery, and to use his considerable fortune for establishing a home for "decayed English artists." Years of litigation ended in the frustration of Turner's will, but his artistic remains did eventually become the nation's property: 282 oil paintings are in the Tate Gallery, and 19,751 water colors and drawings in the British Museum. These constitute by far the most important collections of his work.

Turner's range was extraordinarily comprehensive; it has been said that he sums up the entire history of landscape painting. After mastering the topographical style, under the influence of Dayes, he rapidly absorbed the lessons of Cozens, Wilson, Claude Lorraine, Poussin, Cuijp, and the Dutch sea painters. He could switch with ease from the naturalistic to the ideal, from architectural minutiae to gale-swept seas, from classical serenity to sublime and stormy mountains. In 1812 he began his emulation of Claude Lorraine, which, fortified by exposure to Italy, led to his ultimate preoccupation with light. At all times he was aided by an incredibly retentive visual memory.

As did other romantic landscapists, Turner sought freedom through intimacy with nature, but like his fellow Londoner Girtin, he could visualize this intimacy only as something remote. For Turner, the introvert, the constructions and concerns of humanity, with which the foreground of the painting was traditionally identified, were an impediment through which he had to struggle in order to attain his release. This struggle gives his art its uniquely dynamic character, and the history of his development is essentially the history of his changing conception of these social barriers and the consequent changes in the concept of nature toward which he strives. At first it was the conventional foreground scheme of the 18th-century classical-picturesque type that had to be penetrated. But with the upheavals of the early 19th century—the Napoleonic wars and the accelerating Industrial Revolution—the picturesque framework becomes transformed into the activities of man in a realistic context and especially into the context of man's dramatic struggle for physical and economic survival in a world full of danger. For Turner it was only by engaging and triumphing (as he himself did) in the material conflicts of real life, which loom in the foreground, that the ultimate haven of peace in nature could be reached. His art is basically epic because he identifies his personal quest with the life of mankind in general. In his late work the distant goal becomes vague and ethereal, dissolving into a prismatic fantasy of luminous color—ever more abstract because ever less attainable in reality. The foreground elements also lose focus, but do not disappear; they simply become amorphous artifacts, the detritus of an industrial age.

BIBLIOGRAPHY. Sir W. Armstrong, *J. M. W. Turner*, London, 1902; C. Holme, ed., *The Genius of J. M. W. Turner, R.A.*, London, 1903; B. Falk, *Turner the Painter: His Hidden Life*, London, 1938; A. J. Finberg, *The Life of J. M. W. Turner, R. A.*, 2d ed., Oxford, 1961; L. Gowing, *Turner: Imagination and Reality*, New York, 1966.
DAVID M. LOSHAK

TURNER MOUND, OHIO. Complex of earthworks in Hamilton County, Ohio, probably constructed prior to A.D. 1500 by Indians of the Hopewell culture. The outer walls and mounds extend more than a mile along the Little

Miami River. This site is notable for the monumentality of its plan and for the intricacy of its enclosed oval raised platform and burial mounds.

See also HOPEWELL CULTURE; MOUND BUILDERS; NORTH AMERICAN INDIAN ART (EASTERN UNITED STATES AND CANADA).

BIBLIOGRAPHY. H. C. Shetrone, *The Mound Builders*, New York, 1930.

TURNER OF OXFORD, WILLIAM. English water-color landscapist (1789–1862). He was a pupil of John Varley. Turner's works were exhibited from 1808 at the Old Water-Colour Society and from 1807 to 1851 at the Royal Academy of Arts and at London galleries. He settled at Oxford about 1811 and taught drawing to local families and members of the university. He was careful in drawing and faithful in color, but his compositions lack force and he achieved only a moderate success. Turner is represented fairly generally in collections of English drawings and water colors.

BIBLIOGRAPHY. L. Binyon, *English Watercolours*, London, 1933; I. Williams, *Early English Watercolours*, London, 1952.

TURNOVO: SS. PETER AND PAUL. Small Bulgarian domed cruciform Byzantine church (14th cent.). Its interior is supported on six freestanding columns. Entered through a narthex, the building terminates in a choir with one apse. The exterior is ornamented with niches.

BIBLIOGRAPHY. M. Bichev, *Architecture in Bulgaria*, Sofia, 1961.

TURONE. Italian painter (fl. Verona, mid-14th cent.). Like many Veronese artists of his generation, he was influenced by the sturdy figure style of Giotto. In Turone's polyptych with the Trinity and saints in the Castelvecchio Museum (1360) and the *Crucifixion* fresco in S. Fermo Maggiore, both in Verona, this influence is vigorously expressed but in the context of strangely fluid draperies and crudely detailed features and space.

TURRET. Small tower. Medieval turrets containing stairs often connected several stories, such as those marking the corners of Tattershall Castle, Lincolnshire. Glamis Castle in Scotland has a proliferation of small and large turrets, indicating the decorative use to which turrets were later put. Circular and polygonal turrets were common in German Romanesque, as in St. Gereon, Cologne.

TUSCAN ORDER. Style of Roman architecture classified as one of the five main types, or orders, of classical work. Not used by the Greeks, it is of Roman origin. It is a simplified version of Roman Doric, which Sir William Chambers, after Palladio, distinguished as a separate type. The Tuscan column is about seven diameters high and has an unfluted shaft. Unlike Greek Doric, it has a base. Its capital adds several moldings to its Greek Doric precedent. The Tuscan entablature is usually plain, as in the first tier of the Colosseum, Rome. The early-16th-century Tempiet-

Tomb of Tutankhamen. The inner sarcophagus of the Pharaoh. Egyptian Museum, Cairo.

to in S. Pietro in Montorio, Rome, is Tuscan, its entablature containing Doric triglyphs.

TUSHITA (Tusita). Heaven in which Buddha lived before manifesting himself on earth.

TUTANKHAMEN, TOMB OF. Treasure-laden burial place of Tutankhamen (fl. ca. 1350 B.C.), the 18th-dynasty Pharaoh, located in Egypt's Valley of the Kings. The source of one of the richest finds in the history of archaeology, the tomb was discovered in 1922 by the English archaeologists Lord Carnarvon and Howard Carter. Though the Valley of the Kings had been thoroughly explored long before this expedition, Carter, the Egyptologist of the team, was convinced from miscellaneous artifacts found in earlier excavations that the tomb of Tutankhamen still lay buried. He chose a triangular area bounded by the tombs of Rameses II, Rameses VI, and Meren-Ptah, and began excavating in 1917. In November, 1922, after several winters of work with meager results, Carter turned to the area at the base of the tomb of Rameses VI where modern workers' huts were grouped. There he found buried stairs leading down to a sealed doorway. On the other side a rubble-filled passage led to a second sealed door behind which the excavators found a richly appointed room (the Antechamber), measuring about 26 by 12 feet. Among the contents of the room were a splendid gilded throne, three golden animal-sided couches, four highly decorated golden chariots, a magnificent painted wooden casket, two black wooden statues, alabaster vases, and various art objects of an unexpected quality for their period.

Two additional sealed doors led to more underground chambers. One in the west wall led to a small room (the Annex) measuring about 14 by 8.5 feet. Crowded into this room were a great number of objects—toys, chests, jewelry, weapons, and furniture—all in great disarray, apparently caused by robbers who had visited the tomb in ancient times. The second door, in the north wall of the Antechamber, led to the greatest discovery of all, the Burial Chamber of the Pharaoh, almost completely taken up by the fabulous Golden Shrine, measuring about 11 feet wide by 17 feet long by 9 feet high. This shrine was entirely covered with gold, with inlaid wall panels in blue faïence. Inside were three successively smaller golden shrines and the sarcophagus of Tutankhamen himself, a casket of yellow quartzite and rose granite measuring 8.8 feet long by 4.8 feet wide by 4.8 feet high. Within were three coffins, one inside another, and the now-famous golden mask of the Pharaoh. Inside the innermost coffin were a rich collection of jewelry and the mummy itself, for the most part badly deteriorated.

At the northeast corner of the Burial Chamber a low door led to a smaller room (the Innermost Treasury) measuring about 16 by 12.5 feet. This room contained a golden canopy, treasure caskets, statues, and various funerary and religious objects in gold and other precious materials. The contents of all four chambers of the tomb are at present on display at the Cairo Museum.

BIBLIOGRAPHY. H. Carter and A. C. Mace, *The Tomb of Tut-ankh-Amen*, 3 vols., London, 1923-33; C. Desroches-Noblecourt, *Tutankhamen*, New York, 1963.

EVANTHIA SAPORITI

TUY CATHEDRAL. Spanish church. The choir and the aisles of the transept of the Cathedral of S. María were begun in the last quarter of the 12th century in the Romanesque style. The rest of the building was completed with Gothic forms in the 13th century, and the three rectangular apses were altered and augmented in the late Gothic style between 1495 and 1499. The plan is a Latin cross. The five bays of the nave and two aisles and the transept are covered with rib vaulting. As in the Cathedral of Santiago de Compostela, the aisles, surmounted by galleries, run continuously around the nave and transept. A cloister with five bays on each side is attached to the north side of the Cathedral.

BIBLIOGRAPHY. V. Lampérez y Romea, *Historia de la arquitectura cristiana española en la edad media*, vol. 2, Madrid, 1909.

TWACHTMAN, JOHN HENRY. American painter, etcher, and teacher (b. Cincinnati, Ohio, 1853; d. Gloucester, Mass., 1902). He studied with Duveneck in Cincinnati and went with him to Munich in 1876, where he studied with Ludwig Loefftz. In 1879 Twachtman was in Venice with Duveneck and William Merritt Chase, and in 1881 he traveled in England and on the Continent.

His early landscapes were facile and thickly painted in the prevalent dark Munich style, elements of which are exhibited in *Landscape* (1878; Boston, Museum of Fine Arts), which was painted in Venice. Even during this early period, however, Twachtman characteristically concentrated on the scene before him and carefully avoided all literary subject matter or associations. From 1883 to 1885 Twachtman was mostly in Paris, where he studied with Boulanger and Lefebvre at the Académie Julian. It was at this time that he became acquainted with impressionism. This new concern with light and its pictorial equivalent gradually affected his painting, lightening his palette and making him more aware of tonal relationships. Unfortunately, most of the paintings of this Parisian period were lost in a shipwreck.

Twachtman's mature paintings, as well as his etchings, which give a visual impression of a scene rather than its details, show interesting parallels to the work of Whistler, especially in the use of principles of design derived from Japanese art and in color harmonies pitched around a core of hues or tones. These parallels were probably part of a general tendency of the period. But Twachtman was much more concerned with his personal version of impressionist light and atmosphere than with Whistler's somewhat self-conscious aestheticism. He used the impressionist broken color, but the result was a heavily worked film of subtly nuanced pigment in which simplified forms floated decoratively on the surface and yet retained some feeling of spatial recession, as in the landscape *Summer* (ca. 1900; Washington, D.C., Phillips Collection).

While Twachtman's paintings are generally delicate in treatment, the force of his simplifications sometimes gave them great compositional vigor and excitement, for example, *The Torrent* (ca. 1900; Washington, D.C., National Gallery). His late landscapes, especially snow scenes, are very high in key and much more atmospheric, for example, *The Waterfall* (ca. 1900; New York, Metropolitan

Museum). In 1898 Twachtman was one of the founders of The Ten. *See* TEN, THE.

BIBLIOGRAPHY. E. Clark, *John Twachtman*, New York, 1924; A. Tucker, *John H. Twachtman*, New York, 1931.

JEROME VIOLA

TWITCHELL, RALPH S., *see* RUDOLPH, PAUL MARVIN.

TYCHE. Mythological goddess representing luck or fortune in the classical world. The personification came to be identified with the fortune of individual cities when the sculptor Eutychides created a statue of the Tyche of Antioch, in Syria, after 300 B.C. Thereafter, Tyches were depicted as wearing crowns representing city walls and carrying cornucopias symbolizing wealth, types which persisted into the Christian period, being used to identify cities in illustrated manuscripts.

BIBLIOGRAPHY. C. R. Morey, *Mediaeval Art*, New York, 1942; G. M. A. Richter, *The Sculpture and Sculptors of the Greeks*, new rev. ed., New Haven, 1957.

TYCHE OF ANTIOCH. Greek sculpture of the Hellenistic period, now in the Vatican Museums, Rome.

TYMPANUM. Triangular area bounded by the sloping and horizontal cornices of a pediment, as in the classical examples of the Temple of Poseidon in Paestum and the Pantheon in Rome. The term also denotes, especially in Romanesque and medieval architecture, the round space in doorways between the lintel and the arch above it, as in La Charité-sur-Loire and the west portal of Chartres Cathedral in France.

TYPOGRAPHY. Art of arranging written and pictorial matter on paper so that it is readable and appealing to the eye. In book production, the typographer has at his disposal the font of type consisting of capitals, small capitals, lowercase letters, punctuation marks, numbers, and capital and lowercase italic. He also makes use of spaces, leads, rules (straight lines), an assortment of border decorations, head and tail pieces, the color and texture of the paper, the quality of ink, and the space on the page that is not imprinted.

The most important elements in a successful typographic design are composition and type. Often, in commercial work, an illustration is the prominent focal point and only a few lines of type are used; here, more radical designs and innovations are possible, since this medium is not meant to be read for hours at a time. The English typographer Stanley Morison wrote in 1930: "Type design moves at the pace of the most conservative reader. The good type-founder therefore realizes that, for a new fount to be successful, it has to be so good that only very few recognize its novelty. If readers do not notice the consummate reticence and rare display of a new type, it is probably a good letter."

The earliest example of printing from movable type is a small fragment of paper discovered in Mainz, Germany, in 1892, attributed to part of a book now called *The World Judgement* (ca. 1442) and thought to be the work of Johann Gutenberg. Since Gutenberg's time many a "good letter" has been designed by such men as William Caslon and John Baskerville. There are, however, three main styles of type: Old Style, derived from the old Ro-

man letter; Modern type, originated by Bodoni in 1659; and Gothic type, a simple letter sans-serif. These basic styles can be combined for infinite variation in type design. The point system is the standardized measure for type used throughout the Western world. One point is approximately $1/72$ of an inch; the pica, the most common unit of space measurement in printing, equals $1/6$ of an inch, or 12 points.

Type-setting machines used for book work are the monotype, which produces one character at a time, and the linotype, invented by Otto Mergenthaler in 1886, which casts the type from movable matrixes in lines or slugs and automatically justifies the line so that the right and left margins are consistently straight. The type is not distributed after use but is melted and recast. Continual improvements of type-casting machines allow their use for the finest printing, and as a larger selection of type faces and ornamentation is brought into use, the possibilities of the typographic art continue to grow.

BIBLIOGRAPHY. E. Berry, *Fundamentals of Typographic Art*, Chicago, 1930; S. Jennett, *Pioneers in Printing*, London, 1958.

ILSA KLOTZMAN

TYRANNICIDES, *see* CRITIUS AND NESIOTES.

TYSSENS, JAN BAPTIST. Flemish painter (fl. Antwerp, 2d half of 17th cent.). He was a painter of still life, featuring mainly warlike paraphernalia. He occasionally painted mythological scenes, which also embodied renderings of weapons, such as the Forge of Vulcan.

TYSSENS, PIETER, *see* THYS, PIETER.

TYTGAT, EDGARD. Belgian painter, book illustrator, and graphic artist (b. Brussels, 1879. d. there, 1957). He studied at the Brussels Academy. At first Tytgat worked in an impressionistic style. Such a painting as the nude in a hammock, *Le Reveil du printemps* (1921; Rotterdam, Boymans-Van Beuningen Museum), appears transitional between his early works and the Vuillard-like interiors he painted about 1920. After the middle 1920s he painted in a naïve, primitivistic style derived from Henri Rousseau and popular European prints, at times with great charm and humor, as in the circus subject *Le marchand de coco* (1927; Brussels, Museum of Modern Art). From the 1940s on he showed a lightened palette and a looser technique in landscapes, interiors, and such fables and legends as the *Embarquement d'Iphigénie* (1950; Brussels, Fine Arts Museum).

BIBLIOGRAPHY. J. Milo, *Edgard Tytgat*, Paris, 1930; M. Roelants, *Edgard Tytgat*, Antwerp, 1948.

TZU. Chinese term that refers to one of the alternate names by which an artist may be known. Difficult to translate precisely into English, it is sometimes called "style name." The *tzu* is normally composed of two characters and traditionally was conferred upon an individual as a sign of maturity. It was the name by which most individuals were addressed in social discourse, since the use of the personal name (*ming*) was considered impolite except by members of the family.

See also HAO.

U

UBALDINI, DOMENICO, see PULIGO, DOMENICO.

UBERTINO, FRANCESCO D', see BACCHIACCA.

UCCELLO, PAOLO. Italian painter (b. Pratovecchio, 1397; d. Florence, 1475). Until recently the reputation of Paolo Uccello had remained fundamentally unchanged since the time of Vasari, who insisted on Uccello's obsession with perspective. This resulted in the application of such epithets as "scientific painter" and detracted from Uccello's considerable gifts and attainments as a decorator. None of his works displays a knowledge of or an interest in Renaissance one-point perspective, yet everything points to his involvement in work of a decorative nature—fresco, mosaic, *spalliere*, *cassoni*, and intarsia designs.

Little is known of Uccello's early training, although he does appear in the documents of Ghiberti's shop by 1407. He may have attached himself to an artist of the older generation, such as Starnina or Lorenzo Monaco, for his training as a painter. By 1415 he was registered in the guild of painters and by 1424 he had joined the Company of St. Luke. In 1425 he left Florence for Venice, where he executed a mosaic of St. Peter enthroned (now lost) for the façade of S. Marco. By 1431 he was again in Florence and from 1436 to 1445 was engaged in various programs for the Cathedral. In 1445 he executed the frescoes of the Giants (now lost) for the Casa Vitaliani in Padua. In Urbino from 1465 to 1469 he worked on a project for the Corpus Domini.

Of Uccello's early works only a few remain. The dossal executed for the Carmine church and the mosaic in Venice have both vanished without a trace. In S. Maria Novella, Florence, frescoes seem to indicate the characteristics of this early style. Although there has been much discussion about their date and authorship, the frescoes of the *Creation of Adam* and the *Creation of the Animals* together with the *Creation of Eve* and the *Fall of Man* were proba-

Paolo Uccello, *Battle of San Romano*, detail. Louvre, Paris.

bly executed by Uccello shortly after his return from Venice. The much-damaged frescoes representing scenes from monastic legends in S. Miniato al Monte may well date from this early period, although some scholars have dated them as late as 1440.

Uccello's greatest period of productivity, in both quality and quantity, falls between 1436 and 1460, when he created the *John Hawkwood*, the *Flood*, and the *Battle of San Romano*, the cornerstones of his reputation. The fresco monument to the English *condottiere* Sir John Hawkwood was commissioned by the directors of the Florence Cathedral in 1436. Uccello began the imposing fresco immediately but was required to efface it and begin again after the lapse of one month because the commissioners felt it was "not painted as it should be." Uccello received final payment in August, 1436. Uccello's concern with decorative qualities is clearly indicated here; he makes both horse and rider the vessels for repeated geometric forms. The restrained color and the simplicity of the shapes owe a great deal to sculpture, but it is primarily as a painter and decorator that Uccello functions in this early masterpiece. The fresco apparently brought Uccello a number of commissions from the Cathedral, for in 1443 he decorated the clock face on the interior façade with the heads of four prophets and provided cartoons for two stained-glass windows, *The Nativity* and *The Resurrection*, in the drum.

About that time he returned to S. Maria Novella, where he painted the *Flood* (ca. 1450), formerly considered the prime example of Uccello's mastery of perspective. It has two separate vanishing points and is in no way related to the "legitimate construction" of Alberti and others. It has recently been suggested that Uccello was, in fact, attempting to illustrate the errors of vision listed by the medieval theorist Vitellius. As a result, the chaotic nature of the event is further heightened. The strong nobility of the male figure on the right is a symbol of Renaissance optimism opposed to the savagery of man and nature. The tendency already observable in Uccello's early work of maintaining the integrity of the decorative surface is con-

tinued here, as it is in the much-damaged frescoes at S. Martino alla Scala, despite the apparent use of perspective.

Perhaps Uccello's best-known paintings of this period are panels (ca. 1455) for the Medici Palace representing the *Battle of San Romano* (Paris, Louvre; Florence, Uffizi; London, National Gallery). Each of the three paintings is self-contained rather than part of a decorative frieze, although the paintings were probably intended to be placed in series in the great hall of the Medici Palace to commemorate a battle of 1432 in which the Florentine troops crushed their Sienese adversaries. Despite the apparent use of perspective in the fallen bodies and spears, Uccello is clearly not concerned with the illusion of deep space, for he closes off the backgrounds with flat, almost scenographic, landscapes. The paintings were intended to serve a decorative function, and as such they best represent the mind of the artist.

The last part of Uccello's career was apparently full of frustrations. From the high point of the *Battle of San Romano*, Uccello fell to works of a minor nature and received very few commissions. In Urbino he executed for the Corpus Domini Society the predella of the altarpiece, *The Profanation of the Host* (1465–69; Urbino, National Gallery), but did not receive the commission for the altarpiece itself. Of the extant works from the end of his career the *Hunt* (ca. 1460; Oxford, Ashmolean Museum) indicates that he had not entirely lost his gifts, but that he had turned to decoration on a more modest scale. He may have designed *cassoni*, as Vasari suggests. Uccello strongly influenced minor Florentine masters and may have influenced Piero della Francesca as well.

BIBLIOGRAPHY. J. Pope-Hennessy, *The Complete Works of Paolo Uccello*, London, 1950; *Mostra di quattro maestri del primo Rinascimento* (exhibition catalog), Florence, 1954; A. Parronchi, "Le Fonti di Paolo Uccello: I 'Perspettivi passati'," *Paragone*, VIII, May, 1957; J. White, *The Birth and Rebirth of Pictorial Space*, London, 1957.

JOHN R. SPENCER

UDAYAGIRI (Udaygiri; Udaigiri), BHOPAL. A hill about 30 miles northeast of Bhopal in Madhya Pradesh, India. It contains important architectural and sculptural remains of the Gupta period. The best-known work of art is a monumental relief carving of about A.D. 400 in a niche of the hill, depicting Vishnu in his boar incarnation raising Prithvī, the Earth-Goddess, from the sea. On the hill there are also many Brahmanical temples, largely rock-cut with some construction, a rock-cut Jain temple, and fragmentary remains of a Buddhist stūpa and a lion pillar.

See also INDIA.

BIBLIOGRAPHY. P. Brown, *Indian Architecture*, vol. 1: *Buddhist and Hindu Periods*, 4th ed., Bombay, 1959.

UDAYAGIRI, ORISSA, see KHANDAGIRI AND UDAYAGIRI, ORISSA.

UDEN, LUCAS VAN. Flemish landscape painter and engraver (b. Antwerp, 1595; d. there, 1672). He became a master in 1627. Van Uden is said to have painted numerous landscape backgrounds for Rubens, and in fact repeatedly copied from the master. On his own, he shows himself at his best in paintings whose style proceeds from the flat landscapes of Josse de Momper. When he worked in smaller sizes, the conception often approached that of Jan Breughel I. The figures in his paintings were executed by David Teniers the Younger, Hendrik van Balen, Pieter van Avont, and Gonzales Coques. Van Uden was also a competent etcher and draftsman who sometimes worked after Rubens, Titian, and other Venetians. *Landscape with a View into the Distance* (Munich, Old Pinacothek) exemplifies the most attractive aspect of his manner.

BIBLIOGRAPHY. R. Delevoy, "L'Oeuvre gravé de Lucas van Uden," *Revue Belge d'Archéologie et d'Histoire de l'Art*, X, 1940; Y. Thiéry, *Le Paysage flamand au XVIIe siècle*, Brussels, 1953.

UDINE, MARTINO DA, see PELLEGRINO DA SAN DANIELE.

UFFENBACH, PHILIPP. German painter and etcher (b. Frankfurt am Main, 1566; d. there, 1636). He studied with Adam Grimmer, the son of Grünewald's pupil Johann Grimmer. Uffenbach's works show the influence of Dürer, Grünewald, and also certain Venetian masters. Among his main works are *Crucifixion* (1588; Frankfurt, Historical Museum) and the high altar of the Dominican church in Frankfurt (1599). His etchings include *Resurrection* (1588). Uffenbach taught Adam Elsheimer.

UFFIZI PALACE, FLORENCE. Italian palace, spreading in two wings toward the Arno River. It was commissioned by Cosimo I de' Medici from Giorgio Vasari in 1560 and was finished by Buontalenti and by Alfonso di Santi Parigi, a follower of Ammanati, in 1581. Built to contain the offices of the Magistrates of the Mint of Florence, it now houses the painting and drawing collection known as the Uffizi Gallery. *See* FLORENCE: MUSEUMS (UFFIZI GALLERY).

On each side of a narrow street a long portico raised on steps is divided into bays by piers containing niches and side pilasters. Above a projecting cornice, supported by a high architrave, is a low mezzanine with square windows in groups of three, framed by long consoles. Small pilasters surmounting the consoles carry another projecting cornice. Above this cornice is a high story of windows, again arranged in groups of three, separated by pilasters. Each window has a small balustrade at the foot and is surmounted by a heavy pediment; the outer pediments are triangular, and the central one is round arched. Another cornice supports the top story, whose flat pilaster and window arrangement echoes the lower groupings; in this case, however, the arrangement is partly swallowed by the overhanging eaves.

Behind the colonnade runs a barrel-vaulted space with doors and windows on the closed side. The vault is decorated with a pattern of rectangular and circular coffers. The windows are in sets of two; each has a rectangular panel below it and an oval bench. A rectangular bench is placed between the two windows of each set. The doors and windows have projecting cornices and hanging consoles reminiscent of Michelangelesque detail. A second architrave with consoles decorates a grille above each door. The detail on the wooden leaves is also developed from Michelangelo.

The opposing street façades of the galleries, composed of repeated small units, lack the unifying symmetry that the Renaissance gave to such palace façades by means of a play between major and minor accents of the architectur-

Ugolino da Siena, *Way to Calvary*, panel from a polyptych executed for Sta Croce in Florence. National Gallery, London.

al elements. These façades merely serve as a corridor, leading the eye swiftly toward the Piazza della Signoria. It is a new idea and one characteristic of mannerism, based on Michelangelo's Campidoglio palace façades.

The two wings of the Uffizi are connected at the end near the Arno by an airy portico, a Palladian type of opening that breaks into the architrave. The second story has round-arched windows. In front of the central window is a sculptural group by Vincenzo Danti showing Cosimo between allegorical figures.

In 1565 a corridor was built to unite the Uffizi Palace to the Pitti Palace on the other side of the river. A simple succession of arches continues rhythmically to the Ponte Vecchio, disappears behind the old houses there, and reappears momentarily at the center of the bridge.

When Vasari died in 1574, Buontalenti continued the work, building the gallery and the octagonal tribuna in the east wing.

BIBLIOGRAPHY. A. Venturi, *Storia dell'arte italiana*, vol. 11, pt. 2, Milan, 1939.

RAYMOND LIFCHEZ

UGARIT, *see* RAS SHAMRA.

UGARTE ELESPURU, JUAN MANUEL. Peruvian painter (1911–). Born in Lima, Ugarte Eléspuru began his studies in Europe, completed them in Buenos Aires, and first exhibited in Santiago (1938). He has painted oils and fresco murals (for example, 1956; Lima, Ministry of Edu-

cation) and has made mosaic murals (for example, a nonobjective mural on the exterior of the Universal Building in Lima, ca. 1960). In 1957 he became director of the National School of Fine Arts in Lima.

BIBLIOGRAPHY. S. Catlin and T. Grieder, *Art of Latin America since Independence*, New Haven, 1966.

UGO DA CARPI, *see* CARPI, UGO DA.

UGOLINO DA SIENA (Ugolino de Neri). Italian painter (fl. 1295–ca. 1339). Although many works have been attributed to him, Ugolino's only authenticated painting is a polyptych executed for Sta Croce in Florence. Its major panels are in the Picture Gallery, former State Museums, Berlin; others are in the National Gallery, London, and the Budapest Museum. Vasari claims Ugolino as a student of Cimabue, and there is evidence of his influence at least in the impressive monumentality of Ugolino's single figures. Ugolino was probably a follower of Duccio, as the elongated, Gothicized forms would indicate, although, unlike those of Duccio, his compositions of more than one figure are flat and strung out, as in the *Way to Calvary* in the National Gallery, London.

UGOLINO DI TEDICE. Italian painter (fl. 1273–77). Ugolino was a minor artist to whom a *Crucifixion* in S. Pierino in Pisa has been attributed. His brother Enrico and his son Rainerio painted similar works.

BIBLIOGRAPHY. P. Bacci, "Un Crocifisso ignorato di Giunta Pisano," *Bollettino d'arte*, IV, Dec., 1924.

UGOLINO DI VIERI. Italian goldsmith (fl. from 1329; d. 1380/85). Ugolino was one of a group of 14th-century Sienese goldsmiths who developed a technique of applying translucent enamels over engraved silverleaf. Probably in collaboration with Viva di Lando and Bartolommeo di Tommè, he employed this method in executing the scenes of the Passion and of the miracle of Bolsena on a reliquary in the form of a Gothic gabled triptych (1338; Orvieto, Cathedral, Chapel of the Corporale).

BIBLIOGRAPHY. F. Rossi, *Italian Jeweled Arts*, New York, 1954.

UHDE, FRITZ VON. German painter (b. Wolkenburg, 1848; d. Munich, 1911). In his youth Uhde was a member of the Saxon army; he did not begin his artistic training until 1876, when he began studying the old masters under Lenbach's direction in the Bavarian State Picture Galleries in Munich. Piloty and Makart also influenced Uhde's early development. In 1879–80 Uhde was in Paris, where he studied with Munkácsy, and in Holland, where he studied the Dutch old masters. Back in Munich in 1880, Uhde became a close friend of Max Liebermann and through his influence turned to plein-air painting. From about 1884 to the end of his life Uhde was increasingly interested in religious subject matter. He strove to express the traditional Christian themes in a new realistic style and to set religious drama in a contemporary German peasant environment, for example, *Komm, Herr Jesu, sei unser Gast* (1886; Berlin, former State Museums) and *Sermon on the Mount* (1887; Budapest Museum). Uhde also painted fine portraits (*Actor Wohlmuth*, 1893, Oslo, National Museum; and *Senator Hertz and Wife*, 1906, Hamburg, Art Gallery) and genre subjects (*Sewing Room*, 1882; St. Louis, City Art Museum).

BIBLIOGRAPHY. F. von Ostini, *Uhde* (Künstler-Monographien, LXI), Bielefeld, 1902; H. Rosenhagen, ed., *Fritz von Uhde* (Klassiker der Kunst, XII), Stuttgart, 1908.

DONALD L. EHRESMANN

UHLMANN, HANS. German sculptor (1900–). He studied engineering first and then undertook sculpture in 1925. His first exhibition was in 1930. He taught at the Technische Hochschule in his native Berlin until 1933, meanwhile visiting France and Russia. He was a prisoner of war for several years and, following his release, became a professor at the Berlin School of Fine Arts in 1950. He has exhibited widely in Germany and abroad and was represented in "The New Decade" show at the Museum of Modern Art, New York, in 1955. Uhlmann's works, almost exclusively thin metallic arrangements, are abstract and technological in appearance, influenced directly by his engineering studies.

BIBLIOGRAPHY. E. Trier, *Moderne Plastik*, Frankfurt am Main, 1955.

UIJL, JAN JANSZ. DEN, *see* UYL, JAN JANSZ. DEN.

UJI. Small town 3 miles south of Kyoto, Japan. There are several temples of artistic importance near Uji. Originally a villa, the Byōdōin was turned into a Buddhist temple in 1052, when the breathtakingly beautiful Hōōdō (Phoenix Hall) was built overlooking a lake. Within is the seated figure of Amida in wood, attributed to the famous sculptor Jōchō. The *honden* (sanctuary) of the Ujigami shrine is a noteworthy example of Shintō architecture. The Mam-

Ukiyo-e. Hiroshige, *A Station of the Tokaido*. Wood-block print. Imperial Collection, Tokyo.

pukuji, a temple founded in 1659, contains a number of 18th-century paintings. *See* HOODO OF BYODOIN.

BIBLIOGRAPHY. T. Fukuyama, *Nihon no Tera* (Buddhist Temples in Japan), Tokyo, 1960.

UKHAIDIR, PALACE OF. Fortified palace of brick-vaulted rubble masonry, about 120 miles south of Baghdad, Iraq. It was probably begun in 778 by Isa ibn-Musa, a wealthy Abbasid prince. An outer enclosure roughly 560 feet square, oriented on the cardinal points, has an entrance in the center of each side. There is a rectangular inner precinct, in contact with the principal north façade for about 270 feet and extending south for about 370 feet. Within, a barrel-vaulted entrance hall gives access to a corridor that isolates an inner rectangle consisting of a court of honor. From the south wall of the court of honor opens a liwan (recessed porch) that leads to a square throne room, once domed. The plan shows derivation from Sassanian prototypes through Kufa and Mshatta and gives precedent for the Samarra palaces.

BIBLIOGRAPHY. O. Reuther, *Ocheïdir*, Leipzig, 1912; K. A. C. Creswell, *A Short Account of Early Muslim Architecture*, Harmondsworth, 1958.

UKIYO-E. Japanese paintings and wood-block prints of genre subjects. They were particularly popular in the Edo period (1615–1867). Ukiyo-e (pictures, *e*; of the floating world, *ukiyo*) that depicted the manners and customs of

ordinary people became very important in the late Momoyama period, when the Kanō and Tosa schools of painters first adopted genre subjects in their works. *See* KANO SCHOOL; TOSA SCHOOL.

Ukiyo-e gained greater popularity in the middle of the Edo period, when the teeming city of Edo (modern Tokyo) was enjoying the first affluence in Japanese history. Kabuki theaters and Yoshiwara (gay quarters of Edo) were centers of pleasure and leisure, and there was a great demand for paintings of actors and courtesans. When Moronobu improved upon the technique of wood-block printing and published single-sheet prints at a small cost, woodcuts all but replaced paintings. From this time on, the word Ukiyo-e is almost synonymous with woodcuts. *See* MORONOBU.

In Moronobu's time prints were executed only in black and white. In the late 17th century the color *tan* (orange) was added by hand. In the early 18th century more colors —green, yellow, purple, and black lacquer—were applied to the prints by hand. In the 1740s printmaking technique was greatly advanced when two colors, red and green, were added by printing separate blocks; this type of print was known as *benizuri-e*. Harunobu gave a finishing touch to the many-colored prints when he discovered, in 1765, a technique to make fully developed color prints, called *nishiki-e* (brocade prints). *See* HARUNOBU.

Among the many great printmakers were Hiroshige, Hokusai, Kiyonaga, Sharaku, and Utamaro, as well as Moronobu and Harunobu. The death of Hiroshige at the close of the Edo period signaled the decline of Ukiyo-e printmaking. *See* HIROSHIGE; HOKUSAI; KIYONAGA; SHARAKU; UTAMARO.

See also JAPAN: GRAPHIC ARTS (EDO PERIOD); TORII SCHOOL; WOODCUT.

BIBLIOGRAPHY. J. A. Michener, *Japanese Prints*, Rutland, Vt., 1959; R. Lane, *Masters of the Japanese Print*, Garden City, N.Y., 1962; M. Narazaki, *The Japanese Print: Its Evolution and Essence*, Tokyo, Palo Alto, 1966.

MIYEKO MURASE

ULF (Ulft), JACOB VAN DER. Dutch landscape painter (b. Gorinchem, 1627; d. Noordwijk, 1689). Ulf's master is undocumented but may have been the Gorinchem painter Dirck Govaertsz. van Hedel. Ulf was in Rome about 1650, and from 1660 to 1679 he was magistrate in Gorinchem. In 1687 certain irregularities were discovered, and he was forced to make amends. He left Gorinchem shortly afterward. He painted Italianizing cityscapes, seaports, and landscapes with many small figures.

ULM: CATHEDRAL. German late Gothic cathedral. Begun as a hall church by the Parlers in 1377, it was altered to a basilican design by Ulrich von Ensingen in 1392, when the cornerstone of the west tower was laid. The nave was completed in 1471. Böblinger redesigned the tower and executed the upper story (1474–92). Work on the Cathedral ceased in 1543 because of the series of wars that drained the country's resources. The Cathedral was badly mutilated by the Protestant iconoclasts during the height of the Reformation. Restoration was not begun until 1844 and was finished in 1890, when the tower in the center of the west façade was completed (after Bö-

blinger's plan). The tower is 528 feet high. *See* ULRICH VON ENSINGEN.

Ulm Cathedral has a clerestory and a highly pitched roof. Flying buttresses connect the nave with the aisles. In 1507 Burkhard Engelberg of Hornberg, the new master mason, divided each of the aisles longitudinally by an arcade on slender columns and covered the double aisles with light star vaults. Each of the double aisles terminates in a pentagonal choir in the German Gothic manner.

The forty-eight beautiful choir stalls are by Syrlin the Elder (1469–74). There are several 15th-century wall paintings, a stained-glass window (ca. 1480) formerly attributed to Hans Wild, and a wonderful baldachino by the Master of Weingarten (1469). *See* SYRLIN, JORG, THE ELDER; WILD, HANS.

BIBLIOGRAPHY. "Ulm Cathedral and Its Restoration," *The Builder*, XLII, 1883; J. Baum, ed., *German Cathedrals*, New York, 1956.

LEON JACOBSON

ULM: MUNICIPAL COLLECTION OF ART AND CULTURAL HISTORY. German museum founded in 1875. It is housed in the so-called Kiechelhaus (ca. 1600) and two adjoining houses (partly 16th cent.) and is dedicated mainly to the art and culture of the region around Ulm. The collection includes finds from the Bronze Age and furniture, goldsmith work, and paintings from the Middle Ages to the present. Among the paintings are works by Martin Schaffner and B. Strigel; and there is sculpture by H. Multscher, among others. In the modern art collection the graphic works of masters of expressionism (Die Brücke and the Blue Rider) are well represented.

BIBLIOGRAPHY. H. Jedding, *Keysers Führer durch Museen und Sammlungen*, Heidelberg, Munich, 1961.

ULPIA BASILICA, ROME. Public hall in the Forum of Trajan, inaugurated A.D. 113. The basilica was a rectan-

Ulm, Cathedral. Late Gothic edifice, begun 1377.

gular building with a central nave surrounded by a double range of monolithic columns with Corinthian capitals, many of which are still standing. Galleries were carried over both aisles on the second story, and clerestory windows lighted the interior. Semicircular apses at the two narrow sides constituted the law courts.

BIBLIOGRAPHY. W. J. Anderson, R. P. Spiers, and T. Ashby, *The Architecture of Greece and Rome*, vol. 2: *The Architecture of Ancient Rome*, London, 1927.

ULRICH VON ENSINGEN. German architect of the Swabian school (ca. 1350–1419). In 1392 Ulrich was director of the works at the Cathedral of Ulm, and he retained this post when he moved to Strasbourg in 1399. At Ulm he is responsible for the west façade and tower, the two towers over the choir, and the Besserer Chapel (1410–14), as well as for transforming the nave from a Gothic hall church to a basilican design. In 1394–95 he was at the Cathedral of Milan. From 1399 until his death he directed the work at the Cathedral of Strasbourg, where he designed the crowning balustrade of the west façade and the tower as far up as the turret.

ULTRAVIOLET. Segment of the spectrum directly adjoining violet. It is invisible because its wavelength is below the millimicron pickup of the human eye. In conservation processes ultraviolet radiation is used to detect earlier restorations and to aid the restorer with inpainting.

UMA. Consort of the Hindu god Siva. Umā, whose name means "light," is identified with Devī.

UMAYYAD (Omayyad) AND ABBASID POTTERY (Persia and Mesopotamia), *see* ISLAMIC POTTERY AND TILES.

UMAYYAD (Omayyad) ARCHITECTURE. Islamic architecture began under the caliphs of the Umayyad line (661–750). Initially, existing churches and other structures were

Umayyad architecture. The Great Mosque in Damascus.

converted to the religious demands of Islam. At the same time, primitive mosques, of a plan type unrelated to those of buildings of earlier cultures in the areas now under Islam, were erected and were soon followed by more monumental and elaborately decorated mosques. Soon the Umayyad line established its residence in Syria, and a series of splendid mosques was erected, influenced in plan and decoration by the Christian architecture of the region and built by the local craftsmen. Of nomadic, tribal origin, these caliphs continued to turn to their traditional way of life and ringed the eastern desert limits of Syria with a number of fortified palaces, including Qusayr 'Amra, Qasr al-Hair, Qasr at-Tuba, and Mshatta. *See* MSHATTA PALACE; QUSAYR 'AMRA.

The semicircular arches long in use in these regions gave way to the pointed arch, one of the hallmarks of Islamic architecture. Materials already in use (cut-stone and rubble masonry, mud brick, and baked brick) continued to be used, with baked brick gaining ascendancy. Several major Umayyad monuments have survived; all were rebuilt and most were enlarged in later times. These include the Omar Mosque (Dome of the Rock) in Jerusalem, erected shortly before 700; the Great Mosque of Damascus; the Great Mosque, or Mosque of Sidi Okba, in Kairwan; and the Great Mosque of Harran, now very largely in ruins. *See* DAMASCUS; DOME OF THE ROCK, JERUSALEM; KAIRWAN: MOSQUE OF SIDI OKBA.

Throughout the period, influences from the Christian world of the Mediterranean littoral and from the Sassanian empire of Iran were strong, and conscript craftsmen from these regions were employed by the thousands, many to work on monuments that have long since vanished. The Umayyads diverted vast sums to the embellishment of these monuments, which were decorated with stone carving in low relief, with floral ornament and pictorial scenes in bright mosaics, and with marble paneling. The fortified residences on the edge of the Syrian Desert were rectangular areas enclosed by strong walls. They provided facilities for all needs and for every amenity (living quarters around interior courts, mosques, baths, and stables). Noteworthy was the fact that some desert palaces were enlivened by mural paintings depicting personages, although such representation of living figures was forbidden by the Islamic religion.

See also UMAYYAD ARCHITECTURE (SPAIN).

BIBLIOGRAPHY. K. A. C. Creswell, *A Short Account of Early Muslim Architecture*, Harmondsworth, 1958.

DONALD N. WILBER

UMAYYAD (Omayyad) ARCHITECTURE (Spain). By 711 much of Spain had been conquered by the Arab armies of Islam. When the line of Umayyad caliphs was all but wiped out in Syria, 'Abd ar-Rahman escaped and landed in Spain in 755 to found the Umayyad emirate of Cordova, which endured until the opening years of the 11th century. Few well-preserved monuments of these centuries survive; ruins abound. 'Abd ar-Rahman ordered the building of the Great Mosque of Cordova, and in Toledo sections of the Mosque of Bib Mardom, begun in 980, form part of a later church. *See* CORDOVA: MOSQUE.

The Alcazar palace in Cordova may have been started as early as 789. Another great palace, the Madinat az-Zahra, was begun near Cordova in 936, and hundreds of

αɑbcɩɔɛfʃh
ʋjlʕlɱnopqƒ
ɾʃɑcuuxyʒ

Uncial. Medieval script used by monastic calligraphers.

builders labored for sixteen years on the now vanished structure. Influences of Syrian origins and tastes, of Byzantine decorative techniques, and of local craftsmanship and materials mingle in the style of this period.

See also CORDOVA; MOORISH ARCHITECTURE (SPAIN).

BIBLIOGRAPHY. G. Marçais, *Manuel d'art musulman*, vol. 1, Paris, 1926.

UMAYYAD (Omayyad) PAINTING, *see* ISLAMIC PAINTING (UMAYYAD AND EARLY ABBASID PERIODS).

UMAYYAD (Omayyad) POTTERY (Iran and Mesopotamia), *see* ISLAMIC POTTERY AND TILES (UMAYYAD AND ABBASID PERIODS).

UMBRIAN SCHOOL. Traces of an indigenous Umbrian painting tradition go back to the late 12th century (frescoes in SS. Giovanni e Paolo, Spoleto). The Umbrian school truly emerged in the 14th century, when centers were established at Spoleto, Gubbio, and Orvieto. Guido di Palmeruccio in Gubbio was influenced by the Lorenzettis; Bartolommeo di Tommaso da Foligno worked in a style based upon that of the Marches; and Sienese influence was dominant in the painting of Ugolino di Prete Ilario in Orvieto. In the 15th century Perugia became an important center. Through Domenico Veneziano and Fra Angelico, Perugia absorbed much Florentine influence, as typified in the work of Benedetto Bonfigli. The climax of the Umbrian school was reached in the art of Perugino. *See* BONFIGLI, BENEDETTO; GUIDO DI PALMERUCCIO; PERUGINO.

BIBLIOGRAPHY. H. Keller, *Umbria*, New York, 1961.

UMBRO-FLORENTINE SCHOOL. Group of painters of Umbrian origin who either studied in Florence or were substantially influenced by Florentine art. The most important Umbro-Florentine painters were Piero della Francesca, founder of the tradition, Luca Signorelli, and Melozzo da Forlì. All were painters of great individuality, who adapted the Florentine sense of line and pictorial space to their own highly developed sense of monumentality. *See* MELOZZO DA FORLI; PIERO DELLA FRANCESCA; SIGNORELLI, LUCA.

BIBLIOGRAPHY. H. Keller, *Umbria*, New York, 1961.

UMEHARA, RYUZABURO. Japanese painter (1888–). He is often regarded as one of the two foremost Japanese painters in the Western style, the other being Yasui. Umehara studied in Paris with Renoir. After his return to Japan Umehara became more interested in fusing Western techniques of oil painting with traditional Japanese painting. After 1929 he made frequent visits to China, where he painted a series of Peking scenes in brilliantly contrasting colors. *See* YASUI, SOTARO.

UMLAUF, CHARLES. American sculptor (1911–). Born in Michigan, he studied at the Art Institute of Chicago and at the School of Sculpture in Chicago, and became professor of art at the University of Texas in Austin. He has received prizes from the Art Institute of Chicago, the University of Illinois at Urbana, the Ford Foundation (1960 purchase), and others. His style is based on a modified, sometimes almost schematic, interpretation of the human figure. He frequently interprets religious subjects.

UMMA (Jokha). Sumerian city of Mesopotamia. It was the great rival of neighboring Lagash, whose king, Eannatum, won a victory against Umma during the 3d dynasty of Ur (ca. 2450–2350 B.C.). This event is commemorated in the famous Lagash Stele of the Vultures, which shows the troops marching over the prostrate bodies of Umma soldiers, which birds of prey are already beginning to devour. *See* EANNATUM: STELE OF THE VULTURES.

BIBLIOGRAPHY. A. Parrot, *Sumer: The Dawn of Art*, tr. S. Gilbert and J. Emmons, New York, 1961.

UNCIAL. Early medieval script consisting of rounded capital letters. It was used by monastic calligraphers for the copying of Bibles. Uncial's legibility and uniformity made it the ideal lettering system until the 9th century. At that time, its use began to be reduced to chapter headings, titles, and initials by the rise of more rapidly written scripts such as half uncial and Caroline minuscule. *See* HALF UNCIAL; MINUSCULE.

UNDERGLAZE BLUE, *see* BLUE-AND-WHITE.

UNDERGLAZE PAINTING. Technique of decorating ceramic wares by the application of paint before glazing and firing. Clay surfaces are often coated with slip or engobe to provide a smooth base for painting, but wares can also be prefired and then ornamented by a wash of color brushed onto the porous biscuit surface. Before the introduction of heat-resistant metallic compounds in the 19th century, underglaze pigments were derived exclusively from iron, copper, and cobalt.

BIBLIOGRAPHY. D. Rhodes, *Clay and Glazes for the Potter*, New York, 1957.

UNDERGLAZE RED. Direct application of copper compounds on the body of Chinese ceramic wares before applying the glaze. The process was difficult for the Chinese to control since the copper tended to change to a green-black in the kiln. The technique was mastered in the Ming

dynasty during the reign of Hsüan-te (1426–35), when some of the finest pieces were produced.

UNDERPAINT. First stage in the execution of a painting, in which the general contours and tonal values of the major shapes are layed-in. The underpaint is customarily in monochrome.

UNESCO HEADQUARTERS, PARIS. Secretariat and conference hall for the United Nations Educational, Scientific and Cultural Organization, erected in 1953–58. It was designed by Breuer, Zehrfuss, and Nervi, with an advisory committee of Le Corbusier, Gropius, Lúcio Costa, Ernesto Rogers, and Markelius. The Secretariat is Y-shaped with curved arms and multiwindowed façades in the international modern idiom. A variety of sunshade devices are employed as needed and also provide a decorative effect. The outdoor spaces encompass a sculpture plaza, containing works by such artists as Henry Moore, Calder, and Arp, a ceramic patio wall designed by Miró, and a Japanese garden by Noguchi. The interior halls and conference rooms are decorated with murals and paintings by many artists, including Miró, Picasso, Afro, Appel, Matta, and Tamayo.

UNGUENTARIUM. Antique vessel, made of alabaster or faïence, used to contain ointments. The usual Greek unguentarium was round-bottomed with a narrow neck, like the alabastron, aryballos, and ampulla. In Christian art, Mary Magdalen holds an unguentarium, shaped like a jar with a lid, from which she takes the ointment to anoint the head of Christ.

UNION OF SOVIET SOCIALIST REPUBLICS (U.S.S.R.), MUSEUMS OF. See under the names of the following cities:
Leningrad. Hermitage.
Moscow. National Museum of Fine Arts (Pushkin Museum); Tretyakov Gallery.

UNIT ONE. Short-lived group of British artists organized primarily by the painter Paul Nash in 1933. Its members were the painters Edward Wadsworth, Ben Nicholson, Tristram Hillier, Edward Burra, John Bigge, and John Armstrong; the sculptors Henry Moore and Barbara Hepworth; and the architects Wells Coates and Colin Lucas. Herbert Read was its spokesman. One of the main aims of the group, according to Nash, was to give impetus to the structural aspects of art as opposed to the traditional tendency of the British artist to rely completely on nature. The group arranged the International Surrealist Exhibition in London in 1936. *See* ARMSTRONG, JOHN; BIGGE, JOHN; BURRA, EDWARD; COATES, WELLS W.; HEPWORTH, BARBARA; HILLIER, TRISTRAM PAUL; MOORE, HENRY; NASH, PAUL; NICHOLSON, BEN; READ, SIR HERBERT; WADSWORTH, EDWARD.

UNITED STATES, COLONIAL ART OF, *see* COLONIAL ART: UNITED STATES.

UNITED STATES, MUSEUMS OF. See entries under the names of the following cities:
Baltimore, Md. Baltimore Museum of Art; Walters Art Gallery.
Boston, Mass. Isabella Stewart Gardner Museum; Museum of Fine Arts.
Buffalo, N.Y. Albright-Knox Art Gallery.
Cambridge, Mass. Busch-Reisinger Museum of Germanic Culture; Fogg Art Museum.
Chicago, Ill. Art Institute of Chicago; Oriental Institute of the University of Chicago.
Cincinnati, Ohio. Cincinnati Art Museum.
Cleveland, Ohio. Cleveland Museum of Art.
Dallas, Tex. Museum for Contemporary Arts; Museum of Fine Arts.
Davenport, Iowa. Municipal Art Gallery.
Denver, Colo. Denver Art Museum.
Des Moines, Iowa. Des Moines Art Center.
Detroit, Mich. Detroit Institute of Arts.
Hartford, Conn. Wadsworth Atheneum.
Houston, Tex. Museum of Fine Arts.
Indianapolis, Ind. John Herron Art Institute.
Ithaca, N.Y. Andrew Dickson White Museum of Art, Cornell University.
Kansas City, Mo. William Rockhill Nelson Gallery of Art and Mary Atkins Museum of Fine Arts.
Lawrence, Kans. University of Kansas Museum of Art.
Lincoln, Nebr. Sheldon Memorial Art Gallery.
Los Angeles, Calif. Los Angeles County Art Museum.

Unkei, portrait statue of Mujaku, detail. Wood. Kōfukuji, Nara.

Manchester, N.H. Currier Gallery of Art.
Merion, Pa. Barnes Foundation.
Minneapolis, Minn. Institute of Fine Arts; Walker Art Center.
New Haven, Conn. Yale University Art Gallery.
New Orleans, La. Isaac Delgado Museum of Art.
New York, N.Y. Brooklyn Museum; Cloisters, The; Frick Collection; Guggenheim Museum; Hispanic Museum; Jewish Museum; Metropolitan Museum of Art; Museum of Modern Art; Museum of Primitive Art; Museum of the American Indian; Pierpont Morgan Library; Whitney Museum of American Art.
Northampton, Mass. Smith College Museum of Art.
Omaha, Nebr. Joslyn Art Museum.
Philadelphia, Pa. Pennsylvania Academy of Fine Arts; Philadelphia Museum of Art; University of Pennsylvania Museum.
Pittsburgh, Pa. Carnegie Institute.
Pittsfield, Mass. Berkshire Museum.
Providence, R.I. Rhode Island School of Design, Museum of Art.
Sacramento, Calif. E. B. Crocker Art Gallery.
St. Louis, Mo. City Art Museum.
San Diego, Calif. Fine Arts Gallery.
San Francisco, Calif. California Palace of the Legion of Honor; M. H. De Young Memorial Museum; Museum of Art.
San Marino, Calif. Henry E. Huntington Library and Art Gallery.
Sarasota, Fla. Ringling Museum of Art.
Seattle, Wash. Art Museum.
Toledo, Ohio. Museum of Art.
Washington, D.C. Corcoran Gallery of Art; Dumbarton Oaks Collection; Freer Gallery; National Fine Arts and Portrait Galleries; National Gallery of Art; Phillips Collection.
Williamstown, Mass. Sterling and Francine Clark Art Institute.
Wilmington, Del. Society of the Fine Arts (Delaware Art Center).
Winterthur, Del. Henry Francis DuPont Winterthur Museum.
See also PUERTO RICO, MUSEUMS OF.

UNKEI. Japanese sculptor (d. 1223). He was the son and pupil of Kōkei. His first known work is a statue of the thousand-armed Kannon (1164) in the Rengeōin of Kyoto. In his long and successful career Unkei trained many pupils, including his own sons, who often cooperated with him as members of the Kei school of sculptors. His most important and mature works are found in the Tōdaiji and the Kōfukuji in Nara. Two gigantic and fierce-looking guardian figures at the Nandaimon (South Gate) of the Tōdaiji, made within 70 days by Unkei and Kaikei with the help of numerous pupils, are a testimony to the new creative spirit and vitality of the period. Unkei's style was perfected in imaginary portrait statues of the 5th-century Indian theologians of Buddhism: Mujaku (Sanskrit, Asanga) and his younger brother Seshin (Sanskrit, Vasubandhu). *See* KAIKEI.

BIBLIOGRAPHY. R. T. Paine and A. Soper, *The Art and Architecture of Japan*, Baltimore, 1955.

Uppsala Cathedral. A major landmark of Swedish medieval architecture.

UNKOKU SCHOOL. School of Japanese painters founded by Tōgan. His first and second sons, Tōoku and Tōeki (1591–1644), were its only artists of any importance. The family preserved Tōgan's style of painting, which was based on Sesshū's art but executed in a more conventional and less inspired manner. Although the school never became a significant creative force in Kyoto, it continued to be active in the Yamaguchi area in western Japan, where Sesshū spent his later years. *See* SESSHU TOYO; TOGAN.

UNOLD, MAX. German painter, graphic artist, and writer (1885–). Born in Memmingen, he studied at the Munich Academy and had his first exhibition in 1912 with the Munich Secession. His early work was realistic; later he showed an interest in combining detail with a firm compositional structure.

UNSCHOOLED PAINTERS, *see* SUNDAY PAINTERS.

UPJOHN, RICHARD. American architect and writer (1802–78). Born in Shaftesbury, England, he arrived in the United States in 1829. After working in New England he went to New York City, where he built the famous Trinity Church (1839–46). Upjohn was a proponent of a purer Gothic and of Italianate modes. *See* TRINITY CHURCH, NEW YORK.

BIBLIOGRAPHY. E. M. Upjohn, *Richard Upjohn, Architect and Churchman*, New York, 1939.

UPPER VOLTA, *see* AFRICA, PRIMITIVE ART OF (WEST AFRICA).

UPPSALA CATHEDRAL. Swedish Gothic cathedral, dating from 1273. It is the largest cathedral in Scandinavia and the burial place of Swedish royalty. Its importance in Swedish medieval architecture is rivaled only by that of Lund Cathedral. Uppsala Cathedral was begun in 1273

on an English plan that included two transepts. The Romanesque stonework shows some evidence of work done by masons from Lombardy and the Rhineland.

The plan was altered in 1287 when the Frenchman Etienne de Bonneuil became the architect and built a Gothic *chevet* resembling that at Reims, at least in plan. The elevation is quasi-French, being tall yet heavy, with much flat-wall surface between the main arcades and the English clerestory. Begun in stone and finished in brick, Uppsala has undergone alterations, including nave chapels and a completely new west façade after a fire in 1702.

BIBLIOGRAPHY. T. Paulsson, *Scandinavian Architecture*, London, 1958.

UPRISING, THE. Oil painting by Daumier, in the Phillips Collection, Washington, D.C. *See* DAUMIER, HONORE.

UR (Tell Muqqayyir). Ur, in southern Iraq, is one of the largest archaeological sites in the Near East. Excavations were undertaken for twelve seasons, from 1923 to 1934, by the Joint Expedition of the British Museum and of the Museum of the University of Pennsylvania under Sir Leonard Woolley.

In antiquity Ur was surrounded on its west side by the Euphrates and a number of canals, each with its own harbor. In the center was a temenos, within and below which a number of structures were excavated: the Ziggurat of Ur, the temples built by rulers of the 3d dynasty of Ur (ca. 2125–2025 B.C.) and of the Neo-Babylonian period (612–539 B.C.), the palace and tombs of the 3d dynasty of Ur, and the Royal Cemetery of the 3d Early Dynastic period (ca. 2600–2340 B.C.). Among art objects dating from the 3d dynasty of Ur and later, the Stele of Urnammu (Philadelphia, University Museum) and some sculptures of the 3d dynasty of Ur and the Isin-Larsa period (2017–1763 B.C.) are noteworthy. *See* URNAMMU, STELE OF; ZIGGURAT.

The treasures from the Royal Cemetery, however, are still the most magnificent discoveries in the history of excavation in the Near East. The Royal Cemetery is situated in the southeastern side of the temenos and to the southwest of the massive stone tombs of the 3d dynasty of Ur. The stratigraphy of the Royal Cemetery is confusing, since it was used from prehistoric times as a dump as well as for a cemetery. Above virgin soil lay Ubaid and Jamdet Nasr remains (ca. 4000–3000 B.C.). Over these lay seal impression stratum levels 4 and 5, which produced quantities of seal impressions showing stylistic and iconographic connections with late Jamdet Nasr and Early Dynastic seal designs. In a thick layer of rubbish that overlay this seal impression stratum were the graves of the Royal Cemetery. The graves designated "royal" are of brick or stone; some are single chambers and others are multiroom structures; all are vaulted. These royal tombs, and the so-called death pits for the mass burial of the servants, musicians, charioteers, and soldiers who accompanied their masters to the netherworld, yielded vessels and weapons of gold and semiprecious stones, jewelry, musical instruments, and mosaic panels. *See* UR: HARP FROM ROYAL CEMETERY; UR: STANDARD.

To the west of the Royal Cemetery, building remains of the Early Dynastic and Jamdet Nasr periods were dis-covered. The so-called flood pit abutted on this prehistoric terrace. Below the flood pit, Jamdet Nasr and Ubaid levels were found which overlay another stratum of alluvial sand. Below this, a still earlier level was found to be resting on virgin soil. Outside the temenos were temples and residential areas of the Isin-Larsa, Kassite (1530–1180 B.C.), and Neo-Babylonian periods, among which the palace of Nabonidus on the embankment of the north harbor was outstanding.

BIBLIOGRAPHY. V. Christian and E. F. Weidner, "Das Alter der Gräberfunde aus Ur," *Archiv für Orientforschung*, V, 1929; V. Christian and E. F. Weidner, "Das Alter des frühgeschichtlichen Gräberfeldes von Ur," *Archiv für Orientforschung*, VII, 1931; L. Legrain, "Restauration de la stèle d'Ur-Nammu," *Revue d'Assyriologie et d'Archéologie Orientale*, XXX, 1933; Joint Expedition of the British Museum and of the Museum of the University of Pennsylvania to Mesopotamia, *Ur Excavations* (vol. 2: C. L. Woolley, *The Royal Cemetery*, London, 1934, vol. 3: L. Legrain, *Archaic Seal-Impressions*, Oxford, 1936, vol. 5: C. L. Woolley, *The Ziggurat and Its Surroundings*, Oxford, 1939, vol. 10: L. Legrain, *Seal Cylinders*, Oxford, 1951, vol. 4: C. L. Woolley, *The Early Periods*, Philadelphia, 1955); C. L. Woolley, *Excavations at Ur*, New York, 1954; R. H. Dyson, Jr., "Excavations at Ur, by Sir Leonard Woolley" [Book Review], *Archaeology*, IX, Winter, 1956; M. E. L. Mallowan and D. J. Wiseman, eds., "Ur in Retrospect: In Memory of Sir C. Leonard Woolley," *Iraq*, XXII, 1960.

PRUDENCE O. HARPER

UR: HARP FROM ROYAL CEMETERY. Harp (London, British Museum) found in the tomb of Queen Shubad (ca. 2500 B.C.), whose name is now translated Pu-abi, in the Royal Cemetery at Ur. Musical instruments were a common feature in these royal tombs. The sound box of the harp was originally of wood, but the wood has now decayed. The bitumen back arm, which reached upward vertically, had gold tuning pins and a gold knob on top. At the front of the sound box is a gold calf's head which has upright ears; eyes, hair, and beard of inlaid lapis lazuli and shell; and a double collar of lapis lazuli, shell, and red paste. The sound box has a shell mosaic border; directly beneath the calf's head, in front, is a panel divided into four squares. These contain mythological scenes in shell, with animals and demons.

BIBLIOGRAPHY. C. L. Woolley, *The Royal Cemetery*, 2 vols. (Joint Expedition of the British Museum and of the Museum of the University of Pennsylvania to Mesopotamia, Ur Excavations, vol. 2), London, 1934.

UR: STANDARD. Object, called a "standard" (London, British Museum), excavated from the Royal Cemetery at Ur. Its purpose is uncertain. It was found lying against the right shoulder of a man in PG 779, one of the two largest tombs in the cemetery, and is therefore to be dated in the Early Dynastic III period (ca. 2500 B.C.).

The standard has long sides that slope apart on the vertical plane so that the ends are truncated triangles. The sides (ca. 18 in. long and 8 in. high) are decorated with historical scenes in shell, lapis lazuli, and red limestone set in bitumen. The two ends are in poorer condition and bear fragments of mythological scenes.

On one long side is a banqueting scene, on the other a military victory. The military victory, in three registers, shows the Sumerian ruler defeating and receiving homage from his bald and beardless enemies. This is the earliest known pictorial representation of the Sumerian army. In the top register the Sumerian soldiers, wearing fringed sheepskin skirts and shawls and holding axes and spears, lead bound and naked captives before the king, who is shown slightly larger than the other figures. Behind him

are his bodyguard and the groom bringing his chariot. This vehicle has a long body supported by two solid wheels which were undoubtedly made of half circles of wood. The chariot has a high front rail and is drawn by onagers, or wild asses. In the second register foot soldiers, clad in long felt or leather cloaks and helmets and carrying spears, attack the enemy. In the third register the chariots, each carrying a charioteer and a spearman, race forward over the enemy.

The banqueting scene is also divided into three registers. The king is again larger than the other figures. He sits with a number of other male figures, possibly his generals, while cupbearers serve them. A female dancer and a musician holding a harp decorated with a bull's head approach from the right. In the other two registers animals, fishes, and objects are borne to the king, probably as booty. Some of the bearers are curly-haired and bearded and others are clean-shaven and bald.

Various fantastic animals, lion-headed birds, and human-headed bulls, as well as rearing stags, trees, and a few human figures, are represented on the ends of the standard. The wood that supported this mosaic had decayed by the time of excavation.

BIBLIOGRAPHY. C. L. Woolley, *The Royal Cemetery*, 2 vols. (Joint Expedition of the British Museum and of the Museum of the University of Pennsylvania to Mesopotamia, Ur Excavations, vol. 2), London, 1934; H. Frankfort, *The Art and Architecture of the Ancient Orient*, Baltimore, 1954.

PRUDENCE O. HARPER

URARTU. Kingdom in the mountainous Anatolia region near Lake Van, which reached its height in the 9th–8th centuries B.C., spreading from the Orontes to the Mediterranean Sea. Warring against the Assyrians, it was often invaded by them and others and finally was destroyed by the Mede king Cyaxares in 585 B.C.

Urartu developed an important civilization in which agriculture flourished. It built great irrigational works, cities with cyclopean walls, and numerous fortresses. Citadels, palaces, and houses, two or three stories high, were built on a grand scale; they were decorated with colored tiles, and their interiors were adorned with paintings, some with marble friezes.

Rich in ores, Urartu produced remarkable bronze works of art: statues, reliefs, magnificent bulls' heads, richly decorated weapons and furniture, and carved ivories. It had its own hieroglyphic script, but also used Akkadian cuneiform writing.

See also ALTIN TEPE; TOPRAK KALEH.

BIBLIOGRAPHY. R. D. Barnett and W. Watson, "Russian Excavations in Armenia," *Iraq*, XIV, Autumn, 1952; S. Lloyd, *The Art of the Ancient Near East*, London, 1961; L. Woolley, *The Art of the Middle East*, New York, 1961.

URBINO. Town in central Italy. It was important as a center of Renaissance art and culture under the Montefeltro family, which ruled Urbino from 1213 to 1508. Urbino, the birthplace of Raphael and Bramante, was the residence of other distinguished artists, including Justus of Ghent and Piero della Francesca, who went there at the invitation of Duke Federigo da Montefeltro.

Iron Age hut foundations have been found in the neighborhood. As Urbinum Metaurense the town enjoyed the status of a Roman municipium. The Gothic churches of S. Domenico and S. Francesco (both 14th cent.) have remodeled interiors by Luigi Vanvitelli (18th cent.); the former has a fine portal of 1451 with a lunette representing the Virgin and saints by Luca della Robbia. The late-14th-century Church of S. Giovanni Battista is decorated with a fresco cycle by Jacopo and Lorenzo Salimbeni (1416).

The townscape, which spreads over two hills, is largely Renaissance in character. The rectangular Ducal Palace was begun about 1470, following designs of Luciano Laurana, and completed by Girolamo Genga in 1563. It is noteworthy for its imposing *cortile* and elegant interior decoration. It is now occupied by the National Gallery of the Marches. The Passionei, Palma, Luminati, and Semproni palaces follow, in their lesser way, the example set by Laurana's work. Founded in the mid-15th century, the Cathedral was transformed in the neoclassic style by Valadier between 1789 and 1801; the façade is by Camillo Morigia (1745–95). *See* URBINO: NATIONAL GALLERY OF THE MARCHES.

In the vicinity of Urbino are the Oratory of the Annunziata (1389), with interesting frescoes in the interior, and the serene early Renaissance Church of S. Bernardino (ca. 1472), which has been attributed to Francesco di Giorgio and to Bramante.

BIBLIOGRAPHY. L. Serra, *Catalogo delle cose d'arte e di antichità d'Italia*, Rome, 1932; P. Rotondi, *Il Palazzo Ducale di Urbino*, 2 vols., Urbino, 1950–51; F. Mazzini, *Guida di Urbino*, Vicenza, 1962.

WAYNE DYNES

URBINO: NATIONAL GALLERY OF THE MARCHES. Italian museum located in the Renaissance Ducal Palace designed by Luciano Laurana and erected from about 1470 to 1563. From the rich original décor there survive only the stone ornaments of the staircase, doors, and mantelpieces, and the wooden inlay panels, including the famous set in the Duke's small study. The paintings include some important works commissioned by the Montefeltro family: the predella *The Profanation of the Host* by Uccello, the *Sinigallia Madonna* and *Flagellation* by Piero della Francesca, and some panels from the series of illustrious men by Justus of Ghent and Pedro Berruguete. Other works are by Giovanni Bellini, Titian, Raphael, and Federico Barocci.

BIBLIOGRAPHY. L. Serra, *Il Palazzo Ducale e la Galleria Nazionale di Urbino*, Rome, 1930; P. Zampetti, *Il Palazzo Ducale di Urbino e la Galleria Nazionale delle Marche*, 2d ed., Rome, 1956.

URENA, FELIPE. Mexican architect (fl. 1st half of 18th cent.). Ureña was essentially a master carpenter and retable designer, reputed to have worked on important retables in the sacristy of the Church of S. Francisco at Toluca (1729), and known to have worked with his brothers (José, Carlos, and Hipólito) on the retable of Santiago de los Gallegos in the chapel of the Third Order at S. Francisco, Mexico City (1740), and on a retable for Aguascalientes parish church (1742). His masterpiece was later work on the Church of S. Felipe at Guanajuato (originally the Jesuit church but given to the Filippine brothers at the end of the 18th century), where extraordinary adjacent triple retable-façades, and a side portal, show Ureña's close connections to the circle of Lorenzo Ro-

dríguez in Mexico City. *See* GUANAJUATO, MONASTERY CHURCH OF.

BIBLIOGRAPHY. D. Angulo Iñiguez, *Historia del arte hispanoamericano*, vol. 2, Barcelona, 1950.

URLIENES (Urliones), GIL DE, *see* SILOE, GIL DE.

URN. General name for a variety of vases that have a pedestal, handles, and a wide mouth. In antiquity urns served different purposes, but were used most often as containers for wine. In more recent times, the urn has become purely ornamental; it is also used to contain the ashes of the dead.

URNA. Sanskrit term meaning "tuft of hair." One of the thirty-two superior marks of a Buddha, the *ūrṇā* is a small disk in the middle of the forehead that "shines like silver," representing divine insight.

URNAMMU, STELE OF. Fragmentary limestone stele (Philadelphia, University Museum) excavated at Ur. It was originally about 10 feet high and 5 feet wide. Divided into five registers on each side, the reliefs illustrate the temple-building activities of Urnammu (ca. 2125 B.C.), the first king of the 3d dynasty of Ur. On one side the King stands before the enthroned moon god Nannar; a moon and a sun are above the King, and a goddess with a flowing vase is above the god. Below, the King is shown in duplicate, each time accompanied by a goddess; he is pouring a libation before Nannar at one end and before the goddess Ningal at the other. The remaining fragments of this side show the King with building tools. On the reverse side are ceremonies dedicating the temple and also sacrifices and music.

BIBLIOGRAPHY. L. Legrain, "The Stela of the Flying Angels," *The Museum Journal [of] the Museum of the University of Pennsylvania*, XVIII, March, 1927; G. Contenau, *Manuel d'archéologie orientale*, vol. 2, Paris, 1931; H. Frankfort, *The Art and Architecture of the Ancient Orient*, Baltimore, 1954.

URSULA, ST. English princess of the early Christian period. Having promised to wed the son of the English king, she chose instead a pilgrimage to Rome and martyrdom in Cologne. On disembarking at Cologne, she and her attending 11,000 (sometimes given as 11) virgins were killed by the arrows of the Huns who were besieging the city. Her story, partly from German and partly from English sources, was embellished by SS. Elisabeth of Schönau and Hermann Joseph of Steinfeld. Her attributes are an arrow, banner(s), and a mantle sheltering virgins. Her feast is October 21.

See also SAINTS IN ART.

URTEAGA, MARIO. Peruvian painter (1875–1959). Born in Cajamarca, Urteaga was self-taught. He remained little known until he won first prize at the Salon in Viña del Mar, Chile, in 1937. He exhibited in Lima (1938) and in international group shows (for example, in San Francisco, Calif., in 1942). His work retained naïve precision. He portrayed the life of the Andean Indian in powerful geometric compositions.

BIBLIOGRAPHY. S. Catlin and T. Grieder, *Art in Latin America since Independence*, New Haven, 1966.

URUK, *see* WARKA.

URY, LESSER. German painter and graphic artist (b. Birnbaum, 1861; d. Berlin, 1931). He studied in Düsseldorf, Brussels, and with Jules Joseph Lefèbvre in Paris from 1881 to 1883. Ury's work includes café interiors, street scenes, landscapes, and, later, muralistic paintings of Old Testament subjects. In his café and street paintings he was sensitive to the sort of atmosphere best depicted with an impressionistic palette and manner, where lonely, isolated figures on wet pavement, sky, and setting merge in strokes of loose, bright color. A different use of atmospheric emphasis may be seen in his *Jeremiah* (1900; Tel Aviv Museum).

BIBLIOGRAPHY. A. Donath, *Lesser Ury*, Berlin, 1921.

USHNISHA (Usnisa). First of the thirty-two marks of a Buddha, consisting of a mount on the top of the head, standing for divine wisdom. The *ushnīsha* is represented in different ways in various countries: as a knot of wavy hair by the Gandhāra school, a round protuberance covered with snail-shell-like curls in India, a higher dome in Tibet, and a flame or pointed spike in Burma and Thailand.

USK CASTLE. Norman castle in Monmouthshire, Wales, now in ruins, situated on a steep hill and once important as a border fortress. The principal entrance shows a fine Gothic gateway. During the 15th century it was a favorite residence of Richard, duke of York, and his sons Edward IV and Richard III were born there.

BIBLIOGRAPHY. W. Coxe, *A Historical Tour through Monmouthshire*, rev. ed., Brecon, 1904.

USPENSKY CATHEDRAL, KREMLIN, MOSCOW. The Cathedral of the Dormition (Assumption) was built by the Bolognese architect Aristotele Fioravanti in 1475–79. Its plan, based on that of the Church of the Annunciation by the Russian architect Vladimir, is a square with five apses. The interior, spacious and devoid of galleries, is divided by four supports carrying five domes.

BIBLIOGRAPHY. G. H. Hamilton, *The Art and Architecture of Russia*, Baltimore, 1954.

USSE, CHATEAU OF. French hillside castle in the Department of Indre-et-Loire. The donjon dates from 1480, and the round defensive towers, pointed turrets, and machicolations are of late Gothic construction (1485–1520). During the 17th century the north flank of the château of Ussé was removed to admit light into the courtyard and to permit a view of the terrace and gardens, built in 1664. The three remaining court façades retain their Renaissance character despite 18th- and 19th-century renovations. A separately located chapel (1538) of fine quality is noted for its entrance portal.

BIBLIOGRAPHY. H. Colas and J. Aufort, *Les Châteaux de la Loire*, Bordeaux, 1947; E. de Ganay, *Châteaux de France*, vol. 2, Paris, 1949.

USTAD MUHAMMADI, *see* ISLAMIC PAINTING (SAFAVID PERIOD).

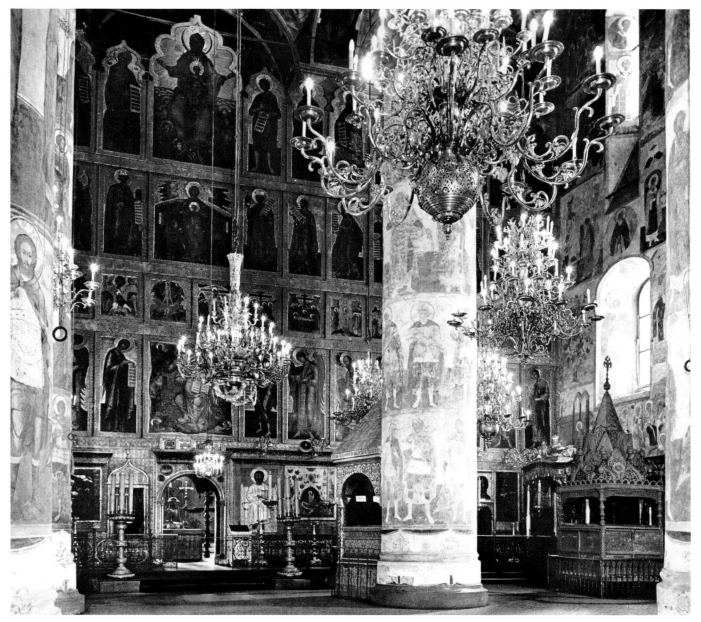

Uspensky Cathedral, Kremlin, Moscow. Interior view of this 15th-century edifice designed by the Italian architect Aristotele Fioravanti.

UTAGAWA SCHOOL. School of Japanese Ukiyo-e print-makers founded by Toyoharu (1735–1814). Toyokuni I, a pupil of Toyoharu, created a distinctive type of portrait of Kabuki actors and beautiful women. The school tradition was carried on by members of the Utagawa family, such as Kunimasa, Kunisada, Toyohiro (the teacher of Hiroshige), and Toyokuni II (b. 1802). Others, such as Kunitora (fl. early 19th cent.) and Kuniyoshi, as well as Toyoharu himself, introduced a Western style of painting into their landscape prints. *See* KUNIYOSHI (UTAGAWA KUNIYOSHI); TOYOHARU; TOYOKUNI I; UKIYO-E.

BIBLIOGRAPHY. R. D. Lane, *Masters of the Japanese Print*, Garden City, N.Y., 1962.

UTAMARO (Kitagawa Utamaro). Japanese Ukiyo-e print designer (1753–1806). He owed his greatest artistic debt to Kiyonaga. After assuming the name Utamaro about 1782, however, he established his own style and became one of the two greatest portrayers of feminine beauty and love, the other being Harunobu. Different from Harunobu's frail, young girls, Utamaro's women are mature and strongly flavored with eroticism. These frankly sensuous women are captured in various moods, and their large faces, often depicted without defining contour lines to suggest soft skin and flesh, are in striking contrast to a flat, neutral background, sometimes sprinkled with powdered mica. In 1804 Utamaro was accused of criticizing the shoguns in his prints, and although he was imprisoned for a short while only, he never recovered psychologically from the experience. His death two years later meant the virtual end to this special genre of the portrayal of beautiful

婦人相學十躰
浮気之相
相見 歌麿画

Kitagawa Utamaro, a young woman from the series "Ten Studies of Female Expressions." Woodcut. National Museum, Tokyo.

women in the Ukiyo-e print, which he had brought to its peak. *See* HARUNOBU; KIYONAGA; UKIYO-E.

BIBLIOGRAPHY. L. V. Ledoux, *Japanese Prints, Bunchō to Utamaro, in the Collection of Louis V. Ledoux,* New York, 1948; J. A. Michener, *Japanese Prints,* Rutland, Vt., 1959.

UTENBROEK (Uyttenbroeck), MOZES VAN (Moyses Wttenbroeck). Dutch painter of landscape and history (b. ca. 1590; d. The Hague, 1648). About 1610 Utenbroek was in Rome, where he was influenced by the work of the German painter Adam Elsheimer. Utenbroek painted mostly landscapes with mythological and Biblical scenes. His later landscapes were influenced by Cornelis van Poelenburgh and Bartholomeus Breenberg.

BIBLIOGRAPHY. U. Weisner, "Die Gemälde des Moyses van Uyttenbroeck," *Oud-Holland,* LXXIX, 1964.

UTILE (Utili) DA FAENZA. Italian painter (fl. late 15th–early 16th cent.). Often active in Faenza, Utile has been identified with Andrea Utili da Faenza (fl. 1481–1502), Giovanni Battista Utili (fl. 1503–15), and Biagio di Antonio da Firenze (fl. 1476–1504), without documentary evidence in any case. The many paintings and cassone panels attributed to him show the strong influence of Ghirlandajo and Verrocchio.

UTRECHT, ADRIAEN VAN. Flemish painter (1599–1652). He was born in Antwerp. He painted still life, first in the manner of Frans Snyders and Jan Fyt, later evolving toward the more elaborate style of Jan Davidsz. de Heem. The figures in Utrecht's canvases were generally by such artists as Jacob Jordaens, Theodoor van Thulden, and Theodoor Rombouts.

BIBLIOGRAPHY. E. Greindl, *Les Peintres flamands de nature morte au XVIIe siècle,* Brussels, 1956.

UTRECHT: CATHEDRAL. Netherlandish Gothic church, begun in 1254 on the site of the former Romanesque cathedral. Today's impression of the Cathedral of Utrecht is marred by the fact that the entire nave was destroyed in a hurricane in 1674. The important single west tower is seen today across the square from the finished choir and apse.

Slow progress was made through the 13th century with the choir and two aisles, and into the beginning of the 14th with the ambulatory. In 1321 the great single west tower was begun, detached from the rest of the church by a small narthex. This unusually designed tower apparently set the vogue for later tower construction. It was completed in 1382, after which work on the church itself continued with the vaulting, flying buttresses, and finally the transept in 1479, and the nave, which was roofed in 1517. Although the church contains beautiful quadripartite vaults, neither the nave nor the transept was ever vaulted. Remaining today are the handsome single tower rising in three tiers, the top one a beautiful openwork hexagon, and the pure Gothic choir and apse, which recall the great French cathedrals. The elevation resembles Amiens; the ground plan, Reims.

BIBLIOGRAPHY. J. Harvey, *The Gothic World, 1100–1600,* London, 1950; Utrecht, Centraal Museum, *Catalogue Raisonné of the Works by Pieter Jansz,* Utrecht, 1961. EDWARD P. LAWSON

UTRECHT: CENTRAAL MUSEUM. Dutch collection. The museum occupies the former Convent of St. Agnes (built in 1420). Its earliest historical exhibits are Roman finds from the Netherlands, including the Utrecht Ship, an oak vessel of the 2d century. Ecclesiastical art is represented by Gothic sculpture from Dutch and other European monasteries and churches as well as by ivories, enamels, manuscript illuminations, tapestries, and so on. Important paintings by Geertgen tot Sint Jans and Jan van Scorel round out this collection. Seventeenth-century paintings of the Utrecht school form the most impressive group with works by Bosschaert, Steen, Wtewael, Bloemaert, Saenredam, Honthorst, Terbrugghen, and others.

BIBLIOGRAPHY. Centraal Museum, *Catalogus der Schilderijen,* Utrecht, 1952.

UTRECHT: SCHRODER HOUSE, *see* SCHRODER HOUSE, UTRECHT.

UTRECHT PSALTER. One of the most amazing illustrated manuscripts (Utrecht, University Library) to be produced during the entire Middle Ages, the Psalter was probably executed about 830–35. The exact place of origin is not known, but current scholarship tends to believe that it was made under the aegis of Archbishop Ebbo of Reims.

The Psalter has 108 folios, of vellum, with—166 pen drawings in brown ink throughout the volume—at least one for each psalm. The text is written in late-antique *capitalis rustica,* with uncial headings. The drawings themselves exemplify the nervous, vibrant, highly expressive linear treatment that was the hallmark of the Reims school and that was so influential on succeeding generations.

UTRECHT SCHOOL. School of painting developed about 1524 when Jan van Scorel established his workshop in Utrecht. Van Scorel had previously been in Italy and Germany, where he was greatly influenced by Raphael, Michelangelo, and Dürer. This established a tradition of close affinity between Italy and the Utrecht school which was to persist into the school's maturity in the baroque era. *See* SCOREL, JAN VAN.

The most important Netherlandish mannerists worked in Utrecht under the direction of Abraham Bloemaert. Bloemaert's art reflects the style of Netherlandish Romanists such as Frans Floris and, in Bloemaert's late works, Caravaggio. Next to Bloemaert, Joachim Wtewael was the most important late mannerist painter of Utrecht. Bloemaert's students, Honthorst, Terbrugghen, Baburen, and Moreelse, made the Utrecht school of the early 17th century one of the chief centers for the dissemination of the new Caravaggesque baroque style in Holland.

See BABUREN, DIRCK VAN; BLOEMAERT, ABRAHAM; HONTHORST, GERRIT VAN; MOREELSE, PAULUS; TERBRUGGHEN, HENDRICK; WTEWAEL, JOACHIM ANTHONISZ.

BIBLIOGRAPHY. M. J. Friedländer, *Die altniederländische Malerei,* vol. 12, Berlin, 1935; W. Bernt, *Die niederländische Maler des 17. Jahrhunderts...,* 3 vols., Munich, 1948.

UTRILLO, MAURICE. French painter of street scenes (b. Paris, 1883; d. Dax, Landes, 1955). His mother was the artist Suzanne Valadon, who had once been a traveling acrobat and later a model for such artists as Degas. By the time he was nineteen Utrillo had become an alcoholic and was unable to hold a job. At his mother's insistence he began to paint. She thought it would occupy him and

Maurice Utrillo, *Rue des Poisonniers*, 1930. Private collection. A characteristic painting of a lonely Montmartre street.

possibly have some therapeutic value, but he sold his works cheaply to maintain his drinking.

His first pictures reveal a debt to the impressionists, notably Pissarro. From the beginning he represented scenes of Paris, particularly Montmartre. He had no formal training, but it can be assumed that he received criticism from his mother, an able draftsman. From 1908 to 1910 he went through his White Period. He painted from illustrated postcards as early as 1909. He exhibited for the first time in the Salon d'Automne in 1910 and two years later had his first one-man show, at Libaude's. He was very prolific despite the fact that his work was interrupted by drinking bouts and stays in hospitals and nursing homes.

In 1913 he designed sets for a Diaghilev ballet, *Barabau*. In 1928 he was made Chevalier of the Legion of Honor. After his marriage in 1935 he gave up drinking, took an interest in religion, and continued to paint prolifically. In fact, he tended to overproduce, and, although his pictures sold well, they fell off considerably in quality.

Utrillo's best-known pictures belong to his White Period. He depicted the deserted streets of Montmartre in subtle harmonies of milky and oyster whites, warm grays, olives, and blue-grays, in strong contrast with rich blacks and browns and surprising touches of rust and vermilion. The breadth of conception lends a monumentality to his modest themes.

BIBLIOGRAPHY. F. Jourdan, *Maurice Utrillo*, Paris, 1948.

ROBERT REIFF

UYL (Uijl), JAN JANSZ. DEN. Dutch painter of still life and etcher (b. Utrecht? ca. 1595; d. Amsterdam, 1640). It is difficult to sort out information concerning Uyl from that relating to his two sons, both also named Jan. This painter seems to be the brother-in-law of the still-life painter Jan Jansz. Treck, who may also have been his pupil. Uyl's still-life paintings recall the work of Willem Claesz. Heda as well as the manner of his brother-in-law. His etchings of animals in landscape settings show something of the influence of Nicolaes Moejaert.

BIBLIOGRAPHY. A. P. A. Vorenkamp, *Bijdrage tot de geschiedenis van het Hollandsch stilleven in de zeventiende eeuw*, Leyden, 1934; W. Bernt, *Die niederländischen Maler des 17. Jahrhunderts...*, vol. 3, Munich, 1948.

UYTEWAEL, JOACHIM ANTHONISZ., *see* WTEWAEL, JOACHIM ANTHONISZ.

UYTTENBROECK, MOZES VAN, *see* UTENBROEK, MOZES VAN.

V

Perino del Vaga, *Jove Striking the Giants with Lightning*, detail of the fresco decoration in the Palazzo Doria, Genoa.

VADDER, LODEWIJK DE. Flemish painter of landscapes and engraver (1605–55). He was born in Brussels. His early works closely follow Adriaen Brouwer, but later on he favored the decorative style of Jacques d'Arthois. The figures in his paintings were sometimes done by David Teniers the Younger.

BIBLIOGRAPHY. Y. Thiéry, *Le Paysage flamand au XVIIe siècle*, Brussels, 1953.

VADSTENA: CONVENT CHURCH. The most famous of all Swedish convent churches, St. Brigitte was begun at the end of the 14th century, consecrated in 1445, and restored in 1890–98. The church terminates abruptly in the east and has a rectangular choir and sanctuary in the west. The high nave and aisles, devoid of ornamentation, are divided by simple octagonal pillars bearing groin vaults.

BIBLIOGRAPHY. A. Hahr, *Architecture in Sweden*, Stockholm, 1938.

VAENIUS, OCTAVIUS, *see* VEEN, OTTO VAN.

VAGA, PERINO DEL (Pietro Buonaccorsi). Italian painter (b. Florence, 1501; d. Rome, 1547). Perino (also Pierin or Pierino) acquired his usual appellation (del Vaga) from a local painter whose assistant he became after studying in Florence with Andrea de' Ceri and then Ridolfo Ghirlandajo, and with whom he went to Rome some time before 1519. Perino adopted the Roman manner of the Raphael school and studied Michelangelo and Roman "antiquities." He worked on the ornamentation of the Vatican Loggie with Giulio Romano and Giovanni Francesco Penni, in company with Giovanni da Udine. He was close, therefore, to Raphael, though he has never been considered distinctly a Raphael pupil like Giulio and Penni.

Several scenes in the Vatican Loggie and the chiaroscuro basements in the Stanze d'Eliodoro and della Segnatura (from a later time under Paul III) are his, and there were other decorative works in the Vatican, in private houses (Baldassini Palace), and in churches (S. Marcello al Corso, Chapel of the Crocifisso; some paintings from this time and others from 1539–40). Altar panels, too, sometimes more Florentine (Fra Bartolommeo, Andrea del Sarto) than

Raphaelesque in tone, come from the years before his Genoese sojourn. He was captured in the Sack of Rome, paid a high ransom, and in 1528 went to Genoa on a commission from Duke Andrea Doria for a series of decorations in the Duke's Genoese palace. Through his extensive works there he spread to Liguria the Raphael school decorative style developed in the Vatican.

In the spring of 1539 he was back in Rome, where he received various commissions for frescoes (Massimo alle Colonne Palace) and panel paintings. The latter are in the general manner of the Raphael workshop, still with Florentine overtones from Del Sarto's softer coloring. They are not imaginative, but often pleasing (*Holy Family*, Chantilly, Condé Museum). In 1545 he was at work on the Castel S. Angelo frescoes, which he continued until his death.

In spite of Perino's close association with the Raphael school, his art never enters the classical-monumental vein. Departing from the Loggie ornament and narrative, it has, in contradistinction to that of other Raphael followers, a rhythmic and ornamental quality which, with his rapid draftsmanship and bright, transparent coloring in fresco, makes it particularly agreeable in the decorative works.

BIBLIOGRAPHY. A. Venturi, *Storia dell'arte italiana*, vol. 9, pt. 2, Milan, 1926; F. Hartt, "Raphael and Giulio Romano," *Art Bulletin*, XXVI, 1944; P. Askew, "Perino del Vaga's Decorations for the Palazzo Doria, Genoa," *The Burlington Magazine*, XCVII, 1956; J. A. Gere, "Two Late Fresco Cycles by Perino del Vaga: The Massimi Chapel and the Sala Paolina," *The Burlington Magazine*, CII, 1960.

ALTHEA BRADBURY

VAGARSHAPAT: ST. HRIPSIME, *see* ECHMIADZIN: ST. HRIPSIME.

VAHANA. Mount of a Hindu god. The *vāhana* is usually an animal.

VAILLANT, WAILLERANT (Wallerand). Flemish-Dutch portrait painter, pastelist, and graphic artist (b. Lille, 1623; d. Amsterdam, 1677). He was the son of a merchant who settled in Amsterdam about 1642. Vaillant is said to have

studied painting under Erasmus Quellinus in Antwerp. In 1647 Vaillant was reported a member of the Middelburg painters' guild. He was presumably in Amsterdam by 1649, when he painted a portrait of Jan Six; he is recorded there in 1652. In 1658 he was in Frankfurt am Main. About this time he turned from etching to mezzotint and was one of the first artists to utilize this technique, which he may have learned from Prince Rupert. Vaillant was active in Paris from 1659 until 1665, when he returned to Amsterdam. His brother Jacques and his half brothers Bernard and Andries made pastel portraits in his style.

BIBLIOGRAPHY. J. E. Wessely, *Wallerant Vaillant*, Vienna, 1881.

VAIROCANA (Chinese, Ta-jih, P'i-lu-she-na; Japanese, Dainichi, Birushana, Rushana). The Great Light or the Illuminator, Buddha supreme and eternal, the first of the five Dhyāni-Buddhas. He is the supreme deity of Esoteric (Tantric) Buddhism in China and Japan, the symbol of the universal force at the center of all creation. Vairocana figures prominently in the pair of mystical paintings known as the *Garbha-kośa-dhātu* (Earth-Womb Element) and *Vajra-dhātu* (Diamond Element) *mandalas* as the source of all life, the "heart" of the lotus. His mudrā (symbolic hand position) is *dharmacakra*, the attitude of teaching, but in Japan the right hand is closed around the index finger of the left, symbolizing wisdom. His worship was particularly popular in China during the 7th and 8th centuries, as the colossal rock-cut image in the Feng-hsien temple of Lung-men shows. *See* DHYANI-BUDDHA; LUNG-MEN; MANDALA.

See also VAJRAYANA.

VAIROCANA (Bronze). Buddhist statue in Pulguksa temple, near Kyungju, Korea. It is about 6 feet high. The deity sits erect and tall with full face, broad shoulders, and fleshy, thick hands in the "gesture of creation." The *ushṇisha* is simple and dome-shaped. The eyebrows are high-arched, and the mouth is small and delicate. The dignity of the statue is somewhat lessened by a coat of whitewash over the original gilt-bronze finish. *See* USHNISHA.

BIBLIOGRAPHY. Ministry of Foreign Affairs, *Korean Arts*, vol. 1: *Painting and Sculpture*, Seoul, 1956.

VAISRAVANA, *see* KUVERA.

VAJRADHARA. Form of Adi-Buddha, whose name means "Thunderbolt Bearer" or the "Indestructible." He is lord of all mysteries and master of all secrets. *See* ADI-BUDDHA.

VAJRAPANI. Second Dhyāni-Bodhisattva. Vajrapāṇi (Thunderbolt Bearer) is identified with the Hindu god Sakra or Indra. He is both a ferocious emanation of Vajradhara and the spiritual reflex of Akṣobhya (second Dhyāni-Buddha). He rarely appears alone but in triads with Amitāyus (or Mañjuśrī) and Padmapāṇi. *See* AKSOBHYA; DHYANI-BODHISATTVA; INDRA.

Giuseppe Valadier, Piazza del Popolo, Rome, 1784–1816. An expression of the Roman baroque style in city planning.

Suzanne Valadon, *Chambre à coucher bleue*, 1923. National Museum of Modern Art, Paris.

VAJRAYANA. Adamantine Vehicle, the third phase of Buddhism. Vajrayāna is also known as Tantrism or Mantrayāna (Vehicle of the Formula). It postulates that from the Adi-Buddha emanate the five Dhyāni-Buddhas, from whom in turn emanate all the forms of the illusory cosmos, including man. The gods with their female counterparts re-create the unity of truth and being, which combine to create man. The spiritual synthesis of the universe is represented by a ritual diagram, or *mandala*. *See* ADI-BUDDHA; DHYANI-BUDDHA; MANDALA; TANTRA.

See also HINAYANA; MAHAYANA.

VALADIER, GIUSEPPE. Italian architect and archaeologist (1762-1839). He worked in Rome. Although his most outstanding work, the Piazza del Popolo (1784–1816), is an ultimate statement of the Roman baroque style in city planning, he was also interested in Palladio, neoclassicism, and the reconstruction of antique buildings.

BIBLIOGRAPHY. E. Schulze-Battmann, *Giuseppe Valadier, ein Klassizist*, Dresden, 1939.

VALADON, SUZANNE. French painter (b. Bessines, 1865; d. Paris, 1938). Her life was as tempestuous and dramatic as the famous era in French art in which she played an important role. As a young girl, Suzanne Valadon was the queen of the balls and studios of Montmartre and attracted the attention of many artists. Renoir admired her lustrous skin, Puvis de Chavannes her slenderness, Toulouse-Lautrec her features, already catching a glimpse of sadness and depravity in spite of her radiant youth. When she was eighteen, her son Maurice Utrillo was born. She settled down to a calmer life and instead of posing for artists began to draw herself. Lautrec, then her neighbor, saw her drawings and encouraged her; later Degas, unstinting in his praise, bought some of her work.

Rather than invent forms, she sought to observe humanity to the point sometimes of biting cruelty. She admitted only to having been influenced by Gauguin's technique and that of his Pont-Aven friends, whose decorative style she had seen and admired at the Universal Exposition in 1899. She also owed much to Degas, whose advice was invaluable. Thanks to him she studied engraving, which she gave up, however, in 1909 (together with drawing) to take up painting.

She usually painted nude figures, generally choosing as a model someone from the working class or a servant. Yet she painted some landscapes and still lifes and a few portraits, mostly of her son but also of her friends and of herself (*Autoportrait*, 1927). All her work is characterized by great power of expression and sharpness of observation, but the color is not always in agreement with the emphasis of her line, with the result that the canvases often give

the impression of colored drawings. When she controlled her passion for crude colors and too obvious contrasts, she produced such superb work as *Chambre à coucher bleue* (1923; Paris, National Museum of Modern Art). The forms are boldly treated with no concession either to delicacy or to charm, and her best canvases show a vigorous style.

Suzanne Valadon was the friend of many outstanding painters of her time, and it was they who recognized her talent. Her close and dramatic relationship with her gifted son Maurice Utrillo formed another facet of her intense, passionate, and creative life.

BIBLIOGRAPHY. N. Jacometti, *Suzanne Valadon*, Geneva, 1947; B. Dorival, *Twentieth-Century French Painters*, 2 vols., New York, 1958; J. Storm, *The Valadon Drama: The Life of Suzanne Valadon*, New York, 1959; R. Nacenta, *School of Paris*, London, 1960.

ARNOLD ROSIN

VALCKENBORCH (Valkenburg), FREDERICK VAN. Flemish painter of landscapes and kermis and animal scenes (b. Antwerp, ca. 1570; d. Nürnberg, ca. 1623/25). He was the son of Martin van Valckenborch and the brother of Gillis van Valckenborch. About 1586 Frederick immigrated with his family to Frankfurt am Main. Only a few signed works are extant to permit us to gain a picture of his style. He was strongly influenced by Gillis van Coninxloo. *Mountainous Landscape* (1605; Amsterdam, Rijksmuseum) is reminiscent of Josse de Momper with its dynamic rock formations; *Wooden Landscape* (Vienna, Museum of Art History) approaches the conception of Coninxloo's kindred subject in the Liechtenstein Collection in Vaduz; and *Kermis* (1595; Vienna, Museum of Art History) is apparently derived from Pieter Brueghel the Younger via Abel Grimmer.

BIBLIOGRAPHY. J. A. Graf Raczyński, *Die flämische Landschaft vor Rubens*, Frankfurt am Main, 1937; W. Bernt, *Die niederländischen Maler des 17. Jahrhunderts...*, vol. 3, Munich, 1948.

VALCKENBORCH (Valkenburg), GILLIS VAN. Flemish painter of landscapes and figures (b. Antwerp, ca. 1570; d. Frankfurt am Main, 1622). He was the son of Martin van Valckenborch and the brother of Frederick van Valckenborch. Gillis worked in the Romanist mannerism of the transition period, often resembling Frans Francken the Elder. His subjects are drawn from Greek and Roman history, and his scenes, generally set in dramatically moving surroundings, feature blocks of figures that are skillfully drawn. The palette is crude, but not devoid of imagination. *Defeat of Sanherib before Jerusalem* (Brunswick, Gallery) is a good signed example of his art.

BIBLIOGRAPHY. J. A. Graf Raczyński, *Die flämische Landschaft vor Rubens*, Frankfurt am Main, 1937; W. Bernt, *Die niederländischen Maler des 17. Jahrhunderts...*, vol. 3, Munich, 1948.

VALCKENBORCH (Valkenburg), LUCAS VAN. Flemish painter of landscapes, figures, and religious scenes (b. Louvain or Mechlin, before 1535; d. Frankfurt am Main, 1597). He was the brother of Martin van Valckenborch. Lucas became a master in Mechlin in 1560, and after 1579 was in the service of Archduke (later Emperor) Matthias in Linz. He is an important artist of the school of Pieter Brueghel the Younger, and his narrative interpretations of kermis, hunting, and other scenes are attractive and full of life. Another aspect of his art is the views of towns and cities, for example, the *View of Linz* (Frank-

furt am Main, Städel), which is signed and dated 1593. He also occasionally painted portraits, such as the one of his patron in the Vienna Museum of Art History, which is monogrammed and dated 1580. His works are often confused with those of Pieter Brueghel the Younger.

BIBLIOGRAPHY. J. A. Graf Raczyński, *Die flämische Landschaft vor Rubens*, Frankfurt am Main, 1937; W. Bernt, *Die niederländischen Maler des 17. Jahrhunderts...*, vol. 3, Munich, 1948.

VALCKENBORCH (Valkenburg), MARTIN VAN. Flemish painter of landscapes and figures (b. Louvain, 1535; d. Frankfurt am Main, 1612). He was the father of Frederick and Gillis van Valckenborch and the brother of Lucas van Valckenborch. Relatively little is known about Martin, with the exception of some of the *Months* paintings from a series of twelve in the Museum of Art History in Vienna, and a *Tower of Babel* (Dresden, State Art Collections). These paintings show that he was strongly influenced by Pieter Brueghel the Younger in his handling of figures and that the landscapes were done in the manner of his brother Lucas. In *January* (Museum of Art History) the figures of the Adoration are rendered in the Romanist idiom of the transition period. The landscape, as usual, is seen with the spectator placed at a high viewpoint.

BIBLIOGRAPHY. J. A. Graf Raczyński, *Die flämische Landschaft vor Rubens*, Frankfurt am Main, 1937; W. Bernt, *Die niederländischen Maler des 17. Jahrhunderts...*, vol. 3, Munich, 1948.

VALDAMBRINO, FRANCESCO DI (Francesco di Domenico). Italian wood and marble sculptor and goldsmith (fl. Siena, early 15th cent.). In 1401–02 he participated in the competition for the doors of the Florentine Baptistery with a *Sacrifice of Abraham*, and in 1408 he collaborated with Jacopo della Quercia on the Fonte Gaia in Siena. In 1409 Valdambrino executed wood statues of saints for the high altar of the Sienese Cathedral. From 1414 to 1422 he was active on the works of the Cathedral and Loggia of S. Paolo. Among his statuary groups is the *Madonna dei Chierici* (Volterra, Cathedral Museum). Valdambrino is one of the masters of wood carving of his time, and owing perhaps to his activity at Pisa and Lucca his style reflects the influence of the Pisanos in its somewhat mannered Gothic mode with attempts at a new realism.

BIBLIOGRAPHY. P. Bacci, *Francesco di Valdambrino emulo del Ghiberti e collaboratore di Jacopo della Quercia*, Siena, 1936; C. L. Ragghianti, "Su Francesco di Valdambrino," *Critica d'arte*, III, 1938.

VAL-DE-GRACE, PARIS. French church begun in 1645 by Anne of Austria in fulfillment of a vow. François Mansart was commissioned to build the church and the convent but was dismissed after little more than a year's work. Mansart, basing his design on Italian prototypes, is responsible for the plan of the church: the short nave of three bays, the chapels on either side, and possibly the crossing area, which covers almost the entire width of the church. He is also responsible for its construction up to the entablature of the nave and the lower story of the exterior façade. In 1646 Jacques Lemercier took over, and he is responsible for the rest of the church, including the famous baroque dome.

BIBLIOGRAPHY. A. Blunt, *François Mansart and the Origins of French Classicism*, London, 1941.

VALDES LEAL, JUAN. Spanish painter (b. Seville, 1622; d. there, 1690). After studying with Antonio del Castillo in Cordova, Valdés stayed in that city until 1653. He lived in Seville from 1656 on and became president of its newly formed academy and the central figure of Sevillian painting for many years. The influence of Herrera the Elder is evident in the monumental figures and vigorous brushwork of Valdés's earliest paintings of saints. His early *Attack of the Saracens*, a panel from an altarpiece in S. Clara, Carmona (1653–54), already displays an extreme form of Rubenism with its merging of forms and colors in a swirling composition. Like Herrera the Younger and Madrid contemporaries, Valdés increasingly stressed the immateriality of forms, rapid and sketchy movement, and the apocalyptic function of light, in anticipation of the rococo style. The violence of his religiosity is expressed by the gruesome chaos and visual stench of two allegorical paintings devoted to the *Triumph of Death* in the Hospital of La Caridad, Seville (1672).

BIBLIOGRAPHY. E. DuG. Trapier, *Valdés Leal, Spanish Baroque Painter*, New York, 1960.

VALENCIA: PROVINCIAL MUSEUM OF FINE ARTS. Spanish collection. Although the museum is important primarily for its holdings from the Valencian school of painting, it also exhibits works by Pinturicchio (*Madonna*), Van Dyck (*Portrait of the Count of Osuna*), Morales (*Calvary*), and Velázquez (*Self-Portrait*).

BIBLIOGRAPHY. F. M. Garín Ortiz de Taranco, *Catálogo-Guía del Museo Provincial de Bellas Artes de San Carlos*, Valencia, 1955.

VALENCIAN SCHOOL. As a center of painting Valencia first manifests itself in the late 14th and early 15th century, when a group of painters, among them Antonio Guerau, worked in the International Gothic style in Valencia. In contrast to Seville, Valencia did not adopt the Netherlandish style to any degree; instead, Italian, specifically Tuscan, influences directed the school toward its Renaissance style. The relationship with Italy was further strengthened in the late 15th century when the Italian Borgia family visited their native province and brought with them several Italian painters, including Paolo da San Leocadio. Around these Italians there grew up a group of native Valencians, such as Juan de Juanes and Fernando Yañez, who adopted the style of Leonardo. The major Valencian painters of the 17th century continued to orient themselves to Italy. Francisco Ribalta succeeded in thoroughly adapting the Italian style to Spanish realism, becoming one of the founders of the Spanish national school of painting. His student Ribera, although he spent much of his life in Naples, was the greatest Valencian painter of the 17th century. *See* JUANES, JUAN DE; RIBALTA, FRANCISCO; RIBERA, JUSEPE DE; YANEZ DE LA ALMEDINA, FERNANDO.

BIBLIOGRAPHY. C. R. Post, *A History of Spanish Painting*, Cambridge, Mass., vol. 2, 1930, vol. 6, 1935, vol. 11, 1953.

DONALD L. EHRESMANN

VALENCIENNES, PIERRE-HENRI DE. French painter (b. Toulouse, 1750; d. Paris, 1819). He was a student of Gabriel-François Doyen and studied in Italy, where he came under Poussin's influence. Valenciennes is chiefly known as a painter of heroic landscapes.

BIBLIOGRAPHY. A. Michel, *Histoire de l'art*, vol. 8, pt. 1, Paris, 1925.

VALENCIENNES: FINE ARTS MUSEUM. French collection containing notable works by Watteau, Pater, Harpignies, and Carpeaux, all natives of Valenciennes. There are also Italian and Flemish pictures, including some large religious compositions by Rubens.

BIBLIOGRAPHY. *Catalogue illustré et annoté des oeuvres exposées au Palais des Beaux-Arts de la Ville de Valenciennes*, Valenciennes, 1931.

VALENTIN, MOISE LE (Jean de Boullogne; Jean Rasset). French painter of historical, religious, and genre subjects (b. Coulommiers, 1591/94 or 1601; d. Rome, 1632/34). Moïse le Valentin's brief but brilliant career unfolded exclusively in Rome after about 1614; there he studied, it is believed, with Simon Vouet, then enrolled at the Academy of the Bentveughel, preferring naturalism and the raucous company of German and Dutch artists to that of his compatriots at the Academy of St. Luke. In spite of his disinclination to Roman classical academicism, he was an associate, perhaps a friend, of Nicolas Poussin, sharing the patronage of Cassiano dal Pozzo and of Cardinal Barberini. The latter's commissions to the two artists, for altarpiece pendants for St. Peter's, were executed simultaneously (1628–30). Many critics preferred Le Valentin's *The Martyrdom of SS. Processus and Martinian*, his only documented work, for its color and vigorous naturalism, to Poussin's *Martyrdom of St. Erasmus* (both Rome, Vatican).

Le Valentin's preferred master was Bartolommeo Manfredi the Younger, whose Caravaggesque manner he followed to the end of his life, well after other Caravaggesque painters in Rome had abandoned the style. Though Le Valentin had little direct influence upon the French school other than through his pupil Nicolas Tournier of Toulouse, he occasionally had powerful admirers in France, including the young Louis XIV, who treasured his *Judith with the Head of Holofernes* (Toulouse Museum), a grisly emulation of the current Netherlandish Caravaggesque manners of Honthorst and Terbrugghen. The heroine, modeled on a contemporary Roman girl and surrounded by strong chiaroscuro, triumphantly communicates defiance to the observer. Le Valentin's fondness for combining antique motifs with low-life subjects is demonstrated in *Concert* (Paris, Louvre), where lackeys, soldiers, and a barmaid eat, drink, and make music around a makeshift table, a cubic plinth of Roman bas-relief.

Le Valentin was the most faithful of Caravaggio's followers; his *Cheats* (Dresden, Picture Gallery) was, until recently, thought to be an important variant from the older master's own *oeuvre*. There are, however, a pervasive melancholy and a peculiar linearism, akin to that of Georges de La Tour, which characterize Le Valentin's work, encouraging the belief in a real affinity with his native school. Works attributed to him are found in Beauvais, Cambridge (Fitzwilliam Museum), Cologne, Dresden, London (National Gallery), Munich, Nantes, Paris, Rome, Strasbourg, Toulouse, Versailles, and Vienna.

BIBLIOGRAPHY. A. de Caix de Saint-Aymour, *Les Boullogne...*, Paris, 1919; H. Voss, *Die Malerei des Barock in Rom*, Berlin, 1924.

GEORGE V. GALLENKAMP

VALENTINIAN I. Roman sculpture (364–375), in Barletta, Italy.

VALK, HENDRIK DE. Dutch painter of genre and portraits (fl. Haarlem, 2d half of 17th cent.). Little is known of Valk's early life and training. He is perhaps the "Handrik de Valck" who was reported in the Haarlem guild in 1693. His style shows him to be a follower of Richard Brakenburg. Valk's scenes of taverns and inns also show the influence of Jan Steen. A portrait, *Hans Willem van Camstra* (Leeuwarden, private collection), is dated 1706.

BIBLIOGRAPHY. W. Bernt, *Die niederländischen Maler des 17. Jahrhunderts...*, vol. 3, Munich, 1948.

VALKENAUER, HANS. Austrian sculptor (ca. 1448–after 1518). Possibly a native of Regensburg, Valkenauer became the leading late Gothic sculptor in Salzburg. His prolific output in Salzburg and other Austrian cities, dated between 1480 and 1520, consists primarily of tombs and tombstones with thick, static effigy reliefs. He also designed the never-completed monument for Emperor Maximilian I for the Cathedral of Speyer. Some of the figures, meant to adorn the columns of the circular monument, are now in the Carolino-Augusteum Museum in Salzburg.

VALKENBURG, *see* VALCKENBORCH.

VALKERT, WARNARD (Werner) VAN DEN. Dutch painter of portraits and history and graphic artist (b. Amsterdam? ca. 1585; d. there, after 1627). He seems to have been a pupil of Hendrick Goltzius in Haarlem about 1604/06. Valkert probably traveled to Italy while still young. He was also active in Copenhagen, where he worked in the Frederiksberg Castle.

BIBLIOGRAPHY. K. Madsen, "Lægebilleder paa Gaunø," *Kunstmuseets Aarsskrift*, II, 1915.

VALLADOLID: SAN GREGORIO. Spanish Dominican college founded in 1487 by Alonso de Burgos, bishop of Palencia. The chapel was built by Juan Guas, and the elaborate late Gothic portal (after 1492) perhaps by Simon de Colonia (Simon of Cologne). The square two-story cloister with timid Renaissance details may be by Enrique Egas of Toledo. *See* GUAS, JUAN.

BIBLIOGRAPHY. G. Nieto Gallo, *Valladolid*, Barcelona, 1954.

VALLAYER-COSTER, DOROTHEE ANNE. French still-life and portrait painter (b. Paris, 1744; d. there, 1818). Dorothée Anne Vallayer-Coster was the daughter of a goldsmith and the wife of a genre painter and engraver named Coster. She became an academician in 1770 and exhibited at the Salon from 1777 to 1817. She was a friend of Marie Antoinette. Her flower pieces, unsurpassed in the 18th century, betray Chardin's influence, though they are more lush and aerated than his still-life subjects.

BIBLIOGRAPHY. C. Sterling, *Still Life Painting from Antiquity to the Present Time*, new rev. ed., trans. J. Emmons, New York, 1959.

VALLE, FILIPPO DELLA. Italian sculptor (1697–1770). He studied in the school of Foggini at Florence prior to working in Rome. His sculptures for St. John Lateran and St. Peter's combine powerful plastic volumes and graceful delicacy of detail, characteristic of his late baroque style, and reveal his knowledge of contemporary developments in French sculpture.

BIBLIOGRAPHY. R. Wittkower, *Art and Architecture in Italy, 1600–1750*, Baltimore, 1958.

Valley of the Kings, Thebes. Mural in the tomb of Rameses I.

VALLEY OF THE KINGS, THEBES. Site in the Egyptian desert on the western bank of the Nile, containing the rock-cut tombs of the Pharaohs of the 18th through the 20th dynasties. This was a third type of royal tomb, invented after the mastaba and the pyramid had proved inadequate protection against robbers. For each tomb there was a corresponding funerary temple that was built far to the east, one of a row along the edge of the cultivated lands, facing the Nile and perhaps oriented to the Temple of Amun at Luxor.

The typical plan of the royal tomb consists of a corridor leading down to an antechamber and a burial chamber. In the earlier tombs deep shafts intercepted the course of the corridor, and the opening to the next stretch beyond was hidden behind a plastered and painted scene (Thutmosis III, Amenhotep II). The plan proceeded usually with a 90°-bend to the left (Thutmosis I, Thutmosis II, Amenhotep II). Later the tomb featured a long corridor at right angles to the face of the cliff.

In both types one front stairway and often one or more inner stairways descend to the lower stretches of the corridors (one stairway: Rameses III and Rameses IX; several: Thutmosis I, Amenhotep II, Thutmosis III, Merneptah, and Seti I). The front stairway, open to the sky, was called the "pathway of the sun." The largest tomb measures about 328 feet (Seti I, No. 17). Small chambers opened off both sides of the front part of the corridor, and recesses for the funerary furniture were in the second and third stairways.

In the main pillared hall, or "Golden Hall," so called because of yellow paint imitating gold, the sarcophagus

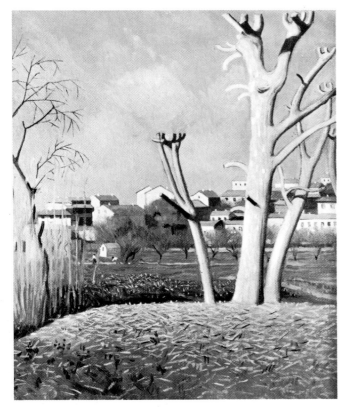

Félix Edmond Vallotton, *Bare Trees*, 1921. Private collection.

was set transversely to the axis of the corridor in a recess of the floor. All the walls were covered with scenes, usually painted only, sometimes in low raised relief (Seti I), representing the deceased Pharaoh in the afterlife, accompanying the sun god in his boat during his nighttime course through the netherworld. Its various regions were described as "twelve caverns" in the *Book of that which is in the Netherworld (Amduat)* or "twelve portals" in the *Book of Portals*, and it was thronged with imaginary creatures. These murals were actually intended as guides to the deceased in this netherworld journey, as was the *Book of the Opening of the Mouth*, which illustrated the rites performed on the statue of the Pharaoh to endow it with the use of his senses.

In the later tombs a yellow color imitating gold pervades mural painting. The style of both relief and painting in the tombs of the 18th and 19th dynasties is comparable to the best achievements on the walls of the contemporary temples. In the 20th dynasty style deteriorates gradually.

BIBLIOGRAPHY. G. Steindorff and W. Wolf, *Die thebanische Gräberwelt*, Leipzig, 1936. ALEXANDER M. BADAWY

VALLFOGONA, *see* PERE JOAN DE VALLFOGONA.

VALLORSA, CIPRIANO. Italian painter (fl. Grosio, Valtellina, ca. 1536–97). Locally, Vallorsa was highly esteemed in his time. He painted frescoes on exterior and interior walls as well as altarpieces that can be seen in churches in numerous towns in the area of Como.

VALLOTTON, FELIX EDMOND. Swiss-French painter, illustrator, graphic artist, and writer (b. Lausanne, 1865;

d. Paris, 1925). He went to Paris in 1882 and studied at the Académie Julian, where he met Denis, Bonnard, and other future members of the Nabis group with whom he first exhibited in 1893. An important and highly influential part of Vallotton's production was his graphic work. Throughout the 1890s he contributed woodcuts (including a successful series of portraits) to *La Revue Blanche* and other publications. In the woodcuts, probably his finest works, the large expressive areas of black and white reflect various influences, such as Gauguin and Beardsley; but Vallotton developed a personal synthesis of powerful outline and plastic form. The strong abstract design is perhaps diluted, however, by the addition of objective details.

Similarly, in his painting the elements of simplification and flattening, the most important general forces in Vallotton's style, are at odds with remnants of a more traditional manner. The composition *L'Eté* (1892; Zurich, Kunstgewerbemuseum), for example, is decoratively flattened by repeated, starkly simplified, and abstracted forms; but the near-naturalistic nudes and indications of spatial depth nullify the flat decorative effect. Comparable conflicts arise in other paintings of the same period, for example, *La Troisième galerie au Théâtre du Châtelet* (1895; Paris, National Museum of Modern Art). In his later paintings, as an adherent of the Neue Sachlichkeit, Vallotton avoided such inconsistencies by applying the same hard linear simplification to all parts of the picture, as in *Les Sables au bord de la Loire* (1923; Zurich, Art Gallery).

BIBLIOGRAPHY. L. Godefroy, *L'Oeuvre gravé de Félix Vallotton*, Lausanne, 1932; H. Hahnloser, *Félix Vallotton et ses amis*, Paris, 1936; F. Jourdain, *Félix Vallotton*, Geneva, 1953.

JEROME VIOLA

VALORI PLASTICI, *see* PITTURA METAFISICA.

VALUE, COLOR. The value of a given color is based upon the intensity of its hue. A painting will have very high color values if the colors are very intense. Color value is independent from tonal value. A dark blue, for example, will be dark in tone while it may be bright in color (value).

VAN. Names beginning with "van" not listed here are found under the last part of the name; for example, Anthony van Dyck is listed as Dyck, Anthony van.

VANBRUGH, SIR JOHN. English architect (b. London, 1664; d. 1726). He was the son of a rich sugar merchant and in contrast to his rival and collaborator, Nicholas Hawksmoor, moved in London society. Little is known of Vanbrugh's early life or education, but it is established that before turning to architecture in 1699 he had already enjoyed some success as a playwright. His first design was Castle Howard; though he was assisted by the better-trained Hawksmoor, the massing and interplay of rhythms between the dependencies is Vanbrugh's own. The central block, topped by a cupola and flanked by quadrants, is a study in form and mass rather than in detail, a quality that characterizes most of Vanbrugh's work. The treatment of the court and garden façades, however, may have been directly influenced by J.-H. Mansart's Marly-le-Roi in Paris (1679). *See* HOWARD, CASTLE.

Sir John Vanbrugh, Seaton Deleval, 1720–29, north front.

Despite his lack of training, Vanbrugh assumed the office of Comptroller of His Majesty's Works in 1702, a position he held, except for a brief interruption in 1713–14, until his death. In 1716 he succeeded Wren as Surveyor to Greenwich Royal Hospital and was responsible for the designs of the Great Hall and King William's Block there. Vanbrugh's greatest commission was Blenheim Palace, near Oxford (1705–24), perhaps the culminating monument of the English baroque. It was ordered by the Crown for the Duke of Marlborough following the latter's military successes in Bavaria. Similar in layout to Castle Howard with its central block and flanking wings, Blenheim has both a greater sweep of movement and a more careful integration of forms. The central block, with a Corinthian portico, sits between strongly accented corner pavilions so that the major masses are distinct and clearly articulated. However, a subsidiary Doric order, which passes across the central unit and marches along the flanking elements, unites the composition. On the skyline of the major blocks, Vanbrugh introduced emphatic attics which support huge urns. *See* GREENWICH ROYAL HOSPITAL.

Vanbrugh further investigated relationships of mass in his later works. Seaton Deleval (1720–29), though relatively small in size, is immense in scale. It has corner towers that impart a Gothic flavor, although no Gothic motifs are used. Rusticated surfaces are used to define the masses as well as for their decorative value. Because of his concern for exterior effect, Vanbrugh's feeling for logical arrangements of interior spaces leaves much to be desired. His designs, however, were highly personal and were unique in England. They derive from the most baroque conceptions of Wren and Hawksmoor and certain Continental examples and are all highly spiced by his strong sense for the picturesque.

See also WHITEHALL PALACE, LONDON.

BIBLIOGRAPHY. L. Whistler, *Sir John Vanbrugh*, London, 1938.

MATTHEW E. BAIGELL

VAN BRUNT, HENRY, *see* WARE AND VAN BRUNT.

VAN DASHORST, ANTHONIS MOR, *see* MOR, ANTHONIS.

VAN DEN BROECKE (Broeck), WILLEM (Paladanus). Flemish sculptor (b. Antwerp, 1520/29; d. there, 1579). In 1557 he became a freemaster in the Guild of St. Luke in Antwerp, and in 1559, a citizen. Van den Broecke was in Spain from 1571 to 1573, executing ironworks for the Cloister of S. Leonardo in Alva. He was later in Rome, but no Roman works are known to have survived. Van den Broecke evidently worked in an agreeable 16th-century idiom.

BIBLIOGRAPHY. E. Marchal, *La Sculpture et les chefs-d'oeuvre de l'orfèvrerie belges*, Brussels, 1895.

VAN DEN BROEK, JOHANNES H., *see* BAKEMA AND VAN DEN BROEK.

VANDERBILT HOUSE, NEW YORK, *see* HUNT, RICHARD MORRIS.

VANDERLYN, JOHN. American portrait, historical, and landscape painter (b. Kingston, N.Y., 1775; d. there, 1852). After study with Archibald Robertson in New York and Gilbert Stuart in Philadelphia, Vanderlyn was sent to Paris in 1796 by Aaron Burr. Probably the first American artist to study in Paris, he worked there under Vincent. From 1801 to 1803 he was back in New York, and among his works at this time were views of Niagara Falls. In 1803 he was commissioned to return to Europe to buy casts of ancient sculpture for the American Academy of Fine Arts, and he remained in Europe until 1815. Most of this period was spent in Paris, except for a visit to Rome from 1805 to 1808.

This second European stay was Vanderlyn's most productive period, witnessing the maturing of his neoclassical manner with its clarity, firm outlines, sharp bright color, and sculpturesque quality. Characteristic of his portraits of this period is *Robert R. Livingston* (1804; New-York Historical Society), but of more significance are his historical paintings. The first of these, *The Death of Jane McCrea* (1804; Hartford, Conn., Wadsworth Atheneum), was taken from American history. Neoclassical in subject as well as style, *Marius Amidst the Ruins of Carthage* (1807; San Francisco, De Young Memorial Museum) won for Vanderlyn a gold medal awarded in 1808 by Napoleon. *Ariadne* (1812; Philadelphia, Pennsylvania Academy of Fine Arts) is a great ideal nude.

Before leaving for New York in 1815, Vanderlyn made sketches of Versailles for a panorama. He exhibited the *Palace and Gardens of Versailles* (1816–19; New York, Metropolitan Museum) and others in a rotunda that he built on the corner of City Hall Park in New York, a property that he leased in 1817. Regrettably, he did not make the fortune from this that he had hoped, and the expiration of his lease in 1829 angered and embittered him. He then retired to Kingston to continue painting.

The period in New York after his return from Europe had also been embittered by his failure to receive a commission from the federal government. Finally, in 1838, the commission came for *The Landing of Columbus* for the United States Capitol. He then went to Paris (1842–44) to work on it, but the *Columbus* was a failure. It was Vanderlyn's tragedy that in 1815 he was probably better

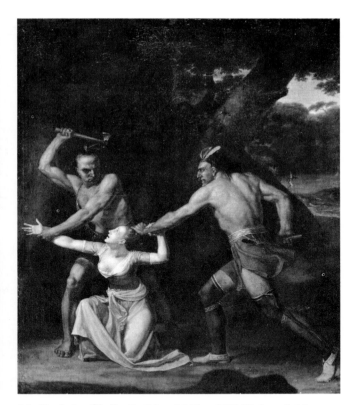

John Vanderlyn, *The Death of Jane McCrea*, 1804. Wadsworth Atheneum, Hartford, Conn.

prepared for such a challenge than any American of his day, whereas more than twenty years later when the opportunity came, it was beyond his capabilities.

Vanderlyn also painted landscapes, both classical scenes done in Europe and the wonders of America, as seen in his *View of Niagara Falls* (1827; Kingston, N.Y., Senate House Association).

BIBLIOGRAPHY. M. Schoonmaker, *John Vanderlyn, Artist, 1775–1852*, Kingston, N.Y., 1950; E. P. Richardson, *Painting in America*, New York, 1956. DAMIE STILLMAN

VANDERLYN, PIETER. American portrait painter (1687–1778). Born probably in Holland, Vanderlyn arrived in New York about 1718 from Curaçao and is believed to have painted portraits in Albany and Kingston, N.Y. Identification rests on family tradition and on the attribution to him, sometimes disputed, of the portrait of his wife's stepmother, *Mrs. Petrus Vas* (1723; Albany Institute of History and Art).

BIBLIOGRAPHY. K. Hastings, "Pieter Vanderlyn: A Hudson River Portrait Painter," *Antiques*, XLII, December, 1942.

VAN DER STAPPEN, CHARLES. Belgian sculptor (b. St-Josse-ten-Noode, 1843; d. Brussels, 1910). His teacher was Portaels at the Brussels Academy. Like many artists of his generation, Van der Stappen was greatly influenced by 15th-century Florentine sculpture during a stay of several years in Italy. Later he became a professor and then director of the Brussels Academy, where he taught such men as Minne,. Rousseau, and Lagae. The influence of his students is felt in his later works, which often use literary themes and are more physically dynamic and expressionistic.

VAN DOREN, HAROLD. American industrial designer (b. Chicago, 1895; d. Philadelphia, 1957). He studied art at the Art Students League, New York City, and in Paris, but did not turn to industrial design until 1930. He became the pioneer in introducing streamlined and functional forms to the Midwest, working primarily out of Toledo, Ohio. Some of the products designed by him are scales for the Toledo Scales Corporation; freezers, refrigerators, and stoves for the Philco Corporation; heavy machinery; printing presses; and gas pumps.

VAN EYCK, HUBERT. Flemish painter (ca. 1370–1426?). He is probably the most enigmatic figure in early Flemish painting, and has been the cause of much contention among art historians. The sole seemingly authentic documentary evidence of Hubert's artistic existence is the inscription on the *Ghent Altarpiece* (Ghent, St. Bavon), which states, in part, "The painter Hubert van Eyck, greater than whom no one was found, began [this work]; and Jan, his brother, . . . carried through the task. . . ." There are four earlier notices (1424–26) in the city archives of Ghent of a painter variously named "Ubrechts," "Hubrechte," and "Lubrecht van Heyke." The last, dated 1426, is a record of inheritance tax paid on the property left by the deceased Lubrecht. But there is no certainty that this is the same painter mentioned on the inscription as the brother of Jan.

Authorities on the subject of Hubert and Jan van Eyck have gone to great lengths to support various, and greatly divergent, views regarding Hubert. Some have gone so far as to deny the existence of Hubert and to call the *Ghent Altarpiece* inscription a forgery. Others, certain of Hubert's existence, differ only as to how much of the work he was responsible for and what other works can be ascribed to him. *See* VAN EYCK, JAN.

The problems concerning which parts of the *Ghent Altarpiece* are to be assigned to Hubert and Jan, respectively, are complex. Generally, it is accepted that the more hieratic, "old-fashioned" portions are Hubert's contributions. These would be, on the interior, the three major, upper figures, and portions of the lower, central panel, depicting the Adoration of the Lamb. However, attributions based on direct stylistic analysis have been qualified by recent theories that the altarpiece is not a "whole," but that it was probably put together from a number of independent, smaller altarpieces.

Taking the more "archaic" portions of the *Ghent Altarpiece* as a criterion, two panels can tentatively be assigned to Hubert. One is the Friedsam *Annunciation* (New York, Metropolitan Museum) and the other is *The Marys at the Tomb* (Rotterdam, Boymans-Van Beuningen Museum). The tomb in the latter has the same exaggerated, inconsistent perspective as the altar in the Adoration of the Lamb panel, assigned to Hubert. And the voluminous, all-enveloping drapery of the figures is also suggestive of the Hubert portions of the *Ghent Altarpiece*. The *Annunciation* panel depicts the scene outdoors, a convention common to late-14th- and early-15th-century illumination and

Italian painting. Thus the painting is related to an older manner, consistent with the older generation of Hubert, and inconsistent with the inventiveness of Jan. A diptych, *Calvary* and *The Last Judgment* (Metropolitan Museum), seems to show an early collaboration of Hubert and Jan. Like the *Ghent Altarpiece*, it was probably incomplete at Hubert's death, and so was finished by his conscientious brother.

BIBLIOGRAPHY. E. Renders, *Hubert van Eyck, personnage de légende*, Paris, 1933; E. Panofsky, *Early Netherlandish Painting*, 2 vols., Cambridge, Mass., 1953.

STANLEY FERBER

VAN EYCK, JAN. Flemish painter (ca. 1380–1441). The "father" of Flemish painting, Jan van Eyck stands out as one of the truly original artists of all time. His place of birth is generally thought to have been Maaseyck, although Maastricht, 18 miles south, has also been suggested. The first documentary evidence of Jan is as painter and *valet de chambre* to John of Bavaria, from about 1422 to 1424, at The Hague. He was employed, among other things, to decorate John's castle, and was by this time already referred to as "master." (From this one infers his birth date, for it is rare for a painter to be listed as "master" prior to the age of thirty-five or forty.) In 1425 he started service with Philip the Good, duke of Burgundy, and took up residence at Lille as painter and *valet de chambre*. About 1430 Jan moved to Bruges, where he remained until his death in 1441. During the last sixteen years of his life he was official court painter to Philip as well as painter par excellence for the wealthy *bourgeoisie* of Bruges and the neighboring area.

Traditionally, in the north, Jan has been credited with the "invention" of oil painting. Although historically this is not accurate, he did develop the medium for panel painting beyond any of his predecessors; oil painting achieved a hitherto unrealized status. Jan's earliest signed and dated work is the *Ghent Altarpiece* (Ghent, St. Bavon), commissioned by Jodocus Vyt, mayor of Bruges, and completed by 1432. But an inscription on this famous work indicates that it was started by his older brother, Hubert van Eyck, and completed by Jan. Exactly how much and what parts of the polyptych were done by each is still a matter of great debate. *See* OIL PAINTING; VAN EYCK, HUBERT.

On the question of the earlier works of Jan van Eyck, most authorities see Jan's hand in the manuscript known as the Turin-Milan Hours (Turin, Municipal Museum of Ancient Art), originally done for John of Bavaria while Jan was in his service. This Book of Hours shows the work of many hands, one of which is late 15th century. But some of the scenes illustrated refer to events in the life of John of Bavaria and his brother William at about the time Jan was in their employ, that is, perhaps as early as 1420. These scenes show such eminent skill and rich painterly technique that many authorities recognize them as the earliest extant works of Jan. Specifically, a scene of the Baptism of Christ is executed in such exquisite detail, with atmospheric effects of the sky and its reflection in the water, a relatively low horizon, and careful attention to jewel-like details, that indeed it seems to partake of the spirit and character of Jan's known work.

We are fortunate in having, for an early painter of the importance of Jan, a number of dated and some signed works, through which to trace his progressive development. Dated 1432, the same year as the *Ghent Altarpiece*, is the *Leal Souvenir* (London, National Gallery). The subject of this profound and penetrating portrait has been tentatively identified as Gilles Binchois, Burgundian court composer during Jan's employ there. The three-quarter profile head, coming out of a dark background and set into space by a foreground ledge, set a pattern for portraiture that remained dominant for centuries. The strength of modeling and coloristic qualities relate this portrait to the head of Adam in the *Ghent Altarpiece*.

There are two dated works for 1433: the *Incehall Madonna* (Melbourne, National Gallery) and the *Portrait of a Man in a Red Turban* (London, National Gallery). The portrait shows an increased concern with light and dark. Shadows in the face are developed by the modulation of lights within them; the whole effect, besides an increased plasticity, being one of an enriched atmosphere surrounding the sitter which seems to create a layer of air between subject and spectator. Another aspect of the same development is seen in the *Incehall Madonna*, where the fluent proliferation of folds in the Madonna's gown deepens and fills the space around her. This is further emphasized by the single, visible light source, the window in the side wall.

These lighting effects show the way to a fuller development in the next dated work, *The Arnolfini Marriage* (1434; London, National Gallery). This work, uniquely signed "Johannes de Eyck fuit hic" ("Jan van Eyck was here") has been interpreted as a record of the marriage of Giovanni Arnolfini and Jeanne Cenami. The strange signatory phrase indicates that Van Eyck was present not only as a painter but also as a witness to the marriage. The imagination and daring of placing two full standing figures within the limited space of an enclosed chamber was not to be repeated again in northern art for a century (Holbein's *The Ambassadors*). The rich colors and textures of clothes and other materials, the atmospheric effects of side and back lighting streaming through the window, and the wealth of iconographic detail make this one of the outstanding paintings of the 15th century.

There is a gap of two years before the next dated works. In 1436 Van Eyck completed the almost life-size panel *Madonna of Canon van der Paele* (Bruges, Municipal Fine Arts Museum). This large work shows the Madonna and Child enthroned, flanked by St. Donatian and the donor, Canon van der Paele, introduced by his patron saint, George. The work is overwhelming in its diversity of rich colors, cloth and metal textures, tapestry rug patterns, and architectural detail. Although undated, the *Madonna with Chancellor Rolin* (Paris, Louvre) should be considered here. It is related in color, style, and monumentality (despite its small size) to the *Madonna of Canon van der Paele*, and might be dated within a year of the larger work. Also dated 1436 is the *Portrait of a Goldsmith* (Vienna, Museum of Art History). This portrait continues in the tradition of the *Leal Souvenir*, but shows some indicative stylistic changes. There is a greater emphasis on outline quality, and the shadow modeling is softer and more trans-

Jan van Eyck, *Portrait of Cardinal Albergati.* **Museum of Art History, Vienna.**

parent, lacking the opaque density of the earlier portraits. A silverpoint drawing, *St. Barbara* (1437; Antwerp, Fine Arts Museum), as the only work dated in that year, aids in establishing dates for other works. The drawing shows a spatial concept of landscape similar to that of the *Madonna with Chancellor Rolin*. Hence the latter work, which we have already related to the *Madonna of Canon van der Paele* of 1436, might be dated about 1437.

The last dated works are the *Madonna at the Fountain* (Antwerp, Fine Arts Museum) and the *Portrait of Margaret van Eyck* (Bruges, Municipal Fine Arts Museum), both 1439. Both works show an increased linearity and a sculptural hardening of form. In the Madonna panel, space is intentionally limited, so as to emphasize the sculptural quality. This sculptural linearity (a seeming paradox), reflective of an International Gothic style revival of the time, gives to these works an asceticism foreign to Jan's earlier works. Whether this change reflects a change in his interests or represents the indirect influence of Rogier van der Weyden is conjectural.

Jan's works might generally be described as possessing a darkness which, as in the works of Rembrandt, glows with deep golden and amber jewel-like tones, shot through with light and flashes of brilliant clarity. His work shows an unabashed interest in the beauties and wonders of the natural world. His rich materialism reflects not only the material-loving rich *bourgeoisie* of Bruges, but also Jan's deep spirituality in glorifying the material world, which to him was no more than an expression of the greatness and munificence of God.

BIBLIOGRAPHY. M. J. Friedländer, *Die altniederländische Malerei*, vol. 1, Berlin, 1924; E. Panofsky, *Early Netherlandish Painting*, 2 vols., Cambridge, Mass., 1953. STANLEY FERBER

VAN GEEL, JAN FRANS. Flemish sculptor (b. Mechlin, 1756; d. Antwerp, 1830). He was a pupil of Pieter Valk. After serving as a professor at the Academy of Malines, Van Geel was appointed professor at the Academy in Antwerp in 1817. Among his works is the tomb of Cardinal Thomas-Philippe d'Alsace (1813) in the Cathedral at Mechlin.

BIBLIOGRAPHY. H. Rousseau, *La Sculpture aux XVIIe et XVIIIe siècles*, Brussels, 1911.

VAN GOGH, VINCENT WILLEM. Dutch-born postimpressionist painter (b. Groot-Zundert, 1853; d. Auvers, France, 1890). Van Gogh was the eldest of six children born to a Calvinist minister. He attended local schools until he was sixteen, when he went to The Hague to work as a clerk in an art gallery, Goupil and Company, run by one of his uncles. In this environment he developed a taste for painting and literature. He began to write about his enthusiasms to his brother Théo (1857–90), and they were to correspond regularly and at length until Vincent's death. Fortunately these letters have been saved and published; they are richly confessional, eloquent, and expressive.

Van Gogh was transferred to the Brussels, London, and Paris branches of Goupil and Company. In Paris he visited the Louvre. His interest in his position disintegrated,

Vincent van Gogh, *Self-portrait*, 1890. Louvre, Paris.

and he finally resigned and began to prepare for the ministry. His family sent him to study theology in Amsterdam, but he failed his entrance examinations to the seminary in 1878 and decided to become a lay preacher. He had no talents as an evangelist, but his zeal led him to sacrifice himself without stint in assisting the poor. He served in the Borinage, a poor Belgian mining district. He began to draw in 1880, using the miners as models, and taught himself by copying reproductions of paintings by Millet. He soon became so ill from self-deprivation that his father had to take him home briefly to recuperate. He moved soon afterward to a small town in the Borinage, where he began to paint full time. He received encouragement, as well as financial assistance, from his brother.

He went to The Hague in 1882 to study with Mauve, but found the academic approach sterile and began to work on his own. Van Gogh's series of tragic experiences with women began at this time. He went to Neunen, where he painted his masterpiece of this early period, *The Potato Eaters* (1885; Laren, V. W. Van Gogh Collection). At this point Van Gogh favored a dark tonality reminiscent of late Hals, Brouwer, and even Rembrandt. He restricted himself to earth colors, and his brushstroke is broadly expressive. The peasants in this painting are solemn creatures numbed by subhuman conditions. He also did still-life paintings of his own shoes, baskets of potatoes, a bird's nest, and other such humble themes. His work at this point is already expressionist in its fervor.

Van Gogh sought salvation for himself and others through his art. He needed an anchor, an outlet for his religious aspirations. He craved love and a sense of belonging and a productive occupation. In February, 1886, Van Gogh went to Paris, where he shared living quarters with his brother Théo, who was in charge of a small branch of Goupil and Company. Vincent entered the studio of Cormon and stayed for four months. There he met Toulouse-Lautrec. Through his brother he came to know impressionist painting. In 1887 he met Degas, Seurat, Signac, and Gauguin as well as Pissarro, who encouraged him to brighten his palette and adopt impressionist techniques. He began to collect Japanese prints. His painting changed rapidly almost at once: he stopped painting peasants and adopted themes of Monet and Renoir—views of Paris, bridges along the Seine, still-life paintings of fruit, and the like. He became interested in the impressionists' use of rainbow colors, applied in small strokes, dabs, and spots of color. Van Gogh was attracted to this quality of intensity, though full expression of it was to come later. He was impressed by Seurat's *Sunday Afternoon at La Grande Jatte*, which was shown at the last impressionist exhibition of 1886, and experimented briefly with pointillism.

In February, 1888, Van Gogh went to Arles and stayed for fifteen months. This was one of the most productive periods that any artist has ever had. He painted every day and nearly always out of doors. He felt he needed to improve his drawings. He took a studio and decorated its walls with paintings of sunflowers. He saw bright color everywhere, as he told Théo in his letters. He became impatient with the broken color of the impressionists and began to hit harder with intense color in large, relatively unmodulated areas. He emphasized contour with line. He began to use impasto and a heavier stroke. In his views

of Arles, he employed a forced perspective, causing roadways to hasten toward the horizon unnaturally.

Van Gogh made foreground areas precise and vivid in comparison to distant background, which often disappeared in fog. He all but eliminated impressionist atmospheric effects. In his pictures he advanced a firm, clear, bold image from which light appears to emanate. He established a polarity of intensity, a new expression of climax and exhilaration with areas of pure color. In *L'Arlésienne* (1888; New York, Metropolitan Museum) he placed the figure of a peasant woman against a chrome-yellow background which resembles a light-reflecting screen, a dazzling vision of pigment transformed into sunlight. With this work, his several self-portraits, and *The Postman Roulin* (1888; Boston, Museum of Fine Arts) he reestablished the importance of the portrait, an art form largely ignored by the impressionist generation.

In October, 1888, Gauguin visited Van Gogh in Arles. The two men were so different in temperament that they constantly disagreed. Tension mounted, and after two months Gauguin left for Paris. It was at this time that Van Gogh cut off his own ear and began to suffer from fits. (His illness has been diagnosed by modern physicians as psychotic epilepsy.) But he continued to paint; painting occupied him and was a stabilizing agent. He produced more than 200 pictures in 1889. His landscapes at this time show nature writhing and convulsed as if suffering and disturbed. Clouds appear as bulging knots. Pathways become a gushing flood of brushstrokes, resembling a log jam in an anguished river. Color is less brilliant than before; it is as if energy were transferred to contours. Forms no longer merely advance, they rush toward the beholder. Convergence dominates over divergence. However, Van Gogh maintained control; even in his last works, form never yields to chaos.

Recognizing his condition, Van Gogh requested that he be committed to an asylum and entered the hospital at St-Rémy. Here he was very productive, painting nearly 150 oils in the last six months of his life. In 1890 he received a favorable notice from the press and sold a picture, the only sale in his lifetime. Two months later he shot himself. Théo died six months later.

Throughout Van Gogh's short and tortured career an emotionally expressive trail can be followed. Beginning with the brooding, dark brown miners and peasants of his early period, he moves toward the emotive intensity of the Arles period with its increasingly heavy and textured paint. Just as his colors become more emotional, they also move toward a distinctly symbolic meaning, which is noted in Van Gogh's letters; for example, blue is used to impart the idea of infinity. Every brushstroke is loaded with feeling as the color writhes across the surface, projecting the anguish of the artist's soul and reflecting "the heartbroken expression of our time."

BIBLIOGRAPHY. V. W. Van Gogh, *Vincent Van Gogh*, text by M. Schapiro, New York, 1950; C. Estienne, *Van Gogh*, Geneva, 1953; V. W. Van Gogh, *Complete Letters*, 2d ed., 3 vols., New York, 1959; V. W. Van Gogh, *Van Gogh: A Self-Portrait*, letters...selected by W. H. Auden, New York, 1961; H. R. Graetz, *The Symbolic Language of Vincent Van Gogh*, New York, 1963.

ROBERT REIFF

VAN HOOL, JAN. Flemish sculptor (b. Antwerp, 1769; d. there, 1837). A student of Frans van Ursel, Van Hool became a professor at the Antwerp Academy in 1821. He is known chiefly as a church sculptor. Among his major works are two saints in the Church of the Jesuits, Antwerp, and the high altar of the church at Oosterhout, Brabant.

BIBLIOGRAPHY. E. Marchal, *La Sculpture et les chefs-d'oeuvre de l'orfèvrerie belges*, Brussels, 1895.

VANITAS. Latin term meaning "vanity," used to denote a type of painting and graphic expression, generally a still life but sometimes a figure painting, in which symbols remind us of the vanity of human existence. Objects such as the hourglass, scales, skull, mirror (of vanity), clock, and so on, are often shown in 17th-century still lifes, while people are also shown using these objects, as in the famous Georges de La Tour *Magdalen* with a skull, mirror, and candle.

VAN LOO, CHARLES AMEDEE PHILIPPE. French history painter (b. Turin, 1719; d. Paris, 1795). He was the son of Jean-Baptiste Van Loo and the brother of Louis Michel Van Loo. In 1738 Charles accompanied his brother to Rome, where he received his training and first success. In 1747 he was elected to membership in the Royal Academy, and he exhibited in the Salons of 1761 and 1763. In 1748 he was called to Berlin as First Painter (1748–69) to Frederick the Great, succeeding Antoine Pesne. Like his predecessor, he divided his time between portraiture and ceiling decorations at Potsdam, and also designed tapestries (*Story of Psyche*, series of seven). Scholars today tend to disparage his art as a pale reflection of his uncle's. In order to distinguish him from his brother, First Painter to the King of Spain, he was nicknamed "the Van Loo of Prussia."

VAN LOO, CHARLES ANDRE (Carle). French history and genre painter (b. Nice, 1705; d. Paris, 1765). Upon the death of his father, Louis van Loo, Carle joined his brother Jean-Baptiste in Turin in 1712. Later, in Rome, he studied with Benedetto Luti, and under Pierre Legros he took up sculpture. Back in Paris in 1719, he worked closely with Jean-Baptiste. As a student of the Royal Academy (1723) he won a medal for drawing and assisted his brother in restoring Rosso's paintings in Fontainebleau. In 1724 he won the painting prize at the Academy. During this period in Paris Carle executed many portraits.

He returned to Rome in 1727, this time with Boucher. There he copied mostly Domenichino, the Carraccis, and Pietro da Cortona and painted *The Apotheosis of St. Isidorus* in the church of that name. In Turin (1732–34) he worked for Charles Emmanuel III (Charles Emmanuel I of Sardinia).

He was back in Paris in 1734. A professor at the Academy in 1737, he became its rector in 1754 and its director in 1763. By 1762 he had replaced Coypel as First Painter to the King and decorated the Salle du Conseil in Fontainebleau (ceiling by Boucher). Carle painted genre scenes, *turqueries*, and *espagnoleries* for Mme de Pompadour and Mme Geoffrin; these are reminiscent of Lancret and De Troy but have little of the grace and elegance of their works. Carle designed a history of Theseus for the Gobe-

lins and worked for the king of Denmark at Christiansborg and for Frederick II of Prussia.

His numerous altarpieces for Paris churches represent the best aspect of his art, in which he was a master craftsman, though in invention he was hardly ever more than a competent disciple of the Carraccis and Guido Reni. Although scarcely remembered today, Carle van Loo was regarded as one of the greatest painters of all Europe during his lifetime. Among his students were Lagrenée the Elder and Doyen. In Germany his influence extended to Johann Heinrich Tischbein.

BIBLIOGRAPHY. L. Réau, "Carle van Loo," *Archives de l'art français*, n.s., XIX, 1938. GEORGE V. GALLENKAMP

VAN LOO, JACOB. Dutch history, genre, and portrait painter (b. Sluis, ca. 1614; d. Paris, 1670). Van Loo first studied with his father before going to Amsterdam (1642), where he was influenced by Thomas de Keyser and Rembrandt. Bartholomeus van der Helst and Jacob Backer also had a strong influence on his style. In 1660 Van Loo killed a man, and was banished from Amsterdam in 1661. He went to Paris, where he became a member of the Academy. Jacob (or Jacques) became a naturalized French citizen; Jean-Baptiste Van Loo and Charles André Van Loo were his grandsons.

BIBLIOGRAPHY. A. von Schneider, "Jacob van Loo," *Zeitschrift für bildende Kunst*, LIX, 1925.

VAN LOO, JEAN-BAPTISTE. French portrait, historical, and religious painter (b. Aix-en-Provence, 1684; d. there, 1745). He worked in Genoa and in the employ of the house of Savoy at Turin in 1713, then went to Rome in

Charles André (Carle) Van Loo, *Charles van Loo and His Family*. Château of Versailles.

1714 to study with B. Luti. In Turin he decorated the Castello at Rivoli in 1719. He was called to Paris by the Prince of Carignan in 1720. He and his more distinguished younger brother, Charles André Van Loo, began their Parisian careers by repairing the decorations of F. Primaticcio at Fontainebleau. Jean-Baptiste's equestrian portrait of the young Louis XV (1728; Versailles Museum) established him as a portraitist, and in 1731 he was named academician. From 1737 to 1742 he was in London, enjoying great success, but poor health forced him to retire to Aix. His altarpieces are found in many Parisian churches. His sons, Louis Michel and Charles Amédée Philippe Van Loo, were his chief pupils. Eclectic similarity characterizes this prolific dynasty of painters, Dutch in origin, Italian in education, and cosmopolitan in habits.

VAN LOO, JULES CESAR DENIS. French landscape painter (b. Paris, 1743; d. there, 1821). He was the son and pupil of Charles André Van Loo. The last and least noteworthy of the family, he was a student in the Royal Academy from 1757 to 1784. He was the disgruntled author of puerile diatribes against the temerity of self-appointed critics of academic art (*César Van Loo aux amateurs des Beaux-Arts*); his own example was the least defensible case, since he competed unsuccessfully six times for the Prix de Rome (1764–76). His works are pretentiously effete, almost perfumed.

VAN LOO, LOUIS MICHEL. French portrait painter (b. Toulon, 1707; d. Paris, 1771). He was the son and pupil of Jean-Baptiste Van Loo, the nephew and pupil of Charles André Van Loo, the pupil of Hyacinthe Rigaud, and the brother of Charles Amédée Philippe Van Loo. Louis won the Prix de Rome in 1725, and became an academician in 1733, First Painter to Philip V of Spain from 1736 to 1752, director of the Academy of San Fernando in Madrid in 1751, and rector of the Paris Academy in 1754. Though he produced mythological subjects in a vein dear to the sculptor Pigalle (*Venus Confiding the Education of Cupid to Mercury*, location unknown), he is above all a portraitist (*The Family of Philip V*, 1743; Madrid, Prado; Versailles Museum). His influence on Luis Egidio Meléndez and, later, on Francisco Goya is far from negligible. Van Loo's style was followed by students of the Ecole des Elèves-Protégés (school of the Royal Academy), of which he was director from 1765, succeeding his uncle.

VAN MULCKEN, ARNOLD (Aert). Flemish architect (fl. 1525–40). Van Mulcken did a number of buildings in the Flamboyant style in Liège. He directed the completion of the choir of St. Martin (1525), the new church of St. James (1513–38), and the Archiepiscopal Palace (1526–40).

VANNI, ANDREA. Italian painter (ca. 1332–ca. 1414). Born in Siena, he combined a political and an artistic career, and is noted for his friendship with St. Catherine of Siena. He opened his workshop together with Bartolo di Fredi in 1353. In Vanni's early works the influence of Simone Martini is most evident, whereas later his style becomes stiffer, with an emphasis on rigid postures and hard outlines. In the *St. Peter* and *St. Paul* panels (Boston, Museum of Fine Arts), the soft modeling of the features,

the graceful drapery folds, and the rich decoration all suggest that Vanni was a student of Simone Martini or one of his close followers, such as Lippo Memmi. The harshness and mannered approach that are apparent in his late works reveal a progressive decline in the fresh and delicate technique that characterizes the early period of his artistic career.

BIBLIOGRAPHY. F. M. Perkins, "Andrea Vanni," *The Burlington Magazine*, II, August, 1903; M. Meiss, *Painting in Florence and Siena after the Black Death*, Princeton, 1951.

VANNI, FRANCESCO. Italian painter (b. Siena, 1563; d. there, 1610). After studying in Bologna and with Giovanni de' Vecchi in Rome, Vanni became one of the most popular devotional painters in Italy, developing a coloristically effulgent style akin to that of Barocci. His later works are harsher and more painterly.

VANNI, LIPPO. Italian painter (fl. Siena, after 1341; d. 1375). He was a painter of miniatures by profession until 1352, when he was commissioned for a fresco in the Biccherna. His work is understood through three more or less authentic paintings, widely separated in date, which reveal his style to have undergone a considerable shift in influence from the Lorenzettis, in his early period, to Simone Martini. Thus, in the *Nativity of the Virgin* miniature (Siena, Cathedral Library), dated 1345, the comparison with the work of Ambrogio Lorenzetti is obvious from the similarities of facial types, the naturalistic setting, and the lively action. In the triptych in the Monastery of SS. Domenico e Sisto, Rome, dated 1358, the figures have become more monumental; they exhibit the soft drapery folds, serene expressions, and mood of tender aloofness that is characteristic of the Gothic style of Simone Martini. In Vanni's works following this period, his style becomes increasingly more graceful and elegant in form, while expressions soften to the point of melancholy, as in the fresco of the Battle of Val di Chiana attributed to him in the Palazzo Pubblico in Siena.

BIBLIOGRAPHY. M. Meiss, *Painting in Florence and Siena after the Black Death*, Princeton, 1951. PENELOPE C. MAYO

VANNI, TURINO, THE SECOND. Italian painter (1349–1438). A native of Rigoli, Turino was a leader of Pisan art during the latter part of the 14th century. He was influenced by the stylistic elegance of Simone Martini in his early works but evolved a more massive and angular style in later ones.

VANNUCCI, PIETRO DI CRISTOFORO, see PERUGINO.

VANRISAMBURGH (Vanrisemburgh), BERNARD II, see RISENBURGH, BERNARD II, VAN.

VAN'T HOFF, ROBERT, see HOFF, ROBERT VAN'T.

VANTONGERLOO, GEORGE. Belgian sculptor, architect, painter, and theorist (1886–1965). Born in Antwerp, he received instruction in painting, sculpture, and architecture at the Antwerp and Brussels art academies. In 1914 he met Theo van Doesburg in Holland, where he had been sent after joining the army. He attached himself to the de Stijl movement and collaborated on a publication of that name with Van Doesburg and Mondrian in 1917. During 1914–17 he was active in designing archi-

tectural projects. From 1919 to 1927 he resided in Menton, France, where he did his first abstract sculpture constructions and developed his theories on the relation of design to modern society. The latter led to the publication in 1924 of his *Art and Its Future*. From 1932 to 1935 he participated in the Paris Abstraction-Création group. He later lived a withdrawn existence in Paris. The Museum of Modern Art, New York, has *Construction in a Sphere* (1917), and Peggy Guggenheim owns *Construction in an Inscribed Square of a Circle* (1924). Vantongerloo was one of the most influential constructivists, combining ideas about science, architecture, painting, and sculpture.

BIBLIOGRAPHY. C. Giedion-Welcker, *Contemporary Sculpture*, New York, 1955; M. Seuphor, *The Sculpture of This Century*, New York, 1960. ALBERT ELSEN

VANVITELLI (Van Wittel), GASPARE (Gaspare dagli Occhiali). Dutch-Italian painter (b. Amersfoort, 1653; d. Rome, 1736). He studied with the landscape and topographical painter Matthias Withoos in Amersfoort. Vanvitelli went to Rome in 1674, where he remained. He became a highly successful topographical painter in Italy, working at first in Venice, Tuscany, and Umbria. In Naples (1699–1707) he worked at his specialty for the viceroy Ludovico. Returning to Rome, he maintained close connections and was in much favor with the Vatican and the courts of Madrid and Paris. His extraordinarily detailed and panoramic views of the cities in which he worked, many now in Neapolitan and Roman museums, prefigure those of Canaletto in Venice. He was the father of Luigi Vanvitelli.

BIBLIOGRAPHY. C. Lorenzetti, *Gaspare Vanvitelli*, Milan, 1934; G. Briganti, *Gaspar van Wittel*, Rome, 1966.

VANVITELLI, LUIGI. Italian architect (1700–73). He worked mainly in Naples. His first interest was painting, which he learned in the studio of his father, Gaspare Vanvitelli. Luigi became an architect in the 1730s; he had uncommon ability as a designer of utilitarian structures and as an engineer. His most important work is the royal residence at Caserta, near Naples, built for Charles III. Influenced by Versailles and the great royal palace tradition in its disposition and in its formal gardening, this building is immense in scale. Characteristic of Vanvitelli are the strict organization and clarity and the emphasis on vistas, which stems from the Italian scenographic tradition. The similarity of the Caserta chapel to that of Versailles has often been noted. *See* CASERTA: LA REGGIA.

BIBLIOGRAPHY. C. Lorenzetti, *Gaspare Vanvitelli*, Milan, 1934.

VAN WITTEL, GASPARE, see VANVITELLI, GASPARE.

VAPHIO CUPS. Two Minoan-Mycenaean gold cups (Athens, National Museum) found in a tholos tomb at Vaphio, Laconia, in the south-central Peloponnesus, in 1889. They are probably to be dated in the first Late Helladic period, about 1525 B.C.

The cups are decorated with repoussé reliefs showing episodes from a bull hunt. One shows a violent scene in which one bull is caught in a net while two others run rampant and attack the hunter and huntress. The other shows the capture of a bull through the use of a decoy cow. Although it is not certain whether the cups were made in Crete or on the Greek mainland, their fluid,

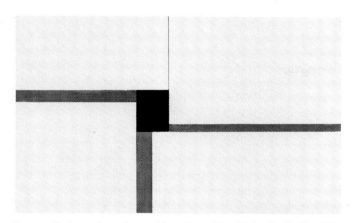

George Vantongerloo, *Composition, Green-Blue-Violet-Black, No. 105,* 1937. Solomon R. Guggenheim Museum, New York.

lively composition and deft workmanship are clearly in the Minoan tradition.

BIBLIOGRAPHY. A. J. Evans, *The Palace of Minos*, vol. 3, London, 1930.

VARA (Varada). Mudrā, or mystic gesture, in Indian art. *Vara*, which means "gift" or "reward," is the hand position symbolizing charity or gift-bestowing. With the arm pendant, the palm of the hand turns outward with the fingers extended.

VARAMIN: FRIDAY MOSQUE (Masjid-i-Jumeh). Iranian mosque on the outskirts of the village of Varamin, south of Teheran. Most famous of the mosques with domed sanctuaries, it was built during the reign of Abu Said (1322–26). The mosque, only parts of which remain, had a rather small court and its plaster, terra-cotta, and faïence wall decorations are typical of the Mongol art of the period. The dome, beautifully proportioned, towers over the rest of the structure, and panels and aisles are decorated with religious inscriptions. Brilliantly designed plaster friezes are adorned with verses from the Koran and floral and geometric patterns in brick. Terra-cotta insets adorned the brick walls, and brick stalactites were used in abundance in the vault of the sanctuary and the dome. Faïence decorations combine light and dark blue glaze with unglazed terra cotta.

BIBLIOGRAPHY. A. U. Pope, ed., *A Survey of Persian Art*, vol. 2, London, 1939; D. N. Wilber, *The Architecture of Islamic Iran: The Il-Khānid Period*, Princeton, 1955.

Gaspare Vanvitelli, *View of Rome*. Pitti, Florence.

VARGAS, LUIS DE. Spanish painter (b. Seville, 1506; d. there, 1568). The son of the painter Juan de Vargas, Luis studied with Diego de la Barrera. About 1522 he went to Rome, where he came under the influence of Perino del Vaga. Vargas returned to Seville in 1550, where he created a number of works in oil, including the *Nativity Altar* in Seville Cathedral and frescoes in the Convent of S. Pablo, Seville Cathedral, the Giralda, and the Hospital of Misericordia. With his experience in Italy, Vargas became one of the early representatives of the mannerist phase of Spanish painting. Massive, energetic forms are crowded into eccentric compositions inundated by complex and dramatic contrasts of light and shade.

BIBLIOGRAPHY. A. L. Mayer, *Die sevillaner Malerschule*, Leipzig, 1911.

VARIGNANA, *see* AIMO, DOMENICO.

VARIN (Warin), JEAN. French medalist, sculptor, and goldsmith (b. 1596; d. Paris, 1672). Varin went to Paris in 1625 and secured a position in the Monnaie du Moulin; in 1630 he married the widow of R. Olivier and succeeded to the post of Conductor of the Mint, in the process reforming the French monetary system. Varin was a member of the French Academy in 1665; he had previously held positions as Engraver General (1646) and Controller General of Effigies (1648). He was the best French diecutter of the 17th century: in 1665 he did the medal commemorating Bernini's appointment as designer for the Louvre, and in 1645 the medal for the foundation of the Val-de-Grâce. He also did statues of Henri IV, Louis XIII, Louis XIV, and Cardinal Richelieu.

BIBLIOGRAPHY. A. Michel, *Histoire de l'art*, vol. 5, pt. 2, Paris, 1915; F. Mazerolle, *Jean Varin . . .*, Paris, 1932.

VARLEY, CORNELIUS. English painter (b. London, 1781; d. there, 1873). Varley worked mostly in water color. He liked to depict quiet landscapes. He published his delineations of sea and riverside craft as a series of etchings. He was the brother of John Varley.

VARLEY, FREDERICK HORSMAN. Canadian painter (1881–). Born in England, he emigrated to Canada in 1912 and has lived in Vancouver and Toronto. His early studies were in Sheffield and Antwerp. Working in oil and occasionally in water color, he is a landscapist of the Canadian countryside, a portrait painter, and a draftsman of sensitivity. Varley was a prominent "Group of Seven" member.

BIBLIOGRAPHY. D. W. Buchanan, *The Growth of Canadian Painting*, London, 1950.

VARLEY, JOHN. English painter (b. London, 1778; d. there, 1842). Early in his career he attended the sketching symposia of Dr. Thomas Monro. Though best known for his topographical views, he occasionally painted moving clouds over brooding countrysides. Some of his canvases have been attributed to Cozens. Still, his paintings tend to be overorganized. His violent contrasts of warm browns with vivid streaks of sunset or deep purple hills are often clumsily handled. Mainly a water-colorist, he worked also in oils. His manual of 1816, *Landscape Design*, provided detailed instructions for composing the landscape.

BIBLIOGRAPHY. T. S. R. Boase, *English Art 1800–1870*, Oxford, 1959.

VARNISH. Any liquid that, when dry, leaves a more or less transparent coating. In art, varnishes are used chiefly to protect and beautify painted surfaces. There are two types: oil varnish, in which the resin is dissolved in a drying oil; and spirit varnish, in which the resin is dissolved in a volatile liquid such as turpentine.

BIBLIOGRAPHY. R. Mayer, *The Artists' Handbook of Materials and Techniques*, New York, 1940.

VARNISHING DAY (Vernissage). A day before an exhibition reserved for artists to touch up or varnish their paintings. Frequently the critics are allowed to view the works during the varnishing day.

VAROTARI, ALESSANDRO, *see* PADOVANINO.

VARUNA. One of the oldest of the Hindu Vedic deities. Varuṇa (the Encompasser) is the maker and upholder of heaven and earth. He is often associated with Mitra, Varuna being the ruler of the night and Mitra of the day. In later mythology he is the god of seas and rivers. His vehicle is the *makara. See* MAKARA; VEDAS.

VASARELY, VICTOR DE. French painter (1908–). Born in Pécs, Hungary, he studied in Budapest and went to Paris in 1930. His paintings, influenced by Bauhaus and constructivist aesthetics, explore the spatial and optical possibilities of geometric shapes and flat, interactive color in what has come to be called Op Art.

BIBLIOGRAPHY. J. Dewasne, *Vasarely*, Paris, 1952; W. C. Seitz, *The Responsive Eye*, New York, 1965.

VASARI, GIORGIO. Italian painter, architect, and important early art historiographer (b. Arezzo, 1511; d.

Giorgio Vasari, tondo portraying Duke Cosimo I, from the fresco decoration of the Sala dei Cinquecento, Palazzo Vecchio, Florence.

Florence, 1574). As a painter, he worked in the mannerist style of Rosso Fiorentino. His most famous works are frescoes in the Palazzo Vecchio, Florence, and in the Scala Regia of the Vatican. He is best known, however, for his history of Italian art, *Le vite de' più eccellenti pittori, scultori e architettori* (1550). This is the most important source for the lives and art of Italian artists from Cimabue to Vasari's time as well as a valuable source for the artistic theories prevalent in Italy during the 16th century. The best modern edition of Vasari's writings is the one by Milanesi (9 vols., 1878–85; 2d ed., 1906).

Vasari as architect. Vasari's reputation as an architect stands today somewhat higher than his reputation as a painter. Although he is traditionally named as the one who helped complete Michelangelo's Laurentian Library, his claim to the title of architect rests primarily on the Uffizi, constructed for Cosimo I from 1560. This early office building combines the power of Michelangelo in its elevations with mannerist compression and tension when seen as a mass surrounding a long, narrow court. For Cosimo's favorite foundation, the Cavaliere di Santo Stefano, he constructed a palace, church, and monastery in Pisa (1562–69). In 1565 he built the corridor connecting the Pitti and Uffizi palaces. In 1574 he designed the Logge in his native Arezzo. *See* UFFIZI PALACE, FLORENCE.

BIBLIOGRAPHY. A. Venturi, *Storia dell'arte italiana*, vol. 11, pt. 2, Milan, 1939.

VASE PAINTING, GREEK. Following the decline of the Mycenaean world, the proto-Geometric (1000–900 B.C.) and Geometric (900–725 B.C.) styles represent the first Hellenic phase of vase painting. At the end of the 8th century B.C. increased contact with the Near East led to an influx of Oriental artistic motifs and the formation of the Orientalizing style (700–550 B.C.), which is best represented by the proto-Corinthian, Corinthian, and proto-Attic styles. *See* GEOMETRIC STYLE.

Toward the end of the 7th century B.C. the Attic black-figured style, the medium of such great artists as Execias, became predominant, although other regional styles existed. About 530 B.C. Attic red-figured replaced black-figured. In the 5th century B.C. vase painting, unable to absorb the progressive innovations of large-scale painting, began to degenerate. Debased red-figured lingered until the 3d century B.C. in southern Italy, at which time vase painting ceased altogether. *See* BLACK-FIGURED VASE PAINTING; RED-FIGURED VASE PAINTING.

BIBLIOGRAPHY. R. M. Cook, *Greek Painted Pottery*, London, 1960.

VASNETSOV, VIKTOR MIKHAILOVICH. Russian painter (1848–1926). His interior decorations of the Cathedral of St. Vladimir at Kiev are an attempt at a Byzantine revival. His settings for Ostrovsky's *Little Snow White* (1882) create a fairytale world.

BIBLIOGRAPHY. G. H. Hamilton, *The Art and Architecture of Russia*, Baltimore, 1954.

VASSILACCHI, ANTONIO, *see* ALIENSE.

VAST (Wast), JEAN. French architect (d. 1524). In 1494 Jean Vast was a mason at the Cathedral of Beauvais. He was appointed assistant to Martin de Chambiges in erecting the transept there in 1500, and carried out the work according to Chambiges's plans until 1520. His son Jean

Vast II (ca. 1509–81) also worked at Beauvais. He was assistant to Chambiges's successor, Michel Lalict, and built the south portal (completed in 1548).

VASTERAS CATHEDRAL. Swedish cathedral founded in the 11th century. The present structure was erected on its site by Birger Jarl and consecrated in 1271. Subsequently altered, it was restored in 1858–61. The tower was built in 1694 by Nicolas Tessin the Younger. The basic form of the building is Romanesque; the façade preserves the recessed portal and the painted indentations and arched gable friezes from this period. The transition from the Nordic-Norman brick style to the Hanseatic Gothic style is shown particularly well.

BIBLIOGRAPHY. A. Hahr, *Architecture in Sweden*, Stockholm, 1938.

VASUDHARA. Buddhist goddess of abundance. Vasudhārā is the consort of Kuvera, god of wealth. Her dress is that of a Bodhisattva. She has six arms, and her special symbol is the *kalaśa*.

VATICAN, THE, ROME. The story of the Vatican begins with the martyrdom and burial of St. Peter on the lower slope of the Vatican hill by the right bank of the Tiber about A.D. 65. The traditional site of his tomb determined the location of the ancient and present Petrine basilicas, beside which the Vatican has developed. At present a congeries of churches, palaces, museums, and administrative buildings, the Vatican in a compressed space contains an imposing record of Mediterranean and European architecture.

About 333 the emperor Constantine I commissioned his architects to build a grand church to the memory of the first apostle. The building, placed over a pagan Roman cemetery, was a five-aisled hall of great size, the center aisle or nave rising above the others and lit by clerestory windows. It was entered from the east by way of a monumental flight of steps and an open atrium, or court. At the west end a semicircular apse marked the location of St. Peter's tomb; left and right were transeptal extensions to accommodate the traffic of pilgrims. *See* St. Peter's (Old), Rome.

Sacked by the Saracens in the 9th century, the building was in perilous condition by early Renaissance times. In the middle of the 15th century Pope Nicholas V began demolishing the ancient church. A series of important architects worked on the new building from that time until the middle of the 17th century, the chief among them being Bramante, Michelangelo, Della Porta, Maderno, and Bernini. The building proper was dedicated by Urban VIII in 1626, and the majestic colonnaded piazza was added some forty years later. Some but by no means all of the many works of art that over the centuries had been gathered in the old building were preserved and placed in the new. A number, however, are displayed in the Vatican grottoes, where stretches of Constantine's foundations can also be seen. Modern archaeological investigation has bared the Roman tomb street, as well as certain remains of the Petrine shrine that may go back to the 2d century. *See* St. Peter's (New), Rome.

The present building takes its form from a symmetrical plan of Bramante (1506) upon which Della Porta erected the magnificent dome after Michelangelo's designs (1588–90). Early in the next century, in order properly to accommodate the ecclesiastical ceremonies, Maderno built the greater part of the nave and the immense façade, and subsequently Bernini and his assistants added much interior decoration in sculpture, mosaic, colored marble, and gilding. Meanwhile the obelisk had been moved (1586) to the space in front of the church, providing the center point for Bernini's piazza. A triumphal arch of heroic proportions was planned for the space between the curving arms of the colonnades, but it was never executed. In the 20th century the warren of buildings on the line of the axis of St. Peter's to the Tiber was demolished, and a broad street was laid out.

In the Middle Ages the popes had resided in another part of Rome, beside the Lateran Basilica, the cathedral of the city, but in the 14th century their residence was moved permanently to the Vatican. The present group of palaces was begun by Nicholas V and is in large part the work of Bramante, Antonio da Sangallo the Younger, and Domenico Fontana, though the Sistine Chapel was built as early as 1483. Julius II (1503–13) commissioned Bramante to build the Belvedere Palace and Michelangelo to paint the ceiling of the Sistine Chapel. The Belvedere extends the papal palaces a great distance to the north in two parallel wings, closed at the far end by a pavilion cross block. In the original design the wings defined a vast court within which the rising ground to the north was accommodated by ramps and steps. Later the prospect of this court was interrupted by transverse wings housing the Vatican Apostolic Library (by Fontana) and the Braccio Nuovo (19th cent.; by Stern) containing part of the sculpture collections. The Papal Palace proper, rising northwest of Bernini's colonnade, is also the work of Fontana (begun 1596), and the perspective architecture of the Scala Regia, just north of the façade of St. Peter's, was built by Bernini for Alexander VII in the 1660s. The history of the Belvedere as a museum begins under Clement XIV (1769–74); since his time it has been expanded several times. There are perhaps 1,400 rooms in the entire palace group; of these a large number are open to the public and are used to house the incomparable Vatican collections. *See* Rome: Museums (Vatican Museums).

See also Borgia Apartments, Vatican, Rome.

In the grounds west of the Belvedere and St. Peter's, beyond a group of official buildings, lie the Vatican Gardens. These contain handsome baroque fountains, the Casino of Leo XIII on the summit of the hill (formerly the Vatican Observatory), and the elegant Casino of Pius IV by Pirro Ligorio (1558–62). Across the Tiber, the Lateran Church and Palace, the Cancelleria Palace, and several other buildings are a part of Vatican City by the terms of the Lateran Treaty of 1929. *See* Cancelleria Palace, Rome; Lateran, The, Rome.

Aside from the Vatican collections proper, which include masterpieces from the Egyptian, Greek, Etruscan, Roman, and Christian periods, as well as rare manuscripts, tapestries, and a considerable collection of paintings, the Vatican contains works of art made specifically for the churches and palaces themselves. These range from antiquities salvaged from Old St. Peter's, such as the bronze statue of Peter in the nave of the present building, of uncertain date,

and the mosaics from the Oratory of John VII (705–707), to world-famous wall paintings by such masters as Fra Angelico, Ghirlandajo, Perugino, Pinturicchio, Mantegna, Raphael, and Michelangelo.

It would be difficult to overestimate the importance of the Vatican in the history of art. From the great dome of St. Peter's to the historical or archaeological importance of the minor objects in the museums, almost every part of the Vatican is relevant to the culture of the Western world.

BIBLIOGRAPHY. P. Letarouilly, *Le Vatican et la Basilique de Saint-Pierre*, 2 vols., Paris, 1882; A. Venturi, *Storia dell'arte italiana*, 11 vols., Milan, 1901–39; A. Carnahan, *The Vatican*, New York, 1949; J. Ackerman, *The Cortile del Belvedere*, Vatican City, 1954; J. Toynbee and J. Ward Perkins, *The Shrine of St. Peter*, London, 1956. WILLIAM L. MACDONALD

VATICANUS, MONS, ROME. Ancient Roman name for the district that occupied the terrain on the right bank of the Tiber, north of the Pons Aurelius. It was known to the early Romans as "ager Vaticanus," the name perhaps having been derived from an early town, Vaticum or Vatica. The term "Mons Vaticanus" came into use by the end of the republic and was synonymous with Janiculum (Janus city). The level ground between the ridge of Mons Vaticanus and the river was called Vaticanum. Caligula built his circus there, on the spot on which St. Peter's now stands.

BIBLIOGRAPHY. S. B. Platner, *The Topography and Monuments of Ancient Rome*, 2d rev. ed., Boston, 1911.

VATICAN VERGIL. Roman illuminated manuscript, in the Vatican Library, Rome. *See* EARLY CHRISTIAN ART AND ARCHITECTURE; MANUSCRIPT WRITING.

VAUDOYER, ANTONIO LAURENT THOMAS AND LEON. French architects: Antonio (1756–1846) and Léon (1803–72). They worked in Paris. Antonio, a pupil of

Vatican Vergil. Illumination showing Aeneas's ship in a tempest. Vatican Museums, Rome.

Marie-Joseph Peyre, was connected with restorations and additions to public buildings under the Empire. His son Léon is associated with the rationalist (Neo-Greek) style. Léon is known for his large Neo-Byzantine Marseilles Cathedral.

BIBLIOGRAPHY. L. Hautecoeur, *Histoire de l'architecture classique en France*, vol. 6, Paris, 1955.

VAUDREMER, JOSEPH AUGUSTE EMILE. French architect (1829–1914). He worked in Paris. Vaudremer was a pupil of Blouet and Gilbert and most original of the rationalist (Neo-Greek) group. He built the Church of St-Pierre-de-Montrouge with a restrained medieval and Near Eastern vocabulary, simplicity of plan, and direct expression of structure and materials that may have influenced Richardson.

BIBLIOGRAPHY. L. Hautecoeur, *Histoire de l'architecture classique en France*, vol. 7, Paris, 1957.

VAULT. Arched roof; also a structure resembling a vault although not embodying arch construction. The term is applied to burial chambers with or without arched roofs and to underground compartments even when not covered by vaults.

Corbeled vaults are attributed to the archaic tomb in Naga ed-Derr, and semicircular ones are found in 3d-dynasty Meidûn, in Egypt. The Assyrians also built vaulted structures, and two intersecting barrel vaults with stone voussoirs were constructed by the Greeks in a funerary chamber in Pergamon. Roman examples of arch and vault have been found dating from the 6th and 5th centuries B.C. The Romans made extensive use of the barrel vault, a cylindrical arched tunnel, and employed cross vaults of intersecting barrels, whose intersections are called groins. An example of a Roman concrete vault on a large scale is found in the Tabularium, or record office, Rome (ca. 78 B.C.). An elliptical vault, attributed to Assyrian prototypes, was built in the Sassanian Palace of Ctesiphon. Intersecting domes, sometimes called "domical vaults," distinguish the Byzantine church of Hagia Sophia, Constantinople, and the apsidal vaults of the Florence Cathedral. *See* GROIN.

Vaults prior to medieval times were primarily of the barrel and cross type. Romanesque architecture made use of intersecting vaults over oblong compartments, the narrower barrel stilted to meet the higher crown of the wider barrel; the intersections were groined. The difficulties in the round arched vault were overcome with the development of the pointed arch, which could be more readily adjusted to compensate for different heights. The groined vault gave way to the ribbed vault, in which vaulting intersections were marked by ribs, the ribs themselves becoming load-bearing members carrying stone panels set between them. In this way vaults became lighter, more articulated, and more flexible. The thrust of the vaults was localized in the ribs and transferred to columns and buttresses instead of resting on load-bearing walls. It accordingly became possible to dematerialize walls, replace masonry by glass, and create large clerestory windows between piers and buttresses. The addition of pinnacles as weights to counteract the outward thrust of vaults contributed to the structural character of Gothic architecture. Norman vaulting expresses the change to the increasing use of transverse and

1. Domical vault; 2. quadripartite vault; 3. ribbed vault; 4. stellar vault; 5. tunnel vault.

diagonal ribs to support thin panels of stone. The Abbaye-aux-Hommes, Caen (1066), has ribbed vaults. *See* VAULTING, RIB AND PANEL.

The quadripartite vault is one of the simpler ribbed types being composed primarily of a skeleton of diagonal and transverse ribs which subdivide the square or oblong bay into four parts. The sexpartite vault is divided into six sections, as in the Abbaye-aux-Hommes and the choir of Canterbury Cathedral. The introduction of intermediate ribs called tiercerons and liernes gave vaults an increasingly intricate appearance, sometimes stellar, as in Gloucester (1337–77) and Canterbury (1379), fan, palm, or conoidal. Aesthetically comparable but structurally dissimilar to Islamic stalactite, or iciclelike, vaults were the pendant vaults with carved bosses typical of French Flamboyant Gothic. *See* LIERNE; TIERCERON; VAULT, FAN; VAULT, STELLAR.

The pointed arch and ribbed vault were eclipsed during the Renaissance, emerging definitively again only in the later Gothic revival. The Renaissance restored the groined vault, sometimes vaulting oblong bays with elliptical intersecting arches to bring the crowns of both arches to one height. The more recent construction of vaults, ribs, and panels is often simulated, being attached to a skeleton trussed-steel frame. Reinforced concrete, prestressed concrete, stressed skin, laminated woods, and other new materials have made possible vaulting types heretofore untried, such as the hyperbolic paraboloids of Le Corbusier's Phillips Pavilion at the Brussels World's Fair, saddle vaults, skewed conoids, and various novel warped surfaces. *See* CONCRETE, PRESTRESSED; CONCRETE, REINFORCED; HYPERBOLIC PARABOLOID.

See also ARCH; DOME; RIB.

MILTON F. KIRCHMAN

VAULT, ANGEVIN. Form of medieval cross-rib vault evolved in the province of Anjou, France. Since the middle of the 12th century the builders of Anjou and Poitou had constructed a cross-ribbed vault, much stilted, as over the nave of the Cathedral of St. Maurice at Angers. By the end of the 12th century the Angevin masters transformed the cross-ribs; now, supplemented by liernes and tiercerons, they were embedded in the masonry of the vault, with no projection to support the panels, and they appeared only as a fine torus molding. The ribs formed a skeleton that facilitated construction by stiffening the structure but did not support the vault. The vault actually rested on strong transverse arches and wide longitudinal arches which were in turn supported by thick walls. Typical examples are in St-Jean at Angers and in the transept and choir of the Cathedral of Angers. *See* SAINT-MAURICE, CATHEDRAL OF, ANGERS.

VAULT, DOMICAL. Roof structure resembling a section of a dome, as in Hagia Sophia, Constantinople, and in the apsidal vaults of the Florence Cathedral.

VAULT, FAN. Vaulting resembling an open fan, especially identified with English Perpendicular architecture. In the fan vault the surface of the inverted and concave vaulting cone is articulated with ribs formed at equal angles and having the same curve. These radiating ribs are often connected at different heights by horizontal lierne, or intermediate, ribs. In earlier 13th- and 14th-century English

vaulting, inverted four-sided concave pyramids were defined by ribs of different curves, fan vaulting with all ribs having a similar curve developing in the 15th century. With fan vaulting and the multiplication of ribs, the ribs lost their earlier structural significance. Rib and panel were often carved from a single piece of stone, superseding earlier usage in which the rib supported a separately carved panel. The cloisters of Gloucester Cathedral have fan vaults in the Perpendicular style.

VAULT, PALM. Vault resembling an outspread palm leaf. *See also* VAULT, FAN.

VAULT, QUADRIPARTITE. Square or rectangular vaulting bay formed by the intersection of cross vaults which divide the bay into four parts, as in much Romanesque and Gothic architecture. The nave and aisles of Reims Cathedral, for example, have quadripartite vaulting.

VAULT, RIBBED. Vault marked by projecting members following the surface of the vault. The Baths of Caracalla and the Basilica of Maxentius (or Constantine), both in Rome, have brick arches or ribs embedded in the vaults, perhaps as permanent centering, inasmuch as they do not function as independent supports. *See* VAULTING, RIB AND PANEL.

VAULT, SEXPARTITE. Vault in which a vaulting bay is subdivided into six parts, as in Romanesque and Gothic construction. The Abbaye-aux-Hommes and the Abbaye-aux-Dames, both in Caen, Notre-Dame in Paris, and the choir of Canterbury Cathedral employ in their vaults an intermediate shaft set between transverse ribs to support an added rib which subdivides what would otherwise be a four-part, or quadripartite, vault into a sexpartite one.

VAULT, STELLAR. Vault resembling a star pattern, as in St. Mary Redcliffe, Bristol. Geometric forms in stellar vaults were obtained by using intermediate ribs, such as the lierne, to subdivide the vaulting panels. Intricate stellar vaults were developed during the late 14th and the 15th centuries.

VAULT, TUNNEL. Vault that extends without intersection; an extension of the arch to cover a long area. Also called a barrel vault, it may be semicircular, pointed, or, presumably, any simple vault shape.

VAULTING, RIB AND PANEL. Framework of ribs supporting panels of stone. Developed in medieval architecture, it is a type of stone skeleton construction. The ribs that support the vaulting panels are unlike the Roman groins, which do not carry loads transferred from the adjacent roof structure but appear to be a kind of permanent centering in vault construction. The brick groins that mark the vault intersections in the Baths of Diocletian would be in this category. The Gothic rib and panel developed especially with the pointed arch and were elaborated with intermediate ribs to produce the intricate fan and stellar vaulting of later Gothic work.

VAUX, MARTIN DE (Martin Devaux). French architect and sculptor (fl. 1508–88). He was one of the last masters of the Gothic style in France. His career is most closely associated with the Church of Ste-Madeleine at Troyes.

He also worked on St-Pierre, St-Pantaléon, and St-Jean-devers-le-Chapitre there.

VAUX-LE-VICOMTE, CHATEAU OF. Private palace, near Melun, France, built by Nicolas Fouquet, Superintendent of Finances under Louis XIV. The building was planned in 1656 by the architect Louis Le Vau and completed in 1661 for a royal fête, after which the jealous King imprisoned its owner. The palatial residence of gray stone is set on a platform and consists of a central block flanked by end pavilions that provide two complete *appartements*, one on the east intended for the King, and one on the west for Fouquet.

A triple-arched, pedimented entrance portico of one story leads to the vestibule and beyond to a vast oval salon. The salon's domed roof is the prominent central feature of the garden façade, which has been criticized because its two-storied portico has no real relation to the distinguished dome and lantern. The building's four corner pavilions are tastefully ornamented with Ionic pilasters, which run through the two main stories, and harmoniously finished by steeply pitched roofs. The pavilions give an air of completion to the main section, which has dispensed with the forecourt and enclosing wings of earlier châteaux.

The decoration of the interior engaged the talents of Charles Le Brun, whose mythological scenes on wall and ceiling panels were planned to form grand ensembles in combination with the stucco sculpture and gilding of Guérin and Thibault Poissant. Their work represents an Italian-derived innovation in French interior design.

The estate's vast formal gardens appear to stretch to the horizon and offer varied perspectives. Designed by André Le Nôtre, they include a moat, terraces, fountains, grottoes, and canals, as well as statuary by Girardon. The château and its gardens served as a training ground for the design and construction of the Royal Palace at Versailles, to which the artists of Vaux-le-Vicomte were transferred upon the fall of Fouquet.

BIBLIOGRAPHY. A. Blunt, *Art and Architecture in France, 1500–1700*, Baltimore, 1954; R. Dutton, *The Châteaux of France*, London, 1957; S. Sitwell, *Great Houses of Europe*, London, 1961.

EMMA N. PAPERT

VAZ, GASPAR. Portuguese painter (fl. ca. 1514–68). Trained in the atelier of Jorge Afonso in Lisbon, Vaz lived in Viseu from 1537 to 1568 and was a leading painter in the Beira region, following in the path of Vasco Fernandes, with whom he may have collaborated. The only reasonably certain attribution to Vaz are three paintings: *St. Peter Enthroned*, a polyptych of the Virgin, and a *St. Michael*, all in the Church of São João de Tarouca. *St. Peter Enthroned* is very close to Vasco's painting of the same theme, although, typically, it is less monumental and more decorative. Vaz's work in general remains closer to Flemish 15th-century painting in its use of the older forms of crinkled drapery and its gentle expressions and poses.

BIBLIOGRAPHY. R. dos Santos, *L'Art portugais*, Paris, 1953.

VAZQUEZ, ALONSO. Spanish-Mexican painter (b. Ronda, Spain, ca. 1565; d. Mexico City, 1608). Reported as studying with Céspedes and Arbasia at Cordova, Vázquez worked in Seville between 1589 and 1603 and then went to Mexico City. A prolific painter of oils, temperas, and frescoes, he produced manneristic pictures with oddly twisting and elongated forms and an ambiguous use of space and light. His only documented paintings are in the Provincial Museum of Fine Arts in Seville and the Academia de San Carlos in Mexico City.

BIBLIOGRAPHY. M. Toussaint, *Pintura colonial en México*, Mexico City, 1965.

VAZQUEZ, GREGORIO. Spanish colonial painter in Colombia (b. Bogotá, 1638; d. there, 1711). Trained by Baltasar de Figueroa in Bogotá, Vázquez was one of the most prolific Spanish colonial masters. Much of his work, which is primarily religious, is preserved in the Museum of Colonial Art, Bogotá (for example, *La Inmaculada*, 1697).

BIBLIOGRAPHY. E. Marco Dorta, in D. Angulo Iñiguez, *Historia del arte hispanoamericano*, vol. 2, Barcelona, 1950.

VECCHIA, DELLA, see MUTTONI, PIETRO.

VECCHIETTA, see LORENZO DI PIETRO.

VECCHIO, PALAZZO, FLORENCE. Italian palace, attributed to Arnolfo di Cambio (1298–1314), built as the seat of the Signoria, the government of the Florentine republic. It is also known as the Palazzo della Signoria. Since 1872 it has been the Town Hall.

The building is a superb example of a fortified palace of the Gothic period. The three-storied rusticated façade has two rows of elegant windows and is surmounted by a crenellated gallery. The beautiful tower (1310) is 308 feet high.

The Palazzo Vecchio was the residence (1540–50) of Cosimo I de' Medici and then of his son Francesco I. It was enlarged between 1548 and 1593 by Vasari, Buontalenti, and others. The magnificently decorated rooms are outstanding examples of Renaissance art. *See* FLORENCE: MUSEUMS (PALAZZO VECCHIO).

BIBLIOGRAPHY. P. Toesca, *Il Trecento*, Turin, 1951.

VECELLIO, MARCO. Italian painter of Venice (1545–1611). A distant cousin and pupil of Titian, he produced hack work in the decoration of the Doge's Palace, Venice, and specialized in portraits of officials.

BIBLIOGRAPHY. G. Fiocco, *Mostra dei Vecellio*, Belluno, 1951.

VECELLIO, TIZIANO, see TITIAN.

VEDAS. Holy books (from the Sanskrit, *vid*, to know) which are the foundation of Hinduism. They go back to 1000 or 1500 B.C. The Vedas are four in number: (1) Ṛg, (2) Yajur, (3) Sāma, and (4) Atharva, the last of comparatively modern origin. Each Veda is divided into two parts: (1) mantras, which are prayers or hymns of praise; and (2) Brāhmaṇas, or treatises.

VEDDER, ELIHU. American painter, illustrator, muralist, and writer (b. New York, 1836; d. Rome, 1923). He studied with Tompkins H. Matteson in Sherbourne, N.Y., and later with F. E. Picot in Paris (1856). Vedder visited Florence and Rome before returning to New York in 1861. He stayed in America for the next five years, then revisited Paris, and finally settled in Rome. His most noted themes were his illustrations for the *Rubáiyát* and his murals for the Library of Congress.

The Cumaean Sibyl (1876) illustrates his unique style of poetic, intellectual academicism. His legendary, antique figures are composed in linear patterns and are hard and contrived in manner. Yet they possess an eerie and haunting imagination, strong visionary power, and an unexpected strangeness.

BIBLIOGRAPHY. E. Vedder, *The Digressions of Vedder*, Boston, 1910; F. J. Mather, Jr., *Estimates in Art, Series II*, New York, 1931.

VEDIKA. Railing in Indian architecture, as around the processional way of a stūpa.

VEDOVA, EMILIO. Italian painter (1919–). Vedova is essentially self-taught, although he studied at Silvio Pucci's Free School of Painting in Florence (1938). In Milan he became a member of the Corrente group (1942) and the Fronte Nuovo delle Arti (1946). Prizes have been awarded him at the Venice Biennale (1948, 1960), the São Paulo Bienal (1951), and the Guggenheim International (1956). Starting as a figural expressionist, Vedova moved through a geometric phase after World War II, and finally to abstract expressionism.

BIBLIOGRAPHY. G. C. Argan, *Vedova*, Madrid, 1961.

VEDUTE. Italian term meaning "views." Realistically true drawings, paintings, or engravings of a city or landscape, *vedute* were especially popular art forms in Venice in the 17th and 18th centuries. Canaletto, for example, was a master of *veduta* painting.

VEE CUT. Cut, such as on a plate or block to be engraved, which is vee-shaped according to the wedge or triangular configuration of the tool which made the cut. The gravers which produce a vee cut are the lozenge, anglet, and spitzsticker.

Vedova, *Multiple 1962/63: At Once*. Artist's collection, Venice.

VEEN, MAERTEN VAN, *see* HEEMSKERCK, MAERTEN VAN.

VEEN, OTTO VAN (Octavius Vaenius). Flemish painter (b. Leyden, 1556; d. Brussels, 1629). He studied in Rome from 1575 to 1580, and was active mainly in Antwerp, though well connected at the court of Brussels. He was the master of Rubens from 1596 to 1598. A distinguished Humanist and painter of religious and historical scenes, and also of occasional portraits, he worked in the style of the Italian and Netherlandish mannerists. He became addicted to a weak classicism in his old age.

BIBLIOGRAPHY. H. Gerson and E. H. ter Kuile, *Art and Architecture in Belgium, 1600–1800*, Baltimore, 1960.

VEGAS PACHECO, MARTIN. Venezuelan architect (1926–). He is noted for his distinguished skyscraper, the Polar Building (with José Miguel Galia; 1953–54), on the Plaza Venezuela in Caracas. It is an isolated slab, supported on four concrete piers from which curtain walls are dramatically cantilevered.

BIBLIOGRAPHY. H.-R. Hitchcock, *Latin American Architecture since 1945*, New York, 1955.

VEHICLE. Any liquid in which a pigment is suspended to make paint. It is essentially the vehicle which determines the type of paint: oil paint uses oil as a vehicle; water color uses water; and tempera uses water and egg. Pigments used are nearly all the same (do not usually vary with paint type).

BIBLIOGRAPHY. R. Mayer, *The Artist's Handbook of Materials and Techniques*, New York, 1940.

VEII. Important Etruscan city situated 12 miles north of Rome. Its name was derived from *Veja*, a word signifying *plaustrum* (Latin, "wagon," "cart"). In ancient times Veii was considered the rival of Rome. It reached its full development in the 7th century B.C., and its splendid culture was equaled only by that of Tarquinia. The citadel of Veii stood on a high and precipitous rock and was surrounded by a strong fortress of cyclopean walls. Veii had a developed drainage system that served as a model for the Roman water system. Its architecture and art greatly influenced the early arts of Rome. The city resisted Roman conquest several times but was finally defeated in 396 B.C.

By the end of the 6th century Veii had a flourishing school of terra-cotta sculpture that produced works of high skill and originality. Veiian artists had decorated the Temple of Jupiter on the Capitoline, Rome, in 509 B.C. The city was completely buried and forgotten, however, until the 17th century, when the first excavations brought it to light. These excavations uncovered remains of houses of the 7th and 6th centuries B.C. The tombs of Veii have not yet been published. A unique painted tomb, the Campana Tomb, was discovered in 1843 in the necropolis of Monte Michele and is considered one of the earliest painted Etruscan tombs. It consists of an entranceway, framed with two sphinxes, and two burial chambers. The door of the first chamber is framed on each side by two square painted panels; three are decorated with Orientalizing motifs and the fourth with figural scenes. The colors employed are red with yellow dots and yellow with red dots. The tomb has been dated between the first quarter of the 7th century and the first half of the 6th century B.C.

The most renowned find of Veii is the life-size terra-cotta statue of Apollo that was discovered in 1916 in the foundations of a sanctuary dedicated to the gods of the water. Recent excavations at this spot have brought to light a life-size terra-cotta statue of a goddess with a child in her arms (perhaps Latona and the infant Apollo). Both works (Rome, National Etruscan Museum) date from the end of the 6th century B.C. and had once surmounted the roof of the so-called Temple of Apollo. They are presumably the work of a Veiian artist, Vulca (end of 6th cent. B.C.), and are fine examples of Etruscan archaic sculpture in the round.

BIBLIOGRAPHY. R. Bloch, *L'Art et la civilisation étrusques*, Paris, 1955; S. von Cles-Reden, *The Buried People*, London, 1955; L. Banti, *Die Welt der Etrusker*, Stuttgart, 1960. EVANTHIA SAPORITI

VEIT, PHILIPP. German painter (b. Berlin, 1793; d. Mainz, 1877). After studying at the Dresden Academy (1809), he moved to Vienna (1811). In Rome (1815–30) he became one of the Nazarenes, a group of religiously oriented German artists who sought to emulate the art of the Italian and German Renaissance, albeit in a congealed and picturesque style. He participated with them in painting frescoes (1816; Berlin, National Gallery) for the Casa Bartholdy (formerly Palazzo Zuccari; now Biblioteca Hertziana) and the Casino of the Villa Giustiniani-Massimo (1818–24), both in Rome. As the director of the Städel Art Institute and Municipal Gallery in Frankfurt am Main, he painted frescoes for the old Institute building (1832–36). Veit was a convert to Catholicism and created many religious works; during his last years, in Mainz, he prepared works on the life of Christ, which were mostly executed by his students.

VELA, VINCENZO. Italian-Swiss sculptor (b. Ligornetto, 1820; d. there, 1891). In his early years he worked as a restorer on the Cathedral of Milan. He studied with Benedetto Cacciatore at the Brera Academy, and in 1848–49 Vela participated in the struggle of Lombardy against Austria. Returning to Milan, he finished and exhibited his statue *Spartacus* (Geneva, Museum of Art and History), the symbol of this struggle. It was a pioneering work of 19th-century realism. Among his other major works are *Portrait of Cavour* (Geneva, Museum of Art and History), *Napoleon on St. Helena* (Versailles Museum), and a statue of Tommaso Grassi (Milan, Brera).

BIBLIOGRAPHY. M. Calderini, *Vincenzo Vela: Scultore*, Turin, 1920; D. Baud-Bovy (pref.), *Catalogue des oeuvres de Vincenzi Vela...*, Neuchâtel, 1926.

VELARIUM. Large awning used to protect spectators in a roofless Roman theater.

VELASCO, JOSE MARIA. Mexican painter (b. Tematzcalzingo, 1840; d. Mexico City, 1912). Velasco was the greatest landscapist of Latin America. At eighteen he entered the Academy of San Carlos, where Landesio and Rebull taught him, respectively, a passion for nature and for careful draftsmanship. In the 1860s Velasco won prizes from the Academy, President Juárez, and Emperor Maximilian. In 1868 he was appointed professor of landscape perspective at San Carlos, but left this post after five years. He won international honors, including a prize at the Philadelphia Centennial of 1876 for his *Valley of Mexico*, the

Legion of Honor at the Paris World's Fair of 1889, a prize at the Chicago World's Fair of 1893, and a decoration from the Austrian emperor in 1902. Despite his exhibitions abroad, which he accompanied, Velasco remained unaffected by landscape painting outside Mexico.

A prodigious worker, Velasco executed more than 400 oils, lithographs, and drawings. His art can be divided into three periods. During his early association with the Academy (1858–73) he began to paint park scenes, townscapes, and courtyards after Landesio. He soon shed that influence, however, and while still in this first period he depicted monumental themes from nature, such as huge rocks and trees. From this phase comes *Un Paseo en los Alrededores de México* (1866; Mexico City, National Museum of Plastic Arts).

His second period started in the middle 1870s, from which time his concepts of nature enlarged to broader proportions. Although Oaxaca and tropical Jalapa sometimes appeared, his art dwelt mostly on the great Valley of Mexico (*El Valle de México*, 1900; Mexico City, National Museum of Plastic Arts). Deep panoramas of endless space, combined with minutely observed flora, are rendered in terms of mystical realism. However poetic, these vast scenes unfold in precisely calculated tones and planes, while the thin, dry atmosphere of the highlands provides a mood of timeless calm. Colors become more and more transparent, until in some landscapes the canvas shows. In spite of such effects Velasco is never merely sentimental or picturesque.

He resumed teaching in 1890, but his illness of 1902 ended it and restricted his art. His third period was characterized by small pictures, some of postcard size.

BIBLIOGRAPHY. J. O'Gorman, "Velazco: Painter of Time and Space," *Magazine of Art*, XXXVI, October, 1943; M. Romero de Terreros, *Paisajistas mexicanos del siglo XIX*, Mexico City, 1943; J. Fernández, *Arte mexicano de sus orígenes a nuestros días*, 2d ed., Mexico City, 1961. JAMES B. LYNCH, JR.

VELATURA. Old Italian method of giving a painting a gloss by rubbing the surface with a mild polish or, gently, with varnish. The result is a smooth, satin gloss rather than the high gloss achieved by painting the surface with varnish.

VELAZQUEZ, CRISTOBAL. Spanish joiner and sculptor (d. 1616). He was a member of a family of joiners who worked with the sculptor Gregorio Fernández on the architectural settings and reliefs for his large altarpieces, the earliest of which is dated 1606. Cristóbal Velázquez intervened directly as a sculptor on the notable *Incarnation Altarpiece* (1602; Valladolid, Las Angustias). The style is more Italianate than that of Fernández, and the altarpiece was attributed to Pompeo Leoni prior to the discovery of a document.

BIBLIOGRAPHY. F. Jiménez-Placer, *Historia del arte español*, 2 vols., Barcelona, 1955.

VELAZQUEZ, DIEGO RODRIGUEZ DE SILVA Y. Spanish painter (b. Seville, 1599; d. Madrid, 1660). Spain's greatest painter and one of the foremost painters of all time, Velázquez was of Portuguese descent. At the age of twelve, after a brief apprenticeship with Francisco Herrera, he entered the studio of Francisco Pacheco, a minor late Roman mannerist. Velázquez married Pacheco's daughter Juana in 1618.

Among his first works (1617–22), in which Herrera's influence is stronger than Pacheco's, were a series of tenebrist *bodegones* (genre paintings), realistically painted in earthen colors, in which the figures are quite monumental. Highly original are their sharply lit foregrounds, given heightened value by being seen from above in a voluntary distortion of perspective, a device that was used again to advantage by Cézanne. Among these paintings are *The Old Cook* (Edinburgh, National Gallery of Scotland) and *The Water Carrier of Seville* (London, Wellington Museum). From 1618 dates another *bodegón, Christ in the House of Martha and Mary* (Madrid, Prado), painted in the Aertsen-Beuckelaer tradition, with the religious scene relegated to the background. In a more ambitious picture, *The Adoration of the Magi* (1617–19; Prado), Velázquez made judicious use of crossing diagonals, as he would throughout his life. Here, characteristic of his early works, the folds of drapery are stiff and the volumes sharply defined—not unlike the work of Zurbarán.

Velázquez visited Madrid briefly in 1622 and there won recognition for his remarkable portrait of Luis de Góngora (Boston, Museum of Fine Arts). He returned to Madrid in 1623, this time for good, and became court painter to Philip IV. From that year dates the first of his many portraits of the King, who is often dressed in black in the severe style of the Spanish court. In his early portraits Velázquez achieves a marvelous feeling for space and atmosphere without the usual expedients of furniture, curtains, or linear perspective; only subtle changes in light or vague indications of the floor or wall line are used. In 1624 he painted the King's prime minister, the Count-Duke of Olivares (Prado). In this, as in all nonroyal portraits, as López Rey observed, he is more realistic and free with the brush; in painting the King, whom he treats as a quasi-divine person, he is more flattering, uses less impasto, and employs more delicate tones.

In 1627 Velázquez was made gentleman usher, the first of many time-consuming positions he was to have at court. That year also, by winning a painting competition, he formally asserted himself over his rivals, the conservative painters previously in vogue in the capital, notably the Italian Vicente Carducho. The famous *Triumph of Bacchus* (*The Drinkers*, ca. 1628; Prado) is more a realistic picaresque scene than mythology. That year Rubens visited Madrid, befriended Velázquez, and painted numerous portraits of the royal family; it is noteworthy that Velázquez was almost completely unaffected by his art. Titian, for whom he professed admiration, had a much greater impact on him.

In 1629–31 Velázquez made his first trip to Italy—Venice, Rome, and Naples, where he met Ribera—during which time he painted *Joseph's Coat*, whose composition is reminiscent of Guercino, and *The Forge of Vulcan* (both, Prado). Both works show the artist's mastery over the nude and his ability to achieve a strong pictorial effect with a restricted color scheme in which half tones dominate. As a result of the Italian experience, he introduced more nudes and landscape settings in his works and his brushwork became more fluid.

Back in Madrid, he painted his first portrait of *Don Balthasar Carlos and His Dwarf* (Boston, Museum of Fine Arts). In 1634 he worked for the Salón de los Reinos in the Buen Retiro Palace (where Rubens had earlier been active), painting equestrian portraits of the royal family and *The Surrender of Breda* (Prado), also known as *The Lances*, whose theme is the generosity of General Spinola to the vanquished Prince of Nassau. It is a noble as well as a human work, one of his pictorially richest paintings. Among the equestrian portraits (which do not follow the allegorical mode of the 17th century) are those of *Philip IV* and *Balthasar Carlos* (both, Prado). Grand and courtly yet warm, they are rather thinly painted in fresh bright colors. The impressive equestrian portrait of Olivares, with its dynamic baroque diagonal composition, dates from 1638 and is more boldly and freely painted. Earlier, for the Torre de la Parada, he painted portraits of the King, Queen, and Infante in hunting costume. These are simple and natural depictions of the royal family (1636); their landscape settings show Velázquez a master of this art.

During these years Velázquez also did numerous portraits of dwarfs and jesters, for example, *Calabacillas* and *Don Sebastian de Morra* (both, Prado), which are remarkable for their profound psychological insight and their pictorial richness. These pathetic creatures, in whom Velázquez spared us no physical deformity or mental suffering, are not painted as caricatures, but with sympathetic understanding and in a way to bring out all they have of human dignity. They illustrate the fact that Velázquez, who painted relatively few religious pictures, was not primarily a painter of the Counter Reformation, as were his contemporaries Rubens and Bernini. Instead he showed his Christian spirit by an immense respect for the individual, God's creature, no matter how ugly. Strongly naturalistic also are his paintings (ca. 1640) of Mars, Aesop, and Menippus (Prado), whom he does not glorify but treats as comical, abject peasants in accordance with Spanish religious thinking, which held that pagan figures were not to be exalted.

In 1644, during the campaign against the French at Fraga, Velázquez painted one of his finest portraits of the King (New York, Frick Collection), a luminous picture done in the subtlest harmonies of pinks and blacks. Velázquez's art was now more pictorial, his portraits featuring more often the usual colorful baroque *staffage* of tables, curtains, and so on. His brushwork is swifter and freer; it suggests and no longer defines. The *Hilanderas* (*Tapestry Weavers*; Prado), one of Velázquez's key works, was painted about 1644–48. Actually a mythological subject—Pallas and Arachne—it is a pictorial feast, a marvel in the play of light, in which lines are dissolved in luminous atmosphere. Velázquez has all but done away with plastic modeling and has translated forms into patches of color, particularly in the background, where the figures become indistinct and reality and illusion are fused. About this time also, he painted the only nude we have by him, the *Rokeby Venus* (London, National Gallery).

Velázquez went again to Italy, between 1649 and 1651, officially to buy works of art. Commissioned to paint a portrait of Pope Innocent X, he practiced by doing a study of his servant, Juan de Pareja, that was exhibited at the Pantheon in March, 1650, and was widely acclaimed. The

Velázquez, *The Infanta Margarita*, ca. 1660. Prado, Madrid.

painting of the Pope (Rome, Doria Pamphili) is certainly one of the greatest portraits of all time in its dignity and grandeur, its subtle psychology, its painterly surface, and its symphony of reds. Back in Madrid, Velázquez took on more duties at the court, while he still painted a number of portraits in his more baroque, pictorial manner, for example, *Marianna of Austria, Maria Teresa, The Infanta Margarita* and the sickly *Felipe Prosper* of 1659 (all, Vienna, Museum of Art History). In or before 1655, he had painted his last portrait of the King, a moving work, strangely intimate and sad in mood, in which the tired ruler is shown sympathetically but this time unflatteringly.

Velázquez's last great work and perhaps his most famous is *Las Meninas* (Prado), in which the dislocation of reality, the fusing of real and pictorial space, reaches its apogee. The scene represents the artist painting the King and Queen, watched by the infanta Margarita and her retinue. The royal parents are shown only through their reflection in a mirror on the far wall. The baroque involvement of the spectator is brought to a peak of refinement as we, the viewers, stand in the very spot where the royal couple are themselves standing. All the art of Velázquez is concentrated in this uncommonly beautiful and enormously complex work: the use of crossing diagonals, the subtle harmonies of pinks and grays, the scintillating brushwork, and the magical rendering of atmospheric space. In this, Velázquez's testament, reality melts into a purely pictorial world.

In 1659 Velázquez was made knight of Santiago, a fitting recompense for the noblest of painters. The influence of this great master on the art of succeeding generations was vast. Among his immediate followers, the leading one was his son-in-law, Juan Bautista Martínez del Mazo.

Velázquez was both courtier and court painter; his numerous portraits of the Spanish royal family, restrained, dignified, and at the same time profoundly human, rank with the finest portrayals ever made. Truly universal, Velázquez excelled in many areas, from genre to mythology, from landscapes—impressionistic views of the Villa Medici gardens—to religious subjects. His skill was prodigious, and no problem was beyond his reach; his rendering of light and atmosphere and of aerial space was revolutionary, and he is often considered the first truly modern painter. Velázquez's fondness for optical effects is reflected in his predilection for the use of mirrors, for example, in the *Rokeby Venus* and *Las Meninas*. In his maturity Velázquez's swift, cursory brushwork literally created splashes of color on his canvases, which are unequaled for the sheer sensuousness of their *matière*. However, he never allowed his painterly skill to dominate, and he maintained a perfect balance of technique and characterization. It is a measure of Velázquez's greatness that his works, which at first sight appear simple, always yield more at each new confrontation.

BIBLIOGRAPHY. A. L. Mayer, *Velazquez: A Catalogue Raisonné of the Pictures and Drawings*, London, 1936; E. Du Gué Trapier, *Velazquez*, New York, 1948; E. Lafuente Ferrari, *Velazquez*, Geneva, 1960; J. A. Gava Nuño, *Bibliografía crítica y antológica de Velázquez*, Madrid, 1963; J. Lopez-Rey, *Velazquez: A Catalogue Raisonné of His Oeuvre...*, London, 1963.

PHILIPPE DE MONTEBELLO

VELDE, ADRIAEN VAN DE. Dutch painter of landscape and history (b. Amsterdam, 1636; d. there, 1672). He received his first training from his father, Willem van de Velde the Elder. Dutch sources tell us that Adriaen also studied with Jan Wijnants, at Haarlem, and it has been suggested that Philips Wouwermans was also one of his teachers. While neither of these relationships is firmly

Adriaen van de Velde, *Beach at Scheveningen*. Louvre, Paris. A beach scene presenting an almost plein-air effect.

documented, the influence of both Wouwermans and Wijnants is readily apparent in Van de Velde's work. The subjects of many of his paintings have led to the suggestion that he traveled to Italy; once more this is not documented, and it is possible that he took up Italianate motifs through secondary northern sources. He was recorded as living in Amsterdam by 1656.

Van de Velde is best known for his landscapes, which usually have somewhat prominent groupings of animals and figures. His somewhat unusual *Ferry* (Strasbourg, Museum of Fine Arts) recalls the work of Wijnants. Such works as *Forest Glade* (1658; Frankfurt am Main, Städel Art Institute and Municipal Gallery) show the clear influence of the animal painter Paulus Potter. His most original and beautiful works are his few beach scenes (*Beach at Scheveningen*, Kassel, State Picture Collections; Paris, Louvre), which present an almost plein-air effect. He collaborated with numerous other painters, executing the figures and animals for such artists as Jacob van Ruysdael, Philips Koninck, and Frederick de Moucheron. Dirck van den Bergen was his pupil and painted in his manner.

BIBLIOGRAPHY. C. Hofstede de Groot, *Beschreibendes und kritisches Verzeichnis der Werke der hervorragendsten holländischen Maler des 17. Jahrhunderts*, vol. 4, Esslingen, 1911; J. G. van Gelder, "Adriaen van de Velde, Christus aan het Kruis," *Kunsthistorische Meddeelingen 's Gravenhage*, I, 1946; N. Maclaren, *National Gallery Catalogues: The Dutch School*, London, 1960; J. Rosenberg, S. Slive, and E. H. ter Kuile, *Dutch Art and Architecture, 1600–1800*, Baltimore, 1966; W. Stechow, *Dutch Landscape Painting of the Seventeenth Century*, London, 1966.

LEONARD J. SLATKES

VELDE, ESAIAS (Esajas) VAN DE. Dutch painter of landscape and genre and graphic artist (b. Amsterdam, 1590/91; d. The Hague, 1630). Stylistic evidence would seem to support the assumption that Van de Velde was a pupil of David Vinckeboons, and perhaps also of Gillis van Coninxloo, but this is not supported by documentary evidence. Van de Velde is first mentioned at Haarlem in 1610, and in 1612 he entered the Haarlem painters' guild, the same year that Willem Buijtenwegh and Hercules Seghers became members. Van de Velde remained in Haarlem until he entered the painters' guild at The Hague in 1618. At this time he became court painter to Prince Maurice and Prince Frederick Henrick. He was the brother of Jan van de Velde II and Willem van de Velde the Elder.

As a painter Van de Velde is important for his role in the development of realism in Dutch landscape painting. One of Van de Velde's earliest works, *Summer* (Oberlin, Ohio, Dudley Peter Allen Memorial Art Museum), which may be as early as 1612, shows his dependence on the works of Coninxloo. This painting, with its Biblical *staffage* representing the Journey to Emmaus, was originally paired with a *Winter* (location unknown), which portrayed the Flight into Egypt. In such works as the *Banquet in the Open* (1615; Amsterdam, Rijksmuseum) Van de Velde shows himself to be a follower of Vinckeboons and a true contemporary of Buijtenwegh and other painters of the merry company who were active in Haarlem.

For the most part Van de Velde executed his most spectacularly advanced landscapes before 1618. His *Village at Wintertime* (1614; Raleigh, N.C., North Carolina Museum of Art) abandons earlier schematic compositional devices for a more unified representation of space and a

Henry van de Velde, silver tea service with tray, ca. 1905. Kunstgewerbemuseum, Zurich.

freer execution. Toward the end of his life Van de Velde took a decisive step in the direction of tonal landscape painting with his *Dune Landscape* (1629; Rijksmuseum), which anticipates the eventual development of this mode of landscape painting by his pupil Jan van Goijen.

BIBLIOGRAPHY. G. Poensgen, *Der Landschaftstil des Esaias van de Velde*, Freiburg, 1924; W. Stechow, "Esaias van de Velde and the Beginnings of Dutch Landscape Painting," *Nederlands Kunsthistorisch Jaarboek*, I, 1947; J. Rosenberg, S. Slive, and E. H. ter Kuile, *Dutch Art and Architecture, 1600–1800*, Baltimore, 1966; W. Stechow, *Dutch Landscape Painting of the Seventeenth Century*, London, 1966.

LEONARD J. SLATKES

VELDE, HENRY VAN DE. Belgian architect, designer, and painter (b. Belgium, 1863; d. Switzerland, 1957). One of the fathers of the modern movement allied with Art Nouveau, he studied painting in Antwerp, and in Paris with Carolus-Duran. Van de Velde allied himself first with the impressionists and the neoimpressionists, returning to Belgium in 1885 to join a group of modernists there, The Twenty. He turned to the decorative arts about 1890 under the influence of John Ruskin, William Morris, and the English arts and crafts movement. A fine theoretician and philosopher as well as a talented and creative artist, he was one of the important forces in Art Nouveau design. He favored abstract ornament as opposed to the naturalistic tendencies of Gallé and other French designers. His own home, built at Uccle (1895), presented his work and led to commissions in France, Germany, and Holland. In 1899 he designed several Art Nouveau shop interiors in Berlin. At the Weimar Art School (1901–14), where he headed the School of Arts and Crafts, he was influential in educational reform. Gropius credits him with being a part of the significant inspiration that led to the Bauhaus. His later work, such as the Werkbund Exhibition theater, became lighter and less decorative.

BIBLIOGRAPHY. M. Casteels, *Henry van de Velde*, Brussels, 1932; Zurich Kunstgewerbemuseum, *Henry van de Velde* [exhibition catalog], Zurich, 1958.

DORA WIEBENSON

VELDE, JAN JANSZ. VAN DE, III. Dutch painter of still life and a few landscapes (b. Haarlem, 1619/20; d. Enkhuizen? after 1663). It is not known who his teacher was, but his style seems to be based on that of Pieter Claesz. and Willem Heda, both of Haarlem. There are paintings by Van de Velde dating from 1640 to 1663. In

1642 and 1643 he was recorded in Amsterdam. He is sometimes said to have died in 1662, but the dated (1663) work, *Still Life* (formerly Rotterdam, J. W. van Es Collection), proves this to be incorrect. He was the son of the engraver Jan van de Velde II.

For the most part Van de Velde represented still-life groupings with only a few essential elements (1658; *Still Life*, Almelo, Collection of H. E. ten Cate). Several of his works contain overtones of either the Vanitas type or the life of the senses type (1653; *Still Life with Clay Pipe*, Oxford, Ashmolean Museum), and all contain a rich sense of color which is perhaps indebted to the works of Willem Kalf.

BIBLIOGRAPHY. A. P. A. Vorenkamp, *Bijdrage tot de geschiedenis van het Hollandsch stilleven in de zeventiende eeuw*, Leyden, 1934; I. Bergström, *Dutch Still-Life Painting in the Seventeenth Century*, New York, 1956; N. Maclaren, *National Gallery Catalogues: The Dutch School*, London, 1960.

VELDE, JAN VAN DE, II. Dutch etcher, engraver, and perhaps painter (1596?–1635/52). He was the son of the calligrapher Jan van de Velde I and in 1613 was a pupil of Jacob Matham. The prints of Van de Velde II are rich in genre scenes, and thus are important culturally and historically. The scenes are couched in terms of the months, seasons, four elements, and four parts of the day (two or more sets of each). He did numerous etchings of pure landscape and seascape, views of the châteaux of Holland, and a large view of Haarlem, where he lived. His 44 portraits are engraved. He also worked after the paintings and drawings of Willem Buijtenwegh, Frans Hals, and Peter Molijn; he copied Adam Elsheimer without acknowledging the source. His last prints are dated 1633. His brothers, Esaias van de Velde and Willem van de Velde the Elder, were also artists.

BIBLIOGRAPHY. D. Franken and J. P. van der Kellen, *L'Oeuvre de Jan van de Velde*, Amsterdam, 1883.

VELDE, WILLEM VAN DE, THE ELDER. Dutch draftsman and painter of sea subjects (b. Leyden, 1611; d. London, 1693). He was the father of Willem van de Velde the Younger and Adriaen van de Velde. Van de Velde the Elder was born in Leyden of Flemish parents. It is not known who his teacher was. In 1631 he was living in Leyden, but between 1634 and 1636 he moved to Amsterdam. In 1653 he joined the fleet of Admiral Tromp as official illustrator of naval activity. In 1656, during the campaigns against Sweden, he was with the fleet at the Battle of the Sound. He was also active in the same capacity during the second English war of 1665.

By 1672, perhaps because of the French invasion, Van de Velde and his son Willem were active in London. The two artists entered the service of Charles II two years later, and then of James II. They both seem to have remained in England, with only brief visits to Holland, for the rest of their lives. They are known to have shared a studio in the Queen's House, Greenwich, where they both worked until 1691. That year father and son moved to Westminster.

Today Van de Velde the Elder is known almost exclusively as a draftsman and painter of grisailles, which are in reality pen drawings on panel or canvas (*The Battle of Ter Heyde*, 1657; Amsterdam, Rijksmuseum, pen-and-ink on canvas). However, Dutch sources tell us that he also painted in oils.

BIBLIOGRAPHY. K. Zoege von Manteuffel, *Die Künstlerfamilie van de Velde* (Künstler-Monographien, no. 117), Bielefeld, 1927; H. P. Baard, *Willem van de Velde de Oude, Willem van de Velde de Jonge*, Amsterdam, 1942; Greenwich, Eng., National Maritime Museum, *Van de Velde Drawings... in the National Maritime Museum*, Cambridge, Eng., 1958. LEONARD J. SLATKES

VELDE, WILLEM VAN DE, THE YOUNGER. Dutch painter of sea subjects (b. Leyden, 1633; d. London, 1707). He was the elder brother of Adriaen van de Velde. According to Dutch sources, Willem also studied with Simon de Vlieger, whom he seems to have followed to Weesp. Van de Velde was recorded at Weesp in 1650, but in 1652 he was living in Amsterdam, where he seems to have remained until the French invasion of Holland in 1672. By 1672 both Van de Velde and his father were active in London; both artists entered the service of Charles II in 1674, and later, of James II. They both seem to have remained in England, with only brief visits to Holland, for the rest of their lives.

Van de Velde is known to have shared a studio with his father in the Queen's House, Greenwich, and to have remained there until 1691, when both artists moved to Westminster. Willem van de Velde's best works belong to his Dutch period. His *Cannon Shot* (ca. 1660; Amsterdam, Rijksmuseum) still belongs to the classic phase of Dutch marine painting.

BIBLIOGRAPHY. K. Zoege van Manteuffel, *Die Künstlerfamilie van de Velde* (Künstler-Monographien, no. 117), Bielefeld, 1927; H. P. Baard, *Willem van de Velde de Oude, Willem van de Velde de Jonge*, Amsterdam, 1942; Greenwich, Eng., National Maritime Museum, *Van de Velde Drawings... in the National Maritime Museum*, Cambridge, Eng., 1958; N. Maclaren, *National Gallery Catalogues: The Dutch School*, London, 1960; W. Stechow, *Dutch Landscape Painting of the Seventeenth Century*, London, 1966. LEONARD J. SLATKES

VELLANO, BARTOLOMMEO, *see* BELLANO, BARTOLOMMEO.

VELLERT, DIRK. Flemish printmaker and painter (fl. 1511–44). Well known as a glass painter by his contemporaries, he began to etch and engrave only after meeting Dürer in Antwerp (1520–21). However, Vellert etched on copper (unlike Dürer, who had used iron). His combination of etching and engraving on one plate was most likely inspired by such prints of Lucas van Leyden as the *Portrait of Emperor Maximilian I* (1520). Vellert's nineteen meticulously detailed intaglios are in the ornamentally elaborate and *retardataire* style of such painters as Jan Gossaert. All but one are signed with his initials and a star, and dated in most cases with month, day, and year. Among his finest prints are *St. Luke Painting the Virgin* and the *Vision of St. Bernard*.

BIBLIOGRAPHY. A. E. Popham, "The Engravings and Woodcuts of Dirick Vellert," *Print Collector's Quarterly*, XII, 1925.

VELLUM. Fine grade of parchment made from the skin of a calf. It is finer in texture, more pliable, and thinner than parchment which is made from other skins. Vellum was traditionally reserved for the finest manuscripts.

VELSEN, JACOB JANSZ. VAN. Dutch genre painter (d. Amsterdam, 1656). Van Velsen was probably born in Delft, where his parents married in 1594. He is not iden-

Vence, Chapelle du Rosaire. Dominican chapel designed and decorated by Henri Matisse.

tical with the painter "Jacob Jansz." mentioned in Delft in 1617 as twenty years old, since he did not become a master in the Delft guild until 1625. Very few paintings by Van Velsen are known, and all are genre scenes in the manner of the early works of Antonie Palamedesz. Stevens, who entered the Delft guild in 1621.

BIBLIOGRAPHY. W. Bernt, *Die niederländischen Maler des 17. Jahrhunderts...*, vol. 3, Munich, 1948.

VENASQUE BAPTISTERY. Small structure attached to the Church of Notre-Dame in the Provençal town of Venasque. It is uncertain whether it is a baptistery or a chapel of St. John the Baptist. A simple cubic structure with an arcaded apse on each side, it may date from the 6th or from the 11th century.

VENCE: CHAPELLE DU ROSAIRE (Matisse Chapel). French chapel of the Dominican nuns, consecrated in 1951. It was designed and decorated as a comprehensive work of art by Henri Matisse, who regarded the chapel as his masterpiece. His work includes paintings, stained glass, sculpture, and vestments. *See* MATISSE, HENRI EMILE.

BIBLIOGRAPHY. H. Matisse, *Chapelle du Rosaire des dominicaines de Vence*, Vence, 1951.

VENDOME: CATHEDRAL OF THE TRINITY. Twelfth-century French church, the interior of which now presents a fine example of the Rayonnant Gothic style of the 15th century. The triforium is glazed and seems to join the clerestory in one unbroken window surface. The west front is an example of Flamboyant Gothic design, the last stage in the development of the French Gothic style.

BIBLIOGRAPHY. G. Plat, *L'Eglise de la Trinité de Vendôme*, Paris, 1934.

VENDRAMIN PALACE, VENICE. Imposing Italian Renaissance palace on the Grand Canal. It was begun in 1509 after designs on Albertian principles by the Genoese ar-

chitect Mauro Codussi (1404–72); the Lombardis supervised its construction. Wagner died here in 1883.

BIBLIOGRAPHY. A. Haupt, ed., *Renaissance Palaces of Northern Italy & Tuscany*, London, 1931.

VENEER. Any thin sheet of material applied over another material which is cheaper in quality. The most common application is to furniture; veneers of mahogany and other beautifully grained and costly woods are glued to a base of cheaper wood.

VENEER, BRICK. In wood-frame construction, a masonry surfacing material not intended to support loads. It is widely used in small houses.

VENETIAN SCHOOL. One of the most important schools of Renaissance painting, known especially for its use of radiant color. Its early masters, Paolo (fl. 1332–62) and Lorenzo Veneziano (fl. 1356–79), though steeped in Byzantine tradition, began to develop rich coloring and textures and elaborate settings. *See* LORENZO VENEZIANO; PAOLO VENEZIANO.

In the early 15th century Gentile da Fabriano (1360?–1427) and Pisanello (fl. ca. 1430–55) fathered an outstanding generation of painters. Chief among these were the Bellinis, Jacopo (ca. 1400–70) and his sons Gentile (1429–1507) and Giovanni (1430?–1516). Giovanni, the greatest of them, produced works of monumentality and sweetness profoundly significant for Renaissance art. His famous pupils Giorgione (1477/78–1510) and Titian (ca. 1488–1576), whose heroic and beautifully painted works rival Michelangelo's art, brought the Venetian school to its glory. *See* BELLINI, GENTILE; BELLINI, GIOVANNI; BELLINI, JACOPO; GENTILE DA FABRIANO; GIORGIONE; PISANELLO, ANTONIO; TITIAN. *See also* VIVARINI, ANTONIO.

Two of Titian's most famous contemporaries were Paolo

Vendramin Palace, Venice. Imposing Italian Renaissance edifice, begun in 1509.

Veronese (1528–88) and Tintoretto (1518–94). In the 18th century the last great phase of the school produced the scenic views of Guardi (1712–65) and Canaletto (1697–1768) and the grandiose decorative paintings of Tiepolo (1696–1769). *See* CANALETTO; GUARDI, FRANCESCO; TIEPOLO, GIOVANNI BATTISTA; TINTORETTO; VERONESE, PAOLO.

BIBLIOGRAPHY. H. Tietze, *Titian, The Paintings and Drawings*, 2d rev. ed., New York, 1950; B. Berenson, *The Italian Painters of the Renaissance*, rev. ed., London, 1952; B. Berenson, *Italian Pictures of the Renaissance. Venetian School*, rev. ed., 2 vols., London, 1957.
SARAH LANDAU

VENETO, BARTOLOMMEO, *see* BARTOLOMMEO VENETO.

VENEZIA, ANTONINO DA, *see* ANTONINO DI NICCOLO DA VENEZIA.

VENEZIA, DOMENICO DI BARTOLOMEO DI, *see* DOMENICO VENEZIANO.

VENEZIANO, AGOSTINO, *see* MUSI, AGOSTINO DE.

VENEZIANO, ANTONIO, *see* ANTONIO VENEZIANO.

VENEZIANO, CARLO, *see* SARACENI, CARLO.

VENEZIANO, CATARINO, *see* CATARINO VENEZIANO.

VENEZIANO, DOMENICO, *see* DOMENICO VENEZIANO.

VENEZIANO, LORENZO, *see* LORENZO VENEZIANO.

VENEZIANO, PAOLO, *see* PAOLO VENEZIANO.

VENEZIA PALACE, ROME. Early Renaissance palace (1455–67) built by Cardinal Pietro Barbo (Pope Paul II, 1464–71). It is a transitional building, as the machicolations show; the entrance door and the windows are Renaissance. The courtyard (1467–71), attributed to L. B. Alberti, has a beautiful two-storied loggia (unfinished), one of the outstanding architectural achievements of the 15th century in Rome. Part of the palace is occupied by a museum. Adjacent to the palace and forming part of it is S. Marco, founded in 336, reconstructed in 833, rebuilt by Cardinal Barbo, and restored in 1740–50. Barbo also built the adjoining Venezia Palazzetto, which has a charming courtyard. *See* ROME: MUSEUMS (PALAZZO VENEZIA MUSEUM).

BIBLIOGRAPHY. T. Magnuson, *Studies in Roman Quattrocento Architecture*, Stockholm, 1958.

VENICE. Capital city of the Veneto, a northern province of Italy. Venice is built on a littoral of 118 small and large islands in a lagoon about 2½ miles from the mainland. The traditional date for the founding of the city is 451, when, under the impact of Alaric's Visigoths and Attila's Huns, the islands of the lagoon were permanently inhabited by groups of people from the mainland. Within the next 400 years the character of Venice as an independent city and as a separate political entity was forged.

From the end of the 10th century Venice followed a policy of conquest, first subjugating the Adriatic coast. A Venetian fleet conquered Constantinople in 1204. In the 14th century Venice became a great power in the political schema of Europe, often acting as arbiter between the kingdoms of Europe and the Papacy. Between 1400 and 1700 a continuous struggle was waged with the Turks, which in the long run cost Venice her overseas empire. In the 19th century the city was first part of Napoleon's kingdom and then under the dominion of the Austrian empire.

The entire city is a veritable museum of architecture, sculpture, and painting. The palaces and houses are in the charming Venetian Gothic style, delicate multistoried façades of pointed arches, with exquisite geometric patterns of polychrome marbles. The Cà d'Oro (1421–40) is a prime example. In church architecture Gothic, Renaissance, baroque, and later styles take on a special Venetian flavor in the monuments of the city. For example, in the Renaissance work of the Lombardo family (late 15th–early 16th cent.) façades and walls are articulated by means of a refined composition of colored marbles, and every detail is of surpassing decorative elegance. The small church of S. Maria dei Miracoli exemplifies this style. The work of Il Sansovino is characterized by a robust classicism employing plastic architectural effects and rich chiaroscuro, as in the Library of S. Marco (begun 1536). Dating from the mid-16th century is the classicizing style of Palladio; his masterpieces in Venice are S. Giorgio Maggiore and Il Redentore. Among his most illustrious successors were Scamozzi (the Procuratie Nuove) and Longhena (Church of the Scalzi). *See* REDENTORE, IL; SAN GIORGIO MAGGIORE.

The Piazza S. Marco is one of the most delightful city spaces in Europe. At the east end stand two enormous columns with the statues of S. Todaro and the lion of Venice, the tall brick campanile of the 12th century (collapsed in 1902 and re-erected in 1903–12 in its original form), the Doge's Palace, and the Cathedral of St. Mark. The Cathedral was begun in 1063, completed in 1071, and consecrated in 1094. Its inestimable treasures and the resplendent mosaics make St. Mark's one of the richest museums of medieval art in Italy. The Doge's Palace (1309–1442), in the Venetian Gothic style, is rich in sculpture (by Bartolommeo Buon, Antonio Rizzo, and others) and in paintings (especially the huge oil painting by Tintoretto called *Paradise* in the Sala del Maggior Consiglio). The covered stone Bridge of Sighs was added in the 16th century to connect the Doge's Palace with the state prison. *See* PIAZZA SAN MARCO; ST. MARK'S.

The course of Venetian painting brought forth some of the most notable names in the history of art, including the Bellini family, Giorgione, Lotto, Veronese, Titian, and Tintoretto during the 15th and 16th centuries. The Scuola Grande di S. Rocco has fifty-six paintings by Tintoretto; and the Gallery of the Academy, with numerous works by Venetian and other painters, is one of the richest painting museums in the world. *See* VENETIAN SCHOOL; VENICE: MUSEUMS.

See also CORNER DELLA CA GRANDE PALACE; FOSCARI PALACE; GLASS; GRIMANI PALACE; LOREDAN PALACE; MURANO; PISANI PALACE; RIALTO BRIDGE; SANTA MARIA DEI FRARI; SANTA MARIA DELLA SALUTE; SS. GIOVANNI E PAOLO, VENICE; SAN ROCCO, SCUOLA DI; SAN ZACCARIA; TORCELLO; VENDRAMIN PALACE.

BIBLIOGRAPHY. M. T. McCarthy, *Venice Observed*, New York, 1956; G. Delogu, *Pittura veneziana dal secolo XIV al XVIII*, Bergamo, 1959.
SPIRO KOSTOF

VENICE: MUSEUMS. Important public art collections in Venice, Italy, are located in the museums listed below.

Ca d'Oro. This picturesque late-Gothic palace (erected in 1421–40) houses the Galleria Giorgio Franchetti. On exhibit are sculptures, carpets, furniture, medals, and paintings; the painting collection includes works by Mantegna, Signorelli, Pontormo, Guardi, and Van Dyck.

BIBLIOGRAPHY. G. Fogolari, *The Giorgio Franchetti Gallery in the Cà d'Oro in Venice*, 2d ed., Rome, 1950.

Correr Museum. Together with numerous objects documenting the history of the Venetian republic, the Correr Museum displays a choice group of paintings. These include works by Jacopo and Giovanni Bellini, Carpaccio (the famous *Two Courtesans*), Tura, Antonello da Messina, and Lotto.

BIBLIOGRAPHY. G. Mariacher, *Dipinti dal XIV al XVI secolo*, Venice, 1957; T. Pignatti, *Dipinti del XVII e XVIII secolo*, Venice, 1960.

Doge's Palace. The former residence of the doges and seat of Venetian government was built between 1309 and 1442 in the Gothic style. The opulent façade displays sculptural decoration by Florentine, Lombard, and Venetian artists of the 14th and 15th centuries. Within, the Scala d'Oro, or Golden Staircase, with its rich décor by A. Vittoria (1559), leads to the public rooms. The extensive pictorial decoration of the interior was carried out by such illustrious masters as Veronese, Tintoretto, Bassano, and Palma Giovane. The great Sala del Maggior Consiglio is dominated by Tintoretto's *Paradise*, reputed to be the largest painting on canvas in existence.

BIBLIOGRAPHY. *Il Palazzo Ducale di Venezia, piccola guida storico-artistica*, Venice, 1938; L. Serra, *The Doge's Palace*, Rome, 1950.

Gallery of the Academy. The largest and most important collection of paintings of the Venetian school (13th–18th cent.) was built up from an original nucleus started in 1756. The twenty-five rooms of the collection occupy the Gothic church, the 15th-century monastery, and the school of S. Maria della Carità. The Venetian primitives, in whose work the imprint of close contact with Byzantium is often evident, are represented by Paolo Veneziano (*Coronation of the Virgin*), Lorenzo Veneziano (*Annunciation with Saints*), and the Gothicizing Jacobello del Fiore (*Coronation of the Virgin*). Some twenty paintings document the entire development of the style of Giovanni Bellini, the greatest master of the Venetian early Renaissance. Other important 15th-century works reflect Italian schools related to the Venetian: Piero della Francesca's *St. Jerome with a Donor*, Mantegna's *St. George*, and Tura's *Madonna with Sleeping Child*. Giorgione's pioneering *The Tempest* was probably the first painting primarily concerned with evoking a specific mood. Carpaccio's colorful cycle of the legend of St. Ursula (1490–96) gives a detailed idea of contemporary Venetian life. From this same time come works by such lesser masters as Cima, Basaiti, and Gentile Bellini.

The apogee of Venetian painting coincided with the High Renaissance in the 16th century. This phase may be studied in outstanding paintings by Titian (*Presentation of the Virgin in the Temple*, *Pietà*), Lotto (*Portrait of a Gentleman*), Veronese (*Madonna and Saints*, *Banquet in the House of Levi*), Tintoretto (*Miracles of St. Mark*, *Deposition*), and Jacopo Bassano (*Adoration of the Shepherds*). In the 17th century Venetian painting underwent a decline, and works of this period are meager. But the last flowering of the city's pictorial genius, in the 18th century, is comprehensively presented in the brilliant theatricality of Tiepolo, the magical Venetian views (*vedute*) of Canaletto and Guardi, the elegant portraiture of Carriera, and the sly observation of social life of Pietro Longhi.

BIBLIOGRAPHY. V. Moschini, *The Galleries of the Academy of Venice*, 4th ed., Rome, 1954; S. Moschini Marconi, *Opera d'arte*, 2 vols., Rome, 1955-62; F. Valcanover, *Gallerie dell'Accademia di Venezia*, Novara, 1955.

WAYNE DYNES

VENNE, ADRIAEN PIETERSZ. VAN DE. Dutch painter of proverbs and folk subjects; also illustrator, graphic artist, and poet (b. Delft, 1589; d. The Hague, 1662). He was a pupil of the goldsmith Simon de Valck in Leyden and of Jeronymus van Diest in The Hague. About 1607 Van de Venne worked in Antwerp, and was possibly influenced by the work of Jan Breughel. Van de Venne was in Middelburg from 1614 to 1625, when he went to The Hague. His paintings are mostly in a grisaille technique. He illustrated the works of Jacob Cats, among others.

BIBLIOGRAPHY. D. Franken Dz., *Adriaen van de Venne*, Amsterdam, 1878.

VENNE, PSEUDO VAN DE. Painter of the Flemish school. He was apparently an artist active in the southern Netherlands, conceivably Antwerp, during the second third of the 17th century. He painted genre scenes with allegorical significance, as well as peasant brawls, ugly tramps, and spookish figures, all caricatured and exaggerated in their peculiarities.

VENUS. Roman name for the Greek goddess Aphrodite, who was born of seafoam to rule over every aspect of love and beauty. Her perfection of face and form has repeatedly excited the artistic imagination, resulting in countless semidraped and nude statues of this deity being carved in the ancient world, the most famous being the *Venus de Milo*, from Melos (Paris, Louvre). Her legendary meetings with such lovers as Ares or Adonis were favorite subjects of Renaissance and baroque painters.

VENUS, TEMPLE OF, ROME. Ancient Roman temple in the Forum of Julius Caesar. It was dedicated to Venus Genetrix by Caesar about the middle of the 1st century B.C. It was Corinthian, prostyle, octastyle, and raised on a podium. Almost square in form, it consisted of a pronaos and a cella which terminated in an apse where the statue of Venus executed by Arkesilaos was placed. The temple was restored at the end of the 1st century of our era, perhaps under Domitian. The remaining reliefs of floral design are interesting examples of the rich and intricate ornamentation of the Flavian period. The interior of the cella had columns which supported an entablature decorated with a frieze of *amorini* (small Erotes) performing various tasks. The porch of the temple served in antiquity as an exhibition hall for several famous Greek paintings. Still standing are three columns and part of the entablature.

BIBLIOGRAPHY. G. Lugli, *Roma antica: Il centro monumentale*, Rome, 1946.

VENUS ANADYOMENE, *see* APELLES; APHRODITE OF CYRENE.

VENUS AND ROMA, TEMPLE OF, ROME. Magnificent ancient Roman temple, built by Hadrian in A.D. 121. A double temple, it was raised on an artificial platform and consisted of two cellas, each with vaulted coffered apses set back to back and a pronaos. The temple was enclosed in a peribolus surrounded by a portico.

BIBLIOGRAPHY. W. J. Anderson, R. P. Spiers, and T. Ashby, *The Architecture of Greece and Rome*, vol. 2: *The Architecture of Ancient Rome*, London, 1927.

VENUS DEI MEDICI. Statue of Aphrodite (Florence, Uffizi). It is the Roman copy of a 4th-century B.C. Greek original ascribed to the sons of Praxiteles. Aphrodite is represented standing in the nude; both her hands shield her body in a gesture of modesty. The statue is an adaptation of the *Cnidian Aphrodite*, a famous work by Praxiteles.

BIBLIOGRAPHY. M. Bieber, *The Sculpture of the Hellenistic Age*, New York, 1955.

VENUS DE MILO, *see* APHRODITE OF MELOS.

VENUS OF WILLENDORF. Upper Paleolithic statuette found at Willendorf, Austria (Vienna, Natural History Museum). It is one of the earliest examples of art dating from the Aurignacian period. The figurine is an abstraction and a symbol of the race's reproduction as well as a derivative of fertility rites. All Venuses of this epoch were represented with highly exaggerated breasts, abdomen, and buttocks.

VENUSTI, MARCELLO. Italian painter (b. Como, 1512/15; d. Rome, 1579). A student of Perino del Vaga, Ve-

Venus of Willendorf. Upper Paleolithic figurine found in Austria. Natural History Museum, Vienna.

nusti was a close follower of Michelangelo in Rome and produced several paintings from drawings by the master. In his highly finished works, mostly small paintings and portraits, the Michelangelesque proportions and postures are seen in the context of vacant expressions and smooth line. Venusti's copy of Michelangelo's *Last Judgment* (1549; Naples, Capodimonte) provides valuable clues to the original condition of the masterpiece.

VERBEECK, JAN. Flemish painter (b. Mechlin? ca. 1535; d. after 1619?). He was a brother of Frans Verbeeck and a master in the Mechlin guild in 1553. Two signed and dated drawings by Verbeeck are known (London, Herbert Bier Collection; Oxford, Ashmolean Museum), of 1548 and 1560 respectively. They are caricatural imitations of the work of Pieter Brueghel the Elder.

BIBLIOGRAPHY. L. van Puyvelde, *La Peinture flamande au siècle de Bosch et Breughel*, Paris, 1962.

VERBEECK (Verbeecq), PIETER CORNELISZ. Dutch painter of battle scenes, horses, and landscapes; also graphic artist (b. Haarlem, ca. 1610/15?; d. there, 1652–54). Verbeeck was the son of the marine painter Cornelis Verbeecq. In 1635 he was reported as a master in the Alkmaar painters' guild. In 1642 he was living in Utrecht, where he was influenced by the Italianate landscape painters. From 1643 he was active in Haarlem. His later works show the influence of Paulus Potter and Isaak van Ostade. His paintings are also related to the early works of Philips Wouwermans, but the exact nature of this relationship has not been established.

BIBLIOGRAPHY. H. Gerson, "Leven en werken van... Pieter Verbeeck," in E. A. van Beresteyn, *De Genealogie van het geslacht van Beresteyn*, The Hague, 1940.

VERBOOM, ADRIAEN HENDRICKSZ. Dutch painter of landscape and etcher (b. Rotterdam, ca. 1628; d. Amsterdam? 1670). Little is known of Verboom's early activity. He was active in Haarlem about 1650–60 and collaborated with P. G. van Os (*Landscape*, 1653; Amsterdam, Rijksmuseum). His style recalls that of Jacob van Ruisdael.

VERBRUGGEN, CASPAR PIETER, I. Flemish painter (1635–81). A native of Antwerp, the artist was a well-known flower painter. He studied with Cornelis Mahu and produced numerous decorative canvases, generally featuring bouquets or garlands. His technique is superficial and the colors are dull.

BIBLIOGRAPHY. M. L. Hairs, *Les Peintres flamands de fleurs au 17e siècle*, Brussels, 1955.

VERBRUGGEN, CASPAR PIETER, II. Flemish painter (1664–1730). Verbruggen was born in Antwerp. He was elected dean of the Guild of St. Luke in 1691. A sojourn in The Hague is documented for the year 1705. He painted flowers in imitation of, though with less skill than, his father, Caspar Pieter Verbruggen I.

BIBLIOGRAPHY. F. J. van den Branden, *Geschiedenis der Antwerpsche Schilderschool*, Antwerp, 1883.

VERBRUGGEN, HENDRIK FRANS. Flemish sculptor (b. Antwerp, ca. 1655; d. there, 1724). The son of Pieter Verbruggen the Elder, Hendrik became a member of the Antwerp Guild of St. Luke in 1682 and deacon in 1689.

He executed works for the St. Bernard Abbey, SS. Peter and Paul, Mechlin, and for St. Bavon, Ghent. His masterpiece is the pulpit with symbols of the Fall and Redemption (1699–1702; Brussels, St-Gudule). Verbruggen worked in a style transitional from baroque to rococo.

BIBLIOGRAPHY. E. Marchal, *La Sculpture et les chefs-d'oeuvre de l'orfèvrerie belges*, Brussels, 1895.

VERBRUGGEN, PIETER, THE ELDER. Flemish sculptor (b. Antwerp, ca. 1609; d. there, 1686). A pupil of Simon de Neve after 1625, Verbruggen became a master in the Antwerp Guild of St. Luke in 1641 and deacon in 1658–61. His best pupils were Peter Scheemaeckers and M. van Beveren. In Antwerp he executed for the Cathedral the organ case (1653–56) and the statues to ornament it (1657–61). Only the *Altar of the Holy Sacrament* and a rood screen remain of his extensive works there. Verbruggen also executed the tomb of Christopher Delphicus v. Dohna (1674; Uppsala Cathedral). The father of Hendrik Frans Verbruggen and Pieter Verbruggen II, Pieter worked in a solid Flemish baroque style.

BIBLIOGRAPHY. E. Marchal, *La Sculpture et les chefs-d'oeuvre de l'orfèvrerie belges*, Brussels, 1895.

VERBURGH, DIONYSIUS. Dutch landscape painter (b. Rotterdam? ca. 1650; d. there, before 1722). Little is known of Verburgh's activity. Between 1703 and 1710 he made a trip to Surinam. The subjects of his paintings suggest that he also traveled to Italy (*View of an Italian City*, Leyden, State Museum "de Lakenhal").

BIBLIOGRAPHY. H. C. Hazewinkel, "De Rotterdamsche schildersfamilie Verburgh," *Oud-Holland*, LV, 1938.

VERDE ANTICO. Patina produced on ancient bronzes by burial in the earth. It results from slow oxidation that attacks the metal. Its variations in color and texture depend upon the alloy ingredients of the bronze and the composition of the earth in which the piece was buried. Although *verde antico* has been artificially obtained in recent times, patina was considered by the ancients to be a defect and was eliminated by careful polishing.

BIBLIOGRAPHY. New York, Metropolitan Museum of Art, *Greek, Etruscan and Roman Bronzes*, ed. G. M. A. Richter, New York, 1915.

VERDUN, NICOLAS DE, *see* NICOLAS DE VERDUN.

VERELST, PIETER HERMANSZ. Dutch painter of genre, portraits, and still life (b. Dordrecht? ca. 1618; d. Hulst? ca. 1678). In 1638 Verelst was reported as a member of the Guild of St. Luke at Dordrecht. About 1643 he went to The Hague, where, in 1656, he was one of the founders of the painters' confraternity Pictura. In 1671 Verelst was a beer brewer near Hulst. His style was influenced by the early Rembrandt school.

VERELST, SIMON PEETERZ. Dutch still-life and portrait painter (b. The Hague, 1644; d. London, 1710/21). A student of his father, Pieter Verelst, Simon went to England in 1669. His fine flower and fruit pieces, reminiscent of Rachel Ruijsch, were enormously popular. Under the patronage of the Duke of Buckingham he painted portraits, mostly in the style of Sir Peter Lely, but often including flowers and fruit as accessories. Simon thought of himself as the "God of Flowers."

VERENDAEL, NICOLAS VAN. Flemish painter (1640–91). A native of Antwerp, Verendael painted fruit and flowers, and followed closely in the footsteps of Daniel Seghers. His works are of high quality. Erasmus Quellinus and Gonzales Coques were among his collaborators.

VERESHCHAGIN, VASILI VASILIEVICH. Russian painter (b. near Novgorod, 1842; d. Port Arthur, 1904). Vereshchagin studied with Biedemann at the Academy of Fine Arts in St. Petersburg, leaving in 1863 to study with Gérôme in Paris. Living in Paris and Munich for extended periods, he became the most widely known Russian painter in Europe. Most of his paintings derived from his wide-ranging travels in Asia. The Tolstoyan pacifism he espoused in pamphlets and lectures is also evident in his paintings of the wars in Turkestan (1867–68) and the Russo-Turkish War (1877–78), which he covered as an artist-reporter. The horrors of war are depicted in a photographic, reportorial style, which Vereshchagin also applied to the landscapes and scenes of local color that derived from his trips through the Caucausus, India (1875–76), and Palestine (1884). In the 1890s he produced a series of paintings recounting Napoleon's invasion of Russia.

BIBLIOGRAPHY. V. Sadoven, *V. V. Vereshchagin*, Moscow, 1950.

VERGOS FAMILY. Catalan painters (fl. 15th cent.). Jaime Vergós the Elder was born by 1434 and died in 1460. Francesco Vergós, perhaps Jaime's brother, was active in 1462. No certain works of either are known. Jaime Vergós the Younger was born by 1459 and died about 1503. He may have been the author of the Retablo del Condestable in the Chapel of S. Agueda in Barcelona and of other works in churches and in the museum of that city. His eldest son, Pablo Vergós the Elder (d. 1495), apparently the most distinguished artist in the family, was strongly influenced by Jaime Huguet. He was responsible for the monumental figures of Abraham, Moses, and David for the altar of S. Esteban in Granollers, which was finished in 1506, and which many consider the point of departure for any consideration of the work of members of the Vergós family. Pablo's brother, Rafael Vergós, also worked on it, as did their father.

BIBLIOGRAPHY. A. L. Mayer, *La Pintura española*, 2d ed., Barcelona, 1929.

VERHAECHT, TOBIAS VAN, *see* HAECHT, TOBIAS VAN.

VERHAEGEN, THEODOR. Flemish wood and stone sculptor (b. Mechlin, 1701; d. there, 1759). He was the pupil of J. Boeckstuyns and P. D. Plumier. Verhaegen's first solo work was the tomb of C. A. Roose at Leeuw-Sainte-Pierre (1723). From 1736 to 1741 he carved the pulpit of SS. Jean Baptiste et Jean at Mechlin and began the high altar there, which was completed after his death (1769). The *Garden of Eden* pulpit (Notre-Dame d'Hanswyck) at Mechlin is one of the largest and richest of its type. Verhaegen was one of the more ambitious pulpit carvers of his time.

BIBLIOGRAPHY. A. E. Brinckmann, *Barockskulptur*, 2 vols. in 1, Berlin, 1932.

VERHAEREN, ALFRED. Belgian painter (b. Brussels, 1849; d. Ixelles, 1924). He studied at the Brussels Academy and with Louis Dubois. His early works were still-life paintings in the carefully realistic Flemish tradition. He also painted portraits, landscapes, and interiors in which the seemingly casual arrangement of objects conceals an also traditional strong compositional structure. His later work is marked by a personal version of a sort of impressionism in which a still life or an interior is painted with form-dissolving little strokes of rich color.

BIBLIOGRAPHY. P. Colin, *La peinture belge depuis 1830*, Brussels, 1930.

VERHAGEN, JORIS, *see* HAAGEN, JORIS VAN DER.

VERHELST, IGNAZ WILHELM. German sculptor (b. Munich, 1729; d. Augsburg, 1792). He was the son and pupil of Egid Verhelst. Ignaz directed the family studio after 1749 with his brother Placidus. They produced religious figures for churches in Augsburg and its vicinity in the popular Bavarian baroque style.

VERHULST, ROMBOUT. Netherlandish sculptor (b. Mechlin, 1624; d. The Hague, 1698). A pupil of R. Verstappen from 1633 to 1636, Verhulst may have gone to Italy between 1646 and 1654. In 1650–55 he collaborated on sculptures for the City Hall, Amsterdam. His funerary works are most significant for the development of the Dutch high baroque manner; they include the tombs of G. van Lyere and M. van Ruygersberg (1663; Katwijk-Binnen), Adrien Clant (1672; Stedum), and C. J. van Innende-Khyphuisen and A. van Eeuwsum (1664–69; Midwolde).

BIBLIOGRAPHY. M. van Notten, *Rombout Verhulst...*, The Hague, 1908.

VERISM (Veristic Surrealism). The post-World War I surrealistic representation of dream images with photographic precision in an illusionistic space. Unlike such practitioners of abstract surrealism as Miró and Masson, who created images through psychic automatism, veristic painters drew on objective reality for images to express subjective states. Ernst initiated this tendency; Tanguy and Dali have been two of its greatest exponents. Its method is illustrative, and its subject matter includes neoromantic idylls, constructed objects, and dream figures. *See* DALI, SALVADOR; ERNST, MAX; TANGUY, YVES.

BIBLIOGRAPHY. W. Haftmann, *Painting in the Twentieth Century*, 2 vols., New York, 1960.

VERKADE, JAN (Dom Willibrord). Dutch painter (b. Zaandem, 1868; d. Beuron Monastery, Germany, 1946). In 1891 he went to Paris, where he met Gauguin and joined the Nabis group, to whom he was "Le Nabi obéliscal" (obelisk-like). A Catholic convert, Verkade entered the Beuron Monastery in 1894 and was thereafter active in the modern revitalization of religious art.

BIBLIOGRAPHY. Dom W. Verkade, *Die Unruhe zu Gott: Erinnerungen eines Malermönches*, Freiburg im Breisgau, 1920.

VERKOLJE, JOHANNES (Jan). Dutch painter of genre and portraits and graphic artist (b. Amsterdam, 1650; d. Delft, 1693). He was a pupil of Jan Lievens the Younger.

In 1672 Verkolje was living in Delft, where he was reported as a member of the Guild of St. Luke the following year. Between 1678 and 1688 he held various official posts in the guild. His work was influenced by Metsu, Ter Borch, and Netscher. His son Nicolaas was his pupil.

BIBLIOGRAPHY. J. G. Burman Becker, *Notices sur la famille Verkolje*, Copenhagen, 1869.

VERKOLJE, NICOLAAS (Nicolaes). Dutch painter of history, genre, portraits, and decorations; also graphic artist (b. Delft, 1673; d. Amsterdam, 1746). He was the son and pupil of Johannes Verkolje. Nicolaas lived in Amsterdam after 1700. His painting style was influenced by Metsu, Ter Borch, and Adriaen van der Werff. He was also an important graphic artist, working after Gerard de Lairesse, among others.

BIBLIOGRAPHY. J. G. Burman Becker, *Notices sur la famille Verkolje*, Copenhagen, 1869.

VERMEER, BAREND, *see* MEER, BARENT VAN DER.

VERMEER, JAN, *see* VERMEER, JOHANNES REYNIERSZ.

VERMEER, JAN, II, *see* MEER, JAN VAN DER, II.

VERMEER, JAN, III, *see* MEER, JAN VAN DER, III.

VERMEER, JOHANNES (Jan) REYNIERSZ. Dutch painter of genre and history (b. Delft, 1632; d. there, 1675). Little is known of Vermeer's life and virtually nothing of his personality. His father, Reynier Jansz. Vos, or Vermeer, was a silk weaver and innkeeper who seems to have done some dealing in art. In 1653, when Vermeer married Catharina Bolnes, the painter Leonard Bramer spoke to Vermeer's future mother-in-law on the young painter's behalf. This close connection has led some scholars to speculate that Bramer was Vermeer's teacher, but this relationship is unsupported by either documentary or stylistic evidence. During the same year as his marriage, Vermeer entered the Delft Guild of St. Luke. In 1662/63 and 1670/71 he was an official (*hoofdman*) of the guild.

At the time of his father's death (1655) he seems to have taken over the tavern, and by 1672 he was also dealing in works of art and acting as a valuer. In 1672 he was apparently in financial difficulties, and a few months after his death his widow, in 1676, petitioned the court for a writ of insolvency and further declared that her painter husband had earned almost nothing since the war with France (1672) and had incurred only losses as an art dealer. The court appointed Anthony van Leeuwenhoek, the Delft scientist who was an early experimenter with the microscope and the "father of microbiology," executor of Vermeer's bankrupt estate. There is no other evidence linking these two prominent Delft citizens, but the two men were born at the same place and virtually at the same hour, according to the baptismal records of the New Church at Delft.

Although there is no firm documentary evidence about Vermeer's artistic training, the name of Carel Fabritius

Johannes Vermeer, *Woman in Blue Reading a Letter*, ca. 1664. Rijksmuseum, Amsterdam.

inevitably is raised in connection with Vermeer's artistic origins. The only documentation linking the two artists is a few lines written by Arnold Bon about 1654, the year of Fabritius's death in the Delft gunpowder explosion, which state that Delft fortunately has Vermeer who follows Fabritius's path. While these lines do not necessarily imply a pupil-teacher relationship between Vermeer and Fabritius, there can be little doubt that the young Vermeer benefited from the stylistic innovations made by the former Rembrandt pupil. It is known that Vermeer, at the time of his death, owned three works by Fabritius.

In terms of his actual artistic production Vermeer seems to have been a slow, careful craftsman. Fewer than forty paintings can be attributed to him, and of these only two have authentic dates: *The Procuress* (Dresden, State Art Collections) of 1656 and *The Astronomer* (Paris, private collection) of 1668. He seems to have done no work in the various graphic media, and no drawing can be attributed to him with any certainty. There is very little else in the way of documentation on individual works by Vermeer, and any chronology of his works must be based completely on the logical development of his style and its relationship to the general trends of Dutch painting during the third quarter of the 17th century.

It is possible, roughly, to divide Vermeer's approximately twenty years of activity into three stylistic groups. The first group, which would date from about 1655 to 1660, can be formed around the 1656 *Procuress*. At least two paintings can be dated earlier than the Dresden picture: *Diana and Her Companions* (The Hague, Mauritshuis Art Gallery) and *Christ at the House of Mary and Martha* (Edinburgh, National Gallery of Scotland). All three have a sense of form, color, and composition that can be related to early Italian baroque painting. In addition, the subject of the *Procuress* can be linked to the Italianate followers of Caravaggio in Utrecht, and in particular to Dirck van Baburen. A Baburen *Procuress* (Boston, Museum of Fine Arts) seems to have been in Vermeer's possession at one time; it is seen hanging on a wall in two of Vermeer's compositions, *The Concert* (Boston, Isabella Stewart Gardner Museum) and *A Young Woman Seated at a Virginal* (London, National Gallery). Seemingly also belonging to this early development of Vermeer would be *A Girl Asleep* (New York, Metropolitan Museum) and the *Officer and Laughing Girl* (New York, Frick Collection). Both works lack the clarity of spatial relationships between figures and their setting that occurs in his more mature works; also there is greater emphasis on the anecdotal aspect of the composition.

Vermeer's well-known *Little Street in Delft* (Amsterdam, Rijksmusem), with its close and geometrically arranged spatial composition and soft coloristic harmonies, probably dates from about 1660. However, his more monumental and equally famous *View of Delft* (Mauritshuis Art Gallery) is far more difficult to date with any real assurance. These two pictures, the only two cityscapes by Vermeer that have come down to us, are usually linked together because of a similarity in subject. The *View of Delft*, technically, makes use of painterly devices normally associated with his early period as well as with those found in his works during the 1660s. It is possible that about this time Vermeer was experimenting with that forerun-

ner of the modern camera, the camera obscura. The crispness of vision found in the *View of Delft* as well as slight spatial distortions and compressions could account for the unique qualities of this unusual painting.

In Vermeer's middle period, when the painter began to concentrate upon single figures, can be placed such works as the *Woman Weighing Pearls* (Washington, D.C., National Gallery). Also belonging to this classic phase are the *Head of a Girl* (Mauritshuis Art Gallery), the *Woman with a Red Hat*, and the *Young Girl with a Flute* (both, Washington, National Gallery). The last three paintings have recently been discussed in relation to Vermeer's use of the camera obscura. There can be little doubt that part of the striking and unique quality of these works is their protophotographic nature. It should be noted in connection with this aspect of Vermeer's work that his Delft contemporary, Anthony van Leeuwenhoek, was one of the leading European lens makers. The organization of Vermeer's paintings is a combination of meticulous detail for the individual object, the placement of that object within a precisely formulated, geometrical space, and finally an awareness of the naturalistic modulations of light never before realized by any other artist.

Vermeer's latest phase is characterized by a noticeable falling-off in quality. This is the period, it should be noted, of Vermeer's financial difficulties. It is doubtful that any work can be dated later than 1672, three years before his death. Of the works which can be dated about 1670, *The Letter* (Rijksmuseum) and the *Allegory of the New Testament* (Metropolitan Museum) both have a forced, somewhat contrived sense of space, especially when compared with his classical phase of the 1660s. The weakening of his artistic powers is most noticeable in the *Girl with a Guitar* (London, Kenwood House).

In his greatest works Vermeer achieves a surpassing degree of skill in spatial representation and a perfection of his technique for depicting his subjects. A sense of time-lessness is conveyed through the illumination of a balanced and harmonious reality, enhanced by Vermeer's mastery of color and brushwork.

BIBLIOGRAPHY. W. Bürger, *Van der Meer de Delft*, Paris, 1866; H. Voss, "Vermeer van Delft und die Utrechter Schule," *Monatshefte für Kunstwissenschaft*, V, 1912; A. B. de Vries, *Jan Vermeer van Delft*, London, New York, 1948; F. van Theinen, *Jan Vermeer van Delft*, London, 1949; P. T. A. Swillens, *Johannes Vermeer*, Utrecht, 1951; L. Gowing, *Vermeer*, London, 1952; A. J. M. van Peer, "Rondom Jan Vermeer van Delft," *Oud-Holland*, LXXIV, 1959; C. Seymour, Jr., "Dark Chamber and Light-Filled Room: Vermeer and the Camera Obscura," *Art Bulletin*, XLVI, 1964; J. Rosenberg, S. Slive, and E. H. ter Kuile, *Dutch Art and Architecture, 1600–1800*, Baltimore, 1966. LEONARD J. SLATKES

VERMEIJEN (Vermeyen), JAN CORNELISZ. Netherlandish painter of history and portraits; also graphic artist and designer of tapestries (b. Beverwijk, ca. 1500; d. Brussels, 1559). His style is generally related to that of such artists as Jan van Scorel and Jan Gossaert, whose works Vermeijen could have known at Utrecht. However, there is no documentary evidence concerning his actual teacher. From about 1525 Vermeijen worked, mainly as a portrait painter, for the regents of the Netherlands—Margaret of Austria and Mary of Hungary—and for Emperor Charles V (*Portrait of Charles V*, Brussels, Delporte Collection). According to Karel van Mander, Vermeijen accompanied Charles V on his campaign to Tunis in 1535 and the fol-

lowing year published a series of engravings related to the campaign. He also designed a series of tapestry cartoons (Vienna, Museum of Art History) based on the same campaign, but these are at least partly studio works. Vermeijen was still working for the Emperor in 1555. Individual works by Vermeijen are difficult to ascertain, but the *Triptych of the Michault Family* (Brussels, Fine Arts Museum) is generally accepted as an authentic work.

BIBLIOGRAPHY. M. J. Friedländer, *Die altniederländische Malerei*, vol. 12, Berlin, 1935; G. J. Hoogewerff, *De Noorde-Nederlandsche schilderkunst*, vol. 4, The Hague, 1942; M. Davies, *National Gallery Catalogues: Early Netherlandish School*, 2d rev. ed., London, 1955; Brussels, *Musées Royaux des Beaux Arts de Belgique, Le Siècle de Bruegel* (exposition catalog), Brussels, 1963.

VERMEIO, BARTOLOMMEO, *see* BERMEJO, BARTOLOME.

VERMEULEN, J(an?). Dutch painter of still life (fl. mid-17th cent.). J. Vermeulen is possibly identical with the painter Jan Vermeulen who was recorded as living in Haarlem in 1657, and Haarlem inventories from the second half of the 17th century frequently mention Vanitas paintings by "Vermeulen" and "I V M." If the first initial on a *Still Life* (The Hague, Mauritshuis Art Gallery) is read correctly as a "J," then Vermeulen is certainly not the painter Isaac Vermeulen cited in a Leyden inventory of 1667. However, this matter is confused by the fact that there are definite influences of the Leyden school in this artist's work, and some influence of Edwaert Colijer is discernible.

BIBLIOGRAPHY. I. Bergström, *Dutch Still-Life Painting in the Seventeenth Century*, New York, 1956.

VERMEYEN, JAN CORNELISZ., *see* VERMEIJEN, JAN CORNELISZ.

VERNET, ANTOINE-CHARLES-HORACE (Carle). French history painter and lithographer (b. Bordeaux, 1758; d. Paris, 1836). He was the son and pupil of Claude-Joseph Vernet and also studied with Nicolas Bernard Lépicié. Carle won the Prix de Rome in 1779 and 1782. In 1816 he took up lithography, which was then a novelty. His specialty was horse subjects conceived in the English vein. His style is more linear than that of his son Emile-Jean-Horace Vernet, of Antoine-Jean Gros, and of Théodore Géricault, who were his pupils.

BIBLIOGRAPHY. H. Lemonnier, *Notices biographiques sur Carle et Horace Vernet*, Paris, 1864.

VERNET, CLAUDE-JOSEPH. French landscape painter (b. Avignon, 1714; d. Paris, 1789). He was one of the twenty-two children of Antoine Vernet, a decorative painter of coaches and sedan chairs, and his father was his first teacher. While he was on his way to Rome by ship, the dramatic impact of a severe storm at sea determined his course as a painter of sea pieces. In Rome (1734) he studied with Adrien Manglard, and N. Vleughels, director of

Emile-Jean-Horace Vernet, *Défense de la barrière à Clichy*, 1826. Louvre, Paris. An artist who had a lifelong passion for military subjects.

the French Academy there, encouraged him to pursue landscape art, but with academic conscience, urged him to proceed by copying antique monuments. His passion for music led to a close friendship with the composer Pergolesi. Later, he visited Naples, Venice, and Greece. Seeking mood inspiration from Salvator Rosa and color from Francesco Solimena, he executed decorations in the Palazzo Rondanini and the Galleria Borghese. *Sporting Contest on the Tiber* (1750; London, National Gallery), carefully detailed in the manner of Giovanni Pannini, successfully integrates the ancient setting of Rome with the gay social life of the day. In 1743 he was made a member of the Roman Academy of St. Luke, and in 1746, of the Royal Academy in Paris.

In 1751 he settled in Marseilles. The Marquis de Marigny, superintendent of buildings, commissioned him, together with J. F. Hüe and other landscapists, to undertake an ambitious series in large scale representing the twenty-four ports of France. Vernet executed fifteen of them, and they were his most significant work (1754–65; *Marseilles, Toulon, Antibes, Cette, Bordeaux, Bayonne, La Rochelle, Rochefort,* and *Dieppe,* all in Paris, Louvre).

In 1762 he established himself permanently in Paris. His landscapes were much sought after, particularly by British patrons, and he has often been referred to as the "Pannini of France." His works extoll the drama of nature, and imply by consequence the age-old message of man's puniness in his attempts to control it. His dramatic interpretations anticipate the subjectivity of the romantic movement at the beginning of the 19th century. He preferred cool grays and blues, but at times depicted vivid sunset scenes, generally over a body of water with high cliffs to one side. His foremost pupils were G. Lacroix and his son Antoine-Charles-Horace Vernet.

BIBLIOGRAPHY. F. Ingersoll-Smouse, *Joseph Vernet...,* Paris, 1926.
GEORGE V. GALLENKAMP

VERNET, EMILE-JEAN-HORACE. French painter and graphic artist (b. Paris, 1789; d. there, 1863). He received his early training from his father, Antoine-Charles-Horace Vernet, and his grandfather, the etcher Jean Moreau. Emile served for a time in the army, and from these experiences as well as from those of his father and grandfather, Vernet derived his lifelong passion for military subjects. His first popular painting, *Défense de la barrière à Clichy* (1820; Paris, Louvre), was drawn from personal experience. (See illustration.)

In 1820 he traveled to Italy, where from 1829 to 1835 he was director of the French Academy in Rome. Upon his return to Paris in 1825 his popularity and output increased. He made several paintings depicting the French Army under Napoleon for the Versailles Museum, and he broadened his repertoire to include portraits and Oriental subjects. In 1842–43 Vernet traveled to Russia and painted the imperial couple and several subjects from Russian military history (*Battle of Wola;* Leningrad, Winter Palace). As a graphic artist his output was large. He did more than 200 lithographs, mostly depicting military subjects, and contributed to the woodcut illustrations for Laurent de l'Ardèche's *Histoire de Napoléon* (1839).

BIBLIOGRAPHY. J. R. Rees, *Horace Vernet and Paul Delaroche,* London, 1880; H. Béraldi, *Les Graveurs du XIXᵉ siècle,* vol. 12, Paris, 1892.
JULIA M. EHRESMANN

VERNISSAGE, *see* VARNISHING DAY.

VERONA, LIBERALE DA, *see* LIBERALE DA VERONA.

VERONA, MAFFEO. Italian fresco painter (b. Verona, 1576; d. Venice, 1618). He was a student of Luigi Benfatto, but followed more closely the styles of Paolo Veronese and Tintoretto. Many of Verona's frescoes, painted in a facile manner, as well as some canvases, are in the public buildings of Venice and Verona.

VERONA. City of the Veneto, northern province of Italy. Verona was colonized by the Romans in 89 B.C. and served thereafter as an important military outpost to the north. Impressive remnants of Roman monuments include the Augustan theater and Arch of the Gavi, the Porta dei Leoni and Porta dei Borsari, and the well-preserved amphitheater, generally dated to the middle of the 1st century of the Christian era. Remains of imperial baths are enclosed within the Church of S. Zeno. See VERONA: AMPHITHEATER.

S. Zeno (completed ca. 1138) is an outstanding example of Lombard Romanesque architecture. The façade has sculpture by Guglielmo da Modena and Nicolaus, concentrated around the main portal and representing scenes from the Scriptures. Nicolaus is also responsible for the portal sculptures of the Cathedral of Verona, another monument of the Lombard Romanesque style. *See* SAN ZENO, BASILICA OF.

The period from about 1150 onward was one of prosperity for Verona; the city was enlarged beyond the confines of the Roman colony. The ruling family, the Scaligeri, erected many buildings. In the 14th century the city was filled with towers, palaces, and castles, of which the most impressive is the Castelvecchio, built in the mid-14th century by the ruler Can Grande II. See CAN GRANDE DELLA SCALA; VERONA: CASTELVECCHIO MUSEUM.

After 1400 Verona became a Venetian colony for several centuries. The Renaissance reached Verona from Florence late in the 15th century. The greatest exponent of Renaissance architecture in the city was the brilliant military engineer and builder Michele Sanmicheli. Verona contains numerous examples of his work, the most noteworthy among them being the Canossa and Bevilacqua palaces. The façades of these buildings, with their rusticated lower stories and bays clearly articulated by engaged columns and pilasters, provide the Veronese parallels to the earlier palace formulations of Alberti and Michelozzo in Florence.

See also POMPEI PALACE; VERONESE SCHOOL.

BIBLIOGRAPHY. L. Simeoni, *Guida della città,* 3d ed., Verona, 1909 (rev. ed. by N. Zanoni, Verona, 1953).
SPIRO KOSTOF

VERONA: AMPHITHEATER (Arena). One of the largest and best-preserved Roman amphitheaters, dating from the end of the 1st century B.C. It lay on the outskirts of the inhabited area and had two tiers of arches in addition to the arena proper.

VERONA: CASTELVECCHIO MUSEUM. Italian collection. The imposing battlemented castle, begun by Can Grande II della Scala in 1354, now houses the Municipal

Museum of Art. The local Veronese school of painting (14th–18th cent.) is copiously represented; of outstanding importance are works by Turone, Altichiero, Stefano da Verona (*Madonna of the Quail*), Morone, Liberale da Verona, and Veronese. There are also paintings by artists of Padua and Venice, including Mantegna, Jacopo and Gentile Bellini, Alvise Vivarini, Titian, Tintoretto, Tiepolo, and Guardi. In addition there is a group of manuscripts illuminated by Veronese artists.

VERONESE, BONIFAZIO, *see* BONIFAZIO VERONESE.

VERONESE (Caliari), PAOLO. Venetian painter (1528–88). Born in Verona, he was an apprentice of Antonio Badile in that city in 1541. By the age of twenty he was painting large works and was clearly the most talented artist of Verona. In 1553 he moved permanently to Venice, taking with him a group of young associates (including his brothers Zelotti and Ponchino). His life was uneventful, marked by a few trips, usually to nearby places for jobs, and by a continuing series of commissions for huge individual works and large series.

His early stylistic interests reach out beyond the minor painters of Verona (though he absorbed the technique of intense luminous color areas from them) to the distinguished local architect Michele Sanmicheli (who obtained commissions for him when he built villas) and to the Brescian masters Moretto and Savoldo. These influences are marked in his earliest dated work, the large *Christ among the Doctors* (1548; Madrid, Prado), which was so mature and typical that it was considered a later Veronese until the inscribed date was found; and in the full-length *Francesco Franceschini* (1551; Sarasota, Ringling Museum of Art), whose composition echoes Moretto. Both use classicistic columns as props for the figures, which have large, simple volume without great weight, for they are formed by light instead of modeling. In the decorative frescoes for the Villa Soranzo (1551; fragments in Castelfranco Cathedral and elsewhere), these figures move in diagonal foreshortening, showing the attraction of Tintoretto's new fame. Here, as later, Veronese collaborated with Zelotti. Similar shock forms are in the *Temptation of St. Anthony* (1552–53; Caen, Fine Arts Museum), one of a set by the young artists in Verona; and in the first Venice project (with Zelotti and Ponchino), the ceiling medallions for the three council chambers of the Doge's Palace (1553–54). His combination of the firmly set figure with intensely bright luminousness is clear here.

Veronese's later development is a constant experiment in retaining the unity of the bodily form while avoiding sculptural weight. He may be considered the quintessence of Venetian painting, the "purest" of the triad that includes Titian and Tintoretto, or a compromise between them. While Titian's interest in the world's color and light refuses to give the body special status, Tintoretto's sense of the figure tends to reduce color to tone to assist in modeling. Veronese avoids Titian's flickering, sketchy continuum (of this late phase) and Tintoretto's shadowiness, to develop color and the figure. Titian's practice has had more effect on modern painting; Veronese's bright forms, usually blond women, have invoked the label "decorative." He avoids tonalism by treating white and gray as colors, by themselves and saturated in blue, gold, and so on, in increasingly flat color lakes, whose translucency creates air. In preserving the figure, he is certainly conditioned by his early Brescian admirations, but through the Brescians descends not from the Lombards like Foppa (who are tonal) but from older Venetians like Cima. He lacks Titian's and Tintoretto's concern for movement and emotion, preferring sensuous, richly textured presentations of rather mild events, so that he is less at home in martyrdoms than in altarpieces and his famous banquets.

Veronese's first long series (1555–56, 1558–60, 1565) was done for the Church of S. Sebastiano. His first work there had been much admired, and led to his painting the ceiling and choir of the main church. (The organ shutters were added in 1570.) Through this series we see his full maturation, from the foreshortened *Coronation of the Virgin*, to the broad, marvelously airy ceilings, to the luxurious yet fresh choir scenes. The commission to seven young artists to paint roundels for the Library ceiling (1556) produced for him the famous prize of a gold medal; he was chosen by Titian. Except for Andrea Schiavone, the competition was not serious.

After a short trip to Rome in 1560, Veronese did the famous frescoes at Maser, his largest villa decoration, in Palladio's recently completed building. Along with allegorical ladies appear the unusual landscapes and the illusionistic perspective columns (both involving specialist assistants) with doors and balconies that frame figures; but the figures are not surprising in perspective movement, illusionistic only in their genre informality. Though much restored, their immediacy is powerful.

In 1562–63 comes the first of the banquets, the huge *Marriage at Cana* (Paris, Louvre), which permits a simple symmetrical composition with formal columns, informal genre figures, and strong, sensuous textures. The sumptuous *Family of Darius before Alexander* (London, National Gallery) is of the same period. Such designs and the smaller portraits (notably in Baltimore, Walters Gallery; Florence, Contini Collection; Rome, Colonna Gallery) meet in the *Cuccina Family Presented to the Virgin* (Dresden, State Art Collections); with its fewer columns and more blue air, it is sometimes called his greatest work. The easy, mild movement of rich figures in atmosphere, with vivid faces and glittering surfaces, appears in its huge, superb mates, the *Adoration of the Magi, Marriage at Cana,* and *Christ Carrying the Cross* (all Dresden, State Art Collections). Similar loosening, in the context of academic allegories of love, appears when we compare those in New York, in the Frick Collection (two), and in the Metropolitan Museum, as well as in London (*Disdain, Respect, Infidelity, Happy Union*), where designs are constructed by moving bodies only.

The banquets retain their columnar symmetry, but the columns lose their emphatic fluting in a series including the *Feast in the House of Levi* (1573; Venice, Academy), which led to the artist's famous appearance before the Inquisition. Attacked for including buffoons and drunkards, he replied that painters by tradition added "ornaments and inventions" of their own in the space left over from the official theme. He was sentenced to make corrections in the painting at his own expense.

The silver-blue *Martyrdom of St. Giustina* (1575; Padua,

S. Giustina), done with his brother, and the flushed-red *Rape of Europa* (1576; Venice, Doge's Palace) contrast with the Crucifixions (Louvre; Venice, S. Lazaro dei Mendicanti), where lonely figures on a dark, heavy sky foretell El Greco. In 1575–77 he painted his great set for the ceiling and end wall of the Sala del Collegio in the Doge's Palace, celebrating the victory of Lepanto in gold and white, with allegorical figures, including the famous *Industry*. Slightly more opaque color, in more complex pattern and brush handling, is seen in the *Annunciation* (ca. 1581; Venice, Academy), the *Rest on the Flight into Egypt* (Ringling Museum), and the large paintings for the Sala del Maggior Consiglio in the Doge's Palace (after 1578), where the work of assistants is conspicuous.

Veronese's late works, along with very many by assistants, include the surprising simplifications of the nocturnal *Christ in the Garden* (Doge's Palace) and *Deposition* (Leningrad, Hermitage). But his chief concern remains clean-washed brightness and brilliant decoration, with surface effects of crystal, silk, and sky.

BIBLIOGRAPHY. R. Pallucchini, *Veronese*, 2d ed., Bergamo, 1943.
CREIGHTON GILBERT

VERONESE SCHOOL. Verona first achieved importance as a center of painting in the late 14th and the early 15th century, when artists such as Pisanello and Stefano da Verona made major contributions to the development of Italian painting in the International Gothic style. These artists were influenced by northern painting. Veronese artists of the late 15th century, including Morone and Liberale da Verona, followed the style of Mantegna. From the beginning to the middle of the 16th century, the Venetian style persisted, as exemplified by Paolo Veronese; then it gave way to influences from Rome, as in Caroto and Torbido. *See* CAROTO, GIOVANNI FRANCESCO; LIBERALE DA VERONA; MORONE, DOMENICO; PISANELLO, ANTONIO; STEFANO DA VERONA; TORBIDO, FRANCESCO; VERONESE, PAOLO.

VERONICA, ST. Legendary woman who possessed the image of the face of Christ on a cloth that was eventually brought to Rome. In various versions of the story the image is said to have been painted by Veronica herself, who then cured the emperor Tiberius with it, or to have been made through direct contact with Christ. According to the most popular version (which first appeared in paintings of the 14th cent.), the image was transferred to the cloth when Veronica wiped the face of Christ while he was carrying the Cross to Calvary. The name may come from the Latin *vera icon* (true image). The image itself is also called a veronica.

See also SAINTS IN ART.

VERONICA MASTER. German painter (fl. Cologne, ca. 1410–20). He is named after the panel in the Old Pinacothek in Munich that depicts *St. Veronica Holding the Miraculous Veil*, one of the most important works of the early Cologne school. His style, in its idealized prettiness, delicate impersonal design, and enamel-like colors, is the epitome of the Cologne school. The Veronica Master was extremely influential on the early development of Stephan

Paolo Veronese, *The Finding of Moses*, 1570–75. Prado, Madrid.

Lochner. Other works attributed to him are the *Madonna with the Pea Blossom* (Nürnberg, German National Museum) and the *Martyrdom of St. Ursula* (Cologne, Wallraf-Richartz Museum).

BIBLIOGRAPHY. A. Stange, *Deutsche Malerei der Gotik*, vol. 3, Berlin, 1938.

VERRE EGLOMISE. Method of decorating glass by painting or applying gold or silver leaf to the back side. It was used particularly in the 17th and 18th centuries for decorating the borders of mirrors with arabesque patterns. Although it had been practiced at least since the medieval period, *verre eglomisé* derived its name from that of the 18th-century art collector Jean-Baptiste Glomy (d. 1786).

VERRIO, ANTONIO. Neapolitan painter (d. 1707). An Agréé of the French Academy, he went to England (probably in 1671) and became court painter in 1684. Little survives of his work at Windsor Castle and Whitehall, but many of his decorations remain in Hampton Court Palace. Verrio's blatantly pretentious late-baroque style achieved success in England because of its novelty. *See* HAMPTON COURT PALACE.

VERROCCHIO, ANDREA DEL. Italian goldsmith, sculptor, and painter (b. Florence, 1435; d. Venice, 1488). The son of a Florentine brick and tile maker, Michele di Francesco Cioni, he adopted the name Verrocchio after his supposed teacher, a goldsmith, Giuliano del Verrocchio. His training and early artistic activity present difficult problems. Vasari's statement that he carved the Madonna above the tomb of Leonardo Bruni (d. 1444) in Sta Croce, Florence, by Bernardo Rossellino, is unacceptable; more likely he assisted Desiderio da Settignano on the tomb of Carlo Marsuppini (d. 1453), also in Sta Croce, as has been lately hypothesized. A terra-cotta relief of the *Resurrection* from the Medici villa at Careggi (Florence, National Museum) may be one of his earliest independent works, though it is regarded by some as late.

Verrocchio's first documented work dates from 1461, when he submitted, in competition with Desiderio da Settignano and Giuliano da Maiano, a model for a chapel of the Madonna della Tavola in the Cathedral at Orvieto (never executed). At some time between 1463 and 1467 he received the commission for the bronze group *Christ and St. Thomas*, in the outside niche at Or San Michele, Florence, left vacant by the removal of Donatello's *St. Louis*. The bronze was weighed in 1470, and the group was installed in 1483. Widely appreciated, it is a masterpiece of harmonious composition, graceful movement, and noble expression. In 1467 he cast a bronze candlestick for the Sala dell'Udienza in the Palazzo Vecchio (Amsterdam, Rijksmuseum). He was commissioned to cast the copper ball for the top of the lantern of Florence Cathedral in 1468; placed in position in 1471, the ball was destroyed by lightning in 1600.

In 1472 Verrocchio completed the tomb of Piero and Giovanni de' Medici, one of the most original creations of the period, in the old sacristy of S. Lorenzo; and in 1473 he acted as assessor for the pulpit of Antonio Rossellino and Mino da Fiesole in Prato Cathedral. The following year he submitted a model for the monument of Cardinal Niccolò Forteguerri (d. 1473) in the Cathedral at

Pistoia. The winner of the competition, Verrocchio did not receive the commission until 1477 and could proceed with the work only after the *Operai* ("works commission"), soliciting also the opinion of Lorenzo the Magnificent, had deliberated further. The monument was completed, and mismanaged, after Verrocchio's death, but the parts carved by him are among the most masterly and refined of his work.

In 1477 Verrocchio received the order for his only known surviving work in precious metal, the relief *The Beheading of the Baptist*, for the silver altar of the Baptistery of Florence (Florence, Cathedral Museum), which he delivered in 1480. In 1479 he appears to have begun work on the bronze equestrian monument of Bartolommeo Colleoni in the Piazza di SS. Giovanni e Paolo, Venice. Executed in Florence, the clay model was shipped to Venice in 1481. Verrocchio died before the casting was begun, and the completion of the monument was entrusted to Alessandro Leopardi.

Among other sculptures by Verrocchio, some of which are mentioned in the sources, are the marble lavabo in the old sacristy of S. Lorenzo, also ascribed to Donatello and to Antonio Rossellino the bronze and marble tomb slab of Cosimo de' Medici in the crypt of S. Lorenzo, probably between 1465 and 1467; the bronze *Putto with a Dolphin*, an early work for the Medici family, now in the courtyard of the Palazzo Vecchio; the bronze *David*, sold by Lorenzo the Magnificent to the Florentine Signoria in 1476, the terra-cotta relief of *The Madonna and Child* from the hospital of S. Maria Nuova, about 1476, and the marble bust *The Woman with the Lovely Hands* of about the same time (all Florence, National Museum); the powerful terra-cotta busts of *Giuliano* and *Lorenzo de' Medici* (late

1470s; Washington, D.C., National Gallery); two full-scale terra-cotta models of angels for the monument of Cardinal Forteguerri (Paris, Louvre); and a marble relief of *Alexander the Great*, carved about 1480 for Matthias Corvinus (New York, Mrs. Herbert N. Straus Collection). A marble relief of a birth and death scene (Florence, National Museum) has been linked uncertainly with the tomb of Francesca Tornabuoni (d. 1477) ordered of Verrocchio for S. Maria sopra Minerva in Rome and destroyed.

Verrocchio was the outstanding Florentine sculptor of the second half of the 15th century and one of the most influential artists of the period. His pupils included such masters as Perugino, Botticelli, and Leonardo. The fame of the last indeed has done much to obscure the true merits of his teacher as an artist. More open in composition, more intricate in detail, and less passionate in spirit than Donatello, Verrocchio belonged to the generation of Florentine artists whose interest lay in the precise knowledge of anatomy and the mechanics of physical movement. But he distinguishes himself from his contemporaries by nobler instincts and a more penetrating insight into the conscious, motivating intellect of his figures. His expression ranged from youthful optimism in the early works, such as the *David* and the *Putto with a Dolphin*, to serenity and composure in the mature works, such as *The Woman with the Lovely Hands*, the *Christ and St. Thomas*, and the Christ and Faith of the Forteguerri monument. In the Colleoni monument he invested the figure with concentrated energy outwardly projected and gave it a magisterial command of the space surrounding it.

BIBLIOGRAPHY. M. Cruttwell, *Verrocchio*, London, 1904; L. Planiscig, *Andrea del Verrocchio*, Vienna, 1941; J. Pope-Hennessy, *Italian Renaissance Sculpture*, London, 1958; C. Seymour, *Sculpture in Italy, 1400–1500*, Baltimore, 1966. DARIO A. COVI

Verrocchio as painter. Verrocchio's career as a painter poses difficult problems of attribution. Only three paintings can be assigned him and these with varying degrees of certainty. The *Baptism of Christ* (ca. 1470–75, perhaps completed by Leonardo ca. 1475–80; Florence, Uffizi) most clearly represents Verrocchio's style. In it are the wiry crisp lines of his metal sculpture and the sculptor's feeling for form. Recent X-rays indicate Leonardo's participation not only in the angels but in the landscape as well. Documentation would seem to suggest that the *Altarpiece of the Madonna di Piazza* in the Cathedral of Pistoia (ca. 1479–86) is his, although it is stylistically much closer to Lorenzo di Credi. A painting in Budapest, *The Madonna Enthroned with Angels and Saints*, conforms to a painting described by Vasari, but some critics believe it to be artistically inferior to similar works attributed to Verrocchio. It is perhaps best to assume that Verrocchio the painter was inferior to Verrocchio the sculptor and that his painting, like some of his sculpture, shows the influence of Pollaiuolo.

Two versions of *Tobias and the Archangel* (Uffizi; London, National Gallery) represent compositions very close to Verrocchio, and serve to indicate his early painting style. Madonnas in Berlin and London are again quite close to Verrocchio and represent his adaptation of a program made popular by Fra Filippo Lippi and Baldovinetti.

BIBLIOGRAPHY. R. van Marle, *The Development of the Italian Schools of Painting*, vol. II, The Hague, 1929; G. Passavant, *Andrea del Verrocchio als Maler*, Düsseldorf, 1960. JOHN R. SPENCER

Andrea del Verrocchio, equestrian statue of Bartolommeo Colleoni. Bronze. Piazza di SS. Giovanni e Paolo, Venice.

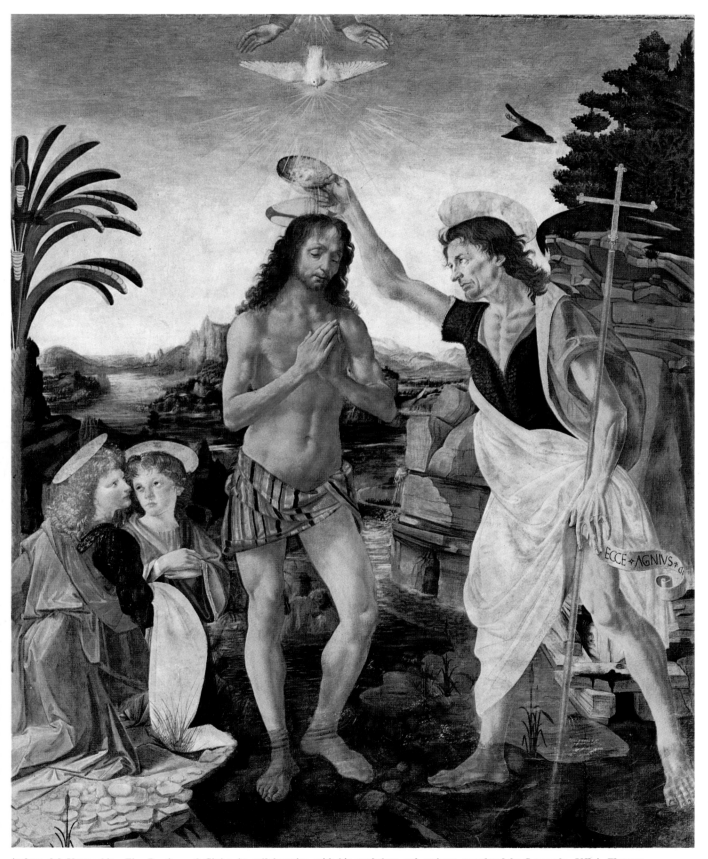

Andrea del Verrocchio, *The Baptism of Christ*, in collaboration with his workshop and perhaps completed by Leonardo. Uffizi, Florence.

VERSAILLES: MUSEUM. French collection. Although the furniture from J.-H. Mansart's great palace was largely dispersed in the Revolution, it has been possible to replace much of it with exact copies. The more permanent furnishings—including the vaulting decorations by Le Brun, A. Coypel, C. de La Fosse, and J.-B. Jouvenet and the sculptures by P. Puget and A. Pajou—have largely survived. The palace now houses a documentary collection illustrating French history, with particular stress on the Napoleonic period. Among the many sculptures in the park are F. Girardon's *Apollo Attended by Nymphs* and a unique group carved by the painter Nicolas Poussin.

BIBLIOGRAPHY. P. de Nolhac, *Histoire du Château de Versailles. Versailles sous Louis XIV*, 2 vols., Paris, 1911; E. Guillou, *Versailles, Le Palais du Soleil*, Paris, 1963.

VERSAILLES: PALACE. French royal residence near Paris. The first royal château in Versailles was a hunting lodge in brick and stone built by Louis XIII in 1624. Parts of the original may be seen in the forecourt, or Cour de Marbre, which has flanking wings enlarged by the architect Louis Le Vau. In the 1660s, however, Louis XIV, having assumed the reins of government for himself and disliking Paris, decided to make Versailles his principal residence. The plans drawn up by Le Vau at first envisaged the destruction of the hunting lodge, but later (1669) it was decided to incase it in a grandiose scheme of Bramantesque type. Ironically, Le Vau's main façade overlooking the gardens was itself subsequently enveloped by J.-H. Mansart's enlargement.

The decoration of the interior set a new standard of magnificence. Of the Louis XIV work the earliest suite to survive is the Grands Appartements of the King and Queen, decorated by a corps of artists under the direction of Charles Le Brun, the artistic "dictator" of the reign. Le Brun's greatest triumph was the famous Hall of Mirrors (begun in 1678) with its allegorical paintings com-

Versailles, Palace. Aerial view showing the grandiose scheme of the royal residence.

memorating the achievements of the Sun King. The style of the latter part of the reign of Louis XIV is represented by J.-H. Mansart's glittering Royal Chapel, which contains decorations by A. Coypel, C. de La Fosse, and J.-B. Jouvenet. Mansart also built a new Orangerie (1681–86), stables (1679–86), and the Grand Trianon (1687), a retreat where the monarch could escape the rigors of court life.

The palace continued to be the royal residence in the following two reigns. Perhaps the finest achievement of this period is J.-A. Gabriel's opera house at the end of the north wing; this was completed in 1770 and restored to its original splendor in the 1950s. Gabriel also planned to rebuild the entranceway, or Cour Royal, but of this scheme only the right-hand wing was executed. First laid out in the 1660s by André Le Nôtre, the gardens were enlarged several times. They focus on a central axis marked by the Grand Canal, on either side of which are groves, statues, and waterworks. Near the Petit Trianon (built by Gabriel in 1763–68) is the picturesque *hameau*, or farm, of Marie Antoinette. The rotunda of the Temple of Love also stands in this area. *See* PETIT TRIANON, VERSAILLES.

See also VERSAILLES: MUSEUM.

BIBLIOGRAPHY. P. de Nolhac, *Histoire du Château de Versailles. Versailles sous Louis XIV*, 2 vols., Paris, 1911; P. de Nolhac, *Histoire du Château de Versailles. Versailles au XVIIIe siècle*, Paris, 1918; C. Mauricheau-Beaupré, *Versailles*, Monaco, 1949; A. Japy, *L'Opéra Royale à Versailles*, Versailles, 1958; G. van der Kemp and J. Levron, *Versailles and the Trianons*, London, 1958; Versailles, Musée national, *Directoire, Consulat, Empire*, Guide officiel [by] G. van der Kemp, Paris, 1958; P. Verlet, *Versailles*, Paris, 1961.

WAYNE DYNES

VERSCHAFFELT, PIETER. Flemish sculptor (b. Ghent, 1710; d. Mannheim, 1793). He was a pupil of Bouchardon in Paris and then spent ten years in Rome. Among the works Verschaffelt executed there was the bronze *Archangel Michael* on the Castel S. Angelo. He next went to work for the elector Charles Theodore at Mannheim (1752). He did not completely break contact with his homeland, however, because he made the monument (1778) for Bishop van der Noot in Ghent Cathedral, portraying the Virgin sitting on a cloud.

VERSCHUIER, LIEVEN (Lieve). Dutch painter of marine landscapes and sculptor (b. Rotterdam, ca. 1630; d. there, 1686). He was the son of the naval sculptor Pieter Cornelisz. Verschuier. Lieven traveled to Italy with Johan van der Meer from Utrecht. About 1652 Lieven was in Amsterdam, where he may have been a pupil of Simon de Vlieger. Lieven worked mainly in Rotterdam.

BIBLIOGRAPHY. F. C. Willis, *Die niederländische Marinemalerei*, Leipzig, 1911.

VERSCHURING, HENDRIK. Dutch painter of landscapes and portraits (b. Gorinchem, 1627; d. Dordrecht, 1690). Dutch sources tell us that he studied drawing with the Gorinchem portrait painter Dirck Govaertsz. At the age of thirteen Verschuring became a pupil of Jan Both at Utrecht, where he remained for six years. Verschuring then went to Italy, where he stayed, with one break, for eight years. In 1657 he was recorded back at Gorinchem; he continued to live there and was a magistrate in that city. He painted Italianizing landscapes with riders and figures.

VERSPRONCK, JOHANNES CORNELISZ. Dutch portrait painter (b. Haarlem, 1597; d. there, 1662). He was the pupil of his father, the portrait painter Cornelis Engelsz. Verspronck, and possibly of Frans Hals. Along with such painters as Bartholomeus van der Helst, Verspronck represents the trend in Dutch portrait painting during its mid-17th-century phase. In such works as *Sea Captain Anthonie Charles de Liedekercke* (1637; Haarlem, Frans Hals Museum) Verspronck comes closest to the style of Frans Hals during the 1630s. For the most part, however, Verspronck lacks the sense of brushwork that one usually associates with Hals. Verspronck is best in his portraits of women and children, and his best-known work, the *Portrait of a Girl in Blue* (1641; Amsterdam, Rijksmuseum), departs completely from any Hals-like sense of brushwork.

BIBLIOGRAPHY. S. Kalff, "Een haarlemsch Portretschilder uit de gouden Eeuw," *De Nieuwe Gids*, XXXIV, 1918; J. Rosenberg, S. Slive, and E. H. ter Kuile, *Dutch Art and Architecture, 1600–1800*, Baltimore, 1966.

VERSTRALEN, ANTHONIE. Dutch landscape painter (b. Gorinchem, 1593/94; d. Amsterdam, 1641). Verstralen was married in Amsterdam in 1628 and gave his age at that time as thirty-four. Considerable confusion about this painter resulted from the reading of the date on a *Winter Landscape* (The Hague, Mauritshuis Art Gallery; signed with the monogram AVS) as 1603. The actual date on the painting has since appeared to be 1623, thus eliminating the possibility of two painters with the same name and similar styles. Verstralen seems to have specialized in winter landscapes in the manner of Avercamp.

VERTANGEN, DANIEL. Dutch painter of landscape and mythology (b. The Hague, ca. 1598 [or 1606?]; d. there, before 1684). He was a pupil and follower of Cornelis van Poelenburgh. In 1658 Vertangen traveled to Denmark. He was recorded in Amsterdam in 1673 and 1681. He is possibly identical with the merchant (*koopman*) of the same name reported in Amsterdam in 1641. He was said to have been forty-nine years old in 1655.

BIBLIOGRAPHY. W. Bernt, *Die niederländischen Maler des 17. Jahrhunderts . . .*, vol. 3, Munich, 1948.

VERTES, MARCEL. French painter and graphic artist (1895–). Vertès, who was born in Ujpest, Hungary, followed his youthful experience in drawing with studies at the Budapest Academy of Fine Arts. After serving in World War I, he made political posters concerned with the drive for Hungarian independence. In 1920 his studies continued at the Académie Julian and with Jean-Paul Laurens in Paris. Throughout his career Vertès has been extremely successful as a book and magazine illustrator, commercial artist, stage designer, and muralist, working out of Paris and New York. For many years he contributed to and, in a sense, set the style of such American magazines as *Vogue*, *Harper's Bazaar*, and *Vanity Fair*. His murals adorn the Waldorf-Astoria, Plaza, and Carlyle hotels in New York City. All his work, which depends on Dufyesque line and gay colors, has great verve in both subject matter and style.

BIBLIOGRAPHY. C. Roger-Marx, *Vertès, un et divers; étude*, Paris, 1961.

VERTUE, ROBERT AND WILLIAM. English architects: Robert (d. 1506) and William (d. 1527), his brother. Both designed Bath Abbey church from 1501, and Robert at the same time seems to have designed a related work, Henry VII's Chapel at Westminster. Robert also worked at Canterbury on the bell tower of St. Augustine's, when John Wastell was erecting the Bell Harry.

William erected the vaulting of St. George's Chapel at Windsor Castle (1500–11), and for a time both brothers may have been associated there (1502–03). William probably also continued the work at Westminster after Robert's death. He designed Corpus Christi at Oxford (1512) and the great domestic works at Thornbury Castle (1511). The Vertue style was really the apotheosis of a great period in English architecture, the Perpendicular, and the elaboration of the fan vault is perhaps its leitmotif. *See* ST. GEORGE'S CHAPEL, WINDSOR CASTLE; WESTMINSTER ABBEY, LONDON.

BIBLIOGRAPHY. J. H. Harvey, comp., *English Mediaeval Architects*, London, 1954.

VERVOORT, MICHEL. Flemish sculptor (b. Antwerp, 1667; d. there, 1737). He studied under Henri Cosyns and became a master of the Antwerp guild in 1690. In a vast oeuvre of primarily religious works, Vervoort's style ranges from the restrained, almost tableaulike quality of the monument of Bishop de Precipiano (1709) in Mechlin Cathedral to the theatrical baroque of the pulpit (1721–23) in the Mechlin Cathedral.

VERWILT, FRANCOIS. Dutch painter of portraits, genre, and history (b. Rotterdam, ca. 1615; d. there, 1691). He was a pupil of Cornelis van Poelenburgh in Utrecht. About 1643 Verwilt was living in Middelburg. He was also active in Rotterdam. In 1661 he was a member of the Middelburg guild.

BIBLIOGRAPHY. W. Bernt, *Die niederländischen Maler des 17. Jahrhunderts . . .*, vol. 3, Munich, 1948.

VESICA PISCIS, *see* MANDORLA.

VESPASIAN, FORUM OF, ROME, *see* FORUM PACIS, ROME.

VESPASIAN, TEMPLE OF, ROME. Roman temple begun by the emperor Titus (79–81), completed by Domitian (81–96), and dedicated to the deified Vespasian. It was prostyle and hexastyle, raised on a podium, and lined with marble slabs. The temple, famous for the overelaborate decoration of its entablature (fragments preserved in the Tabularium), was a typical example of the Flavian style of the period. Three beautiful Corinthian columns still stand.

BIBLIOGRAPHY. S. B. Platner, *The Topography and Monuments of Ancient Rome*, Boston, 1904.

VESPIGNANI, RENZO. Italian painter and graphic artist (1924–). He was born in Rome. Although largely self-taught, he was tutored in the graphic arts by Franco Gentilini and Bianchi Barriviera. Vespignani's earliest works are understated and moving views of war-torn Rome. He is a master of the etched line, which he weaves into delicate space-, atmosphere-, and structure-creating webs. In addition to paintings, etchings, and other graphic works,

he has created illustrations for the *Decameron* and for books by modern Italian authors, titles for movies, and stage sets for plays by Brecht and others.

VESTA, TEMPLE OF, TIVOLI, *see* SIBYL, TEMPLE OF THE, TIVOLI.

VESTALS, HOUSE OF THE, ROME. Residence of the six priestesses of the goddess Vesta, situated in the Roman Forum. The vestals constituted the only group of female priestesses in Rome. Their house, the oldest in Rome, was reconstructed by Nero after the fire of A.D. 64. It was restored first by Domitian, later by Trajan, and finally by Septimius Severus. The house contained an immense atrium (180 by 48 ft.) surrounded by a peristyle of columns in two stories, giving access to a large number of rooms on three sides; the tablinum was covered with a barrel vault. On either side of the tablinum were three rooms assumed to have been the private rooms of the six vestals. The baths, kitchen, and stairs occupied the farther corner of the site. Many of the rooms contained baths. The walls and the floors of the rooms had marble revetments. A large portion of the upper story of the house still exists on the side of the Palatine hill. The house was abandoned in A.D. 364; shortly thereafter it was dedicated to Christ.

BIBLIOGRAPHY. W. J. Anderson, R. P. Spiers, and T. Ashby, *The Architecture of Greece and Rome*, vol. 2: *The Architecture of Ancient Rome*, London, 1927; G. Lugli, *Roma antica: Il centro monumentale*, Rome, 1946.

VESTIER, ANTOINE. French portrait painter in oils, enamel, and miniature (b. Avallon, 1740; d. Paris, 1824). He was in England (ca. 1776) and studied with M. W. Peters. Vestier then went to Holland. In 1784 he settled in Paris. In 1786 he became an academician, and from 1782 to 1806 he exhibited in the Salon. He married the daughter of the master enamelist A. Revérend. Like A.-C. Roslin, he excelled in the rendering of materials, best seen in the portraits of women (*The Artist's Wife* and *The Artist's Daughter*, 1787; both Paris, Louvre), which he imbued with sentimental grace in the English manner. Though he is a fine draftsman, his color is cold, and his touch, habituated to miniature scale, is overly dry, even in full-scale paintings in oil.

VETTERSFELDE GOLD FIND. Hoard of Scythian antiquities, dated about 500 B.C., found near Vettersfelde, Prussia, in 1882. It includes fragments of a large jar and the complete equipment of a Scythian chief, including the center ornament of his shield, a gold breastplate, a dagger handle, a knife sheath with the remains of an iron blade, a gold-plate cover for the sheath, and assorted jewelry and fragments. The breastplate, in the form of four roundels, and the dagger sheath are decorated with animals and fish in relief. Also found was the image of a fish made in gold repoussé and decorated with smaller birds, fish, and animals in relief; it is thought to have been the centerpiece of the chieftain's shield. All the objects except the breastplate resemble objects excavated from Scythian burials in southern Russia. At the same time they show the influence of Ionian work of the late archaic period.

BIBLIOGRAPHY. A. Furtwängler, *Der Goldfund von Vettersfelde*, Berlin, 1883; E. H. Minns, *Scythians and Greeks*, Cambridge, Eng., 1913.

House of the Vettii, Pompeii. The peristyle.

VETTII, HOUSE OF THE, POMPEII. Roman house of the 1st century of our era. The house contains a vestibule, two atria (a principal atrium and a smaller side atrium), and a peristyle. The living quarters surrounded the two atria and were placed near the front of the house. A stairway led to a second story. The peristyle contained fountain basins and statuettes. The house is remarkable for its wall paintings, which are of the fourth Pompeian style. The paintings fall into two groups, an earlier group, of superior quality, executed before the earthquake of A.D. 63, and a later group executed between 63 and 79. Noteworthy among the wall paintings are panels with representations of Cupids and Psyches performing various playful tasks.

BIBLIOGRAPHY. A. Mau, *Pompeii: Its Life and Art*, New York, 1899; L. Curtius, *Die Wandmalerei Pompejis*, Leipzig, 1929.

VEYNAU BEI EUSKIRCHEN CASTLE. Picturesque German *Wasserburg* (water castle) dating from the 14th and 15th centuries. It consists of a *Herrenhaus* (manor house) surrounded by fortified walls with round and square towers at the corners.

VEZELAY: CHURCH OF LA MADELEINE. Abbey church, situated in north central France. One of the most famous French Romanesque monuments, it is the church of an abbey established in the middle of the 9th century by Girart of Roussillon. The presence of relics of St. Mary Magdalen made it a favored place of pilgrimage. Vézelay was the starting point of one of the four routes to Compostela.

The original Carolingian church having become too small for the great numbers of visitors, the present church was built between 1096 and 1104. To accommodate still more pilgrims, the narthex was added about 1120, with a precocious employment of an ogival structure that is characteristic of the Romanesque architecture of Burgundy. Art historians believe that the ogive-vaulted bay in the narthex and the choir built at the end of the Romanesque nave (after 1161) are among the first evidences of Gothic art. The earliest example in France of a groined vault applied

to a nave also appears here, as the nave was revaulted after a fire in 1120.

The tympanum of the central portal of the narthex has been called one of the greatest masterpieces of medieval relief sculpture and has been the subject of numerous iconographic studies. It has been found that the sculptures represent a planned and complex development of remarkable clarity. The two subjects are the Ascension of Christ and the Mission of the Apostles, interwoven in the tympanum.

The beauty of the rosy stone, the vast nave flooded with light from windows reaching to the very summit of the vaulting, and the simplicity and clearness of the organization, joined with the varied and interesting capitals, endow this church with one of the most ingratiating Romanesque interiors. Aside from the fine Romanesque tower over the south transept, little remains of the old exterior.

The great Cistercian abbey, under the sway of Cluny from the 11th century, began a long period of decline after relics of St. Mary Magdalen found at the Abbey of St-Maximin in Provence in 1279 cast doubt on the authenticity of those in Vézelay. The final blow came in 1569, when the church was sacked by Huguenots and the relics were dispersed. Restoration was undertaken by Viollet-le-Duc (1840–59).

BIBLIOGRAPHY. A. Katzenellenbogen, "The Central Tympanum at Vézelay," *The Art Bulletin*, XXVI, 1944; F. Salet and J. Adhémar, *La Madeleine de Vézelay*, Melun, 1948; K. J. Conant, *Carolingian and Romanesque Architecture, 800–1200*, Baltimore, 1959.

MADLYN KAHR

Vézelay, Church of La Madeleine. The nave of this Romanesque monument.

VIA APPIA (Appian Way). The most important of the consular roads of the Roman Empire. It was constructed by the censor Appius Claudius Caecus in 312 B.C. as far as Capua; about 190 B.C. it was extended to Brindisi. The part of the Via Appia leading out of Rome is lined with the ruins of sepulchral monuments; the most imposing is the tomb of Cecilia Metella. The Catacombs of St. Calixtus and of St. Sebastian are on the Via Appia. Some of the original paving of polygonal stones of basalt can still be seen on the road. *See* CALIXTUS CATACOMB, ROME; CECILIA METELLA, TOMB OF, ROME.

BIBLIOGRAPHY. F. Castagnoli, *Appia Antica*, Milan, 1957.

VIA DOLOROSA. Route in Jerusalem along which pilgrims were led, supposed to have been the same one that Christ took on His way from the house of Pilate to Calvary. The Via Dolorosa is marked by fourteen Stations of the Cross; originally there were only seven. The original stations became the models for countless Stations of the Cross erected throughout Europe in the late Middle Ages.

VIANEN, ADAM VAN. Dutch goldsmith (b. Utrecht, ca. 1565; d. there, 1627). He was the brother of Paulus I van Vianen. Adam worked in Utrecht and developed the variety of ornament with flayed anatomical associations (*Kwabornament*) invented by Paulus. Adam used it in an exaggerated form together with embossed, three-dimensional figures on silver and gilded-silver hollow ware, for example, a tazza (1618; Amsterdam, Rijksmuseum) and a sauceboat (1621; New York, Metropolitan Museum).

BIBLIOGRAPHY. J. W. Frederiks, *Dutch Silver from the Renaissance until the End of the Eighteenth Century*, vols. 1, 4, The Hague, 1952–61.

VIANEN, PAULUS I VAN. Dutch goldsmith, medalist, and metalworker (b. Utrecht, ca. 1565/70; d. Prague, 1613/14). He was the son and pupil of Willem van Vianen and the brother of Adam van Vianen. Paulus I was appointed court goldsmith to Rudolph II in Prague (1603). He made mannerist medals, plaquettes, and hollow ware, and introduced (ca. 1600) a new variety of ornament with flayed anatomical associations called *Kwabornament*, which dominated Dutch ornament throughout the first half of the 17th century. The legend of Diana and Actaeon is depicted on a silver plate (1613; Amsterdam, Rijksmuseum).

BIBLIOGRAPHY. J. W. Frederiks, *Dutch Silver from the Renaissance until the End of the Eighteenth Century*, vols. 1, 4, The Hague, 1952–61.

VIANI, ALBERTO. Italian sculptor (1906–). Born in Quistello, he now lives in Venice. He studied at the Venice Academy and was an assistant to Arturo Martini from 1944 to 1947. A member of the postwar Fronte Nuovo delle Arti, Viani is presently working in the tradition of Arp, using abstract but organic forms primarily in the medium of stone.

BIBLIOGRAPHY. A. C. Ritchie, *Sculpture of the 20th Century*, New York, 1952.

VICENTINO, IL, *see* GRANDI, VICENZO; MICHIELI, ANDREA.

VICENZA. Town in the Veneto, in northeastern Italy. As Vicentia the settlement attained the rank of a Roman municipium, but Vicenza's true period of prosperity began

with its incorporation into the Venetian Republic in 1405. In the 16th century Palladio made Vicenza a showcase of Renaissance architecture that is unrivaled in northern Italy.

The vestiges of the Roman period include parts of a theater, cryptoporticus, bridge, and aqueduct. Of about one hundred house towers of the 11th to 13th century, only the Torre di Piazza and the Torre del Girone remain. The sack of Vicenza by Emperor Frederick II in 1236 destroyed much of the old building. The Gothic architecture of the mendicant orders is represented by the churches of the Dominicans (S. Corona, 1260), Franciscans (S. Lorenzo, 1280–1344), and Servites (1407–90). The Cathedral, built in various campaigns in the 14th to 16th century, documents the transition from the Gothic (façade) to the Renaissance (apse); within are paintings by Lorenzo Veneziano and Bartolommeo Montagna.

Palladio's most impressive realization was his rebuilding of the Palazzo della Ragione (also known as the Basilica), in which he enveloped the medieval town hall in a sumptuous fabric consisting of a two-story application of the famous "Palladian motif" (begun in 1549). Nearby is the picturesque Loggia del Capitanio, a late work of Palladio (begun 1571). The Porto-Colleoni and Thiene palaces represent Palladio's efforts to revitalize the ancient Roman house plan. His Chiericati Palace (begun 1557), which now houses the Municipal Museum, is notable for its festive and harmonious façade. His Teatro Olimpico (begun 1580) preserves the original permanent stage settings. Palladio's follower Scamozzi, who was responsible for completing many of the master's projects, built the Palazzo del Comune (begun 1592). In the neighborhood of Vicenza is Palladio's famous Villa Rotondà (begun 1550), which represents the unprecedented introduction of a central dome into secular architecture. The Villa Valmarana contains remarkable frescoes by Tiepolo (1737). *See* CHIERICATI PALACE; ROTONDA, VILLA; TEATRO OLIMPICO; VICENZA: MUNICIPAL MUSEUM.

See also SS. FELICE E FORTUNATO.

BIBLIOGRAPHY. F. Barbieri et al., *Guida di Vicenza*, 2d ed., Vicenza, 1956; Italy, Direzione generale delle antichità e belle arti, *Catalogo di cose d'arte e di antichità d'Italia*, vol. 1: *Vicenza, Le Chiese*, Rome, 1956. WAYNE DYNES

VICENZA: MUNICIPAL MUSEUM. Italian collection located in Palladio's evocative Chiericati Palace (begun 1557). Is is important for its paintings by northern Italian masters. The Venetian school predominates, with work by such artists as Veronese, Lotto, Tintoretto, Jacopo Bassano, Tiepolo, and Piazzetta. There are also paintings by the Flemings Memling and Van Dyck.

BIBLIOGRAPHY. W. Arslan, *La Pinacoteca Civica di Vicenza*, Rome, 1946.

VICES. The struggle between the personified Virtues and Vices was a common subject in medieval art. Unlike the Virtues, who were specifically named and were seven in number, the Vices appeared in varying numbers and types, some personified as men, others as women. *See* PSYCHOMACHIA.

BIBLIOGRAPHY. A. Katzenellenbogen, *Allegories of the Virtues and Vices in Medieval Art...*, New York, 1964.

VICH: EPISCOPAL ARCHAEOLOGICAL MUSEUM. Spanish collection. The museum of the Vich bishopric

Victory of Samothrace. A masterpiece of Hellenistic art. Louvre, Paris.

contains a rich variety of medieval ecclesiastical art, including sculpture (numerous Madonnas and the touching *Descent of the Cross* group from Erill la Vall), Romanesque wall paintings, altarpieces, and metalwork.

BIBLIOGRAPHY. J. Gudiol y Cunill, *El Museu Episcopal de Vich*, Vich, 1918.

VICKREY, ROBERT. American painter (1926–). Born in New York City, he studied at Yale and at the Art Students League with Reginald Marsh and Kenneth Hayes Miller. Vickrey does detailed and eerie tempera paintings of figures, sometimes nuns, as in *The Labyrinth* (1951; New York, Whitney Museum).

BIBLIOGRAPHY. Whitney Museum of American Art, *The New Decade*, ed. J. I. H. Baur, New York, 1955.

VICQ, CHURCH OF. The Romanesque frescoes of St-Martin-de-Vicq in Vicq, France, were discovered in 1849 and largely saved through the efforts of George Sand, who lived at nearby Nohant. The frescoes cover both sides of the arched wall, which divides the nave from the choir, while the choir and apse are also completely painted. The style of the paintings is perhaps rather crude, even ugly, yet it is bold, picturesque, and clear in telling stories. They have been called "paintings created by a peasant for peasants." Here is vitality without religious programming, lacking in intellectual mysticism and occult symbolism. Painted almost entirely in browns and reds, the scenes deal with St. Martin, patron saint of the church; the life of Christ; the story of Lazarus; and a quite remarkable crucifixion of St. Peter.

BIBLIOGRAPHY. R. de la Moussaye, *Petit guide des fresques romanes de France*, Paris, 1956.

VICTOORS, JAN, *see* VICTORS, JOHANNES.

VICTOR, JACOMO (Jacobus). Dutch painter of still life (b. Amsterdam, 1640; d. there, 1705). Victor was active in Venice about 1663. He was recorded in Amsterdam in 1670 and was still there in 1678. He was not active as a painter after 1675. Johannes Victors was his stepbrother.

BIBLIOGRAPHY. W. Martin, *De Hollandsche schilderkunst in de zeventiende eeuw*, vol. 2, Amsterdam, 1936.

VICTORIA AND ALBERT MUSEUM, LONDON, *see* LONDON: MUSEUMS (VICTORIA AND ALBERT).

VICTORICA, MIGUEL CARLOS. Argentine painter (b. Buenos Aires, 1884; d. there, 1955). Victorica, a postimpressionist, studied in Buenos Aires and Paris. The nude *La supersticiosa* (1923; Buenos Aires, National Museum of Fine Arts) is typical. Nudes, interiors, still lifes, and landscapes are his themes.

BIBLIOGRAPHY. M. Mujica Láinez, *Miguel Carlos Victorica*, Buenos Aires, 1954.

VICTORIJNS, ANTHONI. Flemish painter (d. Antwerp, 1655/56). He was a freemaster of the Antwerp Guild of St. Luke in 1640/41. The artist worked in the so-called Dutch manner and is especially known for his copies after early paintings by Adriaen van Ostade, although he also imitated Adriaen Brouwer, David Teniers the Younger, and David Ryckaert III.

BIBLIOGRAPHY. K. Freise, "A. Victoryns, Ein Beitrag zur Ostadeforschung," *Monatshefte für Kunstwissenschaft*, III, 1910.

VICTOR OF MARSEILLES, ST. Roman soldier beheaded under Maximian. After confessing his faith before the Emperor, he was beaten and dragged off to jail; three of his guards were converted. When led before a statue of Jupiter, he kicked it to ground, and his foot was ordered cut off. Later he was crushed between millstones and decapitated. Often shown on horseback, he wears Roman or medieval armor. His attributes are a lance, shield, millstone, and small windmill. His feast is July 21.

See also SAINTS IN ART.

VICTORS, JOHANNES (Jan Victoors). Dutch painter of portraits, history, and genre (b. Amsterdam, 1619/20; d. Dutch East Indies? 1676). He was probably a pupil of Rembrandt in Amsterdam before 1640. Victors was married in Amsterdam in 1642 and was last reported there in January, 1676; later that year he left for the Dutch East Indies and apparently died either there or en route. Until the mid-1650s he painted mostly religious subjects and portraits that are strongly influenced by Rembrandt's style. After 1650 he produced genre scenes in a somewhat more original manner.

BIBLIOGRAPHY. C. Hofstede de Groot, "The Author of a So-called Rembrandt," *The Burlington Magazine*, XLVII, 1925.

VICTORY (Nike) OF SAMOTHRACE. Hellenistic statue in the Louvre Museum, Paris. The statue of Nike, of Parian marble, a famous masterpiece of Hellenistic art, was discovered on the island of Samothrace. The figure originally had stood on a ship's prow in the Nike Precinct. Victory is represented as alighting with outspread wings after a flight. The head and arms are missing. The effect is one of violent movement. The statue has been ascribed to Pythokritos of Rhodes (early 2d cent. B.C.). This connection is established by the similarity of the letters of two inscriptions, one found with the base of the statue and the other from Rhodes signed by Pythokritos. Originally the statue was dated to about 300 B.C. because of its resemblance to a Nike figure on coins of Demetrius I Poliorcetes, victorious at Salamis, Cyprus, in 306 B.C.

BIBLIOGRAPHY. E. A. Gardner, *A Handbook of Greek Sculpture*, 2d ed., London, 1915; M. Bieber, *The Sculpture of the Hellenistic Age*, New York, 1955.

VIEIRA DA SILVA, MARIA-HELENA. French abstract painter (1908–). Born in Lisbon, she studied sculpture under Bourdelle and Despiau and attended the studios of Dufresne, Friesz, and Léger and William Hayter's "Atelier 17." She traveled extensively in Europe, remained in Brazil during World War II, and in 1947 returned to Paris, where she has been living ever since. Beginning with colored spots on a neutral background, she soon developed a personal style through dimensionless space. The painting of 1953 in the Guggenheim Museum, New York, is an excellent example of her infinite labyrinths and collapsing perspectives. In 1961 Vieira da Silva was awarded the Painting Prize at the São Paulo Bienal. Her work appears in various cities, including Paris (National Museum of Modern Art), London (Tate), and Amsterdam (Stedelijk).

BIBLIOGRAPHY. R. de Solier, *Vieira da Silva*, Paris, 1958; A. Michelson, "Vieira da Silva," *Arts Yearbook*, III, New York, 1959; G. Weelen, *Vieira da Silva*, Paris, 1960.

VIEN, JOSEPH-MARIE. French painter of historical, religious, mythological, and allegorical subjects and portraits; decorator and engraver (b. Montpellier, 1716; d. Paris,

Maria-Helena Vieira da Silva, *The Town*, 1953. Solomon R. Guggenheim Museum, New York.

1809). He was the pupil of a local engraver, Legrand, and then became a pupil-collaborator of Giral, a painter-architect, and a disciple of Charles de La Fosse. Vien went to Paris in 1741 and studied under Charles Joseph Natoire and Charles Parrocel. After winning the Royal Academy's Grand Prix (1743), he went to Rome (1744–50). He was a pensioner at the French Academy in Rome under the directorship of Jean-François de Troy, painting for churches and designing costumes for the Carnival (*The Sultan's Caravan to Mecca*, 32 plates engraved after his own designs, 1748).

He was probably acquainted with the classicizing Anton Mengs at that time, when all of Europe was excited by the excavations at Herculaneum. The neoclassicistic ideas of H. Winckelmann (published 1755 and 1764) and the enthusiasm of his protector, the Comte de Caylus, an amateur archaeologist, combined to fire Vien's interest in the antique and to found in him principles which, through his pupil Jacques-Louis David, would revolutionize the French school. He was offered a professorship at the Roman Academy of St. Luke and was invited to work at foreign courts. Nevertheless, on his return to Paris in 1750, the Royal Academy, annoyed by this insurgent classicism, found his work deficient until he wisely reverted to the accepted late *style rocaille* (French version of the rococo style). He subsequently decorated the Châteaux of Crécy and Pompadour, and the Hôtel de Lambert. He also experimented with methods of painting in wax. From the moment of this compromise, his academic career as a teacher evolved spectacularly.

He became rector of the Royal Academy (1781), chancellor (1785), First Painter to the King, and director of the Gobelins manufactory and of the Academy (1789). On the eve of the French Revolution, he recommended reform of the Academy's statutes, aiding his later prestige under the Republic and the Empire. He was made a member of the Institut (1796), a member of the Senate and commander of the newly founded Légion d'Honneur (1800), and count of the Empire (1808), and was accorded official burial at the Panthéon.

Though Vien's success is partially due to teaching ability, good fortune favored him in that he produced a pupil as influential as David. He was hailed as the regenerator of French art, while in truth his works rarely display a marked deviation from the pretty manner of François Boucher. At the Salon of 1763 he exhibited *The Vendor of Love* (Fontainebleau Palace). It was simply composed in the vein of classical relief sculpture and adapted from a fresco found at Herculaneum, and it anticipated the composition of David's *Death of Socrates*. The general opinion of his transitional role was that it resuscitated Poussinist principles. *See* RUBENISTS.

BIBLIOGRAPHY. F. Aubert, "Joseph-Marie Vien," *Gazette des Beaux-Arts*, 1st series, XXII, 1867 and XXIII, 1867; L. Hautecoeur, *Rome et la renaissance de l'antiquité à la fin du XVIIIe siècle*, Paris, 1912.

GEORGE V. GALLENKAMP

VIENNA (Wien). Capital of Austria, on the Danube River. Historically, the capital of the Holy Roman and Austro-Hungarian empires, Vienna acquired international standing as a center of art and architecture during the baroque period (17th–18th cent.) and at the turn of the 20th century. Under the name of Vindobona, the city originated as a fortified Roman camp that was established to protect the town of Carnuntum. From the Roman phase survive fragments of two gates, the Porta Decumana and the Porta Sinistra, and part of the wall. In the Middle Ages Vienna is first mentioned in 881; it received civic privileges under the Holy Roman Empire in 1221. From 1276 until 1918 the city's fortunes were closely bound up with the reigning house of Hapsburg. The renowned university goes back to 1365.

In the center of the city, the Gothic Cathedral of St. Stephen represents the main achievement of the Middle Ages. The central part of the west façade with the two flanking towers survives from a late Romanesque building of the mid-13th century. The new hall choir with its staggered apses dates from 1304 to 1340. The main limb of the church, which was built in the course of the following 100 years, is in the late Gothic style. The many-storied south tower (ca. 1359–1433) has become celebrated as the symbol of Vienna. Among the interior furnishings is the dynamically carved pulpit by Anton Pilgram (ca. 1510) in open stonework with various statues. The narrow Church of St. Maria am Gestade (1330–1444) is a jewel of Gothic architecture; the choir displays late Gothic stained-glass windows (ca. 1436). Out of a number of medieval churches of the mendicant orders only two have survived largely intact, the Minoritenkirche, a vast hall (1339 and after) with interesting façade sculptures, and the austere Augustinerkirche (14th cent.). Within the latter church is Antonio Canova's funerary monument for the archduchess Maria Christina (1805). *See* ST. STEPHEN'S CATHEDRAL.

The portal of the Salvatorkapelle, richly carved in Lombard fashion about 1520, is one of the rare monuments of the Renaissance in Vienna. After a long period of stagnation, art and architecture began to pick up near the end of the Thirty Years' War, when Christoph Gumpp's Mariahilferkirche (1647) set the fashion for oval-plan interiors. The façade of the Jesuit Church of the Nine Angelic Choirs by G. A. Carlone (1662) was the first church front in the style of the Roman baroque. More restrained are the façades of such secular building as the Leopold wings of the Hofburg or Imperial Palace (1661–68; by F. Luchese) and the Starhemberg Palace (1661). These works set the stage for the zenith of the Viennese baroque, which began after the repulse of the Turkish siege in 1683. *See* HOFBURG.

This period was illuminated by two great architects, Johann Bernard Fischer von Erlach (1656–1713) and Johann Lukas von Hildebrandt (1668–1745). Fischer's style is more grandiose and courtly, Hildebrandt's more lively and intimate. Fischer was appointed court architect in 1704; his Viennese masterpiece, the Karlskirche (begun in 1716), is a domed central-plan building with a broad façade framed by two tall historiated columns. The formal richness and variety of this building are the fruit of Fischer's many-sided historical interests. Among his secular structures are the façade and staircase of the Winter Palace of Prince Eugene (1695–96; now the Ministry of Finance), the Batthány Palace (1699–1706), the Trautson Palace, and the great library of the Imperial Palace (begun in 1723 and finished by his son, Joseph Emanuel). Hilde-

brandt, who was influenced by the highly imaginative styles of Guarini and Borromini, built the two splendid belvedere structures for Prince Eugene of Savoy and laid out the gardens connecting them. The brilliance of his work appears in its most concentrated form in the staircase of the Daun-Kinsky Palace (1713–16).

During the baroque period Vienna was embellished with a number of imposing monuments. The Pestsäule, erected by a number of artists between 1682 and 1694, commemorates the ending of the terrible plague of 1679. The Four Rivers Fountain (1737–39) in the Mehlmarkt (Neuermarkt) is the masterpiece of the Austrian sculptor Georg Raphael Donner.

An early version of the neoclassic style appeared in Vienna with the Academy of Science and Letters by J. N. Jadot de Ville-Issey (1753). The chief project of 18th-century Vienna, however, was the building of Schönbrunn, the Austrian Versailles, by Nikolaus Paccassi and Ferdinand von Hohenberg. The latter's gloriette, a picturesque group of linked arches crowning the hill there, was built in 1775. See SCHONBRUNN CASTLE.

In response to the enormous expansion of commerce and trade Vienna became one of Europe's fastest growing cities in the 19th century. The fortifications surrounding the Inner City were pulled down in the middle of the century and replaced by a stately boulevard, the Ring, which was gradually lined with vast public buildings in varied, and not always concordant, styles. These include the Neo-Gothic Votivkirche, the opera house, the town hall, the symmetrical museum buildings by G. Semper and K. von Hasenauer, and the new university. Another civic improvement project was the underground railway (Stadtbahn), with stations by Otto Wagner (1894–97). This architect is more famous for his Post Office Savings Bank (1904–06), a landmark of functional architecture. The radical architectural theorist Adolf Loos built an office building in the Michaelerplatz (1910) and a number of houses in Vienna and its environs. Two other important architects of this period are Joseph Maria Olbrich (Sezession Building, 1897–98) and Joseph Hoffmann, a leading exponent of the Jugendstil, or Art Nouveau.

See also BURG THEATER; VIENNA: MUSEUMS; VIENNA PORCELAIN.

BIBLIOGRAPHY. Austria, Bundesministerium für Unterricht, *Osterreichische Kunsttopographie*, ed. by H. Tietze et al., Vienna, vol. 2, 1908; vol. 14, 1914; vol. 15, 1916; vol. 23, 1931; J. Schmidt, *Wien*, Vienna, 1938; R. K. Donin, ed., *Geschichte der bildenden Kunst in Wien*, vol. 1– , Vienna, 1944– ; F. H. Ottmann, *Barockes Wien in Bildern*, Vienna, 1948; R. K. Donin, *Der Wiener Stephansdom und seine Geschichte*, 2d ed., Vienna, 1952; J. Schmidt and H. Tietze, *Wien*, 3d ed., Vienna, 1954; R. Wagner-Rieger, *Das Wiener Bürgerhaus des Barock und Klassizismus*, Vienna, 1957; K. Schwanzer, ed., *Wiener Bauten, 1900 bis heute*, Vienna, 1964.

WAYNE DYNES

VIENNA: MUSEUMS.

Important public art collections in Vienna, Austria, are located in the museums listed below.

Academy of Fine Arts (Akademie der Bildenden Kunste). Founded in 1692, the Vienna Academy now occupies a building designed in 1872–77 by Théophil von Hansen. Its art gallery exhibits European paintings dating from the 15th to the 18th century. The major works are Giovanni di Paolo's *Miracle of St. Nicholas of Tolentino*, Dirk Bouts's *Coronation of the Virgin*, Bosch's *Last Judgment Altarpiece*, Baldung-Grien's *Rest on the Flight into Egypt*, several paintings by Cranach, Titian's *Tarquinius and Lucretia*, paintings and sketches by Rubens, landscapes by Ruisdael, a *Self-Portrait* by Barent Fabritius, Magnasco's *Raising of the Cross*, and several views of Venice by Francesco Guardi.

BIBLIOGRAPHY. Akademie der bildenden Künste, *Katalog der Gemälde Galerie*, Vienna, 1961.

Albertina. The world's largest and most representative collection of European drawings and prints is still housed in its original quarters in the Hofburg, a palace designed by Moreau in 1804 for Albert Kasimir of Saxony, Duke of Saxe-Teschen (1738–1822). The collection was formed by the Duke, who, during his travels through Europe, acquired more than 15,000 drawings and 116,000 prints. Many of these were bought in Paris from the famous collector Mariette, who specialized in Italian Renaissance, 17th-century Dutch and Flemish, and 18th-century French works. The incorporation of the imperial collection, with its fine group of Dürers, and subsequent acquisitions made by the successive archdukes Charles, Albert, and Frederick during the 19th century, expanded the collections until the takeover by the state in 1918. Today the Albertina has about 40,000 drawings and one million prints.

The balance and scope of the collection is such that most of the great masters, and many of the lesser masters, of Italian, German, French, Flemish, Dutch, Spanish, and English art, from the 15th to the 20th century, are represented. To list all of them would be superfluous, although some of the outstanding individual works should be cited. Rare drawings by Michelino da Besozzo, Ghiberti, and Fra Angelico; a number of studies by Raphael; Correggio's study for the *Ascension* fresco in the dome of S. Giovanni Evangelista, Parma; Michaelangelo's studies of *Three Standing Men in Mantles*, the *Deposition*, and a *Standing Figure* for the *Battle of Cascina* fresco; and Reni's study for the *Aurora* fresco in the Palazzo Rospigliosi, Rome, highlight the Italian collection.

Among the works by Dürer, the leading figure of the German collection, are drawings of an early *Self-Portrait*, *Christ at Gethsemane*, *Hands in Prayer*, and *Adam and Eve*; water colors of *Christ on the Cross*, the *Young Hare*, *Madonna and the Animals*, the *Great Piece of Turf*, and *Knight, Death, and the Devil*; and woodcuts, including the *Great Passion*, *Small Passion*, *Apocalypse*, and *Life of the Virgin* series. Other important works are Schongauer's woodcuts of the *Passion* and several drawings, Grünewald's studies of *St. Peter* and *St. Paul*, Altdorfer's water color *Landscape with a Chapel*, some Cranach portrait drawings, and Holbein's woodcuts for the *Dance of Death*.

Some Flemish drawings of unusual interest are a portrait by Petrus Christus, a Bosch study, Pieter Brueghel the Elder's *Artist and Patron* and *Big Fish Eat Little Fish*, and several works by Rubens and Van Dyck. In the considerable 17th-century Dutch collection are such Rembrandt drawings as the *Elephant* and *Young Woman at Her Toilet*, as well as copies of most of his etchings. The French drawings of note are Poussin and Claude landscapes and numerous studies by Boucher and Fragonard.

BIBLIOGRAPHY. O. Benesch, *Meisterzeichnungen der Albertina*, Salzburg, 1964.

DONALD GODDARD

Austrian Baroque Museum (Osterreichisches Barockmuseum). Established in the apartments of the Lower Belvedere since 1923, this collection is devoted to the most productive period of Austrian art, from 1680 to 1790. The development of Austrian painting from baroque through rococo is traced in major works and studies by Kupetsky, Rottmayr, Faistenberger, Altomonte, Gran, Troger, Kremser-Schmidt, Maulbertsch, and Brand, among others. In sculpture the museum owns the most comprehensive collections of the works of Georg Raphael Donner and Franz Xaver Messerschmidt, as well as important works by Permoser, Zürn, and Moll.

BIBLIOGRAPHY. Osterreichisches Barockmuseum, *Katalog*, Vienna, 1958.

Austrian Gallery of the Middle Ages (Museum mittelalterlicher osterreichischer Kunst). Housed in the Lower Belvedere, this repository of Austrian medieval art is focused primarily on the 15th century, when church art became widespread in Austria. Among the sculptural works are a 12th-century *Enthroned Madonna*, several figures by Hans von Judenburg, and Andreas Lackner's *St. Blasius with SS. Rupert and Virgilius*. Major works by the leading Austrian painters of the 15th and 16th centuries—Hans von Tübingen, Konrad Laib, Rueland Frueauf, the Master of Mondsee, Michael Pacher, Marx Reichlich, and Wolf Huber—are also on view.

BIBLIOGRAPHY. Museum mittelalterlicher österreichischer Kunst, *Katalog*, Vienna, 1953.

Austrian Gallery of the 19th and 20th Centuries (Osterreichische Galerie des 19. und 20. Jahrhunderts). The state collection of modern Austrian art is housed in the Upper Belvedere. The galleries proceed more or less chronologically, starting with the neoclassicist paintings of Füger, Lampi, and Koch, and the religious paintings and landscapes of the Nazarenes Schnorr von Carolsfeld, Scheffer von Leonhardshof, Fuhrich, and Kuppelweiser. The realistic landscapes, portraits, and genre scenes of Ferdinand Georg Waldmüller comprise the largest group of paintings. Other works of this period are by Amerling, Danhauser, Reiter, Loos, Jakob and Rudolph von Alt, and Gauermann. The influence of impressionism is evidenced in the works of Schuch, Romako, Schindler, Pettenkofen, and Hörmann. Klimt, Schiele, Kokoschka, and Boeckl are the major 20th-century painters represented. Modern Austrian sculpture is also included in the collection.

Austrian National Library. Building designed by Fischer von Erlach and erected in 1722–26. The Great Hall runs the length of the first floor on either side of a central dome. Included among the library's holdings is one of the world's greatest collections of ancient Egyptian, Greek, and Roman manuscripts, as well as illuminated manuscripts from Persia and medieval Europe, numbering more than 35,000 works. The core of the collection was formed by emperors Frederick III, Maximilian I, and Ferdinand I, but many princely collections have since been incorporated. The French and Flemish manuscripts of Eugene of Savoy were added in the 18th century, and the Archduke Rainer collection of papyri, found in the Fayoum of Egypt, in the 19th century. Among its treasures are the Vienna Genesis, the Vienna Dioscurides, the Liutold Evangelary, and the Hours of Charles VI.

Czernin Gallery. No longer in existence. The collection is now in Salzburg. See SALZBURG: RESIDENCE GALLERY.

Harrach Picture Gallery (Harrach'sche Gemaldegalerie). The collection of the Counts of Harrach, housed in the family palace (1689–1703; by Domenico Martinelli), comprises about 200 European paintings dating from the 15th to the 18th century. Of particular interest are paintings by Poussin, Ribera, Rosa, Bellotto, Pannini, Vernet, and several works each by Luca Giordano and Francesco Solimena.

Liechtenstein Gallery. No longer in existence; some of the best works from its collection are now in the Museum of Art History (see below).

Museum of Art History (Kunsthistorisches Museum). For the most part this museum is the product of acquisitions made by the House of Hapsburg since the 16th century. In addition to its magnificent Gemäldegalerie, or Picture Gallery, the museum encompasses important departments devoted to ancient Egyptian art, Greek and Roman art, sculpture and applied arts, secular and ecclesiastical crafts, musical instruments, arms and armor, medals and coins, and imperial carriages. These collections are now housed in a Renaissance revival building that was designed by Gottfried Semper and completed by Karl von Hasenauer in 1891. See also Treasury, below.

The history of the collection began modestly with Emperor Maximilian I (1459–1519). Determined collecting was started by Archduke Ferdinand of the Tyrol (1529–95), who obtained Raphael's *Madonna of the Meadow* and Moretto's *St. Justina* of the present collection, and Emperor Rudolph II (1552–1612). Holding forth at his brilliant court in Prague, Rudolph acquired the great collection of paintings by Pieter Brueghel the Elder, Dürer's *Adoration of the Trinity*, Correggio's *Jupiter and Io* and *Rape of Ganymede*, and works by his own court artists Spranger, Heintz, and Hans von Aachen, as well as works of the contemporary decorative arts. The greatest part of the present collection was acquired, after the depletions of the Thirty Years' War, by Archduke Leopold Wilhelm (1614–62), while governor of the Spanish Netherlands. Through his agents he became the bear of the art market at auctions throughout Europe, acquiring many important Venetian, German, Flemish, and Dutch paintings. The Hapsburg portraits by Velázquez were sent to Vienna from the Spanish branch of the family during the reign of Leopold I (1640–1705). Many of the paintings by Rubens and Van Dyck were bought by Empress Maria Theresa (1717–80), who also commissioned Bellotto for the series of views of the imperial palaces in and around Vienna. During her reign the collection was moved to the Belvedere Palace and arranged historically for the first time. A year after her death the gallery was opened to the public.

A selection of about 800 paintings is on view in rooms that have been reconstructed and relighted since the heavy damage to the museum in World War II. Because the history of acquisition is so intimately connected with Hapsburg taste, the collection is unparalleled in some areas and completely deficient in others. The opulence of this taste is reflected in the magnificence of the representations of Venetian, mannerist, and baroque art.

The vast majority of Italian painters represented are Venetian or northern Italian. Important paintings of the 15th century are Mantegna's *St. Sebastian*, Antonello da

Messina's *Madonna and Saints*, and Giovanni Bellini's *Young Woman at Her Toilet*. The 16th-century collection includes Giorgione's *The Three Philosophers*, Correggio's *Jupiter and Io* and *Rape of Ganymede*, Lotto's *Virgin and Child with Saints* and *Portrait of a Young Man*, Palma Vecchio's *Sacra Conversazione*, Moretto's *St. Justina*, Parmigianino's *Cupid Carving His Bow* and *Self-Portrait in a Convex Mirror*, Niccolò dell'Abbate's *Conversion of St. Paul*, and works by Dosso Dossi, Paris Bordone, and Sebastiano del Piombo.

Entire rooms are given over to the works of Titian, Tintoretto, Veronese, and Jacopo and Francesco Bassano. Preeminent among the paintings on view are Titian's *Portrait of Pope Paul III*, *Portrait of Jacopo da Strada*, *Violante*, *Diana and Kallisto*, *Nymph and Shepherd*, *Danaë*, *Lucretia*, *Gypsy Madonna*, and *Ecce Homo*; Tintoretto's cassone panels, *Susanna and the Elders*, *Flagellation of Christ*, *Portrait of a Man in Armor*, and several other portraits; and Veronese's *Lucretia*, *Judith with the Head of Holofernes*, *Christ Healing a Woman with the Issue of Blood*, *Adam and Eve*; and a series of scenes from the New Testament. Later Venetian painting is represented in works by Canaletto, Guardi, Feti, Johann Liss, Tiepolo, and Bellotto, whose views of Austrian palaces are hung in the rotunda gallery.

Several select paintings compose the Tuscan and central Italian group, including Raphael's *Madonna of the Meadow*, Andrea del Sarto's *Lamentation*, Bronzino's *Holy Family* and several portraits, four of the fantastic composite heads of Arcimboldo, and works by Benozzo Gozzoli, Perugino, and Fra Bartolommeo. Prominent among the baroque paintings are Caravaggio's *Madonna of the Rosary* and *David with the Head of Goliath*, Annibale Carracci's *Pietà* and *Venus and Adonis*, Reni's *Baptism of Christ*, and works by Guercino, Carracciolo, Pietro da Cortona, Bernardo Strozzi, and Luca Giordano.

Fifteenth-century Flemish painting comprises a small but select group including Jan van Eyck's *Portrait of Cardinal Niccolò Albergati* and *Portrait of Jan de Leeuwe*, Rogier van der Weyden's diptych of the *Madonna and Child and St. Catherine* and the *Crucifixion* triptych, Memling's *Altarpiece of St. John*, Hugo van der Goes's *Temptation of Adam and Eve*, Bosch's *Christ Carrying the Cross*, and Gerard David's *Altar of St. Michael*. Conspicuous among Renaissance and mannerist paintings are Patinir's *Baptism of Christ*, Gossaert's *St. Luke Painting the Virgin*, several mythological subjects by Spranger, and works by Joos van Cleve, Herri Met de Bles, Barent van Orley, and Bloemaert.

The room devoted to Pieter Brueghel the Elder contains about one third of his *oeuvre*: *Hunters in the Snow*, *Dark Day*, *Return of the Herd*, *Peasant Wedding*, *Peasant Dance*, *Tower of Babel*, *Children's Games*, *Procession to Calvary*, *Conversion of St. Paul*, *Massacre of the Innocents*, *Peasant and the Birdnester*, *Suicide of Saul*, and the *Battle between Carnival and Lent*. The *Temptation of St. Anthony*, *Adoration of the Magi*, and several other paintings by his son Jan Breughel the Elder are also on view.

The collection of 17th-century Flemish painting consists of two rooms devoted to Rubens, one to Van Dyck, and another to the followers and contemporaries of Rubens. The great array of monumental religious, historical, and mythological paintings by Rubens is unequaled in any other museum. Numbered among these are the *Ildefonso Altarpiece*, the *Annunciation*, *Four Quarters of the World*, *Cimon and Ephigenia*, the *Triumph of St. Francis Xavier*, the *Triumph of St. Ignatius of Loyola* (with sketches for the last two paintings), the *Assumption*, the *Hunt of Meleager and Atalanta*, the *Meeting of King Ferdinand of Hungary and Cardinal Infante Ferdinand*, and the *Festival of Venus*. Smaller works of importance are portraits of the Duke of Mantua, Isabella d'Este, Prince Albert, Charles the Bold, Cardinal Infante Ferdinand, King Ferdinand of Hungary, and *Helene Fourment in a Fur*, *Landscape with Philemon and Baucis*, *Angelica and the Hermit*, and a late *Self-Portrait*. Jordaens is represented by the famous *Bean Feast* and Van Dyck by *St. Ambrose and Theodosius*, *Madonna and Child with St. Rosalie and SS. Peter and Paul*, *Christ on the Cross*, *Blessed Hermann Joseph Adoring the Virgin*, *Samson and Delilah*, *Portrait of Prince Rupert of the Palatinate*, and *Portrait of a Young General in Armor*.

The major figures of German Renaissance painting are well represented, as are some of the lesser figures, including Huber, Amberger, Baldung-Grien, and Strigel. The only work by Schongauer is a small *Holy Family*. Dürer's *Adoration of the Trinity*, *Madonna and Child*, *Massacre of the 10,000 Christians*, *Portrait of a Young Venetian Woman*, *Portrait of Maximilian I*, and several other portraits form a rare collection. Other important works are Altdorfer's *Holy Night*, *Entombment*, *Resurrection*, *Martyrdom of St. Catherine*, and *Lot and His Daughters*, Cranach's *Crucifixion*, *Three Young Women*, *Vision of St. Jerome*, *Stag Hunt of Prince Frederick*, and *Paradise*, and Holbein's portraits of Jane Seymour and John Chambers. A unique group of paintings by the mannerist court painters to Emperor Rudolph II includes Hans von Aachen's *Bacchus, Ceres and Cupid*, and *Jupiter, Antiope, and Amor* and Joseph Heintz's *Adonis Taking Leave of Venus*.

Dutch painting is more sparsely represented. Of the 15th- and 16th-century works the most prominent are Geertgen tot Sint Jans's *Lamentation* and *Recovery of the Remains of St. John*, Jan van Scorel's *Presentation of Christ*, Mor's portraits of *Antonie Perrenot de Grenvella* and *Queen Anna of Spain*, and works by Aertsen and Heemskerck. Rembrandt's *Apostle Paul*, *Portrait of the Artist's Mother*, *Titus Reading*, and two *Self-Portraits*; Vermeer's *Artist's Studio*; portraits by Hals; and works by Dou, the Ostade brothers, Metsu, Steen, Ruisdael, Jan de Capelle, and Jan van Goijen highlight the 17th-century collection.

Most of the Spanish paintings originated in the Spanish royal branch of the Hapsburg family, except Ribera's *Christ among the Doctors*. These include royal portraits by Sánchez Coello and Carreño, as well as the famous series by Velázquez in which the subjects are Queen Isabella, Philip IV, Infante Balthasar Carlos, Infanta Maria Teresa, Infanta Margarita Teresa, and Philip Prosper.

Although French painting is little in evidence, there are some interesting works by Clouet, Poussin, Rigaud, Vouet, Corneille de Lyon, Vernet, Largillière, David, and Gérard. The same applies to English painting, the only works being those of Gainsborough, Reynolds, Raeburn, and Lawrence. There is also a small group of 19th- and 20th-century

painting and sculpture with works by Renoir, Monet, Van Gogh, Cézanne, Munch, Beckmann, Nolde, Kirchner, Rodin, Despiau, and Barlach, among others.

The ancient Egyptian collection is composed of statuary, reliefs, architectural fragments, and crafts dating from the Old Kingdom to the Ptolemaic period, notably from the 5th-dynasty mastaba of Prince Kaninisut at Giza. The Greek collection has important examples of vase painting and sculpture, including the bronze statue of an athlete from Ephesus, a portrait of Aristotle, and a Hellenistic head of Artemis from Tralles. Art of the Roman Empire is highlighted by reliefs from Ephesus and a number of cameos, including the famous *Gemma Augustae*.

European sculpture and applied arts in the museum date primarily from the 15th and 16th centuries, but earlier and later periods are also represented. The more than 900 examples of tapestry are mainly of Flemish and French origin. Among the many fine examples of jeweled arts and glassware, one work stands out: Benvenuto Cellini's *Saltcellar of Francis I*. The extensive collection of statuary has works by Antonio Rossellino, Laurana, Gregor Erhart, Riemenschneider, and Hermann Vischer, but is notable for its many small decorative pieces of the mannerist period by Leoni, Adraen de Vries, Jacopo Sansovino, Giovanni Bologna, Jamnitzer, and others.

BIBLIOGRAPHY. *Führer durch die kunsthistorischen Sammlungen in Wien*, 30 vols., Vienna, 1926–44, later revisions. DONALD GODDARD

Treasury (Weltliche und Geistliche Schatzkammer). A part of the Museum of Art History, this imperial treasury of secular and religious objects, connected with the Holy Roman Empire and the ruling families of the Austrian Empire, is housed in the Swiss Court of the Hofburg. The collection of crowns, scepters, ceremonial weapons, ecclesiastical and imperial vestments, paxes, reliquaries, statuettes, and other objects dating from the 10th to the 19th century, includes the crown jewels of the Holy Roman Empire and the Burgundian Treasury.

VIENNA GENESIS. East Christian illuminated manuscript, in the National Library, Vienna. *See* EAST CHRISTIAN ART AND ARCHITECTURE.

VIENNA PORCELAIN. The second factory to produce hard paste in Europe. Its founder was Claudius Innocentius Du Paquier, who began production in 1719, and the factory operated until 1864. The output of the factory can be divided into three periods. Du Paquier's management lasted until 1744 and marked the first period, which was virtually confined to vessels, ornamental or useful. Meissen influence was strong, but Vienna produced a distinctive ware, at times characterized as provincial, with a creamy, sometimes greenish body color that differed from the whiteness of Meissen. A special charm and vitality dif-

Vienna porcelain. Empire-style coffee service, with decorative paintings by Anton Kothyasser. Museum of Art History, Vienna.

ferentiate Vienna's work in the attention to detail as well as the color.

The government took over after 1744, using the shield as its mark and improving the body. Rococo-style tableware was made. Callot figures and crinoline groups were popular. By 1760, neoclassicism began to be used with the rococo. Anton Grassi was the best modeler after 1778 in the Louis XVI style. In the 1780s Konrad von Sorgenthal became director and put the factory on a solid financial basis. He coordinated its activities with the Academy of Arts and inspired artistic experiments that improved the quality of the ware and its design.

The most prosperous period for Vienna was its last, in the 19th century when the Empire style dominated. This was also the period of particular technical development, and both useful wares and figures were produced. The Arts and Crafts Museum in Vienna has a significant collection of this porcelain.

BIBLIOGRAPHY. E. Strohmer and W. Nowak, *Old Viennese Porcelain*, Vienna, 1950. MARVIN D. SCHWARTZ

VIENNE. Department of France in the Poitou region. It is noted for its monuments of Romanesque architecture, sculpture, and painting. The churches of Poitiers, with their provincial architectural *décor* and sculpture, and St-Savin-sur-Gartempe, with its important Romanesque frescoes, are among the major sites in the Department of the Vienne. *See* POITIERS; SAINT-SAVIN-SUR-GARTEMPE: ABBEY CHURCH.

BIBLIOGRAPHY. P. Deschamps, *French Sculpture of the Romanesque Period . . .*, Florence, 1930.

VIENNE. Gallo-Roman city, capital of the Allobroges. Vienne is situated on the flanks of the Rhone River, and in Roman times it was the key station of the territory that stretched between the Rhone, the Alps, and the Isère River. Although its foundation date is not firmly established, it is certain that Vienne has existed since the Celtic period. The city was fortified by surrounding walls of an irregular plan, which were still used in the Middle Ages.

Vienne flourished during imperial Roman times. Its main monuments were the Temple of Augustus and Livia, a circus, and a theater. The temple (in the Forum) was built of limestone from Bourgogne. It consisted of a large portico two columns deep, a pronaos, and a cella, and was surrounded by fluted columns, six in the front and six on each side. The pediment was decorated with bronze sculpture, which is now missing. A large circus was situated outside the walls of the city, but only the aiguille (obelisk), which had probably decorated the spina of the circus, is preserved. The circus consisted of a pyramid built of large regular blocks of stone, supported by a square base in the form of an *arcus quadrifrons* (arch with four passageways). There was also a large theater built on the west slope of the hill of Pipet.

Excavations at Vienne have yielded important works of art such as the statue of a *Crouching Aphrodite* (Paris, Louvre), the statue of *Apollo Drawing His Bow* (Vienne, Musée Lapidaire), the head of a smiling satyr (Louvre), and reliefs, bronzes, ivories, cameos, and mosaics.

BIBLIOGRAPHY. H. Bazin, *Villes antiques, Vienne et Lyon galloromains*, Paris, 1891; Abbé J. Sautel and L. Imbert, *Les Villes romaines de la Vallée du Rhône*, Avignon, 1926.
 EVANTHIA SAPORITI

Church of Vierzehnheiligen. The *Gnadenaltar* in the central oval space.

VIENOT, JACQUES. French industrial designer (1893–1959). He was the founder of Technès (1948), the leading design firm of postwar France, which handles integrated corporate design, ranging from advertising to heavy machinery. Vienot led the movement toward the ideal of beauty in design by forming an organization of design (Syndical Chamber of Industrial Stylists), establishing a central bureau of information (Institute of Industrial Aesthetics), attaining the acceptance of industrial aesthetics as a subject of higher learning, and publishing a magazine (*Esthétique Industrielle*).

VIERENDEEL, *see* TRUSS.

VIERGE DOREE, LA. Gothic stone sculpture, in the Cathedral of Amiens, France.

VIERZEHNHEILIGEN, CHURCH OF. Pilgrimage church of the 18th century, erected on a steep slope overlooking the Main Valley northwest of Bamberg, Germany. Dedicated to fourteen saints who repeatedly appeared to a shepherd in the 15th century, the present church is the third place of worship erected on the site. It is far larger and more opulent than its predecessors and is thus a characteristic, if outstanding, monument to the building enthusiasm that swept 18th-century Germany and particularly the Schönborn family, one of whom was currently Prince-Bishop of Bamberg.

In 1741 Johann Balthasar Neumann, architect to the Schönborns in Würzburg and Bamberg, was invited to make designs. His first project, on which work began in 1743, was for a basilica on a Latin-cross plan, which he then redesigned to take in the foundations executed by J. J. M. Küchel. Externally the completed church has the appearance of a Renaissance basilica with a two-tower west front and three polygonal apses for chancel and transepts. Only the swinging forward of the center bays of the façade hints at the theme of the interior. There the solidity and sobriety of the exterior yield to a finely controlled but sensational contrapuntal play of interlocking oval and circular spaces under sweeping masonry vaults.

The *Gnadenaltar* (designed by Küchel) stands in the center of the church and in the center of the largest oval space, competing effectively with the crossing and the chancel for primacy in the composition. Around it, the architecture seems almost as light and immaterial as the space itself, partly because of the light that pours through numerous windows to glance off white or very palely colored surfaces, catch on gilded details, and illuminate the reticent ceiling frescoes by Giuseppe Appiani. The stucco ornament, as well as the saints' statues and the *putti* on the *Gnadenaltar* and elsewhere, are the work of Johann Michael Feuchtmayer and Johann Georg Ubelhör of Wessobrunn.

BIBLIOGRAPHY. R. Teufel, *Vierzehnheiligen*, Lichtenfels, 1957; H. Reuther, *Die Kirchenbauten Balthasar Neumanns*, Berlin, 1960.

NORBERT LYNTON

VIEW OF TOLEDO. Oil painting by El Greco, in the Metropolitan Museum of Art, New York. *See* GRECO, EL.

VIGA. Log used to frame roofs in Indian pueblos and in Spanish colonial-style architecture. Vigas usually spanned the tops of walls, from which their ends often projected. They carried smaller poles laid across them and a layer of rushes or branches or closely spaced sticks which were covered with a thick layer of clay to form a flat roof. Of Indian origin, vigas affected Spanish colonial style.

VIGARNI (Vigarny), FELIPE DE, *see* BIGARNY, FELIPE DE.

VIGAS, OSWALDO. Venezuelan painter (1926–). Born in Valencia, Venezuela, Vigas abandoned medicine to devote himself entirely to art. He studied at the School of Fine Arts, Valencia, and adopted abstract painting in 1952. In 1953 he went to Paris, where he has been living ever since. Vigas is interested in images of the earth, which he expresses in thick paint, mostly black and white. His paintings have been exhibited at the Salon de Mai, the Carnegie International (1955, 1957), the Venice Biennale (1954), and at the São Paulo Bienal (1953, 1955). In 1952 he was awarded the Venezuelan National Painting Prize and was commissioned to paint a large mural for the University of Caracas. Typical of his recent work is *Pierres fertiles* (1960), which reflects his obsession with earthly objects transposed into abstract forms.

BIBLIOGRAPHY. G. Diehl, *La Peinture moderne dans le monde*, Paris, 1961.

VIGEE-LEBRUN, MADAME LOUISE-ELISABETH. French painter of portraits and landscapes (b. Paris, 1755; d. there, 1842). She was the daughter and pupil of the pastel portraitist Louis Vigée. As a result of lessons and counsel from J. B. Greuze, G. F. Doyen, C. J. Vernet, G. Briard, and P. Davesne, she was admitted to the Academy of St. Luke in 1774. In 1776 she married the picture dealer J.-B.-P. Lebrun. Because of her reputation for talent, beauty, and charm, in 1779 she was called to Versailles to paint the Queen, Marie Antoinette, who became her friend and singing partner in duets during sittings intermissions. The *Portrait of the Queen with Her Children* (Versailles Museum) confirms the royal maternal instinct.

During the next decade she painted some thirty portraits of the Queen in every possible guise: with a rose, with a book, in velvet, in muslin, and others (mostly at Versailles Museum). In all of them the elongation of the Queen's round, myopic eyes, as well as the truncation of her heavy Hapsburg lip, are graciously synthesized with the freshness of her complexion and the nobility of her bearing. Inspired by Rubens's *Portrait of Helena Fourment* (during a visit to Antwerp in 1782), her *Self-Portrait in a Straw Hat* so excited Vernet that he successfully proposed her for membership in the Royal Academy (1783). Her diploma piece was *Peace Restored by Abundance*.

At the outbreak of the French Revolution in 1789, she set off on twelve years of travel, was feted at every court as a friend of the tragic Queen, admitted to all academies for her talents, and acclaimed as "Mme. Rubens." In 1801 she returned to Paris. Finding the social climate of Napoleon's regime unsatisfactory, she went to England (1802–05), where she was welcomed by Sir Joshua Reynolds and painted the court and Lord Byron. She then went to Switzerland (1808–09), where she became the friend and portraitist of Mme. de Staël. Returning again to Paris (ca. 1810), she ceased painting, having executed, according to her *Mémoires* (1835–37), 877 pictures during her career, including 622 portraits and 200 landscapes.

Aside from an occasional excursion into the neoclassical vein of Jacques-Louis David (*Self-Portrait with Her Daughter*, 1787; Paris, Louvre), she favored the sentimental and anachronistic antiquity of A. Kaufmann and J.-M. Vien. She added her personally sincere and feminine instincts to the formulas of F.-H. Drouais and J.-B. Greuze, as in *Madame Grand* (later Princesse de Talleyrand), which is now in New York at the Metropolitan Museum of Art. Though most of her works remain in the families of her sitters, there are others in the public galleries of Florence, Leningrad, London, Montpellier, New York, Paris, Rome, Toulouse, Versailles, Vienna, Warsaw, and elsewhere.

BIBLIOGRAPHY. P. de Nolhac, *Madame Vigée-Le-Brun...*, Paris, 1908; L. Hautecoeur, *Madame Vigée-Lebrun*, Paris, 1917.

GEORGE V. GALLENKAMP

VIGELAND, GUSTAV. Norwegian sculptor (b. Mandal, 1869; d. Oslo, 1943). Norway's best-known sculptor studied with Bergslien in Oslo, Bissen in Copenhagen, and Rodin in Paris (1892). After carving imitation Gothic statues for Trondheim Cathedral to make a living, he designed monuments to Beethoven, Wergeland, and W. H. Abel. However, almost his entire working life was oc-

Louise-Elisabeth Vigée-Lebrun, *Self-portrait in a Straw Hat*, 1783, copy. National Gallery, London.

cupied with the creation of the Sculpture Park, in the Frognerpark outside Oslo. Heated controversies followed the first showing of the model in 1906, but the work was finally begun. The axis of the long, narrow park extends through the fountain and bridge to the great monolith at the end. Each of these monuments is covered with sculpture: simplified human masses involved in various stages, events, and activities of life. The monolith, a column of writhing, intertwined nude figures, climaxes this massive outpouring of forms.

BIBLIOGRAPHY. H. Lødrup, *Gustav Vigeland*, Oslo, 1946; A. Brenna, *Guide to Gustav Vigeland's Sculpture Park in Oslo*, Oslo, 1950.

VIGHI, GIACOMO (D'Argenta). Italian painter (b. Argenta, near Ferrara; d. Turin, 1573). Trained in Bologna, he was long active in Turin, where he served the House of Savoy. Documents show that he worked in Ferrara in 1556, and that he was sent to France in 1561–62 to paint royal portraits and to Germany in 1571 for the same purpose. He also painted in Prague and Vienna. His paintings survive in Bologna and Turin.

VIGNE, PAUL DE. Belgian sculptor (b. Ghent, 1843; d. Brussels, 1901). He studied with his father, Pierre de Vigne, and at the academies of Ghent, Antwerp, and Louvain. Paul's travels in Italy made him a great admirer of Florentine Renaissance sculpture. The suave and lyrical classicism of a work like *Immortality*, in the Fine Arts

Museum, Brussels, derives from this admiration. His monumental works, such as the *Glorification of the Arts* on the exterior of the Fine Arts Museum, are in the heroic French tradition of Rude and Carpeaux.

VIGNETTE. Originally the designation for the small, delicate vine patterns used to decorate the borders of illuminated manuscripts. The term is now extended to mean any small, delicate decoration, with or without figures, whose edges are not definite but shade off into the surrounding page. Vignettes are most often found on the title pages of elaborately printed books, particularly books of the baroque period.

VIGNOLA, GIACOMO BAROZZI (Il Vignola). Italian architect (b. Vignola, 1507; d. Rome, 1573). Traditionally Vignola is said to have begun his career as a painter, although there is no certain indication of such early works except intarsia designs executed for Francesco Guicciardini. By 1534 he was in Rome and associated with the Accademia Vitruviana. From 1537 to 1539 he was in France with Primaticcio. Returning to Bologna in 1541, he was associated as an architect with S. Petronio and numerous civic projects. In 1550 he returned to Rome, where the patronage of the Farnese family allowed him to develop his talents fully. For them he constructed the Oratory of S. Andrea in Via Flaminia (1554) and the palace at Caprarola (from 1558), and began the Farnese palace in Piacenza and the Villa di Papa Giulio in Rome. He submitted a design for the Church of the Escorial in 1562 (now lost) and in the same year published his treatise *Regola delli cinque ordini d'architettura*. He was appointed successor to Michelangelo at St. Peter's Cathedral in 1564 and began the Gesù in 1568 and S. Anna dei Palafrenieri in 1573. *See* ST. PETER'S (NEW), ROME.

Although he is best known for his designs for Caprarola and the Villa di Papa Giulio, Vignola's early work reveals a power of conception beyond the reach of most of his mannerist contemporaries. His design for the façade of S. Petronio is almost 19th century in its approach

Giacomo Barozzi Vignola, Palazzo Farnese at Caprarola, near Rome.

to the Gothic, while his Oratory of S. Andrea maintains all the clarity and simplicity of High Renaissance forms. It is in the palace at Caprarola, however, that Vignola's full mastery is revealed. By utilizing the declivities of the site, he was able to convert Sangallo's polygonal fortress plan into a monumental palace. The wide sweep of the curving ramps creates a movement repeated and modified by the returning stair in a manner quite unique in the 16th century. This movement, however, is controlled by a clearly indicated accent in the major portals and by a Tuscan feeling for massing and edges that focus attention on the vertical axis of the composition. This feeling for movement and accent recurs in Vignola's plan for the Gesù, the first baroque church in Rome. *See* GESU, IL, ROME.

BIBLIOGRAPHY. H. Willich, *Giacomo Barozzi da Vignola*..., Strasbourg, 1906; A. Venturi, *Storia dell'arte italiana*, vol. 11, pt. 2, Milan, 1939.
JOHN R. SPENCER

VIGNON, BARTHELEMY. French architect (1762–1846). He worked in Paris. A pupil of Le Roy and Jacques-Pierre Gisors, he belongs essentially to the era of the Empire. His best-known work is the Church of the Madeleine. The latter part of his life was devoted to teaching. *See* MADELEINE, LA, PARIS.

VIGNON, CLAUDE, THE ELDER. French painter of historical, religious, mythological, and allegorical scenes; decorator, illustrator, and etcher (b. Tours, 1593; d. Paris, 1670). He was a pupil in Paris of the late-mannerist painters G. Lallemand, J. Bunel, and M. Fréminet. After becoming a master in the Guild of St. Luke in 1616, he went to Rome. He traveled through Italy with Simon Vouet and frequented the pupils of M. Caravaggio and A. Elsheimer, including C. van Poelenburgh, L. Bramer, and G. van Honthorst. The eclecticism of Vignon's study is extensive, for not only did the *Adoration of the Magi* (1625; Gentilly Church) show a revision of Venetian decorative models, reminiscent of D. Feti, but the *Martyrdom of St. Matthew* (1617; Arras, Palace of St. Vaast) takes its inspiration directly from Caravaggio's version of the subject in S. Luigi dei Francesi, Rome.

He won the competition sponsored by Prince Ludovisi for a *Marriage at Cana* (Potsdam) and was in contact with the antiquarian dealer F. Langlois, of Chartres, who later handled his and Rembrandt's etchings. He returned to Paris between 1624 and 1627 and was active before Vouet, executing many decorative commissions for the court and great amateurs (*Farewell* and *Warrior Returned*, part of a series in the Château de Raincy; Dijon, Magnin Museum). In these works his frenetic quest for personal expression and his rapid execution result in synthetic overfacility. His faulty composition is occasionally qualified as an early expression of the full baroque in France. He was a favorite among the *Précieux*, such as Claude Deruet, and an acknowledged expert, not only charged with the acquisition of antiquities for the Duc d'Orléans, but also (ca. 1641) for Rembrandt's Paris agent. Vignon was the only French artist before Hyacinthe Rigaud to manifest interest in this Dutch genius—a surprising independence at this time, for Vignon was among the twelve founders of the Royal Academy, in 1648. (This organization was dedicated to classical standards which he never truly understood, though he was made a councillor in 1663.)

The affinities between his style and those of Palma Vecchio, Valdés Leal, and even Murillo may be the consequence of two trips to Spain, where he is known to have left examples of his work. His etchings, with those of P. Brebiette, are among the most vigorous in this rather colorless episode of French art. The most notable characteristic of his style is apparent in an early work, *The Death of the Hermit* (ca. 1620; Paris, Louvre). Here the precious concept of color, pale gray to browns, animated with rainbow hues in angel wings and glistening robes; the meticulously handled, almost bedeviled dry-grained impasto; the complexity of the mannerist composition; and the Caravaggesque naturalism of still life all impose the belief that he was particularly influenced in Rome by A. Elsheimer's pupil P. P. Lastman, who taught Rembrandt during the Leyden period.

BIBLIOGRAPHY. Musée de l'Orangerie, *Peintres de la réalité en France au XVIIe siècle* (exhibition catalog), Paris, 1934; C. Sterling, "Un Précurseur français de Rembrandt: Claude Vignon," *Gazette des Beaux-Arts*, 6th series, 1934.
GEORGE V. GALLENKAMP

VIGNORY, CHURCH OF. French church, dating from the end of the 10th century, and truly a precursor of the Romanesque. It is essentially basilican in plan but lacks the usual transepts, though it adheres to the three-aisle division and a three-story elevation. The nave arcades with their massive square piers support a false triforium, and double-arch openings are divided by broad, squat columns. The purpose of this apparent triforium seems to be only to lighten the weight of the wall above. A single clerestory window pierces the wall above each triforium division. While some barrel vaulting is used, most of the church is covered by wooden truss roofing. A semidome is used over the semicircular sanctuary. A wealth of interesting ancient sculpture is displayed in the side chapels.

VIHARA. Buddhist or Jain monastery. The word *vihāra* means "for wanderers."

VIJAYANAGAR. Ruins covering more than 10 square miles near the modern village of Hampi in Mysore State, India. Capital of the Rāya kingdom (ca. 1350–1565) and the last stronghold of Hindu civilization against the Muslims, Vijaya-nāgara, the "town of victory," was at the height of its power and splendor in the first half of the 16th century during the reigns of Krishna Deva (1509–29) and Acyuta Rāya (1529–42). It was then the chief craft center of the south. The Vitthal temple, dedicated to the god Vishnu, which was begun in 1513 and was still unfinished at the fall of the city in 1565, is the most ornate and exquisitely carved temple on the site, its stone processional wagon being so perfectly wrought that it can be mistaken for a piece of monolithic sculpture. Vijayanagar as a style may be characterized by a striking kind of pillar design in which the shaft has been replaced by a complex group of statuary, carved entirely in the round and featuring a rearing horse, a supernatural animal, or a cluster of slender columns. The sculpture is often so undercut as to give a strongly coloristic effect. Outside the

city of Vijayanagar, the style flourished in other southern sites such as Vellore, Kumbakonam, Kāñchīpuram, and Srīraṅgam.

BIBLIOGRAPHY. H. R. Zimmer, *The Art of Indian Asia*, 2 vols., New York, 1955; P. Brown, *Indian Architecture*, 4th ed., 2 vols., Bombay, 1959.

JANET S. R. HILL

VIKING STYLE. Curvilinear style of decoration based on animal motifs applied to clasps, necklaces, weapons, and sacrificial vessels in Scandinavia from about the middle of the first millennium until about A.D. 1100. On rune stones serpentine forms frequently frame the letters of inscriptions telling of Viking expeditions. But vestiges of the style occur in the early Christian art of Scandinavia. The baptismal fonts of Hegwald, produced from about 1090 to 1130, reveal an animated serpentine ornament intimately connected with Viking art: in relief upon the pedestal of a font at Vänge, Gotland, are grotesque beasts that stare brazenly at the observer. Dragonlike animals serve as focal points in Hegwald's compositions.

BIBLIOGRAPHY. J. Roosval, *Swedish Art*, Princeton, 1932.

VILAMAJO, JULIO. Uruguayan architect (1894–1948). Vilamajó was one of the most distinguished of South America's first generation of moderns. In 1937 he designed the Faculty of Engineering, University of The Republic, Montevideo.

BIBLIOGRAPHY. H.-R. Hitchcock, *Latin American Architecture since 1945*, New York, 1955.

VILLA, *see* name of villa.

VILLA. Traditionally, a country house and its grounds close to a city. Originally Roman, the building of villas was revived in Italy during the Renaissance. They were built by the wealthy classes as retreats from city life and were often palatial. Many had elaborate gardens, such as those of the Villa d'Este in Tivoli, begun about 1560.

VILLABRILLE (Villabrille y Ron), JUAN ALONSO, *see* RON, JUAN.

VILLALPANDO, CRISTOBAL DE. Spanish colonial painter in Mexico (b. Mexico City, 1645; d. there, 1714). Influenced by the work of Valdés Leal, Cristóbal de Villalpando's work is even more baroque. Important examples are the cupola of the Capilla de los Reyes in Puebla Cathedral (1683) and the undated *Iglesia militante* in Mexico City Cathedral, with plumes and sumptuous drapery.

BIBLIOGRAPHY. M. Toussaint, *Arte colonial en México*, 2d ed., Mexico City, 1962.

VILLANDRY, CHATEAU OF. French Renaissance château, in the Department of Indre-et-Loire, of extremely regular and graceful design. It was built in 1532 by Jean Le Breton. Known originally as Colombiers, the moat-bordered residence includes three wings with steeply pitched roofs and tall, decorative dormers. The wings on either side of the Court of Honor have Italianate open loggias. A 14th-century square keep is incorporated into the building's southwest corner. At the rear a lovely geometric garden has been restored to its 16th-century appearance.

BIBLIOGRAPHY. J. de Foville and A. Le Sourd, *Les Châteaux de France*, Paris, 1913; E. de Ganay, *Châteaux de France*, vol. 2, Paris, 1949; C. Terrasse, *Les Châteaux de la Loire*, Paris, 1956.

VILLANOVANS. Members of tribes that settled about the 11th century B.C. in the part of northern Italy having as its boundaries the Reno River to the north and northern Latium to the south. They were named after Villanova, a hamlet 5 miles from Bologna where an ancient cemetery was discovered in 1853. This cemetery has yielded an enormous mass of material, consisting of pottery, bronzes, glass, ivory, and bone, which has been classified in three periods. The Villanovans are the most important of all the Iron Age peoples in Italy. By the 10th century B.C. they had built four villages and lived in round huts with conical roofs and exterior porches with wooden columns. They specialized in hammered bronze vessels of a distinctive type.

BIBLIOGRAPHY. D. Randall-MacIver, *Italy before the Romans*, Oxford, 1928.

VILLANUEVA, CARLOS RAUL. Venezuelan architect (1900–). Born in Croydon, England, he studied at the Ecole des Beaux-Arts in Paris. His recent work includes the Auditorium-Plaza (1952–53) and the bold ferroconcrete Olympic Stadium (1950–51) in University City, Caracas.

VILLANUEVA, JUAN DE. Spanish architect (1739–1811). He worked in Madrid. After seven years of study in Italy, he returned to his native land to design buildings in the romantic-classical mode. His best-known work, the Prado Museum, demonstrates his geometric, classicizing, and severe style.

BIBLIOGRAPHY. G. Kubler and M. Soria, *Art and Architecture in Spain and Portugal and Their American Dominions, 1500–1800*, Baltimore, 1959.

VILLAVICIOSA CHAPEL, *see* CORDOVA: MOSQUE.

VILLON, JACQUES (Gaston Duchamp). French painter (1875–). A brother of Marcel Duchamp and Raymond Duchamp-Villon, the sculptor, he was born in Damville and went to Paris in 1894. He earned a living from satirical and humorous drawings for the newspapers *Le chat noir, Gil Blas, L'Assiette au beurre,* and *Le courrier français.* Villon devoted the first fifteen years of his artistic life to this minor form of art, unable to liberate himself from it. He also made posters for Parisian cabarets and did lithographs. In 1903 he exhibited at the first Salon d'Automne. Toward 1906 he was able to devote himself primarily to painting.

Like many artists of his generation, he was at first influenced by Degas and Toulouse-Lautrec, but he was then seized by the spirit of Fauvism and determined to carry color to its highest intensity. In 1911 he adopted analytical cubism, composing his paintings according to strict principles and in a range of very refined colors. Yet his canvases revealed tendencies and tastes to which he has remained faithful. He constructed his forms according to the principle of a "pyramidal vision" formulated by Leonardo: an object and its various parts come toward us in pyramids, whose apex is in our eye and whose base is in the object or in a section of the object (*La table*, 1912; *Soldats en marche*, 1913). Finally, under his sponsorship the Section d'Or group of cubists met in his studio in Puteaux. *See* SECTION D'OR.

His first abstract period was from 1919 to 1922 (*Le vol; Les chevaux de courses*). Overlapping planes are used

to render a diversity of values, the artist seeking to express the essence of things rather than their exterior attributes. From 1922 to 1930 Villon was obliged, in order to earn a living, to devote himself almost entirely to engraving, and he executed a series of color reproductions of works by Braque, Picasso, Matisse, and others. After another period of abstractionism (*Le Théâtre*, 1933) he turned to pure colors. From 1914 on, he achieved a synthesis of all his ideas and feelings (*Entrée au parc*, 1948). Villon's painting, however, never completely nonfigurative, has retained a pyramidal constructive element and relies on color for spatial effects. His art continued to develop, ever faithful to the spirit of his early cubist works, as in *La Seine, au val de la Haye* (1959; Paris, Galerie Louis Carré), *Les grues près de Rouen* (1960; private collection), and *Au val de la Haye* (1960; private collection).

In 1950 Jacques Villon was awarded first prize at the Pittsburgh International Exhibition. His work is included in many important museums and private collections. In 1961 he was elected an honorary member of the American Academy of Arts and Letters and the National Institute of Arts and Letters.

BIBLIOGRAPHY. J. Bazaine, "Jacques Villon," *Poésie*, no. 21, 1944; P. Eluard and René-Jean, *Jacques Villon: Ou L'Art glorieux*, Paris, 1948; R. Massat, *Jacques Villon*, Paris, 1951. ARNOLD ROSIN

VILLON AS GRAPHIC ARTIST

Between 1895 and 1907 Villon produced more than thirty lithographs, mostly in color, showing the gay life of bohemian Montmartre. Eight posters date from this period, among them the *Guinguette fleurie* of 1899, in which broad unmodulated planes recall the posters of Lautrec. Between 1899 and 1910 Villon made 175 etchings and aquatints, independent of his work for the *journaux amusants*, or illustrated newspapers, for which he periodically drew little vignettes of street and café life. In 1899 he executed his first color aquatints under the supervision of Eugène Delâtre, who had helped Mary Cassatt with this difficult technique. The tender relationship between mother and daughter in *Autre temps* (1904; Boston, Museum of Fine Arts) may derive from Cassatt.

Villon's version of cubism was sometimes geometrically calculated, as can be seen in his preliminary pencil, ink, and water-color drawings (1924; New Haven, Yale University Art Gallery) for the painting *The Jockey*. Profile, top, and side views are superimposed, and then Villon embarks upon a process of methodical dissection. The etching *Table d'échecs* (1920; New York, Museum of Modern Art) is composed of a series of overlapping pyramids. But Villon could record also states of emotion: the etching *Tête de fillette* (1929; Boston Public Library) shows a young girl's face frozen in terror. He was a sensitive portraitist. In one of the ten drypoint cubist portraits he executed in 1913, *Yvonne D. de profil* (a portrait of his sister; Boston Public Library), intermerging cubist planes, suggesting deep shadows cast by the flickering firelight, evoke a mood of serenity.

Villon illustrated, among others, Racine's *Cantique spirituel* (1945), in which the crucified Christ seems to float away from the restraining Cross; Hesiod's *Les travaux et les jours* (1962), in which the linear drawings are remarkably free and delicate; and Max Jacob's *A poèmes rompus* (1960).

BIBLIOGRAPHY. J. Auberty and C. Perusseaux, *Jacques Villon: Catalogue de son oeuvre gravé*, Paris, 1950; F. Stahly, "Jacques Villon: His Graphic Work," *Graphis*, X, 1954; Museum of Fine Arts, Boston, *Jacques Villon: Master of Graphic Art*, Boston, 1964. ABRAHAM A. DAVIDSON

VILNIUS (Wilna): ST. ANNE. Small Lithuanian late Gothic hall church built in the early 16th century. Its red-brick façade is considered the most elaborate and refined example of the Flamboyant Gothic style in Lithuania.

VIMALAKĪRTI (Chinese, Wei-mo-chi; Japanese, Yuima). Legendary disciple of the Buddha and a central figure in a Sūtra written about the 1st century of our era. Vimalakīrti was a layman of great learning, and the Vimalakīrti Sūtra was extremely influential in the development of lay Buddhism in China and Japan. He was visited when very ill by Mañjuśrī and other disciples of the historical Buddha, and on this occasion occurred the great debate that is often depicted in Chinese Buddhist art. Vimalakīrti also appears alone in portrait fashion in later Chinese painting, one of the best known of these portraits being attributed to the great Sung-dynasty painter Li Kung-lin. The association of Vimalakīrti with learning made him a favorite among many of the *wen-jen*, or scholar-gentleman, painters of China. *See* LI KUNG-LIN; MANJUSRI; WEN-JEN-HUA.

BIBLIOGRAPHY. I. Hokei, "Vimalakīrti's Discourse on Emancipation," *Eastern Buddhist*, II, March–April, 1923, III, April–June, 1924, IV, April–June, 1926.

Jacques Villon, *Figure*, 1922. Thompson Collection, Pittsburgh.

VIMANA. Enclosed cult room or shrine in the Hindu temple, mainly of the Deccan and South India. The term is also applied to the temple as a whole, comprising the sanctuary and attached porches. In Jain architecture, the vimāna was usually a small square room, lit only from the door and crowned with a pyramidal tower, or *śikhara*, as in the temples of Orissa, from about 800 to 1200. The Chālukyan temple at Umber has a star-shaped vimāna.

VINCENNES-SEVRES PORCELAIN. The national porcelain manufacture of France was begun at Vincennes and moved to Sèvres. Started in 1738 by workmen from Chantilly, it was 1745 before production was under way. Patronage in the early years came first from Orry de Fulvy (and his brother) and then from Jean-Baptiste de Machault, both controllers of finance; its 1753 privilege forbade others from producing porcelain in France and made it known as "Manufacture Royale de Porcelaine." In 1759 the factory was bought by the King and maintained by him. It continued as a government enterprise after the Revolution and is still operating today.

Vincennes-Sèvres had artistic guidance from the royal goldsmith Duplessis and later from Etienne-Maurice Falconet. Famous sculptors were commissioned to provide models after 1766. The body for a good part of the 18th-century production was soft paste, although hard paste was used in varying degrees from 1772 on. Meissen was an obvious source of inspiration, but new colors and distinctive combinations of color are clearly for the French taste. The blue and crimson of Vincennes began the series of innovations such as the diaper pattern and, later, jeweled decoration. In the rococo style, a number of great forms and extensive services were developed, but neoclassical examples perhaps show Sèvres at its height. Sèvres of the 19th century was the finest porcelain made in Europe, and its designers were among the most serious. It is well represented in the great museums (New York, London, Paris, Pasadena), but the most comprehensive collection is in the Sèvres Museum.

BIBLIOGRAPHY. G. Lechevallier-Chevignard, *La Manufacture de porcelaine de Sèvres*, Paris, 1908; P. Alfassa and J. Guérin, *Porcelaine française du XVIIIe au milieu du XIXe siècle...*, Paris, 1932. MARVIN D. SCHWARTZ

VINCENT, MADAME, *see* LABILLE-GUIARD, ADELAIDE.

VINCENT DE PAUL, ST. Founder of the Lazarist Fathers, or Vincentians, and of the Daughters of Charity of St. Vincent de Paul (ca. 1580–1660). Born in Gascogne, France, of peasant stock, he studied at Toulouse. On a Mediterranean voyage, he was captured by Barbary pirates and sold as a slave in Tunis. Two years later he escaped to Avignon and went to Paris, where he became interested in welfare work. He founded the Lazarists to preach missions to the peasants in France and to aid captives of pirates in Africa. Later, with St. Louise de Marillac, he founded the Daughters of Charity, the first uncloistered order of nuns, to care for the poor and the sick. He also established institutions for foundlings in Paris, and is usually represented with foundlings. His feast is July 19.
See also SAINTS IN ART.

VINCENT FERRER OF VALENCIA, ST. Famous Dominican missionary (1350–1419). He was counselor and confessor to his compatriot Benedict XIII, antipope at Avignon; but later, to end the schism, he withdrew his support from Benedict. For twenty years he traveled on foot through western Europe preaching penance and converting Moors and Jews. He promoted Spanish unity by helping elect Ferdinand of Castile. His attributes are a crucifix, flame (of an evangelist) on his head or in his hand, and a sun with IHS on it on his breast. His feast is April 5.
See also SAINTS IN ART.

VINCENTINO, VALERIO, *see* BELLI, VALERIO.

VINCENT OF SARAGOSSA, ST. Deacon of Saragossa (d. ca. 304). Tortured in Valencia by Dacian, the governor of Spain, for having defended his bishop Valerius, he was placed on an X-shaped cross, his flesh torn by hooks, and roasted on a grill. After his death his corpse was protected from wild beasts by ravens, and, when thrown into the sea with a millstone around the neck, it was miraculously washed to shore and buried by Christians. His attributes are an X-shaped cross, hooks, a raven, and a millstone. His feast is January 22.
See also SAINTS IN ART.

VINCENZO DA SAN GIMIGNANO, *see* TAMAGNI, VINCENZO.

VINCKEBOONS, DAVID. Flemish painter of landscapes and genre scenes (b. Mechlin, 1576; d. Amsterdam, 1629). He went to Amsterdam in 1591. He is among the later followers of the style of Pieter Brueghel the Elder, but Vinckeboons's landscapes are primarily influenced by Gillis van Coninxloo. Vinckeboons adopted Coninxloo's high viewpoint, towering oaks, and manner in which trees and leaves are treated, and, in fact, tended to accentuate Coninxloo's decorative and synthetic vision. Vinckeboons's peasant scenes and similar settings continue the Brueghel tradition, and his figures are skillfully drawn, as, for example, the *Kermis* (Dresden, State Art Collections). It is a moot point whether the finch (*Vinck* in Flemish) constitutes a signature or is merely a decorative motif common also to other artists.

BIBLIOGRAPHY. Y. Thiéry, *Le Paysage flamand au XVIIe siècle*, Brussels, 1953; K. Goossens, *David Vinckboons*, Antwerp, 1954.

VINCOTTE, THOMAS. Belgian sculptor (b. Borgerhout, 1850; d. Brussels, 1925). Vinçotte studied in Brussels with Jaquet and in Paris and later became a professor at both the Antwerp and the Brussels academies. His principal works are portrait busts and monuments in the heroic style, including an equestrian statue of Leopold II in Brussels.

VINGBOOMS, PHILIP. Dutch architect (1607/08–78). Vingbooms was one of the chief architects of the classical style and the grand taste in 17th-century Holland. He worked exclusively in Amsterdam, where he built the Merchants' House, one of the most impressive Italianate structures in the city. Engravings of Vingbooms's designs

were published in 1648 and 1674 and had a marked influence on the architectural taste of the Netherlands. Among them are designs for narrow-faced town houses in Amsterdam, many of which survive today with only slight alterations.

VINGT, LES, *see* ENSOR, JAMES; ROPS, FELICIEN; RYSSELBERGHE, THEO VAN; SIGNAC, PAUL.

VIOLLET-LE-DUC, EUGENE-EMANUEL. French architect (1814–79). Considered the leading restorer of medieval monuments in France—outstanding examples are Notre-Dame de Paris, Carcassonne, Vézelay, and St-Denis—and the leading medieval archaeologist in Europe, he also designed several of his own buildings. However, it was less his work than his writings on architectural educational reforms and on architectural criticism that influenced succeeding generations and perpetuated the notion of the structural rationalism of the Gothic style. Among Viollet-le-Duc's most forward-looking and influential works are late projects in which he exploited the use of iron as a structural framework. These works, through publication, were available to architects of the next generation.

BIBLIOGRAPHY. P. Gout, *Viollet-le-Duc: Sa Vie, son oeuvre, sa doctrine*, Paris, 1914.

VIRGIN AND ST. ANNE. Cartoon drawing by Leonardo, in the National Gallery, London. *See* LEONARDO DA VINCI.

VIRGINIA, UNIVERSITY OF, CHARLOTTESVILLE. A major landmark of American architecture, the University (ca. 1816–42) was designed by Thomas Jefferson, with the aid of Benjamin H. Latrobe and William Thornton.

With two facing rows of small buildings connected by passageways and joined at one end by the library, the plan and scale of the structures epitomize Jefferson's conception of an academic village. It was the first unified, collegiate plan erected in the United States, and the separation of departments and independent library building was also new to American colleges. The library is domed and has a Corinthian portico. The pavilions, each containing a classroom and professorial living quarters, are fronted either by monumental porticos or by pedimented porticos on arcades. Some of the suggestions of Thornton and Latrobe resulted in design variations that create diversified vertical rhythms in counterpoint to the horizontals of the colonnades.

BIBLIOGRAPHY. T. Jefferson, *Thomas Jefferson, Architect...*, with an essay and notes by F. Kimball, Boston, 1916.

VIRGINIA STATE CAPITOL, RICHMOND, *see* JEFFERSON, THOMAS.

VIRGIN OF THE ROCKS, *see* MADONNA OF THE ROCKS.

VIRGIN OF VLADIMIR, *see* MADONNA OF VLADIMIR.

VIRUPAKSHA TEMPLE, *see* PATTADAKAL.

VISBY: CATHEDRAL. A Swedish church, St. Maria was rebuilt at the beginning of the 13th century by the Westphalians, who converted the old basilica into a hall church. It is equipped with a west tower with galleries and a new choir, flanked by two small octagonal towers which have pointed arches. The nave consists of seven vaulted bays, and the bays of the aisles are equal in size to those of the nave. The main entrance, in the south side, has two

Eugène-Emmanuel Viollet-le-Duc, the rebuilt walls of Carcassonne. A restoration by this medieval archaeologist and influential writer on architecture.

gabled portals in the Romanesque style, one of which seems to have led to an antinave.

BIBLIOGRAPHY. J. Roosval, *Swedish Art*, Princeton, 1932; T. Paulsson, *Scandinavian Architecture*, London, 1958.

VISBY: WALLS. Fortifications built in the 13th and 14th centuries on the large island of Gotland off the coast of Sweden in the Baltic Sea. Visby, a prosperous community of traders, rebuilt its fortifications into an impressive circuit of walls, 4,350 yards in length, which are still intact. Forty-nine towers rise at close intervals; of these, six were gateway passage towers and nineteen were saddle towers.

BIBLIOGRAPHY. E. Eckhoff and O. Jansen, *Visby stadsmur*, 2 vols., Stockholm, 1936.

VISCARDI, GIROLAMO. Italian sculptor (fl. Genoa, early 16th cent.). Although he worked for French patrons, there is no evidence that he left his native Genoa. Viscardi and another Genoese sculptor, Michele d'Aria, created the tomb of the dukes of Orléans (1502–15) at St-Denis. It has the traditional French recumbent effigies on an Italian sarcophagus surrounded by figures of the Twelve Apostles in an arcade. Viscardi designed the tabernacle, sarcophagus, and reliefs above the high altar for the Church of Ste-Trinité at Fécamp (1507).

VISCHER, PETER, AND SONS. German sculptors. Peter Vischer the Elder (b. Nürnberg, ca. 1460; d. there, 1529). He was the son of Hermann Vischer the Elder and the father of a number of sons, of whom four, Hermann, Peter, Paul, and Hans, were his assistants in various sculptural projects. The 15th century was a time of intensified interest in the production of sculpture in Germany. The Nürnberg school was composed of a number of distinguished sculptors, among them Veit Stoss, Adam Krafft, Michael Wohlgemuth, and particularly Peter Vischer the Elder and his sons.

In 1494 Peter the Elder began employment with Philip, the elector palatine, in Heidelberg. Shortly afterward, however, Vischer returned to Nürnberg to begin work on several tomb projects. Among his major works are the tombs of Archbishop Ernest in Magdeburg (1494–95) and of Bishop John IV in Breslau Cathedral (1496) and the shrine of St. Sebald in the Sebalduskirche, Nürnberg (1508–19). See ST. SEBALD, TOMB OF, NURNBERG.

The Sebalduskirche shrine sculptures betray a strong classical influence in the elegant posture of the figures, in the generalized drapery arrangements, and especially in the use of nude figures. The Italian influence is also apparent in the handling of relief panels on the shrine. German contacts with Italian art had become more frequent in the latter part of the 15th century, and it is known that Hermann Vischer the Elder spent some time in Italy. Other German artists made drawings and engravings of classical antiquities as well as copies after contemporary Italian masters. In this manner a knowledge and a taste for the classical style developed. But it should be emphasized that the native strain of the Gothic style predominates in the work of Peter Vischer. The shrine of St. Sebald is his most impressive work. It demonstrates his great mastery of bronze-casting techniques that enabled him to reproduce the most intricate, complex forms. The rich-

Peter Vischer, statue of King Arthur, one of the freestanding figures of the monument to Maximilian in the Hofkirche, Innsbruck.

ness of motifs, figures, foliage, and grotesques are skillfully subordinated to the whole.

The monument to Maximilian at Innsbruck includes individual figures of King Arthur and King Theodoric that are testimonies to the eminence of Peter Vischer. Other extant examples are four reliefs surviving from a dismantled and destroyed grill. They were intended for the Fugger brothers in Augsburg and are now in the Château Montrottier, Annecy.

The work of Peter Vischer's sons is not clearly identified except for a monument for Margareta Tucherin in Regensburg Cathedral (1521) and the Cardinal Albrecht Memorial (1525) in the Collegiate Church, Aschaffenburg, credited to Hans Vischer. It is probable that Paul Vischer is responsible for the Eisen Memorial in the Agidienkirche, Nürnberg, and Peter Vischer the Younger is thought to have executed the monument for Prince Frederick the Wise.

BIBLIOGRAPHY. G. Dehio, *Geschichte der deutschen Kunst*, Berlin, 1919–34.
BEN P. WATKINS

VISCONTI, ELYSEU D'ANGELO. Brazilian painter (b. Salerno, Italy, 1867; d. Rio de Janeiro, 1944). Visconti was trained in Rio de Janeiro and Paris, and he traveled often in Europe. He used an academic impressionist style (for example, *Maternidade*, 1906; São Paulo, State Art Gallery). Murals (1905) in the Municipal Theater of Rio de Janeiro reflect Puvis de Chavannes.

VISCONTI, LOUIS TULLIUS JOACHIM. French architect (b. Rome, 1791; d. Paris, 1853). He studied with Charles Percier in Paris. Visconti designed fountains, buildings, and monuments, including the tomb of Napoleon at Les Invalides (1843). He designed the New Louvre (1852), which was completed by H. M. Lefuel. *See* LOUVRE PALACE, PARIS.

VISCONTI CASTLE (Castello Visconteo), PAVIA, *see* PAVIA.

VISENTINI, ANTONIO. Italian architect, painter, and engraver (b. Venice, 1688; d. there, 1782). Although trained by Pellegrini, he worked in the style of Canaletto, as a specialist in architectural landscapes. His series of thirty-eight engravings after paintings by Canaletto (1735), drawings for which are in the British Museum, London, and the Correr Museum, Venice, were executed for the Englishman Joseph Smith. Among his surviving paintings are eight of a series of eleven executed in collaboration with Zuccarelli (1646), also for Smith. These caprices depict English buildings in Italian landscapes. Other works in the Gallery of the Academy, Venice, and the Brescia Museum make use of ruins and have a heavy romantic quality not found in Canaletto. Visentini also worked as a palace architect and was a professor of perspective at the Venice Academy and the author of several treatises on the subject.

BIBLIOGRAPHY. F. J. B. Watson, "Notes on Canaletto and His Engravers—II," *The Burlington Magazine*, XCII, December, 1950.

VISHNU (Visnu). Second god of the Hindu trinity. His name is derived from *viṣ* (to pervade). In the Vedas he is a manifestation of solar energy but later comes to the fore as the Preserver, the embodiment of Satvaguṇa, the quality of mercy and goodness. As Nārāyaṇa, he preserves the world between the world cycles. Vishnu's wife is Srī or Lakshmī, and his vehicle is Garuḍa. He has four arms and holds a conch shell, a wheel, a lotus, and a mace; his images usually wear a high headdress. He has 1,000 names, the best known being Ananta (the Endless), Govinda or Gopāla (Cow Keeper), and Puruṣa (the Man). *See* GARUDA; LAKSHMI.

VISIGOTHIC ART. About A.D. 150 the Goths migrated with other German tribes from the Baltic area to southern Russia, where they settled among the Sarmatian tribes. The earliest graves in their new home, such as those at Romashki in the Ukraine and at Marosszentana in Transylvania, have yielded traditional Germanic pottery and crossbow fibulae but nothing that reveals the influence of the steppe culture. Gradually the Goths and Sarmatians merged their arts and developed a Gotho-Sarmatian style characterized by steppe animal forms and decorative techniques such as inset stone and cloisonné. At this time the crossbow fibula acquired a semicircular head plate and a lozenge-shaped foot plate, which became fields for decoration. Gotho-Sarmatian art, which is known from finds made at Kerch, Petrossa, Szilágy-Somlyó, and other sites, could hardly escape provincial Roman influences radiating from the lower Danubian frontier. In the 3d century the Visigoths occupied the region of Dacia and the Ostrogoths held lands farther to the east.

The short-lived Gotho-Sarmatian culture came to an end with the Hunnic invasion of the late 4th century. In 376 the Visigoths were allowed to settle within the Roman Empire. Led by their king, Alaric, they captured Rome in 410. In the same year Atawulf, Alaric's successor, led the Visigoths into southwestern France and Spain, where they established a kingdom that lasted until the Muslim invasion of 711. Little is known of their art and culture during the years of migration. The Visigoths were Arian Christians and that at times they were allied with Rome. In this light one cannot expect much barbarian Visigothic art. However, graves such as those at Herrara de Pisuerga have yielded buckles and fibulae not unlike those of the Goths of eastern Europe. The bird brooches found in Estremadura have Pontic (Black Sea) affinities. What was left of a barbarian art among these Christianized Germans soon disappeared. Some scholars see echoes of the old art in the famous votive crowns of Guarrazar (Paris, Cluny Museum; Madrid, National Archaeological Museum). The works of art found in 7th-century graves at Quintanilla de Lara, Hinojar del Rey, and Herrera de Pisuerga have a completely Mediterranean style with strong Byzantine relationships. By this time barbarian Visigothic art was dead.

Extant Visigothic structures in Spain are S. Juan Bautista at Baños de Cerrato (661), the crypt (673) of Palencia Cathedral, S. Comba at Bande (7th cent.), and the church at S. Pedro de la Nave (ca. 700). The Archaeological Museum at Mérida has a remarkable collection of Visigothic architectural fragments. *See* BANOS DE CERRATO: SAN JUAN BAUTISTA.

BIBLIOGRAPHY. J. Martínez Santa-Olalla, "Sobre algunos hallazgos de bronces visigóticos en España," Ipek, 1931; H. Zeiss, *Die*

Visigothic art. S. Juan Bautista, Baños de Cerrato, Palencia, Spain.

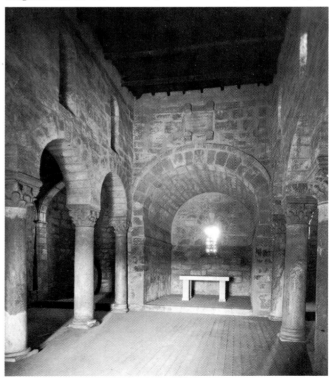

Grabfunde aus dem spanischen westgotenreich, Berlin, 1934; P. Palol Salellas, *Bronces hispano-visigodos de origen mediterráneo*, vol. 1, Barcelona, 1950. HOMER L. THOMAS

VISITA. Type of chapel erected in mission settlements in colonial Florida and the Spanish Southwest during the late 17th and the 18th centuries. The early *visitá*, a "visited" chapel as distinguished from the *asistencia*, or contributing chapel, was in many cases little more than an adobe hut.

VISMARA, GASPARE. Italian sculptor (d. 1651). He is known mainly for his works in the round and in high relief for the Cathedral of Milan, both exterior and interior. These works prolonged the late mannerist tradition to the middle of the 17th century. He was the pupil of Gian Andrea Biffi and his successor as *proto-statuario* for the Cathedral. He headed a family of sculptors who worked at the Cathedral, notably his sons Domenico Vismara and Francesco Vismara.

VISSCHER, CORNELIS. Dutch engraver and painter (1619–62). A brother of Jan and Lambert Visscher, Cornelis was born in Haarlem and was probably a pupil of Pieter Soutman. Visscher is recognized as one of the best portrait engravers of his time, even on a level with Anthony van Dyck. His many portraits—engraved or drawn in crayon or other drawing media—are either after his own designs or after a large variety of painters: Jan de Bray, Van Dyck, Gerard van Honthorst, Guido Reni, Rubens, Titian, and others. He also made a number of genre and animal plates, in his own style or in that of Claes Berchem. His engraving series include *Principes Hollandiae, Zelandiae et Frisiae* (Haarlem, 1650; vols. 3 and 4).

BIBLIOGRAPHY. J. Wussin, *Cornelis Visscher, Verzeichnis seiner Kupferstiche*, Leipzig, 1865.

VISVAKARMA. Sanskrit name meaning "omnificent," originally applied to several of the more powerful Hindu gods, such as Indra or Sūrya. Later it came to designate a personification of the creative power. Specifically, Visvakarmā is the great architect of the universe.

VISVAKARMA CHAITYA HALL, see ELLORA.

VITALE DA BOLOGNA (Vitale d'Aimo de' Cavalli). Italian painter (fl. 1330–53). Vitale worked in Bologna (*The Last Supper* and *St. George and the Dragon*, Pinacoteca; *Madonna dei Denti*, 1345, Galleria Davia Bargellini; frescoes in S. Maria dei Servi; *The Coronation of the Virgin*, 1353, S. Salvatore), Pomposa (apse fresco, S. Maria), and Udine (St. Nicholas cycle, Cathedral). He drew on many cultures, showing a Nordic spirit in his *St. George* (Amsterdam, Rijksmuseum) and the influence of miniature painting in his small panels with their Oriental coloring. His fresco style is lyrical. All of his work is related in one way or another to International Gothic.

BIBLIOGRAPHY. R. Longhi, "La Mostra del Trecento a Bologna," *Paragone*, I, 5, 1950.

VITALIS OF RAVENNA, ST. Purportedly the husband of St. Valeria and the father of SS. Gervase and Protase. While serving as a Roman officer in early Christian times, he was put to various tortures and buried alive for encouraging a would-be martyr. The Church of S. Vitale was founded by Ecclesius in 526 on the supposed site of his martyrdom. He has been confused with St. Vitalis of Bologna. He is sometimes shown on horseback. His attributes are a battle-ax, lance, and mace. His feast is April 28.

See also SAINTS IN ART.

VITARKA. Mudrā, or symbolic gesture in Indian art. In *vitarka* (argument), the arm is bent with the palm outward. The fingers extend upward with the exception of the index or ring finger, the tip of which touches the tip of the thumb.

VITERBO. Italian city in the province of Latium. It was the residence of the popes in the 13th century; the Palace of the Popes (1257–66) has an elegant Gothic Loggia (1267). The Cathedral, built in the 12th century, was remodeled in the 16th and 17th centuries; it has a 14th-century campanile. The Municipal Museum is housed in the former Church of S. Maria della Verità, erected in the 12th century and enlarged in the 14th and 15th centuries; the adjoining cloister dates from the 13th century. The medieval quarter of the city survives almost intact, and has picturesque Gothic houses and palaces. Of the many medieval fountains, the finest is the Great Fountain (1206–79).

VITI, TIMOTEO. Italian painter (b. Urbino, 1469/70; d. there, 1523). Originally he seems to have been a goldsmith and probably a student of Giovanni Santi, Raphael's father. From 1490 to 1495 Viti is thought to have worked in Bologna with Francesco Francia, first as a goldsmith and then as a painter. At this point in his career his work shows the influence of Lorenzo Costa, an associate of Francia. Returning to Urbino, he finished a painting begun by Giovanni Santi and Evangelista di Piandimeleto in the *studiolo* of Duke Guidobaldo II. This painting was a part of the cycle *The Muses with Apollo* (Florence, Corsini Collection). During the years from 1495 to 1500 he may have exerted an influence on the young Raphael, but this is open to question. He is also known to have executed paintings on glass and compositions for majolica, possibly at this time. A second trip to Bologna about 1500, where he would have come in contact with the mature works of Francia, has been suggested.

In 1504, when Cesare Borgia captured Urbino, it was Viti who painted the Borgia arms on the city gate. His painting before 1500 reveals borrowings from Francia, but by 1504 he had moved closer to Perugino, as seen in the painting *SS. Thomas and Martin with Two Worshipers* (Urbino, National Gallery of the Marches), done in association with Girolamo Genga for the chapel of Bishop Giampietro Arrivabene in the Cathedral of Urbino. Although in 1508 he was looking once again to Francia in *Magdalen* (Bologna, National Picture Gallery), within ten years forms from Raphael had obviously attracted him, and *The Vision of St. Magdalen* (1521; Gubbio Cathedral) has a grandeur and a nobility which are distinctly Raphaelesque. This spirit, however, never displaces the Quattrocento schemes of his earlier works.

If Vasari is to be believed, Viti assisted Raphael in the

painting of the *Sibyls* and *Prophets* in S. Maria della Pace, Rome, in 1514, but this has been questioned by contemporary critics. Some of his drawings are so close to those of Signorelli that they have been attributed to that artist. In spite of this confusion, however, many of these drawings, worked in chalk and charcoal, are of fine quality. It was in his drawings that Viti's talent found its most vigorous expression.

BIBLIOGRAPHY. A. Venturi, *Storia dell'arte italiana*, vol. 7, pt. 3, Milan, 1914.

NORMAN W. CANEDY

VITONI, VENTURA. Italian architect of the Tuscan school (1442–1522?). He was a follower of Brunelleschi and, among his contemporaries, is related to Giuliano da Sangallo. Vitoni designed the churches of S. Chiara (1494–98) and S. Giovanni Battista (begun 1500) and directed the execution of the Church of the Madonna dell'Umiltà (designed by Giuliano da Sangallo in 1492), all in Pistoia. Vitoni's contribution to Renaissance architecture was his formulation of a longitudinal church fitted in under a dome.

VITRUVIUS (Marcus Vitruvius Pollio). Roman architect and engineer (fl. 1st cent. B.C.). Vitruvius appears to have served as a military engineer under Julius Caesar in one of his campaigns in 46 B.C. He wrote one masterwork, *De architectura libri X*, composed of ten books in which he expounded his principles of architecture. It is especially valuable for its mention of the names of many Greek architects and for its discussion of the techniques employed by Greek architecture, and it had a far-reaching effect on Renaissance architectural theory. Vitruvius dedicated the whole body of his work to the emperor Augustus. The first book deals with city planning, the second with the materials used in building, the third with the temples, and the fourth with the orders of architecture. The remaining books are devoted, respectively, to public buildings, private houses, interior decorations, waterworks, instruments and sundials, and military engineering. The earliest editions of his work are those by Schneider (3 vols., Leipzig, 1807–08) and Stratico (4 vols., Udine, 1825–30).

BIBLIOGRAPHY. Vitruvius Pollio, *On Architecture*, tr. F. Granger, 2 vols., London, 1931–34.

VITTONE, BERNARDO. Italian architect of the school of Turin (1704/05–70). After studying in Rome, Vittone returned to his native Turin. He came to know closely the later works of Filippo Juvara, which were then under way, and collaborated as an editor of Guarino Guarini's *Architettura Civile*. His own style is a kind of reconciliation of the sober, classical tradition of Juvara with the bizarre manner of Guarini. Vittone's special genius was the design of small, centralized churches marked by the originality of the vaulting techniques of their domes. He was able to create fantastic, diaphanous effects through his development of the pendentive squinch (1751–54; Turin, S. Maria della Piazza) and of multiple vaulting zones (1738–39; the triple-vaulted dome of the Chapel of the Visitation at Vallinatto near Carignano). Vittone's other church designs are S. Chiara at Brà (1742), S. Gaetano at Nice, S. Bernardino at Chieri (1740–44), the church of the almshouse at Carignano (before 1749), Sta Croce at Vil-

lanova di Mondovì (1755), and the church at Riva di Chieri (begun in 1766). Vittone had several followers in Piedmont who carried his highly original phase of the late baroque to the end of the 18th century.

BIBLIOGRAPHY. E. Olivero, *Le Opere di Bernardo Antonio Vittoni*, Turin, 1920; R. Wittkower, *Art and Architecture in Italy, 1600–1750*, Baltimore, 1958.

HELLMUT WOHL

VITTORE DEL GALGARIO, FRA, *see* GHISLANDI, GIUSEPPE.

VITTORIA, ALESSANDRO. Italian architect, sculptor, and stucco worker of the Venetian school (1525–1608). He worked in Venice. He was a pupil and follower of Il Sansovino and of Palladio. Vittoria designed the Balbi Palace on the Grand Canal (1582–90) and the Scuola di S. Gerolamo (1592–1600; now the Ateneo Veneto). His importance as a sculptor far exceeds that as an architect. He did many portrait busts, altars, small bronzes, and statues (among them two figures of St. Jerome in S. Maria dei Frari and in SS. Giovanni e Paolo). His style shows the transition from mannerism to the baroque, and his figures have a certain affinity with those of Tintoretto. Vittoria had a large following among the sculptors of the Veneto.

BIBLIOGRAPHY. J. Pope-Hennessy, *Italian High Renaissance and Baroque Sculpture*, 3 vols., London, 1963.

VITTOZZI, ASCANIO. Italian military engineer and architect (1539–1615). A native of Orvieto, Vittozzi made new plans for the city of Turin. His SS. Trinità (begun in 1598) uses a star-hexagon plan; his façade of the Corpus

Antonio Vivarini, detail of altarpiece, 1446. Academy, Venice.

Domini (1607) shows an early baroque style. He is most famous for his oval plan of the Sanctuary of Vico (begun in 1594).

VIVARINI, ALVISE. Venetian painter (ca. 1446–1503/05). He was a son of Antonio Vivarini and a pupil of his uncle Bartolommeo Vivarini. More old-fashioned and less talented in his time than Giovanni Bellini, Alvise yet evolved a personal style from his traditional base, developed it, and affected many important pupils.

His first known work, the polyptych in the village of Montefiorentino (1475), shows elongated linear figures. His first mature works include the Venice Academy polyptych (1480) and single figures, with a less cutting line, evoking energy through pose. Then a more classic Renaissance approach is predicted both in works with twisted poses but milder forms (polyptych, 1485; Naples, Capodimonte) and in others with nervous line but calm, upright stance (altarpiece, Berlin, former State Museums). By 1489 a classicistic, rather empty balance appears, in the *Capodistria Altarpiece* and in a Madonna in Il Redentore, Venice. These works were much admired by Victorian observers.

In 1488 Vivarini was appointed to share with Giovanni Bellini a major series of works at the Doge's Palace, but since neither these nor other large works were finished at his death it is thought he was in poor health; in 1491 he made a will. But the few late works are unusually individual on the scale of average Venetian style. A portrait (1497; London, National Gallery), which is the only signed one and is unlike the many once attributed to him, is loose in form and more psychologically complex than those of Giovanni Bellini. The *Madonna and Four Saints* (Berlin, former State Museums), with its casual, tired figures, loose drawing, and expressive faces, is still old-fashioned in keeping solid form from merging with atmosphere; the chief modern trend in Venice at that moment—and the one that led to modern art—was thus ignored. But his interests were basic to his young pupils, notably Lorenzo Lotto. Jacopo de' Barbari, the pupil closest to him, probably painted works officially by Alvise, especially the *Resurrection* (1498; Venice, S. Giovanni in Bragora), where the very original pose and space have always led observers to guess that a pupil intervened. An altarpiece left unfinished at his death was painted almost entirely by Marco Basaiti.

BIBLIOGRAPHY. R. van Marle, *The Development of the Italian Schools of Painting*, vol. 18, The Hague, 1936; C. Gilbert, "Alvise e compagni," *Studi di storia dell'arte in onore di Lionello Venturi*, Rome, 1956.

CREIGHTON GILBERT

VIVARINI, ANTONIO. Venetian painter (ca. 1415/20–1476/84). He was the oldest of a family called the "school of Murano" after their birthplace. They were the chief exponents of late Gothic painting in Venice in their time, and were often contrasted with the modern and influential Bellini. Antonio almost always collaborated, first with his sister's husband, Giovanni d'Alemagna (d. 1450), and then with his brother, Bartolommeo Vivarini. Every possible theory has been offered on the share that each individual contributed, but partnership is integral to their work. Since the only early work by Antonio alone is somewhat unlike

subsequent works, it is possible that Giovanni was the leading designer and the style was continued unaltered after his death.

Probably the earliest major work is *The Adoration of the Magi* (Berlin, former State Museums); it is completely International Gothic, with gold leaf, rich costumes, stylized linear arabesques, realistic animals, and shadowy landscape. The round, soft faces recur in the signed works of 1441–50. After one work now in the Vienna Museum of Art History (1441) and a set of three in S. Zaccaria, Venice (1443), the masterpiece is the Venice Academy altarpiece (1446). Gorgeously ornamental, it discards the polyptych system for a single measured space with solid figures, yet the details are still full of jewelry and curlicues. The source was Gentile da Fabriano and especially Masolino, but reduced from personal style to a common denominator. Antonio's *Parenzo Polyptych* (1443) is plainer and less accomplished.

Two polyptychs were done in collaboration with Bartolommeo; the more important one (1450; Bologna Gallery) is dominated by its cathedral-like frame, and the figures may be Bartolommeo's. But they differ little from Antonio's chief late work, the Vatican polyptych (1464), except in the traditional round, soft heads of the latter. Both bow to the new ideas of Andrea Mantegna. Several sets of small narrative paintings by Antonio (Berlin, New York, Washington, and elsewhere) combine clarity of color and architecture with sweet surface and naïve gesture.

BIBLIOGRAPHY. L. Testi, *La Storia della pittura veneziana*, vol. 2: *Il divenire*, Bergamo, 1915; B. Berenson, *Italian Pictures of the Renaissance: Venetian School*, rev. ed., 2 vols., London, 1957.

CREIGHTON GILBERT

VIVARINI, BARTOLOMMEO. Venetian painter (1431/32–91 or later). He was the brother of Antonio Vivarini. In 1448 Bartolommeo signed a Madonna "at age 16" in rivalry with the young Andrea Mantegna, and in 1450 became his brother's partner when Giovanni d'Alemagna died.

Vivarini's most personal work is *St. John Capistrano* (Paris, Louvre), where the delicate characterization recalls Gentile Bellini and the drawing is less sharp than later. By 1464 (*Madonna*, Naples, Capodimonte) he had established a routine style, hard and bright, with clichés based on Mantegna. He is known today mainly because his excellent craftsmanship has led to the preservation of many of his paintings, which are often signed.

BIBLIOGRAPHY. L. Testi, *La storia della pittura veneziana*, vol. 2: *Il divenire*, Bergamo, 1915; B. Berenson, *Italian Pictures of the Renaissance: Venetian School*, rev. ed., 2 vols., London, 1957.

VIVIAN BIBLE. Carolingian illuminated manuscript, in the National Library, Paris.

VIVIEN, JOSEPH. French portrait painter and pastelist (b. Lyons, 1657; d. Bonn, 1734). He was a pupil of Charles Le Brun (1667), an academician (1701), and a councillor (1703). He worked in Brussels, Munich (1710 and 1734), and Cologne. He was among the first to practice pastel portraiture in 18th-century France. His portraits stiffly emulate the style of Hyacinthe Rigaud, and the characterization is more vigorously sober.

BIBLIOGRAPHY. P. Ratouis de Limay, *Le Pastel en France au XVIIIe siècle*, Paris, 1946.

VLADIMIR: CATHEDRAL OF ST. DMITRI. Dedicated to St. Demetrius of Salonika and built between 1193 and 1197, it is the best-preserved example of the Vladimir-Suzdal group of Russian stone churches. The typically square plan encloses a Greek cross. It has three apses, a single dome supported by four piers, and entrances at the middle of each side. The dome is flat and rises from a circular drum pierced by tall, narrow windows. These windows are flanked by niches filled, alternately, with animal and bird reliefs, and enclosed in vine scrolls. Each façade is divided into three vertical panels by slim, engaged columns which rise uninterruptedly from the ground to terminate in arches below the roof. The panels are decorated with reliefs of plants, animals, and figures of saints.

BIBLIOGRAPHY. A. Voyce, *Russian Architecture*, New York, 1948; S. H. Cross, *Mediaeval Russian Churches*, Cambridge, Mass., 1949.

VLAMINCK, MAURICE. French painter (b. Paris, 1876; d. Rueil-la-Gadelière, 1958). His parents were musicians and led a Bohemian existence, so that the young Vlaminck received little schooling. He knew Derain as a boy, and the two artists were lifelong friends. In 1895 he took a few drawing lessons. After 1899 he earned his living as a violinist, but he and Derain set up a studio at Chatou, and he came to know impressionist art. When he saw the Van Gogh exhibition at Bernheim-Jeune's in 1901, he was overwhelmed, and his own painting began to show the influence of Van Gogh. He met Matisse the same year and exhibited for the first time at the Salon des Indépendants. He wrote his first novel in 1901, and two others followed shortly.

By 1905 he and Derain began to frequent a favorite café of avant-garde artists, the Azon in Montmartre. There they met Picasso, Max Jacob, Kees van Dongen, Apollinaire, Matisse, and others. Vlaminck exhibited with a group at Berthe Weill's and at the Salon d'Automne. It was at the latter that a critic referred to the art as that of wild beasts, or *fauves*, a name which the painters themselves then adopted and which has since been used to designate the art of the group at that time. Vollard purchased all the pictures in Vlaminck's studio in 1906.

In 1908 Vlaminck changed his style radically. He moved away from Fauvism and closer to the late Cézanne. In 1919 he was given an extensive exhibition at Drouet's in Paris. In 1925 he moved to Rueil-la-Gadelière, where he was to spend most of the rest of his life.

Vlaminck was rebellious by temperament. He proudly announced that he had never been inside the Louvre and that he wanted to burn down the Ecole des Beaux-Arts with his cobalts and vermilions. He favored brilliant color, straight from the tube. He would combine bright reds with full oranges and heighten their intensity with bright

Maurice Vlaminck, *The Seine River at Nanterre*, 1902. Private collection, Geneva. An early work by the Fauvist.

blues and greens. Like Van Gogh, he favored the pull of forced perspective. Despite all his anarchical intent, he developed little as a Fauve. He chose landscape subjects not unlike those of the impressionists. His art appears limited and brash compared to Matisse's, but almost restrained compared to that of the German expressionists.

Vlaminck admitted that he had exhausted the potential of pure color by 1908 and sensed a frustration when he tried to hit harder with each new work. In 1908 he painted *Baigneuses*, then a series of landscapes and still lifes in dark tones. A typical landscape features thickly pigmented clouds of oyster white slashed through grays and Prussian blues, deep perspectives, ravaged trees, and soil.

BIBLIOGRAPHY. M. Sauvage, *Vlaminck, sa vie et son message*, Geneva, 1956.

ROBERT REIFF

VLIEGER, SIMON JACOBSZ. DE. Dutch painter of seascape, landscape, genre, and animals; also tapestry designer (b. Rotterdam, ca. 1600; d. Weesp, 1653). On the basis of stylistic evidence it is generally assumed that he was a pupil of Julius Porcellis. De Vlieger married in Rotterdam in 1627 and was still living there in 1633. He entered the Delft painters' guild in 1634 and apparently remained in that town until 1638, when he was reported in Amsterdam. He seems to have spent the following years in Amsterdam. He received various payments for tapestry cartoons for the city of Delft, however, and he later received various other commissions from Delft as well as from the city of Rotterdam.

Although he painted other subjects De Vlieger is best known for his seascapes. His dramatic renderings of storms are an important contribution to the development of this Dutch seascape type, and he seems to have preceded even Porcellis in this genre (*Rescue*, 1630). Works such as the 1631 *Seascape with a Boat* (Berlin, former State Museums), however, are more directly dependent upon Porcellis. De Vlieger's style is important for such later painters as Van de Cappelle, Hendrick Dubbels, and others.

BIBLIOGRAPHY. P. Haverkorn van Rijsewijk, "Simon Jacobsz. de Vlieger," *Oud-Holland*, IX, 1891 and XI, 1893; N. Maclaren, *National Gallery Catalogues: The Dutch School*, London, 1960; W. Stechow, *Dutch Landscape Painting of the Seventeenth Century*, London, 1966.

LEONARD J. SLATKES

VLIET, HENDRICK CORNELISZ. VAN. Dutch painter (b. Delft, 1611/12; d. there, 1675). He studied with his uncle, Willem van Vliet, and with Mierevelt. A portraitist through most of his career, he turned to architectural painting in the 1650s, following the lead of Gerard Houckgeest. His interior views of the Oudekerk and other churches in Delft lack the precision and breadth of those of Houckgeest.

VLIET, JAN GEORG VAN. Dutch etcher and painter? (b. Delft, ca. 1610). Van Vliet was in Rembrandt's workshop in 1631 and became one of the first disseminators of the master's painting. His early plates, done while he was still in Rembrandt's shop, are so masterful that they have caused confusion with those of Rembrandt himself. His later works are more coarse.

BIBLIOGRAPHY. A. von Wurzbach, *Niederländisches Künstler-Lexikon*, vol. 2, Vienna, 1910.

VLIET, WILLEM WILLEMSZ. VAN (Der). Dutch painter of portraits and history (b. Delft, 1583/84; d. there, 1642). Little is known of Van Vliet's early background or training. In 1613 he was recorded as a member of the Delft Guild of St. Luke. His few surviving works are all portraits and are dated between the years 1624 and 1640 (*Portrait of Suitbertus Purmerent*, 1631; London, National Gallery). His nephew, Hendrik Cornelisz. van Vliet, a specialist in the rendering of church interiors, was his pupil and executed some portraits in his manner.

BIBLIOGRAPHY. N. Maclaren, *National Gallery Catalogues: The Dutch School*, London, 1960.

VLUGT, L. C. VAN DER, see BRINKMAN, J. A., AND VAN DER VLUGT, L. C.

VOET (Vouet), JACOB FERDINAND. Flemish portrait painter (1639–ca. 1700). Voet is thought to have been born in Antwerp and to have died in Paris. He worked mainly in Rome, where he was painter at the papal court. His chief portraits were those of Christine of Sweden and Cardinals Dezio Azzolini and Ludoviso, and a self-portrait in the Uffizi Gallery, Florence. Stylistically, he was a close follower of Carlo Maratta.

VOGELS, GUILLAUME. Belgian painter of landscapes, flowers, still lifes, and water colors (b. Brussels, 1836; d. Ixelles, 1896). His artistic career spans only the last fifteen years of his lifetime, starting with the public exhibition of *Canal in Holland* in 1881. Before that, he had been a house painter and had also done decorations.

Vogels was a friend of Pantazis, Théo Hannon, and Fritz Toussaint. Since he was also a familiar of certain taverns, he encountered there Johann Toorop (who did a portrait of Vogels, in the Brussels Museum of Modern Art) and James Ensor. Furthermore, he joined the avant-garde circle La Chrysalide. Vogels's mode of expression was that of a tachiste-impressionist blending; he was an ardent and moving virtuoso of the brush who excelled in annotations of various moods. This self-made man is now considered the outstanding exponent of impressionism in Belgium. *Snow Evening* and *Lightning* (both Brussels, Museum of Modern Art) are characteristic of his art.

BIBLIOGRAPHY. P. Colin, *La Peinture belge depuis 1830*, Brussels, 1930; L. Larsen-Roman, *Guillaume Vogels* (in preparation).

VOIS, ARY (Arie) DE (Adriaen de Voys). Dutch painter of portraits, genre, and history (b. Utrecht, 1631–34; d. Leyden, 1680). De Vois was the son of the organist Alewijn Pietersz. de Voys, who moved to Leyden in 1635. He was a pupil of Nicolaes Knüpfer in Utrecht and of Abraham van den Tempel in Leyden. In 1653 he entered the Leyden Guild of St. Luke. He married well and therefore painted little. His style is related to that of Gerrit Dou and Frans van Mieris.

BIBLIOGRAPHY. B. J. A. Renckens, "Drie zelf-portretten van A. de Voys," *Oud-Holland*, LXV, 1950.

VOLCANUS, see VULCAN.

VOLLARD, AMBROISE. French art dealer, publisher, collector, and critic (b. Réunion, 1865; d. Paris, 1939). Vollard's penchant for collecting exhibited itself early; at

four, he collected pebbles and bits of broken crockery and a little later became an avid connoisseur of stuffed birds and animals. He wanted to be a doctor but after witnessing an operation decided to study law in Paris. In 1890, he moved to the Latin Quarter, where he befriended many artists who later became great, and frequented such cafés as the Chat Noir and the Moulin Rouge. Masterpieces could be bought quite cheaply, but for a time Vollard contented himself with the occasional purchase of prints and drawings.

His apprenticeship as an art dealer was spent at Alphonse Dumas's Union Artistique, where he acted as a clerk. In 1893, he went into business for himself, at first favoring the fashionable painters of the day. In 1895, he organized the first Cézanne exhibition, which provoked a scandal. Though the general public was outraged, the lovers of modern art made Vollard's shop a rallying point for what was new and fresh in painting.

His second Cézanne exhibit, in 1898, was followed by one devoted to the works of the Nabis in 1899. Picasso first showed at Vollard's in 1901; Matisse, in 1904. Fauvism flourished there in 1906, after Vollard acquired the contents of Vlaminck's studio. In 1907, he met Rouault; later Rouault was provided with a studio in Vollard's home. His dealings were not limited to paintings; bronzes by Rodin, Renoir, Maillol, and Picasso were always welcome in his shop.

Vollard's interest began to center on art publishing by 1905, when he brought out a collection of lithographs by Bonnard, Toulouse-Lautrec, and Vallotton. Classic and contemporary literature illustrated by Denis, Bernard, Picasso, Degas, Redon, and Rouault followed. Redon, Rouault, and Renoir produced illustrations for a number of Vollard's own works. He published lavish volumes on Cézanne, Renoir, and Degas. Most of the giants of modernism reciprocated by repeatedly painting his portrait.

In addition to his role as dealer and publisher, Vollard was a magnetic personality who combined a love of art and artists with a sharp business sense. His outstanding service to modern art was his early recognition and promotion of great painters before they had become generally accepted.

BIBLIOGRAPHY. A. Vollard, *Souvenirs d'un marchand de tableaux*, rev. ed., Paris, 1948.

FRANKLIN R. DIDLAKE

VOLMARIJN, CRIJN HENDRIKZ.

Dutch painter of genre and history (fl. Rotterdam, 1604–45). His style suggests a direct contact with the Utrecht painter Gerrit van Honthorst. Volmarijn's paintings are usually illuminated by candles and other artificial light sources. His work is often confused with that of the French painter Trophime Bigot. Many works usually assigned to Volmarijn have been convincingly assigned to Bigot by Nicolson, leaving only a few certain paintings by Volmarijn.

BIBLIOGRAPHY. S. J. Gudlaugsson, "Crijn Hendricksz. Volmarijn, een Rotterdamse Caravaggist," *Oud-Holland*, LXVII, 1952; B. Nicolson, "The Rehabilitation of Trophime Bigot," *Art and Literature*, IV, 1965.

VOLPATO, GIOVANNI.

Italian engraver (b. Bassano, ca. 1733; d. Rome, 1803). He studied under Bartolozzi and Giuseppe Wagner in Venice and then settled in Rome, where he founded a popular school of engraving. Volpato engraved chiefly after Italian masters, especially Raphael.

BIBLIOGRAPHY. A. de Vesme, *Le Peintre-graveur italien*, Milan, 1906.

VOLPI, ALFREDO.

Brazilian painter (1895–). Born in Lucca, Italy, Volpi has become one of the leading artists of Brazil, where he has lived since infancy. He is largely self-taught. His most distinctive motifs are derived from the parallel, rectilinear patterns of row houses. These are reduced to simple flat areas of color to the point that his paintings have become completely abstract in recent years. In 1953 Volpi was awarded a prize in the biennial exhibition in São Paolo.

BIBLIOGRAPHY. J.-A. França, "Volpi," *Aujourd'hui*, VIII, July, 1964.

VOLTA RIVER, see AFRICA, PRIMITIVE ART OF (WEST AFRICA: UPPER VOLTA).

VOLTERRA, DANIELE DA (Daniele Ricciarelli).

Italian painter (b. Volterra, 1509; d. Rome, 1566). He studied with the Sienese painter Sodoma, but the brittle classicism of Daniele's early fresco in the Palace of the Priors in Volterra (1532), depicting an allegory of Justice, indicates the influence of the Sienese painter and architect Baldassare Peruzzi. Daniele probably accompanied Peruzzi to Rome, where he settled in 1535. In his fresco frieze (1538) for Peruzzi's Massimo alle Colonne Palace, the influence of Michelangelo is already apparent in the exaggerated geometry and plasticism of forms and in the density of linear rhythm within a constricted spatial setting.

Although Daniele was himself prominent among the second-generation mannerists in Rome, the remainder of his career was linked almost servilely with the life and works of Michelangelo. The fresco of the *Descent from the Cross* in the Church of Trinità de' Monti, Rome, is an eclectic work that derives compositionally and in some details from an earlier painting of the same subject by Daniele's compatriot Rosso. But more evident are the idealized figures and dynamically posed, monumental forms of Michelangelo, gesticulating divergently in the compressed space in the manner of the Sistine Chapel *Last Judgment*. The loose, undulating line creates an abstract pattern that is typical of mannerist painting of this period.

The frescoes in S. Marcello, Rome, date from 1543, at which time Daniele was closely associated with Miche-

Daniele da Volterra, detail of the fresco frieze *Stories of Fabius Maximus*, 1538. Palazzo Massimo alle Colonne, Rome.

langelo, creating several paintings from the master's drawings, including a series on David and Goliath (1542–45). In 1549 Daniele was made superintendent of the works in the Vatican by Pope Paul III on the recommendation of Michelangelo, but he was deprived of the post two years later. In 1550 he executed a fresco frieze in the Farnese Palace.

In his later years Daniele, perhaps following the example of Michelangelo, devoted himself primarily to sculpture. One of his last painting commissions was for the *Murder of the Innocents* in S. Pietro, Volterra (1557). Unable to take on the commission for the equestrian monument of Henry II of France, Michelangelo transferred it to Daniele. Michelangelo provided the drawings, but only the horse was executed (1559–65). The original was destroyed in the French Revolution, but a cast of the horse stands in the Cour du Cheval Blanc at Fontainebleau. As a companion of Michelangelo's last years, Daniele wrote most of the failing master's correspondence and was present at Michelangelo's deathbed. He provided plans for the master's tomb, which were not used. His last work was a bronze bust of Michelangelo, based on the death mask (one cast is in the Louvre, Paris). It is ironic that Daniele was the first artist assigned by Pope Paul IV (1559) to paint draperies on the nude figures of Michelangelo's *Last Judgment*. For this he, as well as each of the artists who continued the work, was known as "Il Braghettone" (the breeches maker).

BIBLIOGRAPHY. M. L. Mez, *Daniele da Volterra*, Volterra, 1935.

DONALD GODDARD

VOLTERRA, FRANCESCO DA (14th cent.), *see* FRANCESCO DA VOLTERRA.

VOLTERRA, FRANCESCO DA (Francesco Capriani). Italian architect (d. 1601, not earlier). His early activity as a wood carver is recorded by Vasari. In architecture he was a notable follower of Vignola, particularly in his use of the oval plan in S. Giacomo degli Incurabili in Rome (begun 1592). He was also an important façade designer.

BIBLIOGRAPHY. M. Zocca, "L'Architetto di San Giacomo in Augusta," *Bollettino d'arte*, XXIX, 1936.

VOLTERRANO, IL, *see* FRANCESCHINI, BALDASSARE.

VOLTO SANTO OF LUCCA. So-called "holy face" (11th–12th cent.), housed in a little temple within the Cathedral of Lucca, Italy. It is an image of the crucified Christ, of Byzantine iconography, clothed in the colobium (mentioned by Dante in *The Divine Comedy*, Inferno 41:28).

VOLTRI, NICCOLO DA. Italian religious painter (fl. Genoa, 1385–1417). His work shows the influence of Barnaba da Modena and Taddeo di Bartolo. Niccolò da Voltri's study of German masters is also in evidence. In the Vatican Museums, Rome, is a dated polyptych (1401) painted for the Church of the Madonna delle Vigne, Genoa.

VOLUME. In painting a sense of volume exists when the illusion of three-dimensional space is emphasized; in sculpture it appears when the fullness of plastic form predom-inates; and in architecture, when the articulation of space is dominant.

VOLUTE. Spiral scroll (Latin *voluta*) associated especially with the Ionic capital and found also in the Corinthian and Composite orders. The volutes in Mycenaean jewelry and those of the Ionic capital emerge from Egyptian and Mesopotamian examples. The Ionic capitals in Delos, Naucratis, and Delphi link early with later types. The distinctive Ionic capital has scrolls on two sides only in Greek work, although angle volutes are found in Bassae. Angle volutes, producing a volute for each of the four sides of the Ionic capital, were adopted in Roman architecture, as in Pompeii and the Temple of Saturn, Rome.

VONCK, ELIAS. Dutch still-life painter (b. Amsterdam, 1605; d. there, 1652). Little is known of Vonck's early training. His work is influenced by the styles of Frans Snyders and Melchior d'Hondecoeter. His son Jan Vonck was his pupil.

BIBLIOGRAPHY. I. Bergström, *Dutch Still-Life Painting in the Seventeenth Century*, New York, 1956.

VONCK, JAN. Dutch still-life painter (b. Amsterdam, ca. 1630; d. 1662 or after). He was the son and pupil of Elias Vonck. Jan painted still-life subjects with birds and fish.

BIBLIOGRAPHY. A. P. A. Vorenkamp, *Bijdrage tot de geschiedenis van het Hollandsch stilleven in de zeventiende eeuw*, Leyden, 1934.

VON DER HEIDE, HENNIG. German wood carver (fl. Lübeck, ca. 1490–1510). A late Gothic master, he stands stylistically close to Bernt Notke. Von der Heide's major work is *St. George and the Dragon* (1504; Lübeck, St. Annen Museum). His other outstanding work was the *St. Johannes* figure (Lübeck, Marienkirche; destroyed in World War II).

BIBLIOGRAPHY. C. G. Heise, *Lübecker Plastik*, Bonn, 1926.

VON HEILBRONN, HANS, *see* SEYFER, HANS.

VOORHOUT, JOHANNES. Dutch painter of portraits, genre, and history (b. Uithoorn, 1647; d. Amsterdam, 1723). He was a pupil of Constantijn Voorhout in Gouda (1666–69) and of Johan van Noort in Amsterdam. At the time of the French invasion (1672) Voorhout went to Friedrichstadt, where he was associated with Jurriaen Ovens. Later Voorhout went to Hamburg, but was back in Amsterdam in 1707.

BIBLIOGRAPHY. H. Schmidt, *Jürgen Ovens: Sein Leben und seine Werke*, Kiel, 1922.

VOORT, CORNELIS VAN DER. Flemish-Dutch painter (b. Antwerp, ca. 1576; d. Amsterdam, 1624). He was a solid portrait painter in the tradition of Frans Pourbus the Elder. Voort decisively influenced such Dutch artists as Nicolaes Eliasz. Pickenoij and Thomas de Keyser.

VORDEMBERGE-GILDEWART, FRIEDEL. Dutch painter and designer (1899–). Born in Osnabrück, Germany, he studied architecture in Hannover. From his first works of 1919, based on constructivist principles, his style has been consistently nonobjective. In 1924 he joined de

Stijl at the invitation of Van Doesburg, and he was later a member of the Abstraction-Création group in Paris. Based upon Van Doesburg's elementarism, his paintings are of strongly colored geometric shapes in superbly balanced compositions.

BIBLIOGRAPHY. H. L. C. Jaffé, *De Stijl, 1917–1931*, Amsterdam, 1956.

VORONIKHIN, ANDREI NIKIFOROVICH. Russian architect (1760–1814). A pupil of De Wailly, he worked in St. Petersburg. His most important works, the Cathedral of the Virgin of Kazan and the Academy of Mines, are outstanding examples of the first stage of the neoclassic style and of the major position held by St. Petersburg in this movement. *See* KAZAN CATHEDRAL, LENINGRAD.

BIBLIOGRAPHY. V. A. Panov, *Arkhitektor A. N. Voronikhin*, Moscow, 1937.

VORONTSOFF PALACE, LENINGRAD, *see* RASTRELLI, BARTOLOMMEO FRANCESCO.

VORSTERMAN, LUCAS EMIL I. Flemish engraver (b. Bommel, 1595; d. Antwerp, 1675). He seems to owe his considerable skill to his early and short association with Rubens's Antwerp workshop (ca. 1620–24). Vorsterman was in the service of Sir Thomas Arundel in England, where he did a number of engravings and drawings in a manner far less refined than those he had done in Rubens's shop. He returned to Antwerp about 1630 and was employed by Anthony van Dyck in the production of his *Iconographie* (28 engraved portraits). Vorsterman's other plates are mostly after Adriaen Brouwer, G. Gehers, Cornelis Schut, Raphael, Holbein, and Elsheimer. Among Vorsterman's pupils were Paul Pontius and M. and J. Mitdoeck.

BIBLIOGRAPHY. H. Hymans, *La gravure dans l'école de Rubens*, Brussels, 1879.

VORTICISM. Variety of cubist futurism, exclusive to England, that was invented by Wyndham Lewis (1884–1957). The movement's manifesto was *Blast*, published in June, 1914. In 1912 Lewis had made his first drawings, which are now recognized as vorticist (the word itself was coined by Ezra Pound in the following year). Vorticism rejected futurism as being too impressionist and sought a purely abstract art which was characterized by flat systems of arcs and angles forming a special focal point (the vortex) to draw the spectator into a whirling recession. Like cubism and futurism, vorticism accepted the machine world and emphasized machine forms. In June, 1915, at the Doré Gallery, there took place the first (and last) vorticist exhibition. After 1915 vorticism died out, and Lewis's work became more figurative, as in his *Portrait of Edith Sitwell* (1921; London, Tate). *See* LEWIS, WYNDHAM.

BIBLIOGRAPHY. C. Handley-Read, ed., *The Art of Wyndham Lewis*, London, 1951; J. Cassou, ed., *The Sources of the Twentieth Century: The Arts in Europe from 1884 to 1914* (exhibition catalog), Paris, 1960.

VOS, CORNELIS DE. Flemish painter of portraits and religious compositions (b. Hulst, ca. 1585; d. Antwerp, 1651). He was a brother of Paul de Vos and a pupil of

Lucas Emil Vorsterman, *The Triumph of Poverty*, after Hans Holbein the Younger. Engraving. Austrian National Library, Vienna.

David Remeeus. Between 1604 and 1608 Cornelis traveled abroad. He was inscribed as a master in the Guild of St. Luke in 1608, and served as dean in 1618–20. In 1616 he bought Antwerp citizenship, in order to deal in paintings.

De Vos is primarily a neat and meticulous portrait painter. His style derives from Rubens and sometimes parallels that of Van Dyck, but never attains the fluidity and sensibility of either. Chronologically, his first authenticated work is the *Portrait of A. Grapheus* (1620; Antwerp, Royal Museum). His model was the messenger of the Guild of St. Luke, who sat for many contemporary artists. This painting translates the old servant's wrinkled face with the honest application that is to be encountered in all his subsequent works. The *Portrait of the Artist and His Family* (1621; Brussels, Musée Ancien) is fully signed and dated, and is hence a marker for critical appreciation of the painter's style. His conception has been called "naïve and objective." The execution of details is dry, factual, and linear rather than painterly. Nevertheless, art historians have, for reasons of superficial resemblance, crowded his catalog with works that, though less inspired, rightly belong to Rubens or, more often, Van Dyck.

De Vos excelled in children's portraits. His *Two Daughters of the Artist* (Berlin, former State Museums, Picture Gallery) and *Child Playing* (Frankfurt am Main, Städel Art Institute and Municipal Gallery), which is signed and dated 1627, rank among works that have always been highly esteemed, and that show the artist in a most favorable light. Rounded hands and clumpy fingers, however, ensure that there will be no confusion with Van Dyck.

A lesser-known aspect of the artist becomes adequately exemplified by *The Host and the Church Vessels Returned to St. Norbert* (1630; Antwerp, Royal Museum), in which the Snoeck family is portrayed in a religious setting. Dependence upon Rubens can be pointed up in this and similar works, which are easily recognizable from a grayish color scheme.

BIBLIOGRAPHY. J. Muls, *Cornelis de Vos, Schilder van Hulst*, Antwerp, 1933; E. Greindl, *Corneille de Vos*, Brussels, 1944.

ERIK LARSEN

VOS, JAN (Johannes) DE. Dutch landscape painter (b. Leyden, 1593; d. there, 1649). Little is known of the early training and activity of this rare Leyden landscape painter. De Vos's few works are painted in the manner of Jan van Goijen.

VOS, MARTIN DE. Flemish history and portrait painter (b. Antwerp, 1532; d. there, 1603). A pupil of his father, Pieter de Vos the Elder, and of Frans Floris, Martin went to Italy in 1552 and visited Rome, Florence, and Venice, where he was the student of Tintoretto.

Back in Antwerp in 1558, he joined the St. Luke Guild, of which he became dean in 1572. In that year he founded a Confrérie des Romanistes for artists who were trained in Italy. In 1594 he was in charge of the decorations for the entry of the archduke Ernest into Antwerp. Among his pupils was Hendrik de Clerck. The most highly sought-after artist in Antwerp after the death of Floris, De Vos was much employed to decorate churches, particularly after the iconoclastic ravages of 1566.

He was an eclectic artist with great powers of invention but no genius. Italianate and accomplished, his numerous works, often on a grand scale, foreshadow the great baroque tradition of the next century in Antwerp. His many drawings and engravings were very popular in his day. His *St. Paul at Ephesus* (1568; Brussels, Fine Arts Museum) shows the influence of Tintoretto. De Vos's *Portrait of the Anselme Family* (1577; Brussels, Fine Arts Museum) is among his best paintings.

BIBLIOGRAPHY. L. van Puyvelde, *La Peinture flamande au siècle de Bosch et Breughel*, Paris, 1962.

PHILIPPE DE MONTEBELLO

Cornelis de Vos, *Portrait of the Artist and His Family*, 1621. Fine Arts Museum, Brussels.

VOS, PAUL DE. Flemish painter of animals, hunting scenes, and still life (b. Hulst, ca. 1596; d. Antwerp, 1678). He was the brother of Cornelis de Vos and the brother-in-law of Frans Snyders. Paul seems to have collaborated with Snyders, and in spite of recent research it is still difficult to separate his production from that of his famous in-law. The tendency is to ascribe to him hunting pictures in brownish or grayish tonalities, as opposed to the strong color accents favored by Snyders. Also, De Vos's hunts are overly dynamic in conception, with lean dogs that have strongly characterized individual physiognomies. The artist occasionally did the animals in the paintings of Rubens and Jacob Jordaens, and Jan Wildens painted landscape backgrounds for him. De Vos's *Stag Hunt* (Brussels, Musée Ancien) is a good signed example of his art.

BIBLIOGRAPHY. W. Bernt, *Die niederländischen Maler des 17. Jahrhunderts...*, vol. 3, Munich, 1948; F. Manneback, "Paul de Vos et François Snyders," *Miscellanea Leo van Puyvelde*, Brussels, 1949.

VOS, SIMON DE. Flemish painter of religious, historical, and genre scenes (b. Antwerp, 1603; d. there, 1676). He studied under Cornelis de Vos. Although Simon authored a number of large-size religious and allegorical representations, it is in the genre picture that he really stands out. Here he mainly adapted the palette of Rubens's later years, and compositions such as *Fortune Teller* (1639; Antwerp, Royal Museum) and *Company Making Music* (Vienna, Schottenstift) are transcribed with a scintillating brush. De Vos borrowed the composition for *Company Making Music* from Johann Liss, but executed it with skill and *brio* in pure Rubensian style. Some portraits are ascribed to De Vos, but their attribution remains doubtful.

BIBLIOGRAPHY. R. Oldenbourg, *Die flämische Malerei des 17. Jahrhunderts*, 2d ed., Berlin, 1922.

VOSMAER, DANIEL. Dutch painter of land- and cityscapes (fl. Delft, mid-17th cent.). He was active in Delft by 1645. He seems to have collaborated with Pieter de Hoogh. Vosmaer painted several scenes of Delft after the gunpowder catastrophe of 1654. He was still alive in 1666.

BIBLIOGRAPHY. S. Donahue, "Daniel Vosmaer," *Vassar Journal of Undergraduate Studies*, XIX, December, 1964.

VOTIVE OBJECTS, *see* CULT OBJECTS.

VOTIVE TABLET. Any picture donated to a church in accordance with a vow. The usual form is a small square relief showing some religious scene; frequently the portrait of the donor is included in the scene.

VOUET, AUBIN. French historical and religious painter (b. Paris, 1595; d. there, 1641). He was the brother and pupil of Simon Vouet and his close collaborator in Italy (1614–24). Aubin was highly esteemed. He executed altarpieces for Paris churches such as Notre-Dame and St-Thomas d'Aquin.

VOUET, JACOB FERDINAND, *see* VOET, JACOB FERDINAND.

VOUET, SIMON. French religious, history, and portrait painter (b. Paris, 1590; d. there, 1649). He was the pre-

Simon Vouet, *Death of Dido.* Louvre, Paris.

cocious pupil of his father, Laurent Vouet. Simon is thought to have gone to England as a portraitist at the age of fourteen. He visited Constantinople in 1611 and Venice in 1613, and settled in Rome in 1614. In 1624 he was elected president of the Academy of St. Luke. At first he was much influenced by Michelangelo and the followers of Caravaggio (*Scenes from the Life of St. Francis,* Rome, S. Lorenzo in Lucina), but after 1620 he vacillated between the early baroque vein of Lanfranco and Guercino and the more classical manners of Domenichino and Reni (*The Virgin Appearing to St. Bruno,* Naples, National Museum of St. Martin). The result was a mildly ecstatic style that led to the full baroque. The occasional portraits of these years, by their color and chiaroscuro, suggest a strong naturalistic Venetian influence.

In 1627 Vouet returned to Paris and immediately launched a successful career as a religious painter and decorator. His Parisian style is a broad, elegant, and essentially decorative compromise between the Roman baroque and the current French late mannerist tradition. He gradually attuned it to the increasingly rational tastes of his clients. In the 1630s he executed some poetical and allegorical compositions, in which the design was freer and the modeling looser, with a greater interest in light and color, palely reminiscent of Veronese. In his decorative commissions (1644, formerly at Fontainebleau; and 1643–47, formerly at Paris, Palais Royale; both works now destroyed), sometimes in collaboration with the sculptor Sarrazin, he resuscitated the Italian early mannerist style but refurbished it in the Venetian and the current, late-16th-

century Roman baroque vein, founding thereby a formula to dominate the French school for nearly a century. His greatest commission, after 1638, was the decoration of various chambers in the Hôtel Séguier. His illusionism here and elsewhere occasionally recalls Correggio at Parma yet anticipates the boldness of Giovanni Battista Tiepolo.

Few of Vouet's portraits remain; some may be erroneously ascribed to others. They are rendered with marked realism in the hard, sculptural manner of Caravaggio's followers (*Portrait of a Man,* Dijon, Magnin Museum). His solid, innovating competence, if not brilliance, had a profound influence upon his pupils, including Eustache Le Sueur, Nicolas and Pierre Mignard, and above all, Charles Le Brun.

BIBLIOGRAPHY. A. Blunt, *Art and Architecture in France, 1500–1700,* Baltimore, 1954. GEORGE V. GALLENKAMP

VOUNI. Archaeological site on the northeastern coast of Cyprus, occupied in the 5th century B.C. Excavations by a Swedish expedition (1928–29) uncovered a palace of about 500 B.C. in the Oriental style.

BIBLIOGRAPHY. P. Demargne, *The Birth of Greek Art,* New York, 1964.

VOUSSOIR. Wedge-shaped unit of an arch. Voussoirs are often determined by the shape of the arch and may be cusped, and so on, according to the intrados or soffit, or joggled, with offsets in the wedges, as in Ptolemaic Egyptian, Roman, and later Near Eastern examples. The voussoir at the crown of the arch is called the keystone.

VOYS, ADRIAEN DE, see VOIS, ARY DE.

VOYSEY, CHARLES FRANCIS ANNESLEY. English architect (1857–1941). He was a pupil of J. P. Seddon and set up practice in 1882. His early work involved wallpapers and decorative fabrics. This field of decoration was of great interest to the leaders of the domestic revival, Richard Shaw and Philip Webb.

Voysey's architectural work became influential about 1900 when it became known to the Continental leaders of the profession. His work was representative of the school of William Morris, but his predecessors were rather Mackmurdo and Shaw. His practice in the 1890s was vast. Two typical and well-known houses are The Orchard at Chorley Wood, built for himself in 1900, and Broadley's on Lake Windermere.

BIBLIOGRAPHY. N. Pevsner, "Charles F. Annesley Voysey, 1857–1941," *The Architectural Review,* LXXXIX, May, 1941.

VRANCX, SEBASTIAEN. Flemish painter (b. Antwerp, 1573; d. 1647). This versatile artist is best known for his kermises, popular open-air scenes, and events taken from military life. His style is archaic, and the numerous figures he painted into works by Josse de Momper and Jan Breughel I, for example, are redolent of the tradition of Pieter Brueghel the Elder.

BIBLIOGRAPHY. H. Gerson and E. H. ter Kuile, *Art and Architecture in Belgium, 1600–1800,* Baltimore, 1960.

VREDEMAN DE VRIES, HANS (Jan). Dutch architectural draftsman, ornamental designer, painter, and decorator (1527–1604/23). Born in Leeuwarden, Friesland,

he wandered throughout Germany and the Netherlands. His engravings mark him as a follower of Cornelius Floris, though he lacks the grace of that master. In Vredeman de Vries's architectural engravings he produced endless variations on the theme of the Antwerp Town Hall. Though some of his projected structures are unrealistic fantasies, various façades of guild halls in the Gildekamerstraat and the Grote Markt, built in the late 16th century in Antwerp, are based on his designs. In his mannerist paintings he plays havoc with normal geometric perspective: his *Fantastic Architecture* (1596; Vienna, Museum of Art History features series of receding colonnades placed within open squares. His son Paul worked with him in Danzig and Prague.

BIBLIOGRAPHY. E. P. Richardson, "Architectural Painting in the Netherlands," *Detroit Institute of Arts, Bulletin*, XVI, Apr., 1937.

VREDEMAN DE VRIES, PAUL. Flemish/Dutch painter (b. Antwerp, 1567; d. Amsterdam? after 1630). Like his father, Hans Vredeman de Vries, Paul specialized in architectural scenes with figures and trompe-l'oeil perspectives. He worked with his father for the city council of Danzig (1594) and for Emperor Rudolf II in Prague. In 1601 Paul settled in Amsterdam. He is known to have painted the architecture in the *Last Supper* by Joos van Winghe.

BIBLIOGRAPHY. R. H. Wilenski, *Flemish Painters, 1430–1830*, 2 vols., New York, 1960.

VREE, NICOLAES DE. Dutch landscape painter (b. Amsterdam, 1645; d. Alkmaar, 1702). He was a pupil of Jan Wijnants. De Vree was active in Amsterdam and Alkmaar. His paintings are rare.

BIBLIOGRAPHY. A. van der Willigen Pz., "Korte berigten over eenige Hollandsche kunstenaars, "*De Nederlandsche Spectator*, 1867.

VREL, JACOB (Jacobus). Dutch painter of genre and cityscapes (fl. ca. 1654–62). He was probably active in Delft and Haarlem. His paintings of cityscapes were formerly attributed to Vermeer. Vrel also painted genre scenes related to the work of Pieter de Hoogh.

BIBLIOGRAPHY. W. R. Valentiner, "Dutch Genre Painters of the Manner of Pieter de Hooch," *Art in America*, XVII, 1929.

VRIENDT, DE, *see* FLORIS DE VRIENDT, CORNELIUS; FLORIS, FRANS.

VRIES, ABRAHAM DE. Dutch portrait painter (b. Rotterdam, ca. 1590; d. The Hague? between 1650 and 1662). Little is known of De Vries's early training, but a *Self-Portrait* that he painted in 1621 (Amsterdam, Rijksmuseum) shows him to be an educated man, for he depicted himself with books on proportions and on the art of painting and included several lines from a Latin ode. In 1626 De Vries was in Bordeaux, the following year he was in Paris, and in 1628 he was in Antwerp. He was active between 1630 and 1639 in Amsterdam but in 1635 he was back in Paris. In 1640, on the evidence of his signature on the *Portrait of David de Moor* (Amsterdam, Rijksmuseum), he was in Rotterdam. In 1643 he was working at The Hague, and he joined the painters' guild there the following year. In 1647 he appears to have been back in Rotterdam. De Vries's style seems to have developed under the influence of Thomas de Keijser, and perhaps of Rembrandt.

BIBLIOGRAPHY. Leyden, Stedelijk Museum, *De Lakenhal*, 2d ed., Leyden, 1951.

VRIES, ADRAEN DE. Dutch sculptor (b. The Hague, ca. 1546; d. Prague, 1626). He was a pupil of Giovanni Bologna and Hubert Gerhard (ca. 1545–1620). These three were among many sculptors who left the Low Countries during the 16th century because of the little demand for sculpture there. De Vries never returned to his homeland; he was active in Rome, Florence, Augsburg, and Prague.

His Italian associations were to shape his style. The influence of the baroque and of the classical elegance of Florentine art of that era may be observed in the fountains of Augsburg executed in collaboration with Gerhard. The Hercules Fountain figure of a Naiad (1596–1602) is representative of De Vries's interpretation of the Italian baroque. The interplay of water and sensuously modeled figures rivals that of Lorenzo Bernini.

BIBLIOGRAPHY. M. Hürlimann and E. Newton, *Masterpieces of European Sculpture*, London, 1959.

VRIES, HANS (Jan) VREDEMAN DE, *see* VREDEMAN DE VRIES, HANS.

VRIES, PAUL VREDEMAN DE, *see* VREDEMAN DE VRIES, PAUL.

VRIES, ROELOF VAN. Dutch landscape painter (b. Haarlem, 1630/31; d. Amsterdam? after 1681). Nothing is known of his early training or activity. He entered the Leyden painters' guild in 1653, and four years later he joined the guild in his native Haarlem. He was living in Amsterdam in 1659 and was last mentioned there in 1681.

Works such as his *Mill in the Forest* (Munich, Alte Pinacothek) show Van Vries to be a follower of Jacob van Ruisdael. *A View of a Village* (London, National Gallery), however, is extremely close to the manner of Cornelis Decker, a Haarlem painter whose works are often confused with those of Van Vries.

BIBLIOGRAPHY. N. Maclaren, *National Gallery Catalogues: The Dutch School*, London, 1960.

VRIES, SIMON DE, *see* FRISIUS, SIMON WEYNOUTS.

VROOM, CORNELIS HENDRIKSZ. Dutch landscape painter (b. Haarlem, 1590/91; d. there, 1661). He was probably a pupil of his father, the marine painter Hendrik Cornelisz. Vroom. Cornelis is first mentioned as a painter in 1621. In 1628 he was in England. He was a member of the Haarlem painters' guild in 1635, but he resigned, after a quarrel, in 1642. His works are rare and represent for the most part woody landscapes. His early works show the influence of Adam Elsheimer, and perhaps of Esaias van de Velde and Salomon van Ruysdael. Vroom's work after 1630 foreshadows the development of Jacob van Ruisdael, whose style he influenced. However, Vroom's later works are in turn influenced by Ruisdael's landscapes.

BIBLIOGRAPHY. W. Stechow, *Dutch Landscape Painting of the Seventeenth Century*, London, 1966.

VROOM, HENDRIK CORNELISZ. Dutch painter of seascapes and sea subjects (b. Haarlem, 1562/63 or 1566; d.

Edouard Vuillard, *Paris Garden*. National Museum of Modern Art, Paris.

there, 1640). In his youth Vroom worked as a faïence painter. He traveled through Belgium, France, Italy, and Germany practicing this craft. He is reported in Haarlem from 1590 on and appears to have started painting shortly afterward. He specialized in paintings of ships and also designed tapestries of sea battles.

BIBLIOGRAPHY. F. C. Willis, *Die niederländische Marinemalerei*, Leipzig, 1911.

VRUBEL, MIKHAIL ALEKSANDROVICH. Russian painter (b. Omsk, 1856; d. St. Petersburg, 1911). Vrubel first studied philosophy at the University of St. Petersburg and was then trained at the Academy of Fine Arts (1880–84). His broad knowledge of European art and literature was enhanced by trips to France and Italy in 1876, 1892, and 1894. Consonant with the exoticism of his later work were his restorations of the murals at St. Cyril in Kiev. Parallels with the symbolist and Art Nouveau movements are evident in his insistence on the decorative qualities of color, pattern, and line. Many of his works are deeply personal, disturbed visions of demons and mythological figures mired in unrelieved opulence. Vrubel's last years were spent in an insane asylum.

BIBLIOGRAPHY. E. P. Gomberg-Verzhbinskaya, ed., *Vrubel'*, Moscow, 1963.

VUILLARD, EDOUARD. French decorative painter (b. Cuiseaux, Saône-et-Loire, 1868; d. La Baule, 1940). His family moved to Paris in 1877, and there Vuillard lived most of his life. In 1886 he became a student of Gérôme at the Ecole des Beaux-Arts, but two years later changed to the Académie Julian, where Bouguereau was the principal teacher. Vuillard's fellow students included Denis, Bonnard, Vallotton, and Sérusier, all of whom were founder-members of the Nabis. They admired Gauguin, and his synthetist ideas influenced their thinking. They began to exhibit as a group.

By 1891 Vuillard and others of the Nabis received critical recognition. In 1892 Vuillard painted the first of his decorative panels and a year later designed scenery for Ibsen's *Rosmersholm* in collaboration with Bonnard, Roussel, and Ranson. Unfortunately, these sets, as well as the decorative panels, are now lost. In 1894 he was commissioned by Alexandre Natanson, one of the editors of the celebrated *Revue Blanche*, to design panels illustrating Parisian parks for his home. The following year he designed a stained-glass window for Tiffany, and in 1896 and 1898 he fulfilled other commissions for decorative murals. In 1899 his series of lithographs, *Paysages et interieurs*, was published by Vollard. That year the Nabis held their last exhibition as a group.

Vuillard, however, exhibited regularly at the Galerie Bernheim-Jeune, the Salon des Indépendants, and the Salon d'Automne. He taught at the Académie Ranson in 1908. In 1913 he and Bonnard made a trip to England and Holland. That year he also produced the decoration for the foyer of the Théâtre des Champs-Elysées. In 1937 he designed decorations for the Palais de Chaillot and two years later for the League of Nations Palace in Geneva.

Vuillard's painting is in close accord with that of Bonnard. They were both influenced by the late art of Monet and by Gauguin, Seurat, the Japanese print, and the then-fashionable Art Nouveau movement. Their subject matter and the treatment of it are similar, and they were termed "intimists." They both were fond of representing the restricted, quiet, and cultivated life of the upper-middle-class French family, always in a peaceful, offhand moment in the routine of its existence. Vuillard would show a woman musing over a teacup or seated in the corner of a large sofa embroidering. These simple scenes are often transformed into a tapestry of impressionist color. *See* INTIMISM.

BIBLIOGRAPHY. A. C. Ritchie, *Edouard Vuillard*, New York, 1954.
ROBERT REIFF

VULCAN (Volcanus). Roman god of fire. He is identified with the Greek god Hephaestus, from whom he inherited all his attributes. Vulcan was the god of destructive fire, although in some places he was also regarded as the god of the hearth fire. His sanctuaries; known as the *Vulcanal*, were installed in all Roman cities as places for worship of the god and also for propitiatory offerings against destructive fire.

VYTLACIL, VACLAV. American painter (1892–). Born in New York City, he studied at the Art Institute of Chicago, the Art Students League, and with Hans Hofmann in Munich. Vytlacil was a founding member of American Abstract Artists. At the beginning of his career he was influenced by cubism and by the orphism of Delaunay. In the late 1930s Vytlacil was painting figure compositions derived from Picasso's classical phase. By the early 1950s he had moved into strongly painted, semi-abstract sea- and landscapes, in which the formal structure was nearly hidden by the emotional expression, as in the vigorous and improvised *Forest* (1949; Washington, D.C., Phillips Collection).

W

Johann Peter Alexander Wagner, *Brush Seller*, ca. 1780. Bavarian National Museum, Munich.

WABEMBE, *see* Africa, Primitive Art of (Central Africa: Congo-Leopoldville).

WADSWORTH, EDWARD. English painter (b. Cleckheaton, Yorkshire, 1889; d. Uckfield, Sussex, 1949). He studied in Munich and at the Slade School, London. Wadsworth exhibited with the vorticists and was a member of the London Group and Unit One. As an official artist during World War I, he became known as a painter of camouflaged vessels, for example, *Dazzle Ships in Drydock at Liverpool* (ca. 1918; Ottawa, National Gallery of Canada). In the early 1920s he was painting still lifes of sea shells and flowers with a cubistic formal structure. Shortly thereafter, he evolved his characteristic combination of semiabstract machine forms seen against a view of sea and sky, as in *Marine* (1928; Leeds, City Art Gallery).

BIBLIOGRAPHY. SELECTION, Cahier 13, *Edward Wadsworth*, Antwerp, 1933; H. Read, *Unit 1*, London, 1934.

WAEL, CORNELIS DE. Flemish painter of religious subjects, seascapes, and kermis scenes (b. Antwerp, 1592; d. Rome, 1667). When he was a young man, he went to Italy with his elder brother Lucas de Wael. Cornelis stayed there for the greater part of his life. He made a specialty of depicting everyday life in Italy. He also executed numerous views of the port of Genoa, battle scenes, and cavalry engagements (for example, *Military Camp*, Brunswick, Gallery). These military scenes are often wrongly ascribed to Palamedes Palamedsz. Some of De Wael's religious paintings are extant in Genoese churches.

BIBLIOGRAPHY. W. Bernt, *Die niederländischen Maler des 17. Jahrhunderts...*, vol. 3, Munich, 1948; L. Baldass, "Two Biblical Histories by Cornelis de Wael," *Art Quarterly*, XX, Autumn, 1957.

WAGENFELD, WILLIAM. German industrial designer (1900–). Born in Bremen, Wagenfeld attended the Bremen State School of Art, was then apprenticed at the Hemelingen silverware factory, and subsequently studied again at the Bauhaus. The best-known German designer in a number of areas, including glassware, porcelain, silverware, and light fittings, he has also been preeminent as an organizer for mass production.

WAGHEMAKER, DOMINICUS. Flemish architect (1460–1542). He was a member of an Antwerp family of architects and the son of Herman de Waghemaker. In 1502 Dominicus succeeded his father as municipal architect of Antwerp and as master of the works at the Church of St. James and at the Cathedral of Antwerp. He completed its north tower, the most ornate example of the Flemish Flamboyant Gothic style. In 1515 Waghemaker built the first Antwerp Stock Exchange; in 1516 the Hotel for the mayor of Antwerp, Arnauld van Lieve; and in 1531 the second Antwerp Stock Exchange. *See* Antwerp: Cathedral of Notre Dame.

WAGMULLER, MICHAEL. German sculptor (b. Karthaus-Brühl, 1839; d. Munich, 1881). He studied at the Munich Academy. Wagmüller was a leading Munich exponent of the return to Renaissance realism and baroque decoration in sculpture.

WAGNER, JOHANN PETER ALEXANDER. German sculptor (b. Obertheres, 1730; d. Würzburg, 1809). He studied with his father, Thomas Wagner, and in Vienna. Johann did some religious sculpture, but is best known for his sculptural decorations for the Episcopal Palace at Würzburg, which show rococo playfulness approaching neoclassicism.

WAGNER, OTTO. Austrian architect (1841–1918). He worked in Vienna. Considered the leading Austrian architect of his period, he was associated with the Academy as professor of architecture. Although slightly interested in Art Nouveau from 1894 to 1901, he is associated with the Viennese classicist reaction against this style. One of his finest works, the Postal Savings Bank (1904–06), retains the grace of Art Nouveau and its concern with metal and glass, but it is organized in an architectonic and geometric rather than in an organic manner. He also planned the layout of the Steinhof Asylum; its chapel is designed with a geometric rationalism reminiscent of Schinkel. His close connection with the Germanic tradition, as well as

Otto Wagner, Postal Savings Bank, Vienna, 1904–06.

his progressive attitude toward structure and materials, is reflected in his book on modern architecture.

BIBLIOGRAPHY. J. A. Lux, *Otto Wagner*, Munich, 1914.

WAGNER, STEWARD, *see* FELLHEIMER AND WAGNER.

WAILLY, CHARLES DE. French architect (1730–98). He worked in Paris. A pupil of Jacques François Blondel and Servandoni, he was more interested in picturesque effects than in antique models and is connected with elaborate decoration projects, such as the interior of the Odéon.

WAINSCOT. Interior wood surface. In Great Britain and 17th-century colonial New England, the term was associated with wood paneling. Generally, a wainscot is any wall surfacing, particularly the lower 3 to 4 feet, so treated as to distinguish it from other wall areas, as in tile, terrazzo, or marble wainscots. It is sometimes called a dado.

WAINWRIGHT BUILDING, ST. LOUIS, MO., *see* SULLIVAN, LOUIS HENRI.

WAKEHURST PLACE. One of the larger English Elizabethan Sussex manor houses, built by Sir Edward Culpeper in 1590. Although considerably altered inside, it retains fine and typical features of the period, particularly the drawing room ceiling and frieze and the library with an elaborate chimney piece.

BIBLIOGRAPHY. C. Latham, *In English Homes*, vol. 1, London, 1904.

WAKE OF THE FERRY. Oil painting by Sloan, in the Phillips Collection, Washington, D.C. *See* SLOAN, JOHN.

WALCH, JACOB, *see* BARBARI, JACOPO DE'.

WALD, SYLVIA. American painter and graphic artist (1914–). A native of Philadelphia, Sylvia Wald studied at the Moore Institute of Art, Science and Industry and taught art under the WPA in Philadelphia and New York. She is noted for her serigraphs, which, in the thirties, dealt with social themes and more recently with abstraction in a calligraphic manner.

WALDMULLER, FERDINAND GEORG. Austrian painter (b. Vienna, 1793; d. Helmstreitmühle, near Mödling, 1865). He was one of the most progressive of the Austrian Biedermeier painters. He began his career as a student of H. Mauer and J. Lampi at the Vienna Academy (1807–13). Waldmüller traveled to Italy in 1825 and became professor at the academy in Vienna in 1829. He is best known for his many fine portraits, such as *Portrait of the Artist's Mother* (1830), *Beethoven* (1823), and *Grillparzer* (1844; all Vienna, Austrian Gallery of the 19th and 20th Centuries). But he also painted landscapes and genre subjects that are significant works of 19th-century protorealism similar to the works of the Barbizon school, for example, *After School* (1841), *Early Spring in the Wiener Wald* (1864; both Berlin, former State Museums), and *Prater Landscape* (1849; Austrian Gallery of the 19th and 20th Centuries).

BIBLIOGRAPHY. W. Kosch, *Waldmüller*, Munich, 1916; B. Grimschitz, *Ferdinand Georg Waldmüller*, Salzburg, 1957.

WALDO, SAMUEL LOVETT. American painter (b. Windham, Conn., 1783; d. New York, 1861). He studied with Joseph Steward, opened studios in Hartford, Conn., and Charleston, S.C., and worked with West and Copley in London. Later he took his pupil William Jewett into partnership. His portraits are solid in form and possess a simplicity and freshness of characterization.

BIBLIOGRAPHY. W. Dunlap, *A History of the Rise and Progress of the Arts of Design in the United States*, vol. 2, Boston, 1918.

WALHALLA, REGENSBURG, *see* KLENZE, LEO VON.

WALKER, FREDERICK. English painter and illustrator (b. Marylebone, 1840; d. St. Fillian's, Perthshire, 1875). His work appeared in such periodicals as *Good Words*, *Everybody's Journal*, and *Cornhill Magazine*. He illustrated W. M. Thackeray's "Philip and His Adventures on His Way through the World" and other works. His painting, as shown in *The Harbour Refuge* of 1872, combines representational skill with a rather blatant sentimentalism. Walker's men are heroically posed in a Greek manner, revealing a long study of the antique at the British Museum. In 1863 he made his first appearance in the Royal Academy with *Lost Path*. Millais influenced his work. He was associated with London's Old Water-color Society.

BIBLIOGRAPHY. T. S. R. Boase, *English Art, 1800–1870*, Oxford, 1957.

WALKER, HORATIO. Canadian-American painter (b. Listowel, Ontario, 1858; d. Isle d'Orléans, Quebec, 1938). Active in New York State and Paris, he became a follower of the Barbizon masters, particularly Millet and Troyon. His landscapes are saturated with an impressionistic haze and bright luminosity and reveal a deep feeling for Canadian and American farm life.

BIBLIOGRAPHY. F. N. Price, *Horatio Walker*, New York, 1928.

WALKER, RALPH. American architect (1889–). Born in Waterbury, Conn., Walker has been intimately associated with the building of office and laboratory complexes often housed within skyscrapers. An example is the New York Telephone Company, where the exterior is distinguished for its jagged outline. *See* NEW YORK TELEPHONE COMPANY BUILDING, NEW YORK.

BIBLIOGRAPHY. F. Albert, ed., *Ralph Walker...*, New York, 1959.

WALKER ART CENTER, MINNEAPOLIS, MINN., see MINNEAPOLIS, MINN.: MUSEUMS (WALKER ART CENTER).

WALKOWITZ, ABRAHAM. American painter (b. Tumen, Siberia, 1880; d. New York City, 1965). Walkowitz went to the United States in early childhood. He studied with Walter Shirlaw at the National Academy of Design and with Laurens at the Académie Julian in Paris. He exhibited at the 1913 Armory Show. An early champion of modern art in the United States, Walkowitz held his first important exhibition at Stieglitz's avant-garde "291" in 1912 and was associated with that gallery until 1917. The basis of his style is a lyrical use of Cézanne-derived treatment of figure and landscape, with an emphasis on strong rhythm most readily apparent in his innumerable Rodinesque water colors and drawings of the dancer Isadora Duncan.

BIBLIOGRAPHY. *One Hundred Drawings by A. Walkowitz*, New York, 1925; A. Walkowitz, *Art from Life to Life*, Girard, Kans., 1951.

WALL, CURTAIN (Panel Wall). Nonbearing wall, or one not intended to carry loads. Curtain walls in modern construction are attached to a skeleton frame. Made of metal, glass, or masonry, they are used to enclose a structure. A masonry enclosure supported at each floor is also called a panel wall, enclosure wall, or filler wall. A light curtain wall is sometimes called a skin.

WALL, RETAINING. Wall built to restrain a mass of earth or similar material. A gravity retaining wall is usually built of concrete or masonry and depends on its own weight to resist earth pressure that would otherwise push it out or turn it over.

WALLACE, WILLIAM. Scottish architect (d. 1631). His principal building is Heriot's Hospital at Edinburgh, which he began in 1628. Derived from a house illustrated by

Curtain wall. Nonbearing wall enclosing a structure.

Serlio, the hospital consists of a hollow square with corner pavilions, and with staircase turrets in the inner angles.

BIBLIOGRAPHY. J. N. Summerson, *Architecture in Britain, 1530–1830*, 4th rev. ed., Baltimore, 1963.

WALLIS, ALFRED. English painter (b. Cornwall, 1855; d. 1942). A primitive and uneducated Cornish painter, he supposedly went to sea at a young age and did not begin painting until in his seventies, to combat his loneliness after his wife's death. He painted things he remembered, such as sailing ships, fish, harbors, and coastlines, which he re-created in his imagination, never drawing what he saw in front of him. His colors are limited, but strong; his compositions awkward and naïve, but clear; his shapes lopsided, but convincing. The elements of the Cornish scene are painted with extraordinary force and freshness, and it is obvious that Wallis was well aware of what he was doing. He painted on bits of old paper and cardboard and also decorated his walls and doors. He was discovered by Ben Nicholson and Christopher Wood, who bought his work and encouraged his efforts, but he was never popularized until after his death. He has influenced such painters as William Scott and Peter Lanyon.

BIBLIOGRAPHY. E. Mullins, *Alfred Wallis, Cornish Primitive Painter*, London, 1967.

WALLOT, PAUL. German architect (b. Oppenheim am Rhine, 1841; d. Langenschwalbach/Taunus, 1912). Wallot is best known for his design of the Reichstag building in Berlin, a monumental, neobaroque composition. He won the commission in a competition in 1882, and the work was executed between 1884 and 1894.

WALLPAPER. Paper with printed or painted designs used as wall covering. It was introduced to Europe in the 18th century from China. The design was originally printed by hand from wooden dies in much the same way as hand-printed textiles. Early application of machine methods to wallpaper destroyed its artistic value.

WALLRAF-RICHARTZ MUSEUM, COLOGNE, see COLOGNE: MUSEUMS (WALLRAF-RICHARTZ MUSEUM).

WALPOLE, HORACE. English author, connoisseur, and amateur architect (1719–97). He was an arbiter of taste whose "bijou" castle, Strawberry Hill, did much to make the Gothic fashionable. His *Anecdotes of Paintings* (1762–71), *Modern Gardening* (1785), and endless letters are valuable commentaries on 18th-century English art and architecture. (See illustration.) See STRAWBERRY HILL.

WALSCAPELLE, JACOB VAN. Dutch still-life painter (b. Dordrecht, 1644; d. Amsterdam, 1727). Walscapelle's name was originally Cruydenier, but he seems to have taken the family name of a great-grandfather by 1667. According to Dutch sources, he was a pupil of Cornelis Kick, presumably in Amsterdam, where Kick lived until 1667. It is not certain exactly when Walscapelle first went to Amsterdam, but it seems likely that it was during the period his brother-in-law, the flower painter Otto Elliger the Elder, was living there, that is, before 1666. Walscapelle's relationship to Kick is also supported by stylistic evidence: his *Vase of Flowers* (1667; London, Victoria and Albert) is closely related to Kick's manner. After 1673 Walscapelle held various municipal posts in Amsterdam

and seems eventually to have given up painting entirely.

BIBLIOGRAPHY. J. Knoef, "Jacob van Walscapelle," *Oud-Holland*, LVI, 1939; I. Bergström, *Dutch Still-Life Painting in the Seventeenth Century*, New York, 1956; N. Maclaren, *National Gallery Catalogues: The Dutch School*, London, 1960.

WALSCHARTZ, FRANCOIS. Flemish history painter (b. Liège, ca. 1595; d. there, 1665/75). After copying Rubens in Antwerp, Walschartz traveled to Italy; he studied with Carlo "le Vénitien" (Saraceni?) and Guido Reni. Later in Liège he painted extensively for churches. In 1650 he worked on the decoration of the Castle of Raesfeld, in Westphalia. Walschartz is best characterized as an undistinguished follower of Rubens.

BIBLIOGRAPHY. J. Philippe, *La Peinture liégeoise au XVIIe siècle*, Brussels, 1945.

WALTER, THOMAS USTICK. American architect (1804–87). A student of William Strickland, Walter was a leading classic revivalist. For Girard College in his native Philadelphia (1832–48), he designed a peripteral Corinthian temple, which was mostly the idea of the banker Nicholas Biddle. Walter also worked at Biddle's estate, Andalusia, on the banks of the Delaware River, near Philadelphia, where he added a portico modeled on the Theseum in Athens. As government architect, he projected the Capitol's cast-iron dome and its House and Senate wings. *See* CAPITOL, THE, WASHINGTON, D.C.

WALTERS, EDWARD. English architect (1808–72). He contributed to the characteristic pattern of Victorian Manchester, designing mills, warehouses (J. Brown warehouse, 1851), and schools. His best work is the Free Trade Hall (1853–56), Manchester's finest public building.

BIBLIOGRAPHY. "The Late Mr. Edward Walters, Architect," *The Builder*, XXX, March 16, 1872.

WALTERS ART GALLERY, BALTIMORE, *see* BALTIMORE: MUSEUMS (WALTERS ART GALLERY).

WALTHER, SEBASTIAN. German sculptor (b. 1576; d. Dresden, 1645). A leading sculptor in Saxony, Walther was influenced by Adriaen de Vries and the art of nearby Prague. He achieved a baroque unity in composition and figure style which superseded the fractionalization of earlier German sculpture. This is evident in his altars for the Sophienkirche in Dresden (1606) and the chapel of Schloss Lichtenburg (ca. 1611–13).

WALTON, HENRY. English genre painter (b. Dickleburgh, Norfolk, 1746; d. London, 1813). He was a pupil of Zoffany and composed small subject pictures that are closer in spirit to Chardin than to any other English painting of the time. Perhaps the best is *Plucking the Turkey* (London, National Gallery). He also painted conversation pieces.

WAMPUM. Shell beads of tubular shape used by North American Indians as a form of currency. Wampum was employed until about 1750 in the East and as late as 1850 in the West. Although beads were often carried in strings, large numbers were applied as decorative embroidery on garments. When used to ornament gift belts marking ceremonial occasions, wampum was worked into pictographic designs.

WANDERERS, THE. Group of artists known as the *Peredvezhniki* in Russian. They broke away from the arid classicism of the Russian Imperial Academy in order to devote themselves to realism. By means of their traveling art exhibitions, their works reached a wider audience than was available in Moscow or St. Petersburg. During the 1870s and 1880s, The Wanderers included all important Russian painters. They emphasized faithful depiction of middle-class life, often in a sentimental manner.

BIBLIOGRAPHY. A. N. Benua (Benois), *The Russian School of Painting*, New York, 1916; G. H. Hamilton, *The Art and Architecture of Russia*, Baltimore, 1954.

WANG CHIEN. Chinese painter (1598–1677). He is counted among the "Six Great Masters" of the Ch'ing dynasty and is one of the Four Wangs. Wang Chien was a contemporary of Wang Shih-min and held a government position in the same district of Lou-Tung. According to Chinese sources, the two men were close friends and were mainly responsible for carrying the tradition of Tung Ch'i-ch'ang into the new dynasty after the fall of the Ming house in 1644. Wang Chien is probably the least well known of the Four Wangs in the West, and he was probably the least prolific of these orthodox masters. He was extolled by Chinese critics of the period, however, and was highly appreciated for his ability to copy older masters faithfully. His paintings are usually handled with great technical skill and dexterity, and he was a colorist of some note. *See* TUNG CH'I-CH'ANG; WANG SHIH-MIN.

BIBLIOGRAPHY. V. Contag, *Die sechs berühmten Maler der Ch'ing-Dynastie*, Leipzig, 1941.

WANG FU. Chinese painter of landscapes and bamboos (1362–1416). His *tzu* was Meng-tuan. An important figure in the transitional period between the Yüan and Ming dynasties, he traveled about the countryside in much the manner of Ni Tsan, earning a minor reputation for being an eccentric. He finally joined the court and gained some eminence for his calligraphy. His paintings have been little studied, and the extant landscapes attributed to him reveal an artistic vision of considerable power. *See* NI TSAN.

BIBLIOGRAPHY. O. Sirén, *Chinese Painting, Leading Masters and Principles*, vol. 4, London, 1958.

Horace Walpole, Strawberry Hill, enlarged in the Neo-Gothic style under the owner's direction.

WANG HUI. Chinese painter (1632–1717). Youngest of the so-called Four Wangs, he is listed among the "Six Great Masters" of the Ch'ing dynasty. Wang Hui had a variety of alternate names, but he is most frequently known under the *tzu* Shih-ku. Undoubtedly the most prolific painter of the great Ch'ing masters, he was at the same time the most eclectic. Chinese critics have praised his ability in combining aspects of various schools, and few would ever contest the general competence of his brush. Many of his paintings were executed on an enormous scale, for example, the *Countless Peaks and Valleys* (Formosa, Sun Yat-sen Museum), and the sheer amount of brushwork contained on the surface of such efforts is in itself dazzling.

It is difficult to discuss concrete elements of style in the work of Wang Hui, for his range was quite wide. In his own day he was perhaps the most famous painter in China, considered by some contemporary critics as almost a savior, a painter who not only rescued the style of the ancients but saved the art of painting by his enormous and energetic output.

BIBLIOGRAPHY. V. Contag, *Die sechs berühmten Maler der Ch'ing-Dynastie*, Leipzig, 1941; P. Hu, *Wang Shih-ku*, Shanghai, 1958; O. Sirén, *Chinese Painting, Leading Masters and Principles*, vol. 5, London, 1958. MARTIE W. YOUNG

WANG KAI, *see* MUSTARD-SEED-GARDEN PAINTING MANUAL.

WANG LU-T'AI, *see* WANG YUAN-CH'I.

WANG MENG. Chinese painter (ca. 1310–85). His *tzu* was Shu-ming and his *hao* (by which he was better known), Huang-ho-shan Ch'iao. A native of Wu-hsing in Chekiang Province, he was the nephew of the famous Chao Meng-fu and was classified one of the "Four Great Masters" of the Yüan dynasty by later critics. Wang Meng was a technically brilliant painter, perhaps the most gifted of the four masters in this respect. His paintings are virtual inventories of the types of brushstrokes used in the Yüan period, and his frequently crowded, dense, and almost impenetrable landscapes are quite at variance with the airy works of Ni Tsan; his nearly compulsive use of overlapping brushstrokes, particularly the hemp-fiber stroke, separates him even further from the sparse brush of Ni Tsan.

Although he enjoyed less immediate fame than the other three great Yüan masters, Wang Meng was greatly admired in later centuries for the sheer brilliance of his brushwork and because a sense of the earlier monumentality of Northern Sung artists such as Kuo Hsi was retained in his works, albeit changed into something quite personal. The writhing, tortured forms of such masterpieces as the *Forest Dwelling at Chü-ch'ü* (Formosa, Sun Yat-sen Museum) represent Wang Meng's personal inner vision as much as the scenery of an actual place. *See* CHAO MENG-FU; KUO HSI; NI TSAN.

BIBLIOGRAPHY. V. Contag, "The Unique Characteristics of Chinese Landscape Pictures," *Archives of the Chinese Art Society of America*, VI, 1952; W. Willets, *Chinese Art*, vol. 2, Harmondsworth, 1958. MARTIE W. YOUNG

WANGS, FOUR, *see* WANG CHIEN; WANG HUI; WANG SHIH-MIN; WANG YUAN-CH'I.

Wang Meng, *Thatched Pavilion*. Color on paper.

WANG SHIH-MIN. Chinese painter (1592–1680). He is referred to sometimes by his *hao* Yen-k'o. A native of T'ai-ts'ang, he was the eldest of the so-called Four Wangs and was a friend and pupil of Tung Ch'i-ch'ang and Ch'en Chi-ju, the two older but leading spokesmen in the region. Wang Shih-min held several official positions but retired to private life at the fall of the Ming in 1644 and became a respected and influential teacher. He was a dedicated student of the past masters and saw himself as a transmitter of established ideals, particularly those of the great 14th-century Yüan-dynasty literati painters. His paintings have been described in modern terms as eclectic, but Wang Shih-min's works were greatly admired in his own age and by later Chinese critics as well. His conservative, orthodox approach to copying the older masters stands in marked contrast to the "eccentric" painters of the 17th century such as Tao-chi and others who responded so differently to the fall of the Ming and the subsequent period

of political confusion. *See* CH'EN CHI-JU; TAO-CHI; TUNG CH'I-CH'ANG.

BIBLIOGRAPHY. V. Contag, *Die sechs berühmten Maler der Ch'ing-Dynastie*, Leipzig, 1941.

WANG WEI. Chinese poet and painter (699–759). He was considered by Tung Ch'i-ch'ang to be the founder of the "southern school" of painting. His life and career became a model for the later literati artists, and in his own age he was renowned for his poetry and general wide learning. According to literary sources he was responsible for establishing the monochrome ink technique as an alternative to the polychromatic style of the masters Li Ssu-hsün and Li Chao-tao. He furthermore employed a distinctive manner of brushwork, called "broken ink" (*p'o-mo*), which depended on a kind of shading with ink to depict the structure of rocks and mountains. Unfortunately Wang Wei today remains a shadowy legend in terms of actual examples that convey his style. The rubbings taken from stone engravings of his most famous work, the *Wang-ch'uan*, barely preserve the composition of the hand scroll that was considered Wang Wei's masterpiece. *See* LI SSU-HSUN; P'O-MO; TUNG CH'I-CH'ANG. *See also* NORTHERN AND SOUTHERN SCHOOLS OF CHINESE PAINTING.

BIBLIOGRAPHY. A. von Herder, "Wang Wei, der Maler der T'ang-Zeit," *Sinica*, V, 1930; J. Hefter, "Abhandlung über die Landschaftsmalerei von Wang Wei," *Ostasiatische Zeitschrift*, XVII (N.F. VII), 1931; H. Franke, "Wang-ch'uan chi," *Ostasiatische Zeitschrift*, XXIII (N.F. XIII), 1937; L. Ho, "*Wang Wei*," Shanghai, 1958.

WANG YUAN-CH'I (Wang Lu-t'ai). Chinese painter (1642–1715). He was the grandson of Wang Shih-min and

Wang Wei, *Two Hsien and a Three-legged Frog*, detail. British Museum, London.

is included among the "Six Great Masters" of the Ch'ing dynasty. Wang Yüan-ch'i entered government service by serving as a district magistrate and then as a member of the Han-lin Academy. Eventually he became one of the favorites of the emperor K'ang-hsi (r. 1662–1722) and was put in charge of the imperial collection of painting and calligraphy, thus giving him a significant voice in the art world of his day. He also compiled one of the major collections of earlier writings, the *P'ei-wen-chai shu-hua-p'u*, and was the author of a small treatise on painting called *Yü-ch'uang man-pi* (Scattered Notes at a Rainy Window).

In his paintings Wang Yüan-ch'i concentrated on landscapes, executing many of them at the request of the Emperor, who often liked to watch the painter at work. Of the orthodox, or traditional, masters of the K'ang-hsi period Wang Yüan-ch'i was probably the most creative and certainly the most distinctive in style. His carefully structured landscapes have been compared with the works of Cézanne in the way he did variations on one particular landscape theme which featured a rocky foreground, an expanse of water, and distant hills. He based many of his compositions on Yüan-dynasty spatial devices, executing his works with a dry, controlled brush. In his concern for structural forms and in his systematic working of a limited theme in the landscape genre, Wang Yüan-ch'i often has striking affinities with some 19th-century painting attitudes in the West. *See* WANG SHIH-MIN.

BIBLIOGRAPHY. V. Contag, *Die sechs berühmten Maler der Ch'ing-Dynastie*, Leipzig, 1941; J. P. Dubosc, "A New Approach to Chinese Painting," *Oriental Art*, III, 1950. MARTIE W. YOUNG

WAPPERS, GUSTAVE. Belgian painter (b. Antwerp, 1803; d. Paris, 1874). Wappers is chiefly known for his large history paintings and portraits. He derived his style from French romantic painting, particularly from Delacroix, as in *Charles I of England on the Way to the Scaffold* (1870; Brussels, Fine Arts Museum).

BIBLIOGRAPHY. H. Billung, *Gustav Wappers*, Leipzig, 1880.

WARD, JAMES. English painter and engraver (b. London, 1769; d. Cheshunt, 1859). He began his career as an engraver under J. R. Smith and later under his brother William. Mezzotints comprise the largest part of Ward's output. Many are of his own design; others are after Reynolds, Hoppner (portraits), and Morland (other subjects). He and his brother dominated English mezzotint during their lifetimes.

From about 1797 James Ward worked mainly in oils, producing many realistic horse and dog pictures. He was elected associate of the Royal Academy of Arts in 1807 and full academician in 1811. Ward was influenced by the Dutch animal painters and by Rubens, but the bold personal style that he cultivated was not derivative. He is now recognized as an important figure in the English romantic movement. His large *Gordale Scar* (1814) is in the Tate Gallery, London.

BIBLIOGRAPHY. C. R. Grundy, *James Ward*, London, 1909.

WARD, JOHN QUINCY ADAMS. American sculptor (b. Urbana, Ohio, 1830; d. New York, 1910). He first considered the study of medicine but finally chose sculpture. He worked with Henry Kirke Brown in New York and remained for many years as Brown's studio assistant. After practicing portraiture in Washington for three years, Ward

Gustav Wappers, *Charles I of England on the Way to the Scaffold*, 1870. Fine Arts Museum, Brussels.

John Ward, statue of Washington, in front of the Sub-Treasury Building, New York City.

returned in 1861 to New York and spent the rest of his life there. He is best known for *Indian Hunter* (New York, Central Park) and *Washington* (New York, Sub-Treasury Building). Ward was once president of the National Academy of Design. He was fully aware of the popularity of the neoclassical style as practiced by many of his contemporaries in the United States, but he was one of a small and unaffiliated group who rejected this mode in favor of a native and direct effort to express nobility through naturalism.

BIBLIOGRAPHY. A. V. Adams, *John Quincy Adams Ward: An Appreciation*, New York, 1912; E. C. Clark, *History of the National Academy of Design, 1825-1953*, New York, 1954.

WARD, LYND. American graphic artist (1905–). Ward was born in Chicago. Since attending Teacher's College of Columbia University in New York City and the Academy for Graphic Arts in Leipzig, he has illustrated more than 100 books with woodcuts, wood engravings, and lithographs. He also invented the novel in woodcuts, examples of which are *God's Man* (1929) and *Vertigo* (1937).

WARD, WILLIAM. English mezzotinter (b. London, 1760; d. there, 1826). The brother of James Ward, he was a pupil and long-time assistant of John Raphael Smith. Ward engraved for a number of royal persons, including Prince Regent George IV. With his brother, he was one of England's leading mezzotinters, working mainly after his brother's paintings and George Morland.

BIBLIOGRAPHY. A. M. Hind, *J. R. Smith and the Great Mezzotinters in the Time of Reynolds*, London, 1911.

WARE, ISAAC. English architect (d. 1766). A Neo-Palladian architect associated with Burlington and Kent, he was the author of an edition of *Palladio* (1738), *Designs of Inigo Jones* (1743), and *A Complete Body of Architecture* (1756). Wrotham Park (1754) is his most important building. His drawings in the Avèry Library, Columbia University, reveal an extensive practice.

WARE AND VAN BRUNT. American architectural firm of William Robert Ware (1832–1915) and Henry Van Brunt (1832–1903). Ware, first architecture professor in the United States, organized the country's first school of architecture at the Massachusetts Institute of Technology (1865) and founded the School of Architecture at Columbia University (1881). The partnership, formed in 1860, did important buildings, such as the First Unitarian Church, Boston (1865–67); Old Union Station, Worcester (1875–77); and Memorial Hall at Harvard University, Cambridge (1870–78), a Victorian Gothic structure.

WAREGA (Balega), *see* AFRICA, PRIMITIVE ART OF (CENTRAL AFRICA: CONGO-LEOPOLDVILLE).

WARHOL, ANDY, *see* POP ART.

WARIN, JEAN, *see* VARIN, JEAN.

WARKA (Uruk). Site in Iraq 50 miles northwest of Ur. Warka is the Biblical Erech (Gen. 10:10), a city con-

nected with Gilgamesh, the semilegendary king of the 1st dynasty of Uruk and hero of the Babylonian *Epic of Gilgamesh.*

Preliminary explorations were carried out by Loftus in 1887. Systematic excavations were undertaken by the Germans in 1912–13 and 1929–38. After a fifteen-year lapse the German excavations were resumed, and they are still continuing. Among archaeological remains so far unearthed, five architectural complexes are outstanding: (1) a great temple complex dedicated to Assur, known as Bit-Resh; (2) a Seleucid temple complex in the southern part of the city, known as Südbau; (3) the Eanna precinct; (4) the Ningizzida Temple; and (5) a large building complex by the city gate.

The main buildings of Bit-Resh were built of baked bricks on limestone foundations, which probably originated in the Old Babylonian or Neo-Babylonian period and were repaired and rebuilt in Achaemenian and Seleucid times. Bit-Resh stood on a number of terraces. Excavations in 1954–55 proved that the oldest terrace was constructed in the Jamdet Nasr period (3200–3000 B.C.) or in the 1st Early Dynastic period (3000–2700 B.C.). On its southwest side the Old Terrace was found to have been connected with the Ziggurat of Anu, on which the White Temple, a typical temple of the protoliterate period, was built. *See* Warka: Temple.

The most important area in Warka is probably the Eanna precinct, east of Bit-Resh. The remains date back into the 4th millennium B.C., proving that the cult was already established at that time. Archaeological discoveries from the Eanna sanctuary, sculptures, stone vessels decorated in high relief, seals, and seal impressions, as well as traces of extensive building activities, reveal the brilliance of protoliterate art and architecture.

The ziggurat of the Eanna precinct, which probably originated in the 3d dynasty of Ur, stood on an Early Dynastic terrace. Its adjoining areas were enclosed by the so-called Zingel walls, which are for the most part Neo-Babylonian (612–539 B.C.). In the area outside and inside the southern corner of the Zingel walls, the protoliterate buildings of the Eanna precinct were discovered: remains of the Eanna temple and the Limestone Temple. Within the oblong court of the Limestone Temple the excavators dug a pit 60 feet deep. The archaeological discoveries in this pit were stratified into the following sequence: Levels IV to VII, representing the late Uruk and early protoliterate period (3500–3200 B.C.); Level VIII and below, representing the early Uruk period (ca. 3800 B.C.); and Levels XI to XVIII, representing the Ubaid period (ca. 4000 B.C.).

The Mosaic Temple (called the Stone Cone by the excavator H. J. Lenzen), which was discovered in a trial trench dug halfway between the east corner of Bit-Resh and the southwest side of the Zingel walls, is assigned to Eanna Levels VI to IV. These building remains illustrate highly developed stone and brick masonry and architectural decoration in the form of *Stiftmosaik* (stone or clay cones with ends dipped in color). *See* Mosaic.

The other known building remains of Eanna Level IV consist of Temples A, B, C, and D, the Red Temple, and the so-called Stiftmosaik Building. The Red Temple is so named because its interior walls were painted red. The Stiftmosaik Building, so named because of its pillared terrace with a terra-cotta *Stiftmosaik* revetment, may have been a palace.

The enigmatic relationship between the Mosaic Temple of Eanna Levels VI to IV and the so-called Riemchengebäude abutting on its north corner was investigated by Lenzen. The Mosaic Temple, the beginnings of which are the most clearly known of all the buildings in the Eanna precinct, stood on a terrace of beaten earth, which was constructed in a pit. The terrace yielded Eridu, Hajji-Muhammad, and Ubaid potsherds (ca. 4000 B.C.). The pit was dug in the site of a former brick factory. To the west of the Riemchengebäude the workyard of the temple was found, where stone *Stiftmosaik* were abundantly produced. The Riemchengebäude is dated to Eanna Level III, which is correlated with the Jamdet Nasr period on the basis of the offerings discovered there. Lenzen thinks that the construction of the Riemchengebäude must have followed the violent destruction of the Mosaic Temple, and this was probably contemporary with the destruction of other buildings in Eanna IV. The other known building remains of Eanna III consist of many offering tables built northeast of the precinct and several unconnected groups of walls running along the southwest and northwest sides of the ziggurat.

The Eanna precinct in later periods contained in the northeast area a large garden court with a network of canals and cisterns. Neo-Assyrian, Neo-Babylonian, Achaemenian, and Seleucid building remains have also been discovered. These building remains can probably be identified with the magazine, the bookkeeping office, and the living quarters of priests and officials of the temple. In

Warka. Head of woman, ca. 3000 B.C. Iraq Museum, Baghdad.

the northwest area of the ziggurat, Early Dynastic, Ur III, Old Babylonian, Neo-Assyrian, and Neo-Babylonian building remains were found. Archaeological discoveries in these areas include a Kassite stele, a Neo-Assyrian stele, and thousands of clay tablets of the Neo-Babylonian and Achaemenian periods, mostly economic and business texts. *See also* KASSITE ART.

A few other architectural monuments inside and outside the city walls were also examined. Those within the city walls are the huge Temple of Ningizzida, which shows all phases from Neo-Babylonian through Seleucid times, and an unidentified Seleucid apsidal building. Those outside the city include the Sassanian building remains and graves in which an olive wreath of the Greco-Roman type, wrought in gold and glass paste, was found. The excavators also investigated the remains of an enormous building in front of the city gate which was formerly believed to be the Bit-Akitu. It is now thought to be a residential building probably used by the priests who participated in the lengthy New Year's festival.

See also WARKA: HEAD OF WOMAN.

BIBLIOGRAPHY. C. Ziegler, *Die Keramik von der Qal'a des Ḥaǧǧi Mohammed*, Berlin, 1953; H. J. Lenzen, "Bericht über die vom Deutschen archäologischen Institut und von der Deutschen Orient-Gesellschaft in Uruk-Warka am Anfang des Jahres 1954 Unternommenen Ausgrabungen," *Mitteilungen der Deutschen Orient-Gesellschaft*, no. 87, 1955; H. J. Lenzen, *Vorläufiger Bericht über die von dem Deutschen archäologischen Institut und der Deutschen Orient-Gesellschaft aus Mitteln der Deutschen Forschungsgemeinschaft unternommenen Ausgrabungen in Uruk-Warka*, Winter 1953/54, Winter 1954/55, Berlin, 1956; H. J. Lenzen, "The Ningišzida Temple Built by Marduk-apal-Iddina II at Uruk (Warka)," *Iraq*, XIX, Autumn, 1957; H. J. Lenzen, "Ein Goldkranz aus Warka," *Sumer*, XIII, 1957; E. Porada, "Orientalists at Munich," *Archaeology*, X, Winter, 1957; A. Parrot [Review of the monograph by H. Lenzen on the Warka excavations during 1953–54, 1954–55], *Syria*, XXXV, 1958; "News and Correspondence: [Item] 6: Warka," *Sumer*, XV, 1959; H. J. Lenzen, "The E-Anna District after Excavations in the Winter of 1958–59," *Sumer*, XVI, 1960. AYAKO IMAI

WARKA (Uruk): HEAD OF WOMAN. Gypsum head dating from the protoliterate period (ca. 3000 B.C.) found at Warka, Iraq (Baghdad, Iraq Museum). It is about 8 inches high. The face is beautifully modeled; the eyes and eyebrows are deeply cut and were probably originally inlaid with lapis lazuli, shell, and obsidian. A wig of some unknown material was undoubtedly also placed over the undulating upper surface of the head. The back of the head is flat, and drill holes suggest that it was attached to a body of another material.

See also WARKA.

BIBLIOGRAPHY. H. Frankfort, *The Art and Architecture of the Ancient Orient*, Baltimore, 1954.

WARKA (Uruk): TEMPLE. One of the earliest (ca. 3000 B.C.) and best-preserved temples in Iraq. It was dedicated to the god Anu. It consists of a structure with a rectangular plan, oriented to the cardinal points of the compass at its corners, and built of massive whitewashed brickwork on a platform with slanting recessed sides, perhaps the prototype of the ziggurat. This so-called White Temple consists of an axial, deep cella with recessed paneling on its walls, an offering table with hearth, and an altar accessible from a stairway at the rear. On both sides are small rooms. *See* ZIGGURAT.

See also WARKA.

BIBLIOGRAPHY. H. J. Lenzen, in *Mitteilungen der Deutschen Orient-Gesellschaft*, no. 83, Berlin, 1951.

WARNEKE, HEINZ. American sculptor (1895–). Born in Bremen, Germany, he studied at the Academy of Art in Bremen and at the Academy of Art in Berlin. He went to the United States in 1923. Warneke has received awards and prizes from the Art Institute of Chicago, the Pennsylvania Academy of Fine Arts, the Washington Artists Association, and others.

Warneke's style is one of simplified, sometimes semi-abstract figural treatment based on the essential planes, volumes, and movement of his subjects (often animals). He has worked in granite, marble, bronze, and brass, sometimes actually carving the last substance from a roughly cast block. Many of his statues have a finely polished surface. Among his characteristic works are *Startled Deer*, *Boar*, *Cat*, and *Stallion Rearing*.

BIBLIOGRAPHY. J. Schnier, *Sculpture in Modern America*, Berkeley, Calif., 1948.

WARNER, OLIN LEVI. American sculptor (1844–96). He studied at the Ecole des Beaux-Arts in Paris and was one of the first Americans to be influenced by the styles of Jouffroy, Barye, Rude, and Carpeaux rather than by those of the Italian neoclassicists. He did the bronze doors on the theme of Tradition at the Library of Congress in Washington. Warner is respected for his early acceptance of a style other than that of late-19th-century Italy and for his native adaptation of a more lyrical French aesthetic.

BIBLIOGRAPHY. W. C. Brownell, "The Sculpture of Olin Warner," *Scribner's Magazine*, XX, 1896.

WAROQUIER, HENRY DE. French painter, sculptor, and graphic artist (1881–). Born in Paris, he had some early training in architecture but is self-taught as a painter. The two sources of his painting can be seen in his early Bretagne landscapes which combine impressionism with the formalization of Japanese art. His first trip to Italy in 1912 resulted in a more sober palette due to the influence of primitive landscapes and Italian frescoes. Waroquier has been more concerned with the linear and volumetric elements in painting than with color; for a period after 1932 he concentrated almost exclusively on the figure, particularly the female nude, and, more recently, he has concentrated on sculpture.

BIBLIOGRAPHY. J. Auberty, *Henry de Waroquier: Catalogue de son oeuvre gravé*, Paris, 1951; "Henry de Waroquier: Dates et documents sur son oeuvre," *Art-Documents*, XLIV, May, 1954.

WARREN, RUSSELL. American architect (b. Tiverton, R.I., 1783; d. 1860). He was the author of a series of original mansions after 1808 and an early New England exponent of Greek revival styles, as exemplified by his Providence Arcade (1827–29). Warren was of the generation that marked the transition between carpenter-designer and professional architect.

WARREN, WHITNEY. American architect (b. New York, 1864; d. there, 1943). Prominent in New York during the 1890s, he had lived and studied in Paris during the 1880s and early 1890s, returning to New York in 1896 to form a partnership with Charles D. Wetmore (1866–1941). Their most important work is Grand Central Terminal in New York City, designed and built between 1903 and 1913 with Reed and Stem.

Wartburg Castle. An example of German Romanesque fortification.

Warwick Castle. The gatehouse and Caesar's Tower (*left*).

WARTBURG CASTLE. German castle near Eisenach, Thuringia. It is famous as the place where Martin Luther took refuge and translated the Bible after the Diet of Worms. The castle was first mentioned in 1080 and again in 1113, but the present structure dates from the early 13th century. Debate exists over the date of the earliest part, the Landgrafenhaus, some dating it as early as 1180. In any case, Wartburg Castle is one of the earliest preserved examples of Romanesque fortifications in Germany. Gothic additions are the circular wall of the main castle, the tower gate, the knights' house, and the bailiff's quarters. The fortifications were badly damaged in the Thirty Years' War.

BIBLIOGRAPHY. S. Asche, *Die Wartburg und ihre Kunstwerke*, 2d ed., Eisenach, 1954.

WARWICK CASTLE. Little of the original Romanesque castle in Warwickshire, England, remains. The exterior is primarily late 14th century. The northeast side was rebuilt with a notable gatehouse and barbican and with flanking towers at each end—Caesar's Tower and Guy's Tower—both masterpieces of military architecture. There are sumptuous Georgian interiors.

WARWICK CHURCH. English Collegiate Church of St. Mary containing the tomb of Richard Beauchamp, Earl of Warwick (d. 1439) in the Beauchamp Chapel (1443–64), an elaborate example of the Perpendicular style. Most of the remainder of the church was rebuilt after a fire of 1694. The church contains an altar tomb with niched figures, saints, and angels; and a bronze effigy with a metal hearse.

BIBLIOGRAPHY. F. H. Crossley, *English Church Monuments, A.D. 1150–1550*, London, 1921.

WASH. Technique in water color in which a small amount of pigment is mixed with a large amount of water and applied in broad strokes to produce a light haze of color. Wash is most often used for creating atmospheric effects and translucent shadows.

WASH DRAWING. A wash drawing is technically a brush drawing, since it is made with a brush and some form of ink. It differs from the pure brush drawing in its use of transparent wash and because it is often used in combination with other drawing media, such as charcoal, pen, pencil, and even chalk. The wash drawing is usually of one color, less often of two. The coloring material is usually bistre, which is a warm brown; sepia, which is a duller brown; or Chinese ink in various degrees of dilution. The wash, therefore, can have a full scale of values. When the wash is used with another medium, it may be applied either first, in broad areas, or last, to fill in the drawn design. Both methods yield distinct styles and are easily distinguishable to the experienced eye.

The wash drawing is particularly effective in rendering shadow, modeling, and painterly light effects. It was, in fact, an outgrowth of the brush drawing created for more naturalistic light and spatial effects. The wash drawing came into use in the late 15th century, when the wash was used sparingly and carefully. As style became less linear, the wash was used more. It was no longer drawn on, but was applied in loose, sketchy patches for indicative or suggestive purposes. Guercino, Claude Lorraine, Poussin, Elsheimer, Tiepolo, and Rembrandt all used the wash drawing with much effectiveness. Rembrandt, particularly, understood the possibilities of wash, and some of his most powerful drawings were a combination of pen and wash.

BIBLIOGRAPHY. C. de Tolnay, *History and Technique of Old Master Drawings*, New York, 1943; J. Watrous, *The Craft of Old-Master Drawings*, Madison, Wisc., 1957.

JULIA M. EHRESMANN

WASHINGTON, D.C. Capital of the United States. The city was laid out in 1791 by Major Pierre l'Enfant; al-

though in the early decades his plan seemed overly ample ("the city of magnificent distances"), it has turned out that his scheme was suitable for a grand capital. The main axes of the city cross approximately at the Washington Monument; in the original plan there would have been an 8-mile vista south down the Potomac River and a canal along the Mall for the use of state barges. Work progressed slowly, and it was only after the Civil War that Washington was really developed.

The competition for the Capitol design was won by William Thornton in 1793; he was the architect until 1802. He was succeeded by Latrobe (1803–17) and Bulfinch (1818–29). The cast-iron dome was added by Walter (1855–63). The White House (originally called the President's House) was begun by Hoban (1792); after it was burned by the British in 1814 it was rebuilt by Latrobe (1815–17) after Hoban's plans. Both buildings have been expanded and altered many times. *See* CAPITOL, THE.

L'Enfant's plan provided for a series of radial avenues passing through a rectilinear grid of streets and converging on the Mall area, where the chief monuments and administrative buildings are clustered. Among them are the Washington Monument, designed by Robert Mills in 1833 and built in 1848–88; the Lincoln Memorial, by Henry Bacon (completed 1923); the Jefferson Memorial, by John Russell Pope (1939–41); the Supreme Court Building, by Cass Gilbert (1933–35); the Old State, War, and Navy Building (1870s); and the Smithsonian Institution, by Renwick (1848–67). The last two are important as examples from a period when official taste departed from more or less classical design and swung toward styles in use for monumental buildings in other parts of the country. Modern Washington government buildings tend to be academic and somewhat frigid, for example, the National Archives Building (completed 1939) and the National Gallery of Art (completed 1941), both by Pope.

Christ Church was designed by Latrobe (1806–07). He also built St. John's Church (1815–16) with its tower and portico (1820); Renwick remodeled the interior in 1883. The Cathedral of SS. Peter and Paul (also called the Washington Cathedral) was begun in 1908 in the Neo-Gothic style; work is still in progress.

There are many fine homes, such as Arlington House, Blair House (now the President's guesthouse), and the Octagon House. The comparatively intimate Georgetown section, with fine buildings in the neoclassic style, is in sharp contrast to the official city.

Important works of art are housed in the National Gallery of Art, Freer Gallery, Corcoran Gallery of Art, and Library of Congress and in specialized collections, such as the Phillips Collection and Dumbarton Oaks Collection. *See* WASHINGTON, D.C.: MUSEUMS.

BIBLIOGRAPHY. G. Brown, *History of the United States Capitol*, 2 vols., Washington, 1900–03; C. E. Fairman, *Art and Artists of the Capitol of the United States*, Washington, 1927; Federal Writers' Project, *Washington, City and Capital*, Washington, 1937; H. P. Caemmerer, *A Manual on the Origin and Development of Washington*, Washington, 1939; H. D. Eberlein, *Historic Houses of Georgetown and Washington City*, Richmond, 1958.
WILLIAM L. MAC DONALD

WASHINGTON, D.C.: MUSEUMS.

Important public art collections in Washington, D.C., are located in the museums listed below.

Corcoran Gallery of Art. Museum founded by William W. Corcoran in 1869. It was established in its present classical revival building in 1897. The scope of the museum was expanded beyond American art with the addition of Sen. William A. Clark's collection of European art in 1926.

The collection of American painting extends from the colonial period to the present day. Noteworthy 18th- and early-19th-century works are Wollaston's *Mrs. Sidney Breese*, Copley's *Jacob Fowle*, a *Portrait of George Washington* by Gilbert Stuart, West's *Cupid and Psyche*, Morse's *Old House of Representatives*, and portraits by Theus, Trumbull, Earl, Wright, Rembrandt Peale, Sully, and Neagle. Representing the Hudson River school are Cole's *Departure* and *Return* and works by Doughty, Durand, Kensett, Inness, Frederick E. Church, and Bierstadt. Other paintings from this period are presidential portraits by Healy and regional works by Ranney and Eastman Johnson.

Outstanding works from the latter half of the 19th century include Eakins's *Pathetic Song*, Homer's *Light on the Sea*, Ryder's *Outward Bound* and *Seascape*, and others by Whistler, Cassatt, Blakelock, Duveneck, Sargent, William Chase, Abbott Thayer, Theodore Robinson, J. Alden Weir, Twachtman, Hassam, Melchers, Prendergast, and Arthur B. Davies. In addition to Sloan's *Yeats at Petitpas*, Glackens's *Luxembourg Gardens*, and Bellows's *Forty-Two Kids*, there are works by Henri, Luks, and Myers representing the Ashcan school. Some of the other 20th-century painters represented are Hopper, Marin, Watkins, Soyer, Evergood, Stuart Davis, Rivers, and Stamos.

French and Dutch painting are the strong areas of the William A. Clark Collection. Notable French works are Chardin's *Woman with a Saucepan*, several Corots, including the *Bacchante*, many Monticellis, Degas's *Dancing School*, and works by Boucher, Daumier, Daubigny, Théodore Rousseau, Delacroix, and Millet. The Dutch group includes Rembrandt portraits and works by Hals, Van Goyen, Cuyp, Dou, Hobbema, De Hoogh, Maes, Ruisdael, Steen, and Terborch. Perugino's *Madonna and Child with Saints and Angels* is prominent in the Italian group, which also includes works by Andrea Vanni, Titian, Annibale Carracci, and Guardi. The Flemish painters Van Cleve, Rubens, and Van Dyck and the English painters Hogarth, Gainsborough, Reynolds, Raeburn, and Turner are also represented.

Decorative arts form part of the Clark Collection. Among these are ancient Greek vases and terra cottas, a 13th-century stained-glass window from a church in Chartres, Arras tapestries of the 15th century, delftware, Palissy ceramics, Italian majolica, and Persian rugs and lace. Works by Canova, Falconet, and Rodin add to the gallery's collection of sculpture, which also includes works by Powers, Remington, Saint-Gaudens, Sargent, Anna Huntington, and Manship and more than 100 bronzes by Barye. The gallery's other activities include the conducting of a prestigious, prize-awarding biennial as well as temporary exhibitions.

BIBLIOGRAPHY. Corcoran Gallery of Art, *Illustrated Handbook of the W. A. Clark Collection*, Washington, 1932; Corcoran Gallery of Art, *Handbook of the American Paintings in the Collection of the Corcoran Gallery of Art*, Washington, 1947.
DONALD GODDARD

Washington, D.C., museums. National Gallery of Art, by John Russell Pope, completed 1941.

Dumbarton Oaks Collection. Specialized collection whose core is formed by Robert Woods Bliss's gift to Harvard University in 1940. Under the administration of Harvard it has been added to by further gifts and purchases. The collection is devoted to the arts of the Byzantine Empire with a corollary concern with the contemporaneous arts of Europe and the Near East and the preceding arts of Greece and Rome. On display are sculptures, metalwork, medallions, jewelry, ivories, glasswork, pottery, enamels, mosaics, paintings, Coptic and other textiles, coins, and seals. Another part of the Bliss Collection is comprised of a magnificent array of pre-Columbian sculpture, pottery, textiles, jewelry, and ornaments from all areas and periods of ancient America, recently housed in an annex designed by Philip Johnson.

BIBLIOGRAPHY. *The Dumbarton Oaks Collection, Harvard University: Handbook*, Washington, 1955.

Freer Gallery. Collection founded by Charles Lang Freer and housed in a Renaissance-style building completed in 1920. The museum is administered by the Smithsonian Institution. The extraordinary collection consists of more than 2,000 of the finest works of Oriental art in the United States; a lesser number of paintings by Freer's contemporaries Sargent, Homer, George de Forest Brush, Gari Melchers, Thomas Dewing, and Abbott Thayer; and more than 1,000 works by James McNeill Whistler, including the famous Peacock Room decorated by the artist for the London house of F. R. Leyland, whose full-length portrait by Whistler is in the collection. On view are choice examples of painting, sculpture, ceramics, metalwork, lacquer, and glass from China, Japan, India, Tibet, Korea, Iran, Iraq, Byzantium, and Egypt.

BIBLIOGRAPHY. W. A. Cartwright, *Guide to Art Museums in the United States*, vol. 1: *East Coast: Washington to Miami*, New York, 1958; E. Spaeth, *American Art Museums and Galleries*, New York, 1960.

National Fine Arts and Portrait Galleries. Museum opened in 1968, combining the National Collection of Fine Arts and the National Portrait Gallery, under the direction of the Smithsonian Institution. It is housed in the Old Patent Office Building, a Greek revival structure (1836–66) by William P. Elliot, Ithiel Town, and Robert Mills.

The National Collection of Fine Arts, the first Federal museum of American art, constitutes a panorama of the evolution of art in the United States. The present collection of about 11,000 works includes 445 paintings by George Catlin, examples by Alfred Ryder, Frederick E. Church, and Benjamin West, and objects such as a gold and diamond snuffbox made for Catherine the Great. Other American artists represented range from Gilbert Stuart in the 18th century to Rauschenberg and Dine in the 1960s.

The National Portrait Gallery exhibits portraiture and statuary of men and women who have figured in the development of the United States. The nucleus of its collection was a bequest by Andrew P. Mellon. The Mellon gift consists of 35 portraits, including examples by Gilbert Stuart and John Singleton Copley. The present collection of the Portrait Gallery totals about 350 paintings and 25 busts, ranging from a 1617 portrait of Pocahontas to likenesses of contemporary Americans.

National Gallery of Art. Museum founded in 1937 on a gift from Andrew W. Mellon, who funded the building and donated his entire collection of paintings. The building, designed in a pure classical style by John Russell Pope (completed 1941), is the largest marble structure in the world. The museum is administered by the Smithsonian Institution. The gallery has perhaps the most complete collection of European painting and sculpture in the United States. Complementing the original Mellon bequest are the Kress, Widener, Rosenwald, and Dale collections, which form the bulk of the gallery collections. An additional building, in a modern style, is being designed (1968) by I. M. Pei.

Masterpieces of Italian 13th- and 14th-century painting are two Byzantinesque versions of the Madonna and Child, Cimabue's *Christ between St. Peter and St. James Major*, Giotto's *Madonna and Child*, Duccio's *Calling of St. Peter and St. Andrew*, Simone Martini's *St. John the Baptist*, Bernardo Daddi's *Madonna and Child with Saints and Angels*, Paolo Veneziano's *Coronation of the Virgin*, and Lippo Memmi's *Madonna and Child with Donor*. Central Italian and Tuscan works of the 15th century include Masaccio's *Profile Portrait of a Young Man*, Fra Angelico's *Adoration of the Magi* and *Entombment of Christ*, Masolino's *Annunciation*, Gentile da Fabriano's *Madonna and Child* and *Miracle of St. Nicholas*, Domenico Veneziano's *St. John in the Desert* and *St. Francis Receiving the Stigmata*, four predella panels by Sassetta, Giovanni di Paolo's *Annunciation* triptych, Piero della Francesca's *St. Apollonia*, Fra Filippo Lippi's *Madonna and Child*, Gozzoli's *Dance of Salome*, Castagno's *Youthful David* and *Portrait of a Man*, Botticelli's *Adoration of the Magi* and portraits of a youth and Giuliano de' Medici, Signorelli's *Eunostos of Tanagra*, Perugino's *Crucifixion* triptych, and Piero di Cosimo's *Visitation*.

Northern Italian and Venetian works of the same period include Mantegna's *Judith and Holofernes*, Giovanni Bellini's *Portrait of a Condottiere, Orpheus, Madonna and Child, Portrait of a Young Man in Red*, and *Feast of the Gods*, Antonello's *Madonna and Child* and *Portrait of a Young Man*, Ercole de' Roberti's Bentivoglio portraits, Cossa's *Crucifixion, St. Florian*, and *St. Lucy*, Pisanello's *Portrait of a Lady*, and Carpaccio's *Flight into Egypt*.

Several extraordinary works by Raphael—*St. George and the Dragon*, the *Alba Madonna*, the *Small Cowper Madonna*, the *Niccolini-Cowper Madonna*, and the *Portrait of Bindo Altoviti*—highlight the group of 16th-century Italian paintings. Other central Italian and Tuscan works of the period are Andrea del Sarto's *Charity*, Sodoma's *St. George and the Dragon*, Pontormo's *Holy Family*, Rosso's *Portrait of a Man*, and Bronzino's *Young Woman and Her Boy*. Venetian and northern Italian paintings of the 16th century include Giorgione's *The Adoration of the Shepherds*, Giorgione's and Titian's *Portrait of a Venetian Gentleman*, Titian's portraits of Doge Andrea Gritti and Ranuccio Farnese, *Venus with a Mirror, Venus and Adonis*, and *St. John the Evangelist on Patmos*, Lotto's *Allegory, Maiden's Dream*, and *Nativity*, Tintoretto's *Christ at the Sea of Galilee* and *Conversion of St. Paul*, Veronese's *Finding of Moses* and *Rebecca at the Well*, Dosso's *Circe and Her Lovers*, Moretto's *Pietà*, and Sebastiano del Piombo and Moroni portraits. Prominent among the paintings of the 17th and 18th centuries are Magnasco's *Baptism of Christ*, Tiepolo's *Madonna of the Goldfinch*, and works by Strozzi, Lys, Canaletto, Guardi, Longhi, Ricci, and Bellotto.

Early Flemish painting is represented by Van Eyck's *Annunciation*, Van der Weyden's *Portrait of a Lady*, Christus's *Nativity* and *Donor and His Wife*, Memling's *Presentation in the Temple, St. Veronica*, and *Man with an Arrow*, the Master of St-Gilles's *Baptism of Clovis* and *Conversion of an Arian by St. Remi*, David's *Rest on the Flight into Egypt*, and Bosch's *Death and the Miser*. Sixteenth-century Flemish works include Van Cleve portraits, Pieter Brueghel's *Temptation of St. Anthony*, and Gossaert's *St. Jerome Penitent*. From the 17th century are Rubens's *Isabella Brant* and *Marchesa Brigida Spinola Doria* and a number of portraits by Van Dyck, including that of Marchesa Elena Grimaldi.

Notable among the Dutch 16th-century paintings are Mor's *Portrait of a Gentleman*, Van Leyden's *Card Players*, and Van Scorel's *Rest on the Flight into Egypt*. The 17th-century group is distinguished by many Rembrandts, including his *Joseph Accused by Potiphar's Wife, The Mill*, two self-portraits, *Girl with a Broom*, and *Descent from the Cross*. Other Dutch works of this period are several portraits by Hals, Vermeer's *Woman Weighing Gold, Young Girl with a Flute*, and *Girl with a Red Hat*, Ter Borch's *Suitor's Visit*, De Hoogh's *Dutch Courtyard*, Ruisdael's *Forest Scene*, and Steen's *Dancing Couple*.

The masterpiece of French 16th-century painting is Clouet's *Diane de Poitiers*. Important 17th-century works are Poussin's *Holy Family on the Steps* and *Baptism of Christ*, Claude Lorraine's *Herdsman*, Louis Le Nain's *Landscape with Peasants*, and Philippe de Champaigne's *Portrait of Omer Talon*. French 18th-century painting is well represented by Watteau's *Italian Comedians*, Chardin's *Attentive Nurse, House of Cards, Kitchen Maid*, and *Soap Bubbles*, Boucher's *Venus Consoling Love* and *Mme Bergeret*, Lancret's *La Camargo Dancing*, Robert's *Old Bridge*, Fragonard's *The Swing, Young Girl Reading*, and *Visit to the Nursery*, and works by Pater, Nattier, Drouais, and Greuze.

Highlighting the collection of Spanish paintings are several works by El Greco, including an early version of *Christ Cleansing the Temple, The Virgin with S. Inés and S. Tecla, Laocoön, S. Ildefonso* and *St. Martin and the Beggar*. Seventeenth-century works include Velázquez's study for the *Portrait of Innocent X* and *The Needlewoman*, Zurbarán's *St. Jerome with St. Paula and St. Eustochium*, Murillo's *Return of the Prodigal Son* and *Girl and Her Duenna*, and Valdés Leal's *Assumption of the Virgin*. There are also a number of portraits by Goya.

The German and Austrian schools of the 15th and 16th centuries are represented by the Master of Heiligenkreuz's *Death of St. Clare*, Grünewald's *Small Crucifixion*, Dürer's *Virgin and Child* and *Portrait of a Clergyman*, Holbein's *Edward VI as a Child* and *Sir Brian Tuke*, several Cranach portraits, Strigel portraits, and Altdorfer's *Fall of Man*. English paintings of the 18th century, mostly portraits, include Gainsborough's *Mrs. Richard Brinsley Sheridan* and *Landscape with a Bridge*, Reynolds's *Lady Caroline Howard*, and Raeburn's *Miss Eleanor Urquhart*.

Most of the great figures of French 19th-century painting are represented in the collection. Neoclassical works include David's *Napoleon in His Study* and Ingres's *Mme Moitessier* and *Pope Pius VII in the Sistine Chapel*. Of the romantic era are Delacroix's *Columbus at La Rabida* and Corot's *View near Volterra, Agostina, Forest of Fontainebleau*, and *Artist's Studio*. Realism is represented by Daumier's *Advice to a Young Artist*, Courbet's *Grotto of the Loue*, and Manet's *Old Musician* and *Dead Toreador*. Notable works of impressionism are Manet's *Gare St-Lazare*, Monet's *Palazzo da Mula, Rouen Cathedral: Sunlight*, and *Banks of the Seine, Vetheuil*, Renoir's *Diana, Mme Henriot, Odalisque*, and *Boatmen at Chatou*, Pis-

sarro's *Boulevard des Italiens*, and Degas's *Mme René de Gas, Achille de Gas in the Uniform of a Cadet*, and *Mme Camus*. Postimpressionist works include Cézanne's *Still Life with a Peppermint Bottle* and *House of Père Lacroix*, Van Gogh's *La Mousmée*, Gauguin's *Fatata te Miti* and *Self-Portrait*, Toulouse-Lautrec's *Quadrille at the Moulin Rouge*, and Rousseau's *Equatorial Jungle*. English paintings of the 19th century include Constable's *Wivenhoe Park*, *White Horse*, and *Salisbury Cathedral* and Turner's *Mortlake Terrace*.

Best known of the American 18th-century paintings are West's *Colonel Guy Johnson*, Copley's *The Copley Family*, and Stuart's *Mrs. Richard Yates* and the *Vaughn Portrait of George Washington*. The major works of 19th-century painting are Inness's *Lackawanna Valley*, Eakins's *Biglen Brothers Racing*, Homer's *Breezing Up*, Ryder's *Siegfried and the Rhine Maidens*, Whistler's *The White Girl*, Cassatt's *Boating Party*, and Sargent's *Repose*.

Most of the sculpture collection is the work of Italian Renaissance masters. This includes Nino Pisano's *Annunciation*, Donatello's *David of Casa Martelli* and *Cupid*, Tino da Camaino's *Madonna and Child with Queen Sancia, Saints, and Angels*, terra cottas by Luca della Robbia, Desiderio da Settignano's *Bust of a Little Boy*, *Portrait of Marietta Strozzi*, and *Tabernacle*, Verrocchio's portraits of Giuliano and Lorenzo de' Medici and *Putto on a Globe*, Amadeo's portraits of Ludovico and Gian Galeazzo Sforza, and Giovanni Bologna's *Mercury*. Notable French works are Houdon's *Diana* and four portraits and Carpeaux's *Neapolitan Fisher Boy* and *Girl with a Shell*. There is also a large group of bronzes of the Renaissance, mostly from the Kress Collection.

A large part of the gallery's collection of drawings and prints derives from the Rosenwald Collection. The Widener Collection, in addition to its paintings, includes decorative arts, such as tapestries, church furniture, ivories, jewelry, ceramics, and enamels from the Romanesque period through the 18th century.

BIBLIOGRAPHY. National Gallery of Art, *Paintings and Sculpture from the Samuel H. Kress Collection*, 2d ed., Washington, 1959; National Gallery of Art, *Summary Catalogue of European Paintings and Sculpture*, Washington, 1965; J. Pope-Hennessy, *Renaissance Bronzes from the Samuel H. Kress Collection*, London, 1965; J. Walker and H. Cairns, *A Pageant of Painting from the National Gallery of Art*, 2 vols., New York, 1966. DONALD GODDARD

Phillips Collection. Founded in 1918 by Duncan Phillips and still operated under the supervision of the Phillips family. The Phillips Memorial Collection is one of the best small collections of painting in the United States. It is housed in the old Phillips family residence; a new wing was added in 1961. The rooms remain furnished to a certain extent, thereby maintaining an intimate relationship with the paintings, most of which are small in size: private rather than public masterpieces.

The Phillips has the largest collection of Bonnards in the United States, including *The Circus Rider*. The French paintings have been chosen selectively: the Courbet landscape *Rocks at Ornans*; Degas's *Women Combing Their Hair*; a tiny but perfect Ingres; the Cézanne landscapes; the Vuillards; and the collection of impressionist and cubist works. Two outstanding French paintings in the collection are Renoir's famous *The Luncheon of the Boating Party* (*Le Déjeuner des canotiers*) and the Matisse *Interior with Egyptian Curtain*.

There are two vastly different works on the theme of the repentant Peter by El Greco and Goya; a large group of pictures by Arthur G. Dove; and works by Chardin, Corot, Daumier, Van Gogh, Ryder, Marin, Arthur B. Davies, Kandinsky, Klee, Soutine, and Derain. The Phillips continues to add to its collection the works of contemporary artists, both American and European; there are paintings by De Kooning, Phillip Guston, Sam Francis, and Joan Mitchell, and three outstanding paintings by Mark Rothko. Some fine pieces of sculpture are also exhibited.

BIBLIOGRAPHY. W. Phillips, intro., *The Phillips Collection, a Museum of Modern Art and Its Sources: Catalogue*, Washington, 1952.
ABBY F. ZITO

WASHINGTON CROSSING THE DELAWARE. Oil painting by Leutze, in the Metropolitan Museum of Art, New York. *See* LEUTZE, EMANUEL.

WASMANN, FRIEDRICH. German painter (1805–86). He studied in Dresden and Munich, and was influenced in Rome (1832–35) by the Nazarenes. He spent most of his life as a portrait painter in Merano. Wavering between sharp, naturalist characterization and arbitrary stylization, his early pencil portraits and landscape studies in oil include some of the freshest examples of early-19th-century naturalism.

BIBLIOGRAPHY. P. Nathan, *Friedrich Wasmann*, Munich, 1954.

WASSENHOVE, JOOS VAN, *see* JUSTUS OF GHENT.

WAST, JEAN, *see* VAST, JEAN.

WASTELL, JOHN. English architect (d. 1515). His work at the abbey church of Bury (1480s) leads to his masterpiece, the central, or Bell Harry, tower of Canterbury Cathedral (erected 1494–97). His work is extensive, and includes the completion of King's College Chapel, Cambridge (1514). He is the great figure of the late English Gothic. *See* CANTERBURY CATHEDRAL; KING'S COLLEGE CHAPEL, CAMBRIDGE, ENGLAND.

BIBLIOGRAPHY. J. Harvey, comp., *English Mediaeval Architects*, London, 1954.

WATENPHUL, MAX PEIFFER, *see* PEIFFER-WATENPHUL, MAX.

WATER COLOR. Painting medium using powder pigments and water. The pigments are mixed with a gum which acts as a binder. This mixture is either pressed into cakes or mixed with water into a paste for packaging in tubes. In executing a water-color painting, the artist combines the pigment mixture with varying amounts of water with a soft hair brush and applies it to the ground, usually paper. The most characteristic effect of water color is its range of translucent washes.

WATERHOUSE, ALFRED. English architect (1831–1905). He first worked in Manchester, whose Town Hall (1869) is his consummate work. He was a master of the silhouette, no better seen than at St. Paul's School, Hammersmith (1881). He favored external treatment in burnt brick and terra cotta.

BIBLIOGRAPHY. H. R. Hitchcock, *Architecture, Nineteenth and Twentieth Centuries*, 2d ed., Baltimore, 1963.

WATERLOO (Waterlo), ANTONIE. Dutch painter and etcher of landscapes (b. Lille? 1609/10; d. Utrecht, 1676 or after). In 1640 Waterloo was reported in Zevenbergen. He was active in Amsterdam in 1639/40, in Leeuwarden in 1653, and once more in Amsterdam in 1673/74. Facts concerning his life are difficult to determine, since there were other painters with the same name. He was possibly self-taught.

BIBLIOGRAPHY. M. Vandalle, "Antoine Waterlo," *Revue belge d'archéologie*, X, 1940.

WATERMARK. The semitransparent sign in papers. It is made by a metal "rake" during the process of manufacture while the paper's fibers are still wet. The watermark can be seen if the paper is held to the light. The identification of watermarks has been a great aid in dating and attributing prints and drawings.

WATER TABLE. Projecting course, generally of brick or stone, set a few feet above the ground and intended to protect a building from rain. In Georgian colonial architecture, the water table of molded brick was a transition element between the basement wall, which projected aboveground, and the offset at the building face above.

WATKINS, FRANKLIN CHENAULT. American painter (1894–). Born in New York City, he studied at the Pennsylvania Academy of Fine Arts and traveled in Europe in 1923. Watkins first attracted attention when his overly dramatic *Suicide in Costume* (1931; Philadelphia Museum of Art) won a prize at the Carnegie International of 1931. The violent pose and fitful painting and lighting reveal a debt to El Greco. Similar expressionist means appear in *The Fire-Eater* (1933–34; Philadelphia Museum of Art), where twisted figures, turbulent setting, and excited brushstrokes effectively parallel the subject. Much of Watkins's later work is of a religious or symbolic nature, for example, *The Angel Will Turn a Page in the Book* (1944; Washington, D.C., Phillips Collection).

BIBLIOGRAPHY. A. C. Ritchie, *Franklin C. Watkins*, New York, 1950.

WATSON, HOMER. Canadian painter (1855–1936). He lived throughout his life at Doon, Ontario. Influenced by the Hudson River school and later by Constable and Inness, he painted landscape in oil exclusively. He made several trips to England, and was the president of the Royal Canadian Academy in 1918–22.

BIBLIOGRAPHY. M. Miller, *Homer Watson...*, Toronto, 1938.

WATSON, JAMES. Irish engraver (b. Dublin, ca. 1740; d. London, 1790). Watson produced almost 300 technically refined and precisely drawn mezzotints, the best of which (about sixty) are portraits after Reynolds, for example, *Dr. Johnson*.

BIBLIOGRAPHY. A. M. Hind, *A Short History of Engraving and Etching*, 2d rev. ed., London, 1911.

WATSON, THOMAS. English engraver (b. London, 1743/48; d. there, 1781). Next to John Raphael Smith, Watson was one of England's best mezzotinters before the Ward brothers. He made plates after Nathaniel Dance,

Daniel Gardner, Peter Lely, Benjamin West, and, above all, Reynolds, for example, *David Garrick* (1779).

BIBLIOGRAPHY. A. M. Hind, *A Short History of Engraving and Etching*, 2d rev. ed., London, 1911.

WATTEAU, JEAN-ANTOINE. French painter of genre, *fêtes champêtres*, and portraits; decorator; and etcher (b. Valenciennes, 1684; d. Nogent-sur-Marne, 1721). He was a pupil of the mannerist genre painter J. A. Gérin. In 1702 he went to Paris and studied with Métayer, an obscure painter. He haunted the publishing house of P. and J. Mariette, where he encountered engravers (including C. Simpol and B. Picart) who reinforced, in the French manner, lessons in genre painting akin to those of the resident colony of Flemish artists he frequented. From about 1704 to 1708, he worked with Claude Gillot, a designer of theater scenery and costumes, who introduced him to the picturesque subject matter relating to the *commedia dell'arte*, which had been banished from France since 1697 but survived unofficially at the fairs of St. Germain and St. Laurent.

After about 1707 he worked with Claude Audran III, a draftsman and formulator of the *style rocaille* (the French version of rococo art), from whom he derived skill in the technique of painting delicate arabesques on white grounds. Through Audran, who was also curator of the Luxembourg Palace, he had access to Rubens's *Life of Marie de Médicis* series, which, through Watteau, so profoundly influenced the course of the *style moderne* (the more advanced coloristic Rubenist trend). *See* RUBENISTS.

Sketches made in the palace gardens and in the environs of Paris in 1709 constituted a repertory of landscape backgrounds later used in figure compositions. Though the realism of his military scenes after this point reflects David Teniers the Younger, the mood of soldiers meandering over a hillside anticipates the languorous movement and gentle arabesques of his future pastoral works, whose wistful vacuity was a reflection of his own lassitude (for by then symptoms of tuberculosis were apparent).

In 1709, when a student at the Royal Academy, Watteau won second place in the competition for the Prix de Rome. In 1712 Charles de La Fosse introduced him to the financier P. Crozat, whose superb collections of Flemish and Venetian paintings and drawings, particularly the pastoral works of Titian and D. Campagnola and the festive compositions of P. Veronese, instantly generated his *fêtes champêtres*. The teaming crowds of his earlier works (*Mariée du Village*, Potsdam, Palace) were tempered into gentle conviviality (*Musical Party*, London, Wallace Collection), reminiscent, but mildly so, of Rubens's *Garden of Love* (Dresden, State Art Collections). Watteau's *Harlequin and Columbine* (Wallace Collection) expresses the gallant spirit and sensibility that perfumes all these pastoral scenes. *See* FETE CHAMPETRE.

In 1712 Watteau became an associate of the Royal Academy, and in 1717 a member. His diploma piece, currently known as *Embarkation from Cythera* (Paris, Louvre; later variant, Berlin, former State Museums), qualified as a *fête galante* and its author as a painter of *fêtes galantes*. In 1719 he went to England, probably to consult the noted physician Richard Mead, who became his patron and friend. Though the London winter permanently undermined

Jean-Antoine Watteau, *Les Comédiens Italiens*. National Gallery, Washington, D.C. (Samuel Kress Collection).

his constitution, his artistic influence upon Thomas Gainsborough, through Philippe Mercier, was significant for the development of the English school in the 18th century.

On his return to Paris in 1720 he lodged with the dealer Gersaint. He painted a signboard for Gersaint's establishment, a work of genre realism unprecedented in his *oeuvre*, in which the spirit of Teniers is again revived. Within the spacious interior of the shop, gaily clad gentlefolk are represented as leisurely inspecting works of "modern art," while clerks quietly lay to rest in a packing case a portrait of Louis XIV, strongly reminiscent of Hya-

cinthe Rigaud's 17th-century manner. This is a subtle commentary upon his own decisive role in the evolution of the *style moderne*. Increasingly restless, he secured new quarters at Nogent-sur-Marne, where Jean-Baptiste-Joseph Pater, his only pupil, came for final instruction and for aid in the completion of his own unfinished works. Watteau's last work, *The Halt during the Chase* (Wallace Collection), pursues the ascendant realism of the *Enseigne de Gersaint* (Berlin, former State Museums) but is hesitant and uncoordinated. Its particularly poor condition is the result of careless technical habits.

An estimate of Watteau's development is best deduced from the chronology, after 1712, of his subject matter: (1) landscape themes and portraiture, (2) theater themes, (3) *fêtes galantes*, (4) mythological subjects and nude studies, and (5) genre realism. The vast compendiums of his drawings for landscape, figures, heads, hands, and draperies reveal no positive evolution, since he compiled them impulsively and drew motifs from them arbitrarily. His drawing style, like that of Gillot, manifests a fundamental preference for sharp, straight lines, nervously broken but cursorily unified, as in the punctuation of poetry, with firmly curved minor accents. His tendency to elongate proportions with sinuous curves harks back to a mannerism akin to Jacques Bellange, yet anticipates the drawing styles of Boucher and Delacroix. His drawing medium was the *trois crayons* technique: red (sanguine), black, and, for highlights, white chalks. His painting is a diminutive, more aerated adaptation of the techniques of Rubens, whose healthy spontaneity he admired. Little red accents at nose, chin, fingertips, and throat serve as tiny anchors. His method of composing figure groups from sketchbooks, repeating heads (such as informal portraits of members of theater troupes), lends a pervasive family resemblance to all his works, though producing a feeling of only partially attained intimacy. The result is an impulse of haunting fondness for these glamorous, not necessarily beautiful beings, whom we would but cannot know.

The language of Watteau is an elegant camouflage of strong emotion by gentle manners and kindly sentiments. *Gilles* (ca. 1719; Louvre), like a philosophical self-portrait, is perhaps a key to the indeterminate quality of his content. Here, as in all great art, the facts are offered, the answers unrevealed. Watteau's art is the essence of the French poetic spirit, Poussin's of the intellectual. The figure in *Gilles* is alone and ludicrous on an eminence, his eye avoiding direct communication. An immemorial Pagliacci, he awaits numbly, like a mime, a cue that can never be given, while his cohorts, on a lower place, disport themselves, unaware of his overwhelming self-awareness, which the ass, whose eyes seek him, alone seems to recognize. Uncomfortable feelings of sympathy result in the audience. With a resurgence of manneristic forcefulness, the monolithic bigness of this form, sheathed in shimmering satin, poetically implies the futility of being, beneath a deliciously pictorial surface.

BIBLIOGRAPHY. E. Pilon, *Watteau et son école* (Bibliothèque de l'art du XVIIIᵉ siècle), Brussels, 1912; E. Dacier and A. Vuaflart, ...*Jean de Jullienne et les graveurs de Watteau au XVIIIᵉ siècle*, 3 vols., Paris, 1921–29; J. A. Watteau, *The Drawings of Watteau* by K. T. Parker, London, 1931; E. L. de Goncourt and J. A. de Goncourt, *French XVIII Century Painters*, New York, 1948; H. Adhémar and R. Huyghe, *Watteau, sa vie, son oeuvre*, Paris, 1950; K. T. Parker and P. Mathey, *Antoine Watteau: Catalogue complet de son oeuvre dessiné*, 2 vols., Paris, 1957. GEORGE V. GALLENKAMP

WATTLE AND DAUB. Type of construction using wattles, or twigs, daubed with clay or plaster. Adopted in the American colonies from English usage, wattle and daub usually consisted of willow or hazel withes woven together and daubed with a mixture of clay and straw. Wattle and daub woven between vertical wood stakes was used in early colonial cabins.

WATTS, FREDERICK WATERS. English painter (1800–86). A prolific landscape painter of the early-19th-century English school, Watts worked chiefly in oils, but also in water color. He was greatly influenced by Constable and relied on conventional rural motifs, which he treated in a loose and romantic style.

WATTS, GEORGE FREDERIC. English painter and sculptor (b. London, 1817; d. there, 1904). As a boy he frequented the studio of William Behnes, the sculptor, and

George Frederic Watts, *Eve Tempted*. Tate Gallery, London.

for a short time in 1835 attended the Royal Academy of Arts schools. In 1837 he exhibited at the Royal Academy for the first time. From then on he practiced portraiture for a living but always painted subject pictures for preference.

Entering the first Houses of Parliament competition in 1843, he was awarded a first prize for his cartoon *Caractacus*. He used the money to go to Italy, where he spent four years, residing in Florence and Careggi as the guest of Lord and Lady Holland. Poverty, depression, and ill-health clouded the first years after his return to England, and during this time he painted *The Irish Famine* (1849–50) and other realistic works dramatizing the sufferings of the poor. He also produced *Time and Oblivion* (1848), the first of his big allegorical pictures. It attracted the favorable notice of Ruskin, who, however, later turned against Watts's art.

During the 1850s and early 1860s, Watts's chief ambition was to paint frescoes on a large scale, and in 1859 he completed his huge fresco *Justice* at Lincoln's Inn. Several smaller fresco decorations followed. In 1864 he married Ellen Terry, the future great actress, then aged seventeen; though the match proved unsuitable and lasted only a year, it temporarily inspired a new lyrical quality in Watts's art. After its termination his life became more withdrawn and his art more impersonal. More and more he devoted himself to large allegorical compositions such as *The Court of Death* and *Time, Death and Judgment*. These and similar designs were conceived in the 1860s, but were executed in numerous versions at different times throughout his life. At the same time he abandoned mural painting and instead turned to monumental sculpture. The bronze equestrian statue *Physical Energy* (versions at Cape Town and in Kensington Gardens, London), which occupied him at intervals from about 1870 until his death in 1904, was his most imposing contribution to this field.

He was belatedly elected an associate of the Royal Academy of Arts in 1867, and a full academician in the same year. His eminence was recognized, but his art was far from popular. For many years he was admired chiefly as a portraitist. C. H. Rickards, a Manchester cotton merchant who met the artist in 1865, was among the first purchasers of the subject pictures. He was followed in time by a few other Lancashire businessmen. An exhibition of Rickards's collection of Watts's paintings, the artist's first one-man show, was held at the Manchester Institution in 1880. With his second solo appearance, at the Grosvenor Gallery in 1881–82, the fame of his literary and symbolical subjects began to spread and continued to do so through the remainder of his life.

The most important repositories of Watts's works are the Watts Gallery, at Compton, Surrey, and the Tate Gallery, in London, to which he presented a collection of his major paintings. An important group of early portrait drawings, rivaling Ingres at his best, belongs to the Earl of Ilchester.

Watts represents a distinctive stage in the late romantic trend toward the alienation from reality. His awareness of the iniquities and inequities of his time led him to abandon his exuberantly romantic early style, which had been influenced by Fuseli and Etty, and to experiment in "social" realism. But this phase was short-lived because he was constitutionally unfitted to explore the harshnesses of social truth. He therefore turned away from realism, but his conscience would not permit him to indulge in simple escapism or abstraction. This led him to a generalizing eclecticism, in theory somewhat akin to that of Reynolds, but charged with a more urgent idealism of purpose and expressed in a vocabulary drawn principally from Titian and the Elgin marbles. Impelled to contribute through his art to the moral regeneration of a perfidious age, he conceived his role as artist to be that of a bard or prophet, but he frequently resorted to a symbolic language of his own. The result was that too often his message became vague and distant. Nevertheless, the power of his greater designs, such as *Hope*, *Mammon*, and *Love and Death*, is such that they seem to achieve the finality of quasi-religious images.

Prominent in 19th-century British portraiture, Watts is at his best in the depiction of important men whose spiritual and intellectual excellences he could searchingly probe. His landscapes are much less well known but show a decided originality. Above all, Watts had the talent of a sculptor. This can be seen not only in his rare busts and monuments but also in many of his paintings, where the space relations are often irrational, but where the figure groups are inventive and masterly in structure.

BIBLIOGRAPHY. G. K. Chesterton, *G. F. Watts*, London, 1904; Mrs. R. Barrington, *G. F. Watts, Reminiscences*, London, 1905; M. S. Watts, *George Frederic Watts*, 3 vols., London, 1912; R. Chapman, *The Laurel and the Thorn: A Study of G. F. Watts*, London, 1945.

DAVID M. LOSHAK

WAX PAINTING. Medium in which the pigment is mixed with bee's wax, the oil being eliminated, to create a more durable substance, particularly for impasto painting. It is distinct from the burning-in process of encaustic.

WAX SCULPTURE. Sculpting in wax has been the preliminary stage in bronze casting since antiquity. In the Middle Ages, wax was used to create independent works of art, and particularly for the execution of death masks and votive gifts (small figures of saints, Christ, *Agnus Dei*, and so on). Wax funeral effigies were particularly popular in the French court of the 14th and 15th centuries. More recently, wax sculpture has been used to produce lifelike portraits of famous people for exhibition in museums and public places. The art of modeling in wax is sometimes called ceroplastics.

WAYNE, JUNE. American self-taught painter, lithographer, writer, and industrial designer (1918–). She was born in Chicago. Her art is infused with lyrical imagery, as in her lithograph series for *The Poems of John Donne* (1959). In 1960 she established the Tamarind Workshop, Los Angeles, with the services of a master printer, to inspire a renaissance in creative lithography.

WEATHERBOARD, *see* CLAPBOARD.

WEAVING, TEXTILE, GREEK AND ROMAN. The only weaving device known to the early Greeks was the warp-weighted loom, the type common throughout prehistoric Europe. Such looms are seen in Greek vase paintings

from the 6th century B.C. onward, and weights have been found in strata of Troy dating to the mid-3d millennium B.C. In design, the warp-weighted loom is an upper beam supported on two posts fixed in the ground or floor. The warp is stretched between the horizontal beam and a series of weights that dangle near the floor. Weaving proceeded across the warp threads from top to bottom. In some looms the finished fabric at the top could be wound around the horizontal beam to permit a constant working height. Two disadvantages of the warp-weighted loom were that it required the weaver to stand and, if the loom was broad, to move back and forth as well. Thus it tended to be replaced by more convenient looms and by the 2d century A.D. had substantially disappeared from Greece. The warp-weighted loom was the earliest form in the Roman world as well, but it fell out of use a little later there than in Greece.

The warp-weighted looms of Greece and Rome were gradually replaced by a vertical two-beamed loom which was probably invented in Syria or Palestine and spread to Egypt, Greece, and the West in the 1st century B.C. The warp in the new loom was suspended between the two beams, the lower beam taking the place of the weights. Thus, the tension on the warp could be made higher and more nearly constant. Though information is scanty about the operation of the new loom, it appears that, on some models at least, the weaver worked sitting down and wove from bottom to top.

In both types of ancient looms, weaving was first accomplished with the fingers, later with the aid of a shuttle, a short rod with the weft yarn wound around it. The shuttle system included the use of a batten, a comblike device to drive the newly woven weft threads close together. Both looms, too, had two horizontal rods between the ends of the warp which served to separate the warp threads into a front and a back series. Thus, the weft thread passed in front of one series and in back of the other. By the Hellenistic period, Greek weavers were able to weave striped and patterned fabrics. Excavations in Dura Europus in eastern Syria have unearthed fragments of such fabrics, probably of much simpler taste than those popular in Hellenistic times, in levels dating before A.D. 256.

Almost all weaving in Greece was done in the home. There was little textile "industry" and little export of fabrics. In Rome, however, weaving was more of an industry, many wealthy homes producing cloth for sale to local merchants and later "factories" producing large amounts of cloth for export.

BIBLIOGRAPHY. R. J. Forbes, *Studies in Ancient Technology*, vol. 4, Leyden, 1956.

EVANTHIA SAPORITI

WEBB, JOHN. English architect (1611–72). He was a pupil of Inigo Jones from 1628. His individualism did not assert itself until the late 1630s, when he designed extensions to Somerset House. His late work, the 1664 Charles II block at Greenwich, is a baroque elevation of much consequence for subsequent architecture.

WEBB, PHILIP SPEAKMAN. English architect (1831–1915). Webb was in G. E. Street's office with William Morris, as was Richard Shaw a little later. All three were to influence English architecture. They experimented with pseudo-period styles. For Morris, Webb designed the famous Red House at Bexley Heath (1859–60). Its plan, simplicity, and exquisite quality of red brick emphasized the craftsman's integrity and attitude toward design; it was influenced at its source by Morris. Webb's effect upon European architecture was considerable and directly molded the evolutionary currents about 1900.

WEBER, MAX. American painter and sculptor (1881–1961). Weber was born in Bialystok, Russia, and went to the United States in 1891. His first formal art education was at the Pratt Institute in New York City (1898–1900), where he was influenced by Arthur Wesley Dow's principles of design. Weber was in Europe from 1905 to 1908; during these years he absorbed the ideas of the crucial early movements in modern art which were later to fuse with his own expressive means in his work. He became a close friend of Henri Rousseau and studied with Matisse in 1907.

Weber's early paintings, executed after his return from Europe, are mostly Fauve in inspiration, but in such a work as *The Geranium* (1911; New York, Museum of Modern Art) the angular treatment of faces, limbs, and drapery is close to early cubism. For the next few years Weber's paintings were dominated by a cubism combined with a futurist concern for the depiction of speed and objects in motion. *Chinese Restaurant* (1915; New York, Whitney Museum) is a synthetic cubist composition of textures and forms derived from the motif with moving figures treated as an essential pattern. In this period Weber also produced sculptures, some completely abstract, others representational in a primitive style. From 1917 on Weber began to paint less abstractly, with more individuality in subject and treatment, and to develop his coloristic gifts. Most of his paintings of the 1920s and early 1930s were classic Cézannesque figure, landscape, and still-life compositions, often poetic in subject and contemplative in mood.

In the late 1930s, Weber became increasingly concerned with religious subjects. They had sporadically appeared earlier but now emerged fully developed. Their themes are

Max Weber, *Chinese Restaurant*, 1915. Whitney Museum of American Art, New York.

of Jewish life, richly and emotionally painted. Some of Weber's finest paintings have been of the Hassidim, a mystical Jewish sect which had impressed Weber during his boyhood in Russia. Their religious intensity found expression in paintings of their joyous dances as well as in more restrained scenes, such as *Adoration of the Moon* (1944; Whitney Museum), where four men in distinctive Hassidic dress are engaged in a moon-struck discussion. Weber continued to use these religious subjects in later work, in near-expressionist paintings of strong color and free linear design. It is noteworthy that he was strong enough to discard abstraction when it no longer served his artistic needs.

BIBLIOGRAPHY. H. Cahill, *Max Weber*, New York, 1930; L. Goodrich, *Max Weber Retrospective Exhibition*, New York, 1949.

JEROME VIOLA

WECHTLIN, HANS. German maker of woodcuts, book illustrator, and painter (ca. 1460–ca. 1526). Wechtlin entered Dürer's workshop in 1498, thus becoming Dürer's first pupil. In 1508 a set of his woodcuts on the Life and Passion of Christ was published in Strasbourg, of which he was a permanent resident from 1514. Wechtlin's woodcuts are for the most part chiaroscuros (the black outline block, as in the German tradition, carries the complete composition). His style resembles that of his fellow Strasbourg painter Hans Baldung-Grien, though it lacks Baldung's drama, vigor, and fantasy. Although the 1508 *Passion* is crude in draftsmanship, his subsequent woodcuts are delicately drawn and cut. Wechtlin also designed chiaroscuro woodcut title pages and borders. He is referred to as "painter" in Strasbourg documents.

BIBLIOGRAPHY. H. Röttinger, "Hans Wechtlin," *Jahrbuch der Kunsthistorischen Sammlungen des Allerhöchsten Kaiserhauses*, XXVII, 1907.

WEDDING AT CANA. The first miracle of Christ (John 2:1–12). In Early Christian art, it was an especially popular subject, sometimes combined with the Miracle of the Loaves as a symbol of the Eucharist. The scene's form has changed little over the ages: Christ stands or sits, surrounded by His apostles and Mary, and directs the servants' pouring of the water into six jars, the water that was soon to be turned into wine.

WEDDING DANCE. Oil painting by Brueghel the Elder, in the Institute of Arts, Detroit. *See* BRUEGHEL, PIETER, THE ELDER.

WEDDING FEAST AT CANA. Oil painting by Veronese, in the Louvre Museum, Paris. *See* VERONESE, PAOLO.

WEDGWOOD, JOSIAH. English pottery manufacturer (b. Burslem, 1730; d. Etruria, 1795). Josiah served his apprenticeship as a potter in the shop of his brother Thomas, from 1744 to 1749. He was a partner of Thomas Alders and John Harrison in the early 1750s, and then in 1754 he joined with Thomas Whieldon, to whom all the mid-18th-century dark glazes in agate and tortoise-shell patterns that were produced in the Staffordshire region are attributed. Wedgwood and Whieldon were partners until 1759, when Wedgwood went into business for himself. Operating the Ivy House, in Burslem, Wedgwood produced wares in a

Josiah Wedgwood, jasperware vase, 1786. British Museum, London.

green glaze he perfected. Cauliflower and pineapple patterns for teapots and milk jugs were among the earliest wares made at the Ivy House. Shortly after 1760, he perfected the cream-colored glaze which was called "Queen's ware" after he obtained royal patronage from Queen Charlotte.

Wedgwood produced only useful wares until 1768, when he started a special partnership with his friend Thomas Bentley to establish a new pottery called "Etruria," which was opened in 1769 and which was devoted to producing ornamental pieces. All the ornamental work was in the neoclassical style. At first marbleizing was applied to creamware in classical shapes. Then fine stoneware was developed to simulate ancient pottery and stone. Black or basaltes was perfected first, then red and finally blue (called jasperware) were introduced for a variety of decorative forms and for reliefs adapted from ancient classical, Renaissance, and baroque models. A number of sculptors were employed, the most famous being John Flaxman in 1775, but the unity of style of the work and the general approach to the classical suggest that Josiah Wedgwood determined what was produced at his factory. Contemporary portraits were another subject of significance; round and oval medallions in jasperware or basaltes, with the heads most often in profile and relief, were made in quantity. Famous people of the moment were represented along with historic personages.

Josiah Wedgwood's achievements are twofold. He was the key figure in establishing the primacy of the English ceramic industry, and he introduced high standards of quality for an ornamental ware in the high style of his day. The useful wares made by Wedgwood and his competitors

Jan Baptist Weenix, *Poultry Seller*. Doria-Pamphili Gallery, Rome.

in the Staffordshire region replaced folk efforts all over the Western world. During his partnership with Thomas Bentley, which lasted from 1768 to Bentley's death in 1780, he made decorative pieces that were a fine expression of the neoclassical style, and with this work, for the first time, English ceramics influenced the design of the great European potters at Sèvres and Meissen.

BIBLIOGRAPHY. E. Meteyard, *The Life of Josiah Wedgwood...*, 2 vols., London, 1865. MARVIN D. SCHWARTZ

WEDITZ, CHRISTOPH, *see* WEIDITZ, CHRISTOPH.

WEENIX, JAN. Dutch painter of still life and portraits (b. Amsterdam, 1642? d. there, 1719). He was the son and pupil of Jan Baptist Weenix. Jan Weenix worked mainly in Amsterdam, but was a member of the Utrecht painters' college in 1664 and was still recorded there in 1668. He returned to Amsterdam and was married there in 1679. Weenix was court painter (1702–12) at Bensberg Castle, near Düsseldorf, for Johann Wilhelm, Elector of the Palatinate. Besides painting still-life subjects, mostly dead and live game, he executed a number of Italian scenes in the style of his father.

BIBLIOGRAPHY. I. Bergström, *Dutch Still-Life Painting in the Seventeenth Century*, New York, 1956.

WEENIX, JAN BAPTIST. Dutch painter of land- and seascapes, still life, and some portraits (b. Amsterdam, 1621; d. Doetinchem, before the end of 1663). He studied first with Jan Micker in Amsterdam, then with Abraham Bloe-

maert in Utrecht, and finally with Nicolaes Moejaert for about two years. Weenix married a daughter of the landscape painter Gillis d'Hondecoeter. Weenix was living in Amsterdam in 1642 and then traveled to Italy, where he may have remained for four years. He worked mainly in Rome, where he enjoyed the patronage of Cardinal Giovanni Battista Pamphili, who later became Pope Innocent X (1644). He was reported back in Amsterdam in 1647 but settled in Utrecht by 1649.

After his return from Italy Weenix painted fantastic and fanciful Italianate landscapes and seaports. His still-life subjects show some knowledge of such Flemish painters as Frans Snyders. He was extremely productive; his son Jan reported that his father could paint three life-size, half-length portraits in one day and that he had seen his father paint a picture six or seven feet wide in the same amount of time.

BIBLIOGRAPHY. W. Stechow, "Jan Baptist Weenix," *Art Quarterly*, XI, 1948.

WEERDT (Werdt), ABRAHAM VAN. Dutch woodcut artist (fl. Nürnberg, 1636–80). Weerdt probably went to Nürnberg to find work in one of its many active publishing houses. He is known from his cipher on a number of works from various Nürnberg publishers: Ovid's *Metamorphoses* (Johann Hoffmann, 1639); the Bible (Martin Luther's translation, 1670); *J. A. Comenii Orbis sensualium picti*, and others.

BIBLIOGRAPHY. G. C. Nagler, *Die Monogrammisten*, vol. 1, Munich, 1858.

WEERTS, JEAN-JOSEPH. French painter (b. Roubaix, 1847; d. Paris, 1927). A student of Cabanel, Mils, and Pils, he began exhibiting at the Salon of 1869 and won a gold medal at the Paris Exposition of 1889. He painted portraits and religious and historical scenes in an academic style.

WEGNER, HANS. Danish designer (1914–). Born in Tönder, Denmark, Wegner studied furniture design at the Danish School of Arts and Crafts in Copenhagen. His furniture is characterized by delicate grace, a sensuous exploitation of wood, and ingenious solutions to problems of joining.

WEICHER STIL (Soft Style). Early-15th-century style of painting in northern Germany. It was influenced by Flemish painting (Jan van Eyck) and was associated with the International Gothic style. *Weicher Stil* is characterized by delicate charm and intricate linear rhythm. A favorite theme is the Madonna and Child; done in this suave and refined manner such pictures have come to be called *Schöne Madonnen*. The style is typified by the works of Stephan Lochner. (See illustration.) *See* INTERNATIONAL GOTHIC PAINTING; LOCHNER STEPHAN.

See also MULTSCHER, HANS.

WEIDITZ (Weditz; Weyditz; Wydiz), CHRISTOPH. German medalist, wood carver, and goldsmith (b. Strasbourg or Freiburg-im-Breisgau, ca. 1500; d. Augsburg, 1560). The son of the Freiburg sculptor Hans Wydiz, Christoph can be traced in Augsburg as early as 1523. In 1526 he settled

there but made numerous visits abroad. With H. Schwarz and F. Hagenauer, he ranks among the leaders of the German Renaissance medalists. His works are in museums in Nürnberg, Munich, Vienna, and Berlin, for example, the wooden model for a portrait medal of Christoph Mulich (1530; Munich, Bavarian National Museum). His later work shows mannerist influences.

BIBLIOGRAPHY. G. Habich, *Die deutschen Schaumünzen des XVI. Jahrhunderts*, vol. 1, pt. 1, Munich, 1929.

WEIDITZ, HANS. German woodcut designer (ca. 1500–after 1536). Weiditz was probably born in Strasbourg. Aside from the few portraits, such as those of Charles V, Maximilian I, and Martin Luther, and the large bird's-eye view of Augsburg that he produced, he worked exclusively as a book illustrator. He was active first in Augsburg from 1516/18 to 1522/23, then in Strasbourg until 1536, illustrating Cicero, Petrarch, the Bible, and other books. In recording the intimate scene on a small scale, Weiditz surpassed all his German contemporaries. His subjects were more varied and his observation more acute. The portly Maximilian I, kneeling at Mass, leans his forearms on the *prie dieu*. In a barnyard, birds attack an owl that has just snatched one of their own. Weiditz is well known for his sensitive pictures of plants in Otto Brunfels' *Herbarium* (Strasbourg, 1530). The large body of unsigned Augsburg work was first rightly recognized to be his only in 1904.

BIBLIOGRAPHY. H. Röttinger, *Hans Weiditz der Petrarkameister*, Strasbourg, 1904; British Museum, Dept. of Prints and Drawings, *Catalogue of Early German and Flemish Woodcuts*, by C. Dodgson, vol. 2, London, 1911.

WEI-MO-CHI, *see* VIMALAKIRTI.

WEINBERG, ELBERT. American sculptor (1928–). Weinberg was born in Hartford, Conn. He studied at the Hartford Art School, at the Rhode Island School of Design, with Waldemar Raemisch, and at Yale University. He won the Prix de Rome in 1951 and a Guggenheim fellowship in 1959. His work is represented in the Museum of Modern Art in New York, the Jewish Museum in New York, and in the Yale University Art Gallery. He has taught at the Rhode Island School of Design, at Yale, and at Cooper Union in New York. He works in wood in an abstract style.

WEINBRENNER, FRIEDRICH. German architect (1766–1836). He worked in Karlsruhe and is responsible for its transformation into a major example of a classical revival urban plan. His Marktplatz, composed of separate balanced buildings emphasizing geometric forms, is typical of his work.

BIBLIOGRAPHY. A. Valdenaire, *Friedrich Weinbrenner, sein Leben und sein Bauten*, Karlsruhe, 1926.

WEINGARTEN, ABBEY CHURCH OF. German church, situated near Ravensburg, Bavaria. The church was rebuilt between 1715 and 1724 to the designs of Kaspar Moosbrugger, lay brother of Einsiedeln. It is a long building with nave and aisles, a domed crossing, and a façade which (as at Einsiedeln) swings forward between two towers. The interior has frescoes by C. D. Asam, sculpture on the high altar by Diego Carlone, and, in the carved choir stalls, the

first great work by the Wessobrunn sculptor and stuccoist Joseph Anton Feuchtmayer.

BIBLIOGRAPHY. A. Raichle and P. Schneider, *Weingarten*, Munich, 1953.

WEIR, J. ALDEN. American painter and etcher (b. West Point, N.Y., 1852; d. New York, 1919). He studied with his father, Robert W. Weir, and with Gérôme in Paris (1873), and was influenced by Bastien-Lepage. He was president of the National Academy (1915–17) and became one of the founders of The Ten. While in Paris he changed his style from a dark, somber palette to a high-keyed one and by 1890 attained a modified impressionism. The *Don-*

Weicher Stil. Stephan Lochner, *The Virgin with Violets*. Diocesan Museum, Cologne.

key Ride (1899) illustrates his serene, idyllic poetry and *pleinairisme*. With translucent, silvery tones, he paints sentimental figure and landscape pieces. His canvases, like Twachtman's, are consciously constructed into formal designs and patterns.

BIBLIOGRAPHY. D. (Weir) Young, *The Life and Letters of J. Alden Weir*, New Haven, 1960.

WEISGERBER, ALBERT. German painter and graphic artist (b. St. Ingbert, 1878; d. near Fromelles, 1915). He studied in Munich. His career as a painter of the human figure was cut short by World War I, just when his thorough academic training was beginning to be tempered by more modern and expressive elements.

WEISSENHOF EXHIBITION. Full-scale architectural housing demonstration, sponsored by the Deutsche Werkbund and held in Stuttgart, Germany, in 1927. Under the direction of Mies van der Rohe, leading European architects, including Le Corbusier, Walter Gropius, and J. J. P. Oud, exhibited the forms, materials, and planning of the new architecture.

BIBLIOGRAPHY. S. Giedion, *Space, Time and Architecture*, 4th ed., Cambridge, Mass., 1962.

WEISWEILER, ADAM. German cabinetmaker (b. Neuwied-on-the-Rhine? ca. 1750; d. Paris, after 1810). He trained at Neuwied in the workshop of D. Roentgen, and by 1778 became a master in Paris. Weisweiler was noted for his elegant furniture mounted with gilded bronze in the Louis XVI style, such as the writing table for the Cabinet of Marie Antoinette at St-Cloud (1784; Paris, Louvre). He remained a prosperous cabinetmaker during the Revolution and the early Empire period.

BIBLIOGRAPHY. F. J. B. Watson, *The Wrightsman Collection*, vol. 2, New York, 1966.

WELFENSCHATZ, *see* GUELPH TREASURE.

WELLENS, JAN, *see* COCK, JAN.

WELLFORD, ROBERT. American composition manufacturer (fl. Philadelphia, 1800–39). Little is known of Wellford other than his activity as the manufacturer of composition decorative elements used on fireplace mantles. He worked essentially in the neoclassical style producing subjects such as the Battle of Lake Erie, American eagles, and portraits of heroes such as Washington and Franklin. Listed in Philadelphia directories of 1801–39, he claimed he made "the original American composition."

BIBLIOGRAPHY. S. F. Kimball, *Domestic Architecture of the American Colonies...*, New York, 1922.

WELL OF MOSES. Stone monument by Sluter, in the Chartreuse de Champmol, Dijon. *See* SLUTER, CLAUS.

WELLS CATHEDRAL. English Gothic church of two main building periods: about 1180–1240 and about 1290–1340. The first phase comprised the east end with ambulatory, the chancel, the crossing with tower, the transepts, and the nave and west front. The second phase included a new east end with east transepts and Lady Chapel, and the completion of the crossing tower and chapter house.

The west front has the finest collection of 13th-century

J. Alden Weir, *Gate—Winchester*, 1913. Whitney Museum of American Art, New York.

sculpture in England, created as a vast screen, or reredos. The towers are later, one after 1386 by William de Wynford, the other after 1424. Other highlights of Wells are the chapter house (1290–1315) with a complete tierceron vault, the north porch with some of the best Early English work, and the strainer arches (ca. 1320), a remarkable example of technical exhibitionism. (See illustration.)

BIBLIOGRAPHY. N. Pevsner, *North Somerset and Bristol*, Harmondsworth, 1958.

Well of Moses. A Calvary base by Claus Sluter, showing statue of King David. Chartreuse de Champmol, near Dijon.

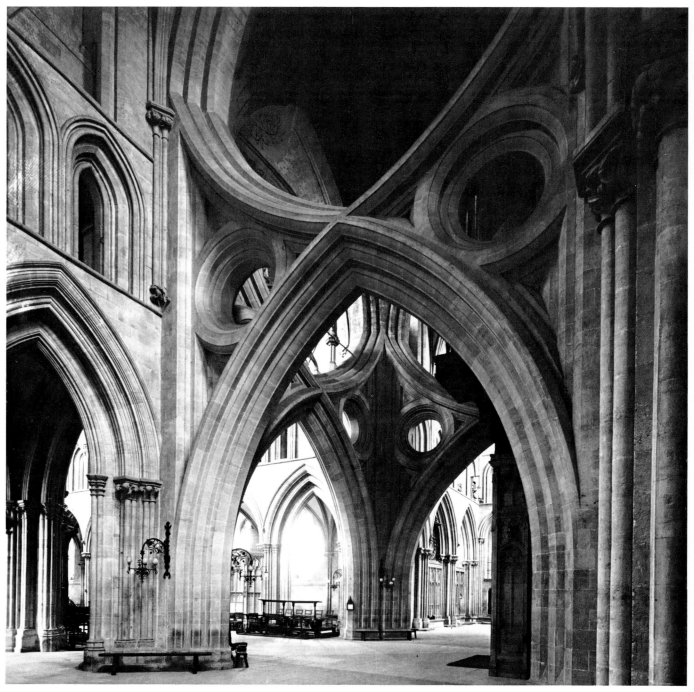

Wells Cathedral. The nave, vaulted in 1338, during the second main building phase.

WEN CHENG-MING (Wen Pi). Chinese painter (1470–1559). The most famous pupil of Shen Chou and a major leader in the *wen-jen* movement of the Ming period, he was one of the "Four Great Masters" of the Ming dynasty. He came from a prominent Su-chou family and was trained in the best tradition of the scholar-gentleman class in China: poetry, calligraphy, the classics, and painting. After he had passed the *chu-sheng* examinations, Wen Cheng-ming spent a period of about five years at the Ming capital in the Han-lin Academy, working mainly on the dynastic

history. His principal period of painting activity did not come until after his return to Su-chou, and most of his dated works fall in the years from 1528 to 1559. The last thirty years of his career were actively devoted to pursuing the life of the mind, and Wen Cheng-ming's home became a meeting place for the scholar-intellectuals of the period. Much of Wen's writing and criticism on painting came in the form of colophons and inscriptions he attached to the paintings and calligraphies which passed through his hands, and he was the leading spokesman of the "Wu

school" after Shen Chou. *See* SHEN CHOU; WEN-JEN-HUA.

In his landscape paintings Wen Cheng-ming, like Shen Chou, drew from a variety of earlier masters for inspiration, with the Yüan painters Wu Chen, Ni Tsan, and Huang Kung-wang serving as the major sources of study and interpretation. The study of older masters, particularly those in the *wen-jen* movement of the Sung and Yüan dynasties, was a constant preoccupation of Wen Cheng-ming and other painters of the Su-chou area. But Wen also exploited the art of painting as a medium of personal expression, and his studies of juniper trees executed over a long span of years reveal the personal identification of the man with the aging old trees. Throughout his life Wen Cheng-ming remained the epitome of the balanced, rational Confucian scholar, gifted with all the skills that typified the best of the cultivated, learned gentleman-scholar in China. *See* HUANG KUNG-WANG; NI TSAN; WU CHEN.

BIBLIOGRAPHY. Y. Tseng, "The Seven Junipers of Wên Chêng-ming," *Archives of the Chinese Art Society of America*, VIII, 1954; Y. Yonezawa, *Painting in the Ming Dynasty*, Tokyo, 1956; S. E. Lee, *Chinese Landscape Painting*, 2d rev. ed., Cleveland, 1962.

MARTIE W. YOUNG

WEN CHIA. Chinese painter, poet, calligrapher, and critic (1501–83). The second son of the illustrious Wen Cheng-ming, he is considered to be the most talented of the great painter's immediate descendants. His paintings exist in some numbers today, although Wen Chia did not start painting until rather late in his career. His landscape paintings epitomize the quiet, scholarly characteristics of the *wen-jen* tradition as it had developed by the mid-16th century. His writings also feature the same qualities: they are urbane, learned, and assured. *See* WEN CHENG-MING; WEN-JEN-HUA.

WENGENROTH, STOW. American lithographer (1906–). Born in Brooklyn, he studied at the Art Students League, the Grand Central School of Art, and with Wayman Adams, George Bridgman, John Carlson, and George P. Ennis. He is a National Academician and a member of the National Institute of Arts and Letters as well as of the Connecticut Academy of Fine Arts. His lithographs, which first appeared in 1931, subtly exploit all the tonal gradations possible in the medium from pure white to dense black. Yet the quality of warmth is generally lacking because of the austerity of his New England subject matter and because of his precise manner of drawing. The best example of this is perhaps his interior view, *Meeting House*. Maine landscapes and animal life, particularly owls, are other subjects associated with Wengenroth.

BIBLIOGRAPHY. C. Reece, "Stow Wengenroth," *The Print Collector's Quarterly*, XXIX, 1942.

WEN-JEN-HUA (Literati Painting). Frequently encountered term in discussions of Chinese art, used to designate a kind of painting. *Wen* literally translated means "letters," or "literature," and *wen-jen* in the broadest sense can be an equivalent for a "cultured man". The entire term *wen-jen-hua* thus implies something like paintings for or by the class of intelligentsia. Historically, the term has more complexities of interpretation, however, and is to be related to fundamental theories of painting.

Wen Cheng-Ming, *Tea under the Trees*. Color on paper. National Palace Museum, Taichung, Formosa.

The first great exponent of *wen-jen-hua* was the many-sided genius Su Shih, or Su Tung-p'o (1036–1101). Around him was gathered a group of intellectuals, who included such great painters as Mi Fu and Li Kung-lin, and out of this circle of close friends emerged the outlines of a startlingly new theory of painting. Essentially, they contended that the superior man of noble character and cultivated learning could produce superior paintings with only modest technical proficiency. Closely related to developments in calligraphy, this theory stressed the qualities of the artistic personality rather than the objective response to the visual world, and for the *wen-jen* artists the representational content of the painting need not be connected with its expressive quality. *See* LI KUNG-LIN; MI FU; SU SHIH.

The early *wen-jen* movement was obviously an attempt to elevate painting to the lofty heights of poetry and calligraphy, relegating the technical aspects of painting to a secondary level. The *wen-jen* painters of the Yüan and Ming dynasties modified the basic theory somewhat but retained its essential outline, putting more stress on the amateur (versus the professional) ideal and furthering the close connection with poetry. Wu Chen in the Yüan period and Shen Chou in the Ming are among the many later exponents of *wen-jen-hua*. In the late 16th and early 17th centuries the movement was led by the painter-critics Tung Ch'i-ch'ang, Mo Shih-lung, and Ch'en Chi-ju. *See* CH'EN CHI-JU; MO SHIH-LUNG; SHEN CHOU; TUNG CH'I-CH'ANG; WU CHEN.

See also LU CHIH.

In Japan the *wen-jen-hua* movement had its counterpart in the Nanga school, which belongs to the period from the 18th century on. *See* NANGA SCHOOL.

BIBLIOGRAPHY. M. Aoki, *Chūka bunjinga dan* (On Chinese Literati Painting), Tokyo, 1949; J. F. Cahill, "Confucian Elements in the Theory of Painting," *The Confucian Persuasion*, ed. A. F. Wright, Stanford, 1960.

MARTIE W. YOUNG

WEN P'ENG. Chinese painter, calligrapher, and critic (1498–1573). Wen P'eng was the eldest son of Wen Cheng-ming and enjoyed some reputation in the Su-chou region as a discriminating connoisseur. He was frequently asked to contribute comments in the form of inscriptions and colophons on paintings of others. A number of paintings do bear Wen P'eng's signature, but they are modest in scale and in numbers.

See WEN CHENG-MING.

WEN PI, *see* WEN CHENG-MING.

WEN PO-JEN. Chinese painter (1502–ca. 1580). He was a nephew of Wen Cheng-ming and almost an exact contemporary of Wen Chia. Of the many members of the Wen family who gained eminence in the Su-chou area, Wen Po-jen was the most uneven in terms of personality. He was considered quite temperamental (in contrast to the more conservative and scholarly character of other members of the family), but his paintings were greatly admired by the *wen-jen* adherents. Principally a landscape painter, Wen Po-jen was particularly fond of the tall, narrow hanging-scroll format, and his style was largely patterned after the Yüan master Wang Meng. *See* WANG MENG; WEN CHENG-MING; WEN CHIA; WEN-JEN-HUA.

Abbey Church of Werden. Detail of Romanesque arcade reliefs.

WEN-SHU, *see* MANJUSRI.

WEN T'UNG. Chinese painter (d. 1079). He was known often under his *tzu* Yu-k'o. Wen T'ung passed the examinations and received his *chin-shih* degree in 1049 and then served as the magistrate of Hu-chou in Chekiang Province. An accomplished painter of bamboos, he owes his place in Chinese art history largely to the fact that he was the teacher and close friend of the great Su Tung-p'o (Su Shih). *See* SU SHIH.

WENZINGER, CHRISTIAN. German sculptor (b. Ehrenstettin, 1710; d. Freiburg, 1797). A painter and architect as well as a sculptor, Wenzinger studied in Rome from 1731 and in Paris in 1737. Examples of his free-flowing baroque style are his altars and statues of saints for the churches of Sankt Blasien and Staufen, among others.

WERDEN, ABBEY CHURCH OF. German Romanesque church built under Abbot Adalwig (1066–81). It is particularly noted for its examples of early German Romanesque sculpture. There are arcade reliefs of seated apostles and female saints and, of special interest, a gable relief of a lion pursuing a deer. The reliefs are vigorous and dynamic in conception.

BIBLIOGRAPHY. H. T. Beenken, *Romanische Skulptur in Deutschland*, Leipzig, 1924.

WERDT, ABRAHAM VAN, *see* WEERDT, ABRAHAM VAN.

WERFF, ADRIAEN VAN DER. Dutch painter of genre, history, and portraits; also architect (b. Kralingen, 1659; d. Rotterdam, 1722). While still a child, Van der Werff was a pupil of the Rotterdam painter Cornelis Picolet. He

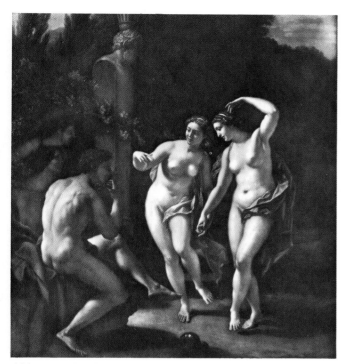

Adriaen van der Werff, *Dancing Nymphs*. Louvre, Paris.

also spent four years (ca. 1671–75) with Eglon van der Neer, also in Rotterdam. At the age of seventeen he was an independent master, and there are dated works by him from 1678 until his death.

Van der Werff remained active in Rotterdam until, in 1697, he was appointed court painter of Johann Wilhelm, Elector of the Palatinate, at Düsseldorf. A condition of the appointment was that Van der Werff paint for the Elector for six months of the year; in 1703, however, the period was increased to nine months. In 1698 Van der Werff visited Düsseldorf, and he seems to have gone there periodically to deliver pictures and paint portraits. In 1703 the Elector knighted him, and after this date he often signed his works *chevalier*. He also enjoyed the patronage of the King of Poland and the Duke of Brunswick.

Van der Werff was extremely famous in his own day, and the Dutch artists' biographer Arnold Houbraken, writing in 1721, called him the greatest of all Dutch painters, a judgment that would hardly be acceptable today. In his genre works (*A Boy with a Mousetrap*, London, National Gallery) Van der Werff paints in the tradition of the Leyden "fine painters"; however, the influence of his teacher Eglon van der Neer can also be seen, especially in his work of the late 1670s and the early 1680s. After about 1685 Van der Werff seems to have concentrated on religious, mythological, and pastoral subjects; he embellished his house with large decorative paintings with related pastoral subjects (Kassel, State Picture Collections).

Van der Werff's 1699 *Self-Portrait* (Amsterdam, Rijksmuseum) shows him to be completely under the influence of French court painting. Of the works commissioned of Van der Werff by the Elector the *Rest on the Flight into Egypt* (1706; London, National Gallery) is a typical ex-

ample of his academic perfection and porcelainlike finish. Van der Werff's brother Pieter was his pupil and collaborator and often copied his brother's work.

BIBLIOGRAPHY. C. Hofstede de Groot, *Beschreibendes und kritisches Verzeichnis der Werke der hervorragendsten holländischen Maler des 17. Jahrhunderts*, vol. 10, Esslingen, 1928; E. Plietzsch, "Adriaen van der Werff," *Art Quarterly*, XIV, 1951; N. Maclaren, *National Gallery Catalogues: The Dutch School*, London, 1960; J. Rosenberg, S. Slive, and E. H. ter Kuile, *Dutch Art and Architecture, 1600–1800*, Baltimore, 1966.

LEONARD J. SLATKES

WERFF, PIETER VAN DER. Dutch painter of history and portraits (b. Kralingen, 1665? d. Rotterdam, 1722). He was a pupil of his brother Adriaen in Rotterdam. Pieter entered the Rotterdam painters' guild in 1703. His style is completely dependent upon that of his brother, and he is known to have collaborated with Adriaen and also to have made copies after the works of the elder artist. The *Madonna and Child with the Young St. John* (1704; Kassel, State Picture Collections), for example, reflects the academic drawing and smooth surfaces characteristic of his brother's manner.

BIBLIOGRAPHY. J. Rosenberg, S. Slive, and E. H. ter Kuile, *Dutch Art and Architecture, 1600–1800*, Baltimore, 1966.

WERNER, THEODOR. German painter (1886–). Born in Jettenburg, he studied in Stuttgart and in Paris with Van Dongen, becoming a leading German abstract painter. In much of his work, lines or basically linear forms thrust or move against a background of colored areas or shapes, at times with a faint reference to the organic or mineral.

BIBLIOGRAPHY. W. Grohmann, *Theodor Werner*, Berlin, 1947.

WERTHEIM DEPARTMENT STORE, BERLIN, *see* MESSEL, ALFRED.

WERTINGER, HANS. German painter (b. Landshut, 1465–70; d. there, 1533). Wertinger is recognized for his attractive portraits of noblemen at the courts of George the Rich and Ludwig X. His *Alexander and His Physician* (1517; Prague, Museum) was the first German painting based on ancient history.

WERTMULLER, ADOLF ULRICH. Swedish history and portrait painter (b. Stockholm, 1751; d. near Wilmington, Del., 1811). He was a pupil in Stockholm of L. Pasch, in Paris (1772) of his cousin Alexandre-Charles Roslin, and in Rome (1773–75) of Joseph-Marie Vien. Wertmuller became an academician in 1784. He worked in Lyons, Paris, Bordeaux, Spain, Stockholm, Portugal, and Philadelphia (1794–96), and became an American citizen in 1802. His portrait characterizations are more romantic than those of Jean-Etienne Liotard, yet his style announces the republicanism of Jacques-Louis David.

BIBLIOGRAPHY. M. Benisovich, "Wertmüller et son livre de raison intitulé la 'Notte'," *Gazette des Beaux-Arts*, 6th series, XLVIII, July, 1956.

WERVE, CLAUS DE. Flemish sculptor (d. Dijon, 1439). A nephew and pupil of Claus Sluter, Werve completed the *Well of Moses* at the Chartreuse de Champmol after the death of his master, supplying the weeping angels at the top. He also completed (1411) Sluter's tomb of Philip

the Bold (Dijon, Museum of Fine Arts), which influenced many of the later tomb monuments. The forms are blocky but less powerfully plastic than the great inventions of Sluter. Werve was commissioned to execute the tomb of John the Fearless, but he never started it because of a lack of funds and he apparently died in poverty.

BIBLIOGRAPHY. D. Roggen, "Klaas van de Werve," *Gentsche bijdragen tot de Kunstgeschiedenis*, VII, 1941.

WESCHLER, ANITA. American sculptor (1903–). Born in New York City, she attended the Art Students League there and the Pennsylvania Academy of Fine Arts in Philadelphia and studied with Albert Laessle and William Zorach. In the 1930s she created sculptures for the United States Post Office in Elkin, N.C. She has also executed a number of portrait commissions but her most impressive works are tightly packed groups of roughly blocked-out figures in stone or cast stone. Her translucent paintings are illuminated abstractions executed in plastic resins.

WESEL, ADRIAEN VAN. Dutch sculptor (fl. 1447–after 1499/1500). The leading and most influential sculptor in the northern Netherlands during his career, he worked at Utrecht Cathedral (1480 and 1489), the Nieuwe Kerk in Delft (1484–86), the Agnetenberg Abbey (1487), and the Burkeerk in Utrecht (1487–88). His *Altar of the Virgin* (1475–77) for the Chapel of the Fraternity of the Virgin Mary in the Church of St. Jan in 's Hertogenbosch (now split up between the Rijksmuseum in Amsterdam, private collections, and 's Hertogenbosch) presents a renewed and vital sense of sculptural form. The tableaux of actively related and intricately balanced figures are dramatically set in deep box spaces.

WESEL, WYNRICH VON. German painter (fl. Cologne, end of 14th and beginning of 15th cent.). All that is known about him is that he took over the workshop of Master Wilhelm of Cologne and that he was a famous master. No verified works are extant.

WESPIN, JEAN (Giovanni Tabachetti). Flemish sculptor (1568/69–1615). A native of Dinant, where he probably received his training, Wespin carried out his life's work in northern Italy, settling there in about 1588. For the chapels at Sacro Monte in Varallo and the Sanctuary at Crea, he created numerous sculptural ensembles depicting scenes from the Old and New Testaments. The polychromed figures achieve a high degree of realism and emotional intensity.

WEST, BENJAMIN. American-English painter (b. Springfield, Pa., 1738; d. London, 1820). Of Quaker stock, he moved to Philadelphia in 1756 and then to New York. During this time he painted portraits. In 1760 he went to Rome and spent three years in Italy visiting Florence, Bologna, and Venice. He devoted himself to studying the strict classical painters of 16th- and 17th-century Rome and Bologna (especially Raphael), and above all, he followed the prevailing fashion in Rome for the neoclassicism of Gavin Hamilton and Mengs under the literary influence of Winckelmann.

On his arrival in London in 1763 he established himself as a portraitist, but also wished to be regarded as a history painter (then ranked above portraits in the accepted hierarchy), for he sent two subject pictures to the Society of Arts the next year. These attracted favorable attention, and he quickly established a reputation in society. Archbishop Drummond, having commissioned *Agrippina Landing at Brindisi*, introduced West to George III in 1768, thus beginning his association with the Crown, his most important patron. The following year *The Final Departure of Regulus from Rome*, painted for the King, was exhibited at the Royal Academy of Arts. Both pictures owed much to Poussin, not only thematically, but also in the small-scale figures.

Soon, however, the formal neoclassical manner was changed for a more baroque style, and in the *Death of Wolfe* (1771) modern history painting was for the first time shown in modern dress. Here was a real contribution to the freeing of history painting from out-of-date conventions, although the composition is based on a traditional *Pietà*. In spite of this new development, West reverted to his earlier style; the *Apotheosis of Prince Alfred and Prince Octavius* (ca. 1784) is pure Mengs. A founder-member of the Royal Academy, West succeeded Reynolds as president in 1792; except for a break during 1805–06 West remained president until his death. Although his attempts to continue Reynolds's discourses were not a success because of his lack of polish and style, his integrity, honesty, and kindness made him generally liked.

His powers remained undiminished in the last decade of his life, and some of his finest pictures were produced in this period, for example, *Our Saviour Healing the Sick* (1811), *Christ Rejected by Caiaphas* (1814), and *Death on the Pale Horse* (1817). The first two are reminders of his early neoclassical style, but the last is a most uncharacteristic work, full of frenzy and movement, which looks ahead to the French romantics.

BIBLIOGRAPHY. J. Galt, *The Life, Studies, and Works of Benjamin West*, London, 1820; Philadelphia Museum of Art, *Benjamin West, 1738–1820*, Philadelphia, 1938.

ROSS WATSON

WEST KENNET LONG BARROW. Largest chambered tomb in England and Wales, situated about ½ mile southwest of West Kennet village, England. It was probably built about 2000 B.C. by the Windmill Hill people and was in use at least three centuries. The mound is 350 feet long. The remains of some thirty skeletons were found in the two pairs of burial chambers and in the larger end chamber connected by a long central passage.

BIBLIOGRAPHY. Great Britain, Ministry of Works, *Stonehenge and Avebury and Neighboring Monuments, an Illustrated Guide*, text by R. J. C. Atkinson, London, 1959.

WESTMACOTT, SIR RICHARD. English sculptor (1775–1856). From his studio poured a great number of neoclassic monuments. He also made busts, statues, and chimney pieces. Two better-known works are the *Waterloo Vase*, in Windsor Castle, and the sculpture in the pediment of the British Museum.

Benjamin West, *Portrait of Colonel Guy Johnson*, ca. 1775. National Gallery, Washington, D.C.

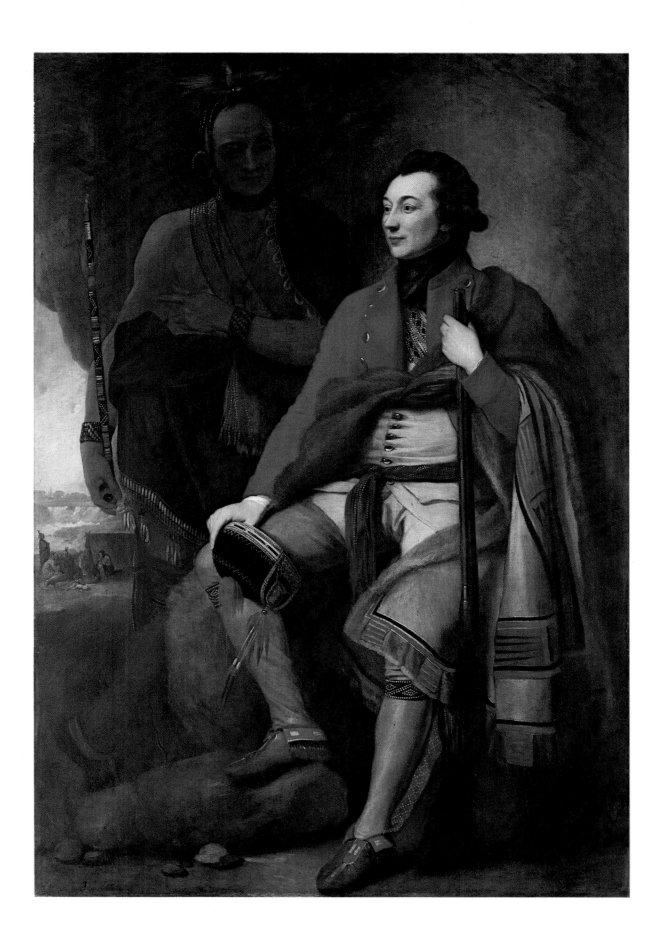

WESTMINSTER ABBEY, LONDON. English abbey. The original structure followed the pattern of the great English Romanesque churches, but this is completely destroyed except for fragments of the east and south ranges of the monastic buildings. The first reliable record of its fabric is the rebuilding by Edward the Confessor in 1050–65; the nave was erected later. The Infirmary Chapel, now in ruins, can be dated 1165–70. Henry III's Lady Chapel, begun in 1220 east of the Norman east end, is also gone.

The first stone of the present abbey was laid in July, 1245, and the architect from the start was probably Henry of Reyns (Reims). The result is the most French of the English cathedrals in its plan, with ambulatory and radiating chapels, and also essentially in the proportions, which are much higher than in any of the other English churches. The cloister and chapter house were built in 1245–50, with additions to the cloister made in 1352–66. The chapter house is a jewel of 13th-century architecture. Its spacious fenestration was an innovation for the time and was again linked to the very latest French work. Reyns was succeeded by the Englishman Henry of Gloucester. From 1262 until the 1280s Robert of Beverley, the king's master mason, was at work.

The Norman nave was demolished by 1376, and windows of the new nave were glazed by 1390. The architect of this nave was Henry Yevele, who expressed remarkable conservatism in following the general principles of the earlier 13th-century work. He designed the west front, which was built up to the tower stage. The towers were designed by Nicholas Hawksmoor about 1734 with Gothic revival details and baroque decorative touches. The north transept and north transept front are mostly 19th century in character, the restoration work of, first, Sir George Scott and then of John Pearson (1878–95), but following the general pattern of the original: the tripartite Chartres arrangement with a great Rose, related to the south-transept Rose of Notre-Dame in Paris. The east end of the church proper (in front of Henry VII's chapel) follows the French precedent of ambulatory and radiating chapels, with bays divided by thin, pinnacled buttresses and, above the chapels, flying buttresses to the clerestory.

Henry VII's chapel was begun, in the traditional En-

Westminster Abbey, London. Perpendicular-style exterior of Henry VII's chapel, 1503–12.

glish way, as a Lady Chapel beyond the east end (1503). Henry VIII completed it about 1512 as a mortuary chapel for Henry VII. The original designer was probably Robert Vertue, followed by his brother William. Their style is a sumptuous late Perpendicular one, relying for much of its effect upon the buttressing of the clerestory. Buttresses are no longer masonry pillars but are formed as octagonal turrets finished off with crocketed domes. The chapel is one of the best existing examples, in both interior and exterior, of English Perpendicular style. The walls are richly decorated with sculptures, and above these is one of the most complex and ingenious English fan vaults. The furnishings include stalls of about 1520. Monuments of particular note are Henry VII and Elizabeth of York (1512–18) by Torrigiano; in the side chapels, the Duke of Richmond and his wife (1639) and the Duke of Buckingham (1628), both by Le Sueur; in the aisles, Lady Beaufort (1511) by Torrigiano and Mary Queen of Scots (1607) by Cornelius Cure.

The chancel has complex piers, a high vault with a ridge rib (an Anglicizing detail), and radiating chapels of the ambulatory aisle. Furnishings of the chancel include the Coronation chair, made by Master Walter in 1300, and the Stone of Scone. The monuments include particularly the feretory of the Chapel of Edward the Confessor with a pavement supplied in 1258 and signed by Odoricus (only the base of the shrine proper remains; it was of Cosmati work by Petrus Romanus in 1270); Henry II and Queen Eleanor (1291), both by William Torel; Queen Philippa (1369) by Hennequin de Liège; and Henry V's Chapel, planned in 1415 (date of will) and completed in the 1450s. In the ambulatory there is a very notable retable, a high-water mark in late-13th-century northern European painting; and in the ambulatory chapels are monuments of John of Eltham (1377; St. Edmund's Chapel); the Duke of Buckingham by Nicholas Stone (1631; St. Nicholas Chapel); and Lord Hunsdon (1596; Chapel of St. John Baptist).

In the south transept, comprising four bays with aisles, is the Poet's Corner. Monuments to note particularly include Shakespeare (1741), by William Kent and Peter Scheemakers, and the Duke of Argyle (1748) by Louis François Roubiliac. In the north transept outstanding monuments include J. G. Nightingale and his wife (1761) by Roubiliac; the Duke of Newcastle (1723) by James Gibbs and Francis Bird; William Pitt (1778) by John Bacon; and Admiral Watson (1757) by James Stuart and Scheemakers.

The chapter house, whose interior was completed by 1253, is approached from the cloister by ingeniously contrived outer and inner vestibules. The octagonal compartment with a central compound pier is a design of wonderful 13th-century purity. The best example of the remaining sculpture is an *Annunciation* of 1253. There also remains a damaged 14th-century scheme of paintings. South of the southwest tower is the Jerusalem Chamber, which contains the best stained glass in the abbey; it was built in the mid-13th century, perhaps by William le Verrer.

BIBLIOGRAPHY. N. Pevsner, *London*, vol. 1: *The Cities of London and Westminster*, Harmondsworth, 1957.

JOHN HARRIS

Wetzlar Cathedral. The west front with Gothic tower.

WESTMINSTER NEW PALACE, LONDON, *see* Parliament, Houses of, London.

WESTWORK. Term for an architectural two-storied structure (from the German *Westwerk*). Usually flanked by towers, the westwork was placed at the west end of a church, where it served as an enclosed entrance porch. Introduced by Carolingian builders, it provided space, on its upper floor, for a west apse and sanctuary. This floor also offered space for a royal seating area since it allowed an unobstructed view down to the nave and across to the east apse.

BIBLIOGRAPHY. N. Pevsner, *An Outline of European Architecture*, 6th (Jubilee) ed., Baltimore, 1960.

WETZLAR CATHEDRAL. German church. The western part of the Cathedral of St. Mary dates from the 12th century and has a Romanesque portal. The Gothic choir, transept, and bays adjacent to it in the south aisle are of the 13th century; the north aisle is partly of the 14th. During the 14th and 15th centuries Gothic towers were erected over the original low Romanesque ones.

WEYDEN, GOSUIN (Goosen) VAN DER. Flemish history painter (b. Brussels, ca. 1465; d. ca. 1538). Grandson of Rogier van der Weyden, Gosuin in 1487 was made a burgher in Lierra, where, in 1492, he painted organ shutters for the Church of St-Grommaire. By 1498 he was in Antwerp and in 1503–04 had a studio with at least two students; one of them was Simon Portugalois. Gosuin was dean of the guild in 1514 and in 1530. In 1533 he painted an altarpiece for the abbey of Tongerloo (destroyed). His style is *retardataire* (derived from Rogier's), but it is decorative and picturesque. Among his documented works are *The Legend of St. Dymphe* (Brussels,

Baron J. van der Elst Collection) and *The Donation of Calmpthout* (1511; Berlin, former State Museums).

BIBLIOGRAPHY. L. van Puyvelde, *La Peinture flamande au siècle de Bosch et Breughel*, Paris, 1962.

WEYDEN, ROGIER VAN DER. Flemish painter (1399/ 1400–1464). One of the triumvirate of "first generation" Flemish primitives, Rogier contributed a new spirituality to the achievements of his contemporaries.

Born in Tournai, he was apprenticed there and left as a master in 1432. There is documentary evidence that Rogelet de la Pasture was apprenticed to Robert Campin in Tournai, late in 1426. It has been more or less accepted that Campin and the Master of Flémalle are one, and the question arises of the influence of master on pupil or vice-versa, since Rogelet (Rogier) would have been an apprentice at the age of about thirty. Rogier might have received earlier training elsewhere. His early works resemble those of Campin, and since Rogier entered the latter's workshop at a relatively mature age, he might have done so as an associate of the Tournai master. Some students go so far as to deny the existence of Flémalle altogether, and give his *oeuvre* to the early Rogier. *See* Master of Flemalle.

By 1435 Rogier resided in Brussels where, as official painter, he enjoyed great wealth and prestige. In the Holy Year of 1450 he made a pilgrimage to Rome; he then returned to Brussels (probably in the same year), where he resided until his death.

There are two major approaches to Rogier's stylistic development. One views his early works as strongly reflecting Flémallian and Eyckian influence, and therefore as relatively soft, warm, and coloristically rich. As Rogier matures, his own style slowly comes to predominate, bringing greater spirituality and austerity to his work and ultimately leading to Rogierian mannerism. The other approach agrees about the early Eyckian and Flémallian influence, but hypothesizes a rapid development of Rogier's individual style in the late thirties and early forties of the century. Rogier reaches one peak of his austere manner prior to his trip to Italy. Perhaps mellowed by contact with the Renaissance, he returns with a softer, richer style, but always within the framework of his unique spirituality. The differing approaches lead to divergent opinions on dating and growth. The discussion is complicated by the need to separate works by Rogier from possible Flémallian works, and excellent workshop copies from works not identified with Rogier at all—separations not always agreed upon by the experts.

The earliest works that may be credited to Rogier, a *Madonna in a Niche* (Lugano-Castagnola, Thyssen-Bornemisza Museum) and a *Standing Madonna* (Vienna, Museum of Art History) might be dated as early as 1430–32. The date is arrived at because both works show a mixture of Eyckian and Flémallian influence, and only the barest suggestion of the later Rogier. Conflicting opinions revolve about Rogier's *Descent from the Cross* (Madrid, Prado). Agreed upon by all as one of Rogier's greatest works (and one of the most influential in the north in the 15th century), it has been variously placed at the beginning of his career (ca. 1432) or a few years later (ca. 1436). For certain, it must have been done before 1443, the date of a

copy in the Church of St. Peter, Louvain. The *Descent*, extremely rich coloristically, is an emotionally overwhelming, dramatic composition. The tension of the figures, mourning in open or thinly suppressed sorrow as they gently lower Christ's body from the Cross, is accentuated by the compact space within which the action occurs. All the action of the large panel, with its restricted depth, is forced into a dynamic horizontal movement. The gracefully sweeping curve carries the movement horizontally. The bent posture of the Magdalene is just one example of the many motifs in this work that were copied and repeated throughout the 15th century. The iconographic innovations and stylistically masterful handling of textures, folds, and emotion mark this as a major work of Rogier.

Agreed upon as works produced between 1430 and 1440 are such panels as the *Annunciation* (Paris, Louvre), two *Visitations* (Turin, Albertina Academy Collection; and Lütschena), and a donor panel (Albertina Academy Collection). The two Turin panels are thought to be the wings of the Louvre *Annunciation*. The style of the *Annunciation* already shows Rogier's departure from Flémalle's influence, and may have been done during the interval 1432-35. Rogier's *St. Luke Painting the Virgin* (Boston, Museum of Fine Arts) could have come at this time also.

In the 1440s dating and development become somewhat firmer. To this period can be attributed the *Crucifixion Triptych* (ca. 1441/42; Vienna, Museum of Art History); the *Granada-Miraflores Altarpiece*, divided between Granada and New York, with an excellent workshop copy in Berlin (ca. 1445); and the *Beaune Altarpiece* (ca. 1446; Beaune, Hôtel-Dieu), commissioned by Chancellor Rolin for his new hospital, the Hôtel-Dieu. These works show a consistent development of characteristics of the Rogier manner: increasing linearity, limitation of space within the picture plane, and spiritualization of the physical into a heightened reserve and austerity.

In 1450 Rogier's Italian journey produced two works: the *Entombment* (Florence, Uffizi), in which the composition and iconography are dependent upon Fra Angelico, and the *Medici Madonna* (Frankfurt am Main, Städel Art Institute and Municipal Gallery). The latter work, showing Mary flanked by various saints, including the Medici patron saints Cosmas and Damian, is modeled after an Italian *Sacra Conversazione*. Both works show Rogier unresolved between the monumentality and humanism of the Renaissance and his own, more spiritual Flemish attitude.

Following his return home, he produced the magnificent and unprecedented *Braque Triptych* (ca. 1451/52; Louvre). It shows no evidence of his Italian stay: the face of Christ almost repeats that of the *Beaune Altarpiece*. Here Rogier has reached the epitome of his spirituality. The half-length figures, though tangible and "real," live in a world created by and for their own spiritual existence. But the work also shows a new richness and vibrancy of color which is indicative of Rogier's future course.

About 1452, Peter Bladelin commissioned Rogier to do an altarpiece for the church of his newly created city, Middelburg. The *Bladelin Altarpiece* (Berlin, former State Museums), with a central *Nativity* panel and wings showing the *Annunciation to the Magi* (right) and the *Annunciation to Augustus* (left), continues the coloristic tendency of the *Braque Triptych*. Here the rich, warm tones and chiaroscuro handling of light and shade are reminiscent of the Louvre *Annunciation*. A softening has taken place without loss of the characteristic spirituality.

Of the same time are the *St. John Altarpiece* (Berlin, former State Museums) and the *Seven Holy Sacraments Altarpiece* (Antwerp, Fine Arts Museum). The former, with its painted architectural framing devices, recalls the *Granada-Miraflores Altarpiece* but in spatial quality is quite different. For here the figures "act" both in front of and behind the frame, with space proceeding in both directions. In the *Granada-Miraflores* work, all the action is compressed behind the painted framing devices. Concomitant with the more flexible space, the figures of the former are more active and less restricted in their movements. The *Seven Holy Sacraments Altarpiece* is a problem. Although it is typically Rogierian in its iconographic inventiveness and general composition, the relative roughness of execution and internal inconsistencies mitigate against Rogier's hand. It has been suggested that the design was Rogier's but that execution was delayed and accomplished only after his death.

The *Columba Altarpiece* (Munich, Bavarian State Picture Galleries) is generally agreed to be one of Rogier's last works, and might be dated about 1460. The central panel, the *Adoration of the Kings*, is flanked by the *Annunciation* (left) and the *Presentation in the Temple* (right). Here the trends of the previous decade seem to reach their ultimate fruition. One is faced with a subtle, sophisticated fusion of a rich and varied palette; soft, warm chiaroscuro; graceful, elegant lines; and the ever-present ascetic spirituality. Rogier appears to have reached the culmination of his powers.

Two last works are a diptych with a *Crucifixion* and a *Virgin and St. John* (Philadelphia, Museum of Art), and the same subjects on one panel in the Escorial. Both works are almost monochromatic and use a solid back wall to severely limit the recession into space. The severe, arbitrary spatial limitation recalls the relatively early *Descent from the Cross*. The flying ends of Christ's loincloth in the Philadelphia *Crucifixion*, as well as the general austerity, recall the Vienna triptych and the works of the mid-forties. The elegant proficiency of the linear quality and the simple emotional power of these works suggest the late, mature Rogier.

Rogier's many masterful portraits generally follow his broad stylistic development and are dated accordingly; for example, the *Portrait of a Young Woman* (ca. 1435; Berlin, former State Museums) and two versions of the *Portrait of a Young Woman* (ca. 1455/60; Washington, D.C., National Gallery, and London, National Gallery). Rogier sacrificed the full physical exploitation of his sitter (Van Eyck's achievement) for a fuller psychological penetration, and it is in this that he excels.

Not only for his own masterly qualities as a craftsman, but also for his independence and genius as an innovator and inventor of emotional symbols, Rogier was the most influential painter of the north in the 15th century.

BIBLIOGRAPHY. M. J. Friedländer, *Die altniederländische Malerei*, vol. 2, Berlin, 1924; J. Destrée, *Roger de La Pasture van der Wey-*

Rogier van der Weyden, The Descent from the Cross. Prado, Madrid.

den, 2 vols., Paris, 1930; E. Renders, *La solution du problème van der Weyden-Flémalle-Campin*, Bruges, 1931; E. Panofsky, *Early Netherlandish Painting*, 2 vols., Cambridge, Mass., 1953.

<div style="text-align: right">STANLEY FERBER</div>

WEYDITZ, CHRISTOPH, *see* WEIDITZ, CHRISTOPH.

WEYR, RUDOLF. Austrian sculptor (b. Vienna, 1847; d. there, 1914). He studied at the Vienna Academy. In his monuments, and especially in his reliefs and decorative sculpture, Weyr showed the Austrian preference for the movement and lightness of the rococo style.

WHEATLEY, FRANCIS. English painter (1747–1801). Born in London, Wheatley was at his best as a portraitist. *Henry Grattan* (1782; London, National Portrait Gallery) and *Gentleman with a Dog* (London, Tate) are distinguished for their characterization and pleasing color arrangement. His genre work is often marred by a shallow sentimentalization, as in the series of engravings *Cries of London* (1795).

BIBLIOGRAPHY. C. H. C. Collins and M. R. James, *British Painting*, London, 1933.

WHEEL OF THE LAW, *see* CAKRA.

WHENCE DO WE COME?... (D'Ou Venons-Nous?...). Oil painting by Gauguin, in the Museum of Fine Arts, Boston. *See* GAUGUIN, PAUL.

WHIPPLE HOUSE, IPSWICH, MASS. American house begun prior to 1650. Its growth typifies the evolution of the New England house of the 17th century. The first section was a two-story structure, with one large room on each floor, and a massive end chimney. In 1670 a similar addition was made, forming a typical 17th-century house with two rooms on each floor and a central chimney. A later addition on the rear caused a different roof pitch on that side of the building. The framing, of post and beam construction, is covered by weatherboarding. The fenestration is asymmetrical with the unusual, hewn overhangs on the ends rather than at the sides. Because of its random growth and lack of academic formality, Whipple House, and houses similar to it, are often called early American Gothic.

BIBLIOGRAPHY. H. S. Morrison, *Early American Architecture*, New York, 1952.

WHISTLER, JAMES ABBOTT McNEILL. American painter and etcher (b. Lowell, Mass., 1834; d. London, 1903). Whistler's formal artistic training consisted of drawing lessons at the Imperial Academy in St. Petersburg, where, from 1843, his engineer father was working on railroad construction, and brief study with Gleyre in Paris beginning in 1855. In Paris Whistler met many important painters, including Courbet, Degas, Manet, and Fantin-Latour. His paintings of this period were influenced by the style and realistic subjects of Courbet, for example, *Head of an Old Man Smoking* (late 1850s; Paris, Louvre). In 1859 Whistler left Paris and settled in London.

The Music Room (1860; Washington, D.C., Freer Gallery) shows Whistler moving away from Courbet toward his characteristic interest in precise arrangement and a carefully adjusted palette of color and tone relationships. The concentration on a few related colors is further advanced in *The White Girl* (1862; Washington, D.C., National Gallery), which was refused by the Salon of 1863 and exhibited at the Salon des Refusés. *Symphony in White*, an addition which Whistler later made to the title of *The White Girl*, as well as his other musical titles were indicative of his increasing concern for the purely aesthetic, as opposed to the literary, elements in art, and he wittily championed his views in London artistic circles. His Paris-acquired admiration of Japanese art was also related to his aesthetic theories. *The Artist in His Studio* (1864; Art Institute of Chicago) shows Oriental influence in the costumes and porcelains depicted and also in the asymmetrical composition and general flattening.

The abstract subtleties of design that Whistler developed can be seen in the two famous portraits *Arrangement in Gray and Black, No. 1: The Artist's Mother* (1871; Louvre) and *Arrangement in Gray and Black No. 2: Thomas Carlyle* (1872; Glasgow, Art Gallery and Museum). In 1876 Whistler was commissioned to decorate the dining room of his patron, F. R. Leyland. The result was the Oriental *Peacock Room, Harmony in Blue and Gold* (Freer Gallery), which went well beyond Leyland's intentions and caused a rupture in their relationship. The next year Ruskin's severe criticism of an exhibition of Whistler's nocturnes prompted a suit for libel, which Whistler won; the expenses of the case, however, were a factor in precipitating his bankruptcy in 1879. His Venetian etchings were done in 1879 and 1880 in an effort to recover his public and his fortune. Whistler painted little toward the end of his life, but he enjoyed the gradual recovery of public esteem and his former artistic position.

He wrote many well-known letters to the London press concerning his views on art and the contemporary artist. In February, 1885, at Prince's Hall he gave a famous lecture, known as "Ten O'Clock," which was attended by prominent intellectuals and critics, including George Moore and Oscar Wilde. Condensing the material of the letters, Whistler defended his times as being as conducive to great art as any other era, and he declared that the artist was an independent vessel of talent.

BIBLIOGRAPHY. J. M. Whistler, *The Gentle Art of Making Enemies*, London, 1890; E. and J. Pennell, *The Life of James McNeill Whistler*, 2 vols., London, 1908; J. Laver, *Whistler*, New York, 1930; H. Gregory, *The World of James McNeill Whistler*, New York, 1959; D. Sutton, *Nocturne: The Life of James McNeill Whistler*, London, 1963.

<div style="text-align: right">JEROME VIOLA</div>

WHISTLER AS GRAPHIC ARTIST

Much of Whistler's popularity resulted from his graphic works, particularly from his etchings. He had learned the technique during his one-year appointment to the U.S. Coast and Geodetic Survey immediately before his departure to France in 1855. As he became a more proficient etcher, he relied increasingly on the technique as a vehicle for his observations of and delight in nature, cityscapes, and people.

His first etchings, the so-called *French Set*, or more correctly *Twelve Etchings from Nature*, were published after he moved to London in 1859 at the very beginning of the etching revival for which Whistler himself was in large measure responsible. The twelve etchings were the

James McNeill Whistler, *The White Girl*, 1862. National Gallery, Washington, D.C.

result of a walking tour of northern France, Luxembourg, and the Rhineland, and they were printed by the eminent Parisian printer of etchings Auguste Delâtre. This first series shows an awareness of Rembrandt and Pieter de Hoogh in the handling of atmospheric effects, though this awareness may have been transmitted through Charles Emile Jacque, with whom he studied.

During the 1850s his talents were actually better displayed in his etchings and drawings (which appeared after 1859 as xylographs in *Once a Week*) than in his paintings. In 1871, a series of sixteen plates made between 1859 and 1871, the *Thames Set*, was published in London by Ellis and Green. The plates were both avant-garde and technically of the highest quality and were no doubt in part responsible for his election to the Société des Aquafortistes in 1862 (called "L'Illustration Nouvelle" after 1868). During the 1870s Whistler's output was large. He sketched constantly, particularly in pastel and charcoal, a preparation for his exquisite Venetian pastels.

In addition, with the encouragement of the commercial lithographic printer Thomas Way, Whistler took up lithography. He executed a number of separate lithographs in the 1870s and became increasingly more proficient in this most direct of all graphic reproducible processes. When in 1879 Whistler's bankruptcy dictated a move to Venice, he was fully prepared to record the beauty of that city in etchings, pastels, and even lithographs. His two sets of Venetian etchings, twelve in 1880 and twenty-one more in 1886, are the high point of his work in this medium. They demonstrate a final refinement of the medium from a linear to a soft impressionistic style. He used the needle lightly and picked out only the most important details with careful modeling. By pulling his own plates, which he was forced to do in Venice, he was able to utilize fully the biting of the acid to enhance his impressionistic effects.

As his fortunes turned more favorable toward the end of his life, he continued to etch and draw, as the *Amsterdam Set* of 1890 demonstrates. Lithography became a more important medium for him and, in fact, dominated his output in the early 1890s. Whistler was more of an innovator as a painter, but his graphic work reveals his thorough proficiency as a draftsman, his keen observation, and his incorruptibly tasteful eye.

BIBLIOGRAPHY. E. G. Kennedy, *The Etched Work of Whistler*, 4 vols., New York, 1910; D. Sutton, *Nocturne: The Art of James McNeill Whistler*, London, 1963. JULIA M. EHRESMANN

WHISTLER, REX. English painter and graphic artist (1905–44). He was born in London. A designer of bookplates, he revived the flamboyant detail of the Chippendale period, as may be seen in his plates for Christabel Maclaren and Osbert Sitwell.

BIBLIOGRAPHY. A. J. A. Symons, "Ex Libris: the Mark of Possession," *London Studio*, X, December, 1935.

WHISTLER'S MOTHER, *see* ARTIST'S MOTHER, THE.

WHITE, STANFORD. American architect (1853–1906). Born in New York City, he entered the office of Richardson and Gambrill in 1872 and left in 1878 after working on the New York State Capitol and Trinity Church, Boston. In 1879 he joined McKim and Mead, and this partnership lasted until his death. White was noted for his skill in design and decoration, and his hand can be seen in such disparate works as the Bell Residence, Newport, R.I. (1881–82), known for its Orientalizing interior; the Italianate old Madison Square Garden, New York City (1889); and the formally planned Breese Residence, Southampton, N.Y. (1906), in the neo-Colonial style. He helped establish the fashion of importing to the United States parts of European buildings. And with Augustus Saint-Gaudens, he designed statuary monuments. *See* McKIM, MEAD AND WHITE.

BIBLIOGRAPHY. C. C. Baldwin, *Stanford White*, New York, 1931.

WHITE, FLYING, *see* FEI-PO.

WHITE-GROUND VASE PAINTING. Technique of Greek pottery decoration. It consisted of executing figures in flush dilute paint, supplemented by purple, brownish-red, and yellow washes for drapery, on a background of white slip. At first, various vessels were thus decorated, but by the mid-5th century B.C. the lekythos became the preferred shape. This shape was admirably suited to classical figures, and the artists strove for delicate effects, since the vessel was intended not for everyday use but as a dedicatory offering for graves. The Achilles Painter (ca. 450–440 B.C.) was the principal stylist in this idiom. Recurring themes include the soldier's farewell, the visit to the grave, and the slain carried by Sleep and Death. *See* ACHILLES PAINTER.

BIBLIOGRAPHY. R. M. Cook, *Greek Painted Pottery*, London, 1960.

WHITEHALL PALACE, LONDON. English palace. Lands north of Westminster Abbey were possessed by Wolsey as archbishop of York. He began to rebuild the palace in 1514, but by 1540 Henry VIII had acquired the buildings and conceived of the palace and site in much grander terms. What he built has disappeared, except for fragments of a tennis court and connecting gallery. His palace was a rambling one, more so than at Hampton Court, and had two gatehouses, both built in 1530: the Holbein Gate of Tudor character adorned with emperors' heads in majolica with roundels of terra cotta; and the King Street Gate in a Franco-Renaissance style. The Great Hall had turrets at the angles such as the one at Hampton Court, and the Long Gallery was reconstructed from Wolsey's palace at Esher.

The next addition was in 1617–20 when the Marquis of Buckingham had a lodging built, probably to designs by Inigo Jones. The old Banqueting House, built in 1607, was burned in January, 1619. Immediately Jones made designs for its rebuilding, which was complete by 1622. It was a building of Mediterranean purity and stood in startling contrast to the still traditional architecture of the time. In the 1630s Jones and his colleague John Webb drew up plans for a comprehensive rebuilding of Whitehall and included the Banqueting House as a unit in the design. In the same decade Rubens's ceiling was put up.

Plans for a great palace were considered in 1647–48 just before the Civil War, and again in 1661 for Charles II. In 1685 Wren built the New Building for King James II. It included the Privy Gallery and a chapel which was perhaps the most lavish in the century, with a baroque deco-

rative ensemble that had sculptures by Grinling Gibbons and Arnold Quellin. William III and Queen Mary began new works, including the Queen's Apartments of 1691–93.

Except for the Banqueting House, the palace was burned to the ground in 1697. The fire virtually closed the building chapter. Yet the idea of a resurgent Whitehall was uppermost in architects' minds and about 1699 came the first of many subsequent schemes, a product of the Office of Works and confused in authorship. Characteristically, the only building that did arise from the ashes was the little house designed by Sir John Vanbrugh for himself, and christened the Goose Pie House. The palace area was broken up into sites either leased to private persons or utilized for public building. The Admiralty went up in 1693–94; the Treasury, in 1736; and the Horse Guards, in 1745–55.

BIBLIOGRAPHY. P. Palme, *Triumph of Peace*, Stockholm, 1956; N. Pevsner, *London*, vol. 1: *The Cities of London and Westminster*, Harmondsworth, 1957.

JOHN HARRIS

WHITE-LINE METHOD. In graphics, a procedure in which the printmaker works in white lines on a black ground as opposed to the "normal" method of working black lines on a white ground. Though the procedure seems most logical in wood engraving, it is also employed in lithography and other graphic media.

WHITE LOTUS SOCIETY, *see* JEN PAI-NIEN.

WHITE MONASTERY, *see* SOHAG.

WHITE PAGODA, *see* NORTHERN LAKE, PEKING.

WHITNEY, GERTRUDE VANDERBILT. American sculptor (b. New York, 1877; d. there, 1942). Mrs. Whitney first received her training under Hendrik C. Anderson and James Earle Fraser in New York and later studied under Andrew O'Connor and Rodin in Paris. Her early work, such as *Boy with a Parrot*, shows a lyric impressionistic quality that was later replaced by a direct realistic handling, often on a large scale, as in the artist's *Titanic Memorial* (1914) in Washington, D.C., representing perhaps

the first monument significant of her mature style. This sense of monumentality is best shown in Mrs. Whitney's statue of Columbus in Palos, Spain, which, with its interplay of large cubistic volumes, creates an effect of power and simplicity. More plastically treated figures, of which *Doughboy* is one, suggest Rodin in the dynamic handling of mass. Mrs. Whitney also founded the Whitney Museum of American Art in New York. *See* NEW YORK: MUSEUMS (WHITNEY MUSEUM OF AMERICAN ART).

BIBLIOGRAPHY. Whitney Museum of American Art, *Memorial Exhibition: Gertrude Vanderbilt Whitney*, New York, 1943.

WHITTREDGE, WORTHINGTON. American landscape painter (b. Springfield, Ohio, 1820; d. Summit, N.J., 1910). He studied painting in Cincinnati and Europe and made sketches of the Western landscape and of the Indians. A member of the Hudson River school, he reflects the poetic romanticism of Thomas Doughty in his early scenes, while his late work is more factual in detail and natural observation.

BIBLIOGRAPHY. C. E. Sears, *Highlights among the Hudson River Artists*, Boston, 1947.

WHORF, JOHN. American painter (b. Boston, 1903; d. Provincetown, Mass., 1959). He studied in Boston and Provincetown and with John Singer Sargent. Whorf painted figures, ballet scenes, and atmospheric land- and seascapes in a modified impressionism.

BIBLIOGRAPHY. E. McCausland, *John Whorf*, New York, 194–?

WIBERT. Goldsmith of Aachen (d. Aachen, 1200). Maker of the famous crown of Frederick Barbarossa preserved in the Cathedral at Aachen, Wibert is one of few identified craftsmen of the 12th century. He was evidently one of a number of goldsmiths active in Aachen, and a small group of works have been attributed to him. He is sometimes called Master Wibert.

BIBLIOGRAPHY. M. Rosenberg, *Der Goldschmiede Merkzeichen . . .* 3d ed., 4 vols., Frankfurt am Main, 1922–28.

WICKEY, HARRY. American etcher and sculptor (1892–). Born in Stryker, Ohio, he studied in Detroit and Chicago and at the Ferrer Modern School and New York School of Industrial Design in New York City. Beginning as an illustrator for the *Saturday Evening Post*, he turned to etching in 1919. His scenes of New York street life express the vitality of the city. Forced to abandon etching in 1935 because of damaged vision, he became a sculptor of animal figures.

WIDOW'S WALK, *see* CAPTAIN'S WALK.

WIEN, *see* VIENNA.

WIES, DIE. Pilgrimage church near Steingaden, in southern Bavaria, Germany, dedicated to Christ at the Column. An ever-growing influx of pilgrims, who had come to pray before a wooden figure of the scourged Christ, led the abbot of Steingaden, in 1744, to commission designs for a church and priory buildings from Dominikus Zimmermann. The foundation stone was laid in 1746; the statue was brought to the church in 1749; and five years later the church was consecrated. Johann Baptist Zimmermann

Whitehall Palace. The Banqueting House, 1619–22, by Inigo Jones.

is credited with the ceiling frescoes. Anton Sturm carved the four figures of the Fathers of the Church that stand against the nave piers. Aegidius Verhelst did the six statues of the prophets Isaiah and Malachi and the four Evangelists in the choir. The miraculous statue of Christ above the tabernacle is an assemblage of parts of two or more wooden figures such as were traditionally carried in processions, put together by monks of Steingaden for the Good Friday procession in 1730. At gallery level above the high altar there is a second altar with a painting by Balthasar Albrecht. At the opposite end of the church is a gallery with an organ of 1757.

The ensemble of Die Wies is one of the triumphs of German rococo. As at Steinhausen, Zimmermann used an oval plan for the body of the church, with projections (here curvilinear) for the entrance at the west end and for the choir at the east end. At Wies, however, the free space of the nave, hardly affected by the delicate pairs of piers supporting the vault, flows into the deep chancel to stress a longitudinal composition.

Light and color dominate one's impression of the interior. In the oval part of the church the piers and walls, the gallery and its organ, and even the figures of the Fathers of the Church are white, enriched with touches of gold. Except for the pulpit and the abbot's loge, which flank the chancel arch, color is relegated in the nave to the broad vault (a coved ceiling rather than a dome) and to the small areas of ceiling beyond the piers, where lightly colored frescoes strike a gay note. The main fresco, covering the whole of the nave vault, offers the pilgrim a promise of divine grace. Even such architectural elements as cornices and arches in the upper region yield their conventional form to take part in a polyphonic play of line and color. Color dominates the choir, where pink and blue marbling in the columns, spandrels, and around the altar is set off by white piers and external walls, a good deal of gilding, and touches of other colors.

Zimmermann's idiosyncratic broken curves appear at their freest in the arcading of the gallery, which, instead of rising in the normal semicircular curve, dips down soon after springing from the columns to allow the architect to

Die Wies. Interior of this German rococo church by Dominikus Zimmermann, consecrated 1754.

pierce a roughly circular opening over the center of each "arch." The frescoes in the choir continue the theme of divine grace.

The exterior of the church is modest. Columns and gable mark the three-bay entrance at the west end. At the east end a sober tower links the church to the contemporary prior buildings.

BIBLIOGRAPHY. C. Lamb, *Die Wies*, Munich, 1964.

NORBERT LYNTON

WIGLEY, JAMES. Australian painter (1918–). He studied with Léger in Paris from 1944 to 1948. His realistic paintings and drawings of Australia's nomadic outback inhabitants are distinguished for their humanism and fine poetic imagery. His perceptive works are among the most sensitive in Australian regionalist art.

WIGWAM. Oblong hut with a cylindrical roof, built of a framework of slender poles, their butt ends stuck in the ground and their tops bent over and lashed to form the curved roof. The framework is covered with woven mats, pressed bark, or skins. Unlike the conical tepee of the Western Plains Indians, the wigwam was an Eastern type prevalent from Quebec to the Carolinas. Wigwam construction was adopted by colonists, who added doors and introduced fireplaces and chimneys to take the place of the square hole in the middle of the roof of the Indian wigwam.

WIJCK (Wyck), THOMAS. Dutch painter of landscape and genre; also graphic artist (b. Beverwijk, ca. 1616; d. Haarlem, 1677). He spent several years in Italy, where he was influenced by the work of Pieter van Laer and Jan Miel. Wijck was reported as a member of the Haarlem painters' guild in 1642. About 1660 he was in England. His son Jan was also a painter. Thomas Wijck's favorite genre subject was alchemists at work (The Hague, Mauritshuis Art Gallery). He also painted Italianate landscapes.

BIBLIOGRAPHY. M. E. Houtzager et al., *Nederlandse 17e eeuwse Italianiserende Landschapschilders*, Utrecht, 1965.

WIJNANTS (Wynants), JAN. Dutch landscape painter (b. Haarlem, 1631/32; d. Amsterdam, 1684). Wijnants seems to have spent his formative years in Haarlem. The subject of almost all his works is the dune landscape characteristic of the Haarlem area. In 1659 he was still reported in Haarlem, but by late 1660 he was living in Amsterdam. In 1672 Wijnants is described as "painter and innkeeper." The figures in his landscapes are often painted by other artists, for the most part by Adriaen van de Velde, who may have been Wijnant's pupil.

BIBLIOGRAPHY. W. Stechow, *Dutch Landscape Painting of the Seventeenth Century*, London, 1966.

WIJNTRACK (Wyntrack), DIRCK. Dutch painter of animals and landscape (b. Drenthe, before 1625; d. The Hague, 1678). Wijntrack was living in Gouda from 1654 to 1655. In 1657 he went to The Hague, where he was a representative of Holland and West Friesland. He collaborated with several other painters and executed figures and animals for Joris van der Haagen, Jacob van Ruisdael, and Meindert Hobbema.

BIBLIOGRAPHY. M. J. F. W. van der Haagen, "De Samenwerking van Joris van der Haagen en Dirk Wijntrack," *Oud-Holland*, XXXV, 1917.

Sir David Wilkie, *The Blind Fiddler*. Tate Gallery, London.

WIJTMAN (Wytmans), MATHEUS. Dutch painter of still life and portraits (b. Gorinchem? ca. 1650; d. Utrecht? 1689). He was a pupil of Hendrik Verschuring and Jan van Bijlert in Utrecht. Wijtman was recorded as a member of the Utrecht painters' guild in 1667. His works are rare.

BIBLIOGRAPHY. A. P. A. Vorenkamp, *Bijdrage tot de geschiedenis van het Hollandsch stilleven in de zeventiende eeuw*, Leyden, 1934.

WILD, HANS. German stained-glass artist (fl. Ulm, late 15th cent.). Wild was formerly thought to be the master who created the stained-glass window in Ulm Cathedral (ca. 1480) that depicts the genealogy of Christ. The attribution was made on the ground that his name appears in the work. The window is now considered the work of Peter Hemmel of Andau, and Wild is currently regarded only as a possible helper.

BIBLIOGRAPHY. H. Rott, *Quellen und Forschungen zur Südwestdeutschen und schweizerischen Kunstgeschichte im 15. und 16. Jahrhundert*, 3 vols., Stuttgart, 1933-38.

WILDENS, JAN. Flemish artist (b. Antwerp, 1586; d. 1653). He was an important painter of landscapes and did his best work while closely associated with Rubens. He painted many backgrounds for Rubens as well as for Frans Snyders, Cornelis Schut, Paul de Vos, and so on. Wildens is more static and decorative than Rubens, and the figuration always plays a prominent part in his independent compositions.

BIBLIOGRAPHY. Y. Thiéry, *Le Paysage flamand au XVIIe siècle*, Brussels, 1953.

WILHELM VON KOLN, *see* MASTER WILHELM OF COLOGNE.

WILIGELMUS DA MODENA, *see* GUGLIELMO DA MODENA.

WILKIE, SIR DAVID. British painter (b. Cults, north of Edinburgh, 1785; d. at sea, 1841). After studying in Edinburgh under John Graham and a short interval as an itinerant portrait painter, Wilkie went to London in 1805. He was fortunate enough to attract the attention of influential patrons such as Lord Mansfield and Sir George Beaumont, and his reputation grew quickly. The pictures he exhibited had immediate appeal and became very popular. His work, at least early in his career, follows the tradition of Dutch 17th-century genre painting. He greatly admired Teniers, and his major source of inspiration was clearly the painting of men such as Teniers, Jan Steen, and Ostade. He had also, however, been affected by the more humanitarian and sentimental genre of the late 18th century and of his own day. His technique in these early years was comparatively tight. He was most meticulous in attention to details, which often accumulate in his pictures in a rather Hogarthian manner. Wilkie was elected associate of the Royal Academy of Arts in 1809 and full academician in 1811.

The major artistic development of his career came in the 1820s. In 1825, after a serious illness, he set out on a prolonged Continental tour and, during this time, studied the works of earlier masters with care. He was one of the first British artists to visit Madrid and was greatly impressed by what he saw there. Wilkie was aware of the change coming over his art and was apprehensive about the reception his new style might receive. Indeed, most of his public thought his work had deteriorated. In recent years, however, the greater breadth and freedom of Wilkie's brushwork in his later paintings have found many admirers. But modern attention has tended to focus even more on his drawings than on his paintings. Here again his late work exhibits a fluent but firm command, especially in handling the human figure.

Wilkie's works are scattered through public and private collections in Great Britain. His paintings are in the National Gallery of Scotland, Edinburgh, and the Tate Gallery, London. There is a fine collection of his drawings in the Ashmolean Museum, Oxford, and a good representative group of his drawings in the Henry E. Huntington Library and Art Gallery, San Marino, Calif.

BIBLIOGRAPHY. T. S. R. Boase, *English Art 1800-1870*, Oxford, 1959. ROBERT R. WARK

WILKINS, WILLIAM. English architect (1778-1839). His classical scholarship and first-hand knowledge of Greek building made him one of the leading Greek revival architects in England. Grange Park, Hants, is his most uncompromising Greek building, and the National Gallery, London, his most famous work.

WILLAERTS, ABRAHAM. Flemish-Dutch painter (1603-69). Born in Utrecht, he was the son of Adam Willaerts and the pupil of Jan van Bijlert and Simon Vouet. Willaerts is best known as a painter of seascapes and shore scenes; his rare portraits are less attractive. He joined the

Count of Nassau in Brazil and accompanied the expedition that took the African seaport of São Paolo de Loanda—hence the nickname "Indian," which was given him by his fellow artists of the Schilderbent in Rome in 1659.

BIBLIOGRAPHY. C. de Bie, *Het Gulden Cabinet*, Lier, 1661.

WILLAERTS, ADAM. Flemish-Dutch painter (b. Antwerp, 1577; d. Utrecht, 1664). He belonged to the archaic tradition of seascape and shore-scene painters in the manner of Hendrik Cornelisz. Vroom. Sometimes Willaerts depicted harbors in Norway or in the Dutch colonies. He was the father of Abraham Willaerts.

WILLE, JOHANN GEORG. German engraver (b. near Giessen, 1715; d. Paris, 1808). Wille (born Will) went to Paris as a young man in the company of Georg Friedrich Schmidt after some training as a painter in his native region of Hesse. Largely self-taught as an engraver, Wille first found work in the Paris engraving firm of Odieuvre. From 1743 until the French Revolution he enjoyed great fame. He was an honorary member of foreign academies, engraver to the king, and court engraver to the Danish king and the Holy Roman emperor. After the Revolution he died a pauper. His style is often called "pure engraving" and is noted for its extreme technical precision and regularity. Wille is associated with the classical revival in France, and his many portraits were influential on younger engravers around him, Bervic and Tardieu among them.

BIBLIOGRAPHY. E. Bocher, *Les Gravures françaises du XVIIIᵉ siècle*, 6 vols., Paris, 1875–82.

WILLEBOIRTS (Willeboorts), THOMAS (Thomas Bosschaert). Flemish painter (b. Berg-op-Zoom, 1613 or 1614; d. Antwerp, 1654). He painted religious, mythological, and allegorical scenes and portraits; he was also an engraver. He was a pupil of Geeraard Zegers but worked in the manner of Anthony van Dyck. Willeboirts's style is distinguished by a strong feeling for plasticity—as can be seen, for example, in his decorations for the Huis ten Bosch in The Hague—but his color scheme lacks the vigor of the Rubens school.

BIBLIOGRAPHY. R. Oldenbourg, *Die flämische Malerei des 17. Jahrhunderts*, 2d ed., Berlin, 1922.

WILLETTE, ADOLPHE. French painter, draftsman, and humorist (b. Châlons-sur-Marne, 1857; d. Paris, 1926). Willette was primarily a decorative artist whose best works were lithographs and wall decorations of Paris cabarets, cafés, coffeehouses, and dance halls, mostly in the region of Montmartre, many of which no longer exist. He used his favorite theme, Pierrot, in the decoration of the Chat Noir. The Gobelin tapestry manufacturers made a series based on his designs, *Salut à Paris*. Willette contributed to many humor magazines and founded two short-lived ones, *Pierrot* (1888–90) and *Le Pied de Nez*. His best lithographs were posters, for example, for the exhibition Nouveau Cirque. Among his lithograph folios is *Pauvre Pierrot* (1895).

BIBLIOGRAPHY. H. Willette, *Willette en chandail*, Paris, 1926.

WILLIAM OF SENS, see CANTERBURY CATHEDRAL.

WILLIAMS, ROBERT (Roger). English mezzotinter (fl. 1680–1704). He created at least sixty high-quality mezzo-

Williamsburg, Va. The Governor's Palace, reconstructed 1931–34.

tints of English personages, mostly after Cooper, Van Dyck, Lely, and Wissing. Williams's *Henry Somerset, Duke of Beaufort*, is after Wissing.

BIBLIOGRAPHY. C. Leblanc, *Manuel de l'amateur d'estampes*, 4 vols., Paris, 1854–90.

WILLIAMSBURG, VA. Colonial city in eastern Virginia. The restoration of Williamsburg, begun in 1928, involved the demolition of 731 modern buildings, the refurbishing of 81 extant 18th-century buildings, and the complete reconstruction of 413 buildings in the old style. The original plan was followed insofar as possible, although many of the individual buildings had to be fabricated on a comparative basis with the architecture of the Tidewater area.

The original building of the city took place during its period as capital of Virginia, between 1699 and 1780, and was carried out according to a rational and comprehensive plan originated by Governor Sir Francis Nicholson. The principal street, named after the Duke of Gloucester, terminates at the Capitol at one end and the College of William and Mary at the other and is met at its center at right angles by the street leading to the Governor's Palace. These most important public buildings, as well as the Gaol, Bruton Parish Church, the Magazine, the Court House, and Brafferton Hall, are gabled red-brick structures with high-pitched roofs. The blocklike forms and simple articulation of windows and doors recall to a certain extent some buildings of Restoration England, although there is also a similarity with Dutch colonial architecture. These buildings, at any rate, set a standard of monumentality for that section of the colonies. *See* WILLIAMSBURG, VA.: BRUTON PARISH CHURCH.

Houses are generally of wood, clapboarded with high-pitched roofs and gables not unlike the colonial buildings of New England. Plots were prescribed by the city partly to encourage the establishment of gardens, which are to be found throughout Williamsburg. The houses are furnished with period pieces and reproductions. The brick Ludwell-Paradise House contains the Abby Aldrich Rockefeller Folk Art Collection.

BIBLIOGRAPHY. M. Whiffen, *The Public Buildings of Williamsburg* (Williamsburg Architectural Studies, vol. 1), Williamsburg, Va., 1958; M. Whiffen, *The Eighteenth-Century Houses of Williamsburg* (Williamsburg Architectural Studies, vol. 2), Williamsburg, Va., 1960.

DONALD GODDARD

WILLIAMSBURG, VA.: BRUTON PARISH CHURCH.
American church begun in 1711 and completed in 1715. Although the designer is unknown, Governor Alexander Spotswood of Virginia is given credit for the drawings. The exterior is of brick, with tall round-headed arch windows and a steep roof. Circular windows are found in the transept end walls and in the chancel wall. In the square west tower is a wooden octagonal spire in two stages (1769). The interior is built on a cruciform plan, with purely Georgian details; the governor's pew is at the northeast side crossing, with the pulpit across from it. The interior was revised in 1839, but it has been restored to its 18th-century appearance.

BIBLIOGRAPHY. H. S. Morrison, *Early American Architecture*, New York, 1952.

WILLIAMSON, HAROLD SANDYS. English painter and designer (1892–). Born in Leeds, he studied there and at the Royal Academy schools. His well-known posters for the London subway combine compositional boldness with an interest in the female figure.

WILLIAMSTOWN, MASS.: STERLING AND FRANCINE CLARK ART INSTITUTE. Opened in 1955, the collection is especially rich in French art of the 18th and 19th centuries. There are works by Gérôme, Géricault, Courbet, Troyon, Corot, Millet, Manet, Toulouse-Lautrec, Daubigny, Decamps, Fantin-Latour, and Boudin, along with a sizable group of impressionist paintings, including works by Monet, Pissarro, Sisley, Degas, and Renoir, the last represented by thirty-two paintings. Some fine Degas bronzes, prints, and drawings are also exhibited. On display are 18th- and 19th-century porcelain, sculpture, drawings, prints, furniture, and an outstanding collection of silver. There are American paintings by Homer, Inness, Sargent, and Remington. European paintings include Piero della Francesca's *Madonna and Child with Four Angels*, Memling's *Portrait of a Man*, Gossaert's *Portrait of David of Burgundy*, Luca Signorelli's *The Martyrdom of St. Catherine*, and Turner's arresting *Rockets and Blue Lights*.

BIBLIOGRAPHY. S. L. Faison, *A Guide to the Art Museums of New England*, New York, 1958.

WILLIBRORD, DOM, *see* VERKADE, JAN.

WILLINK, CAREL ALBERT. Dutch painter (1900–). Born in Amsterdam, he studied in Berlin with H. Balusches (1920–23). Starting as an abstractionist influenced by the Italian futurists and Giorgio de Chirico, Willink later became the leading proponent of magic realism in the Netherlands. His meticulous landscape and city settings evoke a surrealistic sense of isolation and dream.

WILLMAN, MICHAEL. German painter (b. Königsberg, 1630; d. near Lubiąż, 1706). He studied with Backer in Amsterdam, and devoted intensive attention to the Dutch and Flemish masters. Willman's early *Landscape with St. John the Baptist* (1656) shows the impact of Ruisdael but is more fantastic in the manner of Altdorfer. Willman settled in Silesia (1660), where he created a series of twelve large paintings for the collegiate church of the Cistercian abbey near Lubiąż (1661–1700). In these and other works the painterly baroque style is charged with a violent

spirituality. Later paintings such as the ceiling fresco for the Lubiąż refectory (1691/92) and the frescoes at St. Joseph, Krzeszów (1692), are more classical in figure style and composition but retain the anguished emotional expression of earlier works.

BIBLIOGRAPHY. E. Kloss, *Michael Willman*, Breslau, 1934.

WILMINGTON, DEL.: SOCIETY OF THE FINE ARTS (Delaware Art Center). Established in 1912, the center owns a comprehensive group of Pre-Raphaelite paintings in the Samuel and Mary R. Bancroft Collection. There are also works by American artists and a collection of paintings and drawings by Howard Pyle.

WILNA: ST. ANNE, *see* VILNIUS: ST. ANNE.

WILS, JAN. Dutch landscape painter (b. Haarlem, ca. 1600; d. there, 1666). A follower of Jan Both, Wils painted Italianate landscapes. He was one of the teachers of Claes Berchem, who in 1646 married Wils's daughter. Wils collaborated with Berchem, who painted the figures in his father-in-law's landscapes.

BIBLIOGRAPHY. W. Bernt, *Die niederländischen Maler des 17. Jahrhunderts . . .*, vol. 3, Munich, 1948.

WILSON, RICHARD. British landscape painter (b. Wales, ca. 1713; d. Wales, 1782). About 1729 he went to London and was a pupil of Thomas Wright, an obscure portrait painter. Wilson practiced portraiture in the 1740s. The best-known example of this phase of his work is probably *Admiral Thomas Smith* (Greenwich, National Maritime Museum). His portraits are executed with a crisp, attractive rococo type of paint application that is reminiscent of Hogarth.

Wilson left London in 1750 for an extended period of study on the Continent. He was in Venice for about a year and in or around Rome for four or five years. He decided during this time to devote himself to landscape. He saturated himself with the Roman Campagna, which he saw through eyes conditioned by the study of Claude Lorraine. This experience remained probably the dominant influence throughout his artistic career. His later painting is filled with echoes, conscious or otherwise, of the Campagna.

By 1758 Wilson was back in London, and appears to have enjoyed a considerable reputation during the 1760s. He exhibited regularly from 1760 to 1768 at the Society of Artists, and in 1768 he became one of the founder-members of the new Royal Academy of Arts. However, his drinking appears to have affected his health and his ability as a painter. In 1776 the Royal Academy offered some assistance by appointing Wilson librarian. In 1781, however, he returned to Wales, where he died a few months later.

With Wilson, British landscape painting came of age; it culminated in the great achievements of Turner and Constable a half-century later. Wilson firmly established in England the Claudian tradition of ideal landscape, and he made at least the initial steps in adjusting this classical system of composition to the native English scene. The adjustment is seldom complete, and the English landscape, when seen through Wilson's eyes, frequently has a deliberately Italianate cast; yet on occasion he shows that

Richard Wilson, *Castel Gandolfo*. Lady Lever Art Gallery, Port Sunlight, Cheshire, England.

he is aware of English qualities of light and atmosphere.

The best collection of Wilson's work is probably in the National Museum of Wales, Cardiff.

BIBLIOGRAPHY. W. G. Constable, *Richard Wilson*, London, 1953.

ROBERT R. WARK

WILSON, RONALD YORK. Canadian painter (1907–). Wilson studied briefly at the Ontario College of Art, in his native Toronto, and the Detroit Institute of Art, but is largely self-taught. He was a commercial artist and illustrator from 1924 to 1939, when he turned to painting. In his early genre scenes, derived from his travels throughout the Western hemisphere and parts of Europe and Africa and from his observation of life in Toronto, he practiced an attenuated cubism. In more recent works, such as his murals in the Imperial Oil Building and the O'Keefe Center, both in Toronto, he has turned to abstraction.

WILSON, SOL (Solomon). American painter and lithographer (1894–). Born in Vilnius, Lithuania, he studied in the United States with Bellows and Henri. Wilson paints land- and seascapes and figures in a rugged style.

His recent paintings are richly colored and textured cityscapes and beach and rural scenes.

WILTON, JOSEPH. English sculptor (1722–1803). In addition to busts and monuments, he executed a large number of chimney pieces, that at Peper Harow being perhaps his finest. He was receptive to both the rococo and neoclassic styles. Archbishop Tillotson's monument at Sowerby (1796) is his best work.

WILTON DIPTYCH. International Gothic tempera painting, in the National Gallery, London. *See* PLANTAGENET STYLE.

WIMAR, CHARLES FERDINAND. American painter (b. Sieburg, Germany, 1828; d. St. Louis, 1862). He ventured into the Upper Missouri (1839), where he painted scenes of the wild frontier. After studying at Düsseldorf (1852–56), he returned to the United States and executed more paintings of Indian life and country in a hard, academic manner.

BIBLIOGRAPHY. P. T. Rathbone, *Carl Wimar*, St. Louis, 1946.

WIMPFEN IM THAL: ST. PETER'S, *see* Bad Wimpfen im Thal: St. Peter's.

WINCHESTER CATHEDRAL. Norman church, one of the largest in England, begun about 1080. The works were in charge of Master Hugh Mason. The crypt and transepts remain from this period. The transepts have an arcade, a gallery, a clerestory, and a flat ceiling, with details of simple fundamentality. The crypt has groined vaults and reflects in style the transeptal work. The Norman central tower fell in 1107, necessitating partial rebuilding of the transepts from 1108. By 1120 the tower had been rebuilt and so had the adjoining north and south bays. There is a notable advance between the early and later Norman phases: the transept aisles had groined vaults, but the bays of the eastern aisles were rebuilt with ribbed vaults.

About 1202 an eastern extension was begun, consisting of a three-bay retrochoir with an eastern Lady Chapel, square-ended and flanked by square chapels or apses. The work, intended primarily to receive the Shrine of St. Swithin, was probably finished about 1235. Richard the Mason was in charge. In 1308 the stalls with tabernacled canopies were erected. They are the earliest of their type and were designed by William Lyngwode. The presbytery followed from about 1315 when the old Norman apse was removed. The work was not completed until 1360.

The next phase of work concerns the great Perpendicular rebuilding. From about 1360 onward the west front, with two bays of the north aisle and one bay of the south aisle, was rebuilt and the old Norman west towers removed. In 1394 began the Perpendicular clothing of the nave to designs by the great William de Wynford, who accepted the fact of the existent Norman piers. His vault is one of the high achievements of English Gothic. William of Wykeham's chantry chapel was built during his lifetime and is an integral part of the nave, therefore certainly part of Wynford's design.

About 1475–80 the reredos was put up, and a decade later the Early English Lady Chapel was extended by one bay and vaulted with liernes. The presbytery had remained unfinished during these nave operations and was completed about 1520–32. The Norman aisles were given lierne vaults, the walls were opened up for four-light fenestration, and Bishop Fox's reredos, screens, and chantry chapel were erected—all probably to designs by Thomas Berty. Finally, in 1635–40, Inigo Jones erected the remarkable Roman screen (now dismantled) bearing figures of Charles I and Queen Henrietta Maria by Hubert Le Sueur. He also designed some Gothic revival vaulting.

BIBLIOGRAPHY. J. Harvey, *The English Cathedrals*, 2d ed., London, 1956; G. H. Cook, *The English Cathedral through the Centuries*, London, 1957.

JOHN HARRIS

WINCHESTER SCHOOL. The leading English school of manuscript illumination prior to the Norman Conquest. The Winchester school received its impetus under Bishop Aethelwold (963–984), producing such manuscripts as the Benedictional of St. Aethelwold (975–980; Chatsworth, Eng., Duke of Devonshire Collection). The tradition continued for more than a century with such works as the Grimbald Gospels (ca. 1025) and the Cotton Psalter (ca. 1050; both London, British Museum).

WINCKELMANN, JOHANN JOACHIM. German archaeologist and art historian (1717–68). The founder of scientific classical archaeology, Winckelmann was born at Stendal in Brandenburg. During his youth he made attempts at studying theology at Halle and medicine at Jena, but he soon gave up these pursuits and turned to the study of Greek literature and art. In 1748, after several years as a schoolmaster in Seehausen in Altmark, he became the librarian for Count Heinrich von Bünau at Nöthennitz near Dresden. The collections of classical antiquities in Dresden made a deep impression on him, and he soon determined to go to Rome to increase his knowledge of classical art. In 1755 he became librarian to Cardinal Passionei in Rome.

The preceding year he had published his first important work, *Gedanken über die Nachahmung der griechischen Werke in Malerei und Bildhauerkunst (Thoughts on the Imitation of Greek Works in Painting and Sculpture)*. This work was enthusiastically received and prompted Augustus III, Elector of Saxony, to give him a pension with which he could pursue his studies. After the death of Cardinal Passionei, Winckelmann became librarian for Cardinal Archinto and then for Cardinal Albani, for

Winchester school. Bible illumination with scenes from the life of David. Pierpont Morgan Library, New York.

whose great collection of antiquities he eventually became curator.

During the last ten years of his life Winckelmann undertook intensive studies of the examples of ancient art and architecture in Italy. He published a large number of writings, the most important of which are his pioneer excavation reports on Pompeii and Herculaneum in 1758–62; *Anmerkungen über die Baukunst der Alten (Observations on the Architecture of the Ancients)* in 1762; *Geschichte der Kunst des Altertums (History of Ancient Art),* his masterpiece, published in 1764; and in 1767–68, the *Monumenti Antichi Inediti,* a pioneer collection of accurate engravings accompanied by scientific archaeological commentaries.

Winckelmann was the first scholar to write a history of ancient art based on a thorough firsthand study of extant monuments. His greatest technical achievements were in the field of Greek art, where his thorough knowledge of classical texts combined with his curatorial experience led him to a greater understanding of the iconography of classical art. Although modern archaeologists can point to many failings in Winckelmann's knowledge (he could not readily distinguish between Greek originals and Roman copies, for example), his importance as a pioneer is widely acknowledged.

Winckelmann's aesthetic approach to Greek art generated great enthusiasm in his own time and had a deep influence on contemporary thought. He felt that the basic creative principle of Greek art was a process of idealization—the subordination of particulars copied from nature to a general scheme of ideal beauty that has a perfection beyond the capabilities of nature. This concept is held even today in the criticism of Greek art.

BIBLIOGRAPHY. H. C. Hatfield, *Winckelmann and His German Critics, 1775–1781,* New York, 1943; C. Justi, *Winckelmann und seine Zeitgenossen,* 5th ed., 3 vols., Leipzig, 1956. JEROME J. POLLITT

Wheel window (rose window). Example over the main portal of S. Zeno, Verona.

WINDBEAM. Colonial American term for a roof tie beam. The windbeam was a horizontal collar tying rafters together across the middle or upper part of an attic.

WINDER. Tread, usually trapezoidal, in a winding stair.

WINDOW, ATTIC. Window that opens from the uppermost story or attic. It may or may not be in a gable.

WINDOW, CASEMENT, *see* CASEMENT.

WINDOW, LANCET, *see* LANCET.

WINDOW, LUCOME. Window introduced in gables to light garret rooms in 17th-century New England. The term is perhaps derived from the French *lucarne.*

WINDOW, WHEEL (Rose window). Circular window, usually of considerable size, having mullions arranged like the spokes of a wheel. Also known as a rose window, it was especially favored by Gothic architects for upper stories of the nave and transept.

WINDOW OF APPEARANCE. In ancient Egypt, a monumental window where the Pharaoh appeared on ceremonial occasions.

WINDS. In antiquity, the winds were considered divine beings and were given names: Boreas, north; Notus, south; Eurus, east; and Zephyrus, west. Temples and monuments were erected in their honor, the most famous of which, constructed during the 1st century B.C. in Athens, is the extant Tower of the Winds. In art, the winds are represented by winged heads and shoulders with open mouths and inflated cheeks. *See* TOWER OF THE WINDS, ATHENS.

WINDSCREEN. Small circular wall of stone or wood built in the interior of a building around an entrance or surrounding a projecting staircase. Its purpose was to protect the occupants from direct drafts. Windscreens are most common in Gothic architecture, where they are frequently richly decorated with tracery and sculpture.

WINDSOR CASTLE. One of the most magnificent royal residences in the world, it dominates the cliff to the east of the town of Windsor, England. The castle comprises two courts, called the Upper and Lower Wards, surrounded by various buildings, and a ward between them containing the Round Tower. The original fabric of the castle was built by William the Conqueror in about 1070. It was extended by Henry I (1100–35), by Henry II (1154–89), who built the Round Tower, and especially by Henry III (1216–72). In 1356 Edward III ordered William of Wykeham, Bishop of Winchester, to be surveyor of the works. With the exception of the Round Tower, the castle was considerably altered by him. Edward IV began the famous St. George's Chapel. Later monarchs extended the castle in several ways. In 1824 George IV began a series of restorations, under the supervision of Sir Jeffry Wyatville, which were completed during the reign of Queen Victoria. *See* ST. GEORGE'S CHAPEL, WINDSOR CASTLE.

BIBLIOGRAPHY. O. W. Morshead, *Windsor Castle,* London, 1951.

WINDSOR CHAIR. Simple wooden chair with a back of turned spindles set into a saddle seat (in rare instances upholstered), supported by splayed turned legs in a baluster or bamboo pattern. Since the chair was meant to be painted, the parts were of different suitable woods. It was made in England and America from the second quarter of the 18th century. The name, encountered in the earliest documents, is supposedly derived from the town of Windsor, where George II is said to have admired the prototype in a farmhouse. In the United States, it was mass produced first in Philadelphia and then all over the country. In England, High Wycombe was the center of production.

BIBLIOGRAPHY. F. G. Roe, *Windsor Chairs*, London, 1953.

WING. Panel of a triptych or polyptych altar retable that is hinged to the fixed center panel so that it can be folded over the center panel. Most altar wings are painted on both sides; frequently, the outer side is painted with figures in grisaille.

WING CHAIR. Upholstered armchair with wing-shaped sidepieces projecting forward at either side from the top of the back. Generally, the wooden legs are exposed. Introduced in the 17th century, this type was known all over Europe, but it was particularly important in England and the American colonies before 1800 and in later revivals.

WINGED ALTAR, *see* RETABLE; WING.

WINGHE, JOOS VAN. Flemish portrait and history painter (b. Brussels, 1542/44; d. Frankfurt, 1603). Winghe studied in Rome and Paris; later in Brussels he was court painter to Alexander Farnese, duke of Parma. In 1586 he went to Frankfurt, where he continued painting in a *retardataire* mannerist style akin to that of Bartholomeus Spranger.

BIBLIOGRAPHY. R. H. Wilenski, *Flemish Painters, 1430–1830*, 2 vols., New York, 1960.

Windsor chair. American example in hickory, 1750–70. Metropolitan Museum of Art, New York.

WINK, CHRISTIAN. German painter (b. Eichstatt, 1738; d. Munich, 1797). Wink continued the style of illusionistic rococo fresco decoration exemplified in the work of Johann Baptist Zimmerman, working in village churches throughout southern Bavaria. In many of the celestial ceiling frescoes Wink goes further in breaking down the architectural framework and often uses bucolic scenes with animals on the ground plane. He also painted many altarpieces and created mythological and allegorical designs for tapestries.

WINT, PETER DE, *see* DE WINT, PETER.

WINTER, FRITZ. German painter (1905–). Winter studied at the Bauhaus in Dessau (1927–30) and worked with Kandinsky. He was prevented from painting by the Nazi regime in 1933 and served in the German army during World War II. Taken prisoner by the Russians, he was not released until 1949. He has received awards at the Venice Biennale (1950), the Milan Triennale (1954), and the São Paulo Bienal (1955). His work has always been abstract, complex in regard to the use of brushstroke and line, levels of space, and effects of light, and highly disciplined in the Bauhaus tradition.

BIBLIOGRAPHY. J. Buchner, *Fritz Winter*, Recklinghausen, 1963.

WINTERHALTER, FRANZ XAVER. German painter and lithographer (b. Menzenschward, 1806; d. Frankfurt am Main, 1873). In 1818 he went to Freiburg to study engraving at the Herder Institute. He received a modest scholarship to study in Munich and entered the studio of Peter and Robert von Langer. Winterhalter made ends meet by working for Ferdinand Piloty in the then new technique of lithography. He made crayon copies of famous works, including some by Michelangelo and Overbeck. He also made lithographic reproductions of portraits of members of the German royal family, of the poet Jean Paul Richter, of Paganini, and of popular actors and ballet dancers. In 1828 Winterhalter moved to Karlsruhe where he did portraits in oil of Grand Duke Leopold, Grand Duchess Sophie, Margrave Wilhelm von Baden, and others. Winterhalter was appointed painter to the court.

In 1834 he settled in Paris, but he traveled widely. The following year he went to Italy, where he met sympathetic members of the German school in Italy, such as Leopold Robert, Weller, Kirner, and Riedel. He painted a number of idyllic scenes of Italian peasants, fishermen, mothers with their children, and other sentimental subjects. His genre scenes are not so well known as his impressive list of portraits of European royalty and members of the social world. He painted Louis-Philippe, Queen Amélie and members of the Orléans family, Napoleon III, William I of Prussia and his queen, Emperor Maximilian of Mexico, Grand Duchess Helen of Russia, and Queen Victoria and members of her family.

The full-length portrait of the prince consort, Albert of Saxe-Coburg-Gotha (London, National Portrait Gallery), is in the tradition of Van Dyck. It is a "column and flowing drapery" type of picture. Grand, formal, sharply focused, the image flatters the subject. All materials in the painting are idealized: satins are glossy, the skin is smooth

and unblemished, the furniture and floor are given a high finish. In his *Empress Eugénie and Her Ladies* (1855; Compiègne, National Museum) the figures are posed against a pastoral background in a style reminiscent of Corot. The whole work has the charm of a faded fashion plate.

In his will Winterhalter indicated that he had placed examples of his work in a box not to be opened until fifty years after his death. It contained landscapes, battle scenes, flower pieces, and portraits. Unfortunately for his reputation, it did nothing to change the verdict of his contemporaries that he was a skillful, often charming, portraitist, but lacking in depth and aesthetic worth.

BIBLIOGRAPHY. J. Laver, "Winterhalter," *The Burlington Magazine*, LXX, 1937. ROBERT REIFF

WINTER PALACE, THE, LENINGRAD.
Rococo Russian building (1711–62) designed by Schlüter, Tressini, and Rastrelli. The total complex of this palace was erected in four building periods; the first palace was begun in 1711. Little is known about it, except that in style it was related to Dutch architecture. The design of both this and the second palace, begun in 1716 and connected with Schlüter through his German associate Mattarnovi, was very simple. The third building phase, by Tressini, was an enlargement of the palace so that the original façade became only an end pavilion of a gigantic scheme.

The fourth and final phase was the rebuilding of the palace by Rastrelli (1754–62), assisted by Velten, a German-educated architect. The enormous enlargement and extension of an interminable façade is dominant in this scheme. As a result there are strongly projecting end pavilions and a subdivision of the façade into many bays, which are accented at the centers by engaged columns. The general vocabulary of the Italian baroque is used—a giant order for the two main stories emphasizing the center sections of the bays, and repeated on the basement level—but highly ornamental rococo framing devices are employed around the windows, with statues and urns adorning the balustrade.

The whole building was originally painted turquoise blue with a white trim, characteristic of Russian exuber-

The Winter Palace, Leningrad. An 18th-century rococo building.

ance of color, as the size of the palace is characteristic of Russian monumental scale. In the 19th century the building was painted a uniform dark red, and in 1837, after a three-day fire, the interior was completely rebuilt and renovated in the predominating eclectic tastes of the reigning monarch. Only the so-called "Jordan staircase" remained from the original Rastrelli building.

The handling of this long building has been described as restless and fragmented. The façades are conceived separately and lack relationship to one another. Its importance lies in the reliance on color and the linear motifs of design and ornament, with the piling up of decoration at certain points to emphasize climaxes, and the method of considering the façade in terms of details, which make the Winter Palace building the most rococo of all the 18th-century buildings in Leningrad.

BIBLIOGRAPHY. E. Lo Gatto, *Gli artisti in Russia*, 3 vols., Rome, 1934–43; G. H. Hamilton, *The Art and Architecture of Russia*, Baltimore, 1954. DORA WIEBENSON

WINTERTHUR, DEL.: HENRY FRANCIS DU PONT WINTERTHUR MUSEUM.
American museum 5 miles from Wilmington. The building was begun in 1839 as the home of a Du Pont son-in-law. It was enlarged in 1903 by Henry A. Du Pont. His son Henry Francis Du Pont enlarged it further in 1928–30 to accommodate his collection of American furniture and woodwork from nearly 150 rooms. When the building was opened to the public as a museum in 1951, it contained the largest collection of American decorative arts in existence, together with 450 paintings and engravings. The name Winterthur has since become synonymous with the decorative arts made in or imported to America between 1640 and 1840.

The collection consists of more than 50,000 objects of wood, metal, glass, earthenware, and weaving. Their provenance ranges up and down the entire Eastern seaboard. They vividly illustrate the styles of the 17th century and American folk art, as well as the high-style periods of William and Mary, Queen Anne, Chippendale, Federal, and Empire. To preserve a lived-in atmosphere the objects are exhibited in rooms, alcoves, and hallways as though they had been placed there by their original owners.

The collection of American engravings is one of the most comprehensive anywhere. The paintings, covering the period of the 1770s to the 1820s, include works by Copley (*Self-Portrait, Portrait of Mrs. Copley*), Charles Willson Peale (*Edward Lloyd of Wye with His Wife and Daughter*), Trumbull (*George Washington*), Stuart (*Mrs. Perez Morton*), and West (*American Commissioners of the Preliminary Peace Negotiations with Great Britain*). In the beautiful gardens seasonal displays are held.

BIBLIOGRAPHY. W. A. Cartwright, *Guide to Art Museums in the United States*, vol. 1: *East Coast: Washington to Miami*, New York, 1958; E. Spaeth, *American Art Museums and Galleries*, New York, 1960. JOHN D. MORSE

WINTERTHUR, SWITZERLAND: MUSEUMS.
Important public art collections in Winterthur, Switzerland, are located in the museums listed below.

Art Museum. This museum is devoted primarily to works of the 19th and 20th centuries, although it also owns works of earlier periods, including paintings by Cranach, Metsys, Handmann, and a number of Swiss art-

ists. Swiss painters, particularly from the area of Winterthur, are much in evidence. There are, for instance, twenty-four works by the 18th-century artist Anton Graff. Hodler, with such paintings as *Glimpse of the Infinite* and *Weary of Life*, Vallotton, Amiet, Auberjonois, Klee, David Steiner, and the sculptor Haller are also well represented.

The German school is especially prominent, with many works by Liebermann, Von Marées, Corinth, Hofer, Kirchner, Beckmann, Kokoschka, and the sculptors Hildebrand and Wotruba. Among the noteworthy examples of French art are paintings by Bonnard, Braque, Van Gogh, Marquet, Monet, Pissarro, Redon, Renoir, and Vuillard and sculptures by Brancusi, Daumier, Despiau, Duchamp-Villon, Maillol, Richier, and Rodin.

BIBLIOGRAPHY. Kunstverein Winterthur, *Katalog der Gemälde und Plastiken*, Winterthur, 1958.

Reinhart Foundation (Stiftung Oskar Reinhart). The Swiss industrialist Oskar Reinhart started to accumulate this collection of about 400 paintings and 200 drawings and water colors in the early years of this century. More than half the collection, the works of Swiss, German, and Austrian artists, was installed in a new city museum in 1961. These are 19th- and 20th-century works by such artists as the Swiss Agasse, Anker, Auberjonois, Böcklin, Calame, Haller, Hodler, and Liotard; the Germans Blechen, Friedrich (including his striking *Chalk Cliffs of Rügen*), Hofer, Leibl, Liebermann, Von Marées, Menzel, Runge, Slevogt, Spitzweg, Thoma, and Wasmann; and the Austrians Von Schwind and Waldmüller.

The remainder of the collection, which covers more familiar areas of European art, has been donated to the Swiss Confederation, but remains in Reinhart's private house on the outskirts of Winterthur and is closed to the public. The representation of French 19th-century painting is exceptionally rich, but there are also a number of distinguished works dating from the 15th through the 18th century. These include *Philippe le Beau* by the Master of St. Gilles, Geertgen tot Sint Jans's *Adoration of the Magi*, Grünewald's drawing of a weeping woman, Cranach's portraits of Dr. Johannes Cuspinian and his wife, Pieter Brueghel the Elder's *Adoration of the Magi in the Snow*, El Greco's *Portrait of Cardinal Guevara*, Poussin's *Holy Family in a Landscape*, Rembrandt's *Man by a Furnace*, Hals's *Boy Reading*, and several paintings by Chardin and Goya.

The 19th-century collection is also specialized, with several works each by Delacroix, Corot, Daumier, Courbet, Manet, Cézanne, Renoir, and Van Gogh. There are single works by Ingres, Degas, Monet, Gauguin, and Toulouse-Lautrec and two works each by Géricault, Pissarro, and Sisley. Outstanding individual works are Delacroix's *Death of Ophelia*, *Death of Hassan*, and *Moroccan Military Exercise*, Daumier's *Fugitives*, *Don Quixote and Sancho Panza in a Valley*, and *End of Breakfast*, Courbet's *The Hammock*, Manet's *Folkestone Boat* and *Au Café*, Cézanne's *Self-Portrait* and *Still Life with Jug and Apples*, Renoir's *La Grenouillère*, and Van Gogh's *Courtyard of the Hospital at Arles*.

BIBLIOGRAPHY. Stiftung Oskar Reinhart, *Katalog der Gemälde und Skulpturen*, Winterthur, 1951; *Die Privatsammlung Oskar Reinhart. Ausstellung im Kunstmuseum Winterthur*, Winterthur, 1955; D. Cooper, ed., *Great Private Collections*, New York, 1963.

DONALD GODDARD

WIRKKALA, TAPIO. Finnish designer, sculptor, and craftsman (1915–). Born in Hanko, he completed his education at the Industrial Art Institute in Helsinki in 1935. Wirkkala is especially associated with original dishes and bowls made of laminated veneers. In crystal, his work is curiously brutal yet somehow sensitive, as his heavy chanterelle, or drinking type, vases show.

WISE AND FOOLISH VIRGINS, THE. Parable (Matt. 25:1–13) represented in art by two groups of young women, one group holding burning oil lamps, the other, lamps that have been allowed to go out. The theme reached its highest expression in the portal sculpture of German cathedrals (Magdeburg, ca. 1240; Strasbourg, ca. 1300), where the foolish Virgins, especially, are often beautifully expressive.

WISMAR: PRINCE'S CASTLE. German Renaissance building (1553–54). The Fürstenhof is a brick structure ornamented with stucco. In the center of its tripartite façade is a portal with all three sections articulated by closely spaced windows in the upper two stories. A restoration of 1879–81 altered the appearance of the original building, leveling the façade under a single crowning cornice. It is now the seat of the Mecklenburg District Court.

BIBLIOGRAPHY. F. Sarre, *Der Fürstenhof zu Wismar und die norddeutsche terrakotta-Architektur im Zeitalter der Renaissance*, Berlin, 1890.

WISSING, WILLIAM. Dutch-English painter (b. Amsterdam, 1655; d. Burghley, England, 1687). He received his early training at The Hague and went to England in 1676, entering the studio of Lely. Probably after Lely's death he went to France, where he acquired his taste for metallic flowers and huge weeds, and his love of accessories. In the portrait *Elizabeth Brownlow* (ca. 1685), the infant is nearly submerged by various exotic flowers. *Lord Burleigh* (ca. 1687; Burghley House) is more tastefully done: the proud mien of the young nobleman does not betray an obvious flattery on the part of the painter. All of Wissing's known work was crowded into a four-year span. His death left Kneller the chief portraitist in England.

BIBLIOGRAPHY. E. K. Waterhouse, *Painting in Britain, 1530–1790*, 2d ed., Baltimore, 1962.

WIT, JACOB DE. Dutch painter of history and decorations, graphic artist, and draftsman (b. Amsterdam, 1695; d. there, 1754). He received his first training in Amsterdam from Albert van Spiers, who had been a pupil of Gerard de Lairesse. About 1708 De Wit went to Antwerp, where he studied with Jacob van Hal. While there De Wit made numerous copies after Rubens and Anthony van Dyck, which were decisive in the formation of his style. In 1714 De Wit entered the Antwerp painters' guild, but two years later he was recorded back in his native Amsterdam. In 1747 he published a book on human proportion (*Teekenboek der Proportien van het menschelijk ligchnaam*).

In his own day De Wit was famous for his numerous altarpieces, which combined elements borrowed from Rubens and Van Dyck; they were commissioned mainly by the newly emancipated Dutch Catholics. However, his

Emanuel de Witte, *Vertumnus and Pomona*, 1644. Boymans-Van Beuningen Museum, Rotterdam.

finest work is as a decorative painter. His beautiful ceiling painting *Bacchus and Ceres in the Clouds* (1751; Heemstede, Huis Boschbeek) is indebted to Rubens's lost cycle for the ceiling of the Church of St. Charles Borromeus in Antwerp (destroyed 1718), which introduced into the Lowlands the Italian tradition of figures painted as if seen from below (*di sotto in su*). Rather than using the full-bodied color schemes of either Rubens or the Italian baroque, however, De Wit introduced a higher-keyed, almost rococo, palette in his ceiling painting.

BIBLIOGRAPHY. A. Staring, *Jacob de Wit, 1695–1754*, Amsterdam, 1958; J. Rosenberg, S. Slive, and E. H. ter Kuile, *Dutch Art and Architecture, 1600–1800*, Baltimore, 1966. LEONARD J. SLATKES

WITDOECK (Witdouc), JAN. Dutch engraver and publisher (b. ca. 1615; d. Antwerp, 1642). About 1630 he studied with Lucas Vorsterman. After 1635 Witdoeck was in the Antwerp shop of Rubens, where he made copies of Rubens's paintings. After Rubens's death in 1640 Witdoeck seems to have turned exclusively to publishing.

BIBLIOGRAPHY. A. Rosenberg, *Die Rubensstecher*, Vienna, 1893.

WITHOOS, MATHEUS. Dutch painter of portraits, landscape, and still life (b. Amersfoort, 1627; d. Hoorn, 1703). He was the pupil of Jacob van Campen. Withoos traveled to Rome about 1648 with Otto Marcellis van Schrieck, Hendrik Grauw, and several other young painters. Withoos was reported back in Amersfoort in 1650 and went to Hoorn in 1672. His specialty was detailed views of plant, animal, and insect life.

BIBLIOGRAPHY. T. von Frimmel, "Eine italisierende Landschaft von Mathias Withoos," *Blätter für Gemäldekunde*, V, 1910.

WITTE, ELIAS DE (Elia Candid). Flemish bronze molder-caster (fl. ca. 1550–75). Originally from Florence, he settled with his son, Pieter de Witte, in the Netherlands. No authenticated works by Elias exist, but the statue of *Perseus* that was in the Hainauer Collection, Berlin, prior to World War I was attributed to him by Wilhelm von Bode.

WITTE, EMANUEL DE. Dutch painter of genre, history, portraits, and architectural interiors (b. Alkmaar, 1617?

d. Amsterdam, 1691/92). He received his first training in Delft from the still-life painter Evert van Aelst. In 1636 De Witte was living in Alkmaar, where he was a member of the painters' guild. He was living in Rotterdam in July, 1639, and at that time was said to be twenty-three. In 1641 he was active in Delft, and he joined the guild there the following year. He seems to have remained in Delft until early in 1652, when he was reported living in Amsterdam.

Although De Witte is best known as a painter of architectural interiors, he began as a figure painter. His earliest dated work is a *Danaë* (London, F. H. Rothmann Collection) of 1641. *Vertumnus and Pomona* (Rotterdam, Boymans-Van Beuningen Museum), dated 1644, indicates that he had some contact with the Utrecht school, but the nature of this contact has not been defined. He also painted several small portraits during the 1640s (1646/47? Boymans-Van Beuningen Museum).

After 1650 De Witte began to produce the various church interiors that make up the greater part of his production. Not all of his works in this genre are representations of actual buildings, as was the case with Saenredam's paintings; for example, his *Interior of a Church* (1668; Boymans-Van Beuningen Museum) is a composite of elements from the Old Church in Amsterdam and St. Bavo's Church in Haarlem. However, De Witte did paint recognizable interiors of individual buildings (*View in the New Church at Amsterdam*, 1656? Boymans-Van Beuningen Museum). Possibly his architectural interiors developed partly under the influence of such architectural artists as Gerard Houckgeest and Hendrick van Vliet, who began painting similar scenes during the early 1650s.

After 1660 De Witte painted several market scenes with portraits, such as *Adriana van Heusden and Her Daughter at the New Fishmarket in Amsterdam (?)* (ca. 1661–63; London, National Gallery). After 1660 De Witte was forced, several times, to indenture himself in return for his keep, and this may explain the uneven quality of his later works. There are no dated pictures by him after 1688.

BIBLIOGRAPHY. E. P. Richardson, "De Witte and the Imaginative Nature of Dutch Art," *Art Quarterly*, I, 1938; N. Maclaren, *National Gallery Catalogues: The Dutch School*, London, 1960; I. Manke, *Emanuel de Witte, 1617–1692*, Amsterdam, 1963; J. Rosenberg, S. Slive, and E. H. ter Kuile, *Dutch Art and Architecture, 1600–1800*, Baltimore, 1966. LEONARD J. SLATKES

WITTE, GASPARD DE. Flemish painter of religious subjects and landscapes (b. Antwerp, 1624; d. there, 1681). He traveled to Italy and France, returned to Antwerp in 1651, and became a master the same year. Cornelis Huysmans was one of his pupils. De Witte was a prominent exponent of classicist landscape, in the manner of Gaspard Dughet, and his paintings feature antique ruins that furnish the framework and backdrop for ably constructed compositions. Figures in his paintings are often from the brush of Antoon Goubau, who also painted a portrait of de Witte. A representative work is *Fortune Teller* (1667; Antwerp, Royal Museum).

BIBLIOGRAPHY. F. J. van den Branden, *Geschiedenis der Antwerpsche Schilderschool*, Antwerp, 1883.

WITTE, PIETER DE (Candid; Pietro Candido). Flemish painter, sculptor, and architect (b. Bruges, 1544/1548; d.

Munich, 1628). He received his artistic training in Flanders. He then joined his father, Elias de Witte, a metalworker, in Florence, where he entered the service of the Grand Duke of Tuscany. De Witte left with Vasari in 1579, and worked at the Sala Regia in Rome. About 1585 he was called to Munich, where he served first under William V and then, after 1598, as court painter to Maximilian I. De Witte was a seasoned exponent of mannerism. He contributed, among other works, sculptural decorations to numerous churches and to the Residence in Munich, distinguishing himself in the field of allegorical and mythological compositions. The Old Pinacothek in Munich preserves his *Portrait of Duchess Magdalena*.

BIBLIOGRAPHY. C. Leurs, ed., *Geschiedenis van de Vlaamsche Kunst*, vol. 2, Antwerp, 1939.

WITTELSBACH FOUNTAIN, MUNICH, *see* HILDEBRAND, ADOLF E. R. VON.

WITTEN, HANS, *see* MASTER H. W. (HANS WITTEN).

WITTINGAU FRIARY, *see* TREBON FRIARY.

WITZ, KONRAD. German painter (b. Rottweil, ca. 1400; d. Basel or Geneva, ca. 1445). His early life and training are obscure, as is the case with most artists of this period, when the artistic personality was just beginning to emancipate itself from the collectivism of the medieval tradition. In 1434 Meister Konrat van Rotwil, as he was called in the documents, was accepted into the Himmelzunft in Basel. It is reasoned that he was attracted to Basel by the great council that was held there in 1431. In 1435 Witz was made a citizen of Basel, and in 1443 he purchased a house there. A year later he completed the *St. Peter Altarpiece* (commissioned by François de Mies, bishop of Geneva). It bears the inscription HOC OPUS PINXIT MAGISTER CONRADUS SAPIENTIS DE BASILEA MCCCCXLIIII [1444] on the old frame.

His art shows great familiarity with the Master of Flémalle and Jan van Eyck. Witz's *oeuvre*, however, like his life, is still not completely understood. The confusion surrounding his sources and his actual workshop has resulted in disputed attributions. The undisputed works are the panels from the *Heilsspiegelaltar* (ca. 1435; nine in Basel, Public Art Collections; two in Dijon, Museum of Fine Arts; one in Berlin, former State Museums, Picture Gallery); three panels from another altar, *Meeting at the Golden Gate* (Basel, Art Museum), *Annunciation* (Nürnberg, Germanic National Museum), *SS. Catherine and Magdalen in the Church* (Strasbourg, Notre-Dame Museum); and two panels of the *St. Peter Altarpiece*, painted on both sides, showing on the outside the *Miraculous Draught of Fishes* and the *Liberation of St. Peter from*

Pieter de Witte, *Portrait of Duchess Magdalena.* **Old Pinacothek, Munich.**

Konrad Witz (attrib.), *Sacra Conversazione.* **Capodimonte, Naples.**

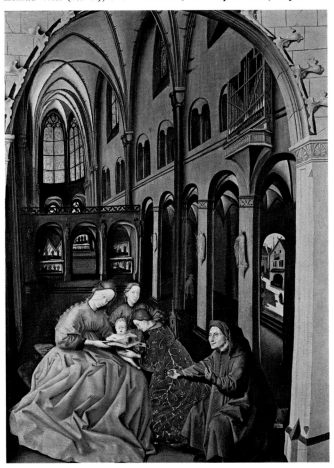

Prison and on the inside the *Adoration of the Magi* and the *Presentation of the Donor to the Madonna* (both Geneva, Museum of Art and History).

Witz was the first German master to represent in his painting a fully developed three-dimensional space and landscape that is topographically recognizable. The landscape in the *Miraculous Draught of Fishes* panel is the most remarkable landscape of 15th-century painting; it is a careful, realistic rendering of Lake Geneva. Other advanced features in Witz's art are the realistic optical effects of objects viewed under water. These abound in the *Miraculous Draught of Fishes* panel and in the exceptional three-dimensional interior space in the Nürnberg *Annunciation* and *SS. Catherine and Magdalen*. This spatial realism together with the sculptural plasticity of Witz's figures is remarkably similar to the style of the Master of Flémalle. Witz, however, goes considerably further in his plastic rendering of form. His figures achieve monumentality and power through an almost cubistic emphasis on basic geometric shapes.

BIBLIOGRAPHY. W. Uberwasser, *Konrad Witz*, Basel, 1938; J. Gantner, *Konrad Witz*, Vienna, 1943.

DONALD L. EHRESMANN

WOENSAM, ANTON. German woodcutter and painter (b. Worms? before 1500; d. Cologne, 1541). He worked mainly in Cologne. About 550 woodcut book illustrations are attributed to him. They are stylistically dependent on Dürer, Holbein, and Antwerp mannerism. Woensam's paintings, less important, are more individual.

WOESTIJNE, GUSTAVE VAN DE. Belgian painter and graphic artist (b. Ghent, 1881; d. Brussels, 1947). He studied at the Ghent Academy and was a member of the anti-impressionist, symbolist first school of Laethem-Saint-Martin, where he went in 1899. He began generally in the tradition of Flemish realism, as in the grimacing *Blind Man* (1910; Antwerp, Fine Arts Museum), but the realism was often generously mixed with personal symbolism, as in *The Two Springtimes* (1910; Antwerp, Fine Arts Museum). His later paintings, mostly mystical religious scenes, combine very hard detail, for example, *Christ Offering His Blood* (1925; Brussels, Fine Arts Museum), with increasing formal stylization, as in the strongly silhouetted *The Judas Kiss* (1937; Brussels, Fine Arts Museum).

BIBLIOGRAPHY. K. van de Woestijne, *Gustave van de Woestijne*, Brussels, 1931; F. van Hecke, *Gustave van de Woestijne*, Antwerp, 1949.

WOLF, EBERT (Eckbert), THE YOUNGER. German sculptor (d. 1608/09). Probably trained by Albert von Soest, Wolf was active in Hildesheim with his father from 1603. Between 1605 and 1608 he worked with his father and his brothers Hans and Jonas at the castle of Graf Ernst of Schaumburg-Lippe in Bückeburg. There he created works of great elegance and mannerist inventiveness, particularly the mythological figures in the Golden Room and the altar, upheld by two kneeling angels, in the chapel.

WOLFENBUTTEL: MARIENKIRCHE. German church. It is the most important architectural monument built between the Reformation and the Peace of Westphalia in northern Germany. The Marienkirche was begun in 1604 by Paul Franke and completed in 1623 by Johann Meyer

Gustav van de Woestijne, *The Judas Kiss*, 1937. Fine Arts Museum, Brussels.

and Johann Langenlüddeke. Stylistically it is a curiously effective mixture of late Gothic and Renaissance forms.

WOLFFLIN, HEINRICH. Swiss art historian (b. Winterthur, 1864; d. Zurich, 1945). He was a student of Jakob Burckhardt and a professor at Basel, Berlin, Munich, and Zurich. Wölfflin was one of the most influential scholars in the development of art history. In his major work, *Kunstgeschichtliche Grundbegriffe* (1915; English ed., 1932), he sought to establish more precise rules for the analysis of period changes in the development of style. With a remarkably acute eye and an ability to verbalize his impressions with great precision, Wölfflin practically established the descriptive terminology used by art history today. His other works include *Renaissance und Barock* (1888; 5th ed., 1961), *Die klassische Kunst* (1899; English ed., 1952), *Italien und das deutsche Formgefühl* (1931; English ed., 1958), and *Die Kunst Albrecht Dürers* (1905).

WOLFGANG, JOHANN GEORG. German engraver (b. Augsburg, 1662; d. Berlin, 1744). In 1704 he was made court engraver at Berlin in order to engrave the coronation ceremonies of Frederick I and Sophia Charlotte. Wolfgang developed an active profession there, engraving mostly from German painters.

BIBLIOGRAPHY. A. Rümann, *Das deutsche illustrierte Buch des 18. Jahrhunderts*, Strasbourg, 1931.

WOLFGANG ALTAR (Coronation of Mary). Wooden sculpture and painting by Pacher, in the Church of Sankt Wolfgang, Austria. *See* PACHER, MICHAEL.

WOLGEMUT, MICHAEL. German painter and designer of woodcuts (b. Nürnberg, 1434; d. there, 1519). Informa-

Wolfgang Altar. Side panel depicting the Wedding at Cana. Church of Sankt Wolfgang am Ambersee, Austria.

St. Catherine Altar in St. Lorenzkirche, Nürnberg, and the high altar of the Jakobkirche, Straubing, are disputed attributions.

The large series of woodcut illustrations that were produced by Wolgemut and his workshop were some of the greatest of their kind in the 15th century and formed the basis for the climax of the art of the woodcut, Dürer's *Apocalypse* and *Passion* series. Wolgemut's two most important woodcut series are those of the *Schatzbehalter* (1491) and the famous *Schedel'sche Weltchronik* (1493), both published in Nürnberg. The latter contains 645 separate cuts, which, when repeated, bring the number of illustrations to 1809. The aesthetically most successful cuts from the *Weltchronik* are the title page and the various views of towns.

BIBLIOGRAPHY. M. Weinberger, *Nürnberger Malerei an der Wende zur Renaissance*, Strasbourg, 1921; A. Stange, *Deutsche Malerei der Gotik*, vol. 9, Munich, 1958.　　　DONALD L. EHRESMANN

WOLLASTON, JOHN. Anglo-American painter (fl. 1736–67; d. Bath, England, 1770). An enigmatic portrait painter with little known about the beginning and end of his career, Wollaston went to America in 1749 and became a prolific and influential painter along the eastern coast. Recurring characteristics in his portraits have only recently led to his works in various cities being united under his name. These mannerisms—almond eyes, stereotyped

Michael Wolgemut (attrib.), panel of the high altar of the Jakobkirche, Straubing, Germany.

tion about his early training is uncertain, but it appears that he was taught in his father's workshop. About 1450 he went on his *Wanderjahre*, possibly to the Netherlands. In 1471 he was recorded in Nürnberg as in the service of a painter Gabriel, of whom nothing is known. In 1472 Wolgemut married the widow of the famous painter Hans Pleydenwurff and took over his shop. It is believed that Wolgemut worked with Hans Pleydenwurff in the late 1460s and early 1470s. In 1473 Wolgemut first appears in the Nürnberg tax books. Late in 1476 he received a commission for the six-winged altar of the Marienkirche in Zwickau; he finished this work in 1479. In 1486 Albrecht Dürer, then fifteen years old, entered Wolgemut's studio as an apprentice. Wolgemut's major woodcut work, the *Schedel'sche Weltchronik*, was finished in 1493 in collaboration with Wilhelm Pleydenwurff. Dürer valued his teacher highly and in 1516 painted Wolgemut's portrait (Munich, Old Pinacothek).

Recent scholarship has emancipated Wolgemut's artistic personality from a confusion of false attributions that had made him appear as merely an imitator of Hans Pleydenwurff. Wolgemut was one of the first artists to explore seriously the woodcut medium, elevating it from simple illustration to the level of artistic creation. He was strongly influenced by Netherlandish painters, particularly the Master of Flémalle and Hans Memling. Wolgemut was one of the last important German painters to continue the Netherlandish tradition.

His major painted works are the high altar of the Marienkirche in Zwickau, of the Heiligenkirche in Nürnberg (ca. 1486), and of the Stadtkirche of Schwabach (1506–08), which is his most extensive piece and contains some shop work. A large number of works, such as the

cap and gown, and a consistently similar pose for the hands of subjects—can be seen in the portrait *Cornelia Beekman* (ca. 1750–55; New-York Historical Society). In 1758 Wollaston went to India. He was back in America in 1767 but shortly thereafter returned to England.

BIBLIOGRAPHY. J. H. Morgan, "Notes on John Wollaston and His Portrait of Sir Charles Hardy," *Brooklyn Museum Quarterly*, X, Jan., 1923.

WOLS (Wolfgang Schulze). German painter (b. Berlin, 1913; d. Paris, 1951). He studied briefly at the Bauhaus. In 1932 he moved to Paris, where he was associated with the surrealists. He began to paint seriously after World War II and had his first one-man show at the Galerie Drouin in Paris. Influenced by Klee, Kandinsky, and Fautrier, Wols's free improvisations of line and color exemplify what has become known as *art informel* or *art autre*.

BIBLIOGRAPHY. G. Dorflès, *Wols*, Milan, 1958; A Schulze (Wols), *Watercolors, Drawings, Writings*, ed. with introd. by W. Haftmann, New York, 1965.

WOMAN OF ARLES, *see* ARLESIENNE, L'.

WOMAN WITH THE PEARL. Oil painting by Corot, in the Louvre Museum, Paris. *See* COROT, JEAN-BAPTISTE-CAMILLE.

WOOD, CHRISTOPHER. English painter (b. Knowsley, Lancashire, 1901; d. Salisbury, 1930). He studied at the Académie Julian in Paris and traveled widely on the Continent and around the Mediterranean. He was a friend of Cocteau and Nicholson and of Picasso, through whose influence Wood was commissioned (1926) by Diaghilev to design costumes and settings for a *Romeo and Juliet* ballet, which never materialized. Wood first exhibited in London in 1927.

Wood's "primitivism," like that of Henri Rousseau, is merely on the surface, more the product of a personal method of vision than of a lack of technical skill. His fine sense of color enabled him to paint playfully, at times inserting a spot of seemingly discordant color that yet keeps its place, adds excitement, and works with the total design. At first Wood borrowed from Modigliani, Matisse, Seurat, and Picasso, but borrowings became fewer as his work progressed. His subjects include mostly still lifes, landscapes, beach scenes, and a few portraits, such as *Max Jacob* (1929; Paris, Louvre). In his best works, harbor scenes and fishing villages in Cornwall and Brittany, he used color schemes of white, brown, gray, and green with his characteristic grayish crosshatching for areas of sky and foam. Within the limits of his style, Wood was remarkably successful at depicting conditions of weather and light.

In his last years, his palette became darker and more intense. His late works show new interests in imaginative subject matter and formal composition, for example, *Tiger and Arc de Triomphe* (1930; Washington, D.C., Phillips Collection) and *The Red Funnel, Mousehole, Cornwall* (1930; Collection of H. M. the Queen). Although outside the main traditions of modern art, Wood was a significant lyrical painter of man and nature.

BIBLIOGRAPHY. T. McGreevy, "Christopher Wood: An Appreciation," *London Studio*, XV, March, 1938; E. Newton, *Christopher Wood*, London, 1938; "Christopher Wood," *Apollo*, LXIX, March, 1959.
JEROME VIOLA

Christopher Wood, *Tiger and Arc de Triomphe*, 1930. Phillips Collection, Washington, D.C.

WOOD, GRANT. American painter (b. Anamosa, Iowa, 1892; d. Iowa City, 1942). He studied in Chicago and Paris. Associated with the American Scene artists, Wood painted detailed, sometimes satirical, rural subjects of strong design. His best-known painting is *American Gothic* (1930; Chicago, Art Institute).

WOOD, JOHN, THE ELDER AND THE YOUNGER. English architects: John the Elder (1704–54) and John the Younger (1728–81), his son and partner. Beginning as an architect of country houses such as Prior Park (1731–34), the elder Wood became England's first great town planner. Creator of Georgian Bath, he was the first architect after Inigo Jones to project a uniform Palladian theme on an entire city street or square.

He was succeeded as chief architect of Bath by his son, who finished the Circus (begun 1754) and added the Royal Crescent (1767–75), an entirely new form, which became one of the most important and popular themes of English town planning. The younger John Wood was also responsible for the New Assembly Rooms at Bath (1769–71).

WOOD, THOMAS WATERMAN. American painter (b. Montpelier, Vt., 1823; d. New York, 1903). He studied with Harding in Boston. Wood opened studios in Quebec, Washington, D.C., New York, Baltimore, and Paris. A onetime president of the National Academy (1891), he painted portraits that were photographically realistic, and his genre anecdotes show a natural observation and strong sentiment.

BIBLIOGRAPHY. V. Barker, *American Painting*, New York, 1950.

WOODCUT. Relief print process in which the design remains raised above the cut-away spaces. Woodcut prints are characterized by strong, bold contrasts of black and white. Although they require only the simplest tools and materials, they have provided a rich heritage of prints in the Western world since the 15th century. In modern Mexico, the woodcut represents a significant aspect of folk art, since it is the traditional medium of the *corrido*, a popular topical satire form.

A brush and India ink are used to draw the composition on a block of wood. The quality of the black line derives from the working process itself. A knife is used to cut V-shaped grooves that will appear as white areas, leaving sharp-edged black lines. In no other medium is it possible to define and control both edges of a line in this manner.

In Japan, the multicolor woodcut has had wide popularity since the flowering of the Ukiyo-e school in the 17th century. According to the Japanese method, a sketch on rice paper is pasted face down on a key block, so that the sketch appears clearly through the paper. Grooves are cut in the block at the bottom of the paper in such a way that in printing each color the paper can be precisely placed and the colors will be in register. The key block is the guide for the individual color blocks.

In the printing process, water color plus a tiny amount of rice paste is brushed on the block, and a lightly damped sheet of rice paper is placed in the registration marks. A baren is rubbed across the back of the sheet to print the color. This process is repeated for each color in the print.

BIBLIOGRAPHY. H. A. Mueller, *How I Make Woodcuts and Wood Engravings*, New York, 1945; J. Heller, *Printmaking Today*, New York, 1958.

JULES HELLER

WOOD ENGRAVING. Relief print process, known also as xylography. It involves cutting into a block of hard end-grain wood so that black areas are left standing in relief. Within the area in relief, the effect of the print may derive from white lines cut out of the black area or from the black lines in relief. Today, wood engravings are quite large and sometimes composed of multiple blocks. They may combine both white line and black line approaches.

Most wood engravers run a wash of India ink over the working surface of the block to allow their lines to show up clearly and precisely. The composition may be traced or engraved directly. The engraver defines his composition, stroke by stroke, with a sharpened burin, sometimes using an engraver's pad that permits the block to turn freely. A flexible shaft, an electric power tool, may be employed in certain portions of the work. After inking, the engraving can be printed mechanically on a Washington press.

BIBLIOGRAPHY. H. A. Mueller, *How I Make Woodcuts and Wood Engravings*, New York, 1945.

WOODVILLE, RICHARD CATON. American genre painter (b. Baltimore, 1825; d. London, 1855). He studied Dutch and Flemish figure painting in the private collection of Robert Gilmor and took painting lessons in Düsseldorf. In his painting both at home and abroad Woodville detailed in an academic and humorous manner genre themes of Baltimore life.

BIBLIOGRAPHY. E. H. Payne, "America at Leisure in the 1840s," *Detroit Institute of Arts Bulletin*, XXXV, 1955–56.

WOODWARD, BENJAMIN, *see* DEANE AND WOODWARD.

WOOLETT, WILLIAM. English engraver (b. Maidstone, 1735; d. London, 1785). He made landscapes after English imitators of Lorraine (Richard Wilson, especially) and battle scenes, especially after Benjamin West. Woolett developed a technique in which only the final biting was done with the gravure; the first two or three bitings were etched, as in *Death of Wolfe*, after West.

BIBLIOGRAPHY. A. M. Hind, *A Short History of Engraving and Etching*, 2d rev. ed., London, 1911.

WOOLWORTH BUILDING, NEW YORK. Designed by Cass Gilbert and erected in 1913, this 52-story building has been termed the "Cathedral of Commerce" because of its Gothic-style exterior. It was celebrated as the greatest and tallest building of its day, with its central tower rising 792 feet over a U-shaped plan. The flanking wings appear as setbacks when viewed from the front and curiously anticipate setback skyscrapers of the following decade. Among tall buildings with Gothic-style exterior sheathing, the Woolworth Tower can trace its descent to Daniel Burnham's Fisher Building in Chicago (1897) and to Gilbert's own West Street Building in New York (1905). The Tower, however, possesses a greater elaboration of detail than either.

Such vertically styled structures offered an alternative

Wood engraving. Detail of a 17th-century map of Venice executed in the process also known as xylography.

mode of design for those architects who desired neither to reveal the underlying structure too clearly nor to enclose the building in a motionless envelope. In the Woolworth Tower's design, applied ornament and structural form were united so that one can observe the lines of strength and distribution of loads, extending from apex to foundations, expressed in the form of Gothic-styled piers. The building exhibits, as well, a continuous growth from base to summit and bursts into ornament at the top of each block and at the tower. As Gilbert had desired, the locations of the supporting elements were clearly stated within a decorative formula; they were not hidden by a clifflike masonry cloak.

These features were recognized at the time, and the architect was praised for handling the recessions in a way that precluded the building's appearing as a lumpy mass. In that period, the Woolworth Tower seemed to settle the question of a proper skyscraper because of its popularity and appearance. The skeleton frame was sheathed in terra cotta, thus accounting for the crispness and sharpness of outline observable in the decoration hundreds of feet above ground level. Although ornament at the eaves' lines is extraordinarily rich, such decoration is superfluous since it cannot be truly appreciated by the sidewalk stroller.

The Woolworth Building also raises the question of the viability of applying as decoration the structural and ornamental vocabulary of the Gothic cathedral to a modern office building; the latter is erected according to a different structural system and used for different purposes. At certain levels of the Tower, the ornament interferes with the lighting of those offices immediately behind. The problem of inventing a style suitable to the tall building was one that Gilbert never properly faced; even his New York Life Insurance Building (1928), though designed with determined setbacks, still has numerous Gothic flourishes and embellishments.

BIBLIOGRAPHY. M. Schuyler, "The Towers of Manhattan, and Notes on the Woolworth Building," *Architectural Record*, XXXIII, Feb., 1913.

MATTHEW E. BAIGELL

WORCESTER CATHEDRAL. English church. The Norman cathedral, replacing a Saxon one, was rebuilt between 1084 and 1092. Except for walling around the north and south transepts and parts of the cloisters, only the crypt remains from this early building. It is remarkable among the few remaining Norman crypts, with four aisles and a staggering array of pillars, at one time more than seventy. There was a fire in 1113, after which the unique circular chapter house with central support and groined vaulting was built, about 1120; but its exterior is about 1400.

The nave had been completed by the Normans in seven bays. About 1170 two further western ones were added which are significant for an understanding of the transition to the Early English style. The bay is of unified design, and the details and composition of a fresh quality. From 1224 the entire east parts were rebuilt with aisles, eastern transepts, and a square, indented east 'end. Master Alexander Mason was the architect for this work.

In the Decorated period the five east bays on the north of the nave were rebuilt by William of Shockerwick (1317–24), and the work was completed in the early Perpendic-

Worms Cathedral. Polygonal west choir with crossing and bell towers.

ular style by the 1390s. By this time the nave vaults had gone up, the northwest porch had been built, and a new central tower had been erected to replace one that had fallen in 1176. For this work, and for the cloisters begun in 1372, Master John Clyve was responsible. The tower is regarded as perhaps the finest product of the English Gothic, of unimpeachable form and proportions. The west parts of the cloisters were rebuilt in 1435–38 by John Chapman. The latest addition was the sumptuous chantry chapel of Prince Arthur, begun in 1502. It has been allied to work by the Westminster masons.

BIBLIOGRAPHY. J. Harvey, *The English Cathedrals*, 2d ed., London, 1956; G. H. Cook, *The English Cathedral through the Centuries*, London, 1957.

JOHN HARRIS

WORKSHOP FOR POPULAR GRAPHIC ART, *see* TALLER DE GRAFICA POPULAR.

WORMS. One of the most ancient cities in Germany, Worms became a bishopric in the 5th century. The Frankish kings and Charlemagne frequently resided there. During the Middle Ages Worms, espousing the cause of the emperors, was often awarded commercial privileges, which greatly aided its prosperity. In the Thirty Years' War both Swedes and Spaniards ravaged the city, and in the 17th century the French burned most of the town, severely damaging the Cathedral and destroying its cloister forecourt. World War II very nearly completed the ruin of previous centuries. Fortunately, this time the Cathedral was spared, though the handsome Romanesque Church of St. Paul was severely damaged.

The Synagogue, which was destroyed by the Nazis in 1938, had an especially noteworthy interior. The part occupied by the men was Romanesque, dating from about 1200, while that used by the women, though rebuilt in the 17th century, was essentially Gothic of the 13th century. There were some fine ancient embroideries and curious bronze candelabra, and in the adjacent Raschi Chapel were prayer books dating from Romanesque times. The Jewish cemetery (Israelitischer Friedhof), containing interesting tombstones, is the oldest of its kind in Germany.

The 15th-century Liebfrauenkirche is a noble cruciform-plan Gothic basilica. A 19th-century monument in the Bishopshof marks the site where, in 1521, Luther defended his doctrines before Emperor Charles V at the meeting of the Imperial Diet. The dominating monument of Worms is the Romanesque Cathedral of SS. Peter and Paul. Reflecting some of the monumentality of Speyer, but lacking the grandeur of Mainz, it is nevertheless one of the most significant Romanesque structures in Germany. See WORMS CATHEDRAL.

BIBLIOGRAPHY. H. La Farge, *Lost Treasures of Europe*, New York, 1946; J. Baum, *German Cathedrals*, London, 1956.

ALDEN F. MEGREW

WORMS CATHEDRAL. German church. In Merovingian times, by the year 600, a Cathedral of SS. Peter and Paul already stood on the site of the former Roman Forum and had nearly the same dimensions as the present Cathedral. Shortly after the year 1000 Bishop Burchard I built a new Cathedral, of which the socles of the east choir and east staircase towers remain. This church, which had Ottonian characteristics, was dedicated in 1018. The monument was essentially a flat-roofed basilica, and vaulting was not begun until 1171 under Bishop Conrad II. The work moved quickly, and the east choir and transept were dedicated ten years later. After several decades the conical superstructure of the east staircase towers was added. Shortly afterward the nave and aisles were groin-vaulted. The shafts of the piers and the arcades around the clerestory windows were inspired by Speyer and Mainz.

The plan was to construct a west façade, but instead a polygonal west choir was substituted, incorporating the substructure of a crossing tower built between the west bell towers. Work on this phase was completed about 1235. The magnificent flat east façade was largely concealed by medieval houses until they were destroyed in World War II. Projecting over the sills of the three large windows of this façade, as well as from the sill of the arcade above, is a series of fantastic beasts and almost equally strange human beings. These reflect the ancient German love of legendary creatures, yet they also symbolize the victory of divine over satanic powers. Though St. Bernard of Clairvaux preached much against such figures, he had little success in abolishing them. The whole of the east front, with its handsomely proportioned round towers and its squat octagonal tower over the crossing, is typical of the spirit of 12th-century German Romanesque art.

In the interior the east choir reflects great restraint. The west choir, dedicated to St. Lawrence, with its richer ornamentation and curious round segmented window (which may have been copied by the Lombard masons from some church in Lombardy), is not so tasteful but does not lack originality.

The south portal, which clearly shows the influence of the French High Gothic, was built toward the end of the 13th century, and is decorated with a fine statue of the Church seated upon a Tetramorph. There is also an impressive scene of the Entombment (ca. 1490) by Hans Seyfer of Heilbronn.

Though the church was severely damaged and the cloistered forecourt destroyed in the 17th century, it was well restored. The high altar was carved by Johann Wolfgang von der Anwera from designs by Balthasar Neumann in the 18th century.

BIBLIOGRAPHY. J. Baum, *German Cathedrals*, New York, 1956.

ALDEN F. MEGREW

WORPSWEDE SCHOOL. In 1895 the painter Fritz Mackensen established an artists' colony in the village of Worpswede, near Bremen. Painters who joined him included Otto and Paula Modersohn, Heinrich Vogeler, Hans am Ende, Fritz Overbeck, and Bernard Hoetger. The Worpswede artists painted the surrounding heath landscape and peasant life in a style that combined realism and a tendency toward the exuberance of the then current Art Nouveau style (in Germany, Jugendstil). The Worpswede school was a major step toward German expressionism. See HOETGER, BERNHARD; MACKENSEN, FRITZ; MODERSOHN, OTTO; MODERSOHN-BECKER, PAULA.

BIBLIOGRAPHY. R. M. Rilke, *Worpswede*, 3d ed., Bielefeld, 1910; S. D. Gallwitz, *Dreissig Jahre Worpswede*, Bremen, 1922.

WOTRUBA, FRITZ. Austrian sculptor (1907–). He studied at the Vienna School of Arts and Crafts and lived in Switzerland and Paris from 1937 to 1945. He exhibited in many international expositions including those at Arnhem, Venice, London, and Amsterdam. His style, which is semiabstract, refers to figural forms.

BIBLIOGRAPHY. E. Trier, *Moderne Plastik*, Frankfurt am Main, 1955.

WOUTERS, FRANS. Flemish painter (b. Lierre, 1612; d. 1659). He was a pupil of Pieter van Avont and Rubens, and became a master in 1634. Wouters was court painter to Emperor Ferdinand II and later to the Prince of Wales (Charles II). His specialties were oils of landscapes and mythological scenes with small figures, and he did occasional portraits. He also made some interesting etchings. His style is graceful and pretty; the compositions are usually small and permeated with the influence of Rubens and Van Dyck.

BIBLIOGRAPHY. G. Glück, *Rubens, Van Dyck und ihr Kreis*, Vienna, 1933.

WOUTERS, RIK. Belgian painter, sculptor, and draftsman (b. Mechlin, 1882; d. Amsterdam, 1916). He studied at the Mechlin Academy, then at the academy in Brussels, where he settled in 1905. He participated in the so-called Brabançon Fauvism. Wouters went to Paris in 1912, and was strongly influenced by impressionism. He endeavored to reconcile Cézanne's constructiveness, Renoir's interest in life, and Matisse's decorative composition. Wouters's best paintings and sculpture date from that period (for example, *Fleurs d'anniversaire*, 1912; *Soucis domestiques*, 1913). In less than seven years he made a remarkable contribution to Belgian art and was its principal represen-

Rik Wouters, *Woman Ironing*. Fine Arts Museum, Antwerp.

Philips Wouwermans, *The Pilgrims*. Louvre, Paris.

tative of Fauvism; his work prepared the way for Belgian expressionism.

BIBLIOGRAPHY. A. Delen, *Rik Wouters*, Antwerp, 1944; W. Vanbeselaere, *De Vlaamse Schilderkunst van 1850 tot 1950*, Brussels, 1959; P. Haesaerts, *Histoire de la peinture moderne en Flandre*, Brussels, 1960.

WOUWERMANS (Wouwerman), JAN PAUWELSZ. Dutch painter of landscape and animals; also graphic artist (b. Haarlem, 1629; d. there, 1666). He probably received his training from his father, Pauwels (Paulus) Wouwermans. Jan was the younger brother of Philips and Pieter Wouwermans. In 1655 Jan entered the Haarlem painters' guild, and he is recorded in the city regularly until his death.

Wouwermans's works are somewhat rare, and most of those extant are landscapes, such as the *Landscape with a Farm on the Bank of a River* (London, National Gallery), which reflect the style of Jan Wijnants. In other works, for example, *Rocky Landscape* (Vaduz, Liechtenstein Collection), the influence of his brother Philips can be seen.

BIBLIOGRAPHY. N. Maclaren, *National Gallery Catalogues: The Dutch School*, London, 1960.

WOUWERMANS (Wouwerman), PHILIPS. Dutch painter of animals, genre, and landscape (b. Haarlem, 1619; d. there, 1668). He received his first training from his father, Pauwels (Paulus) Wouwermans, and may also have studied with Pieter Cornelisz. Verbeeck. Philips is said to have run away to Hamburg, at the age of nineteen, to marry. At that time he may have spent several weeks in Evert Decker's workshop. Cornelis de Bie tells us that Wouwermans also studied with Frans Hals at Haarlem, but this is in no way documented. Wouwermans entered the Haarlem painters' guild in 1640 and was an officer of the organization in 1645.

He is best known for his scenes with horses, and his earliest known renderings of this type, such as *Cavalry Making a Sortie from a Fort on a Hill* (1646; London, National Gallery), have strong stylistic connections with the works of Jan Wijnants and Verbeeck. Wouwermans was almost certainly also influenced by Pieter van Laer, who had returned from Italy in 1638. Wouwermans's *The Rest* (1646; Leipzig, Museum of Fine Arts) shows him to be an inventive artist, and his use of landscape is extremely close to that in the early works of Jacob van Ruisdael and anticipates developments that appear in Wijnants's landscapes of the early 1650s. Wouwermans also painted a few winter landscapes (*Snowy Day*, New-York Historical Society).

He was extremely productive, and in addition to his numerous paintings with horses and landscape, he also produced a few religious and mythological scenes. His two brothers, Jan and Pieter Wouwermans, were also painters.

BIBLIOGRAPHY. N. Maclaren, *National Gallery Catalogues: The Dutch School*, London, 1960; J. Rosenberg, S. Slive, and E. H. ter Kuile, *Dutch Art and Architecture, 1600–1800*, Baltimore, 1966; W. Stechow, *Dutch Landscape Painting of the Seventeenth Century*, London, 1966. LEONARD J. SLATKES

WOUWERMANS (Wouwerman), PIETER. Dutch painter of animals, genre, and landscape (b. Haarlem, 1623; d. Amsterdam, 1682). He received his first training, as did his brothers Philips and Jan, from his father, Pauwels (Paulus) Wouwermans. In 1646 Pieter became a member of the Haarlem painters' guild. The influence of his older brother, Philips, was important in shaping his style, as it was in the work of his brother Jan. However, unlike Jan, Pieter seems to have worked only in Philips's manner, which he followed closely in works such as *Travelers before an Inn* (Kassel, State Picture Collections) and *Attack on Coevorden by Night* (after 1672; Amsterdam, Rijksmuseum), a late work.

BIBLIOGRAPHY. Amsterdam, Rijksmuseum, *Catalogue of Paintings*, Amsterdam, 1960.

WREN, SIR CHRISTOPHER. English architect (1632–1723). He was born in East Knoyle, Wiltshire. Two years later his father, who had been rector there, was appointed dean of Windsor and registrar of the Order of the Garter. Wren was educated at Westminster School, which he left in 1646. In 1647 he was appointed demonstrator in anat-

omy at the College of Surgeons in London. In 1649 he entered Wadham College at Oxford, where he studied geometry and astronomy and moved in the circle of brilliant men who later were founders of the Royal Society. He took his degree in 1651, but stayed on at the university. In 1657 he was named Gresham Professor of Astronomy at London, and in 1661, Savilian Professor of Astronomy at Oxford.

Although Wren devoted himself chiefly to scientific work until about 1665—Newton thought of him as one of the best geometricians of his day—he was actively engaged in architecture by 1662, when he designed the Sheldonian Theatre in Oxford. In 1663 he was appointed to the commission for the restoration of St. Paul's in London. After the Great Fire (1666) he became one of the surveyors under the Building Act of 1667, and in 1669 he was named Surveyor General of the King's Work and resigned his post at Oxford. In 1673 he was knighted. He was elected a Member of Parliament from 1685 to 1687 and from 1701 to 1702. On the accession of George I in 1714, he was dismissed from office.

Wren's career as an architect began when he was thirty, with the Sheldonian Theatre and the Chapel of Pembroke College in Cambridge (both 1663). In 1665–66 Wren went to Paris, where he met Bernini, and to the Low Countries. French and Dutch architecture, particularly the buildings of Mansart and Levau, became the key influences on his work. After the Fire he proposed a utopian city plan for London, but it was rejected.

His enormous capacities for invention found a virtually limitless field of expression in the rebuilding of St. Paul's and the fifty-one city churches which, with the exception

Sir Christopher Wren, St. Paul's Cathedral, London, 1675–1709.

of the designs of Inigo Jones, were the first classical churches in London. They were built between 1670 and 1686. Their most original features are their steeples, which range from Neo-Gothic to Borrominesque forms. The two-storied church with vaulted nave and aisles—later adopted in countless English and American congregational churches—was developed here, for example, in St. Peter's, Cornhill (1677–81); St. Clement Danes (begun in 1680); and St. James, Piccadilly (begun in 1683).

Wren's greatest work, St. Paul's Cathedral (1675–1709), which is anticipated in St. Stephen Walbrook (1672–87), is the most classically and intellectually refined example of monumental baroque architecture. After a number of alternative projects had been considered, the Cathedral was built with a Latin-cross plan. The exterior is dominated by the twin towers of the façade and the majestic, calm dome whose outer shell is supported high above its inner one by a tall cone. See ST. PAUL'S CATHEDRAL, LONDON; ST. STEPHEN WALBROOK, LONDON.

Wren's most important domestic buildings are Chelsea Hospital (1682–92) and Greenwich Royal Hospital (begun in 1694). The latter is the grandest and most sumptuous of all his designs. Its painted hall (1698) is one of the most magnificent rooms in England. Wren's designs for additions and alterations to Whitehall Palace, Winchester Palace, and Hampton Court Palace have only partially survived in their original form. His most important independent commissions (not executed for the Office of Works) are the Trinity College Library in Cambridge (1676–84) and Tom Tower at Christ Church in Oxford (1681–82). Wren had a deep and continuing influence on the course of English architecture. His only significant pupil was Nicholas Hawksmoor. See GREENWICH ROYAL HOSPITAL; HAMPTON COURT PALACE; WHITEHALL PALACE, LONDON.

BIBLIOGRAPHY. G. Webb, *Wren*, London, 1937; J. Summerson, *Sir Christopher Wren*, London, 1953.

HELLMUT WOHL

WRIGHT, FRANK LLOYD. American architect (b. Richland Center, Wis., 1869; d. Scottsdale, Ariz., 1959). One of the great artists of our time, Wright was largely self-taught—about three semesters of civil engineering at the University of Wisconsin was the extent of his higher education. He went to Chicago in 1887, first to work for Lyman Silsbee and, in the same year, for the firm of Adler and Sullivan, the leading architectural office in Chicago at that time. Throughout his life Wright expressed his artistic indebtedness to Louis Sullivan, and he formally acknowledged the debt in *Genius and the Mobocracy* (New York, 1949), a romantic biography of Sullivan. Their association lasted until 1893, when Wright started an independent career. He traveled to Japan in 1905; visited Europe in 1910–11; and returned to Japan in 1916, remaining until 1922. After a decline in his practice during the 1920s and early 1930s he began, at the age of sixty-six, what amounted to a second lifetime, which spanned the next 2½ decades. See SULLIVAN, LOUIS HENRI.

While working for Sullivan, Wright handled most of the firm's domestic jobs: the Charnley House (Chicago, 1891) was the most notable of this period. Up to 1910 his independent work, which was largely domestic, was for a wealthy clientele, located mostly in the suburbs of Chicago. The Winslow House (River Forest, 1893) was

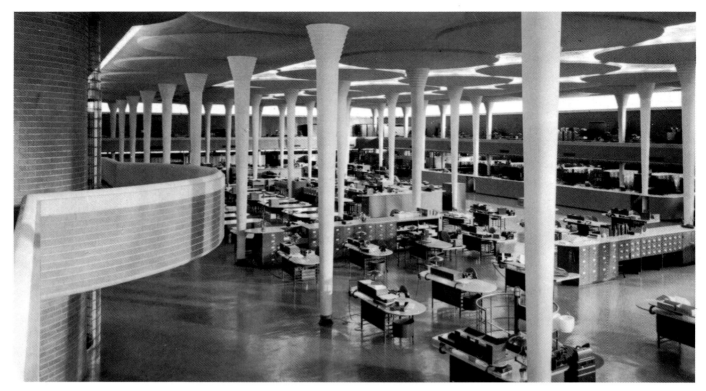

Frank Lloyd Wright, office area of the S. C. Johnson Wax Company Administration Building, Racine, Wis., 1937–39.

his first major building, its horizontal emphasis and broad, hovering roof suggestive of the mature Prairie houses yet to come. Its massive form is like that of H. H. Richardson and its intricate ornament similar to Sullivan's.

By about 1900 Wright's personal style had matured. With the River Forest Golf Club (1898; demolished), the Husser House (Chicago, 1899; demolished), and the Waller House (River Forest, 1899), the beginnings of his characteristic open, centrifugal plans emerged. During the first decade of the 20th century the definitive Prairie house was formulated in the Bradley and Hickox Houses (Kankakee, Ill., 1900); the *Ladies' Home Journal* projects (pub. February and June, 1901); the Willits House (Highland Park, 1902); the Roberts House (River Forest, 1908); and the Robie House (Chicago, 1909), the latter culminating Wright's Prairie house phase. Aligned on a suburban street and lavishly decorated with polychrome brick, leaded windows, and flower vases, the home is typical of 19th-century well-to-do American suburbia. Yet its flexible spaces, loosely defined by screens, and its planar elements, centrifugally oriented about a massive vertical chimney, are decidedly of the 20th century.

The two important nondomestic works of Wright's early period are Unity Church (Oak Park; designed 1904, built 1906–07) and the Larkin Building (Buffalo, N.Y., 1904; demolished). The church, an early example of the architectural application of reinforced concrete, consists of two major spaces—worship and living—linked by a common entry space. The cubic auditorium, with galleries on three sides, is defined by the three-dimensional interlocking of structural and spatial elements, with corner blocks used for circulation and utilities.

The Larkin Building was like a contemporary office building turned inside out. Open work spaces were arranged around an inner court, glazed overhead and supported by corner piers, which were again used for mechanical activities. The massive, sculptural bulk of this building attracted the attention of the architectural world at the beginning of the century, where it ranked with such key commercial and industrial works as Sullivan's Carson Pirie Scott and Company Store (Chicago, 1899–1904); Peter Behrens's AEG Turbine Factory (Berlin, 1909); and Gropius's Fagus Factory (Alfeld an der Leine, 1911–16). Wright's influence spread abroad through first-hand contacts with architects such as the Dutch H. P. Berlage and by two publications of his major early works (*Ausgeführte Bauten und Entwürfe von Frank Lloyd Wright*, Berlin, 1910; and C. R. Ashbee, ed., *Frank Lloyd Wright: Ausgeführte Bauten*, Berlin, 1911).

On his return from Europe in 1911 Wright undertook several large projects. He started construction on his own home in Spring Green, Wis., which suffered two fires and underwent countless expansions and variations until the time of his death. Like Thomas Jefferson's Monticello, it has the quality of a self-contained plantation, with production handled on the premises and with a design worked out empirically over a lifetime. Midway Gardens (Chicago, 1913–14; demolished) was an outdoor dining-entertainment area, a kind of beer hall organized by a series of terraces. Wright's chief work of this period was the Imperial Hotel (Tokyo, 1915–22; demolished 1967), a massive, brooding, ornamented pile on an H plan, organized around water pools. An engineering success more than an aesthetic triumph, the building was designed (with Paul

Mueller) to withstand earthquakes; and it did survive the destructive quake of 1923.

Aside from some small houses in the early 1920s (Hollyhock House, Los Angeles, 1920; Millard House, Pasadena, 1923), Wright's practice went into a total decline until the mid-1930s. During this period of inactivity, however, he designed the unexecuted Broadacre City (pub. 1935) and projects for skyscrapers: the National Life Insurance Company (1924) and St. Mark's Tower (1929), which was realized later in the Price Tower (Bartlesville, Okla., 1955).

In the 1930s Wright renewed his production with the Willey House (Minneapolis, Minn., 1932–34) and a series of Usonian houses, including the Jacobs House (near Madison, Wis., 1937); the Schwartz House (Still Bend, Two Rivers, Wis., 1939); and the Winkler-Goetsch House (Okemos, Mich., 1939). Taliesin West, in Scottsdale, Ariz., was also started at this time (1938) and, like Spring Green, continued to be built until the time of the architect's death. The classic of this period, Falling Water (Bear Run, Pa., 1936), dramatically hovers above a waterfall. Intersecting concrete planes are cantilevered from a central tower of rough, natural stone. This explosion of undecorated planes seems to combine the horizontality of the Robie House with the more vertical and aseptic quality of contemporary European works, such as Gerrit Rietveld's Schröder House (Utrecht, 1924).

In the industrial realm, Wright built the S. C. Johnson Wax Company Administration Building (Racine, 1937–39). Curvilinear forms enclose a city block; myriads of mushroom columns of various heights support everything from the tight, low parking garages below to the soaring, imaginative offices above. As in the Larkin Building, the offices dramatically embrace a central space; the building turns its back on its surroundings. The research tower (1950), a concrete trunk supporting cantilevered floors, is the focal point of the composition. Like a precision machine in action, the building symbolizes 20th-century industry. *See* JOHNSON, S. C., WAX COMPANY, ADMINISTRATION AND LABORATORY BUILDINGS, RACINE, WIS.

Wright's work proliferated after World War II. Of small dimensions but immense quality is the Morris Gift Shop (San Francisco, 1948–49). A blank brick wall, pierced by a yawning Richardsonian arch, invites the pedestrian to enter a dreamworld of curvilinear forms organized within a cubical volume. Inside, the spiral ramp foreshadows the totally curvilinear form and completely continuous space of the Guggenheim Museum (New York; completed 1959), one of Wright's last and most provocative buildings. *See* NEW YORK: MUSEUMS (GUGGENHEIM MUSEUM).

A giant figure historically, Wright stems from the 19th-century romantic tradition of Thoreau, Whitman, and Sullivan. Yet his masterful handling of space, his intuitive engineering, and his poetic sense of modern industry are decidedly of this century.

BIBLIOGRAPHY. F. L. Wright, *Frank Lloyd Wright on Architecture*, ed. F. Gutheim, New York, 1941; H.-R. Hitchcock, *In the Nature of Materials, 1887–1941: The Buildings of Frank Lloyd Wright*, New York, 1942; F. L. Wright, *An Autobiography*, New York, 1943; G. C. Manson, *Frank Lloyd Wright to 1910*, New York, 1958; J. D. Randall, *A Guide to Significant Chicago Architecture of 1872 to 1922*, Glencoe, Ill., 1958; V. J. Scully, *Frank Lloyd Wright*, New York, 1960; F. L. Wright, *Writings and Buildings*, selected by E. Kaufmann and B. Raeburn, New York, 1960.

THEODORE M. BROWN

WRIGHT, JOHN LLOYD. American architect (1892–). The son of Frank Lloyd Wright, John was born in Oak Park, Ill., and educated at the University of Wisconsin and the Chicago Art Institute. He was chief draftsman in his father's office between 1913 and 1919, and established his own practice in 1926, doing mostly domestic works in the Midwest and Far West. Wright has also written several books, including *My Father Who Is on Earth* (New York, 1946) and *Appreciation of Frank Lloyd Wright* (London, 1960).

WRIGHT, JOSEPH. American painter, sculptor, and engraver (b. Bordentown, N.J., 1756; d. Philadelphia, 1793). He studied in London with Benjamin West and John Hoppner. Wright was a portraitist in both England and the United States and was the first engraver of the United States Mint. He painted at least three portraits of George Washington.

WRIGHT, JOSEPH. English portrait, genre, and landscape painter, known as Wright of Derby (b. Derby, 1734; d. there, 1797). He studied in London under Hudson, but worked entirely in Derby except during 1774–76, when he traveled in Italy, and 1776–79, when he lived at Bath. He was elected associate of the Royal Academy of Arts in 1781. His work is characterized by independence of outlook and integrity. He made a special study of the representation of scenes by artificial light, ranging from small pictures in the manner of Schalken to large groups such as *The Experiment with the Air Pump* (London, Tate) and night scenes in the Bay of Naples and in Dovedale. He was closely associated with intellectual circles in the Midlands at the beginning of the Industrial Revolution.

BIBLIOGRAPHY. W. Bemrose, *The Life and Works of Joseph Wright*, London, 1885; Arts Council, *Catalogue, Wright of Derby*, London, 1958.

WRIGHT, MICHAEL. British painter (b. London? 1617?; d. there, 1700). He studied with George Jamesone in Edinburgh (1636–42) and later went to Rome, where he was a member of the Academy of St. Luke (1648) and became known as an antiquarian and scholar. After serving the governor of the Netherlands as antiquary, Wright returned to England about 1656 and became the chief rival of Lely, although Wright seldom received royal commissions. Until about 1685, when he was eclipsed by Kneller, Wright produced a great number of portraits of aristocratic sitters in the traditional English mode, influenced somewhat by Lely and the Roman baroque, but rougher and less elegant than the works of Lely. Wright's largest commission was for twenty-two portraits of members of the Court of Alderman in the City of London (1671–75; two in the Guildhall Library).

BIBLIOGRAPHY. E. K. Waterhouse, *Painting in Britain, 1530–1790*, Baltimore, 1953.

WRIGHT, PATIENCE LOVELL. American sculptor (b. Bordentown, N.J., 1725; d. London, 1786). After her husband died in 1769, Mrs. Wright and her sister opened a waxworks in New York City. In 1772 she moved to London and opened a waxworks which became very popular. Using colored wax, she made both busts and life-size statues, which she dressed in real clothing. Her wax statue

of Lord Chatham was placed in Westminster Abbey in London.

BIBLIOGRAPHY. O. W. Larkin, *Art and Life in America*, rev. ed., New York, 1960.

WRIGHT, RUSSEL. American industrial designer (1904–). He was born in Lebanon, Ohio, and educated at Princeton, Columbia, and the New York University School of Architecture. Wright left his career as a stage designer in 1929 to become one of the pioneer industrial designers in the United States. He is perhaps most famous for his design of "American Modern" dinnerware, which was included in a list of the 100 best-designed products of the century. He has designed hundreds of other products, ranging from electric clocks to furniture. Since 1956, Wright has been a consultant to small industries for the United States government's International Cooperation Administration. Under this program, he has served in Taiwan, Hong Kong, Cambodia, Vietnam, and Japan.

WROUGHT IRON, HISTORY OF. Wrought iron, as distinguished from cast iron (which is poured in molds and not worked beyond the point of being poured), is hammered on the anvil while it is hot or cooling, or sometimes cold. It is light gray in color. As it is worked, it becomes dense, brittle, and hard, but it can be brought back to its original state by heating and then cooling slowly. Excessive hammering renders wrought iron easily breakable and liable to split.

Wrought iron was first used in antiquity; remains of iron beads dated about 4000 B.C., found in an Egyptian cemetery at El Gerseh, were made of hydrated ferric oxide, a substance produced by the rusting of wrought iron. During medieval times wrought iron was used extensively for grilles and portals. French and English grilles of the 11th century, such as the St. Swithin grille of 1093 in Winchester Cathedral, betray a predilection for C and S scrolls. During the 13th century the best work was found in France: mountings on the portal of Notre-Dame in Paris remain distinct down to the leaflike terminations. A grille from the Ourscamp Abbey shows an elaboration of the C-curve motif, for the ends of the curve terminate in volutes, suggesting the tendrils of a plant. The ironwork in Germany of the same period has a primitive and heavy look, distinct from the elegant dynamism of the French work: a prominent example is the Cathedral door at Erfurt from the first half of the 14th century.

No ironwork previous to the 13th century is extant in Italy, where the quatrefoil, rather than the C and S scroll, was employed extensively. The large quatrefoil units of the Tombs of the Scaligeri (ca. 1380) in Verona are fastened together after the fashion of links on a coat of mail. The quatrefoils of the grille (ca. 1370) in Sta Croce, Florence, are smaller, enclosed by a border, and without interior bud motifs. By the 15th century in Italy, although the quatrefoiled grille changed but slightly, classical motifs became current. Stiles and rails accepted dentils, and crowning friezes were surmounted by simplified entablatures enriched with dentils and molded forms. Door hardware, such as hinges and keys, did not receive the attention in Italy that it did to the west and north, but Italy excelled in its workmanship in armor: in a Spanish tournament in 1434 only Italian weapons and armor were permitted. In the 16th century, iron was used to imitate bronze in lanterns, knockers, standard holders, and torch holders. Iron came to be widely used for furniture, as in the fashioning of bed frames and posts, brackets for desks and tables, and lighting fixtures. In Venice, especially, the quatrefoil became modified into a design of C scrolls and spearheaded accents, as in the grilles of S. Giorgio degli Schiavoni.

Spain, from the 15th through the first quarter of the 16th century, manifested a brilliant inventiveness in ironwork. The *rejas* (grilles) had bars with plain and ornamental twists, spindles and balusters, and Corinthian capitals with luxurious leaves and flowers. The moving of the priest's choir into the nave west of the crossing necessitated the erection of grilles to separate the choir from the high altar. These grilles, as at the Avila and Toledo Cathedrals, were remarkably ornate. The great *reja* in the Royal Chapel at Granada Cathedral, designed by Bartolomé de Jaen in 1523–30, screened the royal tombs. Incorporated into it was the human figure made of wrought iron. But with the waning of national prosperity about the middle of the 16th century, Spanish ironwork suffered something of a decline. Church grilles, for example, became low and horizontal rather than vertical.

Typical of the French grille of the 14th century is the one in the cloister of Le Puy-en-Velay: it is composed of vertical bars hammered into caps and bases at the ends and garnished by crockets and terminations of welded and riveted sheet iron. In the 15th century French ironwork became renowned for locks, keys, knockers, caskets, coffers, and screens chiseled from solid iron. In England in the 15th century ironwork craftsmanship began to deteriorate. During the reign of the Tudors, German and Flemish workmen were given preference over native smiths.

In France in the 17th century grandiose railings and gates surrounded the *cours d'honneur* of the castles and hotels, which they both protected and embellished. Square bars with lance heads and tassels were often the main features of the gates, as in the forecourt gates of Versailles (ca. 1680). The rococo period was characterized by an exuberance of motifs, as can be seen in the gateway of the Place Stanislas in Nancy, fashioned by Jean Lamour in the middle of the 18th century. The ornamental details surmounting the railings are of *rocaille* patterns as delicate in detail as stucco work. Gradually greater restraint gained the day in France. The curved ornament became angular, and the frame and piers were embellished with plain circles, as in the gates of the Château Maisons-Lafitte. England, after the Restoration of 1660, enjoyed a revival of ironwork usage. The gates at New College, Oxford, designed by Thomas Robinson, feature a synthesis of French flamboyance and English sobriety: the screen, made of plain vertical bars, contrasts with the almost frothy scrollwork of the gate panels. Toward the middle of the 18th century ironwork designs occasionally became codified through the dissemination of the engravings of the Adam brothers, John Carter, and others.

In the United States during the 17th and early 18th centuries ironwork was consigned to simple, practical items, such as strap hinges, fireplace necessities (toasters, bottle warmers, and so on), cupboard and wagon hinges,

and weather vanes. The first railings, appearing in the late 18th century, lacked the tortuous convolutions typical of contemporary European work. But after the American Revolution there were to be found baroque roller-coaster curves in balcony panels. New Orleans exhibits a succession of ironwork styles; the best work was done under Spanish governors using French designs. New Orleans's balconies often show a repeated form of ornament, with an elaborate central panel such as a monogram flanked by variously shaped scrolls.

Wrought iron in the 19th century played an increasingly important role in industry. By 1850 the cast-iron stanchions used in English mill building were replaced by wrought-iron beams. Wrought iron widely replaced cast iron for the beams and girders in bridge work, for it was discovered that though wrought iron was inferior to cast in resistance to compression, it was superior in withstanding many kinds of strain (tensile, transverse, shearing, and vibrating strains, and those caused by the effects of temperature). Some bridges were made of both wrought and cast iron; the road bridge over the Trent River at Nottingham, designed in 1871, contained 173 tons of wrought iron and 696 tons of cast iron.

In the late 19th and early 20th centuries in the United States there was a widespread application of classical motifs in boulevard balconies and elsewhere. This self-conscious emulation of European taste was instigated by architects who had studied at the Ecole des Beaux-Arts in Paris. Gradually, however, dependence upon tradition has finally abated. Wrought iron has come to be applied to more imaginative forms, as seen at the Exposition des Arts Modernes held in Paris in 1925, and many expert craftsmen have developed. For example, Edgar Brandt of Paris produces wrought-iron fireplace screens that assume the delicacy of beaten silver.

BIBLIOGRAPHY. A. H. Sonn, *Early American Wrought Iron*, 3 vols., New York, 1928; G. K. Geerlings, *Wrought Iron in Architecture*, New York, London, 1929; J. Gloag, *A History of Cast Iron in Architecture*, London, 1948. ABRAHAM A. DAVIDSON

WTEWAEL (Uytewael), JOACHIM ANTHONISZ. Dutch history and genre painter (b. Utrecht, ca. 1566; d. there, 1638). He was a student of his father, Anthonisz. Wtewael, and of Joos de Beer. Joachim traveled to Italy (1587) and France (1587–91) and, in 1592, joined the Utrecht guild. His style is akin to the late mannerism of Abraham Bloemaert and Bartholomeus Spranger (known through the engravings of Goltzius). Wtewael painted mostly mythological subjects in exuberant colors dominated by reds and yellows.

BIBLIOGRAPHY. C. M. A. A. Lindeman, *Joachim Anthonisz Wtewael...*, Utrecht, 1929.

WTTENBROECK, MOYSES, *see* UTENBROEK, MOZES VAN.

WU CH'ANG-SHIH. Chinese painter (b. Chekiang, 1844; d. Shanghai, 1927). His given name was Chun-ch'ing, but he is best known by his *hao* Ch'ang-shih or Fou-li. Wu Ch'ang-shih was a pupil of the eminent master Jen Pai-nien and was a great admirer of the 17th-century eccentric painter Tao-chi Shih T'ao. He became the leading figure of the Shanghai school in central China, and his most famous pupil was Ch'i Pai-shih. *See* CH'I PAI-SHIH; JEN PAI-NIEN; TAO-CHI.

WU CHEN. Chinese painter (1280–1354). A native of Chia-hsing in Chekiang Province, he was classified by Chinese historians as one of the "Four Great Masters" of the Yüan dynasty. His *tzu* was Chung-kuei, but he is more frequently referred to by his colorful *hao* Mei-hua tao-jen (Taoist of the Plum Blossom). Wu Chen was greatly admired by later Chinese, especially the *wen-jen* painters of the Ming dynasty such as Shen Chou. He led the "lofty and pure" life of the Yüan-dynasty self-proclaimed hermit-recluse who lamented the Mongol rulers and the "corruption" of the times. The appreciation of his art came later, however, and in his own time Wu Chen was not considered a great success; indeed, most of his paintings were given to his immediate friends. He was a poet and calligrapher in addition to being a painter, but his living was earned through his talents as a diviner. *See* WEN-JEN-HUA.

In some of his landscape paintings Wu Chen reveals a close stylistic affinity with the 10th-century master Chü-jan, and several paintings in the Sun Yat-sen Museum, Formosa, seem to echo sharply the characteristics of Chü-jan's art. But Wu Chen was not a historically minded painter, and his studies of earlier masters were secondary to his concern with painting as a means of expressing the freedom and independence of spirit he treasured. He did many "ink plays," or modest sketches, and he found the bamboo a perfect subject for displaying the *wen-jen* attitude toward form and technique: a calculated "awkwardness" of handling and a naïve kind of vision in contrast to the technical dexterity of the professional painter. *See* CHU-JAN.

Even more expressive of Wu Chen's involvement with life and the simpler pleasures of the world are his paintings devoted to the theme of fishermen. Among the fine examples of this aspect of Wu Chen's art is a hand scroll dated 1352, from the end of his career (Washington, D.C., Freer Gallery). Painted with a poet's sensitivity, the hand scroll glorifies the simple life of the fisherman in a deceptively casual and abbreviated style.

BIBLIOGRAPHY. J. F. Cahill, *Wu Chen, A Chinese Landscapist and Bamboo Painter of the Fourteenth Century*, Ann Arbor, Mich., 1958. MARTIE W. YOUNG

WU LI (Wu Yu-shan). Chinese painter (b. Ch'ang-shu, Kiangsu Province, 1632; d. Shanghai, 1718). His *tzu* was Yü-shan and his *hao* Mo-ching tao-jen. Wu Li is traditionally counted among the "Six Great Masters" of the Ch'ing dynasty. Born in the same town, Wu Li and Wang Hui were close friends, both having studied with the master Wang Shih-min, but the two painters eventually separated. Wu Li became acquainted with local Jesuit missionaries in his hometown, and about 1680 he was converted to Christianity, taking the name Simon Xavier. He eventually entered the order in Macao in 1682, and after being ordained in 1688, he spent the remainder of his life as a missionary, mostly in Shanghai. For all this background in Western thought, however, Wu Li seems to have been impervious to any Western influence on his painting. He was a great admirer of the Yüan masters and, as in the case of the Four Wangs, he was greatly influenced by the theories of Tung Ch'i-ch'ang. His output shows variations, as is to be expected among the orthodox Ch'ing masters, but the most striking of Wu Li's landscapes reveal a preoccupation with the powerful façade of mountain forms, find-

ing in them human or zoomorphic shapes on occasion. *See* Tung Ch'i-ch'ang; Wang Hui; Wang Shih-min.

BIBLIOGRAPHY. Y. Ch'en, "Wu Yü-shan," *Monumenta Serica*, III, 1938; A. Lippe, "A Christian Chinese Painter," *New York, Metropolitan Museum of Art, Bulletin* [n.s.], 11, Dec., 1952.

MARTIE W. YOUNG

WU-LIANG-KUANG, *see* Amitabha.

WU LIANG TOMBS. Chinese tombs near Chia-hsiang in present Shantung Province. The ancient temple where members of the Wu family had been buried in the 2d century of our era was mentioned in literary sources as early as the Sung dynasty. In the late 18th century a series of slabs containing engraved carvings were dug from this region and assembled under one roof. They have been identified as the reliefs of the Wu Liang Tz'u (Shrine of Wu Liang), and Wilma Fairbank has reconstructed the various slabs into a very convincing scheme of four separate shrines.

The importance of the Wu family tombs for the study of Chinese painting of the Han dynasty can hardly be exaggerated. For many years they were almost the only source of information for Han painting, preserving the composition and subject matter if not the actual brushstroke used by painters. The style of the Wu Liang slabs appears now to be distinctive of the region, with fullround forms dominating. As is typical of most Han art, the style is lively and exploits the silhouette, the crowded compositions being put into a series of horizontal registers with a distinct sense of horror vacui throughout. The subject matter of the reliefs is drawn from varied sources: official histories, Confucian tales, apocryphal legends, and miscellaneous texts. The wealth of folklore contained in these slabs has added greatly to the significance of the Wu tombs in Chinese history.

BIBLIOGRAPHY. T. Sekino, *Shina Santōshōni okeru Kandai fumbo no hyōshoku* (*Sepulchral Remains of the Han Dynasty in Shantung, China*), Tokyo, 1916; W. Fairbank, "The Offering Shrines of Wu Liang Tz'u," *Harvard Journal of Asiatic Studies*, VI, 1941.

MARTIE W. YOUNG

WU-MEN, *see* Peking.

WURM, HANS. German draftsman (fl. Nürnberg, ca. 1510–30). He is known only from a single ink drawing (colored) now in the German National Museum, Nürnberg, which is the first to show the entire city of Nürnberg in a topographically correct manner. It appears to have been made by a certain Windenmacher mentioned in chronicles of 1524, but nothing more is known about the artist, and the drawing itself is not dated.

WURSTER, WILLIAM WILSON. American architect (1895–). Born in Stockton, Calif., and educated at the University of California, afterward he worked in the office of J. Ried in San Francisco (1920) and of C. F. Dean (1921–22) and Delano and Aldrich in New York (1923–24) before starting his own office (1926). He developed an influential practice with T. Bernardi and D. Emmons in San Francisco; the firm of Wurster, Bernardi, and Emmons was founded in 1945. Wurster was dean of architecture at the Massachusetts Institute of Technology (1944–50) and at the University of California (1950–59); in 1959 he became dean of environmental design at California.

BIBLIOGRAPHY. I. R. M. McCallum, *Architecture USA*, New York, 1959.

WURZACH ALTAR, *see* Multscher, Hans.

WURZBURG: CATHEDRAL. Imposing German Romanesque church built between 1042 and 1188 on the site of a church of 862. The Cathedral is basilican in plan, with pier arcades and transepts terminating in apses. Its four towers were completed in 1240, the dome over the crossing in 1731. The exterior was restored in 1882–83.

The interior contains sculpture in relief and in the round of the medieval, Renaissance, baroque, and rococo periods, with baroque and rococo works predominating. In the north transept are two Renaissance tombs by Riemenschneider (d. 1531). At the north end of the transept is the Schönborn Chapel, built by Neumann (1729–36), a domed structure in florid, rococo style with three-dimensional arches.

BIBLIOGRAPHY. F. Mader, *Die Kunstdenkmäler von Unterfranken und Aschaffenburg*, vol. 3, XII, Munich, 1915; W. Burmeister, *Dom und Neumünster zu Würzburg*, Burg, 1928.

WURZBURG: MAINFRANKISCHES MUSEUM. German collection founded in 1913, housed in the Marienberg citadel. It contains an interesting collection of art and artifacts, especially from Franconia, beginning with finds from prehistory and protohistory. The museum contains a number of works by two Italian artists who were called to Würzburg in the 18th century: Giovanni Battista Tiepolo and Giovanni Domenico Tiepolo. There are paintings and drawings by German artists (17th–19th cent.); plans and drawings for castles in the Main region; and views of Würzburg from the late Middle Ages through the 20th century. The sculpture collection (mainly Franconian) ranges from the 12th century to about 1900; Riemenschneider's *Adam and Eve* (1493), which originally decorated the Marienkapelle, is the most famous work. The museum's applied arts—furniture, textiles, metalwork, and ceramics—reflect Würzburg's importance, especially during the 16th, 17th, and 18th centuries.

BIBLIOGRAPHY. H. Jedding, *Keysers Führer durch Museen und Sammlungen*, Heidelberg, Munich, 1961.

WURZBURG: RESIDENZ. Magnificent German palace, the town residence of the prince-bishops of Würzburg, built mainly by Neumann from 1720 to 1744. That the Residenz is one of the most splendid secular buildings of its century and country is the outcome of a conjunction of enthusiastic and substantial patronage, a high standard of architectural design from various quarters coordinated by one outstanding architect, and the employment of decorators who ranged from the good to the superb.

Johann Philipp Franz von Schönborn, who became the prince-bishop in 1719, decided to replace a small, recently built palace (by Antonio Petrini) with a new building on the same site. The foundation stone was laid in 1720; in 1723 sculptors were working on the decoration of the north

Würzburg, Residenz. The garden façade.

wing. In 1729 Friedrich Carl von Schönborn became the prince-bishop and he immediately pressed on with the work. The south wing was built in the 1730s; the long east wing, overlooking the garden, in the early 1740s. The decoration of the south wing and parts of the east wing were executed under Friedrich Carl's patronage; the decoration of the great stair hall and of the main reception room, the Kaisersaal, was done during the time of his successor, Karl Philipp von Greifenklau (1749–54). Then Adam Friedrich von Seinsheim completed a further sequence of rooms and developed the large square on the town side of the palace.

Neumann built a great part of the Residenz and was the coordinating architect. Maximilian von Welsch of Mainz influenced the basic layout by suggesting the oval pavilions of the north and south fronts; otherwise the plan is essentially Neumann's. Wings forming internal courts to the north and south are tied together on the east by the long garden wing and enclose between them, on the west, or town, side, a *cour d'honneur*—all on a very large scale. Johann Lucas von Hildebrandt of Vienna contributed particularly to the garden front and to the interior of the chapel. The intricate organization of the chapel (1732), however, and of the superb stair hall (begun 1737), both Neumann's, dominate the internal architecture. In 1751–53 Giovanni Battista Tiepolo executed the frescoes in the Kaisersaal (*Apollo Conducting to Barbarossa His Bride, Beatrice of Burgundy*, on the ceiling; *Wedding of Barbarossa* and *Investiture of Bishop Harold*, on the walls) and the ceiling fresco over the stair hall depicting the four parts of the world; these are Europe's finest 18th-century frescoes.

BIBLIOGRAPHY. R. Sedlmair and R. Pfister, *Die fürstbischöfliche Residenz zu Würzburg*, Munich, 1923. NORBERT LYNTON

WURZELBAUER, BENEDIKT.

German sculptor (b. Nürnberg, 1548; d. there, 1620). Famous as a sculptor and caster in bronze, he derived his style from his uncle Georg Labenwolf and was influenced by Netherlandish and Italian mannerists. Wurzelbauer's major work is the Virtues Fountain in Nürnberg (1585–89).

WU SCHOOL, *see* SHEN CHOU; WEN CHENG-MING.

WU TAO-TZU.

Chinese painter of Buddhist and Taoist subjects (d. 792). Wu Tao-hsüan was his later "official" name. Wu Tao-tzu was born of humble parents in the region of Lo-yang in Honan Province, and apparently he demonstrated his genius with the brush at an early age. He was called to the court of the T'ang emperor Hsüan-tsung, but most of his time was spent in traveling or executing murals for the many temples in the Ch'ang-an area.

No painter in Chinese history has gained greater acclaim than Wu Tao-tzu among native critics, and the praise bestowed upon him appears remarkably consistent throughout the long and changing history of art criticism in China. However, we actually know little of him or his works. Chang Yen-yüan, the 9th-century critic, speaks in reverent terms of this great master, and many anecdotes and legends have surrounded Wu Tao-tzu from early times. But Wu is not recorded in the official history of the T'ang dynasty, and most of his major creations were destroyed in the Buddhist persecutions of 845 that saw the magnificent temples of Ch'ang-an ruthlessly sacked. By the late 11th century the eminent Su Shih claimed that no more than one or two original works of Wu Tao-tzu remained, although a large number of attributed Wu Tao-tzu paintings were recorded in the 12th-century imperial collection.

Among the few remnants of the Wu Tao-tzu "style" available in our time are the stone engravings supposedly executed after the master's wall paintings. Among these, the example on the wall of the terrace in front of the Tao-wang-tien in Ch'ü-yang, Hopei, representing a flying devil, is well known and certainly conveys the sense of demoniacal energy so often associated with the brushwork of the T'ang master. The same sense of freedom and boldness of handling are observable in the sketch of a Bodhisattva, in ink on coarse hemp, preserved in the collection of the Shōsōin, Nara. Although this particular work is not an original of the gifted master, it is a useful bit of evidence for suggesting his style. It is a vigorous, spontaneous painting, the work of an anonymous craftsman who in all probability was in the mainstream of the Wu Tao-tzu style as it was known in the late 8th or early 9th century, and it offers a unique contrast to the more formalized Buddhist paintings seen at Tun-huang in this period. The looser, freer brush, the greater sense of individual personality in art, the newfound naturalism—these were the contributions of Wu Tao-tzu, and they constituted a concrete heritage that kept his name supreme among painters long after his works had disappeared. *See* TUN-HUANG.

BIBLIOGRAPHY. C. Chu, "Tang Ch'ao Ming Hua Lu" (The Famous Painters of the T'ang Dynasty...), *Archives of the Chinese Art Society of America*, IV, 1950; W. R. B. Acker, ed. and tr., *Some T'ang and pre-T'ang Texts on Chinese Painting* (Sinica leidensia, vol. 8), Leyden, 1954; B. Rowland, "A Note on Wu Tao-tzŭ," *The Art Quarterly*, XVII, Summer, 1954; O. Sirén, *Chinese Painting, Leading Masters and Principles*, vol. 1, New York, 1956; P. Wang, *Wu Tao-tzŭ*, Shanghai, 1958. MARTIE W. YOUNG

WU WEI.

Chinese painter of landscapes and figures (1459–1508). Born in Chiang-hsia in Hupei Province, he was summoned to the court twice, once in the reign of the emperor Hsien-tsung and again under emperor Hsio-tsung. He was a great favorite of both emperors, although he was quite a bohemian in his conduct, fond of wine and

adverse to any kind of criticism of his work. His style was more rough and reckless than that of Tai Chin, with whom Wu Wei is often linked in traditional Chinese histories. To consider Wu Wei the second great master in the Che school seems an aberration, for in both personality and style he was an independent genius, and for this reason some critics have considered him the founder of a new "school" named after his hometown of Chianghsia. *See* CHE SCHOOL; TAI CHIN.

BIBLIOGRAPHY. O. Sirén, *Chinese Painting, Leading Masters and Principles*, vol. 4, New York, 1958.

WU YU-SHAN, *see* WU LI.

WYANT, ALEXANDER HELWIG. American landscape painter (b. Port Washington, Ohio, 1836; d. New York, 1892). He first hand-colored photographs and painted portraits in Cincinnati. In 1857 he fell under the influence of Inness; later he studied with Hans Gude in Karlsruhe and followed the styles of Turner and Constable in London. Wyant was made an academician (1869) and became a founder of the American Water Color Society.

His early scenes are in the Hudson River school tradition. However, his late canvases (*Forenoon in the Adirondacks*, 1884) reveal a poetic interpretation of nature. With free brushstrokes and subtle tonal relations of atmospheric effects, he emulates the Barbizon painters and Inness. His intimate, vaporous landscapes foreshadowed the painterly manner of the American impressionists.

BIBLIOGRAPHY. E. C. Clark, *Alexander Wyant*, New York, 1916; C. E. Sears, *Highlights among the Hudson River Artists*, Boston, 1947.

WYATT, JAMES. English architect (1746–1813). He was a pupil in Venice of Visentini. Wyatt returned to England about 1768. His Pantheon (ca. 1770; demolished) in London made him immediately famous. He synthesized the style of Robert Adam and the later Palladianism of Sir William Chambers. Wyatt was far more prolific than either and is known to have been concerned with more than 130 projects. He was equally competent in the classic and Gothic styles.

The design of Fontill Abbey (1796) was a child of Lee Priory (1783) and culminated in Ashridge Park (1808), the most monumental surviving expression of this Gothic style. Wyatt's great classic houses include Castelcoole, Ireland (1790), and the chaste Dodington (1797), both part of the culmination of his superb neoclassic training.

WYCK, THOMAS, *see* WIJCK, THOMAS.

WYDIZ, CHRISTOPH, *see* WEIDITZ, CHRISTOPH.

WYETH, ANDREW NEWELL. American painter (1917–). Born in Chadd's Ford, Pa., he is the son of the painter and illustrator N. C. Wyeth, with whom he studied. Wyeth is a skilled water-colorist but is best known for his microscopically detailed tempera paintings of Maine and Pennsylvania landscapes and rural subjects. The minutely depicted surfaces rarely become cloying because Wyeth combines his realism with unusual angles of vision and strong design and surrounds his subjects with a seemingly symbolic atmosphere all the more powerful because it is vague, as in the often reproduced *Christina's World* (1948; New York, Museum of Modern Art).

See also MAGIC REALISM.

BIBLIOGRAPHY. D. C. Miller and A. H. Barr, Jr., eds., *American Realists and Magic Realists*, New York, 1943; A. Wyeth and R. Meryman, *Andrew Wyeth*, New York, 1968.

WYNANTS, JAN, *see* WIJNANTS, JAN.

WYNDHAM SISTERS. Oil painting by Sargent, in the Metropolitan Museum of Art, New York. *See* SARGENT, JOHN SINGER.

WYNFORD, WILLIAM DE. English architect. He was the designer of New College, Oxford (1380–85), for William of Wykeham. By 1394 he had transformed the Norman nave at Winchester Cathedral. As a college and domestic designer he is of the first importance. *See* WINCHESTER CATHEDRAL.

BIBLIOGRAPHY. J. Harvey, comp., *English Mediaeval Architects*, London, 1954.

WYNGAERDE, ANTONIUS VAN DEN (Antonio de Bruxelas or de Las Vinas). Flemish painter and engraver of topographic and cartographic views (fl. ca. 1510–72). First active in Antwerp, he worked in Rome and England before entering the service of Philip II in Spain, where he retired.

WYNTRACK, DIRCK, *see* WIJNTRACK, DIRCK.

WYTMANS, MATHEUS, *see* WIJTMAN, MATHEUS.

Andrew Newell Wyeth, *Albert's Son*. National Gallery, Oslo, Norway.

X

XANTEN CATHEDRAL. German late Romanesque hall church dedicated to St. Viktor. The massive twin-tower west façade up to the third story dates from 1190 to 1213. It was completed in the Gothic period. The huge window above the west portal dates from the 16th century. The interior, a five-aisled plan without transept, was mostly rebuilt from 1263 to 1437. The western part of the nave was completed in 1559.

BIBLIOGRAPHY. E. Gall, *Cathedrals and Abbey Churches of the Rhine*, New York, 1963.

XANTEN GOSPELS, see PALACE SCHOOL.

XANTHOS, FUNERAL TOWER OF, see LYCIA.

XANTHUS (Gunuk). Ancient city in Lycia (modern Turkey), on the Xanthus (Koca) River. The significant finds, dated between the 6th century B.C. and the early Christian period, include the now-famous funerary monuments, a well-preserved Roman theater, the ruins of a temple and of decorated houses, Attic black-figured ware, other ceramics, jewelry, and glass. Xanthus has long been known and excavated. The sources of its architecture and sculpture, native, Greek, and Oriental, have been studied and defined.

BIBLIOGRAPHY. E. Akurgal, *Die Kunst Anatoliens von Homer bis Alexander*, Berlin, 1961.

XANTO AVELLI DA ROVIGO, FRANCESCO. Italian majolica painter (b. Rovigo, ca. 1500; fl. ca. 1528–42). One of the best and most prolific painters of Renaissance *istoriato* majolica, Xanto was active in Urbino between 1530 and 1542. Earlier and later unsigned works have been identified on the basis of style. He was strongly influenced by Pellipario and, according to B. Rackham, by the Raphaelesque style of Master F. R. *See* MASTER F. R.

Xanto's work is often based on prints by such masters as Marcantonio Raimondi and Marco Dente, as in a plate, *Triumph of Venus*, after a print by Dente (1533; London,

Jean Xceron, *White Form, No. 271*, 1944. Solomon R. Guggenheim Museum, New York.

Wallace Collection), and often on a combination of several prints. Xanto nearly always made a note of the literary source on the reverse side. His work was sometimes lustered at Gubbio, often by Maestro Giorgio, whose signature frequently appears on the plates with that of Xanto. Xanto made several large table services, including those for G. Pucci (1532–33) and J. Pesaro (1535). Numerous examples of his work survive, in Milan (Civic Museum), Venice (Correr Museum), London (British Museum; Victoria and Albert), New York (Metropolitan Museum), Baltimore (Walters Art Gallery), Boston (Museum of Fine Arts), and elsewhere.

BIBLIOGRAPHY. M. Bonomi, "Fonti iconografiche delle maioliche de Francesco Xanto Avelli," *Commentari*, X, 1959.

CLARE VINCENT

XAVERY, see SAVERY.

XCERON, JEAN. Greek-American painter (b. Isari, 1890; d. New York, 1967). Xceron was a pioneer of nonobjective painting in the United States, where he first went in 1904. In 1912 he began to study at the Corcoran Art School in Washington, D.C., but he soon became interested in Cézanne and in cubism and increasingly concerned with the geometric structure of objects and the use of color as a means of modeling. During the 1920s in Paris he met Arp, Braque, and Picasso, and in 1931 Xceron's first one-man show brought critical acclaim. He returned to the United States in 1937, joined the staff of the Guggenheim Museum in New York in 1939, and exhibited widely. A number of his works are owned by the Guggenheim Museum, which gave him a one-man exhibition in 1965. His art is characterized by clarity of outline, austerity of means, and structural design.

XERXES, APADANA OF (Hall of a Hundred Columns). The throne hall at Persepolis, begun by Xerxes in 486 B.C. and finished by Artaxerxes, is a good example of the typical Persian apadana, a ceremonial square hall with columns. The prototype is unknown, but in the official palace of Akhenaten at Amarna (1364–1350 B.C.) there was a similar hall on a square plan with 540 pillars. Xerxes'

apadana had ten rows of ten columns each and, on the north, a portico with two rows of eight columns each, flanked by two towers with colossal bull statues built into the lower sections.

Along the three other sides were passages meant for protection; they were connected by two stone doorways to the hall, each side of which was carved in relief with scenes of the king enthroned (north and south) and the king attacking monsters (east and west). Six stone windows opened between the hall and the portico, and were recalled in the three other walls by niches of similar design. The columns in the hall were of the composite type: a base of inverted leaves, a fluted shaft, and a pseudo-palmiform capital rising from a crown of drooping leaves were surmounted by a tall cubical block with two double volutes applied vertically on each of its four sides and topped by the foreparts of bulls set back to back.

BIBLIOGRAPHY. E. F. Schmidt, *Persepolis I*, Chicago, 1953.

ALEXANDER M. BADAWY

X:ET, *see* ERIXSON, SVEN.

X GROUP. Short-lived successor to the vorticist movement in England. Like the latter, it was led by Wyndham Lewis. The group, including Wadsworth, Roberts, Ginner, Dobson, Kauffer, Etchells, and others, exhibited in 1920. *See* DOBSON, FRANK; GINNER, CHARLES; LEWIS, WYNDHAM; ROBERTS, WILLIAM PATRICK; WADSWORTH, EDWARD.

XOANON. Simple figures of deities carved from wood by the ancient Greeks. Although Pausanias mentions many, none are extant. Their nature has been ascertained from figures of beaten metal that were made around such wooden figures. It is generally believed that the xoanon was the earliest form of Greek sculpture and that it gradually passed out of use with the rise of stone sculpture in the 8th century B.C.

X RAY. Photographs made with penetrating X rays are of great service to the conservation of paintings. X-ray photographs can reveal hidden defects in the layers of paint and ground, and can also determine the extent of overpainting.

BIBLIOGRAPHY. A. Burroughs, *Art Criticism from a Laboratory*, Boston, 1938.

X-RAY STYLE. Mode used by the aboriginals of Arnhem Land in Northern Australia to depict animal life, particularly in rock paintings in the area of Darwin and the Alligator River. In these representations the artist sees through to the skeletal structure and internal organs, which are drawn in realistic detail.

XYLOGRAPHY, *see* WOOD ENGRAVING.

XYSTUS. In ancient Greece, a covered promenade or running track. It was a long, open portico used for athletic exercises, especially during the winter and inclement weather. In Rome the xystus was often a garden planted with groves of plane trees and laid out with flower beds.

Apadana of Xerxes (Hall of a Hundred Columns). The throne hall at Persepolis, begun by this King in 486 B.C.

Y

YAHUDIYAH. Site located in the southern Delta of Egypt, northeast of Heliopolis. In Arabic it is known as Tell el-Yahudiah; in Greek, Leontopolis. Most prominent is a rectangular enclosure 400 yards square surrounded by beaten-earth walls 15 to 20 yards high, which has been explained as either a Hyksos encampment or Egyptian ruins. The Tell el-Yahudiyah ware, mainly small-handled jugs with dot-filled geometric figures, seems to have Syro-Palestinian affinities and has been found as far south as the Third Cataract (Kerma) in Nubia.

YAKSHA (Yaksa). Demon in the suite of the Buddhist god Kuvera. The female was called yakshi (yakṣī; yakṣiṇī).

YAKUSHI IN JINGOJI. Japanese wood sculpture (ca. 793) in the Jingoji temple, near Kyoto. The massive Yakushi Buddha (Healing Buddha) stands erect holding a medicine jar in his left hand. His snail-shell curls are large, and his austere, virile face imparts an inner power and vigor seemingly about to burst forth. The statue is undecorated except for the red of the lips and the whites of the eyes. The heavy proportions and the powerful carving of the deeply cut drapery folds represent the new spirit in the sculpture of the early Heian period.

BIBLIOGRAPHY. Tokyo National Museum, *Pageant of Japanese Art*, vol. 3: *Sculpture*, Tokyo, 1952; *Masterpieces of Japanese Sculpture*, introd., text and commentaries by J. E. Kidder, Jr., Rutland, Vt., 1961; National Commission for the Protection of Cultural Properties, ed., *Kokuhō (National Treasures of Japan)*, vol. 2: *The Heian Period*, Tokyo, 1964.

YAKUSHIJI, NARA. Japanese Buddhist temple. The Yakushiji, dedicated to the Yakushi (Buddha of Healing), was founded sometime between 686 and 697 outside the city of Nara. It was transferred to the present site within the new capital city of Nara in 718. No definite conclusion has been reached as to whether the new monastery in Nara was built as an entirely new one or whether the buildings of the original Yakushiji were transferred to this site. The three-storied East Pagoda, the sole survivor of fires and typhoons that destroyed other buildings of this temple, is sometimes believed to be at least partially built with materials transported from the original monastery. The general layout of the temple, in which twin pagodas stand in an east-west relationship, is often found in temples of the Korean kingdom of Silla. Its roof is doubled and gives an impression of a six-storied building. Among the art treasures housed here are a large bronze triad of the Yakushi and his attendants and a bronze statue of Shō Kannon (Sanskrit, Avalokiteśvara) from Tōindō, both excellent examples of Nara sculpture, reflecting the mature style of China's T'ang art; a portrait sculpture of Empress Jingū; and painting of Kichijōten. (See illustration.) *See* JINGU KOGO IN YAKUSHIJI, NARA.

BIBLIOGRAPHY. K. Machida, *Yakushiji*, Tokyo, 1960; National Commission for the Protection of Cultural Properties, ed., *Kokuhō (National Treasures of Japan)*, vol. 1: *From the Earliest Time to the End of the Nara Period*, Tokyo, 1963.

MIYEKO MURASE

YALE UNIVERSITY ART GALLERY, NEW HAVEN, CONN., *see* NEW HAVEN, CONN.: YALE UNIVERSITY ART GALLERY.

YAMAMOTO, KANAE. Japanese painter and print designer (1882–1946). Yamamoto was educated at the Tokyo Fine Arts School and in Europe. He was one of the leaders of the movement to revolutionize the traditional method of making Japanese wood-block prints so that the entire process would be conducted by the designer himself. Greater control over the final product was assured, as compared with prints of the Edo period, which were made by the collaboration of many craftsmen.

BIBLIOGRAPHY. O. Statler, *Modern Japanese Prints: an Art Reborn*, Rutland, Vt., 1956.

YAMASAKI, MINORU. American architect (1912–). Born in Seattle, Wash., he was educated at the University of Washington (graduated 1934). He traveled to Japan (1933) and worked in several New York offices before practicing in Detroit. A well-known work is the St. Louis

Yaksha. Female yaksha (yakshi), Rājārāṇi temple, Bhuvaneśvara.

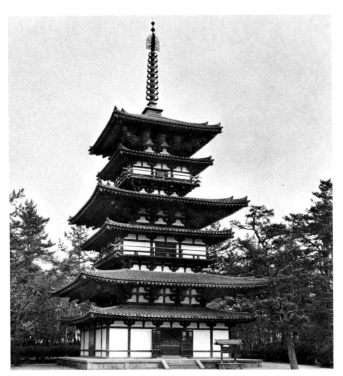

Yakushiji, Nara. The three-storied East Pagoda.

Airport (1953–55; with Hellmuth and Leinweber), a large space dramatically defined by three shell concrete groin vaults. In 1966, at Princeton University, he constructed a building with a lacy concrete façade, for the Woodrow Wilson School of Public and International Affairs.

BIBLIOGRAPHY. I. R. M. McCallum, *Architecture USA*, New York, 1959.

YAMATO-E. Japanese term for a type of secular painting. The term, literally "Japanese picture," made its first appearance in literary records of the late 9th century. It was apparently used as an antonym of another type of secular painting called Kara-e, or "Chinese picture." The term is often misunderstood by students of Japanese art and thought to designate a particular style of painting. The distinction between Yamato-e and Kara-e, however, was based on subject matter rather than on stylistic features. *See* KARA-E.

The exact meaning and the early development of Yamato-e can be only conjectured, and though the literary references to Yamato-e are numerous, none of them can be connected with any particular existing work. It may be safely surmised from the literary evidence that in the intensely nationalistic cultural ambience of the 9th century, Yamato-e gradually developed out of Kara-e, finally replacing it to become the popular type of painting.

The *shinden*-style houses of the Fujiwara court nobles required folding screens, sliding doors, and other types of room dividers. These were decorated with paintings, at first by Kara-e artists, representing Chinese themes against Chinese settings. Later, Yamato-e was more commonly used in the decoration of these room dividers. Unfortunately, however, the houses of the Fujiwara period were all destroyed, and there is no extant example of Yamato-e screens. Literary records of the period testify that Yamato-e designs on these screens represented Japanese subject matter shown against Japanese settings, and were executed in a style that satisfied the sophisticated taste of the Fujiwara court nobles. *See* SHINDEN-ZUKURI.

These screens are also a testimonial to the close collaboration found among the arts of poetry, calligraphy, and painting. Scenes of famous views of Japan were represented both in painting and poetry, not merely for their beautiful

Yamato-e. *The Emperor Leaves the Palace Disguised as a Woman*, detail of the *Heiji War Scrolls*. National Museum, Tokyo.

landscape qualities, but as a setting for festivals and other human activities, closely associated with the seasons of the year. Yamato-e landscape may be clearly distinguished from Kara-e landscape, therefore, by its close association with seasonal changes, by the presence of human activities as an inseparable element, and by its close connection with the arts of poetry and calligraphy. The landscape background of the Amida's descent, painted on the walls of the Phoenix Hall (Hōōdō) in Uji, is a good example of Yamato-e. Man's life during the different seasons of the year is depicted against the gentle, rolling hills so typical of the area around Uji. *See* Hoodo of Byodoin.

Some stylistic features of Yamato-e screen paintings may be studied directly from representations of miniature screen paintings, shown in the interior scenes of illustrated narrative scrolls (*emaki*) of the late Fujiwara and Kamakura periods. The best extant examples of Yamato-e are found among the *emaki* of the 12th and 13th centuries, such as the *Ban Dainagon Scrolls*, the *Heiji War Scrolls*, the *Shigisan Engi Scrolls*, and the *Tale of Genji Scroll*. Illustrations painted on fans in the Shitennōji, commonly known as the Fan Sutras, are also good examples of Yamato-e of the late 12th century. *See* Ban Dainagon Scrolls; Heiji War Scrolls; Shigisan Engi Scrolls; Tale of Genji Scroll.

Many excellent painters who specialized in Yamato-e are known in literature, but none of their works has survived. Asukabe Tsunenori, Kose-no Kintada, and Kose-no Kimmochi were active in the middle of the 10th century, and Kose-no Hirotaka, in the late 10th century. Later, Fujiwara Takayoshi (mid-12th cent.), Fujiwara Takanobu (1142–1205), and his son Nobuzane (b. 1176) were the most renowned Yamato-e painters. In the Muromachi period the Yamato-e painters were eclipsed as the ink painters dominated the field, but the tradition of Yamato-e was continued by the Tosa family of court painters, among whom Mitsunobu was the best known. *See* Mitsunobu; Nobuzane; Takanobu; Takayoshi; Tosa School.

BIBLIOGRAPHY. A. Soper, "The Rise of Yamato-e," *Art Bulletin*, XXIV, December, 1942; K. Toda, "Japanese Screen Paintings of the Ninth and Tenth Centuries," *Ars Orientalis*, III, 1959; T. Akiyama, *Heian jidai sezokuga no kenkyū (Secular Painting in Early Mediaeval Japan)*, Tokyo, 1964. MIYEKO MURASE

YANEZ DE LA ALMEDINA, FERNANDO. Spanish painter (fl. 1506–31). A native of La Mancha, Yáñez, like his compatriot Llanos, studied and worked with Leonardo da Vinci in Florence. He may have assisted the master on the *Battle of Anghiari* fresco. Yáñez collaborated with Llanos on an altarpiece and paintings for the doors of the high altar in Valencia Cathedral (1507–10). In these twelve monumental paintings, depicting the joys of the Virgin and other episodes of her life, the classical preoccupations of Italian art enter Spanish painting, including the use of *sfumato*, architectural settings, and perspective. After a stay in Barcelona in 1515, Yáñez worked at Cuenca Cathedral (1526–31). Although he adopted some of Leonardo's methods, his spatial settings never involve the figures, which are set in planes and have a cluttered, provincial look. But the *St. Catherine* (Madrid, Prado) has the linear suavity, subtle shading, feminine beauty, and architectural clarity of a Leonardo, while retaining its particular Spanish quality of isolation.

BIBLIOGRAPHY. F. P. Garín Ortiz de Taranco, *Yáñez de la Almedina*, Valencia, 1953.

Fernando Yañez de la Almedina, *St. Catherine*. Prado, Madrid.

YANG-CHOU, EIGHT ECCENTRICS OF. Appellation used by Chinese critics in their discussion of a number of painters who worked in the area of Yang-chou in Kiangsu Province during the reign of Ch'ien-lung (1736–96) of the Ch'ing dynasty. The eight eccentrics, or "eight strange masters" (Yang-chou pa-Kuai), consisted of Chin Nung, usually considered the foremost painter of the group, Hua Yen, Cheng Hsieh, Huang Shen, Li Fang-ying, Li Shan, Wang Shih-shen, and Lo P'ing. To this standard grouping are sometimes added the names of Kao Hsiang and Kao Feng-han. *See* Chin Nung; Hua Yen; Li Shan; Lo P'ing.

The makeup of this group is arbitrary in the sense that these men are not closely knit in stylistic terms but shared the accident of a common location. Yang-chou, a beautiful town on the Grand Canal with a marked degree of pros-

perity in the 18th century, was situated in the Chiang-nan region, which had been the focal point of much intellectual activity throughout the earlier Ming period. Although the painters in this group differed in technique and style, they shared a common spirit of independence and in many ways can be considered the last truly creative and vital painters in China before the 20th century.

BIBLIOGRAPHY. M. Kitano, *Yang-chou School of Painters* in *Chūgoku no meiga*, series 1, Tokyo, 1957; S. E. Lee, *Chinese Landscape Painting* [2d rev. ed.], Cleveland, 1962.

YANG-TSAI, *see* FAMILLE-GROUP PORCELAINS.

YASUI, SOTARO. Japanese painter (1888–1955). He went to Paris to study painting in 1907 and took lessons from Jean-Paul Laurence of the Académie Julian, but he was more influenced by Cézanne. Yasui's portraits show a severe interpretation of the sitter, often strongly outlined by stark blacks.

YAYOISHIKI, *see* JAPAN: CERAMICS.

YAZILIKAYA. Hittite sanctuary (14th–13th cent. B.C.), near Boghazkeuy, Turkey, the ancient Hattusas, capital of the Hittites. Striking reliefs adorn this famous rock sanctuary. One relief has warriors wearing high ribbed caps, short skirts, and shoes with upturned toes. Another shows a god embracing a young king, and a huge sculptured dagger with a symbolically ornamented hilt.

BIBLIOGRAPHY. S. Lloyd, *The Art of the Ancient Near East*, London, 1961.

YBL, MIKLOS. Hungarian architect (1814–91). Ybl worked in Budapest. Trained in Vienna, he was the leading Hungarian architect of his time. Stylistically eclectic, ranging from medieval and Renaissance to Second Empire modes, he represents the creative application of diverse styles in his period.

BIBLIOGRAPHY. E. Ybl, *Ybl Miklós*, Budapest, 1956.

YEATS, JACK BUTLER. Irish painter (b. Sligo, 1871; d. Dublin, 1957). He was the son of the painter John B. Yeats and brother of the poet William B. Yeats. Jack was first influenced by impressionism, but even some of his

Jack Butler Yeats, *Above the Fair.* **National Gallery of Ireland, Dublin.**

dark-toned early works show the ease with which he could catch a likeness or render a scene. By the middle 1920s, however, Yeats had adopted a spontaneous, loose, expressionistic manner of painting. This technique of bright color and excited, slashing strokes was applied to landscapes, figures, and scenes from Irish daily life or Celtic mythology, not with ironic social intent but rather as an expression of abundant life and immense vitality.

BIBLIOGRAPHY. T. McGreevy, *Jack B. Yeats*, Dublin, 1945.

YEB, *see* ELEPHANTINE.

YELLOW CHRIST, THE. Oil painting by Gauguin, in the Albright-Knox Art Gallery, Buffalo. *See* GAUGUIN, PAUL.

YEN, *see* HSIEN.

YEN HUI. Chinese painter (fl. 14th cent.). His *tzu* was Ch'in-yüeh. A native of Chiang-shan in Chekiang Province, he was a painter of Buddhist and Taoist subject matter for the most part, although a few landscape and animal paintings have been attributed to him. Nothing is known of the details concerning his career, and his place in Chinese painting history stems from a handful of extraordinary paintings preserved principally in Japanese collections. The most often reproduced of these paintings is the pair in the Chionin in Kyoto representing the Taoist immortals Li T'ieh-kuai and Liu Hai-hsien. In the United States, Yen Hui is represented by a hand scroll depicting the demon queller Chung K'uei in the collection of the Cleveland Museum of Art. In all these paintings the proclivity of Yen Hui for grotesque imagery and expressive monochrome ink effects is revealed.

BIBLIOGRAPHY. O. Sirén, *Chinese Painting, Leading Masters and Principles*, vol. 4, New York, 1958; S. E. Lee, "The Lantern Night Excursion of Chung K'uei," *Bulletin* [*of the*] *Cleveland Museum of Art*, XLIX, 1962.

YEN LI-PEN. Chinese painter (d. 673). Yen Li-pen was active in the early years of the T'ang dynasty at the courts of T'ai-tsung (r. 627–649) and Kao-tsung (r. 650–683). He was the most celebrated of the early court artists, skilled in many areas besides painting. His main reputation as a painter was gained for his Buddhist and Taoist subjects and for his portraits commissioned by the emperors. He rose to a high government position and in 668 became one of the two ministers of state.

Among the best known of Yen Li-pen's paintings, according to early literary accounts, were his many depictions of foreign envoys bringing tribute to the great T'ang emperors. This subject matter was apparently among the greatest favorites of the first emperors of the expanding kingdom. Yen Li-pen was also called upon to portray the distinguished scholars of antiquity and other famous men in history. Among these paintings, one has survived, the famous long scroll of the *Thirteen Emperors* in the Museum of Fine Arts, Boston. Although the painting has suffered considerable retouching, enough of the original is left to give us an important document for the study of this master. The painting was attributed to Yen Li-pen as early as the 11th century, and there is nothing in the painting that seems inconsistent with the period when he was active. The portraits of the emperors, beginning with Wen-ti of the Han dynasty and ending with Yang-ti of the

Sui dynasty, are idealized symbols of power and stature. Each emperor is accompanied by attendants, just as religious deities were flanked by disciples, following a hieratic formula for scale. The figures may be stock types in terms of dress and pose, but the faces are individualized to some extent. The figures are also ponderously heavy when compared with the proportions used by Ku K'ai-chih in the preceding Six Dynasties period. A degree of arbitrary shading introduced in this painting is also consistent with the growing awareness of Central Asian painting conventions, and this adds another important dimension to this remarkable hand scroll. *See* KU K'AI-CHIH.

BIBLIOGRAPHY. K. Tomita, "Portraits of the Emperors, a Chinese-Scroll Painting, Attributed to Yen Li-pen (died A.D. 673)," *Boston, Museum of Fine Arts, Bulletin*, XXX, February, 1932; W. R. B. Acker, ed. and tr., *Some T'ang and pre-T'ang Texts on Chinese Painting* (Sinica Leidensia, vol. 8), Leyden, 1954; L. Sickman and A. Soper, *The Art and Architecture of China*, Baltimore, 1956.
MARTIE W. YOUNG

YEN WEN-KUEI. Chinese painter (fl. 2d half of 10th cent.). A native of Wu-hsing in Chekiang Province, he is sometimes associated with Tung Yüan and Chü-jan as a southern painter of the Five Dynasties and early Sung periods. He went north to the capital and served in the academy and the court after 976, gaining some distinction for his tight, meticulous, and richly detailed paintings. A few examples of his work are preserved in the Sun Yat-sen Museum, Formosa. *See* CHU-JAN; TUNG YUAN.

YEON, JOHN. American architect (1910–). Born in Portland, Ore., and largely self-taught, Yeon was technically trained by apprenticeships in several architectural offices. He traveled in Europe in 1930 and went into private practice in 1935. He is noted for his sensitive handling of homes in the Portland area and for other small-scale works, such as the Tourist Center (Portland, 1949).

BIBLIOGRAPHY. New York, Museum of Modern Art, *Built in USA, 1932–1944*, ed. E. Mock, New York, 1944.

YEVELE, HENRY. English architect (d. 1400). By 1360 he may have designed Queensborough Castle, one of many castle works, and by 1375 he had appeared at Canterbury Cathedral with the design for the Black Prince's tomb. Yevele was engaged in many royal duties. By 1395 he had designed the Great Hall at Westminster Palace, with a roof by Hugh Herland, and had continued the work on Westminster Abbey. There is little doubt that he designed the nave of Canterbury Cathedral, vaulted in 1400 and the highest achievement of the English Perpendicular style. He is among the greatest of English architects; royal patronage over a long period enabled him to perfect the most English of all styles. *See* CANTERBURY CATHEDRAL; WESTMINSTER ABBEY, LONDON.

BIBLIOGRAPHY. J. Harvey, comp., *English Mediaeval Architects*, London, 1954.

YI CHONG (Rae-ong; Sul-ak). Korean painter (1578–1607). Although he died young, he established his fame as a master of landscape and Buddhist painting. According to the account in *Listening to the Bamboo History of Art*, he was a scion of the famous master Yi Sang-jwa, whose style Yi Chong was said to have followed. The *Landscape* in the Toksu Palace Museum of Fine Arts,

Seoul, is one of his better-known masterpieces. The composition and mood of this painting are reminiscent of the landscapes of the Yüan period in China. *See* YI SANG-JWA.

YI-HSING, *see* I-HSING.

YI IN-MUN (Yu-chun). Korean landscape painter (1746–1821). He was a member of the Royal Academy, known for his masterful use of ax-cut strokes in the dry-brush and splash-ink technique. His landscapes exhibit a marvelous blend and contrast of ink tones. Two of his most celebrated works are *Spring Landscape* (Mr. Hyung-pil Chun Collection) and a horizontal scroll more than 30 feet long in the Chinese northern style, entitled *Mountains and Rivers without End* (Seoul, Toksu Palace Museum of Fine Arts). *See also* P'O-MO; TS'UN.

BIBLIOGRAPHY. E. McCune, *The Arts of Korea*, Rutland, Vt., 1962.

YING-CH'ING (Ch'ing-pai). Term used in Chinese ceramic history, translated literally as "shadowy blue." It does not appear in early Chinese texts on ceramics and seems to have been coined in the modern period by writers to describe a class of Sung-dynasty wares with a hard whitish glaze, which deepened to light blue in the thicker sections. The wares are very close to those of the Ting type in general design and decoration and usually have a finely incised design. It is generally recognized that *ying-ch'ing* porcelains should be called *ch'ing-pai* (literally, blue-white), a term which does appear in Chinese texts as early as the Southern Sung period (1127–1279). The two terms are now used interchangeably by most modern writers on Chinese ceramics. *See* TING WARE.

The *ying-ch'ing* type of porcelains apparently was produced at a number of kilns in China, with Kiangsi Province as a leading area. The wares of this class were widely distributed outside China, numerous fragments being found in Korea, Japan, southeast Asia, and Egypt and elsewhere in Africa. Literary records testify that Chinese merchants used these porcelains in trading throughout Java in the 13th century.

BIBLIOGRAPHY. J. A. N. Barlow, *Chinese Ceramics, Bronzes and Jades in the Collection of Sir Alan and Lady Barlow*, by M. Sullivan, London, 1963.
MARTIE W. YOUNG

YING-TSAO FA SHIH. Chinese architectural manual compiled by the state architect Li Chiai (Li Chieh) and presented to the throne in 1100. It is the only treatise on building methods of classical times that has survived and consequently is an invaluable source of information about Sung and pre-Sung construction methods. The modern version of the text is based on a copy made in 1821, which in turn was based on a 12th-century revised edition, and the plates are completely redrawn with color designs added on the basis of marginal notes in the original Sung edition.

The *Ying-tsao fa shih* is primarily a builders' manual rather than an architectural treatise, for the work contains rather detailed instructions for carpentry, masonry, decorating, and so forth. It is not a scholarly work on principles of design, nor does it discuss aspects of historical style. But the treatise does cover a wealth of technical data, containing the thoughts and observations of a

practical experienced master builder, and for this reason the work was highly regarded in its time.

BIBLIOGRAPHY. L. Sickman and A. Soper, *The Art and Architecture of China*, Baltimore, 1956; W. Willets, *Chinese Art*, vol. 2, Harmondsworth, 1958. MARTIE W. YOUNG

YING YU-CHIEN. Chinese painter (fl. mid-13th cent.). He was associated with Ch'an (Zen) ink-splash landscapes. There is some dispute about the identification of this painter. The signature "Yü-chien" (Jade Stream) appears on a number of paintings that have been connected with Ying Yü-chien, recorded in Chinese sources as a Ch'an monk who lived in a temple near Hang-chou. Another Ch'an artist of the same period was the monk Jo-fen Yü-chien. Information in Chinese sources concerning Jo-fen is more complete than for Ying Yü-chien, and most Japanese scholars now seem to favor the identification of Jo-fen Yü-chien with the ink-splash landscapes found in many Japanese collections. Jo-fen served as a scribe in the Shang-chu temple in Hang-chou and later retired to his native hills, where he built a pavilion named Yü-chien. He gained a modest reputation for his cloudy mountain landscapes. *See* P'O-MO.

Regardless of the identification of Yü-chien, several important paintings with this signature found in Japanese collections give us some idea of the development of Ch'an landscape painting apart from the major master Mu Ch'i. Yü-chien's landscapes, with the extremely abbreviated approach, take the void of Ma Yüan to a kind of ultimate conclusion. The void becomes the subject of the painting, with blurred forms emerging and disappearing in the all-enveloping mist. The unsubstantial landscapes, full of wet "spontaneous" brushstrokes and depending on mystery rather than clarity, seem the visual equivalent of the Zen *kōan. See* MA YUAN; MU CH'I; ZEN.

BIBLIOGRAPHY. *Sekai bijitsu zenshu*, XX, Tokyo, 1955; J. Cahill, *Chinese Paintings, XI-XIV Centuries*, New York [1960]. MARTIE W. YOUNG

YIN-YANG. Famous Chinese symbol of duality, denoting male-female, active-passive, and so on. It is represented by a circle divided into two equal parts by an S-shaped line through the center. One half of the circle is black; the other half, white.

YI SANG-JWA (Hak-bo). Korean painter (fl. late 16th cent.). He excelled in both landscape and figure painting and is said to have followed the style of the Northern Sung masters. Although he came from a "slave-class" family, he was admitted to the Royal Academy because of his extraordinary talent. His painting of a windblown pine tree jutting from a crag beneath the moon, entitled *Moon Viewing* (Seoul, Toksu Palace Museum of Fine Arts), is his best-known masterpiece.

BIBLIOGRAPHY. E. McCune, *The Arts of Korea*, Rutland, Vt., 1962.

YKENS, FRANS. Flemish painter (b. Antwerp, 1601; d. ca. 1693). He was the nephew and pupil of Osias Beert. Ykens was primarily a painter of still life. The greater part of his production consists of breakfast pieces done during his early years, but flower-and-fruit garlands around medallions painted by others are also extant.

BIBLIOGRAPHY. W. Bernt, *Die niederländischen Maler des 17. Jahrhunderts...*, vol. 3, Munich, 1948.

YKENS, PIETER, II. Flemish artist (b. Antwerp, 1648; d. 1695). He painted religious subjects and portraits, and did cartoons for tapestries. This prolific artist worked in the Van Dyck tradition, tempered by classicist tendencies.

BIBLIOGRAPHY. R. Oldenbourg, *Die flämische Malerei des 17. Jahrhunderts*, 2d ed., Berlin, 1922.

YOGA. Indian doctrine of the uniting of the spiritual with the physical, or communion with the universal spirit. It is loosely applied to anything signifying "oneness," as an image maker with his image. One who practices yoga is called a yogi.

YOKOYAMA, TAIKAN. Japanese painter (1868–1958). Trained by Gahō, Yokoyama became one of the most important painters in modern Japan. He followed the spiritual guidance of Okakura, whom he helped to found the Nihon Bijutsuin group of artists. Yokoyama stood against the general tendency of the period toward linearism and preferred soft washes almost without the use of clear outlines, thereby creating a deep poetic impression. *See* HASHIMOTO, GAHO.

BIBLIOGRAPHY. N. Ueno, *Japanese Arts and Crafts in the Meiji Era* (Centenary Culture Council Series, Japanese Culture in the Meiji Era, vol. 8), Tokyo, 1958; C. Yoshizawa, *Taikan, Modern Master of Oriental-Style Painting, 1868-1958*, Tokyo, 1962.

YONI. Hindu symbol of the female organ of generation, in the form of a ring. The *yoni* is an object of Sakti worship.

YON-TAN, *see* KIM MYONG-GUK.

YORK CATHEDRAL. Post-Norman English church whose east arm was rebuilt in 1154–81. The crypt remains, with squat piers and ribbed vault. The first stages of the great Gothic remodeling program began about 1226 with the south transept on an ambitious scale and with rich Early

York Cathedral. The nave of this English Gothic Church.

English detail. It was completed about 1241. The north transept was begun about 1242. Both transepts have aisles, and the north has the famous "Five Sisters" window, a group of five lancets, each 54 feet high and 5 feet wide. This transeptal phase was complete about 1255.

Nave work began about 1291 and was completed by about 1345, except for vaulting. The great space, a span of 58 feet, presented complicated problems to Master Simon. The vaults were eventually erected (1354–70), then suspended from a timber frame. This remarkable prefabricated work was done by the carpenter Philip Lincoln. The nave shows an increased feeling for verticality with the clerestory mullions embracing the lower gallery. The west window was glazed in 1338.

Reconstruction commenced on the choir from 1361 and on an equally ambitious scale. There are two phases: 1361–70, comprising a four-bay retrochoir, the Chapel of St. William of York, an ambulatory, and the Lady Chapel; and 1380–1400, comprising the five western bays of the choir. For the first phase William Hoton was the designer, and for the second, Hugh Hedon, who put up the east window from about 1400–05. The choir is the largest in England, nine bays long and longer than the eight-bay nave. The central tower is of a breadth that makes it one of the most satisfactory, from an interior viewpoint, in England. It was designed by William of Colchester, a pupil of Henry Yevele, between 1407 and 1423.

The west front still lacked its towers, and the southwest one was begun about 1432 above an earlier lower story. The designer was Thomas Pak, who had probably completed it by his death in 1441. The northwest tower was not started until 1470 but was quickly completed by 1474. At about this time the central tower was vaulted by William Hyndeley, who began building the pulpitum shortly after the consecration in 1472. York is preeminent for its stained glass, especially the filling of the great east window by the glazier John Thornton of Coventry.

BIBLIOGRAPHY. J. Harvey, *The English Cathedrals*, 2d ed., London, 1956; G. II. Cook, *The English Cathedral through the Centuries*, London, 1957.

JOHN HARRIS

YORK SCHOOL, *see* NORTHUMBRIAN ART.

YORUBA, *see* AFRICA, PRIMITIVE ART OF (WEST AFRICA: NIGERIA); NIGERIA.

YOSHIDA, HIROSHI. Japanese painter and printmaker (1876–1950). His father, Kosaburō Yoshida, studied with Antonio Fontanesi, one of the first European artists to teach in Japan, and his work reflected the Italian influence. Hiroshi Yoshida studied in Kyoto and Europe, and he skillfully incorporated the technique of European painting into wood-block prints. His sons, Toshi (1911–) and Hodaka (1926–), continue the tradition of the Yoshida family in printmaking.

BIBLIOGRAPHY. O. Statler, *Modern Japanese Prints: an Art Reborn*, Rutland, Vt., 1956.

YOSHIDA, ISOYA. Japanese architect (1894–). Yoshida teaches architecture at the Tokyo College of Art. Many of his works reflect a strong influence of the native tradition, particularly evident in the way in which he successfully introduces gardens into architecture. Yoshida's efforts to revitalize the native tradition, and at the same

Junzō Yoshimura, exhibition temple with Japanese tea garden. Philadelphia Museum of Art.

time to transform it to suit modern needs, are crystallized in such works as the Tsuruya Restaurant in Kyoto, the Gotō Art Museum in Tokyo, and Yamato Bunkakan Museum in Nara prefecture. He is also known in Europe for his Japanese Cultural Center in Rome.

BIBLIOGRAPHY. U. Kultermann, *New Japanese Architecture*, New York, 1961.

YOSHIMURA, JUNZO. Japanese architect (1905–). He teaches at the Tokyo College of Art. As a young man, he worked in the Tokyo office of Antonin Raymond. Junzō Yoshimura is well known in the United States for an exhibition house built originally for the Museum of Modern Art, New York, and later transferred to the Philadelphia Art Museum; and for the Hotel on the Mountain in Suffern, N.Y. He is primarily a designer of residential houses, and his works often show a lively treatment of interiors.

BIBLIOGRAPHY. U. Kultermann, *New Japanese Architecture*, New York, 1961.

YOUNG, AMMI B. American architect (1798–1874). Born in New Jersey, he was possibly a pupil of Alexander Parris. Young was a vigorous designer who handled the forms of the various revival styles with firmness and integrity. He was active in New England, and designed the U.S. Custom House (1840), Boston. Between 1852 and 1860 he was the Treasury Department architect.

YOUNG, MAHONRI MACKINTOSH. American sculptor and printmaker (1877–1957). Born in Utah, he studied at the Art Students League in New York City and at the Académie Julian and elsewhere in Paris. Young received awards at the American Art Association in Paris in 1904, at Buenos Aires in 1910, at the National Academy of Design in 1911 and 1932, and at the Panama-Pacific Exposition in 1915. Among characteristic and well-known examples of Young's sculpture, most of it in bronze, are the *Sea Gull Monument* (Salt Lake City); *Man with a Pick* (New York, Metropolitan Museum); *Laborer* and *Rigger* (Newark Museum); *Prizefighters* (Brooklyn Museum); and *Groggy*, a dazed boxer (New York, Whitney Museum). He taught for many years at the Art Students League.

Young's style was formulated early in his career, and though it underwent a certain maturation, it remained typically free of identification with avant-garde 20th-century expression. He was a realist and preferred to work with subjects such as workers and athletes.

YOUNG ENGLISHMAN, THE. Oil painting by Titian, in the Pitti Palace, Florence. *See* TITIAN.

YOUNG LADIES OF AVIGNON, *see* DEMOISELLES D'AVIGNON, LES.

YOUNG SAILOR, THE. Oil painting by Matisse in the Mr. and Mrs. Leigh Block Collection, Chicago. *See* MATISSE, HENRI EMILE.

YOUNG WOMAN WITH WATER JUG. Oil painting by Vermeer, in the Metropolitan Museum of Art, New York. *See* VERMEER, JOHANNES REYNIERSZ.

YPRES. City in western Belgium, situated in the province of West Flanders. Ypres, called Ieper in Flemish, was founded early in the 10th century by Baldwin II the Bald, count of Flanders. By the late 11th century Ypres was important for its manufacture of textiles, which has remained to the present the chief source of wealth of the city. The city was fortified in 1214, and survived many wars until World War I, when it suffered nearly complete destruction. Ypres's greatest prosperity occurred in the 13th and 14th centuries, when it was one of the major centers of art in the Scheldt region. Its prominence was eclipsed by that of other Flemish cities in the 15th century.

From the late Romanesque period date the tower and west portal of the Church of St-Pierre. During the 13th century a distinctive architectural style appeared in Ypres, particularly in the Collegiate Church of St. Martin (begun in 1221), and other centers in the Scheldt region. It represents a fusion of local traditions with influences from the French cathedral Gothic style. The features of the Scheldt Gothic style are the use of the polygonal apse, Tournai capitals, a triforium with alternating coupled piers, a crossing tower flanked by four small round stair towers, exterior balconies on the upper windows, and the placing of four chapels at the angles of the *chevet*. This style spread north to Holland in the course of the 13th century. In Ypres is found another creation of Scheldt Gothic architecture, The Great Market, begun in 1200, which is the earliest example of a covered market.

Ypres played a minor role in the great age of Flemish art; during the 15th century it was dominated by its more powerful neighbor, Bruges. The only important painter to come from Ypres was Broederlam, who, it seems, took his training elsewhere and sought patronage in the courts of Burgundy.

Several interesting 16th-century palaces, among them the Ghent Palace and the Biebuyck House, the latter built in 1544, are found in Ypres. The Merghelynck Palace typifies the ornateness of Flemish baroque architecture. The Municipal Museum in the old meat market houses a collection of Ypres art.

See also CLOTH HALL, YPRES.

BIBLIOGRAPHY. H. Hymans, *Brügge und Ypern*, Leipzig, 1900; V. de Deyne, *Ypres avant et après la guerre mondiale*, Liège, 1926; A. van de Walle, *Histoire de l'architecture en Belgique*, Brussels, 1951.
DONALD L. EHRESMANN

YSELIN (Iselin). German sculptor (d. 1513). Yselin was born in Constance. He worked almost exclusively in wood: he made the choir stalls and altar for St. Gall Church in Bregenz, sculptural busts for the pews of Kloster St. Katherinental, and busts of prophets and apostles for the Constance Cathedral. His is a unique expressionistic style that recalls the work of Nikolaus Gerhard from Leyden, who had worked in Constance in 1467 with Yselin's father-in-law, Simon Haider.

YSENBRAND, ADRIAEN, *see* ISENBRANDT, ADRIAEN.

YSTAD: CONVENT CHURCH OF ST. PETER. Swedish church belonging to the group of Hanseatic, or Baltic, late Gothic brick structures of the 14th century, which also includes the Church of St. Peter at Malmö.

BIBLIOGRAPHY. E. Lundberg, *Byggnadskonsten i Sverige under Medeltiden, 1000–1400*, Stockholm, 1940.

YU. Chinese term designating a class of ancient ceremonial bronzes. The *yu* is a covered wine bucket with a tightly fitted lid and a swing handle used for carrying. It is usually oval or round in section and appeared frequently among the bronzes of the Shang and early Chou dynasties. The shape disappeared after about 900 B.C. The name *yu* was given to the vessels of this description by Chinese scholars during the Sung dynasty (960–1279), and as far as is now known the term was not current during the periods when the vessels were actually made. *See* CHINA: BRONZES.

BIBLIOGRAPHY. W. K. Ho, "Shang and Chou Bronzes," *Cleveland Museum of Art Bulletin*, LI, Sept., 1964.

YU (Jade), *see* CHINA: JADE.

YUAN, FOUR MASTERS OF, *see* HUANG KUNG-WANG; NI TSAN; WANG MENG; WU CHEN.

YUAN ART, *see* CHINA: ARCHITECTURE, CALLIGRAPHY, CERAMICS, JADE, LACQUER, PAINTING, SCULPTURE.

YUAN CHIANG. Chinese landscape painter (fl. Manchu court, early 18th cent.). He came from Yang-chou, the city that sponsored the great individualists of the Ch'ing period, but his paintings are mostly of bizarre and fantastic landscapes executed on a large scale. Many of his paintings came into American and European collections in the early part of the 20th century disguised with signatures of Kuo Hsi and other eminent artists of the monumental-landscape school.

BIBLIOGRAPHY. J. Cahill, "Yüan Chiang and His School," *Ars Orientalis*, V, 1963.

YU-CHIEN, *see* YING YU-CHIEN.

YU-CHUN, *see* YI IN-MUN.

YUEH WARE. Famous class of Chinese ceramic ware. The term "Yüeh" is derived from the ancient Yüeh-chou (modern Shao-hsing) in Chekiang Province, but the name

Yumedono. Octagonal pavilion (Hall of Dreams) in the Tōin (Eastern Precinct) of the Hōryūji, near Nara, dating from before 761.

applies to most of the early celadon wares manufactured in southern China around Hang-chou. The term also covers the famous 10th-century ware referred to in literary sources as *pi-se*, or "secret color," ware which became so greatly coveted throughout the Far East when it was reserved for the exclusive use of the house of Wu-Yüeh. The ware is gray-bodied with a thick olive-colored glaze and is the ancestor of celadon. *See* CELADON.

Yüeh ware has a long history in China, going back to at least the Earlier Han dynasty (2d–1st cent. B.C.). It was the first of the great classic wares, the first at least to be referred to by the term *tz'u* in literary sources. During the T'ang dynasty the ware was refined considerably in body while the grayish-green glaze continued to be admired and celebrated by poets and writers. The ware was produced in Chekiang Province. In its heyday (6th–10th cent.) it reigned supreme and was exported in great quantities to southeast Asia and the Near East, where it was eagerly sought after. No other ware in Chinese history has had quite so long a history of total admiration.

BIBLIOGRAPHY. O. Karlbeck, "Proto-Porcelain and Yüeh Ware," *Transactions of the Oriental Ceramic Society*, XXV, 1949–50; G. S. G. M. Gompertz, *Chinese Celadon Wares*, London, 1958.

MARTIE W. YOUNG

YUGOSLAVIA, MUSEUMS OF. See under the names of the following cities:
Belgrade. National Museum of Yugoslavia.
Ljubljana. National Museum of Ljubljana.
Sarajevo. Museum of Sarajevo.
Split (Spalato). Archaeological Museum of Split; Palace of Diocletian.
Zadar. Archaeological Museum.
Zagreb. Archaeological Museum; Modern Gallery; Museum of Minor Arts; Picture Gallery (Strossmayer Gallery).

YUIMA, *see* VIMALAKIRTI.

YUMA INDIANS, *see* NORTH AMERICAN INDIAN ART (SOUTHWEST).

YUMEDONO. Japanese Buddhist temple at the Tōin (Eastern Precinct) of the Hōryūji near Nara. It was built for Prince Shōtoku by the priest Gyōshin as the main hall of the Tōin, at the site of the prince's palace. The date of the temple is not certain, but it was completed prior to 761. It has been restored a number of times, most extensively in 1230. However, the octagonal building standing on a double stone terrace, and a bronze finial surmounting the entire structure, still preserve the original features of the Nara construction. The portrait sculptures of Gyōshin and others and the statue of the Yumedono Kannon are housed here. *See* HORYUJI; YUMEDONO KANNON.

BIBLIOGRAPHY. Tokyo National Museum, *Pageant of Japanese Art*, vol. 6: *Architecture and Gardens*, Tokyo, 1952; National Commission for the Protection of Cultural Properties, ed., *Kokuhō (National Treasures of Japan)*, vol. 1: *From the Earliest Time to the End of the Nara Period*, Tokyo, 1963.

YUMEDONO KANNON. Japanese sculpture (7th cent.), in Yumedono of the Hōryūji, near Nara. It is made of wood and covered with gold leaf. Also known as the Kuze Kannon (World-saving Kannon), it stood wrapped in layers of silk until the 19th century and is therefore in an excellent state of preservation. The tall figure, with its slender proportions, long, draped scarves crossing before the knees, and sharply delineated facial features set in a faint smile, bears a close resemblance to the attendants of the Shaka Triad by Tori Busshi, in the Golden Hall of the Hōryūji. *See* TORI BUSSHI.

BIBLIOGRAPHY. L. Warner, *Japanese Sculpture of the Suiko Period*, New Haven, 1923; Tokyo National Museum, *Pageant of Japanese Art*, vol. 3: *Sculpture*, Tokyo, 1952.

YUN-KANG. Complex of caves located near Ta-t'ung, in Shansi Province near the Great Wall of China. Ta-t'ung was the capital of the Tatar tribes known to history as the Northern Wei. The name Yün-kang literally means "cloud hill," and refers to the sandstone cliffs where cave temples, following Indian precedent, were hollowed out. Approximately forty caves and numerous statuary niches can be seen at this site, one of the most famous of all Buddhist monuments in Asia. Work was begun under the Northern Wei in 460 and continued for thirty-four years, thousands of stonemasons and sculptors being employed to create this great tribute to the new religion. The shift of the Wei capital to Lo-yang in Honan Province ended the intense activity at this site, although a small number of caves were fashioned between 500 and 535.

Of the early caves the first five that were excavated are sometimes referred to as the T'an-yao caves after the name of the priest who instigated the work. Constructed under imperial patronage, the five caves are colossal in size, patterned unquestionably on the model of the colossal Buddha images at Bāmiyān in Afghanistan, known throughout the Buddhist world. Cave 20, one of the most frequently reproduced of the Yün-kang series, contains a giant seated Buddha measuring 45 feet from base to top. The roof and façade of this cave have fallen away to reveal the Buddha seated in the meditation pose. The drapery of the monastic robe is derived from the string pattern seen at Bāmiyān, while the full, pudgy faces show traces of Gandhāra and Central Asian styles. From this hybrid style, created no doubt by Central Asian artists who were brought to the Wei center of culture from Tunhuang to the west, a more Chinese style gradually evolved and can be detected in the caves made toward the end of the 5th century. Cave 6, for example, thought to be the last cave constructed before the move of the Tatar capital south, is sumptuous and well organized. In contrast to the T'an-yao series, which were basically simple cave openings in the façade of the cliff, the later caves were intended to be chapels, complete with anterooms. The interior walls of Cave 6 are arranged in horizontal registers, the upper series consisting of niches with Buddhas, Bodhisattvas, and other heavenly beings, while the lowermost register contains reliefs depicting the life of the historical Buddha. The style is much more linear and seems to fuse successfully the polyglot vocabulary of early Buddhism in China. *See* BAMIYAN; TUN-HUANG.

The caves that were made after the transfer of the capital in 494 reflect the fully mature Six Dynasties style seen at Lung-men. Cave 11, for example, dating from the early 6th century, carries the trend of Cave 6 another step forward. The Buddha image has become slimmer, taking on the elongated and attenuated figure proportions so typical of the Six Dynasties style at Lung-men.

BIBLIOGRAPHY. S. Mizuno, "Archeological Survey of the Yünkang Grottoes," *Archives of the Chinese Art Society of America,* IV, 1950; L. Sickman and A. Soper, *The Art and Architecture of China,* Baltimore, 1956; S. Mizuno and T. Nagahiro. *Unkō sekkutsu (Yün-kang, The Buddhist Cave Temples of the Fifth Century A.D. in North China),* 16 vols., Kyoto, 1951–56.

MARTIE W. YOUNG

YUNKERS, ADJA. Latvian-born American printmaker, painter, and pastelist (1900–). Born in Riga, he studied in Leningrad, Berlin, Paris, and London before going to the United States in 1947. From 1942 to 1945, in Stockholm, he edited and published *Creation, ARS,* and *ARS-Portfolios* containing original prints by Scandinavian artists, and in 1950 published *Prints in the Desert* in Albuquerque, N.Mex. He has been awarded two Guggenheim fellowships and a Ford Foundation grant. His most ambitious print was published in 1953, a polyptych of large color woodcuts, with a center panel entitled *Magnificat.* It has been described as his personal ontology, combining symbolism and abstraction.

BIBLIOGRAPHY. Stedelijk Museum, *Adja Yunkers,* Amsterdam, 1962.

YUN SHOU-P'ING (Yün Nan-t'ien). Chinese landscape and bird- and flower-painter (1633–90). That Yün Shou-P'ing is usually considered among the "Six Great Masters" of the Ch'ing period is indicative of the high esteem in which he is held in Chinese circles. He is perhaps best remembered for his many flower paintings (although his landscapes exist in some numbers), and he may well be considered the last great painter of this particular genre. Since he was born of a poor family and held no high office, being for the most part a professional painter, his influence on his contemporaries was less than in the case of the Four Wangs.

YURIRIA (Yuririapundaro), CHURCH OF. Part of an Augustinian monastery in northwestern Mexico, dedicated to St. Paul. Originally founded as a secular site, it became Augustinian in 1550. Under the builder-director Fray Diego de Chávez, work began in the late 1550s and continued into the 1560s (dated earlier by some); Pedro del Toro was *maestro mayor.* Building was completed by Gerónimo de la Magdalena. Related to the Augustinian work at Acolman (the church façade is an elaborated variant of Acolman), it is of more massive and complex construction. The church interior has a coffered nave vault, with crossing and apse in ribbed vaulting; a magnificent cloister is attached to the church. *See* ACOLMAN, MONASTERY CHURCH OF.

BIBLIOGRAPHY. D. Angulo Iñiguez, *Historia del arte hispanoamericano,* vol. 1, Barcelona, 1945; G. Kubler, *Mexican Architecture of the Sixteenth Century,* 2 vols., New Haven, 1948.

YUROK INDIANS, *see* NORTH AMERICAN INDIAN ART (CALIFORNIA).

YURT. Tent used by nomadic Kirghiz and Kazakh tribes. Covered with felt, which may be rolled up, the framework of the yurt is a cylindrical lattice of branches with a conical roof. It is easily taken down and reassembled.

YUSHO (Kaiho Yusho). Japanese painter (1533–1615). He was a warrior and studied painting with Motonobu. Kaihō Yūshō was also influenced by the works of Liang K'ai of Sung China. Yūshō's works vary from brilliantly colored screens to quieter ink paintings. His training as a warrior is revealed in his vigorous, swift, yet subtle handling of ink and brush. *See* LIANG K'AI; MOTONOBU.

BIBLIOGRAPHY. J. E. H. C. Covell, *Masterpieces of Japanese Screen Painting: The Momoyama Period (Late 16th Century),* New York, 1962.

Z

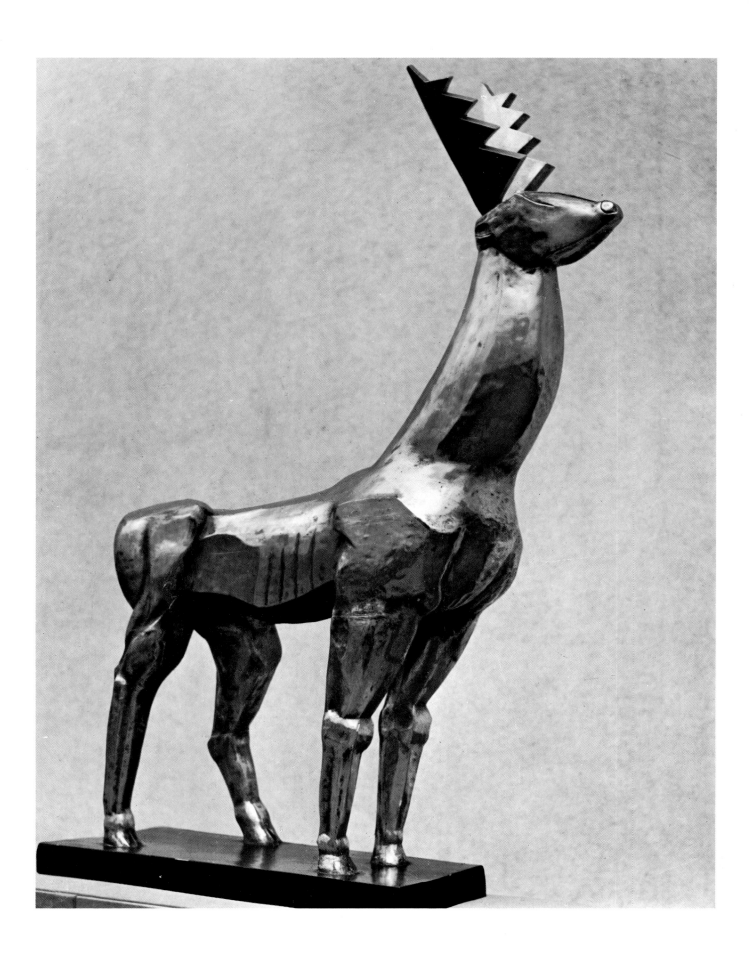

ZACATECAS CATHEDRAL. Former parish church in north-central Mexico, begun in 1567. Work continued between 1602 and 1625 under Francisco Jiménez. The building was reconstructed after 1718; although dedicated in 1752, it was not completed until 1761. It was made a cathedral in 1864. The exterior has extraordinary main and side façades of local brownish stone; the principal façade, dating to the 1740s and 1750s, has a proliferation of foliate ornament over twisted columns, with a complex iconographical scheme. The side portals are more "folk," though with inventive details. The interior was revised in 1852.

BIBLIOGRAPHY. F. de la Maza, "El arte en la ciudad de Nuestra Señora de los Zacatecas," *México en al Arte*, VII, 1949; D. Angulo Iñiguez, *Historia del arte hispanoamericano*, vol. 2, Barcelona, 1950.

ZACATLAN, MONASTERY CHURCH OF. Monastery church at a remote frontier site in southern Mexico. The first church building dates from 1562–67, but the present church probably dates from the 1580s (incorporating inscriptions from the older church). It is part of an unusual group of classicizing three-aisled basilicas, including Tecali and Quecholac. The simple exterior features a wide façade and end towers. Interior aisles are divided by round-headed arches on Tuscan columns, with walled *oculi* on the upper part of the nave. The present ceiling, of wood, apparently replaces a more elaborate early construction.

BIBLIOGRAPHY. J. McAndrew and M. Toussaint, "Tecali, Zacatlán, and the Renacimiento Purista in Mexico," *Art Bulletin*, XXIV, December, 1942; G. Kubler, *Mexican Architecture of the Sixteenth Century*, 2 vols., New Haven, 1948.

ZACCAGNI FAMILY. Italian architects of the school of Parma (fl. ca. 1500–50). Bernardino Zaccagni (1455–1529) and his son Giovanni Francesco Zaccagni (1491–1543) were the most important architects of the Renaissance in Parma. Their work was influenced by the Lombard style and particularly by Bramante. Bernardino worked on the completion of S. Giovanni Evangelista (1510–25) and on

Ossip Zadkine, *Stag*, 1927. Bronze. Stedelijk Museum, Amsterdam.

the Church of the Steccata (begun in 1521). The latter was designed by Giovanni Francesco, who also built the Church of S. Luca in Parma (begun in 1529).

ZACCARIA DA VOLTERRA, *see* ZACCHI, ZACCARIA.

ZACCHI, GIOVANNI. Italian medalist, architect, and sculptor (b. Volterra, 1512; d. Rome? 1565). He was the son and pupil of Zaccaria Zacchi. Giovanni worked in Bologna, Venice, and Rome. A number of his portrait medals, those of a 1537 casting, have survived. He also created terra-cotta statues in Bologna.

ZACCHI, ZACCARIA (Zaccaria da Volterra). Italian painter and sculptor (b. Arezzo, 1473; d. Rome, 1544). His major work was the sculptural decoration for the residence of Cardinal Bernardino Clesio, the Castle of Buonconsiglio, in Trent, which he began in 1535. Earlier, Zaccaria had worked in Bologna on decorations for the triumphal entry of Charles V.

ZACCHIA, LORENZO (Zacchia il Giovane). Italian painter and engraver (b. Lucca, 1524; d. there, after 1587). His many works in the churches and the National Gallery of Lucca show him to be strongly influenced by Zacchia di Antonio and the Florentines Fra Bartolommeo and Bronzino.

ZADAR: ARCHAEOLOGICAL MUSEUM. Yugoslavian collection. In addition to its ancient and medieval sculpture, the Zadar Museum is noted for its outstanding collection of Roman glass.

ZADKINE, OSSIP. French sculptor and teacher (1890–1967). He was born in Smolensk, Russia, and lived and taught in Paris. In 1906 he studied at the Polytechnic School of Art, London, and in 1909 he was at the Ecole des Beaux-Arts, Paris. He began stone carving in 1911 and was influenced by Rodin, African art, and cubism, as can be seen in *The Prophet* (1915; Grenoble Museum) and

Woman with a Fan (1918). His first exhibition was in Belgium, in 1919, and after 1922 he had several other shows in Holland, where his work is especially highly regarded.

From 1946 to 1953 he was professor of sculpture at the Grande-Chaumière Academy in Paris; he also taught at his own school. In 1951–53 he worked on a commission from Rotterdam for a memorial to the victims of the Nazis' destruction of that city. *Orpheus* (1928) is in the Petit Palais Museum, Paris; *Stag* (1927) is in the Stedelijk Museum, Amsterdam; and the 1949 version of *Orpheus* is in the National Museum of Modern Art, Paris. One of the pioneering cubists, Zadkine was an influential teacher.

BIBLIOGRAPHY. O. Zadkine, *Zadkine* [by] A. M. Hammacher, New York, 1959.

ZAGANELLI, FRANCESCO. Italian painter of Cotignola (ca. 1480–1531). Active in Ravenna, he worked first with his brother Bernardino (ca. 1470–1510), and then alone, doing many altarpieces. Influenced by Amico Aspertini and others in Ferrara, Zaganelli's work shows a skilled High Renaissance, even Raphaelesque, base, dynamized in twisted poses, thin shapes, and gaudy cloth. It is also possibly influenced by knowledge of the Antwerp mannerists.

BIBLIOGRAPHY. A. Martini, *La Galleria dell'Accademia di Ravenna,* Venice, 1959.

ZAGREB: MUSEUMS. Important public art collections in Zagreb, Yugoslavia, are located in the museums listed below.

Archaeological Museum. Among other objects, the museum owns the famous mummy of a red-haired woman from Alexandria, wrapped in bandages decorated with Etruscan letters. This Etruscan text is the longest in existence.

Modern Gallery. The Modern Gallery of the Yugoslavian Academy of Arts and Sciences is exclusively devoted to examples of Croatian and Yugoslavian painting and sculpture of the 18th and 19th centuries.

Museum of Minor Arts. It contains a rich collection of old textiles and furniture as well as book bindings, ceramics, and clocks.

Picture Gallery (Strossmayer Gallery). The Picture Gallery of the Yugoslavian Academy of Arts and Sciences has the largest collection of old master western European paintings in the Balkans. It contains works by Fra Angelico, Veronese, Piazzetta, and David Teniers and an outstanding portrait by Antoine-Jean Gros.

ZAIS, GIUSEPPE. Italian painter of landscapes (b. Forno di Canale, Agordo, 1709; d. Treviso, 1784). His style was initially based on that of Marco Ricci, but Zais's later work shows the influence of Francesco Zuccarelli, who settled in Venice about 1732. The Villa Pisani at Stra has some decorative frescoes by Zais.

BIBLIOGRAPHY. R. Pallucchini, *La pittura veneziana del Settecento,* Venice, 1960.

ZAKHAROV (Sacharov), ADRIAN DMITRIEVICH. Russian architect (1761–1811). He worked in St. Petersburg. He studied in Paris (1782–86) under Chalgrin and then traveled in Italy. Zakharov's masterpiece, the Admiralty (1806–15), is considered the high point of Russian classicism; it combines a Russian concept of extended length, variety of silhouette, and geometric forms with the monumental scale and classical vocabulary of the French Empire style. He also designed Kronstadt Cathedral. *See* KRONSTADT CATHEDRAL.

BIBLIOGRAPHY. D. Arkin, *Zakharov i Voronikhin,* Moscow, 1953.

ZAKRO. Minoan town complex on the eastern coast of Crete. (A lower part on the coast was called Kato Zakro, and an upper, inland part was called Epano Zakro.) Zakro was an important link in the trade routes between Cnossus and the Orient, especially Egypt. Traces of habitation in the area of the site have been found from the Neolithic (before 3000 B.C.) and Early Minoan (ca. 3000–2000 B.C.) periods, but it was not until the period between 1700 and 1500 B.C. (Middle Minoan III and Late Minoan I) that Zakro was extensively settled.

Excavation of a number of houses at Zakro revealed pottery and artifacts belonging to the Late Minoan period. The most important find, however, was a hoard of stone stamp seals decorated with lively, fantastic designs that were produced by elaborate variations of patterns drawn from animal, marine, and floral life, and even from Egyptian hieroglyphs.

In 1961 a joint Greek and American excavation at Kato Zakro discovered and began to clear a structure that appears to be a Minoan palace similar to those at Cnossus, Phaestus, and Mallia.

BIBLIOGRAPHY. D. G. Hogarth, "Excavations at Zakro, Crete," *Annual of the British School at Athens,* VII, 1900–01; D. G. Hogarth, "The Zakro Sealings," *Journal of Hellenic Studies,* XXII, 1902. JEROME J. POLLITT

ZALCE, ALFREDO. Mexican painter (1908–). Zalce was born in Pátzcuaro, Michoacán. His long years at art schools help account for his impressive mastery of mural, easel, and graphic techniques. The first Mexican artist to apply frescoes to cement, Zalce was also one of the first to use plastics and was among the first members of the Workshop for Popular Graphic Art. Since 1931 he has been at times art educator, cultural missionary to the provinces, and charter member of the League of Revolutionary Writers and Artists. In his murals (for example, those at the Government Palace in Morelia) Zalce often suggests a calm Orozco. His prints, although many are reminiscent of Covarrubias and Posada, possess a superb control of line and composition that is all his own.

See also TALLER DE GRAFICA POPULAR.

BIBLIOGRAPHY. A. Reed, *The Mexican Muralists,* New York, 1960.

ZAMORA CATHEDRAL. Spanish church begun in 1152 and dedicated in 1174. Many indications suggest the architect was not Spanish (for example, the Oriental qualities of the Bishop's Door and the somewhat exaggerated style of the crossing tower). The transept façade has touches of Poitevin influences, and the nave is strongly Burgundian in flavor. The lantern over the crossing was partly inspired by the Church of the Holy Sepulchre in Jerusalem, which had been dedicated in 1149, but there are also French and Muslim elements in the dome construction.

Besides the fine Romanesque sculptures of the Bishop's Door, there are elaborately carved 15th-century Gothic choir stalls and the notable tombs of Juan Mella and Canon Juan de Granada.

BIBLIOGRAPHY. K. J. Conant, *Carolingian and Romanesque Architecture, 800–1200,* Baltimore, 1959.

ZAMPIERI, DOMENICO, *see* Domenichino.

ZANGUIDI, JACOPO, *see* Bertoja.

ZANOBI, MACHIAVELLI, *see* Machiavelli, Zanobi.

ZAO WOU-KI. Sino-French painter and printmaker (1921–). Born in Peking, he studied at the School of Fine Arts in Hangchow and taught there until 1947. By the time of his first exhibition in Shanghai (1941), his work already showed the influence of Western artists, notably Picasso, Matisse, and Modigliani. After settling in Paris (1948) he achieved great success with both his paintings and graphic work, exhibiting there for the first time in 1951. His paintings, etchings, and lithographs of this period are highly imaginative evocations of landscapes, animals, and other forms, which drew inspiration from the delicate and concise meanderings of Paul Klee. He has since developed a nonfigurative style using clusters of brushstrokes that resemble a kind of calligraphy.

BIBLIOGRAPHY. N. Jacometti, *Catalogue raisonné de l'oeuvre gravée et lithographie de Zao Wou-ki,* Bern, 1955.

ZAPOTEC ART. The Zapotecs were a pre-Columbian Indian people whose principal center was at Monte Alban, Oaxaca, Mexico. Carbon 14 tests indicate occupation before 600 B.C. with a Classic period ending about A.D. 1000 in a Mixtec occupation. Relations with Mayan peoples are implied. At Monte Alban a mountain top was leveled to

Zapotec art. Idol from Oaxaca. National Museum of Anthropology, Mexico City.

create a great ceremonial city embellished with severely precise temple bases and temples. Zapotec stone sculpture is limited to work in relief; the primary three-dimensional sculptures are in terra cotta. Mitla, near Monte Alban, was a Zapotec necropolis of related rectangular courts, roofed chambers, and subterranean tombs. The walls were covered with geometrical mosaiclike patterns formed by the cut ends of volcanic stone spikes inserted in the adobe wall cores and covered with plaster and paint.

See also Americas, Ancient, Art of (Mexico); Mixtec Art.

BIBLIOGRAPHY. P. Kelemen, *Medieval American Art,* New York, 1943; F. A. Peterson, *Ancient Mexico,* New York, 1959; I. Marquina, *Arquitectura prehispanica,* 2d ed., Mexico City, 1964.

ZARAGOZA, *see* Saragossa.

ZARCILLO, FRANCISCO, *see* Salzillo, Francisco.

ZASINGER, MATTHAUS. German goldsmith and publisher (b. Munich, ca. 1477). A stepson of Hans Uttenhofer. Zasinger is mentioned in Munich documents between 1498 and 1555. In 1507 he was associated with Hans Ostendorfer in Altötting. A portrait bust medal of Friedrich Hagenauer (1525) is by Zasinger. He is generally considered to be identical with Master M. Z., a Munich engraver, although documents shed no light on the question. *See* Master M. Z.

BIBLIOGRAPHY. G. Habich, "Studien zur deutschen Renaissancemedaille," *Jahrbuch der Königlich Preussischen Kunstsammlungen,* XXVIII, 1907.

ZAUNER, FRANZ ANTON VON. Austrian sculptor (1746–1822). A major artist of Austrian classicism, Zauner studied in the school of Johann Beyer, with whom he executed the stone figures in the park of Schönbrunn Castle. He lived in Rome from 1776 to 1781 and reveals his knowledge of contemporary trends in Italian classicism in his great equestrian statue of the Holy Roman Emperor Joseph II in Vienna.

BIBLIOGRAPHY. F. Novotny, *Painting and Sculpture in Europe, 1780–1880,* Baltimore, 1960.

ZAVATTARI FAMILY. Milanese painters, of whom six are recorded (fl. 1404–79). The only certain work, signed "the Zavattaris," is the large fresco cycle of the *Life of Theodolinda* (1444) in Monza Cathedral, the most monumental International Gothic painting in Lombardy. Its aristocratic decorativeness derives from Domenico Michelino, but is less refined.

BIBLIOGRAPHY. R. van Marle, *The Development of the Italian Schools of Painting,* vol. 7, The Hague, 1926.

ZAWIYEH (Ziviya; Ziwiyeh) TREASURE. Rich hoard of gold, silver, and ivory objects discovered in the Iranian village of Zawiyeh, southeast of Lake Urmya. The site was occupied by the Scythians in the 7th century B.C. In 1947 a magnificent treasure was found in a Scythian royal tomb. Earlier civilizations—Assyrian, Babylonian, Urartian, and Iranian of the protohistoric era—probably inspired the Scythian artists, and the findings are evidence of the many contacts the Scythians had with other peoples during the 7th century. These objects (Teheran, Archaeological Museum; New York, Metropolitan Museum; and elsewhere) have been variously dated from the 9th to the 7th

century B.C. and may have belonged to one or several groups of peoples.

Among the Zawiyeh finds were a bronze sarcophagus (London, British Museum), royal weapons, shields, and vases in gold and silver, as well as iron spearheads, terracotta shields, and pottery, suggesting that perhaps guards and servants were sacrificed at the king's death and buried with him. Ivories, gold ornaments and goblets, polychrome jewelry, and articles of furniture decorated with horizontal and vertical plaques of gold and ivory were also found. A silver dish with gold inlays (Teheran, Archaeological Museum) is engraved with concentric circles, within which are typical Scythian representations of crouching stags, hares, and heads of birds.

BIBLIOGRAPHY. A. Parrot, *The Arts of Assyria*, New York, 1961; R. Ghirshman, *The Arts of Ancient Iran: From Its Origins to the Time of Alexander the Great*, New York, 1964.

ZEELANDER, MORYN CLAESSONS, see REYMERSWAELE, MARINUS VAN.

ZEEMAN (Nooms), REINIER. Dutch painter and etcher (b. Amsterdam, 1623; d. there, ca. 1667). He worked in the tradition of Willem van de Velde, painting marinescapes (*Sea Battle near Livorno*; Amsterdam, Rijksmuseum) and city views (*View into a Dutch City*; Kassel, State Picture Collections). Zeeman also executed a considerable number of marine and architectural etchings, the latter being especially notable.

BIBLIOGRAPHY. A. M. Hind, *A Short History of Engraving and Etching*, 2d rev. ed., London, 1911.

ZEFERINO DA COSTA, JOAO. Brazilian painter (b. Rio de Janeiro, 1840; d. there, 1915). He went to Rome (1869), where he worked with Cesare Mariani at the Academy of St. Luke. Zeferino taught for a while at the Academy of Fine Arts in Rio de Janeiro and executed his major works for the Church of Candelária in his native city. These murals, depicting scenes from the history of the church, are in a simple and realistic narrative style.

ZEGERS, GEERAARD (Gerardo Seghers). Flemish painter of historical and religious subjects (b. Antwerp, 1591; d. there, 1651). He apparently studied with Abraham Janssens. Zegers became a master in 1609, left the next year for Rome and Spain, and returned to Antwerp in 1620. In 1635 he worked on the decorations for the Joyous Entry of Cardinal Infant Ferdinand, and two years later he became Painter to His Highness. In 1645 the Guild of St. Luke elected him dean. After Rubens's death Zegers became one of the best-known and wealthiest painters in Antwerp.

His youthful style was pure Caravaggism in the manner of Bartolommeo Manfredi and Gerrit van Honthorst. Numerous half-length figure scenes survive in print only. Shortly before 1630 he switched to the then-fashionable Rubensian manner and colorful palette. Finally, and unsuccessfully, he attempted to parallel the master's painterly conception of 1630–40. From that period stems the *Martyrdom of St. Livinus* (Ghent, St. Bavon).

BIBLIOGRAPHY. R. Oldenbourg, *Die flämische Malerei des 17. Jahrhunderts*, 2d ed., Berlin, 1922; G. Glück, *Rubens, Van Dyck und ihr Kreis*, Vienna, 1933; D. Roggen and H. Pauwels, "Het Caravaggistisch oeuvre van Gerard Segers," *Gentsche Bijdragen*, XVI, 1955–56.

ZEHRFUSS, BERNARD H. French architect (1912?–). He collaborated with Marcel Breuer and Pier Luigi Nervi on the design of the important UNESCO complex at the Place Fontenoy in Paris (1953–58). His style expresses the contemporary idiom, as in the exhibition building of the Centre National des Industries et Techniques (1958; with J. de Mailly and R. Camelot). One of the most significant structures built in France since World War II, it is conceived in bold parabolic planes. *See* UNESCO HEADQUARTERS, PARIS.

ZEITBLOM, BARTHOLOMAUS. German painter (b. Nördlingen, ca. 1455; d. Ulm, 1518). He was the principal exponent of the late Gothic style of painting in Ulm. Little is known about his early training, but because of stylistic affinities to the work of Friedrich Herlin and the Master of the Sterzing Altar it is assumed that Zeitblom studied in Herlin's circle. Zeitblom operated a large workshop in Ulm, which produced many large altarpieces, executed for the most part by assistants. His major works are the *Altar from Kilchberg* (ca. 1482; Stuttgart, State Gallery) and *Altar Wings with SS. Margaret and Ursula* (ca. 1500; Munich, Old Pinacothek).

BIBLIOGRAPHY. A. Stange, *Deutsche Malerei der Gotik*, vol. 8, Munich, 1957.

ZELOTTI, GIAMBATTISTA. Italian painter from Verona (1526–78). An assistant and close imitator of Paolo Veronese in works in Venice, Zelotti later collaborated with other artists in fresco cycles in nearby villas. He uses a harder, linear version of Paolo's early designs, under Raphaelesque influence.

ZEN. Japanese name for a branch of Buddhism known in China as Ch'an Buddhism (the words Zen and Ch'an both derive from the Sanskrit *dhyana*). Zen teaching acknowledges the Buddha nature in every man and maintains that this nature is perceptible through a realization of self. In order to achieve this goal, the Zen sect emphasizes the special importance of long hours of ceaseless meditation and strict self-discipline. Zen teachings are said to have been introduced in China in the late 5th century by a southern Indian monk, Bodhidharma (Japanese, Daruma). The introduction of Zen Buddhism into Japan is generally attributed to Eisai (also called Yōsai), who imported the Rinzai (Chinese, Lin-chi) sect in 1191. Zen, more than any other sect of Buddhism, has penetrated into the secular life of the Japanese, profoundly influencing their art and aesthetics. The development of the tea ceremony and of art forms such as Noh drama, *haiku* poetry, and ink painting depended on the basic teachings of Zen Buddhism.

BIBLIOGRAPHY. D. T. Suzuki, *Essays in Zen Buddhism*, first series, New York, 1949; second series, Boston, 1952; third series, London, New York, 1953; H. Munsterberg, *The Ceramic Art of Japan*, Rutland, Vt., 1964; E. D. Saunders, *Buddhism in Japan*, Philadelphia, 1964.

ZENALE, BERNARDINO. Milanese painter and architect (1436–1526). He painted two works in collaboration with Butinone: the frescoes (1489–93), now ruined, in S. Pietro in Gessate, Milan, and the altarpiece (1485–1507) in S. Martino, Treviglio. Zenale executed an altarpiece (1494) for S. Ambrogio, Milan. He was influenced by Bramante.

Temple of Zeus, Olympia. Fragments of marble sculptures from the west pediment representing the Battle of the Lapiths and Centaurs, 5th century B.C. Archaeological Museum, Olympia.

There are several theories about other groups of works that may have been executed by Zenale.

BIBLIOGRAPHY. *Arte lombarda dai Visconti agli Sforza*, Milan, 1958.

ZENANA. Women's quarter in a Muslim house.

ZENOBIUS OF FLORENCE, ST. Bishop and patron of Florence (d. ca. 422). Born of a noble family, he became an outstanding scholar. In the period of Arian ascendancy, he condemned Arianism and championed Orthodoxy and the Council of Nicaea. Ambrose of Milan recommended Zenobius to Pope Damasus, who sent him to Constantinople to repress heresy. He exorcised devils, healed the blind, and raised the dead. Touched by his coffin, a dead elm tree burst into leaf. His attributes are a tree in leaf and the red lily of Florence on the morse of his cope. His feast is May 25.

See also SAINTS IN ART.

ZERBE, KARL. German-American painter and teacher (1903–). Born in Berlin, he studied with Joseph Eberz and Karl Caspar in Munich and in Italy. Zerbe went to the United States in 1934. Throughout his career he has worked in several variations on his basic expressionism: early, colorful landscapes and flower pieces; the incorporation of influences from Kokoschka, Lehmbruck, and Grosz in the early 1930s; the formally composed still lifes of the late 1930s with a treatment akin to that of Beckmann; and his mature and more personally expressive figures and symbolic paintings. Zerbe has successfully experimented with different media, including encaustic, where the potentially richly colored and worked surface led to particularly happy results, for example, *Harlequin* (1943; New York, Whitney Museum), and most recently with polymer tempera. In his latest paintings his expressionism has approached abstraction.

BIBLIOGRAPHY. F. S. Wight, *Karl Zerbe*, Boston, 1951.

ZEUS (Jupiter). Ancient Greek god of the sky and all its phenomena, akin to the Roman Jupiter. He was considered to be the supreme ruler of gods and men and the administrator of justice and equity. The son of Cronus and Rhea, Zeus wrested celestial power from his father but was forced to fight onslaughts by the Titans and giants to maintain his rule. In his great temple at Olympia, an enormous seated statue by Phidias (5th cent. B.C.) depicted him as a strong, bearded man of great dignity.

ZEUS, ALTAR OF, *see* PERGAMON.

ZEUS, ARTEMISION, *see* ARTEMISIUM ZEUS.

ZEUS, TEMPLE OF, OLYMPIA. Greek temple erected from the designs of Libon of Elis. Begun about 468 B.C., it was dedicated in 460/456 B.C. One of the largest Doric temples on the Greek mainland, it was peripteral and hexastyle and consisted of a cella with a double colonnade and of a distyle-in-antis pronaos and opisthodomos. The temple was built mainly of local coarse shell-like limestone. Parian marble was used for the sculptured parts (pediments and metopes). The east pediment represented the preparation for the chariot race of King Oenomaus and Pelops. The west pediment contained groups representing the Battle of the Lapiths and Centaurs. Above the columns of the pronaos and opisthodomos were twelve metopes carved in relief, depicting the twelve Labors of Hercules. The sculptured pieces (Olympia, Archaeological Museum) are magnificent examples of early classical Greek art. In the interior of the cella the chryselephantine seated statue of Zeus Olympieios, a renowned work by Pheidias, was placed behind a parapet. The temple was destroyed by earthquake sometime during the early Byzantine period. *See* PHEIDIAS; ZEUS.

BIBLIOGRAPHY. W. B. Dinsmoor, *The Architecture of Ancient Greece*, 3d ed., London, 1950. EVANTHIA SAPORITI

ZEUXIS. Greek painter from Herakleia, in southern Italy (fl. late 5th–early 4th cent. B.C.). By elaborating on the innovations in perspective first made by Agatharcus and by further developing the technique of shading begun by Apollodoros, Zeuxis became one of the most influential and famous painters of antiquity. Descriptions of his works by ancient authors indicate that he had a leaning toward exotic subject matter, perhaps a reaction against the idealism of the early classical masters.

Perhaps the most famous work by Zeuxis was the

Family of Centaurs, a copy of which was seen in Athens by Lucian, who described it in detail (*Zeuxis*, 3–8). It has been suggested that other centaur scenes—a mosaic in Berlin and a monochrome on marble from Herculaneum—go back to this work of Zeuxis for their inspiration.

BIBLIOGRAPHY. M. H. Swindler, *Ancient Painting...*, New Haven, 1929.

ZEVIO, STEFANO DA, *see* STEFANO DA VERONA.

ZIA (Sia) INDIANS, *see* PUEBLO INDIANS.

ZIEGLER, JORG, *see* MASTER OF MESSKIRCH.

ZIESENIS, JOHANN GEORG. Danish painter (b. Copenhagen, 1716; d. Hannover, 1777). After studying at the Düsseldorf Art Museum, Ziesenis stayed in Germany and later became painter to the court of Hannover. His brittle, materialistic portraits of court figures are couched in the elegant tonalities of the rococo.

ZIGGURAT (Zikurat). Tall, stepped, pyramidal base upon which a shrine was erected (from the Akkadian, "high one, pointed one"). It was a typical Mesopotamian monument imitating, and even replacing, the sacred mountain, as is implied by such ziggurat names as "House of the Mountain," "Mountain of the Storm," and "Bond between Heaven and Earth." In the initial stage of its development it was perhaps a shrine on a platform with slanting recessed sides, such as the so-called White Temple at Warka, dated 3000 B.C. *See* WARKA: TEMPLE.

The ziggurat dedicated to the moon god by King Urnammu (2125 B.C.) at Ur was built of brick with layers of matting. It had a rectangular plan (190 by 130 m.), oriented to the cardinal points of the compass at its corners and accessible by means of three stairways, one perpendicular to and two lengthwise on the northeast side, rising to about the middle of the structure. An upper stairway led to the top platform. The Assyrian ziggurat, on a square plan, did not have an open stairway (ziggurat of King Tukulti Ninurta I, 1250–1210 B.C.; ziggurat at Assur). That built by Sargon II at Khorsabad (706 B.C.) had a ramp rising around the sides, each of which was recessed and of a different color. In Elam the ziggurat at Choga Zambil had a staircase on each of the three sides.

See also CHALDEAN ART.

BIBLIOGRAPHY. H. J. Lenzen, *Die Entwicklung der Zikkurat von ihren Anfängen bis zur Zeit der dritten Dynastie von Ur*, Leipzig, 1941. ALEXANDER M. BADAWY

Ziggurat. Reconstruction of the ziggurat at Ur, 2125 B.C.

ZIGZAG. Very common and ancient dec[oration] consisting of lines that are bent at regular [intervals at] more or less right angles. It is particularly common in the primitive and archaic phases of various cultures.

ZIJL (Zyl), GERARD PIETERSZ. VAN. Dutch painter of portraits and genre (b. Leyden or Amsterdam, ca. 1609; d. Amsterdam, 1665). In 1639 he was in London working with Anthony van Dyck. On Van Dyck's death in 1641 Zijl returned to Amsterdam.

BIBLIOGRAPHY. J. H. J. Mellaart, "The Works of G. P. van Zyl," *The Burlington Magazine*, XLI, 1922.

ZIKURAT, *see* ZIGGURAT.

ZILLE, HEINRICH. German draftsman and etcher (b. Radeberg, 1858; d. Berlin, 1929). Zille's drawings and graphics alternated between humorous tolerance and satirical indictment of the common people of Berlin. He studied for a short period with Hosemann after training as a lithographer. Zille's satirical style was well suited to the publications to which he contributed: *Lustige Blätter*, *Jugend*, and *Simplicissimus*. His etching portfolios include *Das Heinrich Zille Werke* (1926), *Bilder vom alten und neuen Berlin* (1927), *Zilles Vermächtnis* (1930), and *Zille, sein Milliöh* (1952).

BIBLIOGRAPHY. O. Nagel, *H. Zille*, Berlin, 1955.

ZILLIS: SAINT-MARTIN. Parish church of the Schams Valley, in Switzerland, since 940 (830?). The nave, built over Roman foundations possibly in the 10th century, is flanked by a Romanesque tower. A Gothic apse (1509) replaced the original three apses. The ceiling consists of 153 square wooden panels depicting (1) an outer cycle of a *mappa mundi* with winds, fabulous beasts of sea, land, and air; and (2) an inner cycle of 105 paintings showing a few Old Testament scenes, the genealogy and life of Christ, and a few saints. The style is based on Ottonian prototypes, but the ceiling must be dated shortly before the middle of the 12th century. As the oldest example of its kind in Europe, it can only be compared to the ceiling at St. Michael in Hildesheim.

BIBLIOGRAPHY. E. Poeschel, *Die romanischen Deckengemälde von Zillis*, Zurich, 1941.

ZIMMERMANN, DOMINIKUS. Bavarian architect and stuccoist (b. Gaispoint, near Wessobrunn, 1685; d. Wies, 1766). He worked in close collaboration with his brother, Johann Baptist Zimmermann. Dominikus at first was a stuccoist, and his work in this medium includes six altars for the Abbey in Fishingen, Switzerland, and the stucco decoration in the Rathaus in Landsberg, Germany.

Zimmermann was a prolific architect. His masterpieces are the pilgrimage church at Steinhausen, considered his most elaborate design, and at Wies. Steinhausen marks a new step in the development of the oval church and in the concept of space, predictions of style that are fulfilled in his designs for Die Wies. His style, a mixture of native Bavarian motifs and French elements possibly derived through the influence of Cuvilliés, for whom his brother worked, is notable for its extreme lightness and delicacy.

See STEINHAUSEN, PILGRIMAGE CHURCH OF; WIES, DIE.

BIBLIOGRAPHY. S. L. Faison, "Dominikus Zimmermann," *Magazine of Art*, XLV, 1952.

... decoration, Nymphenburg palace

ZOAMI. Japanese sculptor (fl. 1st half of 16th cent.). Zoami was the pseudonym of the artist and Noh dancer Hisatsugu. He is mentioned in the latter capacity in the writings of the Noh dancer Se-ami, and it is probable that he started carving masks for Noh plays after his dancing career had ended. Few originals of the subtly expressive wooden masks have survived. Zoami also served as an art adviser to the shogun Ashikaga Yoshimitsu. *See* NOH MASK.

ZOAN, ANDREA. Italian engraver and painter (fl. ca. 1475–1505). First forming his engraving style on Mantegna, and later on Dürer, Zoan never succeeded in creating a distinctive personal manner. Early engravings such as *Hercules and Deianeira* copy Mantegna's system of parallel lines of shading with an oblique line laid between. That he was engraving Mantegna's designs in 1475 without Mantegna's consent is known from documentary evidence, and many anonymous prints of the master's school are probably his work.

Zoan greatly simplified Dürer's multidirectional patterns of line, substituting straight parallels and plain crosshatching in his copies of the engravings Dürer made between 1497 and 1503, such as *Virgin and Child with a Monkey* and *St. Jerome in Penitence*. Dürer's example may have confirmed him in his change from Mantegna's style, although he worked after the Italian master's designs throughout his career.

Zoan settled in Milan, probably about 1490, where he made an engraving based on Leonardo's spirited drawing *Lion Attacked by a Dragon*. His most interesting plates are a group of bold and handsome ornament panels.

BIBLIOGRAPHY. A. M. Hind, *Early Italian Engraving*, 2 pts. in 7, London, New York, 1938–48. CAROLINE KARPINSKI

ZODIAC. Twelve constellations, named according to their shapes in the heavens. They are made to correspond to the months of the year, since Hellenistic astronomy held that the sun, moon, and planets passed through these areas or "houses" during their yearly courses. Since it was commonly believed until the 18th century that these planetary travels influenced human fate and daily activities, the astrological zodiac was widely illustrated. Beginning with April, the signs of the zodiac consist of Aries (Ram), Taurus (Bull), Gemini (Twins), Cancer (Crab), Leo (Lion), Virgo (Virgin), Libra (Scales), Scorpio (Scorpion), Sagittarius (Archer), Capricorn (Goat), Aquarius (Water Bearer), and Pisces (Fishes).

ZOFFANY, JOHANN. English painter of conversation pieces and portraits (b. Frankfurt am Main, 1734/35; d. London, 1810). He studied at Regensburg under Martin Speer and, after some years as a traveling painter in Austria and Italy, went to England about 1758. After meeting David Garrick, Zoffany began to paint scenes from the contemporary theater; these made his reputation. He was made full academician of the Royal Academy of Arts in ... He was in Italy and Austria again in 1770 and in ... 1783–89. Zoffany was patronized by the royal ... and painted for Queen Charlotte the celebrated ... showing connoisseurs in the tribune of the Uffizi. He animated the English conversation piece by introducing

Johann Zoffany, *Charles Townley in His Sculpture Gallery*. British Museum, London.

William Zorach, *The Future Generation*, 1942–47. Marble. W... Museum of American Art, New York.

much more in the way of activity and personal anecdote.

BIBLIOGRAPHY. V. Manners and G. C. Williamson, *Johann Zoffany*, London, 1920.

ZOOMORPHIC. Term applied to a large variety of ornamental motifs that consist primarily of animal forms. Zoomorphic ornament was particularly characteristic of the art of the early Germanic tribes. It is also called Germanic and animal ornament.

BIBLIOGRAPHY. B. Salin, *Die altgermanische Thierornamentik...*, 2d ed., Stockholm, 1935.

ZOOPHORUS. Continuous frieze sculptured in relief with people and animals. Notable examples are found in the west portico of the Theseum, with its frieze of the Battle of the Centaurs and Lapiths, and in the Panathenaic frieze on the naos wall of the Parthenon, both in Athens.

ZOPPO, MARCO. Italian painter (b. near Bologna, 1433; d. Venice, 1478). He appears in Padua in 1453–55 as the assistant and adopted son of Francesco Squarcione. He lived chiefly in Venice, but had few commissions there; most of his work was for Bologna. His main works are signed polyptychs in Berlin (from Pesaro) and Bologna (Collegio di Spagna, dated 1471). He has also left numerous drawings, the most interesting being in a parchment album in the British Museum, London. Zoppo's art is dominated by the influence of Cosimo Tura, which he treats in a provincial, niggling manner, but with a firm hand and self-confident stylization.

BIBLIOGRAPHY. A. E. Popham and P. Pouncey, *Italian Drawings in the Department of Prints and Drawings in the British Museum*, 3 vols., London, 1950–62.

ZORACH, WILLIAM. American sculptor (188... Born in Lithuania, he was brought to the United ... a young child. He studied in Cleveland and at the ... Academy of Design from 1906 to 1908 and wi... son and Blanche in Paris in 1910–11. He th... mainly as a painter and exhibited at the Salon ... in Paris in 1911 and at the New York Arm... 1913. He did direct carving before 1920. A... began to devote his energies exclusively to sc... of his work was in very hard stones, and ... in wood; he also did some modeling.

Zorach's painting had been influence... 20th-century avant-garde movements, b... style was more restrained. Using Egyp... chaic Greek sculpture, and to a lesser ... of primitive peoples as referents, he ... volumed, modified naturalistic expres... great stability and quietness. From t... cerned with themes of tenderness—... dren with animals, motherhood, an... used natural boulders in his anim... out the form with great economy ... umentality even when the physi...

Zorach's works in various ... guished collections, public and ... His public monuments include ... New York, Radio City Musi... *lin* (1937; Washington, D.... taught at the Art Students L...

ZORAH: ST. GEORGE, ...

ZORN, ANDERS LEONARD. Swedish painter, etcher, and sculptor (1860–1920). From 1875 to 1881 he attended the Royal Academy Art School in Stockholm. He worked in London (1882–85) and Paris (1888–96) and traveled widely (six trips to the United States). Internationally famous, Zorn returned often to Dalarna, where he painted the healthy peasant girls with as much joy and vivacity as he did the great figures of Paris or Chicago. His nudes are as innocently sensuous as those in Renoir's late works, and his portraits capture the momentary expression and character of his sitters (*Coquelin Cadet*). Although his dancing brush and moving light and color ally him to the impressionists, his forms usually remain more solid than theirs, except in his etchings (*Rodin*), where substance is often dematerialized in the parallel, rapidly flowing lines. His etchings, oils, water colors, and sculpture are in the National Museum, Stockholm; the Zorn Museum, Mora; and major European and American collections.

BIBLIOGRAPHY. A. Romdahl, *Anders Zorn als Radierer*, Dresden, 1922; G. Boethius, *Anders Zorn, an International Swedish Artist*, Stockholm, 1954.

ZOSER, PYRAMID OF, *see* DJESER'S COMPLEX AT SAQ- QARA.

ZSISSLY, *see* ALBRIGHT, MALVIN MARR.

ZUAN DA MILANO, *see* DENTONE, GIOVANNI.

ZUCCARELLI, FRANCESCO. Italian landscape painter (b. Pitigliano, Tuscany, 1702; d. Florence, 1788). A pupil of Paolo Anesi in Florence, Zuccarelli later possibly studied with Locatelli in Rome. Zuccarelli settled in Venice about 1732 and after the death of Marco Ricci became the leading Venetian landscapist. Much patronized by the English, Zuccarelli made three important trips to London (1742–43, 1752–62, and 1765–71), where he was a founding member of the Royal Academy (1768). He also worked in Paris and Dresden. His landscapes, characterized by an atmospheric luminosity, adorn many English country houses, and some (as in Syon, Middlesex) were planned as an integral part of the decoration. (See illustration.)

BIBLIOGRAPHY. G. Rosa, *Zuccarelli*, Milan, 1945; M. Levey, "Francesco Zuccarelli in England," *Italian Studies*, XIV, 1959.

ZUCCARI (Zuccaro), FEDERICO. Italian painter and art theorist (b. S. Angelo in Vado, ca. 1542; d. Ancona, 1609). He began his training in 1555/56 as a student and close follower of his elder brother, Taddeo Zuccari. Federico's first important commission, the decoration of a Roman palace façade consisting of scenes from the life of St. Eustace (ca. 1560; Rome, Piazza S. Eustachio; still visible but badly restored), was secured with Taddeo's help. Highly acclaimed by his contemporaries, a preparatory study for *The Vision of St. Eustace* (New York, Metropolitan Museum) reveals Federico's close adherence to Taddeo's Neo-Raphaelesque style. By 1563 Federico was at work in the Vatican Palace on a cycle of frescoes illustrating the life of Moses, using some of Taddeo's designs.

During the next several years Federico was called upon to complete projects left unfinished by other painters. Such is the case with the altarpiece *The Adoration of the Magi* (Venice, S. Francesco della Vigna, Grimani Chapel), begun by Battista Franco and completed by Federico in 1564. Furthermore, upon the death of Taddeo in 1566, the younger Zuccari continued work on the frescoes in the Sala Regia of the Vatican, as well as on those in Caprarola, the Farnese villa near Rome, both begun by the elder brother. Among other important commissions obtained by Federico in Rome during those years were the lunette frescoes in the Collegio Romano and *The Flagellation of Christ* in the Oratory of S. Lucia del Gonfalone (1573), both in Rome. Not long afterward Federico traveled through northwestern Europe, stopping in Lorraine, Holland, and England. Although there is little visual evidence extant, he is known to have been working for the English court in 1574.

Within the same year, however, he had returned to Italy and completed the decoration of the cupola of the Cathedral of Florence, begun by Vasari. This work was as severely criticized by the Florentine painters as was his *Procession of St. Gregory* (Bologna, S. Maria del Baraccano) soon afterward by the artists of Bologna. In both instances Federico was incited to execute satirical allegorical compositions in which he defended his art in the face of chauvinistic criticism. One of these designs, the *Porta Virtutis*, which circulated in Rome in 1581, caused such an uproar that Pope Gregory XIII, himself a Bolognese, had both Federico and his assistant, Domenico Passignano, exiled from the papal states.

During this absence from Rome Federico was commissioned to decorate a chapel in the Holy House in Loreto

Anders Zorn, *Midsummer Dance*, 1897. National Museum, Stockholm.

Francesco Zuccarelli, *Landscape*. Private collection, Venice. A Venetian landscapist much patronized by the English.

by the Duke of Urbino. During this period he also re-turned to Venice, where he painted the scene of *Barba-rossa before the Pope* for the Sala del Consiglio in the Doge's Palace (1582). Reinstated in the good graces of the papacy, Federico returned to Rome and completed the frescoes in the Pauline Chapel in the Vatican that had been begun by Michelangelo. By the mid-1580s, however, he was invited to Spain by Philip II. He was Philip's court painter from 1586 to 1588; his main work in Spain is found on the high altar of the Escorial. Yet Federico felt that the Spanish monarch was unappreciative of his talents, and in 1589 he once again returned to Rome, where he was elected director of the Academy of St. Luke.

During his later years Federico became intensely oc-cupied with the training of young artists, and though he moved about almost as often now as he had earlier, he found time to set down his theories about art. Some of these were published under the title *Idea de' pittori, scul-tori e architetti* in 1608. As critics have often noted, this treatise is as much concerned with scholastic thought in the period of the Counter Reformation as with the im-portant artistic problems of his time.

See also ZUCCARI, TADDEO.

BIBLIOGRAPHY. H. Voss, *Die Malerei der Spätrenaissance in Rom und Florenz*, vol. 2, Berlin, 1920; D. Heikamp, "Vicende di Federico Zuccari," *Rivista d'arte*, XXXII, 1957; D. Heikamp, "Ancora su Fe-derico Zuccari," *Rivista d'arte*, XXXIII, 1958.

NORMAN W. CANEDY

ZUCCARI (Zuccaro), TADDEO. Italian painter (b. S. Angelo in Vado, 1529; d. Rome, 1566). Beginning in the workshop of his father, Taddeo first went to Rome at fourteen and there discovered those sources which were to play a considerable role in his development: antique sculpture and the antiquizing works of Raphael's circle. In his mature paintings, such as the frescoes in the Mattei Chapel (1556; Rome, S. Maria della Consolazione), he combined a full-bodied figural type with a kind of pre-High Renaissance literalness of detail. His followers, in-cluding his brother Federico, who are numerous in the third decade of the century, rarely succeeded in infusing their work with the bravura by which Taddeo's is distin-guished.

While documents confirm that the Moses cycle in the Vatican was executed largely by Federico (1563), several drawings connected with this decoration (two in London, British Museum; one in Minneapolis, private collection) have been recognized as Taddeo's, indicating the not in-frequent use by Federico at this time of his brother's de-signs.

See also ZUCCARI, FEDERICO.

BIBLIOGRAPHY. A. Venturi, *Storia dell'arte italiana*, vol. 9, pt. 5, Milan, 1932.

NORMAN W. CANEDY

ZUCCATO FAMILY. Mosaicists active in Venice in the 16th century. Giacomo Zuccato, a painter from Dalmatia, had settled in Venice about 1450. He is said to have taught Titian, who later intervened in the Zuccato family's behalf to get them the commission to do mosaics in S. Marco. Francesco (d. 1572), Valerio (d. 1577), and Ar-minio (d. 1606) achieved fame executing mosaics after cartoons by Pordenone, Titian, and other Venetian paint-ers of their day.

BIBLIOGRAPHY. A. Venturi, *Storia dell'arte italiana*, vol. 9, pt. 3, Milan, 1928; E. W. Anthony, *A History of Mosaics*, Boston, 1935.

ZUCCHI, ANTONIO. Italian painter (b. Venice, 1726; d. Rome, 1795). The most important member of a family of engravers and stage designers, he first studied with Francesco Fontebasso and then with Jacopo Amigoni. Robert Adam invited Zucchi to England, where he became a member of the Royal Academy (1770). Many buildings by the Adam brothers were decorated by Zucchi. The latter part of his life was spent in Rome. He was a versatile artist who created landscapes in the manner of Canaletto or Pannini, designed book illustrations, and executed mural decorations such as those in Home House, London (now the Courtauld Institute).

BIBLIOGRAPHY. R. Pallucchini, *La pittura veneziana del Settecento*, Venice, 1960.

ZUCCHI, JACOPO. Italian painter (b. Florence, ca. 1541; d. there, ca. 1590). A student of Salviati and Vasari, Zucchi worked with the latter on frescoes for the Palazzo Vecchio in Florence and contributed to the *studiolo* of Cosimo de' Medici. In Rome he created frescoes for three chapels of S. Stefano in the Torre Pia at the Vatican, as well as for other churches and palaces. He returned to Florence in 1589 to paint a mythological fresco cycle for the Sala delle Carte Geografiche in the Uffizi. In carrying on the complicated and obscure mannerist manner of Vasari, Zucchi developed a more somber sensitivity and fluid figure style, with an emphasis on graceful female forms.

BIBLIOGRAPHY. A. Calcagno, "Jacopo Zucchi e la sua opera in Roma," *Il Vasari*, V, 1932.

ZUCCONE, IL. Stone sculpture by Donatello, in the Campanile, Florence. *See* DONATELLO.

ZUG: ST. OSWALD. Swiss church, the most unified late Gothic structure in Switzerland. H. Felder the Elder supervised Magister Johannes Eberhard, whose diary on the construction is preserved. St. Oswald was built between 1487 and 1511; new vaults were added about 1545. The simple nave with high side aisles culminates in steep, complex vaulting systems, rich in sculptural details. The tall tabernacle structure of 1486 was brought from Cham in the 19th century.

BIBLIOGRAPHY. L. Birchler, *Die Kunstdenkmäler des Kantons Zug*, vol. 2, Basel, 1935.

ZUGNO, FRANCESCO. Italian painter (b. Venice, 1709; d. there, 1787). A student of Giovanni Battista Tiepolo, Zugno worked with the master on frescoes at the Labia Palace in Venice and the Villa Soderini in Nervesa. Zugno was elected to the Venice Academy in 1755. He seems to have stopped painting after 1761. Those works attributed to him derive stylistically from Tiepolo.

ZULOAGA Y ZABOLETA, IGNACIO. Spanish genre and portrait painter (b. Eibar, near Bilbao, 1870; d. Madrid, 1945). Son of a metalworker and ceramist of note, Zuloaga was essentially self-taught and started by copying old masters in the Prado, Madrid. He went in 1889 to Rome and in 1890 to Paris, where he exhibited at the Salon. After a brief trip to London (1893), where he painted the portrait of Oscar Browning (Cambridge, Fitzwilliam Museum), he returned to Spain. The rest of his life was divided between Spain (Zumaya, in the Basque region) and Paris, except for a trip to New York in 1925 to attend the opening of his one-man show, which was a resounding success. In Paris Zuloaga had frequented the symbolist group, especially Mallarmé and Gauguin, and he also knew Degas and Rodin. In 1901 he became a member of the Société Nationale des Beaux-Arts, where he exhibited frequently.

He was among the first to "rediscover" El Greco. The influence of El Greco, Velázquez, Goya, and Manet is paramount in his art. Strongly national in character, he is a real chronicler of Spanish folklore, painting mostly bullfighters, dancers, peasants in regional costumes, and *majas*, both clothed and nude. These are saved from falling into the category of mere illustration by their pictorial qualities. Zuloaga also left some fine landscapes and a great number of portraits, often very fashionable à la Boldini, but more vigorously painted and sometimes reminiscent of those of Edvard Munch.

Zuloaga, who was very prolific and not overly profound, opposed a conservative and literary, even at times the-

Ignacio Zuloaga y Zaboleta, *The Bleeding Christ*. Museum of Modern Art, Madrid.

Zuñi Indians. Pottery vessel from Pueblo country, New Mexico. Museum of the American Indian, New York.

atrical, attitude to the impressionistic, modernistic tendencies of his older contemporary Sorolla. His palette is heavy with earthen colors, yet very strong and varied. His portrait of Maurice Barrès (1913; Paris, Louvre), with its view of Toledo in the background, is among his most impressive works.

BIBLIOGRAPHY. E. Lafuente Ferrari, *La Vida y el arte de Ignacio Zuloaga...*, San Sebastián, 1950. PHILIPPE DE MONTEBELLO

ZUMBUSCH, KASPAR CLEMENS EDUARD. Austrian
sculptor (b. Herzebrock, Westphalia, 1830; d. Rimsting, 1915). He studied in Munich and was in Rome in 1857–58 and in 1867. He executed many monuments in Vienna, naturalistic and tending toward complications of figures.

ZUNI INDIANS. The Zuñi have occupied their present
site in the Pueblo country of western New Mexico since the time of Spanish conquest in 1540, and it is evident that their progenitors were present in that vicinity for some preceding centuries. Theirs was one of about seventy villages extant when the Spaniards arrived.

Like other Pueblo Indians, the Zuñi lived in group apartments constructed of adobe (sun-dried mud bricks or blocks) and masonry, some buildings ascending in multiple stories. Terraced effects were often constructed. Wooden beams supported the successively higher levels or the roof. (These beams are now critically important for their use in the scientific dating process known as dendrochronology, which was discovered by Dr. A. E. Douglass.) A special room known as the kiva, sometimes located underground but often constructed aboveground, serves as a ceremonial chamber and as a social retreat for the men. The kiva is of prehistoric origin.

The Zuñi are best known as fine craftsmen in pottery and as makers of *kachina* masks and figures ("dolls"). The choicest of their recent pottery compares favorably in design with their early historic and prehistoric bowls and jars, although commercialism is not absent from much contemporary Pueblo ceramic art. Huge water urns with geometrical or plant forms or with simplified animal shapes are characteristic.

Kachina masks and figurines are prepared for a powerful secret society which uses them in traditional ceremonies. The figures represent *kachina* spirits and are carved in soft wood by male artist-dancers in the isolation of the kiva. Colorful miniature costumes and related details are carefully worked out. The masks, equally elaborate and frequently ornamented with animal fur and brightly colored textiles, are intended to transform the wearer into the actual spirit of the *kachina*, the ultimate purpose of the ritual being the perpetuation of tribal and individual security. The *kachina* cult is a major force in Pueblo society. See KACHINA.

Zuñi arts, especially the finer examples of modern pottery, derive from and continue a strong and admirable pre-European design tradition. (See illustration.)

See also NORTH AMERICAN INDIAN ART (SOUTHWEST).

BIBLIOGRAPHY. R. Bunzell, *The Pueblo Potter* (Columbia Univ. Contributions to Anthropology, VIII), New York, 1929; R. Benedict, *Patterns of Culture*, Boston, 1934; F. J. Dockstader, *The Kachina and the White Man* (Cranbrook Inst. of Science), Bloomfield Hills, Mich., 1954; A. V. Kidder, *An Introduction to the Study of Southwestern Archaeology*, rev. ed., New Haven, 1963.

JOHN C. GALLOWAY

ZURBARAN, FRANCISCO DE. Spanish painter (b.
Fuente de Cantos, Extremadura, 1598; d. Madrid, 1664). One of the leading Spanish baroque painters, Zurbarán is well known for paintings of monks and for other austere religious works combining realistic treatment with deep spiritual feeling. From 1614 to 1617 he studied with Pedro Díaz de Villanueva. He knew the works of Ruelas and Pacheco, but he was most strongly influenced by the sculptor Montañez, as is apparent in the naturalism and plastic strength of Zurbarán's earliest-known work, *The Immaculate Conception* (Bilbao, Valdés Collection) of 1616. Zurbarán spent the next few years in Llerena, some distance from Seville, and three paintings for the charterhouse of Cuevas date from this period.

His *Christ on the Cross* of 1627 (Art Institute of Chicago) first brought him fame. It is strongly tenebrist, monumental, and moving. In 1626 Zurbarán had been commissioned to paint twenty-one scenes of the life of St. Dominic, the first of the monastic narrative cycles for which he is famous. Among the early cycles are *The Life of S. Pedro Nolasco* for the Merced Calzada, in 1628, and *The Life of S. Buenaventura* for the Franciscans, in 1629 (a project that had been left unfinished by Herrera). These works, somewhat awkward in composition and uneven in drawing, are characterized by large areas of deep color and strong but simple forms.

From 1629 on Zurbarán resided in Seville, where he had a large workshop. His style was now fully developed, and he painted large altarpieces that are wholly baroque, executed with strength and virility. These works include a large *Vision of S. Alonso Rodríguez* for the Jesuits (1630) and the famous *Triumph of Thomas Aquinas* (1631; Seville, Provincial Museum of Fine Arts). Zurbarán's vast vertical compositions are usually divided into two distinct zones, the celestial and the terrestrial, with architecture below and clouds above. The figures are sometimes stiff and the perspective faulty, but the bright colors, the strong naturalism, and the mystical feeling combine to place these paintings among the most imposing Spanish works of the baroque period.

Zurbarán painted many individual standing figures, among which are eleven doctors of the Merced (five in the San Fernando Academy, Madrid) and the Twelve Apostles (1633; Lisbon, National Museum). He also painted more modest works, humble devotional pictures such as the *Holy Face* of 1633 (Pacheco Collection) and the *Child Jesus with a Crown of Thorns* (Sánches Ramos Collection). In 1633 he produced the famous *Still Life* (Rome, Contini-Bonacossi Collection), the only certain still life by his hand; lemons, oranges, and a cup are arranged with stunning simplicity on a table and have been aptly described as looking like an offering on an altar.

In 1634 Zurbarán traveled briefly to Madrid and was asked to paint the Twelve Labors of Hercules for the Buen Retiro Palace. His contact with Velázquez and the great Venetian and Flemish masters Titian and Rubens is felt in his later works, notably in his most impressive cycles at Jerez (now dismantled) and at Guadalupe (still intact), a majestic and highly spiritual ensemble. Four of the Jerez series, which rank with his more colorful works, are in the Museum of Painting and Sculpture, Grenoble.

Francisco de Zurbarán, *The Apostle Peter Appearing to S. Pedro Nolasco*, **from the** *Life of S. Pedro Nolasco* **cycle painted for the Merced Calzada, 1628. Prado, Madrid.**

Zurbarán's production then slowed down appreciably (perhaps because of his wife's death in 1639), and more works betray the hand of assistants, one of whom was probably his son Juan (who died at twenty-nine). Juan was the author of a number of still lifes often attributed to his father. During these years Zurbarán painted many standing figures, monks in white robes (his whites are as famous as Velázquez's blacks) and female saints shown stepping forward as if walking in a procession, a common sight in Seville. Much of Zurbarán's work during the 1640s and 1650s was destined for America, notably a series of twelve paintings (1647) portraying Caesars on horseback (two in Lisbon), based on engravings by Tempesta. Zurbarán, who had little imagination, made frequent use of prints; his real talent lay in a sharp sense of observation, in a feeling for the poetry of beings and things, and in the use of light.

In the 1650s his works became more sentimental and softer in harmony, reflecting the influence of Murillo, who was now the leading painter of Seville. Zurbarán's *Way to Calvary* of 1653 (Orléans, Museum of Fine Arts) attests to this influence. In 1658 he went to Madrid, where he received a few commissions from nobles and the church. His subjects became meditative and lyrical in character and he painted mostly Holy Families (San Diego, Fine Arts Gallery) and penitent saints. Although Zurbarán had many assistants and some followers, very little is known about them, and scholars disagree about attributions and even about the painters' identities. Among those mentioned are the brothers Polanco, Barnabé Ayala, and Mateo Gilarte.

BIBLIOGRAPHY. M. S. Soria, *The Paintings of Zurbarán*, London, 1953; P. Guinard, *Zurbarán et les peintres espagnols de la vie monastique*, Paris, 1960.

PHILIPPE DE MONTEBELLO

ZURICH: MINSTER OF SS. FELIX AND REGULA.
Swiss church (Grossmünster) begun in 1078 and completed in three campaigns. It was strongly influenced by Lombard architecture. In the first campaign, the rectangular apse was built, above a large crypt, and consecrated in 1101, 1117, and 1146. In the second, the nave walls and an independent south chapel were constructed. In the third, nave piers supporting monumental galleries, such as those of S. Ambrogio in Milan, were built. Figured capitals show influences from Lombardy and the Auvergne. In the fourth campaign (1227–78), the choir was heightened and rib vaults were introduced. The twin towers of the west façade were completed in 1487–92 and restored in 1778–82 in Neo-Gothic style. Choir windows by Alberto Giacometti (1932–33) and a largely rebuilt Romanesque cloister complete the ensemble.

BIBLIOGRAPHY. K. Escher, *Die Kunstdenkmäler des Kantons Zürich*, vols. 4, 5, Basel, 1948.

ZURICH: MUSEUMS.
Important public art collections in Zurich, Switzerland, are in the museums listed below.

Art Gallery. Museum established in 1787. A new building was designed for the museum in 1910 by the Swiss architect Karl Moser; it was enlarged in 1924–25. The collection is composed primarily of European painting,

Zwinger Pavilion, Dresden. A baroque palace complex.

sculpture, drawings, and prints from the Renaissance to the present, although the sculpture collection includes groups of Greek, Roman, and medieval works.

The extensive collection of Swiss painting begins with works by the 15th-century Master of the Carnation. Nikolaus Manuel-Deutsch, Hans Leu the Elder, Hans Fries, and Hans Asper are outstanding representatives of the 16th century, as are Henry Fuseli and Anton Graff of the 18th. Works by Stäbli, Koller, Anker, Welti, and Böcklin (including a version of his famous *Island of the Dead*) highlight the 19th-century collection. Among the *fin-de-siècle* and 20th-century artists represented are Vallotton, Buri, Amiet, and Auberjonois, but the outstanding figure is Hodler, with eighty of his paintings on view, including *Glimpse of Eternity*, painted for the museum in 1916.

There are a number of Netherlandish, German, and Italian paintings dating from before the 19th century, the largest single group being the Ruzicka Collection, which is devoted primarily to Dutch and Flemish painting of the 17th century. Prominent in this group are Rembrandt's *Apostle Simon*, Rubens's *Portrait of Philip IV*, Ruisdael's *View of Haarlem* and other landscapes, and works by Joos van Cleve, Patinir, Jan Breughel the Elder, Provost, Brouwer, Van Goyen, Hals, Heyden, Hobbema, Salomon Ruysdael, Steen, and Verspronck.

The comprehensive 19th-century collection is comprised primarily of minor works by major masters, including Delacroix, Daumier, Courbet, Manet, Monet, Renoir, Cézanne, Rousseau, Toulouse-Lautrec, Van Gogh, Feuerbach, Thoma, and Liebermann. In the 20th-century group are works by Bonnard, Matisse, Rouault, Utrillo, Picasso, Gris, Léger, Modigliani, Carrà, Kokoschka, Corinth, Beckmann, Kandinsky, and Klee, among others, and several by Munch. Notable sculptures from the same period are by Hildebrand, Rodin, Maillol, Despiau, Kolbe, Lehmbruck, Barlach, Haller, Giacometti, and Moore.

The Graphische Sammlung, containing more than 20,000 drawings and water colors, and 30,000 prints, features the work of Swiss artists. The Landolthaus, adjoin-

ing the Kunsthaus, exhibits Swiss paintings as well as a rich display of Swiss and southern German goldwork dating from the 14th to the 18th century.

BIBLIOGRAPHY. Zürcher Kunsthaus, *Bilder nach Skulpturen und Gemälden der Sammlung*, Zurich, 1936; Zürcher Kunsthaus, *Gemälde der Ruzicka Stiftung*, Zurich, 1949.

DONALD GODDARD

E. G. Buhrle Foundation Collection. The private collection of the Swiss industrialist Emile Bührle, now administered by his family, was started in the 1930s. Although known primarily for its remarkable group of 19th-century French paintings, the collection also contains Mesopotamian, Egyptian, Etruscan, Greek, Roman, and medieval statuary, as well as paintings by Wolf Huber, Tintoretto, El Greco, Rubens, Van Dyck, Hals, Rembrandt, Van Goyen, Koninck, Saenredam, Terborch, Claude Lorraine, Fragonard, Guardi, Tiepolo, and other artists of the Renaissance and baroque periods.

The extraordinary collection of 19th- and 20th-century paintings includes 12 Delacroixs, 15 Manets, 14 Degas, 12 Renoirs, 13 Monets, 10 Toulouse-Lautrecs, 19 Cézannes, 14 Van Goghs, and 12 Picassos, as well as works by Goya, David, Ingres, Corot, Géricault, Daumier, Courbet, Boudin, Puvis de Chavannes, Pissarro, Sisley, Seurat, Redon, Rousseau, Bonnard, Vuillard, Dufy, Rouault, Modigliani, Utrillo, Chagall, Soutine, Corinth, Marc, Kokoschka, Matisse, Gris, and Braque. Outstanding individual works are David's *Self-Portrait*, Ingres portraits, Delacroix's study for *Dante and Virgil in Hell* and his *Self-Portrait*, Daumier's *Smoker and Absinthe Drinker* and *Mother and Child*, Manet's *Harbor at Bordeaux*, Toulouse-Lautrec's *Au Lit*, *Confetti*, and *Messalina*, Cézanne's *Portrait of Mme Cézanne*, *Mont-Ste-Victoire*, *Temptation of St. Anthony*, *Melting Snow at L'Estaque*, *Boy in a Red Vest*, and *Self-Portrait with a Palette*, and Van Gogh's *Cornfield with Cypresses* and *The Sower*.

BIBLIOGRAPHY. Zürich Kunsthaus, *Sammlung Emil G. Bührle*, Zurich, 1958.

DONALD GODDARD

Graphics Collections of the Federal Technical College. This extensive collection of Italian, German, French, Dutch, and Swiss prints, dating from the 15th to the 20th century, is owned by the Technical College in Zurich. It includes works by Raimondi, Schongauer, Dürer, Lucas van Leyden, Callot, Rembrandt, Piranesi, Goya, and others.

ZURN, JORG. German sculptor (b. Waldsee, ca. 1583; d. Uberlingen, ca. 1635). An early baroque sculptor, brother of Martin and Michael Zürn, Jörg Zürn grew out of the late Gothic tradition and was influenced by J. Degler and the Dutch and Italian mannerists. His major work is the carved high altar for the Minster of Uberlingen (1613–19). His nephew Michael Zürn was a baroque sculptor.

BIBLIOGRAPHY. A. Feulner, *Die deutsche Plastik des 17. Jahrhunderts*, Munich, 1926.

ZURN, MARTIN AND MICHAEL. German sculptors (fl. Bavarian-Austrian area, 1624–65); brothers of Jörg Zürn. Together Martin and Michael produced the *Rosenkranzaltar* (1631–40) in the Uberlingen Minster and the high altar and pulpit of the Pfarrkirche of Wasserburg am Inn (1638–39). The style of the Zürn brothers is tran-

sitional between the mannerist and the baroque. Their nephew was the baroque sculptor Michael Zürn.

BIBLIOGRAPHY. A. Feulner, *Die deutsche Plastik des 17. Jahrhunderts*, Munich, 1926.

ZURN, MICHAEL. German sculptor (b. Wasserburg am Inn, ca. 1626; d. after 1691). He was the nephew of Jörg, Martin, and Michael Zürn. His major works, sixteen over-life-size figures in the Stiftskirche at Kremsmünster (1682–85), are in the fully developed baroque style and are reminiscent of the works of Bernini.

BIBLIOGRAPHY. H. Decker, *Barockplastik in den Alpenländern*, Vienna, 1943.

ZUTMAN, LAMBERT. Flemish printmaker, painter, architect, and publisher (b. Liège, ca. 1510; d. 1567). He worked in Liège, Antwerp, Rome, and Frankfurt am Main. His engravings, in a delicate and regular line, are after his own designs of figures set in Roman ruins, and after Lambert Lombard, his teacher and brother-in-law. Zutman signed his prints with the Latinized name "Suavius."

ZWINGER PAVILION, DRESDEN. Festive building complex in Germany. It represents the masterpiece of Saxon baroque architecture. Although the Zwinger was gutted in the catastrophic bombing raid of February, 1945, it has been slowly rebuilt to a state that offers a fair approximation of its original glory. The history of the building goes back to 1710, when King Augustus the Strong sent his court architect Matthäus Daniel Pöppelmann to Vienna and Rome in search of ideas for a grandiose new palace. As executed, the Zwinger represents only a part of a larger project. The plan is a square with two stilted hemicycles opening out on two opposite sides. In elevation the complex consists of one-story galleries punctuated at intervals by ornate pavilions. The word *Zwinger* means court, but this does not begin to describe its varied functions. The surrounding galleries and pavilions housed an orangery, reception rooms, and museums devoted to art works and natural history collections. Open space in the center served as a kind of amphitheater for the lavish spectacles of the baroque age.

Building proceeded vigorously in the second decade of the 18th century so that by 1719 a royal wedding could be celebrated in the Zwinger. However, further work on the original scheme was to continue almost to the end of the century. Although the building was planned by the architect Pöppelmann, in the execution he had the collaboration of a brilliant sculptor, Balthasar Permoser, who had been trained with Bernini in Rome. Permoser was the creator of the famous grimacing hermae and of the triumphal crowning figure of Atlas, which was probably an allusion to Augustus's assumption of the Polish crown. In the 18th-century work, the northeastern side had been left open with the idea of continuing the building down to the Elbe River, but this side was closed in between 1847 and 1849, when Gottfried Semper built his massive Picture Gallery to house the Saxon painting collections. *See* DRESDEN: STATE ART COLLECTIONS.

BIBLIOGRAPHY. J. L. Sponsel, *Der Zwinger*, 2 vols., Dresden, 1924; H. G. Ermisch, *Der Dresdner Zwinger*, Dresden, 1953; E. Hempel, *Der Zwinger zu Dresden*, Berlin, 1961.

WAYNE DYNES

ZYL, GERARD PIETERSZ. VAN, *see* ZIJL, GERARD PIETERSZ. VAN.

ILLUSTRATION CREDITS

A. C. L., Brussels: (I) 170, 225; (II) 173(a), 211, 296, 299, 306; (III) 561; (IV) 58, 135, 541; (V) 62, 170, 197(r), 469, 481(l), 524, 530(l). — Hélène Adant, Paris: (V) 425(l). — Airviews (M/CR) Ltd.: (V) 440. — Albertina, Vienna: (IV) 12, 25, 326. — Alinari: (I) 6, 57, 61, 63, 66(r), 112, 120, 122, 123, 128(r), 138, 144, 149, 159, 161, 179(r), 230(l), 231, 241, 254, 256(r), 257, 258, 278, 291, 292, 300, 304, 309(l), 318, 324, 325, 331, 362, 365, 371, 375, 389, 396, 403, 407, 432, 456, 462(r), 505, 527(l), 121(a); (II) 11(l), 79, 82(r), 86, 110, 154, 161, 183(al), 246, 257, 259(r), 272, 295, 343, 379, 404, 408, 492, 494, 499, 511, 515, 520, 564; (III) 17(b), 58, 75(r), 90, 130, 156, 200, 336, 370, 374, 383(r), 387, 455, 456, 457, 461, 467, 468, 481, 493, 502(l), 503, 541(l), 557(r), 563; (IV) 9, 28, 39, 42(a), 63, 81, 84, 92, 99, 101, 126, 154, 166, 167, 173, 179, 182, 185, 208, 245, 261(l), 270, 288, 295(a), 318, 329(l), 343, 356, 359, 372, 375(a), 386, 387, 395(a), 398(r), 401, 403, 411, 418, 428, 434, 435(r), 448, 454, 460, 470, 486, 517, 523, 524, 525, 531, 556, 559; (V) 13, 14, 23, 70, 74, 82, 84, 85(a), 86, 90, 133, 145, 156, 202, 207, 251, 321, 335(l), 348, 351(r), 352, 358, 368(l), 409, 422, 433, 442, 453(r), 462, 466, 495, 501, 530(r), 561. — Almasy: (I) 401. — AME: (I) 34, 45, 108, 267, 273, 296(l), 298, 344, 458, 476, 504; (II) 9, 104(r); 177, 213, 214, 218, 227, 322, 346, 351, 361, 378, 419, 552; (III) 111, 112, 259, 417, 498; (IV) 27, 77, 103, 105, 205, 212(l), 219, 364, 376, 390, 427(l), 432; (V) 43(a), 126, 288, 349(b), 400, 482. — Anderson, Rome: (I) 50, 139, 167, 234, 235(bl), 309(r), 315, 317, 357, 441, 455; (II) 102(l), 105, 142, 264(r), 444, 476, 485, 514; (III) 80, 119, 275, 373, 382, 428, 443, 478, 512(r), 533, 547, 562; (IV) 54, 55, 117, 177, 199, 202, 384, 413, 426(r), 455, 500, 504, 508, 561(l); (V) 74, 83, 98, 103, 104, 114, 142(b), 151(l), 208, 216(l), 220, 223, 248, 269, 336, 396. — Annan, Glasgow: (I) 491. — Archives Photographiques, Paris: (I) 212; (III) 363, 565; (V) 41, 146. — Artaud: (III) 513. — Art Gallery, Aberdeen, Scotland: (III) 390. — Art Gallery and Temple Newsam House, Leeds: (II) 67; (V) 162. — Art Institute of Chicago: (III) 63, 65, 86, 175, 177(b), 557(l); (V) 165(r). — Associated Press: (IV) 348. — Atkins Museum of Fine Arts, Kansas City, Mo.: (III) 353. — Aubert: (I) 367. — Bacci, Rome: (I) 227, 474; (II) 401. — Oliver Baker, New York: (I) 217(r); (II) 336; (III) 496; (IV) 20; (V) 327(r). — J. Band, Australian Official Photograph: (I) 163. — Bartesago, Avignon: (I) 203. — Bavarian State Antiquities Collection, Munich: (II) 390. — Bavarian State Art Collections, Munich: (II) 209, 368. — Dr. P. H. Beighton: (IV) 438. — The Bettmann Archive, New York: (I) 481(r); (IV) 111; (V) 165(l), 252, 481(r), 514. — Carlo Bevilacqua, Milan: (I) 177, 330, 431, 446, 526, 532; (II) 65, 80, 143(l), 179, 244, 403, 431, 451, 455, 467, 487, 517, 521; (III) 99, 104, 203, 214, 248, 262, 291, 323, 331; (IV) 255, 287; (V) 85(b), 92, 137, 189, 278(r), 295, 368(r), 370, 372, 458, 464. — Bibliothèque National, Paris: (III) 207; (IV) 363. — Bildarchiv Foto Marburg: (I) 7, 15(l), 43(b), 77(b), 80, 109, 127, 173, 180, 192(l), 193(l), 200, 205, 229(b), 284, 296(r), 306, 316, 326, 480, 487, 496; (II) 34, 102(r), 109, 145(l), 185, 196, 210, 240, 305, 369, 417, 438, 473, 545, 561(l); (III) 2, 26, 32, 46, 79, 224, 309, 317, 335, 360, 476, 482, 514, 522, 541(r); (IV) 31, 34, 43, 149, 176(l), 186, 224, 225(l), 227, 232(a), 279, 298, 308, 331, 346, 354, 370(r), 392, 462, 475, 490, 494, 515; (V) 42, 43(b), 48, 78, 206, 219, 241, 285, 342, 381, 443, 451, 474, 484(l), 496, 497(b), 498, 500, 505, 512, 525, 528, 537, 550. — E. Irving Blomstrann, New Britain, Conn.: (I) 301; (V) 403. — Borromeo: (III) 298, 311(r), 352, 524; (IV) 139. — Boudot-Lamotte: (III) 327; (IV) 141. — Boymans–Van Beuningen Museum, Rotterdam: (I) 28; (II) 278; (III) 123; (V) 522. — B.B.C. Publications, London: (III) 9. — Brera, Milan: (I) 255(l). — British-China Friendship Association: (II) 12. — British Museum, London: (I) 74, 77(a), 220; (II) 51, 156, 551; (III) 138, 383(l); (IV) 21, 234; (V) 480, 494, 564(l). — Brogi, Florence: (I) 252, 329, 355; (II) 78, 136, 557; (V) 88, 89, 289, 394, 411(b), 412. — Brooklyn Museum, Brooklyn, N. Y.: (I) 435; (III) 484. — Lewis Brown Associates: (I) 409. — Bulloz, Paris: (I) 37, 143, 189(b), 198, 201, 261, 288, 337, 353, 358, 379, 404(l); (II) 19, 25, 89, 98, 100, 162(l), 207, 219, 248, 297, 298, 383, 387, 442, 472, 504, 505, 535; (III) 10, 28, 35, 48(a), 74, 85(a), 181, 229, 361, 366(r), 367, 386(a), 388, 389, 391, 396, 400, 402(l), 407, 420, 502(r), 516, 523, 532; (IV) 8(r), 35, 47, 121, 225(r), 283, 329(r), 334, 451, 457, 487, 555; (V) 151(r), 154, 233, 274. — Bundesdenkmalemt, Vienna: (II) 11(r). — Caisse Nationale des Monuments Historiques, Paris: (IV) 98. — Calzolari, Mantua: (I) 53. — Cambridge University Museum of Archaeology and Ethnology: (IV) 297(a). — Camera Press, London: (I) 208. — Alfred Carlebach, London: (V) 200. — J. Allen Cash: (IV) 325; (V) 53. — CEAM: (I) 5, 14, 16, 20, 24, 38, 79, 81(a), 131, 132, 142, 147, 150, 152, 156, 160(l), 188, 192(r), 235(a), 256(l), 260(a), 266, 272(r), 294(r), 481(l), 482, 522, 529; (II) 10(b), 22, 30, 33, 68, 71(l), 82(l), 84, 90, 91(r), 103(l), 121(b), 122, 129, 130, 140, 143(r), 145(r), 150, 158, 169, 183(r), 188, 193, 197(b), 224, 274, 275, 285, 352, 371, 466; (III) 13(b), 31, 47(a), 48(b), 54, 66, 100, 127(l), 151, 160, 180, 237, 270, 310(b), 362(l), 371, 375, 376, 453, 454, 460, 485(l), 486, 500(a), 564; (IV) 30, 69, 96, 109, 129, 148, 170(l), 176(r), 242, 243, 253, 254, 261(r), 297(b), 327, 332, 338, 367, 374, 375(b), 389, 393, 394, 395(b), 433, 444, 449, 453, 466, 471, 484, 496, 510,

519, 552, 553, 554; (V) 96, 135, 149, 157, 192, 193(b), 203(r), 205, 216(r), 221(a), 222(b), 224, 225(l), 237, 242, 246(l), 249, 250, 268, 298(a), 306, 315, 337, 346, 350, 354, 355, 360, 361(b), 383, 415, 477, 562. — Centraal Museum, Utrecht: (I) 471. — Chicago Natural History Museum: (III) 231. — G. Chiolini, Pavia: (I) 75. — Cincinnati (Ohio) Art Museum: (II) 307. — City Art Museum, St. Louis, Mo.: (III) 33. — Geoffrey Clements, New York: (II) 281, 549, 561(r); (III) 59, 354, 553(b); (IV) 379(r), 564; (V) 199, 234, 497(a). — Cleveland (Ohio) Museum of Art: (II) 13. — Conzett-Huber, Zurich: (II) 357. — A. C. Cooper Ltd., London: (IV) 76, 252, 429. — Corning Museum of Glass, Corning, N. Y.: (II) 529. — Country Life, London: (I) 21, 343. — Dal Gal, Verona: (III) 518; (IV) 184, 293(r), 416, 539; (V) 518. — Danske Folk Museum, Copenhagen: (II) 135. — D. Darbois: (I) 33. — Darmstadt Museum: (I) 155. — De Antonis, Rome: (V) 314. — De Biasi: (I) 12, 66(l), 466. — J. Delherce, Saint-Omer: (III) 416(b). — Department of Archaeology, Government of India: (I) 322; (III) 289(r). — Detroit (Mich.) Institute of Arts: (II) 35, 279, 526; (III) 94, 109; (V) 134. — Deutsche Fotothek, Dresden: (III) 509. — Deutsches Archäologisches Institut, Rome: (I) 168. — A. Dingjan, The Hague: (I) 302; (II) 234, 349; (III) 75(l), 404; (IV) 417. — Dr. S. Ducret: (IV) 232(b). — Dulwich College, London: (V) 203(l). — R. Durandaud, Paris: (IV) 302. — Charles Eames: (III) 170. — Electa Editrice: (IV) 558. — Electra Cliché: (I) 405. — Ewing Galloway: (II) 115. — Expo-67 Information Service: (II) 447. — Georges Falls: (I) 11. — Farina, Monza: (IV) 114. — Ferruzzi: (V) 418. — Feuillie: (V) 196. — Fine Arts Museum, Brussels: (III) 64; (IV) 257. — Fine Arts Museum, Dijon: (IV) 5. — Finnish Travel Association, Helsinki: (V) 369. — Hans Finsler SWB: (I) 404(r). — Fiorentini, Venice: (IV) 561(r); (V) 566. — Fitzwilliam Museum, Cambridge, Eng.: (II) 253. — Fogg Art Museum, Cambridge, Mass.: (II) 76(a), 252, 538. — Fondo Editorial de la Plastica Mexicana: (I) 206. — Werner Forman: (V) 72(l). — Fotofast: (I) 117. — Fototeca ASAC Biennale, Venice: (II) 532; (III) 87(b). — John R. Freeman and Co., London: (V) 258. — Freer Gallery, Washington, D.C.: (II) 15; (III) 355. — A. Frequin, The Hague: (I) 485; (II) 87(r); (IV) 217. — Frisia: (I) 130(br). — Gabinetto Fotografico Nazionale, Rome: (V) 94(r). — Gallimard, Paris: (IV) 436; (V) 276(r). — Garanger, Paris: (II) 200; (V) 2, 153. — Gasparini, Genoa: (I) 465. — Gemäldegalerie, Dresden: (II) 124(r). — General Department of Information and Broadcasting, Teheran: (III) 177(a). — Germanisches National Museum, Nürnberg: (I) 224; (IV) 11. — Giacomelli, Venice: (II) 93; (III) 226; (V) 425(r). — Fernand Gigon, Geneva: (II) 39; (III) 71. — G. Gioia: (I) 148(r). — Studio Giorgi, Verona: (V) 332(r). — Giraudon, Paris: (I) 219, 251(a), 276, 366, 370, 376, 386(r), 400; (II) 157(l), 168, 287, 389, 460; (III) 14, 93, 158, 435, 441; (IV) 7, 95, 162, 396; (V) 186, 397, 472. — Goldner: (IV) 29. — Lucio Gorzegno, Verona: (II) 183(ar). — Ian Graham: (II) 7(l); (III) 121, 256, 266; (IV) 75; (V) 66, 72(r), 544. — Graphis: (II) 436. — Greek National Tourist Office: (I) 19. — Gregorietti: (I) 130(bl). — Solomon R. Guggenheim Museum, New York: (I) 179(l); (V) 411(a), 445, 541. — Hammel, Paris: (III) 73. — David Harris, Jerusalem: (III) 315(a). — Nihon Hasshoku: (II) 245. — Editions Hazan: (III) 380. — Heikki Havas, Museum of Finnish Architecture, Helsinki: (V) 30. — André Held, Lausanne: (I) 15(r), 69, 189(a), 517; (II) 5, 229, 294, 321, 453; (III) 88; (IV) 345; (V) 204, 392. — Lucien Hervé, Paris: (III) 398. — Foto Hinz SWB Basel: (I) 13, 18, 428; (II) 331, 366, 556; (III) 106. — Hirmer Foto Archiv, Munich: (I) 169(r); (II) 445; (III) 297; (V) 444. — Michael Holford, London: (II) 470; (IV) 93(l). — V. and S. Holford: (I) 349. — Holle Verlag: (I) 196. — Horniman Museum, London: (I) 35; (IV) 191; (V) 147(b). — Images et Reflets, Paris: (III) 137(a). — Imperial War Museum, London: (IV) 171. — Independent Features: (III) 286. — International Society for Educational Information, Inc., Tokyo: (III) 127, 176(a), 330, 560; (IV) 142; (V) 152, 167, 275(b), 384. — Foto Irpa, Brussels: (I) 194. — ISMEO, Rome: (II) 225.— Sidney Janis Gallery, New York: (III) 325(l). — Japan National Tourist Association, London: (III) 300; (IV) 164; (V) 546(a). —

Peter A. Juley & Son, New York: (I) 439. — A. Kempter, Bavaria-Verlag: (III) 89. — Shinzu Kensetsu: (V) 278(l). — A. F. Kersting, London: (I) 232; (II) 406, 412; (III) 98, 307; (IV) 273; (V) 478, 504. — Kleinhempel, Hamburg: (I) 242; (III) 38, 178, 403, 566; (IV) 175, 534; (V) 221(b). — Kodansha Ltd., Tokyo: (I) 25, 48, 55, 59, 71, 124, 141, 182, 297, 311, 372, 382, 385, 413, 418, 424, 448, 450, 488, 499, 500, 527(r); (II) 2, 17, 24, 57, 61, 74, 94, 104(l), 138, 147, 149, 159, 171, 174, 231, 269, 290, 303, 309, 337, 339, 340, 376, 396, 425, 427, 475, 484, 489, 498, 503(l), 507, 536, 563; (III) 19, 25, 77, 114, 140, 164, 172, 211, 240, 246, 252, 273, 343, 351, 385, 414, 425, 427, 434, 444, 529, 534; (IV) 16, 36, 38, 49, 56, 67, 88, 127, 136, 145, 155, 231, 278, 289, 307, 315, 342, 351, 369, 370(l), 383, 399, 409, 420, 479, 495, 502, 511, 562; (V) 10, 129, 139, 177, 183, 229, 231, 245, 257, 299, 316, 322, 325, 335(r), 340, 376, 390, 405, 406, 421, 431, 436, 439, 490, 503, 506, 509, 523(l), 546(b), 547, 569. — Kröller-Müller Museum, Otterlo: (V) 310. — Kunsthalle, Bremen: (II) 212. — Kunsthalle, Hamburg: (II) 440; (III) 430(r); (IV) 2. — Kunsthalle, Mannheim: (V) 131. — Kunsthistorisches Museum, Vienna: (I) 157, 280; (V) 450. — E. Kusch, Nürnberg: (I) 97. — R. Lakshmi: (I) 42. — Lenbach Gallery, Munich: (III) 409. — Library of Congress, Washington, D.C.: (IV) 414. — Louvre: (I) 218; (II) 144, 166, 380(r). — Lundhal, Stockholm: (IV) 80. — G. Mairani, Milan: (I) 47, 70, 148(l), 249, 265(l); (II) 28, 265; (III) 71, 410; (IV) 239, 450; (V) 56, 61, 87. — Foto Mandel: (V) 12. — W. F. Mansell Collection, London: (V) 307(a). — Aldo Margiocco, Genoa: (II) 338, 422. — E. Mariani, Como: (I) 17. — Marzari: (III) 392, 462, 483; (IV) 377. — MAS, Barcelona: (I) 64, 158, 204, 374, 417, 438, 462(l), 470, 477, 531; (II) 77, 182, 206, 394, 474, 541(r); (III) 92(r), 147, 415, 480; (IV) 23, 140, 143, 216, 276, 285, 290, 295(b), 323, 391(r), 447; (V) 75, 94(l), 147(a), 179, 210, 270, 349(a), 460, 567(l). — Robert E. Mates, New York: (IV) 195. — Mauritshuis, The Hague: (IV) 264. — Terence Mead: (II) 548. — Federico Arborio Mella, Milan: (I) 27, 29, 46, 56, 60, 76, 78, 85, 110, 116, 129, 146, 160(r), 169(l), 178(l), 187(r), 191, 210(r), 213, 218, 221(a), 240, 245, 246, 255(r), 261, 280, 289, 310, 340, 342, 347, 350, 360, 363, 390, 393, 394, 408, 410, 427, 433, 434, 437, 469, 490, 497, 502, 503, 520, 521; (II) 21, 32, 36, 43, 46, 70, 85, 87(r), 97, 103(r), 124(l), 127, 132, 164, 173(b), 187, 197(a), 198, 203, 228, 236, 237, 238, 239, 243, 258, 259(l), 261, 273, 293, 316, 320, 334, 354, 370, 380(l), 397, 402, 405(a), 423, 433, 465, 477, 479, 500, 503(r), 524, 525, 530, 540, 543, 546, 555, 558, 560; (III) 15, 16, 24(r), 27, 34, 41, 43, 47(b), 49, 50, 55, 69, 76, 85(b), 87(a), 92(l), 101, 102, 108, 110, 116(l), 129, 131(b), 136, 155, 182, 185, 186, 187, 191, 194, 198, 223, 244, 258, 261, 269, 271, 284, 287, 293, 299, 311(l), 315(b), 316, 320, 322, 325(r), 332(b), 337, 348, 364, 365, 368, 372, 381, 386(b), 401, 408, 418, 419, 422, 426, 436, 437, 448, 465, 469, 472, 473, 477, 479, 485(r), 489, 491, 492, 494, 499, 500(b), 501(r), 508, 511, 515, 525, 528, 536, 537, 539, 544(r), 548, 549, 553(a), 554(r), 556, 567; (IV) 19, 46, 53, 60, 79, 82, 89, 91, 94, 102, 106, 108, 120, 128, 134, 158, 172, 174, 178, 190, 211, 213, 214, 236, 241, 249, 263, 281, 293(l), 294, 309, 311(b), 328, 330, 336, 337, 341, 371, 380, 381, 398(l), 405, 406, 407, 425, 426, 445, 446, 472, 480, 485, 492, 503(b), 516, 529, 557; (V) 7, 18, 28, 31, 32, 60, 99, 105, 110, 112, 113, 115, 117(b), 119, 120, 122, 123, 132, 136, 143, 144, 148, 159, 166, 168, 178, 181, 182, 188, 190, 194(r), 209, 212, 222(al), 225(r), 227, 271, 272(a), 275(a), 280, 283, 284, 291, 298(b), 301, 305, 309, 318(r), 332(l), 334, 341, 344, 347, 351(l), 364, 380, 382, 385, 401, 414, 423, 456, 459, 468, 476, 479, 520, 527, 542, 570. — Mercurio, Milan: (I) 31, 36(r), 95, 104, 136, 166, 171, 237, 268, 348, 388, 398, 443; (II) 69, 233, 288, 386, 392, 462; (III) 257, 313, 318, 321, 356, 378, 452, 466, 488, 501(l), 542, 552; (IV) 86, 119, 150, 311(a), 321, 333, 361(r), 385, 388, 402; (V) 101, 127, 215, 276(l), 300, 516, 523(r), 531, 563. — Metropolitan Museum of Art, New York: (I) 51, 81(b), 174, 215, 264, 272(l), 293, 327, 335, 345, 361; (II) 23, 26, 92, 95(a), 133, 223; (III) 13(a), 117, 141, 146, 219, 306, 345, 358, 366(l), 446(l), 554(l); (IV) 110, 118, 159, 210, 246, 313, 358, 465, 473, 488; (V) 26, 108, 222(ar), 519. — Moncalvo: (III) 280. — Paolo Monti: (I) 422. — Ann Münchow: (I) 2. — Musée de la Malmaison: (III) 521. —

Musée Guimet, Paris: (V) 281. — Musée du Jeu de Paume, Paris: (V) 174. — Museo della Scala, Milan: (V) 303. — Museo delle Terme, Rome: (IV) 160. — Museo Nacional de Antropología, Mexico City: (III) 230; (V) 559. — Museo Nacional de Arte Moderna, Mexico City: (I) 128(l), 187(l); (II) 241; (III) 12; (IV) 258, 296. — Museu Nacional de Arte Antiga, Lisbon: (II) 541(l). — Museum für Völkerkunde, Munich: (I) 88. — Museum of Fine Arts, Boston: (I) 67, 251(b); (II) 27, 106, 189; (III) 7, 61, 125, 341, 512(l); (V) 161, 366. — Museum of Modern Art, New York: (I) 23, 229(a), 260(b), 269; (II) 131, 264(l); (III) 295, 369, 402(r), 416(a), 423, 442, 538, 544(l); (IV) 97, 188; (V) 186, 255, 287, 317. — Museum of the American Indian, Heye Foundation, New York: (I) 305; (II) 359; (III) 44, 124, 183(b), 308, 357; (IV) 222, 452; (V) 328(l), 567(r). — Bernard S. Myers: (I) 40. — National Gallery, London: (I) 202, 283, 463; (II) 126, 139, 192, 216, 438; (III) 470, 506; (IV) 391(l); (V) 24, 379, 453(l). — National Gallery, Oslo: (V) 538. — National Gallery of Art, Washington, D.C.: (I) 121, 475, 510, 550; (II) 83, 91(l), 204, 399, 420; (III) 30, 510; (IV) 124; (V) 117(a), 246(r), 486. — National Gallery of Canada, Ottawa: (IV) 520. — National Gallery of Ireland, Dublin: (I) 250; (V) 548. — National Gallery of Scotland, Edinburgh: (IV) 468, 476. — National Monuments Record, London: (III) 67(l), 430(l); (IV) 170(r); (V) 40, 214, 402, 484(r). — National Museet, Copenhagen: (V) 361(a). — National Museum, Sofia: (III) 105. — National Museum, Stockholm: (I) 386(l); (III) 274; (V) 565. — National Museum of Ireland, Dublin: (V) 50. — National Portrait Gallery, London: (I) 282; (III) 267, 303, 326, 405. — Natural History Museum, Vienna: (V) 428. — William Rockhill Nelson Gallery of Art, Kansas City, Mo.: (III) 134, 429(r). — Benito Nevi: (III) 24(l). — New Gallery, Linz: (III) 324. — Newport (R.I.) Historical Society: (IV) 513. — New-York Historical Society: (IV) 138. — New York Public Library, Prints Division: (II) 194, 301. — North Carolina Museum of Art, Raleigh: (I) 265(r). — Mario Novaïs, Lisbon: (III) 137(b). — Novosti: (III) 302; (IV) 132, 228; (V) 59, 389. — Office du Livre S.M., Fribourg: (III) 91. — Ontario Royal Museum, Toronto: (II) 52. — Orion Press, Tokyo: (V) 328. — Orlandini, Modena: (III) 29; (IV) 93(r). — Österreichische Nationalbibliothek, Vienna: (I) 58. — Pagliarani, Museo di Castelvecchio, Verona: (III) 429(l); (V) 116. — Foto Parigi, Florence: (I) 211(r); (II) 215. — Fabrizio Parisio, Naples: (II) 384. — Peabody Museum, Harvard University: (I) 359. — Rocco Pedicini, Naples: (III) 546. — Pennsylvania Academy of the Fine Arts, Philadelphia: (V) 253. — Percival David Foundation, London University: (V) 320. — Antonello Perissinotto, Padua: (I) 41(b); (II) 405(b); (IV) 169. — Mario Perotti, Milan: (I) 515. — Philadelphia Museum of Art: (II) 292(l); (V) 158. — Phillips Collection, Washington, D.C.: (II) 458; (V) 526. — Photo Central de Publicationes, Mexico City: (IV) 521. — Picturepoint, Ltd., London: (V) 238, 272(b), 307(b). — Pierpont Morgan Library, New York: (II) 95(b); (IV) 90, 269; (V) 517. — Pinacothek, Turin: (IV) 74. — Pitt Rivers Museum, Oxford: (I) 36(l). — Axel Poignant: (V) 21. — Paul Popper, London: (I) 41(a), 49, 140, 193(r), 233, 440; (II) 385, 502, 506; (III) 56, 60, 169, 305, 312, 333, 463; (IV) 48, 144, 282; (V) 109, 169, 239, 259, 367. — A. C. Price Company, Bartlesville, Okla.: (IV) 435(l). — Ezio Quiresi, Cremona: (II) 413. — RAI, TV: (I) 73. — K. Raphaelidis, Athens: (IV) 355. —

Remy, Dijon: (I) 216. — Rheinisches Bildarchiv, Cologne: (V) 125. — Rijksmuseum, Amsterdam: (I) 178(r), 210(l), 211(l), 285, 321, 338, 354, 381, 415; (II) 326, 480; (III) 51, 83, 120, 122, 131(a), 184, 222, 289(l), 310(a), 334, 432; (IV) 8(l), 13, 71; (V) 142(a). — Rijksmuseum voor Volkenkunde, Leyden: (I) 100. — H. Roger-Viollet, Paris: (I) 43(a), 91, 445; (II) 10(a), 96, 157(r), 167, 550. — Jean Roubier: (II) 125. — Royal Commission on Historical Monuments, London: (V) 511. — Foto Saebens Worpswede: (II) 249(r). — Sakamoto Photo Research Laboratory, Tokyo: (III) 301. — Oscar Savio, Rome: (II) 118, 153. — Scala, Florence: (I) 39, 119, 151, 165, 221(b), 223, 243, 253, 263, 270, 290, 314, 387, 449, 492, 513, 525; (II) 151, 202, 267, 277, 363, 365, 461, 497, 509, 512, 519; (III) 23, 279, 517, 558; (IV) 64, 122, 130, 360, 361(l), 422, 424, 464, 544, 549; (V) 5, 37, 46, 81, 140, 173, 296. — A. Scarnati, Paris: (I) 281. — John D. Schiff, New York: (III) 6. — Schlossmuseum, Weimar: (I) 507. — Photo Schuch: (I) 464. — Joseph Seagram and Sons, Inc., New York: (IV) 72. — SEF, Turin: (I) 230(r), 286, 323, 351; (II) 71(r), 114, 342; (III) 20, 62, 161, 296; (IV) 112, 146, 551; (V) 35, 76, 118, 230(r), 438. — F. Wilbur Seiders: (I) 452. — SEM: (III) 135. — Ronald Sheridan: (III) 116(r); (IV) 42(b). — Julius Shulman, Los Angeles: (IV) 187. — Smithsonian Institution, Washington, D.C.: (IV) 503(a). — Staatliche Kunsthalle, Karlsruhe: (III) 84. — Former Staatliche Museen, Berlin: (II) 7(r); (IV) 271. — Stedelijk Museum, Amsterdam: (I) 472; (II) 266; (III) 520; (V) 197(l), 556. — Henry Stierlin, Geneva: (II) 29, 262, 324. — Dr. Franz Stoedetner: (IV) 40. — Ezra Stoller Associates, Mamaroneck, N.Y.: (I) 294(l); (V) 193(a), 532. — Studio Piccardy, Grenoble: (V) 22. — Soichi Sunami, New York: (II) 107; (III) 332(a). — Eric Sutherland, Minneapolis, Minn.: (I) 459; (II) 76(b). — Wim Swaan: (II) 314; (III) 540. — Tate Gallery, London: (I) 68, 334, 416, 442, 444; (II) 165, 184, 250, 251, 263, 443; (III) 67(r), 96, 126, 379, 424, 475; (IV) 115, 125, 201, 291, 379(l); (V) 171, 218, 232(l), 247, 491, 513. — V. and N. Tombazi, Athens: (V) 187. — Ellen Traubenkraut, Ettringen: (V) 353. — Trinity College Library, Dublin: (III) 95, 304. — Uffizi, Florence: (II) 176. — United Arab Republic Tourist and Information Center, London: (III) 150. — Universitets Oldsaksamling, Oslo: (III) 362(r); (IV) 262. — University Museum, Philadelphia: (IV) 206. — A. Vaering, Oslo: (III) 346; (V) 230(l). — Vaghi, Parma: (I) 133; (IV) 306. — Vallerini: (I) 190, 235(br). — Vasari, Rome: (I) 479; (V) 51. — H. Vanhaelewyn: (I) 341. — Mireille Vautier: (V) 312. — José Verde: (IV) 41, 45. — John Vickers Studio, London: (II) 170. — Victoria and Albert Museum, London: (I) 172, 217(l); (II) 48, 276, 523; (III) 154, 292, 350(l), 487; (V) 277. — A. Villani, Bologna: (III) 176(b); (V) 124. — Wadsworth Atheneum, Hartford, Conn.: (II) 221, 315. — Wallace Collection, London: (III) 377. — Warburg Institute, London: (IV) 215. — Mortimer Wheeler: (IV) 310. — Whitney Museum of American Art, New York: (I) 82; (II) 190, 195, 220, 335, 350(r), 446(r); (IV) 410, 431, 481; (V) 160, 195, 333, 493, 564(r). — Jean Willemin: (I) 130(a); (III) 128, 144, 183(a), 282, 285, 294; (IV) 22, 73; (V) 8, 164, 211, 273, 499. — Worcester (Mass.) Art Museum: (II) 117. — A. J. Wyatt, Staff Photographer, Philadelphia Museum of Art: (II) 312; (III) 78; (IV) 57, 319. — Yale University Art Gallery, New Haven, Conn.: (II) 292(r), 300; (IV) 349, 483; (V) 198, 359. — © S.P.A.D.E.M. and A.D.A.G.P., Paris, and A.A.P.B., Brussels.